Degas

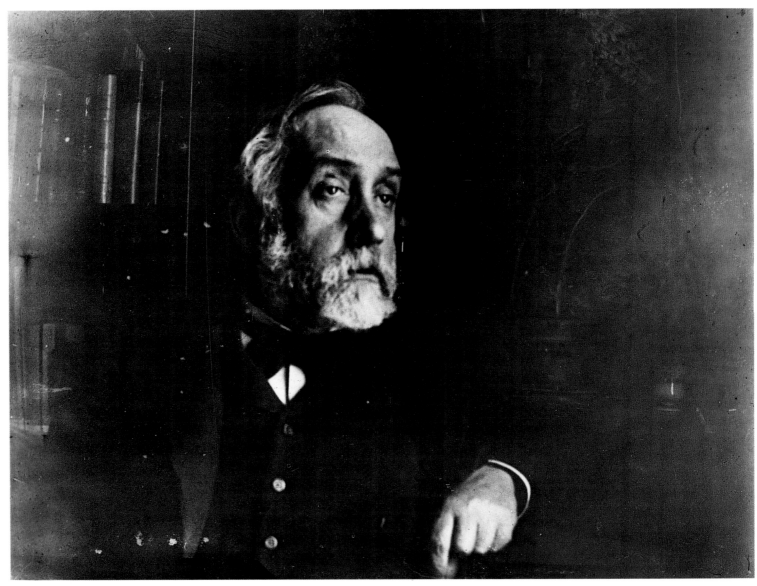

Attributed to René de Gas, *Degas in front of His Library* (T38), c. 1900. Bibliothèque Nationale, Paris

Degas

Jean Sutherland Boggs

Douglas W. Druick
Henri Loyrette
Michael Pantazzi
Gary Tinterow

Galeries Nationales du Grand Palais, Paris
9 February–16 May 1988

National Gallery of Canada, Ottawa
16 June–28 August 1988

The Metropolitan Museum of Art, New York
27 September 1988–8 January 1989

The Metropolitan Museum of Art, New York
National Gallery of Canada, Ottawa

Published in conjunction with the exhibition *Degas*, organized by the Réunion des Musées Nationaux/Musée d'Orsay, Paris, the National Gallery of Canada, Ottawa, and The Metropolitan Museum of Art, New York.

Published by The Metropolitan Museum of Art, New York, and the National Gallery of Canada, Ottawa.
John P. O'Neill, Editor in Chief, The Metropolitan Museum of Art
Serge Thériault, Chief, Publications Division, National Gallery of Canada
Emily Walter, Coordinating Editor
Usher Caplan and Norman Dahl, Editors
Colleen Evans, Photograph Editor
Bruce Campbell and Bruno Pfäffli, Designers
Gwen Roginsky, Production Manager

Translation of Chapter I, and quoted material, by the National Gallery of Canada, Ottawa.

Library of Congress Cataloging-in-Publication Data

Degas, Edgar, 1834–1917.
 Degas: [an exhibition held at the] Galeries Nationales du Grand Palais, Paris,
9 February–16 May 1988, the National Gallery of Canada, Ottawa, 16 June–
28 August 1988, The Metropolitan Museum of Art, New York, 27 September 1988–
8 January 1989/Jean Sutherland Boggs . . . [et al.].
 p. cm.
 Bibliography: p.
 Includes index.
 ISBN 0–87099–519–7 ISBN 0–87099–520–0 (pbk.)
 1. Degas, Edgar, 1834–1917—Exhibitions. I. Boggs, Jean Sutherland.
II. Galeries Nationales du Grand Palais (France). III. National Gallery of Canada.
IV. Metropolitan Museum of Art (New York, N.Y.) V. Title.
N6853.D33A4 1988
709'.2'4–DC19 88–12066 CIP

ISBN 0–88884–581–2 (National Gallery of Canada)

© Éditions de la Réunion des Musées Nationaux, Paris, 1988
© National Gallery of Canada for the Corporation of the National Museums of
Canada, Ottawa, 1988
© The Metropolitan Museum of Art, New York, 1988

Type set in Bembo by Columbia Publishing Company, Inc., Baltimore, Maryland
Printed on Nivis Demi Matte 125 gram
Color separations by Digamma, Paris
Printed and bound in Verona, Italy, by Arnoldo Mondadori Editore S.p.A.

On the jacket/cover: *At the Races in the Countryside* (cat. no. 95), detail.
Museum of Fine Arts, Boston

This exhibition is made possible by United Technologies Corporation

In the ten years since United Technologies first became a major supporter of the arts, we have sponsored a wide variety of painting, drawing, sculpture, and photography exhibitions. Some of these have been hugely popular. Some have attracted smaller audiences, but have been impressive for critics and art historians.

With this survey of the works of Edgar Degas, we are happy to be the sponsors of an exhibition we know will be both enormously important artistically and an unprecedented hit with the general public.

We hope *Degas* brings much pleasure to everyone who visits it.

Robert F. Daniell
Chairman and Chief Executive Officer
United Technologies Corporation

Curators of the Exhibition

Jean Sutherland Boggs
Chairman of the Scientific Committee
and General Editor of the Catalogue

Henri Loyrette
Musée d'Orsay, Paris

Michael Pantazzi
National Gallery of Canada, Ottawa

Gary Tinterow
The Metropolitan Museum of Art, New York

with the participation of

Douglas W. Druick
The Art Institute of Chicago

and with the assistance of

Anne M. P. Norton
The Metropolitan Museum of Art,
New York

Anne Roquebert
Musée d'Orsay, Paris

John F. M. Stewart
National Gallery of Canada, Ottawa

Contents

Lenders to the Exhibition

Public Institutions

ARGENTINA
Buenos Aires Museo Nacional de Bellas Artes, 202

CANADA
Ottawa National Gallery of Canada, 13, 18, 72, 147, 176a, 179, 185, 192, 296, 353, 374
Toronto The Art Gallery of Ontario, 338, 387

DENMARK
Copenhagen Den Kongelige Kobberstiksamling, Statens Museum for Kunst, 292
Ny Carlsberg Glyptotek, 355
Ordrupgaardsamlingen, 111

FRANCE
Gérardmer City of Gérardmer, 99
Paris Bibliothèque d'Art et d'Archéologie, Universités de Paris (Fondation Jacques Doucet), 14, 183, 186, 195
Bibliothèque Littéraire Jacques Doucet, 333
Bibliothèque Nationale, 176b, 178, 191, 207, 335, 357
Musée des Arts Décoratifs, 380
Cabinet des Dessins, Musée du Louvre (Orsay), 4, 21, 22, 23, 30, 31, 32, 33, 34, 35, 36, 37, 38, 41, 46, 47, 48, 49, 50, 51, 52, 53, 54, 55, 56, 57, 59, 62, 69, 91, 118, 119, 121, 126, 134, 137, 156, 169, 223, 246, 247, 252, 299, 365
Musée d'Orsay, 1, 15, 20, 29, 42, 45, 58, 68, 79, 80, 81, 92, 93, 97, 100, 102, 107, 112, 120, 123, 129, 142, 157, 160, 162, 163, 166, 172, 174, 190, 203, 226, 227, 231, 240, 241, 251, 257, 262, 265, 271, 273, 275, 276, 280, 281, 287, 290, 291, 309, 310, 311, 314, 318, 321, 322, 323, 332, 343, 347, 349, 350, 358, 372, 373, 379, 381, 384, 392
Musée du Petit Palais, 391
Musée Picasso, 170, 180, 181, 182, 184, 188
Pau Musée des Beaux-Arts, 115
Tours Musée des Beaux-Arts, 27

FEDERAL REPUBLIC OF GERMANY
Frankfurt Städtische Galerie im Städelschen Kunstinstitut, 98
Karlsruhe Kupferstichkabinett der Staatlichen Kunsthalle, 211
Munich Neue Pinakothek, 336
Stuttgart Staatsgalerie Stuttgart, 167, 302
Wuppertal Von der Heydt-Museum, 10

GREAT BRITAIN
Birmingham Birmingham City Museum and Art Gallery, 11
Edinburgh National Gallery of Scotland, 201, 362
Leicester Leicestershire Museums and Art Galleries, 356
Liverpool Walker Art Gallery, 325
London Trustees of the British Museum, 74, 164, 245, 300
The Trustees of the National Gallery, 40, 344
Victoria and Albert Museum, 104, 105, 159
Oxford Ashmolean Museum, 238

JAPAN
Kitakyushu Kitakyushu Municipal Museum of Art, 82

THE NETHERLANDS
Rotterdam Museum Boymans-van Beuningen, 279, 282

NORWAY
Oslo Nasjonalgalleriet, 345

PORTUGAL
Lisbon Calouste Gulbenkian Museum, 44

SWITZERLAND
Basel Oeffentliche Kunstsammlung, Kunstmuseum Basel, 351
Lausanne Musée Cantonal des Beaux-Arts, 389
Zurich E. G. Bührle Foundation Collection, 361

Foreword

As early as 1983, there were rumblings in the art world that it was time to organize a retrospective exhibition of the work of Edgar Degas. The following year, the 150th anniversary of the artist's birth, there was some criticism that the event had not been fully acknowledged in Paris. However, for that year, an unusual number of small and highly focused exhibitions of Degas's work had been planned—on his prints (*Edgar Degas: The Painter as Printmaker*, by the Museum of Fine Arts in Boston), on Degas and Italy (*Degas e l'Italia*, at the Villa Medici in Rome), on the great riches in the works of Degas at The Art Institute of Chicago (*Degas in The Art Institute of Chicago*), on the artist's development of certain themes in the dance (*Degas: The Dancers*, by the National Gallery of Art in Washington, D.C.), and on his pastels, oil sketches, and drawings (*Edgar Degas: Pastelle, Ölskizzen, Zeichnungen*, by the Kunsthalle Tübingen). These were to be followed in 1987 by *The Private Degas* at the Whitworth Art Gallery at the University of Manchester. The publication in 1984 of the first serious biography of the artist (*Degas: His Life, Times, and Work*, by Roy McMullen) as well as the catalogues of these exhibitions were clearly preparing the way for the first major retrospective exhibition of the work of the artist in fifty years.

In 1983, the Réunion des Musées Nationaux, the National Gallery of Canada, and The Metropolitan Museum of Art, under the directorship, respectively, of Hubert Landais, Joseph Martin, and Philippe de Montebello, decided to collaborate on this retrospective exhibition. A Scientific Committee was formed, composed of a curator from each of the three institutions, to make the selection of works and to write the catalogue: Henri Loyrette from the Musée d'Orsay, Gary Tinterow from the Metropolitan Museum, and Douglas W. Druick from the National Gallery of Canada, to be replaced by Michael Pantazzi when Mr. Druick went to The Art Institute of Chicago in 1985. Jean Sutherland Boggs, esteemed Degas scholar, then chairman of the Canada Museums Construction Corporation, was appointed chairman of the committee.

It was decided that the exhibition should follow the pattern of the 1983 exhibition of the work of Manet on which both the Réunion and the Metropolitan collaborated, though it soon became evident that there would be many more (and much smaller) works in any single location of the Degas exhibition and that, because so many works are on paper, the exhibition would have to vary from one location to another. In the end, however, we have provided a comparable selection for each of the three venues, and the catalogue includes commentaries on each exhibited work.

In the organization of such an ambitious project there are inevitable disappointments. The small early portraits of Bonnat and his brother-in-law Mélida could not be borrowed from the Musée Bonnat in Bayonne. The severe portrait of Mme Gaujelin from the Isabella Stewart Gardner Museum in Boston, the spirited *Rehearsals* in the Frick Collection in New York and the Burrell Collection in Glasgow, and the dazzling pastel *Two Dancers in Yellow and Pink* in Buenos Aires could not be lent because of the bequests of their donors. Similarly, policies established by two great Degas collectors, Norton Simon and Paul Mellon, have precluded their collaboration. In other instances the fragility of the works—most sadly, Cleveland's great *Frieze of Dancers*, for example—prevented them from traveling.

We must emphasize, however, the great generosity and noble contribution to public knowledge and enjoyment of those who do lend works of art to exhibitions. This is particularly true of private collectors who give up what often may be their most precious possessions for a very long period of time. Although we will express our thanks to them individually, we should like in the more permanent form of this catalogue to

express our gratitude now in assessing the contributions of the lenders. It seems particularly appropriate to thank those who have lent three works or more to all three sites of the exhibition. This honor roll includes: the Museum of Fine Arts, Boston; the Brooklyn Museum; The Art Institute of Chicago; the Victoria and Albert Museum, London; the Philadelphia Museum of Art; and the Sterling and Francine Clark Art Institute, Williamstown. There are also three private collectors in Switzerland who have lent at least three works—Baron H. H. Thyssen-Bornemisza and two anonymous lenders. But we must also acknowledge our delight in individual loans such as the magnificent *Portraits in an Office (New Orleans)* (cat. no. 115) from the Musée des Beaux-Arts in Pau, or *M. and Mme Édouard Manet* (cat. no. 82) from the Kitakyushu Municipal Museum of Art, which has never been seen in North America and has not been seen in Europe since 1924.

Among the generous lenders are very naturally the collaborating institutions. The Musée d'Orsay is lending fourteen paintings to the three venues, having freely allowed the committee to make this selection when condition was not at issue. This group of loans includes three of Degas's great early works, *The Bellelli Family* (cat. no. 20), *Semiramis Building Babylon* (cat. no. 29), and *Scene of War in the Middle Ages* (cat. no. 45), the latter two of which are traveling to North America for the first time. The Metropolitan Museum is lending fifteen paintings, including the beloved *Woman Leaning near a Vase of Flowers* (cat. no. 60), and *The Dance Class* (cat. no. 130), recently bequeathed to the museum by Mrs. Harry Payne Bingham. In lending these works, we have been conscious of the importance of those collectors who bought the work of Degas during his lifetime and eventually gave them to our museums. At the Louvre, we recall especially Comte Isaac de Camondo, who gave the museum eleven paintings, nine pastels, one drawing, and three monotypes, and Gustave Caillebotte, who bequeathed seven pastels. The gift of Louisine Havemeyer in her husband's name to the Metropolitan Museum was even richer: fourteen paintings, eleven pastels, ten drawings, four prints, and fifty-nine bronzes. Even then there were many other works by Degas that remained to be given to her children. It is estimated that 66 of the 392 works in this exhibition were once owned by Mrs. Havemeyer.

It has been a great pleasure to put this exhibition together, and the capable leadership Jean Sutherland Boggs has brought to the project has made it more agreeable still. The tireless devotion with which she, Henri Loyrette, Michael Pantazzi, and Gary Tinterow have pursued the study of Degas over the past five years has transformed our knowledge of the life and work of this great artist.

An exhibition of this scale cannot be mounted without financial support. We are grateful to United Technologies Corporation for its generous grant to the exhibition. Air Canada is providing transportation for works of art and couriers from Paris to Ottawa. In addition, insurance in Canada has been provided by Communications Canada through the Insurance Program for Traveling Exhibitions; at The Metropolitan Museum of Art, it has the support of the U.S. Government Indemnity Program. Additional funding has been provided by the National Endowment for the Arts.

We expect that this exhibition and catalogue will finally pierce the obscurity that has veiled the legacy of Edgar Degas. Enigmatic, he wanted to be "illustrious but unknown." Now, through the generosity of many lenders, he shall be not only renowned but better understood.

Philippe de Montebello
Director
The Metropolitan Museum
of Art

Shirley L. Thomson
Director
National Gallery of
Canada

Olivier Chevrillon
Director
Les Musées de France

Acknowledgments

The organization of the first large retrospective exhibition of the work of Edgar Degas in more than fifty years has been an international undertaking requiring the collaboration of an incalculable number of colleagues. More than 70 institutions and 90 private collectors from 13 countries have agreed to participate in generously lending the works in their possession. Other institutions—museums, universities, libraries, archives, government agencies, dealers, and auction houses—along with many other colleagues and friends, have contributed to the success of this enterprise. To all we should like to express our deepest gratitude. We heartily acknowledge, in addition, those who have guided, with resourcefulness and discretion, our search for often very elusive works; those who have negotiated and expedited loans on our behalf when time was of the essence; and those who have shared with us their personal knowledge of Degas and his contemporaries, critics, and patrons. Many of them are named on pages 18 and 19.

Like all scholars working on Impressionism, we are particularly indebted to the Durand-Ruel archives in Paris, to Mme Charles Durand-Ruel, and to Mme Caroline Durand-Ruel Godfroy, who permitted Henri Loyrette and Anne Roquebert of the Musée d'Orsay to work there weekly, with the kind assistance of Mlle France Daguet, in the interest of all of us collaborating on the exhibition and the catalogue. In a spirit of great collegiality Charles S. Moffett, now of the National Gallery of Art in Washington, D.C., and Ruth Berson, of the Fine Arts Museums of San Francisco, provided us with reviews and lists of reviews of the Impressionist exhibitions that were more extensive than they were able to publish in the catalogue of the 1986 exhibition in Washington and San Francisco, *The New Painting: Impressionism 1874–1881*.

Highly important in justifying the loans to the exhibition is our provision in the catalogue of new information about the physical condition of the works and about Degas's techniques and approach. In this, we were given invaluable help by the conservation and research staffs of the three collaborating institutions. In particular, we have benefited from the valuable advice of Charles de Couessin of the Laboratoire de Recherche des Musées de France, Gisela Helmkampf and Marjorie Shelley of The Metropolitan Museum of Art, and Anne Maheux and Peter Zegers, who, for the National Gallery of Canada, have studied a large number of pastels. Often the lenders—such as the Kunstmuseum Basel, the Sterling and Francine Clark Art Institute, the Smith College Museum of Art, or the Philadelphia Museum of Art—were particularly generous in providing information acquired through X-radiographs of their works, undertaken at our request.

This exhibition would never have taken place without the goodwill and devoted support of the directors and staff of the three collaborating institutions. In Paris, we express our thanks to Olivier Chevrillon, Director of the Musées de France, and to his predecessor, Hubert Landais; Françoise Cachin, Director of the Musée d'Orsay, and her predecessor, Michel Laclotte; Irène Bizot, Deputy Administrator of the Réunion des Musées Nationaux; Claire Filhos-Petit, Chief of the Exhibitions Division, and Catherine Chagneau, Administrative Officer of the Division. In Ottawa, we thank Shirley L. Thomson, Director of the National Gallery of Canada, and her predecessor, Joseph Martin, who suggested the exhibition originally; Gyde V. Shepherd, Assistant Director, Public Programs; Margaret Dryden, Chief of the Exhibitions Division; Catherine Sage, Coordinator of Ottawa Exhibitions, and her collaborator, Jacques Naud. In New York, we thank Philippe de Montebello, Director of The Metropolitan Museum of Art; Mahrukh Tarapor, Assistant Director; Emily K. Rafferty, Vice President for Development; Everett Fahy, Chairman of the Department of European Paintings, and his predecessor, Sir John Pope-Hennessy.

This catalogue, the result of a collaborative effort, has been realized under the supervision of Jean Sutherland Boggs, general editor. The National Gallery of Canada assumed the great responsibility of editing and translating the catalogue texts in English and French. This was done in its bilingual Publications Division under Serge Thériault, who also edited the French manuscript with Hélène Papineau. Usher Caplan and Norman Dahl have been responsible for the editing of the English manuscript, bringing it to a remarkable level of completion in a very short time. At peak periods, the Division was assisted by editors Monique Lacroix and André La Rose. Translations were provided by the Secretary of State Department of Canada, whose translators over many months made the subject of Degas a minor specialty. The quality of the more than 730 photographs illustrating this catalogue is due to the expertise and patience of the National Gallery's indefatigable photograph editor, Colleen Evans, who was assisted by Degas student Lori Pauli. Everyone in the Gallery's Publications Division worked with a high degree of professionalism and dedication to prepare the material for publication both in Paris and New York.

In Paris, Uté Collinet, Nathalie Michel, Bruno Pfäffli, and Claude Blanchard have shown imagination, skill, and determination in producing the catalogue in record time. In New York, we are extremely grateful for the good offices of John P. O'Neill and Barbara Burn, of the Metropolitan's Editorial Department. Emily Walter, coordinating editor of the catalogue, worked closely with designer Bruce Campbell and Production Manager Gwen Roginsky in the exacting task of producing the English edition. To them, we owe the present handsome volume. We should also like to thank Walter Yee, Chief Photographer, and Karen L. Willis for taking such remarkable photographs of works by Degas in the collection of the Metropolitan Museum.

There are some who have worked particularly intimately on the project and who should be given special thanks. In Paris, Henri Loyrette had the collaboration of Anne Roquebert, who energetically and enthusiastically hunted and found original archival material, not only at Durand-Ruel but in other archives and in libraries, auction houses, autograph and rare book shops, and the collections of descendants of the friends and family of Degas. Both he and she benefited from the invaluable archival research of Caroline Larroche and the assistance of Didier Fougerat. The discoveries of this French team were put at the disposal of all of us working on the exhibition. In Ottawa, John F. M. Stewart acted as a disseminator of information to all three participating institutions and produced the first draft of the chronology, which was later revised and divided into four (one for each section). He also made a contribution to all three institutions in giving advice on the use of computers and other technology in research. Gary Tinterow in New York had the great advantage of working with Anne M. P. Norton, who tirelessly hunted sales catalogues, sought out elusive periodical and newspaper articles, discovered material which she shared with both Ottawa and Paris, and devoted her keen eye and intellect to solving research problems. Susan Alyson Stein devoted her remarkable gifts for research to the project, in particular to the histories of the works in the exhibition and Degas's interaction with the artistic community in Paris in the 1880s. Lucy Oakley diligently catalogued the works by Degas in the Metropolitan's collection, and Perrin Stein, through her research, contributed to the accuracy of the catalogue entries. There was a very gratifying sense of collaboration in the three institutions—working together from Paris, Ottawa, and New York—to understand the enigmatic figure of Degas.

Our indebtedness to the scholars of the past and present is repeatedly acknowledged in our footnotes, the bibliography, and the apparatuses for the catalogue entries. Nevertheless, we should like to single out the late Jean Adhémar, who will not see this exhibition in which he expressed such a great interest.

There are moments when we can with some envy project ourselves back to an event in the life of Max Beerbohm, which he described:

> And of all the great men whom I have merely seen the one who impressed me most was Degas. Some forty years ago I was passing, with a friend, through the Place Pigalle; and he, pointing up his stick to a very tall building, pointing up to an

open window *au cinquième*—or was it *sixième*? said, "There's Degas." And there, in the distance, were the head and shoulders of a gray-bearded man in a red beret, leaning across the sill. There Degas was, and behind him, in there, was his studio; and behind him, there in his old age, was his lifework; and with unaging eyes he was, I felt sure, taking notes of "values" and what not of the populous scene down below, regretting perhaps (for he had never cast his net wide) the absence of any ballet dancers, or jockeys, or laundry girls, or women sponging themselves in hip baths; but deeply, but passionately observing. There he was, is, and will always be for me, framed.[1]

We hope this catalogue is another window to Degas.

Members of the Scientific Committee

We wish to express our gratitude to all those who assisted us in our work, and, in particular, the following:

William Acquavella; Henry Adams; Hélène Adhémar; Götz Adriani; Maryan Ainsworth; Eve Alonso; Richard Alway; Daniel Amadei; Frau Hortense Anda-Bührle; the Baroness Ansiaux; Irina Antonova; Mme Aribillaga; Marie-Claire d'Armagnac; Françoise Autrand; Manfred Bachmann; Roseline Bacou; Katherine B. Baetjer; Colin B. Bailey; Patricia Balfour; Anika Barbarigos; Armelle Barré; Isabelle Battez; Guy Bauman; Jacob Bean; Kay Bearman; Laure Beaumont; W. A. L. Beeren; Knut Berg; Christian Bérubé; Peter Beye; Ernst Beyeler; Erika Billeter; Béatrice de Boisséson; Suzanne Boorsch; Robert Bordaz; J. E. von Borries; Michael Botwinick; Edgar Peters Bowron; Jacques Bouffier; P. J. Boylan; Philippe Brame; John Brealey; Claude Bréguet; Richard R. Brettell; Barbara Bridgers; David Brooke; Harry Brooks; Calvin Brown; J. Carter Brown; Yvonne Brunhammer; John Buchanan; Robert T. Buck; Christopher Burge; James D. Burke; Thérèse Burollet; Marigene Butler; James Byrnes; Jean and Marie-Annick Cadoux; Bianca Calabresi; Evelyne Cantarel-Besson; Victor I. Carlson; Laura Catalano; Mme Chagnaud-Forain; François Chapon; Christine Chardon; Jean-Louis Chavanne; Alison Cherniuk; André Citroën; Michael Clarke; Timothy Clifford; Denys Cochin; Patrick F. Coman; Isabelle Compin; Philippe Comte; Philip Conisbee; Philippe Contamine; Jean Coudane; Karen Crenshaw; Marie-Laure Crosnier-Leconte; Deanna D. Cross; Pierre Cuny; Roger Curtis; Jeffrey Daly; Jean-Patrice Dauberville; Lyliane Degrâces; M. and Mme Devade; Pierre Dieterle; Michael Diamond; Bruce Dietrich; Robert Dirand; Anne Distel; Peter Donhauser; Susan Douglas-Drinkwater; Ann Dumas; Claire Durand-Ruel; Peter Eikemeier; Denise Faïfe; Sarah Faunce; Sabine Fehlemann; Marianne Feilchenfeldt; Walter Feilchenfeldt; Norris Ferguson; Alan Fern; Rafael Fernandez; Maria Theresa Gomes Ferreira; Hanne Finsen; Eric Fischer; F. J. Fisher; M. Roy Fisher; Jan Fontein; Jacques Foucart; Elisabeth Foucart-Walter; José-Augusto França; Claire Frèches; Alice C. Frelinghuysen; Gloria Gaines; John R. Gaines; Dr. Klaus Gallwitz; Christian Garoscio; Dr. Ulrike Gauss; Elisabeth Gautier-Desvaux; Denise Gazier; Christian Geelhaar; Pierre Georgel; Susan Ginsberg; Catherine Goguel-Monbeig; Nicholas Goldschmidt; Carrolle Goyette; Anne Grace; MacGregor Grant; Mlle Greuet; Michael Gribbon; Philippe Grunchec; M. and Mme Guy-Loë; Jean-Pierre Halévy; Maria Hambourg; Eve Hampson; Anne Coffin Hanson; Kathleen Harleman; Anne d'Harnoncourt; Françoise Heilbrun; Jacqueline Henry; Karen Herring; Sinclair Hitchings; Meva Hockley; Allison Hodge; Joseph Holbach; Grant Holcomb; Ay-Whang Hsia; Jacqueline Hunter; John Ittmann; Colta Feller Ives; Eugenia Parry Janis; Flemming Johansen; Moira Johnson; Betsy B. Jones; Jean-Jacques Journet; Martine Kahane; Diana Kaplan; Yousuf Karsh; C. M. Kauffmann; Richard Kendall; George Keyes; David Kiehl; Penny Knowles; Eberhard Kornfeld; Susan Krane; Lisa Kurzner; André Labarrère; Pauline Labelle; Craig Laberge; Geneviève Lacambre; Jean-Paul Lafond; Marie de La Martinière; Bernardo Lanaido;

1. S. N. Behrman, *Portrait of Max: An Intimate Memoir of Sir Max Beerbohm*, New York: Random House, 1960, p. 133.

Guide to the Use of the Catalogue

General Organization of the Catalogue

The catalogue is divided chronologically into four parts: I (1853–1873), II (1873–1881), III (1881–1890), and IV (1890–1912), each written by a member, or members, of the Scientific Committee for the exhibition. When one author has contributed a catalogue entry in another author's section, his or her initials appear at the end of the entry. Each section includes an essay, a chronology, and catalogue entries. Occasionally, two or more catalogued works are discussed under one entry.

Form of the Catalogue Entries

Titles: Although Degas would occasionally, for public exhibition, provide ambitious titles for his works—for example, *Scene of War in the Middle Ages* (cat. no. 45), when it was shown at the Salon of 1865, or *Spartan Girls Challenging the Boys* (also called *Young Spartans*; cat. no. 40), when he proposed to exhibit it in the Impressionist exhibition of 1880—he seemed on the whole indifferent to titles, perhaps because he exhibited and published his works so rarely. He did give them nicknames, as when he spoke of "mon tableau de genre" (my genre picture) instead of *Interior* (also called *The Rape*; cat. no. 84). Sometimes he wrote of his "Coton" (cotton) in letters of 1876, or of his "Cotonniers" (cotton workers), as when he objected to the loan to an exhibition at the Grand Palais in 1900, of what in the Impressionist exhibition of 1876 he had called *Portraits in an Office (New Orleans)* (cat. no. 115). When his pictures were sold to Durand-Ruel or stored or exhibited by the dealer, they were given descriptive titles, often carelessly applied. This is also true of the titles given in the inventory of the contents of Degas's studio after his death, which were produced under great pressure but have become standard usage, accepted for the most part by Paul-André Lemoisne in his catalogue raisonné of the artist's work. Often the titles are insufficiently precise; many are even misleading. In defense of those who bestowed these titles, one must acknowledge that Degas constantly repeated certain themes so that duplications are inevitable. He might have been happier, as are certain twentieth-century artists, with only numbers.

Every attempt has been made to use the artist's own title for a work when it is known, or a title used by his contemporaries. Titles in the atelier sales, in Lemoisne's catalogue raisonné, and in literature since the death of the artist have also been considered. The title used for each work represents an effort to be as precise as possible, while still respecting traditional usage. When a title has been changed, the conventional title, if it is well known, is also given. Variations in titles under which works have been exhibited, published, bought, or sold, are provided, between quotation marks, under the headings *Provenance*, *Exhibitions*, and *Selected References*.

Dates: Degas dated very few works—less than five per cent of the approximately 1,500 paintings and pastels in Lemoisne's catalogue raisonné. Even when he did inscribe dates, he often did it sometime later—and occasionally inaccurately—as Theodore Reff has demonstrated for the drawings from the mid-1850s. He dated some drawings "Florence 1857," for example, though family correspondence reveals that he went to Florence for the first time in 1858 (see Reff 1963, pp. 250–51). There is also very little additional supporting documentation for dating because he exhibited his works rarely and they were seldom published during his lifetime. As a result, the authors of this catalogue have made a particular effort to uncover information—such as the records of purchases from the artist by his dealer, Paul Durand-Ruel—that could help to date the works more precisely.

Medium and support: Degas was an experimenter; he tried many unconventional combinations of mediums and supports. This has made it difficult to ascertain the exact materials used. Whenever possible, the advice of conservators has been sought, though because of the varied provenances of the works, this could not be done systematically.

Dimensions: Dimensions in most instances have been provided by the lender. They are given in inches and centimeters, height preceding width.

Inscriptions: Inscriptions are given when the work is signed, dated, or otherwise inscribed by the artist.

Stamps: Vente and atelier stamps are recorded, indicating their location on the work. The Vente stamp (Frits Lugt, *Les marques de collections de dessins et d'estampes*, Amsterdam: Drukkerijn, 1921, p. 117, no. 658) imitates the Degas signature and is normally printed in red; any departures in color are identified. The Vente stamp was used on most of the works sold in the atelier sales (see Ventes I–IV below). The atelier stamp (Lugt, op. cit., p. 117, no. 657), "Atelier Ed. Degas" within an oval, was printed in black on the works in the artist's studio after his death.

Venues: Unless otherwise indicated, the work reproduced in the catalogue is being exhibited at all three venues: Paris, Ottawa, and New York.

Standard catalogue numbers: Following the identifying information for each work and preceding the catalogue entry, the num-

ber in the standard catalogue that includes the work (Lemoisne, Rewald, etc.) or the Vente catalogue number is given. See abbreviations above.

Provenance: Although every effort has been made to trace the history of each work, there are inevitable breaks in knowledge; such breaks are identified by periods. A semicolon indicates a direct transfer in the provenance.

Exhibitions: Exhibitions are cited either in abbreviated form or in full depending on the frequency of citation, giving the date and the city in which the exhibition has taken place.

Selected references: An effort has been made to select only those bibliographical references that have added to the knowledge or understanding of the catalogued work. Frequently cited sources have been keyed to a list of abbreviations for selected references (p. 614). For works in the collections of the Musée du Luxembourg, the Musée du Louvre, and the Musée d'Orsay, only the first and last editions of the catalogue have been cited.

Citations of reproductions: When all works cited are reproduced in a catalogue or monograph, such as Lemoisne, no indication of reproduction is given. When a publication does *not* reproduce all works, a reproduction is indicated by the abbreviation pl., fig., or repr.

Degas's notebooks: References to Degas's notebooks are cited as they are given in Theodore Reff's catalogue (*The Notebooks of Edgar Degas*, New York: Hacker Art Books, 1985), providing in parentheses the inventory number of the notebook owner— for example, Reff 1985, Notebook 18 (BN, Carnet 1, p. 21).

Location of works: The authors have endeavored to indicate the location of works not included in the exhibition. When the title of a work is followed only by an identifying number from a catalogue raisonné, the location of that work is not known.

Translations: Published translations have been used where possible, and where appropriate. When no source is given, the translation has been provided by the authors and editors. In some instances, for reasons of accuracy and style, published translations have been revised for this catalogue and are indicated as such.

Orthography of the Degas Surname: Degas, De Gas, or de Gas?
The painter's grandfather, Hilaire Degas, was born in Orléans and spent most of his life in Naples. The spelling Degas, without the particle, is used on his birth certificate and on his tomb, and his Italian children followed the same form. This spelling is therefore used in the catalogue in referring to the Italian members of the family. The exception is the painter's father, Auguste, who began to use the particle—thus, De Gas—when he moved to Paris. The painter, like his brothers and sisters, also used De Gas—for example, in the Salon exhibitions of the 1860s—but by the time of the Impressionist exhibition of 1874,

he had changed the spelling to Degas. The other members of the family in France continued to use De Gas, but the painter's brother René, by 1901, when he had received the Legion of Honor, changed the form to de Gas. Thus, in the catalogue, Degas is used for the artist and for the Italian members of the family, De Gas for the French members of the family, and de Gas for René and his children after 1900.

Abbreviations
Short forms for the most frequently used bibliographical and exhibition references are to be found in the *Key to Abbreviations* (pp. 611–20). In addition, the following abbreviations are used:

BN	Bibliothèque Nationale, Paris (abbreviated only in citations of Degas's notebooks)
BR Brame and Reff	Philippe Brame and Theodore Reff, *Degas et son oeuvre: A Supplement*, New York: Garland Press, 1984
D Delteil	Loys Delteil, *Edgar Degas*, Le peintre-graveur illustré, IX, Paris: privately printed, 1919
J Janis	Eugenia Parry Janis, *Degas Monotypes*, Cambridge, Mass.: Fogg Art Museum, 1968
A or C Adhémar or Cachin	Jean Adhémar and Françoise Cachin, *Degas: The Complete Etchings, Lithographs and Monotypes*, New York: Viking Press, 1974
L Lemoisne	Paul-André Lemoisne, *Degas et son oeuvre*, 4 vols., Paris: Paul Brame and C. M. de Hauke, Arts et Métiers graphiques, [1946–49]
R Rewald	John Rewald, *Degas: Sculpture*, New York: Abrams, 1956
RS Reed and Shapiro	Sue Welsh Reed and Barbara Stern Shapiro, *Edgar Degas: The Painter as Printmaker*, Boston: Museum of Fine Arts, 1984
T Terrasse	Antoine Terrasse, *Degas et la photographie*, Paris: Denoël, 1983
I: Vente I:	*Vente Atelier Degas* (first Degas atelier sale), Galerie Georges Petit, Paris, 6–8 May 1918
II: Vente II:	*Vente Atelier Degas* (second Degas atelier sale), Galerie Georges Petit, Paris, 11–13 December 1918
III: Vente III:	*Vente Atelier Degas* (third Degas atelier sale), Galerie Georges Petit, Paris, 7–9 April 1919
IV: Vente IV:	*Vente Atelier Degas* (fourth Degas atelier sale), Galerie Georges Petit, Paris, 2–4 July 1919

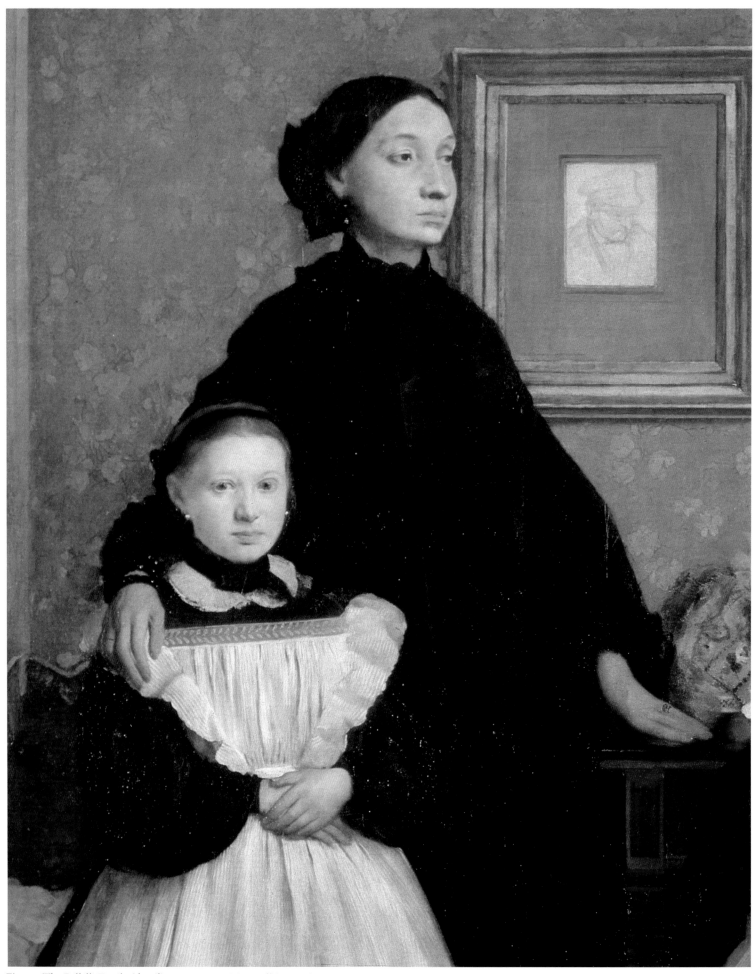

Fig. 1. *The Bellelli Family* (detail), cat. no. 20. Musée d'Orsay, Paris

Degas and Equilibrium

JEAN SUTHERLAND BOGGS

The longer one reflects on the work of Edgar Degas, the more elusive it seems. But some key to the work, if not necessarily to the man, may be found in his fascination with equilibrium. Whether it was in the dizzy heights reached by Mlle La La in the Cirque Fernando,[1] or the efforts of young dancers at the exercise barre,[2] he was attracted by the relationship of man to the earth, sometimes challenging gravity, sometimes reconciled with it. As the poet Paul Valéry observed in his perceptive writings about the artist, whom he knew quite well, Degas more than any other artist gave floors—the symbol of the earth on which balance was achieved—an important role in many of his works.[3]

It is difficult to know about Degas's personal sense of equilibrium. Theodore Reff has written so incisively about Degas in relation to Whistler in a chapter entitled "The Butterfly and the Old Ox" that, since we know Whistler used a butterfly as his monogram, we are apt to think of Degas as a heavy four-footed mammal.[4] This seems stamped even more indelibly on our memories when we read a letter of 15 July 1858 to Degas from his older friend the painter Joseph Tourny, to which Mme Tourny added a footnote, "In Rome we often complained about the little bear, but now we find ourselves regretting his absence." Tourny himself wrote, "We think constantly of the Degas who grumbles and of the Edgar who growls, and we are indeed going to miss that grumbling and growling during the coming winter."[5] As a result, we are inclined to think of Degas lumbering like the bear that Toulouse-Lautrec drew being led on a chain by Degas's old friend the bassoonist Désiré Dihau, who appears in *The Orchestra of the Opéra*.[6] But there is another side of the relationship of Degas to his body, Degas who in old age surprised his male friends and acquaintances by his lack of embarrassment about his nakedness when he dressed,[7] who would thank an Italian photographer for having used a passerby to conceal his furtive buttoning of his trousers as he left a urinal,[8] and, more significantly, who seemed to have enjoyed his body as a gifted mimic, even a clown. It was Valéry again who wrote about Degas's talents as a mime, which he attributed to the artist's Italian ancestry.[9] Others have described Degas performing the steps of a dance;[10] in photographs taken about 1900 outside the Château Ménil-Hubert in Normandy, we see him dancing, gesturing, and bowing with his younger friends Jacques Fourchy and his wife,[11] who had been born Hortense Valpinçon in 1862.[12] In 1912, when he was still walking obsessively, he told Daniel Halévy, after the sale of the paintings in the collection of his schoolfriend Henri Rouart (in which his

Dancers Practicing at the Barre[13] sold for the phenomenal sum of Fr 478,000), "You see, my legs are good. I walk well."[14] His own relationship to the earth, even in his advanced years, seems to have remained a happy one.

When Degas began to work, he undoubtedly had a strong affection for his family and a deep sense of pride in the relatives of his Neapolitan-born father. This seems crystallized in the great family portrait of his father's sister Laura Bellelli, her husband, and the Bellellis' two daughters Giulia and Giovanna, which he began during their exile in Florence from their native Naples.[15] Across the surface of the canvas he painted later in Paris, the hands of the Bellellis play like the hands of mimes to give an indication of the relative composure of each family member. The baron's hands are furtively folded in shadow. Those of Giulia in the center are cockily and awkwardly turned under her wrists at her waist. Giovanna's are shown sanctimoniously and, as Henri Loyrette suggests on the basis of hitherto unpublished letters, probably hypocritically folded, for she was an undisciplined child. And the mother places one gentle but controlling hand on her daughter's shoulder, while she gracefully uses the other to balance her pregnant body. Everywhere within the work equilibrium is sought, in spite of the tensions and shadows Degas suggests could be threatening the family.

The mother, Laura Degas Bellelli, stands out as the dominating figure. She represents the supreme ideal of balance, as a detail of the painting of her head and shoulders reveals (fig. 1). In her recent restoration of the picture, Sarah Walden has shown that Degas probably retouched the head in the 1890s, but he did so with exquisite discretion. We feel that the model's sense of poise must have been innate from the head that rises so proudly above the slender neck set upon sloping shoulders. Her eyebrows reinforce that suggestion of inner pride. Although there have been many speculations about the sources for Degas's conception of his aunt—including the works of Clouet, Holbein, Bronzino, and Ingres—he himself seems to have found the strongest echo of her in the painting of Paola Adorno by van Dyck in Genoa.[16] He saw that painting on his trip back to Paris after having spent several months with the Bellelli family in the fall and winter of 1858–59, making the studies that would lead to the family portrait. After seeing the van Dyck, he made a drawing from memory of its composition and wrote notes over three pages in one of his notebooks, now (thanks to his brother René) in the Bibliothèque Nationale

in Paris.[17] It seems as if he was responding to his sadness at leaving his beautiful aunt. He says of van Dyck's Genoese countess, "Artists no longer paint such a woman, with such a subtle and distinguished hand."[18] And wonders about van Dyck's relationship to her, as he must have questioned his own relationship to his aunt: "Was this the result of van Dyck's love for the Countess Brignole? Or, indeed, do I find the work charming even though there was no such feeling?" He answers himself almost immediately, "There was perhaps more than a natural fondness on the part of van Dyck."[19] He even thinks of her in terms of gravity, "purposeful and light as a bird,"[20] noting the ground, the rug, and the steps on which she stands. But it is the head, like that of Baroness Bellelli, that finally captivates him: "Her head," he writes, "in its grace and delicacy, is life itself,"[21] adding, at the top of another page, "Her head alone dominates all else."[22]

In *The Bellelli Family*, though a balance is achieved among the four principal actors, we are aware that they form a tableau against a background that is somewhat alien. We may not know that the baron, who would have his political fortunes restored with the Unification of Italy in 1860, had complained about the ignominy of living in Florence in "rented rooms."[23] We might guess that the baroness had grown up in an environment like the colossal Palazzo Pignatelli, with its portal by Sanfelice, near the Gesù Nuovo in Naples, a house acquired floor by floor by her adventurous father (a drawing of whom by Degas hangs on the wall behind her). Nevertheless, in the painting we feel something amiss in the door at the left opened into unknown space beyond an empty bassinet, or in the reflections in the mirror above the mantelpiece. But perhaps these reflections are evocative simply of the dreams and longings contained within what seemed to its inhabitants to be the prison of the conventional Bellelli drawing room in Florence.

When within the same decade Degas conceived another room as evocative as that in *The Bellelli Family*, it was for *Interior*,[24] in which all the earlier painting's proper posturing for a stable image before society is shattered (fig. 2). Although the drama has never been satisfactorily explained—which may have been as Degas intended—the painting is charged with emotion. Neither of the two characters—the woman crouching in her chair or the man leaning with his back against the door—displays any of the attributes of decorum. The room is conventional enough, so that the disorder of clothes thrown over the end of the bed or a corset fallen on the floor is conspicuous. Every detail seems to contribute to the intensity of the drama, a drama that cannot be solved. There is a floor here for Valéry's admiration, with red stripes leading dramatically back beside the narrow bed. The flowers on the wallpaper glow like the coals in the fireplace. The slender pedestal table shows Degas playing with equilibrium, particularly by not putting the kerosene lamp on the axis of the pedestal and appearing to support it by identifying it with the edge of the mantel and the gold mirror above it. Some soft white fabric spills tantalizingly over the open case. The beads are further evidence of the woman's provocative state of semidress. Finally, the mirrored image is even more illusive than the reflections in *The Bellelli Family*, sufficiently so

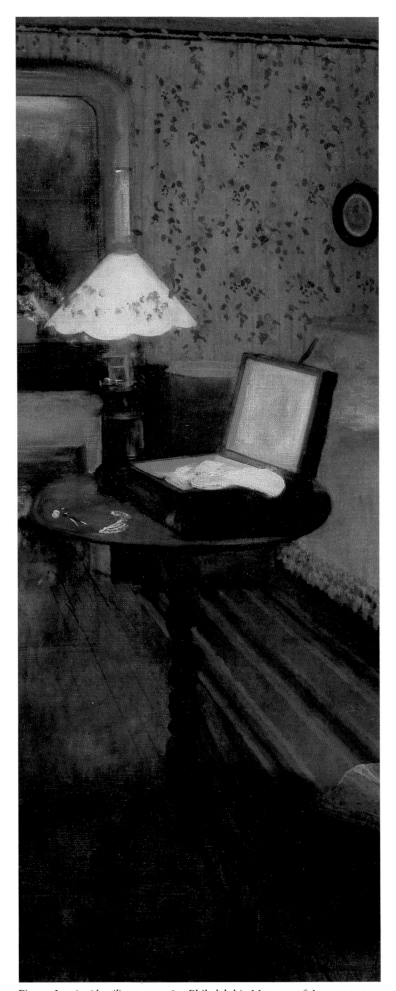

Fig. 2. *Interior* (detail), cat. no. 84. Philadelphia Museum of Art

24

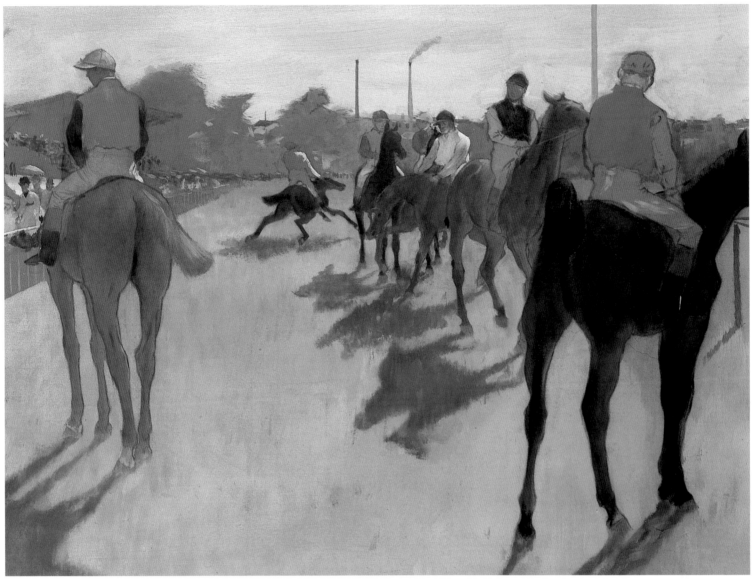

Fig. 3. *Racehorses before the Stands* (detail), cat. no. 68. Musée d'Orsay, Paris

that Sidney Geist has seen in it the "magical apparitional image" of the husband murdered by the guilty lovers in Zola's *Thérèse Raquin*, a novel some critics believe to be the source for the painting.[25] The result, particularly with the emotive light from the lamp, seems far removed from the apparently rational calm of *The Bellelli Family*.

The significance of the detail in figure 2 was recognized by Quentin Bell in the Charlton Lecture on the painting at the University of Newcastle upon Tyne in 1965:

> The central axis from which all the drawing grows is, surely, the pedestal table, the open box and the lamp. I cannot express my sense of the importance of this passage better than by saying that I can well imagine Degas feeling that if only he could get *that* part solidly stated the rest would fall into place. Everything, it seems to me, is governed by this central axis, the mirror balancing the shape of the bedstead, the strong horizontal that is broken by the top hat and the girl's head, which itself terminates a majestic series of curves made by her arm and her petticoat—note in passing that the arm

itself is a miracle of integrity—who but Degas would have dared to describe such inexplicable contours? From the same nexus the fringe of the counterpane, produced by the angle of the box, is itself integrated with the carpet and the floorboards. This, the vital element in the composition, is surely one of the great feats of painting of the nineteenth century.[26]

Degas painted only one *Interior*, and indeed seldom produced other works as saturated with dramatic power. At the same time, he was turning to subjects that could be seen in everyday Paris. One of these is *Racehorses before the Stands*, which he would not have painted at the racetrack but later in his studio from drawings and from memory (fig. 3).[27] Although it is conventionally believed that the work was painted at Longchamp, which has a similar wooden spectators' stand, Henri Loyrette points out (see cat. no. 68) that the stand is not exactly the same and that the source must have been another racetrack in Paris, such as the popular one at Saint-Ouen. Even as early as this, Degas was experimenting with his materials, as he would for the rest of his life. He used oil paints but blotted the

25

oil from them and thinned them with turpentine, applying this to paper; the medium has the dryness and delicacy of surface of an eggshell and is known as "essence," called "peinture à l'essence" by Degas. Although he made many drawings with essence on dark oil paper—such as *Four Studies of a Jockey* from the Art Institute of Chicago[28]—that show him seeking the most natural balancing of a jockey on a horse, in *Racehorses before the Stands* he toys with stability. Framed by two substantial horses and riders are other jockeys and their mounts that seem more spirited (if not necessarily unstable) because of the animated shadows they make on the ground and the complicated pattern of the horses' legs. And indeed, farthest from us are a horse and rider in exaggerated and improbable trouble, adding a certain dynamism to what otherwise would be a tranquil scene. On the other hand, the smokestacks of Paris in the distance are a reminder of the equilibrium that Degas, in spite of certain intentional dissonances, was trying to achieve.

It may have been before he went to New Orleans (where his mother had been born) for the winter of 1872–73 that Degas began his first version of *The Dance Class*, now in the Musée d'Orsay.[29] And it was almost certainly after his return that he completed it and the second version (recently bequeathed to the Metropolitan Museum),[30] which had been commissioned by the baritone Jean-Baptiste Faure in a complicated series of acquisitions from Degas that Michael Pantazzi has unraveled.[31] Dominating the composition (fig. 4) is the aging dancer Jules Perrot, who is conducting the class, though the nineteen young dancers and their chaperones seem largely indifferent to him. Even if in his very stillness Perrot is the antithesis of the dancers around him, Degas by no means suggests that he is impervious to change; his suit is baggy; his hair is thin; his position, as suggested by the strokes of paint, somewhat uncertain. Nevertheless, as he leans on a heavy stick (which seems a reminder of equilibrium like the edge of the frame in *The Bellelli Family*, the pedestal of the table in the *Interior*, and the smokestacks in *Racehorses before the Stands*), he is the pivot around which this world revolves.

Degas, who had begun to paint dancers not long before going to New Orleans, was now in the 1870s frequently devoting much of his time to the theme. On the one hand, he could be compassionate about the aging of a great dancer of the romantic period, Jules Perrot. On the other, he was infinitely touched by the efforts of dancers to give an illusion that they could flout the laws of gravity. He admired their efforts, which were often less successful than those of the young dancer performing an arabesque here for Perrot. They are placed, brilliantly, in opposition to each other—one defying the earth, the other with his stick seeking a securer relationship to it.

Perrot's stick is one of many that appear in Degas's work, always as symbols of the relationship of their bearer to the force of gravity.[32] Degas also used the umbrella—Mary Cassatt's, for example—in the same way.[33] Walking sticks were to become an obsession for him; he collected them compulsively, as he had once collected printed handkerchiefs and would later collect works of art.[34]

At the time Degas painted *The Dance Class*, he was entering the period of his life in which his own personal equilibrium was most threatened.[35] The year he reached forty, in 1874, his father died leaving his private bank facing bankruptcy, perhaps because of his own impracticality, perhaps because he had overextended its credit, lending money to his two other sons, Achille and René, for the business they were establishing in New Orleans. The painter had to assume a heavy financial obligation to clear the family name. His brother Achille, when he returned from New Orleans in 1875, was tried and subsequently served one month in jail for shooting (but not killing) the husband of his mistress. In 1876, the family was sued by the Banque d'Anvers for unpaid debts. Early in 1878 in New Orleans, René De Gas deserted his blind wife (and their first cousin), Estelle Musson De Gas, and eloped with her reader; it was fifteen years or so before the painter forgave him. Somewhat later that year, his sister Marguerite emigrated to Argentina with her architect husband, Henri Fevre, and he was never again to see this sister of whom he seemed particularly fond. Although these family events must have threatened Degas's sense of stability, there may have been compensations in the collegiality with which he worked with his fellow artists toward the series of Impressionist exhibitions starting in 1874, in his increasing reputation as an artist, and in some successes with sales, including his first to a museum—the museum at Pau. Although he did make some concessions to his financial instability in the small "articles" he produced, such as fans or drawings of dancers, his work was as valiant as were the efforts of his young dancers. An important part of that courage was to be found in his wit, which usually took the form of approaching a subject from an unexpected angle of vision.

Degas, like some of his colleagues—in particular the Braquemonds, Pissarro, and Mary Cassatt, who together planned to produce a review, *Le Jour et la Nuit*, to publish fine prints—saw in printmaking the possibility of a popular and even profitable art.[36] At the same time, his desire for experimentation pushed him forward, so that he made many variations on states of prints—for example, at the most extreme, twenty-two of the drypoint and aquatint *Leaving the Bath*, of about 1879.[37] One print that does exist in a single state, except for one variation and the pastel he made over it in 1885, is the lithograph *Mlle Bécat at the Café des Ambassadeurs* (fig. 5).[38] The fifteen impressions of the print that Reed and Shapiro were able to discover in preparing their important catalogue of his prints may not seem a large edition, but for Degas it was. Its subject also has a charm that would justify greater distribution. In considering Degas on the subject of equilibrium, it is the sky and the mirrored reflection at the left that interest us. Reed and Shapiro describe the lights felicitously: "It [the print] exhibits every form of natural and artificial lighting that could manifest itself in a nocturnal scene: a large gas lamppost, a cluster of gas globes, and a string of lights, seen at the right, are reflected, along with a prominent hanging chandelier, in the mirror at left behind the performer. In the dark sky, the moon shines through the trees of the Champs-Elysées, while fireworks send down streamers of light."[39] It is as if all these elements of light joyously celebrate

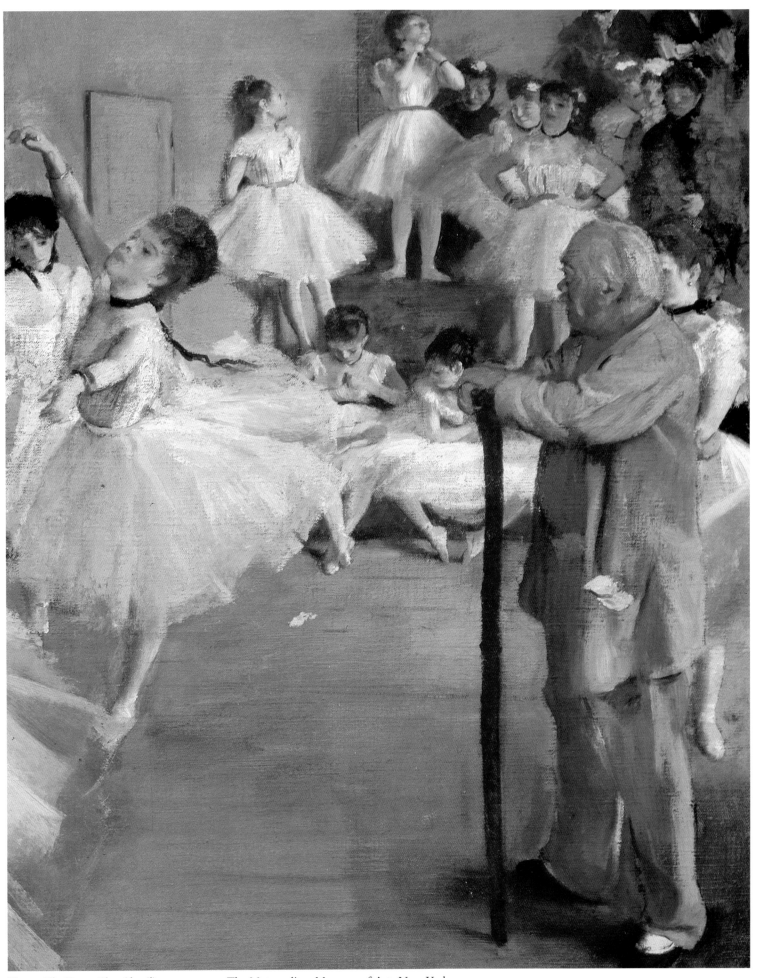

Fig. 4. *The Dance Class* (detail), cat. no. 130. The Metropolitan Museum of Art, New York

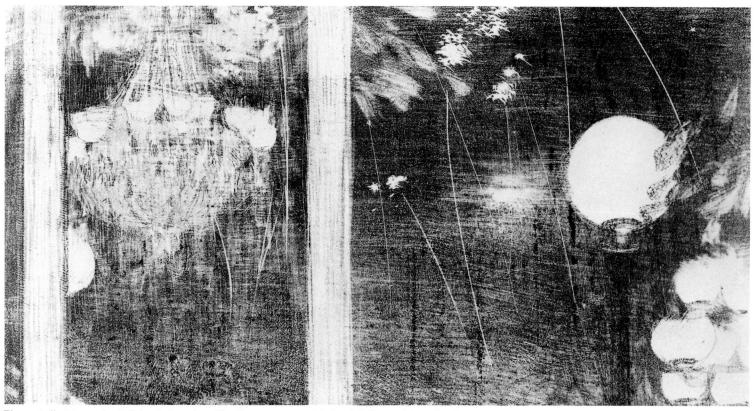

Fig. 5. *Mlle Bécat at the Café des Ambassadeurs* (detail), cat. no. 176. National Gallery of Canada, Ottawa

the universe while their explosions challenge its laws. Degas seemed briefly to be master of a brilliant cosmos.

By the time he reached fifty in 1884, Degas's financial position was, as Gary Tinterow documents, considerably more secure.[40] Although he remained estranged in the eighties from his brother René, there do not seem to have been any family events to upset his equanimity, aside from the desire to settle his frustrating affairs in Naples with his young cousin Lucie Degas. But still he was unhappy. He wrote the younger painter Henry Lerolle, who had been buying his works, of his melancholy:

> If you were single, fifty years of age (for the last month), you would know similar moments when a door shuts inside you and not only on your friends. You suppress everything around you, and once all alone you finally kill yourself, out of disgust. I have made too many plans; here I am blocked, impotent. And then I have lost the thread of things. I thought there would always be enough time. Whatever I was doing, whatever I was prevented from doing, in the midst of all my enemies and in spite of my infirmity of sight, I never despaired of getting down to it some day.
>
> I stored up all my plans in a cupboard and always carried the key. I have lost that key. In a word, I am incapable of throwing off the state of coma into which I have fallen. I shall keep busy, as people say who do nothing, and that is all.[41]

Degas's work was no longer explosive, defying, devastatingly witty. As he withdrew from his increasing fame, it became more reflective and more classically serene.

A detail of *The Visit to the Museum* (fig. 6), now in the National Gallery of Art in Washington, shows a woman in the Grande Galerie of the Louvre, which Gary Tinterow identifies by its pink scaglio columns.[42] She is looking at a work that is even more mysterious than the mirrored reflections in *The Bellelli Family* or *Interior.* These reflections are, however, as subdued and withdrawn as the sky above Mlle Bécat is explosive. They are almost like reflections of reflections of paintings—or perhaps dreams of works of art. It is as if the world the young woman sees should be magical within the frames, which are therefore not rationally described. Degas's comment as he applied what Sickert called "undecided strokes" to suggest these reflections—"With this, I must give a bit of the idea of the Marriage at Cana"[43]—may have an ironic reference to the miracle he wished to perform.

The young woman herself is contained. Her head, balanced by the absurdity of the hat on her neck, edged with white, is as exquisitely tuned as that of Baroness Bellelli. We barely see her face, but the light on her ear is painted with a certain affection. Although very modern for the 1880s, she seems to embody Degas's desire for an art like that of the ancient Greeks. From two remarks he made—one at the beginning of his career and the other at the end—it is clear that Degas did not think of Greek art as static or hermetic, as suggested by frigid neoclassic art. The first reference was in jottings he made in a notebook about a performance he had seen of the great Italian actress Adelaïde Ristori in Legouvé's *Medée* on 15 April 1856: "When she runs, she often evokes the movement of the Winged Victory [*Iris*] of the Parthenon."[44] The second was when he was

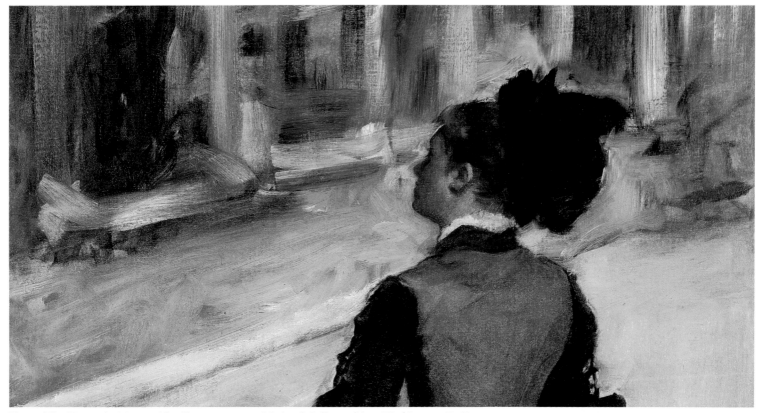

Fig. 6. *The Visit to the Museum* (detail), cat. no. 267. National Gallery of Art, Washington, D.C.

asked by Louisine Havemeyer, presumably in the late nineties, why he painted so many scenes of the dance and he answered: "Because only there can I recapture the movements of the Greeks."[45] In this visitor to a museum, we find that genuinely classical sense of life, with an equilibrium beautifully and easily achieved.

Suggesting both the straining and the attainment of equilibrium is one of Degas's fine nudes from the eighties, a pastel, *After the Bath* (fig. 7).[46] Degas here uses light to show his pleasure in this bather's body as he had used light on the young woman's ear in *The Visit to the Museum*. As the bather lifts her left knee to sponge it and balances her body with the pressure on her right leg and with her right hand lightly grasps the back of a chair, there is an exquisite suggestion of the act of balancing to achieve equilibrium. The application of pastel is disciplined and thin, without the indulgence in the wild mass of color that can make the later works so thrilling. But this very restraint is what enhances the sense of perfection in composure restored.

Once having achieved equilibrium, Degas seemed determined in his old age—at least by the time he was sixty in 1894—to strain it, to shake it up, if not to destroy it utterly. This may have been the result of his personal unhappiness, much of it self-induced, like his stand on the Dreyfus Affair or his reaction to the climate of the times.[47] Curiously, however, he did not ignore the significance of a stable and measured relationship of man to his universe. On 27 August 1892, from Ménil-Hubert, where, for diversion, he was making a painting of the billiard room,[48] he wrote to his friend the sculptor Albert Bartholomé, "I thought I knew a little about perspective. I knew nothing at all, and thought I could replace it through a process of perpendiculars and horizontals, measuring angles in space, just through an effort of will. I kept at it."[49] Even stranger is the letter he wrote to the painter Henry Lerolle on 18 December 1897: "It is in vain that I repeat to myself every morning, tell myself, yet again, that one must draw from the bottom upward, begin with the feet, that the form is far better drawn upward than downward. Alas, mechanically, I begin with the head."[50] Very few works painted in the nineties or in this century placed on him the same demands for a sense of ordered perspective as those of the rooms at Ménil-Hubert. There is also little evidence that he overcame his habit of beginning the drawing of a figure with the head; increasingly, he ignored the feet. And yet the shift in both order and emphasis that took place in his work must have been based on a conscious denial of the security and optimism of his past.

The late works become increasingly spectral, itself a contradiction of his earlier classicism. Although one small detail of one work (fig. 8) can hardly represent all that was happening, the horse and rider in the background of a pastel, *Racehorses*, in the National Gallery of Canada,[51] can symbolize a great deal. It is curious that the clue to the significance of the work rests in the horse and rider farthest from us, as it had in *Racehorses before the Stands*, painted nearly thirty years earlier. Although the work of Degas was still understated in this period, it is a shock to consider how far removed this jockey is from the chronologically closer nude of the early eighties. There is no sense of

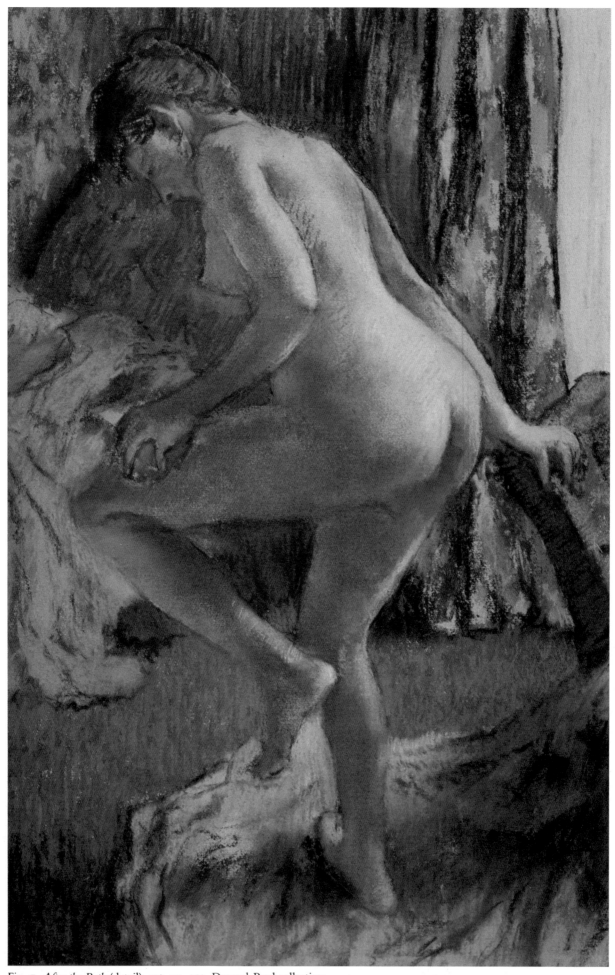

Fig. 7. *After the Bath* (detail), cat. no. 253. Durand–Ruel collection

physical beauty here, or of radiant health. Nor is there any articulation of the pathetic body. The jockey, with feeble arms, struggles with a force that is stronger than he, giving the detail of the picture a disturbing disequilibrium. The brilliance of the orange silks—almost a vermilion—with the patches of indigo carries the scene into a world of great intensity. Rational order has vanished, and any hint of stability is further violated by the vibration, of horse, jockey, and stormy sky—as if all were one.

Two anecdotes told by the dealer René Gimpel are significant in what they reveal about Degas's apparent rejection of equilibrium. One was of Degas's telling Monet, after the other artist had exhibited his *Water Lilies* at Durand-Ruel in 1909: "I remained for only a second at your exhibition. Your pictures gave me vertigo."[52] And though it is true that while his own works were courting vertigo, like those of Monet, in the paintings he was buying for his own collection, with the possible exception of his El Grecos, he preferred the sense of balance in works by Ingres, Delacroix, or Cézanne. The second anecdote concerns Degas's remark at the first exhibition of the Cubists: "This is more difficult to do than painting," a remark that suggests some admiration for artists who shared his preoccupation with equilibrium.[53]

Degas was certainly part of the emerging twentieth century, despite the fact that he had exhibited in the Salon in the 1860s and in the first Impressionist or Independent exhibitions in the 1870s. He was not unaffected by the spirit at the turn of the century. He had always known younger artists; his relationships with them had at times been ambivalent, but at least they knew each other's work. Degas had received them in his studio,

even when they came from abroad. And in turn, he was respected, though that respect could take curious forms.

One typical incident took place during the winter of 1898–99, before the death of Toulouse-Lautrec. After a dinner to which he had invited friends, including Édouard Vuillard and Thadée and Misia Natanson, Lautrec took his guests to the Montmartre apartment of two distant cousins, Désiré Dihau, the bassoonist whom he had drawn leading a bear, and Dihau's sister Marie, who gave singing lessons. In their apartment were two paintings by Degas, *The Orchestra of the Opéra* with Désiré[54] and a portrait of Marie at the piano, both from the late sixties, both now in the Musée d'Orsay. Leading his friends over to the pictures, Lautrec said, "This is your dessert."[55]

Quite different is the story the "Cubist" writer André Salmon tells about the Bateau-Lavoir, where Picasso, who was to buy some of Degas's finest monotypes, was then living. In about 1913, the artists used to play a game: "One of us would ask, 'Shall we play Degas?' The next question was, 'Who'll be Degas today?' We'd argue about it . . . then one of us would start. We would play Degas, the illustrious old grouch, visiting Pablo and judging his work. . . . To play at being Degas meant, alas, to play at what one ran the risk of becoming once one grew old—to act out, well in advance, the absurdities of old age in order to be better able to defend oneself, once the fatal day arrived, by recollecting the silly games of one's youth."[56]

There were other, more serious tributes, such as Pissarro's, in a letter he wrote to his son Lucien in 1898: "Degas . . . constantly pushes ahead, finding expressiveness in everything

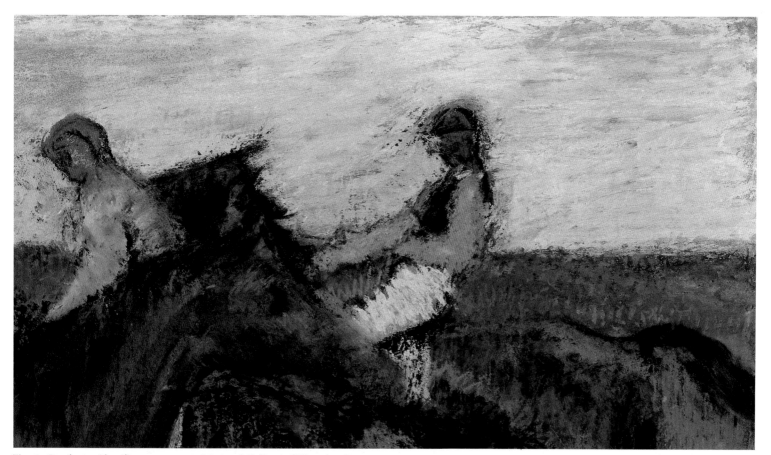

Fig. 8. *Racehorses* (detail), cat. no. 353. National Gallery of Canada, Ottawa

around us."[57] Or Renoir's, in his comment to his son Jean: "Degas painted his best things when his sight was failing."[58] Finally, there is the assessment made by Renoir to the dealer Vollard: "If Degas had died at fifty, he would have been remembered as an excellent painter, no more; it is after his fiftieth year that his work broadens out and that he really becomes Degas."[59]

Degas had begun within the seemingly certain, established world into which he was born, symbolized by the Bellellis, in whose apparently exquisite balance he was able, however, to detect and suggest certain insecurities. He ended his career expressing, through his challenges to equilibrium, the anxieties of a world facing the abyss of the First World War.

Notes

1. L522, 1879, National Gallery, London. See fig. 98.
2. Cat. nos. 164, 165.
3. Valéry 1965, p. 91; Valéry 1960, p. 42.
4. Reff 1976, chapter I.
5. Lemoisne [1946–49] I, pp. 227–28; English translation in McMullen 1984, p. 58.
6. Cat. no. 97. The Toulouse-Lautrec image of Dihau was a lithograph for a sheet of music, "Les vieilles histoires," with music by Dihau to poems by Jean Goudezki, 1893.
7. Valéry 1946, p. 37; Valéry 1960, p. 22.
8. See Chronology III, 25 July 1889.
9. Valéry 1938, pp. 98–99; Valéry 1960, p. 56.
10. Michel 1919, p. 469.
11. See fig. 287.
12. See cat. nos. 101, 243.
13. Cat. no. 165.
14. Halévy 1960, pp. 145–46; Halévy 1964, p. 110.
15. For Henri Loyrette's full discussion and documentation of the painting, see cat. no. 20.
16. Van Dyck, *Paola Adorno*, c. 1621–25, Genoa, Palazzo Rosso.
17. Reff 1985, Notebook 13 (BN, Carnet 16, pp. 41–43).
18. Ibid., p. 41.
19. Ibid.
20. Ibid.
21. Ibid.
22. Reff 1985, p. 43.
23. Raimondi 1958, p. 246, letter of 8 February 1860 from Baron Bellelli to his brother-in-law, Édouard Degas.
24. For Henri Loyrette's full discussion and documentation of the painting, see cat. no. 84.
25. Sidney Geist, "Degas' *Intérieur* in an Unaccustomed Perspective," *Art News*, October 1976, pp. 81–82.
26. Quentin Bell, *Degas: Le Viol*, Newcastle upon Tyne: University of Newcastle upon Tyne, 1965, p. 2.
27. For Henri Loyrette's full discussion of the painting, see cat. no. 68.
28. Cat. no. 70.
29. Cat. no. 129. Michael Pantazzi, the author of this commentary, dates the beginning of the work in 1873 as he does the two preparatory drawings (cat. nos. 131, 132), which I believe (1967 Saint Louis, no. 65) to be 1872.
30. For Michael Pantazzi's full discussion and documentation of the painting, see cat. no. 130.
31. See "Degas and Faure," p. 221.
32. See cat. nos. 75, 107.
33. See cat. nos. 206, 207, 208, 266; see also cat. nos. 166, 185.
34. See Chronology IV, 23 January 1896.
35. For the details of his life at this period, see Chronology II.
36. See cat. no. 192 for the details.
37. Cat. nos. 192, 193, 194.
38. For Michael Pantazzi's full discussion and documentation of the print, see cat. no. 176.
39. Reed and Shapiro 1984–85, p. 94.
40. See "The 1880s: Synthesis and Change," pp. 363–74, and Chronology III.
41. Lettres Degas 1945, LIII, p. 80; Degas Letters 1947, no. 63, p. 81 (translation revised).
42. For Gary Tinterow's full discussion and documentation of the painting, see cat. no. 267.
43. Sickert 1917, p. 186.
44. Reff 1985, Notebook 6 (BN, Carnet 11, p. 9).
45. René Gimpel, *Journal d'un collectionneur*, Paris: Calmann-Lévy, 1963, p. 186.
46. For Gary Tinterow's full discussion and documentation of the pastel, see cat. no. 253.
47. For the details of his life at this time, see "The Late Years: 1890–1912," pp. 481–85, and Chronology IV.
48. Cat. no. 302.
49. Lettres Degas 1945, CLXXII, p. 194; Degas Letters 1947, no. 185, p. 183 (translation revised).
50. Lettres Degas 1945, CCX, p. 219; Degas Letters 1947, no. 227, p. 206 (translation revised).
51. Cat. no. 353.
52. René Gimpel, *Journal d'un collectionneur*, Paris: Calmann-Lévy, 1963, p. 179.
53. Ibid., p. 435.
54. Cat. no. 97.
55. Henri Perruchot, *La vie de Toulouse-Lautrec*, Paris: Hachette, 1958, p. 369; Henri Perruchot, *Toulouse-Lautrec* (translated by Humphrey Hare), London: Perpetua, 1960, p. 249.
56. André Salmon, *Souvenirs sans fin*, Paris: Gallimard, 1956, II, pp. 99, 100.
57. Lettres Pissarro 1950, p. 451; Pissarro Letters 1980, p. 323.
58. Jean Renoir, *Renoir, My Father*, London: Collins, 1962, p. 198.
59. Vollard 1936, p. 320.

I

1853–1873

Henri Loyrette

Fig. 9. Anonymous, *Edgar Degas*, c. 1855–60. Photograph printed from a glass negative in the Bibliothèque Nationale, Paris

"What is fermenting in that head is frightening"

1. Alexandre 1935, p. 146.
2. Albert André, *Degas*, Galerie d'Estampes, Paris: Brame, n.d.
3. Louis Vauxcelles, *La France*, 29 September 1917.
4. André Michel, "E. Degas," *Journal des Débats Politiques et Littéraires*, 6 May 1918.
5. In July 1906, Paul Valéry wrote to André Lebey: "I also dined with Degas, who is quite worn down by his seventy-two years. . . . On the wall he had hung a picture from his youth, from the time when he was haunted by Poussin. The picture, which was far from finished, was titled 'Young Spartan Girls Challenging the Boys to Combat.' There are two well-studied and finely drawn groups of figures—the girls are charming, the boys disdainfully flex their muscles. In the background is the Taygetus Range and a fantasized city of Sparta." Paul Valéry, *Oeuvres*, Paris: Pléiade, 1984, II, p. 1568.
6. Blanche 1927, pp. 294–95.
7. Alexandre 1935, p. 153.
8. André, op. cit.

The first twenty years of Degas's career, from 1853 until his return to Paris from New Orleans in 1873, are a complex and still little-studied period, in which most observers see a long apprenticeship gradually progressing toward *The Orchestra of the Opéra* (cat. no. 97) or *Dance Class at the Opéra* (cat. no. 107), masterpieces in which the "real" Degas finally seems to emerge. Arsène Alexandre, who knew Degas slightly, wrote in precisely such terms of this long period of time in which "his path was to be laid out, directed. . . . From then on, Degas would not stray from it, regardless of the twists and turns it might take."[1]

Thus, the early works are often regarded as palimpsests in which can be detected both a marked and constant attachment to the old masters and "clear signs of the modernism that would soon be his domain."[2] Sometimes overlooked, they emerge as the interesting but inconclusive efforts of a painter who has yet to find himself, of a "Degas before Degas" still awaiting the revelations that would come to him from his friendships with Manet and Duranty. The classical beginnings, without "any gesture of revolt,"[3] seem to many to have heralded nothing more than a mediocre history painter who was knocked into shape in the 1860s by his companionship with the habitués of the Café Guerbois. Rare are those like André Michel who praised the beauty and originality of the early works: "I should like to bring to the attention of our fiercest 'revolutionaries,' our 'wild men,' these 'classical' beginnings of the man they have so often claimed as their own." Foreshadowing today's revisionism, the critic added: "If certain evidence is to be believed, we may shortly have the surprise and satisfaction of hearing Degas called a *pompier*."[4] The studies under Louis Lamothe, the training at the École des Beaux-Arts, the stay in Italy, and the sustained effort over several years to carry through large history compositions sparked the mistrust of most biographers, who saw these works as nothing more than first efforts, cast in the mold of a career that could have been an official one. As a result, the long stay in Italy (1856–59) is often viewed with suspicion by those who see it as simply the leaven of academicism: even if he did not win the Prix de Rome and despite the excuse that most of his father's family lived in Italy, Degas had nevertheless made a trip lasting three years, a trip that, in its very justification, its length, and the work for which it was undertaken—first and foremost the many life studies and copies (see "Life Drawings," p. 65, and cat. no. 27)—was very similar to that of a student of the French Academy in Rome. The history paintings—the present exhibition features the four principal ones (cat. nos. 26, 29, 40, 45)—were largely responsible for this attitude. Throughout his life, Degas would demonstrate a genuine attachment to these works,[5] but those in his circle were already more reserved about them. Jacques-Émile Blanche saw in them nothing but "dry, emaciated canvases."[6] Arsène Alexandre considered *Young Spartans* (cat. no. 40) to be "an inconsequential work . . . agreeable but with a thin story."[7] The critics were unanimously hostile, finding in them only "pledges to the academic tradition."[8]

Indeed, everything in Degas's beginnings contrasts with the comfortably established idea of the "modern" painter. But instead of emphasizing the successive breaks, as is usually done, it is more reasonable and more correct to point out the obvious continuity within Degas's work; instead of waiting for the definitive flashing revelations of Realism to mark the painter's true beginnings, it is more reasonable and more correct to analyze what he would come to regard as the "dubious proximities" of academicism. We

can then see that, in spite of the uncertainties and hesitations to which the painter later confessed, we have "all of Degas" with his own style as early as the inaugural self-portrait (cat. no. 1), and that from *Semiramis Building Babylon* (cat. no. 29) to the final bathers and dancers there is the same passion, the same inspiration, the same tenacity, and an obvious continuity.

The three years from 1853 to 1856, crucial to Degas's formation as an artist, are known only from a few meager archival sources and mainly through the information to be found in the notebooks that he used regularly at the time. Degas had not shone in drawing at his lycée, Louis-le-Grand. The quarterly reports noted, "Degas applies himself successfully" (fourth term, 1847), "good work and good progress" (first term, 1848), and "good work, satisfactory progress," and afterward, until he left the school, they bore the constant notation "good."[9] He gleaned a few awards—a prize in 1848 ("heads after an engraving") and a second in 1849 ("heads after a plaster cast")—but his fellow students Henri Rouart and Paul Valpinçon, who later would show some small talent as painters, did as well if not better. What remains a mystery is how Degas set his course so quickly once he finished school. After leaving Louis-le-Grand on 27 March 1853 (four days after receiving his baccalaureate), he registered on 7 April as a copyist at the Louvre,[10] and on 9 April obtained permission to copy in the Cabinet des Estampes of the Bibliothèque Nationale.[11] It is true that Degas enrolled at the Faculté de Droit in November (for the first and last time),[12] but that was only in order to appease his father, who despite his interest in painting could not think of his son as an artist without apprehension. When he dined at the Halévys' in May 1889, Degas, usually tight-lipped about everything concerning his early years, admitted that he had indeed studied law, but that "while I was doing it I copied all the Primitives at the Louvre. I ended by telling my father that I couldn't go on."[13]

At Louis-le-Grand, Degas had three professors of drawing: Léon Cogniet (a very busy man who could come only once a week[14]), Roehn, and Bertrand—excellent masters whose classes were filled to capacity. "To train that crowd, not only was it divided into two groups—one drawing plaster casts (almost a quarter of the students) and one engravings (the other three-quarters)—but each of the two groups was further split into sections, of which there were ten in all. Some drew with lines, others made renderings with stump and shading."[15]

It was probably Cogniet, a painter of renown and a member of the Institute of France since 1849, who advised Degas to attend the classes in the studio of his pupil Félix-Joseph Barrias (1822–1907), whose large composition *The Exiles of Tiberius* (1851) had recently made him famous. Of Degas's progress under Barrias we know nothing, and Degas himself apparently never spoke of his first independent master. However, we can detect traces of the teaching of Cogniet and Barrias in certain history subjects that briefly attracted Degas in 1856–57. This is particularly true of studies Degas made in one of his notebooks,[16] inspired by one of Cogniet's most celebrated paintings, *Tintoretto Painting His Dead Daughter.*

Louis Lamothe (1822–1869), whom Degas is said to have taken as a teacher on the advice of Édouard Valpinçon, a friend and collector of Ingres, was important in an altogether different way. Lamothe, a native of Lyons, was a disciple of Hippolyte Flandrin, for whom he worked at the Château de Dampierre, at Saint-Paul-de-Nîmes, and above all at Saint-Vincent-de-Paul in Paris. Lamothe passed on to Degas the precepts of Ingres's teaching, which he had learned through Flandrin: a passion for drawing ("Draw lines, lots of lines, and you will become a good artist," Ingres is reported to have said to Degas during their brief meeting[17]), the cult of the Italian masters of the fifteenth and sixteenth centuries (whom Degas had been copying at the Louvre since 1853), and also the fundamental integrity, the wholly provincial honesty, and the taste for well-executed work characteristic of the Lyons school, to which Lamothe and Flandrin belonged. It was this mediocre artist, more a practitioner than a creator (and yet the author of "a few admirable drawings," as Maurice Denis conceded[18]), whom Degas claimed as a teacher

9. Archives, Lycée Louis-le-Grand, Paris.
10. Archives, Musée du Louvre, Paris, LL9.
11. Lemoisne [1946–49], I, p. 227 n. 13.
12. Ibid., n. 14.
13. Halévy 1960, p. 30; Halévy 1964, pp. 33–34.
14. Gustave Dupont-Ferrier, *Du Collège de Clermont à Lycée Louis-le-Grand*, Paris: Bastard, 1922, II, p. 361.
15. Ibid.
16. Reff 1985, Notebook 8 (private collection, pp. 86–86v).
17. Alexandre 1935, p. 146.
18. Maurice Denis, "Les élèves d'Ingres," *L'Occident*, 1902, pp. 88–89.
19. Reff 1985, Notebook 2 (BN, Carnet 20, passim).
20. Reff 1985, Notebook 1 (BN, Carnet 14, p. 12).
21. Letter from Auguste De Gas to Edgar, 25 November 1858, private collection; cited in part in Lemoisne [1946–49], I, p. 31.

Fig. 10. Louis Lamothe, *Self-Portrait*, 1859. Oil on canvas,
34⅝ × 27¾ in. (88 × 70.5 cm). Musée des Beaux-Arts, Lyons

when he entered the École des Beaux-Arts on 5 April 1855, ranking thirty-third in the entrance competition. Once again, our information on his brief stay at the École des Beaux-Arts is limited. We do not even know in whose studio the young painter worked; all we know is that he did not persevere and that he disappeared the following semester. Perhaps he was shocked by the somewhat brutal customs of the school; perhaps, following Ingres's advice to Amaury-Duval, he preferred to bypass an uncongenial instruction, and to give up the possibility of the Prix de Rome since he had his own means of financing a prolonged stay in Italy.

The "Flandrinian-Lamothian" influence on Degas, to use his father's term, was then considerable. Visiting the Exposition Universelle of 1855, Degas looked only at Ingres, whose works were shown in a major retrospective exhibition.[19] He copied Flandrin at Saint-Vincent-de-Paul,[20] and during the summer of 1855 saw him, accompanied by his faithful Lamothe, working on the frescoes in Saint-Martin-d'Ainay in Lyons. But this marked ascendancy of Flandrin, Ingres's favorite disciple, was fortunately balanced by the influence of Degas's family circle and of his father, Auguste De Gas, in particular. Auguste had never really opposed his son's wishes, and showed himself attentive to his progress from the beginning. His lack of admiration for Delacroix did not make him an unwavering supporter of Ingres and even less of his imitators; his predilection was for fifteenth- and sixteenth-century Italian painting, which he felt had never been surpassed. For him, the value of Lamothe's teaching lay solely in his proclaimed respect for "those adorable fresco painters," as Auguste called them.[21] Auguste De Gas's close ties with the great collectors Marcille and La Caze, to whose homes he sometimes took his son after school, his friendship with the Romanian Grégoire Soutzo, an engraver and print collector, and his own knowledge of works of art gave the young painter another string to his bow and softened the possibly desiccating effects of a strict adherence to Flandrinian principles.

The influence of Ingres on Degas's early career, which could be the subject of much discussion, seems considerably less certain than has been claimed. The *Self-Portrait* of the spring of 1855 (cat. no. 1), his first masterpiece, is significantly different from Ingres, and his painting of his brother René (cat. no. 2) in no way resembles the portraits by

Ingres and his successors. On the other hand, the influence of Flandrin and the Lyons school is apparent in several canvases from the early part of Degas's stay in Italy: the 1856 portrait of his cousin Giovanna Bellelli (L10, Musée d'Orsay, Paris), the portrait of his grandfather Hilaire Degas (cat. no. 15), and in particular *Woman on a Terrace* (cat. no. 39), an exotic translation of a famous work by Flandrin.

The consequences of Degas's close relations with Soutzo are difficult to assess. An enigmatic figure (unfortunately we have none of his prints), Soutzo introduced Degas to printmaking and in the course of their long discussions ("great talk with Soutzo," Degas noted on 18 January 1856;[22] "remarkable conversation" with him, he observed on 24 February[23]) gave him advice on landscapes (see "The Landscapes of 1869," p. 153) and encouraged him not to prevaricate with nature, but to "confront" it "with its main outlines."[24] Thanks to Soutzo, Degas discovered Corot and the Flemish and Dutch engravers of the seventeenth century, of whose works the Romanian prince had assembled a fine collection (see "The Etched Self-Portrait of 1857," p. 71). In short, it was he who first made of Degas a landscape painter and a printmaker.

The Degas who left for Naples in July 1856 was more than a novice, despite his twenty-two years. It is true that the self-portraits of the period show him still hesitant, uncertain of the road to follow—but about ten years later, sitting beside his friend Éva-riste de Valernes (see cat. no. 58), he seems the same. He arrived in Italy with the intention of undertaking the usual tour, that of all French artists with or without the Prix de Rome. His ideas and ambitions were very openly those of a follower of Ingres, even if his works were already notably different from the Ingres tradition. We need only compare his moving *Self-Portrait* in the Musée d'Orsay (cat. no. 1) with the haughty, boastful self-portrait by Lamothe (fig. 10), painted a few years later, to appreciate all that already separated the master from the young man who was still his disciple. From his apprentice years, Degas occupied a place apart in French painting that would always be his own—one that defied both comparison and classification. The long stay in Italy, an obligatory stage in any artistic career, instead of casting him in a mold, was to widen even further the gulf that already existed between the young Degas and most of his contemporaries.

Curiously, Degas did not find in Italy what he had expected. More than a knowledge of the Italian masters (which he already possessed, thanks to the Louvre's sizable collection), it was his meeting with Gustave Moreau in early 1858, the long discussions with him about art, and his new mentor's revelation of artists whose works were shown little or not at all in Italy—van Dyck, Rubens, Chassériau, and above all Delacroix— that unquestionably affected his development. In Rome, Degas moved for a while in an artistic circle of a kind he had had no chance to frequent in Paris, made up of pensioners of the French Academy, such as Émile Lévy, Élie Delaunay, Henri Chapu, and Ferdinand Gaillard; painters on other scholarships, like Léon Bonnat, whose stay was supported by the city of Bayonne; painters who had come to undertake commissions, like Joseph-Gabriel Tourny, who was then copying the frescoes of the Sistine Chapel for Adolphe Thiers; and those who were financing their own visits, like François-Édouard Picot, a teacher of several of the pensioners, and Gustave Moreau. All were welcomed by the French Academy, were readily admitted to the director's "Sundays," and took advantage of the evening life classes, where artists could work from nude models (see "Life Drawings," p. 65). The French artists in Rome formed a community that was close-knit and restricted, because they had no contact with Italian society in general and Italian artists in particular. Rome seemed to them a provincial city, "untidy, badly planned, baroque, and dirty."[25] It would disappoint them at first, but a few years later they would take leave of it "with regret, indeed with heartbreak."[26] Contemporary art there was anemic—there were only a "small number of true artists," but "a plethora of manufacturers living off the reputations of their ancestors."[27] As a result, Henner could confess that he stayed five years in Rome "without seeing a single modern picture."[28] Moreau, Chapu, Delaunay, and Bonnat, as well as Taine and About, could have said the same: one did not go to Italy to see contemporary painting, which in any case was wretched.

22. Reff 1985, Notebook 5 (BN, Carnet 13, p. 33).
23. Reff 1985, Notebook 6 (BN, Carnet 11, p. 65).
24. Reff 1985, Notebook 5 (BN, Carnet 13, p. 33).
25. Hippolyte Taine, *Voyage en Italie*, Paris: Hachette, 1866 (1965 edition, Paris: Julliard, p. 24).
26. Edmond About, *Rome contemporaine*, Paris: N. Lévy Frères, 1861, p. 62.
27. Ibid., p. 187.
28. Jean-Jacques Henner, unpublished journal, Musée Henner, Paris.
29. See 1984–85 Rome, p. 25. Nothing is known of Leopoldo Lambertini. Stefano Galletti (died 1904) was a sculptor; according to Olivier Michel, he worked mainly at Santa Maria in Aquiro and San Andrea della Valle, Rome.
30. See 1983 Ordrupgaard, p. 84; *Cristiano Banti: un macchiaiolo nel suo tempo, 1824–1904* (catalogue by Giuliano Matteucci), Milan, 1982.
31. Letter from Moreau to his parents, Rome to Paris, 14 January 1858, Musée Gustave Moreau, Paris.

In spite of his many family connections (limited, it is true, to Naples, where the core of his paternal family resided, and Florence, where his uncle Gennaro Bellelli lived in exile; see cat. no. 20), Degas did not demonstrate any particular readiness to participate in Italian life, confining his contacts to two obscure artists, Stefano Galletti and Leopoldo Lambertini,[29] with the possible addition of Cristiano Banti.[30] All his new friendships, except with the engraver Tourny and the sculptor Chapu, were established through the all-powerful Moreau.

Moreau and Degas probably met early in 1858. Moreau, who had arrived in Rome at the end of October 1857, was a regular figure at the Villa Medici's evening life classes,[31] where he would go after long hours of copying in the Farnesina and in the Sistine Chapel. On 9 June 1858, Moreau left for Florence; Degas met up with him there two months later for about fifteen days; they saw each other again only in December of that year, and then at the end of March 1859, when Degas was leaving for Paris. Chapu and Bonnat later recalled the amiable fellowship of Moreau on many joint excursions; for Degas, however, he was more than just a traveling companion helping him to endure the occasional boredom of life in Rome or Florence. Eight years older than Degas— Moreau was born in 1826—and with a body of work already behind him, he was indisputably a gifted teacher, with the talents to introduce new ideas, as Matisse and Rouault were subsequently to testify. In his discovery of Italy, there was about Moreau (to use

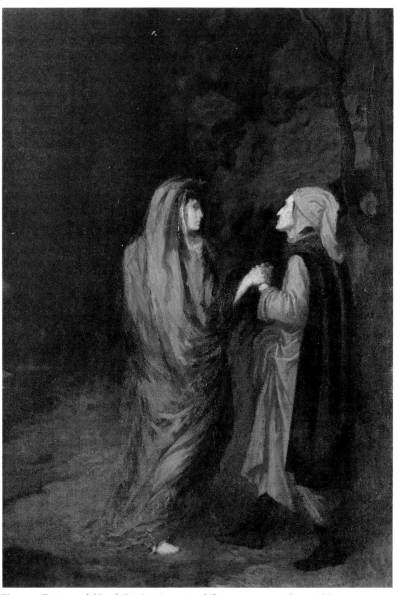

Fig. 11. *Dante and Virgil* (L34), 1857–58. Oil on canvas, 43¼ × 29½ in. (110 × 75 cm). Private collection

his own term) a great "receptiveness." "Since my departure from Paris," he wrote to his parents, "I have the feeling of a keen sensibility. I have never experienced things so vividly. . . . There is a great excitement within me, a great movement of ideas and feelings."[32] This "receptiveness" of Moreau's had its effect on the young Degas. The eclecticism of his senior, who was simultaneously interested in Raphael, Michelangelo, the sixteenth-century Florentines, Correggio, and especially the Venetians (Carpaccio, and above all Titian and Veronese), soon became his own and then that of most of the pensioners at the French Academy at the end of the 1850s. Aware that drawing was now "his strong suit," Moreau was directing his endeavors toward color and conducting "studies in values and decorative hues," which had "nothing to do with the study of detail."[33] These investigations were of particular interest to Degas, who was following a parallel development and as a result was able to throw off the confining teaching of Flandrin and Lamothe. Moreau increased his technical investigations in order to reproduce, as faithfully as possible, the colors and textures of old paintings: in turn he used watercolor to give "the matte tones and the gentleness of fresco," "distemper heightened with watercolor" to "imitate frescoes with oil,"[34] and then pastel. Degas, who would from this time never tire of experimenting with new techniques, owed a good part of his insatiable curiosity about such matters to Moreau, and probably also his initiation into pastel, which he would use to test the balance of colors in the sketches for *The Bellelli Family* (see fig. 36) and *Semiramis* (see fig. 45).

Degas's friendship with Moreau and the considerable ascendancy the latter had over the young painter for at least two years are particularly evident in the moving *Dante and Virgil* (fig. 11) that Degas sent to his father from Florence just after finishing it in the fall of 1858.[35] Like Virgil, Moreau guided and supported his young follower. The "sorrows that are the lot of anyone who takes up art," as they had discussed,[36] and the hazards of a profession that his new master had made difficult for him, as Degas would later complain,[37] led him to seek Moreau's encouragement, which placed the younger artist in the metaphorical position of Dante. But while the friendship with Moreau was represented symbolically in the image of the two poets helping each other to make the perilous passage, that image also has a formal significance: indeed, as his father noted on receiving the packing case containing *Dante and Virgil*, Degas had rid himself of "that weak, trivial, Flandrinian, Lamothian manner of drawing and that dull gray color."[38] This momentary abandonment of the sound precepts of Ingres drove Degas toward Delacroix, to whom he was probably never so close (though he had not as yet studied much of his work).

The encounter between Degas and Moreau, long obscured—what could one of the masters of the "new painting" owe to the now neglected painter of Jason and Salome?—was a decisive point in the young artist's development. Without Moreau, the trip to Italy would have been only the confirmation of what he had already known. Like his pensioner friends, Degas would have turned out more of the tediously repeated pictures of a conventional Italy—daughters of the people in local costume, noble beggars (see cat. no. 11), and the usual landscapes of the environs of Naples or Rome (though when he did broach these themes early in his trip, he did so with unquestionable originality).

Moreau's hold over the twenty-five-year-old painter can best be measured in 1859. On returning at last to Paris after three years in Italy, Degas broke with Lamothe[39] and now had no time for what he had previously admired. His reactions during a visit to the Salon of 1859 in the company of some of Moreau's friends demonstrated the rapid change in his tastes: now he preferred portraits by Ricard ("composed in a more picturesque fashion") to those by Hippolyte Flandrin and, despite Émile Lévy's dismissal of them as "horribly ugly," defended all the works exhibited by Delacroix, a painter he had completely ignored at the Exposition Universelle of 1855.[40]

Degas's meetings with his Roman friends, however, were soon less frequent. He would do two fine portraits of Bonnat in 1863 (see cat. no. 43), and would maintain close ties with Moreau into the early 1860s, as is evident both in the little canvas he painted of Moreau (L178, Musée Gustave Moreau, Paris) and in several of his history paintings. But the lengthy development of *Semiramis* (cat. no. 29) is testimony to the

32. Letter, 19 November 1857, Musée Gustave Moreau, Paris.
33. Letters from Moreau to his parents, 12 November 1857, 7 and 14 January 1858, Musée Gustave Moreau, Paris.
34. Letter from Moreau to his parents [February 1858], Musée Gustave Moreau, Paris.
35. Reff 1976, I, p. 68; 1984–85 Rome, no. 45, pp. 135–39.
36. Letter from Degas to Moreau, 2 September 1858; Reff 1969, p. 282.
37. Letter from Eugène Lacheurié to Moreau, 12 August 1859, Musée Gustave Moreau, Paris.
38. Letter from Auguste De Gas to Edgar, 11 November 1858, private collection; cited in part in Lemoisne [1946–49], I, p. 30.
39. Lemoisne [1946–49], I, p. 228 n. 32.
40. Letter from Eugène Lacheurié to Moreau, 9 June 1859, and letter from Émile Lévy to Moreau, 12–13 May 1859, Musée Gustave Moreau, Paris.
41. Address, 13 rue de Laval, written on envelope of 1 October 1859, private collection.
42. Reff 1985, Notebook 18 (BN, Carnet 1, pp. 161–77).
43. Lemoisne [1946–49], I, p. 73; Brame and Reff 1984, no. 43.
44. See Chronology I.
45. Reff 1985, Notebook 19 (BN, Carnet 19, pp. 1, 3). See Chronology I.
46. Letter from René De Gas to Michel Musson, Paris to New Orleans, 13 October 1861, Tulane University Library, New Orleans.
47. Letter from René De Gas to the Musson family, Paris to New Orleans, 22 April 1864, Tulane University Library, New Orleans; cited in part in Lemoisne [1946–49], I, p. 41.
48. Ibid.
49. Ibid.
50. Letter to Michel Musson, Paris to New Orleans, 21 November 1861, Tulane University Library, New Orleans; cited in part in Lemoisne [1946–49], I, p. 41.
51. Lemoisne [1946–49], II, no. 186.

distance that Degas gradually put between himself and his mentor of the Italian years. Starting with a tumultuous and resonant subject and composition in the manner of Moreau, he progressively changed the work so that it became very different—slow, serene, and with little color. In his later years, he would have a few politely cruel words to say about the painting of his former guide, minimizing the critical role played in his own education by the man who was one day to become the venerated teacher of Matisse and Rouault.

In many ways, 1859 marks the true beginning of Degas's career as an artist: back from a prolonged stay in Italy, he left his father's apartment for a studio on rue de Laval in the Ninth Arrondissement;[41] he would reside in this neighborhood, with occasional changes of address, until his death. Degas now became a Parisian painter, very attached to his city and leaving it only infrequently, sometimes during the summer. Starting in 1861, he often went to see his friends the Valpinçons at Ménil-Hubert in Orne,[42] but his distant trips were rare: to Bourg-en-Bresse, where in January 1864 and January 1865 he visited his family from New Orleans;[43] to London, which he first saw in October 1871;[44] and to Italy (Florence and Naples in 1860,[45] with other visits until 1906). The voyage to Louisiana of 1872–73, long pondered and decided on after much equivocation, is an exception in this settled, sedentary way of life.

In the vast space of his new studio in 1859, the painter was finally able to tackle large canvases, which had been impossible until then because he had not had the room. Thus, the early 1860s are characterized by his sustained effort to cover large surfaces— such as *The Daughter of Jephthah* (cat. no. 26) and *The Bellelli Family* (cat. no. 20), which were then in progress, as well as the smaller *Semiramis* (cat. no. 29) and *Young Spartans* (cat. no. 40). Frequent allusions in the family correspondence are evidence of his ambition to present one of these works in a finished state at the Salon. Degas labored furiously: he is "slaving away at his painting," noted his brother René in 1861.[46] "Edgar is still working enormously hard, though he does not appear to be," René wrote three years later.[47] Degas had scarcely arrived in New Orleans before he began to do portraits, and during his five months' stay he was to produce an impressive series of masterpieces. The taciturn, hesitant, dreamy Degas of the self-portraits, the man whose feverish anxiety we feel so often in his notebooks (which are still our chief source of information for these years because so little correspondence has survived), the man his relatives saw as immersed in his work to the point of sometimes seeming brusque and surly—"what is fermenting in that head is frightening,"[48] his brother René noted in that same letter of April 1864—the artist perpetually displeased with his work, who could spend years on canvases without really finishing them, was the same person who in a few hours, amid the ceaseless bustle of a noisy household, could also execute elaborate studies for a complex portrait (see cat. nos. 87–91).

But the combination of dissatisfaction and obvious facility, the perpetual need to rework something that might have been thought completed, to return yet again to a picture left for a while in a corner of the studio, inevitably gave rise to some uncertainties among his relatives as to the young painter's gifts. While René was convinced that he had "not only talent, but genius,"[49] his father did not fail to observe ironically that "our Raphael is still working, but has not produced anything that is really finished," and then to worry that "the years are passing."[50] According to the Dihau family, the Degas family did not display real satisfaction until about 1870, when the painter did *The Orchestra of the Opéra* (cat. no. 97). As the surprised model (Désiré Dihau, the bassoonist in the orchestra) was told as he took the canvas off to Lille, thereby removing it from all possible retouching, "It's thanks to you that he has finally produced a finished work, a real painting!"[51]

Unlike his friends Tissot and Alfred Stevens, or even Moreau and Manet, Degas did not yet have an established reputation; in the 1860s, he was completely unknown to the public. Tissot, the product of a similar background, built a substantial fortune once he found success, increasing his output of pleasing pictures for a clientele that quickly found him and buying a town house on avenue de l'Impératrice. Moreau, with whom

Degas had practically broken off relations, had his *Oedipus and the Sphinx* bought by Prince Napoleon at the Salon of 1864 and in November of the following year was invited by the emperor to one of his famous entertainments at Compiègne. Manet, whose role was that of the leader of a school, enjoyed a "Garibaldi-like" celebrity[52]—to use one of Degas's expressions—beginning with the Salon des Refusés in 1863, while Degas himself could draw only very scant and not always kind comments on the pictures he exhibited at the Salon between 1865 and 1870.

The Salon, which Degas criticized bitterly in a letter published in *Paris-Journal* on 12 April 1870 (see Chronology I), was in fact his only opportunity at that time to display his works. The eight he showed there over six years were hardly noticed: not a word in 1865 on *Scene of War in the Middle Ages* (cat. no. 45), complete silence in 1867 (except for Castagnary's brief mention of one of the two works listed as "Family Portrait"; see cat. no. 20), a mixed review by Zola in 1868 of the portrait of Mlle Fiocre (cat. no. 77), more sustained praise for the portraits hung in 1869—in all, not a very rich harvest. What is more, Degas was selling next to nothing. Of course, unlike most of his peers, he had no need to dispose of what he himself called his "wares" in order to live; and yet when he found himself, in 1869, in "one of the most celebrated galleries in Europe," that of M. Van Praet, one of the king's ministers in Brussels, he felt, as his brother Achille put it, "a certain pleasure" and gained at last "a little confidence in himself and his talent."[53] The end of the 1860s and beginning of the 1870s marked a definite change: in 1868 Duranty, who felt the wind turning for Degas, remarked that "he is on his way to becoming the painter of high life."[54] Four years later, on 7 March 1872, Durand-Ruel paid the artist for three pictures transferred in January,[55] thus beginning a collaboration that would last over half a century and inaugurate the painter's true career—in the commercial sense of the term.

Unknown to what is today called "the general public," seldom exhibited and then only in a setting—the Salon—that was inappropriate for his work, Degas nevertheless enjoyed an undeniable reputation among a limited group of artists. No one was quite sure what would become of him, but his manners, his cultivation, the urbanity of his conversation, the already well-known fierceness of his remarks, the intransigence of his positions, and a charm mixed with brusqueness made him a figure who was both feared and respected.

Along with Manet, Degas was a leading figure among the habitués of the Café Guerbois (Manet, Astruc, Duranty, Bracquemond, and Bazille, as well as Fantin, Renoir, and, when they were in Paris, Sisley, Monet, Cézanne, and Pissarro). "Degas, the great aesthetician," as the painter of *Olympia* called him, not without irritation,[56] had a remarkable talent as a debater, which immediately set him apart in the group. His friendships—"alliances" would be the more accurate term—had changed: Moreau had been succeeded by Tissot, to whom he was already very close in the early 1860s, and then by Manet (whom tradition has it he met about 1862 in the Louvre; see cat. no. 82), Fantin, Whistler, and the Morisot sisters, in addition to the unassuming Valernes, in whose company he showed himself in the last of his self-portraits. In the early 1860s, there were a few survivors from his stay in Italy: Bonnat (whose portrait—cat. no. 43—he did in 1863), Henner, and the mysterious Édouard Brandon, who was one of the first collectors of his works (see cat. no. 106).

If Degas's circle of acquaintances altered appreciably from 1860 to 1873 while his true friends came mainly from the milieu in which he grew up, the decent Parisian bourgeoisie, educated and active (the constellation of the Niaudets, Bréguets, and Halévys, the Valpinçons, and, after 1870, the Rouarts, childhood friends with whom he renewed contact when the war began), the same was also true of his tastes, which were ever broadening. Ingres, who had reigned supreme before the departure for Italy and was then eclipsed by Delacroix at the very end of the 1850s, returned in force, without altering Degas's love for the painter of the *Women of Algiers*. His interests were never exclusive, and he took a certain exception to the mandatory alternatives of the Flandrinian-Lamothian sectarianism, whereby strict loyalty to Ingres made it impossible to be fond of Delacroix, not to mention Courbet, of course, and the masters of the Barbizon

52. Jacques-Émile Blanche, *Essais et portraits*, Paris: Dorbon aîné, 1962.
53. Lemoisne [1946–49], I, p. 63.
54. Quoted by Manet in a letter to Fantin-Latour, cited in Moreau-Nélaton 1926, I, p. 103.
55. Durand-Ruel archives, Paris, stock nos. 943, 976, 979.
56. Moreau-Nélaton 1926, I, p. 102.
57. Letter from Jacques-Émile Blanche to an unidentified correspondent (Fantin-Latour?), n.d., Musée d'Orsay, Paris.
58. March 1898, Lettres Pissarro 1950, p. 451; Pissarro Letters 1980, p. 323.
59. Letter, private collection, cited in part in Lemoisne [1946–49], I, p. 30.
60. Reff 1985, Notebook 14A (BN, Carnet 29, fol. 599v).
61. Reff 1985, Notebook 16 (BN, Carnet 27, p. 6).

school. Degas took his pleasure—and profit—where he could find it: with Meissonier, whose equestrian science he admired (see cat. no. 68 and "The First Sculptures," p. 71), with De Dreux, Whistler, and the English painters he inspected at the Exposition Universelle of 1867, and also with Courbet (see cat. no. 77), though he later admitted that in looking at the paintings of the Master of Ornans he felt they were "a personal judgment on him [Degas], as someone who had spent his life overrefining his painting. . . . He felt as if a calf's sticky muzzle had just nudged him."[57]

Degas's insatiable curiosity, which, as Pissarro acknowledged years later, spurred him to continue to forge ahead,[58] is evident not only in the scope, the complexity, and sometimes the ambiguity of his pictorial interests, but also in the works themselves. Over these twenty years of his career, as he tackled the most diverse subjects, using many techniques and styles (at times so dissimilar that the most practiced eye would probably never ascribe them to one artist), constantly questioning, always dissatisfied, scraping a canvas to begin tirelessly again, he nevertheless succeeded in producing an uninterrupted flow of masterpieces.

From 1853 to 1873, Degas worked—though not with equal application—in all genres: copies, portraits, landscapes, history paintings, religious paintings, and scenes from contemporary life, not to mention his studies from life and a very few still lifes. If one compiles the works catalogued by Lemoisne and by Brame and Reff, it appears, despite certain irresolvable ambiguities (for example, whether *The Orchestra of the Opéra* [cat. no. 97] and *Portraits in an Office* [cat. no. 115] are portraits or genre scenes), that the portraits (over a hundred) are the clear numerical winners, representing about 45 percent of the artist's production; a little more than 6 percent are self-portraits; next come the sixty or so landscapes (approximately 25 percent), about twenty-five scenes from contemporary life (10.5 percent), the copies (5 percent), the history paintings (4.25 percent), and a similar percentage of miscellaneous works. These statistics are revealing, but must be taken with caution. Their chief interest is that they indicate the staggering preponderance of portraits. On the other hand, they veil the considerable effort applied over many years to the difficult development of history paintings. They give an exaggerated importance to the sporadic landscapes (essentially the series of pastels done in 1869), and overlook the irruption of scenes from contemporary life, increasingly frequent from the mid-1860s.

There are many reasons for this emphasis on portraiture, starting with the worldly but not improvident remarks of Auguste De Gas, who saw in this genre the only way for his son to earn an adequate living if he wanted a career as an artist. Admonishing Edgar, who in 1858 in Florence was expressing some "boredom" with portraits (see cat. no. 20), he explained to him that portraits would be "the finest jewel in your crown" and that "the problem of keeping the pot boiling is so grave, so urgent, so crushing, that only madmen can scorn or ignore it."[59]

Living off his fortune—or, to be more exact, his family's comfortable income—Degas did not feel the need (pursuing his father's metaphor) to produce potboilers, and so did not begin a career as a fashionable portrait painter. In fact, Auguste's entreaties were beside the point, because from the very outset (Lamothe's instruction contributing to, but inadequate to explain, the persistence of this obsession) the painter demonstrated an unflagging interest in this genre. In a notebook used in 1859–60, he noted as future projects: "I must do something with Vauvenargues's face, which is close to my heart. And not forget to do René full-length with his hat, as well as a portrait of a lady with her hat, putting on her gloves while she is getting ready to go out."[60] He wondered about the possible appearance of an effigy of his favorite poet, Alfred de Musset—"How does one do an epic portrait of Musset?"[61]—testifying to the depth of his investigation into the very nature of a genre that he practiced with such obvious success and which led him, in a clear and progressive development, from the first portraits of 1853–55 to the complex *Portraits in an Office* of 1873.

Until his return from Italy, his models—aside from himself, in the self-portraits he executed during these formative years (see cat. no. 1)—were almost exclusively family

members, brothers and sisters, aunts and uncles. One exception was his father: although Auguste was attentive to the progress of his son, he would not be portrayed until the early 1870s, behind the singer Pagans (cat. no. 102). The painter did not make portraits of all his many relations with the same frequency. His good and worthy aunt Rose Morbilli is given no more than a small watercolor (cat. no. 16). His brother Achille (cat. no. 4) appears less often than René, the youngest (cat. no. 2). His favorite subjects—his sister Thérèse (cat. nos. 3, 63, 94), her husband Edmondo (cat. nos. 63, 64), his aunt Laura Bellelli (cat. nos. 20, 23)—were not necessarily those he preferred as people but those who were most interesting for strictly pictorial reasons: Thérèse for her Ingresque countenance, more frequently studied and reproduced than that of the intelligent and musical Marguerite; Edmondo Morbilli, whose physiognomy was like that of a sixteenth-century lord; Laura Bellelli, with her air of a queen regent in deep mourning, a princess by van Dyck. The women often have "that saving touch of ugliness"[62]—Berthe Morisot, commenting on the Salon of 1869, noted: "M. Degas has a very pretty little portrait of a very ugly woman in black [fig. 25]."[63] Degas delighted in emphasizing the exaggerated features of his models in works such as *The Collector of Prints* (cat. no. 66) or *Portrait of a Man* (cat. no. 71), and in highlighting the faces of a Roman beggar woman (cat. no. 11) or of his grandfather Hilaire (cat. no. 15) with all their signs of old age—the wrinkled skin, the bags under the eyes.

Paradoxically, the "boredom" that Degas felt in doing portraits, whether in 1858 in Florence when he produced a great number to please his uncle and host Gennaro Bellelli or in 1873 when he successively "did" all the members of his American family by popular demand, resulted in two ambitious works, *The Bellelli Family* (cat. no. 20) and *Portraits in an Office (New Orleans)* (cat. no. 115), which were not of a different genre but true portraits, each of which he tackled with passion, in singular contrast to the apathy and lassitude he had shown earlier.

Degas's chief concern remained the placing of the figure against its background: the plain dark background of the 1855 self-portrait (cat. no. 1) was followed by more picturesque arrangements, notably after the Salon of 1859, where he had admired the novel compositions of Ricard.[64] As early as September 1855, when visiting the museum in Montpellier, he had been struck by the vivid and resonant backgrounds of certain Renaissance portraits;[65] a little later, in a notebook used in 1858–59, he observed: "I have to think of the *faces* before all else, or at least study them while *thinking* only of the backgrounds."[66] Consequently, he tested various solutions over these twenty years: installing the model, along with the attributes of his or her social situation, on a neutral background (*René De Gas*, cat. no. 2) or against more vibrant and colorful walls, yet simplified to an extreme so as to leave scarcely a hint of the surrounding architecture (*M. and Mme Edmondo Morbilli*, cat. no. 63); the portrait in an interior in the tradition of the Lyons school (*Hilaire Degas*, cat. no. 15); and soon after, beginning in the mid-1860s, more complex arrangements—one might almost say "staged scenes"—in which Degas sets the subject, usually very informally, in a significant environment. In this regard, the series of portraits of artists that he executed sometime between 1865 and 1872 marked a decisive phase—"series" here implying similarity neither in size nor intention but in the continuing search for a formula to capture the artists in their circumstances. Dressed in bourgeois attire, the painters pose in studios piled with canvases (cat. nos. 72, 75); the musicians, at the theater or in a drawing room, play their instruments, whose odd shapes Degas enjoyed emphasizing. In *La nouvelle peinture* (1876), Duranty was to pinpoint (under the influence of the painter) what the art of the portrait had become: "In actuality, a person never appears against a neutral or vague background. Instead, surrounding him and behind him are the furniture, fireplaces, curtains, and walls that indicate his financial position, class, and profession."[67] But what distinguishes the Degas portrait from traditional portraits in an interior is the model's attitude: "The individual will be at a piano, or examining a sample of cotton in an office, or waiting in the wings for the moment to go on stage, or ironing on a makeshift table. . . . When at rest, he will not be merely pausing or striking a meaningless pose before the photographer's lens. This moment will be as much part of his life as are his actions."[68] As Clouet's por-

62. Lettres Degas 1945, III, p. 28; Degas Letters 1947, no. 5, p. 27.
63. Morisot 1950, p. 28; Morisot 1957, p. 32.
64. See 1984–85 Rome, p. 31.
65. Reff 1985, Notebook 4 (BN, Carnet 15, p. 99).
66. Reff 1985, Notebook 11 (BN, Carnet 28, p. 60).
67. Edmond Duranty, *La nouvelle peinture*, Paris, 1876 (translation 1986 Washington, D.C., p. 44).
68. Ibid.
69. Reff 1985, Notebook 16 (BN, Carnet 27, p. 6).
70. Unpublished letter from Gustave Moreau to Degas, Rome to Paris, 18 May 1859, Musée Gustave Moreau, Paris.
71. Duranty, op. cit., p. 478.
72. Halévy 1960, pp. 159–60; Halévy 1964, p. 119.

traits were, for Michelet, irreplaceable historical testaments, as eloquent as archival sources, so too would Degas's portraits of his contemporaries have documentary value, revealing the circumstances of each person, describing a milieu or a profession: Degas wished "to find a composition that paints our time," as he had already noted in 1859 when reflecting on the art of portraiture.[69]

While we can detect an appreciable evolution in this genre, which Degas practiced throughout his life (even if he did not demonstrate the same interest and persistence after 1870), such is not the case with his history paintings. These amount to several ambitious but mainly unfinished works for which there are a great many often admirable preparatory drawings or sketches in oil. After the exhibition of *Scene of War in the Middle Ages* (cat. no. 45) at the Salon of 1865 (an allegory, not a history subject in the proper sense), the history paintings cease. There has of course been talk of failure, of Degas's deep-seated inadequacy in this genre; it has not been appreciated that in just a few canvases, Degas (along with Moreau and Puvis de Chavannes) had proposed an original solution to this tormenting problem. It is true that, from one picture to the next, it is difficult to see where he was heading: *The Daughter of Jephthah* (cat. no. 26) casts a longing gaze toward Delacroix's large formats and the brilliant tumult of his colors; *Semiramis* (cat. no. 29) bears witness to his overcoming the ascendancy of Moreau; *Young Spartans* (cat. no. 40) disregards archaeology, its girls "provoking" Gérôme and the neo-Greeks more than the boys of Sparta. At first, the situation appeared desperate and totally confused. It no longer even seemed clear what was meant by "history painting"; Moreau, receiving news of the Salon of 1859 in Rome, commented wryly: "A few laments for the death of history painting. Poor history painting! I'm not quite sure what the term means, and am waiting for a little information before raising my handkerchief to my eyes."[70] At that time, Degas probably shared his mentor's position: there was indeed a crisis, but history painting was not dead; it had to be given back some of its color, and other subjects had to be found, as well as new ways of treating them. It had to be removed from the arduous exhumations of an artist such as Gérôme who, on the barest of data, gave birth to a world while claiming its exactitude. Salvation thus lay not in "reconstruction" in the strict sense of the submission for entrance to the Academy in Rome, but in seeking a different and resolutely contemporary truth. *Semiramis* and especially *Young Spartans* prove that Degas realized that archaeology is not an exact science and that a discovery, however crucial, does not determine things forever; archaeology is constantly renewing both itself and, inevitably, the knowledge of bygone ages. Gérôme's brand of truth was illusory; what was needed, as Duranty wrote in his 1876 essay, was to illuminate "these ancient things by the flame of contemporary life,"[71] and the novelist proposed Renan and Veronese as models. Such was Degas's procedure in *Young Spartans*—rejecting the antique ideal and, in a desolate plain where we search in vain for the shade of the plane-tree grove, setting Parisian urchins like anachronisms in this scene from mythic Greece.

Degas would later imply that he did not continue with history painting because it was an exhausted genre, commenting in relation to one of his many women in a tub: "To think that in another age I would have been painting Susanna and the Elders."[72] In his youth, he had in fact painted compositions taken from the Bible or from ancient history that were perfectly original and had no equivalent in the art of his period. Like the Renaissance painters to whom he so often referred, he had concealed very contemporary concerns beneath a thin archaeological veneer: *The Daughter of Jephthah* can be read as a criticism of the Italian policy of Napoleon III; *Semiramis* implicitly deplores the urban planning of Haussmann; and *Scene of War in the Middle Ages* evokes the American Civil War and the Northern soldiers' cruel treatment of the women of New Orleans.

It was not the "discovery" of scenes from contemporary life under the influence of Manet and the habitués of the Café Guerbois—a misapprehension later fostered by Manet—that led to the disappearance of historical themes. The introduction of horses and, later, dancers into Degas's work owed nothing to these artists. While Degas was working on his first racecourse scenes (see cat. no. 42)—a theme already treated by Moreau, who perhaps inspired him—he continued the slow development of *Semiramis*

and turned to those who had preceded him in this genre, Géricault and in particular De Dreux. Until the end of the 1860s, this was the only subject drawn from contemporary life that Degas treated regularly. The first dancers were the result of research for the portrait of the bassoonist Désiré Dihau: in *The Orchestra of the Opéra* (cat. no. 97), a few legs and tutus appear, lit by the footlights over the heads of the dour musicians. A little later, in *Orchestra Musicians* (cat. no. 98), the group portrait becomes a genre scene, a pertinent study of that incongruous and brutal gulf separating two juxtaposed worlds— compact and somber (black and white, but mainly black) of the instrumentalists in the orchestra pit, and light, vibrant, and luminous of the ballerinas on stage. Soon after, Degas followed the little dancers into the vast, run-down rooms on rue Le Peletier. Out of their daily exercises and varied poses, he made little pictures, precisely and meticulously painted, with polished surfaces, whose immediate success explains their recurrence in his work.

Meanwhile, there were two pictures that had no real posterity in the painter's work, *Interior* (cat. no. 84) and *Sulking* (cat. no. 85)—enigmatic, deliberately ambiguous canvases that do not invite conventional explanations. It would be unfair to see them as simply the French equivalent of the countless English genre scenes that Degas had admired at the Exposition Universelle of 1867. *Interior* is not an anecdote in the manner of Tissot but the unaffected description of a drama, painted on a canvas of some size. In another age, to return to what he later said about his women in a tub, Degas would have painted a *Tarquin and Lucretia*: now the modest iron bed, the oil lamp, the flowered wallpaper, and the lower-middle-class fireplace have replaced columns and pilasters, tapestries and candelabra. No classical peplos here, but a corset and dressing gown; no plumed crest, but a black top hat. *Interior* is the fulfillment of a contemporary wish—"Ah! Giotto, let me see Paris, and you, Paris, let me see Giotto!"[73]—and the result of a considerable mutation: the banal elevated to the level of history painting.

In addition to the variety of genres and subjects dealt with by Degas over these twenty years, there is the variety in his techniques (oil, essence, chalk, pencil, watercolor, and pastel, as well as etching and sculpture) and of his handling—rapid or deliberate, but always flat as a board, as Ingres recommended, in a paint that was sometimes thin but usually oily. More attention should be devoted to the beauty of his secret notations—those "black gloves shining like leeches"[74]—and to the variety and frequency of the images: the questioning, thirsty eyes, the uncertain and perplexed gaze of the painter, the imperious yet absent air of Laura Bellelli, the weary face of a father soon to die, and the beaming, impish expression of a little girl chewing a piece of an apple; and then those slender youngsters in that arid plain of Sparta, a hieratic queen contemplating the serene and monumental architecture of her city of Babylon, a huge bouquet of end-of-summer flowers, the jockeys' bright caps and jackets on the darker green of the fields, the smoke from a steamer on a motionless sea, ghostly nuns dancing above impassive operagoers, and already the rustle of the first dancers skipping on stage or exercising at the barre, their tutus white, their shoes pink, and their bows of many colors.

73. Reff 1985, Notebook 22 (BN, Carnet 8, p. 5).
74. Reff 1985, Notebook 23 (BN, Carnet 21, p. 17).

Chronology I

1832

14 July

Marriage at the church of Notre-Dame-de-Lorette of "Laurent Pierre Augustin Hyacinthe Degas, banker, of rue de la Tour-des-Dames and formerly of via Monte Oliveto, Naples, of age, son of René Hilaire Degas, broker, and of Jeanne Aurore Freppa of Naples, to Marie Célestine Musson of 4 rue Pigal, her father's house, of age, daughter of Jean Baptiste Étienne Germain Musson, formerly a merchant, and of Marie Céleste Vincent Rillieux, deceased." Augustin, known as Auguste De Gas, is twenty-four years old (born 27 September 1807 in Naples) and Célestine Musson is seventeen (born 10 April 1815 in New Orleans).

> Lemoisne [1946–49], I, p. 225 n. 5.

Fig. 12. Anonymous miniaturist, *Célestine De Gas* and *Auguste De Gas*, c. 1832–34. Location unknown. Reproduced in Lemoisne [1946–49], I, between pp. 8–9

1834

19 July

Hilaire Germain Edgar De Gas is born at 8 rue Saint-Georges, his parents' apartment. He is almost the same age as his cousin Alfredo Morbilli, born 29 June in Naples. Two of his closest friends are born the same year—Ludovic Halévy on 1 January and Paul Valpinçon on 29 October.

> Lemoisne [1946–49], I, p. 225 n. 6; Raimondi 1958, genealogical table IV, p. 284.

1836

9 January

Edmondo Morbilli, a cousin and future brother-in-law of the artist, is born in Naples.

10 June

Together with his sons Henri, Édouard, and Achille, Hilaire Degas establishes the company Degas Padre e Figli in Naples.

> Raimondi 1958, p. 118.

1838

16 November

The artist's brother Achille De Gas is born at 21 rue de la Victoire, Paris.

> Lemoisne [1946–49], I, p. 225 n. 7.

1840

8 April

His sister Thérèse De Gas is born in Naples.

> Boggs 1965, p. 275 n. 32.

1841

13 April

Death of his grandmother Giovanna Aurora Teresa Freppa, wife of Hilaire Degas, in Naples (born 1783 in Livorno).

> Raimondi 1958, genealogical table II, p. 282.

1842

2 July

His sister Marguerite De Gas is born in Passy.

> Lemoisne [1946–49], I, p. 226 n. 8.

31 August

His aunt Laura Degas marries Baron Gennaro Bellelli in Naples.

> Raimondi 1958, genealogical table II, p. 282.

1845

6 May

His brother René De Gas is born at 24 rue de l'Ouest, Paris.

> Lemoisne [1946–49], I, p. 226 n. 9 (records baptism at Saint-Sulpice 15 June).

5 October

Begins attending the Lycée Louis-le-Grand, entering the "classe de septième." Alfred Niaudet has attended Louis-le-Grand since 2 October 1843; Paul Valpinçon will begin on 16 February 1846 and Ludovic Halévy on 20 April.

> Archives, Lycée Louis-le-Grand, Paris. Lemoisne's chronology of Degas's education (Lemoisne [1946–49], I, p. 226 n. 10) is incorrect. All information provided here concerning Degas's years at Louis-le-Grand is taken from the school's archives.

1846

5 October

Enters the "classe de sixième" at Louis-le-Grand.

1847

5 September

Death of his mother, Mme Auguste De Gas, née Célestine Musson, in Paris.

4 October

Enters the "classe de cinquième" at Louis-le-Grand.

1848

15–16 May

Revolution in Naples; his cousin Gustavo Morbilli is killed.

> Raimondi 1958, pp. 190, 196ff.

2 October

Enters the "classe de quatrième" at Louis-le-Grand.

10 December

Birth of his cousin Giovanna Bellelli in Naples.

> Raimondi 1958, genealogical table VIII, p. 288.

1849

May

Gennaro Bellelli is exiled from Naples as a result of his active participation in the events of 1848. He will go to Marseilles, London, Paris, and Florence.

> Raimondi 1958, pp. 226–36.

8 October

Enters the "classe de troisième" at Louis-le-Grand.

1850

19 June

"Edgar is a little man, and argues logically."

> Unpublished letter from Hilaire Degas to MM. Degas, Marseilles to Genoa, private collection.

24 September
His brother Achille begins attending Louis-le-Grand.

7 October
Enters the "classe de seconde" at Louis-le-Grand.

1851

13 July
Birth of his cousin Giulia Bellelli.
> Raimondi 1958, genealogical table VIII, p. 288.

6 October
Enters Rhetoric at Louis-le-Grand. The punishment records for November–December 1851 and January 1852 (the only ones surviving for those years) show that he received five detentions—three for "laziness," one for "untidiness," and one for "careless homework."

1852

18 February
Alfred Niaudet, through whom Degas will become acquainted with the Bréguet and Halévy families, is expelled from Louis-Le-Grand.

20 September
Obtains the *certificat d'aptitude* for the baccalaureate.
> Diploma, private collection.

4 October
Enters Logic, arts section, at Louis-le-Grand.

1853

23 March
Obtains his baccalaureate.
> Diploma, private collection.

27 March
Leaves Louis-le-Grand.

7 April
Receives permission to copy at the Louvre (card no. 611: De Gas, Edgar; age, 18½; address, 4 rue de Mondovi; teacher, Barrias).
> Archives, Musée du Louvre, Paris, LL9.

9 April
Receives permission to copy at the Cabinet des Estampes of the Bibliothèque Nationale.
> Lemoisne [1946–49], I, p. 227 n. 13.

after 10 May
Death of his grandfather Germain Musson in Mexico.

12 November
Registers at the Faculté de Droit for the first and last time.
> Lemoisne [1946–49], I, p. 227 n. 14.

11 December
Drawing of his brother Achille (formerly Nepveu-Degas collection), inscribed "11 Xbre 53," the first dated drawing on a separate piece of paper.

1854

31 October
Begins copying Raphael's *Portrait of a Young Man* (now attributed to Franciabigio).
> Archives, Musée du Louvre, Paris, LL26; Reff 1985, Notebook 2 (BN, Carnet 20, p. 31).

1855

Degas is taken by Édouard Valpinçon (father of his friend Paul and a well-known collector) to visit Ingres.
> Moreau-Nélaton 1931, p. 269.

12, 19, and 26 March
Competition for places at the École des Beaux-Arts.
> Archives Nationales, Paris, AJ⁵²76.

5 April
Judging of competition for places for the summer term, with Dumont presiding. Degas (ranking thirty-third) is admitted along with Léon Tourny, Ottin, Régamey, and Fantin-Latour.

6 April
Registers at the École des Beaux-Arts as a student in the painting-and-sculpture section. He is the only student presented by Louis Lamothe; his fellow students work under Lecoq de Boisbaudran, Hippolyte Flandrin, Cogniet, Picot, and Gleyre.
> Archives Nationales, Paris, AJ⁵²235.

spring
Paints *Self-Portrait* (cat. no. 1) and *René De Gas* (cat. no. 2).

May–July
Visits the Exposition Universelle, where he copies among other things several works by Ingres.
> Reff 1985, Notebook 2 (BN, Carnet 20, pp. 9, 30, 48, 53–54, 59, 61, 68, 79, 82–83).

26 June
First performance of Schiller's *Mary Stuart* (translated into Italian), with the celebrated Adélaïde Ristori, is presented at the Salle Ventadour; Degas makes several sketches of the tragedienne in this role.
> Reff 1985, Notebook 3 (BN, Carnet 10, p. 96).

July–September
Visits Lyons. Flandrin is there, working on the Saint-Martin-d'Ainay frescoes with the assistance of Lamothe.
> Reff 1985, Notebook 3 (BN, Carnet 10, p. 20).

16–22 September
Travels to Arles, Sète, Nîmes, and Avignon; copies David's *Death of Bara* at the Musée Calvet.
> Reff 1985, Notebook 4 (BN, Carnet 15, p. 64).

late September–mid-July 1856
Stays in Paris, where he continues copying at the Louvre and does preliminary sketches for *Saint John the Baptist and the Angel* (unrealized; see cat. no. 10 and L20) and *Candaules's Wife* (unrealized; see BR8).
> Reff 1985, Notebook 5 (BN, Carnet 13, p. 48), Notebook 6 (BN, Carnet 11, pp. 54–63).

Fig. 13. Notebook drawing inscribed "D'après M. Soutzo 15 février 1856." Pencil, 4⅛ × 5⅜ in. (10.5 × 13.7 cm). Bibliothèque Nationale, Paris, Dc327d, Carnet 11, pp. 43–42 (Reff 1985, Notebook 6)

Fig. 14. At left, Hilaire Degas's residence, Palazzo Pignatelli, Calata Trinità Maggiore, Naples

Fig. 15. Entrance to Hilaire Degas's residence, Palazzo Pignatelli, Calata Trinità Maggiore, Naples. Portal by Sanfelice, 1718

1856

18 January

A "great talk" with Grégoire Soutzo, an engraver and friend of the artist's father. "His studies show such courage. Courage is what's needed—never haggle with nature. It is courageous to confront nature with its main outlines, and cowardly to approach it through facets and details." On 15 February, Degas copies a landscape by Soutzo (fig. 13) and on 24 February has another "remarkable conversation" with him.

> Reff 1985, Notebook 5 (BN, Carnet 13, p. 33), Notebook 6 (BN, Carnet 11, p. 65).

24 January

Sketch of a young man inscribed "after M. Serret, Thursday, 24 January 1856."

> Reff 1985, Notebook 5 (BN, Carnet 13, p. 49).

7 April

"I cannot say how much I love that girl since she turned me down."

> Reff 1985, Notebook 6 (BN, Carnet 11, p. 21).

15 April

Sees Adélaïde Ristori in her second Paris appearance, in Legouvé's *Medea* (translated into Italian); the actress's costumes were designed by Ary Scheffer.

> Reff 1985, Notebook 6 (BN, Carnet 11, p. 14); Adélaïde Ristori, *Études et souvenirs*, Paris: P. Ollendorff, 1887, pp. 140, 194.

17 July

Arrives in Naples from Marseilles. During his stay, he will make numerous copies of works at the National Museum, as well as a portrait of his cousin Giovanna Bellelli (L10) and *View of Naples Seen through a Window* (L48).

> *Giornale del Regno delle Due Sicilie*, 19 July 1856; Reff 1985, Notebook 4 (BN, Carnet 15, p. 17).

7 October

Leaves Naples for Civitavecchia and Rome, where he will stay until late July 1857. During this first visit, he attends the academy at the Villa Medici in the evenings (see "Life Drawings," p. 65), copies in the churches and Vatican museums, and sketches street scenes. He continues his studies for *Saint John the Baptist and the Angel* (see cat. no. 10) and begins various subjects after Dante's *Divine Comedy*.

> Reff 1985, Notebook 7 (Louvre, RF5634, p. 27 and passim), Notebook 8 (private collection, passim).

1857

Dated works: *Roman Beggar Woman* (cat. no. 11); *The Old Italian Woman* (fig. 31). In 1857–58, paints *Woman on a Terrace*, which he will later rework as *Young Woman and Ibis* (cat. no. 39).

6 February

From the Villa Medici, sketches the gardens of the Villa Borghese.

> Reff 1985, Notebook 8 (private collection, pp. 36v, 37).

5 March

"I feel much calmer now."

> Reff 1985, Notebook 8 (private collection, p. 35v).

9 April

Holy Thursday. Sketches the crowd at Saint Peter's.

July

Visits Terracina, Fondi, and Mola di Gaëta.

> Reff 1985, Notebook 10 (BN, Carnet 25, passim).

July–September

Élie Delaunay (1828–1891), a painter from Nantes whom Degas had known at the École des Beaux-Arts, visits Naples and Campania.

> Drawings in the Musée du Louvre, Paris, and the Musée de Nantes.

Fig. 16. *Édouard Degas*, 1857. Pencil, 10⁴⁄₄ × 8⁰¾ in. (26⁴ × 20⁵ cm). Cabinet des Dessins, Musée du Louvre (Orsay), Paris (RF22998)

16 July

Degas is still in Rome; his grandfather urges him to join him at his villa at Capodimonte, where he has been for a month.

> Unpublished letter from Hilaire Degas to Edgar, Naples to Rome, private collection.

1 August

Arrives in Naples. Stays in Naples and at his grandfather's villa at San Rocco di Capodimonte until late October. Does two portraits of his grandfather (L33, Musée d'Orsay, Paris; cat. no. 15) and a pencil drawing of his uncle Édouard Degas (fig. 16).

> Reff 1985, Notebook 8 (private collection, p. 90v).

29 August

During his visit, his cousin Germaine Argia Morbilli, who is married to the Marquis Tommaso Guerrero de Balde, gives birth to a baby girl.

> Raimondi 1958, genealogical table IV, p. 284.

22 October–June 1858

First visit to Rome of the painter Gustave Moreau (1826–1898), whom Degas has not yet met. He stays at 35 via Frattina. From November on, Moreau sees the painters Édouard Brandon (who will become a friend of Degas's and an important collector of his works) and Émile Lévy.

> Mathieu 1974, pp. 173–77; unpublished letters from Moreau to his parents, Rome to Paris, 24 and 30 October, 2 and 5 November 1857, Musée Gustave Moreau, Paris.

late October

Degas arrives in Rome. This time he stays at "18 San Isidoro." Before leaving for Florence in July 1858, he does many copies of works in the Sistine Chapel, the Doria Pamphili Gallery, and the Capitoline Gallery; begins *David and Goliath* (L114); and continues

his studies for *Dante and Virgil* (see fig. 11) and *Saint John the Baptist and the Angel* (see cat. no. 10).

> Unpublished letter from Thérèse De Gas to Sophie Niaudet, Paris to Paris, 11 November 1857, private collection; Reff 1985, Notebook 11 (BN, Carnet 28, pp. 34–36, 49).

2 November

Moreau, accompanied by his friend the painter Frédéric Charlot de Courcy, visits Schnetz, the director of the French Academy in Rome; he begins going to the Villa Medici. Between 8 November and 4 December, he copies part of Sodoma's *Alexander and Roxana* at the Villa Farnesina.

> Unpublished letters from Moreau to his parents, Rome to Paris, 30 October, 2, 5, and 8 November 1857, Musée Gustave Moreau, Paris.

10 November

Degas is in Tivoli.

> Reff 1985, Notebook 10 (BN, Carnet 25, p. 46).

11 November

Thérèse De Gas informs Sophie Niaudet that she has returned from Saint-Valéry-sur-Somme and does not intend to go to Naples before the following August.

> Unpublished letter, private collection.

13 November

Degas studies Claude Lorrain's etchings at the Corsini Gallery.

> Reff 1985, Notebook 10 (BN, Carnet 25, p. 50).

20 November

Sketches the Castel Sant'Angelo on the banks of the Tiber.

> Reff 1985, Notebook 10 (BN, Carnet 25, p. 58).

December–January 1858

Moreau copies the Sibyls and Prophets at the Sistine Chapel. Bothered by the frequent ceremonies, he often goes to work at the Villa Medici, "where there are some very beautiful works of art."

> Mathieu 1974, pp. 173–74; unpublished letter from Moreau to his parents, Rome to Paris, n.d., Musée Gustave Moreau, Paris.

1858

January

Moreau continues frequenting the Villa Medici, where he studies the nude. It is probably during this period that he makes Degas's acquaintance. From February to May, he copies Giulio Romano, Correggio, Raphael, and Veronese at the Borghese Gallery and the Academy of Saint Luke.

> Unpublished letter from Moreau to his parents, Rome to Paris, 14 January 1858, Musée Gustave Moreau, Paris.

June–August

Moreau's first visit to Florence, where he stays at 1169 Borgo Sant'Apostoli.

> Mathieu 1974, pp. 171–79.

June

Émile Lévy writes to Moreau from Rome: "Delaunay, Camille [Clère], the bear, and the *ciociaro* send you their regards. You will see them all shortly; I alone will be absent." (The "bear" apparently is Degas.)

> Unpublished letter, Rome to Florence, n.d., Musée Gustave Moreau, Paris.

1 July

Émile Lévy has returned to Paris; he sorely misses Rome.

> Unpublished letter from Lévy to Moreau, Paris to Florence, Musée Gustave Moreau, Paris.

13 July

Joseph-Gabriel Tourny (1817–1880) writes to Degas: "We are always thinking of the Degas who grumbles and the Edgar who growls." Tourny sends greetings to Clère, Moreau, and Abbé Aulanier.

> Letter, Ivry to Florence, private collection; cited in part in Lemoisne [1946–49], I, p. 227 n. 24 (misdated 15 July).

14 July

De Courcy returns to Paris.

> Unpublished letter from Moreau to his parents, Florence to Paris, 3 July 1858, Musée Gustave Moreau, Paris.

24 July

Degas travels from Rome to Florence by way of Viterbo, Orvieto (27 July), Perugia, Assisi (31 July), Spello, and Arezzo. He describes the trip in a notebook and, on the way, makes quick copies of the Signorelli frescoes at Orvieto, among other things (IV:74.a, IV:81.c).

> Reff 1985, Notebook 11 (BN, Carnet 28, passim).

31 July

His aunt Laura Bellelli, who is in Naples, invites him to stay with her when she will be in Florence.

> Unpublished letter from Laura Bellelli to Degas, Naples to Florence, private collection.

4 August

Degas is in Florence. He will be there until March 1859, staying at the Bellelli apartment, 1209 Piazza Maria Antonia (not Marco Antonin, as Lemoisne claims; today Piazza dell'Independenza). While in Florence, he does numerous copies of works in the Uffizi.

> Reff 1985, Notebook 12 (BN, Carnet 18, passim).

13 August

Auguste De Gas congratulates his son on a drawing of Angèle and Gabrielle Beauregard, ten-year-old twins from New Orleans, and passes on praise from Grégoire Soutzo and from Edmond Beaucousin, a well-known collector and friend of the family. However, he is not pleased with "three other portraits"—of M. and Mme Millaudon (the stepfather and mother of the young Beauregards) and of Mme Millaudon's mother, Mme Ducros.

> Unpublished letter, Paris to Florence, private collection.

Fig. 17. Gustave Moreau, *Edgar Degas*, c. 1858–59. Pencil, 9⅞ × 6¼ in. (24.9 × 15.7 cm). Musée Gustave Moreau, Paris

Fig. 18. Gustave Moreau, *Edgar Degas*, c. 1858–59. Pencil, 5¾ × 2⅞ in. (14.6 × 7.1 cm). Musée Gustave Moreau, Paris

19 August

Degas submits a request to the director of the Academy of Fine Arts in Florence for permission to "draw studies in the cloister of the Annunziata."

> Mathieu 1974, p. 67.

20 or 21 August

Moreau leaves Florence for Lugano.

> Mathieu 1974, p. 67.

31 August

Hilaire Degas dies in Naples. "It was scarcely light when suddenly our poor father died."

> Unpublished letter from Achille Degas to his nephew Edgar, Naples to Florence, 14 September 1858, private collection.

September

Beaucousin visits Florence; he talks to Degas about Carpaccio.

> Letter from Degas to Moreau, Florence to Venice, 21 September 1858, Musée Gustave Moreau, Paris; Reff 1969, pp. 281–82.

September–December

Moreau goes to Venice, where he rejoins Delaunay, the engraver Ferdinand Gaillard (1834–1887), and Félix Lionnet (1832–1896), a pupil of Corot's.

> Mathieu 1974, p. 179.

21 September

Degas gets bored in Florence. His only companions are the painter John Pradier and the English watercolorist John Bland. He remains solely in order to see his aunt and his two cousins, who are kept in Naples by Hilaire's death. Reads Pascal's *Provinciales*; copies Giorgione and Veronese.

> Letter from Degas to Moreau, Florence to Venice, Musée Gustave Moreau, Paris; Reff 1969, pp. 281–82 (Bland erroneously given as Blard).

28 September

Goes on a two-day excursion to Siena with Antoine Koenigswarter, a banker's son and friend of Moreau's.

> Letter from Degas to Moreau, Florence to Venice, 27 November 1858, in Reff 1969, p. 283; Reff 1985, Notebook 12 (BN, Carnet 18, p. 27); unpublished letter from Auguste De Gas to Edgar, Paris to Florence, 14 October 1858, private collection.

Tourny writes to Degas from Paris advising him, after his grandfather's death, to work hard and "keep his nose to the grindstone." He mentions the removal of varnish from paintings in the Louvre: "a good lesson for these modern artists who use such dark colors in imitation of the old paintings."

> Unpublished letter, private collection.

6 October

Auguste worries about his son's prolonged stay in Florence, as Laura Bellelli has again delayed her departure from Naples.

> Unpublished letter from Auguste De Gas to Edgar, Paris to Florence, private collection.

14 October

Auguste complains that he receives news of his son only through Koenigswarter; however, with the postponement of Achille's departure (to serve in the Navy), he allows Edgar to wait in Florence until his aunt's return.

> Unpublished letter from Auguste De Gas to Edgar, Paris to Florence, private collection.

25 October

Degas and his uncle Gennaro Bellelli plan to go to Livorno to wait for Laura and her two daughters.

> Letter from Degas to Moreau, Florence to Paris, 27 November 1858, Musée Gustave Moreau, Paris; Reff 1969, p. 283.

November

De Courcy and Émile Lévy visit Florence. At the same time, Delaunay is staying in Venice, where he sees Moreau. He later brings back numerous photographs from Venice to show to his former

teacher Louis Lamothe and to the sculptors Eugène Guillaume (1822–1905) and Henri Chapu (1833–1891).

> Letter from Degas to Moreau, Florence to Paris, 27 November 1858, Musée Gustave Moreau, Paris; Reff 1969, p. 283; handwritten notes by Mme de Beauchamp, Musée d'Orsay, Paris.

1 November

Degas goes to Livorno, no doubt on impulse, to wait for his aunt Laura and her daughters.

> Unpublished letters from Gennaro Bellelli to Degas, Florence to Leghorn, 1 and 2 November 1858, private collection.

11 November

Tourny, who has seen Auguste De Gas the day before, leaves Paris for Rome, traveling overland by way of Florence. On the same day, Auguste receives a packing case from his son; among its contents are the *Dante and Virgil* (fig. 11). He expresses satisfaction with his son's progress: "I have unrolled your paintings and some of your drawings. I was very pleased, and I can tell you that you have taken a great step forward in your art; your drawing is strong, the colors are right. You have rid yourself of that weak, trivial, Flandrinian, Lamothian manner of drawing and that dull gray color. My dear Edgar, you have no reason to go on tormenting yourself, you are on the right track. Calm yourself and, working quietly but with perseverance, without slackening, follow the path you're on. It belongs to you and nobody else. Work calmly now and stick to this path, I tell you, and rest assured that you will succeed in doing great things. You have a great destiny ahead of you; don't become discouraged, don't fret." To his son's complaint of "boredom" with portrait work, Auguste replies that portraits insure a painter's material security.

> Letter, Paris to Florence, private collection; cited in part in Lemoisne [1946–49], I, p. 30.

19 November

Degas has "just sketched" the portrait of his aunt Laura.

> Unpublished letter from Auguste De Gas to Edgar, Paris to Florence, 25 November 1858, private collection.

25 November

Delaunay, passing through Florence on his way from Venice, visits Degas, who writes to Moreau: "Delaunay talked to me for a long time about Venice, about Carpaccio, about you, and a bit about Veronese." Degas adds that he has begun a portrait of his aunt and cousins and is devoting himself wholly to it.

> Letter from Degas to Moreau, Florence to Venice, 27 November 1858, Musée Gustave Moreau, Paris; Reff 1969, pp. 282–83.

30 November

Moreau leaves Venice for Florence. Auguste De Gas hears about his departure from Koenigswarter and is not at all pleased. "With M. Moreau in Florence, you will stay there even longer." He also warns his son: "If you have begun painting your aunt's portrait in oil, you'll find yourself making a mess in your hurry to finish."

> Unpublished letter from Auguste De Gas to Edgar, Paris to Florence, private collection.

mid-December–March 1859

Moreau's second visit to Florence. He is ill for about three months; does a number of copies.

> Mathieu 1974, pp. 180–82.

1859

4 January

Auguste De Gas, in a letter, gives his son more advice on his career as a painter; he does not share his liking for Delacroix and has reservations about Ingres, ranking him below the Italian masters of the fifteenth century, for whom he saves all his admiration; finally, he doubts that his son will be able, in a short period of time, to complete the portrait he has begun of the Bellelli family: "You start

such a large painting on 29 December and think you will finish it by 28 February."

> Letter, Paris to Florence, private collection; cited in part in Lemoisne [1946–49], I, pp. 31–32.

22 January

"Your new and already old friend Degas."

> Unpublished letter from Koenigswarter to Moreau, Paris to Florence, Musée Gustave Moreau, Paris.

10 February

De Courcy, who has found a studio in Paris at 39 rue de Laval, asks Moreau to give his address to Degas, whom he would like to see again.

> Unpublished letter from De Courcy to Moreau, Paris to Florence, Musée Gustave Moreau, Paris.

25 February

Auguste De Gas gives his son news of Paris: the marriage of Mélanie Valpinçon, the sister of Edgar's childhood friend Paul; the departure of Edgar's brother Achille for Brest, where he will set sail for the African coast; a visit to Paris by Edgar's uncle Eugène Musson, whom he will see on his return; long talks with Soutzo about the excessive rents being charged for studios ("700, 800, 900, as if it were nothing"). He ends by exhorting him to be patient: "Finish calmly the work you've begun, do not botch what you have to do."

> Unpublished letter, Paris to Florence, private collection.

early March

Moreau goes to Siena and Pisa with Degas; in Pisa, they copy the Benozzo Gozzoli frescoes in the Campo Santo.

> Mathieu 1974, p. 182; pencil drawing inscribed "Siena 1859" (IV:85.d); copies done at Siena and Pisa, Reff 1985, Notebook 13 (BN, Carnet 16, p. 41); copies after Gozzoli (Kunsthalle Bremen).

late March–early April

Degas leaves Florence to return to Paris, traveling overland by way of Livorno, Genoa (2 April; he is very impressed by the van Dycks at the Palazzo Rosso), Turin, Mont-Cenis, Saint-Jean-de-Maurienne, Lac du Bourget, and Mâcon.

> Reff 1985, Notebook 13 (BN, Carnet 16, p. 41); Reff 1969, p. 284.

April–July

Moreau's second visit to Rome.

> Mathieu 1974, pp. 184–85.

about 6 April

Degas arrives in Paris. He stays at his father's apartment, 4 rue de Mondovi, and on several occasions sees Moreau's friends Émile Lévy and De Courcy, who have now become his friends too. (Contrary to Lemoisne, he does not seem to have taken Soutzo's apartment on rue Madame, though Soutzo had proposed it in a letter to Auguste De Gas dated 6 April 1859 [private collection].)

> Reff 1969, p. 284; Lemoisne [1946–49], I, pp. 32, 229 n. 36.

24 April

Visits the Salon with Koenigswarter and Eugène Lacheurié, one of Moreau's friends whom he has just met.

> Reff 1969, p. 284; unpublished letter from Lacheurié to Moreau, Paris to Rome, 9 June 1859, Musée Gustave Moreau, Paris.

14 May

"It seems that you are once again immersed in Parisian life, and, since returning, have done nothing but stand and stare. As laziness is not your style, I am convinced that you will soon have had enough loafing and will get back to work."

> Unpublished letter from Achille Degas to his nephew Edgar, Naples to Paris, 14 May 1859, private collection.

25 May

Degas meets Émile Lévy at the home of De Courcy; Lévy is not pleased to receive news of Moreau through the conversation of Degas and De Courcy.

> Unpublished letter from Lévy to Moreau, Paris to Rome, 27 May 1859, Musée Gustave Moreau, Paris.

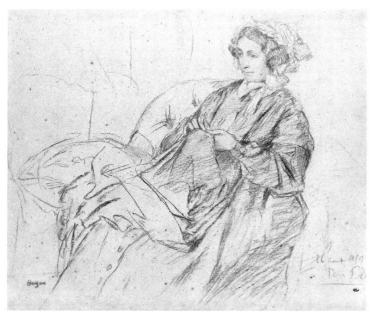

Fig. 19. *Woman Seated in an Armchair, Sewing* (III:159.2), dated 1859. Charcoal, 11⅜ × 13¾ in. (29 × 35 cm). Cabinet des Dessins, Musée du Louvre (Orsay), Paris (RF29292)

26 June

Continues to see De Courcy and Koenigswarter frequently. Writes a few lines to his uncle Achille Degas in Naples to tell him about Moreau's visit.

Reff 1969, pp. 285–86.

early July–September

Moreau visits Naples, where he is joined by Chapu and by Léon Bonnat (1833–1923). Degas's sisters, Marguerite and Thérèse, and his brother René also spend the summer in Naples.

Mathieu 1974, pp. 185–86; Reff 1969, pp. 285–86.

30 July

Edmondo Morbilli writes to Degas from Naples: "Now you have your own studio: that will make you feel more like working, though I do not think the desire is lacking; what you need is the courage to reach your goal. . . . We have not seen your friend M. Moreau, he must have been afraid to come."

Unpublished letter, Naples to Paris, private collection.

August

Koenigswarter spends a few evenings with Degas in Paris: "The poor fellow is quite down in the dumps just now."

Unpublished letter from Koenigswarter to Moreau, Paris to Naples, 30 August 1859, Musée Gustave Moreau, Paris.

26 August

Woman Seated in an Armchair, Sewing, charcoal drawing inscribed "26 August 1859/Paris E.D." (fig. 19).

5 September

René De Gas mentions the departure for New Orleans of the Millaudon family, whose portraits Degas had painted: "The Millaudons left on 30 August, not without regret, I imagine. Did they say when they planned to return? And you painted the portrait of Master Philippe, not without difficulty, I'm sure. Poor Mme Ducros must be very happy to be rejoining M. Marcel. Papa had to give them his letters for Uncle Michel."

Unpublished letter, Naples to Paris, private collection.

September

Moreau returns to France by sea.

Mathieu 1974, p. 186.

1 October

Degas moves to 13 rue de Laval.

Empty envelope with this address, and rent receipt for a studio, made out to M. Caze, private collection.

6 October

The painter Leopoldo Lambertini writes a long letter to Degas in which he describes the situation in Italy in detail; he is connected with another Italian friend of Degas's, the sculptor Stefano Galletti, but has little news of him.

Unpublished letter, Bologna to Paris, private collection.

31 December

Tourny, who is in Rome, where he has just met Henner, writes to Degas: "I was very pleased to hear that you had found a studio and were preparing for the next exhibition. I hope to see a completed work when I return." He also alludes to Degas's recent quarrel with Lamothe: "You are too frank and too sincere to put up with Jesuitism."

Jean-Jacques Henner, unpublished journal, Musée Henner, Paris; letter, Rome to Paris, private collection.

1860

Degas does some rapid sketches after two works by Delacroix, *Christ on the Lake of Gennesaret* and *Mirabeau and Dreux-Brézé*, at an exhibition organized by the Association des Artistes, 26 boulevard des Italiens.

Reff 1985, Notebook 16 (BN, Carnet 27, p. 20A), Notebook 18 (BN, Carnet 1, p. 53).

21 March

Coming from Marseilles, Degas arrives in Naples for the first time since his grandfather's death. He stays with his aunt Fanny (1819–1901), Marchessa di Cicerale and Duchessa di Montejasi. He finds there his two sisters, Thérèse and Marguerite, accompanied by their governess, Adèle Loÿe. During his brief stay, he visits his Morbilli cousins (22 March), makes an excursion to Posilipo, and visits the museums.

Reff 1985, Notebook 19 (BN, Carnet 19, p. 1); unpublished letter from Thérèse De Gas to her brother René, Naples to Paris, 31 March 1860, private collection.

2 April

Leaves Naples for Livorno and then goes to the Bellellis in Florence. He does a drawing of Gennaro Bellelli, in which he is posed as he will be in the family portrait (cat. no. 20). (The date of Degas's departure is unknown, but he seems to have stayed in the Tuscan capital less than a month before returning to Paris.)

Reff 1985, Notebook 19 (BN, Carnet 19, p. 3); Cabinet des Dessins, Musée du Louvre (Orsay), Paris, RF15484.

7 July

In a letter to his father from Gabon, where he is serving on board the *Recherche*, Achille worries about the progress of his brother's work: "Is Edgar's canvas coming along? Doesn't he intend to exhibit it at the next Salon?"

Unpublished letter, private collection.

9 July

Rossini's *Sémiramis* returns to the Opéra. (This new run of performances has been seen as a possible source for the painting by Degas; see cat. no. 29.)

23 July

Following the expedition of Garibaldi's "Thousand" and the fall of Francis II, Gennaro Bellelli can now return from exile. He leaves Livorno for Naples. In 1861, he will be appointed a senator of the Kingdom of Italy.

Raimondi 1958, pp. 247–48.

1861

17 January

"Edgar is so wrapped up in his painting that he writes to no one despite our remonstrances. . . . When will his wishes, which are ours as well, come true? The violin is still going well but very slowly. Edgar is also learning to play."

> Unpublished letter from René De Gas to his uncle Michel Musson, Paris to New Orleans, Tulane University Library, New Orleans.

early July

Achille De Gas returns to Paris.

> Unpublished letter from Achille De Gas to his father, Gorée to Paris, 31 May 1861, private collection.

3 September

Degas registers as a copyist at the Louvre (De Gas, Edgar; age 26; 4 rue de Mondovi). He fictitiously lists his friend Émile Lévy as his teacher.

> Archives, Musée du Louvre, Paris, LL10.

September–October

Degas spends three weeks with his friends the Valpinçons at their country estate at Ménil-Hubert, Orne, in Normandy. (On 13 October, Marguerite and René De Gas write to their uncle Michel Musson in New Orleans: "Edgar has returned from a three-week trip in Normandy and is slaving away at his painting.") Degas is to go to Ménil-Hubert on many other occasions throughout his life. With Paul Valpinçon, he visits Camembert and Haras du Pin. "I think of M. Soutzo and Corot. They alone would lend some interest to this calm."

> Unpublished letter, Tulane University Library, New Orleans; Reff 1985, Notebook 18 (BN, Carnet 1, p. 161).

1862

Dated work: *The Gentlemen's Race: Before the Start* (cat. no. 42).

Degas is interrupted by Manet while copying Velázquez's *Infanta Margarita* directly onto a copper plate at the Louvre. This is their first meeting.

> Paul Jamot and Georges Wildenstein, *Manet*, Paris: Les Beaux-Arts, 1932, p. 75; Moreau-Nélaton 1926, I, p. 36.

Fig. 20. *Paul Valpinçon* (L99), 1861. Oil on paper, 15¾ × 12⅝ in. (40 × 32 cm). The Minneapolis Institute of Arts

January

Delaunay returns to France after five years at the Villa Medici.

14 January

Degas again registers as a copyist at the Louvre.

> Reff 1964, p. 255.

17 January

Thérèse De Gas writes to her cousin Mathilde Musson in New Orleans: "There will be a change in our family in Naples; our uncle Édouard is going to marry a Cicerale girl, a sister-in-law of my aunt Fanny. She's not pretty, and she's about 27 or 28."

> Unpublished letter, Tulane University Library, New Orleans.

26 February

Mathilde Musson marries William Alexander Bell.

April

Exhibition of engravings by Manet at Cadart's, 66 rue de Richelieu.

20 May

Désiré Dihau, who is to become a friend of Degas's and the principal model for *The Orchestra of the Opéra* (cat. no. 97), joins the orchestra of the Opéra as a bassoonist; he starts 1 July and remains with the orchestra until 1 January 1890.

> Archives, Bibliothèque de l'Opéra, Paris.

31 May

Bracquemond founds the Société des Aquafortistes.

18 September

The painter James Tissot (1836–1902), who is traveling in Italy, writes to Degas from Venice; he asks him about the progress of his *Semiramis* and about some affair of the heart, of which we know nothing: "And Pauline? What about her? Where are you now with her? That pent-up passion is not being wasted only on Semiramis. I can't believe that by the time I'm back your virginity in relation to her will still be intact. You must tell me all about it."

> Lemoisne [1946–49], I, p. 230 n. 45.

21 November

"Our Raphael is still working, but has not produced anything that is really finished, and the years are passing."

> Letter from Auguste De Gas to his brother-in-law Michel Musson, Paris to New Orleans, Tulane University Library, New Orleans; cited in part in Lemoisne [1946–49], I, p. 41.

24 November

In Naples, Hilaire Degas's heirs take an inventory of his property in the presence of a notary, Leopoldo Cortelli. Throughout his life, Degas will make many trips to Naples, attempting to settle the interminable division of his grandfather's estate, and later that of his uncle Achille as well.

> Raimondi 1958, p. 121.

1863

René-George Degas, the son of the painter's uncle Édouard, is born in Naples.

6 March

"He works furiously, and thinks of only one thing, his painting. He works so hard that he does not take time out to enjoy himself."

> Letter from René De Gas, in Lemoisne [1946–49], I, pp. 41, 230 n. 41.

"What can I say about Edgar? We are waiting impatiently for the opening of the exhibition. I myself have good reason to believe he will not finish in time; he will scarcely have tackled what needs to be done."

> Unpublished letter from Auguste De Gas to Michel Musson, Paris to New Orleans, Tulane University Library, New Orleans.

Fig. 21. Jean-Auguste-Dominique Ingres, *The Turkish Bath*, 1863. Oil on canvas, diameter 42½ in. (108 cm). Musée du Louvre, Paris

16 April
Thérèse De Gas marries her first cousin Edmondo Morbilli at the church of La Madeleine in Paris. Degas had painted his sister's engagement portrait shortly before the marriage (fig. 54).

> Lemoisne [1946–49], I, p. 232 n. 59; 1984–85 Rome, no. 78.

15 May
The Salon des Refusés opens.

18 June
Odile Musson, the wife of Degas's maternal uncle Michel, arrives in France accompanied by two of her daughters—Estelle, who is a widow with a baby, and Désirée. They are fleeing New Orleans and the Civil War, in which Estelle's husband was killed. Degas writes to his uncle: "Your family arrived here last Thursday, 18 June, and is now entirely our family." Following the advice of Odile's doctor, they spend the better part of their eighteen-month visit at Bourg-en-Bresse.

> Letter from Degas to Michel Musson, in Lemoisne [1946–49], I, p. 73.

24 June
"Edgar, who we had been told was so brusque, is thoroughly attentive and friendly."

> Letter from Désirée Musson, in Lemoisne [1946–49], I, p. 73.

13 August
Death of Eugène Delacroix.

7 November
Thérèse Morbilli is having a difficult pregnancy—the baby is due in late February. (She will lose this child, very likely before term.)

> Unpublished letter from Désirée Musson, Bourg-en-Bresse to New Orleans, Tulane University Library, New Orleans; unpublished letter from Marguerite De Gas to Michel Musson, Paris to New Orleans, 31 December 1863, Tulane University Library, New Orleans.

November
Edgar alone encourages his brother René to move to America and leave their father's business.

> Unpublished letter from Désirée Musson, Bourg-en-Bresse to New Orleans, 18 November 1863, Tulane University Library, New Orleans.

29 December
Degas leaves Paris for Bourg-en-Bresse to celebrate the New Year with the Mussons. "He took with him a lot of pencils and paper in order to draw, to do their portraits, and to sketch Didy's [Désirée's] hands in all their aspects, for such pretty models are rare."

> Letter from Marguerite De Gas to the Musson family, Paris to New Orleans, 31 December 1863, Tulane University Library, New Orleans; cited in part in Lemoisne [1946–49], I, p. 73.

1864
Degas visits Ingres, who has organized "a small exhibition in his studio, in the manner of the old masters." At this exhibition, Degas sees a Homer supported "by I do not know what companion" (*Homer and His Guide*, Musées Royaux des Beaux-Arts, Brussels) as well as *Mme Moitessier* (National Gallery, London) and "a round version of the Turkish bath" (fig. 21).

> Moreau-Nélaton 1931, p. 270.

5 January
"Edgar has done several sketches of little Joe but isn't happy with them. It's impossible to make her hold still for more than five minutes."

> Letter from Désirée Musson to the Musson family, Bourg-en-Bresse to New Orleans, Tulane University Library, New Orleans; cited in part in Lemoisne [1946–49], I, p. 73.

22 April
"Edgar is still working enormously hard, though he does not appear to be. What is fermenting in that head is frightening. I myself think—I am even convinced—that he has not only talent, but genius. But will he express what he feels? That is the question."

> Letter from René De Gas to the Musson family, Paris to New Orleans, Tulane University Library, New Orleans; cited in part in Lemoisne [1946–49], I, p. 41.

21 May
Death of Gennaro Bellelli in Vietri.

> Raimondi 1958, genealogical table VII, p. 287.

At the Salon, Moreau exhibits *Oedipus and the Sphinx*, which will be purchased by Prince Napoleon. It is probably at the Salon that Degas copies a work by Meissonier, *Napoleon III at the Battle of Solferino* (fig. 68), which is to be exhibited at the Musée du Luxembourg in August.

> Reff 1985, Notebook 20 (Louvre, RF5634 ter, pp. 29–31).

1865
Dated works: *Hélène Hertel*, pencil drawing (cat. no. 62); study for *Woman Leaning near a Vase of Flowers*, pencil drawing (cat. no. 61); *Woman Leaning near a Vase of Flowers* (cat. no. 60).

January
Degas returns to Bourg-en-Bresse, where he draws a portrait of Mme Michel Musson and her daughters (fig. 22).

> Jean Sutherland Boggs, "Mme Musson and Her Two Daughters," *Art Quarterly*, XIX:1, Spring 1956, pp. 60–64; Boggs 1962, p. 21.

1 May
Scene of War in the Middle Ages (cat. no. 45) is exhibited at the Salon.

1 June
The artist's sister Marguerite marries Henri Fevre, an architect, at the church of La Madeleine. Except for René, the entire family, including Thérèse and Edmondo Morbilli, is gathered for the occasion.

> Lemoisne [1946–49], I, p. 232 n. 56; unpublished letter from Auguste De Gas to Michel Musson, Paris to New Orleans, 9 June 1865, Tulane University Library, New Orleans.

Fig. 22. *Mme Michel Musson and Her Daughters Estelle and Désirée* (BR43), 1865. Pencil and watercolor, 13¾ × 10¼ in. (35 × 26.5 cm). The Art Institute of Chicago

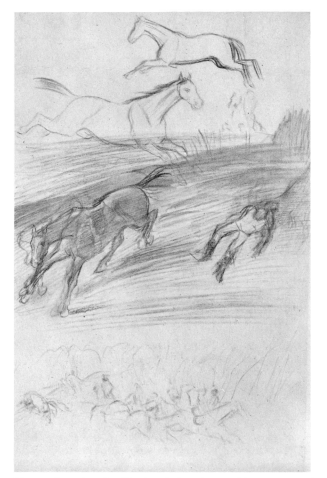

Fig. 23. Drawing for *The Steeplechase* (IV:232.b), 1866. Pencil and charcoal, 13¾ × 8⅞ in. (35 × 22.5 cm). Private collection

August

This is probably when Degas makes a quick pencil copy of *Symphony in White* by Whistler, after a sketch sent by Whistler to Fantin-Latour.

Reff 1985, Notebook 20 (Louvre, RF5634 ter, p. 17).

26 October

Receives permission from the Louvre to copy Sebastiano del Piombo's *Holy Family*, attributed at the time to Giorgione.

Reff 1985, Notebook 20 (Louvre, RF5634 ter, pp. 3–8).

November

Moreau is invited by the emperor to one of the celebrated entertainments at Compiègne.

Mathieu 1976, p. 94.

1866

Dated work: *The Collector of Prints* (cat. no. 66).

From this year to 1874, Degas appears on the electoral lists as a resident of rue de Laval.

1 May

Exhibits *The Steeplechase* (fig. 67) at the Salon.

12 November

The ballet *La Source* premieres at the Opéra (see cat. no. 77).

1867

Dated work: *Mme Gaujelin* (fig. 25).

14 January

Death of Ingres. He is buried at Père-Lachaise on 17 January. A large retrospective exhibition is held at the École des Beaux-Arts.

21 January

Lucie Degas, the daughter of Édouard Degas, is born in Naples (see cat. no. 145).

Raimondi 1958, genealogical table X, p. 290.

13 March

Degas writes to the Surintendant des Beaux-Arts requesting permission to retouch the works sent to the Salon (see cat. no. 20).

Archives, Musée du Louvre, Paris, Salon of 1867; Rome 1984–85, pp. 171–72.

15 April

Exhibits two works titled "Family Portrait" at the Salon (see cat. nos. 20, 65).

April–May

Courbet's Pavillon du Réalisme.

May–June

Degas visits the Exposition Universelle at the Champ-de-Mars, apparently several times. He seems particularly interested in the exhibition of works by English painters.

Reff 1985, Notebook 21 (private collection, pp. 30, 31, 31v).

22 or 24 May
Manet's specially constructed pavilion opens outside the Exposition Universelle, near Courbet's.

3 August
A study for the portrait of Mlle Fiocre (fig. 71) is dated 3 August 1867.

after 10 August
Degas's ambiguous judgment of Moreau's art: "Moreau's painting is the dilettantism of a greathearted man." Further, he notes: "Ah! Giotto, let me see Paris, and you, Paris, let me *see* Giotto!"
 Reff 1985, Notebook 22 (BN, Carnet 8, p. 5).

24 December
Célestine, Daughter of Marguerite De Gas Fevre, in Her Bath (fig. 24), drawn at the Fevre apartment, 72 boulevard Malesherbes, Paris.
 Boggs 1962, p. 28, pl. 56.

1867–68
Degas meets the German painter Adolf Menzel at the home of Alfred Stevens.
 Lemoisne [1946–49], I, p. 233 n. 63; Reff 1985, Notebook 24 (BN, Carnet 22, p. 116).

1868
Dated work: *Évariste de Valernes* (L177, Musée d'Orsay, Paris).

Estelle Musson De Gas becomes blind in her left eye; she retains some vision in her right eye until 1875.
 Unpublished letter from Odile De Gas Musson (daughter of Estelle Musson) to Paul-André Lemoisne, Tulane University Library, New Orleans.

22 February
Giovanna Bellelli marries Marquis Ferdinando Lignola in Naples.
 Raimondi 1958, genealogical table VIII, p. 288.

spring
Degas frequents the Café Guerbois, 11 grande rue des Batignolles (today 9 avenue de Clichy).

26 March
Registers for the last time as a copyist at the Louvre (Degas, Edgar; age 33; 13 rue de Laval; again gives Émile Lévy as his teacher).
 Archives, Musée du Louvre, Paris, LL11.

Fig. 24. *Célestine, Daughter of Marguerite De Gas Fevre, in Her Bath*, 1867. Pencil, 7½ × 10¼ in. (19 × 26 cm). Private collection

1 May
Opening of the Salon. Degas exhibits *Mlle Fiocre in the Ballet "La Source"* (cat. no. 77).

29 July
From Boulogne-sur-Mer, Manet writes to Degas (at 4 rue de Mondovi) suggesting that he accompany him to London: "I am of a mind to test the waters on that side, perhaps there will be an outlet for our wares." They would stay three or four days. If Degas agrees, Manet will tell Legros, who is in London. In conclusion, he asks Degas to persuade Fantin-Latour to come, and sends his regards to Duranty, Fantin-Latour, and Zola.
 Unpublished letter, private collection.

26 August
Manet writes to Fantin-Latour mentioning Duranty's observation that Degas "is on his way to becoming the painter of high life."
 Moreau-Nélaton 1926, I, p. 103.

1869
16 February
Degas's brother Achille writes to the Mussons in New Orleans: "Edgar came to Brussels with me. He has met M. Van Praet, one of the king's ministers, who had purchased one of his paintings, and he saw his work displayed in one of the most celebrated galleries in Europe. That has afforded him a certain pleasure, as you can well imagine, and has at last given him a little confidence in himself and his talent, which is genuine. He has sold two other paintings during his stay in Brussels, and a well-known art dealer, Stevens [Arthur Stevens, brother of the painter Alfred Stevens], has proposed a contract of twelve thousand francs a year." Nothing came of Stevens's offer.
 Lemoisne [1946–49], I, p. 63.

1 May
Opening of the Salon. Degas exhibits *Mme Gaujelin* (fig. 25).

before 11 May
"Degas is mad about Yves's face" and begins to do a portrait (see cat. no. 87, *Mme Théodore Gobillard, née Yves Morisot*). The sittings will continue until Yves's departure at the end of June.
 Morisot 1950, pp. 31–32; Morisot 1957, pp. 35–36.

22 May
Manet tells Berthe Morisot of Degas's shyness with women.
 Morisot 1950, p. 31; Morisot 1957, p. 35.

12 June
The artist's aunt, Mme Édouard Degas, née Candida Primicile Carafa, the mother of Lucie Degas, dies in Naples.
 Raimondi 1958, genealogical table X, p. 290.

late June
Yves Gobillard-Morisot finishes sitting for her portrait, which Degas will complete in his studio during July.
 Morisot 1950, p. 32; Morisot 1957, p. 36.

July
From Boulogne-sur-Mer, Manet writes to Degas asking him to return the two volumes of Baudelaire that he had lent him.
 Unpublished letter, n.d., private collection.

July–August
Degas visits Étretat and Villers-sur-Mer. He also goes to Boulogne-sur-Mer to see Manet, who is spending the summer there. On the Normandy coast, he does a series of pastel landscapes (L199–L205; see cat. nos. 92, 93).
 Reff 1985, Notebook 25 (BN, Carnet 24, pp. 58–59); Lemoisne [1946–49], I, p. 61.

15 December
Death of Louis Lamothe in Paris.

Fig. 25. *Mme Gaujelin* (L165), dated 1867. Oil on canvas, 23¼ × 17⅜ in. (59 × 44 cm). Isabella Stewart Gardner Museum, Boston

1870

17–18 March

Estate sale of the collection of Grégoire Soutzo.

Catalogue d'estampes anciennes . . . formant la collection de feu M. le prince Grégoire Soutzo, Paris, 1870.

12 April

Paris-Journal publishes a letter from Degas to the Salon jury, in which he makes a number of proposals intended to improve the way the works are displayed: two rows of paintings only, a distance of at least twenty or thirty centimeters between each painting, a mixture of drawings and canvases, and the right of each exhibitor to withdraw his work after a few days.

15 April

Death of Édouard Degas, the artist's uncle, in Naples.

May

Ludovic Halévy publishes "Madame Cardinal" in *La Vie Parisienne*.
See "Degas, Halévy, and the Cardinals," p. 280.

1 May

At the Salon, Degas exhibits *Mme Camus in Red* (fig. 26) and *Mme Théodore Gobillard* (cat. no. 90).

2 May

Théodore Duret praises Degas in *L'Électeur Libre*.
Lemoisne [1946–49], I, p. 62.

8 May

Duranty comments on *Mme Camus in Red* in *Paris-Journal*.
Lemoisne [1946–49], I, p. 62.

17 May

In a short note, Champfleury (1821–1889), the writer and critic who has supported Courbet, informs Degas that he will pay him a visit about ten o'clock.
Note from Champfleury to Degas, private collection.

19 July

France declares war on Prussia.

September

Degas, in Paris, volunteers for the National Guard.

4 September

Proclamation of the Third Republic, after Sedan (2 September).

28 September

Frédéric Bazille (b. 1841), the painter who had been a friend of the future Impressionists, is killed at Beaune-la-Rolande near Orléans.

early October

Degas is posted to the Bastion 12 fortifications, north of the Bois de Vincennes, under the command of Henri Rouart.
Lemoisne [1946–49], I, pp. 67–68.

21 October

Degas's friend Joseph Cuvelier is fatally wounded at Malmaison; Tissot, who returns with a drawing of him dying, is reproved by Degas.
Lemoisne [1946–49], I, p. 67; Halévy 1960, p. 157; Halévy 1964, p. 118.

26 October

Mme Morisot writes to her daughter Yves: "M. Degas was so affected by the death of one of his friends, the sculptor Cuvelier, that he was impossible. He and Manet almost came to blows arguing over the methods of defense and the use of the National Guard, though each of them was ready to die to save the country. . . . M. Degas has joined the artillery, and by his own account has not yet heard a cannon go off. He is looking for an opportunity to hear that sound because he wants to know whether he can endure the detonation of his guns."
Morisot 1950, p. 44; Morisot 1957, p. 48; cited in Lemoisne [1946–49], I, p. 67.

19 November

"Degas and I are in the artillery, with the volunteer gunners."
Letter from Manet to Eva Gonzalès, in Moreau-Nélaton 1926, I, p. 127.

Fig. 26. *Mme Camus in Red* (L271), 1870. Oil on canvas, 28¾ × 36¼ in. (73 × 92 cm). National Gallery of Art, Washington, D.C.

1871

Dated work: *Horses in the Field* (L289).

27 February

"Degas is always the same, a little mad, but his wit is delightful."
> Morisot 1950, p. 48; Morisot 1957, p. 53.

March

Dated work: *Jeantaud, Linet, and Lainé* (cat. no. 100).

7 March

Achille De Gas, who has returned from America to fight, is on the Loire.
> Unpublished letter from Alfred Niaudet to Degas, Chalindrey to Paris, private collection.

18 March

Proclamation of the Commune. During the Commune, *The Orchestra of the Opéra* (cat. no. 97) is exhibited at Lille.

25 May

Mme Morisot writes to her daughter Berthe about the fires during the Commune: "Should M. Degas have got a bit scorched, he will have well deserved it."
> Morisot 1950, p. 58; Morisot 1957, p. 63.

1 June

Degas returns to Paris from Ménil-Hubert in Normandy.
> Unpublished letter from Auguste De Gas to his daughter Thérèse Morbilli, Paris to Naples, 3 June 1871, private collection.

3 June

In a letter to his daughter Thérèse Morbilli in Naples, Auguste De Gas recounts the events of the Bloody Week and gives news of the dispersed family: his son-in-law Henri Fevre is in Paris; Henri's wife, Marguerite, and her children are in Deauville; Achille is in Belgium.
> Unpublished letter, private collection.

5 June

Mme Morisot writes again to her daughter Berthe: "Tiburce has met two Communards, at this moment when they are all being shot. . . . Manet and Degas! Even at this stage they are condemning the drastic measures used to repress them. I think they are insane, don't you?"
> Morisot 1950, p. 58; Morisot 1957, p. 63.

14 July

Degas spends the evening at the Manets: "The heat was stifling, everybody was cooped up in the one drawing room, the drinks were warm. But Pagans sang, Mme Édouard played, and M. Degas was there. This is not to say that he flitted about; he looked very sleepy—your father seemed younger than he."
> Morisot 1950, pp. 65–66; Morisot 1957, p. 70; cited in Lemoisne [1946–49], I, p. 68.

31 August

Death of Degas's aunt Odile Musson in New Orleans.

30 September

Degas writes to Tissot who, exiled because of his Communard sympathies, is living in London. He is considering a trip to London, says that he has exhibited *The Orchestra of the Opéra* (cat. no. 97) on rue Laffitte, and complains of problems with his eyes.
> Letter, Paris to London, Bibliothèque Nationale, Paris; Degas Letters 1947, no. 1, pp. 11–12.

October

Finally visits London, which he had planned to do in 1870, before the war prevented all such activity; stays at the Conte Hotel, Golden Square. He probably sees the *Second Annual Exhibition of the Society of French Artists*, 168 New Bond Street, organized by Durand-Ruel.
> Letter from Tissot to Degas, Paris to Paris, 15 May 1870, private collection; letter from Degas to Alphonse Legros, London to London, October 1871, private collection; Reff 1968, pp. 88–89, n. 20; McMullen 1984, p. 208.

1872

Dated works: *Woman with a Vase of Flowers* (cat. no. 112); *The Ballet from "Robert le Diable"* (cat. no. 103).

January

For the first time, Durand-Ruel buys three works directly from Degas.
> Durand-Ruel archives, Paris (stock nos. 943, 976, 979).

summer

Fourth Exhibition of the Society of French Artists in London; Degas exhibits *The False Start* (fig. 69) and *The Ballet from "Robert le Diable"* (cat. no. 103).

Mme Morisot describes to her daughter Berthe the Stevenses' latest Wednesday party: "They did not even attend. . . . The Manets and M. Degas were playing host to one another. It seemed to me they had patched things up."
> Morisot 1950, p. 69; Morisot 1957, p. 73.

26 June

René, who has just arrived in Paris, writes to his family in New Orleans, giving news of his brother, who now lives at 77 rue Blanche: "I found Edgar at the station. He has aged, and there are a few white hairs sprinkled in his beard; he is also calmer and more serious. Father and I had dinner at his place, and afterward we went to see Marguerite. Edgar is doing some really charming things. He has a profile portrait of Mme Camus [fig. 26] in a garnet-red velvet dress, seated on a brown chair and silhouetted against a pink background; for me, it's a pure masterpiece. His drawing is ravishing. Unfortunately, his eyes are very weak and he is forced to use them with the greatest caution. I have lunch with him every day. He has a good cook and a charming bachelor apartment. Yesterday I had dinner there with Pagans, who sings to the accompaniment of a guitar."
> Letter to Michel Musson, Tulane University Library, New Orleans; cited in part in Lemoisne [1946–49], I, p. 70.

12 July

René writes again to New Orleans about his brother: "Edgar, with whom I have lunch every day, tells me to give all of you his love. His eyes are weak and he must be extremely careful. He is the same, but has a mania for saying English words, and has repeated *turkey buzzard* for a week."
> Letter, Tulane University Library, New Orleans; cited in part in Lemoisne [1946–49], I, p. 71.

17 July

"Although his eyes are better, he has to take care of them, and you know how he is. Right now, he is painting small pictures, which are what tire his eyes the most. He is doing a dance rehearsal that is charming [see cat. no. 107]. As soon as the painting is finished, I'll have a large photograph taken of it. Edgar has got it into his head to come back with me and stay with us [in New Orleans] for a couple of months. . . . I have lunch with him every day. . . . After dinner, I go with Edgar to the Champs-Elysées and from there to the café-chantant to listen to idiotic songs, such as the 'Song of the Mason' and other absurd nonsense. Sometimes, when Edgar is in high spirits, we dine in the country and visit the places made memorable by the siege. Prepare yourselves to give a fitting reception to the Gr-r-r-eat Artist. He asks that you not come to meet him at the station with the Bruno Band, militia, firemen, clergy, etc."
> Letter from René De Gas to his family, Paris to New Orleans, Tulane University Library, New Orleans; cited in part in Lemoisne [1946–49], I, p. 71.

12 October

Edgar and René leave Liverpool for America on board the *Scotia*.
> Reff 1985, Notebook 25 (BN, Carnet 24, p. 166).

24 October

The brothers arrive in New York, where they spend thirty hours before taking the train to New Orleans.

> Letter from Degas to Désiré Dihau, New Orleans to Paris, 11 November 1872; Lettres Degas 1945, I, p. 16; Degas Letters 1947, no. 2, p. 13.

2 November

Fifth Exhibition of the Society of French Artists in London. Degas exhibits *At the Races in the Countryside* (cat. no. 95) and *Dance Class at the Opéra* (cat. no. 107).

4 November

Degas is in New Orleans, staying with his family: "All day long I am among these dear folk, painting and drawing, making portraits of the family." Shortly after, in a letter to Tissot, he already speaks of his longing for Paris and complains that he has heard nothing from Manet.

> Letter from Degas to Dihau, New Orleans to Paris, 11 November 1872; Lettres Degas 1945, I, p. 19; Degas Letters 1947, no. 2, p. 15; letter from Degas to Tissot, New Orleans to London, 19 November 1872, Bibliothèque Nationale, Paris; Degas Letters 1947, no. 3, pp. 18–19.

19 November

Degas writes to Tissot: "I am doing some family portraits but I am thinking above all of my return." Further on, he alludes to *Children on a Doorstep (New Orleans)* (cat. no. 111), which he has begun.

> Letter, New Orleans to London, Bibliothèque Nationale, Paris; Degas Letters 1947, no. 3, p. 18.

27 November

"Everything attracts me here, I look at everything. . . . I accumulate plans that would take me ten lifetimes to complete. I will abandon them in six weeks, without regret, to return to and never again leave *my home*. . . . My eyes are much better. True, I am working very little, but what I am doing is difficult. Family portraits must be done to suit the taste of the family, in impossible lighting, with many interruptions, and with models who are very affectionate but a little too bold—they take you much less seriously because you are their nephew or cousin. I have just ruined a large pastel, to my considerable mortification. If I have time, I plan to bring back something from this part of the world, but for myself, for my room."

> Letter from Degas to Lorentz Frölich, New Orleans to Paris; Lettres Degas 1945, II, p. 23; Degas Letters 1947, no. 4, pp. 21–22 (translation revised).

5 December

"I shall certainly be back in January. To vary my journey I intend going back via Havana. . . . The light is so strong that I have not yet been able to do anything on the river. My eyes are so greatly in need of care that I scarcely take any risk with them at all. A few family portraits will be the sum total of my efforts. . . . Oh well, it will be a journey I have made and very little else. Manet would see lovely things here, even more than I do. He would not make any more of them. One loves and gives art only to the things to which one is accustomed."

> Letter from Degas to Henri Rouart, New Orleans to Paris, 5 December 1872; Lettres Degas 1945, III, p. 26; Degas Letters 1947, no. 5, pp. 24–25.

1873

18 February

Degas writes to Tissot that he is working on two versions of the "Cotton Buyers' Office" (see cat. nos. 115, 116).

> Letter, New Orleans to London, Bibliothèque Nationale, Paris; Degas Letters 1947, no. 6, p. 29.

late March

Degas has returned to Paris and is once more living at 77 rue Blanche.

> Lemoisne [1946–49], I, p. 81.

I.

Self-Portrait

1855
Oil on canvas
31⅞ × 25¼ in. (81 × 64 cm)
Musée d'Orsay, Paris (RF2649)

Exhibited in Paris

Lemoisne 5

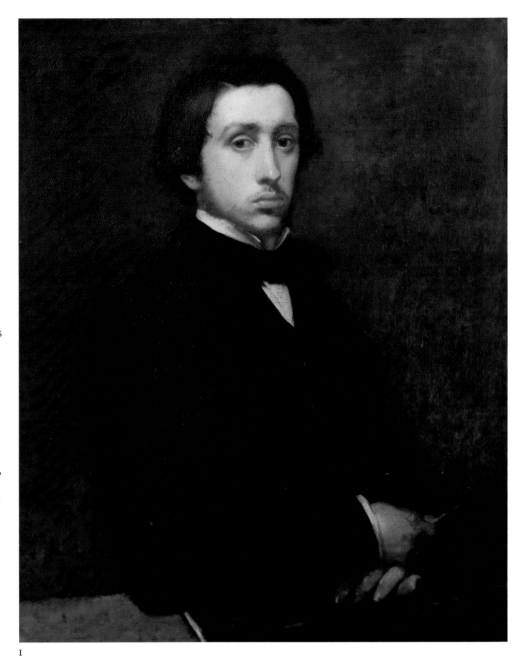

I

In the 1850s, Degas often used himself as a model, painting eighteen self-portraits (Lemoisne catalogues fifteen, and three more are added by Brame and Reff).[1] Sixteen of these are busts, and the other two are half-length portraits. The self-portrait in the Musée d'Orsay is the largest, most complete, and most ambitious of them all, a true painting rather than a sketch. It is often cited and reproduced as a good example of the painter's early work before he left for Italy, when he was still a student of Louis Lamothe and therefore under the influence of Ingres—as is borne out by the comparison frequently made with Ingres's famous *Self-Portrait* (fig. 27) in the Musée Condé at Chantilly. On the basis of two modest sketches that appear in a notebook used in 1854–55,[2] Lemoisne assigns the self-portrait to that period, noting in passing Ernest Rouart's claim that he "saw Degas rework the background about 1895."[3]

However, taking into account the date of the painting, the artist's pose, the instrument in his hand, the portfolio on which he is leaning, and the generally acknowledged reference to Ingres, some additional observations may be made. Unlike Ingres, Degas did not portray himself as an artist but as a young "bourgeois" gentleman. He is dressed

Fig. 27. Jean-Auguste-Dominique Ingres, *Self-Portrait*, 1804. Oil on canvas, 30⅜ × 24 in. (77 × 61 cm). Musée Condé, Chantilly

in the severe black suit (over a brown vest he rarely took off—see L13 and cat. no. 12) that he is also wearing, not without affectation, in the two famous self-portraits of the 1860s, *Self-Portrait: Degas Lifting His Hat* (cat. no. 44) and *Self-Portrait with Évariste de Valernes* (cat. no. 58). Unlike Ingres, he did not portray himself as a painter but as a draftsman, with a charcoal holder in his right hand, while four thick awkward fingers of his left hand rest on a portfolio, out of which protrudes the edge of a sheet of white paper (the paper appears to have been covered by the marbled cardboard portfolio at a later date[4]). The charcoal holder may seem surprising, since Degas never drew with charcoal in the 1850s, but it becomes understandable once we realize that it was commonly used for life drawing at the École des Beaux-Arts, where Degas studied briefly after passing the entrance examination on

6 April 1855. The presence of the charcoal holder and also the reference to (more than the influence of) Ingres, whom Degas met at this time through his friends the Valpinçons, and whose works he copied at the Exposition Universelle of 1855, make it possible to date this self-portrait more precisely to the spring of 1855.

Degas was not yet twenty-one, and this was, without a doubt, his first major painting. The steady gaze of his large black questioning eyes and the thick pouting lips give him the same air that he has in most of his self-portraits: aloof and uncertain. One can easily see in it the young painter's perplexed reaction to a kind of teaching—that of the École des Beaux-Arts—that he found uncongenial. However, the austerity of the picture, the dark tones (scarcely relieved by the few patches of white), and the deliberate concentration on the face and hands to the

exclusion of anything that could be considered unessential are an assertion of Degas's fierce and tenacious resolve to sacrifice everything to his calling as an artist.

1. Lemoisne [1946–49], II, nos. 2–5, 11–14, 31–32, 37, 51, 103–05; Brame and Reff 1984, nos. 28–30.
2. Reff 1985, Notebook 2 (BN, Carnet 20, pp. 58B, 67).
3. Lemoisne [1946–49], II, no. 5. If there was a later reworking, it is barely discernible today.
4. "Les peintures de Degas au Musée d'Orsay: étude du Laboratoire de Recherche des Musées de France," unpublished report, May 1987.

PROVENANCE: Atelier Degas; René de Gas, the artist's brother, Paris, 1918–21 (René de Gas estate sale, Drouot, Paris, 10 November 1927, no. 69, repr.); bought at that sale by the Louvre, for Fr 150,000.

EXHIBITIONS: 1931 Paris, Orangerie, no. 2; 1933 Paris, Orangerie, no. 82; 1936 Venice, no. 1; 1937 Paris, Orangerie, no. 1, pl. 1; 1956, Limoges, Musée Municipal, *De l'impressionnisme à nos jours*, no. 6; 1969 Paris, no. 1; 1973, Pau, Musée des Beaux-Arts, April–May, *L'autoportrait du XVIIe siècle à nos jours*, p. 44; 1976–77 Tokyo, no. 1, repr. (color).

SELECTED REFERENCES: Lafond 1918–19, I, p. 103, repr.; Paul-André Lemoisne, "Le portrait de Degas par lui-même," *Beaux-Arts*, 1 December 1927, repr.; Paul Jamot, "Acquisitions récentes du Louvre," *L'Art Vivant*, 1928, pp. 175–76; Guérin 1931, repr.; Lemoisne [1946–49], II, no. 5; Paris, Louvre, Impressionnistes, 1958, no. 53; Boggs 1962, p. 9, pl. 12; Minervino 1974, no. 112; Paris, Louvre and Orsay, Peintures, 1986, III, p. 196, repr.

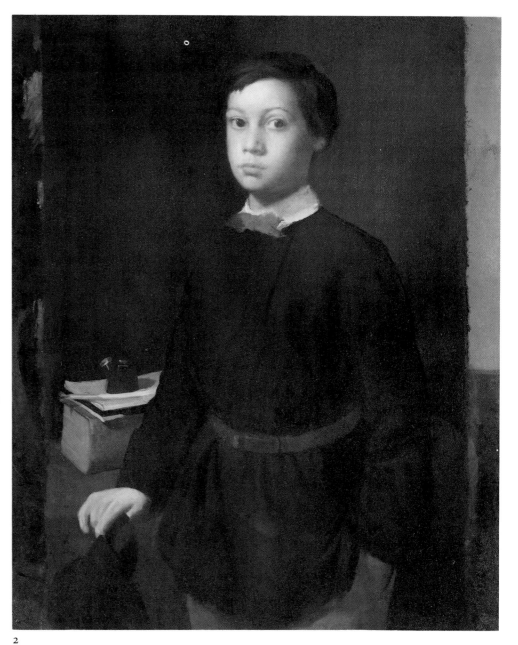

2

2.

René De Gas

1855
Oil on canvas
36¼ × 28¾ in. (92 × 73 cm)
Smith College Museum of Art, Northampton, Massachusetts (1935:12)

Lemoisne 6

The portraits of Degas's early career are all family portraits; not until the 1860s did he also begin to depict a few close friends. In the 1850s, he drew and painted his brothers and sisters, aunts, uncles, and cousins—the single exception was his father, who although attentive to his son's first efforts would not be portrayed until many years later, in the painting with the guitarist Pagans (cat. no. 102). The artist's brother René, eleven years his junior (born in 1845), was, like his sisters Thérèse and Marguerite, a frequent model, doubtless more available and more amenable than their other brother, the boisterous Achille; it is perhaps René whom we see already in a small canvas painted about 1853, *Boy in Blue* (BR24A), which subsequently belonged to him. His recollections many years later are recorded in the

words of Paul-André Lemoisne: "René often told us that when he came home from school, he would barely have put away his books when Edgar would get hold of him and make him pose."[1]

In 1855, Degas did a number of preparatory studies for this portrait, now at Smith College. For the head alone, he did two pencil drawings (Mellon collection, Upperville, Va.; Pierpont Morgan Library, New York) and an oil sketch (L7). For the overall composition, there are two rough studies in a notebook[2] and a more elaborate drawing (fig. 28) that he gave and dedicated to his brother. The final composition departs significantly from this last drawing. Degas did not stop at merely changing some of the details (the left hand, which had held a glove and was hooked in the belt, now disappear-

Fig. 28. Study for *René De Gas*, 1855. Pencil, 11½ × 9 in. (29.2 × 22.9 cm). Collection of Mr. and Mrs. Paul Mellon, Upperville, Va.

ing into the trouser pocket) but actually altered the very conception of the portrait by sacrificing the background, which in the drawing is clearly legible even if only hastily sketched. Its mantelpiece with a mirror above, its wallpaper motifs, its oval frame hanging on the wall, in short everything that would have contributed to making this a portrait in an interior in the tradition of Ingres has disappeared. The schoolboy stands out against a dark and uniform background (its opaqueness concealing an already used canvas); he is resting his right hand on what must be a table, upon which are piled one thick book (probably a dictionary), two exercise books, a pen, and an inkwell—attributes more than accessories, revealing, like the sculpture in the hands of Bronzino's young man (which Degas at the time was copying in the Louvre[3]), the model's occupation. The boy's tender age, his casual bearing (hand in pocket) and simple outfit, and the familiar, obviously well-worn everyday objects that surround him contrast with the complete absence of a setting, the severity of the background, and the stiffness of the pose that would seem to suggest something of an official portrait.

It is a somber work, like those of many painters of the 1850s, enlivened by brighter, more resonant patches of color, such as the red bow tie on the white collar. The face and hand, vividly lit, loom up out of the dark; they are painted with an obvious sensitivity, showing us little René, the favorite, as seen by his big brother, the younger so evidently attentive to the older's first efforts at painting.

1. Guérin 1931, preface by Lemoisne, n.p.
2. Reff 1985, Notebook 2 (BN, Carnet 20, pp. 32, 75).
3. Reff 1985, Notebook 2 (BN, Carnet 20, p. 40).

PROVENANCE: Atelier Degas; René de Gas, the artist's brother, Paris, 1918–21 (René de Gas estate sale, Drouot, Paris, 10 November 1927, no. 72, repr.); bought at that sale by Ambroise Vollard, Paris, for Fr 90,100; Knoedler and Co., New York, 7 October 1933; bought by Bignou, Paris, January 1934; sent to Bignou, New York, July 1934; bought by the museum 1935.

EXHIBITIONS: 1933, New York, M. Knoedler and Co., November–December, *Paintings from the Ambroise Vollard Collection, XIX–XX Centuries*, no. 16, repr.; 1934, London, Alex Reid and Lefevre, June, *Renoir, Cézanne and Their Contemporaries*, no. 16; 1938 New York, no. 7; 1939, Boston, Institute of Modern Art, 2 March–9 April/New York, Wildenstein and Co., May, *The Sources of Modern Painting*, no. 3, repr.; 1947 Cleveland, no. 1, pl. 15; 1948 Minneapolis, no number; 1949 New York, no. 2, repr.; 1953, New York, M. Knoedler and Co., 30 March–11 April, *Paintings and Drawings from the Smith College Collection*, no. 11; 1954 Detroit, no. 65, repr.; 1955 San Antonio; 1960 New York, no. 2, repr.; 1961, Arts Club of Chicago, 11 January–15 February, *Smith College Loan Exhibition*, no. 8, repr.; 1962, Northampton, Smith College Museum of Art, *Por-*

traits from the Collection of the Smith College Museum of Art, no. 16; 1963, Oberlin, Allen Memorial Art Museum, 10–30 March, *Youthful Works by Great Artists*, no. 22, repr.; 1963, Cleveland Museum of Art, 2 October–10 November, *Style, Truth and the Portrait*, no. 89, repr.; 1964, Chicago, National Design Center, Marina City, *Four Centuries of Portraits*, no. 8; 1965 New Orleans, pl. XV, fig. 10 p. 21; 1968, Baltimore Museum of Art, 22 October–8 December, *From El Greco to Pollock: Early and Late Works by European and American Artists*, no. 59, repr.; 1969, Waterville, Me., Colby College Art Museum, 3 July–21 September/Manchester, N.H., Currier Gallery of Art, 11 October–23 November, *Nineteenth and Twentieth Century Paintings from the Smith College Museum of Art*, no. 24, repr. text and cover; 1970, Waterville, Me., Colby College Art Museum, June–September/Manchester, N.H., Currier Gallery of Art, 11–23 November, *19th and 20th Century Paintings from the Collection of the Smith College Museum of Art*, no. 16, repr.; 1972, New York, Wildenstein and Co., 2 November–9 December, *Faces from the World of Impressionism and Post-Impressionism*, no. 19, repr.; 1974 Boston, no. 1; 1978 New York, no. 2, repr. (color).

SELECTED REFERENCES: Marcel Guérin, "Remarques sur des portraits de famille peints par Degas à propos d'une vente récente," *Gazette des Beaux-Arts*, XVII, June 1928, pp. 371–72; J.A. [Jere Abbott], "Portrait by Degas Recently Acquired by Smith College," *The Smith Alumnae Quarterly*, XXVII:2, February 1936, pp. 161–62, repr. p. 161; J.A. [Jere Abbott], "A Portrait of René de Gas by Edgar Degas," *Smith College Museum of Art Bulletin*, 1936, pp. 2–5, repr. p. 2; *Smith College Museum of Art, Catalogue*, Northampton, 1937, p. 17, repr. p. 77; Rewald 1946 GBA, pp. 105–26, fig. 10 p. 115; Lemoisne [1946–49], I, p. 14, II, no. 6; Boggs 1962, p. 8, pl. 9; 1967 Saint Louis, p. 22; Minervino 1974, no. 113, pl. 1 (color).

3.

Thérèse De Gas

c. 1855–56
Pencil
12⅝ × 11⅛ in. (32 × 28.4 cm)
Atelier stamp lower left
Museum of Fine Arts, Boston. Julia Knight Fox Fund (31.434)

Exhibited in Ottawa and New York

Degas did a number of portraits of his sister Thérèse (see cat. nos. 63, 94)—the "heroic" Thérèse, as he called her later when she was married to an invalid.[1] This is the best of many drawings he did of her about 1855–56, before his departure for Italy. Even more than his other sister, the intelligent and musical Marguerite (to whom he was just as close, if not closer), Thérèse seems to have been one of his favorite models, both out of affection and for purely pictorial reasons. He probably admired her perfectly oval face—with the broad nose, full mouth, and large, slightly protruding brown eyes—and her shy, attentive, placid look, her air of never understanding what was happening. No doubt he particularly liked the Ingresque appearance of this face, which is reminiscent of Ingres's Mlle Rivière or Mme Devauçay, and which seems to invite this firm, calm drawing.

3

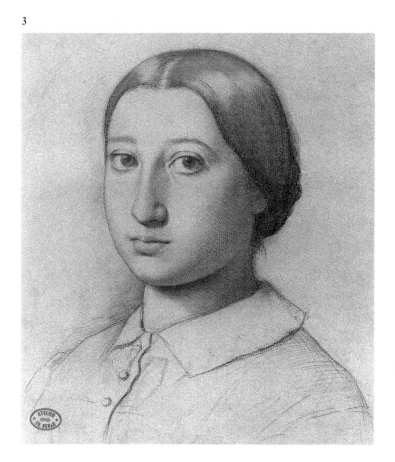

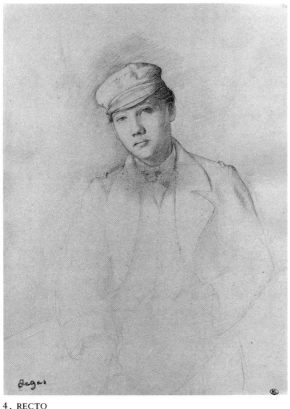

4, RECTO

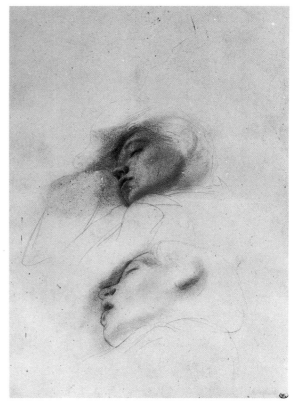

4, VERSO

1. Letter to Ludovic Halévy, 31 August 1893, Lettres Degas 1945, CLXXVI, p. 196; Degas Letters 1947, no. 189, p. 186.

PROVENANCE: Atelier Degas; René de Gas, the artist's brother, Paris, 1918–21 (René de Gas estate sale, Drouot, Paris, 10 November 1927, no. 17, repr.); bought by the museum through Paul Rosenberg 1931.

EXHIBITIONS: 1931 Cambridge, Mass., no. 15b; 1947 Cleveland, no. 54, pl. XLVII; 1947 Washington, D.C., no. 25; 1948 Minneapolis, no number; 1965 New Orleans, p. 57, pl. X; 1967 Saint Louis, no. 4.

SELECTED REFERENCES: Philip Hendy, "Degas and the de Gas," Bulletin of the Museum of Fine Arts, Boston, XXX:179, June 1932, repr. p. 44.

4.

Achille De Gas

1855–56
Pencil
10½ × 7½ in. (26.7 × 19.2 cm)
Vente stamp and atelier stamp lower left
On the verso, two pencil studies of the head of a sleeping adolescent (presumably René De Gas)
Cabinet des Dessins, Musée du Louvre (Orsay), Paris (RF29293)

Exhibited in Ottawa

Vente IV:121.c

Often considered a study for the portrait of Achille De Gas now in the National Gallery of Art in Washington (fig. 29), this pencil drawing, very much imbued with the influ- ence of Ingres, in fact precedes the painting by several years. In the drawing, the paint- er's younger brother is wearing the quiet, unobtrusive attire of the Naval Academy, where he was a student from 1855 to 1857; in the canvas, however, he is dressed, rather ostentatiously, in the more striking uniform of a midshipman. The drawing was there- fore executed sometime between 27 Sep- tember 1855, the day Achille entered the Naval Academy, and July 1856, when the painter left for Italy. The canvas was in all likelihood painted after Degas's return to Paris in April 1859 and before Achille was promoted to naval ensign on 8 February 1862.[1]

The archives of the Lycée Louis-le-Grand, as well as those of the Service Historique de la Marine, describe the handsome Achille as a turbulent, often impulsive boy and a con- sistently average student. When he entered the Naval Academy, before the age of sev- enteen (he was born on 17 November 1838), he went essentially unnoticed; but in July 1858, while a midshipman, he was put un- der close arrest and threatened with dismis- sal for unruliness and insubordination. The intervention of Auguste De Gas, asking the naval minister to offer the young man "an assignment that would enable him to make amends for his past mistakes," helped re- solve the situation.[2] Achille briefly continued his naval career, without incident, first as a midshipman first-class (6 February 1860) and then as a naval ensign (8 February 1862),

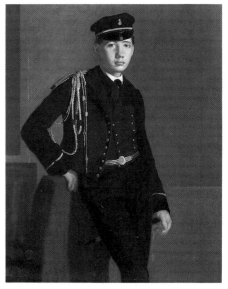

Fig. 29. Achille De Gas as a Naval Ensign (L30), c. 1859–62. Oil on canvas, 25⅜ × 20⅛ in. (64.5 × 46.2 cm). Chester Dale Collection, National Gallery of Art, Washington, D.C.

before resigning on 17 November 1864, dis- appointed by the uneventful life he was lead- ing. He later founded, along with René, the firm of De Gas Brothers in New Orleans. During the war with Germany, he entered the service again for several months (from 12 November 1870 to 2 March 1871) and, temporarily restored to his former rank, served on the Loire.

1. Archives, Service Historique de la Marine, file on Achille De Gas.
2. Ibid.

PROVENANCE: Atelier Degas (Vente IV, 1919, no. 121.c); bought at that sale by Paul Jamot with nos. 121.a and 121.b, for Fr 700; his bequest to the Louvre 1941.

EXHIBITIONS: 1924 Paris, no. 74; 1931 Paris, Orangerie, no. 85; 1969 Paris, no. 44.

Life Drawings

cat. nos. 5−7

After the directorship of Ingres (1835–40), the French Academy in Rome on the whole opened its doors, welcoming to its life classes artists who were not pensioners but who wished to work there.[1] Since good models were hard to find in Rome, this hospitality was appreciated, as Degas himself remarked in a brief note sent in 1857 to the sculptor Henri Chapu, in which he asked him, "given the shortage of models," to try "a man who is very handsome."[2]

The evening life classes quickly became a "club," giving French artists not only a chance to practice but a place to meet as well. Degas, like the others, must have been grateful for the chance to work from models. After meeting Gustave Moreau, who we know had an immediate influence on him, Degas probably came to share his new mentor's less than favorable opinions about the companions with whom they found themselves every evening after dinner from seven to nine-thirty. Moreau found Victor Schnetz, the director of the Academy, vulgar and a poor conversationalist, and the boarders, while not unpleasant, seemed to him common, boastful, and lacking in talent—"a few decent young fellows, who consider themselves artists, but are crassly ignorant."[3]

Degas, benefiting from the liberality of the Villa Medici, drew a number of academic nudes in Rome. When he came upon them later, he often added the annotation "Rome 1856," a generic date for works executed between 1856 and 1858.[4] For some of these studies, the precise date can be ascertained by comparing them with those in which the same model was used by Moreau (or for that matter by Delaunay, Chapu, or Bonnat). Thus, it is quite likely that the *Seated Male Nude* (cat. no. 7) dates from 1858, since a similar drawing in the Musée Gustave Moreau bears that date.

A gesture, a movement, and a pose gradually and almost inevitably suggest certain subjects: the traps of an art that had become routine, leading to stereotypes and, in the correct sense, academicism. The models often assumed the poses of works that were already celebrated: the muscular young man, whose abundant dark hair makes it clear that he is a *ragazzo romano*, becomes the Apoxyomenos of Lysippus (cat. no. 6), and the gaunt old man adopts the penitent pose of Saint Jerome (cat. no. 5).

1. See H. Lapauze, *Histoire de l'Académie de France à Rome, II, 1802–1910*, Paris: Plon-Nourrit, 1924, p. 236.
2. See 1984–85 Rome, p. 24.
3. Letters from Gustave Moreau to his parents, Rome to Paris, 12 November 1857 and 3 March 1858, Musée Gustave Moreau, Paris.
4. Reff 1963, pp. 250–51.

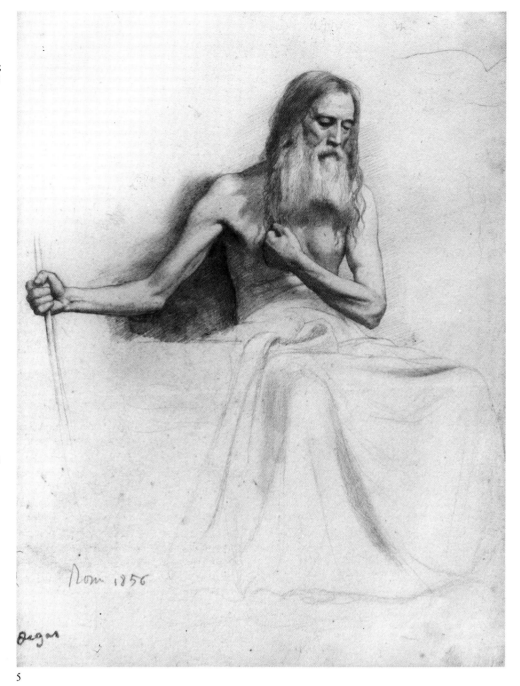

5

5.

Study of an Old Man Seated

1856–58
Pencil on off-white laid paper
12⅝ × 9¼ in. (32 × 23.5 cm)
Inscribed in pencil lower left: Rome 1856
Vente stamp lower left
Collection of Marc Sand, Switzerland

Vente IV:97.e

PROVENANCE: Atelier Degas (Vente IV, 1919, no. 97.e); bought at that sale by Pozzi with nos. 97.a, 97.b, 97.c, 97.d, and 97.f, for Fr 1,080. Galerie Prouté, Paris; bought by Marc Sand 1972.

EXHIBITIONS: 1984–85 Rome, no. 24, repr.

SELECTED REFERENCES: Paul Prouté, Gauguin catalogue, Paris, 1972, no. 83, repr.

6.

Standing Male Nude

1856–58
Pencil on pale green wove paper
12⅛ × 8⅞ in. (30.7 × 22.5 cm)
Inscribed in pencil lower right: Rome 1856
Vente stamp lower right; atelier stamp on verso
Private collection, New York

Vente IV:108.a

PROVENANCE: Atelier Degas (Vente IV, 1919, no. 108.a); bought at that sale by Cottevielle with no. 108.b, for Fr 220; Walter Goetz; bought by David Daniels, June 1965; present owner.

EXHIBITIONS: 1967 Saint Louis, no. 7; 1968, The Minneapolis Institute of Arts, 22 February–21 April/The Art Institute of Chicago, 3 May–23 June/Kansas City, Nelson Gallery-Atkins Museum, 1 July–29 September/Cambridge, Mass., Fogg Art Museum, 16 October–25 November, *Selections from the Drawings Collection of David Daniels*, no. 45.

SELECTED REFERENCES: Reff 1964, p. 251 n. 18.

7.

Seated Male Nude

1856–58
Pencil on pale green wove paper
12¼ × 8⅞ in. (31 × 22.5 cm)
Vente stamp lower left
Private collection, New York

Vente IV:83.c

PROVENANCE: Atelier Degas (Vente IV, 1919, no. 83.c); bought at that sale by Henriquet with nos. 83.a, 83.b, and 83.d, for Fr 1,020; Marcel Guérin, Paris; Galerie Cailac, Paris; David Daniels, New York; present owner.

EXHIBITIONS: 1958, New York, Charles E. Slatkin Gallery, 7 November–6 December, *Renoir, Degas*, no. 5; 1960, The Minneapolis Institute of Arts, 1 July–15 August, *Paintings from Minneapolis Collections*; 1960, New York, The Metropolitan Museum of Art, summer, *Three Private Collections*, no. 70; 1962 Baltimore, no. 56; 1964, Iowa City, University of Iowa Museum of Art, *Drawing and the Human Figure*, no. 93, repr.; 1967 Saint Louis, no. 11, repr.

SELECTED REFERENCES: Reff 1964, p. 251 n. 19.

8.

Four Studies of the Head of a Young Girl

1856
Pencil on pale buff wove paper
18⅛ × 12 in. (45.9 × 30.5 cm)
Inscribed in pencil upper left: Rita Sora/Cacciala; lower right: Rome
Nepveu-Degas stamp lower left
Collection of Mrs. Noah L. Butkin

This drawing is an "expressive head," and not, as has been suggested, a sketch for a composition that has disappeared. It was drawn in Rome in the fall of 1856. One of Degas's notebooks in the Louvre contains a watercolor after the same model, convincingly dated 1856 by Reff.[1]

1. Reff 1985, Notebook 7 (Louvre, RF5634, p. 45). For another related drawing, see Degas Sonnets 1947, facing p. 4.

PROVENANCE: Atelier Degas; René de Gas, the artist's brother, Paris, 1918–21; Nepveu-Degas collection,

6

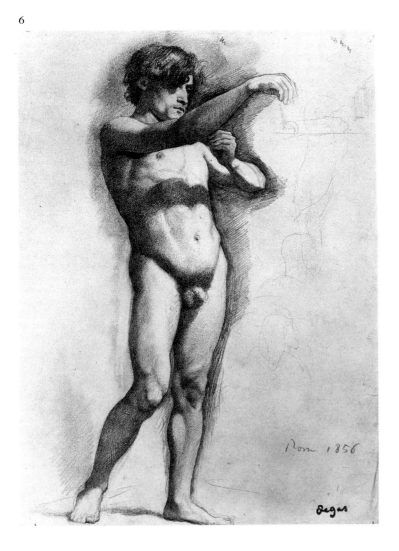

7

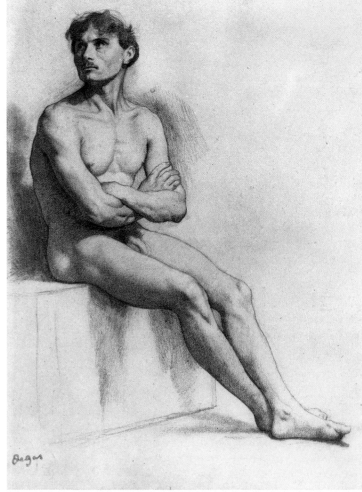

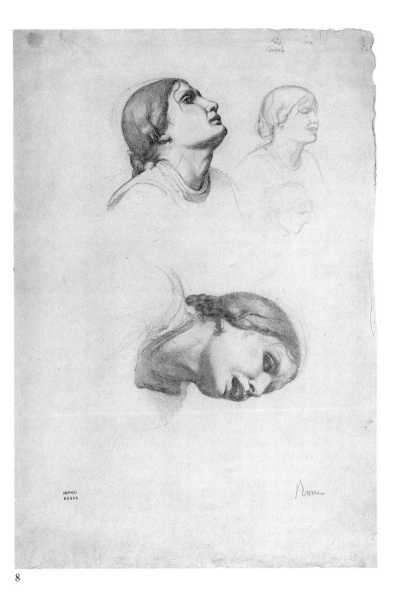

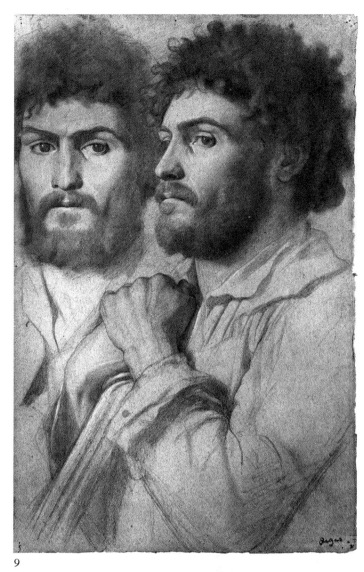

8

9

Paris (Nepveu-Degas sale, Drouot, Paris, 6 May 1976, no. 13); Shepherd Gallery, New York; Mrs. Noah L. Butkin, Shaker Heights, Ohio.

EXHIBITIONS: 1976–77, New York, Shepherd Gallery, *French Nineteenth Century*, no. 24, repr.; 1984–85 Rome, no. 31, repr.

9.

Two Studies of the Head of a Man

c. 1856–57
Pencil heightened with white chalk on
rose-brown paper
17½ × 11¼ in. (44.5 × 28.6 cm)
Vente stamp lower right
Sterling and Francine Clark Art Institute,
Williamstown, Massachusetts (1393)

Vente IV:67

This drawing, which appeared in the catalogue of the fourth atelier sale as "Two Male Heads (after a painting of the Italian school)," is not a copy, but a study of one man from two different angles, most probably executed during Degas's first stay in Rome in 1856–57.

As did most of his contemporaries, Degas devoted himself to the study of common people, sketching an old man dressed in rags, a pretty young girl in peasant costume, or, as here, a youth from the streets in whom we can readily see the plebeian descendant of the ancient Caesars.

PROVENANCE: Atelier Degas (Vente IV, 1919, no. 67); bought at that sale by Durand-Ruel, Paris, for Fr 400 (stock no. 11542); Durand-Ruel, New York, 27 September 1929 (stock no. N.Y. 502); bought by Robert Sterling Clark, 6 July 1939; his gift to the museum 1955.

EXHIBITIONS: 1935, New York, Durand-Ruel Galleries, 22 April–11 May, *Exhibition of Pastels and Gouaches by Degas, Renoir, Pissarro, Cassatt*; 1959 Williamstown, no. 34, pl. XIX; 1970 Williamstown, no. 10.

SELECTED REFERENCES: "Exhibition of Drawings of Degas," *Art News*, XXXV, 28 December 1935, pp. 5, 12, repr.; Williamstown, Clark, 1964, I, pp. 74–75, no. 149, II, pl. 143; Williamstown, Clark, 1987, no. 5, repr. (color).

10.

Saint John the Baptist, study for Saint John the Baptist and the Angel

1856–58
Black chalk on off-white laid paper, squared for
transfer
17½ × 11⅜ in. (44.5 × 29 cm)
On the verso: a drawing of an angel blowing a
trumpet, inscribed lower right: Rome
Vente stamp lower left on verso
Von der Heydt-Museum, Wuppertal
(KK1960/165)

Vente IV:70.a and IV:70.b

Between 1856 and 1858, in preparation for a painting of Saint John the Baptist and the Angel, Degas did a great number of drawings, sketches of the overall composition and of individual figures, and studies for the background, all in varying degrees of detail. But in spite of the copious documentation, this unrealized work remains an enigma. In

fact, these efforts resulted only in a small watercolor (L20) that, judging from reproductions, appears to have been a disappointing work and not at all what might have been expected from the preliminary studies. The very subject is difficult to understand; in his notebooks, Degas cites passages from Revelation about John the Evangelist rather than John the Baptist. Yet the watercolor undoubtedly depicts Saint John the Baptist, dressed in an animal skin and holding a cross in his hand, just as Paul Dubois was to represent him somewhat later (see fig. 30). In the footsteps of Elijah, John the Baptist is fulfilling the mission of the angel announced by God—that is, preparing the way for the Messiah; the angel, as foretold in the Old Testament, is guiding him and speaking through him.

The drawings Degas made in Rome for this composition are among the most beautiful of his youth. They include rigorous studies of adolescent bodies, skillful renderings of drapery, and tireless repetitions of the same movements. The drawing on the recto of the Wuppertal sheet, which was squared in preparation for an oil sketch (L21), is also a particularly fine, highly articulated academic drawing, made from a model in spite of the transformation of his staff to the cross of the Baptist, the precursor of Christ.

PROVENANCE: Atelier Degas (Vente IV, 1919, nos. 70.a, 70.b); bought at that sale by Bernheim-Jeune, Paris, for Fr 400; Dr. Eduard Freiherr von der Heydt, Ascona; given to the museum 1952.

EXHIBITIONS: 1951–52 Bern, no. 82; 1967 Saint Louis, no. 26, repr.; 1969, Saint-Étienne, Musée d'Art et d'Industrie, 18 March–28 April, *Cent dessins du Musée Wuppertal*, no. 19, repr.; 1984 Tübingen, no. 22, repr.; 1984–85 Rome, no. 35, repr.

SELECTED REFERENCES: Hans-Günter Wachtmann, *Von der Heydt-Museum, Wuppertal, Veirzeichnis der Handzeichnungen, Pastelle und Aquarelle*, Wuppertal, 1965, no. 38, repr.; 1969 Nottingham, under no. 5; Günter Aust, *Das Von der Heydt-Museum in Wuppertal*, Rechlinghausen, 1977, p. 284, pl. 164; C. A. Nathanson and E. J. Olszewski, "Degas's Angel of the Apocalypse," *The Bulletin of the Cleveland Museum of Art*, 1980, p. 247, repr.

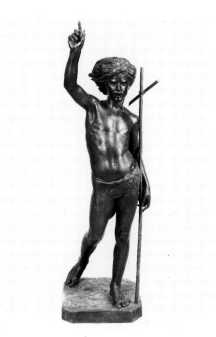

Fig. 30. Paul Dubois, *Saint John the Baptist as a Child*, 1861. Bronze, height 64⅛ in. (163 cm). Musée d'Orsay, Paris

10, RECTO

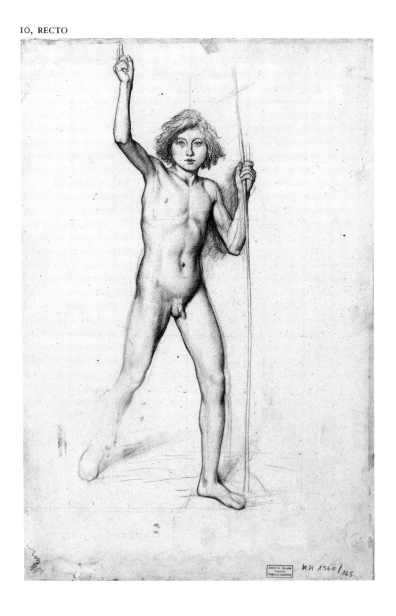

10, VERSO

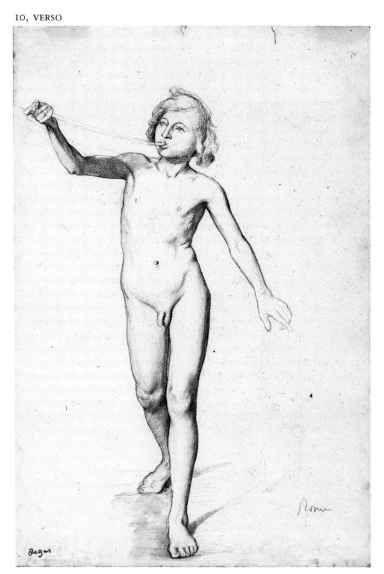

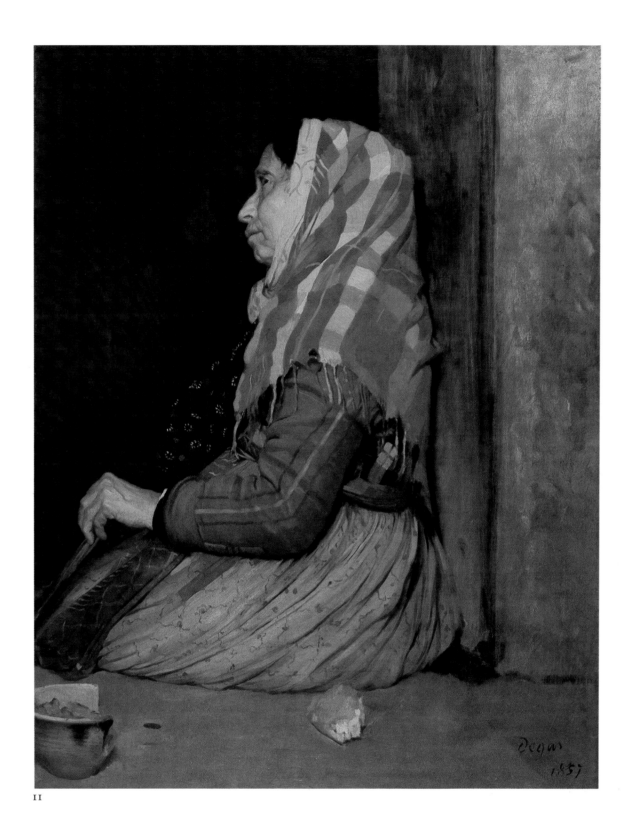

II

II.

Roman Beggar Woman

1857
Oil on canvas
39½ × 29⅝ in. (100.3 × 75.2 cm)
Signed and dated lower right: Degas/1857
Birmingham City Museum and Art Gallery,
 Birmingham, England (P44'60)

Exhibited in Paris

Lemoisne 28

The provenance of this painting immediately gives it a special place in the history of Degas's work. When Degas deposited it and *Sulking* (cat. no. 85) with Durand-Ruel on 26 December 1895, it was simply called "Beggar Woman." Durand-Ruel bought it a year and a half later, on 13 April 1897, and sold it the same day to the dealer Decap. No earlier work by Degas had ever entered the market (the painter was to keep most of his early works until his death). He signed it—probably at the time of one or the other of these

transactions—and dated it 1857, the period of his first stay in Rome.

Like the Metropolitan's *Old Italian Woman* (fig. 31), *Roman Beggar Woman* is part of a tradition that the director of the French Academy in Rome, Victor Schnetz, worked zealously to help revive in the 1850s. As Léonce Bénédite was to point out, Schnetz played "a key role in the Realist evolution of our contemporary art"; he was a chronicler of the "popular life of Italy," which along with Léopold Robert he had raised from

Fig. 31. *The Old Italian Woman* (L29), dated 1857. Oil on canvas, 29½ × 24 in. (75 × 61 cm). The Metropolitan Museum of Art, New York

"genre" status to that of the "elevated style of history," and it was his influence that was responsible for the innumerable portraits of Italian men and women in local costume to which the Villa Medici students then devoted themselves.[1] In several notebooks and on separate sheets, Degas made pencil sketches and watercolors of people of this sort in 1856–57, though with less insistence and certainly less conviction than some of his contemporaries, such as Chapu, Delaunay, Henner, or Clère. "I am not mad about this well-known Italian picturesque," he noted in July 1858. "Whatever moves us no longer owes anything to this genre. It is a fashion that will always be with us."[2] His meeting with Gustave Moreau, who was not very interested in this fashion, probably made him decide to give it up. It had become a veritable commonplace by the end of the 1850s: painters and sculptors as well as photographers and even society ladies relentlessly pursued these unfortunate natives, many of whom found it lucrative to become professional models. Thus Mme Gervaisais, in the novel of the same name by the Goncourts, admires what everyone has agreed henceforth to admire, those "abraded colors of moss green or touchwood; vermin-ridden rags worn by all, with the slow movements of Arcadian shepherds,"[3] and she has one of these women come to her house in order to make sketches of her.

Degas was more conventional in his watercolors, but he demonstrated an unquestionable originality in the two canvases in Birmingham and New York. Unlike Bouguereau, Hébert, or Bonnat, he did not "stage a scene," nor did he proffer works of "bourgeois sentimentality" (to use the un-

kind words of Paul de Saint-Victor[4]). There is no indulgence in misery here, only the careful study of two old women, monumental isolated figures, to whom he gives, in Taine's phrase, "the prominent traits of the ancient race and of former genius."[5] They are, to quote the Goncourts again, cast "in a pose of sovereign reverie that Michelangelo might have drawn."[6]

Degas distinguished himself from his contemporaries just as Giacomo Antonio Ceruti, in the tradition that he followed, distinguished himself from the *bamboccianti* of the seventeenth century. *Roman Beggar Woman* is certainly a portrait *and* a genre scene, but more the former than the latter, because the story, the local color, and the exotic references are barely noticeable. The painter's attention is focused on everything that suggests old age, decay, and poverty: wizened skin, gnarled hands, clothes that bespeak destitution, faded colors[7]—dull, muted chords establishing a magnificent harmony of browns.

1. Léonce Bénédite, "J. J. Henner," *Gazette des Beaux-Arts*, XXXIX, January 1908, p. 49.
2. Reff 1985, Notebook 11 (BN, Carnet 28, p. 94).
3. Edmond and Jules de Goncourt, *Madame Gervaisais*, Paris: A. Lacroix, 1869 (Folio, 1982, p. 139).
4. "Salon 1865," *La Presse*, 21 May 1865.
5. Hippolyte Taine, *Voyage en Italie*, Paris: Hachette, 1866 (1965 edition, Paris: Julliard, p. 132); *Italy, Rome and Naples* (translated by J. Durand), 4th edition, New York: H. Holt and Co., 1875, p. 118.
6. Goncourt, op. cit., p. 139.
7. See Degas's notes on this subject in Reff 1985, Notebook 9 (BN, Carnet 17, p. 21).

PROVENANCE: Deposited by the artist with Durand-Ruel, Paris, 26 December 1895 (as "Mendiante," deposit no. 8847); bought by Durand-Ruel, Paris, 13 April 1897, for Fr 10,000 (stock no. 4158); bought the same day by Maurice Barret-Decap, Biarritz, for Fr 15,000 (Maurice B. sale, Drouot, Paris, 12 December 1929, no. 4, repr.); Paul Rosenberg, Paris; bought by Mrs. Alfred Chester Beatty, London, after 1934; Sir Alfred Chester Beatty, her husband, after 1952; deposited with the Tate Gallery, London, 1955–60; bought by the museum 1960.

EXHIBITIONS: 1934, New York, Durand-Ruel Galleries, 12 February–10 March, *Important Paintings by Great French Masters of the Nineteenth Century*, no. 13, repr.; 1936 Philadelphia, no. 4, repr.; 1937 Paris, Orangerie, no. 2; 1962, London, Royal Academy of Arts, 6 January–7 March, *Primitives to Picasso*, no. 212, repr.

SELECTED REFERENCES: Camille Mauclair, *The French Impressionists*, London: Duckworth, 1903, p. 77, repr.; Camille Mauclair, *The Great French Painters*, London: Duckworth, 1903, p. 69, repr.; Mauclair 1903, p. 382; Camille Mauclair, *L'impressionnisme: son histoire, son esthétique, ses maîtres*, Paris: Baranger, 1904, p. 226; Geffroy 1908, p. 15, repr.; Lemoisne 1912, pp. 21–22, pl. III; Lafond 1918–19, II, repr. facing p. 2; Jamot 1924, p. 129, pl. I; Alexandre 1935, p. 154, repr.; Roberto Longhi, "Monsù Bernardo," *Critica d'Arte*, III, 1938, pl. 99, fig. 34; Lemoisne [1946–49], II, no. 28; Minervino 1974, no. 71; *Foreign Paintings in the Birmingham Museum and Art Gallery: A Summary Catalogue*, Birmingham, 1983, p. 28, no. 41, repr. p. 29; 1984–85 Rome, pp. 116–18, repr.

12.

Self-Portrait in a Soft Hat

1857
Oil on paper mounted on canvas
10¼ × 7½ in. (26 × 19 cm)
Sterling and Francine Clark Art Institute, Williamstown, Massachusetts (544)

Lemoisne 37

Initially dated 1855 and then moved by Lemoisne closer to the etched *Self-Portrait* (cat. nos. 13, 14) of 1857,[1] the little Williamstown picture is probably contemporary with the etching. However, it is difficult to say for certain whether the painting was executed before the etching, and so might have been a study for it, or whether these were two independent works—variations, with different techniques, on a single theme. Comparing it with the self-portrait in the Musée d'Orsay (cat. no. 1), one can see how far the artist has come in two years, even taking his differing intentions into account: the 1855 work is a finished, austere, somber picture, whereas this is a brisk rough sketch, with unexpected *fa' presto* qualities in the treatment of the clothes.

The soft hat, which Degas wears also in the drawings made of him at the time by Stefano Galletti and Gustave Moreau,[2] throws half his face in shadow and gives his eyes a dreamy, faraway look. Along with the orange scarf and the white smock, it makes the young man seem an artist; clearly, he wanted to show himself at work. Just as in the self-portrait of 1855 he was the draftsman, so here Degas is the painter, possibly influenced by the many small portraits done by the students at the French Academy, but discovering, along with a new freedom in behavior, a freedom in handling hitherto rare in his work.

1. Lemoisne 1931, p. 284; Lemoisne [1946–49], II, no. 37.
2. See 1984–85 Rome, pp. 25, 27, repr.

PROVENANCE: Marcel Guérin, Paris; Daniel Guérin, his son, Paris; bought by Durand-Ruel, New York, 20 April 1948 (stock no. N.Y. 5747); bought the same day by Robert Sterling Clark, New York, for $28,000; his gift to the museum 1955.

EXHIBITIONS: 1925, Paris, Musée des Arts Décoratifs, 28 May–12 July, *Cinquante ans de peinture française*, no. 27; 1931 Paris, Orangerie, no. 13, repr.; 1936 Philadelphia, no. 1, repr.; 1956, Williamstown, Sterling and Francine Clark Art Institute, opened 8 May, *French Paintings of the Nineteenth Century*, no. 103, repr.; 1959 Williamstown, no. 5, repr.; 1970 Williamstown, no. 1, repr.; 1978, Chapel Hill, The William Hayes Ackland Memorial Art Center, 5 March–16 April, *French Nineteenth Century Oil Sketches: David to Degas*, no. 23, repr.

SELECTED REFERENCES: Guérin 1931, p. 12, pl. 13; Lemoisne 1931, fig. 47 p. 284; Lemoisne [1946–49], II,

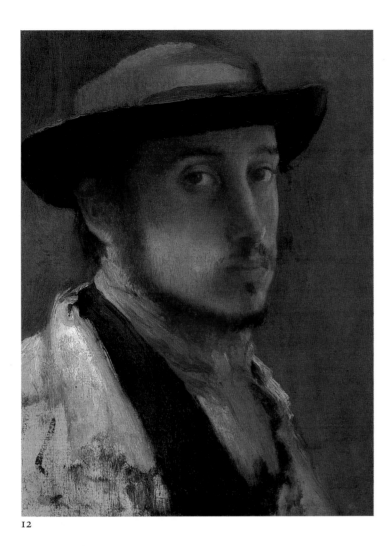

12

no. 37; Boggs 1962, p. 11, pl. 15; *List of Paintings in the Sterling and Francine Clark Art Institute*, Williamstown, 1972, p. 34, no. 544, repr.; Minervino 1974, no. 125; *List of Paintings in the Sterling and Francine Clark Art Institute*, Williamstown, 1984, p. 12, fig. 253; Williamstown, Clark, 1987, no. 9, repr. (color) p. 6.

The Etched Self-Portrait of 1857

cat. nos. 13, 14

From the very beginning of his career, Degas was keenly interested in printmaking. This was highly unusual in the 1850s, when most artists considered it merely a useful means of reproduction and publication and paid only cursory attention to what was known as original printmaking. On 9 April 1853, Degas registered as a copyist at the Cabinet des Estampes,[1] which he frequented regularly until his departure for Italy. At the same time, he was advised by Prince Grégoire Soutzo (1818–1869), a Romanian nobleman and engraver,[2] and friend of Auguste De Gas (Auguste considered him a little mad—"his

head is . . . a little cracked"[3]). He was, above all, a knowledgeable collector: the catalogue drawn up for the sale of his estate lists prints by Callot, Dürer, van Dyck, Claude Lorrain, Marcantonio Raimondi, and Rembrandt, as well as the complete works of Adriaen van Ostade.[4] Degas was able to examine these works at his leisure. Besides Soutzo, who awakened Degas's interest in engraving and taught him the rudiments of the art, there was also Joseph Tourny, whom he was to meet a little later in Rome, where Tourny had been commissioned by Adolphe Thiers to copy the Sistine Chapel frescoes. A professional copyist, Tourny was also an engraver and had reproduced works of art for Achille Martinet. However, his correspondence with Degas in 1858–59 (for the most part unpublished) reveals an embittered artist who was conscious of having to perform unworthy tasks and who wanted to return to France to do work more in keeping with his ambitions. His fondness for engraving was limited: "I will try to do some portraits, perhaps a little engraving, although my eyes object and my love for this art is not the greatest."[5] Auguste De Gas, who had had an opportunity to examine Tourny's copy of the Sistine Chapel

Jeremiah, was critical of the engraver's draftsmanship and urged his son not to follow his example: "The outline is correct, but it is soft, weak, and without vigor; from a distance it looks as if it had been drawn by a young lady—it has that same fuzziness."[6]

Nevertheless, Degas's friendship with Tourny can be discerned in the fine etched portrait (RS5) that he did of him in Rome in 1857, largely inspired by Rembrandt's *Young Man in a Velvet Cap*. In 1857, Degas also dated an etching of himself (cat. no. 14) in the pose of the Orsay self-portrait (cat. no. 1), wearing the same soft hat as in the Williamstown canvas (cat. no. 12), which was painted about the same time. There is a black-chalk drawing in the Metropolitan Museum in New York that has sometimes been considered a study for this print. In style, however, it is closer to Fantin. Its origin is unknown, and it must be regarded with suspicion; it first appeared in an exhibition at the Ny Carlsberg Glyptotek, Copenhagen, in 1948, listed as part of a private collection.

There are four known states of the etching. With each state the image becomes more intense and more dramatic; the effects of chiaroscuro are heightened, and shadow progressively engulfs the face of the young artist. Once again there is a suggestion of Rembrandt, whom Degas discovered, oddly enough, while examining the publications of Charles Blanc during his stay in Italy. Tourny's admiration for Rembrandt had been one of the reasons Degas's father considered him a harmful influence on his son. Auguste would concede only that Rembrandt was a painter "who astonishes us by his ability to create a sense of depth."[7]

Degas must have been pleased with this beautiful image of himself as a young man (published by Lemoisne in 1912) since he distributed it to his friends, whereas no other self-portrait left his studio during his lifetime. He gave Burty the print that now belongs to the Bibliothèque d'Art et d'Archéologie, and Soutzo the one now in Ottawa.

1. Lemoisne [1946–49], I, p. 227 n. 13.
2. The only record of his work is a copy by Degas; see fig. 13.
3. Unpublished letter from Auguste De Gas to Edgar, Paris to Florence, 14 October 1858, private collection.
4. *Catalogue d'estampes anciennes . . . formant la collection de feu M. le prince Grégoire Soutzo*, Paris, 17–18 March 1870.
5. Unpublished letter from Tourny to Degas, Rome to Paris, 31 December 1859, private collection.
6. Unpublished letter, Paris to Florence, 13 August 1858, private collection.
7. Unpublished letter to Edgar, Paris to Florence, 25 February 1859, private collection.
8. Letter from Auguste De Gas to Edgar, Paris to Florence, 25 November 1858, private collection; Lemoisne [1946–49], I, p. 31.

13.

Self-Portrait

1857
Etching on white wove paper, second state
10¼ × 7⅛ in. (26 × 18.2 cm)
National Gallery of Canada, Ottawa (28293)

Exhibited in Ottawa and New York

Reed and Shapiro 8.II

PROVENANCE: Given by the artist to Prince Grégoire Soutzo, Paris (Soutzo stamp, Lugt suppl. 2341, on verso, lower right). Sale, Sotheby's, London, *Nineteenth and Twentieth Century Prints*, 16 June 1983, no. 52, repr.; David Tunick, New York; bought by the museum 1983.

EXHIBITIONS: 1983 London, no. 2.

SELECTED REFERENCES: Delteil 1919, no. 1; Adhémar 1974, no. 13; Reed and Shapiro 1984–85, no. 8, p. 24.

14.

Self-Portrait

1857
Etching on white laid paper, third state
14⅛ × 10¼ in. (36 × 26 cm)
Signed and dated in pencil lower right:
 Degas 1857
Bibliothèque d'Art et d'Archéologie, Universités de Paris (Fondation Jacques Doucet), Paris (B.A.A. Degas 17)

Exhibited in Paris

Reed and Shapiro 8.III

PROVENANCE: Given by the artist to Philippe Burty. Jacques Doucet, Paris; Fondation Jacques Doucet 1918.

EXHIBITIONS: 1924 Paris, no. 193; 1984–85 Paris, no. 106, p. 383, fig. 230 p. 377.

SELECTED REFERENCES: Lemoisne 1912, pp. 17–18, repr.; Delteil 1919, no. 1; Guérin 1931, n.p.; Adhémar 1974, no. 13; Reed and Shapiro 1984–85, no. 8, p. 24.

15.

Hilaire Degas

1857
Oil on canvas
20⅞ × 16⅛ in. (53 × 41 cm)
Inscribed and dated upper right, below the frame on the wall: Capodimonte 1857
Musée d'Orsay, Paris (RF3661)

Lemoisne 27

On 16 July 1857, Hilaire Degas, then eighty-seven years old, wrote a short letter to his grandson in Rome asking him to come as soon as possible to see him in his villa at San Rocco di Capodimonte near Naples, where he normally spent the summer.[1] Edgar arrived fifteen days later, no doubt torn between joy at seeing his grandfather (from whom he had parted ten months before) and the bleak prospect of an extended stay in the boring Capodimonte countryside.[2] The previous year, he had made a pencil

13

14

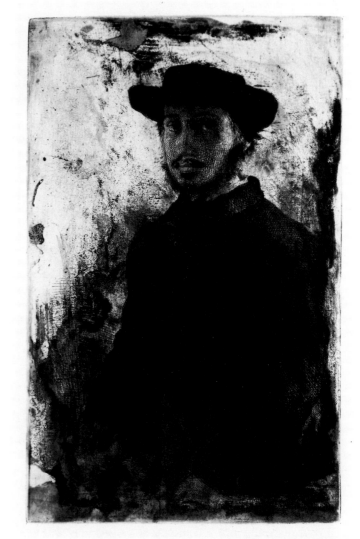

15

Fig. 32. Auguste Flandrin, *Woman in Green*, 1835. Oil on canvas, 18⅛ × 13¾ in. (46 × 35 cm). Musée des Beaux-Arts, Lyons

portrait (head only) of Hilaire not once but three times; but it was in the summer or fall of 1857 that he executed the two painted portraits: first, a picture of Hilaire Degas wearing a cap, examining what must be a drawing or an etched plate (L33, Musée d'Orsay, Paris), and then the present work, which shows him sitting on a sofa, legs crossed, cane in hand. The first portrait, which is unfinished, presents an informal image of Hilaire that would reappear later, disguised in red chalk, in *The Bellelli Family* (cat. no. 20). The second, which is finished, is more ambitious and solemn: Degas portrays an old man for whom he feels affection and admiration, as is attested in family correspondence and in the account he gave of his grandfather's life to Paul Valéry in 1904.[3]

This painting must have been given to Hilaire, for it remained in the family in Naples until acquired by the Société des Amis du Louvre. Degas presumably arrived at the format and pose with his grandfather, who was not ignorant about painting and had assembled an important collection of contemporary Neapolitan works. It is perhaps this that explains Degas's return here to a formula at once provincial and old-fashioned, namely that of the small-scale portrait in an interior of the kind frequently found in Lyons from the period of the July Monarchy, one of the finest examples being Auguste Flandrin's *Woman in Green* (fig. 32). Degas's period of study under Louis Lamothe, who was from Lyons, and his extended stay in that city in the summer of 1855 had clearly made him familiar with this type of portrait, which in the 1850s seems to have survived, much as the critics protested its "meanness" and the "dryness" of its excessively meticu-

lous handling. But with this old-fashioned formula, which would seem to have condemned him to the niggardly approach of the miniaturist, Degas succeeded in creating powerful effects with a paint that, as Marcel Guérin noted, was "rich" and "smooth."[4]

This portrait of Hilaire, like the portrait of René painted two years earlier (cat. no. 2), has the trademark of all of Degas's youthful portraits: a mixture of austerity and good nature, of rigor and familiarity—the rigor here of a knowing geometric construction and the familiarity of a summer portrait in the country. The impressive stature of the model is reinforced by the severe background of verticals and horizontals against which he declares his individuality. The light, coming (perhaps symbolically) from the west, from the setting sun—a summer light, entering only through small openings that will not let it spread too far—casts the rest of the room into a semidarkness in which only the metal of a doorknob gleams. Warm and golden, it falls irregularly on the weary features of the old man—the very long nose, the white hair through which his pink pate is altogether visible, the hand drooping on the armrest, the wrinkles, the pendulous cheeks, the bags under the eyes—and on the knob of the cane, bespeaking infirmity, that cane which sent a familiar tapping through the house, a sound that, following his death, his sons were to remember with sorrow.[5]

1. Unpublished letter from Hilaire Degas to Edgar, 16 July 1857, private collection; cited in part in 1984–85 Rome, no. 40, pp. 124–25.
2. Unpublished letter from Edmondo Morbilli to Edgar Degas, Naples to Paris, 30 July 1859, private collection.
3. Valéry 1965, pp. 55–57; Valéry 1960, pp. 26–27.
4. Guérin 1932, pp. 106–07.
5. Unpublished letter from Achille Degas to his nephew Edgar, Naples to Florence, 15 September 1858, private collection.

PROVENANCE: Degas family, Naples; Marchesa Edoardo Guerrero de Balde (née Lucie Degas), the artist's cousin, Naples; Signora Marco Bozzi (née Anna Guerrero de Balde), Lucie Degas's daughter, Naples, 1932; bought with the portraits of Giovanna Bellelli (RF3662) and Édouard Degas (fig. 16), for 75,000 lire, by the Société des Amis du Louvre 1932.

EXHIBITIONS: 1933 Paris, Orangerie, no. 81; 1934, Paris, Musée des Arts Décoratifs, May–July, *Les artistes français en Italie de Poussin à Renoir*, no. 108; 1947, Paris, Orangerie, December, *Cinquantenaire des "Amis du Louvre" 1897–1947*, no. 62; 1969 Paris, no. 3; 1984–85 Rome, no. 40, repr. (color).

SELECTED REFERENCES: Guérin 1932, pp. 106–07, repr.; Lettres Degas 1945, p. 251; Lemoisne [1946–49], II, no. 27; Fevre 1949, pp. 18–21, repr.; Boggs 1958, p. 164, fig. 26; Paris, Louvre, Impressionnistes, 1958, no. 55; Raimondi 1958, pp. 121, 127, 256, pl. 15 p. 257; Boggs 1962, p. 11, pl. 20; Boggs 1963, p. 273; Reff 1965, p. 610; Valéry 1965, pp. 55–57; Minervino 1974, no. 120; Paris, Louvre and Orsay, Peintures, 1986, III, p. 197, repr.

16.

The Duchessa Morbilli di Sant'Angelo a Frosolone, née Rose Degas

1857
Watercolor and pencil
13¾ × 11⅜ in. (35 × 29 cm)
Vente stamp lower right
Collection of Mr. and Mrs. Eugene Victor Thaw, New York

Exhibited in Ottawa and New York

Lemoisne 50 bis

By comparing this picture with a retouched photograph published in Riccardo Raimondi's invaluable book on Degas's Neapolitan family, Jean Sutherland Boggs was able to identify the subject as the painter's aunt Rose Degas, Duchessa Morbilli di Sant'Angelo a Frosolone.[1] Raimondi, who married the great-granddaughter of Rose Morbilli, described the duchess as "tall and slender, with blonde hair and blue eyes,"[2] but marked at the end of her life by accumulated tribulations: repeated pregnancies (six in seven years of marriage—"the woman is a precious asset to the fatherland," was her brother Édouard's ironic comment[3]), her

16

husband's death and the ensuing financial difficulties, and the loss of three of her children, most painfully that of her eldest son Gustavo, who was killed on a barricade during the Neapolitan uprising of May 1848.

Little is known about Degas's relations with his "ever excellent aunt Rosine."[4] As a painter, he was not interested in her the way he was in Laura or Fanny; there is no finished painting of her, though this drawing, executed during one of his visits to Naples in 1856 or 1857 (more probably the later date), can, it is true, be regarded as a study for a full-length portrait. Rose Morbilli adopts a stilted pose, as if for a formal portrait. As he did with most members of his family, Degas conferred on her an image that is at once familiar and distant: the rigid frontality of the pose is offset in part by the modesty of the black dress (brightened by the big white apron) and also by the fragility of the watercolor.

1. Raimondi 1958, pl. VII, pp. 140–41; Boggs 1963, p. 255.
2. Raimondi 1958, p. 133.
3. Letter from Édouard Degas to his mother, Paris to Naples, 14 March 1831, Raimondi 1958, pp. 86–87.
4. Unpublished letter from René De Gas to his brother Edgar, Naples to Paris, 5 September 1859, private collection.

PROVENANCE: Atelier Degas (Vente IV, 1919, no. 102.b [as "Femme au tablier blanc"]); bought at that sale by Durand-Ruel, Paris, for Fr 1,550 (stock no. 11546); Durand-Ruel, New York, 17 December 1919 (stock no. N.Y. 4311); bought by William M. Ivins, Milford, Conn., 24 March 1920, for $300 (Ivins sale, Parke-Bernet, New York, 24 November 1962, no. 32, repr.); bought at that sale by present owners.

EXHIBITIONS: 1964, New York, E. V. Thaw, 29 September–24 October, *19th and 20th Century Master Drawings*, no. 10; 1965 New Orleans, pl. IX p. 56; 1967 Saint Louis, no. 22; 1969, Kunsthalle Bremen, 9 March–13 April, *Handzeichnungen französischer Meister des 19. Jahrhunderts, von Delacroix bis Maillol*, no. 51, repr.; 1975–76, New York, Pierpont Morgan Library, 10 December 1975–15 February 1976/The Cleveland Museum of Art, 16 March–2 May/The Art Institute of Chicago, 28 May–5 July/Ottawa, National Gallery of Canada, 6 August–17 September, *Drawings in the Collection of Mr. and Mrs. Eugene V. Thaw*, no. 92, repr. (color); 1984 Tübingen, no. 31, repr. (color).

SELECTED REFERENCES: Lemoisne [1946–49], II, no. 50 bis; Boggs 1962, pp. 88 n. 49, 105, 125; Boggs 1963, p. 275, fig. 33; Minervino 1974, no. 131.

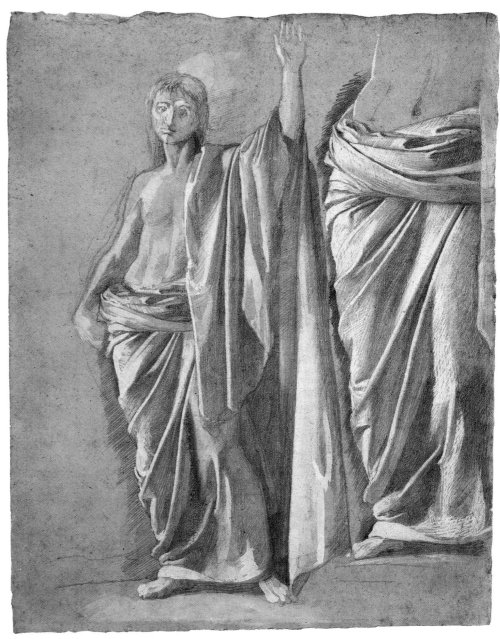

17

17.

Study of a Draped Figure

c. 1857–58
Pencil heightened with white gouache on beige laid paper
11½ × 8⅞ in. (29.2 × 22.5 cm)
On the verso, a pencil copy of the *Mona Lisa*
The Metropolitan Museum of Art, New York. Rogers Fund (1975-5)

This drawing is probably a copy of a figure in a late fifteenth-century Italian work, in a style close to the paintings of Raffaellino del Garbo. It seems to be a drawing "from the antique" for *Saint John the Baptist and the An-gel* (see cat. no. 10). The generosity of the lines and the intensity of the white gouache on the beautiful drapery, foreshadowing *Semiramis* (cat. no. 29), lead to the proposal of a date of c. 1857–58 for this drawing.

PROVENANCE: Atelier Degas; Jeanne Fevre, the artist's niece, Nice (Fevre sale, Galerie Charpentier, Paris, 12 June 1934, no. 63 [as "Deux études d'après l'antique"]). Sale, Drouot, Paris, 8 June 1973, no. 34, repr. Bought by the museum 1975.

EXHIBITIONS: 1975–76, New York, The Metropolitan Museum of Art, 1 October 1975–4 January 1976, *European Drawings Recently Acquired, 1972–1975*, no. 42; 1977 New York, no. 1 of works on paper; 1984–85 Rome, no. 16, repr.

18

Portrait of a Young Woman, after a drawing then attributed to Leonardo da Vinci

1858–59
Oil on canvas
25 × 17½ in. (63.5 × 44.5 cm)
National Gallery of Canada, Ottawa (15222)

Lemoisne 53

During his first visit to Florence in 1858–59, Degas copied in pencil (fig. 33) a red-chalk drawing in the Uffizi, *Portrait of a Young Woman* (fig. 34), attributed at that time to Leonardo da Vinci (it was later given to Pontormo and still later to Bacchiacca). From it, he then painted the present portrait of a proud-looking young woman, probably about the same time he was beginning his studies for *The Bellelli Family* (cat, no. 20), for which he may have found some inspiration in the Uffizi drawing. The painting is an exercise in style in the truest sense of the term. It is a subtle variation on an ancient theme—of the sort that was admired in the nineteenth century—in which Degas assumes the role of Leonardo himself, completing what the master had only sketched.

PROVENANCE: Atelier Degas; Jeanne Fevre, the artist's niece, Nice (Fevre sale, Galerie Charpentier, Paris, 12 June 1934, no. 136). Paul Rosenberg, Paris, 1946. Baron de Rothschild, Paris; André Weil, Paris; Paul Petridès, Paris (Petridès sale, Galerie Charpentier, Paris, *Tableaux modernes*, 12 May 1950, no. 24, repr.); R. W. Finlayson, Toronto, 1950–66 (sale, Sotheby's, London, 23 October 1963, no. 46, repr., bought in); bought by the museum 1966.

EXHIBITIONS: 1957, Art Gallery of Toronto, 11 January–3 February, *Comparisons*, no. 63c; 1958 Los Angeles, no. 2, repr.; 1960 New York, no. 5, repr.; 1971, Halifax, Dalhousie Art Gallery, 25 February–5 March/St. John's, Memorial University Art Gallery, 20 March–4 April/Charlottetown, Confederation Art Gallery and Museum, 15 April–6 May/Fredericton, Beaverbrook Art Gallery, 10–25 May/Quebec City, Musée du Québec, 30 May–15 June, *French Painting 1840–1924 from the Collection of the National Gallery of Canada*, no. 3, repr.; 1975, Ottawa, National Gallery of Canada, 6 August–5 October, *Exploring the Collections: Degas and Renaissance Portraiture*, p. 1; 1984–85 Rome, no. 21, repr.

SELECTED REFERENCES: Lemoisne [1946–49], II, no. 53; Bernard Berenson, *I disegni dei pittori fiorentini*, Milan: Electa, 1961, p. 460, fig. 973; Boggs 1962, p. 12, pl. 25; Reff 1964, p. 255; Minervino 1974, no. 47.

Fig. 33. *Portrait of a Young Woman*, after a drawing then attributed to Leonardo da Vinci (IV:114.a), 1858–59. Pencil, 13¾ × 10¼ in. (35 × 26 cm). Private collection

Fig. 34. Formerly attributed to Leonardo da Vinci, *Portrait of a Young Woman*. Red chalk, 15⅜ × 10½ in. (38.9 × 26.7 cm). Galleria degli Uffizi, Florence

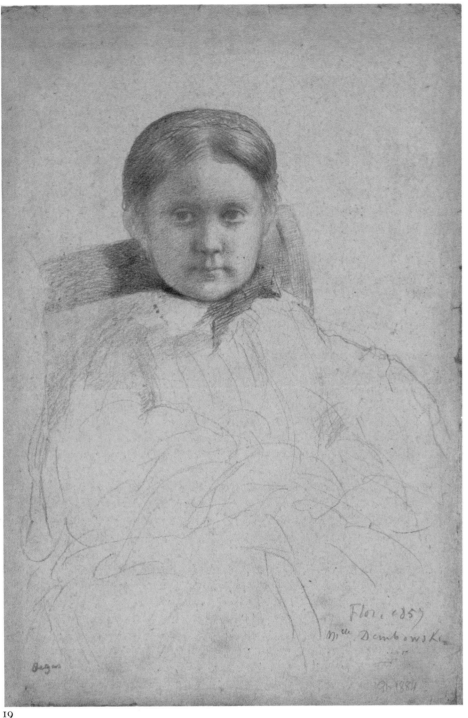

19

19.

Mlle Dembowska

1858–59
Black crayon on pink paper
17⅜ × 11⅜ in. (44 × 29 cm)
Inscribed lower right: Flor, 1857/Mlle Dembowski
Vente stamp lower left
Private collection, San Francisco

Vente IV:98.a

During his Italian trip, Degas stayed in Florence only from 4 August 1858 to March 1859.[1] Later, he mistakenly inscribed a number of drawings "Florence 1857," whereas they should in fact have been dated 1858 or 1859.[2] One such drawing is the portrait of Mlle Dembowska, the daughter of the renowned astronomer Baron Ercole Federico Dembowski (1812–1881) and of Enrichetta Bellelli, a sister of his uncle Gennaro Bellelli (see cat. no. 20). At the same time, Degas did two pencil drawings of Enrichetta Dembowska, showing her sitting, her body three-quarters and her head in profile.[3] These drawings, as well as the one of the young girl, were probably studies for a portrait that was either lost or never exe-

cuted. We know from a letter written by Auguste De Gas that in the last few months of 1858 the young painter was bored with drawing the portraits he was undoubtedly persuaded to do (as later in New Orleans) to satisfy family propriety.[4] Some of these—for example, one of Baroness Bellelli, mentioned by her daughter-in-law Laura in a letter to Degas[5]—have been lost.

Here, on pink paper, Degas used black crayon, a medium with which he was not familiar; he normally preferred pencil. He gave his young sitter the same focused, questioning look that her cousin Giovanna would have in *The Bellelli Family* (cat. no. 20), heavily shadowing her face and upsetting its strict frontality with the angle of the chair on which the nape of her neck rests.

1. Letter from Laura Bellelli to Degas, 31 July 1858, private collection. See Chronology I.
2. Reff 1963, pp. 250–51.
3. René de Gas estate sale, Drouot, Paris, 10 November 1927, no. 7, repr. (later Koenigs collection, Netherlands, and now lost); and IV:90; both reproduced in 1984–85 Rome, under no. 49.
4. Letter from Auguste De Gas to Edgar, 11 November 1858, private collection; cited in part in Lemoisne [1946–49], I, p. 30.
5. Letter, 19 July 1859, private collection.

PROVENANCE: Atelier Degas (Vente IV, 1919, no. 98.a); bought at that sale by Paul Jamot, Paris, with nos. 98.b and 98.c, for Fr 1,410. (Sale, Hôtel George V, Paris, *Tableaux modernes*, 25 May 1976, no. 187, repr.; Galerie Wertheimer, Paris; Arnoldi-Livie Gallery, Munich; private collection, San Francisco, 1978.

EXHIBITIONS: 1984 Tübingen, no. 33, repr. (color).

SELECTED REFERENCES: Boggs 1955, p. 128; Boggs 1962, p. 115; Reff 1964, p. 251 n. 15.

20.

Family Portrait, also called The Bellelli Family

1858–67
Oil on canvas
78¾ × 98⅜ in. (200 × 250 cm)
Musée d'Orsay, Paris (RF2210)

Lemoisne 79

Family Portrait, latterly identified as a portrait of the Bellelli family, was undoubtedly the highlight of the atelier sales held after Degas's death. It immediately stood out as the masterpiece of his early years, and is still recognized as such. At the time of his last move, on 22 February 1913, Degas had left this painting at Durand-Ruel,[1] along with some other cumbersome canvases (see cat. no. 255); there it remained, apparently in very poor condition: "It isn't much to look

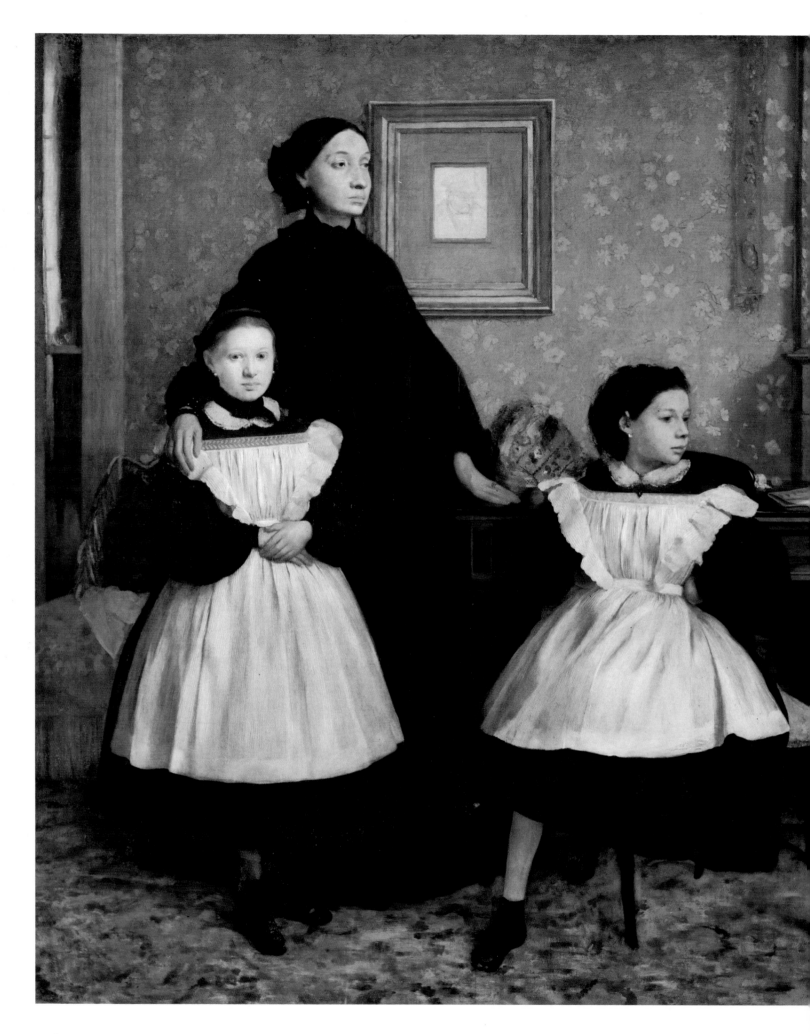

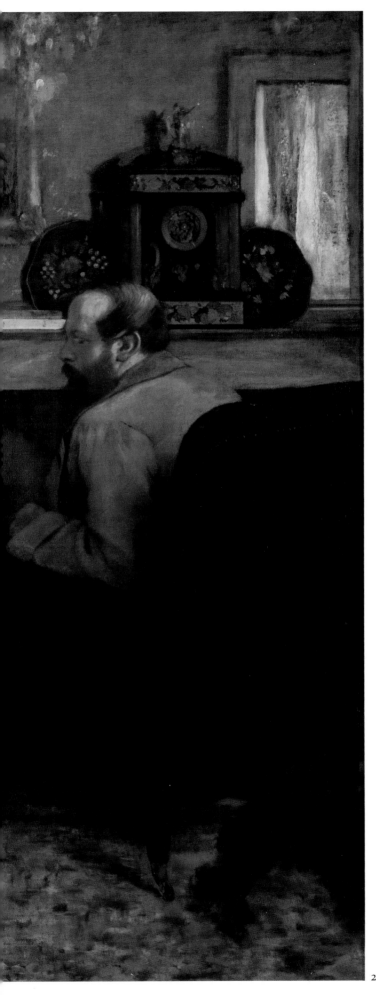

20

at, has been very badly treated by time, and even appears not to have been given the care it should have received in the artist's studio. It has a shabby makeshift frame, the canvas has been torn, and it is covered with an ancient coat of dust that has not been disturbed for years."[2]

Although this was a portrait of his beloved relatives and a painting on which he had labored for several years, Degas does not seem to have regarded it with the same interest and affection he displayed for *Semiramis* (cat. no. 29) and *Young Spartans* (cat. no. 40). It remained hidden from the few visitors he had—perhaps rolled up in a corner of each of his successive studios.

Since it is so difficult to trace the history of this work prior to its sudden appearance in 1918, there has even been some question as to whether or not Degas exhibited it at the Salon. However, it seems improbable that he would have tackled such a large painting—only *The Daughter of Jephthah* (cat. no. 26), which he began soon after, is comparable in size—simply as a remembrance of his Florentine relatives or to thank them for their extended hospitality. He clearly hoped to have it accepted at the Salon and to make his debut with an enormous work. In April 1859, without referring specifically to the project, he wrote to his father asking him to look for a studio so that he could work on a canvas for the exhibition.[3] The only Salon at which the painting could conceivably have been exhibited was some years later, in 1867. The catalogue for that year gives the same title, "Family Portrait," for the two paintings Degas exhibited under nos. 444 and 445—and that was the only name by which this work was known until the scholarly research of Louis Gonse, Paul Jamot, and Marcel Guérin between the wars made it possible to identify the sitters.[4] Unfortunately, the reviews in 1867 were even more niggardly than in 1866, when *The Steeplechase* (fig. 67) was exhibited at the Salon. Only Castagnary, without going into any detail, praised Degas's "Two Sisters,"[5] which has led some to believe that he may have been referring to the Los Angeles double portrait (cat. no. 65). However, two comments from a later period corroborate the hypothesis that *The Bellelli Family* was exhibited at the Salon of 1867. The clearest is a reference made by the critic Thiébault-Sisson, who met with Degas on several occasions. In 1879, he had a chance to see "the admirable Family Portrait of 1867" in the artist's studio; his description is undoubtedly of the Bellelli family portrait.[6] In January 1881, in conversation with Émile Durand-Gréville, Jean-Jacques Henner (who knew Degas at the beginning of the 1860s) discussed his colleague's early difficulties and men-

tioned his successive failures at the Salon: "Degas used to exhibit at the Salon. He stopped doing so because his work was badly hung and, in his opinion, the public did not pay enough attention to it, although the artists gave him the appreciation he deserved. The portrait of his brother-in-law (I believe) and his family is a great work."[7] Despite the vague identification of the painting, Henner's remarks explaining Degas's bitterness and desire to renounce any sort of official career must surely refer to *The Bellelli Family*. It probably also explains why there were so few comments about this masterpiece: if the painting was poorly hung, it would have been difficult to see, in spite of its size.

There is one other indication that *The Bellelli Family* was indeed exhibited in 1867: in several places (most notably in the multicolored embroidery lying on the table), the paint has developed a crackle because of hasty retouching before the canvas had had time to dry. We know from a letter Degas wrote to the Surintendant des Beaux-Arts shortly before the opening of the Salon that at the last minute the painter wanted to retouch the two works he had already sent to the Palais de l'Industrie, where the Salon was held.[8] He was finally granted permission to remove them for three days, which he did. In his haste, Degas used a large amount of a drying agent, which mixed with the paint layer and produced blackish streaks in places.

While the condition of the canvas, together with the recollections of Henner and Thiébault-Sisson, leads to the conclusion that the painting was indeed exhibited in 1867, its fate up to the time of Degas's death in 1917 remains a mystery. Riccardo Raimondi, a Neapolitan lawyer who married one of the painter's grandnieces, has proposed a very different history for this canvas.[9] According to him, the painting remained at the Bellelli apartment when Degas left Florence in the spring of 1859, and was brought to Naples when the family finally returned from exile. Many years later, at the home of Giulia Bellelli-Maiuri (the little girl on the right, the painter's cousin), the canvas fell on an oil lamp, which left holes and burns. Sometime between 1898 and 1909, after one of his trips to Naples, Degas brought the canvas back to Paris to restore it and "neglected" to return it to those who, for nearly forty years, had been its owners. This account is widely accepted, but it appears to be pure fantasy. For one thing, it is contradicted by the evidence that the work was exhibited at the Salon of 1867 and seen in the painter's studio about 1880. Nor does it tally with the condition of the painting itself, which, as its restorer Sarah Walden confirmed in 1984, appears not to have been burned, but rather torn by some sharp object (as André Michel had

Fig. 35. *Giovanna and Giulia Bellelli* (L65), c. 1858. Oil on canvas, 27½ × 23⅝ in. (70 × 60 cm). Private collection

Fig. 36. *The Bellelli Family* (L64), c. 1859. Pastel, 21⅝ × 24¾ in. (55 × 63 cm). Ordrupgaardsamlingen, Copenhagen

earlier observed). Finally, the large size of the canvas would have made transportation and handling difficult. It therefore seems certain that it never left any of the painter's studios until it was stored with Durand-Ruel in 1913.

Contrary to what Raimondi and most other writers say, *The Bellelli Family* could not have been finished when Degas left Florence. Once again, however, unclear accounts leave room for doubt. The story begins late in the summer of 1858. Degas arrived in Florence, which he had never visited before, early in August and was staying with his uncle Gennaro Bellelli, who had been exiled to the Tuscan capital. Relations between the two were cool and sometimes difficult.[10] Degas was bored; his only companions were the taciturn John Pradier and the English watercolorist John Bland. He was impatiently awaiting the arrival of his aunt Laura and his two cousins, who had been delayed in Naples by the death of Hilaire Degas on 31 August.[11] As he would do in Paris the following year, Degas bided his time, copying some works by Venetian artists—Giorgione, Veronese—and (on the advice of Gustave Moreau, who was in Venice) reading Pascal's *Les provinciales*, "in which regarding oneself as hateful is recommended." He was like someone who "has only himself in front of himself, sees only himself, thinks only of himself."[12] He made little effort to hide his boredom at having to do portraits of some of his Florentine relatives.[13] After the arrival of his aunt and cousins early in November, however, he started on what was to become, after many transformations, *The Bellelli Family*. This was to be not just another portrait, but a *picture* ("un *tableau*"—in a letter to Moreau, he repeated the word and underlined it[14]). It was to be a large and ambitious work, with a wide variety of models for inspiration; in his correspondence, Degas mentions a potpourri of names including van Dyck, Giorgione, Botticelli, Rembrandt, Mantegna, and

Carpaccio. He wrote of painting his two young cousins, experimenting (as in the final canvas) with tones of black and white: "I am doing them in their black dresses and their little white pinafores, in which they look delightful."[15] Impatient letters from Auguste De Gas in Paris, awaiting his son's continually postponed return, provide information about the work's progress: "If you had begun the portrait of your aunt, I could understand your wanting to finish it. But you haven't even roughed it out, and the sketch must dry for some time before you can go back and add something, or else you make a mess of it. If you want this to be good and lasting, it is unfortunately impossible for you to do it in a month, and the more rushed you are, the more your impatience will make you do it and redo it and thus waste time. It seems to me, therefore, that rather than begin a canvas you'll have to limit yourself to making a drawing. Take my advice, leave your aunt a drawing that shows off your talents and then hurry and pack up your belongings and get back here."[16] Auguste continued to send more advice—"If you have begun painting your aunt's portrait in oil, you'll find yourself making a mess in your hurry to finish"[17]—as well as warnings. He was torn between wanting to be reunited at last with the son he had not seen for over two years and wanting him to finish the work he had begun without ruining it.

In late December, Degas abandoned what seems to have been a double portrait, depicting only his cousins,[18] in order to start work on a large picture. It is not clear whether he was already working on the Orsay canvas or was doing more sketches in preparation for this large work. His father wrote: "You start such a large painting on 29 December and think you will finish it by 28 February. That's extremely doubtful. If I can give you a piece of advice, it's to do it calmly and patiently; otherwise you run the

risk of not finishing it at all and giving your uncle Bellelli good reason to complain. Since you decided to undertake this picture, you must finish it and finish it properly. I dare to hope that your habits have changed, but I admit that I have so little faith in your resolutions that it will be a great weight off my mind when your uncle writes to tell me that you have completed your painting and completed it well."[19] In any case, Degas's sketches were beginning to include the figure of Gennaro Bellelli, which would explain Auguste's concern, for he knew his brother-in-law's irascible nature. In a sketchy canvas, now in a private Italian collection, Degas depicts Gennaro standing alone behind his two daughters (fig. 35).

It is not clear exactly how much work the young painter had done when, in late March 1859, he finally made up his mind to leave Florence. Certainly *The Bellelli Family* was not finished, since Degas made and dated another drawing of Gennaro Bellelli when he returned to Florence for a month in 1860 (Cabinet des Dessins, Musée du Louvre [Orsay], Paris, RF15484, inscribed "Florence 1860"). It is unlikely that he had begun painting the huge Orsay canvas; he could hardly have done anything as large in the bourgeois apartment in the Piazza Maria Antonia, where there was no studio. The theory advanced by Hanne Finsen in the very comprehensive catalogue for the *Bellelli Family* exhibition (1983 Ordrupgaard) seems, in the absence of any further documentation, the most plausible.[20] Finsen postulates that when he left Florence, Degas took with him, besides the numerous sketches he had done in his notebooks, a number of studies on separate sheets of paper (see cat. nos. 21–25)—some very detailed, such as the Dumbarton Oaks study of Giulia Bellelli (cat. no. 25)—and a compositional study in pastel, now in Ordrupgaard (fig. 36), which

shows the pose and position of each figure but is noticeably different from the final painting in its treatment of the room.

In the first few months after his return to Paris, it seems that Degas did not enjoy the peace of mind he needed to work on such a complex painting. He was slow to readjust to Parisian life, had no studio for several months, missed the encouragement of Moreau, who was still in Italy, clashed with his father over financial matters,[21] was apparently very much absorbed by a brief and mysterious love affair with a Mlle Bréguet (could it have been the Louise Bréguet who was to marry Ludovic Halévy?),[22] and was soon busy with another painting, probably suggested to him by the Peace of Villafranca, *The Daughter of Jephthah* (cat. no. 26). He could not have made much progress with *The Bellelli Family*. Assuming that the Ordrupgaard pastel gives an indication of the work as Degas had planned it in 1859 and that the Orsay canvas was exhibited, after last-minute retouching, at the Salon of 1867, the most notable differences are in the setting: in place of the pastel's simple arrangement (the background unbroken except for a gilt frame and an opaque mirror), Degas developed a more elaborate setting, brightening the blue wall with a sprinkling of white flowers, opening the view to another room on the left, and reflecting in the mirror the crystal pendants of a chandelier, part of a painting (apparently a racing scene, which, since Degas did not use this theme earlier, would confirm a date in the 1860s), and a door or window frame. Much later, perhaps in the 1890s, when he restored the damaged painting, Degas sewed up—or had Chialiva sew up—the tears, put a little gesso on them, and redid the badly damaged face of Laura Bellelli, at the same time retouching the faces of his uncle and cousins. An overzealous restorer, probably when

the canvas was being relined before the sale,[23] must have thought the entire work had been repainted, and scraped off Degas's last retouchings, seriously marring the faces of Giulia and Gennaro.

The Bellelli Family is not merely a group portrait, but rather, as Degas himself stressed, a "picture"—one in which he displays, to use Jamot's felicitous words, "his taste for domestic drama, a tendency to discover hidden bitterness in the relationships between individuals . . . even when they seem to be presented merely as figures in a portrait."[24] In November 1858, after awaiting her return with great impatience, Degas was reunited with his aunt Laura, clearly his favorite among his father's sisters. The young woman's health was fragile, and she seems to have been slightly unbalanced. In the letters she wrote to her nephew after his return to Paris, she dwelt on the sorrows of a prolonged exile, far from her Neapolitan family and in a "detestable country,"[25] and on her sad life with a husband whose character was "immensely disagreeable and dishonest."[26] She refers constantly to the madness she thought was stalking her ("I truly believe that I will end up in a hospital for the insane"[27]) and to her imminent death, which would find her abandoned by those closest to her ("I believe you will see me die in this remote corner of the world, far from all those who care for me."[28] "Living with Gennaro, whose detestable nature you know and who has no serious occupation, shall soon lead me to the grave"[29]). Suffering from what could be called a persecution complex, convinced that the very heavens were utterly against her ("Am I right in saying that nothing goes my way in this world, and that even my most innocent desires are forbidden me by chance, or by I know not what fate that hounds me right to the grave?"[30]), and plunged into despair at the

Fig. 37. Honoré Daumier, *A Man of Property*. Lithograph. Published in *Le Charivari*, 26 May 1837

Fig. 38. Francisco Goya, *The Family of Charles IV*, 1800. Oil on canvas, 110¼ × 132¼ in. (280 × 336 cm). Museo del Prado, Madrid

Fig. 39. Léon Bonnat, *Mother Bonnat with Two Orphans*, 1850–60. Oil on canvas. Location unknown

slightest disagreement with her husband,[31] Laura found support and consolation only in the affection of her nephew.

It stands to reason that, what with the "disagreeable countenance" of a bitter and always idle Gennaro on one hand and the "sad face"[32] of a seriously neurotic Laura on the other, there must have been days when the atmosphere in the apartment was suffocating, despite the lively presence of the two little girls. Enlarged to the size of a history painting, *The Bellelli Family* depicts a family drama: Laura, lost in her black thoughts, poses as if for an official portrait; Giovanna, as in the 1856 portrait (L10, Musée d'Orsay, Paris), gazes intently at the painter; Gennaro, reading by the fireplace and, to use the cruel words of his wife, "without any serious occupation to make him less boring to himself,"[33] deigns, with a show of indifference, to turn his head slightly; Giulia, in the center of the painting, is the only link between a mother and father who are visibly estranged. She sits awkwardly on her small chair, showing signs of the boisterousness and impatience to be expected in a child her age, and breaks the oppressive and solemn atmosphere. The recently departed Hilaire Degas good-naturedly surveys the entire scene: on the wall, Degas has hung his most informal image of his grandfather—here the artist is playing with a small oil he had painted some time before (L33, Musée d'Orsay, Paris), disguising it with red chalk, a gray mat, and a wide gilt frame to make it look like a "master drawing."

It would be difficult to find, among paintings done at the time, a work equivalent to this masterpiece. Many diverse influences have been cited, including works by the old masters—Holbein and (especially for Laura's pose) van Dyck, whom Degas discovered with admiration on his trip to Genoa in April 1859. There are the works of nineteenth-century artists as well, such as Ingres with his family portraits and even Courbet's *After Dinner at Ornans*, which could have influenced the overall composition. However, as Daniel Schulman points out in a forthcoming publication, Degas's picture may be closest to Daumier; the composition is strikingly similar to that of an 1837 caricature by Daumier entitled *A Man of Property* (fig. 37). The group formed by Laura and her two daughters is reminiscent of Goya (whom Degas must have discovered through Bonnat) and his *Family of Charles IV* (fig. 38). It also recalls Bonnat and his portrait *Mother Bonnat with Two Orphans* (fig. 39), painted in the 1850s. Bonnat's picture too plays with tones of black and white and with the monumentality of its protective figure who, like one of the Virgins of Mercy, looks after waifs and strays. But Degas sets himself

apart from Daumier by the large scale of his canvas and from Bonnat by the complex arrangement of his interior scene. This remote and difficult painting, "conceived, painted, and presented without any desire to please and without the slightest concession to the taste of the average viewer,"[34] thus remains unique in the painter's oeuvre and unique among the works of his contemporaries. This explains the universal astonishment caused by its appearance after Degas's death and its immediate purchase by the Musée du Luxembourg. The enormous price that the French National Museums paid to acquire it before the atelier sales provoked an animated response from the press, giving the diehards a chance to let fly. "The family portrait," said Sâr Péladan, "is as dull as a Flemish interior, although the dry technique is distinctive. . . . 400,000 francs for the Degas family portrait! And what a ballyhoo over this name! It is certainly not at all sincere."[35] A "Fevre nephew," during the difficult negotiations with the museums, even went so far as to maintain that "it was not one of his uncle's better paintings."[36]

Although the critics were obviously baffled by a work they did not know how to approach, the admiring reviews carried the day. These were especially favorable and emotional because, in a country still at war, the profoundly French character of *The Bellelli Family* was not unnoticed. François Poncetton asked that it be hung in the Louvre next to the *Pietà of Avignon*: "The faces of the woman and of the children have the same grave quality we so admire in the calm, radiant faces of the donors. This modern primitive renews that gentle tradition."[37] Paul Paulin, an old friend of Degas's, felt the same way, and, running out of superlatives, in his enthusiasm he mixed together some very illustrious references: "This work should be in the Louvre. It is so beautiful and personal; it definitely reminds one of Ingres, but it is pure Degas; the little girl's slender leg is inspired, and the woman's face recalls Holbein as well as Ingres."[38]

1. Durand-Ruel archives, Paris, deposit no. 10255.
2. André Michel, "E. Degas," *Journal des Débats Politiques et Littéraires*, 6 May 1918.
3. Lemoisne [1946–49], I, p. 32.
4. See 1924 Paris, no. 13 (with note by Marcel Guérin), and Selected References below.
5. "The *Two Sisters* by M. E. Degas—a remarkably skilled newcomer—shows that this artist has an accurate feeling for nature and life." Castagnary, *Salons (1857–1870)*, Paris: Bibliothèque Charpentier, 1892, pp. 246–47.
6. François Thiébault-Sisson, "Edgar Degas: l'homme et l'oeuvre," feuilleton in *Le Temps*, 18 May 1918.
7. *Entretiens de J. J. Henner: notes prises par Émile Durand-Gréville*, Paris: A. Lemerre, 1925, p. 103.
8. Letter, 13 March 1867, Archives, Musée du Louvre, Paris; 1984–85 Rome, p. 171.

9. Raimondi 1958, p. 261.
10. Letter from Laura Bellelli to Degas, Florence to Paris, 20 June 1859, private collection.
11. Reff 1969, p. 281.
12. Ibid.
13. Letter from Auguste De Gas to Edgar, 11 December 1858, private collection; cited in part in Lemoisne [1946–49], I, p. 31.
14. Letter from Degas to Gustave Moreau, 27 November 1858, Musée Gustave Moreau, Paris; Reff 1969, p. 283.
15. Ibid.
16. Lemoisne [1946–49], I, p. 31.
17. Lemoisne [1946–49], I, p. 30.
18. Probably the canvas that the painter Cristiano Banti, in a letter to Boldini dated 11 February 1885, claims to have seen in Degas's studio. See 1984–85 Rome, p. 165; 1983 Ordrupgaard, p. 84; *Cristiano Banti, un macchiaiolo nel suo tempo, 1824–1904* (catalogue by Giuliano Matteucci), Milan, 1982.
19. Letter, 4 January 1859, private collection; cited in part in Lemoisne [1946–49], I, pp. 31–32.
20. 1983 Ordrupgaard, no. 44, p. 90.
21. Letter from Laura Bellelli to Degas, Florence to Paris, 19 July 1859, private collection.
22. Letters from Laura Bellelli to Degas, 17 December 1859 and 19 January 1860, private collection.
23. Unpublished letter from Paul Paulin to Paul Lafond, Paris to Pau, 14 April 1918, private collection.
24. Jamot 1924, p. 43.
25. Letters, 25 September 1859 and 19 January 1860, private collection; for all of Laura's letters quoted here, see also 1984–85 Rome, pp. 175–76.
26. Letter, 20 June 1859, private collection.
27. Letter, 19 July 1859, private collection.
28. Letter, 20 June 1859, private collection.
29. Letter, 19 January 1860, private collection.
30. Letter, 19 July 1859, private collection.
31. For example, when Gennaro refused to let her go to Livorno to greet René De Gas and his sisters on their arrival; letter, 19 July 1859, private collection.
32. Letter, 5 April 1859, private collection.
33. Ibid.
34. Michel, op. cit.
35. Sâr Péladan, "Le Salon de 1918," *La Revue Hebdomadaire*, 1918, pp. 254–56.
36. Unpublished letter from Paul Paulin to Paul Lafond, Paris to Pau, 14 April 1918, private collection.
37. "Press Clippings Collected by René de Gas," Musée d'Orsay, Paris.
38. Unpublished letter from Paul Paulin to Paul Lafond, Paris to Pau, 7 March 1918, private collection.

PROVENANCE: Deposited by the artist with Durand-Ruel, Paris, 22 February 1913 (as "Portrait de famille," deposit no. 10255); bought before the first atelier sale (Vente I, 1918, no. 4), by the Musée du Luxembourg, for Fr 300,000, including a Fr 50,000 contribution from the Comte and Comtesse de Fels (René de Gas, the artist's brother, lowered the original price of Fr 400,000 by Fr 100,000).

EXHIBITIONS: (?) 1867, Paris, 15 April–5 June, Salon, no. 444 or 445 (as "Portrait de famille"); 1918 Paris, no. 8; 1924 Paris, no. 13 (as "Portrait de la famille Bellelli," c. 1862); 1926, Venice, *XVe Esposizione internazionale d'arte della città di Venezia*, p. 195, no. 15c; 1931 Paris, Orangerie, no. 17; 1936 Venice, repr.; 1967–68 Paris, Jeu de Paume; 1969 Paris, no. 7, repr.; 1974–75 Paris, no. 9, repr. (color); 1980 Paris, no. 1, repr.; 1983 Ordrupgaard, no. 1, repr. (color); 1984–85 Rome, no. 54, repr. (color).

21

22

SELECTED REFERENCES: Paul Jamot, "The Acquisitions of the Louvre during the War," pt. 4, *Burlington Magazine*, XXXVII:212, November 1920, pp. 219–20, repr. facing p. 219; Fosca 1921, p. 20; Louis Gonse, "État civil du 'Portrait de famille' d'Edgar Degas," *Revue de l'Art Ancien et Moderne*, XXXIX, 1921, pp. 300–02; Lemoisne 1921, pp. 223–24; Léonce Bénédite, *Le Musée du Luxembourg*, Paris, 1924, no. 163, repr. p. 63; Marcel Guérin, "Remarques sur les portraits de famille peints par Degas," *Gazette des Beaux-Arts*, XVII:788, June 1928, pp. 371–75; Paul Jamot, "Acquisitions récentes du Louvre," *L'Art Vivant*, 1 March 1928, p. 176; Lemoisne [1946–49], II, no. 79; Boggs 1955, pp. 127–36, fig. 8; Raimondi 1958, pp. 152–58, 173–89, 258–62, pl. 19 (color); Boggs 1958, pp. 199–202; Paris, Louvre, Impressionnistes, 1958, no. 59; Boggs 1962, pp. 11–17, 58, 88–90 nn. 51–90, repr.; Keller 1962; Boggs 1963, pp. 273–76; Reff 1965, pp. 612–13; Theodore Reff, "Degas's Tableau de Genre," *Art Bulletin*, LIV:3, September 1972, pp. 324–26; Minervino 1974, no. 136, plates IV, V (color); R. H. Noël, "La famille Bellelli," *L'École des Lettres*, 11, 15 March 1983, pp. 2–7, 67, repr.; [Denys Sutton], "Degas and the Bellelli Family," *Apollo*, October 1983, pp. 278–81, repr.; Britta Martensen-Larsen, "Degas and the Bellelli Family: New Light on a Major Work," *Hafnia*, 10, 1985, pp. 181–91, repr.; Paris, Louvre and Orsay, Peintures, 1986, III, p. 195, repr.; Pascale Bertrand, "Degas: La famille Bellelli," *Beaux-Arts Magazine*, 47, June 1987, pp. 81–83, repr. (color).

21.

Giulia Bellelli, study for *The Bellelli Family*

1858–59
Black chalk, gray wash, and essence heightened
 with white on cream-colored paper
9¼ × 7¾ in. (23.4 × 19.6 cm)
Atelier stamp at bottom
Cabinet des Dessins, Musée du Louvre (Orsay),
 Paris (RF11689)

Exhibited in New York

See cat. no. 20

PROVENANCE: Atelier Degas; René de Gas, the artist's brother, Paris, 1918–21 (René de Gas estate sale, Drouot, Paris, 10 November 1927, no. 8, repr.); bought by the Musée du Luxembourg, for Fr 18,500.

EXHIBITIONS: 1931 Paris, Orangerie, no. 89; 1934, Paris, Musée des Arts Décoratifs, May–July, *Les artistes français en Italie de Poussin à Renoir*, no. 409; 1935, Paris, Orangerie, August–October, *Portraits et figures de femmes*, no. 41; 1938, Lyons, *Salon du Sud-Est*, no. 20; 1955–56 Chicago, no. 148, repr.; 1957, Paris, Cabinet des Dessins, Musée du Louvre, June–October *L'enfant dans le dessin du XVe au XIXe s.*, no. 43; 1959–60 Rome, no. 178, repr.; 1967, Copenhagen, Statens Museum for Kunst, 2 June–10 September, *Hommage à l'art français*, no. 36, repr.; 1969 Paris, no. 65, repr.; 1980 Paris, no. 12, repr.; 1983 Ordrupgaard, no. 26, repr.

SELECTED REFERENCES: Leymarie 1947, no. 7, pl. VII; Boggs 1955, pp. 130–31, fig. 6.

22.

Giovanna Bellelli, study for *The Bellelli Family*

1858–59
Black chalk on pink paper
12⅞ × 9⅜ in. (32.6 × 23.8 cm)
Atelier stamp lower right; estate stamp on verso
Cabinet des Dessins, Musée du Louvre (Orsay),
 Paris (RF16585)

Exhibited in New York

See cat. no. 20

PROVENANCE: Atelier Degas. Possibly one of the nine drawings acquired from Marcel Guérin by the Musée du Luxembourg 1925; transferred to the Louvre 1930.

EXHIBITIONS: 1931 Paris, Orangerie, no. 88; 1934, Paris, Musée des Arts Décoratifs, May–July, *Les artistes français en Italie de Poussin à Renoir*, no. 411; 1957, Paris, Cabinet des Dessins, Musée du Louvre, *L'enfant dans le dessin du XVe au XIXe s.*, no. 44; 1969 Paris, no. 64; 1980 Paris, no. 5, repr.; 1983 Ordrupgaard, no. 9, repr. (color); 1984–85 Rome, no. 58, repr.

SELECTED REFERENCES: Keller 1962, p. 31.

23

23.

Laura Bellelli, study for *The Bellelli Family*

1858–59
Pencil heightened with green pastel on gray
 paper, squared for transfer
10¼ × 8 in. (26.1 × 20.4 cm)
Atelier stamp lower left
Cabinet des Dessins, Musée du Louvre (Orsay),
 Paris (RF11688)

Exhibited in New York

See cat. no. 20

PROVENANCE: Atelier Degas; René de Gas, the artist's
brother, Paris, 1918–21 (René de Gas estate sale,
Drouot, Paris, 10 November 1927, no. 13, repr.);
bought at that sale by the Louvre.

EXHIBITIONS: 1931 Paris, Orangerie, no. 90; 1937 Par-
is, Orangerie, no. 61; 1962, Rome, Palazzo Venezia,
Il ritratto francese da Clouet a Degas, no. 72, pl. XXXII;
1967 Saint Louis, no. 23, repr.; 1980 Paris, no. 15,
repr.; 1984–85 Rome, no. 61, repr.

SELECTED REFERENCES: Boggs 1955, pp. 130–31; Keller
1962, p. 30; 1983 Ordrupgaard, no. 22, p. 85, repr.

24

24.

Giovanna Bellelli, study for *The Bellelli Family*

1858–59
Pencil, black crayon, and gouache on blue-green
 wove paper
11⅝ × 8⅝ in. (29.5 × 21.8 cm)
Atelier stamp lower left; Nepveu-Degas stamp
 lower right; present owner's stamp lower right
Private collection, Paris

See cat. no. 20

PROVENANCE: Atelier Degas; René de Gas, the artist's
brother, Paris, 1918–21; Nepveu-Degas collection,
Paris (Nepveu-Degas sale, Drouot, Paris, 6 May
1976, no. 30); bought at that sale by the present
owner.

EXHIBITIONS: 1955 Paris, GBA, no. 19; 1983 Ordrup-
gaard, no. 31, repr.; 1984–85 Rome, no. 60, repr.
(color).

SELECTED REFERENCES: Louis-Antoine Prat, *La ciguë
avec toi*, Paris: La Table Ronde, 1984, p. 133.

25.

Giulia Bellelli, study for *The Bellelli Family*

1858–59
Essence on buff wove paper mounted on panel
15⅛ × 10½ in. (38.5 × 26.7 cm)
Signed lower right in crayon: Degas
Dumbarton Oaks Research Library and
 Collection, Washington, D.C. (H.37.12)

Lemoisne 69

See cat. no. 20

PROVENANCE: Manzi collection, Paris (Manzi sale,
Galerie Manzi-Joyant, Paris, 13–14 March 1919,
no. 32, repr.). Dikran Khan Kelekian, New York
(Kelekian sale, American Art Association, New York,
30–31 January 1922, no. 101, repr., bought in through
Durand-Ruel, at $2,900). Robert Woods Bliss, 1937–40;
gift of Mrs. Robert Woods Bliss to Harvard Univer-
sity, for the Dumbarton Oaks Research Library and
Collection, November 1940.

EXHIBITIONS: 1921, New York, Brooklyn Institute of
Arts and Sciences, 26 March–24 April, *Paintings by
Modern French Masters*, no. 74; 1924 Paris, no. 21,
repr. p. 215; 1931 Paris, Rosenberg, no. 51; 1934
New York, no. 4; 1936 Philadelphia, no. 59, repr.;
1937, Washington, D.C., Phillips Memorial Gallery,
15–30 April, *Paintings and Sculpture Owned in Wash-
ington*; 1938, Washington, D.C., Museum of Modern
Art Gallery, 22 February–20 March, *Portraits of Chil-
dren*; 1940, Washington, D.C., Phillips Memorial
Gallery, 7 April–1 May, *Exhibition of Great Modern
Drawings*, no. 36; 1947, San Francisco, California
Palace of the Legion of Honor, 8 March–6 April,
19th Century French Drawings, no. 89, repr.; 1958–59
Rotterdam, no. 33, repr. (color), in Paris and New
York no. 159, pl. 152; 1962 Baltimore, no. 30; 1983
Ordrupgaard, no. 33, repr. (color).

SELECTED REFERENCES: *Collection Kelekian: tableaux de
l'école française moderne*, Paris, 1920, repr.; Lemoisne
[1946–49], II, no. 69; Boggs 1955, p. 131, fig. 11;
Minervino 1974, no. 141.

25

26.

The Daughter of Jephthah

c. 1859–61
Oil on canvas
77 × 115½ in. (195.5 × 293.5 cm)
Vente stamp lower left
Smith College Museum of Art, Northampton,
 Massachusetts (1933-9)

Lemoisne 94

When Degas returned to Paris after a three-
year stay in Italy, his first task was to find a
studio; his father had been making inquiries
since the beginning of 1859, and Grégoire
Soutzo had offered his own apartment on
rue Madame.[1] Rents were high, and a suit-
able place was not easy to find, but Degas
finally found what he was looking for that
summer at 13 rue de Laval.[2]

All this might seem inconsequential, but
it inevitably had an effect on the young mas-
ter's production. The painful separation
from his aunt Laura, the need to leave Italy
at last, and the difficult reentry into Parisian
life after the long stay abroad all help to ex-
plain this period of several months, from
April to the fall of 1859, in which an indeci-

sive and indolent Degas was, as his friend
Antoine Koenigswarter observed, down in
the dumps.[3]

In the fall, Degas's situation improved
markedly. For one thing, he finally had a
large studio—the first rent receipt, from a
M. Caze, is dated October.[4] For another
thing, his mentor Gustave Moreau returned
to France from Italy in September.

Degas could now settle down to work.
He had brought from Florence the studies
for *The Bellelli Family* (cat. no. 20), which
had occupied all the winter of 1858–59. The
large Paris studio allowed him to do what

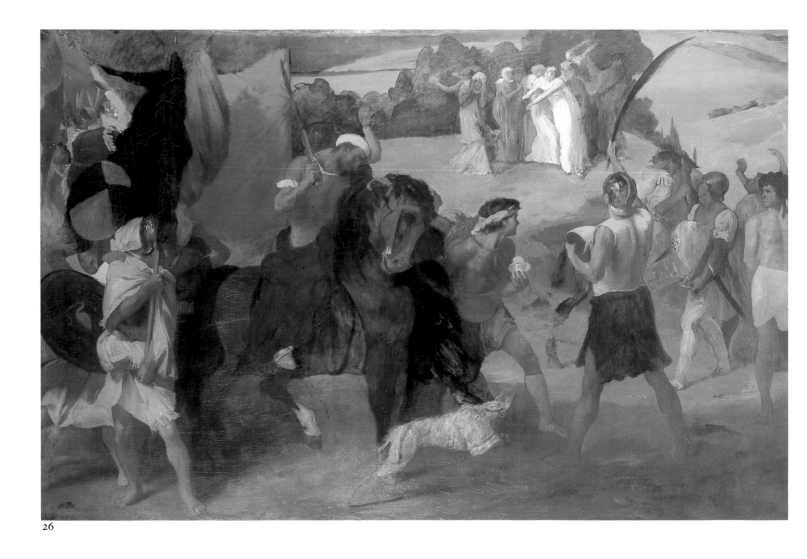

26

he had never been able to before—not in his father's apartment on rue de Mondovi, nor in Naples, nor in the Bellellis' Florentine apartment—to attempt large paintings, which he obviously intended to exhibit at the Salon. It was at this point that he set to work on *The Daughter of Jephthah*, a painting that is little known and often misjudged today, even though it was the largest and perhaps the most ambitious of his history compositions. Its size at once gives it a special place among the artist's works and demonstrates his frequently recorded ambition to pit his efforts against the great history compositions of Delacroix. Its size also makes all the more striking his return to small or medium-sized works afterward—with the exception of *The Bellelli Family*, which he was to complete later but had already begun.

The subject of *The Daughter of Jephthah* is from the Book of Judges: Jephthah the Gileadite is the son of a harlot but a devout man, a valiant warrior with a band of followers; he has been recalled from exile by the Israelites to fight the Ammonites, who have declared war. In order to guarantee his victory, he vows before the Lord to sacrifice "whatsoever cometh forth of the doors of my house to meet me, when I return in peace from the children of Ammon." He returns home victorious, and the first to greet him is his daughter, his only child. As vowed, he sacrifices her to God, after granting her two months in which to "bewail her virginity."[5]

Throughout the nineteenth century, this biblical tale inspired many writers, including Byron, Chateaubriand, and Vigny, whose poem *La fille de Jephté* is, as Reff has shown, a possible source for Degas's work.[6] There were both romantic and political reasons for this sustained interest. The story of Jephthah's daughter is the biblical equivalent of the tragedy of Iphigenia, and thus lends itself to the same poetic flights. Furthermore, the many passages in Judges telling of Israel's battles to recover the territory promised to it were often invoked in relation to the struggles of oppressed peoples throughout history fighting for their independence. It is therefore tempting to see in Degas's choice of this particular episode from the Bible (a source he used less than the *Divine Comedy* or the ancient classics) some connection with recent events in Italy, which

for many reasons, including the fate of his aunt, had profoundly affected him. The emperor of France, Napoleon III, was, after all—with his past as a Carbonaro and his turbulent accession to the throne—but a modern Jephthah who had inexplicably sacrificed Italy at the Peace of Villafranca (11 July 1859), just when the victories won had made it possible to hope that the country would be liberated.

In all likelihood begun in 1859, the canvas was evidently still not finished by 1861 (see cat. no. 27). Its slow development, its clearly unfinished condition, the numerous borrowings from the old masters, and Degas's subsequent lack of interest in the work—in contrast to what happened with *Semiramis* (cat. no. 29) and *Young Spartans* (cat. no. 40)—are all evidence of unresolved difficulties and the painter's profound dissatisfaction with it. *The Daughter of Jephthah* remains unique, however, because of its power, its savagery, and its strident, barbarous rhythms. From the outset, Degas's ambitions were firmly if not altogether clearly expressed: to combine "the spirit and love of Mantegna with the verve and color of Veronese."[7] And unlike

the drawings for *Semiramis*, all the studies (drawn rapidly, sometimes frenetically) point in one direction—toward a violent, turbulent composition.

Without spoiling the homogeneity of the canvas, Degas included a number of quotations from other artists, such as Girolamo Genga (in the Academy of Siena) for the half-naked prisoner with his hands bound and for the soldier with his back to the viewer in the foreground,[8] and Mantegna for the man on the left holding a banner (from *The Triumph of Caesar*, at Hampton Court) and for the grouping of Jephthah's daughter and her companions (from the holy women in *The Crucifixion*; see cat. no. 27).[9] *The Daughter of Jephthah*, like Degas's other history paintings, has no real equivalent among pictures of the period. Delacroix's influence, frequently mentioned, is more evident in the ambitious nature of the work than in its treatment or composition. There is a great similarity between Degas's preparatory studies and those Moreau was drawing at the same time for a large composition on a history subject, *Tyrtaeus Singing during the Battle* (Musée Gustave Moreau, Paris); in 1864, Moreau, while indexing his copy of the *Magasin Pittoresque*, listed in the margin, as one of his planned subjects, "The Daughter of Jephthah."[10]

The Daughter of Jephthah was painted just when Delacroix's influence over Degas was most strongly felt. Oddly enough, it was during his stay in Italy that Degas had discovered Delacroix, thanks to Moreau; on returning to Paris he had begun to show a keen interest in the artist's work.[11] Here color dominates everything, and means everything. Degas wrote in a notebook: "A blue-and-gray sky in which the lights are transparent and, of course, the shadows are black. For the red of Jephthah's robe remember the orange-red tones of that old man in Delacroix's *Pietà*. The hill with its dull, pale sea-green tones. Reduce the countryside to patches."[12] None of this appealed to Auguste De Gas, who had already felt compelled to warn his son: "You know that I do not share your opinion of Delacroix; he abandoned himself to the spirit of his ideas and neglected, unfortunately for him, the art of drawing, the Ark of the Covenant on which all else depends; he is completely lost."[13] And in fact the young painter would never again achieve the effect he does here: intense and dull areas are juxtaposed, sometimes inexplicably, resonating here and there with touches of red, yellow, and orange. More than Jephthah's exaggerated, theatrical gesture, more than the disordered movement of troops, it is this dominance of color or, more precisely, the deliberate and emphatic contrast between vibrant and dull

colors, the violent and the muted, that so admirably renders the barbarism and latent paganism of biblical times and gives the painting its syncopated rhythm. It is also this element that gives the painting its modern flavor, as does the astonishing countryside, simplified to the extreme ("reduce the countryside to patches"), with its geometrically rolling vegetation and softly curving, morphologically incomprehensible hills.

1. Letter from Grégoire Soutzo to Auguste De Gas, 6 April 1859, private collection.
2. Letter from Edmondo Morbilli to Degas, 30 July 1859, private collection.
3. Unpublished letter to Moreau, 30 April 1859, Musée Gustave Moreau, Paris.
4. Private collection.
5. Judges 11.
6. Reff 1976, pp. 153–54, 320 nn. 26, 27; Degas's niece Jeanne Fevre tells us that Degas considered Vigny a poet of the first rank, just slightly below Musset (Fevre 1949, p. 117).
7. Reff, Notebook 15 (BN, Carnet 26, p. 40).
8. Eleanor Mitchell, "La fille de Jephté par Degas: genèse et évolution," *Gazette des Beaux-Arts*, XVIII:140, October 1937, fig. 3 p. 176, fig. 13 p. 183.
9. Tietze-Conrat 1944, p. 420, fig. 6.
10. Musée Gustave Moreau, Paris.
11. In the notebooks of that period he copied *Apollo Conquers the Serpent Python* in the Gallery of Apollo in the Louvre, and the *Pietà* of Saint-Denis-du-Saint-Sacrement; Reff 1985, Notebook 14 (BN, Carnet 12, pp. 73, 72, 70, 65, 64, 63, 59), Notebook 16 (BN, Carnet 27, p. 35).
12. Reff 1985, Notebook 15 (BN, Carnet 26, p. 6).
13. Letter, 4 January 1859, private collection.

PROVENANCE: Atelier Degas (Vente I, 1918, no. 6.a); bought at that sale by Seligmann, Durand-Ruel, Vollard, Bernheim-Jeune, for Fr 9,100 (Seligmann sale, American Art Association, New York, 27 January 1921, no. 71, repr.); bought at that sale by Carlos Baca-Flor, for $1,700; Wildenstein, New York; bought by the museum 1933.

EXHIBITIONS: 1933 Northampton, no. 5, repr.; 1935, University of Rochester, Memorial Art Gallery, *French Exhibition*; 1935, Kansas City, William Rockhill Nelson Gallery of Art, Mary Atkins Museum of Fine Arts, 31 March–28 April, *One Hundred Years: French Painting 1820–1920*, no. 20, pl. V; 1936 Philadelphia, no. 7, repr.; 1937 Paris, Orangerie, no. 3, pl. 2; 1946, Poughkeepsie, Vassar College; 1953, New York, Knoedler Galleries, 30 March–11 April, *Paintings and Drawings from the Smith College Collection*, no. 12; 1956, New York, Brooklyn Museum of Art, 2 October–13 November, *Religious Painting, 15th–19th Century: An Exhibition of European Paintings from American Collections*, no. 25, repr.; 1960 New York, no. 7, repr.; 1961, Cambridge, Mass., Fogg Art Museum, 20 April–20 May, *Ingres and Degas: Two Classic Draftsmen*, no. 17; 1961, The Arts Club of Chicago, 11 January–15 February, *Smith College Loan Exhibition*, no. 8; 1969, The Minneapolis Institute of Arts, 3 July–7 September, *The Past Rediscovered: French Painting 1800–1900*, no. 25, repr.; 1974 Boston, no. 2, fig. 3; 1978–79 Philadelphia, no. VI-41, repr. (English edition), no. 209, repr. (French edition); 1984–85 Rome, no. 51, repr. (color).

SELECTED REFERENCES: Lemoisne 1912, p. 30; Lafond 1918–19, I, repr. p. 17, II, p. 2; Lemoisne 1921, p. 222; "Smith College Buys Huge Work by Degas," *Art Digest*, VIII:5, 1 December 1933, p. 38, repr.;

"Degas, Smith College," *American Magazine of Art*, XXVII:1, January 1934, p. 43, repr.; Jere Abbott, "A Degas for the Museum," *The Smith Alumnae Quarterly*, XXV:2, February 1934, p. 166, repr.; J.A. [Jere Abbott], "La Fille de Jephté," *Smith College Museum of Art Bulletin*, 15, June 1934, pp. 2–12, figs. 4–7 (details), repr. p. 2 and cover; Eleanor Mitchell, "La fille de Jephté par Degas: genèse et évolution," *Gazette des Beaux-Arts*, XVIII:140, October 1937, pp. 175–89, figs. 4, 5, 24, 25 (detail); *Smith College Museum of Art Catalogue*, Northampton, 1937, p. 17, repr. p. 79; Tietze-Conrat 1944, p. 420, fig. 6; Lemoisne [1946–49], II, no. 94; George Heard Hamilton, *Forty French Pictures in the Smith College Museum of Art*, Northampton, 1953, pp. iv, xiv, xvi, xxi, no. 23, repr.; Germain Seligman, *Merchants of Art: 1880–1960: Eighty Years of Professional Collecting*, New York: Appleton Century Crofts, 1961, p. 156; Phoebe Pool, "Degas and Moreau," *Burlington Magazine*, CV:723, June 1963, p. 253; Reff 1963, pp. 241–45; Phoebe Pool, "The History Pictures of Edgar Degas and Their Background," *Apollo*, LXXX:32, October 1964, pp. 310–11; Reff 1964, pp. 252–53; Reff 1971, pp. 537–38; Minervino 1974, no. 102; Reff 1976, pp. 45, 58–60, 152, 313 n. 18, pl. 32 (color), fig. 35 (detail) p. 61; Reff 1977, fig. 3 (color); 1984–85 Paris, fig. 14 p. 16; Reff 1985, pp. 8, 19–21, 24, 29, Notebook 12 (BN, Carnet 18, p. 93), Notebook 13 (BN, Carnet 16, p. 58), Notebook 14 (BN, Carnet 12, pp. 2, 6, 8–10, 13, 22, 25, 30–31, 33, 35–36, 38, 52, 80), Notebook 14A (BN, Carnet 29, pp. 17–18, 20–23, 30, 32), Notebook 15 (BN, Carnet 29, pp. 6, 11, 17–18, 23–24, 26–33, 35, 39, 40, 42), Notebook 16 (BN, Carnet 27, pp. 5, 8, 12–15, 25, 27, 29, 37, 39, 41), Notebook 18 (BN, Carnet 1, pp. 5–6, 17, 21, 51, 59, 61, 67, 76–77, 79, 85, 92, 94, 99, 139), Notebook 19 (BN, Carnet 19, pp. 53–57, 102A).

27.

The Crucifixion, after Mantegna

1861
Oil on canvas
27⅛ × 36⅜ in. (69 × 92.5 cm)
Vente stamp lower right
Musée des Beaux-Arts, Tours (934-6-1)

Lemoisne 194

Degas's position was uncompromising and continually reasserted: "The masters must be copied over and over again, and it is only after proving yourself a good copyist that you should reasonably be permitted to draw a radish from nature."[1] His was not a servile admiration of the masters that could lead to a narrow attachment to the past or rigid academicism, but only a desire to discover in the work of his predecessors the "mot juste," the right formula. The bias that he noted in others ("No bias in art? And the Italian Primitives, who paint the softness of lips by using hard lines and who bring eyes alive by cutting off the eyelids as with a pair of scissors . . . "[2]) he adopted for his own use when it suited his purposes.

27

Fig. 40. Andrea Mantegna, *The Crucifixion*, 1456–59. Oil on panel, 26⅜ × 36⅝ in. (67 × 93 cm). Musée du Louvre, Paris

The vast majority of Degas's copies date from his formative years between 1853 and 1861; some others he did later in his career (see cat. no. 278). While they are mostly copies after the old masters, especially the Italians of the fifteenth and sixteenth centuries, they also include copies of works from the ancient world (Assyrian, Egyptian, Greek, and Roman) and of course from the nineteenth century—David, Ingres, Delacroix, and Daumier, and contemporaries like Meissonier, Menzel, and Whistler.[3] Such eclecticism is not at all surprising—it was typical of most of the artists of Degas's time, including his friends and acquaintances Moreau, Bonnat, Delaunay, and Henner. But Degas repeatedly went back to the Italians of the Renaissance, who were also preferred by his father. For Auguste De Gas,

"the masters of the fifteenth century are the only true guides; once they have thoroughly made their mark and inspired a painter unceasingly to perfect his study of nature, results are assured."[4] When he felt that his son was on the wrong path and that, under the influence of Moreau, he was inclined to give himself up exclusively to studying the colorists (Rubens, Delacroix), he brought him back into line: "Have you carefully examined, contemplated those adorable fresco painters of the fifteenth century? Have you saturated yourself in them? Have you drawn, or rather made watercolor copies so as to remember their colors?"[5]

From his earliest copies (before departing for Italy, he made a pencil sketch, about 1855, of the impenitent thief from *The Crucifixion* at the Louvre[6]) until his latest (BR144, *Minerva Chasing Vice from the Garden of Virtue*, Musée d'Orsay, Paris), Degas studied Mantegna. It was an interest he reaffirmed many times over and never more strikingly than in this "copy" of *The Crucifixion* (fig. 40). Lemoisne placed the work rather late, c. 1868–72, and Reff then narrowed it to c. 1868–69.[7] It should probably be moved further back by several years, making it contemporary with *The Daughter of Jephthah* (cat. no. 26). Degas himself said that Mantegna was one of the sources of inspiration for that work, the largest of his history paintings. In a notebook he wrote, somewhat obscurely, that he sought to combine "the spirit and love of Mantegna with the verve and color of Veronese."[8] The group

made up of Jephthah's daughter and her companions, which appears on the final canvas and in the last of the compositional studies,[9] is taken directly from Mantegna's group of holy women at the foot of Calvary. It is very likely that Mantegna's painting finally provided Degas with the solution he had been seeking for several months. This copy of *The Crucifixion* may therefore be placed in the last quarter of 1861—Degas reregistered as a copyist at the Louvre on 3 September.[10] Although he used a canvas the same size as Mantegna's, Degas did not paint a scrupulously accurate copy, but rather produced an exercise in style, a variation on a theme, "with a deeply Christian feeling, a firm touch, the tonality more acid perhaps than in the original, exactly the hallmarks of the copyist."[11] To Mantegna's "spirit and love" he added "the verve and color of Veronese." Bought at the atelier sale by Jeanne Fevre, one of Degas's nieces, the copy had, according to reports at the time in the press, been promised to the Carmelite order in Nice, to which one of her sisters (a niece and heir of the artist) belonged.[12] It ended up, more prosaically, and through the efforts of the Compagnie Générale du Gaz, in the Musée des Beaux-Arts at Tours in 1934.

1. Vollard 1924, p. 64.
2. Halévy 1960, p. 56; Halévy 1964, p. 49 (translation revised).
3. For the copies, see Reff 1963; Reff 1964; Theodore Reff, "Addenda on Degas's Copies," *Burlington Magazine*, CVII:747, June 1965, pp. 320, 323; Reff 1971, pp. 534–43.
4. Letter from Auguste De Gas to Edgar, Paris to Florence, 4 January 1859, private collection.
5. Letter, 25 November 1858, private collection; cited in Lemoisne [1946–49], I, p. 31.
6. See 1984–85 Rome, nos. 6 and 7, repr.
7. Lemoisne [1946–49], I, no. 194; Reff 1963, p. 245, n. 22.
8. Reff 1985, Notebook 15 (BN, Carnet 26, p. 40).
9. BR36; Reff 1985, Notebook 18 (BN, Carnet 1), used between 1859 and 1864.
10. Archives, Musée du Louvre, Paris, "Registre d'inscription."
11. *Cri de Paris*, 19 May 1918.
12. Ibid.; "Degas's Picture to Find Home in a Carmelite Convent?" *Herald Tribune*, "Press Clippings Collected by René de Gas," Musée d'Orsay, Paris. The painter's niece, Madeline Marie Pauline Fevre, was a sister in the Carmelite order.

PROVENANCE: Atelier Degas (Vente I, 1918, no. 103); bought at that sale by Jeanne Fevre, the artist's niece, for Fr 17,500 (Fevre sale, Galerie Charpentier, Paris, 12 June 1934, no. 116); bought by the Compagnie Générale du Gaz pour la France et l'Étranger, who gave it to the museum.

EXHIBITIONS: 1937, Kunsthalle Basel, *Kunstlerkopien*, no. 105; 1951–52 Bern, no. 12; 1952 Amsterdam, no. 9, repr.; 1952 Edinburgh, no. 9, pl. II; 1957, Vienna, Palais Lobkowitz, November–December, *Chefs-d'oeuvre du Musée de Tours*, no. 49; 1964–65 Munich, no. 77, repr.; 1984–85 Rome, no. 23, repr. (color); 1987 Manchester, no. 36, repr. (color).

SELECTED REFERENCES: *Cri de Paris*, 19 May 1918; "Musée de Tours: une copie de Degas d'après le

'Calvaire' de Mantegna," *Bulletin des Musées de France*, June 1934, no. 6; Tietze-Conrat 1944, pp. 418–19, fig. 7; Lemoisne [1946–49], I, repr. between pp. 12 and 13, II, no. 194; Fevre 1949, p. 28; Minervino 1974, no. 59; Alistair Smith, *Second Sight: Mantegna "Samson and Delilah," Degas "Beach Scene,"* London: National Gallery, 1981, pp. 18–19, repr.

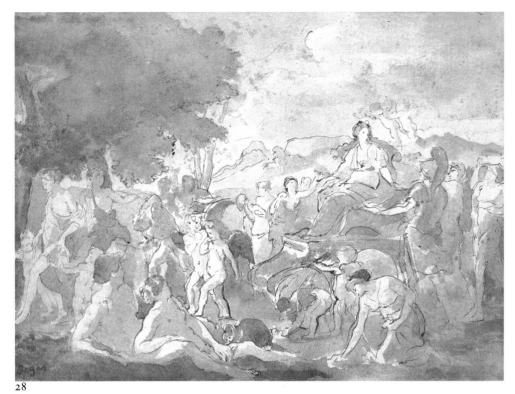

28

28.

The Triumph of Flora, after Poussin

c. 1860
Pen and ink and wash on off-white laid paper
9¼ × 12⅝ in. (23.5 × 32 cm)
Vente stamp lower left
Private collection, Zurich

Vente IV:80.c

Degas, like Ingres, always had a great admiration for Poussin and envied his successful career.[1] In the 1850s and 1860s, he copied many of Poussin's works, including, most notably, *The Plague at Ashdod* (IV:85.a) and *The Rape of the Sabine Women* (L273, Norton Simon Museum, Pasadena), the latter copy an oil on canvas the same size as the original. Theodore Reff has pointed out a short story by Duranty in which the hero, while copying Poussin's painting in the Louvre about 1863, notices "beside him, also struggling with the Poussin, . . . Degas, an artist of rare intelligence, preoccupied with ideas."[2] Duranty adds, "Degas was copying the Poussin admirably."[3]

In undertaking *The Triumph of Flora* (fig. 41), Degas was not tackling one of Poussin's most reproduced works. Far more popular were *The Assumption of the Virgin*, copied by Fantin-Latour in September 1852, or *Et in Arcadia Ego*, copied by Cézanne in April 1864.[4] *The Triumph of Flora* attracted very little attention in the nineteenth century. Al-

though we know some contemporary copies by artists such as Bouguereau (private collection) and the little-known Oscar-Pierre Mathieu (Musée Rolin, Autun), the Louvre registers show that the painting was not often copied between 1851 and 1871.

Degas did not produce an exact copy, which would have meant, above and beyond the same support and medium, a drawing that was more defined and truer to the original. Instead, he used the seventeenth-century technique of pen and wash to re-create what could have been a quick, lively preliminary drawing by Poussin himself, giving only the broad outline and the spirit of the final composition.

1. Lettres Degas 1945, III, p. 28; Degas Letters 1947, no. 5, p. 26.
2. Reff 1964, p. 255.
3. Edmond Duranty, "La simple vie du peintre Louis Martin," *Le Siècle*, 13–16 November 1872; reprinted in *Le pays des arts*, Paris [1881], pp. 315–50.
4. Archives, Musée du Louvre, Paris, LL22, "Copistes. Écoles Française et Flamande, 1851–1871."

PROVENANCE: Atelier Degas (Vente IV, 1919, no. 80.c [as "Le triomphe de Vénus"]); bought at that sale through Durand-Ruel, Paris, by Olivier Senn, Le Havre, with nos. 80.a and 80.b, for Fr 1,400. Bignou estate; acquired by the present owner 1962.

EXHIBITIONS: 1984 Tübingen, no. 37, repr. (color).

SELECTED REFERENCES: Walker 1933, p. 184; Reff 1963, p. 246; Minervino 1974, no. 25.

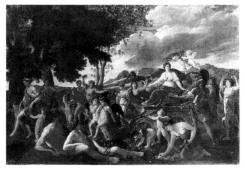

Fig. 41. Nicolas Poussin, *The Triumph of Flora*, c. 1627. Oil on canvas, 65 × 94⅞ in. (165 × 241 cm). Musée du Louvre, Paris

29.

Semiramis Building Babylon

c. 1860–62
Oil on canvas
59 × 101⅝ in. (150 × 258 cm)
Vente stamp lower right
Musée d'Orsay, Paris (RF2207)

Lemoisne 82

Degas always showed great fondness for his history paintings, even long after he had left them to turn his talents exclusively to subjects from contemporary life. He knew that, contrary to what others believed, they were not "unsuccessful efforts" or proof that his genius had been stunted by his devotion to ancient formulas. As very few critics have recognized, the painter was right. From *Alexander and Bucephalus* (L92, private collection, Lugano) to *The Daughter of Jephthah* (cat. no. 26) and *Young Spartans* (cat. no. 40), he produced a series of disturbingly original works unlike anything anyone else was doing at the time. It is admittedly difficult to see a consistent progression from one composition to the next, and, despite years of hard work during the late 1850s and early 1860s, Degas does not seem to have known exactly where he wanted to go. The works that influenced him were diverse as well: while *The Daughter of Jephthah* recalls Delacroix, *Semiramis Building Babylon* is reminiscent of Moreau, and *Scene of War in the Middle*

Fig. 42. Compositional study for *Semiramis* (L86), c. 1860–62. Pencil and brown wash, 10¼ × 13¼ in. (25.9 × 33.8 cm). Cabinet des Dessins, Musée du Louvre (Orsay), Paris (RF15533)

Fig. 43. Compositional study for *Semiramis* (L85 bis), c. 1860–62. Watercolor, 9½ × 16⅜ in. (24 × 41.6 cm). Cabinet des Dessins, Musée du Louvre (Orsay), Paris (RF12275)

Fig. 44. Compositional study for *Semiramis* (L84), c. 1860–62. Oil on paper mounted on canvas, 9⅞ × 15¾ in. (25 × 40 cm). Private collection

Fig. 45. Compositional study for *Semiramis* (L85), c. 1860–62. Pastel, 15¾ × 26⅜ in. (40 × 67 cm). Musée d'Orsay, Paris

Ages (cat. no. 45) evokes Puvis de Chavannes. It would nevertheless be a mistake to follow the majority of critics, who disregard these ambitious works (which Degas spent so long planning and returned to again and again) and who consider only the admirable preliminary drawings of nudes and draperies, which according to Paul Jamot are "infinitely superior to the paintings for which they were the studies."[1] The complimentary remarks made by André Michel soon after the acquisition of *Semiramis* by the Musée du Luxembourg (granted he was somewhat weary of "bathrooms, baths, and bidets") remain virtually unique in the work's critical fortunes: "There is not one part, not one element of the painting—with its rich, vibrant hues, at once enveloping and delicately balanced, the grave and almost solemn simplicity of the draftsmanship, and the original arrangement of the figures—that does not assert itself with a slow and persuasive authority."[2]

Throughout his life, Degas retained a genuine affection for *Semiramis*, as he did for *Young Spartans*; he did not hide this youthful work, but showed it readily to those who visited his studio, including George Moore, Paul-André Lemoisne, and probably Jacques-Émile Blanche[3]—not to mention Manet,

who reportedly advised him to exhibit it, adding maliciously, "It will make for some variety in your work."[4] In 1881, Degas allowed Durand-Gréville to examine the preliminary drawings.[5] Five of them were selected by Degas himself to be reproduced in the 1897 album *Vingt dessins*, published by Michel Manzi.

The subject is easy to read and does not pose the difficult problems of interpretation presented by *Young Spartans* or *Scene of War*. Semiramis, accompanied by attendants, warriors, and ministers, is standing on a terrace, from which she is surveying the progress of the construction of Babylon, the city she has founded on either side of the Euphrates. Although the suggestion made by Lillian Browse is often repeated,[6] Degas was not in the least inspired by Rossini's *Sémiramis*, which returned to the Opéra for several performances beginning 9 July 1860. On the contrary, he seems to have deliberately distanced himself from the Babylonian sets designed by Cambon and Thierry (which consisted of painted backdrops with lush, overgrown vegetation and huge, gaudy buildings) to strive for the simpler lines of a dignified and serene style of architecture, rendered in monochrome. Disregarding the mannered costumes designed by Alfred Al-

bert for Rossini's characters, eschewing fringes, shawls, pompons, tiaras, and heavy jewels, he dressed Semiramis and her attendants in long belted robes in muted colors. Degas's Babylon is concocted pell-mell out of the latest discoveries in Assyriology, innovations in the theater, and, more vaguely, the climate of the times.

A useful comparison may be drawn here with *Salammbô*, begun by Flaubert in September 1857, finished in April 1862, and published on 24 November of that year, probably while Degas was still working on his canvas. The world of *Salammbô*, like that of *Semiramis*, hardens and turns to rock. Pierre Moreau's comments on Flaubert's novel could be applied equally well to *Semiramis*: "Even nature and living beings seem to be made of metal and wrought by a goldsmith. The large shimmering lagoon is like a silver mirror. . . . The pomegranate trees, almond trees, and myrtles stand immobile, as if their leaves had been bronzed. . . . Even the unremittingly pure expanse of sky is as smooth and cold as a metal dome."[7] Flaubert's Carthage—"conical roofs atop hexagonal temples, staircases, terraces, ramparts"[8]—is akin to Degas's Babylon. There is no evidence of a direct influence. "Degas would naturally have been interested in reading *Salammbô*," his niece Jeanne Fevre wrote. "In those sometimes hallucinatory pages he should have found some beautiful pictorial motifs—but he did not say or write so."[9] However, the similarity of atmosphere and intention is apparent.

Degas drew primarily on the image given to us by Diodorus Siculus in his *Biblioteca historica* (which had been retranslated by Ferdinand Hoefer in 1851) of the queen who built and founded the city of Babylon. He also took certain details (Semiramis's hair and the chariot on the right) from Assyrian works which had recently been acquired by the Louvre.[10] Notebooks from this period reveal the diversity of his borrowings and the originality of his approach: he accumulated a veritable wealth of documentation, borrowing not only from Assyrian reliefs, but also from Mughal miniatures and Egyptian and Persian wall paintings.[11] He

Fig. 46. Gustave Moreau, *The Magi* (detail), c. 1860. Oil on canvas, 16⅞ × 24⅜ in. (43 × 62 cm). Musée Gustave Moreau, Paris

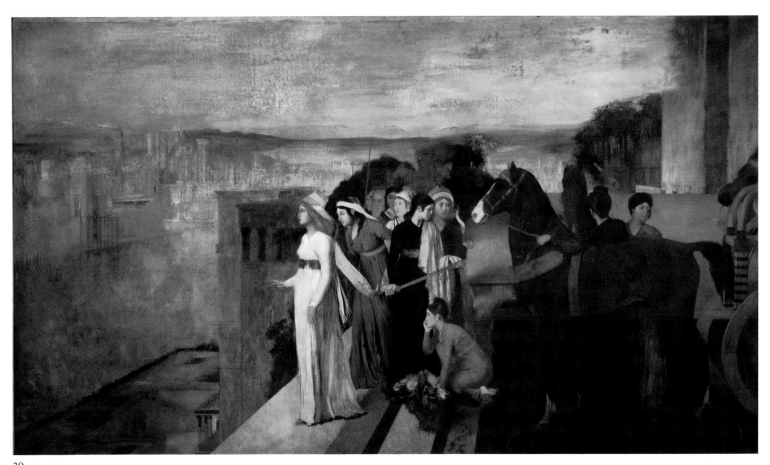

29

did copies of the Parthenon frieze (on which he based the horse in the center of his picture) and parts of works by Luca Signorelli and Clouet, and he sought out uncommon sources and unusual and eclectic references, usually from periods known then as "primitive." These influences make *Semiramis*, more than any other of Degas's paintings, a striking testimony to the deliberate "primitivism" that was evident throughout the nineteenth century, from Ingres to Gauguin to Matisse.

It is impossible to know when Degas began this painting. A letter from James Tissot, however, tells us that although the painter was apparently working on it intensively, it was still not finished in September 1862.[12] The large number of preliminary drawings and the diversity of the compositional sketches—thoroughly analyzed by Geneviève Monnier[13]—attest to a particularly long and difficult evolution. With the exception of two canvases (L83, L84, private collections, Paris), all were purchased by the Musée du Luxembourg at the atelier sales. Starting with a pyramidal composition animated by a rearing horse and dense overgrown foliage (fig. 42), Degas moved progressively toward a serene friezelike arrangement (figs. 43, 44). In the final version, everything seems frozen. Stony architecture predominates, confining the now sparser foliage; the water is leaden and slack, the sky is evenly calm, and the poses of the figures are fixed. Here nothing stirs: any sign of movement that could be detected in the preceding sketches has disappeared.

Along with the compositional sketches, Degas did detailed individual studies of the figures of Semiramis and her attendants. The numerous drawings that have been preserved (see cat. nos. 30–38), together with those for *Scene of War in the Middle Ages* (cat. nos. 46–57), are among the artist's finest works. They include drapery studies heightened with white gouache (which seem to derive from Panathenaic scenes), drawings of a model that reveal her progressive transformation from a little Parisian with a commonplace face into the hieratic companion of the Queen of Babylon, and a drawing of the immobile profile of a horse inspired by Greek sculpture.

The evolution of Degas's canvas closely mirrors the changes in his relationship with Moreau. At the beginning, there is an obvious affinity between the two artists: the subject matter could have been inspired by Degas's mentor from the Italian years, and the first compositional studies bear witness to common research they had undertaken at the same time (see fig. 46 and cat. nos. 26, 39, 40). However, Moreau's influence fades from one sketch to the next, giving way (even more clearly in the Orsay painting) to that of the fifteenth-century Italians, including Pisanello (*Saint George and the Princess*, Sant'Anastasia, Verona) and especially Piero della Francesca (whose *Queen of Sheba Adoring the Holy Wood* Degas must have discovered in San Francesco, Arezzo, on his way to Florence in the summer of 1858). By the time Degas finished the painting (perhaps 1862 or 1863, though he later repainted parts of it, including the sky), the links with Moreau were already weakening. Rejecting the tinsel, the often disorderly jumble, and the marked fondness for jewelry seen in some of his master's canvases, Degas opted for simplicity, bareness, rigor, and even deliberate stiffness. There is nothing about *Semiramis* to suggest an early prefiguration of the tedious "fin-de-siècle" women. It is, rather, like *Young Spartans*, a perfectly original response to the frequently debated problem of history painting: an artist could not restore life to this moribund genre through scrupulous archaeological reconstruction in the manner of Gérôme, nor (to use the cruel words Degas flung at Moreau) with unlimited jewelry;[14] rather, it was necessary, relying on the example of the old masters and translating antiquity as carefully as the

painters of the fifteenth and sixteenth centuries, to seek another and in the end truer reality than some laborious reconstruction.

Degas's Semiramis, like Paul Valéry's, looks down on the city she has founded, indulging her "desire for unyielding temples" and contemplating the "evidence of her authority."[15] Degas's canvas contains an implicit criticism of contemporary town planning. While he was still in Florence, his friend Tourny had already warned him of the changes taking place: "When you see Paris again, in spite of all the immense buildings being erected, you will often miss our beautiful Italy. What a detestable stench of tar and gas!"[16] To create his imaginary Babylon, the painter borrowed from Italian architecture: the Temple of Castor and Pollux in the Forum, the column of the Piazzetta in Venice surmounted by Saint Mark's lion, the fortified towers of medieval towns, Tuscan churches sitting on the tops of hills. In the Paris that Haussmann built—"the new Babylon"—Degas expressed his longing for an imaginary city that would replace the cold monotony of gray buildings lined up along straight avenues; hence this picturesque and monumental tangle of stairways, terraces, palaces, and ramparts, all constructed by "wise Semiramis, enchantress and monarch."[17]

1. Jamot 1924, p. 27.
2. André Michel, "Degas et les Musées Nationaux," *Journal des Débats*, 13 May 1918.
3. Lemoisne 1912, p. 24.
4. Moore 1891, p. 306.
5. *Entretiens de J. J. Henner: notes prises par Émile Durand-Gréville*, Paris: A. Lemerre, 1925, p. 103.
6. Browse [1949], p. 50.
7. Pierre Moreau, introduction to Gustave Flaubert, *Salammbô*, Paris: Folio, 1974, pp. 24–25.
8. Ibid., p. 63.
9. Fevre 1949, p. 51.
10. For example, the reliefs *Sargon, a Vizier and Government Official* (Inv. Napoléon 2872) and *King Sargon's Chariot* from Khorsabad (AO-19882), acquired in 1847 and already published by P. E. Botta and E. Flandrin (*Monument de Ninive*, Paris: Imprimerie Nationale, 1849–50, I, pl. 17). Furthermore, in 1861, when Degas was working on his canvas, Sir H. C. Rawlinson published the inscription from the *Statue of the God Nadir*, which contained the name Sammuraat and finally caused history to coincide with the ancient legend (*The Cuneiform Inscriptions of Western Asia*, I, London: British Museum, 1861). Finally, there are some similarities between Assyrian architecture, as known at the time through Sir A. H. Layard's famous plates (in particular, *A Second Series of the Monuments of Nineveh*, 71 plates, London: J. Murray, 1853), and some details of Degas's Babylon: massive structures with feeble projections, colonnades up above, and whole walls with very few openings.
11. See Reff 1985, Notebook 18 (BN, Carnet 1).
12. Lemoisne [1946–49], I, p. 230.
13. Monnier 1978, pp. 407–26.
14. Huyghe 1931, p. 271.
15. Paul Valéry, "Air de Sémiramis," *Album de vers anciens*, in *Oeuvres*, I, Paris: Éditions de la Pléiade, 1980, pp. 91–93.
16. Unpublished letter from Joseph Tourny to Degas, Ivry to Florence, 13 July 1858, private collection.
17. Valéry, op. cit., p. 94.

30

PROVENANCE: Deposited by the artist with Durand-Ruel, Paris, 22 February 1913 (deposit no. 10252) (Vente I, 1918, no. 7.a); bought at that sale by the Musée du Luxembourg, for Fr 33,000.

EXHIBITIONS: 1919, Paris, Musée du Louvre, *Collections nouvelles*; 1943, Paris, Galerie Parvillée, *L'eau vue par les peintres contemporains et quelques maîtres du XIXe siècle*, no. 10; 1967–68 Paris, Jeu de Paume; 1969 Paris, no. 6; 1984–85 Rome, no. 65, repr. (color).

SELECTED REFERENCES: "L'atelier de Degas," *L'Illustration*, 16 March 1918; Jamot 1918, pp. 145–50, repr. facing p. 150; André Michel, "Degas et les Musées Nationaux," *Journal des Débats*, 13 May 1918; Lafond 1918–19, I, p. 148, repr. p. 19; *Catalogue des collections nouvelles formées par les Musées Nationaux de 1914 à 1919*, Paris, 1919, no. 181; Meier-Graefe 1920, pp. 6–7; Paul Jamot, "The Acquisitions of the Louvre during the War," pt. 4, *Burlington Magazine*, XXXVII:212, November 1920, p. 220; Léonce Bénédite, *Le Musée du Luxembourg*, Paris, 1924, no. 160, repr. p. 62; Lemoisne [1946–49], I, pp. 42–44, II, no. 82; Browse [1949], p. 50; J. Nougayrol, "Portrait d'une Sémiramis," *La Revue des Arts, Musées de France*, May–June 1957, pp. 99–104; Phoebe Pool, "The History Pictures of Edgar Degas and Their Background," *Apollo*, LXXX, October 1964, p. 310; Minervino 1974, no. 91; Reff 1976, pp. 196, 224, 326, no. 199; Monnier 1978, pp. 407–26; Denys Sutton, "Degas: Master of the Horse," *Apollo*, CXIX: 226, April 1984, p. 282; Reff 1985, pp. 19, 21, Notebook 18 (BN, Carnet 1, pp. 15, 197, 222, 224, 230, 232); Paris, Louvre and Orsay, Peintures, 1986, III, p. 194, repr.

30.

Head of a Young Girl, study for *Semiramis*

c. 1860–62
Pencil
10⅜ × 8¾ in. (26.3 × 22.2 cm)
Vente stamp lower left; atelier stamp lower right
Cabinet des Dessins, Musée du Louvre (Orsay), Paris (RF15525)

Exhibited in Ottawa

See cat. no. 29

PROVENANCE: Atelier Degas (Vente I, 1918, as part of lot no. 7.b); bought at that sale by the Musée du Luxembourg, for Fr 29,000.

EXHIBITIONS: 1931, Bucharest, Muzeul Toma Stelian, 8 November–15 December, *Desenul francez in secolele al XIX–si al XX*, no. 100; 1961, Compiègne, Musée Vivenel, June–August, *Les courses en France*, no. 19; 1969 Paris, no. 99; 1979 Bayonne, no. 20, repr.; 1984–85 Rome, no. 71, repr.

SELECTED REFERENCES: Monnier 1978, p. 420, repr.

31.

Nude Woman Crouching, study for *Semiramis*

c. 1860–62
Black chalk heightened with pastel on off-white
 wove paper
13⅜ × 8⅞ in. (34.1 × 22.4 cm)
Signed lower right: Degas
Inscribed in pencil upper right: la grande lumière
 est sur l'épaule/et un peu sur la cuisse ployée
Vente stamp lower left
Cabinet des Dessins, Musée du Louvre (Orsay),
 Paris (RF15488)

Exhibited in Paris

See cat. no. 29

PROVENANCE: See cat. no. 30.

EXHIBITIONS: 1924 Paris, no. 76a; 1936 Philadelphia, no. 60, repr.; 1937 Paris, Orangerie, no. 64; 1967–68 Paris, Jeu de Paume; 1969 Paris, no. 93; 1970, Rambouillet, Sous-préfecture, 11–22 April, *Degas, danse, dessins: l'équilibre dans l'art*, no. 28, repr.; 1972, Darmstadt, Hessisches Landesmuseum, 22 April–18 June, *Von Ingres bis Renoir*, no. 25, repr.; 1980, Montauban, Musée Ingres, 28 June–7 September, *Ingres et sa posterité jusqu'à Matisse et Picasso*, no. 183; 1984–85 Rome, no. 72, repr.

SELECTED REFERENCES: Vingt dessins [1897], pl. 1; Lafond 1918–19, I, repr. (color) facing p. 20; Jamot 1924, p. 25; Monnier 1978, pp. 408, 417, fig. 22.

32.

Drapery, study for *Semiramis*

c. 1860–62
Pencil and watercolor heightened with white
 gouache on gray-blue paper
9⅝ × 12¼ in. (24.4 × 31.1 cm)
Signed lower right: Degas
Cabinet des Dessins, Musée du Louvre (Orsay),
 Paris (RF22615)

Exhibited in Paris

See cat. no. 29

PROVENANCE: See cat. no. 30.

EXHIBITIONS: 1924 Paris, no. 77; 1936 Philadelphia, no. 61, repr.; 1959–60 Rome, no. 179, repr.; 1962, Paris, Musée du Louvre, March–May, *Première exposition des plus beaux dessins du Louvre et de quelques pièces célèbres des collections de Paris*, no. 125; 1969 Paris, no. 95; 1983, Paris, Cabinet des Dessins, Musée du Louvre, *L'aquarelle en France au XIXe siècle: dessins du Musée du Louvre*, no. 41, repr.

SELECTED REFERENCES: Monnier 1978, pp. 408–10, fig. 23.

31

32

A Horse with Attendants of Semiramis, *study for* Semiramis

c. 1860–62
Pencil and black chalk heightened with green
 crayon on buff wove paper
10⅝ × 13⅝ in. (26.8 × 34.7 cm)
Atelier stamp lower left; vente stamp lower right
Cabinet des Dessins, Musée du Louvre (Orsay),
 Paris (RF15530)

Exhibited in Paris

See cat. no. 29

PROVENANCE: See cat. no. 30.

EXHIBITIONS: 1967 Saint Louis, no. 38, repr.; 1969
Paris, no. 104.

SELECTED REFERENCES: Lafond 1918–19, I, repr. (color)
between pp. 36 and 37; Monnier 1978, p. 408, fig. 52.

Woman Seen from Behind, Climbing into a Chariot, *study for* Semiramis

c. 1860–62
Pencil
12 × 8⅞ in. (30.4 × 22.6 cm)
Signed lower center: Degas
Cabinet des Dessins, Musée du Louvre (Orsay),
 Paris (RF15515)

Exhibited in New York

See cat. no. 29

PROVENANCE: See cat. no. 30.

EXHIBITIONS: 1924 Paris, no. 79a; 1931, Bucharest,
Muzeul Toma Stelian, 8 November–15 December,
Desenul francez in secolele al XIX–si al XX, no. 102;
1937 Paris, Orangerie, no. 66; 1952–53 Washington,
D.C., no. 152, pl. 41; 1967–68 Paris, Jeu de Paume;
1969 Paris, no. 80; 1976–77, Vienna, Albertina, 10
November 1976–25 January 1977, *Von Ingres bis Cé-
zanne*, no. 48, repr.; 1984–85 Rome, no. 69, repr.

SELECTED REFERENCES: Vingt dessins [1897], pl. 4;
Jamot 1924, p. 132, pl. 7b; Monnier 1978, pp. 408,
416, fig. 20.

Woman Holding a Horse's Bridle, *study for* Semiramis

c. 1860–62
Black chalk
14⅛ × 9 in. (35.9 × 23 cm)
Vente stamp lower left; atelier stamp lower right
On the verso, a study of drapery in pencil
Cabinet des Dessins, Musée du Louvre (Orsay),
 Paris (RF15490)

Exhibited in New York

See cat. no. 29

PROVENANCE: See cat. no. 30.

EXHIBITIONS: 1969 Paris, no. 102; 1984–85 Rome,
no. 73, repr.

SELECTED REFERENCES: Monnier 1978, pp. 408, 424,
fig. 49.

33

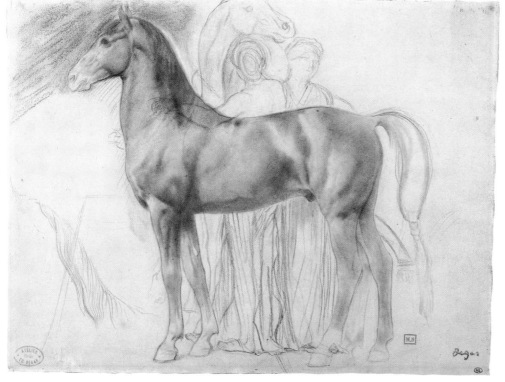

Standing Woman, Draped, *study for* Semiramis

c. 1860–62
Pencil heightened with watercolor and gouache
 on blue-green paper
11½ × 8⅝ in. (29.1 × 21.9 cm)
Signed lower left: Degas
Cabinet des Dessins, Musée du Louvre (Orsay),
 Paris (RF15502)

Exhibited in New York

See cat. no. 29

PROVENANCE: See cat. no. 30.

EXHIBITIONS: 1924 Paris, no. 79b; 1936 Philadelphia,
no. 62; 1969 Paris, no. 91, repr.; 1983, Paris, Cabinet
des Dessins, Musée du Louvre, *L'aquarelle en France
au XIXe siècle: dessins du Musée du Louvre*, no. 40,
repr.

SELECTED REFERENCES: Lemoisne 1912, pl. IV, after
p. 24; Jamot 1924, pl. 7a.

34

35

36

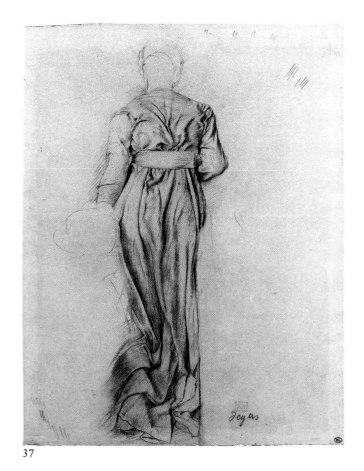

37

37.

Standing Woman, Draped, Seen from Behind, study for *Semiramis*

c. 1860–62
Pencil
12 × 9⅛ in. (30.6 × 23.2 cm)
Signed bottom center: Degas
Cabinet des Dessins, Musée du Louvre (Orsay),
 Paris (RF15485)

Exhibited in Ottawa

See cat. no. 29

PROVENANCE: See cat. no. 30.

EXHIBITIONS: 1967–68 Paris, Jeu de Paume; 1969 Paris, no. 106.

SELECTED REFERENCES: Rivière 1922–23, pl. 6; Maurice and Arlette Sérullaz, *L'ottocento francese*, Milan: Fabbri, 1970, p. 81, repr.; Monnier 1978, pp. 408, 416, fig. 21.

38.

Drapery, study for *Semiramis*

c. 1860–62
Pencil and watercolor heightened with gouache
4⅞ × 9¼ in. (12.3 × 23.5 cm)
Vente stamp lower right
Cabinet des Dessins, Musée du Louvre (Orsay),
 Paris (RF15538)

Exhibited in Ottawa

See cat. no. 29

PROVENANCE: See cat. no. 30.

EXHIBITIONS: 1955–56 Chicago, no. 149; 1969 Paris, no. 109.

SELECTED REFERENCES: Monnier 1978, pp. 408, 417, fig. 27.

38

39.

Woman on a Terrace, also called *Young Woman and Ibis*

1857–58; reworked c. 1860–62
Oil on canvas
38⅝ × 29⅛ in. (98 × 74 cm)
Collection of Stephen Mazoh

Lemoisne 87

Attribution of this painting to Degas has not been a straightforward matter. The inventory made after his death placed a question mark beside his name as its author. When the picture was sold in 1918, it was not as from his studio but as part of his collection of works by other artists. The canvas is indeed disconcerting and seems unlike any other by Degas. Yet this peculiarity must not be grounds for suspicion: among the works that can reliably be assigned to the young Degas, there are in the space of a few years a great many that are so different from each other, so dissimilar in handling and technique, and so varied in subject matter that in the absence of any historical evidence the most practiced eye would probably never ascribe them to one artist.

In this particular case, there can be no doubt about the attribution, as there are several pencil sketches for the veiled woman: two rather pale drawings in a notebook,[1] a study of the drapery on the back of a drawing in the Metropolitan Museum (1980.200), and a nude study of the figure, repeating a

drawing of the woman in the same pose but clothed (IV:108.b).

The two drawings on separate sheets were later inscribed by Degas "Rome 1856"; the notebook in question, as Reff convincingly demonstrates, was used during the second stay in Rome, between the end of October 1857 and the last days of July 1858.[2] Since dates inscribed by Degas long after the fact—most probably in the early 1890s when he was preparing to publish reproductions of a selection of drawings with the Italian painter and publisher Michel Manzi—are not very trustworthy,[3] it is preferable, on the evidence of the notebook dates, to assign this group of studies and the first phase of the canvas itself to the period of Degas's second stay in Rome.

Degas modified this work in the early 1860s. At first, it had been but an insignificant translation of *Dreaming* (fig. 47), a famous canvas, now lost, by Hippolyte Flandrin. Degas added the background of the Oriental, or rather pseudo-Oriental, city (Gérôme would certainly have found it "Turkish" enough for his taste[4]), the quickly sketched pink flowers, and above all, the red ibis, which appear in none of the studies from 1857 to 1858 but which give the picture its character. This last change may have been suggested by Gustave Moreau, whom Degas was seeing regularly at the time. Drawing up a list of possible subjects in a notebook he began using in 1863, the mentor of Degas's years in Italy imagined a scene of "a young Egyptian girl feeding ibis."[5] It should also be noted that these changes were made when Degas was working out *Semiramis* (cat. no. 29, c. 1860–62), slowly and with difficulty. It was while he was thinking about the larger painting (which is closely related in composition to the present work) that he went back to this canvas that he had begun in Rome.

The red ibis were drawn summarily in a notebook[6] and temporarily inserted in compositional sketches for *Semiramis* (fig. 44; Cabinet des Dessins, Musée du Louvre [Orsay], Paris, RF15527). One of the reasons they were added to this work was to test the effect produced by their vivid red patches; incongruously framing the figure of the veiled woman, their presence, almost by accident, turns the trite *Woman on a Terrace* into the strange and baffling *Young Woman and Ibis*.

1. Reff 1985, Notebook 11 (BN, Carnet 28, pp. 4, 39).
2. Reff 1985, p. 67.
3. Reff 1963, pp. 250–51.
4. See George Moore, *Impressions and Opinions*, New York: Scribner's, 1891, p. 306.
5. Musée Gustave Moreau, Paris. The first page is inscribed: "The book was given to me by my best friend—Alexandre Destouches—Saturday, 30 June 1860—G.M."
6. Reff 1985, Notebook 18 (BN, Carnet 1, p. 24).

39

Fig. 47. Hippolyte Flandrin, *Dreaming*, 1855. Oil on canvas. Location unknown

PROVENANCE: Atelier Degas (Vente Collection II, 1918, no. 56); bought by Gérard, for Fr 1,050. Svensk-Fransk Konstgalleriet, Stockholm. Paul Toll, Stockholm. Sale, Sotheby's, London, *Impressionist and Modern Paintings, Drawings and Sculpture*, 4 December 1968, no. 17, repr. (color); bought at that sale by Mario di Botton, for $25,000. Sale, Sotheby Parke Bernet, New York, 18 May 1983, no. 20A, repr. (color); bought at that sale by present owner.

EXHIBITIONS: 1954, Liljevalchs, Kunsthalle, *Från Cézanne till Picasso*, no number; 1958, Stockholm, Nationalmuseum, *Cinq siècles d'art français*, no. 146; 1976–77 Tokyo, no. 6, repr. (color).

SELECTED REFERENCES: Lemoisne [1946–49], II, no. 87; Minervino 1974, no. 98; 1984–85 Rome, pp. 20, 100, 205, repr. p. 21; Reff 1985, Notebook 11 (BN, Carnet 28, pp. 4, 39), Notebook 18 (BN, Carnet 1, p. 24).

40.

Young Spartans

c. 1860–62; reworked until 1880
Oil on canvas
42⅞ × 61 in. (109 × 155 cm)
Vente stamp lower right
The Trustees of the National Gallery, London
(3860)

Lemoisne 70

Degas never disowned the works of his youth; it was the critics who did so. His friend Daniel Halévy tells us of *Young Spartans*: "In his later years, Degas was very fond of this painting; he had taken it from the vast reserves where he concealed his life's work and displayed it prominently on an easel before which he often stood—a unique honor and sign of his fondness for it."[1] Arsène Alexandre, who came upon it in rather poorer circumstances, "unframed, on the floor, amid the clutter of our dear friend's apartment," was dazzled by it, though he changed his mind later, on the "great day of the atelier sale," when it appeared to him as "agreeable but with a thin story."[2]

Many years earlier, Degas had hoped to show it at one of the Impressionist exhibitions—the fifth, in 1880—where, against his recent portraits and scenes of the dance, as well as the works of Cassatt, Gauguin, Morisot, and Pissarro, it would have been manifestly identifiable as a history painting. It would inevitably have contrasted sharply with the other works, but would have proved, as was undoubtedly his intention, that the "new painting" included not only landscapes, portraits, and genre scenes, but also history paintings. For reasons unknown to us, this work, which was catalogued as no. 33, "Petites filles spartiates provoquant des gar-

çons (1860)," was not shown. In a review published in *Le Voltaire* (6 April 1880), Gustave Goetschy regretted its absence, commenting: "M. Degas isn't an 'Indépendant' for nothing! He is an artist who produces slowly, as he pleases, and at his own pace, without concerning himself about exhibitions and catalogues. . . . We will not see his *Dancer* [cat. no. 227], nor his *Young Spartans*, nor a number of other works he has announced." Even though he must have worked and reworked this painting, as was his habit, right up to the last minute, he was probably still not satisfied with it.

Although we must therefore do without the enlightening critical comments that would certainly have been elicited by the exhibition of this painting, its listing in the catalogue at least provides us with the exact title chosen by Degas, which, curiously, is seldom used. It was followed by the date "1860," which was also "chosen" by the artist and may not have been absolutely accurate. Degas often deliberately backdated his canvases—a flagrant example is *The Gentlemen's Race: Before the Start* (cat. no. 42)—assigning the date of original conception, without regard to successive reworkings.

It seems that Degas's choice of this seldom painted subject (Douglas Cooper, in his learned discussion of the work, mentions an 1836 fresco by Giovanni Demin in Villa Patt, near Sedico[3]) can be explained only by his excellent knowledge of classical authors. Phoebe Pool, Martin Davies, and, more recently, Carol Salus have indicated the direct sources for the painting.[4] First there was Plutarch, who in his *Life of Lycurgus* comments on the very manly upbringing of young Spartan girls. Daniel Halévy recalled Degas explaining to him, as they stood before the painting, "'It is young Spartan girls challenging the young boys to combat,' and

I think he added, 'I read about it in Plutarch.'"[5] A second and undoubtedly more direct influence was Abbé Barthélemy, who in his once famous *Voyage du jeune Anacharsis en Grèce* provides a few details that may have impressed the painter: "Spartan girls are not raised at all like those of Athens. They are not obliged to stay locked up in the house spinning wool, nor to abstain from wine and rich food. They are taught to dance, to sing, to wrestle with each other, to run swiftly on the sand, to throw the discus or the javelin, and to perform all their exercises without veils and half naked, in the presence of the kings, the magistrates, and all the citizens, not excepting the young boys, whom the girls incite to glory by their examples, or by flattering praise or stinging irony."[6]

The choice of this unusual subject may be a result of Degas's frequent reading of the "great authors." Contrary to popular belief, however, it was not at Louis-le-Grand that he became steeped in the classics. ("Nothing is more deadly," wrote the headmaster in 1845, "than the need to return each year to the same authors. In Rhetoric, for instance, two tragedies are studied over and over, while all the rest of Greek drama is neglected."[7]) It is much more likely that the impetus came from some prolonged conversations with Gustave Moreau.

In the same period, Moreau was beginning his first studies for a large composition, *Tyrtaeus Singing during the Battle*, glorifying the Spartan poet who led the Greek youths to victory.[8] It is tempting to compare the two compositions on the theme of Sparta (curiously, several years earlier, Delacroix, at the Palais Bourbon, had already contemplated linking these two subjects but decided to abandon the idea), particularly since the preliminary drawings for both these works have an undeniable similarity. Perhaps the

Fig. 48. Attributed to Polidoro Caldara, *Group of Women Arguing*. Red chalk, 11 × 7¼ in. (27.9 × 18.5 cm). Cabinet des Dessins, Musée du Louvre, Paris (Inv. 949)

Fig. 49. Study for *Young Spartans*, c. 1860. Pencil, brush and brown wash, 8¾ × 13⅛ in. (22.5 × 33.2 cm). Private collection

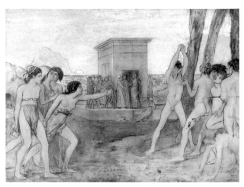

Fig. 50. *Young Spartans* (L71), c. 1860. Oil on canvas, 38½ × 55⅛ in. (97.4 × 140 cm). The Art Institute of Chicago

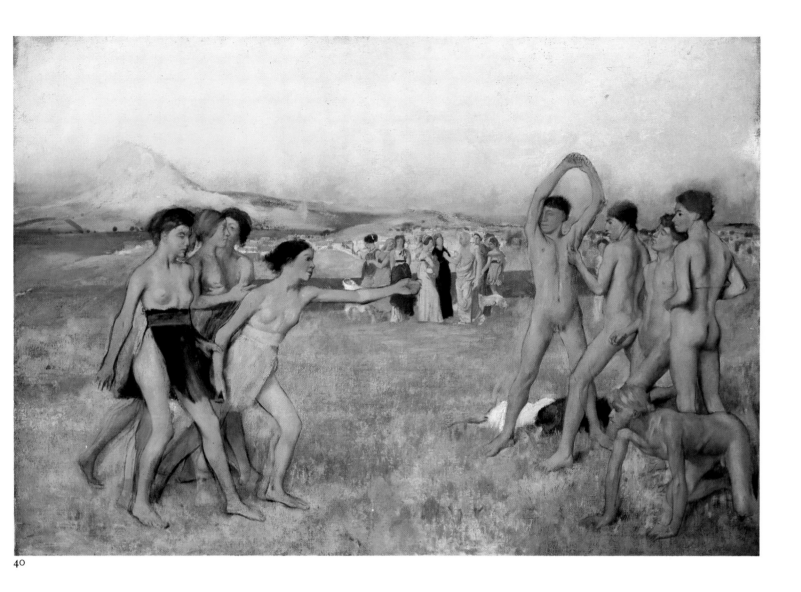

40

young painter and his mentor wished, at one time, to carry out parallel studies in the field of history painting, the imminent demise of which was regularly being prophesied, and, using similar methods, to find an original solution.

Degas began this canvas in 1860. Like *The Daughter of Jephthah* (cat. no. 26), already in progress, and *Semiramis* (cat. no. 29), which was almost contemporary, *Young Spartans* would undergo a number of transformations before the final version—London's—was completed. Many studies, ranging from a simple rough outline to a detailed large oil painting, show a marked development of the composition; although it is difficult to trace the chronology, it is quite likely that the changes go beyond 1860. The starting point may have been a jotting by Degas in a notebook: "Young girls and young boys wrestling in the plane-tree grove, under the eyes of the aged Lycurgus along-side some mothers." He added: "There is a red-chalk drawing by Pontormo portraying some old women, seated, quarreling and showing something"[9]—referring to a draw-ing in the Louvre today attributed to Poli-doro Caldara and formerly attributed to Rosso Fiorentino (fig. 48).

Fewer preparatory drawings remain for *Young Spartans* than for *Semiramis* or *Scene of War in the Middle Ages* (cat. no. 45). The notebooks of this period contain almost nothing for this composition. However, the inventory compiled after Degas's death lists, in addition to eight separate studies, "thirty-seven drawings for Sparta, in pencil, pen and ink, and watercolor,"[10] which appeared, in all likelihood, in the first atelier sale (I:62.b). Today, most of these have disap-peared, and we are unfortunately unable to piece together more than a few fragments of this important material. The first composi-tional study (fig. 49) appeared at a recent sale.[11] This drawing in pen and ink with brown wash (very similar to Moreau's works) shows, in accordance with Degas's description, the two antagonistic groups of boys and girls "in the plane-tree grove," but without Lycurgus and the mothers. Degas's attention subsequently shifted (the evolution of *Semiramis* is comparable in many ways)

toward an increasingly spare composition in which the landscape is gradually reduced to its simplest form, and in which the young boys and girls quickly take their final posi-tions and are set in their poses of tranquil ri-valry. The large monochromatic canvas in Chicago (fig. 50) is not a sketch at an inter-mediate stage, but a version abandoned by the artist before its completion. Unlike the London version, it has elements that are ob-viously "Greek"—in the landscape (the plane-tree grove is represented by a few spindly trunks), the features of the young people, and the central architecture.

Next, Degas abandoned all specific refer-ence to ancient Greece, suppressing the ar-chaeological details and, as has often been noted, modeling the faces of his girls and boys on the commonplace faces of the chil-dren of the streets of Paris.

The explicit title given by Degas himself in 1880 (as Devin Burnell has shown, Degas most likely reworked the canvas in succes-sive stages up to that date) has not stopped scholars from providing their own learned interpretations. The most recent and most

astute, by Carol Salus, attempts to prove that Degas, so interested in matters of matrimony, set out to portray a nuptial rite: Spartan girls choosing young husbands. Linda Nochlin, in response, has rightly observed that there is no *single* meaning, and that Degas constantly played with ambiguity and polysemy.[12] Rather than venture into this slippery area of interpretation, it seems preferable to focus on the obvious originality of Degas's solution to the by then vexing problem of history painting.

It is known that when Gérôme expressed utter surprise at this canvas, which bore little resemblance to his own work, Degas mockingly retorted: "I suppose that it is not Turkish enough for you, Gérôme?"[13] Degas's choices were, in fact, clear and, one is tempted to say, resolutely modern: the rejection of exoticism and archaeology, the search for a historical truth which, far from being a laborious resurrection of a distant past, would be "truer" than the studied exactitude of his fellow history painters. The trees disappear, and the Spartan plain corresponds less to the ancient vision of Pausanias than to the sad picture of it as described by Larousse: "A stream which empties into the Eurotas is the only sign of the location of the plane-tree grove, stripped of the trees which had once adorned it."[14] Ancient Sparta is here not the proud rival of Athens, but a Greek village, with the cubes of its white, ochre, and pink houses scattered in the distance—thus did Aline Martel observe it in 1892—the seat of power of King Othon, "who had attempted to bring back all the great names of Greece."[15] Only the costumes and hairstyles of the mothers and the discreet presence of Lycurgus give this canvas a hint of Hellenism.

Very different from neo-Greek painters with their scholarly, cold reconstructions, Degas rejected the stereotypical Greece with its permanently blue sky, and instead put forward a very personal image, for which there is no equivalent in contemporary French painting. He took a fresh look at Greek history, like a producer who succeeds in giving new life to a play that has been performed again and again by breaking with the conventions that have accumulated over the years. Jeanne Fevre, his devoted and possessive niece, who expressed her admiration for the *Voyage du jeune Anacharsis*, was right when she stated quite simply: "Degas had a very lively, very keen, and very intellectual sense of ancient Greece."[16]

1. Daniel Halévy in 1924 Paris, p. 24.
2. Alexandre 1935, p. 153.
3. Douglas Cooper, "List of Emendations to the Courtauld Catalogue," *Burlington Magazine*, XCVI, April 1954, p. 120.
4. Phoebe Pool, "The History Pictures of Edgar Degas and Their Background," *Apollo*, LXXX,

October 1964, pp. 307, 311; Martin Davies, *National Gallery: French School*, London, 1957, pp. 70–71; Carol Salus, "Degas' *Young Spartans Exercising*," *Art Bulletin*, LXVII:3, September 1985, pp. 501–06.
5. Halévy 1960, p. 184; Halévy 1964, p. 115.
6. Jean-Jacques Barthélemy, *Le voyage du jeune Anacharsis en Grèce*, Paris: Chez De Bure, 1788 (reprint, Paris: A. Payen, 1836), p. 293.
7. Cited in Gustave Dupont-Ferrier, *Du Collège de Clermont à Lycée Louis-le-Grand*, Paris: Bastard, 1922, II, p. 223.
8. See Mathieu 1976, p. 86.
9. Reff 1985, Notebook 18 (BN, Carnet 1, p. 202).
10. Durand-Ruel archives, Paris, no. 2011.
11. Sale, Christie's, London, 2 December 1986, no. 205, repr. (color).
12. Devin Burnell, "Degas and His 'Young Spartans Exercising,'" *The Art Institute of Chicago Museum Studies*, 4, 1969, pp. 49–65; Salus, op. cit.; Linda Nochlin, "Degas's 'Young Spartans Exercising,'" *Art Bulletin*, LXVIII:3, September 1986, pp. 486–88.
13. Cited in Moore 1891, p. 306.
14. Pierre Larousse, under "Sparte," in *Grand dictionnaire universel*, Paris, 1873.
15. Aline Martel, "Sparte et les gorges du Taygète," *Annuaire du Club Alpin Français*, Paris, 1892, p. 9.
16. Fevre 1949, p. 51.

PROVENANCE: Atelier Degas (Vente I, 1918, no. 20 [as "Jeunes spartiates s'exerçant à la lutte"]); bought at that sale by Seligmann, Bernheim-Jeune, Durand-Ruel, Vollard, for Fr 19,500 (Seligmann sale, American Art Association, New York, 27 January 1921, no. 67, repr., bought in at that sale by Seligmann, Bernheim-Jeune, Durand-Ruel, Vollard); deposited with Bernheim-Jeune, Paris, 21 April–21 May 1921; bought by Durand-Ruel, New York, and Vollard, Paris, in half shares, from Bernheim-Jeune and Seligmann, 2 July 1921 (stock no. N.Y. 4669); deposited by Durand-Ruel, New York, with Durand-Ruel, Paris, 4 July 1921 (deposit no. 12559); deposited by Durand-Ruel, Paris, with the Goupil Gallery, London, 26 September 1923; bought (from Goupil? no trace of a transaction in the Durand-Ruel archives) by the museum with the aid of the Courtauld Fund 1924.

EXHIBITIONS: 1880 Paris, no. 33 (listed in the catalogue but not exhibited); 1922, Paris, Galerie Barbazanges, 17–31 November, *Le sport dans l'art*, p. 13; 1923, London, Goupil Gallery, October–December, *Salon*, no. 87; 1952 Edinburgh, no. 4; 1955–56, Paris, Orangerie, 27 October 1955–8 January 1956, *Impressionnistes de la collection Courtauld de Londres*, no. 18, repr.

SELECTED REFERENCES: Goetschy 1880; Moore 1891, pp. 306, 311; Lemoisne [1946–49], II, no. 70; Martin Davies, *National Gallery: French School*, London, 1957, pp. 69–72; William M. Ittmann, Jr., "A Drawing by Edgar Degas for the Petites filles spartiates provoquant des garçons," *The Register of the Museum of Art, the University of Kansas, Lawrence, Kansas*, III:7, 1966, pp. 38–49, repr.; 1967 Saint Louis, pp. 60–67; Devin Burnell, "Degas and His 'Young Spartans Exercising,'" *The Art Institute of Chicago Museum Studies*, 4, 1969, pp. 49–65, repr.; Minervino 1974, no. 86; 1984 Chicago, pp. 32–35; Carol Salus, "Degas' *Young Spartans Exercising*," *Art Bulletin*, LXVII:3, September 1985, pp. 501–06, repr.; B. A. Zernov, *Tvorcestvo E. Degas i vnefrancuzskie hudozestvennye tradicii*, Leningrad: Trudy Gosudarstvennogo Ermitaza, 1985, pp. 124–28, 156; Linda Nochlin, "Degas's 'Young Spartans Exercising,'" *Art Bulletin*, LXVIII:3, September 1986, pp. 486–88; 1986 Washington, D.C., pp. 300–01; 1987 Manchester, pp. 33–39, repr.

41.

Young Spartan Girl, study for *Young Spartans*

c. 1860
Pencil and black crayon on tracing paper
9 × 14⅛ in. (22.9 × 36 cm)
Vente stamp lower right
Cabinet des Dessins, Musée du Louvre (Orsay), Paris (RF11691)

Exhibited in Paris

See cat. no. 40

41

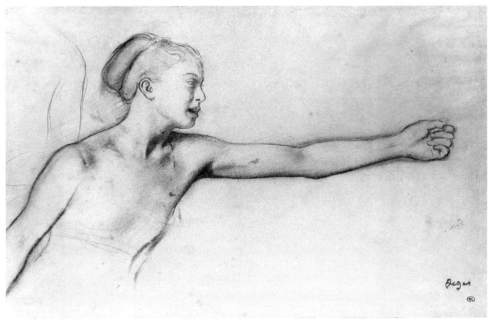

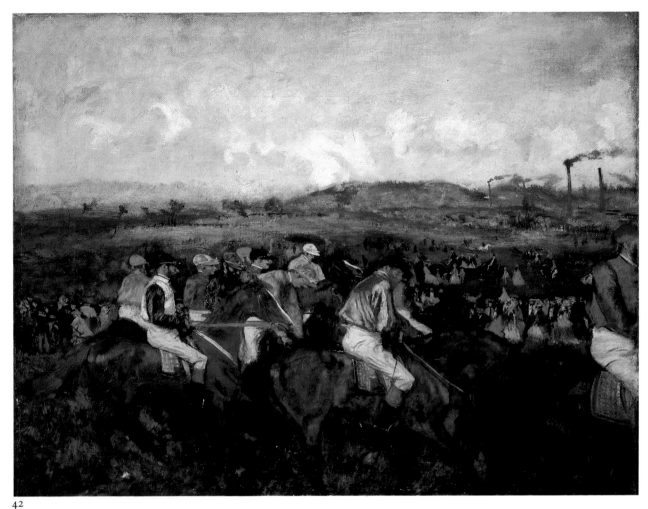

42

PROVENANCE: Atelier Degas (Vente I, 1918, no number, sold under no. 20 [sketches and studies]); bought at that sale by René de Gas, the artist's brother, Paris (René de Gas estate sale, Drouot, Paris, 10 November 1927, no. 24.a, repr.); bought at that sale by the Musée du Luxembourg, for Fr 8,400.

EXHIBITIONS: 1969 Paris, no. 72.

42.

The Gentlemen's Race: Before the Start

1862; reworked c. 1882
Oil on canvas
18⅞ × 24 in. (48 × 61 cm)
Signed and dated lower right: Degas 1862
Musée d'Orsay, Paris (RF1982)

Exhibited in Paris

Lemoisne 101

The date on this canvas, 1862, has always been questioned. For those who tend to see Degas's depictions of modern life as coming somewhat later, this work usually appears to have come slightly before its time; after all, *Semiramis* (cat. no. 29) would be exactly contemporary. Degas's notebooks of the late 1850s and early 1860s show, however, that he was not neglecting contemporary life and that racecourse scenes, which as we know would become one of his favorite subjects, were already emerging. In fact, there are a number of examples—quick sketches of horses running free in the traditional Roman races on the Corso—made as early as his stay in Rome.[1] The first jockey makes a timid appearance in a slightly later notebook, used between August 1858 and June 1859—a pale, moving effigy framed by the more usual images of leaping horses.[2]

Once Degas had returned to France, such scenes increased in number; the reason for this has been seen in his repeated visits to his friends the Valpinçons in Normandy. The Valpinçons had a beautiful estate in Orne at Ménil-Hubert, near the national stud farm at Haras du Pin and the Argentan racecourse (see "The Landscapes of 1869," p. 153). In a notebook used between 1859 and 1864, Degas did elaborate drawings of the stud farm (the Château du Pin and surrounding land) and the nearby village of Exmes, but not, curiously, of the horses. He did, however, record his enthusiasm for the countryside, which was so new to him and so different from anything he had seen before, especially around Saint-Valéry-sur-Somme, where nature seemed "much less thick and bushy than here."[3] It reminded him of "England precisely. Pastures, small and large, enclosed by hedgerows; damp footpaths, ponds green and umber."[4]

The constant references to England—its painters and landscapes ("I remember the backgrounds of English genre pictures"), as well as its writers (he was reading Fielding's *Tom Jones* at the time)—played a key role when Degas began his first racecourse scenes. Another, more overlooked influence was that of two artists who had not formerly attracted his attention: Géricault, whose works he had copied in the Louvre on his return from Italy, and Alfred De Dreux, whose lithographs he studied carefully.[5] What is rarely noted is that the impetus definitely came from Gustave Moreau, who apparently became interested in the subject through De Dreux in the 1850s and made a few drawings of jockeys about 1860.[6] Most curiously, then, it was the master of the Jasons and Salomes who turned Degas toward this modern subject that he would explore for the rest of his life.

Fig. 51. *At the Races: The Start* (L76), c. 1860–62. Oil on canvas, 12 × 18½ in. (30.4 × 47 cm). Harvard University Art Museums (Fogg Art Museum), Cambridge, Mass.

Fig. 52. *At the Races* (L77), c. 1860–62. Oil on canvas, 16⅞ × 25¾ in. (43 × 65.5 cm). Kunstmuseum Basel

The combined interest in England, Géricault, and De Dreux and the constant proximity of Moreau would give rise to a first series of racecourse scenes about 1860–62. Lemoisne catalogues within this period four small canvases (L75–L78; see figs. 51, 52) that display as many similarities as marked differences when compared to the Orsay painting. Thus in *At the Races: The Start* (fig. 51), which has a similar composition—horses in a frieze in the foreground, crowd scattered in the background—the mounts seem more spindly and tense, the jockeys less substantial. The X-radiograph of *The Gentlemen's Race*—in which there is a fuzzy effect apparent in all the horsemen (a sign of the painter's hesitations and reworkings)—shows that this work was originally very similar to *At the Races: The Start*.

Later, Degas reworked *The Gentlemen's Race* considerably; these important alterations, which were made before 14 February 1883 (since Durand-Ruel bought it from Degas on that date), give the canvas its present appearance, making it more a work of the 1880s than of the early 1860s. These changes were preceded by—or accompanied by, for these may have been contemporaneous variations on a single theme—three pastels (L850, L889 [fig. 217], L940) of a similar composition, depicting not only (as has always been noted) the landscape, but also horses and jockeys. Only the figures in the background, which are very similar to those in *At the Races* (fig. 52)—gray, black, and pink silhouettes very delicately painted and standing out against a dark green backdrop—have clearly not moved; they are the sole evidence for the early date of 1862 that Degas (anxious to establish that his scenes from modern life preceded those of other artists, most notably Manet) claimed for the picture and deliberately inscribed on it when it was sold in 1883.

When Degas went back to this painting, about 1882, he remodeled the landscape, probably by adding the central hill and the smokestacks, which lend a curiously suburban look to what previously had been flat countryside, and reworked the jockeys, who no longer seem anonymous as in the 1860–62 canvases but have faces with distinguishable features, such as that of the gentleman rider in the middle, whose name, M. de Broutelle, is known to us from a drawing of the time (III:160.2). Despite all the changes, *Gentlemen's Race* remains a somber picture, where all that stands out under a leaden sky and against the emerald fields are the bright tones of the jackets and caps—mostly imaginary, although a few were colors that were actually used at the time (white, green sleeves, green cap, J. Fouquier; blue, blue cap, J. Conolly; yellow, red sleeves, red cap, Captain Saint-Hubert; red, yellow cap, Baron de Varenne).[7]

However, in cutting through a rider and his mount on the right, opening onto countryside at the left, arranging the three principal horses in a frieze as in some antique relief, and creating a bouquet of multicolored caps and jackets in the middle, Degas has immediately achieved a completely original composition, very different from the racecourse scenes of English painters or the equestrian scenes of De Dreux or Géricault. From here, the variations on this theme will multiply, chiefly in pastel. Eliminating the spectators or any other reference to a particular track, Degas will draw or paint his jockeys wandering peacefully through undefined countrysides, walking their horses, heading we do not know quite where, or why.

1. Reff 1985, Notebook 8 (private collection, p. 24v).
2. Reff 1985, Notebook 12 (BN, Carnet 18, pp. 15–16).
3. Reff 1985, Notebook 18 (BN, Carnet 1, p. 161).
4. Ibid.
5. Reff 1985, Notebook 13 (BN, Carnet 16).
6. See 1984–85 Rome, p. 34, repr.
7. Information provided by M. Jean Romanet.

PROVENANCE: Acquired from the artist by Durand-Ruel, Paris, 14 February 1883, for Fr 5,000 (as "Courses de gentlemen," stock no. 2755, label on the back); deposited with Durand-Ruel, 9 boulevard de la Madeleine, Paris, 8 August–12 September 1883 (perhaps for an exhibition); deposited with Fritz Gurlitt, Berlin, 25 September 1883–17 January 1884; deposited with M. Cotinaud, Paris, 6 June 1884 (to whom the work appears to have belonged during the 1884–85 exhibition, Galerie Georges Petit, Paris). Hector Brame, Paris; deposited with Durand-Ruel, Paris, 12 June 1889 (deposit no. 6784); acquired by Durand-Ruel, Paris, 16 August 1889, for Fr 7,500 (stock no. 2437); deposited with Manzi, 19 August 1889, who bought it the next day, for Fr 8,000; acquired from Manzi by Comte Isaac de Camondo, April 1894, for Fr 30,000; his bequest to the Louvre 1911; exhibited 1914.

EXHIBITIONS: 1883, London, Dowdeswell and Dowdeswell, April–July, *Paintings, Drawings and Pastels by Members of "La Société des Impressionnistes,"* no. 6; (?) 1884–85, Paris, Galerie Georges Petit, 14 December 1884–31 January 1885, *Le sport dans l'art,* no. 28; 1937 Paris, Orangerie, no. 5; 1955, Brive/La Rochelle/Rennes/Angoulême, *Impressionnistes et précurseurs,* no. 16; 1961, Vichy, June–August, *D'Ingres à Renoir: la vie artistique sous le second empire,* no. 57; 1961–62, Tokyo, National Museum of Western Art, 3 November 1961–15 January 1962/Kyoto, City Art Museum, 25 January–15 March, *Exposition d'art français 1840–1940,* no. 65, repr. p. 73; 1962, Mexico City, Museo Nacional de Arte Moderno, October–November, *Cien años de pintura en Francia de 1850 a nuestros días,* no. 36, repr.; 1965, Lisbon, Calouste Gulbenkian Museum, March–April, *Un século de pintura francesa 1850–1950,* no. 38, repr.; 1969 Paris, no. 9; 1970–71 Leningrad, p. 25; 1971 Madrid, no. 32, repr.; 1974, Bordeaux, Galerie des Beaux-Arts, 3 May–1 September, *Naissance de l'impressionnisme,* no. 90, repr.; 1980, Athens, National Picture Gallery and Alexander Soutzos Museum, 30 January–20 April, *Impressionnistes et post-impressionnistes des musées français de Manet à Matisse,* no. 8, repr.

SELECTED REFERENCES: Jamot 1914, p. 459; Paris, Louvre, Camondo, 1914, no. 158; Lafond 1918–19, II, p. 41; Jamot 1924, p. 95; Lemoisne [1946–49], II, no. 101; Minervino 1974, no. 209; Reff 1977, fig. 64 (color); Paris, Louvre and Orsay, Peintures, 1986, III, p. 194, repr.; Sutton 1986, p. 147.

43.

Léon Bonnat

1863
Oil on paper mounted on panel
30¾ × 20⅛ in. (78 × 51 cm)
Private collection, Paris

Lemoisne 150

The subject of this little-known and rarely exhibited portrait was correctly identified by Waldemar George in 1925 as the painter Léon Bonnat.[1] In the catalogue of the 1931 exhibition, Paul Jamot, for reasons unknown, entitled it "Portrait of a Man" even though its owner, Dr. Viau, had clearly specified "Portrait of Bonnat" on the loan form.[2] Fifteen years later, Lemoisne opted for "Portrait of an Artist" and dated it between 1866 and 1870,[3] much later than the pre-

viously accepted date, about 1864. Comparisons of this portrait with the one in Bayonne (fig. 53) and with a pen-and-ink self-portrait by Bonnat in Paris (Cabinet des Dessins, Musée du Louvre [Orsay], Paris, RF29974) substantiate the identification proposed by Waldemar George.

Bonnat himself stated that Degas painted his portrait in 1863.[4] The two may have met at the École des Beaux-Arts: Bonnat was enrolled 6 April 1854,[5] while Degas passed through briefly in 1855. But it was in Italy that they became friends: Bonnat, who had missed the Prix de Rome, spent two years there (1858–60) thanks to a scholarship from the city of Bayonne, and joined the group of Moreau, Henner, Delaunay, Chapu, and Degas. His not inconsiderable work of the 1850s, and especially his numerous portraits of friends and relations, often show an interesting closeness to Degas's pursuits (see cat. no. 20 and fig. 39). Aside from Moreau,

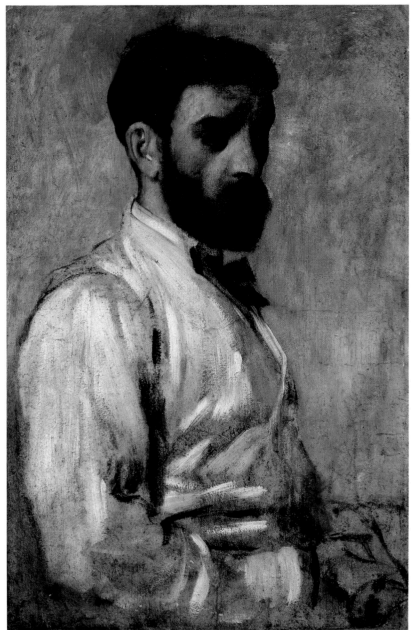

43

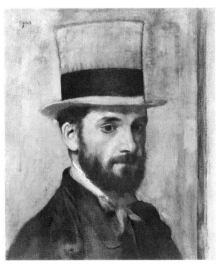

Fig. 53. *Léon Bonnat* (LIII), 1863. Oil on canvas, 16⅞ × 14⅛ in. (43 × 36 cm). Musée Bonnat, Bayonne

who was a true mentor and had an influence on Degas, there is no doubt that it was Bonnat, a completely original artist then, who was closest to him in the late 1850s and early 1860s.

The famous canvas in the Musée Bonnat was delivered by Degas to his sitter long after their relations had become distant and their friendship had dissolved through a mutual lack of understanding. Bonnat subsequently mentioned only this one portrait painted by the friend he had known in Rome. The painting in the exhibition is very probably an unfinished sketch for it, larger in size and of a different character. Here Bonnat is not the elegant young bourgeois of the Bayonne

picture, in whom Degas saw the air of a "Venetian ambassador,"[6] but an artist at work. The emaciated face with jet-black beard and hair and the dark eyes that disappear in their sockets give him an arresting expression, dramatic and troubled (unusual for Degas, who is normally more staid: one is reminded of the slightly earlier self-portraits by Fantin-Latour)—an expression whose tormented gaze belies the later image of the formal, corpulent Bonnat, official portrait painter to the notables of the Third Republic.

1. Waldemar George, "La collection Viau," *L'Amour de l'Art*, 1925, pp. 362–68.
2. Archives, Musée du Louvre, Paris, files for 1931 Paris, Orangerie.
3. Lemoisne [1946–49], II, no. 150.
4. Lemoisne 1912, p. 27.
5. Archives Nationales, Paris, AJ⁵²235.
6. Lemoisne [1946–49], II, no. 111.

PROVENANCE: Presumably atelier Degas (photographed by Durand-Ruel, probably during the inventory of the studio). Dr. Georges Viau, Paris. Private collection, Paris.

EXHIBITIONS: 1931 Paris, Orangerie, no. 29; 1932, Paris, Galerie Georges Petit, *Cent ans de peinture française*, no. 57.

SELECTED REFERENCES: Waldemar George, "La collection Viau," *L'Amour de l'Art*, 1925, pp. 362–68, repr. (as "Portrait de Léon Bonnat"); Lemoisne [1946–49], II, no. 150 (as "Portrait d'artiste"); Minervino 1974, no. 236; 1984–85 Rome, p. 32, repr. (as "Portrait de Bonnat").

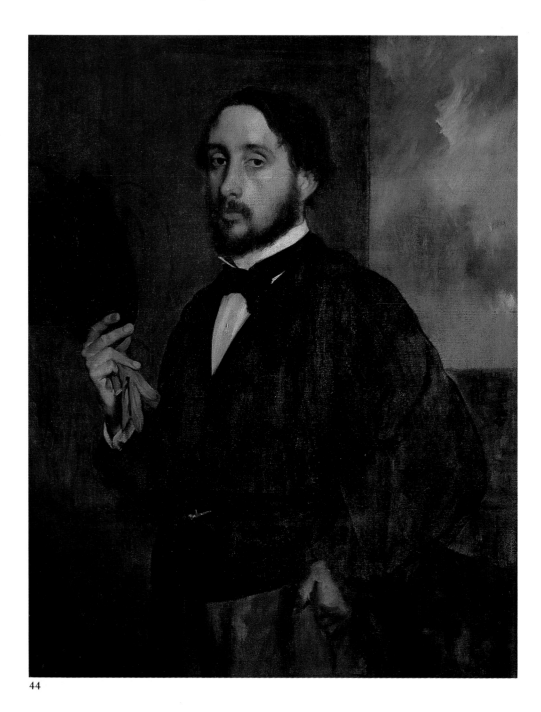

44

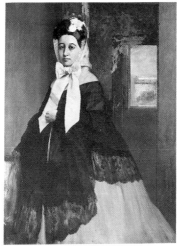

Fig. 54. *Thérèse De Gas* (L109), 1863. Oil on canvas, 35 × 26⅜ in. (89 × 67 cm). Musée d'Orsay, Paris

Fig. 55. Anonymous, *Edgar Degas*, c. 1860–65. Photograph printed from a glass negative in the Biblio-thèque Nationale, Paris

44.

Self-Portrait: Degas Lifting His Hat

c. 1863
Oil on canvas
36⅜ × 26⅛ in. (92.5 × 66.5 cm)
Calouste Gulbenkian Museum, Lisbon (2307)

Lemoisne 105

Like the other self-portraits, this painting offers the historian few footholds—it is obviously unfinished, bears no date, and is accompanied by no preparatory sketches. The picture displays no accessories that might enable us to identify its location; only the subject's apparent age permits us to place the picture in the early 1860s, when the painter was approaching thirty. Such, at least, is the view of all those who cautiously bracket this work somewhere between 1862 and 1865. The date 1863 is proposed here, a year of intense activity (René De Gas is our source[1]) in which the artist also painted a portrait of Thérèse De Gas (fig. 54). The latter can be compared with the Lisbon picture: it is the same size, the figure is positioned in the same way, there is the same smooth and, in places, very thin paint, and there is even the same simplified background of verticals in the tradition of sixteenth-century portraits.

Once again, Degas does not represent himself as the painter at work, but as a young gentleman, neither dandy nor sloven, but simply wearing with casual elegance the costume and attributes (the gloves, the hat) of his station in life. The young artist's greeting to his public has been seen as reminiscent of the more supercilious attitude of Courbet meeting Bruyas on the Montpellier road;[2] everything in this canvas, however, removes us from Courbet—its composition, its handling, even the demeanor of the painter here, which is at once unaffected and well mannered, indeed rather affable, with none of Degas's already legendary brusqueness.[3]

Degas never portrayed himself in an interior; here, as in the self-portrait of 1855 (cat. no. 1), the background is neutral, even though there is on the right a hint of sky

and possibly a landscape. In contrast to the portrait of Tissot (cat. no. 75), there is no studio, but in conformity with a tradition that was reviving, there is an inexplicable break in what must be a wall, comparable to backgrounds in certain portraits by Titian, particularly that of Paul III, which Degas had copied in Naples several years earlier.[4] Back in Paris in 1859, Degas had asked himself, "How does one do an epic portrait of Musset?" and apparently found no solution, since he limited himself to just a rough sketch in a notebook.[5] In this self-portrait (which has sometimes been seen, incorrectly, as but an enlarged, canvas-size, photographic "visiting card"; see fig. 55), Degas, true to the lessons of the old masters and using (one is tempted to say, "exalting") all the most prosaic items of dress available— frock coat and black tie, white shirt, top hat, buff-colored gloves (again, a discreet homage to Titian)—in short, all the trappings of the bourgeois uniform (as they will also be worn in his other portraits of painters: Manet, Tissot, Moreau)—succeeded in creating an "epic portrait" of himself, finding at last, to use his own term, "a composition that paints our time."[6]

1. Lemoisne [1946–49], I, p. 41 n. 41.
2. *Bonjour, Monsieur Courbet*, Musée Fabre, Montpellier.
3. Lemoisne [1946–49], I, p. 73.
4. Reff 1985, Notebook 4 (BN, Carnet 15, p. 20).
5. Reff 1985, Notebook 16 (BN, Carnet 27, p. 6).
6. Ibid.

PROVENANCE: Atelier Degas; Jeanne Fevre, the artist's niece, Nice. André Weil, Paris; bought by Calouste Gulbenkian, Paris and Oeiras (Portugal), 1937; deposited with the National Gallery, London, with part of the Gulbenkian collection, 1937–45; Calouste Gulbenkian Foundation, Lisbon, 1956 (museum opened 2 October 1969).

EXHIBITIONS: 1924 Paris, no. 15; 1931 Paris, Orangerie, no. 27; 1936, London, Burlington Fine Art Club, 1–31 October, *French Art of the XIXth Century*; 1937–50, London, National Gallery, *Pictures from the Gulbenkian Collection Lent to the National Gallery*, hors catalogue; 1950, Washington, D.C., National Gallery of Art, *European Paintings from the Gulbenkian Collection*, no. 8, repr.; 1960, Paris, *Tableaux de la Collection Gulbenkian*; 1961–63, Lisbon, Museu Nacional de Arte Antiga, *Pinturas da colecção da Fundação Calouste Gulbenkian*, no. 16; 1964, Porto, Museu Nacional Soares dos Reis, *Colecçao Calouste Gulbenkian: Artes plasticas francesas de Watteau a Renoir*, no. 34, pl. 35; 1965, Oeiras, Palacio Pombal, *Fundaçao Calouste Gulbenkian: Obras de arte da Colecçao Calouste Gulbenkian*, no. 268.

SELECTED REFERENCES: Guérin 1931, n.p., repr.; Lemoisne [1946–49], II, no. 105; Boggs 1962, p. 20, pl. 33; *Works of Art in the Calouste Gulbenkian Collection*, Lisbon: Oeiras, 1966, no. 268; *Museu Calouste Gulbenkian: Arte europeia*, Lisbon, 1969, no. 837; Minervino 1974, no. 151; *Museu Calouste Gulbenkian*, Lisbon, September 1975, no. 959; *Calouste Gulbenkian Museum Catalogue*, Lisbon, 1982, p. 150, no. 959, fig. 959; Rona Goffen, *The Calouste Gulbenkian Museum*, New York: Shorewood Fine Art, 1982, p. 136, repr. (color) p. 137.

45.

Scene of War in the Middle Ages, erroneously called *The Misfortunes of the City of Orléans*

c. 1863–65
Essence on several pieces of paper joined and mounted on canvas
31⅞ × 57⅞ in. (81 × 147 cm)
Signed lower right: Ed. De Gas
Musée d'Orsay, Paris (RF2208)

Lemoisne 124

The brief description of this painting given in the 1947 Jeu de Paume catalogue ends in a terse sentence that sums up the almost universally held view of it: "The work was the artist's last attempt at history painting."[1] Shortly after it was acquired by the Musée du Luxembourg, Paul Jamot set the tone when he praised, as he did also with *Semiramis* (cat. no. 29), only the preparatory drawings, calling them "infinitely superior to the paintings for which they were the studies."[2] He pointed out, however, the significant part played by this unusual work in the discovery, at the time of the atelier sales held after the artist's death, of another Degas, very different from the Degas who was until then known only as a "painter of dancers." Jamot termed the history paintings "very strange documents . . . completely unanticipated by those who had Degas pegged as a sort of congenital Realist," and saw them as evidence "not only of a long, diligent period of classical and, one might say, academic training, but also of the spontaneous awakening of a thoroughly bold and individual style."[3] And so this "document" met the fate of the other history paintings, receiving some guarded interest, due primarily to the admirable preliminary drawings but heightened by the fact that it had been included in the Salon of 1865 and, above all, by the strangeness of its subject matter.

Degas himself does not seem to have been as fond of this painting as of *Semiramis* or *Young Spartans* (cat. no. 40). It was not shown in any subsequent exhibition, nor were the preliminary drawings included in the album of reproductions of twenty drawings by Degas published by Manzi about 1897.[4] Instead, the work remained buried in his studio; there is no indication of its having been noticed by anyone, apart from a mention by the journalist and art critic Émile Durand-Gréville in 1925 that he had seen preliminary sketches for the "Horrors of War" in Degas's studio a few days before 16 January 1881.[5]

The work's original title, "Scene of War in the Middle Ages," was used for the 1865 Salon but was not accompanied by any ref-

erence or quotation that might point to a literary source for the theme of this "pastel" (as it was described). That title was then eclipsed for decades by another, "The Misfortunes of the City of Orléans," used at the brief exhibition that opened at the Petit Palais on 1 May 1918; it appeared again in the catalogue for the atelier sale. No one really knows how the painting came by this title, but Hélène Adhémar, to whom we owe an interesting analysis of this difficult work, has proposed the most ingenious explanation.[6] She considers the painting to be an allegory of the cruelty of the Northern soldiers toward the women of New Orleans after that city's capture by Union forces on 1 May 1862, and she traces its erroneous title to a misreading. Some list or document must have read: "Les malheurs de la Nlle Orléans" (The Misfortunes of New Orleans), and the abbreviation of "nouvelle" (new), sometimes used by Degas, must have been read as "ville" (city). This is a plausible hypothesis and a tempting one, since it fully supports Adhémar's interpretation of the work. It should be noted, however, that in the inventory made after the artist's death, the painting is listed as "Archers and Young Girls (Scene from the Hundred Years' War)"[7]—this being, in effect, an intermediate title between that of the Salon and that of the atelier sale.

This work clearly is an allegory, in the tradition of enigmatic Renaissance paintings, and it is unfair to label it a history painting. In fact, two eminent experts on the fourteenth century, Philippe Contamine and Françoise Autrand, have confirmed that this strange scene does not depict a precise historical event. The medieval history of Orléans (if it *is* Orléans) does not contain any episodes of cruelty directed so specifically against women. Degas apparently did not do any special research, as he did for *Semiramis*, and was unconcerned about the many anachronisms in the picture. While the men-at-arms are in costume (hoods, armor) that can be dated about 1470, they are riding stirrupless horses whose harnesses are barely sketched in, and are using fanciful bows (the bows of that time actually measured about six feet, or nearly two meters, and could not possibly have been used by men on horseback) to shoot their arrows at naked women in an indistinct, ravaged country setting with a vaguely Gothic church.

Hélène Adhémar seems correct in linking this allegorical painting to contemporary events in New Orleans, events of which Degas was certainly aware. On 1 May 1862, the capital of Louisiana, where his entire maternal family resided, was captured by Northern soldiers, who treated the women of the city with indisputable cruelty. About

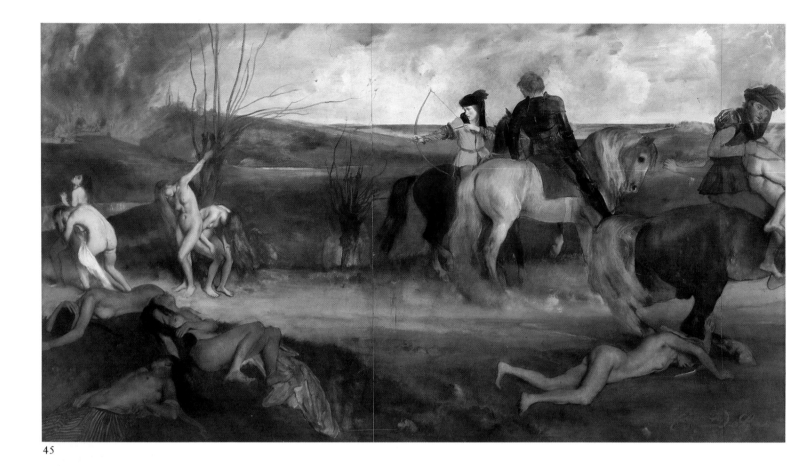

45

a year later, on 18 June 1863, Odile Musson, the wife of Degas's maternal uncle Michel Musson, left New Orleans for France together with her daughters Estelle (widowed in the Civil War, mother of a baby) and Désirée.[8] On the advice of Odile's doctor, they spent the better part of their eighteen-month stay at Bourg-en-Bresse, but Degas, who was extremely fond of them, saw them often, first in Paris and then at Bourg-en-Bresse, where he visited them early in 1864. He was undoubtedly struck by their accounts of "atrocities," and these accounts, allegorized and transposed to the time of notorious barbarism that the Middle Ages represented to the nineteenth century, were the inspiration for the *Scene of War*. It should be noted, finally, that it was about this period that Degas could have acquired the 1863 edition of Goya's *Disasters of War*, which is still in the possession of the painter's family. There he would have found, though in a completely different style, striking images of the sufferings of war in every age— acts of cruelty, rape, and torture.

Along with the painting in the Musée d'Orsay, which was purchased in 1918, came the complete lot of pencil studies, and like the drawings for *Semiramis*, they form an invaluable record. Most are studies of single figures in poses generally used for the final work. In addition there are two quick

sketches of armor (RF15498, RF15499) and, most important, a drawing (cat. no. 46) that provides the only indication we have of an earlier state of the composition.

Unlike the case with *The Daughter of Jephthah* (cat. no. 26) or *Semiramis* (cat. no. 29), no series of compositional studies has survived that would enable us to retrace the successive transformations of this work with any certainty. Even Degas's notebooks do not contain any sketches or any mention of this work. Two explanations may be advanced: first, Degas did not in this instance conduct any archaeological investigations, as he did for the other works; and second, he does not seem to have experienced the endless vacillations that characterized the development of the history paintings. This time, the studies and the painting cohere perfectly, indicating that there was little indecision and that the work was probably executed quickly.

The rather strange pencil study (cat. no. 46) already shows, despite some notable variations, the general outlines of the composition: a group of naked women on the left, two horsemen on the right, fires burning here and there in the background, and, perched on a small hill off in the distance, a town oddly like Exmes, in Orne, which Degas had sketched in a notebook during a stay at the Valpinçons.[9] The abject women, looking more tired than terrified, plead in

Fig. 56. *Nude Woman Holding a Bow*, study for *Scene of War in the Middle Ages*, c. 1863–65. Pencil, 9 × 14 in. (22.8 × 35.6 cm). Cabinet des Dessins, Musée du Louvre (Orsay), Paris (RF15522)

Fig. 57. Puvis de Chavannes, *Bellum*, 1861. Oil on canvas, 141¾ × 215 in. (360 × 545 cm). Musée de Picardie, Amiens

vain with the indifferent men, who are already continuing on their way; this group of men, drawn on a sheet that was subsequently glued on the drawing, replaces a previous arrangement that cannot be seen.

It is a curious drawing, at once precise, almost meticulous (as in the gnarled tree at the center of the composition), and yet stiff—some might say awkward—and deliberately primitive. In any case, it is utterly unlike the more fluid and boldly drawn watercolor sketches for *Semiramis*, and instead shows a determined rigidity that has no equivalent anywhere else in Degas's work. Two hypotheses have been proposed. The first is the rather tenuous suggestion that the sketch is a very early and as yet clumsy study (which would have to date back to before Degas's sojourn in Italy), reworked to create the *Scene of War* as we know it. The other possibility is that it was Degas's original intention to imitate the occasionally harsh drawing style of the "adorable fresco painters" (Auguste De Gas's phrase)[10] of the fifteenth and sixteenth centuries—an intention which, though blunted in the end, did not interfere with the references to early painting. These women were to change and somehow come to life. The composition, which in the study is strangely calm despite the horror, was to gain in tension and violence. Some of the sketches remain incomprehensible: the nude woman shooting an arrow (fig. 56), clearly redone as the hooded man, oddly weakens the impression of male barbarism evoked by the final painting. She may in fact have been taken directly from *Semiramis*, for which some sketches show the figure of a woman with a bow, which in turn comes from *The Death of Procris*, an anonymous fifteenth-century Florentine work in the Campana Collection at the Musée du Petit Palais in Avignon.[11] The horsemen in armor may have had an even more remote origin in two unexplained sketches in a notebook used in 1859–60.[12]

After making the compositional study, Degas worked on each figure separately (see cat. nos. 46–57). Some were not included in the final composition, such as the dazed woman crouching at the foot of the tree—though he did prepare a finished and squared drawing of her (cat. no. 50)—or the woman standing in the center foreground, who was painted out only at the last minute and is still detectable in the Orsay painting, just to the left of the horsemen. These drawings, which together with the studies for *Semiramis* rank among Degas's finest, are remarkably alike, which suggests that Degas drew them in one campaign. It is quite possible that *Scene of War in the Middle Ages* was painted, or begun, about 1863, not to be exhibited at the Salon until 1865.

The aberrant cruelty of the subject—soldiers shooting arrows but inflicting no apparent wounds—serves as a pretext for a somewhat clinical observation of the female figure: the women's bodies writhe, their hair tumbles down, their genitals show through the rents in their clothing; there are inanimate women, women fleeing, women crawling on the ground, women riveted to a tree as if crucified. There are definitely some Renaissance references, as others have pointed out (the woman lying under the horse's hooves is from Maineri, the group of wailing women at the left suggests the Andrea del Sarto at the Annunziata in Florence), but as in *The Daughter of Jephthah* and *Semiramis*, the references are so submerged and so carefully integrated that their direct source is forgotten; one is struck rather by how amazingly the figures here foreshadow all the female nudes yet to come. The women in this picture, who seem to be posing, like studio models strewn about a desolate countryside, strike the same immodest attitudes as the women Degas would later depict in the act of bathing, drying themselves, combing their hair, or sleeping—in this picture revealing themselves because they have been hunted down, raped, or killed, and in the later pictures because they are performing their most intimate ablutions unobserved.

The complete silence with which this work was greeted at the Salon of 1865 can be explained largely in terms of its strange subject matter (an extreme instance of violence between the sexes, an eruption of the absurd), the difficulty of interpreting the allegory, and the very technique used by Degas for this essence painting, which has, to borrow a phrase from Moreau, "the matte tones and the gentleness of a fresco."[13] Puvis de Chavannes supposedly complimented Degas on it (according to Rewald, who cites no source[14]); a few years earlier, Puvis himself, in his *Bellum* (fig. 57), had produced one of the few works that can be compared with this painting. A compliment from Puvis would not have been surprising, because only he (though probably also Moreau, for other reasons) could have truly appreciated this work, praised the allegory that distinguishes it from ordinary history painting, admired its muted hues, envied its flawless draftsmanship, and perceived finally that this was no mere "essay" but in fact a masterpiece, isolated in its time and, even today, misunderstood.

1. Paris, Louvre, Impressionnistes, 1947, no. 53, p. 32.
2. Jamot 1924, p. 27.
3. Ibid., p. 28.
4. Vingt dessins [1897].
5. *Entretiens de J. J. Henner: notes prises par Émile Durand-Gréville*, Paris: A. Lemerre, 1925, p. 103.
6. Hélène Adhémar, "Edgar Degas et 'La scène de guerre au moyen âge,'" *Gazette des Beaux-Arts*, LXX, November 1967, pp. 295–98.
7. Durand-Ruel archives, Paris, no. 204.
8. Lemoisne [1946–49], I, pp. 72–74.
9. Reff 1985, Notebook 18 (BN, Carnet 1, p. 173).
10. Letter from Auguste De Gas to Edgar, 25 November 1858, private collection; cited in Lemoisne [1946–49], I, p. 31.
11. Reff 1985, Notebook 18 (BN, Carnet 1, p. 231).
12. Reff 1985, Notebook 14 (BN, Carnet 12, pp. 62, 61, 60).
13. Unpublished letter, Moreau to his parents, [5 February 1858], Musée Gustave Moreau, Paris.
14. Rewald 1973, p. 122.

PROVENANCE: Atelier Degas (Vente I, 1918, no. 13 [as "Les malheurs de la ville d'Orléans"]); bought at that sale by the Musée du Luxembourg, for Fr 60,000.

EXHIBITIONS: 1865, Paris, 1 May–20 June, Salon, no. 2406 (as "Scène de guerre au moyen âge, pastel"); 1918 Paris, no. 10 (as "Les malheurs de la ville d'Orléans"); 1924 Paris, no. 17; 1933–34, lent to the Berlin, Cologne, and Frankfurt museums in exchange for Renoir paintings; 1967–68 Paris, Jeu de Paume; 1969 Paris, no. 12.

SELECTED REFERENCES: Lafond 1918–19, I, repr. p. 15, II, p. 41; Léonce Bénédite, *Le Musée du Luxembourg*, Paris, 1924, no. 161, repr. p. 62; Jamot 1924, pp. 11, 23–24, 27, 29; Walker 1933, p. 180, fig. 15; Ricardo Perez, "La femme blessée dans l'oeuvre de Degas," *Aesculape*, March 1935, pp. 88–90; Lemoisne [1946–49], II, no. 124; Pierre Cabanne, "Degas et 'Les malheurs de la ville d'Orléans,'" *Gazette des Beaux-Arts*, May–June 1962, pp. 363–66, repr.; Hélène Adhémar, "Edgar Degas et 'La scène de guerre au moyen âge,'" *Gazette des Beaux-Arts*, LXX, November 1967, pp. 295–98, repr.; Carlo Ludovico Ragghianti, "Un ricorso ferrarese di Degas," *Bollettino Annuale Musei Ferraresi*, 1971, pp. 23–29; Minervino 1974, no. 107; Paris, Louvre and Orsay, Peintures, 1986, III, p. 195, repr.

46

46.

Compositional study for *Scene of War in the Middle Ages*

c. 1863–65
Pencil and gray wash on two pieces of pale buff wove paper joined, the whole framed with a pencil outline
10½ × 15⅝ in. (26.6 × 39.7 cm)
Vente stamp lower left; atelier stamp on verso
Cabinet des Dessins, Musée du Louvre (Orsay), Paris (RF15534)

Exhibited in Paris

See cat. no. 45

PROVENANCE: Atelier Degas (Vente I, 1918, no number, sold under no. 13 [sketches and studies]); bought by the Musée du Luxembourg.

EXHIBITIONS: 1969 Paris, no. 116.

47.

Nude Woman Lying on Her Back, study for *Scene of War in the Middle Ages*

c.1863–65
Pencil on pale buff wove paper
10½ × 13⅞ in. (26.5 × 35.1 cm)
Vente stamp lower left; atelier stamp on verso
Cabinet des Dessins, Musée du Louvre (Orsay), Paris (RF15519)

Exhibited in Paris

See cat. no. 45

PROVENANCE: See cat. no. 46.

EXHIBITIONS: 1969 Paris, no. 122.

48.

Nude Woman, study for *Scene of War in the Middle Ages*

c. 1863–65
Pencil
14⅝ × 7¾ in. (37.3 × 19.7 cm)
Vente stamp lower left; atelier stamp on verso
Cabinet des Dessins, Musée du Louvre (Orsay), Paris (RF12261)

Exhibited in New York

See cat. no. 45

PROVENANCE: See cat. no. 46.

EXHIBITIONS: 1969 Paris, no. 117.

49.

Two Nude Women Standing, study for *Scene of War in the Middle Ages*

c. 1863–65
Pencil
12¼ × 7⅞ in. (31 × 19.8 cm)
Vente stamp lower left; atelier stamp on verso
Cabinet des Dessins, Musée du Louvre (Orsay), Paris (RF15505)

Exhibited in New York

See cat. no. 45

PROVENANCE: See cat. no. 46.

EXHIBITIONS: 1969 Paris, no. 120.

50.

Nude Woman Seated, study for *Scene of War in the Middle Ages*

c. 1863–65
Pencil with black crayon on pale buff wove paper, squared for transfer
12¼ × 10⅞ in. (31.1 × 27.6 cm)
Vente stamp lower left; atelier stamp on verso
Cabinet des Dessins, Musée du Louvre (Orsay), Paris (RF12265)

Exhibited in Paris

See cat. no. 45

PROVENANCE: See cat. no. 46.

EXHIBITIONS: 1959–60 Rome, no. 180; 1964 Paris, no. 68; 1967 Saint Louis, no. 39, repr.; 1969 Paris, no. 119; 1977, Paris, Musée du Louvre, 21 June–26 September, *Le corps et son image: anatomies, académies,* no number.

SELECTED REFERENCES: Maurice and Arlette Sérullaz, *L'ottocento francese,* Milan: Fabbri, 1970, pp. 91–92, repr. p. 73; Carlo Ludovico Ragghianti, "Un ricorso ferrarese di Degas," *Bollettino Annuale Musei Ferraresi,* 1971, pp. 26–27, 35, repr.

51.

Nude Woman Lying on Her Stomach, study for *Scene of War in the Middle Ages*

c. 1863–65
Pencil
8⅞ × 14 in. (22.6 × 35.6 cm)
Vente stamp lower left; atelier stamp on verso
Cabinet des Dessins, Musée du Louvre (Orsay), Paris (RF12267)

Exhibited in Ottawa

See cat. no. 45

PROVENANCE: See cat. no. 46.

EXHIBITIONS: 1947, Strasbourg/Besançon/Nancy, *Les origines de la peinture contemporaine: de Manet à Bonnard,* no number; 1969 Paris, no. 133; 1980, Montauban, Musée Ingres, 28 June–7 September, *Ingres et sa postérité jusqu'à Matisse et Picasso,* no. 188.

47

48

50

49

51

52.

Nude Woman Lying on Her Back,
study for *Scene of War in the
Middle Ages*

c. 1863–65
Pencil
9 × 14 in. (22.8 × 35.6 cm)
Vente stamp lower right; atelier stamp on verso
On the verso, a study of the same figure,
 reversed
Cabinet des Dessins, Musée du Louvre (Orsay),
 Paris (RF12833)

Exhibited in New York

See cat. no. 45

PROVENANCE: See cat. no. 46.

EXHIBITIONS: 1949, Brussels, Palais des Beaux-Arts,
November–December/1950, Paris, Orangerie, Feb-
ruary–March, *Le dessin français de Fouquet à Cézanne*,
no. 95, repr.; 1955–56 Chicago, no. 150; 1958, Ham-
burger Kunsthalle, 1 February–16 March/Cologne,
Wallraff-Richartz Museum, 22 March–5 May/Stutt-
gart, Württembergischen Kunstverein, 10 May–7 June,
*Französische Zeichnungen, von den Anfängen bis zum
Ende des 19. Jahrhunderts*, no. 178; 1967, Copenhagen,
Statens Museum for Kunst, 2 June–10 September,
Hommage à l'art français, no. 38; 1969 Paris, no. 124.

53.

*Seminude Woman Lying on Her
Back,* study for *Scene of War
in the Middle Ages*

c. 1863–65
Pencil
9 × 14 in. (22.8 × 35.6 cm)
Vente stamp lower right; atelier stamp on verso
On the verso, a study of the same figure,
 reversed
Cabinet des Dessins, Musée du Louvre (Orsay),
 Paris (RF12834)

Exhibited in New York

See cat. no. 45

PROVENANCE: See cat. no. 46.

EXHIBITIONS: 1936–37, Brussels, Palais des Beaux-
Arts, December 1936–February 1937, *Les plus beaux
dessins français du Musée du Louvre*, no. 99, repr.; 1937
Paris, Palais National, no. 637, repr.; 1939–40, Buenos
Aires, no. 40; 1939, Belgrade, Prince Paul Museum,
La peinture française au XIXe siècle, no. 125; 1962,
Mexico City, University of Mexico, October–No-
vember, *100 años de dibujo francés 1850–1950*, no. 21,
repr.; 1969 Paris, no. 126; 1976–77, Vienna, Albertina,
19 November 1976–25 January 1977, *Von Ingres bis
Cézanne*, no. 49, repr.

SELECTED REFERENCES: Leymarie 1947, no. 11, pl. XI.

54.

Nude Woman Lying on Her Back,
study for *Scene of War in the
Middle Ages*

c. 1863–65
Pencil
8⅞ × 14 in. (22.6 × 35.6 cm)
Vente stamp lower left; atelier stamp on verso
Cabinet des Dessins, Musée du Louvre (Orsay),
 Paris (RF12271)

Exhibited in Ottawa

See cat. no. 45

PROVENANCE: See cat. no. 46.

EXHIBITIONS: 1948, Kunstmuseum Bern, 11 March–
30 April, *Dessins français du Musée du Louvre*, no. 112;
1969 Paris, no. 128; 1979 Bayonne, no. 22, repr.

55.

Standing Nude Woman,
study for *Scene of War in the
Middle Ages*

c. 1863–65
Pencil heightened with white
14 × 9 in. (35.6 × 22.8 cm)
Vente stamp lower right; atelier stamp on verso
Cabinet des Dessins, Musée du Louvre (Orsay),
 Paris (RF15516)

Exhibited in Ottawa

See cat. no. 45

PROVENANCE: See cat. no. 46.

EXHIBITIONS: 1964, Bordeaux, Musée des Beaux-
Arts, 22 May–20 September, *La femme et l'artiste de
Bellini à Picasso*, no. 113; 1969 Paris, no. 138; 1977,
Paris, Musée du Louvre, 21 June–26 September, *Le
corps et son image: anatomies, académies*, no number;
1982, Paris, Musée Hébert, 19 May–4 October, *Mu-
siciennes du silence*, no number.

56.

Standing Nude Woman,
study for *Scene of War in the
Middle Ages*

c. 1863–65
Black crayon and pencil, with a touch of water-
 color, on pale buff wove paper, with strip of
 paper added at bottom.
15½ × 8⅞ in. (39.3 × 22.5 cm)
Vente stamp lower right; atelier stamp on verso
Cabinet des Dessins, Musée du Louvre (Orsay),
 Paris (RF15517)

Exhibited in Paris

See cat. no. 45

PROVENANCE: See cat. no. 46.

EXHIBITIONS: 1924 Paris, no. 84a; 1936 Philadelphia,
no. 68, repr.; 1952–53 Washington, D.C., no. 153,
pl. 42; 1962, Paris, Musée du Louvre, March–May,
*Première exposition des plus beaux dessins du Louvre et de
quelques pièces célèbres des collections de Paris*, no. 126,
repr.; 1969 Paris, no. 139; 1987 Manchester, no. 25,
repr.

SELECTED REFERENCES: Lafond 1918–19, I, repr. after
p. 14; Rivière 1922–23, I, pl. 13; Jamot 1924, pl. 8b;
Maurice Sérullaz, *Dessins du Louvre: école française*,
Paris: Flammarion, 1968, no. 91.

57.

*Nude Woman Lying on Her
Stomach,* study for *Scene of War
in the Middle Ages*

c. 1863–65
Pencil
9 × 14 in. (22.8 × 35.6 cm)
Vente stamp lower left; atelier stamp on verso
On the verso, a summary sketch of a head, in
 pencil
Cabinet des Dessins, Musée du Louvre (Orsay),
 Paris (RF12274)

Exhibited in Ottawa

See cat. no. 45

PROVENANCE: See cat. no. 46.

EXHIBITIONS: 1969 Paris, no. 146; 1979 Bayonne,
no. 21, repr.

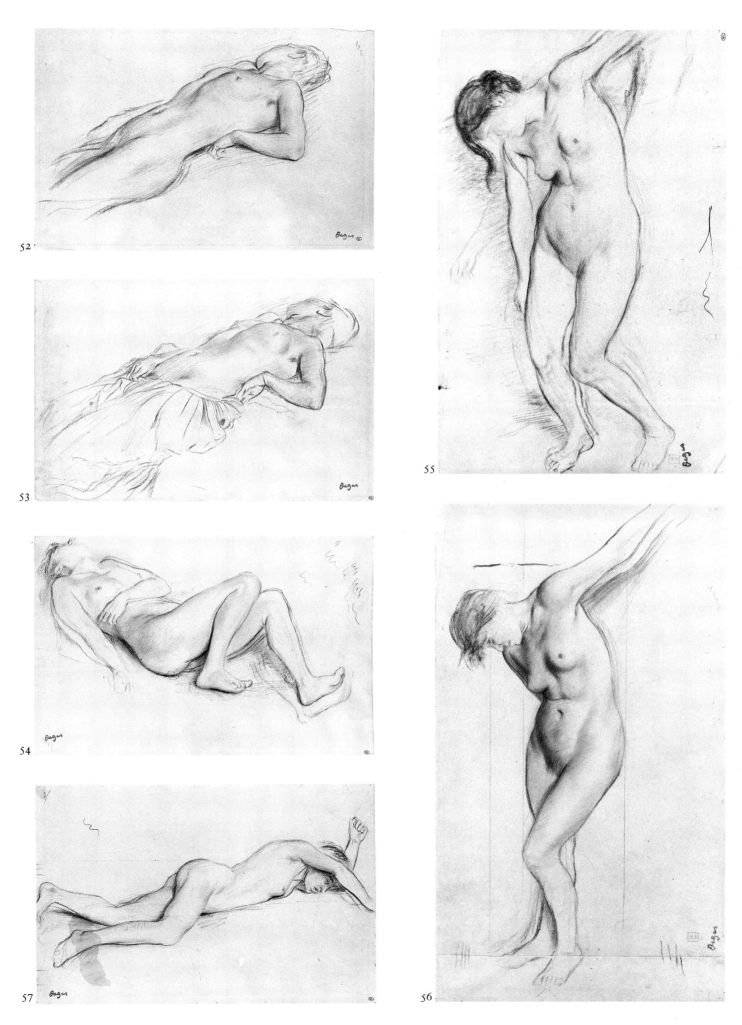

52

53

54

55

56

57

58.

Self-Portrait with Évariste de Valernes

c. 1865
Oil on canvas
45⅝ × 35 in. (116 × 89 cm)
Musée d'Orsay, Paris (RF3586)

Lemoisne 116

Self-Portrait with Évariste de Valernes is the last of Degas's self-portraits. Whereas in the 1850s he frequently depicted himself alone, here he shows himself in the company of another artist, a painter like himself, who was about twenty years his senior (Valernes was born in 1816) and whom he probably met about 1855 at the Louvre, where they both used to copy the old masters.[1]

Degas's choice of Valernes—it resulted in the other artist's being immortalized—is hard to understand. Given what we know of his friendships and affinities at the time, he might have been expected to show himself in the company of Manet, or Tissot, or Stevens, rather than the obscure Valernes, who in spite of his sincere and touching efforts never achieved the glory to which he aspired. A descendant of a noble family originally from the Vaucluse, Valernes was a struggling painter with no family fortune—in 1863, he was "nearly poverty-stricken," noted one of his patrons, the Marquis de Castelbajac.[2] He eked out a living by making copies commissioned by some ministry.[3]

Fig. 58. X-radiograph of *Degas and Valernes* (cat. no. 58)

His situation was especially distressing because he did have true artistic ambitions. Some twenty years later, having retired to Carpentras, resigned though not bitter, he looked back on his hopes and efforts of the past with pangs of regret, and attached this note to the back of another portrait Degas had painted of him in 1868 (L177, Musée d'Orsay, Paris): "My portrait, a study from life, painted by my famous and intimate friend Degas in Paris at his studio on rue de Laval, in 1868, at the time I was on the verge of success and close to becoming famous."

That "intimacy" was probably the primary reason for this double portrait. Degas, whose friends often shared his background rather than his talents, must have enjoyed the company of this indifferent artist but affable gentleman who shared his passion for Delacroix, an artist the two men still admired and discussed in 1890. Valernes was also an admirer of Duranty, and had been one since the novelist's debut (he once drew a pencil portrait of him); when *La nouvelle peinture* appeared, he wrote the author a long letter expressing his admiration and support.[4]

The X-radiograph of this work (fig. 58) shows that originally Degas too was wearing a top hat, his frock coat was open to reveal more of his white shirt, and he had not raised his hand to his chin. The last of these changes can be traced through a preliminary drawing (cat. no. 59). In the accuracy and deliberate rigidity with which the features are drawn, it is very similar to a study Degas made about the same time for *Woman Leaning near a Vase of Flowers* (cat. no. 60), which suggests a slightly later date than that given by most writers: it must be about 1865. The familiar gesture, which characterized Degas from then on, indicated, according to Georges Rivière, who knew him later, reflection or some hesitation while thinking.[5] Seated beside Valernes, who appears to be either indifferent or already sure of his achievement, the young artist is obviously perplexed. Some years later, in the famous letter he sent to Valernes in Carpentras on 16 October 1890, Degas harked back to his state of mind at that time, depicting himself, in contrast to Valernes's constancy ("You have always been the same man, my old friend. . . . "), as vacillating, hesitant, and unintentionally brusque and hurtful: "I felt myself so badly formed, so badly equipped, so weak, whereas it seemed to me that my calculations on art were so right. I brooded against the whole world and against myself."[6]

In adopting the formula of the double portrait, Degas placed himself in a Renaissance tradition. This particular work is more reminiscent of Raphael's *Raphael with*

a Friend (fig. 59) than of the portrait in the Louvre attributed at that time to Gentile Bellini and said to depict *Giovanni and Gentile Bellini*, which he copied (L59, private collection). But Degas was using an old format to create a new image, substituting, in place of the usual neutral background, a large studio window looking out onto a vast hieroglyphic city—a magnificent arrangement of grays, blacks, blues, and pinks, against which domes and columns emerge.

Abandoning the traditional timeless apparel (such as Ingres wears in his self-portrait) and rejecting the garb of the artist, Degas dressed his figures, as in most of his portraits of himself (see cat. nos. 1, 12) and of his painter friends a little later (see cat. nos. 72, 75), in the completely black bourgeois suit, without any show of excessive severity or elegance. This is Degas's most classical, most deliberate composition since the 1855 self-portrait (cat. no. 1): the two artists are enclosed within a circle which, with Valernes's heart at its center, coincides with the edges of the long canvas on the left and the right, and is enclosed by Valernes's thigh below and Degas's head and his friend's hat above. More than any possible influence of the daguerreotype, what we see in this work is the reaffirmation of a principle that Degas continued to proclaim throughout his life: modern painting proceeds from study of the old masters.

1. Valernes's address is written in a notebook used by Degas during that period; Reff 1985, Notebook 3 (BN, Carnet 10, p. 3).
2. Archives Nationales, Paris, F²¹186.
3. In 1861, he was quick to apply for a commission to do a full-length portrait of Napoleon III, but he seems not to have won the commission in spite of the aristocratic support he enjoyed; Archives Nationales, Paris, F²¹186.

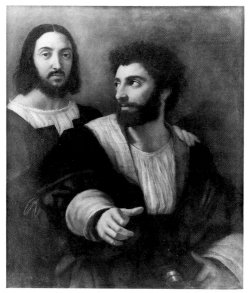

Fig. 59. Raphael, *Raphael with a Friend*, c. 1519. Oil on canvas, 39 × 32⅝ in. (99 × 83 cm). Musée du Louvre, Paris

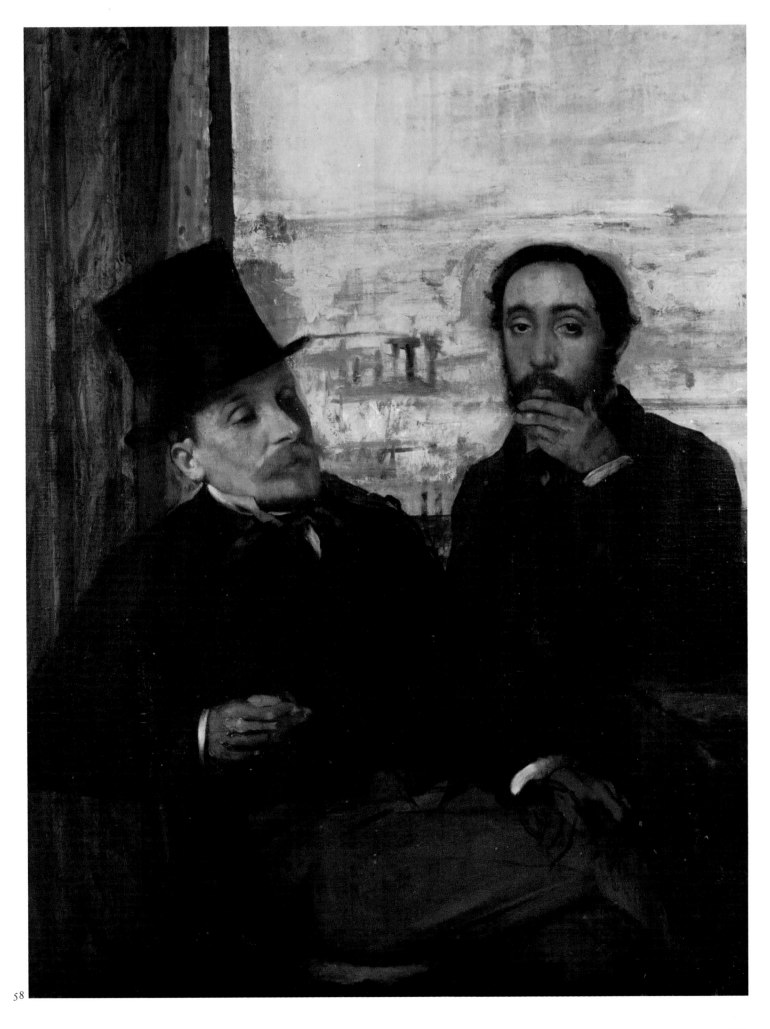

4. Crouzet 1964, pp. 270–71, 338.
5. Rivière 1935, p. 108.
6. Lettres Degas 1945, CLVII, pp. 178–79; Degas Letters 1947, no. 170, p. 171.

PROVENANCE: Atelier Degas; Gabriel Fevre, the artist's nephew, Nice, 1918–31; his gift to the Louvre 1931.

EXHIBITIONS: 1924 Paris, no. 3 (as "Degas et son ami Fleury," c. 1860); 1931 Paris, Orangerie, no. 40, pl. V; 1932, Munich, June; 1939, San Francisco, Golden Gate International Exposition, 18 February–2 December, *Masterworks of Five Centuries*, no. 146, repr.; 1951, Rennes, Musée des Beaux-Arts, June, *Origines de l'art contemporain*, no. 21; 1957 Paris, no. 82; 1964–65 Munich, no. 78, repr.; 1969 Paris, no. 11; 1978, Paris, Palais de Tokyo, 8 March–9 October, *Autoportraits de peintres des XVe–XIXe siècles*, no. 57; 1980, Montauban, Musée Ingres, 28 June–7 September, *Ingres et sa postérité jusqu'à Matisse et Picasso*, no. 186; 1982, Tokyo, National Museum of Western Art, 17 April–13 June, *L'angélus de Millet: tendances du réalisme en France 1848–1870*, no. 22, repr. (color); 1983, Paris, Grand Palais, 15 November 1983–13 February 1984, *Hommage à Raphaël: Raphaël et l'art français*, no. 65, pl. 144; 1984–85 Rome, no. 80, repr. (color).

SELECTED REFERENCES: Jean Guiffrey, "Peintures et dessins de Degas," *Bulletin des Musées de France*, March 1931, no. 3, p. 43; Paul Jamot, "Une salle Degas au Musée du Louvre," *L'Amour de l'Art*, 1931, pp. 185–89; Guérin 1931, n.p.; Lemoisne [1946–49], II, no. 116; Fevre 1949, pp. 77–78, repr.; Cabanne 1957, pp. 104–05, repr.; Paris, Louvre, Impressionnistes, 1958, no. 62; Boggs 1962, pp. 18–19, pl. 34; *De Valernes et Degas* (exhibition catalogue), Musée de Carpentras, 1963, n.p.; *Bulletin du Laboratoire des Musées de France*, 1966, pp. 26–27 (repr. and X-radiograph); Minervino 1974, no. 161; Koshkin-Youritzin 1976, p. 38; Sophie Monneret, *L'impressionnisme et son époque*, Paris, 1978–81, III, p. 13; Eunice Lipton, "Deciphering a Friendship: Edgar Degas and Évariste de Valernes," *Arts Magazine*, LVI, June 1981, pp. 128–32, fig. 1; Theodore Reff, "Degas and Valernes in 1872," *Arts Magazine*, LVI, September 1981, pp. 126–27; McMullen 1984, pp. 120–22, repr.; Paris, Louvre and Orsay, Peintures, 1986, III, p. 197, repr.

59.

Self-Portrait, study for *Self-Portrait with Évariste de Valernes*

c. 1865
Pencil on tracing paper, laid down on bristol board
14⅜ × 9⅝ in. (36.5 × 24.5 cm)
Atelier stamp lower left; estate stamp on verso
Cabinet des Dessins, Musée du Louvre (Orsay), Paris (RF24232)

Exhibited in Paris

See cat. no. 58

59

PROVENANCE: Atelier Degas; Jeanne Fevre, the artist's niece, Nice (Fevre sale, Galerie Charpentier, Paris, 12 June 1934, no. 42, repr.); bought at that sale by the Société des Amis du Louvre, for Fr 7,918.

EXHIBITIONS: 1969 Paris, no. 113.

SELECTED REFERENCES: Jean Vergnet-Ruiz, "Un portrait au crayon de Degas," *Bulletin des Musées de France*, June 1934, no. 6, p. 108.

60.

Woman Leaning near a Vase of Flowers (Mme Paul Valpinçon?), erroneously called *Woman with Chrysanthemums*

1865
Oil on canvas
29 × 36½ in. (73.7 × 92.7 cm)
Signed and dated lower left: 1865/Degas [over earlier: Degas/1865]
The Metropolitan Museum of Art, New York. Bequest of Mrs. H. O. Havemeyer, 1929. H. O. Havemeyer Collection (29.100.128)

Lemoisne 125

It was Paul Lafond who first put forward the often repeated claim that the woman in this painting is Mme Hertel[1]—the same Mme Hertel whose daughter Hélène became Contessa Falzacappa (see cat. no. 62). This identification can no longer be maintained. A drawing by Degas in the Louvre (RF29294) inscribed "Mad. Hertel" shows the regular, commonplace features of the mother of the Roman countess, quite different from the more pronounced features (with that strangeness that so pleased Degas) of the subject of the so-called "Woman with Chrysanthemums," who is quite clearly someone else.

The picture is of a country scene. The window opens on a mass of greenery, and the flowers gathered in an enormous bouquet are freshly cut garden flowers—not chrysanthemums, as is generally thought, but a mixture of white, pink, and blue asters, black and yellow stock, centaurea, gaillardia, and dahlias: end-of-summer flowers which, in all well-kept grounds, normally grew in the cut-flower beds next to the vegetable garden. Casually dressed, her protective gloves doffed and lying on the table, a black scarf wrapped around her neck, the sitter—or let us say, rather, the mistress of the house—has gone out in the morning to gather flowers for her bouquet; she has put them in water and, tired now, stops for a moment to rest. It is out of that final moment in a bourgeois ritual that Degas produced this magnificent portrait.

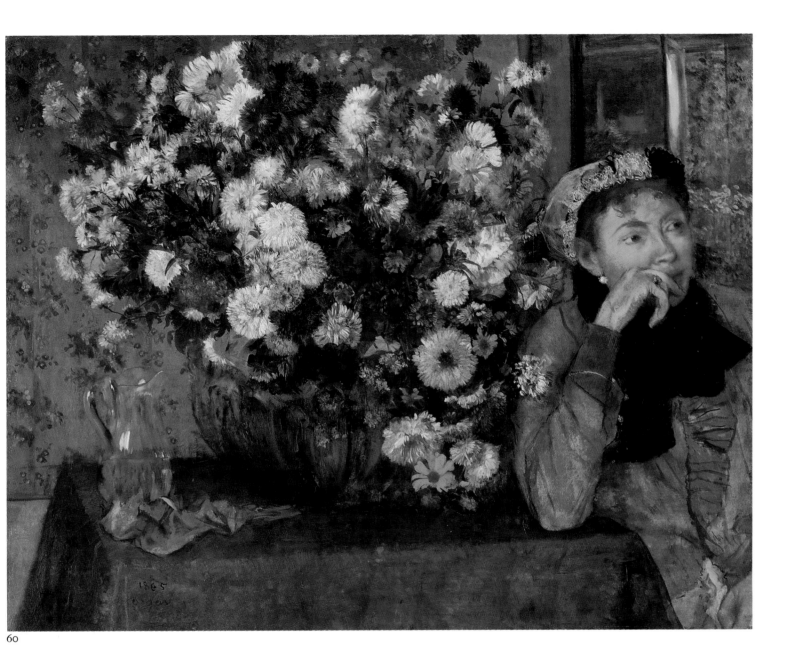

60

The time of year (August to September), the rural setting, and the woman's age all point to the possibility that she is a member of the Valpinçon family. Starting in the early 1860s, Degas often stayed at their Ménil-Hubert property, and it clearly became one of his favorite places. Though we do not know how he spent the summer of 1865, it is not unreasonable to suppose that he went there and found an opportunity to carry out a long-delayed project he had been considering since the early 1860s—a portrait of "Paul's wife."[2] He had made a drawing of her with her husband in 1861 (fig. 84). Degas's description of her several years later in *At the Races in the Countryside* (cat. no. 95) is unfortunately too small to provide any supporting evidence. The only corroboration of our hypothesis comes from a small drawing probably removed from a notebook that Degas used at Ménil-Hubert in 1862.

(The present location of any of these drawings is not known; all the sheets are the same size and are inscribed with the names of the people represented and "Ménil-Hubert/ 1862/Degas.") Among some other caricatured figures drawn in pencil, occasionally heightened with red chalk, there appears the distinctive face of "Mme Paul" (fig. 60), with her lively dark eyes open wide, her large, flat face, and her wide mouth, which could be those of our hitherto unidentified sitter.

The other problem raised by this canvas is how it was composed. It is generally thought that Degas first painted the vase of flowers, and that he added the off-center figure of the young woman much later. The partially erased date in the lower left corner of the canvas—usually read as "1858," or sometimes "1868"—situated next to the very legible "1865" would appear to corroborate this

supposition. However, the hypothesis of an original still life hardly seems plausible. Stylistically, this bouquet cannot have been painted during the artist's stay in Italy, and these flowers do not grow in the south but only in a more moderate climate. If this bouquet were to be set alone on this table, it

Fig. 60. *Mme Paul Valpinçon*, c. 1862. Pencil. From an unpublished notebook. Location unknown

Fig. 61. Gustave Courbet, *The Trellis*, 1862. Oil on canvas, 43¼ × 53¼ in. (109.8 × 135.2 cm). The Toledo Museum of Art

Fig. 62. Jean-François Millet, *Bouquet of Daisies*, c. 1871–74. Pastel, 27⅝ × 32⅝ in. (70.3 × 83 cm). Musée d'Orsay, Paris

SELECTED REFERENCES: Hourticq 1912, pp. 109–10; Lemoisne 1912, pp. 33–34, pl. IX; Jamot 1918, pp. 152, 156, repr. p. 153; Lafond 1918–19, II, p. 11; Jamot 1924, pp. 23, 47ff., 53ff., 90–91, 133, pl. 11; Henri Focillon, *La peinture aux XIXe et XXe siècles: du réalisme à nos jours*, Paris: Librairie Renouard, 1928, II, p. 182; Burroughs 1932, pp. 144–45, repr.; Lemoisne [1946–49], I, pp. 55ff., 239 n. 117, repr. facing p. 56, II, no. 125; Fosca 1954, p. 29, repr. (color) p. 28; Boggs 1962, pp. 31ff., 37, 41, 59, 119, pl. 44; New York, Metropolitan, 1967, pp. 57–60, repr. and detail cover (color); Rewald 1973 GBA, pp. 8, 11, fig. 5; Reff 1977, fig. 10 (color); Moffett 1979, p. 61, plates 7, 8 (color); Weitzenhoffer 1986, pp. 240, 257, fig. 162.

would be the only example in Degas's oeuvre of a bouquet in an interior. Finally, it appears, according to a recent X-radiograph, that the reading of "1858" is incorrect and that this date too should be read as "1865."

The fine drawing of the figure alone (cat. no. 61), in the position she would occupy in the canvas, does not prove that she was a later addition—any more than the drawing for Degas's self-portrait means that the painter added himself to a picture in which Valernes originally appeared alone (see cat. no. 58). The portrait differs profoundly from two others with which it has often been compared: Courbet's *The Trellis* (fig. 61) and Millet's *Bouquet of Daisies* (fig. 62), both of which are true genre scenes. The "familiar and typical"[3] pose of the sitter is reinforced by her off-center position, but she is by no means peripheral. Placing her at the edge of the painting, Degas paradoxically gives her greater prominence. The luxuriant bouquet nuzzling her neck and encroaching on her sleeve becomes, like René De Gas's inkwell (cat. no. 2), an attribute of the sitter's circumstances.

Everything here speaks of what might be called a calm disarray—femininity, comfort, blossoming, maturity, gentility: the explosion of multicolored flowers (their hues muted but from which burst forth, here and there, patches of yellow or white), the worn and crumpled dressing gown, the carelessly donned scarf, the curls on the forehead, the ruffles on the bonnet, the rich pattern of the tablecloth, the interlacing floral motifs of the wallpaper, and the luxuriance of the garden, just glimpsed in the distance.

1. Lafond 1918–19, II, p. 11.
2. Reff 1985, Notebook 18 (BN, Carnet 1, p. 96), Notebook 19 (BN, Carnet 19, p. 51).
3. Reff 1985, Notebook 13 (BN, Carnet 21, p. 46).

PROVENANCE: Bought from the artist by Theo van Gogh for Goupil et Cie (as "Femme accoudée près d'un pot de fleurs"), 22 July 1887, for Fr 4,000; deposited with Goupil Gallery, The Hague, 6 April–9 June 1888; bought by Émile Boivin, 28 February

1889, for Fr 5,500; Mme Émile Boivin, his widow, 1909–19; deposited with Durand-Ruel, Paris, 10 June 1920 (deposit no. 12097); bought from the heirs of Émile Boivin by Durand-Ruel, New York, 3 July 1920 (stock no. N.Y. 4546); sent to Durand-Ruel, New York, 11 November 1920; bought by Mrs. H. O. Havemeyer, New York, 28 January 1921, for $30,000; her bequest to the museum 1929.

EXHIBITIONS: 1930 New York, no. 45, repr.; 1936 Philadelphia, no. 8, repr.; 1937 Paris, Orangerie, no. 6, pl. VI; 1938, Hartford, Wadsworth Atheneum, 25 January–15 February, *The Painters of Still Life*, no. 55; 1947 Cleveland, no. 8, p. VII; 1950–51 Philadelphia, no. 72, repr.; 1974–75 Paris, no. 10, repr. (color); 1977 New York, no. 3 of paintings, repr.

61.

Study for *Woman Leaning near a Vase of Flowers (Mme Paul Valpinçon?)*

1865
Pencil on off-white wove paper
14 × 9¼ in. (35.5 × 23.4 cm)
Signed and dated lower right: Degas/1865
Harvard University Art Museums (Fogg Art Museum), Cambridge, Massachusetts. Bequest of Meta and Paul J. Sachs (1965.253)

Vente I:312

See cat. no. 60

61

PROVENANCE: Atelier Degas (Vente I, 1918, no. 312); bought at that sale by Paul Rosenberg, Paris, for Fr 5,300; bought by Paul J. Sachs, 1927; bequeathed to the museum 1965.

EXHIBITIONS: 1929 Cambridge, Mass., no. 34, p. 25; 1930, New York, Jacques Seligmann and Co., *Drawings by Degas*, no. 19; 1932, Saint Louis, City Art Museum, *Drawings by Degas*; 1933–34, Pittsburgh, Junior League, 12 December 1933–6 January 1934, *Old Master Drawings*, no. 31; 1935 Boston, no. 120; 1936 Philadelphia, no. 69, repr.; 1937 Paris, Orangerie, no. 73; 1939, New York, Brooklyn Institute of Arts and Sciences Museum, *Great Modern French Drawings*, no. 11, repr. cover; 1941, Detroit Institute of Arts, 1 May–1 June, *Masterpieces of 19th and 20th Century Drawings*, no. 20; 1945, New York, Buchholz Gallery, 3–27 January, *Edgar Degas Bronzes, Drawings, Pastels*, no. 58; 1946, Wellesley College, Farnsworth Art Museum; 1947 Cleveland, no. 62, repr.; 1947, New York, Century Club, *Loan Exhibition*; 1947 Washington, D.C., no. 31; 1948 Minneapolis, no. 10; 1950–51 Philadelphia, no. 94, repr.; 1952, Richmond, Virginia Museum of Fine Arts, March–April, *French Drawings from the Fogg Art Museum*; 1955 Paris, Orangerie, no. 69, repr.; 1955 San Antonio; 1956, Waterville, Me., Colby College, 22 April–23 May, *An Exhibition of Drawings*, no. 28, repr. cover; 1961, Cambridge, Mass., Fogg Art Museum, 24 April–20 May, *Ingres and Degas—Two Classical Draftsmen*, no. 8; 1965–67 Cambridge, Mass., no. 57, repr.

SELECTED REFERENCES: Rivière 1922–23, II, pl. 59; Arthur Pope, "The New Fogg Museum: The Collection of Drawings," *Arts*, XII:1, July 1927, p. 32, repr.; *Fogg Art Museum Handbook*, Cambridge, Mass., 1931, p. 112, repr.; Mongan 1932, p. 65, repr. cover; Paul J. Sachs, "Extracts from Letters of Henri Focillon," *Gazette des Beaux-Arts*, XXVI, July–December 1944, pp. 11–12; 1965 New Orleans, p. 74, repr.

62.

Hélène Hertel

1865
Pencil
10⅞ × 7¾ in. (27.6 × 19.7 cm)
Signed and dated upper right: Degas/1865
On the verso, a summary sketch of the head of a woman, in pencil
Cabinet des Dessins, Musée du Louvre (Orsay), Paris (RF5604)

Exhibited in Ottawa

Vente I:313

62

Published by Manzi and Degas about 1897 as "Portrait of a Young Person" in the album *Degas: vingt dessins, 1861–1896*, this beautiful pencil drawing bearing the date 1865 appeared as "Portrait of Mlle Hélène Hertel (Comtesse Falzacappa)" at the first atelier sale; that identification has never been questioned. It is listed in the inventory drawn up after Degas's death,[1] and there it is related to twelve sketches called "Portrait of Mlle Hertal" [sic],[2] which are otherwise unknown. "About 1860," if we accept the

annotation that he added later, Degas drew Hélène's mother, Mme Hertel, née Charlotte Matern (Cabinet des Dessins, Musée du Louvre [Orsay], Paris, RF29294), who is often mistakenly identified as the sitter in *Woman Leaning near a Vase of Flowers* (cat. no. 60). Mme Hertel was from a Hamburg family and the wife of a man of property who had settled in Paris, Charles Hertl (this seems to be the original spelling of the name, Hertel being the French version). Their daughter Hélène was born in Paris on 4 January 1848. On 5 July 1869, in Rome, where her mother's sister Mme Luigi Manzi lived, she married Conte Vincenzo Falzacappa, of a noble family from Corneto.[3]

The 1865 drawing was perhaps a study for an unfinished, or lost, oil portrait. In a style that Degas began using in the late 1850s, Hélène's dress is sketched rapidly, but the hands, and even more so the face, are carefully drawn, with fuller, firmer, calmer lines. Emphasized in the three-quarter view of her face are the somewhat broad nose and especially the wide, dreamy eyes of the seventeen-year-old girl.

1. Durand-Ruel archives, Paris, no. 924.
2. Ibid., no. 2024.
3. On the Hertl and Falzacappa families, see Archivio del Vicariato, Rome, NOTAI, Ufficio IV "Positiones," no. 8195 (information kindly provided by Olivier and Geneviève Michel).

PROVENANCE: Atelier Degas (Vente I, 1918, no. 313); bought at that sale by Reginald Davis, for Fr 5,700. Marcel Bing, Paris; his bequest to the Louvre 1922.

EXHIBITIONS: 1924 Paris, no. 87; 1931 Paris, Orangerie, no. 107; 1935, Kunsthalle Basel, 29 June–18 August, *Meisterzeichnungen französischer Künstler von Ingres bis Cézanne*, no. 158; 1936 Venice, no. 16; 1937 Paris, Orangerie, no. 74; 1969 Paris, no. 114; 1972, Darmstadt, Hessisches Landesmuseum, 22 April–18 June, *Von Ingres bis Renoir*, no. 26, repr.

SELECTED REFERENCES: Vingt dessins [1897], pl. 6; Lemoisne 1912, pp. 31–32, repr.; Rivière 1922–23, I, pl. 10; Jamot 1924, pl. 12; Boggs 1962, p. 119.

63.

M. and Mme Edmondo Morbilli

c. 1865
Oil on canvas
45⅞ × 34¾ in. (116.5 × 88.3 cm)
Museum of Fine Arts, Boston. Gift of Robert Treat Paine II (31.33)

Lemoisne 164

Little is known about this double portrait apart from the identity of the sitters. The uncertainty of the chronology for the 1860s, the absence of dated sketches, and the delay in the appearance of this canvas until the sale of the estate of René de Gas in 1927 do not make the historian's task any easier; one is left having to resort to stylistic evidence or psychological assessments. Thérèse De Gas, who in the 1850s (see cat. no. 3) and 1860s (see cat. no. 94) was one of her brother's favorite subjects, is shown here at the side of her husband and first cousin Edmondo Morbilli, whom she had married in 1863. The few letters that we have from Thérèse suggest a modest girl of few enthusiasms and probably only average intelligence, without the talents and "prima donna" side of her sister Marguerite. As for Edmondo, he seems to have been rather dull and a bit sententious; he clearly had little understanding of Degas's vocation, and yet (even though he was a year and a half Degas's junior) was quite prepared to scold him.[1]

Before their marriage, the couple saw a lot of each other when Edmondo spent the winter of 1858–59 in Paris,[2] and after that during Thérèse's repeated stays in Naples. The idea of marriage, which no doubt arose then, became a reality despite the fact that they were blood relations and needed papal dispensation to marry. On 16 April 1863, at the Madeleine, Thérèse married Edmondo Morbilli, "a young Neapolitan with little money, high hopes, twenty-six years behind him, and a great deal of love."[3] Thérèse's

poor health,[4] the absence of children—Thérèse adored them, and lost a child that was due in February 1864[5]—and the modesty of Edmondo's fortune and situation did not make them a particularly happy couple. They led a quiet and uneventful life, attracting, like the Fevres but for different reasons, the sympathy of the painter.

Degas had first painted them together presumably not long after their marriage, during Thérèse's pregnancy, in a canvas that is now in Washington (fig. 63). Although it is the same size as the Washington painting, the Boston double portrait is very different. The arrangement is not the same, the scale has been altered, and the positions of the figures have been changed, even in the way they face and look at each other. The background, which in the first picture is more elaborate (an open door framing a woman's silhouette, a wallpaper or fabric motif on the wall, two frames hanging in the next room), is here no more than the neutral and nondescript background of certain Renaissance paintings: a mustard-yellow hanging curving behind Edmondo and opening onto bluish white net curtains. Thérèse, previously in the foreground, is now no more than the shadow of her husband. Whereas in the earlier painting the female element dominates, with Thérèse's ample dress and the woman in the background behind Edmondo, here it has become a man's world. The lifelike, lively, spirited portrait in Washington yields to a stricter, more monumental composition in the tradition, as Denys Sutton has noted, of Titian.[6] Probably equally pictorial were Degas's reasons for choosing to paint his sister and brother-in-law twice (while he never did a portrait of Marguerite with her husband Henri Fevre). With his long beard, aquiline nose, and undeniable presence, the imposing Edmondo is like a sixteenth-century lord—Agnes Mongan has perceptively compared the preparatory drawing in Boston (cat. no. 64) to a pencil drawing by Clouet. Thérèse's perfectly oval face, broad nose, full mouth, and large, somewhat protruding black eyes recall Ingres's faces of Mlle Rivière or Mme Devauçay; the delicate hand supporting the chin is equally reminiscent of his portraits of Mme Gonse, Baronne de Rothschild, and Comtesse d'Haussonville (fig. 83). But Thérèse's usual placidity is here replaced by an anxiety that is underscored by her intense, melancholy look, her body half hidden behind the table, her lips parted, her hand seeking her husband's shoulder. Clearly, time has passed since the last portrait; the faces have matured, the roles have been defined. It is probably about 1865—the portrait may have been occasioned by the couple's arrival in Paris to celebrate the wedding

of Marguerite De Gas and Henri Fevre on 9 June.[7] Thérèse is not yet the cool and distant woman of the small pastel of 1869 (cat. no. 94), and Edmondo no longer has the smiling unselfconsciousness of the Washington portrait. Lord and master, he wears—in his blue tie fixed with a gold pin—the colors of his lady.

1. Unpublished letter from Edmondo Morbilli to Degas, Naples to Paris, 30 July 1859, private collection.
2. Letter from Thérèse De Gas to Edgar, Paris to Florence, 4 January 1859, private collection.
3. Letter from René De Gas to Michel Musson, Paris to New Orleans, 6 March 1863, Tulane University Library, New Orleans.
4. Unpublished letter from Auguste De Gas to Edmondo Morbilli, Paris to Naples, n.d., private collection.
5. Letter from Désirée Musson, Bourg-en-Bresse to New Orleans, 7 November 1863, and letter from Marguerite De Gas to Michel Musson, Paris to New Orleans, 31 December 1863, Tulane University Library, New Orleans.
6. Sutton 1986, p. 68.
7. Letter from Auguste De Gas to Michel Musson, Paris to New Orleans, 9 June 1865, Tulane University Library, New Orleans.

PROVENANCE: Atelier Degas; René de Gas, the artist's brother, Paris, 1918–21 (René de Gas estate sale, Drouot, Paris, 10 November 1927, no. 71, repr., for Fr 265,000). Wildenstein and Co., New York; Robert Treat Paine II, Brookline, Mass.; his gift to the museum 1931.

EXHIBITIONS: 1933 Northampton, no. 3; 1936 Philadelphia, no. 10, repr; 1941, Boston, Museum of Fine Arts, 19 February–6 April, *Portraits through Forty-five Centuries*, no. 144; 1970, New York, The Metropolitan Museum of Art, 24 May–26 July, *100 Paintings from the Boston Museum*, no. 51, repr. (color); 1978–79 Philadelphia, no. VI–42, repr. (English edition), no. 210, repr. (French edition).

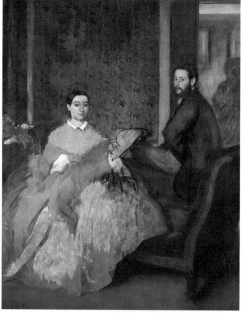

Fig. 63. *M. and Mme Edmondo Morbilli* (L131), c. 1863. Oil on canvas, 46⅛ × 35⅜ in. (117.1 × 89.9 cm). Chester Dale Collection, National Gallery of Art, Washington, D.C.

63

SELECTED REFERENCES: Paul-André Lemoisne, "Le portrait de Degas par lui-même," *Beaux-Arts*, December 1927, p. 314; Philip Hendy, "Degas and the de Gas," *Bulletin of the Museum of Fine Arts, Boston*, XXX:179, June 1932, repr. p. 43; *Catalogue of Oil Paintings, Museum of Fine Arts*, Boston, 1932, repr.; Lemoisne [1946–49], II, no. 164; Boggs 1962, pp. 16, 18–20, 24, 59, 125, pl. 39; Minervino 1974, no. 228; Petra Ten Doesschate Chu, *French Realism and the Dutch Masters*, Utrecht, 1974, p. 60, pl. 117; S. W. Peters, "Edgar Degas at the Boston Museum of Fine Arts," *Art in America*, LXII:6, November–December 1974, pp. 124–25; Kirk Varnedoe, "The Grand Party That Won the Second Empire," *Art News*, LXXVII:10, December 1978, pp. 50–53, repr. p. 53; Alexandra R. Murphy, *European Paintings in the Museum of Fine Arts, Boston: An Illustrated Summary Catalogue*, Boston, 1985, p. 75, repr.

64.

Edmondo Morbilli, study for *M. and Mme Edmondo Morbilli*

c. 1865
Pencil
12½ × 9 in. (31.7 × 22.8 cm)
Atelier stamp lower left
Museum of Fine Arts, Boston. Julia Knight Fox Fund (31.433)

Exhibited in Ottawa and New York

See cat. no. 63

PROVENANCE: Atelier Degas; René de Gas, the artist's brother, Paris, 1918–21 (René de Gas estate sale, Drouot, Paris, 10 November 1927, no. 9, repr.);

64

Wildenstein and Co., New York; bought by the museum 1931.

EXHIBITIONS: 1931 Cambridge, Mass., no. 15a; 1934, Cambridge, Mass., Fogg Art Museum, 6–22 December, *One Hundred Years of French Art 1800–1900*, no. 152; 1936 Philadelphia, no. 72, repr.; 1937 Paris, Orangerie, no. 76; 1947 Cleveland, no. 65, pl. XLVII; 1947 Washington, D.C., no. 21; 1948 Minneapolis, no number; 1953, Montreal Museum of Fine Arts, October–November, *Five Centuries of Drawings*, no. 208; 1958–59 Rotterdam, no. 162, repr.; 1967 Saint Louis, no. 48, repr.

SELECTED REFERENCES: Philip Hendy, "Degas and the de Gas," *Bulletin of the Museum of Fine Arts, Boston*, XXX:179, June 1932, p. 45, repr.; Mongan 1932, p. 64, repr.; Lemoisne [1946–49], II, under no. 164.

65.

Giovanna and Giulia Bellelli

c. 1865–66
Oil on canvas
36¼ × 28¾ in. (92 × 73 cm)
Vente stamp lower right
Los Angeles County Museum of Art, Los Angeles. Mr. and Mrs. George Gard De Sylva Collection (M.46.3.3)

Lemoisne 126

Paul-André Lemoisne was the first to identify the sitters as the two Bellelli sisters, Giovanna and Giulia (or, as they were called in the Degas family, Nini and Julie), the blonde and the brunette, painted a few years after they had posed for the large *Family Portrait* (cat. no. 20), meaning, according to Lemoisne's scheme, about 1865.[1]

Though the identification of the sitters has, quite rightly, been accepted without dispute, the work has generally been dated earlier, about 1862–64; this is the period to which it was assigned, for example, by Jean Sutherland Boggs, who has written the most pertinent remarks on the subject.[2] However, some difficulties arise as a result of the apparent ages of the sisters in this picture. Giovanna, on the left, would have to have been between thirteen and fifteen years old if we are to accept the usual dating (she was born 10 December 1848); Giulia, on the right, would have to have been between eleven and thirteen (she was born 13 July 1851). But these figures are far from the little girls sketched in 1858: even if they are still lacking in polish, these are developed young ladies (the preparatory drawing in the Boymans-van Beuningen [fig. 64] is more telling on this point than the final canvas), wearing the modest jewelry and severe dresses of their peers. Nini is probably about

seventeen years old, which would make Julie fourteen or fifteen and permit a date of about 1865–66 for the double portrait.

There are other arguments to support this later dating. A rough sketch of the final composition, only inverted, appears in a notebook that Degas is known to have used between 1864 and 1867—very likely in 1865–66, to be more precise.[3] Furthermore, there is an oil study of the head of Giulia Bellelli (L139, private collection), turned to the left as in the notebook sketch, largely covered by a study for *The Collector of Prints* (cat. no. 66), a work of 1866. Finally, the dresses of half-mourning worn by the two sisters suggest that a full year has already gone by since the death of their father, Gennaro Bellelli, in Naples on 21 May 1864.

Degas thus painted his two cousins at a time when he had still not finished the large *Bellelli Family*, begun seven years earlier, where they appear as little girls in sober schoolgirl dress. This metamorphosis, which he was able to consider daily in his studio, was something he no doubt found amusing. To make the comparison even more striking, he returned, as Boggs has noted,[4] to his first idea for *The Bellelli Family*, which shows the two sisters in the very same position as here (see fig. 35). Like photographs taken with the same pose from one year to the next, which inevitably convey a sense of maturing or aging, the two canvases permit us to measure the passage of time, the transformation of the little girls into young ladies who are still a bit ponderous and awkward, the disappearance of the father, and, for Degas, the distance he has traveled as an artist. Perhaps these are the best reasons to claim that this work was presented at the Salon of 1867, where it would have seemed like an echo of the other "Family Portrait," *The Bellelli Family*. Nevertheless, in spite of the few words of praise of Castagnary for "les deux soeurs" (see cat. no. 20), the title of "Family Portrait," which was used in the Salon, seems totally inappropriate for a composition that, according to common sense, could only have been titled "Two Sisters."

Although the title inevitably calls to mind Chassériau's painting of his sisters (his pupil Gustave Moreau, whom Degas was still seeing about this time, had a photograph of this famous picture hanging in his apartment[5]), Degas's canvas has little in common with its celebrated predecessor (fig. 65). Whereas Chassériau played on the striking resemblance of the twins, Degas, despite the physical likeness and similar attire, emphasizes the sisters' differences by pointing them away from each other; it is as if only the accident of being in the same family and the obstinacy of a cousin who was a painter

could have brought these young ladies together—sisters whom their mother described as being very unlike each other.[6]

A marked influence of the daguerreotype image has been noted in the composition of this double portrait, as also in that of *Self-Portrait: Degas Lifting His Hat* (cat. no. 44), *Self-Portrait with Évariste de Valernes* (cat. no. 58), and *Woman Leaning near a Vase of Flowers* (cat. no. 60). A few years earlier, however, Degas himself had already countered this notion: on a page of one of his notebooks (fig. 66), he had done a sketch of two young women, probably sisters, pressed against each other in a setting typical of a photographer's studio, with the obligatory drapery and "period" chair or balustrade, and mischievously signed it "Disdéri photog.," thus pointing out not only that his art owed nothing to the conventions of photography, but that in this particular case he felt these conventions to be vulgar.

1. Lemoisne [1946–49], II, no. 126.
2. Boggs 1955, pp. 134–36.
3. Reff 1985, Notebook 20 (Louvre, RF5634 ter, p. 19).
4. Boggs 1955, p. 134.
5. Mathieu 1976, p. 32.
6. Unpublished letters from Laura Bellelli to Edgar Degas, Florence to Paris, 25 September and 17 December 1858, private collection.

PROVENANCE: Atelier Degas (Vente I, 1918, no. 84); bought at that sale by Paul Rosenberg, Paris, for Fr 34,000; Henri-Jean Laroche, Paris, 1928; Jacques Laroche, Paris, 1937. Paul Rosenberg, New York; Mr. and Mrs. George Gard De Sylva, Holmby Hills, Calif.; their gift to the museum 1946.

EXHIBITIONS: (?)1867, Paris, 15 April–5 June, Salon, no. 444 or 445 (as "Portrait de famille"); 1928, Paris, Galerie de la Renaissance, 1–30 June, *Portraits et figures de femmes de Ingres à Picasso*, no. 52; 1937 Paris, Orangerie, no. 7, pl. V; 1947 Cleveland, no. 13, pl. XII; 1949 New York, no. 8, repr.; 1954 Detroit,

65

no. 67, repr.; 1958 Los Angeles, no. 12, repr.; 1960 New York, no. 9, repr.

SELECTED REFERENCES: Lemoisne [1946–49], I, p. 54, II, no. 126; W. R. Valentiner, *The Mr. and Mrs. Gard De Sylva Collection of French Impressionist and Modern Paintings and Sculpture*, Los Angeles County Museum, Los Angeles, 1950, no. 3, repr.; Boggs 1955, pp. 134–36, fig. 12; Boggs 1962, pp. 16, 20, pl. 28; Minervino 1974, no. 215; 1983 Ordrupgaard, p. 94, no. A, repr. (color) p. 72.

Fig. 64. *Giovanna and Giulia Bellelli* (III:156.3), c. 1865–66. Pencil, 11 × 7⅞ in. (28 × 20 cm). Museum Boymans-van Beuningen, Rotterdam

Fig. 65. Théodore Chassériau, *Two Sisters*, 1843. Oil on canvas, 70⅞ × 53⅛ in. (180 × 135 cm). Musée du Louvre, Paris

Fig. 66. Notebook drawing inscribed "Disdéri photog.," 1859–64. Brown ink, 10 × 7⅝ in. (25.4 × 19.2 cm). Bibliothèque Nationale, Paris, Dc327d, Carnet 1, p. 31 (Reff 1985, Notebook 18)

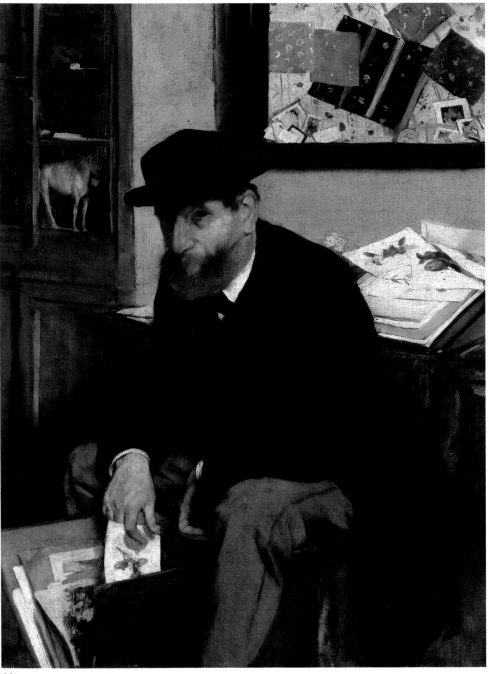

66

66.

The Collector of Prints

1866
Oil on canvas
20⅞ × 15¾ in. (53 × 40 cm)
Signed and dated lower left: Degas/1866
The Metropolitan Museum of Art, New York.
 Bequest of Mrs. H. O. Havemeyer, 1929.
 H. O. Havemeyer Collection (29.100.44)

Lemoisne 138

The anonymity of the sitter has often meant that this little canvas has been considered more as genre than as a portrait. However, just as much as the paintings of Tissot (cat.

no. 75) or of Mlle Dubourg (cat. no. 83), it is a portrait in an interior, following a formula Degas developed in the 1860s: the man's features are perfectly discernible and indeed (note the size of the nose) imbued with character; having been disturbed as he looks through a portfolio of prints, he strikes a pose for a fleeting moment and gazes at the spectator. Even if the allusion to Daumier is clear, we are far from those figures of Daumier's who, leafing through portfolios or contemplating a canvas, are, with their indistinct faces, archetypes of the collector, the *amateur*. Degas was to come much closer to the caricaturist fifteen years

later, in a panel, now in the Cleveland Museum of Art, commonly referred to as *The Collectors* (L647, c. 1881), which is a portrait of two of his friends, Paul Lafond and Alphonse Cherfils. In *The Collector of Prints*, on the other hand, the assurance of the line, the smooth and precise handling, and the legibility of the objects surrounding the model take us far from Daumier.

Dated 1866 (a date probably inscribed in 1895, when Degas sold the painting to Mrs. Havemeyer after tripling the advertised price and making her wait two years on the pretext that retouching was needed), this portrait was preceded by a study of the man's head (L139, private collection), painted over a sketch for the portrait of Giovanna and Giulia Bellelli (cat. no. 65); the study is comparable to other sketches of bearded men in soft hats that Degas did later (for example, L170, L293). The pictures in the portfolio, scattered on the table, or stuck to the wall, and the horse in the display cabinet have been identified by Theodore Reff:[1] colored lithographs by Redouté, a T'ang dynasty horse, and samples of Japanese or Japanese-inspired fabrics (actually, they look as much like ordinary European textiles) pinned on the bulletin board with photographs and visiting cards—unless this board is a trompe l'oeil, of a kind often made throughout the nineteenth century. From the evidence, this man is not what might be called a great collector but a hunter after outmoded and cheap images. Perhaps—and this might help to identify him—he is looking for the prints that Redouté did during the July Monarchy as models for floral-patterned fabrics or wallpaper, prints that were not highly regarded at the time. As for the man's outfit, Reff very aptly quotes Degas's recollections late in life (as told to Étienne Moreau-Nélaton) of how he would go with his father to visit Marcille and La Caze, both of whom left a great impression on him: "He [Marcille] wore a hooded cape and a rumpled hat. People in those days all wore rumpled hats."[2]

In this portrait, Degas depicts a type that, in the Second Empire, was thought to be a vanishing breed: the enthusiastic collector, a fanatic more anxious to acquire than to show—in short, what Degas himself a few years later would become. At the opposite pole was the man who paid a fortune for his acquisitions, thus driving prices up—a person with no true taste, no avowed passion, who only made buying all the more difficult for the genuine collectors. Zola, in the notes he was assembling for *L'Oeuvre*, pinpointed this change in the marketplace: "The speculation of the Empire is upon us, the madness for gold; much money is made, people reach for the moon and the stars, and collectors

multiply; but they don't know the first thing about it anymore."[3]

Degas, in turn, painted the sort of man who throughout nineteenth-century literature, from Balzac to René Maizeroy, had become a familiar character—one of "those bizarre fanatics who end up falling into curios, becoming merchants without shops who traffic in knickknacks the way other people traffic in stocks and bonds."[4] Here we see this fanatic rummaging through his folios amid all the evidence of his collector's passion: the precious object carelessly displayed, the jumble of etchings, the hodgepodge of multicolored pictures, their vivid touches of red, pink, and green on white backgrounds thrown around his severe black coat.

1. Reff 1976, pp. 98–101.
2. Moreau-Nélaton 1931, p. 267.
3. Émile Zola, *Carnets d'enquête*, Paris: Plon, 1986, pp. 245–46.
4. René Maizeroy [pseud.], *La fin de Paris*, Paris: Victor Havard, 1886, pp. 124–25.

67

PROVENANCE: Bought from the artist by Mr. and Mrs. H. O. Havemeyer, New York, for Fr 3,000 (sent to New York, 13 December 1894, through Durand-Ruel); Mr. and Mrs. H. O. Havemeyer, New York, from 1894; Mrs. H. O. Havemeyer, New York, from 1907; her bequest to the museum 1929.

EXHIBITIONS: 1930 New York, no. 47; 1977 New York, no. 5 of paintings, repr.; 1978 New York, no. 4, repr. (color).

SELECTED REFERENCES: Lemoisne [1946–49], II, no. 138; Havemeyer 1961, p. 252; New York, Metropolitan, 1967, p. 61, repr.; Minervino 1974, no. 219; Reff 1976, pp. 90, 98–101, 106, 138, 144–45, figs. 65, 66; Moffett 1979, p. 7, pl. 12; Weitzenhoffer 1986, p. 81, pl. 34.

67.

Runaway Horse, study for *The Steeplechase*

1866
Charcoal
9⅛ × 14 in. (23.1 × 35.5 cm)
Vente stamp lower left; atelier stamp on verso
Sterling and Francine Clark Art Institute, Williamstown, Massachusetts (1397)

Vente IV:241.a

In 1866, Degas submitted a large painting to the Salon, *The Steeplechase* (fig. 67; see cat. no. 351). Like *Scene of War in the Middle Ages* (cat. no. 45) the year before, it attracted little attention. Edmond About spared two words of praise for "this brisk and lively composition."[1] A more verbose anonymous author praised "the clarity and delicacy of tone" of

Fig. 67. *The Steeplechase* (L140), 1866, reworked 1880–81. Oil on canvas, 70⅞ × 59⅞ in. (180 × 152 cm). Collection of Mr. and Mrs. Paul Mellon, Upperville, Va.

this painting, "somewhat in the English style," before attacking the faulty rendering of the animals: "Like the jockey, this painter is not yet entirely familiar with his horse."[2] Years later, Degas admitted his earlier incompetence to the journalist Thiébault-Sisson during a stay at Mont-Dore:

You are probably unaware that about 1866 I perpetrated a *Scène de steeplechase*, the first and for long after the only one of my pictures inspired by the racecourse. Even though I was quite familiar with "the noblest conquest ever made by man," even though I had had the opportunity to mount a horse quite often, even though I

could distinguish a thoroughbred from a half-bred without too much difficulty, even though I had a fairly good understanding of the animal's anatomy and myology, having studied one of those plaster models found in all the casters' shops, I was completely ignorant of the mechanism of its movements, and I knew infinitely less than any noncommissioned officer, who, because of his years of meticulous practice, could imagine from a distance the way a certain horse would jump and respond.[3]

The Clark Art Institute drawing, which is a detailed study for the horse in the foreground of the painting—in the painting its head is lowered—proves beyond any doubt the truth of Degas's later confession. Nevertheless, with all four hooves in the air, covering, as on the canvas, the entire width of the paper, and boldly displaying his anatomical absurdities, just as Ingres's women show off their extra vertebrae, the animal has a force that nothing seems able to bridle.

1. Edmond About, *Salon de 1866*, Paris: Hachette, 1867, p. 229.
2. *Salon de 1866*, Paris, 1866.
3. Thiébault-Sisson 1921.

PROVENANCE: Atelier Degas (Vente IV, 1919, no. 241.a, repr.); bought at that sale by Knoedler, with no. 241.b, for Fr 500; Robert Sterling Clark, New York, 1919–55; his gift to the museum 1955.

EXHIBITIONS: 1959 Williamstown, no. 20, pl. V; 1970 Williamstown, no. 22, repr.

SELECTED REFERENCES: Lemoisne [1946–49], II, under no. 140; Williamstown, Clark, 1964, I, pp. 81–82, no. 159, II, pl. 159; Williamstown, Clark, 1987, no. 19, repr.

68.

Racehorses before the Stands

1866–68
Essence on paper mounted on canvas
18⅛ × 24 in. (46 × 61 cm)
Signed lower left: Degas
Musée d'Orsay, Paris (RF1981)

Lemoisne 262

Once again, we are faced with problems in dating a famous work which, though often reproduced and discussed, still has an uncertain history and raises a number of questions. *Racehorses before the Stands*, known in French as *Le defilé*, is traditionally believed to have been exhibited in 1879 at the fourth Impressionist exhibition, which to Germain Bazin meant that it was executed that year.[1] The few comments of the critics make it difficult to identify the work exhibited then as no. 63, "Racehorses (essence)," but the mention of essence narrows the choice to this picture or the Barber Institute's *Jockeys before the Race* (fig. 180). In *La Vie Moderne* of 24 April 1879, Armand Silvestre wrote, "I also very much like the semilunar light that bathes the racecourse of no. 63," clearly referring not to *Racehorses before the Stands*—a sunny painting of high summer—but to the Barber's picture, lit by a "pale winter sun."[2]

The preparatory drawings permit us to be somewhat more definite about the chronology. In a notebook used basically from 1867 to 1869—its contents include sketches for the portrait of James Tissot (cat. no. 75) and for *Interior* (cat. no. 84)—we find, if not a compositional study, several sketches of details: a group of women in the open air,[3] and a jockey seen from behind,[4] next to partial copies of Meissonier's celebrated painting *Napoleon III at the Battle of Solferino* (fig. 68), which was exhibited at the Salon of 1864 and was immediately acquired by the Musée du Luxembourg.[5] For the horse in the center of his composition, Degas adapted, in reverse, one of the mounts by Meissonier—an artist he held in derision (dubbing him the "giant of the dwarfs"[6]) but whose knowledge of horsemanship he respected (see "The First Sculptures," p. 137). Furthermore, the Art Institute of Chicago's drawing (cat. no. 70), which has often been related to the Orsay picture and is part of a whole series on the theme of mounted jockeys (L151–L162), was published by Manzi about 1897 with the date of 1866 provided by Degas, who selected the plates and supervised the publication.[7] In addition, there is a letter of 4 January 1869 from Fantin-Latour to Whistler which mentions, on the subject of Degas, that Fantin was then seeing Degas "once or twice a week . . . in the Café des Batignolles"

and had seen "some small racing pictures that are spoken of very highly."[8] Theodore Reff thinks that the works referred to could only be this picture and *The False Start* (fig. 69), but two other possibilities could be added—*At the Racetrack* (L184, Weil Enterprises and Investments, Ltd., Montgomery) and *Racehorses at Longchamp* (cat. no. 96). *Racehorses before the Stands* should therefore presumably be dated 1866–68, somewhat earlier than Lemoisne's proposal of 1869–72.

Degas uses a highly personal technique, mounting paper on canvas—as he often did, starting with the self-portrait in the Clark Art Institute (cat. no. 12)—leaving the paper blank in many places and staining it in

Fig. 68. Ernest Meissonier, *Napoleon III at the Battle of Solferino*, 1863. Oil on panel, 17⅛ × 29⅞ in. (43.5 × 76 cm). Musée National du Château, Compiègne

the darkest parts of the composition. The preparatory drawing, very largely visible, is reworked almost everywhere with a pen; thus, in the architecture of the stands the construction lines, traced in ink, can be clearly distinguished. (For the related *False Start* [fig. 69], he made a pencil drawing of the stands, now in a private collection in New York.)

The use of this technique, as much as the originality of the composition, is responsible for its novelty, and distinguishes it not only from Degas's previous and contemporary racecourse scenes (see cat. no. 70) but also from those by Tissot (*Races at Longchamp*, c. 1866–70), by the lesser-known Olivier Pichat (*Grand Prix de Paris*, Salon of 1866, no. 1545, photographed in the Michelez albums, Musée d'Orsay, Paris), and above all by Manet, who about this time painted his *Races at Longchamp* (1867?, The Art Institute of Chicago) and later the *Races in the Bois de Boulogne* (1872, private collection, New

York), canvases that are basically very different but which, as Moreau-Nélaton has pointed out, owe an undeniable thematic debt to Degas.[9]

It is difficult to know exactly where this scene is set. Contrary to what has often been suggested, Degas does not seem to have placed his races at Longchamp, whose stands, built in 1857 and enlarged in 1863, appear in César Daly's 1868 publication *Revue générale d'architecture*.[10] While the stands in the Orsay picture present an identical structure of cast iron and wood, they also show a central pavilion topped with a turret, which is not to be found at Longchamp; furthermore, the point of view chosen by Degas would mean that the mill and the hills on the other side of the Seine would be visible instead of the improbable smokestacks. Perhaps, then, this is the more popular track at Saint-Ouen. It could also be some provincial racecourse, though the substantial development of the facilities makes this hypothesis somewhat improbable.

Whereas in Manet's racetrack scenes the swarming crowd presses as an indistinct mass of black and gray against the wooden barriers, here the crowd is calmer and thinner, with the dark spots of men's suits rising in tiers to the top of the stands and the scattered white and bluish patches of parasols shading the women in their bright summer dress (see cat. no. 69). Separated from the public by a thin barrier of white wood, seven horsemen, casting broad shadows that indicate it is late in the afternoon, file past under the uniform light of summer or of a warm spring. Their vivid colors—we can recognize only those of Captain Saint-Hubert

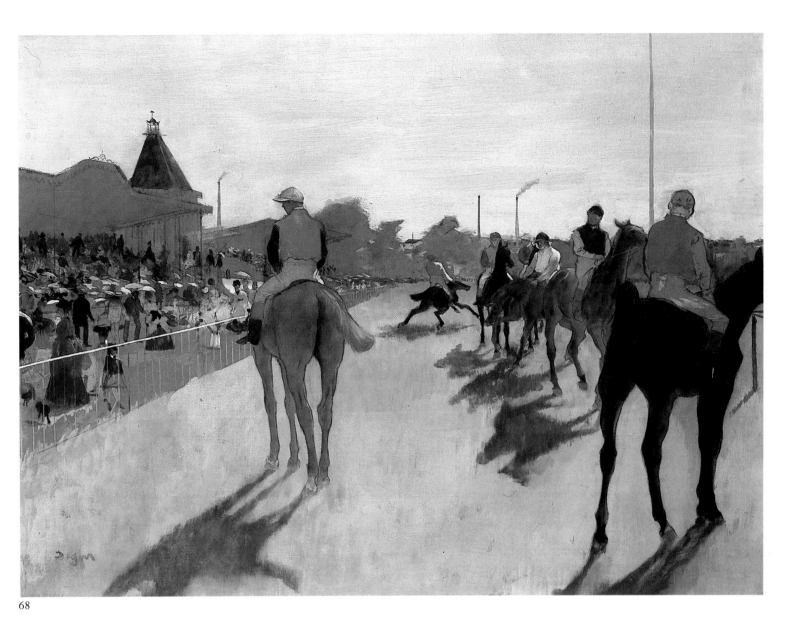

68

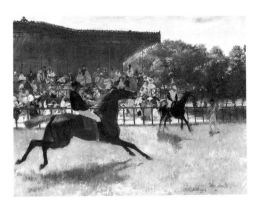

Fig. 69. *The False Start* (L258), 1866–68. Oil on panel, 12⅝ × 15¾ in. (32 × 40 cm). Yale University Art Gallery, New Haven

(yellow, red sleeve, red cap) and of Baron de Rothschild (blue, yellow cap),[11] the others, once again, seemingly fictitious—are muted, due to the use of essence. In this extraordinarily tranquil scene, barely disturbed by a horse rearing before an indifferent public,

there is nothing of the turbulence of Géricault. Nor is there anything of the busy animation described by Zola in a famous passage in *Nana*—nothing of the flurry of elegant dresses, of the "whirlwind of the most lively colors, of the confusion of the most dazzling subtleties"[12] that turn the entire racetrack, as the contemporary *Paris-guide* put it, into "a lively meadow on which one would say Diaz had poured forth his palette."[13]

1. Germain Bazin, *Impressionist Paintings from the Louvre*, London: Thames and Hudson, 1958, p. 190.
2. Lemoisne [1946–49], II, p. 366, no. 649.
3. Reff 1985, Notebook 22 (BN, Carnet 8, pp. 109–17).
4. Ibid.(p. 129); Reff 1971, p. 538, figs. 56–58.
5. Reff 1985, Notebook 22 (BN, Carnet 8, pp. 123, 127), Notebook 23 (BN, Carnet 21, p. 41).
6. Valéry 1949, p. 109; Valéry 1960, p. 69.
7. *Vingt dessins* [1897], no. 7.
8. University Library, Glasgow; letter mentioned in Reff 1985, Notebook 22 (BN, Carnet 8, p. 109).
9. Moreau-Nélaton 1926, I, p. 139.
10. "Longchamp—Hippodrome," XVI, plates 13–18.
11. Information provided by M. Jean Romanet.
12. Émile Zola, *Nana*, Paris: G. Charpentier, 1880, chapter 11.
13. Amédée Achard, *Paris-guide*, pt. 2, Paris, 1867, p. 1236.

PROVENANCE: Jean-Baptiste Faure, Paris, from 1873 or 1874 to 1893; bought by Durand-Ruel, Paris, 2 January 1893 (stock no. 2568), for Fr 10,000; bought by Comte Isaac de Camondo, 18 December 1893, for Fr 30,000; his bequest to the Louvre 1911; exhibited 1914.

EXHIBITIONS: 1968, Amiens, Maison de la Culture, March–April, *Degas aujourd'hui*, no number; 1969 Paris, no. 18.

SELECTED REFERENCES: Mauclair 1903, repr. facing p. 384; Moore 1907–08, repr. p. 105; Jamot 1914, p. 29; Paris, Louvre, Camondo, 1914, no. 165; Lafond 1918–19, II, p. 42; Jamot 1924, pl. 48b; Jamot 1928, pl. 50; Rouart 1945, p. 13; Lemoisne [1946–49], II, no. 262; Reff 1971, p. 538; Minervino 1974, no. 194, pl. XV (color); Reff 1985, Notebook 22 (BN, Carnet 8, pp. 109–17, 129), Notebook 31 (BN, Carnet 23, p. 68); Paris, Louvre and Orsay, Peintures, 1986, III, p. 194, repr.; Sutton 1986, p. 146.

Women before the Stands, study for Racehorses before the Stands

c. 1866–68
Essence and brown wash, heightened with
 white gouache on ochre-colored paper
 prepared with oil
18⅛ × 12⅞ in. (46 × 32.5 cm)
Vente stamp lower left
Cabinet des Dessins, Musée du Louvre (Orsay),
 Paris (RF5602)

Exhibited in Paris

Lemoisne 259

For *Racehorses before the Stands* (cat. no. 68)
and *The False Start* (fig. 69), Degas did this
study and two others (L260, L261) of women
before the stands on large sheets of oiled pa-
per, probably in his studio and using the
same model for all the figures. In the final
pictures, he grouped them differently,
spreading them out and emphasizing the
bright patches of their umbrellas and
springlike dresses. The variety of their ac-
tivities, their apparent indifference to the ap-
proaching race, and the way they are scattered
about on the sand-colored background of
the paper explain why certain authors have
titled the three sketches "Women on the
Beach."

PROVENANCE: Atelier Degas (Vente III, 1919,
no. 153.1); bought at that sale by Marcel Bing, with
no. 153.2, for Fr 3,300; his bequest to the Louvre
1922.

EXHIBITIONS: 1935, Kunsthalle Basel, 29 June–18 Au-
gust, *Meisterzeichnungen französischer Künstler von Ingres
bis Cézanne*, no. 160; 1969 Paris, no. 158; 1979 Edin-
burgh, no. 1, repr.

SELECTED REFERENCES: Rivière 1922–23, II, pl. 65; Le-
moisne [1946–49], II, no. 259; Leymarie 1947, no. 19,
pl. XIX; Minervino 1974, no. 195.

Four Studies of a Jockey, study for Racehorses before the Stands

1866
Essence heightened with white gouache on
 brown paper
17¾ × 12⅜ in. (45 × 31.5 cm)
Vente stamp lower left
The Art Institute of Chicago. Mr. and Mrs.
 Lewis Larned Coburn Memorial Collection
 (1933.469)

Exhibited in Ottawa and New York

Lemoisne 158

See cat. no. 68

PROVENANCE: Atelier Degas (Vente III, 1919, no. 114.1);
bought at that sale by Fiquet, Paris, with nos. 114.2
and 114.3, for Fr 3,050; with Nunès, Paris; Mr. and
Mrs. Lewis Larned Coburn, Chicago; their gift to
the museum 1933.

EXHIBITIONS: 1939, Seattle; 1946, The Art Institute of
Chicago, *Drawings Old and New*, no. 15, repr.; 1947
Cleveland, no. 63, pl. LII; 1958 Los Angeles, no. 16;
1963, New York, Wildenstein Gallery, 17 October–
30 November, *Master Drawings from the Art Institute of
Chicago*, no. 103; 1967 Saint Louis, no. 46; 1974,
Palm Beach, Society of Four Arts, *Drawings from the
Art Institute of Chicago*, no. 10, repr.; 1976–77, Paris,

69

70

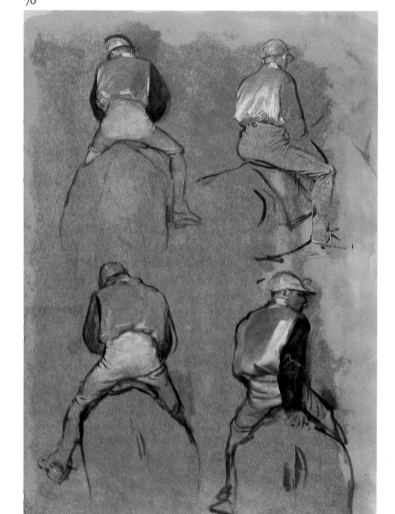

Cabinet des Dessins, Musée du Louvre, 16 October 1976–17 January 1977, *Dessins français du XVIIIe au XXe siècle de l'Art Institute of Chicago de Watteau à Picasso*, no. 58, repr.; 1977, Frankfurt, Städtische Galerie, 10 February–10 April, *Französische Zeichnungen aus dem Art Institute of Chicago*, no. 59, repr.; 1984 Chicago, no. 17, repr. (color).

SELECTED REFERENCES: Vingt dessins [1897], pl. 7; Lemoisne 1912, pp. 35–36, repr. (detail); Lemoisne [1946–49], II, no. 158; Agnes Mongan, *French Drawings*, Great Drawings of All Times, III, New York: Sherwood Press, 1962, no. 778, repr.; Minervino 1974, no. 186; The Art Institute of Chicago, *100 Masterpieces*, Chicago, 1978, III, repr.

71.

Portrait of a Man

c. 1866
Oil on canvas, with strip of canvas at bottom
33½ × 25⅝ in. (85 × 65 cm)
Vente stamp lower right
The Brooklyn Museum, Museum Collection
 Fund, New York (21.112)

Lemoisne 145

Ever since its appearance at the first atelier sale, this portrait has baffled viewers because of the sitter's odd physiognomy and the strangeness of the setting. Expected to sell for Fr 10,000, the canvas was sold for only Fr 6,500, to Vollard, Bernheim-Jeune, Durand-Ruel, and Seligmann, who had made an agreement to buy a number of works together. The sitter remains unidentified. Agreement cannot even be reached on a simple description of the setting or the objects surrounding him: on the table covered with a white cloth, an opulent dish of trotters and sausage, a pear, and probably a glass; on the wall, a white canvas partially covered with oil sketches, framed by a wide strip of dark wood and half hidden by a white veil; on the floor, on a wooden board, cuts of meat (some observers have seen a woman's hat there) in which the white of the fat and the dark red of the eye are distinctly visible.

The nature and disposition of these accessories belie the notion of a guest at table in a restaurant or of a middle-class gentleman who has strayed into a butcher shop. Quite clearly, then, we are in a painter's studio: the pieces of meat are for still lifes, very cursory red-and-white sketches of which can be found on the wall, and the host of these premises is some Realist artist or perhaps some critic who has recommended the study of these bloody subjects. Unfortunately, we cannot attach a name to the extraordinary face, with its low forehead and large nose, half in shadow.

Degas plays on the incongruity of this figure, in his very bourgeois attire, calmly

71

sitting with these pieces of meat, and underscores the strangeness—today, we would say the surrealism—of the trotters and sausage combined with a pear and perhaps a glass forming a little picture finely painted on a white ground of studio drapery. It is also an opportunity for him to work in a reduced and subtle harmony of browns and blacks, as he often does, but also of whites and reds, thus heralding the later, almost two-tone experiments of *After the Bath* (cat. no. 342) and *The Coiffure* (cat. no. 345).

PROVENANCE: Atelier Degas (Vente I, 1918, no. 36); bought at that sale by Vollard, Bernheim-Jeune, Durand-Ruel, Seligmann, for Fr 6,500 (Seligmann sale, American Art Association, New York, 27 February 1921, no. 35, for $1,750); bought at that sale by the museum.

EXHIBITIONS: 1921, New York, The Brooklyn Museum, 26 March–24 April, *Paintings by Modern French Masters*, no. 72; 1922–23, New York, The Brooklyn Museum, 29 November 1922–2 January 1923, *Paintings by Contemporary English and French Painters*, no. 159; 1947 Cleveland, no. 6, pl. V; 1953–54 New Orleans, no. 72; 1967–68, New York, The Brooklyn Museum, 3 October–19 November/Richmond, Virginia Museum of Fine Arts, 11 December 1967–19 January 1968/San Francisco, California Palace of the Legion of Honor, 17 February–31 March, *The Triumph of Realism*, no. 6, repr.; 1978 New York, no. 5, repr. (color); 1980–82, Cleveland Museum of Art, 12 November 1980–18 January 1981/New York, The Brooklyn Museum, 7 March–10 May/Saint Louis Art Museum, 23 July–20 September/Glasgow Art Gallery and Art Museum, 5 November 1981–4 January 1982, *The Realist Tradition*, no. 149, repr. (color).

SELECTED REFERENCES: Lemoisne [1946–49], II, no. 145; Minervino 1974, no. 222.

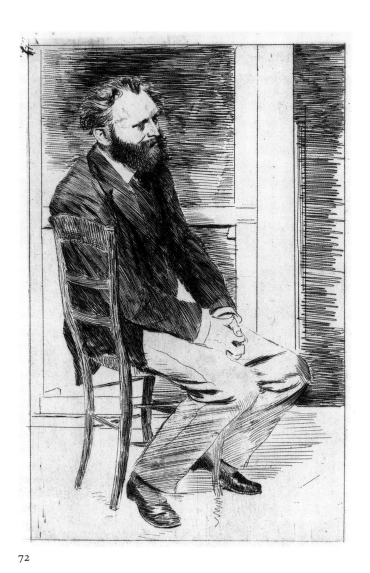

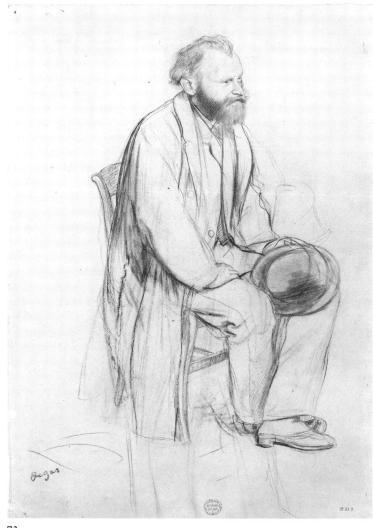

72

73

72.

Édouard Manet Seated, Turned to the Right

c. 1866–68
Etching on off-white wove paper, first state
11¾ × 8⅝ in. (29.8 × 21.8 cm)
National Gallery of Canada, Ottawa (9487)

Reed and Shapiro 18.I

A few years after meeting him in the Louvre (see cat. no. 82), Degas drew three portraits of Manet in preparation for three etchings, two of which show him sitting on a chair, the other half-length. In the drawing in New York (cat. no. 73), the painter of *Olympia* looks as if he is on a visit and has sat down for only a minute (still wearing his overcoat and holding his hat) in what we know is an artist's studio. The generally suggested dating of 1864–65 seems a little early for this drawing; it should probably be placed closer to later studies for the portrait of James Tissot (cat. no. 75) because of the comparable pose, the identical circumstances, the fine,

keen line, and the use of the stump for accents. It was probably drawn during the years 1866–68, which correspond, as far as we know, to the period when the friendship between the two painters was closest and when Degas was preoccupied with a series of portraits of artists, beginning timidly with the small painted likeness of Gustave Moreau (L178, Musée Gustave Moreau, Paris).

The etching exhibited here, which was preceded also by a pencil drawing now in a private collection in Paris, shows a calmer, more thoughtful Manet. He has thrown off his overcoat. Beginning with the second state—this is the first—the top hat he previously held between his fingers can be seen lying on the ground. The interior of the studio, not visible in the drawing, is now carefully indicated by a large frame resting against the wall, forming a flat background of verticals and horizontals against which Manet is drawn somewhat askew, his apparent lassitude and his tilt contrasting with the geometric severity of the background. The large number of impressions made of

this etching (we know of forty from the four successive states) proves that Degas was satisfied with this portrait of his infamous colleague and was eager to have it distributed. It also represents part of his noteworthy contribution to the revival of original printmaking in the 1860s, although greater contributions were actually made by friends of his from this period—Bracquemond, Legros, Fantin-Latour, Whistler, and Manet. Degas was not even a member of the Société des Aquafortistes, founded in August 1861. Nevertheless, he produced a few sporadic masterpieces using this technique, then considered a minor art.

PROVENANCE: Charles B. Eddy, New York (sale, Kornfeld und Klipstein, Bern, 9–10 June 1961, no. 194, repr. frontispiece); William H. Schab, New York; bought by the museum 1962.

EXHIBITIONS: 1979–80 Ottawa.

SELECTED REFERENCES: Delteil 1919, no. 16; Adhémar 1974, no. 19; Reed and Shapiro 1984–85, no. 18, pp. xix–xx.

73.

Édouard Manet Seated

c. 1866–68
Black chalk on off-white wove paper
13 × 9 in. (33.1 × 23 cm)
Vente stamp lower left
The Metropolitan Museum of Art, New York.
 Rogers Fund (1918.19.51.7)

Vente II:210.2

Study for cat. no. 72

PROVENANCE: Atelier Degas (Vente II, 1918, no. 210.2); bought at that sale through Jacques Seligmann, with nos. 210.1 and 210.3, for the museum, with the aid of the Rogers Fund, for Fr 4,000.

EXHIBITIONS: 1936, New London, Conn., Lyman Allyn Museum, 2 March–15 April, *Drawings*, no. 155; 1955 Paris, Orangerie, no. 67, repr.; 1973–74 Paris, no. 27, pl. 56; 1977 New York, no. 8 of works on paper; 1984–85 Boston, no. 17.a, repr.

SELECTED REFERENCES: Burroughs 1919, pp. 115–16, repr.; Jacob Bean, *100 European Drawings in The Metropolitan Museum of Art*, New York: The Metropolitan Museum of Art, 1964, no. 75.

74.

Young Woman with Field Glasses

1866
Essence on pink paper
11 × 9 in. (28 × 22.7 cm)
Vente stamp lower right
Trustees of the British Museum, London
 (1968-2-10-26)

Exhibited in Paris

Lemoisne 179

This drawing of a young woman at the racetrack looking through her binoculars is clearly a prototype for three other drawings Degas made in the 1870s of a slimmer young woman wearing a hat of the period tilted down over her forehead (cat. no. 154; fig. 131; L269, private collection, Switzerland). These three drawings were undoubtedly related, if only as afterthoughts, to the production of the painting *At the Racetrack* (L184, Weil Enterprises and Investments, Ltd., Montgomery), over which Degas was to suffer such anxieties and where he would paint out the young woman.[1]

The drawing has a youthful tenderness, although the concept of the figure's looking directly at us through her binoculars has great daring. Even more than in the later works, Degas emphasized the field glasses that make possible the magnifying of her vision, which in itself must have fascinated him. But he did not ignore the young woman, whose simple loose jacket and skirt proba- bly conceal a pregnant body. Under her soft hat, which is placed back on her head, the long twisted curl that falls over her shoulder is reminiscent of a drawing Jeanne Fevre published of her mother, the painter's sister Marguerite De Gas Fevre, with a similar curl.[2] There is a note on that drawing that she was dressed for a costume ball one or two years before her marriage, which took place in June 1865. It is not impossible that sometime in 1866, pregnant with her first daughter, Célestine, Marguerite might have posed for her brother.

Degas drew the model very gently, in particular using a little pink wash on the lower lip to give the expressive mouth a hint of color. He also brushed in to the right of her head some pink that would originally have been rose, as one can see from the edge of the drawing. The pink smudge in any case draws us to the round eyes of the bin- oculars, which are also emphasized by the black used in the drawing of the glasses and the hands, whereas the rest of the lines are dark brown. Degas used some white on the top of the hat, a faint white wash on the forehead, and an even thinner white on the rest of the face—all handled with refinement and sensitivity.

The young woman is undoubtedly a first thought of what Degas would eventually plan as a complex racecourse composition. She is barely detectable in the Metropoli- tan's pencil drawing of a jaunty Édouard Manet (II:210.3), in which the horses are presumably the object of her attention as she is the object of his. Faintly drawn and placed back in what could be regarded as a protected position in the Metropolitan's drawing, or gently restrained and feminine in this draw- ing, she does not seem to symbolize the power that Eunice Lipton has seen in her successors.[3]

JSB

74

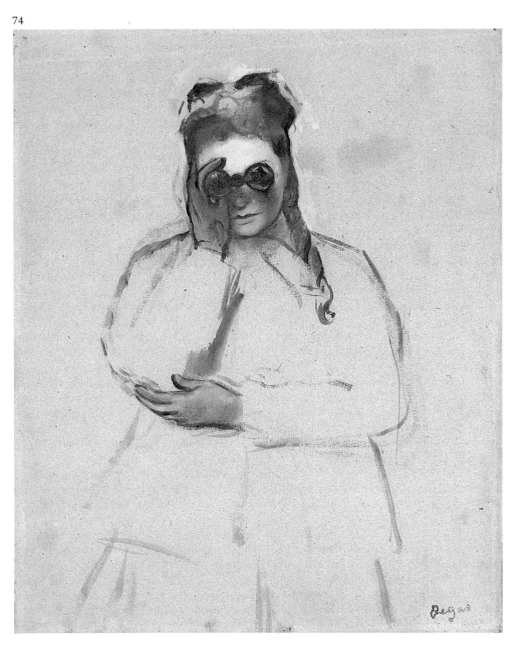

1. See Ronald Pickvance on the history of this work in 1979 Edinburgh, no. 10, p. 14, pl. 2 (color) p. 34.
2. Fevre 1949, facing p. 81.
3. Lipton 1986, pp. 66, 68.

PROVENANCE: Atelier Degas (Vente IV, 1919, no. 261.c); bought at that sale by Marcel Guérin; César M. de Hauke, Paris and New York; his bequest to the museum 1968.

EXHIBITIONS: 1936 Philadelphia, no. 81, repr.; 1979 Edinburgh, no. 3; 1984 Tübingen, no. 60.

SELECTED REFERENCES: Lemoisne 1931, p. 289, pl. 59; Mongan 1938, p. 295; Rouart 1945, p. 71 n. 29; Lemoisne [1946–49], II, no. 179; Benedict Nicolson, "The Recovery of a Degas Race Course Scene," Burlington Magazine, CII:693, December 1960, pp. 536–37; 1967 Saint Louis, under no. 55; Minervino 1974, no. 232; Thomson 1979, p. 677.

75.

James Tissot

1867–68
Oil on two pieces of canvas
59½ × 44⅛ in. (151 × 112 cm)
Vente stamp lower right
The Metropolitan Museum of Art, New York. Rogers Fund (1939.39.161)

Lemoisne 175

Little is known of the origins of what seems to us the unexpected friendship between Degas and Tissot. Tissot had not, however, always been the "plagiarist painter" whom the Goncourts began denouncing in 1874.[1] In the 1860s, he not only shared certain tastes with Degas, but brought to French painting of the time, in both his history compositions and his portraits, a new note, original solutions (even if the influence of the Belgian Henri Leys was overly evident), and a skillful mixture, which we may now find somewhat adulterated, of respect for tradition and attention to the fashions of the moment. At nineteen years of age, Tissot left his native Nantes and advanced on Paris; he became a student of Lamothe's, as Degas had been a little earlier, and enrolled in the École des Beaux-Arts. If their paths crossed at that time, it could only have been very briefly in Lamothe's class: Tissot's name does not appear in Degas's notebooks of the period, nor is there any record of Degas's having mentioned him during his three-year sojourn in Italy.

They became acquainted in the early 1860s, possibly through Élie Delaunay, also a native of Nantes, who returned to Paris in January 1862 after spending five years in Rome. The first evidence of their friendship is a long letter[2] that Tissot wrote to Degas from Venice during his Italian trip in late 1862. This letter, which is important for the dating of Semiramis (cat. no. 29), also shows that the two artists were already friendly: Tissot was following Degas's work as well as the progress of his love affairs, about which he inquires with labored innuendo. Tissot's fine education, his charming manners, and their common taste for fifteenth-century Italian painters sealed a friendship that would last about fifteen years. It has been said by many that Degas broke with Tissot on learning that he had sided with the Communards in 1871, but the letters (now in the Bibliothèque Nationale, Paris) that Degas sent to him between 1871 and 1874 in London, where Tissot had gone into exile, prove that this was not the case; Degas at that time must have known the reasons for his friend's flight.

The notebooks used by Degas in the early 1860s show his interest in the work of the young Tissot: partial copies, no doubt done from memory, of The Dance of Death (Salon of 1861; Museum of Art, Rhode Island School of Design, Providence) and of A Walk in the Snow (1858; Salon of 1859),[3] and studies for compositions in the manner of Tissot.[4] In portrait painting, the two artists often used the same formula, inherited from Ingres, of the portrait in an interior. However, in Tissot's case it is accomplished with a meticulousness, a taste for the anecdotal, a stylishness, and a porcelain-like surface that we do not find in the work of Degas, which is spacious, more powerful, and more meaningful—in short, it possesses the very qualities that distinguish a series of pleasant, mundane canvases from an uninterrupted flow of masterpieces.

Generally dated between 1866 and 1868,[5] this large portrait—apart from The Bellelli Family (cat. no. 20), it is the largest of the portraits Degas painted in the 1860s—was preceded by three detailed drawings of Tissot: a single sheet with two studies of his head (III:158.2, private collection), and two full-length studies on separate sheets, one showing him in a position similar to that in the final work (III:158.3), and the other a quick sketch giving the general plan of the composition (III:158.1, Fogg Art Museum, Cambridge, Mass.).

Tissot is at the center of the canvas, a bit weary and apathetic, elegant, toying with his stick, sitting down for just a moment, a visitor (note the hat and overcoat) in a studio that is neither his nor that of any other particular painter. The black top hat placed against a brightly colored painting and the carelessly deposited overcoat here serve in place of the usual studio hangings. Contrasting with the deliberate nonchalance of both the man and his possessions is the rigidity of the frames and stretchers, which (as in Poussin's Self-Portrait in the Louvre) provide

the setting for the sitter. Theodore Reff has assiduously identified the works decorating this studio: behind Tissot, the only fully legible work, Cranach's portrait of Frederick the Wise (Frederick III); at the top, a long composition on a Japanese theme; on the table, a canvas that seems to portray some women in contemporary costume under trees with thick, brightly lit trunks; finally, on the easel, a fragment of an outdoor scene that appears to be a Finding of Moses.

For his portrait of Frederick the Wise, Degas surely reproduced, from among the many known copies, the one in the Louvre, which had been part of Napoleon's booty. He does not present it as a copy, however, but as an original in its old wide frame hung in the place of honor; to make it more conspicuous, he enlarges it appreciably (the panel in the Louvre measures 5⅛ by 5½ inches, or 13 by 14 centimeters). He had shown his interest in Cranach earlier, when in a brief entry in a notebook used between 1859 and 1864, he imagined "a portrait of a lady with a hat extending to her waist," making it "the size of the Cranach" and seeing it in a "supple color scale, bright, as tightly drawn as possible."[7] The canvas with the Japanese theme is perhaps a Western transcription of a makimono scroll (magazines like Tour du Monde were publishing some very free adaptations of Japanese works as faithfully engraved reproductions) or more probably a Japanese-inspired invention in the manner of Tissot or Stevens. In any case, of all the works in this studio, it is the only one that might be by Tissot. It is difficult to connect any names with the two outdoor scenes (they seem the work of two different painters), and especially so with the Moses, which is more fragmentary and less legible. Perhaps, as Reff believes, the biblical scene is a reference to the interest Degas and Tissot shared in sixteenth- and seventeenth-century Venetian painting, which often treated this subject. It is even more likely that there is a connection between the silhouette of Pharaoh's daughter and the figure of Mlle Fiocre in the Brooklyn Museum's painting (cat. no. 77): the similarity in their situations (standing over a river in one case, a spring in the other) and their poses is striking, and suggests that the two pictures were done very close together in time, in 1867–68.

The portrait of Tissot is ambiguous, as was the man himself—he seemed to Edmond de Goncourt (much later, it is true) "a complex creature, half mystic and half trickster."[8] The painter is in a studio, but unlike Henri Michel-Lévy (L326, Calouste Gulbenkian Museum, Lisbon) he is not at work; he is in bourgeois attire, like Manet, Moreau, or Valernes, but unlike them he is surrounded by canvases that reveal his profession as well as

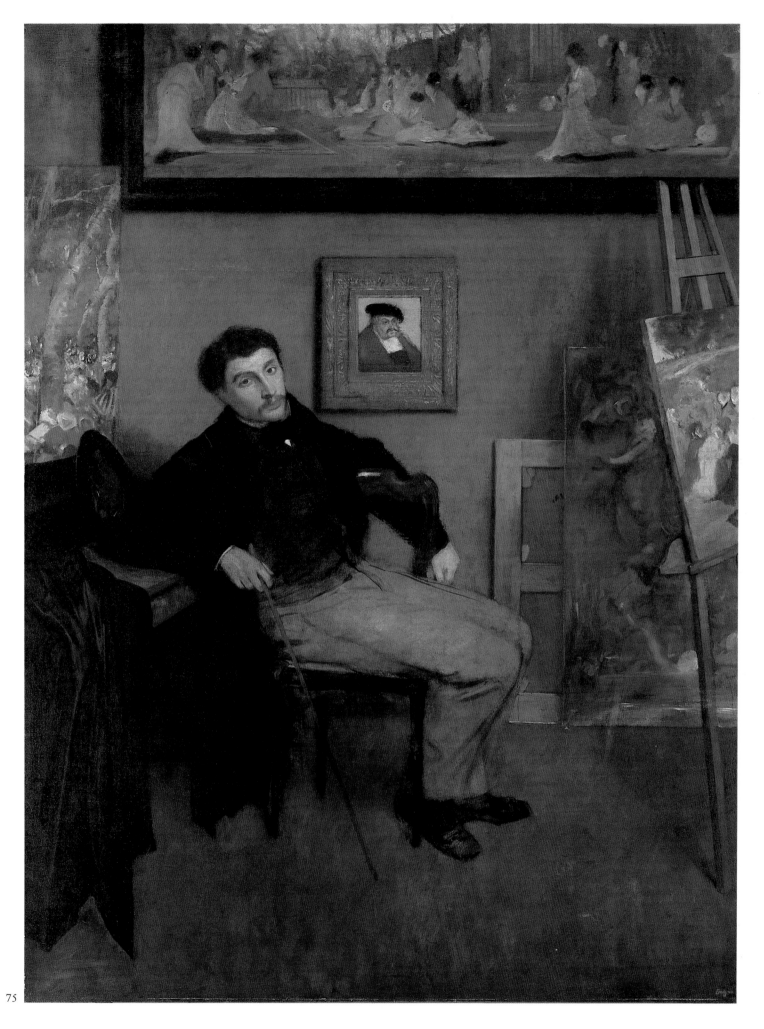

75

his tastes. The portrait of Frederick the Wise—the protector, it should be noted, of Luther, who figured in a work by Tissot at the 1861 Salon, *Martin Luther's Doubts* (Art Gallery of Hamilton)—alludes to the interest Degas and Tissot shared in sixteenth-century German painting, and more particularly to the subjects Tissot in the 1860s increasingly chose from German history. The "Japanese" canvas emphasizes Tissot's enthusiasm for Japanese art, of which he was one of the first collectors. The outdoor scenes would be evidence of his interest in the work of artists such as Manet and Monet. The five canvases surrounding Tissot may also be seen as samples of the genres in which he was achieving success—portraiture, exotic compositions, outdoor scenes, history painting. But the eclecticism of his gifts cannot mask the precariousness of his situation. Here we see Tissot before us, perfectly at ease, it is true, but in an unstable position. Although earning a handsome livelihood and residing in a town house on the avenue de l'Impératrice, he is no longer an innovative artist but has become a fashionable painter. Degas captures him at this pivotal moment in his career, treating him with curiosity and sympathy, but also with a touch of envy and some irony. Perhaps the big "Japanese" canvas, a simple picturesque variation on an Oriental theme—everything that Degas detested—is there to remind us of the danger of yielding in a facile way to exotic reference, which was to be Tissot's normal style of painting to the end of his days. For the moment, Degas is amused by the nonchalance of the painter who has "arrived," but he is not duped; the severe countenance of the Lutheran prince, which repeats that of the Parisian dandy like a Renaissance echo, is not simply a subtle reminder of Tissot's tastes, but also a warning.

1. Journal Goncourt 1956, II, p. 1001.
2. Lemoisne [1946–49], I, pp. 230–31, n. 45.
3. Reff 1985, Notebook 18 (BN, Carnet 1, p. 109).
4. Ibid. (pp. 11, 133, 183).
5. It is dated 1866 in Boggs 1962, p. 32; 1868 in Lemoisne [1946–49], II, no. 175; 1866–68 in Reff 1976, p. 103.
6. Reff 1985, Notebook 21 (private collection, p. 6).
7. Reff 1985, Notebook 18 (BN, Carnet 1, p. 194).
8. Journal Goncourt 1956, III, p. 1112.

PROVENANCE: Atelier Degas (Vente I, 1918, no. 37 [as "Portrait d'homme dans un atelier de peintre"]); bought at that sale by Jos Hessel, Paris, for Fr 25,700; deposited with Durand-Ruel, Paris, 14 March 1921 (deposit no. 12384); bought by Durand-Ruel, New York, 28 April 1921 (stock no. N.Y. 8087); bought by Adolph Lewisohn, New York, 6 April 1922, for $1,400; Jacques Seligmann, New York, 1939; acquired by the museum 1939.

EXHIBITIONS: 1931 Cambridge, Mass., no. 3; 1931, New York, The Century Association; 1936, Cleveland Museum of Art, 26 June–4 October, *Twentieth Anniversary Exhibition*, no. 268, repr.; 1937 New York, no. 2, repr.; 1938 New York, no. 9; 1941 New York, no. 34, fig. 40; 1951, New York, The Metropolitan Museum of Art, 2 November–2 December, *The Lewisohn Collection*, no. 22, repr. p. 33; 1960 New York, no. 14, repr.; 1968, Providence, Rhode Island School of Design, 28 February–29 March/Toronto, The Art Gallery of Ontario, 6 April–5 May, *James Jacques Joseph Tissot 1836–1902*, no number, repr. frontispiece; 1972, New York, The Metropolitan Museum of Art, 18 January–7 March, *Portrait of the Artist*, no. 22; 1974–75 Paris, no. 11, repr. (color); 1977 New York, no. 6 of paintings.

SELECTED REFERENCES: *Renaissance de l'art français*, I, 1918, p. 146; Lafond 1918–19, II, p. 15; Stephan Bourgeois, *The Adolph Lewisohn Collection of Modern French Paintings and Sculptures*, New York: E. Weyhe, 1928, pp. 98ff., repr.; Louise Burroughs, "A Portrait of James Tissot by Degas," *Metropolitan Museum Bulletin*, XXXVI, 1941, pp. 35–38, repr. cover; Lemoisne [1946–49], I, pp. 56, 240, II, no. 175; Boggs 1962, pp. 23, 32, 54, 57, 59, 106, 131, pl. 46; New York, Metropolitan, 1967, pp. 62–64, repr.; Minervino 1974, no. 240; Reff 1976, pp. 28, 90, 101–10, 138, 144, 145, 223–24, pl. 68 (color), figs. 69, 71, 73, 75 (detail); Moffett 1979, pp. 7–8, pl. 9 (color); Michael Wentworth, *James Tissot*, Oxford: Clarendon Press, 1984, pp. xv, 49, 59, pl. 37; 1985, Paris, Petit Palais, 5 April–30 June, *Tissot*, pp. 43–44; 1987 Manchester, pp. 26–27, repr.

76.

Julie Burtey (?)

c. 1867
Pencil heightened with white on off-white wove paper
14¼ × 10¾ in. (36.1 × 27.2 cm)
Inscribed in black crayon upper right: Mme Julie Burtey [?]
Vente stamp lower left; atelier stamp on verso
Harvard University Art Museums (Fogg Art Museum), Cambridge, Massachusetts. Bequest of Meta and Paul J. Sachs (1965.254)

Vente II:347

It was probably in the 1890s, in putting his drawings in order, that Degas most conscientiously added the name of the sitter to this study for a painting now in Richmond (fig. 70). But the handwriting is partly illegible, and the young woman's name has, since 1918, been read in so many different ways as to produce a comic collection of misnomers. The inventory drawn up after Degas's death (Durand-Ruel archives, Paris) mentions a "Julie Burty"; the catalogue of the atelier sale has her as "Julie Burtin," the most widely adopted version of the name; an inscription, not by Degas, on a study of the head alone in the Clark Art Institute, Williamstown (III:304), reads "Mme Jules Bertin"; and in addition to "Burley" there is also the "Lucie Burtin" invented in the catalogue for the Degas exhibition of 1924.[1]

Theodore Reff has proposed the most likely identification, that of Julie Burtey, a dressmaker whose address, according to the Paris street directory for 1864–66, was 2 rue Basse-du-Rempart, in the Ninth Arrondissement, near the Opéra.[2] Three other studies for *Julie Burtey* are contained in a notebook used between 1867 and 1874, which also includes studies for *Mme Gaujelin* (fig. 25), *James Tissot* (cat. no. 75), and *Interior* (cat. no. 84).[3] This notebook, which is consistent in style, was definitely not used before 1867, apart from a drawing dated 1861, which was obviously pasted in later.[4] The date 1863 inscribed by Degas on the Williamstown drawing would therefore seem to be inexplicable. We must assume either that the notebook was used partly in 1863 and then set aside for four or five years, or that the artist put an incorrect date on the

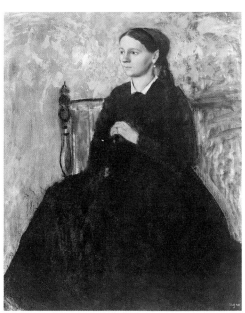

Fig. 70. *Julie Burtey* (?) (L108), c. 1867. Oil on canvas, 28¾ × 23½ in. (73 × 59.7 cm). Virginia Museum of Fine Arts, Richmond

Williamstown drawing later on, as he often did. The latter explanation seems the more reasonable: the beautiful Cambridge study is very similar, for example, to sketches for the portrait of Victoria Dubourg (cat. no. 83)—in the description of the clothing, the details of the hands, and the shadows on the face. The lines Degas uses here are more accentuated and forceful, deliberately harder and sharper than in the drawings of the early 1860s. The simple placing of the sitter, the stiffness of her bearing against a background of very rapidly drawn verticals and horizontals, the absence of any setting other than a tawdry "period" chair, the precision of the

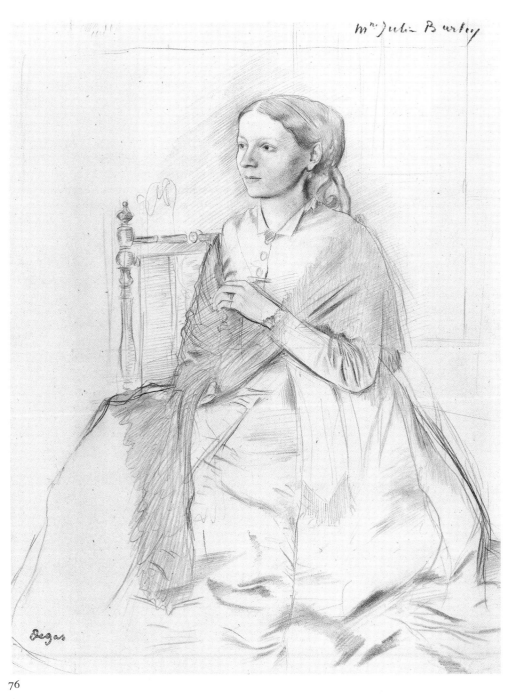

Mʳᵉ Julie Burtin

Degas

76

of Honor, 8 March–6 April, *19th Century French Drawings*, no. 87; 1948 Minneapolis, no number; 1951, Detroit Institute of Arts, 15 May–30 September, *French Drawings from the Fogg Museum of Art*, no. 33; 1952, Richmond, Virginia Museum of Fine Arts, *French Drawings from the Fogg Art Museum*; 1956, Waterville, Me., Colby College, hors catalogue; 1958 Los Angeles, no. 13, repr.; 1958–59 Rotterdam, no. 160, pl. 155; 1961, Cambridge, Mass., Fogg Art Museum, 24 April–20 May, *Ingres and Degas: Two Classical Draughtsmen*, no. 4; 1965–67 Cambridge, Mass., no. 55, repr.; 1966, South Hadley, Mass., Mount Holyoke College; 1967 Saint Louis, no. 47, repr.; 1970 Williamstown, no. 17, repr.; 1974 Boston, no. 73; 1979, Tokyo, National Museum of Western Art, *European Master Drawings from the Fogg Art Museum*, no. 89; 1984 Tübingen, no. 55, repr.

SELECTED REFERENCES: Rivière 1922–23, pl. 56; Mongan 1932, pp. 64–65, repr. cover; Cambridge, Mass., Fogg, 1940, I, no. 663, III, pl. 339; Lassaigne 1945, p. 6, repr.; Lemoisne [1946–49], II, under no. 108; Degas Letters 1947, pl. 6 facing p. 48; R. Schwabe, *Degas: The Draughtsman*, London: Art Trade Press, 1948, p. 8, repr.; James Watrous, *The Craft of Old-Master Drawings*, Madison: University of Wisconsin Press, 1957, pp. 144–45, repr.; Rosenberg 1959, p. 108, pl. 201; Boggs 1962, pp. 17–18, III, pl. 35; Williamstown, Clark, 1964, pl. 62 p. 80; Reff 1965, p. 613 n. 88; Gabriel Weisberg, *The Realist Tradition: French Painting and Drawing 1830–1900*, Cleveland Museum of Art, 1981, pp. 30ff., pl. 50.

77.

Mlle Fiocre in the Ballet "La Source"

1867–68
Oil on canvas
51⅛ × 57⅛ in. (130 × 145 cm)
The Brooklyn Museum, New York. Gift of A. Augustus Healy, James H. Post, and John T. Underwood (21.111)

Lemoisne 146

This work is often mistakenly regarded as Degas's first painting of the ballet. It is in fact a problematic masterpiece that is difficult to classify. It is important to keep in mind the rather enigmatic title under which this work was exhibited at the Salon of 1868: "Portrait de Mlle E. F. . . ; à propos du ballet de la Source." Although the phrase "à propos de" (in connection with) is difficult to interpret, the subject is easy to discern: a break in a rehearsal of the ballet (and not, as is ordinarily claimed, a moment of rest during the actual performance). *La Source*, in three acts and four scenes, with libretto by Charles Nuitter and Saint-Léon, choreography by Saint-Léon, and music by Ludwig Minkus and Léo Delibes, opened in Paris on 12 November 1866. Ingres and Verdi, among others, attended the particularly brilliant dress rehearsal.[1] The ballet was a great success; on 5 January 1875, an excerpt was chosen

contours, the lack of affectation—all these ingredients give it a primitive purity and elegance which, even more than in the works of Ingres, are reminiscent of sixteenth-century pencil drawings.

1. 1924 Paris, no. 81.
2. Reff 1985, Notebook 22 (BN, Carnet 8, p. 37).
3. Ibid. (pp. 37, 39, 41).
4. Ibid. (p. 9).

PROVENANCE: Atelier Degas (Vente II, 1918, no. 347 [as "Femme assise dans un fauteuil. Étude pour le portrait de Mme Julie Burtin"]); bought at that sale by Reginald Davis, Paris, for Fr 5,500. Mme Demotte collection, Paris, 1924; bought by Paul J. Sachs, Cambridge, Mass., 3 July 1928, to 1965; Meta and Paul J. Sachs bequest to the museum 1965.

EXHIBITIONS: 1924 Paris, no. 81 (as "Lucie Burtin"); 1929 Cambridge, Mass., no. 32; 1930, New York, Jacques Seligmann and Co., 30 October–8 November, *Drawings by Degas*, no. 17; 1935 Boston, no. 119; 1935, Buffalo, Albright Art Gallery, January, *Master Drawings*, no. 114; 1936 Philadelphia, no. 64, repr.; 1937 Paris, Orangerie, no. 69, pl. IV; 1939, New York, Brooklyn Institute of Arts and Sciences Museum, *Great Modern French Drawings*; 1940, Washington, D.C., Phillips Memorial Gallery, 7 April–1 May, *Great Modern Drawings*, no. 16; 1941, Detroit Institute of Arts, 1 May–1 June, *Masterpieces of 19th and 20th Century Drawings*, no. 16; 1945, New York, Buchholz Gallery, 3–27 January, *Edgar Degas*, no. 57; 1946, Wellesley, Farnsworth Art Museum, 16 February–10 March, *Drawings by Degas*; 1947, New York, Century Club, 19 February–10 April, *Loan Exhibition*; 1947, San Francisco, California Palace of the Legion

133

for performance at the inaugural celebration of the new Opéra, the Palais Garnier. Its tale of the hunter Djémil's love for the cruel and unapproachable Nouredda, a beautiful Georgian woman, provided the pretext for an Oriental as well as magical theme, and the ballet was a showcase for the talents of its two female protagonists, Fiocre as Nouredda and Salvioni as Naïla the sacrificial nymph.

Though much about the canvas has already been well documented—the dating is fixed, since the painting was submitted to the Salon of 1868 and the ballet had opened a year and a half earlier, and there are numerous preliminary studies to shed light on its development—Degas's purpose in painting it has remained an enigma. Newly discovered documents suggest a possible explanation.

The first, very sketchy, compositional studies are found in a notebook in the Louvre[2] and in another notebook in a private collection;[3] both already indicate what was to be the final composition, with the single, notable difference of an attendant inserted between the ballerina and the drinking horse. Several pencil studies of Fiocre follow. The first (IV:102, private collection, New York) shows the dancer in informal dress rather than in costume, and without the tiara that she wears in the painting. A second study, published here for the first time (fig. 71), given by Degas to the model and kept by her descendants, shows her in precisely the same pose, but wearing her stage costume. This study is dated 3 August 1867 and therefore helps establish the time in which the work was painted: between August 1867 and April 1868 (it was shown at the Salon from 1 May). About the same time, Degas made a study of the dancer's head (fig. 72), which he signed and dated

August 1867 and gave to her as well.

These studies were preceded by two portraits of the dancer made from photographs. Members of her family recognized the portraits and bought them at the atelier sale after Degas's death (L129 [identified in Minervino 1974, no. 212] and IV:96.b [fig. 73]). Before beginning to work in oil, Degas again sketched the attendant on the left playing the gusla (IV:79.a, The Art Institute of Chicago) and the attendant crouched near the water (IV:77.a, IV:79.b), from which (perhaps later, as Daniel Halévy believed) he made the beautiful detail of the foot she is wiping, in pastel (IV:18).

As in *Semiramis* (cat. no. 29), and following Ingres's method, Degas then painted, on a slightly reduced scale, a study (cat. no. 78) of the nude figures of Fiocre and the seated attendant, but putting them closer together and giving them the same features—those of the model who posed in the studio. For the horse drinking, he made use of a wax statuette that was one of his first works of sculpture (cat. no. 79). As he later told Ernest Rouart, he continued painting the final canvas right up to the eve of the Salon (the same thing had happened the year before). At the last minute, the artist applied a coat of varnish to the still wet paint; he was not pleased and later had the varnish removed. It was "a disaster," to quote Rouart.

Naturally, in removing the varnish, half the paint was removed. So as not to destroy the whole thing, the work had to be left unfinished. The canvas sat like that in a corner of the studio for years. It was only much later (between 1892 and 1895, I believe) that Degas came across the picture and got it into his head to work on it

some more. He engaged a restorer who succeeded, more or less, in removing what remained of the varnish and who gave instructions for retouching it and repairing the damage Degas had done to his own painting. He was only half satisfied with the result.[4]

Like earlier works Degas had exhibited at the Salon, the portrait of Eugénie Fiocre received little attention. Only Zola devoted a few laudatory but ambiguous lines to it. In the final article he wrote on the Salon for *L'Événement Illustré* (9 June 1868), he grouped under the heading "some good canvases" artists and styles that he had not managed to classify in his preceding accounts—Manet, the "naturalistes" (Pissarro), the "actualistes" (Monet, Bazille, Renoir), and the landscape painters (Jongkind, Corot, the Morisot sisters). After a long discussion of Courbet, Bonvin, and Valernes, he comes to the "well-observed and very fine" *Portrait de Mlle E. F. . . . ; à propos du ballet de la Source*. He does not like the title; he would have preferred *A Halt beside a Pool*. "Three women are gathered at the water's edge; beside them a horse is drinking. The horse's coat is magnificent and the women's clothes are handled with great delicacy. There are exquisite reflections in the river. As I looked at this painting, which is a little thin and has strange embellishments, I was reminded of Japanese prints, so artistic in the simplicity of their handling of color."

It is unlikely that anyone reading Zola's commentary would think, unless reminded by Degas's title, that the painting was supposed to be of a ballet. It suggests instead some "naturaliste" or "actualiste" scene, such as those painted by Pissarro or Monet.

Fig. 71. *Eugénie Fiocre*, dated 3 August 1867. Pencil. Private collection

Fig. 72. *Eugénie Fiocre*, dated August 1867. Pencil. Private collection

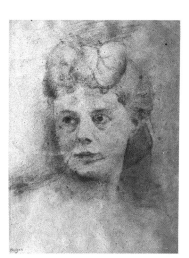

Fig. 73. *Eugénie Fiocre* (IV:96.b), c. 1866. Charcoal, 13¾ × 10⅝ in. (35 × 27 cm). Location unknown

77

Furthermore, the words used by Zola in this brief paragraph to describe the painting—"delicacy," "exquisite," "embellishments"—all evoke something quite different from the solid, compact work seen today, which has none of the thinness or delicacy of some earlier works. The obscure, well-meaning Raoul de Navery shared Zola's view when he labeled Degas one of the many gentleman painters exhibiting at the Salon (it is true that in the catalogue Degas's name is still written with the particle) and praised the "very harmonious and very remarkable" canvas on which Degas had portrayed "one of the great beauties of Paris."[5]

Although a portrait of the celebrated Eugénie Fiocre could not but invite comments from the fashionable world (as would not be the case the next year with the portrait of the obscure Joséphine Gaujelin or, more accurately, Gozelin), Degas's friends of the Café Guerbois, just like the viewer of today, must have found it difficult to understand his compulsion to paint this portrait. Eugénie Fiocre, born in Paris on 22 July 1845 (she died there on 6 June 1908), soon became, with her sister Louise, one of the stars of the Opéra, more for her charm and vivacity, her body, and her truly Parisian manner than for any real talent as a dancer. She first began to attract attention in *Nemea ou l'Amour Vengé*, a soon forgotten ballet by Minkus, Meilhac, Halévy, and Saint-Léon, in which she created a sensation in the role

of Love. She looked like "a flawlessly beautiful statue," recalled the not overly fond Marie Colombier, "so wonderfully desirable that one would have said she was not merely a representation, but Love itself."[6] From then on, she pursued the career—both choreographic and sentimental—of a dancer, with frequent stage appearances and numerous wealthy lovers, until her brilliant marriage in 1888 to the Marquis de Courtivron, a descendant of an excellent Burgundian family.

When Degas began his portrait of Eugénie Fiocre in August 1867, between two performances of *La Source* (the thirteenth, on Saturday, 27 July, and the fourteenth, on Monday, 5 August), he took as his model a woman who was one of the most glittering

celebrities of Paris. The image he presents of this young woman, who is posing for him and whom he obviously admires (according to her descendants, there is a tradition that the Degas family and the Fiocres were related), is not the more worldly one offered by Carpeaux (plaster, Musée d'Orsay, Paris; marble, private collection, Paris) or by Winterhalter (private collection, France). He does not represent her as a dancer any more than he emphasizes her curves—hiding the well-developed figure under the billowing Oriental costume. "What a figure to kneel before— and behind!" was the ribald comment of an old Opéra subscriber.[7] Even her very distinctive features, the slight squint and the long pointed nose—"a nose one would have to make an umbrella for"[8]—which are so clearly depicted in the unpublished drawing mentioned above, have been effaced in the painting. If Degas ever had an opportunity to become a "painter of high life,"[9] it was surely in portraying this most celebrated Parisian, and the fact that he did not seize the opportunity is an indication that this was not his goal. One explanation for the reaction to the painting lies in the unquestionable discomfort that Zola, Castagnary, and Duranty must have felt when confronted with the effigy of someone who was not at all of their world, a visual symbol of the *fête impériale*. On the other hand, it was also incomprehensible to the society critics, the celebrity lovers, and the habitués of the wings at the Opéra who did not recognize "their" Fiocre.

This no doubt explains the "à propos" in Degas's title, otherwise an utter mystery. He portrays a celebrated ballerina, but not as a star, or even as a dancer, since nothing in the setting enables us to guess that the scene is on a stage. The rocks, as Charles F. Stuckey has correctly pointed out, do not appear to be made of painted canvas, but rather seem to be genuine, with the solidity of Courbet's Franche-Comté boulders.[10] In fact, never was the influence of Courbet so strong as in this work. The comments made by Zola and Navery, together with Rouart's later remarks concerning the repainting of the canvas, might suggest that it was only later, in the nineties, that Degas "solidified" a canvas that had left him perplexed, and that at the Salon of 1868 the painting might have been thinner and smoother, without the thick paint of the background. This is unlikely. The portrait of Mlle Fiocre was painted in the midst of passionate discussions about Courbet. Whistler, whose *Symphony in White, No. 3* (Barber Institute of Fine Arts, Birmingham), which Degas copied at this time, is cited by Reff as a possible source for the composition of the Brooklyn canvas,[11] acknowledged his debt to Courbet.

Castagnary, in his *Salon de 1866*, championed Courbet, thereby arguing, to use his own words, the cause of "all the idealistic and realistic young artists who will come after," and extolling, according to Marcel Crouzet, "a monstrous alliance of realism and idealism as a definition of the contemporary pictorial movement."[12] In this painting, Degas apparently followed Castagnary to the letter, introducing magical elements into a realistic setting. The landscape behind Nouredda and her attendants contains nothing of the exotic setting described in the libretto of *La Source*: "A pass in the Caucasus: impenetrable rock everywhere. A spring trickles from the sides of a boulder; green plants flourish round about. Beside the stream, creeping vines coil up the rough surface of the rock to the top, from which they tumble down again bearing clusters of blue flowers."[13] Instead, we see a harsh, compact pile of rocks lapped by dark, glassy water. The stillness and lassitude of the three figures and the quiet pose of the drinking horse contrast with this somewhat forbidding mass. Against this mixed backdrop of browns and deep greens, taken from studies of rocks said to have been done at Bagnoles-de-l'Orne during a stay at the Valpinçons (see L191 and L192, dating a little later, 1868–70), the gowns of the two attendants and, in particular, the costume of Nouredda-Fiocre stand out: "a Tartar headdress in flaming red satin. Embroidered with white jet, black pearls, red pearls, and gold spangles . . . a jeweled belt and a bodice embellished with Moses gems; earrings and a necklace of gemstones; an outer dolman in sky-blue Pekin silk trimmed with silver braid."[14]

Better understood, Degas's canvas could have acted as a manifesto, breathing new life into what was already a Realist heritage. But perhaps this was not Degas's intention, and it was certainly not his style.

The painting, which went virtually unnoticed, has now, with the passage of time, become one of Degas's masterpieces, summing up all the work he did in the 1860s in studying the art of history painting (for *Fiocre* also descends from *Semiramis*) and foreshadowing the dancers to come, through the strange and moving appearance, between the solid hooves of the horse, of a pair of little pink ballet slippers.

1. Archives Nationales, Paris, AJ[13]505.
2. Reff 1985, Notebook 20 (Louvre, RF5634 ter, pp. 20–21).
3. Reff 1985, Notebook 21 (private collection, pp. 12–13).
4. Rouart 1937, p. 21.
5. Raoul de Navery, *Le Salon de 1868*, Paris, 1868, no. 686, pp. 42–43.
6. Marie Colombier, *Mémoires: fin d'empire*, Paris: Flammarion [1898–1900], I, p. 98.
7. Un vieil abonné [An Old Subscriber], *Ces demoiselles de l'Opéra*, Paris: Tresse et Stock, 1887, p. 196.
8. Ibid., p. 195.
9. Letter from Manet to Fantin-Latour, 26 August 1868, cited in Moreau-Nélaton 1926, I, p. 103.
10. 1984–85 Paris, p. 21.
11. Reff 1985, Notebook 20 (Louvre, RF5634 ter, p. 17).
12. Crouzet 1964, pp. 237–38.
13. Archives Nationales, Paris, AJ[13]505.
14. Manuscript, Bibliothèque de l'Opéra, Paris.

PROVENANCE: Atelier Degas (Vente I, 1918, no. 8.a); bought at that sale by Seligmann, Bernheim-Jeune, Durand-Ruel, and Vollard, for Fr 80,500 (Seligmann sale, American Art Association, New York, 27 January 1921, no. 68); bought at that sale through Durand-Ruel by A. Augustus Healy, James H. Post, and John T. Underwood; their gift to the museum.

EXHIBITIONS: 1868, Paris, 1 May–20 June, Salon, no. 686; 1918 Paris, no. 9; 1921, New York, The Brooklyn Museum, *Paintings by Modern French Masters*, no. 71, repr. frontispiece; 1922–23, New York, The Brooklyn Museum, 29 November 1922–2 January 1923, *Paintings by Contemporary English and French Painters*, no. 158; 1931 Paris, Rosenberg, no. 37a; 1932 London, no. 340 (391); 1933 Chicago, no. 285; 1933 Northampton, no. 9; 1934, San Francisco, California Palace of the Legion of Honor, 8 June–8 July, *Exhibition of French Painting*, no. 88, repr.; 1935 Boston, no. 10; 1936 Philadelphia, no. 9, repr.; 1940, New York World's Fair, October, *European and American Paintings, 1500–1900*, no. 277; 1942, Art Association of Montreal, 5 February–8 March, *Masterpieces of Painting*, no. 65; 1944, New York, Wildenstein, 13 April–13 May, *Five Centuries of Ballet, 1575–1944*, no. 226 (as "Mlle Fiocre dans le rôle de Nomeeda"); 1947 Cleveland, no. 12, pl. XI; 1949 New York, no. 13, repr.; 1953–54 New Orleans, no. 73; 1960 New York, no. 13, repr.; 1960 Paris, no. 4; 1971, New York, Wildenstein, 4 March–3 April/Philadelphia Museum of Art, 15 April–23 May, *From Realism to Symbolism: Whistler and His World*, no. 63, repr. p. 27; 1972, New York, Wildenstein and Co., 2 November–9 December, *Faces from the World of Impressionism and Post-Impressionism*, no. 21, repr.; 1978–79 Philadelphia, no. VI–43 (English edition), no. 211, repr. (French edition).

SELECTED REFERENCES: Raoul de Navery [pseud.], *Le Salon de 1868*, Paris: Librairie Centrale, 1868, pp. 42–43, no. 686; Castagnary, *Le bilan de l'année 1868*, Paris: A. Le Chevalier, 1869, p. 354; Jamot 1924, pp. 25, 57, 58, 97, 135–36, pl. 18; 1924 Paris, pp. 9–11; Rouart 1937, p. 21; Lemoisne [1946–49], I, pp. 60, 62–63, II, no. 146; Browse [1949], pp. 21, 28, 51, 333, pl. 3; H. Wegener, "French Impressionist and Post-Impressionist Paintings in the Brooklyn Museum," *The Brooklyn Museum Bulletin*, XVI:1, Autumn 1954, pp. 8–10, 23, fig. 4; Rewald 1961, pp. 158, 186, repr. p. 175; Reff 1964, pp. 255–56; Minervino 1974, no. 282, pl. IX (color); Émile Zola, "Mon Salon," *Le bon combat: de Courbet aux impressionnistes*, Paris: Hermann, 1974, pp. 121–22; Reff 1976, pp. 29–30, 214, 232, 298, 306, 327 n. 33, fig. 9; 1984–85 Paris, pp. 18–19, fig. 16 (color) p. 18.

78

78.

Study of Nudes, for *Mlle Fiocre in the Ballet "La Source"*

1867–68
Oil on canvas
32 × 25⅜ in. (81.3 × 64.5 cm)
Vente stamp lower right
Albright-Knox Art Gallery, Buffalo, New York.
 Gift of Paul Rosenberg and Co., 1958 (58:2)

Lemoisne 148

See cat. no. 77

PROVENANCE: Atelier Degas (Vente I, 1918, no. 38); bought at that sale by Alphonse Kann, Saint-Germain-en-Laye, for Fr 14,500; the heirs of Alphonse Kann, from 1948; Walter Feilchenfeldt, Zurich, 1952; Paul Rosenberg and Co., New York, 1952; his gift to the museum 1958.

EXHIBITIONS: 1924 Paris, no. 26; 1961, Art Gallery of Toronto, 21 June–25 September, *Two Cities Collect,* no. 9.

SELECTED REFERENCES: Lemoisne [1946–49], II, no. 148; Browse [1949], p. 335, under no. 3; Minervino 1974, no. 283; Stephen Nash et al., *Albright-Knox Art Gallery, Painting and Sculpture from Antiquity to 1942,* New York: Rizzoli, 1979, p. 212, repr. p. 213.

The First Sculptures

cat. nos. 79–81

It is not clear when Degas began making sculpture. The sculptor Bartholomé, describing himself to Lemoisne in 1919 as a friend of Degas's "from way back," said that he "remembered seeing him make—very early, before 1870—a large and very attractive bas-relief in clay, half life-size, of young girls picking apples."[1] As Charles Millard has correctly pointed out, Bartholomé became very close to Degas in the 1880s and remained so for the rest of his life, but he was not in any sense a friend "from way back"; born in 1848, he certainly did not know the painter before 1870. Pierre Borel in his summary book on the works of sculpture mentions a letter written by Degas during his Italian trip "to his friend Pierre Cornu" (about whom we know nothing) in which the young artist questions his vocation: "I often wonder if I will be a painter or a sculptor. I have to say I am very undecided."[2] More interesting than this letter—which appears to be sheer fantasy—are certain remarks by Auguste De Gas in a letter

to his son in 1858, when Degas was staying with his uncle Gennaro Bellelli in Florence. There was some question of two plasters belonging to Degas that had been sent to his friend Émile Lévy in Paris and which Auguste had arranged to pick up. "I sent to Mme Lévy's for the plasters, and Pierre found M. Lévy junior there, who said that the plasters had been broken en route and that he had had them repaired together with some of his own."[3] After a month, Auguste wrote: "M. Lévy told Pierre he had given your two plasters to the caster to be repaired."[4] Given such limited information, it is difficult to say for certain whether these references are to original works or—more likely—to the commercial Italian casts that cluttered almost every artist's studio.

The most valuable testimony is supplied by the journalist Thiébault-Sisson, who met Degas at Clermont-Ferrand during the summer of 1897 and then spent two days with him at Mont-Dore, where the painter was taking a cure but was bored. Delighted to have someone to whom he could talk, Degas reminisced, including a great deal about sculpture. "When I asked him," reported the journalist, "if he had had difficulty learning this new craft, he exclaimed, 'But I've been working in this medium for a long time! I have been making sculpture for more than thirty years. Not, it is true, on a regular basis, but from time to time, when it appealed to me or I needed to.'"[5] In explanation of this "needed to," Degas spoke of a technique used by Dickens. According to the novelist's biographers, "whenever he began to get lost in the complicated weave of his characters," he constructed figures bearing their names and made them talk. It was this need to "resort to the three-dimensional" that Degas said he had felt while painting *The Steeplechase* in 1866 (see cat. no. 67). Not having Marey's or Muybridge's photographs (which later would analyze the animal's movements) to rely on, and reluctant to condemn himself to spending hours on the Champs-Élysées "studying the mounted horsemen and the beautiful smart carriages as they go by" (as Meissonier had done—"one of the most knowledgeable men when it came to horses [that Degas had] ever known"), he took up modeling. There is no trace of a wax horse made in preparation for *The Steeplechase,* but conditions in Degas's studio were not the best for the preservation of such works. Rewald is probably right, however, in connecting *Horse at a Trough* (cat. no. 79) with *Mlle Fiocre in the Ballet "La Source"* (cat. no. 77), dating it 1866–68—though I would limit it further to 1867–68, since the positions of the horses and the slightly sloping ground are identical in both works.

Fig. 74. X-radiograph of the wax *Horse at Rest* (cat. no. 80)

However, it is much more difficult to date the thoroughly classical *Horse at Rest* (cat. no. 80), which Degas may have used for one or another of the racing scenes he did in the 1860s. It is not directly related to any known work from that period, unless it is the horse seen from an angle and reined in by Paul Valpinçon in Boston's *At the Races in the Countryside* (cat. no. 95). It is tempting here to suggest a date close to 1869, when the often cited influence of the mediocre sculptor Cuvelier (who specialized in statuettes of horses and whose death in 1870 had such a profound effect on Degas) could still make itself felt.

A recent exhibition published an X-radiograph (fig. 74) of the Musée d'Orsay wax, revealing Degas's genius.[6] The artist improvised the sculpture's armature with a network of tightly twisted metal rods and shaped the animal's head around a cork. As Degas was fond of saying, this was part of the pleasure of making sculpture: working with an unfamiliar material, improvising, experimenting in an effort to hold it together, advancing cautiously into unknown territory, leaving the work in a corner of the studio and taking it up again later, until finally he produced with the means at hand some of the finest sculpture of the nineteenth century.

1. Lemoisne 1919, p. 110.
2. Pierre Borel, *Les sculptures inédites de Degas*, Geneva: Pierre Cailler, 1949, p. 7.
3. Letter, 28 August 1858, private collection.
4. Letter, 6 October 1858.
5. Thiébault-Sisson 1921. This source escaped Rewald, and Millard, too, oddly enough, did not make use of it.
6. 1986 Paris, pp. 58–59.



79.

Horse at a Trough

1867–68
Bronze
Height: 6½ in. (16.4 cm)
Original: red wax. Collection of Mr. and Mrs. Paul Mellon, Upperville, Virginia

Rewald II

SELECTED REFERENCES: 1921 Paris, no. 42; Havemeyer 1931, p. 223, Metropolitan 13A; Paris, Louvre, Sculptures, 1933, no. 1759, p. 70, Orsay 13P; Rewald 1944, no. II, Metropolitan 13A (as 1865–81); John Rewald, "Degas Dancers and Horses," *Art News*, XLIII:11, September 1944, p. 23, repr.; Rewald 1956, no. II, Metropolitan 13A; Beaulieu 1969, pp. 370–72, fig. 2, Orsay 13P; Minervino 1974, no. S42; Millard 1976, pp. 5–6, 20, 97, 100 (as 1875–81); Paris, Orsay, Sculptures, 1986, p. 132, repr. p. 33, Orsay 13P.

A. *Orsay Set P, no. 13*
Musée d'Orsay, Paris (RF2106)

Exhibited in Paris

PROVENANCE: Acquired in 1930 thanks to the generosity of the heirs of the artist and of the Hébrard family; entered the Louvre 1931.

EXHIBITIONS: 1931 Paris, Orangerie, no. 42 of sculptures; 1937 Paris, Orangerie, no. 228; 1969 Paris, no. 226; 1971 Leningrad, p. 58; 1971 Madrid, no. 105, repr.; 1973, Paris, Musée Rodin, 15 March–30 April, *Sculptures de peintres*, no. 46; 1984–85 Paris, no. 98 p. 210, fig. 222 p. 214.

79, METROPOLITAN

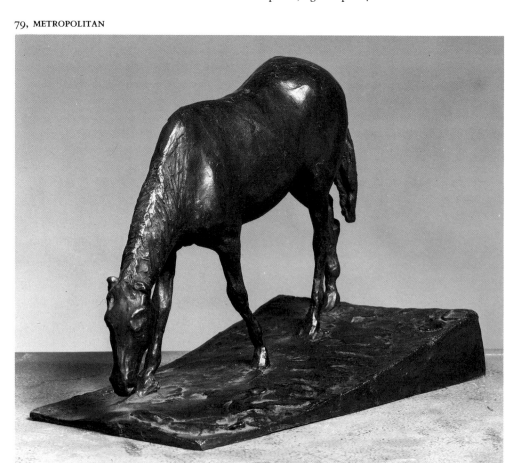

B. *Metropolitan Set A, no. 13*
The Metropolitan Museum of Art, New York.
 Bequest of Mrs. H. O. Havemeyer, 1929.
 H. O. Havemeyer Collection (29.100.433)

Exhibited in Ottawa and New York

PROVENANCE: Bought from A.-A. Hébrard by Mrs.
H. O. Havemeyer 1921; her bequest to the museum
1929.

EXHIBITIONS: 1922 New York, no. 45; 1930 New
York, under Collection of Bronzes, nos. 390–458;
1947 Cleveland, no. 75; 1974 Dallas, no number;
1977 New York, no. 6 of sculptures; 1978 Rich-
mond, no. 36.

80.

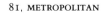

Horse at Rest

c. 1869
Wax with wooden base
Signed on base near left hind leg: Degas
Height: 11⅝ in., with base 12⅜ in. (29.5 cm,
 with base 31.5 cm)
Musée d'Orsay, Paris. Gift of Paul Mellon
 (RF2772)

Exhibited in Paris

Rewald III

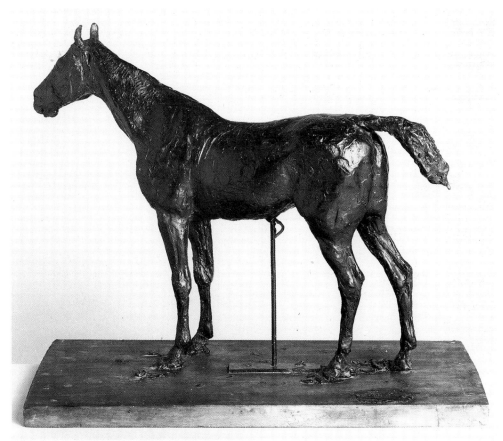

80

PROVENANCE: Atelier Degas; the artist's heirs; A.-A.
Hébrard, Paris, 1919–c. 1955; on consignment with
M. Knoedler and Co., New York; bought by Paul
Mellon 1956; his gift to the Louvre 1956.

EXHIBITIONS: 1955 New York, no. 2; 1967–68 Paris,
no. 328; 1969 Paris, no. 227; 1986 Paris, no. 64, repr.

SELECTED REFERENCES: Rewald 1956, no. III, no. 47,
pp. 4–5; Beaulieu 1969, no. 6, p. 373; Minervino
1974, no. S47; Millard 1976, pp. 20, 35; Paris, Or-
say, Sculptures, 1986, p. 138, repr.

81, METROPOLITAN

81.

Horse at Rest

c. 1869
Bronze
Height: 11⅜ in. (29 cm)
Original: red wax. Musée d'Orsay, Paris
 (RF2772). See cat. no. 80

Rewald III

SELECTED REFERENCES: 1921 Paris, no. 47; Havemeyer
1931, p. 223, Metropolitan 38A; Paris, Louvre,
Sculptures, 1933, no. 1764, p. 70, Orsay 38P; Re-
wald 1944, no. III, Metropolitan 38A (as 1865–81);
Rewald 1956, no. III; Pierre Pradel, "Quatre cires
originales de Degas," *La Revue des Arts*, January–
February 1957, repr. p. 30, fig. 2, wax; Beaulieu
1969, p. 373; Minervino 1974, no. S47; Millard 1976,
pp. 20, 35 (as 1875–81); Paris, Orsay, Sculptures,
1986, p. 133, repr., Orsay 38P.

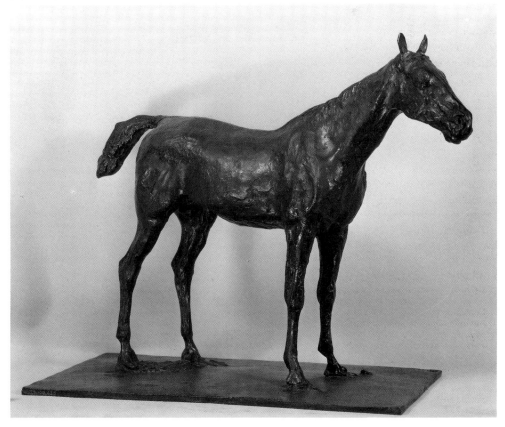

A. *Orsay Set P, no. 38*
Musée d'Orsay, Paris (RF2111)

Exhibited in Paris

PROVENANCE: Acquired in 1930 thanks to the generosity of Degas's heirs and of the Hébrard family; entered the Louvre 1931.

EXHIBITIONS: 1931 Paris, Orangerie, no. 47 of sculptures; 1937 Paris, Orangerie, no. 231; 1969 Paris, hors catalogue; 1971 Leningrad, p. 58; 1971 Madrid, no. 105, repr.; 1984–85 Paris, no. 92 p. 209, fig. 217 p. 212.

B. *Metropolitan Set A, no. 38*
The Metropolitan Museum of Art, New York.
 Bequest of Mrs. H. O. Havemeyer, 1929.
 H. O. Havemeyer Collection (29.100.425)

Exhibited in Ottawa and New York

PROVENANCE: Bought from A.-A. Hébrard by Mrs. H. O. Havemeyer 1921; her bequest to the museum 1929.

EXHIBITIONS: 1922 New York, no. 50; 1923–25 New York; 1925–27 New York; 1930 New York, nos. 390–458, under bronzes; 1974 Dallas, no number; 1977 New York, no. 3 of sculptures.

82.

M. and Mme Édouard Manet

c. 1868–69
Oil on canvas
25⅝ × 28 in. (65 × 71 cm)
Vente stamp on added canvas lower right
Kitakyushu Municipal Museum of Art (0-119)

Lemoisne 127

References to the relationship between Degas and Manet are often made but rarely documented. We know about it from sketchy sources that are difficult to confirm, especially since the only surviving letters between the two men are a few from 1868–69. The story of their first meeting is like a fairy tale, reminiscent of the quasi-mythical encounters of other pairs of great artists, such as Cimabue and Giotto or Perugino and Raphael. According to Moreau-Nélaton, Manet was spending a day at the Louvre (we are told by Tabarant that this was in 1862[1]), when he noticed the young Degas—Manet was his senior by two and a half years—starting to etch a copy of Velázquez's *Infanta Margarita* directly onto a copper plate. Manet gave an exclamation, astonished at the young painter's daring, and seeing that he would not have much success with the copy he had begun, ventured some advice. Moreau-Nélaton reports: "Degas was not getting along well at all, and would never forget (he told me so himself) the lesson he received from Manet that day along with his

lasting friendship."[2] Regardless of the accuracy of this account, what is clear is that the friendship between the artists was at its most intense in the late 1860s and early 1870s. Of this there is ample evidence in Berthe Morisot's correspondence, Degas's correspondence with Tissot, the unpublished letters from Manet to Degas, the obvious mutual interest that is discernible in their works (see cat. no. 68), and not least this double portrait. Their admiration for each other (after Manet's death, Degas put together a magnificent collection of the older artist's work) was clouded by harsh words on both sides, avidly reported by followers who were amused by the rivalry—malicious comments made by Manet about Degas's lack of interest in women,[3] and caustic remarks by Degas, which became more common in the 1870s, concerning Manet's bourgeois respectability and his desire to "make it."[4] Yet this was the same Manet who, finding himself bored at Boulogne-sur-Mer the summer of 1868, said he missed most of all the conversation of "Degas the great aesthetician," and wished he would write.[5] Degas, four years later, complained in a letter to Tissot from New Orleans that he had not heard from Manet.[6]

Four unpublished letters from Manet to Degas now in a private collection, datable to 1868–69 and constituting the only direct records that we have of their friendship (all the rest being secondhand statements or hearsay), give us a clearer view of the nature of their relationship. These letters consist of an undated invitation to dinner with the Stevenses and Puvis de Chavannes; a brief note in which Manet expresses his regrets at having missed Degas at the Tortonis and the Stevenses recently and asks if Auguste De Gas is receiving visitors the next day; a letter dated 29 July 1868 and mailed from Calais, in which Manet suggests that Degas accompany him to London, where "perhaps there will be an outlet for our wares"; and a note (mentioned by Reff, who dates it July 1869[7])

in which Manet asks Degas to return the two volumes of Baudelaire he has borrowed.

While they do not indicate a close friendship, these letters do show that the two men saw each other often and shared common interests. To a large extent, Degas moved in the same circles as Manet: the habitués of the Café Guerbois, Duranty, Fantin-Latour, Zola (in the letter of 29 July 1869, Manet sends him regards), Alfred Stevens (who received on Wednesdays), the Morisots, and Nina de Callias. Often they met at the apartment of Manet's mother on rue de Saint-Pétersbourg or in the salon of Degas senior on rue de Mondovi. Since Degas painted portraits of several of his artist friends, it is not at all surprising that he also painted Manet, who so impressed and irritated him at the same time.

The portrait of the Manets has attracted a great deal of attention because of the incident to which it gave rise. We are told Manet's side of the story by Moreau-Nélaton and Degas's side by Ambroise Vollard, both of whom were writing in the 1920s, long after the fact. Around the turn of the century, when he was visiting Degas in his studio one day, Vollard noticed "one of his canvases representing a man seated on a sofa and a woman on the side who had been cut in half vertically." (In a photograph from that same period showing Degas in his apartment with Bartholomé [fig. 75], we can see the double portrait on the wall next to Manet's *Ham*, exactly as it would have looked to Vollard. Framed by a strip of dark wood with white or gilt beveling, it was not yet extended by the band of prepared canvas that Degas—no doubt intending, as he had said, to "restore" Mme Manet—must have had added a little later, because that is how it appeared at the first atelier sale.) Vollard's account of the incident goes as follows:

Vollard: Who slashed that painting?
Degas: To think that it was Manet who did that! He thought that something about

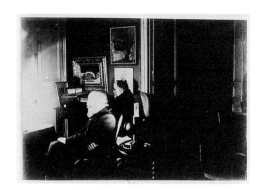

Fig. 75. *Albert Bartholomé and Degas*, c. 1895–1900. Photograph from a glass negative in the Bibliothèque Nationale, Paris

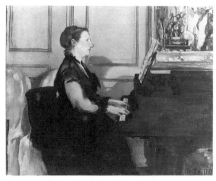

Fig. 76. Édouard Manet, *Mme Manet at the Piano*, c. 1867–68. Oil on canvas, 15 × 18⅛ in. (38 × 46 cm). Musée d'Orsay, Paris

Mme Manet wasn't right. Well . . . I'm going to try to "restore" Mme Manet. What a shock I had when I saw it at Manet's. . . . I left without saying good-bye, taking my picture with me. When I got home, I took down a little still life he had given me. "Monsieur," I wrote, "I am returning your *Plums*."

Vollard: But you saw each other again afterward.

Degas: How could you expect anyone to stay on bad terms with Manet? Only he had already sold the *Plums*. What a beautiful little canvas it was! I wanted, as I was saying, to "restore" Mme Manet so that I could return the portrait to him, but by putting it off from one day to the next, it's stayed like that ever since.[8]

Vollard's account of the affair tallies with that given by Moreau-Nélaton, who attributes the incident to Manet's being unable to tolerate "a distortion of his dear Suzanne's features," but does not mention Degas's sending back the *Plums*. Vollard gives no indication of the date of this incident, but Moreau-Nélaton includes it in the chapter of his book devoted to the years 1877–79, when Degas had already been a friend of Manet's "for twenty years."[9]

Although the date this painting was completed is not known, it is reasonable to assume that Manet did not wait years to commit his infamy and that the slashing of the canvas must have taken place soon after its delivery to the Manets. It is, however, out of the question to date the work 1877–79; more weight should probably be given to Mme Morisot's reference, in 1872, to a "patching up" of a disagreement between the two artists; she does not specify the cause of the disagreement, but it could well have had to do with the mutilation of the double portrait.[10]

The *Plums*, which, according to Vollard, Manet had given to Degas in return for the

82

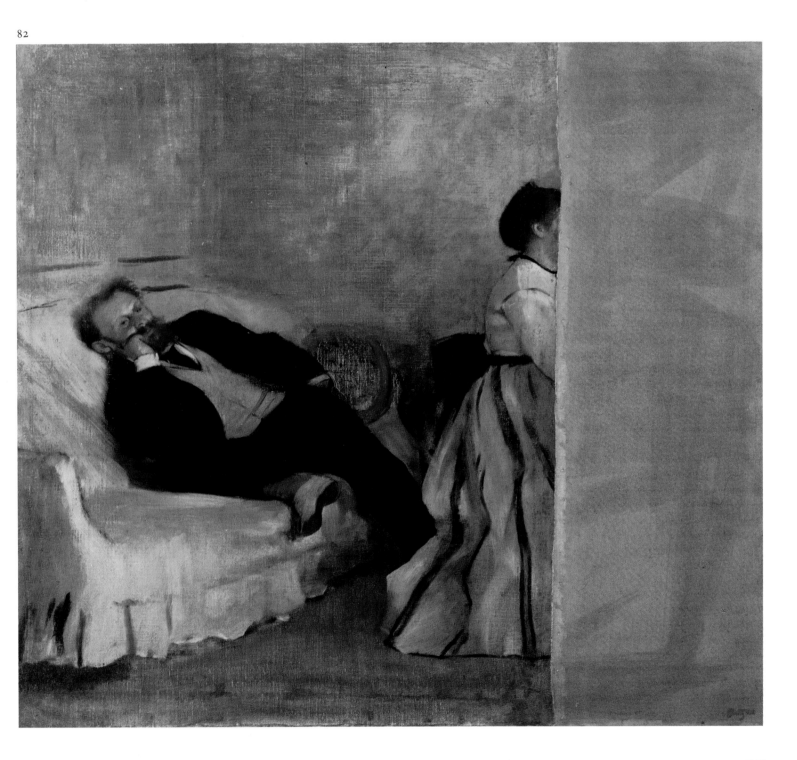

portrait, might be a valuable source of information. But Denis Rouart and Daniel Wildenstein in their catalogue raisonné of Manet's work make no reference to a *Plums* until much later (1880).[11] There is no mention of the work in the 1860s, unless it is the *Walnuts in a Salad Bowl* (1866),[12] an attribution rejected by Tabarant,[13] reportedly given by Manet to Degas after a dinner party at which Manet had broken a salad bowl. Degas apparently returned it after a quarrel, the reason for which is not known, though it could be the argument in question.

While it is thus difficult to determine the time of the incident, the painting itself can be dated more precisely. One clue is found in a small picture by Manet of 1867–68 that represents Mme Manet at the piano (fig. 76). It was painted in Manet's mother's third-floor apartment on rue de Saint-Pétersbourg, which Manet and his wife did not occupy until October 1866.[14] All the evidence suggests that Degas used the same setting for his painting: the same armchairs with white slipcovers, the same placing of the piano along the wall, the same chair on which Mme Manet is seated, and—though the setting is very sketchy in Degas's picture—above the figure of Manet sprawled on the sofa, the two parallel gold lines of the same wainscoting. The generally accepted date of 1865 given by Lemoisne must, therefore, be moved forward by at least one year; the earliest possible date for the double portrait is late 1866 or early 1867. It is even more likely that it was painted during the period when Degas and Manet saw each other most frequently, about 1868–69; there is support for this in the lightness and delicacy of the painting, which make it more like *Mme Théodore Gobillard* (cat. no. 87) than *Giovanna and Giulia Bellelli* (cat. no. 65) or *M. and Mme Edmondo Morbilli* (cat. no. 63).

Here, for the last time until his later portraits of the Rouarts (L1437–L1444), Degas painted a married couple. Mme Manet appears to be concentrating on her piano playing, while her husband lolls on a sofa; Jacques-Émile Blanche[15] and George Moore,[16] who saw Manet often, vouched for the accuracy of the pose and demeanor. Evidently bored—though Moreau-Nélaton saw him as "intoxicated by the enveloping perfume of the melody"[17]—Manet (who, according to his friend Antonin Proust, had no ear for music[18]) seems to be only half listening to his wife (who was an excellent musician). Nonchalant (at the home of Degas senior, he would sit cross-legged on the floor[19]), he does not "pose," like Gustave Moreau or James Tissot (see cat. no. 75), and there is nothing of "the artist" about him.

But Degas, amused by this debonair image, portrays Manet with obvious pleasure

and, as a great fan of his work, competes with its luminosity, using, as later in *The Song Rehearsal* (cat. no. 117), a fluid range of whites, grays, and salmon pink, darkened only by the black suit. And in the words Degas himself was to use soon after to praise his sitter's talents, he was painting in a style that shows "finish" and a "caress."[20]

1. Adolphe Tabarant, *Manet et ses oeuvres*, Paris: Gallimard, 1947, p. 37.
2. Moreau-Nélaton 1926, I, p. 36.
3. Morisot 1950, p. 31; Morisot 1957, p. 35.
4. See Degas Letters 1947, no. 17, p. 39.
5. Moreau-Nélaton 1926, I, p. 102.
6. Degas Letters 1947, no. 3, p. 19.
7. Reff 1976, p. 150.
8. Vollard 1924, pp. 85–86.
9. Moreau-Nélaton 1926, I, p. 36.
10. Morisot 1950, p. 69; Morisot 1957, p. 73.
11. Denis Rouart and Daniel Wildenstein, *Édouard Manet: catalogue raisonné*, 2 vols., Lausanne/Paris: La Bibliothèque des Arts, 1975, RW363.
12. Ibid., RW119.
13. Tabarant, op. cit., p. 519.
14. Letter from Manet to Zola, 15 October 1866, in *Manet* (exhibition catalogue), Paris, 1983, p. 520 (English edition, New York: The Metropolitan Museum of Art, p. 519).
15. Blanche 1919, p. 148.
16. Moore 1891, p. 321.
17. Moreau-Nélaton 1926, II, p. 40.
18. Antonin Proust, *Édouard Manet: souvenirs*, Paris: Renouard, 1913, p. 11.
19. Marcel Guérin, "Le portrait du chanteur Pagans et de M. De Gas père par Degas," *Bulletin des Musées de France*, 3 March 1933, pp. 34–35.
20. Letter from Degas to Tissot, 30 September 1871, Bibliothèque Nationale, Paris; Degas Letters 1947, no. 1, p. 11.

PROVENANCE: Atelier Degas (Vente I, 1918, no. 2); bought at that sale by Trotti, for Fr 40,000. Wilhelm Hansen, Copenhagen, 1918–23; bought by Kojiro Matsukata, Paris and Tokyo, 1923; Kyuzaemon Wada, Tokyo; private collection, Tokyo, 1967; deposited with the National Museum of Western Art, Tokyo, 1971–73; bought by the museum 1974.

EXHIBITIONS: 1922, Copenhagen/Stockholm/Oslo, Foreningen for Fransk Kunst, *Degas*, no. 6; 1924 Paris, no. 20; 1924–25, San Francisco, California Palace of the Legion of Honor, *Inaugural Exposition of French Art*, no. 16; 1953, Osaka, Fujikawa Galleries, *Occidental Renowned Paintings*, no. 4; 1953, Tokyo, National Museum of Modern Art, *Japan and Europe*, no. 72; 1960, Tokyo, National Museum of Western Art, *Selected Masterpieces of Collection Matsukata*, no. 29; 1974, Kitakyushu, *Opening Exhibition of Kitakyushu Municipal Museum*, no. 101.

SELECTED REFERENCES: Moore 1891, p. 321; Lafond 1918–19, II, repr. between pp. 12 and 13; Blanche 1919, p. 148; Vollard 1924, pp. 85–86; Moreau-Nélaton 1926, I, p. 36; Boggs 1962, pp. 22–24, 91 nn. 10, 11, 15, pl. 42; Lemoisne [1946–49], I, p. 51, II, no. 127; Minervino 1974, no. 214; Y. Yamane, *Degas, "Portrait de M. et Mme Manet,"* Kitakyushu, 1983.

83.

Victoria Dubourg

c. 1868–69
Oil on canvas
32 × 25½ in. (81.3 × 64.8 cm)
Vente stamp lower right
The Toledo Museum of Art. Gift of Mr. and Mrs. William E. Levis (63.45)

Lemoisne 137

Born in 1840, Victoria Dubourg was a painter of still lifes (she exhibited regularly starting with the Salon of 1869) who is remembered today mainly as the not seductive but certainly attentive wife, and later widow, of Henri Fantin-Latour. Degas probably met her in the Manet-Morisot circle, which he frequented at the end of the 1860s, unless it was at the house of her father, whose address, "47 r[ue] N[eu]ve St Augustin," he jotted down in a notebook he used from 1867.[1]

There are a number of drawings for the Toledo portrait, which show minor but interesting variations with the final composition. Degas apparently found the pose he wanted right at the outset: Mlle Dubourg in a chair set against a wall, holding her hands together, her head and shoulders tilted slightly forward. After making a compositional study (III:239.3, private collection), he made separate studies of the face (III:238.2) and hands (III:239.2, private collection). In addition, he drew the main outlines of the composition in a quick sketch in one of his notebooks,[2] suggesting in very summary fashion the setting he would develop later. Although it is difficult to make out what is framing Victoria Dubourg on the right—a drawing on the wall or the rough outline of a mantelpiece—a small, thick-framed picture stands forth in the center, hung just behind the young woman's head. When we compare this sketch with the one for the portrait of Tissot (cat. no. 75) in the same notebook, the similarity is striking and suggests that they were drawn at almost the same time.[3]

When he moved on to the oil painting, however, Degas chose to abandon (though only at a later stage—signs of the change are still discernible on the now bare wall) the idea of having a picture adjacent to the head of the woman painter, which, as in the Tissot portrait, would almost certainly have been closely tied to the sitter's activities and tastes. He erased it, and thereby suppressed all explicit reference to Mlle Dubourg's vocation; even so, this portrait is more closely related to the pictures of his artist friends than to the more worldly pictures of, say, Mme Camus (L207, E. G. Bührle Collection, Zurich; fig. 26) or even Yves Gobillard

know. And so, in his own manner, he did this double portrait of the young woman and the phantom of her fiancé—they were to be married some years later, in 1876—giving his sitter a solidity and a presence that his female portrait subjects do not always have. True, he hesitated to show her as an actual painter in a studio, brush in hand—for a woman, that was probably just not done—but through her eyes, her hands, the bouquet, and the empty chair, he acknowledged that she too was, as he would have put it, in the trade.

1. Reff 1985, Notebook 22 (BN, Carnet 8, p. 202).
2. Reff 1985, Notebook 21 (private collection, p. 27).
3. Ibid., p. 6v.
4. In the Morisot correspondence, she is first mentioned in a letter of 2 May 1869. See Morisot 1950, p. 27; Morisot 1957, p. 31.
5. Morisot 1950, p. 29; Morisot 1957, p. 33.

PROVENANCE: Atelier Degas (Vente I, 1918, no. 87 [as "Portrait d'une jeune femme en robe brune"]); bought at that sale by Mme Lazare Weiller, Paris, for Fr 71,000; Paul-Louis Weiller, her son, Paris; with Paul Rosenberg, New York; Mr. and Mrs. William E. Levis, Perrysburg, Ohio; their gift to the museum 1963.

EXHIBITIONS: 1924 Paris, no. 23, repr. (as "Portrait de Mlle Dubourg [Mme Fantin-Latour]"); 1931 Paris, Rosenberg, no. 26, pl. IV; 1936 Venice, no. 10; 1940–41 San Francisco, no. 29, pl. 68; 1941 Los Angeles County Museum of Art, June–July, The Painting of France since the French Revolution, no. 35; 1941 New York, no. 35, fig. 41; 1966, The Hague, Mauritshuis, 25 June–5 September, In the Light of Vermeer, no. 43, repr.

SELECTED REFERENCES: Lemoisne [1946–49], I, p. 56, II, no. 137; Boggs 1962, pp. 31, 48, 92 n. 50, 117, fig. 50; 1967 Saint Louis, pp. 84–86; Minervino 1974, no. 221; The Toledo Museum of Art, European Paintings, Toledo, 1976, p. 52, pl. 244; 1987 Manchester, pp. 17, 20–21, fig. 12.

(cat. no. 87). Seated in a straight chair in a not very feminine posture in a corner of a bourgeois living room, wearing a plain brown dress with a green ribbon around her neck as the only bright bit of finery, Victoria Dubourg fixes her intelligent gaze on the painter as she attentively watches him working. Her joined hands, in full light, are set off against the dark background of the fabric of her dress and take on extreme importance right at the center of the composition, as a discreet allusion to the métier of the sitter, who "works with her hands"; the bouquet on the mantelpiece further reminds us that her talents were devoted to painting flowers.

The date proposed by Lemoisne, 1866, seems somewhat early. The notebook with the sketch was used in 1867–68; furthermore, Victoria Dubourg appears not to have actually entered the Manet-Degas-Morisot

circle until about 1868–69.[4] One key element corroborates this hypothesis: the empty chair against the wall. There are some signs of hesitation in it, indicating that it was probably added at a later date; it does not appear in the overall study and remains very vague in the notebook sketch. This empty chair is already the chair of Fantin-Latour. In the spring of 1869, in answer to a letter from her sister Berthe Morisot, Edma Pontillon passed severe judgment on Fantin-Latour: "The latter has certainly fallen even lower since his intimacy with Mlle Dubourg. I cannot believe that he is the person we admired so much last year."[5] Thus we learn that Fantin-Latour and Victoria Dubourg were already close by the end of 1868, and that Degas, who was not inattentive to the gossip of this malicious circle—he too paid the price—was, like everyone else, in the

84.

Interior, also called *The Rape*

c. 1868–69
Oil on canvas
31⅞ × 45⅝ in. (81 × 116 cm)
Signed lower right: Degas
Philadelphia Museum of Art. The Henry P. McIlhenny Collection. In memory of Frances P. McIlhenny (1986-26-10)

Lemoisne 348

Interior may be Degas's most baffling work; it is assuredly one of his masterpieces. "Among his masterpieces, the masterpiece," wrote Georges Grappe,[1] while Arsène Alexandre declared: "There is not a more arresting picture in all modern painting, nor one more austere or of greater morality; next to it,

Rousseau's *Confessions* are mere platitudes."[2]

Uncertainty surrounds the very title of the painting. Lemoisne, in 1912, was the first to claim that it was originally "Le viol" (The Rape), a title that many writers continued to use because it suited their reading of the scene.[3] Ernest Rouart maintained that Degas himself ("God knows why") gave it that title.[4] However, there is no evidence to corroborate this claim. When Degas entrusted the canvas to Durand-Ruel on 15 June 1905, it was simply entitled "Interior" (in 1909, it was "Interior Scene"). Paul Poujaud, who was a close friend of the painter's and saw the painting for the first time in 1897, stated that Degas never called it "The Rape"— "That title is not from his lips. It must have been invented by a literary man, a critic."[5]

The date of execution is equally disputed. Lemoisne dates it c. 1874, Boggs 1868–72,[6] and Reff 1868–69.[7] For a number of reasons, we are in complete agreement with the dating proposed by Reff (which Poujaud had already proposed in 1936: sometime "before 1870"[8]). Reff published a detailed analysis of this work in 1972, producing new material and arriving at some convincing

conclusions.[9] A rough sketch of the composition—it is the only such drawing known to exist and differs from the final canvas in many respects—is scribbled on the back of a card announcing a change of address and bearing the date 25 December 1867 (fig. 77). In a notebook used between 1867 and 1872 (unlike Reff, I do not believe it was used any later than that), Degas did a pencil sketch of the empty room, without the bed but with the box open on the table,[10] and two pages later, a sketch of the man leaning against the wall.[11] Apart from one other sketch of the bed alone (IV:266), Degas then worked only on isolated figures of the man and woman, in an effort to find the most expressive attitude for each. The model for the man—there is a pastel study of his head (L349)—may have been the painter Henri Michel-Lévy, later depicted by Degas in Lévy's studio (L326, Calouste Gulbenkian Museum, Lisbon); more likely, it was a M. Roman or de Saint-Arroman (BR51), about whom nothing but his name is known. Among all these sketches, there is one (fig. 78) that is troubling: a young woman in street clothes, her face hidden by a veil and a muff in her hand,

stands in the doorway behind the man, who leans against the wall. This study suggests that Degas temporarily considered a different version.

While he was working on this canvas, Degas received advice from one of his friends, scribbled on an envelope addressed to him at his studio at 13 rue de Laval. The anonymous author, after apologizing for the delay that caused him to miss the painter— "Jenny turned out of the house, Pierre very annoyed, carriage difficult to find, delay because of Angèle, arrived at the café too late, a thousand apologies"—poured out his thoughts on the work-in-progress that he had just seen in the studio: "I shall compliment you on the picture only in person. Be careful of the rug beside the bed, shocking. The room too light in the background, not enough mystery. The sewing box too conspicuous, or rather not vivid enough. The fireplace not enough in shadow (think of the vagueness of the background in the 'green woman' by Millais without succumbing to his influence). The floor too red. The man's legs not proprietary enough. Only hurry up, there is just enough time. I shall be at

84

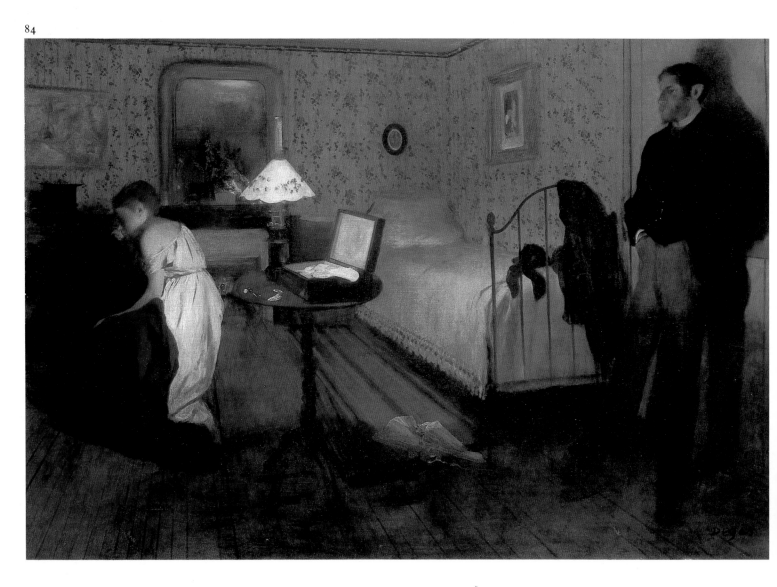

Stevens's tonight. For the mirror here is the effect, I think [a rough sketch of the mirror above the fireplace]. The ceiling should be lighter in the mirror, very light, while throwing the room into shadow." And, after repeating "hurry up, hurry up," he continued on the back of the envelope: "Beside the lamp on the table, something white to thrust the fireplace back, a spool of thread (necessary) [a quick sketch of the table, with the open box, the lamp base, and a spool of thread with pins stuck in it]. Darker under the bed. A chair there or behind the table would perhaps be good and would make the rug beside the bed acceptable [a sketch of the table, with a chair in front of it]."[12]

Unfortunately, the identity of this friend is not known. Poujaud, to whom the mysterious envelope belonged, ruled out Guérin's suggestions of Duranty ("Degas did not take advice from critics") and Bracquemond (Degas "admired him but found him unsympathetic"). Poujaud believed it was some other painter: "The reference to Millais may suggest a painter from England . . . Whistler, Edwards, Legros. . . . Perhaps it was some forgotten painter, a patron of the Café Guer-

tered, according to Ernest Rouart, "about 1903," with the help of Chialiva, "a very knowledgeable painter who was technically very well versed . . . which enabled him, after so many years, to tackle this painting and retouch it without altering it in the slightest."[14] Poujaud is more cautious: "You probably remember that [Interior] was hung in a room at Durand-Ruel's on rue Laffitte late in the nineteenth century or early in the twentieth [in fact, between 1905 and 1909, the date of its purchase by Jaccaci]. I remember hearing that Degas—who could hardly see at all by that time—had taken his painting and done some retouching. . . . the people at Durand-Ruel say that the little red and green flowers on the lampshade were added. I myself think that the small green pearl adorning the woman's earlobe was added at the same time, since it does not appear on the study of the woman that I bought at the Marcel Bing estate sale and which originally came from the atelier sale. The painting is very faithful to this study, except that in the painting, apart from the pearl, Degas put a small upturned nose and a not very pretty hand in the light, whereas in my

abandoned pose of the little working girl and the dullness of the man, mixed with a certain brutality."[17] Rivière was the first to propose a possible literary source for this work, which he saw in one of Duranty's novels, *Les combats de Françoise Du Quesnoy*.[18] The date of publication, 1873, makes Rivière's suggestion impossible, though it should be noted that the book is a recycling of "Les combats de Françoise d'Hérilieu," originally published in serial form in *L'Événement Illustré* between 29 April and 1 July 1868. In any case, there seems to be no scene in this story comparable to Degas's, except perhaps for a vaguely suggestive passage in which the indignant husband beats his wife and smashes the cabinet containing her lover's letters.[19] Jean Adhémar suggested a more likely source in Zola's *Madeleine Férat* (published in 1868). Relying on a now lost drawing that he considered to be a representation of Madeleine and Francis at the inn and an early study for the painting, he thought that Degas had illustrated the climax, "the hotel scene where Madeleine weeps, saying to Francis: 'You suffer, for you love me and I cannot be yours.'"[20] More recently, Reff read in the painting an episode from another novel by Zola, *Thérèse Raquin*, which appeared in the bookstores in December 1867 after being published in three installments in the August, September, and October 1867 issues of *L'Artiste*. The scene in the novel is the one in which the two lovers, now married after having murdered Thérèse's first husband, meet a year later for their wedding night:

> Laurent carefully shut the door behind him, then stood leaning against it for a moment looking into the room, ill at ease and embarrassed. A good fire was blazing in the hearth, setting great patches of golden light dancing on the ceiling and walls, illuminating the whole room with a bright and flickering radiance, against which the lamp on the table seemed but a feeble glimmer. Mme Raquin had wanted to make the room nice and dainty and everything was gleaming white and scented, like a nest for young and virginal love. She had taken a delight in decorating the bed with some extra pieces of lace and filling the vases on the mantelpiece with big bunches of roses. . . . Thérèse was sitting on a low chair to the right of the fireplace, her chin cupped in her hand, staring at the flames. She did not look round when Laurent came in. Her lacy petticoat and bodice showed up dead white in the light of the blazing fire. The bodice was slipping down and part of her shoulder emerged pink, half hidden by a tress of her black hair.[21]

Fig. 77. Study for *Interior*, c. 1868–69. Pencil and stump, 40½ × 51⅛ in. (103 × 130 cm). Cabinet des Dessins, Musée du Louvre (Orsay), Paris (RF31779)

Fig. 78. Study for *Interior* (L353), c. 1868–69. Oil on canvas, 13⅝ × 7⅞ in. (34.5 × 20 cm). Private collection

bois."[13] Reff, after identifying the two people mentioned as the painter Pierre Prins and the musician Jenny Claus, concluded, probably correctly, that the anonymous correspondent was James Tissot (which would lend support to a dating prior to 1871, since after the Commune Tissot had to go into exile in London). In any case, Degas seems to have followed some of the advice, accentuating the shadow, darkening the floor, adding a touch of white on the table, and lightening the ceiling in the mirror.

The completed canvas was apparently al-

study the (straight) nose and the hand are in shadow."[15] The canvas in fact seems very uniform, and any retouching must have been quite limited.

Since its appearance at the turn of the century, this painting has given rise to many interpretations, largely because of the recurrence of the title "The Rape." Degas himself made no pronouncements on it; showing it to Poujaud—"on the floor against the wall"— about 1897, he said simply, "You know my genre picture, don't you?"[16] Some years later, Lemoisne commented on "the desperate,

There is indeed a striking similarity between the poses of the characters as described in the novel and the figures in the painting, and it is quite likely that Degas's *Interior* was inspired by this book (it had just come out and had caused something of a scandal). However, his intention was plainly not to illustrate this precise episode from *Thérèse Raquin*. There are many differences between the painting and the scene in the book: apart from some rather trivial details such as Thérèse's "tress of black hair," these differences are mainly in the décor of the room. There are no roses in the vases, no lace on the bed, nothing to suggest a room lovingly prepared for a wedding night by a deluded mother-in-law; instead, Degas depicts a girl's modest room, neat and sinister, in which two objects take on considerable significance: the narrow single bed (which could not be the matrimonial bed of *Thérèse Raquin*) and the box lined with pink cloth sitting wide open on the table.

Any number of readings are possible. Certainly Degas intended to show a man intruding where he had no business, to suggest a "rape" committed by a young bourgeois gentleman. The open box may suggest a hasty search for some jewel that was hidden there. Apart from the obvious signs of rejected intimacy—the corset lying on the floor, the man's clothing strewn about—there had not, since Greuze's *Broken Pitcher* (Musée du Louvre, Paris), been a more expressive symbol of lost virginity than that gaping box, with its pink lining glaringly exposed in the lamplight.

The painting also embodies purely pictorial ambitions, such as those outlined in a notebook from the period: "Work a great deal on nocturnal effects, lamps, candles, etc. The fascinating thing is not always to show the source of light but rather its effect."[22] But it should also be pointed out that in this painting Degas was breaking what for him was new ground, in literary terms much closer to Zola than to Duranty. This painting could have been a response to Zola's mixed review of his 1868 Salon painting, *Mlle Fiocre in the Ballet "La Source"* (cat. no. 77). Abandoning the "artistic" and "strange embellishments" of pseudo-Japanese inspiration, Degas produced a dark, dense painting with nothing "thin" or "exquisite" about it, choosing a subject that had very little to do with elegant Parisian society. Perhaps it was also his intention—seemingly confirmed by Tissot's intervention and the reference to Millais—to create something for the English market, which Degas and Manet saw at the time as a possible outlet for their work.

Interior is a deliberately ambiguous canvas, loaded with meaning. As has often been

pointed out, it also raises the question of Degas's difficult relationships with women. In this connection, two quotations are illuminating even if they seem contradictory. The first is a bit of gossip passed from Manet to Berthe Morisot in 1869: "He lacks spontaneity, he isn't capable of loving a woman."[23] The second is a passage scribbled by Degas in a notebook used twelve or thirteen years earlier, before his departure for Italy: "I cannot say how much I love this girl since she turned me down on Monday, 7 April. I cannot refuse to . . . say it is shameful . . . a defenceless girl."[24] The rest is illegible.

1. Grappe 1936, p. 52.
2. Alexandre 1935, p. 167.
3. Lemoisne 1912, p. 62.
4. Rouart 1937, p. 21.
5. Letter to Marcel Guérin, 11 July 1936, *Lettres Degas* 1945, p. 255; *Degas Letters* 1947, p. 235.
6. 1967 Saint Louis, no. 61, p. 98.
7. Reff 1976, p. 201.
8. *Lettres Degas* 1945, p. 256; *Degas Letters* 1947, p. 236.
9. Theodore Reff, "Degas's Tableau de Genre," *Art Bulletin*, September 1972, reprinted in Reff 1976, pp. 200–38.
10. Reff 1985, Notebook 22 (BN, Carnet 8, p. 98).
11. Reff 1985, Notebook 22 (BN, Carnet 8, p. 100).
12. Bibliothèque Nationale, Paris, n.a. fr. 24839; published in English in Reff 1976, pp. 225–26.
13. Letters from Paul Poujaud to Marcel Guérin, Paris, 6 and 11 July 1936, Bibliothèque Nationale, Paris, n.a. fr. 24839.
14. Rouart 1937, p. 21.
15. Letter from Poujaud to Guérin, 6 July 1936, Bibliothèque Nationale, Paris.
16. *Lettres Degas* 1945, p. 255; *Degas Letters* 1947, p. 235.
17. Lemoisne 1912, p. 62.
18. Rivière 1935, pp. 97–98.
19. See Crouzet 1964, p. 260.
20. *Émile Zola* (exhibition catalogue), Paris: Bibliothèque Nationale, 1952, no. 114, p. 20.
21. Translation by Leonard Tancock, London: Penguin, 1962; quoted in Reff 1976, p. 205.
22. Reff 1985, Notebook 23 (BN, Carnet 21, p. 45).
23. Morisot 1950, p. 31; Morisot 1957, p. 35.
24. Reff 1985, Notebook 6 (BN, Carnet 11, p. 21).

PROVENANCE: Deposited by the artist with Durand-Ruel, Paris, 15 June 1905 (as "Intérieur 1872," deposit no. 10803); deposited with Durand-Ruel, New York, 26 August 1909; bought from the artist by Durand-Ruel, Paris, 30 August 1909, for Fr 100,000; bought by M. Jaccaci, New York, the same day, for Fr 100,000; A. A. Pope, Farmington; Harris Whittemore, Naugatuck, 1911; J.H. Whittemore Co.; bought by Henry P. McIlhenny, Philadelphia, 1936, to 1986; his bequest to the museum 1986.

EXHIBITIONS: 1911 Cambridge, Mass., no. 2; 1924–26, New York, The Metropolitan Museum of Art; 1932 London, no. 346 (438); 1935 Boston, no. 13; 1936, Paris, Galerie Rosenberg, 15 June–11 July, *Le grand siècle*, no. 17; 1936 Philadelphia, no. 23; 1937 Paris, Palais National, no. 303; 1937 Paris, Orangerie, no. 20, repr.; 1944, New York, Museum of Modern Art, *Art in Progress*, p. 219, repr. p. 20; 1947, Philadelphia Museum of Art, May, *Masterpieces of Philadelphia Private Collections*, no. 12; 1962, San Francisco, California Palace of the Legion of Honor, 15 June–31 July, *The Henry P. McIlhenny Collection*, no. 16, repr.

(color); 1977, Allentown Art Museum, 1 May–18 September, *French Masterpieces of the 19th Century from the Henry P. McIlhenny Collection*; 1979, Pittsburgh, Carnegie Institute, 10 May–1 July, *French Masterpieces from the Henry P. McIlhenny Collection*; 1984, Atlanta, High Museum of Art, 25 May–30 September, *The Henry P. McIlhenny Collection: Nineteenth Century French and English Masterpieces*, no. 18.

SELECTED REFERENCES: Lemoisne 1912, pp. 61–62, repr.; Jamot 1924, pp. 70, 72, 84, pl. 41; Rivière 1935, pp. 49, 97, repr.; Rouart 1937, p. 21; Lemoisne [1946–49], II, no. 348; *Degas Letters* 1947, pp. 235–36; *Émile Zola* (exhibition catalogue), Paris: Bibliothèque Nationale, 1952, no. 114, p. 20; Quentin Bell, "Degas: *Le Viol*," *Charlton Lectures on Art*, Newcastle-upon-Tyne, 1965, n.p.; Minervino 1974, no. 374; Sidney Geist, "Degas' *Interieur* in an Unaccustomed Perspective," *Art News*, LXXV:87, October 1976, pp. 80–81, repr.; Reff 1976, pp. 206–38, fig. 134 (color).

85.

Sulking

c. 1869–71
Oil on canvas
12¾ × 18¼ in. (32.4 × 46.4 cm)
Signed lower right: E. Degas
The Metropolitan Museum of Art, New York. Bequest of Mrs. H. O. Havemeyer, 1929. H. O. Havemeyer Collection (29.100.43)

Lemoisne 335

It has long been assumed that the mysterious title of this work—in French, "Bouderie"—first appeared in a critical article by Georges Lecomte in 1910;[1] for this reason, it was regarded with some skepticism as his invention. In fact, it dates back to 27 December 1895, when Degas stored the painting with Durand-Ruel; thus it is quite probable that it was the artist's title. This small canvas has on occasion been identified as "Le banquier," which was sold by Degas to Durand-Ruel and then bought by Faure with five other pictures on 5 March 1874[2] (see "Degas and Faure," p. 221). There is nothing in the Durand-Ruel records, however, to support that tempting hypothesis.

Although *Sulking* was dated 1873–75 by Lemoisne, Theodore Reff, who has made the most thorough study of the painting, believes it to date to 1869–71. Three sketches in a notebook used during this period show details of the half door, the rack filled with ledgers (fig. 79), and the table piled up with papers (an X-radiograph of the canvas [fig. 80] shows many changes in this area).[3] Apart from its provenance, the sketches are the only documentation we have on this enigmatic work; anything else—placing it, identifying

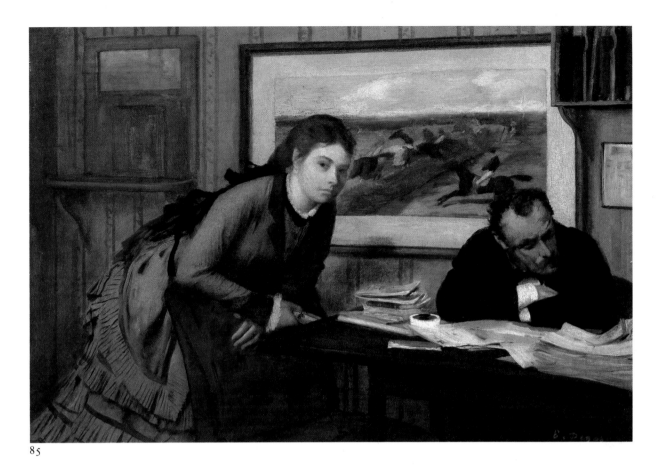

85

the figures, interpreting the subject—is strictly conjectural.

Two people, a man at work and a woman visiting, have been interrupted in their discussion, which we must imagine as heated and strained—in any case, a discussion in no way resembling the momentarily disturbed scene of tender intimacy described in an anonymous article about the painting in the *Revue encyclopédique* in 1896. The setting is either an office connected with horse racing (suggested by the color engraving on the wall) or, more likely, a small bank like the one owned by the De Gas family on rue de la Victoire, which the artist might have used for his studies of the furniture. Reff recognized the young woman as Emma Dobigny, painted by Degas in 1869 (see cat. no. 86), and the scowling man (though his features are less visible) as the writer Duranty (see cat. no. 198). Not that Degas was painting their portraits here—he was rather using them as models for this ambiguous genre scene, just as he would later use Ellen Andrée and Marcellin Desboutin in *In a Café (The Absinthe Drinker)* (cat. no. 172). Be-hind them hangs an extremely careful English engraving, much simplified, *Steeplechase Cracks* (1847), by J. F. Herring. (Degas borrowed part of it in his *False Start* [fig. 69], painting a reversed image of the horse on the right.) The engraving undoubtedly has a close, though as yet unexplained, relationship to the scene before us. In any case, its presence underscores the close connection between this canvas and English painting, which Degas knew well and appreciated—he had studied the British section of the 1867 Exposition Universelle at length.

Fig. 79. Notebook study for *Sulking*, c. 1869–71. 7⅜ × 4¾ in. (18.7 × 12 cm). Bibliothèque Nationale, Paris, Dc327d, Carnet 24, p. 37 (Reff 1985, Notebook 25)

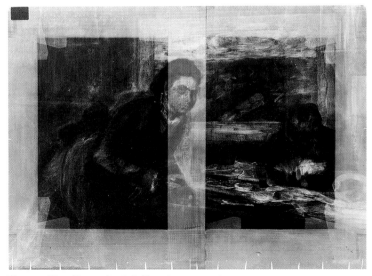

Fig. 80. X-radiograph of *Sulking* (cat. no. 85)

Among Victorian painters, and also among certain Continental painters such as Tissot and Stevens who were strongly influenced by the Victorians, we find this interest in bourgeois private life, meticulously depicted and often disturbed by the intrusion of a third party. We do not really know what has happened or what is about to happen between the couple (undoubtedly lovers or husband and wife)—perhaps the woman has just asked the "banker" for money. Taking a more saccharine view, Lemoisne saw the two as father and daughter—so obviously at odds, but united in their common desire to see the indiscreet visitor depart as quickly as possible. Perhaps, as with *Interior* (cat. no. 84), the painting is based on some unidentified literary source. However, as usual in his genre scenes, Degas plays mainly on the ambiguity of the situation, stressing the mysterious, complicated relations between men and women, and posing existential questions in an entirely prosaic manner.

Years later, when Bartholomé and his wife sat for *Conversation* (cat. no. 327), Degas depicted them in exactly the same poses as the couple in *Sulking*, only placing them much closer to each other. Yet everything has changed: the lovers, interrupted in their confidences, have become husband and wife, impatient for the end of the impromptu sitting; the fine, controlled handling has become broad and quick; the precise study of two "expressive heads"[4] has been replaced by two vibrant, simplified portraits.

1. "La crise de la peinture française," *L'Art et les Artistes*, XII, October 1910, p. 27.
2. Reff 1976, pp. 116–18.
3. Reff 1985, Notebook 25 (BN, Carnet 24, pp. 36–37, 39). Contrary to Reff, the sketch of a woman's head in the contemporaneous Notebook 22 (BN, Carnet 8, p. 43) is not a study for *Sulking*.
4. At the time he painted *Sulking*, Degas wrote in a notebook: "Make of expressive heads (academic style) a study of modern feeling." Reff 1985, Notebook 23 (BN, Carnet 21, p. 44).

PROVENANCE: Deposited by the artist with Durand-Ruel, Paris, 27 December 1895 (deposit no. 8848); bought by Durand-Ruel, Paris, 28 April 1897, for Fr 13,500 (stock no. 4191) (before buying it, however, Durand-Ruel, Paris, had sold it to Durand-Ruel, New York [stock no. N.Y.1646], for Mrs. H. O. Havemeyer); bought by Mrs. H. O. Havemeyer, New York, 15 December 1896, for $4,500; her bequest to the museum 1929.

EXHIBITIONS: 1915 New York, no. 25; 1930 New York, no. 46, repr.; 1936, London, Thomas Agnew, *Exhibition of Pictures, Pastels and Drawings by E. Degas*, no. 34; 1936 Philadelphia, no. 19, repr.; 1937 Paris, Orangerie, no. 11; 1937 Paris, Palais National, no. 299; 1948 Minneapolis, no number; 1948, Springfield Museum of Fine Arts, 7 October–7 November, *Fifteen Fine Paintings*, no number, repr.; 1949 New York, no. 28, repr.; 1951, Seattle Art Museum, 7 March–6 May; 1968 New York, no. 6, repr.; 1977 New York, no. 10 of paintings; 1978 Richmond, no. 6; 1979 Edinburgh, no. 38, repr.

SELECTED REFERENCES: *Revue encyclopédique*, 1896, p. 481; G. Lecomte, "La crise de la peinture française," *L'Art et les Artistes*, XII, October 1910, repr. p. 27; Burroughs 1932, p. 144, repr.; Lemoisne [1946–49], I, p. 83, II, no. 335; Cabanne 1957, pp. 29, 97, 110; Ronald Pickvance, *Burlington Magazine*, CVI:735, June 1964, p. 295; New York, Metropolitan, 1967, pp. 71–73; Reff 1976, pp. 116–20, 144, 162–64, fig. 83 (color); Moffett 1979, p. 10, fig. 14 (color).

86.

Emma Dobigny

1869
Oil on panel
12 × 10½ in. (30.5 × 26.5 cm)
Signed and dated lower right: Degas/69
Private collection, Zurich

Lemoisne 198

Little is known about Emma Dobigny. Her real name was Marie Emma Thuilleux; she was born in Montmacq, Oise, in 1851, and died in Paris in 1925. When Degas knew her, between 1865 and 1869 (at that time he spelled her name "Daubigny," like the painter), she lived on a small street in a poor area of Montmartre, at 20 rue Tholozé,[1] and posed for painters; Corot (*The Spring*), Henri Rouart, Puvis de Chavannes (*Hope*, fig. 81), and possibly Tissot (*Afternoon Tea*[2]) had already used her or would be using her as a model. Degas painted her as a common laundress (L216, Neue Pinakothek, Munich; BR62, Musée d'Orsay, Paris) and as the more bourgeois, but less comely, companion of a "banker" (see cat. no. 85). That she was one of his favorite models is demonstrated by a short note (now in a private collection) that he wrote to her during this period: "Little Dobigny, another session and right away if possible." She is perhaps the same model we see again, looking placid and slightly plumper, in the beautiful *Girl in Red* (L336, Chester Dale Collection, National Gallery of Art, Washington, D.C.), which Lemoisne dates slightly later, 1873–75. Unlike Theodore Reff, I do not see her in the fat, common face of the woman at the National Gallery in London (L355), nor in the notebook sketch of a young girl with a more drooping nose, slight squint, and less finely chiseled jaw.[3] The same year that Degas painted this small portrait, Puvis did a pencil drawing of Emma Dobigny dated 1 August 1869; it was reproduced first in *L'Estampe Moderne* in April 1896, and then in *Le Figaro Illustré* in February 1899,[4] before assuming the title *Hope*.[5] Puvis's head and shoulders of the young woman, with her hair loosened, obviously stylized to create

an allegorical figure rather than a portrait, shows the same features found in each of the other works—the firm round face, the slightly upturned nose, the small full-lipped mouth, and the long, delicate, even eyebrows above a melancholy gaze. As for Degas, he does not portray the professional model. Instead, he paints a pensive young woman, choosing a formula he employed deliberately in the late 1860s, particularly for people of whom he was very fond (Altès, Rouart, Valpinçon[6]): a small profile portrait of the head and shoulders, done with a light touch and great detail, which lovingly captures the features of the face and rapidly brushes in the background.

1. Reff 1985, Notebook 21 (private collection, p. 34).
2. See Michael Wentworth, *James Tissot*, Oxford: Clarendon Press, 1984, p. 66.
3. Reff 1985, Notebook 22 (BN, Carnet 8, p. 43).
4. See entry by Jacques Foucart in *Puvis de Chavannes* (exhibition catalogue), Paris: Grand Palais/Ottawa: National Gallery of Canada, 1976, no. 91, p. 113.
5. See Paul Prouté, Dandré-Bardon catalogue, Paris, 1975, no. 107, repr.
6. Altès, L89, The Metropolitan Museum of Art, New York; Rouart, L293, private collection; Valpinçon, L99 (fig. 20).

PROVENANCE: Ludovic Lepic, Paris (Lepic sale, Drouot, Paris, 30 March 1897, no. 51 [as "Buste de femme"]); bought at that sale in half shares by Durand-Ruel and Manzi (stock no. 4135), for Fr 700; deposited with Mr. and Mrs. Erdwin Amsinck, Hamburg, 16 November 1897, who bought it 24 November 1897, for Fr 3,000; their bequest to the Hamburger Kunsthalle 1921; exchanged, along with *A Vase of Flowers* by Renoir, for *Evening: The Artist's Mother and Sister in the Garden* by Hans Thoma, with Karl Haberstock, Berlin dealer, 1939. Acquired on the Munich market by present owner 1952.

Fig. 81. Puvis de Chavannes, *Hope*, 1869. Published in *L'Estampe Moderne*, April 1896

86

EXHIBITIONS: 1937 Paris, Orangerie, no. 10, pl. VIII; 1959, Paris, Petit Palais, March–May, *De Géricault à Matisse*, no. 41; 1964, Lausanne, Palais de Beaulieu, *Chefs-d'oeuvre des collections suisses de Manet à Picasso*, no. 4, repr.; 1967, Paris, Orangerie, 2 May–2 October, *Chefs-d'oeuvre des collections suisses de Manet à Picasso*, no. 4, repr.; 1976–77 Tokyo, no. 10, repr. (color).

SELECTED REFERENCES: Lemoisne [1946–49], II, no. 198; Boggs 1962, p. 64; Minervino 1974, no. 254, pl. XIII (color).

87.

Mme Théodore Gobillard, née Yves Morisot

1869
Oil on canvas
21⅜ × 25⅝ in. (54.3 × 65.1 cm)
Signed lower left: Degas
The Metropolitan Museum of Art, New York.
 Bequest of Mrs. H. O. Havemeyer, 1929.
 H. O. Havemeyer Collection (29.100.45)

Lemoisne 213

In 1864, Tiburce Morisot was appointed to a senior position with the French government audit office and moved with his wife, his three daughters Yves, Edma, and Berthe, and his son Tiburce to a "very simple house" on rue Franklin, "with doors on the ground floor leading to a beautiful garden with large shade trees."[1]

Painting was the family's main activity. Tiburce had a studio built in the garden for his daughters, and a whole circle of artists (forming what today seems a rather eclectic group) came to rue Franklin: Puvis de Chavannes, Stevens, Fantin-Latour, and later Manet. The Manets and the Morisots quickly struck up a friendship, and it was probably at Mme Auguste Manet's "Thursday evenings" that the Morisots also made the acquaintance of Degas who, despite initial reservations about Berthe, was not indifferent to the bohemian charm of this good bourgeois family.

Shortly after meeting them, Degas began a portrait of Yves, the eldest daughter (5

October 1838–8 June 1893). Yves had been married since 1866 to Théodore Gobillard, a former officer who had lost an arm fighting in Mexico and had obtained a position as a tax collector, first in Quimperlé and then in Mirande, where he was transferred in the spring of 1869. Yves, following her husband, stopped on the way in Paris for several weeks, and Degas took the opportunity to paint a portrait of the young woman. Thanks to the family correspondence, which provides an incomparable record of the painting's progress, we can follow Degas's work from the initial sketch to the final canvas.

First, a dry comment by Berthe Morisot to her sister Edma Pontillon in a letter dated 22–23 May 1869—"M. Degas has made a sketch of Yves that I find mediocre"[2]—is expanded in more interesting detail by Mme Morisot: "Do you know that M. Degas is mad about Yves's face, and that he is doing a sketch of her? He is going to transfer the drawing that he is doing in his sketchbook onto the canvas. A peculiar way of doing a portrait!"[3] A month later, on 26 June, Yves herself wrote to her sister Berthe and, after apologizing for having neglected her and blaming Degas, who "took up all my time," added: "The drawing that M. Degas made of me in the last two days is really very pretty, both true to life and delicate, and it is no wonder that he could not detach himself from his work. I doubt if he can transfer it onto the canvas without spoiling it. He announced to mother that he would come back one of these days to draw a corner of the garden."[4]

Despite Yves's imminent departure for Limoges and the incessant comings and goings this occasioned, "Degas took up her last moments" in Paris. "That original came on Tuesday," noted the kindly Mme Morisot. "This time he took a big sheet of paper and set to work on the head in pastel; he seemed to be doing a very pretty thing, and drew with great skill."[5]

A few brief comments can be made concerning this valuable exchange of letters. The first drawing, mentioned by Mme Morisot as having been done in a sketchbook, has not survived; the ones we have today are on sheets too large to come from a notebook. The sketch mentioned by Yves Gobillard on 26 June may be one of two drawings recently acquired by the Metropolitan Museum in New York (cat. nos. 88, 89). The pastel that Degas did just before Yves left for Limoges, and which he submitted to the Salon of 1870, is also in the Metropolitan (cat. no. 90). The motive behind all this work was Degas's infatuation with the strange face of Yves Gobillard—the prominent features, the square jaw and thin lips, the pointed and slightly upturned nose, the deep creases

on either side of her mouth. There was nothing beautiful about her face, and, unlike her sister Berthe, she was not a "femme fatale," the epithet that circulated when Manet's *Balcony* (Musée d'Orsay, Paris), in which Berthe appears, was exhibited at the Salon the same year. In the course of a little over a month, Degas went to the house on rue Franklin several times. The sittings were not at all constrained; he dropped in when he had a minute and when the Morisots could receive him; he worked not in the sacred silence of a studio, but in the everyday disorder of an inhabited and bustling house: "He asked me to give him an hour or two during the day yesterday," noted Mme Morisot in late June. "He came to lunch and stayed the whole day. He seemed to like what he had done, and was cross to have to tear himself away from it. He really works with ease, for all this took place amid the visits and the farewells that never ceased during those two days."[6] A month before, Berthe Morisot had already written with regard to the first drawing: "He chattered all the time he was doing it."[7] Yves and her mother marveled at his facility, the one finding his drawing "really very pretty, both true to life and

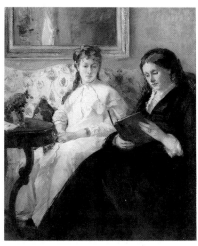

Fig. 82. Berthe Morisot, *The Artist's Mother and Sister*, c. 1869–70. Oil on canvas, 39¼ × 32¼ in. (101 × 81.8 cm). National Gallery of Art, Washington

delicate," and the other noting that the pastel was "a very pretty thing" and that he "drew with great skill."[8] Only Berthe showed some reticence, considering the first drawing of Yves "indifferent." She also reported Manet's unkind remarks about Degas, and was quite hard on him herself: "I certainly do not find his personality attractive; he has wit, but nothing more."[9] However, she redeemed herself a year later when she described the pastel portrait of Yves exhibited at the Salon as a "masterpiece."[10] Finally, it should be noted that a short time later Berthe was to do a double portrait (fig. 82) of her mother and her sister Edma Pontillon seated on the same sofa and below the same mirror as in Degas's canvas.[11]

The first drawing, which Mme Morisot says was done in a sketchbook, was followed by the beautiful pencil sketch (cat. no. 89) acquired by the Metropolitan Museum from a member of the family in 1985; it shows Yves Gobillard in a pose very similar to that in the canvas, with the exception of the face, which is turned toward the viewer but later would be shown in profile. Next came the squared drawing (cat. no. 88), acquired by the museum the previous year, in which the

young woman found her final pose. Degas was to supplement these two studies with a detailed drawing of the interior of the apartment (cat. no. 91), undoubtedly made after Yves's departure—she has only been roughly sketched in. Just as the initial conception of this painting does not seem to have been

87

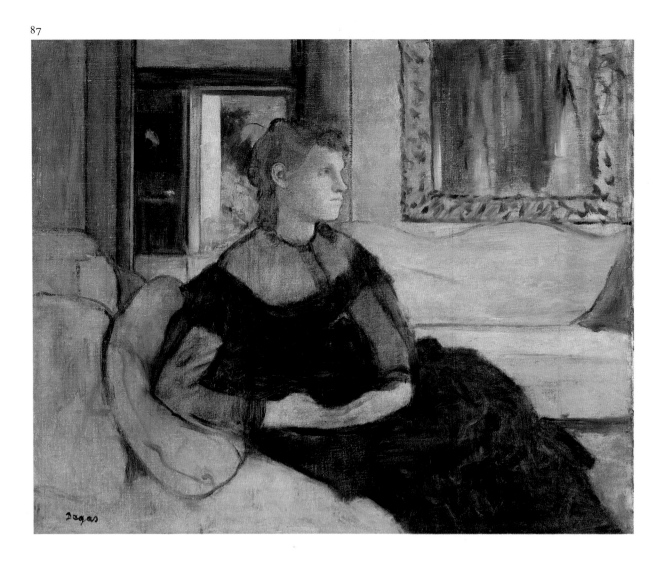

preserved, we are also missing one of the final links, the study of "a corner of the garden" that Degas wanted to do after Yves had left. As for the pastel (cat. no. 90), which we know Degas worked on for two days running in late June,[12] it appears to be a study of "general tonality," to borrow a phrase from Gustave Moreau; it explores the model's features in greater detail than the preliminary drawings, causing her profile to stand out against the barely decipherable background of vertical lines and dense foliage flecked with red.

The studies from life display a coherence and sense of progression that would seem to suggest quite a different painting from the studio portrait, which, though it is unfinished, must be considered the final work. The increasing precision with which Degas drew Yves's face, making of the pastel a striking portrait, led, strangely enough, to a canvas in which the model's pronounced and characteristic features are indistinct, leaving only the readily identifiable bone structure of the face (Mary Cassatt compared it, curiously, to a Vermeer[13]). Even the dress, which the drawings show in such detail, including buttons, lace, and ruffles, becomes no more than a contrast between the opacity and transparency of its fabrics. The Morisots' sitting room, whose furnishings and layout Degas indicated so precisely in the Louvre drawing (cat. no. 91)—a room with large curtained windows, separated from the garden by an anteroom and a salon, on the wall of which hangs a canvas—is now cut off well below the ceiling and consists only of a succession of planes that are difficult to distinguish, while the image in the mirror, previously so clear, is now an indecipherable arrangement of whites and browns. Only the distant garden is still clearly represented, with the dense foliage of chestnut trees and the lawn strewn with red petals.

To paint a portrait in full view of the Morisot family, who lived for painting, was inevitably to invite comments and comparisons. According to Berthe, the latest thing was to place a figure in a landscape. Describing Bazille's submission to the Salon of 1869, at the same time that Degas was studying Yves's profile, she wrote: "He has tried to do what we have so often attempted—a figure in the outdoor light—and this time he seems to have been successful."[14] Shortly after she announced: "I am going to do my mother and Yves in the garden; you see I am reduced to doing the same things over and over again."[15]

Degas, a fierce enemy of the outdoors, must have smiled at these unsuccessful efforts; but with the portrait of Yves Gobillard he gives, in a way, his response to the problem. No doubt amused at challenging

88

Berthe Morisot on her own territory, since he did not have much sympathy for her at the time and she was somewhat contemptuous of him, he places his sitter, as Ingres would have done, in a bourgeois sitting room, but, by opening the successive doors of the apartment, lets in a strictly defined segment of the luxuriant spring garden. In this harmony in brown, the garden is the only note of color, its different greens arranged, behind the profile of Yves, like the vivid backgrounds sometimes seen in Renaissance portraits.

1. Morisot 1950, p. 13; Morisot 1957, p. 17 (translation revised).
2. Morisot 1950, p. 31; Morisot 1957, p. 35 (translation revised).
3. Ibid.
4. Morisot 1950, p. 32; Morisot 1957, p. 36.
5. Ibid.
6. Ibid.
7. See note 2 above.
8. See note 4 above.
9. See note 2 above.
10. Morisot 1950, p. 39; Morisot 1957, p. 43.
11. Exhibited in the Salon of 1870.
12. See note 4 above.
13. Weitzenhoffer 1986, pp. 230–31.
14. Morisot 1950, p. 28; Morisot 1957, p. 32.
15. Morisot 1950, p. 29; Morisot 1957, p. 33.

PROVENANCE: Michel Manzi, Paris; bought from his heirs, on the advice of Mary Cassatt, by Mrs. H. O. Havemeyer, 5 December 1915; her bequest to the museum 1929.

EXHIBITIONS: 1876 Paris, no. 39; 1930 New York, no. 52; 1931 Paris, Orangerie, no. 110; 1948 Minneapolis, no number; 1952, Art Gallery of Toronto, 20 September–26 October, *Berthe Morisot and Her Circle: Paintings from the Rouart Collection*, Paris, handwritten note under no. 28 in a copy of the catalogue in the

Art Gallery of Ontario; 1977 New York, no. 9 of paintings, repr.; 1978 New York, no. 8, repr. (color).

SELECTED REFERENCES: Lemoisne [1946–49], I, pp. 57–58, II, no. 213; Morisot 1957, pp. 33, 35–36; Havemeyer 1961, pp. 264–67; Boggs 1962, pp. 27, 61, 119, pl. 64; Burroughs 1963, repr. facing p. 169; New York, Metropolitan, 1967, pp. 65–66; Minervino 1974, no. 249; Moffett 1979, nos. 8, 9, pl. 5 (color); Moffett 1985, nos. 62, 63, repr. (color); Weitzenhoffer 1986, pp. 230–31, fig. 156.

88.

Study for *Mme Théodore Gobillard*

1869
Pencil on buff tracing paper mounted
 on laid paper
12⅜ × 17⅜ in. (31.5 × 44 cm)
Signed in crayon lower left: Degas
The Metropolitan Museum of Art, New York
 (1984.76)

See cat. no. 87

PROVENANCE: Presumably given by the artist in 1901 to Jeannie Gobillard, daughter of the sitter, or Paul Valéry, on the occasion of their marriage on 31 May 1900; Wildenstein and Co., New York, 1983; bought by the museum 1984.

EXHIBITIONS: 1924 Paris, no. 88; 1931 Paris, Orangerie, no. 109; 1937 Paris, Orangerie, no. 78; 1955 Paris, GBA, no. 33, repr.

SELECTED REFERENCES: Morisot 1957, pp. 33, 35–36; Boggs 1962, p. 27; Burroughs 1963, fig. 3 p. 171; Moffett 1979, p. 9, fig. 7; Jacob Bean, "Yves Gobillard-Morisot," *Notable Acquisitions 1983–1984, The Metropolitan Museum of Art*, New York, 1984, p. 73, repr.; Gary Tinterow, "Yves Gobillard-Morisot," *Notable Acquisitions 1984–1985, The Metropolitan Museum of Art*, New York, 1985, p. 30.

89

90

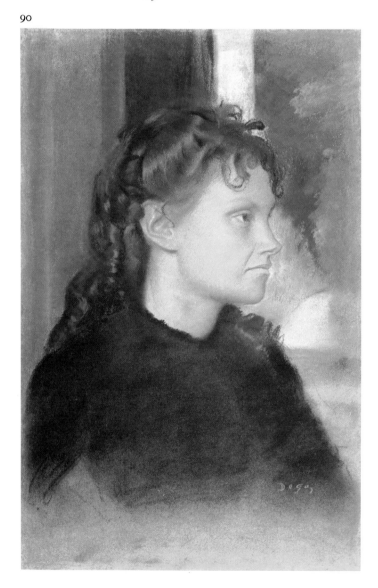

91

89.

Study for *Mme Théodore Gobillard*

1869
Pencil on pale buff wove paper
13⅛ × 17⅜ in. (33.3 × 44 cm)
Signed in crayon lower left: Degas
The Metropolitan Museum of Art, New York
 (1985.48)

See cat. no. 87

PROVENANCE: Presumably given by the artist in 1901 to Jeannie Gobillard, daughter of the sitter, or Paul Valéry, on the occasion of their marriage on 31 May 1900; Mme Paul Rouart (née Agathe Valéry), their daughter, Neuilly; bought by the museum and John R. Gaines 1985.

EXHIBITIONS: 1924 Paris, no. 89; 1931 Paris, Orangerie, no. 108; 1955 Paris, GBA, no. 34, repr.

SELECTED REFERENCES: Morisot 1957, pp. 33, 35–36; Boggs 1962, p. 27; Burroughs 1963, fig. 2 p. 171; Moffett 1979, p. 9, fig. 6; Gary Tinterow, "Yves Gobillard-Morisot," *Notable Acquisitions 1984–1985*, *The Metropolitan Museum of Art*, New York, 1985, p. 30, repr.

90.

Mme Théodore Gobillard, née Yves Morisot

1869
Pastel
18⅞ × 11⅞ in. (48 × 30 cm)
Signed lower right: Degas
The Metropolitan Museum of Art, New York.
 Bequest of Joan Whitney Payson, 1975
 (1976.201.8)

Exhibited in New York

Lemoisne 214

See cat. no. 87

PROVENANCE: Given by the artist to Berthe Morisot, sister of the sitter; given by Berthe Morisot to her niece Paule Gobillard, on the death of Yves Gobillard, her mother, 1893; Mme Paul Valéry (née Jeannie Gobillard), her sister, Paris, 1946; bought by Joan Whitney Payson, New York; her bequest to the museum 1975.

EXHIBITIONS: 1870, Paris, 1 May–20 June, Salon, no. 3320 (as "Portrait de Mme G . . . ," pastel); 1924 Paris, no. 90, repr.; 1931 Paris, Orangerie, no. 110; 1960 Paris, no. 10, repr.; 1977 New York, no. 9 of works on paper, repr.

SELECTED REFERENCES: Lemoisne [1946–49], I, pp. 57–58, II, no. 214; Morisot 1957, pp. 33, 35–36; Boggs 1962, pp. 27, 61, fig. 62; Burroughs 1963, fig. 1 p. 170; Jacob Bean, "Drawings," *Notable Acquisitions 1975–1979*, *The Metropolitan Museum of Art*, New York, 1979, p. 57, repr.; Moffett 1979, pp. 7–9, pl. 6 (color); Moffett 1985, pp. 60–61, repr. p. 60.; Gary Tinterow, "Yves Gobillard-Morisot," *Notable Acquisitions 1984–1985*, *The Metropolitan Museum of Art*, New York, 1985, p. 30.

91.

Interior of the Morisot Sitting Room, study for *Mme Théodore Gobillard*

1869
Pencil and black chalk heightened with white on cream-colored paper
19⅛ × 12¾ in. (48.7 × 32.4 cm)
Atelier stamp on verso
Cabinet des Dessins, Musée du Louvre (Orsay), Paris (RF29881)

Exhibited in New York

See cat. no. 87

PROVENANCE: Atelier Degas; Henri Fevre, Paris; Marcel Guérin, Paris (sale, Drouot, Paris, 11 December 1950, no. 79); bought at that sale by the Louvre.

EXHIBITIONS: 1969 Paris, no. 150.

The Landscapes of 1869

cat. nos. 92–93

The important exhibition of French Impressionist landscapes held in Los Angeles, Chicago, and Paris in 1984–85 did not include any of Degas's landscapes,[1] not because he was not regarded as an Impressionist (Manet was represented) but probably because the organizers considered his work as a landscape painter very marginal, if they considered it at all. It is true that only about a hundred of the roughly fifteen hundred paintings and pastels listed in Lemoisne's catalogue of Degas's work can be considered pure landscape; it is also clear that Degas's interest in landscape was confined to brief periods—the late 1860s and the 1890s. Furthermore, the pronouncements he liked to make regarding "outdoor" painters could be taken as a profound contempt for the genre: "If I were the government, I would have a squad of gendarmes to keep an eye on these people painting landscapes from nature. Oh! I do not wish anyone dead; I would, however, agree to spraying them with a little bird shot, for starters!"[2] This attitude must, however, be taken with a grain of salt. We can begin by admitting that nothing in Degas's training predisposed him to become a landscape painter: neither his teachers, Barrias and Lamothe, nor his mentor, Gustave Moreau, nor the artists he admired so much, Ingres and Delacroix, were landscape painters. Of his circle, only the unpretentious Grégoire Soutzo, about whom not much is known, might be called a landscape painter, and it is to him that we owe De-

gas's first comments on the subject and his first landscape studies (see Chronology I, 18 January 1856). Degas adopted Soutzo's enthusiasms: for Corot, and especially for Claude Lorrain, some thirty of whose etchings Soutzo possessed when he died.[3] During his stay in Italy, Degas became very enthusiastic about Claude's landscapes. In Naples, he noted the *Landscape with the Nymph Egeria*—"the finest Claude Lorrain there is. The sky is like silver and the shadows speak to you."[4] In Rome, at the Doria Pamphili Gallery, he wrote: "Perhaps the finest I have seen and the finest there are."[5] He also admired the etchings at the Corsini Gallery.[6] Oddly enough, Claude's influence can be seen more clearly in the pen-and-ink drawings, often heightened with wash, that Degas did shortly after his return to France[7] than in the pencil studies of the Roman or Neapolitan countryside, which are very similar to those Bonnat, Chapu, and Delaunay were drawing then.

He painted few landscapes in the 1850s: *View of Naples Seen through a Window* (L48, private collection); *View of Rome* (L47 bis), which was probably the view from his studio in the Piazza San Isidoro and which shows the *manica lunga* of the Quirinal palace; and *Horses in a Landscape* (L50, Kunstmuseum Bern), the attribution of which may be contested.

On his return to France, Degas fell in love with the Normandy countryside, which he discovered during his first stay with the Valpinçons at Ménil-Hubert in September and October of 1861,[8] and which he claimed changed all the beliefs he had held up to then. During a walk to Haras du Pin, he made some detailed drawings[9] of the "green hills" and the "pastures, both large and small, completely surrounded by hedges"[10] that he would use in the background of some racing scenes. But again, the sudden enthusiasm, the references to English painters, the recollections of Corot and Soutzo were limited to a few studies in a notebook.

It may, therefore, come as a surprise to see the sudden rash of landscapes in 1869—seven pastels bearing this date (L199–L205), to which Lemoisne adds another thirty-seven (L217–L253), proposing that they were done at the same time. It is difficult to believe that Degas made all of them during his brief stay at Étretat and Villers-sur-Mer the summer of 1869. He left Paris toward the middle of July, after finishing his portrait of Yves Gobillard (cat. no. 87), but it is not certain when he returned. It is unlikely, however, that he lingered in Normandy beyond September. Other visits to the coast are plausible, but not, it should be noted, in 1867[11] or 1868,[12] nor in 1870, when the progress of military operations

92

him at Boulogne that same summer, took an entirely different approach.

Degas avoided oils and concentrated on the seashore. No doubt considering his contemporaries too "herbivorous," to use a term of Baudelaire's, he composed, perhaps on returning to the calm of his Paris studio, his small landscapes reflecting, as he said much later, not his "soul" but his "eyes."[16] Perhaps he hoped to obey the injunctions of Baudelaire, whom he was reading at the time (in July 1869, Manet wrote to him, "Please return the two volumes of Baudelaire I lent you"[17]). The poet, in his *Salon de 1859*, wondered, before praising Boudin's studies, "Why does imagination flee the studio of the landscape painter?" and decided the answer must lie in these painters' overly slavish and direct copying of nature "which perfectly suits their lazy minds."[18]

With his remembered landscapes, Degas gave his entirely original answer; once

(which he followed closely) almost certainly kept him in Paris. It is also quite possible, knowing the opinions he later repeatedly expressed about painting outdoors, that he did not do these landscapes from nature, but in the studio. In a notebook he used at that time,[13] Degas did not sketch the places he visited, such as Étretat or Villers-sur-Mer, but noted the colors of the sea and sky at sunset: "the sunset orangey pink, cold and dull, neutral, the sea like a sardine's back and lighter than the sky."[14] So what Lemoisne says about the making of the landscapes must be accurate: "As he looks at them, Degas's keen eye also registers the appearance of the countryside, the pale sea-green shore fringed with foam, the curve of a bank of golden sand, the outline of hills, a velvety meadow, the color of the sky. Later, back in the studio, the artist delights in recreating some of these places from memory, attempting to reproduce the colors and outlines with his sticks of pastel."[15] Thus it is very difficult to identify the sites represented in Degas's pictures, whether from the Normandy coast or from recollections of visits to Saint-Valéry-sur-Somme with his father and his brothers and sisters. He is not concerned with topographical accuracy or strict climatic observation, but shows, reconstructed from memory, bleak cliffs to which low-roofed houses cling like barnacles to a rock, beaches at low tide, the sea and sand barely distinguishable, boats that appear to be stranded and not a sign of human life (see cat. no. 92), or a long wisp of smoke trailing behind a steamer, four black points representing sailboats on a skyline that separates

93

the blue of the sea from the blue of the sky (see cat. no. 93).

These are not ambitious compositions like those painted in the same location at the same time by Courbet, who spent the summer of 1869 at Étretat; nor are they studies like the many pastels done by Boudin during his years on the Normandy coast. Rather, they are a homogeneous, self-contained series of works identical in technique, close in size, and similar in subject matter. Degas, who was already familiar with Pissarro's landscapes, and who may well have seen the seascapes done by Manet when he visited

again, he did not waver, but remained steadfast throughout his long career, reinventing the morphology of the glimpsed landscapes, pointing out topographical oddities, delighting in winding streams and in trees with bizarre shapes, playing with the green of the meadows and the brown of the plowed soil, and always bringing imagination back to the studio of the landscape painter.

1. 1984–85, Los Angeles County Museum of Art, 28 June–16 September 1984/The Art Institute of Chicago, 23 October 1984–6 January 1985/Grand Palais, Paris, 8 February–22 April 1985, *A Day in*

the Country: Impressionism and the French Landscape.

2. Vollard 1924, pp. 58–59.
3. See *Catalogue d'estampes anciennes . . . formant la collection de feu M. le prince Grégoire Soutzo*, Paris, 17–18 March 1870, nos. 78–106.
4. Reff 1985, Notebook 4 (BN, Carnet 15, p. 18).
5. Reff 1985, Notebook 7 (Louvre, RF5634, p. iv).
6. Reff 1985, Notebook 10 (BN, Carnet 25, p. 50).
7. Reff 1985, Notebook 18 (BN, Carnet 1).
8. Letter from Marguerite and René De Gas to Michel Musson, Paris to New Orleans, 13 October 1861, Tulane University Library, New Orleans.
9. Reff 1985, Notebook 18 (BN, Carnet 1, pp. 162–63, 165, 167–68, 171, 173, 175–76).
10. Reff 1985, Notebook 18 (BN, Carnet 1, p. 161).
11. See Reff 1985, Notebook 22 (BN, Carnet 8, pp. 5, 221).
12. See letter from Manet to Fantin-Latour, Boulogne-sur-Mer to Paris, in Moreau-Nélaton 1926, pp. 102–03; unpublished letter from Manet to Degas, Calais to Paris, 29 July 1868, private collection.
13. Reff 1985, Notebook 23 (BN, Carnet 21, pp. 58–59, 149).
14. Reff 1985, Notebook 23 (BN, Carnet 21, p. 58).
15. Lemoisne [1946–49], I, p. 61.
16. Lettres Degas 1945, p. 278; Halévy 1964, p. 66.
17. Letter from Manet to Degas, [July 1869], private collection, mentioned in Reff 1976, p. 150.
18. See Charles Baudelaire, *Salon de 1859*, in *Oeuvres*, Paris: Pléiade, 1966, p. 1081.

92.

Cliffs at the Edge of the Sea

1869
Pastel on buff wove paper
12¾ × 18½ in. (32.4 × 46.9 cm)
Signed and dated lower right: Degas/69
Vente stamp lower left
Musée d'Orsay, Paris (RF31199)

Exhibited in Paris

Lemoisne 199

PROVENANCE: Atelier Degas (Vente IV, 1919, no. 58.b); bought at that sale by Nunès et Fiquet, Paris, with no. 58.a, for Fr 4,000; Baronne Éva Gebhard-Gourgaud, Paris; her gift to the Louvre 1965.

EXHIBITIONS: 1966, Paris, Cabinet des Dessins, Musée du Louvre, May, *Pastels et miniatures du XIXe siècle*, no. 46; 1969 Paris, no. 151; 1975, Paris, Musée Delacroix, June–December, *Delacroix et les peintres de la nature*.

SELECTED REFERENCES: Lemoisne [1946–49], II, no. 199; Maurice Sérullaz, "Cabinet des dessins: la donation de la baronne Gourgaud," *La Revue du Louvre et des Musées de France*, 16th year, 2, 1966, pp. 100–01, repr.; Minervino 1974, no. 297; Paris, Louvre and Orsay, Pastels, 1985, no. 77, repr.

93.

Seascape

1869
Pastel on buff wove paper
12⅜ × 18½ in. (31.4 × 46.9 cm)
Vente stamp lower left
Musée d'Orsay, Paris (RF31202)

Exhibited in Paris

Lemoisne 226

PROVENANCE: Atelier Degas (Vente IV, 1919, no. 47.a); bought at that sale by Nunès et Fiquet, Paris, with no. 47.b, for Fr 5,550; Baronne Éva Gebhard-Gourgaud, Paris; her gift to the Louvre 1965.

EXHIBITIONS: 1966, Paris, Cabinet des Dessins, Musée du Louvre, May, *Pastels et miniatures du XIXe siècle*, no. 49; 1969 Paris, no. 154.

SELECTED REFERENCES: Lemoisne [1946–49], II, no. 226; Maurice Sérullaz, "Cabinet des dessins: la donation de la baronne Gourgaud," *La Revue du Louvre et des Musées de France*, 16th year, 2, 1966, pp. 99–111, repr.; Minervino 1974, no. 306; Reff 1977, fig. 79 (color); Paris, Louvre and Orsay, Pastels, 1985, no. 80, repr.

94.

Mme Edmondo Morbilli, née Thérèse De Gas

1869
Pastel, with strips of paper added at top and bottom
20⅛ × 13⅜ in. (51 × 34 cm)
Private collection, New York

Lemoisne 255

Some time after painting the double portraits in Washington and Boston (see cat. no. 63), which show Thérèse with her husband Edmondo Morbilli, Degas undertook to paint his sister by herself as he had so often done before her marriage. The occasion was a visit by Thérèse to Paris, the setting her father's drawing room at 4 rue de Mondovi, and the moment just as she is preparing to step out or just as she is coming in. But the technique, the format, and the aim of this portrait set it apart from Degas's previous works in this genre.

Thérèse stands before us in a plain spring or summer dress, with one elbow on the mantelpiece in a pose that echoes that of Ingres's famous portrait of the Comtesse d'Haussonville (fig. 83), but a Comtesse d'Haussonville who is stern, distant, and somewhat stiff. In all her portraits, Thérèse retains the same air, one of incomprehen-

sion, but her face—more mature here, and thinner—now has a certain severity, an uncustomary reserve. This not very likable young woman no longer has much in common with the good little girl about whom her brother Achille, writing from Gabon, asked in 1860, "And is Thérèse still embroidering for all the children in the family?"[1]—the stay-at-home girl always busy with some domestic chore.

She is surrounded by an array of modern comforts—sofas and armchairs, cushion, bell-pull—as well as works produced in the previous century, such as the Rococo candlesticks or the pastels on the wall. The red velvet of the chairs and around the top of the mantelpiece, the frames that are almost side by side, and the flower-patterned carpet give this low room, which is scarcely enlarged by the mirror, a confined atmosphere that is very different from the more open interiors of Degas's other portraits of her.[2]

As in his landscapes of the Normandy coast (see "The Landscapes of 1869," p. 153) and the study for the portrait of Mme Théodore Gobillard (cat. no. 90), Degas used pastel, which leads us to accept the date of 1869 generally proposed for this work. Not only was pastel preferred for portraits in the eighteenth century—by such artists as Perronneau, whose painting of Mme Miron de Porthioux hangs on the wall at the right—but it could also bring out better than oil the softness, the silkiness, and the plush of the wools, cottons, and velvets. Apart from the landscapes, this was the first time that Degas employed pastel for the final version of a work. He had used it earlier in sketches for *The Bellelli Family* (fig. 36) and *Semiramis* (fig. 45), no doubt because it allowed him to analyze the balance of colors, and later in working on the portraits of Mme Camus at the piano (L208–L212)[3] and of Yves Gobillard-Morisot (cat. no. 87), but with larger canvases in mind.

This homage to the eighteenth century and, through the objects surrounding Thérèse, to their father's taste for this period—also the tastes of the Marcilles and the La Cazes, whom Degas had visited with him as a boy—does not lead Degas into pastiche, into neo-La Tour or neo-Perronneau, as it did many of his contemporaries. Taking his inspiration once again from Ingres, he gives his sister a new image, unlike that in any other painting of the time, with harmonies of red, pink, and gold, heralding the subtleties of colors of the Nabis. This was to be Degas's last portrait of his beloved Thérèse, standing primly in her yellow dress with white trim, holding that curious hat which looks like the oval of a bearded head, and somehow cut off from her brother by the angles of the crimson velvet sofas.

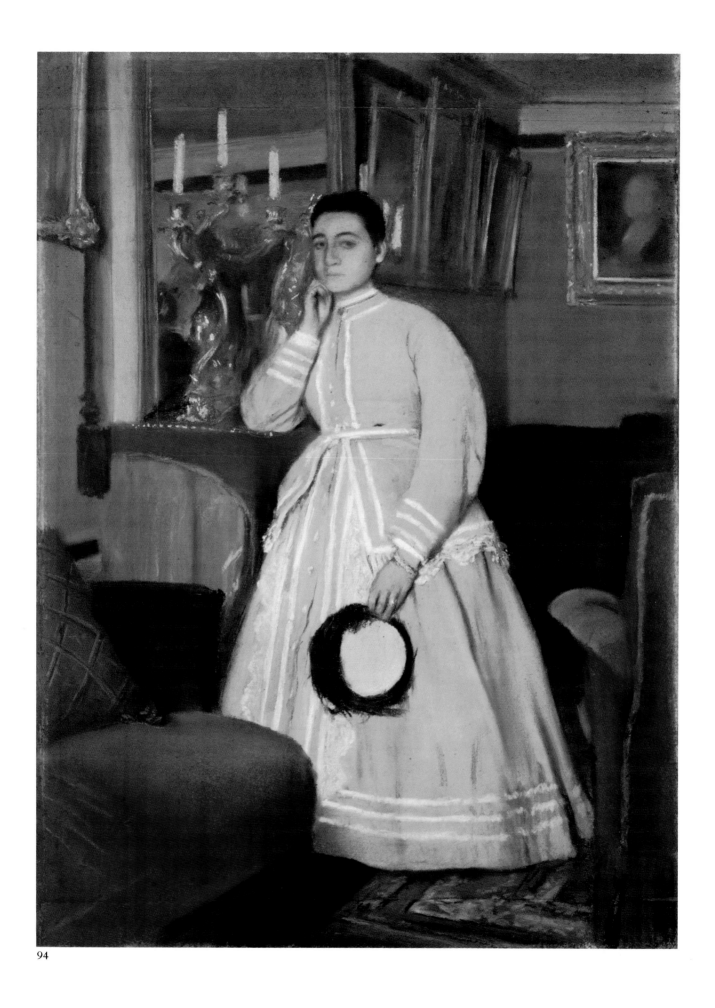

94

1. Unpublished letter from Achille De Gas to Edgar, 7 July 1860, private collection.
2. The posthumous inventory drawn up on 4 April 1874 describes the furnishings from the parlor on rue de Mondovi: "two gilded bronze firedogs . . . one gilded bronze clock with painting of children, two gilded bronze candalabra, each with four sockets, two gilded bronze candlesticks . . . two double-branched plated candlesticks . . . a mahogany grand piano bearing the name Érard, a piano stool, and a music stand. . . . Two armchairs with spiraled wood covered with gray fabric. . . . Two velvet-covered rosewood love seats, two comfortable armchairs, two small padded velvet armchairs, two velvet-covered chairs with spiraled wood . . . six caned chairs and four painted wooden chairs with embroidered covers. . . . One rosewood piece with glass door, shelf, and mirror. . . . A rosewood games table. . . . Four embroidered muslin curtains and four silk damask window curtains, in poor condition. . . . "
3. L211 and II:183, pastel studies of arms, are in the E. G. Bührle Collection, Zurich, as is the finished painting, L207. The other pastels are in a private collection.

PROVENANCE: Atelier Degas; René de Gas, the artist's brother, Paris (René de Gas estate sale, Drouot, Paris, 10 November 1927, no. 41, repr.); bought at that sale by D. David-Weill, Paris, for Fr 180,000.

EXHIBITIONS: 1931 Paris, Orangerie, no. 86; 1972, Paris, Galerie Schmit, May–June, *Les impressionnistes et leurs précurseurs*, no. 34, repr. (color); 1975, Paris, Galerie Schmit, 15 May–21 June, *Degas*, no. 13, repr. (color); 1985–86, New York, Frick Collection, 19 November 1985–16 February 1986, *Ingres and the Comtesse d'Haussonville*, no. 113, repr. (color).

SELECTED REFERENCES: Lemoisne [1946–49], II, no. 255; Minervino 1974, no. 252.

Fig. 83. Jean-Auguste-Dominique Ingres, *The Comtesse d'Haussonville*, 1845. Oil on canvas, 51⅞ × 36¼ in. (131.8 × 92 cm). The Frick Collection, New York

95.

At the Races in the Countryside

1869
Oil on canvas
14⅜ × 22 in. (36.5 × 55.9 cm)
Signed lower left: Degas
Museum of Fine Arts, Boston. 1931 Purchase Fund (26.790)

Lemoisne 281

In November 1872, three weeks after Degas's arrival in New Orleans, the fate of this canvas was uppermost in his mind. "And the [picture] of the family at the races, what is happening to that?" he asked Tissot, who was in exile in London.[1] The small canvas, now in Boston, had been bought by Durand-Ruel two months earlier, on 17 September 1872, and on 12 October had been sent to London, where it was shown at the *Fifth Exhibition of the Society of French Artists* and was praised by the critic Sydney Colvin.[2] The following spring, on 25 April 1873, Degas's wishes were answered when his painting became part of the important collection of the baritone Jean-Baptiste Faure. A year later, the artist chose to show it under the title "Aux courses en province" at the first Impressionist exhibition, where it went largely unnoticed apart from a review by Ernest Chesneau, who praised it as "exquisite in color, drawing, the felicity of the poses, and overall finish."[3]

Although its provenance is prestigious and well documented, the painting's precise date, the identity of the people portrayed, and the location of the scene have remained the subject of some debate. Wilenski felt the elegant driver of the tilbury was Ludovic Lepic,[4] while André Marchand believed it was Charles Jeantaud, "the painter's uncle and friend."[5] However, it is surely Degas's old friend from his childhood days, Paul Valpinçon—as identified by his daughter Hortense (later Mme Jacques Fourchy)[6] and by Marcel Guérin.[7] The date 1870–73 proposed by Lemoisne and constantly repeated must be rejected for two reasons: first, the canvas was already completed by 1872, since that is when it was sold by Degas; second, the child in the carriage, in the arms of his nurse and under the attentive eye of the father, mother, and family bulldog, can be none other than the Valpinçons' only son, Henri, born in Paris on 11 January 1869.[8] (Their daughter Hortense was born several years earlier, in 1862; see cat. no. 101.) Everything fits perfectly: in the summer of 1869, Degas made a long trip to the coast of Normandy and, as was his custom, he visited the Valpinçons at Ménil-Hubert (see "The Landscapes of 1869," p. 153). *At the*

Fig. 84. *M. and Mme Paul Valpinçon*, dated 1861. Pencil, 13⅝ × 10¾ in. (34.4 × 25.6 cm). The Pierpont Morgan Library, New York

Races in the Countryside is the recollection of an outing at the races in Argentan, about fifteen kilometers from Ménil-Hubert—the closest racecourse to the estate, and the only one that could be reached by carriage and with an infant without undue difficulty.

The Boston canvas is not the only one in which Degas portrayed his beloved Valpinçon family (see cat. no. 60). Shortly after Paul's marriage, Degas made a drawing of the young couple and dated it 1861 (fig. 84). At one time, he had contemplated doing a more ambitious portrait of Mme Valpinçon in mourning, for which there is a vague sketch in a notebook.[9] Probably in the late 1860s, he did a painting of the handsome, somewhat heavy face of his friend Paul (L197). (In a notebook used between 1865 and 1868, Degas noted their respective weights: 64.5 kilograms for himself and 94 for Valpinçon.) The two children, Hortense (see cat. no. 101) and Henri (L270, E. G. Bührle Collection, Zurich), were in turn to become subjects in his paintings.

Some have suggested a Japanese influence in the Boston canvas, but this view is hardly convincing. Others are perhaps more correct in emphasizing the influence of English painting, arguing that this part of Normandy reminded Degas of England and its painters.[10] Doubtless this is truer of the woods and hillocks around Exmes than of the flat and melancholy plain of Argentan, the green expanse of which is scarcely broken here by several low-lying houses and the thin silhouettes of three trees. But the three horses in the background running without any spectators in sight suggest, it is true,

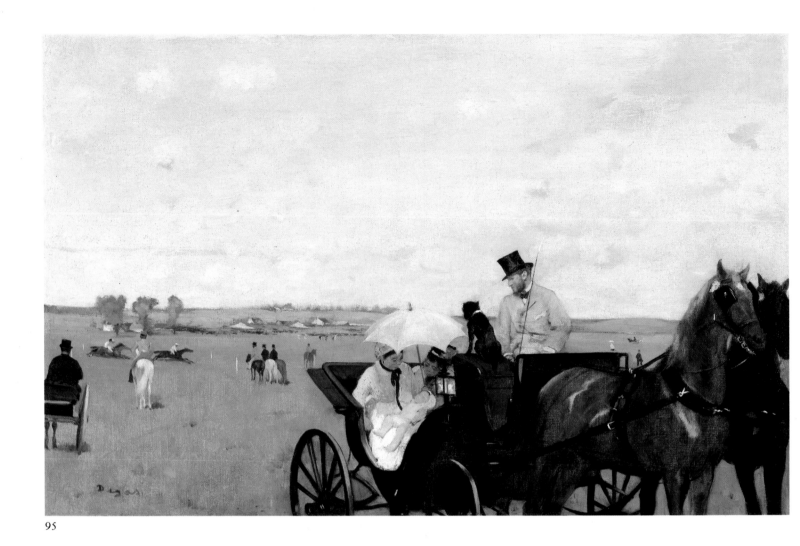

95

the colored English etchings that Degas particularly loved. The even distribution of land and sky—a beautiful light sky, thickened here and there by some clouds—and the smooth, rich, and precise handling remind us, once again, of Dutch painting in its polish and care, its calm and delicacy. In 1912, Lemoisne perceived in this canvas the "slight confusion [of the painter] during this period," which shows up in "small errors in perspective, the horsemen being too large for their horses or not in the proper depth, background elements that . . . jut forward instead of blending in and receding."[11] Today, this hardly strikes us any more than does the evident boldness of the composition, which Lemoisne judged as "a little too choppy" and affected.[12] It is a delightful piece of painting, with its blacks standing out against the clear backgrounds, the dimpled legs of a six-month-old baby on a white blanket in the radiant sun, the vivid red of the pants and cap, and the blissfulness of a family outing in the peaceful countryside.

1. Letter from Degas to Tissot, New Orleans to London, Bibliothèque Nationale, Paris; Degas Letters 1947, no. 3, p. 17.
2. *Pall Mall Gazette*, 28 November 1872.
3. "À côté du Salon," *Paris-Journal*, 7 May 1874.

4. R. H. Wilenski, *Modern French Painters*, New York: Reynal and Hitchcock, 1940, p. 53.
5. 1955 Paris, Orangerie, no. 20.
6. Barazzetti 1936, 190, p. 1.
7. Lettres Degas 1945, p. 80.
8. Archives, City of Paris, electoral lists.
9. Reff 1985, Notebook 18 (BN, Carnet 1, p. 96).
10. Reff 1985, Notebook 18 (BN, Carnet 1, p. 161).
11. Lemoisne 1912, p. 53.
12. Ibid., p. 54.

PROVENANCE: Bought from the artist by Durand-Ruel, Paris, 17 September 1872 (as "La voiture sortant du champ de courses," stock no. 1910), for Fr 1,000; sent to Durand-Ruel, London, 12 October 1872, for Fr 1,000; bought through Charles Deschamps by Jean-Baptiste Faure, 25 April 1873, for Fr 1,300; bought by Durand-Ruel, Paris, 2 January 1893 (as "Voiture aux courses," stock no. 2566), for Fr 10,000; deposited with the Durand-Ruel family, Les Balans, 29 March 1918; bought by the museum, in New York, 1926.

EXHIBITIONS: 1872, London, 168 New Bond Street, *Fifth Exhibition of the Society of French Artists*, no. 113; 1873, London, 168 New Bond Street, *Sixth Exhibition of the Society of French Artists*, no. 79 (as "A Racecourse in Normandy"); 1874 Paris, no. 63 (as "Aux courses en province"); 1899, Saint Petersburg, Exhibition of paintings organized by *Mir Iskousstva*, no. 81; 1903–04, Vienna, Secession; 1905 London, no. 57, repr.; 1917, Kunsthaus Zürich, 5 October–14 November, *Französische Kunst des 19. und 20. Jahrhunderts*, no. 88, repr.; 1922, Paris, Galerie Barbazanges, 17–31 November, *Le sport dans l'art*, p. 27; 1922, Paris, Musée des Arts Décoratifs, 27 May–10 July, *Le décor de la vie sous le second empire*, no. 57; 1924 Paris, no. 40; 1929 Cambridge, Mass., no. 25, pl. XVII; 1933 Chicago, no. 282, repr.; 1936 Philadelphia, no. 21, repr.; 1937 Paris, Orangerie, no. 14, pl. X; 1937 Paris, Palais National, no. 301, pl. LXXXVI; 1938, Cambridge, Mass., Fogg Art Museum, *The Horse: Its Significance in Art*, no. 15; 1939, San Francisco, Golden Gate International Exposition, *Masterworks of Five Centuries*, no. 147, repr.; 1946–47, Toledo Museum of Art, November–December/Art Gallery of Toronto, January–February, *The Spirit of Modern France: An Essay on Painting 1745–1946*, no. 42; 1955 Paris, Orangerie, no. 13, repr. (color); 1986 Washington, D.C., no. 4, repr. (color).

SELECTED REFERENCES: Ernest Chesneau, "À côté du Salon," *Paris-Journal*, 7 May 1874; Lemoisne 1912, pp. 53–54, repr.; Barazzetti 1936, 190, p. 1; R. H. Wilenski, *Modern French Painters*, New York, 1940, p. 53; Lettres Degas 1945, p. 80; Lemoisne [1946–49], I, pp. 85, 102, repr. (detail) facing p. 70, II, no. 281; Boggs 1962, pp. 37, 46, 92, 93 n. 66, pl. 72; Minervino 1974, no. 203, plates XVI, XVII (color).

96.

Racehorses at Longchamp

1871; reworked in 1874?
Oil on canvas
13⅜ × 16½ in. (34.1 × 41.8 cm)
Signed lower left: E. Degas
Museum of Fine Arts, Boston. S. A. Denio
 Collection (03.1034)

Lemoisne 334

This was the first of Degas's paintings to enter the collection of an American museum. In 1912, Paul-André Lemoisne reproduced it in the only full-scale monograph devoted to the artist within his lifetime, with the curious admission that he had included it, sight unseen, on the advice of Jules Guiffrey. Nevertheless, he described it as a "warm and golden painting"—perhaps Guiffrey's description—and dated it about 1878.[1] Subsequently, in a briefer commentary, Lemoisne altered his view on the date, concluding that even if the painting appeared to belong to the late 1860s and the abbreviated "E" in the signature was something Degas no longer used on his works in the 1870s, it was so accomplished that it distinctly belonged to the earlier 1870s, probably about 1873–75.[2]

Regardless of pragmatic questions of dating, it is readily apparent, as Lemoisne noted, that the painting represents a culminating point in a series of works devoted to the racetrack. This is a subject that Degas largely neglected after his return from New Orleans in April 1873, and only in the 1880s did he resurrect it to any extent.[3] Very much unlike his earlier works of the 1860s,

Racehorses at Longchamp anticipates a type of composition he was to refine at a much later date, and its closest early equivalent, *Racehorses before the Stands* (cat. no. 68), provides an uneasy comparison. The Boston painting is the most serene and poetic of Degas's earlier evocations of the races. In those compositions, he was apt to stress the atmosphere of nervousness around the track before a race, or the repressed energy at the first sign of a start. In *Racehorses at Longchamp*, horses are being taken on their round at a leisurely pace, at an unusual hour of the day—dusk. Were it not for the bright colors worn by the jockeys, the hint of fence rails, and the bolting horse at the far left—the one suggestion of animation in an otherwise even-tenored cavalcade—this could be a pastoral scene far removed from the world of the racetrack.

96

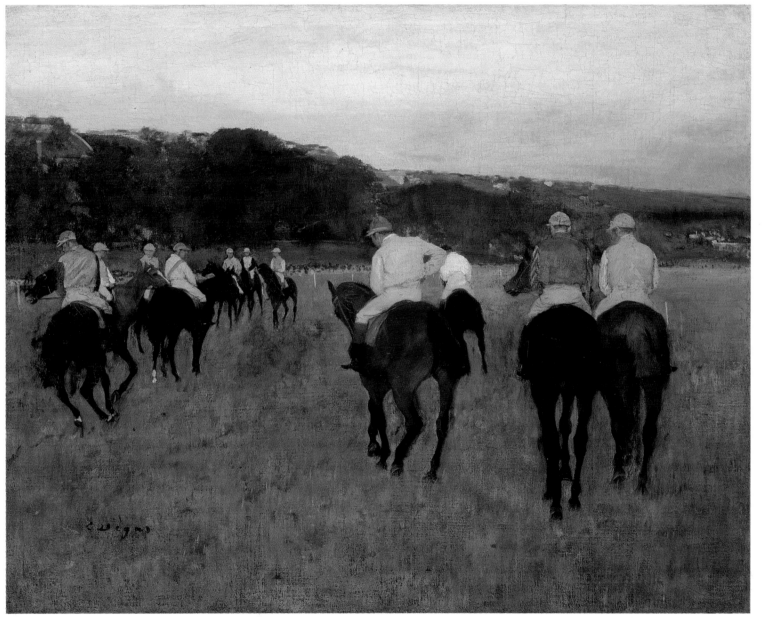

Fig. 85. *Three Studies of a Mounted Jockey* (III:354.2), c. 1866–68. Pencil, 7½ × 10¼ in. (19 × 26 cm). Harvard University Art Museums (Fogg Art Museum), Cambridge, Mass.

Fig. 86. *Three Studies of a Jockey* (L157), c. 1866–68. Essence, 10⅝ × 16⅛ in. (27 × 41 cm). Location unknown

Fig. 87. *Before the Race* (L317), c. 1873. Oil on canvas, 10¼ × 13⅜ in. (26 × 34 cm). National Gallery of Art, Washington, D.C.

The drawings used for the painting, all dating from the 1860s, are of particular interest, as they reveal the extent to which Degas, in such instances, counted not on new studies but on the intricate, sometimes unrecognizable permutation of parts of extant studies used in other compositions. The three principal horses at the right are based on three matching studies, one of them ruled for transfer, shown in a different order on a sheet in the Fogg Art Museum (fig. 85). However, none of the jockeys appearing with the horses in the Fogg drawing were used. Instead, Degas turned to a sheet of

three essence studies (fig. 86), adapting two of the jockeys and using one of them twice. The horse and jockey at the far left are based on a drawing, also ruled for transfer (III:114.2), that was in turn worked up from the remaining jockey on the sheet of essence studies and a riderless horse appearing in a different drawing (IV:221.d).

Two of the resulting combinations of horses with jockeys, those shown at the far left and at the center of the Boston painting, appear in slightly different form—with one of the combinations reversed—in *Before the Race* (fig. 87), which Degas sold to Durand-Ruel in April 1872.[4] The painting in Washington is half the size of the one in Boston, and the figures are quite small and correspondingly sketchy. It seems difficult to accept that the fairly elaborate preparation of studies would have been carried out in anticipation of *Before the Race*. The likelihood is that the studies were done for the larger, more finished figures in *Racehorses at Longchamp* and that these were merely repeated in the Washington painting. If this is the case, the accepted chronology of the works no longer stands and, perforce, the Boston painting must date before 1872.

The lack of details of provenance prior to 1900 removes the possibility of dating the work from external evidence. The concerns expressed by Lemoisne still stand and, stylistically, it is the richly textured expanse of grass that corresponds least to Degas's hand at the end of the 1860s and in the first years of the 1870s. An examination of an X-radiograph of the canvas, as communicated by Philip Conisbee, indicates in effect that the artist reworked this section and made several important changes, for example in the two mounted jockeys painted out at the right and at the left of center.

MP

1. Lemoisne 1912, pp. 77–78.
2. Lemoisne [1946–49], II, no. 334.
3. Between 1874 and 1881, Degas exhibited only four racetrack compositions. The following appeared in the exhibition of 1874: no. 58, "The Start of the Race, Essence Drawing" (unidentified); no. 59, "The False Start, Essence Drawing" (fig. 69); and no. 63, *At the Races in the Countryside* (cat. no. 95). In the 1879 exhibition, there appeared under no. 63 a composition incorrectly identified by Lemoisne as *Racehorses before the Stands* (cat. no. 68); this work was subsequently recognized by Ronald Pickvance as the strange *Jockeys before the Race* (fig. 180), which he dates c. 1878–79 (see 1979 Edinburgh, no. 11). The group of horizontal compositions with horses, dated by Lemoisne between 1877 and 1880 (L446, L502, L503, L596, L597, L597 bis), represent a separate problem discussed under cat. no. 158.
4. Purchased from Degas by Durand-Ruel in April 1872 (stock no. 1332); sent to Brussels on 3 September 1872 (brought back on 21 December); sold to Jean-Baptiste Faure on 7 May 1873 (see journal, Durand-Ruel archives, Paris). It was engraved in 1873 by Laguillermie prior to its sale to Faure.

PROVENANCE: With Bernheim-Jeune, Paris; bought by Durand-Ruel, Paris, 10 February 1900 (as "Chevaux de courses," stock no. 5689); deposited with Cassirer, Berlin; returned to Durand-Ruel, Paris, 10 June 1900; deposited with M. Whitaker, Montreal, 19 December 1900; deposited with Durand-Ruel, New York, 18 February 1901 (stock no. N.Y. 2494); bought by Mrs. William H. Moore, New York, 27 March 1901; returned to Durand-Ruel, New York, 1 April 1901; bought by the museum, with the aid of the Sylvanius Adams Denio Fund, 1903.

EXHIBITIONS: 1911 Cambridge, Mass., no. 10; 1929 Cambridge, Mass., no. 32; 1935, Kansas City, William Rockhill Nelson Gallery of Art and Mary Atkins Museum of Fine Arts, 31 March–28 April, *One Hundred Years [of] French Painting*, no. 21; 1937 Paris, Orangerie, no. 12; 1938, Amsterdam, Stedelijk Museum, 2 July–25 September, *Honderd Jaar Fransche Kunst*, no. 98, repr.; 1938, Cambridge, Mass., Fogg Art Museum, 20 April–21 May, *The Horse: Its Significance in Art*, no. 16, repr.; 1939, New York, M. Knoedler and Co., 9–28 January, *Views of Paris*, no. 28, repr.; 1947 Cleveland, no. 31, pl. XXIII; 1949 New York, no. 29, repr.; 1957, Fort Worth Art Center, 7 January–3 March, *Horse and Rider*, no. 103; 1960, Richmond, Virginia Museum of Fine Arts, 1 April–15 May, *Sport and the Horse*, no. 59; 1968 New York, no. 5, repr.; 1973, Boston, Museum of Fine Arts, 15 June–14 October, *Impressionism: French and American*, no. 5; 1974 Boston, no. 11; 1977–78, Boston, Museum of Fine Arts, 8 November 1977–15 January 1978, *The Second Greatest Show on Earth: The Making of a Museum*, no. 25; 1978 New York, no. 10, repr. (color); 1978 Richmond, no. 8; 1979–80, Atlanta, High Museum of Art, 21 April–17 June/Tokyo, Seibu Museum of Art, 28 July–19 September/Nagoya City Museum, 29 September–31 October/Kyoto, National Museum of Modern Art, 10 November–23 December/Denver Art Museum, 13 February–20 April 1980, *Corot to Braque: French Paintings from the Museum of Fine Arts, Boston*, no. 35, repr. (color); 1984, Boston, Museum of Fine Arts, 13 January–2 June, *The Great Boston Collectors: Paintings from the Museum of Fine Arts*, no. 38, repr. (color).

SELECTED REFERENCES: Grappe 1911, pp. 20–21, repr. p. 48; Lemoisne 1912, pp. 77–78, pl. XXXI (as 1878); Lafond 1918–19, II, p. 42; Lemoisne [1946–49], no. 334 (as c. 1873–75); Cabanne 1957, pp. 28, 48, 110, pl. 45 (detail); Minervino 1974, no. 384; Dunlop 1979, p. 120 (as c. 1874), pl. 107 p. 116 (as 1873–75); McMullen 1984, p. 239; Alexandra R. Murphy, *European Paintings in the Museum of Fine Arts, Boston: An Illustrated Summary Catalogue*, Boston: Museum of Fine Arts, 1985, p. 74, repr.; Lipton 1986, pp. 20, 23, 30, 62, fig. 12 pp. 21, 53; Sutton 1986, p. 146, fig. 114 (color) p. 144.

97.

The Orchestra of the Opéra

c. 1870
Oil on canvas
22¼ × 18¼ in. (56.5 × 46.2 cm)
Signed lower right on back of chair: Degas
Musée d'Orsay, Paris (RF2417)

Lemoisne 186

The Orchestra of the Opéra, which is now, quite justly, one of Degas's most famous paintings, was exhibited in all probability as early as 1871, and then disappeared from sight. It remained hidden at the home of its owner, Désiré Dihau, on rue de Laval, and then, after his death in 1909, at the home of his sister Marie Dihau, who sold it to the Musée du Luxembourg along with a portrait of herself (L263, Musée d'Orsay, Paris) in return for a life annuity and life interest. Until 1935, the canvas hung in her modest apartment on rue Victor Massé, where the "charming old spinster," who was a pianist, lived "on a small income and the proceeds from some music lessons she gave—often free—to young girls from Montmartre who were preparing to be singers in cafés." Marcel Guérin, who is quoted here, reports that a prior arrangement had been made after Marie Dihau had sold another of her portraits (L172, The Metropolitan Museum of Art, New York) to Durand-Ruel.

After the Russian Revolution, she soon ran out of money, but did not want to give up her cherished paintings. We therefore arrived at an arrangement by which, in return for a life annuity of Fr 12,000 paid to her by me and my friend D. David-Weill, head of the Conseil des Musées Nationaux, the two paintings would belong to us after her death, "The Orchestra" to him and the portrait to me. Then came the first exhibition of Degas's work that we organized in 1924 at Galerie Petit, then run by Schoeller; the two paintings, which were being exhibited for the first time, caused a sensation; the Musée du Louvre asked us to cede our contract with Mlle Dihau to them, which we did, and the two paintings thus went to the Louvre.[1]

The Orchestra of the Opéra, like the paintings purchased from the Neapolitan branch of the family or those kept by René de Gas, is one of the works that, appearing a few years after the atelier sales, enable us to arrive at a better assessment of a period that remains somewhat unclear, given our uncertain knowledge of the chronology of the 1860s. The difficult composition of the work led some writers to express judgments that seem surprising to us today. Paul Jamot, one

of the first to write about this painting, summed it up in this way: "Here Degas has already given up his attempts to produce great history paintings—the strength and beauty of the draftsmanship make this painting look like the work of a classicist, whereas his curiosity about human beings and the exactitude of the composition make it seem like the work of the primitives."[2] Jamot's assessment has been restated in one form or another until the present day—by those who see in this canvas Degas's definitive break with his past as a history painter, by those who see it as his first attempt to represent a ballet, and by those who observe that the stage, which in this work is still narrowly confined to the upper part of the painting, was to occupy more and more space in Degas's subsequent canvases (see cat. nos. 98, 103) before taking over completely to become the very subject of his work, eliminating the orchestra pit, which would appear only occasionally at the bottom of the painting as an incidental border. To clinch his argument, Jamot claimed that Degas added the dancers only as an afterthought—despite Marie Dihau's insistence that she never saw the painting without them.

In fact, we owe almost everything we now know about the painting, including the dating and the identification of the figures, to Marie Dihau, who was interviewed by Lemoisne, Jamot, and Guérin. Painted just before the war of 1870 (there is no reason to accept Lemoisne's date of 1868–69), it was scarcely finished when Degas, who was still considering some changes, entrusted it to Désiré Dihau for an exhibition at Lille, no record of which has been discovered. It earned Dihau the praise of the Degas family: "It's thanks to you that he has finally produced a finished work, a real painting!"[3]—a belated (and unwarranted) rejoinder to Auguste De Gas's comment in November 1861 that "our Raphael is still working, but has not produced anything that is really finished, and the years are passing."[4] We do not know whether Dihau bought it or was given it.

In the stage box can be seen the head of the composer Emmanuel Chabrier, who knew Manet, Nina de Callias, and Tissot, and who had "just been brought by Désiré Dihau to pose at Degas's." Seated in the orchestra at the extreme left is the cellist Louis-Marie Pilet (1815–1877),[5] a musician who joined the Opéra in March 1852.[6] Behind Pilet is a figure identified by Jamot, from his portrait in the Musée Bonnat in Bayonne, as the painter Enrique Mélida, Bonnat's brother-in-law; a more plausible identification is made by Lemoisne, who sees him as the Spanish tenor Lorenzo Pagans (1838–1883).

The crown of curly white hair belongs to Gard, "a stage director at the Opéra," concerning whom all records are silent. Next, pensively playing the violin, is the painter Alexandre Piot-Normand (1830–1902), a student of Picot's. Looking toward the audience is Souquet—according to Lemoisne a composer, and according to Jamot a doctor; he could be the little-known Louis Souquet who composed a capriccio waltz for piano in 1884. Turned toward the stage is someone who has been identified variously as Dr. Pillot, Pilot "a medical student," and Pilot "an amateur musician"[7]—possibly Adolphe Jean Désiré Pillot, born 12 November 1832 and admitted to the solfeggio class at the Paris Conservatory on 21 October 1846.[8] In front of him, in the very middle of the picture, is the bassoonist Désiré Dihau (1833–1909), who was with the Opéra from 1862 to 31 December 1889.[9] Then there is the flutist Henry Altès (1826–1895), also portrayed alone by Degas (L176, The Metropolitan Museum of Art, New York), who was with the Opéra from 1 February 1848 to 1 September 1876.[10] Next come Zéphirin-Joseph Lancien (1831–1896), violinist at the Opéra and solo violinist from 1856 to 31 December 1889;[11] Jean-Nicolas Joseph Gout (1831–1895), violinist at the Opéra from 23 April 1850 to 31 December 1894; and finally, the figure always referred to as "Gouffé, double bass," but whose identification poses several problems. The Conservatory records do mention an Albert Achille Auguste Gouffé, born in Paris on 9 March 1836, but he was a cellist, and the figure in Degas's picture is obviously more than thirty-three or thirty-four years old. The Gouffé we are dealing with here is probably his father, Achille Henri Victor Gouffé, first double bass player at the Opéra, who, since he was thirty-one when his son was born, would have been born about 1805.[12] It should be noted that a tracing found in the Musée d'Orsay records, which identifies the figures, states that "Mlle Parent probably posed for the dancers."

This is a somewhat eclectic orchestra; musicians are certainly in the majority, but some of the figures, such as Pagans and Souquet, are not instrumentalists. It also contains obscure friends of Degas's, such as the mysterious Gard (affectionately referred to by Degas as a "tyrant"[13]) and the painter Piot-Normand. Both of them were regulars at Auguste De Gas's Monday gatherings at his home on rue de Mondovi; Degas may have met them, as he met Dihau, at Mère Lefebvre's restaurant on rue de la Tour d'Auvergne.[14]

The evolution of *The Orchestra of the Opéra*, which is, above all, a portrait of Désiré Dihau, is not easy to trace. Marcel Guérin

Fig. 88. *The Orchestra of the Opéra* (L187), c. 1870. Oil on canvas, 19⅝ × 24 in. (50 × 61 cm). The Fine Arts Museums of San Francisco

Fig. 89. X-radiograph of *The Orchestra of the Opéra* (cat. no. 97)

claims that originally Degas wanted to do a portrait of the bassoonist alone, and then thought of placing him in the midst of an orchestra. However, nothing in the existing studies—incomplete though they are—supports this hypothesis. The only compositional study that has been preserved is an oil on canvas (fig. 88) that is quite different from the Orsay work: the dimensions are comparable, but differently proportioned, so that its width is Orsay's height; it does not show the orchestra at an angle, but gives a direct frontal view; the wooden railing which separates the orchestra from the first row of seats in the auditorium is omitted; and a strictly horizontal stage is merely hinted at in the upper portion of the canvas. From the confused mass of the orchestra, only the fairly detailed face of Dihau blowing into his bassoon emerges, along with the sketchier form of Gouffé's wide back. The X-radiograph of the Orsay painting (fig. 89) reveals Degas's indecision: it seems

that he had deliberately cut off the sides and top of the canvas—the composition originally had been larger—and thus altered the framing of the scene. The edge of the stage, which now cuts off the dancers' feet, was considerably higher, and the railing around the orchestra pit was inserted later. Some of the dancers' legs were removed and others added. Most noteworthy, however, are three essential elements that seem to have been added later, since they cannot be detected or are just barely visible in the X-radiograph: the harp emerging at the left above the melee of musicians, the box in which Chabrier is sitting, and in particular the double bass player Gouffé on his chair—in the X-radiograph the full length of Dihau's bassoon is shown. Two of the notebooks contain pencil sketches in preparation for these changes.[15]

The Orchestra of the Opéra is a portrait of a man practicing his art, surrounded—and herein lies Degas's bold innovation—by minor characters whose features are equally individualized and who, though they are not in the foreground, are apt to steal the limelight, as it were, from the person being portrayed. It is not a group portrait, like Fantin-Latour's various homages, but a portrait of an individual within a group. In order to highlight Dihau, Degas does not hesitate to shake up the orchestra in the pit, placing the bassoon in the front row, though it is normally hidden behind a wall of alternating cellos and double basses.[16] It does not matter, however, for what counts here are the faces placed close together, one above the other, and the vivid fragments that emerge from the uniform black of the suits and white of the shirts—an eye, a bald head, a shining brow, a patch of curly hair, figures severed by bows or obscured by the neck of a cello, but attentive only to the music, playing imperturbably, while above, in the magic of the footlights, legs and tutus move.

1. Lettres Degas 1945, p. 18; Degas Letters 1947, pp. 260–61 (translation revised).
2. Paul Jamot, "Deux tableaux de Degas acquis par les Musées Nationaux," *Le Figaro Artistique*, 3 January 1924, pp. 2–4, repr.
3. Cited in Lemoisne [1946–49], II, no. 186.
4. Cited in Lemoisne [1946–49], I, p. 41.
5. His name is constantly misspelled Pillet. Degas was to paint him separately (L188, Musée d'Orsay, Paris).
6. The information provided by Marie Dihau is supplemented here by biographical details from the Conservatory records (Archives Nationales, Paris, AJ³⁷) and by Constant Pierre, *Le Conservatoire National de Musique et de Déclamation*, Paris: Imprimerie Nationale, 1900.
7. Lemoisne [1946–49], II, no. 186; 1924 Paris, no. 30; Jamot 1924, p. 136.
8. Archives Nationales, Paris, AJ³⁷353(1).
9. Archives Nationales, Paris, AJ³⁷353(2).
10. Ibid.
11. Archives Nationales, Paris, AJ³⁷353(1).

12. Archives Nationales, Paris, AJ³⁷353(2).
13. Lettres Degas 1945, I, p. 20; Degas Letters 1947, no. 2, p. 16.
14. Marcel Guérin, "Deux tableaux acquis par le Musée du Luxembourg," *Beaux-Arts*, 15 January 1923, pp. 311–13; Jamot 1924, p. 136.
15. Reff 1985, Notebook 24 (BN, Carnet 22, p. 1) for the box and the framing of the stage; Notebook 25 (BN, Carnet 24, pp. 29, 33, 35) for the harp and Gouffé's chair and double bass. There is also a study, removed from the same notebook and now in the Thaw collection, New York, of Gouffé holding his double bass.
16. "Rapport sur l'Opéra par M. Garnier architecte," Garnier archives, Bibliothèque de l'Opéra, Paris.

PROVENANCE: Désiré Dihau, Paris, from 1870 or 1871 to 1909; Marie Dihau, his sister, Paris, 1909–35; bought in 1924, along with Degas's portrait of Marie Dihau (RF2416), by the Musée du Luxembourg from Marie Dihau, who retained life interest and received a life annuity from the museum; entered the museum 1935.

EXHIBITIONS: During the Commune of 1871, according to Lemoisne [1946–49], II, no. 186; (?)1871, Paris, Galerie Durand-Ruel; 1924 Paris, no. 30, repr. facing p. 32; 1926, Amsterdam, Rijksmuseum, 3 July–3 October, *Exposition rétrospective d'art français*, no. 40; 1931 Paris, Orangerie, no. 44; 1932 London, no. 354 (502); 1932 Paris, Orangerie, no. 9; 1933 Paris, no. 77; 1936 Philadelphia, no. 12, repr.; 1937 Paris, Orangerie, no. 9; 1951, Albi, Musée Toulouse-Lautrec, 11 August–28 October, *Toulouse-Lautrec, ses amis et ses maîtres*, no. 234; 1969 Paris, no. 16; 1971 Leningrad, p. 25, repr.; 1971 Madrid, no. 33; 1974–75 Paris, no. 12, repr. (color); 1982, Paris, Musée Hébert, 19 May–4 October, *Musiciens du silence*, no number; 1984–85 Washington, D.C., no. 1, repr. (color); 1986, New York, The Brooklyn Museum, 13 March–15 May/Dallas Museum of Art, 1 June–3 August, *From Courbet to Cézanne: A New Nineteenth Century*, no. 66, repr. (color).

SELECTED REFERENCES: Marcel Guérin, "Deux tableaux de Degas acquis pour le Musée du Luxembourg," *Beaux-Arts*, 15 January 1923, pp. 311–13; Paul Jamot, "Deux tableaux de Degas acquis par les Musées Nationaux," *Le Figaro Artistique*, 3 January 1924, pp. 2–4, repr.; Paul Jamot, "La peinture au Musée du Louvre: école française, XIXe siècle," pt. 3, *L'Illustration*, Paris, 1928, pp. 54–57; Gabriel Astruc, *Le pavillon des fantômes: souvenirs*, Paris: B. Grasset, 1929, p. 224; Lemoisne [1946–49], II, no. 186; Browse [1949], pp. 21, 22, 28, 335–36, pl. 4; Paris, Louvre, Impressionnistes, 1958, no. 68; Boggs 1962, pp. 28–30, 90 nn. 40–42, pl. 60; Pickvance 1963, p. 260; Browse 1967, p. 104, fig. 1; Minervino 1974, no. 286, pl. XII (color); Roger Delage, *Chabrier: iconographie musicale*, Paris: Minkoff et Lattès, 1982, p. 57, repr.; Reff 1985, pp. 76–79, repr.; Paris, Louvre and Orsay, Peintures, 1986, III, p. 195, repr.

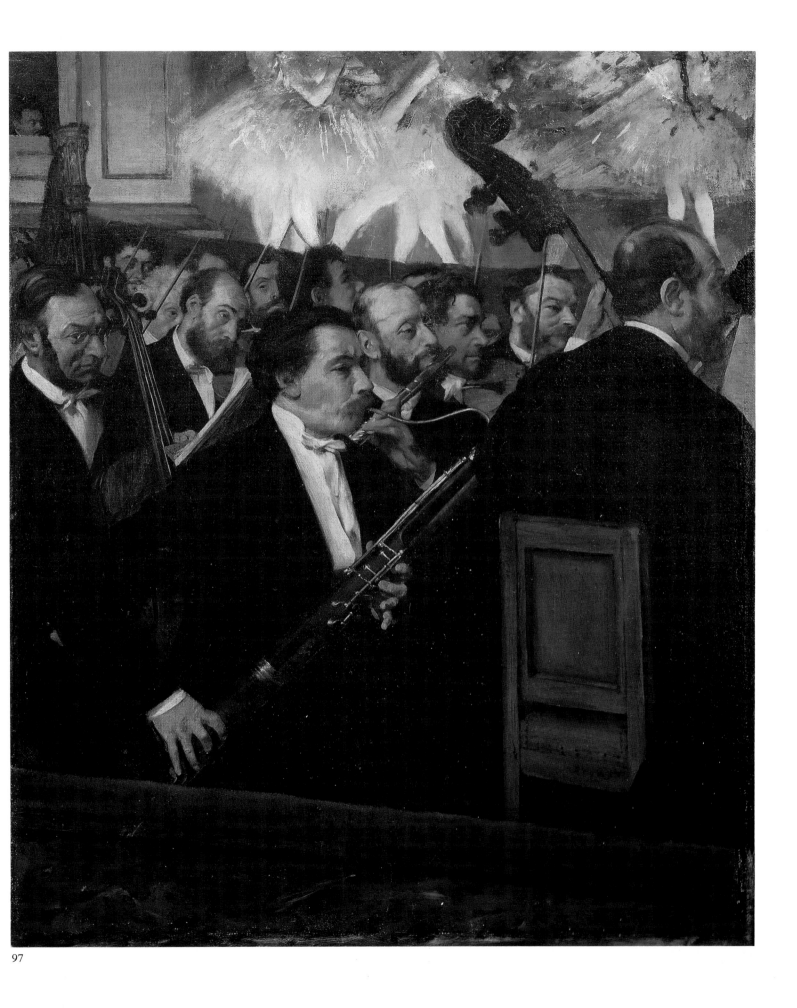

97

Orchestra Musicians

c. 1870–71; reworked c. 1874–76
Oil on canvas
27⅛ × 19¼ in. (69 × 49 cm)
Signed lower right: Degas
Städtische Galerie im Städelschen Kunstinstitut,
 Frankfurt (SG237)

Exhibited in Paris and Ottawa

Lemoisne 295

This work's early entry into a German museum in 1913 and its publication the year before by Lemoisne, who commented on it in ambiguous terms,[1] earned it a reputation during the first part of this century that has now been somewhat eclipsed by *The Orchestra of the Opéra* in the Musée d'Orsay (cat. no. 97), with which it is frequently compared. Although the similarities in format and execution might suggest that these works are pendants, the differences between them are numerous. If *The Orchestra of the Opéra* is a portrait—of Désiré Dihau, among others—*Orchestra Musicians* is what is usually called a genre scene, for the only conceivable "portrait" here is the rapt profile of the musician on the left; the rest of the musicians are seen from behind, and the dancers have the indistinct commonplace features of most of the young ballerinas Degas would later paint. The scene of the ballet, which in the Orsay canvas is limited to the uppermost band of the picture (showing only the dancers' legs), here takes on as much importance as what is happening in the orchestra pit, thus accentuating the contrast between these two worlds that are so closely linked and yet so oblivious of each other.

Lemoisne therefore saw this as a "transitional work": in style, technique, and theme, the lower register is connected to the past, to the 1860s, while the upper register prefigures all the ballet scenes to come. Lemoisne is both right and wrong. The complicated history of this painting reveals that it was bought from Degas by Durand-Ruel on 14 June 1873—it was first painted at a date close to that of *The Orchestra of the Opéra*, about 1870–71—and then purchased less than a year later, on 5 or 6 March 1874, by the baritone Jean-Baptiste Faure (see "Degas and Faure," p. 221). Faure gave it back to Degas together with five other pictures that the artist was not satisfied with and wanted to rework, in exchange for which Degas was to give him "four large, very elaborate pictures . . . *Les danseuses roses, L'orchestre de Robert le Diable, Grand champ de courses, Les grands blanchisseuses*."[2]

While Degas did not retouch *Robert le Diable* (see cat. no. 103), he made major changes

to *Orchestra Musicians*, adding—as is plainly visible—a sizable piece of canvas so that he could show the dancers in full length rather than cut off at the waist. Thus, while it was originally similar in size and composition to *The Orchestra of the Opéra*, it then departed from it considerably. Yet we are not left with some strange conjoining of two distinct works: rather, in this very disjunction lies the essence of Degas's modernity.

In *The Orchestra of the Opéra*, Degas somewhat distorted the arrangement of the musicians in order to highlight the valiant Dihau; here, he returns to the traditional distribution of players, joining bassoon (doubtless Désiré Dihau, from behind, in the center), cello, and bass beside the first row of spectators. As in *Dancer Onstage with a Bouquet* (cat. no. 161), he chose that moment when the prima ballerina takes her bows. The disorderly supporting cast relax against the framework of the flats, and the musicians, having put down their instruments for a moment, are ready to begin again, their eyes fixed on the score. Avoiding the panoramic perspective of all theater paintings from Pannini to Menzel, Degas (seated, as it were, in the first row of the audience) adopts a restricted point of view and concentrates on the resulting oddities and contrasts: differences in scale (three men cut off above the waist, seven dancers full length), in lighting (the individually lit music stands, the diffuse footlights), and in technique (precise and smooth for the musicians, lighter, quicker, and more vibrant for the dancers). Two worlds are juxtaposed and set off from each other (tenuously linked by the upward intrusion of the bows, the bassoon, and the tops of the heads), as in certain medieval paintings, with the musicians in black in gloomy Acheron and the women moving like angels in an Eden of painted backdrops, showing that Degas, too, like his venerated master Ingres, had more than one brush.

1. Lemoisne 1912, pp. 41, 43.
2. Lettres Degas 1945, V, p. 32; Degas Letters 1947, "Annotations," no. 10, p. 261.

PROVENANCE: Bought from the artist by Durand-Ruel, Paris (as "Les musiciens," stock no. 3102), 14 June 1873, for Fr 1,200 (the painting had already been sent to Durand-Ruel, London, 24 May 1873); bought by Jean-Baptiste Faure, 5 March 1874, for Fr 1,200 (according to Guérin, Faure returned it immediately to Degas, who wanted to rework it[1]). With Bernheim-Jeune, Paris; bought by Durand-Ruel, Paris, 11 October 1899, for Fr 37,500 (stock no. 5466); acquired by Durand-Ruel, New York, 8 December 1899 (stock no. N.Y. 2285); returned to Durand-Ruel, Paris, 15 February 1910, for Fr 20,000 (stock no. 9236); bought by the museum 4 January 1913, for Fr 125,000 (paid in three installments: Fr 20,000 in April 1913, Fr 70,000 in April 1914, Fr 35,000 in April 1915).

1. Lettres Degas 1945, pp. 17–18.

EXHIBITIONS: 1900–01, Pittsburgh, Carnegie Institute, 1 November 1900–1 January 1901, *Fifth Annual Exhibition*, no. 58 (as "Musicians at the Orchestra"); 1904, New York, The American Fine Arts Society, 15 November–11 December, *Comparative Exhibition of Native and Foreign Art*, no. 34 (as "Musiciens à l'orchestre"); 1906, Art Association of Montreal, 12–28 February, *A Selection from the Works of Some French Impressionists*, no. 3 (as "The Orchestra"); 1907, Buffalo, Albright Art Gallery, 31 October–8 December, *Exhibition of Paintings by the French Impressionists*, no. 23; 1911, Berlin, Paul Cassirer, March, *XIII. Jahrgang, VIII. Ausstellung*, no. 9; 1931, Frankfurt, Städelsches Institut, 3 June–3 July, *Von Abbild zum Sinnbild: Meisterwerke moderner Malerei*, no. 44; 1937 Paris, Orangerie, no. 15, pl. VII; 1951, Paris, Musée de l'Orangerie, *Impressionnistes et romantiques français dans les musées allemands*, no. 24, repr.

SELECTED REFERENCES: Lemoisne 1912, pp. 41, 43, pl. XIV; Lemoisne [1946–49], II, no. 295; Pickvance 1963, p. 258; E. Holzinger and H.-J. Ziemke, *Städelsches Kunstinstitut, Frankfurt am Main, Die Gemälde des 19. Jahrhunderts*, Frankfurt, 1972, I, pp. 78–79, II, pl. 270; Minervino 1974, no. 291, pl. XIV (color); T. J. Clark, *The Painting of Modern Life*, New York: Knopf, 1985, pp. 223–24.

99.

General Mellinet and Chief Rabbi Astruc

1871
Oil on canvas
8⅝ × 6⅜ in. (22 × 16 cm)
Signed lower right: Degas
City of Gérardmer

Lemoisne 288

This double portrait is an amusing record of one of those chance encounters that occur in wartime. The making of the picture brought together a painter, a chief rabbi, and a general who was a musician and a Freemason. We know nothing of the circumstances that united these three men, although the catalogue of the Degas exhibition held in Paris in 1924, which is a usually reliable source, says that Mellinet and Astruc had met in the French field ambulance service during the Franco-Prussian War, and had asked Degas to paint them together.[1] Gabriel Astruc, the chief rabbi's son, reported that years later, when he entered the Café La Rochefoucauld, Degas stared at him with great interest because he "recognized the features of my father, whose portrait he had painted during the siege at Metz, together with General Mellinet, their mutual friend."[2] It is hard to know how to reconcile these two versions.

Émile Mellinet (1798–1895) was the son of a Belgian general of French descent who had a brilliant career during the First Empire.[3] He became a brigadier in 1850, received the Grand Cross of the Legion of

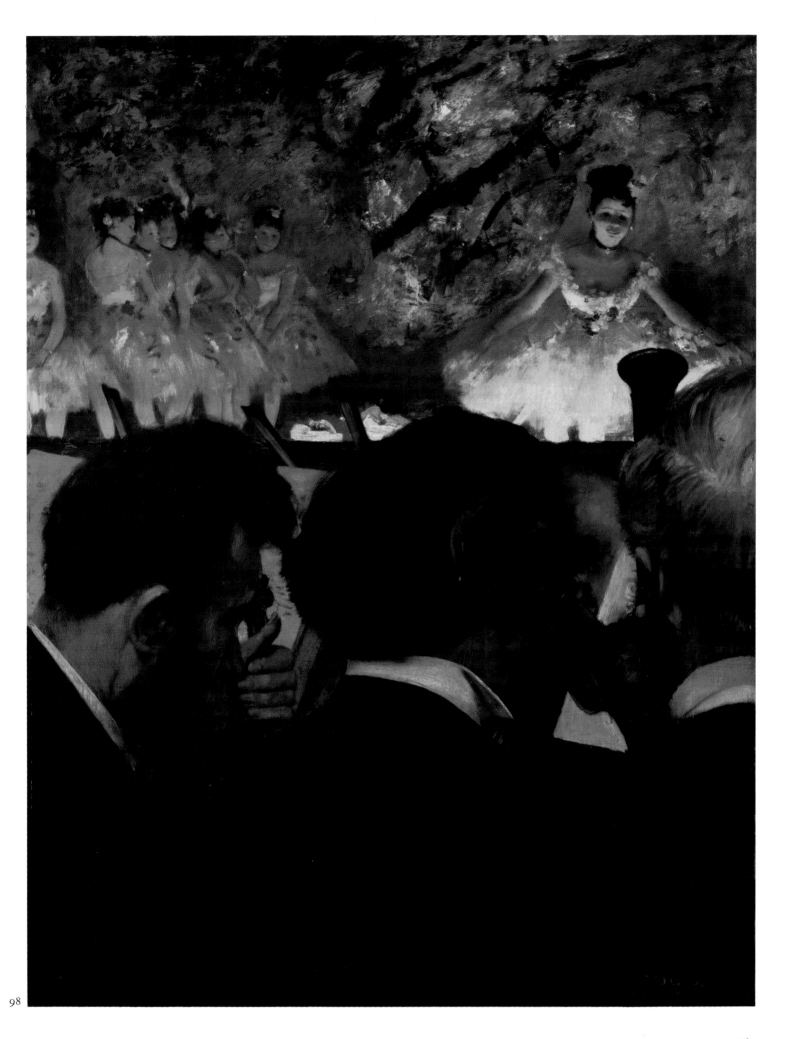

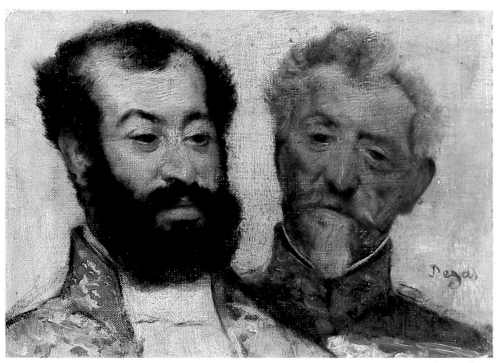

99

Honor in 1859, served as senior commander of the National Guard of the Seine from 1863 to 1869, and became a senator in 1865. He also succeeded Marshal Magnan as Master of the Grand Masonic Lodge of France (1865–70) and, according to Vapereau, was known for having greatly improved the quality of the regimental bands. At the time of the Franco-Prussian War, he was responsible for the depots of the Paris Imperial Guards (17 August) and was appointed a member of the committee on fortifications of Paris (20 August).[4]

Élie-Aristide Astruc (1831–1905) descended from a Jewish family from Avignon that had settled in Bordeaux in 1690. He was appointed an assistant rabbi in Paris in 1857. A chaplain at several lycées,[5] he gave the young Isaac de Camondo religious instruction, and soon became a leading figure in the Jewish world, helping to lay the foundations of the Alliance Israelite Universelle before being appointed chief rabbi of Belgium in 1866. In 1870, as a member of the Belgian prisoner assistance committee chaired by the Comte de Mérode, he was sent to Metz, at the very moment of capitulation, 29 October 1870, to bring back food supplies for the civilian population. Therefore, he could not have met Mellinet—who was trapped in Paris, surrounded by German troops—until after the siege of Paris had ended, on 28 January 1871.

In painting these two very different men, undoubtedly linked only by a sense of social responsibility, Degas again took up, in very small format, a formula he was fond of, that of the double portrait: here, against a neutral background, the sad and abstracted face of the old general, receding slightly, and the more prominent face of the chief rabbi of Belgium. Except for the simple juxtaposition of their faces, nothing links these men, momentarily brought together by mere chance. Degas painted them rapidly, and magnificently, stressing the ravages of age in Mellinet's face, accentuating in Astruc's (perhaps unconsciously) what he thought were the traits of his race. Photographs of Astruc (see fig. 90) do not show the thick, puffy features and drooping lower lip seen in the painting; nor was he remembered by those who knew him as looking like this. Rather, he is said to have had a handsome, lively face and an intelligent gaze. His grandniece, the sculptor Louise Ochsé, who knew Astruc in his last days, wanted to reproduce his "large skull," his "regular nose," and his "fine, well-balanced frame."[6]

Gabriel Astruc, the sitter's enterprising son (he helped found the Théâtre des Champs-Elysées), did not forgive the painter, and undoubtedly the Dreyfus Affair had left its traces: "Degas, whose phobia about Jews had closed his eyes to the point of color blindness, made a wreck of his splendid subject, replacing his tiny mouth with thick, sensual lips, and changing his tender, loving regard into a look of greed. This painting is not a work of art—it is a pogrom."[7]

1. 1924 Paris, no. 35.
2. Gabriel Astruc, *Le pavillon des fantômes: souvenirs*, Paris: B. Grasset 1929, p. 98.
3. See Pierre Larousse, *Grand dictionnaire universel*, X, Paris, 1873; Vapereau, *Dictionnaire universel des contemporains*, Paris, 1865.
4. Service records of Major-General Émile Mellinet, Château de Vincennes, Land Forces Historical Service, Major-Generals, second series, no. 1331.
5. See *Biographie nationale* (Académie Royale de Belgique), XXX, 1958, pp. 108–09; Astruc, op. cit., pp. 1–14.
6. Astruc, op. cit., p. 3.
7. Ibid., p. 98.

PROVENANCE: Charles Ephrussi, Paris; Théodore Reinach, Paris; Mlle Gabrielle Reinach, his daughter, Paris; her bequest to the city of Gérardmer 1970.

EXHIBITIONS: 1924 Paris, no. 35; 1936, Paris, Galerie André Seligmann, 9 June–1 July, *Portraits français de 1400 à 1900*, no. 113; 1937 Paris, Orangerie, no. 51; 1987–88 New York, no. 16, p. 102, fig. 7 p. 103.

SELECTED REFERENCES: Jamot 1924, p. 137, pl. 21; Gabriel Astruc, *Le pavillon des fantômes: souvenirs*, Paris: B. Grasset, 1929, p. 98; Lemoisne [1946–49], II, no. 288; Boggs 1962, pp. 34–35, 124, pl. 69; Minervino 1974, no. 271.

Fig. 90. Pierre Petit, *Chief Rabbi Astruc*. Photograph. Private collection

100.

Jeantaud, Linet, and Lainé

March 1871
Oil on canvas
15 × 18⅛ in. (38 × 46 cm)
Signed and dated upper left: Degas/mars 1871
Musée d'Orsay, Paris (RF2825)

Exhibited in Paris

Lemoisne 287

The war of 1870 and the siege of Paris by the Prussians led Degas to serve in the National Guard, along with many other Parisians. Assigned to the artillery, he met up again with Henri Rouart, who had been one of his schoolmates at Louis-le-Grand and was to remain one of his closest friends. It

was also an opportunity for Degas to meet a wide variety of people from all walks of life. Francisque Sarcey, in his acute recollections of the siege, gives an amusing account of the rather odd assortment of men who defended Paris: "Beside an old man with a white beard stood a youth with nary a whisker; farther off, a jolly round father, his enormous belly trotting along on two little legs; the honest faces of peaceful townsmen alongside the martial figures of veterans; many pairs of glasses that bore witness to annoying nearsightedness; red noses identifying the men who regularly frequented the wine shops: it was the strangest medley of faces that one could possibly imagine."[1]

At Bastion 12, where Rouart commanded the battery, Degas came to know Jeantaud, Linet, and Lainé, whom he painted together in March 1871, more than a month after Paris capitulated (28 January 1871).[2]

Jean-Baptiste Jeantaud, known as Charles Jeantaud (1840–1906), is shown sitting at the left with his arms folded on the table. The son of a Limoges saddler, Jeantaud was an engineer who in 1881 distinguished himself by building the first electric automobile. On 1 February 1872, he married Berthe Marie Bachoux; Degas painted two beautiful portraits of her a short time later (see cat. no. 142).[3]

The identification of Linet, at the center, wearing a top hat, is more problematic. One should not confuse him with Charles Linet, a career officer who became a captain, first class, on 28 August 1868. Charles Linet distinguished himself at Metz, where he escaped during the siege (1 September–29 October 1870) to join the armies of the Rhine and the Loire, and for this he was awarded the Legion of Honor and, on 11 January 1871, the rank of staff major.[4] Nothing in the relaxed

pose of the young bourgeois whom Degas painted here brings to mind the volunteer of modest origins who served in the provinces and apparently did not take part in defending Paris. Moreover, the artist had jotted down the Paris address of a "P. Linet, 46 boulevard Magenta" in one of his notebooks[5]—in all likelihood that of the distinguished-looking man in this picture.

The third man is Édouard Lainé (1841–1888), depicted in the background reclining in an armchair and reading his newspaper. According to Anne Distel, Lainé was a friend of Rouart's and Lepic's, and "the director of a major brass foundry which specialized in taps."[6]

Degas creates an elegant and relaxed image of these three young men from the newly emerging industrial and business bourgeoisie. These "veterans" could be taken for a group of stylish clubmen who, having fin-

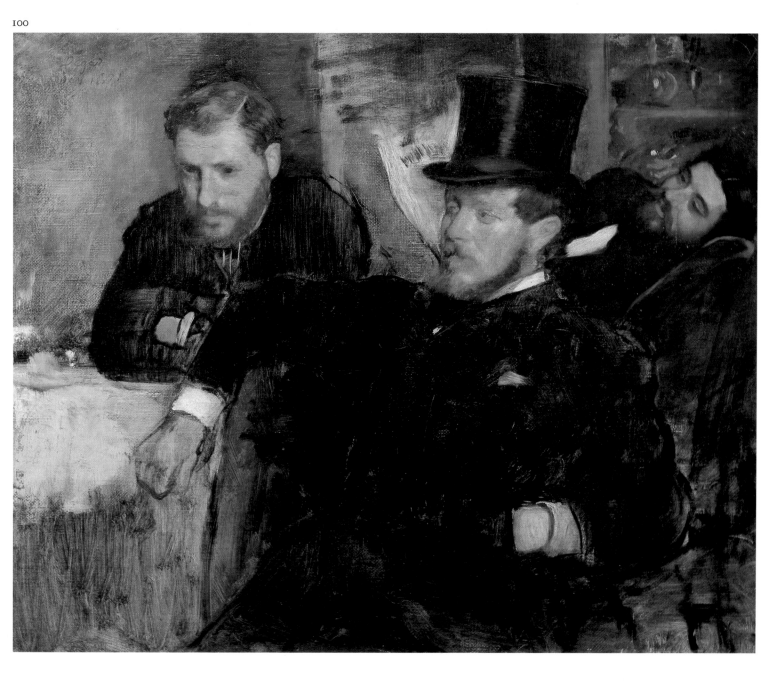

ished their meal (there is still a cup on the table), are stretching out and relaxing for a moment, their bellies full, their thoughts adrift. In this small painting, done over a preparatory drawing executed with a brush, Degas concentrates on the faces, neglecting the details. He uses a palette he was fond of, brown, black, and garnet, heightened by the bright whites of the tablecloth, sleeve, and collar, admirably capturing the leisurely, nostalgic atmosphere of this reunion of comrades.

1. Francisque Sarcey, *Le siège de Paris*, Paris: E. Lachaud, [1871–72], pp. 101–02.
2. A copy of this canvas dated 1872 (not an original replica, as thought by Félix Fénéon and Theodore Reff) was included in the exhibition *L'art contemporain dans les collections du Quercy*, Musée Ingres, Montauban, July–September 1966 (no. 24, repr.).
3. See files on Charles Jeantaud, Archives, Fourth Arrondissement, Paris; Archives Nationales, Paris, records of the Legion of Honor; Archives Départementales, Haute-Vienne, Limoges.
4. See files on Charles Linet, Archives Nationales, Paris, records of the Legion of Honor.
5. Reff 1985, Notebook 24 (BN, Carnet 22, p. 104).
6. *Renoir* (exhibition catalogue), Paris: Réunion des Musées Nationaux, 1985, no. 26 (English edition, New York/London, no. 27, p. 204).

PROVENANCE: Given by the artist to Charles Jeantaud, one of the sitters; Mme Charles Jeantaud, his widow, Paris, 1906–29; her bequest to the Louvre 1929.

EXHIBITIONS: 1924 Paris, no. 37; 1931 Paris, Orangerie, no. 53; 1933 Paris, no. 106; 1969 Paris, no. 20; 1973, Turin, Galleria civica d'arte moderna, March–April, *Combattimento per un immagine: fotografi e pittori*, no number; 1982–83, Prague, September–November/Berlin (G.D.R.), 10 December 1982–20 February 1983, *De Courbet à Cézanne*, no. 28, repr. (Czech edition), no. 30, repr. (German edition).

SELECTED REFERENCES: René Huyghe, "Le portrait de Jeantaud par Degas," *Bulletin des Musées de France*, December 1929, no. 12; Lemoisne [1946–49], II, no. 287; Paris, Louvre, Impressionnistes, 1958, no. 74; Boggs 1962, pp. 35, 120–21, pl. 70; Minervino 1974, no. 270; Paris, Louvre and Orsay, Peintures, 1986, III, p. 196, repr.

101.

Hortense Valpinçon

1871
Oil on canvas with herringbone weave
29⅞ × 43⅝ in. (76 × 110.8 cm)
The Minneapolis Institute of Arts. The John R. Van Derlip Fund (48.1)

Lemoisne 206

Hortense Valpinçon was the first child and only daughter of Degas's old schoolmate Paul Valpinçon and his wife, born Marguerite Claire Brinquant. Hortense was born in Paris on 14 July 1862, a year and a half after the marriage of her parents on 14 January 1861.[1]

Years later, after marrying Jacques Fourchy, she recounted the circumstances surrounding the painting of this portrait to an interviewer by the name of Barazzetti, who wrote:

It was during the Commune and at Ménil-Hubert, the estate where his friends had invited him so often, that Degas painted the portrait. . . . It was an impromptu effort and materials were scarce. Degas had nothing at hand to serve as a canvas. He was given a piece of ticking found in the bottom of a wardrobe in the château. The little girl, dressed in a black dress and white apron, a shawl around her shoulders, a most amusing hat on her head, leaned on the end of a table covered with a cloth embroidered by her mother, which appears in another of Degas's canvases. . . . The painter had told her to be good, but it was with some difficulty that he succeeded in drawing the firm, supple contour of her cheek. He had been foolish enough to offer his model an apple, cut into quarters. Of course, a little girl cannot be asked to pose for several hours with an apple in her hand. What else could she do but eat it? So, as she grimaced, with one cheek bulging, and her mouth alternately straining and relaxing, the painter's exasperation grew into rage, then scoldings, and the work came to an abrupt halt. At other times, when the child had been well behaved and Degas was happy with his work, the session ended in laughter.[2]

In 1924, while Hortense was still living and still the owner of this portrait, it was shown at Galerie Georges Petit and listed in the catalogue (no. 33) with the date 1869. This would seem to invalidate Barazzetti's report that it had been painted during the Commune. Both dates are in fact possible: in 1869, Degas spent the summer at Ménil-Hubert, where he painted *At the Races in the Countryside* (cat. no. 95), but he also returned there in May of 1871.[3]

Trying to guess the age of the girl in the picture is no help, for she could as easily be seven years old as nine. And there is no other evidence in the portrait to assist us in choosing between the two dates—except perhaps the apple, since it is an end-of-summer fruit, though apples can be preserved all year round. If we accept the year 1869 for *At the Races in the Countryside*, which is a very different painting, in a fine, concise style, then the portrait of Hortense is more likely to have been painted in 1871.

Nonetheless, the composition is evocative of the works done in the mid-1860s, such as the double portrait of M. and Mme Edmondo Morbilli (cat. no. 63) and in particular *Woman Leaning near a Vase of Flowers* (cat. no. 60), presumably the portrait of her mother. The portrait of Hortense has a flat background of wallpaper, and a table creating depth; there is nothing of the more elaborate backgrounds of some of Degas's portraits in interiors of the late 1860s, with their complex spaces broken up by mirrors, woodwork, and open doors. As in the portrait presumed to be of Mme Valpinçon, the "accessory"— here the floral-patterned tablecloth—assumes a place of importance; according to Barazzetti's account of Hortense's recollections, "it once caused great consternation among lovers of sensible, well-balanced composition."[4] That remark is not quite fair: the sewing basket, overflowing with an unfinished piece of embroidery and skeins of yarn, balances the figure of the little girl leaning on the other end of the table; the piece of apple she innocently holds is at the very center of the canvas. The tones are warm and subdued, never brilliant but discreet and polite in the manner of the well-bred bourgeoisie, like the pretty, sensible patterns designed by Mme Valpinçon for her embroidery. Among these objects, which call to mind many months of quiet, patient domesticity in this somewhat protected ambience—it could as easily be a Parisian apartment, there is no hint of the nearby countryside—the little Hortense, who we presume is restless and tired of posing, introduces an element of vivaciousness and impertinence, crushing in her hand what is left of her apple, waiting anxiously to go out and play, holding her pretty face against the background of the millefleur wallpaper for just one more moment.

1. Marriage certificate of Jacques Fourchy and Hortense Valpinçon, 15 April 1885, Archives, Eighth Arrondissement, Paris.
2. Barazzetti 1936, 190, p.3.
3. Unpublished letter from Auguste De Gas to Thérèse Morbilli, 3 June 1871, private collection.
4. Barazzetti 1936, 190, p. 3.

PROVENANCE: M. and Mme Paul Valpinçon, Paris; Mme Jacques Fourchy (née Hortense Valpinçon), their daughter, Paris; with Wildenstein, Paris, then

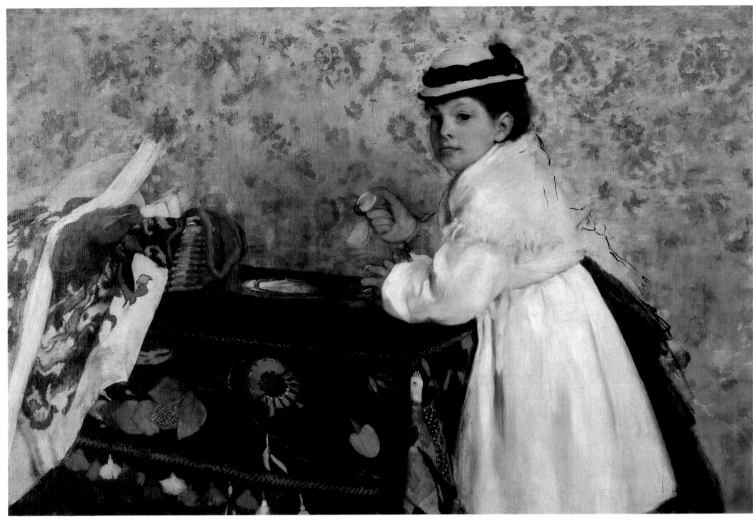

101

New York, 1936–48; Chester Dale, New York; bought by the museum with the aid of the John R. Van Derlip Fund 1948.

EXHIBITIONS: 1924 Paris, no. 33, repr.; 1932 London, no. 341 (473); 1936 Philadelphia, no. 15, repr.; 1945, New York, Wildenstein, 1–28 March, *The Child through Four Centuries*, no. 32; 1947 Cleveland, no. 17, pl. XV; 1948 Minneapolis, no number; 1949 New York, no. 17, repr.; 1951, New York, Wildenstein, 8 November–15 December, *Jubilee Loan Exhibition*, no. 47, repr.; 1953, Vancouver Art Gallery, *French Impressionists*, no. 51, repr.; 1954 Detroit, no. 68, repr.; 1955, The Art Institute of Chicago, 20 January–20 February, *Great French Paintings: An Exhibition in Memory of Chauncy McCormick*, no. 14, repr.; 1955, The Minneapolis Institute of Arts, *Fortieth Anniversary Exhibition of Forty Masterpieces*, no. 14, repr.; 1955 Paris, Orangerie, no. 18, repr.; 1957, New York, Knoedler Galleries, 14 January–2 February/Palm Beach, The Society of the Four Arts, 15 February–10 March, *Paintings and Sculpture from the Minneapolis Institute of Arts*, repr.; 1958 Los Angeles, no. 18, repr.; 1960 New York, no. 17, repr.; 1963, Cleveland Museum of Art, 2 October–10 November, *Style, Truth and the Portrait*, no. 91, repr.; 1969, New York, The Metropolitan Museum of Art, *Degas* (lent to the National Gallery of Art, Washington, D.C., August 1972–1974); 1974–75 Paris, no. 14, repr. (color); 1976, Tokyo, National Museum of Western Art, 11 September–17 October/Kyoto, National Museum, 2 November–5 December, *Masterpieces of World Art from American Museums*.

SELECTED REFERENCES: Barazzetti 1936, 190, p. 3; Lemoisne [1946–49], I, pp. 56, 239, II, no. 206; "Institute Acquires Degas' Portrait of Mlle Hortense Valpinçon," *Bulletin of the Minneapolis Institute of Arts*, XXXVII:10, 6 March 1948, pp. 46–51; Boggs 1962, pp. 37, 41, 69, 132, pl. 75; *European Paintings from the Minneapolis Institute of Arts*, New York/Washington, D.C./London, 1971, pp. 229–31, repr.; Minervino 1974, no. 253, pl. XI (color).

102.

Lorenzo Pagans and Auguste De Gas

c. 1871–72
Oil on canvas
21¼ × 15¾ in. (54 × 40 cm)
Musée d'Orsay, Paris (RF3736)

Exhibited in Paris

Lemoisne 256

This portrait, which stayed in the De Gas family, was one of those acquired by the French National Museums between the wars through the initiative of Marcel Guérin, who published it shortly thereafter.[1] The information he passed on still constitutes all that is known about the work today. His direct source was Paul Poujaud, "one of the men who knows most about the history of French painting and music in the late nineteenth century" (see cat. no. 334), a lawyer and a friend of Debussy's (he was one of the most ardent defenders of *Pelléas*), Chausson, D'Indy, Duparc, and Messager, and also of Carrière, Besnard, and Degas.

Poujaud admired Degas enormously. "He fascinated me for fifty years," he admitted to Guérin in 1931. "I was constantly scrutinizing and trying to animate the features of that handsome face preserved in old age, that brow, that gaze, those sensual lips through which breathed a chaste soul."[2] Guérin's acquisition of Degas's portrait of Pagans, like a later article he wrote on Degas's *Interior* (cat. no. 84), gave rise to a series of letters between him and Poujaud. Guérin was able to retrace part of Pagans's career in society primarily from the recollections of his parents, who had heard Pagans sing in the drawing room of his grandmother,

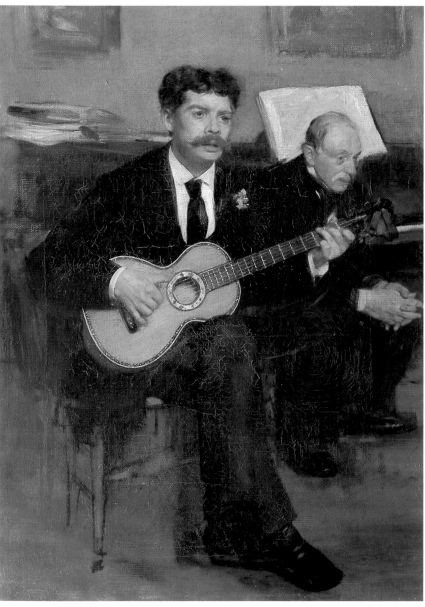

102

the basis of a photograph of Pagans (which does not, in fact, tell us much), moved the work back to about 1869. But it must have been painted somewhat later, at the same time as Degas's portraits of the musicians Désiré and Marie Dihau, Pilet, and Altès, about 1871–72.

Strictly speaking, the painting is not a double portrait, like the pictures of the Morbillis (cat. no. 63) or of Degas and Valernes (cat. no. 58); it is primarily a portrait of Lorenzo Pagans, with Auguste De Gas in the background, and is comparable in this respect to *The Orchestra of the Opéra* (cat. no. 97). In the late 1860s, Degas had devoted himself to portraits of painters; now, in the early 1870s, he did many small portraits of musicians in various situations—at home (Pilet), at the Opéra (Désiré Dihau), in a friend's drawing room (Pagans), playing an instrument (Dihau, Pagans), striking a pose (Marie Dihau), or composing (Pilet), but always together with those seemingly essential attributes, their musical instruments, whose often eccentric shapes played a decisive role in the composition of the canvases.

We know little about Lorenzo Pagans. The artist files at the Archives Nationales and at the Bibliothèque de l'Opéra contain scant information about him, mentioning only a conflict with the Opéra management in 1860 when he revived the difficult role of Idrène in Rossini's *Sémiramis*.[4] The *Enciclopedia universal ilustrada* lists a Lorenzo Pagans who was born at Celrá, Gerona, in 1838 and died in Paris in 1883.[5] This man was first an organist, afterward a tenor, and then mainly a singing teacher, who taught both budding vocalists and young men from good families, such as the chocolate maker Gaston Menier.[6] The repertoire he performed in the Parisian salons was very eclectic. Edmond de Goncourt heard him one year singing Rameau at the De Nittises and the next year playing an Arabic melody.[7] Edmond Guérin (Marcel's father) remembered his Spanish accent in a love song by the little-known C. A. Lis. Pagans was known primarily as a "Spanish singer," devoting himself to the popular melodies of his country, singing them to his own guitar accompaniment and occasionally composing ("La niña que a mí me quiere" was one of his great successes).

Here Degas probably shows Pagans performing a song from this repertoire (since he is accompanying himself on the guitar) at one of the musical evenings held by Auguste De Gas on Mondays in his apartment at 4 rue de Mondovi, which were attended by Dr. and Mme Camus, the Dihau brother and sister, and the Manets—"Manet, who sat cross-legged on the floor, beside the piano." Guérin goes on to describe the scene: "M. De Gas senior, who was a dedicated music

Mme Louis Bréton, on boulevard Saint-Michel, but he still needed the essential information obtained from Poujaud.

In a letter dated 15 January 1933, Poujaud recounts the circumstances of his discovery of the portrait. After having had lunch alone with Degas, sometime about 1893, Degas ushered Poujaud into his room.

[He] showed me the precious painting hanging above the small iron bedstead. "You knew Pagans? This is a portrait of him and my father." Then he left me alone. It was his way of showing me his work. Through a sort of proud modesty, he did not stay for the inspection. . . . After a few minutes, he came back into the room and, without either of us saying a word, looked me in the eye. That was enough for him. He was always grateful for my silent admiration. I am sure that he did not show me the Pagans as a souvenir of

his father, whom I did not know and whom he had never mentioned, but as one of his most prized finished works. There can be no doubt about that. This exceptional piece made a very strong impression on me.[3]

On another occasion, Degas spoke to him of the three paintings in his possession that he preferred, and after mentioning a Manet and a Delacroix, gave Poujaud to understand that the third, which he would not name, was his own portrait of Pagans. Later, Poujaud, like Guérin, considered it essential that this work, once known only to a few close friends (Henri and Alexis Rouart, Bartholomé), be included in the French national collection.

Regarding the exact date of the canvas, Poujaud was hesitant in deciding between 1871 and 1872, but finally settled on 1872, the date adopted by Guérin. Lemoisne, on

lover, drank in the music, sitting just as his son depicted him. . . . When there was a slight delay between pieces, M. De Gas senior would call the performers to order. 'My children,' he would say, 'we are wasting precious time.'"[8]

The room's furnishings, seen from a different angle in the portrait of Thérèse Morbilli (cat. no. 94), are recognizable from the inventory made after Auguste De Gas's death, which (unfortunately omitting the paintings) mentions "a mahogany grand piano bearing the name Érard, a piano stool, and a music stand, all appraised at four hundred francs."[9] It was in this familiar interior that Degas for the first time painted his father, who willingly plays a subordinate role, attentive only to the music. It is puzzling that there is not one portrait of this man by himself—a father so interested in his son's progress, encouraging him in his vocation and unstintingly offering advice. Perhaps he refused; perhaps Degas did not dare. After his father's death, Degas was to repeat this double image in a painting now in the Museum of Fine Arts in Boston (L257); later still, when both his father and Pagans were dead, he was to do a variation on the same theme (see fig. 299).

In the Pagans portrait, Auguste's innate nobility and the features made gaunt with age (recalling those of his father Hilaire—the strong nose, hollow temples, and balding pate) contrast sharply with the more commonplace physiognomy of the Spanish singer. Even posthumously, they make a strange pair. One day in 1871 or 1872, Degas must have been struck by the sight of his father, worn and already withdrawn, old and bent, approaching death, haloed by the white pages of an open score—a fleeting image which took root in his imagination. The memory of what was certainly an evening like many others became in time an icon above his bed. And so this small painting has a place of its own in his work, a sentimental place occupied by none of the other canvases found in his studio.

By way of epilogue: Auguste De Gas died in Naples on 23 February 1874 and was buried in the Degas mausoleum in the Poggioreale cemetery. Lorenzo Pagans died while still young, in 1883. A few months after his death, Edmond de Goncourt, who happened to be passing by the Hôtel Drouot on Easter Monday, attended one of those pitiful sales that were held on the sly "by lowly secondhand dealers, in an atmosphere of impious hooliganism"; on that occasion, "a tambourine, some guitars, sketches of painters, and baskets of underwear and flannel waistcoats were being sold. A handwritten notice stuck on the door said that it was a sale of the belongings of one Monsieur P———. This Monsieur P——— was poor Pagans, whose guitars and tambourine had for so many years produced such brilliant and entrancing music."[10]

1. Marcel Guérin, "Le portrait du chanteur Pagans et de M. de Gas père par Degas," *Bulletin des Musées de France*, March 1933, pp. 34–35.
2. Lettres Degas 1945, p. 250.
3. Lettres Degas 1945, pp. 252–54; excerpted in Degas Letters 1947, pp. 233–34 (translation revised).
4. Archives Nationales, Paris, AJ[13]1162.
5. Madrid: Espasas-Calpe, 1958, XL, p. 1477.
6. Unpublished memoirs of Gaston Menier, private collection.
7. Journal Goncourt 1956, II, p. 1274.
8. Guérin, op. cit.
9. See cat. no. 94, n. 3.
10. Journal Goncourt 1956, III, p. 331.

PROVENANCE: Atelier Degas; René de Gas, the artist's brother, Paris, 1918–21; Mme Nepveu-Degas, his daughter, Paris; bought by the Société des Amis du Louvre with the assistance of D. David-Weill 1933.

EXHIBITIONS: 1933 Paris, Orangerie, no. 76; 1937 Paris, Orangerie, no. 16, pl. II; 1939, Belgrade, Prince Paul Museum, *La peinture française au XIXe siècle*, no. 39, repr.; 1946, Paris, Musée des Arts Décoratifs, *Les Goncourt et leur temps*, no. 133; 1947, Paris, Orangerie, *Cinquantenaire des "Amis du Louvre" 1897–1947*, no. 61, repr.; 1949, South America, exhibition of French art; 1953, Paris, Orangerie, 6 May–7 June, *Donations de D. David-Weill aux musées français*, no. 39; 1969 Paris, no. 17.

SELECTED REFERENCES: Lafond 1918–19, I, p. 115, repr.; Marcel Guérin, "Le portrait du chanteur Pagans et de M. de Gas père par Degas," *Bulletin des Musées de France*, 3 March 1933, pp. 34–35; Lemoisne [1946–49], II, no. 256; Degas Letters 1947, pp. 70 n. 2, 233–34; Paris, Louvre, Impressionnistes, 1958, no. 69; Boggs 1962, pp. 22, 27–28, 127, pl. 58; Minervino 1974, no. 255; Paris, Louvre and Orsay, Peintures, 1986, III, p. 197, repr.

103.

The Ballet from "Robert le Diable"

1871
Oil on canvas
26 × 21⅜ in. (66 × 54.3 cm)
Signed and dated lower right: Degas 1872
The Metropolitan Museum of Art, New York.
 Bequest of Mrs. H. O. Havemeyer, 1929.
 H. O. Havemeyer Collection (29.100.552)

Lemoisne 294

First exhibited in 1872, immediately after it was completed, and then frequently afterward, *The Ballet from "Robert le Diable,"* together with its later London version (cat. no. 159), is among the pictures by Degas that were known and discussed during his lifetime. Despite the uncertainties of its history as recently revised by Anne Distel, we have sufficient information to be able to reconstruct the precise circumstances of its creation.[1] Although it bears the date 1872, it was certainly painted the year before, since Durand-Ruel bought it from Degas in January 1872 before sending it to London for exhibition on 6 April. (Contrary to Distel, I do not believe that this work is the "Orchestra of the Opéra" exhibited on rue Laffitte in 1871—although it is true that it sometimes bore that title.) It was among the six pictures that Durand-Ruel sold on 5 March 1874 to Jean-Baptiste Faure and that the baritone, as he had agreed with Degas, returned to the painter, who wanted to retouch them (see "Degas and Faure," p. 221).

Whereas Degas made major changes to *Orchestra Musicians* (cat. no. 98), he did not rework his first *Ballet from "Robert le Diable,"* but instead painted a second, larger version for the singer before returning the first version—in its January 1872 state—to Durand-Ruel on 20 August 1885.

The first studies date from 1870 or 1871. Meyerbeer's famous opera was staged twenty-three times between March and July 1870, and then (following the closing of the theater on rue Le Peletier from 12 September 1870 to 12 July 1871 because of the war and the Commune) ten times between September and December 1871. The programs could provide us with more accurate dating; in a notebook that is full of sketches of musicians and spectators, Degas wrote above the conductor, who is seated and raising his baton, "head of Georges in silhouette."[2] Unfortunately, since the management books prior to 1877 are missing and the conductor's name was always omitted from the posters, we cannot know exactly when the Georges Hainl in question conducted *Robert le Diable*.

Any one of the quick sketches done by Degas at the Opéra, which he so assiduously attended (even if, contrary to what is always said, he was not yet a subscriber), could have served for the theater scenes that he executed in the very early 1870s. Around these cursory pencil drawings from life, Degas wrote many notes on colors and lighting effects, such as "shadow cast by the score on the rounded back of the music stand" and "horsehair bow vividly lit by the lamps."[3] While making the sketches of musicians and spectators for *The Ballet from "Robert le Diable"*—Degas sat in the first rows of the orchestra—he reproduced the main lines of the highly celebrated stage set of the nuns' ballet as we see it in the final canvas.[4]

Degas was particularly fond of this famous scene from one of the best-known works in the repertoire, a work that made the fortune of the Opéra de Paris in the nineteenth century. First produced on 21 November 1831, Meyerbeer's *Robert le Diable* was staged continually throughout the century, until its last performance (the 758th!)

on 28 August 1893. There were few periods when it was not presented; at most, there were intermittent hiatuses of one or two years—for example, between 23 February 1868 and 7 March 1870.[5]

Most fortuitously, we have in manuscript form the setting for the work dated 21 December 1872, which is as Degas would have seen it not long before.[6] It gives a very precise description of Cicéri's set for the second scene in the third act, a set that, from the time it was created in 1831, "produced an astounding effect" and came to have a central place in the history of nineteenth-century theater design because, as Charles Séchan has reported, it permitted the revival of stage sets in the Romantic period. "The ruins of a monastery under brilliant moonlight. Backdrop of ruins among which tombs are visible. . . . A great arched entranceway stage right, from which one can see a row of columns extending to the back of the theater, where another arched gate, much lower, opens in the rear curtain. . . . Stage left, near the stylobate facing the public, is the tomb of Saint Rosalie. . . . In the foreground, stages right and left, are sloping tombs on which the nuns have lain down; on the one on stage left is the Mother Superior Helena."[7]

After Bertram's invocation, "Nuns who take your rest . . . ," the "will-o'-the-wisps appear and flutter about the tombs," bringing to life the dead nuns, who with the first bars of the andante sostenuto begin a procession. Soon the theater is fully lit and the nuns launch into an unrestrained bacchanal—this is the moment that Degas has chosen—when they recognize each other and "profess their satisfaction at seeing one another again." Helena, the mother superior (from 1865 to 1879 almost always performed by Mlle Fonta), "invites them to seize the moment and deliver themselves up to pleasure."

On four separate sheets, Degas did some quick, extraordinarily lively essence drawings of the reprobate nuns who in the course of the strange ballet timidly—with broken, awkward movements and uncertain poses— and then frenetically regain their taste for life (cat. nos. 104, 105, and III:363.1, III:363.2, all Victoria and Albert Museum, London). Forty years after it was first staged, this endlessly repeated scene had lost none of its fascination. Théophile Gautier (who, it is true, was of the Romantic generation) still described it admiringly in 1870: "Shadows rise and take shape dimly in the gloom; one hears faint rustlings, like the beating of moths' wings; indistinct forms stir in the depths of darkness, stand out against each pillar, ascend from each stone slab like wisps of smoke. A beam of livid light, produced by an electric wire, penetrates the arches,

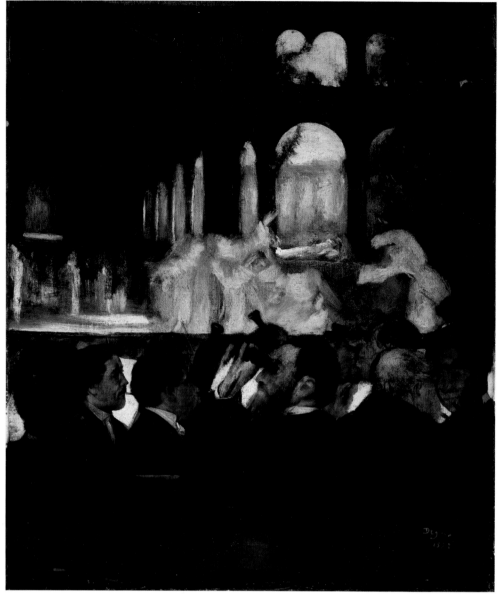

103

searching, outlining in the bluish obscurity female forms that move under their white shrouds with a deathly sensuality."[8]

Degas's annotations to the quick sketches of the set show that he was above all impressed by the lighting effects, the obscurity of the apparitions, and the singularity of the colors: "the moonlight barely touches the columns of the receding arches," "black vault, indistinct beams," "the pommel of the footlights is reflected by the lamps"— the "four church lamps" suspended from the vault of the gallery—and "luminous mist around receding arches."[9] The strangeness of the scene, which remained unequaled forty years after it was created, the chiaroscuro effects (which Degas was so fond of), the unclassical aspect of this ballet of ectoplasmic forms, and the contrast it generated—the musicians and spectators in the darkness, the bizarre cohabitation of these

two juxtaposed worlds—could not but intrigue and seduce the painter. For a true opera lover, of course, nothing could have been more hackneyed. It was fashionable at the time to treat Meyerbeer with condescension. When performances resumed in 1870, an event which Degas's close friend Ludovic Halévy termed a "disaster," Gounod, encouraged by the author of Les petites Cardinal, made fun of the antiquated music: "Three quarters of the score of Robert isn't worth a damn . . . ten years from now the work will have disappeared from the Opéra's repertoire."[10] The obvious indifference of the man looking through his binoculars at the boxes in the grand circle (traditionally identified as the collector Albert Hecht [1842–1889]—he seems older than his thirty years, but a later photograph published by Anne Distel suggests that this identification is not without basis[11]) and the equally obvi-

ous indifference of the other spectators, among them perhaps Ludovic Lepic, another opera fan, indicate that there was not much left in this repeatedly observed scene to titillate the subscriber any longer—not even any pretty dancers to ogle, encased as they were in their shapeless habits.

But it was just this that pleased Degas, and that he shows in this canvas: the whole opera world, the faded charm of a music known almost by heart and of a production that was trotted out year after year, the lack of interest on the part of the spectators, and those nuns who still continued to thrash about, exhibiting, before this audience of impassive men, their suddenly revived desires.

Between 1885 and 1892 (seven years for which we have specific information on the performances he attended), Degas viewed *Robert le Diable* six more times—proof of his touching fondness for a virtually defunct part of the repertoire—repeatedly watching this scene that had once been the epitome of Romanticism but was now no more than a well-worn museum piece, still enjoying the slender dancers he knew, all transformed into delinquent nuns swaying their hips over the heads of dour opera subscribers while Désiré Dihau puffed imperturbably into his bassoon.

1. Anne Distel, "Albert Hecht, collectionneur (1842–1889)," *Bulletin de la Société de l'Histoire de l'Art Français*, 1981, pp. 267–79.
2. Reff 1985, Notebook 24 (BN, Carnet 22, p. 7).
3. Ibid.
4. Ibid. (pp. 13, 15–17).
5. See *Robert le Diable* (exhibition catalogue edited by Martine Kahane), Paris: Théâtre National de l'Opéra, 1985.
6. Archives, Bibliothèque de l'Opéra, Paris, B.397(4).
7. Charles Séchan, *Souvenirs d'un homme de théâtre, 1831–1855*, Paris: Calmann Lévy, 1893, pp. 8–10.
8. *Journal Officiel*, 15 March 1870.
9. Reff 1985, Notebook 24 (BN, Carnet 22, p. 20).

10. Ludovic Halévy, *Carnets*, Paris: Calmann-Lévy, 1935, II, p. 74.
11. Distel, op. cit. X-radiography reveals that he was added to the canvas at a later stage.

PROVENANCE: Bought from the artist by Durand-Ruel, Paris, January 1872, for Fr 1,500 (stock no. 978); bought by Jean-Baptiste Faure, 5 or 6 March 1874, for Fr 1,500 (according to Guérin, Faure returned it immediately to Degas[1]); bought from the artist by Durand-Ruel, Paris, 20 August 1885, for Fr 800 (stock no. 732); bought by Rouart, 10 November 1885, for Fr 3,000, and resold 31 December 1885, for Fr 3,000; the work, which does not appear to have left Durand-Ruel, was deposited with Robertson for sale 24 December 1885 and returned 11 January 1886; bought by Jean-Baptiste Faure (as "Robert le Diable"), 14 February 1887, for Fr 2,500; bought by Durand-Ruel, Paris, 31 March 1894, for Fr 10,000 (as "Le ballet de Guillaume Tell," stock no. 2981); bought by Durand-Ruel, New York, 4 October 1894, for Fr 10,000 (as "Robert le Diable," stock no. N.Y. 1205); bought by H. O. Havemeyer, 14 February 1898, for $4,000; Mrs. H. O. Havemeyer, New York, 1907–29; her bequest to the museum 1929.

1. Lettres Degas 1945, pp. 31–32; Degas Letters 1947, p. 261.

EXHIBITIONS: 1872, London, *Fourth Exhibition of the Society of French Artists*, no. 95, asking price 100 guineas; 1886 New York, no. 17; 1897–98, Pittsburgh, Carnegie Institute, 4 November 1897–1 January 1898, *Second Annual Exhibition*, no. 65; 1930 New York, no. 50; 1935 Boston, no. 12; 1944, New York, Wildenstein, 13 April–13 May, *Five Centuries of Ballet 1575–1944*, no. 238; 1947, Huntington, N.Y., Neckshow Art Museum, June, *European Influence on American Painting of the 19th Century*, no. 28; 1948, Columbus Gallery of Fine Arts, 1 April–2 May, *The Springtime of Impressionism*, no. 8; 1949 New York, no. 23, repr.; 1949–50, Honolulu Academy of Fine Arts, 8 December 1949–24 January 1950, *Four Centuries of European Painting*, no. 26; 1950, Art Gallery of Toronto, 21 April–20 May, *Fifty Paintings by Old Masters*, no. 9; 1951–52 Bern, no. 17; 1952 Amsterdam, no. 11; 1955, New York, The Metropolitan Museum of Art, 24 October–13 November, *The Comédie Française and the Theater in France*, p. 6; 1958–59, Pittsburgh, Carnegie Institute, 4 December 1958–8 February 1959, *Retrospective Exhibition of Paintings from Previous Internationals*, no. 7; 1963, Little Rock, Arkansas Arts

Center, 16 May–26 October, *Five Centuries of European Painting*, p. 46; 1975, Sydney, Art Gallery of New South Wales, 10 April–11 May/Melbourne, National Gallery of Victoria, 28 May–22 June/New York, The Museum of Modern Art, 4 August–1 September, *Modern Masters, Manet to Matisse*, no. 25, repr. p. 39; 1977 New York, no. 12 of paintings; 1984–85 Washington, D.C., no. 2, repr.

SELECTED REFERENCES: Iakov Tugendkhol'd, *Edgar Degas*, Moscow: Z. I. Grzhebin, 1922, repr. p. 44; Alexandre 1929, p. 484, repr. p. 478; Havemeyer 1931, p. 107, repr. p. 106; Burroughs 1932, p. 144; Mongan 1938, p. 296; Huth 1946, p. 239 n. 22; Lemoisne [1946–49], I, p. 68, II, no. 294; Browse [1949], pp. 22, 28, 52, 61, 66, 337, pl. 8; Boggs 1958, p. 244; Havemeyer 1961, p. 263; Mayne 1966, pp. 148–56, fig. 2; New York, Metropolitan, 1967, pp. 3, 66–68; Moffett 1979, pp. 7, 9, 10, III, fig. 15 (color); 1985, Paris, Théâtre National de l'Opéra, 20 June–20 September, *Robert le Diable*, pp. 65–66; Reff 1985, I, pp. 7 n. 2, 9, 21.

104.

Nuns Dancing, study for The Ballet from "Robert le Diable"

1871
Essence on buff laid paper, laid down
11⅛ × 17⅞ in. (28.3 × 45.4 cm)
Vente stamp lower right
Victoria and Albert Museum, London (E.3688-1919)

Vente III:364.1

See cat. no. 103

PROVENANCE: Atelier Degas (Vente III, 1919, no. 364.1); bought at that sale by Knoedler, Paris, with no. 364.2, for Fr 1,000; bought by the museum 1919.

EXHIBITIONS: 1984 Tübingen, no. 85, repr.

SELECTED REFERENCES: Mayne 1966, p. 155, fig. 4.

104

105

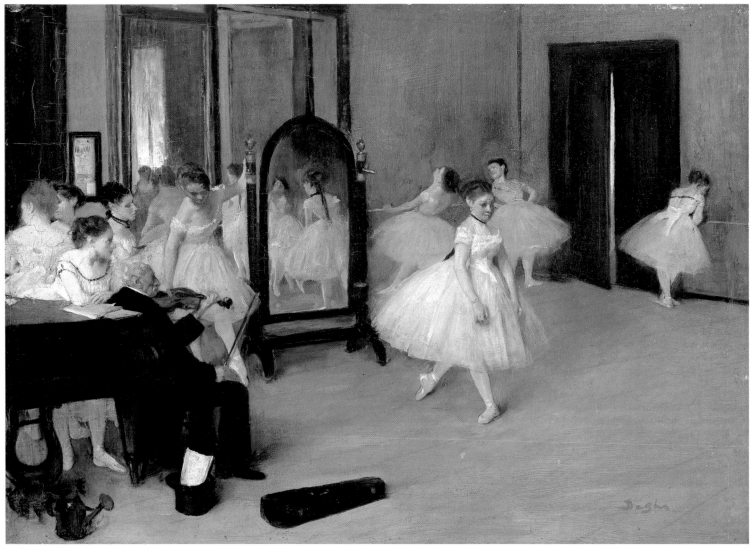

106

105.

Nuns Dancing, study for *The Ballet from "Robert le Diable"*

1871
Essence on buff laid paper, laid down
11 × 17¾ in. (28 × 45 cm)
Vente stamp lower left
Victoria and Albert Museum, London
(E.3687-1919)

Vente III:364.2

See cat. no. 103

PROVENANCE: Atelier Degas (Vente III, 1919, no. 364.2); bought at that sale by Knoedler, Paris, with no. 364.1, for Fr 1,000; bought by the museum 1919.

EXHIBITIONS: 1967 Saint Louis, no. 64, repr.; 1969 Nottingham, no. 15; 1984 Tübingen, no. 84, repr.

SELECTED REFERENCES: Browse [1949], pp. 336–37, pl. 6; Mayne 1966, p. 155, fig. 6.

106.

Dance Class

1871
Oil on panel
7¾ × 10⅝ in. (19.7 × 27 cm)
Signed lower right: Degas
The Metropolitan Museum of Art, New York.
 Bequest of Mrs. H. O. Havemeyer, 1929.
 H. O. Havemeyer Collection (29.100.184)

Exhibited in New York

Lemoisne 297

The history of this painting has been traced by Ronald Pickvance in an article that deals with the dating of the first dance pictures in masterly fashion.[1] Durand-Ruel bought it from Degas together with *The Ballet from "Robert le Diable"* (cat. no. 103) in January 1872. After going to Premsel's for a short while, the picture was sold (as we know from an entry in Durand-Ruel's journal for 6 February 1872) to the painter Édouard Brandon (1831–1897; not to be confused

with his father), whom Degas had known ever since his stay in Rome and whose portrait he painted (L360). It was therefore this work, catalogued as "no. 55, 'Dance Class,' belonging to M. Brandon," and not the picture in the Musée d'Orsay, as Lemoisne claims, that appeared in the first Impressionist exhibition, in 1874. There it drew the praises of Philippe Burty[2] and of the lesser-known Marc de Montifaud, who praised "a fine, profound study featuring something never to be found in certain genre painters who would blush at putting undraped figures in a small canvas: the study of women in their opulent nudity, with their elegant or slender curves."[3] Predating *Dance Class at the Opéra* (cat. no. 107) by several months, *Dance Class* was the first of many pictures by Degas on the recurring theme of dancers exercising.

Nothing is known of the circumstances that led Degas to turn his attention to this subject. His depictions of ballet performances of the early 1870s probably sparked

his interest in the very special world of the Opéra, which was so faithfully frequented by some of his friends—Lepic, the Hechts, Halévy. In May 1870, Halévy had published "Madame Cardinal," the first in a series of short stories relating the humorous misadventures of two young dancers from the Opéra, Pauline and Virginie Cardinal, and their comical parents. November 1871, when in all likelihood Degas was working on his small canvas, saw the appearance of "Monsieur Cardinal," which opens with a brief description of the entry on stage of the corps de ballet for an evening's performance.

Clearly, Degas was not illustrating Halévy's stories, though he would do so later (see "Degas, Halévy, and the Cardinals," p. 280); however, as yet unacquainted with backstage activities, he certainly profited by the writer's advice. It must be remembered that in 1871 Degas was not permitted to go backstage at the Opéra on rue Le Peletier; that was a privilege he obtained only about fifteen years later, at the Palais Garnier. While during the day he could doubtless visit the premises he later painted, it is almost certain that he was not present at any of the scenes depicted; a few years later, he was still writing to Albert Hecht to request "a pass for the day of the dance examination," adding, "I have done so many of these dance examinations without having seen them that I am a little ashamed of it."[4]

At the center of the picture, we see probably Joséphine Gaujelin (that is how Degas spelled her name, though the 1870 money orders for paying dancers mention a Joséphine Gozelin[5]). The dancers came to Degas's studio to pose (we know this from the painting that his friend Valernes did in 1872, which he annotated "Study just begun of a dancer from the Opéra in the studio of her friend Degas, rue de Laval"), and Degas did many drawings of them that he would later use for more than one picture.

In one of the old rooms of the Opéra on rue Le Peletier, with its dirty walls and big doors of dark wood, the dancers, having "cracked their joints" at the barre, move in front of an Empire-style cheval glass, where they will begin their exercises in the middle of the floor: "jetés, balancés, pirouettes, gargouillades, entrechats, fouettés, ronds de jambes, assemblées, pointes, parcours, petits temps. . . ."[6] In the center, en pointe arrière, Joséphine Gaujelin awaits the sign from the ballet master—here he has the features of a *metteur en scène* named Gard who appeared in *The Orchestra of the Opéra* (cat. no. 97) and about whom we know nothing—who has taken up his pocket violin. The supporting dancers wait, resting against the barre, leaning with their elbows on the piano (for which we have several sketches[7]) or

chatting among themselves. Over the entire scene there falls a soft, golden light that some have found "rather muted";[8] it shines here and there (on the polished watering can, a sheet of the score, the heel of a pink shoe), whitens the thin cleft between the double doors, and is reflected in a large mirror. The smooth, even finish, lustrous without being thick, and the precise brushstrokes are reminiscent of Flemish or Dutch paintings, as are the small size, the uniform, quiet lighting, and the peacefulness of this interior scene. Across the small surface of the panel, there is nothing that is niggardly, nothing that is overpolished; rather, there is an amplitude, an entire world that invites examination of its fullness and its great empty spaces, of its arms, shoulders, ears pierced with pearl, of the somber bulk of the piano and the ballet master who is ensconced in it, of the lightness of the white tutus and the little pink feet, and of the bare floor with the strange interplay of a watering can, a top hat, and a pocket-violin case.

1. Pickvance 1963, pp. 256–59, 265–66.
2. *La République Française*, 25 April 1874.
3. *L'Artiste*, May 1874, p. 309.
4. Lettres Degas 1945, XXXIV, p. 63; Degas Letters 1947, no. 43, p. 66.
5. Archives, Bibliothèque de l'Opéra, Paris.
6. Un vieil abonné [An old subscriber], *Ces demoiselles de l'Opéra*, Paris: Tresse et Stock, 1876, p. 28.
7. Reff 1985, Notebook 24 (BN, Carnet 22, pp. 22–24).
8. Ernest Chesneau, *Paris-Journal*, 7 May 1874.

PROVENANCE: Bought from the artist by Durand-Ruel, Paris, January 1872 (as "Foyer de la danse," stock no. 943); acquired by Premsel, 16 January 1872, with a painting by Henry Levy and one by Héreau in exchange for two paintings by Zamacoïs, two by Richet, and Fr 1,500 in cash; acquired by Durand-Ruel, Paris, 30 January 1872 (stock no. 979), for Fr 1,000 plus Fr 6,000 in cash, in exchange for a painting by Corot; acquired by Édouard Brandon, 6 February 1872, for Fr 1,200, in exchange for a painting by Puvis de Chavannes (Fr 400), a painting by Brandon (to be delivered, Fr 300), and Fr 500 in cash; Édouard Brandon, Paris. Durand-Ruel, Paris and London, 1876; Captain Henry Hill, Brighton, from 1875 or 1876 (Hill sale, Christie's, Brighton, 25 May 1889, no. 26 [as "A Pas de Deux," 7½ × 10 in.]); bought by Wallis (French Gallery, London), for 111 guineas, 1889; with Michel Manzi, Paris, until 1915; bought from his heirs through Mary Cassatt by Mrs. H. O. Havemeyer, New York, April 1917; her bequest to the museum 1929.

EXHIBITIONS: 1874 Paris, no. 55 (as "Classe de danse, appartient à M. Brandon"); 1876 London, no. 2 (as "The Practising Room"); (?)1928, New York, Durand-Ruel, *French Masterpieces of the XIXth Century*, no. 6 (as "La leçon de foyer," anonymous loan, probably this painting); 1930 New York, no. 48; 1974–75 Paris, no. 15, repr. (color); 1975, Leningrad, Hermitage, 15 May–20 July/Moscow, Pushkin Fine Art Museum, 28 August–2 November, *100 Paintings from the Metropolitan Museum*, no. 66; 1977 New York, no. 11 of paintings.

SELECTED REFERENCES: Philippe Burty, "Exposition de la Société Anonyme des Artistes," *La République*

Française, 25 April 1874 (reprinted in Venturi 1939, II, p. 289); M. de Montifaud, "Exposition du boulevard des Capucines," *L'Artiste*, XIX, 1874, p. 309; *Art Journal*, XXXVIII, 1876, p. 211; *The Atheneum*, 1876, p. 571; Havemeyer 1931, p. 111, repr.; Burroughs 1932, p. 144; Lemoisne [1946–49], I, p. 69, II, no. 297; Browse [1949], pp. 53–54, 60, 341, pl. 17, pl. II (color); Havemeyer 1961, pp. 265–66; Pickvance 1963, pp. 256–59, 265–66; New York, Metropolitan, 1967, pp. 69–71, repr.; Minervino 1974, no. 296; Moffett 1979, p. 11, pl. 17 (color); 1984–85 Washington, D.C., pp. 26–28, 43, 45; Moffett 1985, pp. 66–67, repr. (color) p. 250; Weitzenhoffer 1986, p. 231, fig. 157 (color).

107.

Dance Class at the Opéra

1872
Oil on canvas
12⅝ × 18⅛ in. (32 × 46 cm)
Signed lower left: Degas
Musée d'Orsay, Paris (RF1977)

Exhibited in Paris

Lemoisne 298

"This is without question the completed work that can give the best idea of the artist's talents in that period." So wrote Lemoisne in 1912, before the great atelier sales, when knowledge of Degas's work was still quite fragmentary.[1] Gustave Coquiot, a little later, in an eccentric book criticized the very finish of the canvas, its completeness: "All these dancers, in this vast bare room, form what would make an excellent photograph, and nothing more. The picture is accurate, and frozen; it is well balanced, but a skilled photographer could easily have recorded the same scene."[2]

Even today this masterpiece, so famous and so often reproduced (from as early as 1873, when an etching of it by Martinez appeared in Durand-Ruel's publication of prints[3]), has a reputation for accessibility that does it harm. It is somehow a quintessential work of Degas "the painter of dancers." The most knowledgeable authorities give it very little attention, consigning it to the delectation of the "general public," describing it as "traditional,"[4] "carefully depicted,"[5] and "conservative,"[6] and usually omitting to point out the modernity of this little scene in the context of French painting of the 1870s.

No doubt encouraged by the success of his first *Dance Class* (cat. no. 106), which had immediately found a buyer, Degas returned to the theme in 1872, but on a slightly larger scale, and giving it an even more

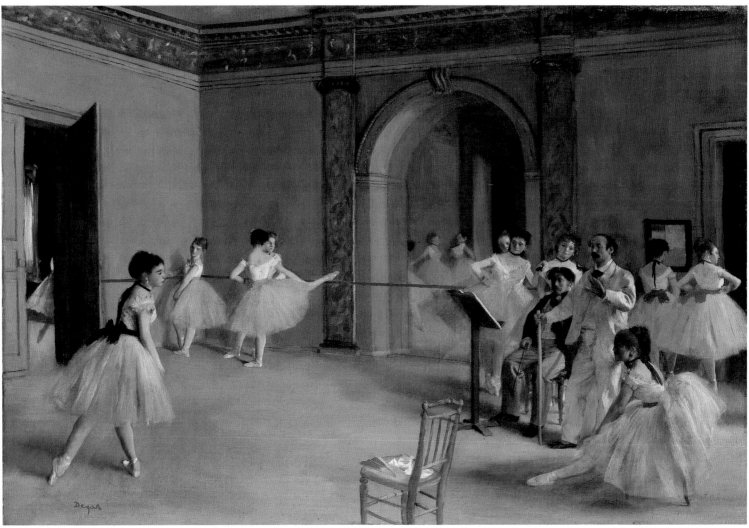

107

"Parisian" look by situating it in an actual re-hearsal room of the Opéra on rue Le Peletier and introducing the well-known figure of Louis Mérante. It was probably this canvas that René De Gas, arriving from New Or-leans, saw in his brother's studio and men-tioned in a letter of 17 July 1872: "Right now he is painting small pictures, which are what tire his eyes the most. He is doing a dance rehearsal that is charming. . . . I'll have a large photograph taken of it."[7] A month later, on 10 August, Durand-Ruel purchased it; he shipped it to London on 29 October, and there it was sold to Louis Huth on 7 December.

Worried about the fate of the picture, De-gas wrote from New Orleans in November to ask Tissot, then in exile in London: "What impression did my dance picture make on you, on you and the others?—Were you able to help in selling it?"[8] The canvas was noticed by the London critic Sydney Colvin, who wrote an enthusiastic article on this masterpiece in the *Pall Mall Gazette* of 28 November 1872: "It is impos-sible to exaggerate the subtlety of exact per-ception, and the felicitous touch in expressing it, which reveal themselves in his little pic-ture of ballet-girls training beneath the eye of the ballet-master."

For the two dancers in the foreground (the X-radiograph shows that Degas changed the positions of nearly all the ballerinas), this exhibition includes two beautiful essence studies on pink paper done in the studio (see cat. nos. 108, 109). The study for the stand-ing dancer (cat. no. 108), annotated by Degas "93 [or 96] rue du Bac/d'Hugues," shows the lovely profile of Mlle Hugues,[9] who was at the Opéra before moving on to the Bouffes-Parisiens. Preparing to do a reverse ara-besque, she awaits, like Joséphine Gaujelin in *The Dance Class* (cat. no. 106), the sign from the ballet master Mérante, here cou-pled with a pocket-violin player. Louis Mé-rante (1828–1887) had begun his career as a dancer, appearing regularly on the stage of the Opéra from 1863. Named first ballet master in 1870, he held the post for seven-teen years and, as Ivor Guest tells us, car-ried out his duties "with an amiable authority, leaving the more arduous task of maintaining discipline to his stage manager, Édouard Pluque."[10]

As in the *Dance Class*, though in a differ-ent setting, Degas reproduces the moment when, having completed their exercises at the barre, the dancers are about to move to the center of the room. In both works, the poses are comparable, the moment is that instant when everything is temporarily frozen, just before movement begins, and the light is soft, even, and golden. But there is more solemnity here, not only because of the impressive nature of the place, with its marble-surfaced columns, the frieze running along the edge of the ceiling, and the deep recess of the mirror, but also because of the Olympian presence of Mérante himself, ac-companied by his pocket-violin player.

While the texture is the same, the color-ing differs appreciably: the faded gold of the capitals, the frieze, and the frame of the mirror that appears through the open door; the uneven ochre of the wall; the grayish white of the tutus and of Mérante's outfit (there is hardly any bright white apart from the piece of linen on the chair); the scattered

black of a jacket, a cravat, ribbons, sashes, and the notice board; and the more sonorous vermilion patches supporting that gilded white page, the bow displayed on a dancer seen from behind, the thin line of the barre running along the wall, the fan, and finally the signature, delicately entered with the brush. Such subtlety, harmony, and discretion have reminded viewers of Watteau, Lancret, Pater—and, of course, Vermeer. When, much later, speaking of a "dressing table scene by Fantin" on exhibit at the École des Beaux-Arts, Degas remarked to Paul Poujaud, "In our beginnings, Fantin, Whistler, and I, we were all on the same road, the road from Holland,"[11] he must have been thinking of these small canvases, among others. As Mary Cassatt tells us, he could not help recalling them with regret, yearning as he surely did for the blessed time when his poor tired eyes were still capable of such detailed work.[12]

1. Lemoisne 1912, p. 48.
2. Coquiot 1924, p. 169.
3. See Reed and Shapiro 1984–85, fig. 8.
4. Fosca 1954, p. 47.
5. Terrasse 1974, p. 24.
6. 1984–85 Washington, D.C., p. 28.
7. Lemoisne [1946–49], I, p. 71.
8. Letter from Degas to Tissot, 19 November 1872, Bibliothèque Nationale, Paris; Degas Letters 1947, no. 3, p. 17.
9. Further proof that this is Miss Hughes may be found in an 1893 photograph of her by Reutlinger in the Bibliothèque de l'Opéra, Paris.
10. Ivor Guest, *Le ballet de l'Opéra de Paris*, Paris: Théâtre National de l'Opéra, 1976, pp. 136–37.
11. Lettres Degas 1945, p. 256; Degas Letters 1947, p. 236.
12. Havemeyer 1961, p. 265.

PROVENANCE: Bought from the artist by Durand-Ruel, Paris, 10 August 1872, for Fr 2,500 (as "La leçon de danse," stock no. 1824); sent to Durand-Ruel, London, 29 October 1872, for Fr 2,500; bought by Louis Huth, 7 December 1872, for £168, to 1888.[1] Henri Vever, Paris; with Michel Manzi, Paris; bought by Comte Isaac de Camondo, January 1894, for Fr 5,000;[2] his bequest to the Louvre 1911; exhibited 1914.

1. Pickvance 1963, p. 257.
2. The provenance "From Manzi the Dance Class, from Vever" is given in Isaac Camondo's notebook recording purchases, p. 227.

EXHIBITIONS: 1872, London, 168 New Bond Street, *Fifth Exhibition of the Society of French Artists*, hors catalogue; 1888, Glasgow, *Glasgow International Exhibition*, no. 836 (as "Le maître de ballet"); 1955 Paris, GBA, no. 48, repr.; 1957 Paris, no. 83, repr.; 1969 Paris, no. 22.

SELECTED REFERENCES: Galerie Durand-Ruel, *Recueil d'estampes*, 12th issue, Paris/London/Brussels, 1873, pl. 103, engraved by Martinez (as "Foyer de la danse à l'Opéra"); Lemoisne 1912, p. 47; Paris, Louvre, Camondo, 1914, no. 160; Lemoisne [1946–49], II, no. 298; Browse [1949], pp. 53, 340, pl. 16; Pickvance 1963, pp. 256–58; Minervino 1974, no. 292, pl. XXIV (color); Ivor Guest, *Le ballet de l'Opéra de Paris*, Paris: Théâtre National de l'Opéra, 1976, pp. 130–31, 136–37, repr.; 1984–85 Washington, D.C., pp. 26–27, repr.; Paris, Louvre and Orsay, Peintures, 1986, III, p. 193, repr.; Sutton 1986, p. 166, repr.

108.

Dancer Standing, study for *Dance Class at the Opéra*

1872
Essence and pencil on pink paper
10⅝ × 8¼ in. (27.1 × 21 cm)
Inscribed lower right: 93 [or 96] rue du Bac/ d'Hugues
Vente stamp lower right
Collection of Thomas Gibson, London

Lemoisne 300

See cat. no. 107

PROVENANCE: Atelier Degas (Vente II, 1918, no. 231.1); bought at that sale by René de Gas, the artist's brother, with no. 231.2, for Fr 12,900 (René de Gas estate sale, Drouot, Paris, 10 November 1927, no. 23.a, repr.); bought at that sale by Rodier, with no. 23.b, for Fr 45,000; Galerie Georges Petit, Paris; Wildenstein Galleries, New York; bought by John Nicholas Brown, Providence, 1928; deposited with Joslyn Art Museum, Omaha, 1941–46; heirs of John Nicholas Brown, Providence, to 1986. Bought by Thomas Gibson 1987.

108

EXHIBITIONS: 1929 Cambridge, Mass., no. 21; 1931, Providence, Rhode Island School of Design, no. 21 of drawings; 1936 Philadelphia, no. 73, repr.; 1958–59 Rotterdam, no. 165; 1962, Cambridge, Mass., Fogg Art Museum, 11 June–28 July, *Forty Master Drawings from the Collection of John Nicholas Brown*, no. 7; 1974 Boston, no. 77; 1981 San Jose, no. 60; 1984 Tübingen, no. 80, pl. 80 (color).

SELECTED REFERENCES: Vingt dessins [1897], pl. XI (color); Lemoisne [1946–49], II, no. 300; Browse [1949], p. 53, pl. 14; Pickvance 1963, p. 258 n. 24; Minervino 1974, no. 294.

109

109.

Dancer Seated, study for Dance Class at the Opéra

1872
Essence and pencil on pink paper
10¾ × 8¼ in. (27.3 × 21 cm)
Vente stamp lower left
Collection of Mr. and Mrs. Eugene Victor
 Thaw, New York

Lemoisne 299

See cat. no. 107

PROVENANCE: Atelier Degas (Vente II, 1918, no. 231.2); bought at that sale by René de Gas, the artist's brother, Paris, with no. 231.1, for Fr 12,900; René de Gas, Paris, 1918–21 (René de Gas estate sale, Drouot, Paris, 10 November 1927, no. 23.b, repr.); bought at that sale by Rodier, with no. 23.a, for Fr 45,000; Galerie Georges Petit, Paris; Wildenstein Galleries, New York; bought by John Nicholas Brown, Providence, 1928; deposited with Joslyn Art Museum, Omaha, 1941–46; heirs of John Nicholas Brown, Providence, to 1986; bought by David Tunick, New York; bought by Mr. and Mrs. Eugene Victor Thaw, New York, 1986.

EXHIBITIONS: 1929 Cambridge, Mass., no. 22; 1931, Providence, Rhode Island School of Design, no. 22 of drawings; 1936 Philadelphia, no. 74, repr.; 1958–59 Rotterdam, no. 164; 1962, Cambridge, Mass., Fogg Art Museum, 11 June–28 July, *Forty Master Drawings from the Collection of John Nicholas Brown*, no. 8; 1974 Boston, no. 76; 1981 San Jose, no. 59, repr.; 1984 Tübingen, no. 83, repr. (color) p. 21.

SELECTED REFERENCES: Lemoisne [1946–49], II, no. 299; Browse [1949], pp. 53, 340, pl. 15; Pickvance 1963, p. 258 n. 24; Minervino 1974, no. 295.

Violinist and Young Woman Holding Sheet Music

c. 1872
Oil on canvas
18¼ × 22 in. (46.4 × 55.9 cm)
Vente stamp lower left
The Detroit Institute of Arts. Bequest of
 Robert H. Tannahill (70.167)

Lemoisne 274

The fact that we cannot today attach any names to these two people and are unable to give this canvas more than a descriptive title should not deter us from viewing it primarily as a portrait of two musicians, to be considered with the portraits of the Dihaus, Pilet, Altès, and Pagans, which Degas painted very early in the 1870s (see cat. nos. 97, 102). However, its incompleteness, the poses of the figures, the light background (which is only sketched in and was probably added later), and the unusual combination of blacks, grays, and reds make it a very different work from those just mentioned. The picture shows a break during a rehearsal—not a musical evening, as some have claimed, for it is daylight and the musicians are not dressed in evening wear. A violinist, his instrument on his knees (some ten years earlier, Degas had tried to learn the violin[1]), and a young female pianist or singer with an open score in her hands, caught as if surprised in their conversation, look toward the viewer. The violinist, slightly in the background, wears an artist's jacket of a beautiful red; he is sunk in a low armchair, which only accentuates his plumpness—it may be one of the garnet-red velvet chairs that furnished the drawing room of rue de Mondovi (see cat. no. 94). The elegant young woman wears a gray dress with a black belt and ruffles, jet earrings, and hair ornaments, perhaps indicating that she is in half mourning.

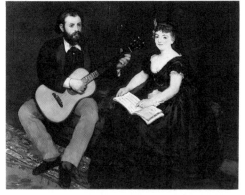

Fig. 91. Édouard Manet, *The Music Lesson*, 1870. Oil on canvas, 55⅛ × 68⅛ in. (140 × 173 cm). Museum of Fine Arts, Boston

It is about 1872, and the two musicians are rehearsing for an upcoming soirée.

Jean Sutherland Boggs was the first to point out the connection between this small canvas and Manet's *The Music Lesson*, exhibited at the Salon of 1870 (fig. 91), which shows Zacharie Astruc accompanying a placid, smiling songstress on the guitar.[2] But the related subject matter should not lead us to overlook the great differences between the two canvases—in size, in intention (Manet was thinking ahead to the Salon), and in balance of color (Manet's canvas is dark, painted with the magnificent "prune juice" that Degas was to miss so much when his friend subsequently stopped using it, while Degas's canvas is light). In Manet's painting, there is something deliberately conventional that Degas sought to avoid, roughly outlining his figures in black, play-

ing with the brilliant white of the score in the middle of the picture, and painting the background in the changeable hue of some Italian walls, against which the woman's beautiful face stands out in three-quarter profile, her red lips, black eyebrows, and dark, glittering jewels calling to mind an earlier work (L163, Musée d'Orsay, Paris), but also reminding us of portraits by Clouet and Corot.

1. Unpublished letter from René De Gas to Michel Musson, Paris to New Orleans, 17 January 1861, Tulane University Library, New Orleans.
2. Boggs 1962, p. 33.

PROVENANCE: Atelier Degas (Vente I, 1918, no. 49, repr.); bought at that sale by Seligmann, Bernheim-Jeune, Durand-Ruel, and Vollard, Paris, for Fr 37,100 (Seligmann sale, American Art Association, New York, 27 January 1921); bought at that sale by J. H. Whittemore, Naugatuck, for $7,000; Durand-Ruel,

New York, 4 May 1936 (stock no. N.Y. 5301); bought by Robert H. Tannahill, Detroit, 11 January 1936, for $30,000; his bequest to the museum 1970.

EXHIBITIONS: 1934 New York, no. 10; 1974–75, Detroit Institute of Arts, 6 November 1974–5 January 1975, *Works by Degas in the Detroit Institute of Arts*, no. 8, repr. p. 32.

SELECTED REFERENCES: Lemoisne [1946–49], II, no. 274; Boggs 1962, p. 33, pl. 75; *The Detroit Institute of Arts Illustrated Handbook* (by Frederick J. Cummings and Charles H. Elam), Detroit: Wayne State University Press, 1971, p. 157, repr. (color) p. 20; Minervino 1974, no. 275; Theodore Reff, "Works by Degas in the Detroit Institute of Arts," *Bulletin of the Detroit Institute of Arts*, LIII:1, 1974, pl. 8 p. 32; *100 Masterpieces from the Detroit Institute of Arts* (by Julia P. Hinshaw), New York: Hudson Hills Press, 1985, p. 118, repr. (color) p. 119.

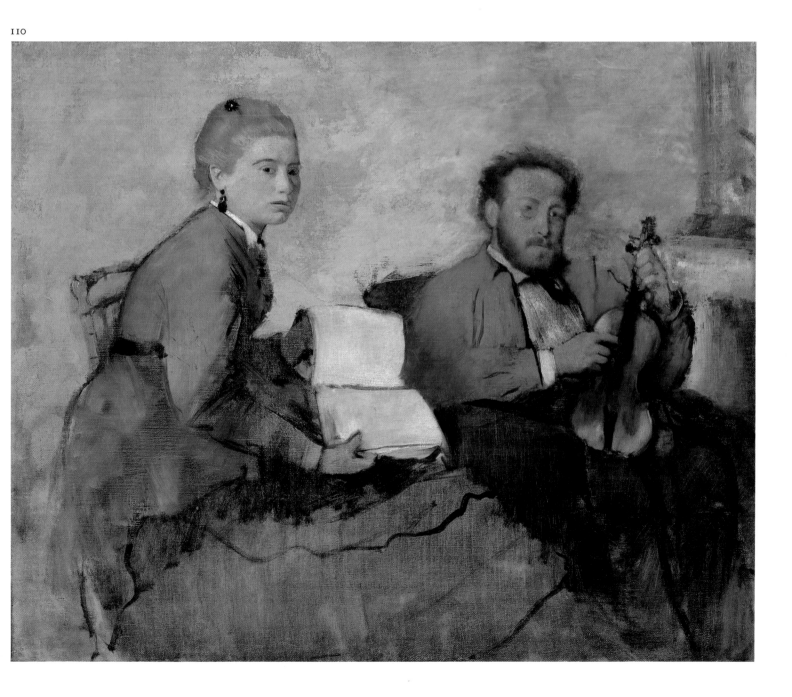

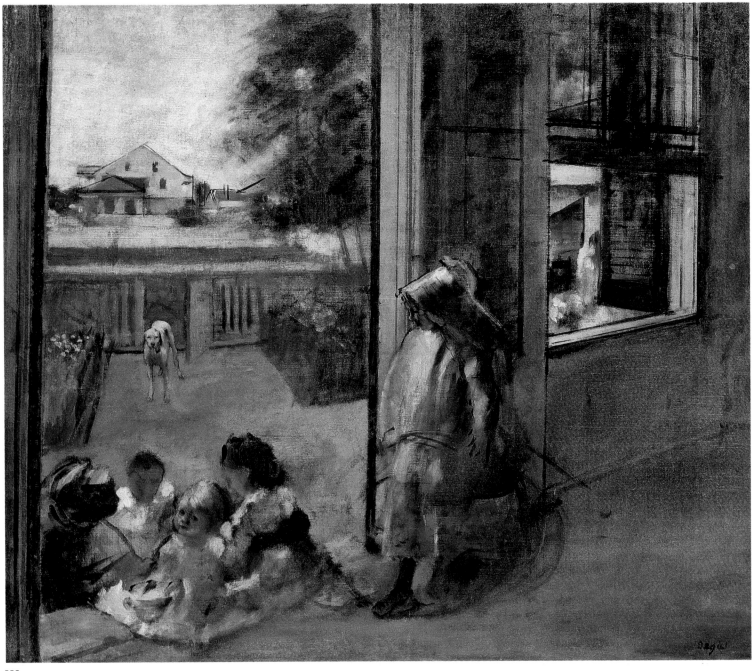

III

III.

Children on a Doorstep (New Orleans)

1872
Oil on canvas
23⅝ × 29½ in. (60 × 75 cm)
Signed lower right: Degas
Ordrupgaardsamlingen, Copenhagen (31)

Lemoisne 309

When it was presented at the second Impressionist exhibition, in 1876, this work—listed as no. 40, "Courtyard of a House (New Orleans, sketch)"—went unnoticed amid the reaction to *Portraits in an Office*

(New Orleans) (cat. no. 115) and a picture of a laundress whose "black arms" (in silhouette) severely shocked the critics (see cat. no. 122). The fact that the painting, along with some of the other works Degas exhibited, was unfinished contributed greatly to the notion, still with us, that Degas was an artist who was perpetually unsatisfied, incapable of completing things, and, in the final analysis, a draftsman more than a painter. Degas began this work three weeks after he arrived in New Orleans. In a letter to Tissot dated 19 November 1872, after complaining about being so far away and receiving so little mail, he wrote: "Nothing is as difficult as doing family portraits. To make a cousin sit

for you who is feeding an imp of two months is quite hard work. To persuade young children to pose on the steps is twice as tiring. It is the art of giving pleasure and one must look the part."[1]

Degas did not portray a "courtyard," as the 1876 title suggests, but rather the small garden that separated the house of his Musson relatives from the road. John Rewald thought that the picture depicted the plantation on the outskirts of New Orleans belonging to the Millaudons, family friends of the Mussons'.[2] However, James Byrnes, a former director of the Delgado Museum in New Orleans, recognized the house of Degas's uncle Michel Musson on the Esplanade and

in the background the house of their friends the Oliviers at 1221 (now 2306) North Tonti Street.[3] In a letter to Paul-André Lemoisne, René's daughter Odile De Gas Musson wrote that the house was situated in the French quarter and surrounded by a large garden. She described it as a three-story house with several reception areas; the rooms of the Mussons and of their daughter Désirée and the room used by Degas were on the ground floor, the rooms of Mathilde Musson Bell and of Estelle Musson De Gas (each with her respective family) were on the second, and on the third was a large attic where the children could play when it rained.[4] However, an anonymous watercolor of 1860 gives a perspective view that shows a two-story loggia supported by columns at the front of the house;[5] nothing of this appears in Degas's picture, where the entrance opens directly, after a few steps, not onto Odile De Gas's "large garden," but onto a little garden enclosed by a low railing, different from the railing in the perspective drawing.

The identification of the children presents as many problems. Odile De Gas Musson, in the letter to Lemoisne, identifies Carrie Bell (a daughter of Mathilde Musson Bell) as the child standing with a hoop in her hand and wearing a "sunbonnet, a shade that was worn at that time as protection from the sun" (Degas did a small oil study for this figure, L311); Joe Balfour (Estelle Musson De Gas's eldest daughter by her first marriage; see cat. no. 112) as the seated child in three-quarter profile wearing a white dress with a black belt; Odile De Gas herself as the blond child turned toward the painter; and Pierre De Gas, her older brother, first-born of Estelle and René De Gas, as the boy facing her. On the extreme left is the mammy in charge of these youngsters. The identifications are probably correct for Pierre and Odile, born in 1870 and 1871 respectively, but harder to accept for Joe Balfour, who was born in 1862 and therefore ten years old at the time, and yet appears in this painting (and even more so in Degas's preliminary sketch, L310) to be a little girl of four or five. Only the identity of the hunting dog in the background is certain: his name, "Vasco de Gama," was apparently given to him by Degas.[6]

Apart from *Portraits in an Office* and *Cotton Merchants in New Orleans* (cat. nos. 115, 116), this is the only typically New Orleans canvas painted by Degas, the only one where a little—a very little—of the Louisiana countryside appears; but his weary eyes were unable to stand the bright light there,[7] and so he placed himself in the entrance, sheltered from the sun, and showed nothing through the door except a few paltry elements of local color. The notations in his letters—

"villas with columns in different styles, painted white, in gardens of magnolias, orange trees, banana trees, Negroes in old clothes like the junk from La Belle Jardinière or from Marseilles, rosy white children in black arms"[8]—would lead us to suppose that there were more detailed studies and to expect a more exotic version of the faraway America than is shown here. But when we consider how little effort Degas made to acclimatize himself to Louisiana, how fitfully he worked on all the projects he had vowed to carry out, and how quickly he dropped them to dwell instead on his cherished Parisian themes, we must appreciate the unusualness of this work.

In what he himself listed as a "sketch" in the 1876 Impressionist exhibition (though we do not really know if it was an unfinished canvas or a detailed study for a larger work), Degas achieved one of his most surprising compositions. By a skillful organization of partitions and openings, he played with rigorous frontality (the Olivier house, which appears in the frame of the door) and oblique perspective (the angled wall, whose solid spaces and voids, like those in *Portraits in an Office*, give the whole scene its rhythm). The colors are once again muted, in a limited range of browns, whites, beiges, pinks, and pale greens, without the violent contrasts and radiance that, according to his letters, he liked so much in Louisiana. The *fa' presto* of the sketch emphasizes the constant shifting of the children, who could not (as Degas already knew from his first attempt to do a portrait of young Joe in Bourg-en-Bresse in January 1864) "sit still for five minutes."[9]

Children on a Doorstep recaptures an old ambition Degas had as a portraitist, already expressed in the late 1850s, namely, "to do a portrait of a family outdoors"—to which he added, "but one must be a painter, a fine painter."[10] In that respect, the Ordrupgaard canvas is unique, a delightful example of a childhood scene in which the restless group, for an instant well behaved, is packed into a corner of the picture and yet still draws our eyes—and the eyes of the painter, who is exasperated but moved.

1. Letter from Degas to Tissot, 19 November 1872, Bibliothèque Nationale, Paris; Degas Letters 1947, no. 3, p. 19 (translation revised).
2. Rewald 1946 GBA, pp. 118–19.
3. 1965 New Orleans, pp. 37–38.
4. Tulane University Library, New Orleans.
5. City of New Orleans Notarial Archives; published in Sutton 1986, p. 103, fig. 85.
6. Lemoisne [1946–49], I, p. 77.
7. Lettres Degas 1945, III, p. 26; Degas Letters 1947, no. 5, p. 25.
8. Letter from Degas to Tissot, 19 November 1872, Bibliothèque Nationale, Paris; Degas Letters 1947, no. 3, p. 18.

9. Unpublished letter from Désirée Musson, 5 January 1864, Tulane University Library, New Orleans.
10. Reff 1985, Notebook 13 (BN, Carnet 16, p. 50).

PROVENANCE: Atelier Degas (Vente I, 1918, no. 45 [as "Enfants assis sur le perron d'une maison de campagne"]); bought at that sale by Jos Hessel, for Fr 17,600. Wilhelm Hansen, Copenhagen; bequeathed by his widow in 1951 to the state toward the establishment of the Ordrupgaardsamlingen, which opened in 1953.

EXHIBITIONS: 1876 Paris, no. 40 (as "Cour d'une maison [Nouvelle-Orléans, esquisse]"); 1920, Copenhagen/Stockholm/Oslo, Foreningen for Fransk Kunst, 23 January–19 April, *Edgar Degas*, no. 5; 1948 Copenhagen, no. 124; 1981, Paris, Musée Marmottan, October–November, *Gauguin et les chefs-d'oeuvre de l'Ordrupgaard*, no. 10, repr.

SELECTED REFERENCES: K. Madsen, *Malrisamlingen Ordrupgaard, Wilhelm Hansens Samling*, Copenhagen, 1908, no. 72; Leo Swane, "Degas: billederne pa Ordrupgaard," *Kunstmuseets Aarskrift*, VI, Copenhagen, 1919, p. 67, repr.; Hoppe 1922, p. 27 (Wilhelm Hansen collection); Lemoisne [1946–49], II, no. 309; Rewald 1946 GBA, pp. 118–19, fig. 16; 1965 New Orleans, pp. 37–38, fig. 7 (detail); H. Rostrup, *Catalogue of the Works of Art in the Ordrupgaard Collection*, Copenhagen, 1966, p. 11, no. 32; Minervino 1974, no. 346, pl. XIX (color); A. Stabell, *Katalog over Ordrupgaardsamlingen*, Copenhagen, 1982, no. 31.

112.

Woman with a Vase of Flowers

1872
Oil on canvas
25⅝ × 13⅜ in. (65 × 34 cm)
Signed and dated lower left: Degas/1872
Musée d'Orsay, Paris (RF1983)

Lemoisne 305

The few doubts expressed by Lemoisne in 1912 about whether this work had been painted in New Orleans were soon resolved, and it is generally accepted today that *Woman with a Vase of Flowers*, which bears the date 1872, was painted there by Degas soon after his arrival at the end of October of that year. An X-radiograph shows that shortly afterward, Degas made minor changes to the canvas, elaborating the bouquet, erasing what was perhaps an ornament in the chignon of the young woman's hair, and reinscribing the date and signature.

The sitter's identity, on the other hand, has been the subject of more disagreement. At an early stage, she was identified as Estelle Musson, the nearly blind wife (and first cousin) of René De Gas, the artist's brother;[1] John Rewald, in a long article providing important details on the American

family, suggested Mme Challaire, a friend of Estelle's.[2] There is, however, no supporting evidence for Rewald's claim in any published photographs, and, in view of Degas's "boredom" with portrait painting (which is how he had characterized the subject ever since his stay in Italy), it is hard to understand why he would have persisted—for this same sitter appears in *Young Woman Arranging a Bouquet* (L306, Isaac Delgado Museum, New Orleans)—in painting someone who was not a member of his family and whom he had never met before his arrival in America. There is also the testimony of Lemoisne (more reliable than that of Gaston Musson, son of René and Estelle, who identified Mme Challaire) to the effect that René himself recognized the sitter here as his first wife.[3]

This identification can, nevertheless, be challenged. It is difficult to see the same person in this woman with a vase and in the woman in a white muslin dress sitting on a sofa (L313, Chester Dale Collection, National Gallery of Art, Washington, D.C.) whom Boggs, Rewald, and Byrnes, setting aside Lemoisne's uncertainties (he calls her Mrs. William Bell), have correctly identified as Mme René De Gas, née Estelle Musson. Estelle's soft gaze, darkened with blindness, is unlike the sterner, more willful look of the woman in this painting; the latter's features are angular and determined, without that slightly flaccid softness characteristic of the young blind woman. One last point: Degas dated *Woman with a Vase of Flowers* 1872, at which time Estelle was pregnant with her fourth child, Jeanne, born 20 December 1872, to whom the painter was godfather. However, the young woman in this picture does not appear to be pregnant. We are therefore obliged to search elsewhere—though in the family itself, since Degas mentions only portraits of close relations. It is very possible that the sitter here is the same as the one who was to pose for *The Invalid* (cat. no. 114), and who has been clearly identified as Estelle's older sister Désirée Musson (1838–1902). If we compare the present painting with the fine drawing that Degas did of Estelle during his stay in Bourg-en-Bresse in January 1865 (fig. 22), where she appears together with her sister and mother, we find the same features, the rather heavy jaw and long nose—though here she is thinner and inevitably older. Degas was then thinking of marriage and family: "I am thirsting for order. I do not even regard a good woman as the enemy of this new method of existence," he wrote to Henri Rouart.[4] So perhaps he was not indifferent to the fate of this woman who was already an "old maid"— she was thirty-four years old—and it may have crossed his mind to follow in his brother's footsteps and marry a cousin.

From the time of his arrival in New Orleans, Degas began painting more "by popular demand" than from his own inclination. Nothing, of course, would have been more natural than that the large American family should have wanted to see what the cousin from Paris could do. And so, on 11 November 1872, two weeks after his arrival, he wrote to Désiré Dihau: "All day long I am among these dear folk, painting and drawing, making portraits of the family."[5] In a letter to Frölich on 27 November, he was already exasperated: "True, I am working little, but what I am doing is difficult. Family portraits must be done to suit the taste of the family, in impossible lighting, with many interruptions, and with models who are very affectionate but a little too bold—they take you much less seriously because you are their nephew or cousin."[6] And when he wrote to his close friend Rouart on 5 December, already preparing for the trip back, he was totally disenchanted: "A few family portraits will be the sum total of my efforts."[7]

As we look at this *Woman with a Vase of Flowers*, it is hard to believe that it could have been a chore: as early as 1912, Lemoisne, who saw it as "one of the artist's finest portraits," praised "the powerful, detailed character of the head, lit somewhat harshly by the light from a window, creating strong shadows on one whole side of the face, whose calm and pensive expression is curiously opposed to the rather rough manner of its treatment."[8]

As in *Woman Leaning near a Vase of Flowers* (cat. no. 60), Degas gives importance to an accessory—the exotic flower surrounded by wide drooping leaves in a multicolored vase— pushing his sitter farther back and partly concealing her with the back of a chair. Yet, as in the other picture too, such artifice serves only to better accentuate the face, with its faraway gaze—though here the face is partially in shadow, and hasn't that slightly sardonic expression. The brushwork is at once full and precise, the technique smooth, and the coloring sober yet brightened by an intense sidelong light that brings out the emerald of the leaves, the greens of the two walls, and the shadow that is cast. The light resonates quietly against the gold of the jewels set on the table and caresses the crumpled gloves and the soft golden beige dress of the young woman. The sitter adopts the pose that the painter has given her (perhaps she was somewhat taken aback by it, since it was so little in keeping with the concepts of painting and portraiture in America) and turns into the light that somewhat unprepossessing face, a face whose "saving touch of ugliness" her cousin from Paris doubtless appreciated.[9]

1. 1924 Paris, no. 39.
2. Rewald 1946 GBA, pp. 115–16.
3. Reported in Boggs 1962, p. 93 n. 82.
4. Lettres Degas 1945, III, p. 27; Degas Letters 1947, no. 5, p. 26.
5. Lettres Degas 1945, I, p. 19; Degas Letters 1947, no. 2, p. 15.
6. Lettres Degas 1945, II, p. 23; Degas Letters 1947, no. 4, p. 22 (translation revised).
7. Lettres Degas 1945, III, p. 26; Degas Letters 1947, no. 5, p. 25.
8. Lemoisne 1912, p. 46.
9. Lettres Degas 1945, III, p. 28; Degas Letters 1947, no. 5, p. 27 (translation revised).

PROVENANCE: Michel Manzi, Paris; bought by Comte Isaac de Camondo, 18 June 1894, for Fr 16,000 (as "La femme aux fleurs"); his bequest to the Louvre 1911; exhibited 1914.

EXHIBITIONS: 1924 Paris, no. 39; 1931 Paris, Orangerie, no. 55; 1954, London, Tate Gallery, 24 April–7 June, *Manet and His Circle*, no. 54, repr.; 1969 Paris, no. 21, pl. 3; 1976–77, Paris, Grand Palais, 17 September 1976–3 January 1977, *L'Amérique vue par l'Europe*, no. 342, repr.

SELECTED REFERENCES: Lemoisne 1912, pp. 45–46, pl. XV; Paris, Louvre, Camondo, 1914, no. 159; Rewald 1946 GBA, pp. 115–16, fig. 17; Lemoisne [1946–49], II, no. 305; Boggs 1962, pp. 41, 126, pl. 76; 1965 New Orleans, pp. 24, 37, figs. 4, 17; Minervino 1974, no. 341, pl. XVIII (color); Paris, Louvre and Orsay, Peintures, 1986, III, p. 194, repr.

113.

Woman with a Bandage

1872–73
Oil on canvas
12⅝ × 9½ in. (32 × 24 cm)
Signed lower left: Degas
The Detroit Institute of Arts. Bequest of Robert H. Tannahill (70.168)

Lemoisne 275

This small canvas appeared under the title "At the Oculist's" in an anonymous sale at the Hôtel Drouot on 10 June 1891. It may have belonged to the unfortunate Dupuis, a knowledgeable collector who bought several major works by Monet, Gauguin, Pissarro, and Degas from Theo van Gogh between 1887 and 1890 and committed suicide in December 1890 because of financial problems.[1] Most of the paintings he owned were bought by the dealer Salvador Meyer; a few ended up in the rather mixed sale of June 1891, which included works from various sources. There are no clues today allowing us to trace the history of *Woman with a Bandage* before 1891. In 1898, when the canvas (then part of the Laurent collection) was once again sold at auction, it had the same title it bears today, "La femme au bandeau." The sale catalogue, though it does not include a reproduction, describes the painting as a

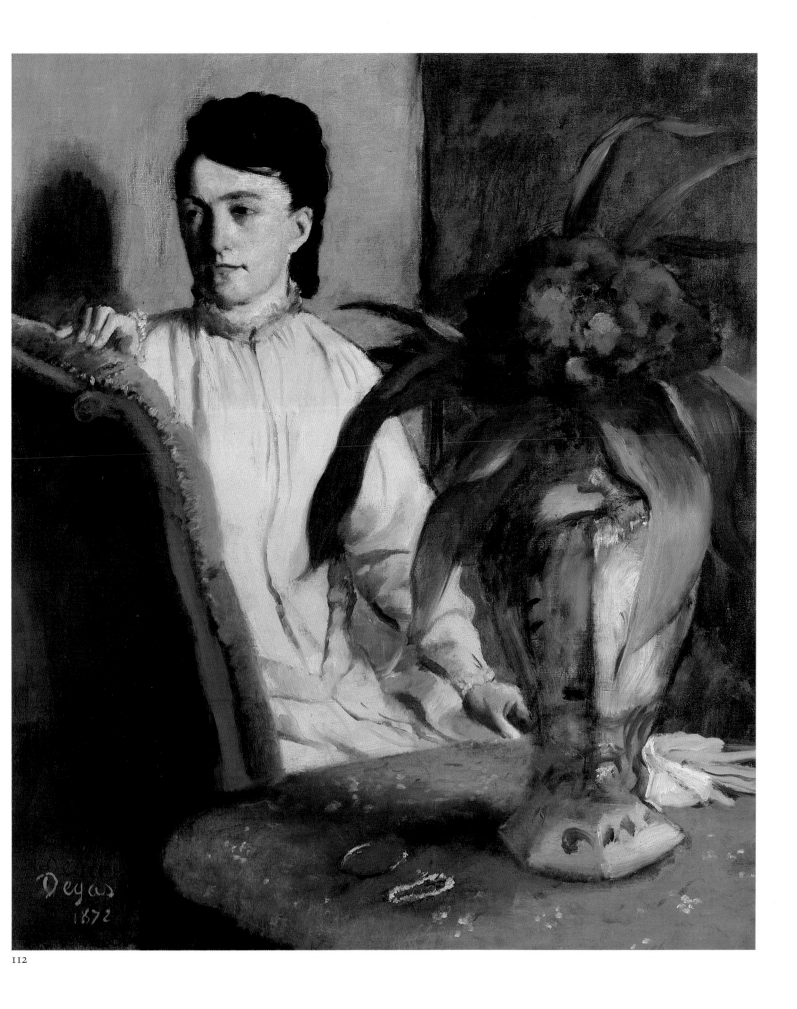

112

"delightful *morceau de peinture* by the master," saying that it depicts not a "Cléo" (referring jokingly to the famous bandages of Cléo de Mérode), but rather a "woman of the people wearing a grayish blouse."[2]

The woman remains unidentified, but the intimacy of the tiny portrait indicates that she was in all likelihood a close relative. It is tempting to see in her Estelle Musson, the wife of the artist's brother René De Gas. Estelle began losing her sight in 1866; in 1868, she became blind in her left eye, but retained some vision in her right eye until 1875.[3] This identification is all the more plausible in that the date 1872–73 (when Degas visited New Orleans) seems more likely than 1870–72, suggested by Lemoisne.

Arms crossed, seated in an unspecified setting (though surely it is a home, because the only objects shown are a cup and the glass that abuts curiously against her profile), the woman looks at some unknown object to the right. Degas uses a light, soft range of colors, in which whites and grays predominate. He observes his subject with amusement and tenderness—playing with the thick bandage that together with the bonnet forms such an odd assemblage—and is obviously moved by the affliction from which he too would suffer throughout his life.

1. Rewald 1973 GBA; Rewald 1986, "Theo van Gogh as Art Dealer."
2. *Vente Collection de M. X. . .* [Laurent], Paris: Drouot, 8 December 1898, no. 3.
3. Unpublished letter from her daughter Odile De Gas Musson to Paul-André Lemoisne, Tulane University Library, New Orleans.

PROVENANCE: (?) Dupuis collection; sale, Drouot, Paris, 10 June 1891, no. 16 (as "Chez l'oculiste"); bought at that sale by Hubert du Puy, Louviers, for Fr 250. Laurent collection, Paris (M. X . . . [Laurent] sale, Paris, 8 December 1898, no. 3 [as "La femme au bandeau"]); bought at that sale by Durand-Ruel, Paris, for Fr 2,010 (stock no. 4873); bought by Raymond Koechlin, Paris, 4 May 1899, for Fr 4,000. Denys Cochin, Paris (sale, March 1919, no. 9, repr.); Mme Jacques Cochin, Paris; Robert H. Tannahill, Detroit, 1949; his bequest to the museum 1970.

EXHIBITIONS: 1924 Paris, no. 55; 1936 Philadelphia, no. 17, repr.; 1974–75, Detroit Institute of Arts, 6 November 1974–5 January 1975, *Works by Degas in the Detroit Institute of Arts*, no. 7, repr.

SELECTED REFERENCES: Lemoisne [1946–49], II, no. 275; Minervino 1974, no. 274; Theodore Reff, "Works by Degas in the Detroit Institute of Arts," *Bulletin of the Detroit Institute of Arts*, LIII:1, 1974, pl. 7, pp. 31–32.

114.

The Invalid

1872–73
Oil on canvas
25⅝ × 18½ in. (65 × 47 cm)
Signed upper right: Degas
Private collection, New York

Exhibited in New York

Lemoisne 316

Traditionally viewed as a portrait of Degas's cousin Désirée Musson painted in New Orleans in 1872 or 1873, this picture was given the title "The Invalid" when Degas sold it to Durand-Ruel on 31 January 1887. The catalogue for the 1924 Degas exhibition at Galerie Georges Petit gives this curt but accurate description of a scene, which at first glance is difficult to make out: "Seated at the foot of her bed, which forms, on the left, a light background, wearing a nightgown and a dark dressing gown; on her head a scarf, one end falling across her chest."[1]

It is, in many respects, the most unexpected of the New Orleans portraits. It is not a portrait in an interior, like *Woman with a Vase of Flowers* (cat. no. 112), *The Nurse* (L314, private collection, Federal Republic of Germany), or *Mme René De Gas* (L313, Chester Dale Collection, National Gallery of Art, Washington, D.C.); rather, it is the description, on an imposing scale, of a solid and monumental figure against an indistinguishable background. We find neither the smooth, precise execution nor the scope of *Portraits in an Office* (cat. no. 115), but rather broad, rapid strokes in a reduced harmony of "superb whites"[2] and browns discreetly highlighted by a few touches of pink. Everything here speaks of illness: the languorous body draped in nightgown and negligé, the drooping of the heavy head on the bent arm, the pale and blotchy flesh tones, and the massive presence of Désirée Musson in a canvas that she occupies almost entirely, conveying the stifling sense of a sickroom.

1. 1924 Paris, no. 38.
2. Lemoisne [1946–49], II, no. 316, p. 160.

113

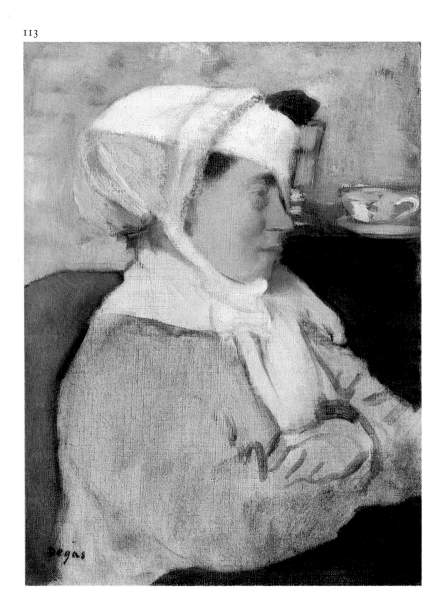

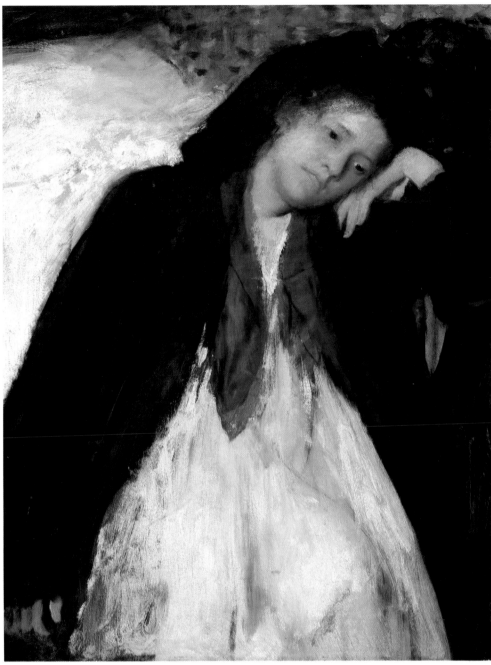

114

PROVENANCE: Bought from the artist by Durand-Ruel, Paris (as "La malade" in stock book, "Convalescente" in journal), 31 January 1887, for Fr 800 (stock no. 919); bought by Henry Lerolle, Paris, 15 February 1888, for Fr 2,000; Mme Henry Lerolle, Paris; Captain Edward Molyneux, Paris; M. Knoedler and Co., New York; bought by the present owner 2 January 1958.

EXHIBITIONS: 1924 Paris, no. 38; 1931 Paris, Orangerie, no. 54; 1936, London, New Burlington Galleries, 1–31 October, *Exhibition of Masters of French 19th Century Painting*, no. 61; 1965 New Orleans, pl. VIII; 1978 New York, no. 9, repr. (color).

SELECTED REFERENCES: Lemoisne [1946–49], II, no. 316; Boggs 1962, p. 126; Minervino 1974, no. 353.

115.

Portraits in an Office (New Orleans)

1873
Oil on canvas
28¾ × 36¼ in. (73 × 92 cm)
Signed and dated lower right: Degas/Nlle
 Orléans/1873
Musée des Beaux-Arts, Pau (878.1.2)

Lemoisne 320

Portraits in an Office, more commonly—and unfortunately—known as "The Cotton Market at New Orleans," was the first picture by Degas to enter a public collection. The circumstances are well known: the

work was exhibited in 1878 at the Société Béarnaise des Amis des Arts, at Pau, where it was priced at Fr 5,000. Thanks to the initiative of Alphonse Cherfils, a friend of Degas's who was originally from Pau, it was acquired for the Pau museum by its curator, Charles Lecoeur (and not by Paul Lafond, as is sometimes said).[1] Degas, who had been trying to sell the canvas for several years (as we know from his letters to Charles Deschamps, the agent for Durand-Ruel[2]), was in the end satisfied with the modest price of Fr 2,000 and even happier that it had been purchased by a museum. In an unpublished letter to Lecoeur on 31 March 1878, he could not hide his pleasure: "I must offer my warmest thanks for the honor you have done me. I must also admit that it is the first time that a museum has so honored me and that this *official* recognition comes as a surprise and is terribly flattering." After announcing he would visit the following summer, he continued: "I do not know if the picture has been varnished. If not, I recommend myself to you for the task." He ended by announcing: "I have just written to the mayor, M. de Montpezat, [thanking him] for the money order he is sending me."[3]

Two years before it was acquired by the museum, the canvas was hung at the second Impressionist exhibition, where it received a lukewarm reception. The only unqualified praise came from Armand Silvestre: "an exceedingly witty painting that one could spend days contemplating."[4] Some critics, while regretting that Degas "felt he had to make concessions elsewhere to the school of patches of color,"[5] praised the "wonderful realism"[6] of a picture that would "not disappoint those who like painting that is accurate and frankly modern, who think that the expression of ordinary life and fineness of execution should count for something."[7] The majority opinion was that *Portraits in an Office* was a departure not only from the other works exhibited, but also from the rest of Degas's work. Amazement was expressed at the presence of this picture "in such company"—it was "the most reasonable of all," and revealed, in spite of itself, the undeniable gift of a "defrocked draftsman."[8]

However, Albert Wolff, in an infamous diatribe in *Le Figaro* (3 April 1876), said exactly the opposite: "You can try to reason with M. Degas; you can try to persuade him that in art there are such things as drawing, color, execution, and will power, but he will laugh in your face and call you a reactionary." Curiously—and uncharacteristically—Zola assumed the role of the implacable foe of the Impressionists. He wrote of Degas: "This painter is very taken with modernity, life indoors, and everyday life. What is annoying, though, is the way he

spoils everything as soon as he adds the final touches. His best pictures are sketches. In finishing a work, his drawing turns into something blurred and lamentable; he paints pictures like *Portraits in an Office (New Orleans)*, halfway between a seascape and a plate from an illustrated journal. His artistic insights are excellent, but I am afraid that his brush will never be creative."[9] Perhaps he was annoyed, without admitting it, by the very thing that pleased Louis Enault: "It lacks warmth; it is bourgeois; but it is seen in a way that is accurate and correct, and furthermore it is properly drawn."[10] (One can imagine what Degas would have made of "compliments" such as these.)

In one form or another, these comments on what is today, quite justly, one of Degas's most famous paintings, have continued—whether applauding "a masterpiece of fine observation and classic handling,"[11] or detecting "a triviality, to be blunt about it, a snapshot,"[12] or praising "that superior and conscious naïveté which leads straight to true mimicry,"[13] or denouncing "the boredom" and "arbitrariness" of this "sad chore."[14]

A letter from Degas to Tissot of 18 February 1873 explains why Degas, after having been in New Orleans for three months, undertook this picture:

After having wasted time in the family trying to do portraits in the worst conditions of day that I have ever found or imagined, I have attached myself to a fairly vigorous picture which is destined for Agnew and which he should place in Manchester: for if a spinner ever wished to find his painter, he really ought to hit on me. *Intérieur d'un bureau d'acheteurs de coton à la Nlle Orléans, Cotton buyers office.*

In it there are about fifteen individuals more or less occupied with a table covered with the precious material, and two men, one half leaning and the other half sitting on it, the buyer and the broker, are discussing a pattern. A raw picture if there ever was one, and I think from a better hand than many another. (Canvas about 40 it seems to me.)[15]

After announcing to Tissot that he was preparing a second version of the same subject (cat. no. 116), he continued:

If Agnew takes both from me all the better. I do not, however, wish to give up the Paris plan. . . . In the fortnight that I intend spending here, I shall finish the said picture. But it will not be possible for it to leave with me. A canvas scarcely dry, shut up for a long time, away from light and air, you know very well that that would change it to chrome yellow no. 3.

So I shall not be able to bring it to Lon-don myself or to have it sent there before about April. Retain the good will of these gentlemen for me until then. In Manchester there is a wealthy spinner, de Cotterel, who has a famous picture gallery. A fellow like that would suit me and would suit Agnew even better. But let's be cautious how we talk about it and not count our chickens too soon.[16]

Degas did in fact leave New Orleans two weeks later, since he was back in Paris in late March, and the recently finished canvas had to undergo the vicissitudes of transport about which he had worried. However, there is no evidence that the planned negotiations with Agnew ever took place, and the work had a very different fate from the one originally envisaged for it.

Degas evidently had extended his stay in New Orleans specifically to complete this picture—in a letter to Henri Rouart dated 5 December 1872, he had announced that he was returning to Paris in January. We do not know how the idea for this ambitious composition came to him. There are few sketches, although the catalogue for the Georges Viau sale (Drouot, Paris, 24 February 1943) lists under no. 9 a pencil drawing, "Study for the 'New Orleans Cotton Buyers' Office.'" However, there are several references in Degas's correspondence to the omnipresence of cotton in New Orleans, and this obviously captured his imagination: "One does nothing here, it lies in the climate, nothing but cotton, one lives for cotton and from cotton."[17]

The individuals portrayed have been identified by John Rewald in an indispensable article on the Louisiana branch of the family. In the foreground, feeling a sample, is Michel Musson, Degas's maternal uncle; behind him, his two sons-in-law, René, the painter's brother, reading the local *Daily Times-Picayune*, and (in profile) William Bell, seated on the edge of the table; to the left, standing with his legs crossed and leaning against a counter, Achille De Gas, the painter's other brother; to the right, his nose in a thick register, the cashier, John Livaudais; and perched on a stool behind René and wearing a beige coat, James Prestidge, Michel Musson's partner.[18]

Degas here returns, though in a different mode, to a formula he had first used three years earlier in his *Orchestra of the Opéra* (cat. no. 97), that of the group portrait—here with Michel Musson and there with Désiré Dihau in the foreground—casting each of the other figures in a "typical" or "familiar" attitude.[19] However, as he himself remarked: "It is not good to do Parisian art and Louisiana art indiscriminately; it is liable to turn it into *Le Monde Illustré*."[20] He thus endeavored, without giving way to facile exoticism,

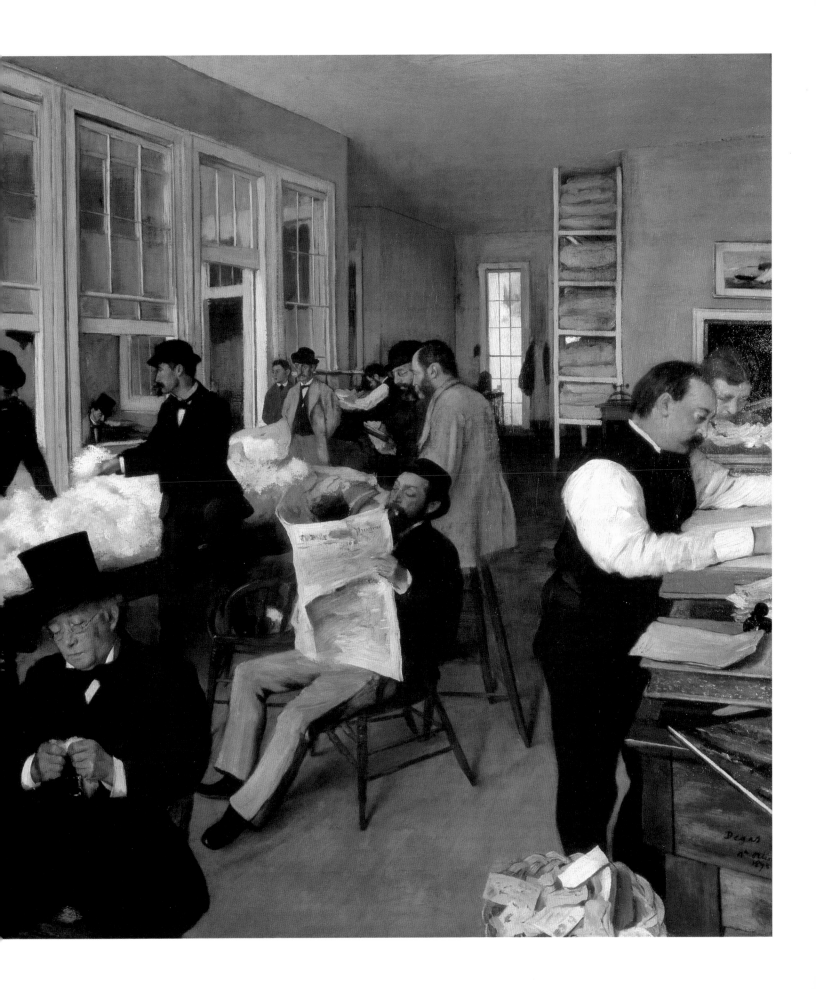

to produce an "American" work, to translate the intense activity of "this crowd of cotton brokers and cotton dealers"[21] within a framework typical of New World business establishments, that of Michel Musson's offices at 63 Carondolet.[22]

In this prosperous and tranquil vision of America, what dominates is the intense contrast between the black of the suits and the white of the shirts, the papers, and especially the cotton, all against the soft background of the pale green walls, the ceiling, and the pinkish woodwork. The floor is of a more intense shade, and the few lively touches of the admirable still life on the right (papers in the basket, letters and registers on the table) break up the predominance of blacks and whites in the central section. The composition has nothing of the arbitrary, snapshot quality denounced by some—"The snapshot is photography and nothing more," Degas had said shortly before.[23] The artist has given the picture something close to a bird's-eye view (the floor has the steep slope of a stage), and by means of an oblique perspective has managed to expand the rather cramped quarters to include fourteen people at various activities without overly crowding them. Degas thus produced an effectively clean and clear image of the family business, bustling but orderly, reinforced by the smooth and glossy paint surface and the precise touch with its Dutch flavor. Along for the visit to their uncle's office, Achille and René, completely inactive amid their hardworking American friends, add a hint of Parisian nonchalance and dandyism.

1. The telegram from Degas to Lecoeur, Paris to Pau, 19 March 1878 (Musée des Beaux-Arts, Pau), reads: "I accept offer. Ask Cherfils to send news of himself. Many thanks."
2. Letters of 1 and 16 June 1876, Durand-Ruel archives, Paris.
3. Musée des Beaux-Arts, Pau. The letter to the mayor is preserved in the Archives Départementales of Pau, on paper with the letterhead "Clermont et Cie" (the furriery of his friend Hermann de Clermont), along with the money order endorsed by Degas. The letter ends by thanking the mayor for "his kind involvement in this matter."
4. Armand Silvestre, L'Opinion, 2 April 1876.
5. Marius Chaumelin, La Gazette, 8 April 1876.
6. Le National, 7 April 1876.
7. Chaumelin, op. cit.
8. Arthur Baignères, L'Écho Universel, 13 April 1876.
9. Le Messager de l'Europe, June 1876.
10. Le Constitutionnel, 10 April 1876.
11. Jamot 1918.
12. Huyghe 1974, p. 86.
13. Léonce Bénédite, Histoire des beaux-arts, 1800–1900, Paris, 1900, p. 276.
14. Cabanne 1957, p. 34.
15. Letter from Degas to Tissot, New Orleans to London, 18 February 1873, Bibliothèque Nationale, Paris; Degas Letters 1947, no. 6, p. 29.
16. Ibid.
17. Lettres Degas 1945, III, p. 26; Degas Letters 1947, no. 5, pp. 24–25.
18. Rewald 1946 GBA, no. 2, pp. 116–18.
19. Reff 1985, Notebook 23 (BN, Carnet 21, p. 46).
20. Letter from Degas to Frölich, 27 November 1872, Lettres Degas 1945, II, p. 23; Degas Letters 1947, no. 4, p. 22.
21. Letter from Degas to Tissot, 19 November 1872, Bibliothèque Nationale, Paris; Degas Letters 1947, no. 3, p. 18.
22. Guérin incorrectly suggests that the office depicted is that of De Gas Brothers, which was at 3½ Carondolet (Lettres Degas 1945, I, p. 18 n. 1; Degas Letters 1947, no. 2, p. 15 n. 2).
23. Lettres Degas 1945, II, p. 23; Degas Letters 1947, no. 4, p. 22 (translation revised).

PROVENANCE: Bought from the artist in 1878 (priced at Fr 5,000), on the occasion of the exhibition organized by the Société Béarnaise des Amis des Arts at Pau, by the Musée des Beaux-Arts, Pau, thanks to the Noulibos bequest, for Fr 2,000.

EXHIBITIONS: 1876 Paris, no. 36 (as "Portraits dans un bureau [Nouvelle Orléans]"); 1878, Pau, Société Béarnaise des Amis des Arts, 15 January, no. 87; 1900, Paris, Centennale de l'art français, no. 209, repr.; 1924 Paris, no. 43, repr. facing p. 34; 1932 London, no. 343 (400); 1936 Philadelphia, no. 20, repr.; 1937 Paris, Orangerie, no. 18; 1937 Paris, Palais National, no. 302; 1939–40 Buenos Aires, no. 10; 1941, Los Angeles County Museum, June–July, The Painting of France since the French Revolution, no. 36; 1947–48, Brussels, Palais des Beaux-Arts, November 1947–January 1948, De David à Cézanne, no. 124, repr.; 1951–52 Bern, no. 20, repr.; 1964–65 Munich, no. 80, repr.; 1974–75 Paris, no. 16, repr. (color); 1984–85 Paris, no. 2 p. 104, fig. 30 (color) p. 31; 1986 Washington, D.C., no. 22, repr. (color) and cover.

SELECTED REFERENCES: Alexandre Pothey, "Chroniques," La Presse, 31 March 1876; [Philippe Burty], La République Française, 1 April 1876; A. de L. [Alfred de Lostalot], "L'exposition de la rue Le Peletier," La Chronique des Arts et de la Curiosité, 1 April 1876, pp. 119–20; Armand Silvestre, "Exposition de la rue Le Peletier," L'Opinion Nationale, 2 April 1876; Charles Bigot, "Causerie artistique: l'exposition des intransigeants," La Revue Politique et Littéraire, 8 April 1876, p. 351; Marius Chaumelin, La Gazette des Étrangers, 8 April 1876; Louis Enault, "L'exposition des intransigeants dans la Galerie de Durand-Ruelle," Le Constitutionnel, 10 April 1876; G. d'Olby, "Salon de 1876," Le Pays, 10 April 1876; Arthur Baignères, "Exposition de peinture par un groupe d'artistes, rue Le Peletier," L'Écho Universel, 13 April 1876; Philippe Burty, The Academy, London, 15 April 1876; Pierre Dax, "Chronique," L'Artiste, 1 May 1876; Émile Zola, "Deux expositions d'art en mai," Le Messager de l'Europe, Saint Petersburg, June 1876 (reprinted in Le bon combat: de Courbet aux impressionnistes, Paris, 1974); Charles Le Coeur, Musée de la ville de Pau, notice et catalogue, Paris, 1891, no. 41; Léonce Bénédite, Histoire des beaux-arts 1800–1900, Paris, 1900, pp. 276–77; Lemoisne 1912, pp. 49–50, repr.; Jamot 1918, pp. 124, 127, 132–33, repr.; Lemoisne [1946–49], II, no. 320; Rewald 1946 GBA, no. 2, pp. 116–18; Degas Letters 1947, nos. 29–30; Albert Krebs, "Degas à la Nouvelle-Orléans," Rapports France–États-Unis, 64, July 1952, pp. 63–72; Cabanne 1957, pp. 33, 110, pl. 47; Raimondi 1958, pp. 262–65, pl. 21; Boggs 1962, pp. 38–40, 93 n. 76, pl. 80; 1965 New Orleans, pp. 22, 88–89, fig. 12 p. 24; Rewald 1973, pp. 372, 396 n. 40; Huyghe 1974, pp. 85–86, pl. VII (color); Minervino 1974, no. 356, plates XXVIII, XXIX (color); Ph. Comte, Ville de Pau, Beaux-Arts: catalogue raisonné des peintures, Pau, 1978, n.p.

116.

Cotton Merchants in New Orleans

1873
Oil on canvas
23⅝ × 28¾ in. (60 × 73 cm)
Vente stamp lower right
Harvard University Art Museums (Fogg Art Museum), Cambridge, Massachusetts. Gift of Herbert N. Straus

Exhibited in New York

Lemoisne 321

Considered by some to be a sketch for the Pau canvas (cat. no. 115), *Cotton Merchants in New Orleans*—to give it the title under which it was sold at the first atelier sale—must be the unfinished picture Degas mentioned in his letter to Tissot of 18 February 1873, in which he announced that he had settled down to *Portraits in an Office.* Degas wrote: "I am preparing another [painting,] less complicated and more spontaneous, better art, where the people are all in summer dress, white walls, a sea of cotton on the tables."[1] Degas's words would suggest that this painting was the "artistic" version of the same subject, the other being more commercial, more easily understood, and, turning Degas's own words around, "more complicated" and "less spontaneous," since it was intended for sale (to Agnew, the English dealer). As the Fogg canvas was never completed, it is impossible to make a significant comparison with the Pau canvas. However, we can see that in subject matter and intention they are different. On the somewhat smaller canvas, Degas shows only three people, all busy with the cotton samples spread out on the table; these samples become the main element of the picture, evoking the omnipresence of cotton in New Orleans. Although the setting (the office of Michel Musson) is the same, there is very little that would enable us to identify the room, except the seascape on the wall. The very disposition of the space, seen from above, cramped and somewhat flattened, is difficult to understand. One wall abuts directly into the right corner of the display table, cutting a merchant in half. The back wall, opening onto a glimpse of blue sky, compresses the central figure (wearing a boater), who emerges in silhouette, flattened between the white background and the table. The angle of the table is the only element that gives any depth to the scene. Theodore Reff quite correctly identified a strong Japanese influence in this work, particularly from Ukiyo-e prints,[2] though Degas certainly did not have any such prints in front of him when he painted this canvas in America. Its originality comes primarily

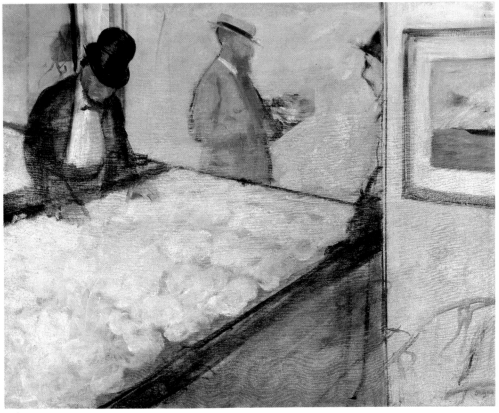

116

from the desire, clearly stated in his letters, to create "Louisiana art" in the paintings he did there, and not a banal Parisian variation on an exotic theme. The syncopated composition gives this work its special rhythm— it is lively, light, and modern (Matisse comes to mind). Degas plays with the dazzling whiteness of the cotton, which he tempers with the brown of the woodwork and of the men's suits; only the seascape—with its blue sky, green sea, and gold frame—adds a touch of color to this painting in which white and brown predominate. The artist, who complained that he was unable to paint anything on the river because of his weak eyes and the harsh glare of the sun, here re-creates, in a billowing sea of cotton, the intense light of Louisiana.

1. Bibliothèque Nationale, Paris; Degas Letters 1947, no. 6, pp. 29–30.
2. Theodore Reff, "Degas, Lautrec and Japanese Art," *Japonisme in Art*, Tokyo, 1980, p. 196.

PROVENANCE: Atelier Degas (Vente I, 1918, no. 3); bought at that sale by Rosenberg, for Fr 17,500. Herbert N. Straus, New York; his gift to the museum.

EXHIBITIONS: 1929 Cambridge, Mass., no. 31, pl. XXI; 1947 Cleveland, no. 18, pl. XVI; 1949 New York, no. 26, repr.; 1953–54 New Orleans, no. 74, repr. (color, detail); 1965 New Orleans, pp. 88–89, pl. XXIV p. 84, fig. 14 p. 25.

SELECTED REFERENCES: Rewald 1946 GBA, pp. 116, 119, fig. 14; Lemoisne [1946–49], II, no. 321; Degas Letters 1947, no. 6, pp. 29–30; Minervino 1974, no. 358.

117.

The Song Rehearsal

1872–73
Oil on canvas
31⅞ × 25⅝ in. (81 × 65 cm)
Dumbarton Oaks Research Library and Collection, Washington, D.C. (H18.2)

Lemoisne 331

Dated c. 1873 by Lemoisne—Jamot, years earlier, had dated it 1865—this painting has been convincingly linked to Degas's stay in Louisiana by James Byrnes, who saw it as possibly depicting Estelle and Mathilde (or Désirée) Musson and René De Gas.[1] The handling (with its smooth and fluid paint), the composition (a perspective view, from a slightly raised angle, of the corner of the room, showing a long diagonal wall and steeply sloping floor), and the light palette (white, pale yellow, salmon) all clearly link the painting to *Portraits in an Office* (cat. no. 115). Byrnes also mentions three additional clues: the tropical plant at the left, whose thick, wide leaves are reminiscent of those in *Woman with a Vase of Flowers* (cat. no. 112); the dress of the singer at the right, described in the 1924 Paris exhibition as "a 'matinée' of yellow muslin with black polka dots, trimmed with white flounces,"[2] like the dresses worn by Estelle De Gas in the Washington portrait (L313, Chester Dale

Collection, National Gallery of Art) and by Mathilde Bell in the Ordrupgaard pastel (L318); and the piano, which could be the one René De Gas mentions in a letter to Estelle from Paris on 26 June 1872 telling her he is thinking of replacing the large Chickering with a small Pleyel[3] (although this is hardly proof, since virtually all bourgeois families had a grand piano at the time).

Placing this scene in New Orleans would mean ruling out the possibility that the young woman holding the score is Marguerite De Gas Fevre, the painter's younger sister, an accomplished musician endowed with a "superb voice," according to both Jeanne Fevre, her daughter, and more notably Louise Bréguet-Halévy, in her unpublished memoirs.[4] The 1931 Paris catalogue went so far as to present the intriguing hypothesis that *The Song Rehearsal* is a double portrait of Marguerite, revealing "as do other experiments by the painter depicting several images of the same person in a single picture or sketch, seen from different viewpoints, the artist's wish to capture his subject completely, to convey the fullness of her form, a tendency that was to lead him to sculpture."[5]

However, the two fine preparatory drawings on large sheets of paper (cat. nos. 118, 119), which describe each singer, indicate that two different women posed for the painter. Both drawings are accompanied by small sketches showing (for the woman on the right) two very quick, barely legible views of the room and (for the woman on the left) a perspective view indicating that at first Degas placed the visible corner of the room at the right. Although the two women cannot be identified, it should be noted that the face of the singer on the left (whom Degas envisioned at one point as also holding a score) is not the same in the drawing, where it is long and thin, as in the canvas, where it is rounder and younger, quite like the face of the musician in the Detroit painting (cat. no. 110). Degas probably brought these two drawings back from New Orleans and painted—or finished painting—the picture in Paris, using another model. This would also account for the quick sketch of the piano and the chair on the right in a notebook that Degas did not use in Louisiana.[6]

The Song Rehearsal was not a new subject for Degas. Accustomed since childhood to musical evenings—in his own home, and somewhat later at the Bréguets—in which singing played an important role, he could not avoid being affected by this theme, which was one of the favorite subjects of painters of bourgeois family life throughout the century. As early as his stay in Italy, he had planned to paint a musical evening.[7] Somewhat later (although before 1871, since Auber died in that year), he drew a scene in

India ink strangely resembling *The Song Rehearsal* on a score of Auber's *Fra Diavolo*. The drawing, whose present location we do not know, was described as a "most curious piece" in the catalogue of the sale of autographs in which it appeared in 1954.[8] According to the catalogue, "these sketches seem to have been done by Degas as he listened to a performance of *Fra Diavolo* in a drawing room. They depict a woman singing, and next to her, a second woman, listening. Beside the two, there is a rough sketch, probably of Auber at the piano. Above these sketches, Degas wrote the following dedication: 'Enough of Pierre/come and see Auber. I hope to see you soon. Your friend, Degas.'"

For most of Degas's contemporaries, this subject was an opportunity to paint a rapturous singer in the confined and generally nocturnal atmosphere of a bourgeois drawing room, such as the singer in Stevens's *Song of Passion*, now at the Musée du Second Empire, Château de Compiègne. Degas, however, paints a daytime scene that is both intimate and theatrical, in the clear light of a southern house. The two singers are surrounded by the enormous room with its bare walls (the admirable salmon wall topped by a dark frieze with lightly sketched motifs) and by the sofas and armchairs in their white dust covers, forming a rectangle (which Degas later opened up by changing the chaise longue in the foreground into an armchair) and marking off the scene on a dark, stagelike floor. In their passionate and dramatic duet, they affect the exaggerated, stereotypical gestures of operatic divas.

117

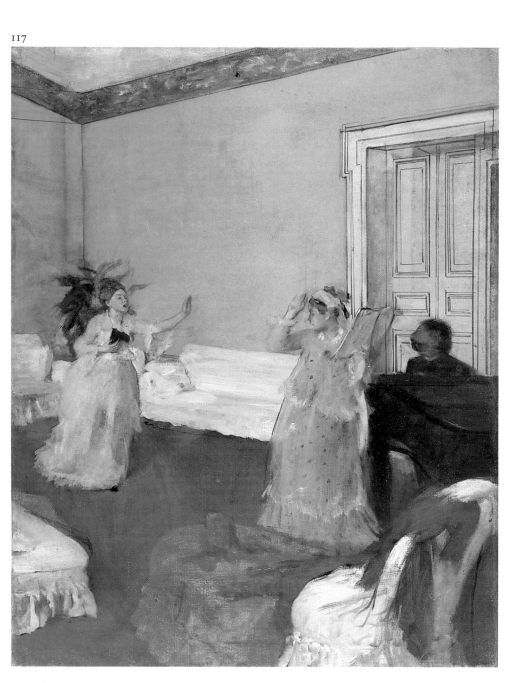

1. 1965 New Orleans, pp. 79–80, 82.
2. 1924 Paris, no. 24.
3. Tulane University Library, New Orleans.
4. Fevre 1949, p. 56; Louise Bréguet-Halévy memoirs, private collection.
5. 1931 Paris, Orangerie, pp. 40–41.
6. Reff 1985, Notebook 22 (BN, Carnet 8, p. 133).
7. Reff 1985, Notebook 7 (Louvre, RF5634, p. 26).
8. Drouot, Paris, 23 November 1954, no. 25 bis.

PROVENANCE: Atelier Degas (Vente I, 1918, no. 106 [as "Deux jeunes femmes en toilette de ville répétant un duo"]); bought at that sale by Walter Gay, for Fr 100,000. Mr. and Mrs. Robert Woods Bliss, Washington, D.C.; their bequest to the Dumbarton Oaks Research Library 1940.

EXHIBITIONS: (?) 1918 Paris, no. 11 (as "Répétition de musique"); 1924 Paris, no. 24, repr. (as "La répétition de chant"); 1931 Paris, Orangerie, no. 31, pl. III (as "Double portrait de Mme Fèvre, dit 'La répétition de chant'"); 1934 New York, no. 4; 1936 Philadelphia, no. 22, repr.; 1937, Washington, D.C., Phillips Memorial Gallery, 15–30 April, *Paintings and Sculpture Owned in Washington*, no. 275; 1947 Cleveland, no. 19, pl. XVIII; 1959, Washington, D.C., National Gallery of Art, 25 April–24 May, *Masterpieces of Impressionist and Post-Impressionist Painting*, no. 21; 1962 Baltimore, no. 39, repr.; 1987 Manchester, no. 38, repr. (color) p. 58.

SELECTED REFERENCES: Jamot 1924, p. 69; Alexandre 1935, p. 153; Lemoisne [1946–49], II, no. 331; 1965 New Orleans, p. 79, fig. 42 p. 82; Minervino 1974, no. 361.

118.

Woman Singing, study for *The Song Rehearsal*

1872–73
Pencil on buff wove paper
19 × 12⅜ in. (48.3 × 31.5 cm)
Vente stamp lower left
Cabinet des Dessins, Musée du Louvre (Orsay), Paris (RF5606)

Exhibited in Paris

Vente III:404.1

See cat. no. 117

PROVENANCE: Atelier Degas (Vente III, 1919, no. 404.1); bought at that sale by Marcel Bing with *Young Woman Standing* (cat. no. 119), for Fr 13,100; his bequest to the Louvre 1922.

EXHIBITIONS: 1924 Paris, no. 98; 1931 Paris, Orangerie, no. 112; 1935, Paris, Orangerie, August–October, *Portraits et figures de femmes*, no. 37, repr.; 1936 Venice, no. 23; 1969 Paris, no. 164.

SELECTED REFERENCES: Rivière 1922–23, I, pl. 20; 1987 Manchester, fig. 56, p. 44.

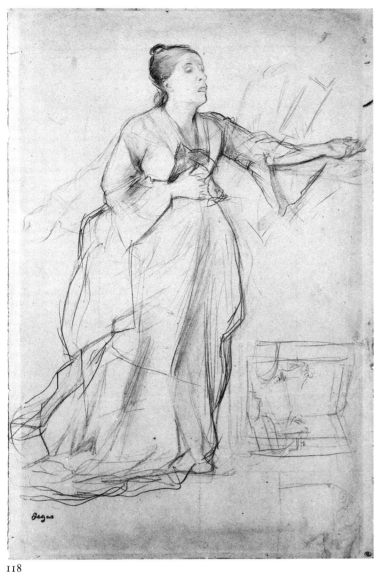

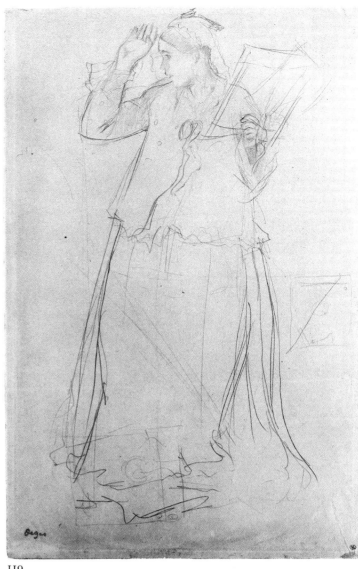

118 119

119.

Young Woman Standing, study for *The Song Rehearsal*

1872–73
Pencil on buff wove paper
19¼ × 12¼ in. (49 × 31.2 cm)
Vente stamp lower left; atelier stamp on verso
Cabinet des Dessins, Musée du Louvre (Orsay),
 Paris (RF5607)

Exhibited in Paris

Vente III:404.2

See cat. no. 117

PROVENANCE: Atelier Degas (Vente III, 1919, no. 404.2); bought at that sale by Marcel Bing with *Woman Singing* (cat. no. 118), for Fr 13,100; his bequest to the Louvre 1922.

EXHIBITIONS: 1924 Paris, no. 99; 1931 Paris, Orangerie, no. 112; 1935, Paris, Orangerie, August–October, *Portraits et figures de femmes*, no. 36, repr.; 1937 Paris, Orangerie, no. 75; 1955–56 Chicago, no. 153; 1969 Paris, no. 165; 1987 Manchester, no. 39, repr. p. 45.

SELECTED REFERENCES: Rivière 1922–23, I, pl. 21; Jamot 1924, p. 69, pl. 13; Lemoisne [1946–49], I, repr. facing p. 82; Maurice Sérullaz, *Dessins du Louvre: école française*, Paris: Flammarion, 1968, no. 92.

120.

The Pedicure

1873
Essence on paper mounted on canvas
24 × 18⅛ in. (61 × 46 cm)
Signed and dated lower right: Degas/1873
Musée d'Orsay, Paris (RF1986)

Lemoisne 323

The purchase of this painting on 21 January 1899 by Comte Isaac de Camondo resulted in a brief quarrel between Paul Durand-Ruel and H. O. Havemeyer, who had believed it was reserved for him. A few years earlier, Mary Cassatt, who counseled the American

collector on his acquisitions, had described *The Pedicure* as "a remarkably fine work of the artist."[1] Indeed, the great difference between the Fr 5,000 which Degas received for the work in July 1892 and the Fr 60,000 Camondo paid for it less than seven years later is a reflection not only of the relative scarcity of works by Degas on the market, but also of the exceptional quality of this painting.

Julius Meier-Graefe, who is not at his best when discussing Degas, likens it to the work of Adolf Menzel—which is, to say the least, surprising—and thus to the work of a colorist.[2] Paul Jamot, after emphasizing the "paradox" and the "tour de force" of the "foreshortening of the leg resting on the chair," more rightly praises the study of the subject's apparel and the effects of light and backlighting, in which one feels "that blessed concentration of the primitives who felt the joy of creating for the first time an image resembling objects and living creatures."[3]

It is quite likely that Degas painted *The*

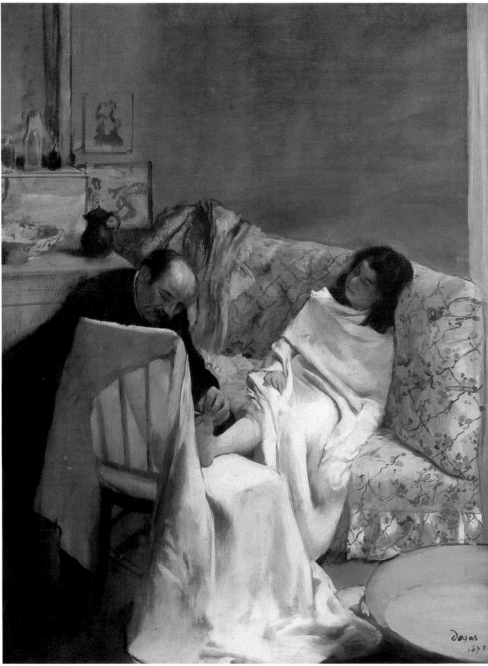

120

the previously visible collar of his shirt, and extending the top of the dresser and altering the objects on it. The painter's "tour de force," to use Lemoisne's term, lies not only in the foreshortening of young Joe's body, but in the treatment of the white fabrics, in the interplay of transparency and opacity, of shadows and glancing light, and in the solid yet changing green background, enlivened on the left by a mirror and by two children's drawings or maps hung on the wall, oddly evocative of landscapes to come. Wrapped as if in a shroud, eyes closed, attended by the watchful chiropodist leaning over her, the child is like a saint in a medieval or Renaissance work, whose death is being mourned by a faithful disciple. The use of essence reinforces this connection with classical painting. But the shroud is only a protective sheet, the instruments of the Passion only the tub and file, and the Lamentation, now secularized, becomes the "portrait of two sheets, one used as a dressing gown."[5]

1. Letter from H. O. Havemeyer to Paul Durand-Ruel, 24 January 1899, cited in Weitzenhoffer 1986, p. 134.
2. Meier-Graefe 1924, p. 44.
3. Jamot 1914, p. 456.
4. Lettres Degas 1945, II, p. 23; Degas Letters 1947, no. 4, p. 21.
5. Lemoisne 1912, p. 51.

PROVENANCE: Bought from the artist by Durand-Ruel, Paris, 25 July 1892, for Fr 5,000 (stock no. 2451); bought by J. Burke, London, 26 August 1892, for Fr 9,000; bought by Durand-Ruel, Paris, 27 December 1898, for Fr 27,000 (stock no. 4922); bought by Comte Isaac de Camondo, 11 January 1899, for Fr 60,000; his bequest to the Louvre 1911; exhibited 1914.

EXHIBITIONS: 1924 Paris, no. 41; 1969 Paris, no. 23.

SELECTED REFERENCES: Moore 1907–08, repr. p. 101; Geffroy 1908, p. 17, repr.; Max Liebermann, *Degas*, Berlin: Cassirer, 1912, pp. 17, 23, repr.; Lemoisne 1912, p. 52, pl. XVIII; Jamot 1914, p. 36; Paris, Louvre, Camondo, 1914, no. 161; Lafond 1918–19, I, p. 147, repr.; Jamot 1924, p. 91, pl. 31; Meier-Graefe 1924, p. 44; Rewald 1946, pp. 109, 110, 124; Lemoisne [1946–49], II, no. 323; Boggs 1962, p. 108; 1965 New Orleans, pp. 78, 81, fig. 39; Minervino 1974, no. 359; Paris, Louvre and Orsay, Peintures, 1986, III, p. 194, repr.; Weitzenhoffer 1986, pp. 133–35, pl. 92.

Pedicure during his last three months in New Orleans, since it is dated 1873. According to Lemoisne, who relied on the accounts of the family in Louisiana, the young girl in the picture is the ten-year-old Joe Balfour, daughter of Estelle Musson (later Mme René De Gas) and Lazare David Balfour, who was killed in October 1862 in the Civil War battle at Corinth, Mississippi. Although the subject matter is American, there is no evidence that the work was actually executed in the United States. In his correspondence, Degas mentions painting only family portraits (see cat. no. 112) and the two versions of the "Cotton Market" (see cat. nos. 115, 116) while in New Orleans; it is very probable that *The Pedicure*, like *The Song Rehearsal*

(cat. no. 117), which is also more a genre scene than a portrait, was among the accumulated projects he described in a letter to the Danish painter Frölich on 27 November 1872, saying they would "take me ten lifetimes to complete"[4] and which were finished in the calm of his Paris studio.

As he had for *Racehorses before the Stands* (cat. no. 68), Degas mounted paper on canvas and used essence over previously brushed-in outlines; this technique produced soft, matte tones and was superior to oil in subtly translating the effects of shadow and light. X-radiography of the painting shows that he added a few more touches at a later stage, draping the piece of clothing over the sofa, further tilting the chiropodist's head, hiding

121.

Rider in a Red Coat

1873
Essence heightened with white on pink paper
17⅛ × 10⅞ in. (43.6 × 27.6 cm)
Signed and dated upper right: De Gas/73
Cabinet des Dessins, Musée du Louvre (Orsay), Paris (RF12276)

Exhibited in Ottawa

Brame and Reff 66

The dating of this drawing poses a problem. Inscribed in pencil with the year "73," the drawing served as a study for *The Meet* (fig. 92), a somber painting in which a group of riders dressed in red jackets and white trousers is silhouetted against an autumnal landscape bathed in golden light. The painting, which seems to be related to several outdoor scenes done by Degas in the mid-1860s (see, for example, *Horseback Riding*, L117), has been unanimously dated as before 1870, in keeping either with Lemoisne's proposal of 1864–68 or with the tighter time frame of c. 1866–68 proposed by Reff.

It is difficult to reconcile a preliminary drawing from 1873 with a finished canvas that is thought to have been painted six or seven years earlier. The obvious solution is to maintain, as Theodore Reff has done, that the drawing is inscribed with an incorrect date and that it too must have been done about 1866–68. However, this seems implausible for several reasons. Both the date and the signature (the painting bears an identical signature) appear to be authentic, notwithstanding the surprising use of the particle ("De Gas"), which the artist seems to have abandoned after *Scene of War in the Middle Ages* (1865; cat. no. 45). The drawing was bequeathed in 1921 to the Musée du Luxembourg by Mme André, who had owned it at the time she drew up her will on 6 August 1913. It was therefore not on the art market, and thus there is no reason to suspect that someone wanting to legitimize the work added the signature and date.

Finally, *The Meet* does not depict a French scene but an English one. In France, members of hunting parties certainly wore riding coats like the ones seen here. But on their heads they wore velvet riding caps; the use of top hats was reserved for guests. In England, on the other hand, a riding cap was worn only by the whipper-in, whereas the hunters wore the top hats. One may there-fore hypothesize as follows: Degas traveled to England in the fall of 1873, and returned to France with both the drawing and the painting, for which he had made some very rough sketches.[1] He was undoubtedly thinking of the English market—a matter he had already discussed with Manet as early as 1868—and the "aristocratic" signature was just another commercial stratagem.

The study is remarkable for the fullness of its confident, rapid strokes, for the way in which Degas plays with the color of the paper (exposing it in the pink of the skull amid the sparse gray tufts of hair), and for its tonal harmony (the scarlet of the jackets, the yellow of the boot tops, and the thin sliver of the shirt collar against the uniform salmon pink). It is a work that could, if there were not a precise date, be related only to the drawings on colored paper that Degas produced in great numbers at the beginning of the 1870s (see cat. nos. 136, 138). Thus, the painting that followed, despite certain archaisms, must also now be accepted as 1873.

1. See especially the sale at Christie's, London, 1 December 1981, no. 308, repr. (color).

PROVENANCE: Bequest of Mme Eugène Frédéric André (née Alquié), to the Musée du Luxembourg 1921.

EXHIBITIONS: 1924 Paris, no. 42; 1952–53 Washington, D.C., no. 155, repr.; 1969 Paris, no. 162; 1979 Bayonne, no. 23, repr.; 1984 Tübingen, no. 64, repr. (color).

SELECTED REFERENCES: Rouart 1945, p. 13; Rosenberg 1959, pp. 114, 219; Brame and Reff 1984, no. 66.

121

Fig. 92. *The Meet* (L119), c. 1873. Oil on canvas, 27½ × 35 in. (70 × 89 cm). Private collection

II

1873–1881

Michael Pantazzi

L'attention

Fig. 93. Jean-Louis Forain, *Attentiveness (Portrait of Edgar Degas)*, c. 1880. Pencil, 6⅝ × 4 in. (17.2 × 10.2 cm).
Collection of Mme Chagnaud-Forain, Paris

Scientific Realism: 1873–1881

DOUGLAS W. DRUICK
PETER ZEGERS

For their help in preparing this essay, the authors are indebted to Charles Hupé, Claude Lupien, Anne Maheux, and Maija Vilcins of the National Gallery of Canada; Valerie Foradas, Suzanne Folds McCullagh, and Martha Tedeschi of the Art Institute of Chicago; and Catrine Louis, Paris.

The letters Degas wrote from New Orleans in 1872–73 reveal him in crisis, intensely reviewing both his personal and professional life. During his stay in New Orleans he resolved to pursue his career more aggressively, with the aim of making "the Naturalist movement . . . worthy of the great schools." Degas echoed this ambition in a letter of 1874 urging Tissot's participation in the first group exhibition, which he justified by arguing the need for a "distinct . . . salon of Realists."[1] His interchangeable use of the terms "Realist" and "Naturalist" was typical of the period. The latter term was coined in the early 1860s to distinguish the new generation of painters spawned by Realism; Naturalism denoted the same rigorous truth to external reality, but now updated and brought into "equilibrium" with science. The need to balance art with science was the major tenet of the art criticism of Degas's close friend the writer Edmond Duranty (see "The Portrait of Edmond Duranty," p. 309). An early advocate of Realism, Duranty had long been urging artists to keep abreast of science and to allow its findings to alter their view of reality; only by thus embracing change, Duranty believed, could artists secure a position in a future whose shape would inevitably be determined by science.[2]

Degas's proclaimed ambition to advance the cause of Realism through his art and through the group exhibitions was sincere, and from the time of his return from New Orleans until 1881, it was carried out with a truly remarkable consistency. This can be fully appreciated only if we recognize what contemporary reviewers read in Degas's artistic activity: its every aspect—presentation, materials, composition, and subject—was infused with the scientific bias he shared with Duranty.

Degas had long held strong views about the conditions under which art should be viewed; as early as 1870, he had petitioned the Salon jury to integrate works in different mediums and to allow more space for their installation. In the group exhibitions that he helped to organize beginning in 1874, he implemented ideas that revealed a keen sensitivity to the effects of presentation on critical appraisal. In these innovations, as the language of the reviews testifies, critics discerned the ambitions of scientific realism.

In 1876, Émile Blavet defended the group's desertion of the traditional route to recognition, the Salon, in favor of a separate exhibition space, for as he saw, "the movement they have initiated requires great freedom for experimentation and a laboratory of its own."[3] Critics had already recognized that these "laboratory" conditions affected their assessment of the pictorial experiment. In 1874, they noted that the intimately scaled rooms and spacious hanging facilitated the viewer's ability to appreciate the works displayed. Two years later, the experiment was carried further by the grouping together of all the works by each artist, allowing the public, as Alexandre Pothey wrote, "to move from details to the whole, and so arrive at an opinion with full knowledge of the case." The decisive role lighting played in this process was signaled in 1874 by Degas's friend Philippe Burty. He explained the evening viewing hours by stating that the artist and his friends "have invited the public and critics to judge, again from eight to ten P.M. under gaslight, what they had already viewed in daylight." Gaslight, however, cast a reddish glow that, as many critics realized, acted to deaden color. The new electric lamp invented by Jablochkoff in 1877, and introduced into the Salon two years later, was welcomed for casting a "truer" light on pictures.[4] Anxious to harness new technology in

1. Letters to Tissot of 18 February 1873 and February–March 1874, Degas Letters 1947, nos. 6, 12. See also Lettres Degas 1945, II, III; Degas Letters 1947, nos. 3, 5, 7.
2. Edmond Duranty, "La science vulgarisée," *Revue de Paris*, December 1864, pp. 160–64.
3. The authors thank Charles S. Moffett of the National Gallery of Art, Washington, D.C., for generously providing copies of the reviews of the Impressionist exhibitions. References to these will be footnoted only when either the author or the date is not clearly indicated. Otherwise readers are referred to the list of reviews published in 1986 Washington, D.C., pp. 490–96.
4. "Le Salon à la lumière électrique," *Le Monde Illustré*, 5 July 1879, p. 7; Henry Vivarez, "Chronique scientifique: la lumière électrique et l'art," *La Vie Moderne*, 27 December 1879, pp. 605–06.

the service of art, Degas contacted Jablochkoff and Co. while organizing the fourth group exhibition, although it is unclear whether electric light was finally used in the 1879 installation. Similarly uncertain is whether Degas's employment of Belloir as "tapissier-décorateur" resulted in the use of the variety of wall colors that Burty, reviewing the 1880 exhibition, would justify as complementary to the varied effects of the pictures.[5] Pissarro's work hung in a room painted lilac with a border of canary yellow—possibly the same shade of yellow Degas adopted in 1881 as the background for his work at the sixth group exhibition.[6] These unorthodox colors announced a new way of viewing art; they proclaimed an emphatic modernity as consonant with the pictures as their frames.

Having, with Pissarro, used white frames for his entries at the 1877 exhibition, Degas introduced frames of different colors and profiles to the group show of 1879. Monet later explained that Degas did this "to make the frame assist and complete the picture" by enhancing its color. Degas attached such importance to this that he stipulated to Monet and others that his pictures had to be kept in their original frames; occasionally, when he discovered a work of his reframed in a conventional gilded molding, he repossessed it in a rage.[7] But in 1879, the critic Henry Havard echoed others when he likened Degas's "combinations of multicolored frames" to inconclusive "laboratory experiments" in novelty; he advised Degas and his "gang of researchers" to adopt the more responsible behavior of "physicians and chemists who generally wait until they've made a discovery before communicating their research to the public." Havard's choice of metaphor was apparently not inspired by Chevreul's earlier experiments with the modifying effect of frame colors on pictures; rather, it was provoked by Duranty's review proclaiming the successful outcome of Monet's and Pissarro's "color research" following years of "laborious experiments similar to a chemist's." Havard's intolerance of Degas's experiments was fostered by his negative attitude toward "Impressionism," the term that since 1874 had become synonymous with Monet's style and perceived aim to render "not the landscape, but the sensation produced by the landscape."[8] At issue was the question of "truth," for which science was now widely regarded as the measure and to which the Impressionist painters were seen as falsely laying claim.

Degas realized that the banner under which his work was shown, like the frames, affected its reading. The Impressionist label impeded critical appreciation of his Realist ambitions. Although the emphasis on drawing, the greater degree of finish, and the urban subject matter distinguished Degas's work from Monet's, the critics tended either to assess it in terms of Impressionist issues or, dissociating Degas altogether from Impressionism's "revolutionary techniques," to view him as the "honest" bourgeois posing as a radical.[9] In 1876, Degas was thus among the group of disgruntled exhibitors on whose behalf Édouard Béliard chastised the influential critic Alfred de Lostalot for labeling them "Impressionists" when their pursuit of truth could best be understood by the terms "Realism" or "Naturalism." Largely influenced by Degas, Duranty's *La nouvelle peinture* was an even more ambitious attempt to clarify the essential nature of the new painting as a Realism of precise observation based on the "solid foundations" of science. The critic conceded that the new painting included both "colorists" (Monet and the Impressionists) and "draftsmen" (Degas), but he clearly believed that the latter were better able to achieve Realist goals.[10] However, these attempts to expunge the term "Impressionist" so failed that in 1877 it was emblazoned on the sign over the entrance to the third group exhibition. Displeased, Degas proposed at first to put on the poster for the fourth exhibition "Groupe d'Artistes Indépendants, Réalistes, et Impressionnistes," thereby acknowledging the differences within the group. Although "Artistes Indépendants" was the label ultimately adopted for the 1879 poster, many critics—including Duranty—now allowed such distinctions.[11]

Within the group, Degas fostered Realist-Impressionist factionalism through the new rules and members he introduced. As Caillebotte bitterly observed early in 1881, Degas's strategies served to advance "the great cause of Realism" and his own reputation while alienating such key Impressionists as Renoir, Sisley, and Monet. Consequently, at the sixth group exhibition, Degas and his followers were the principal contributors and the reviewers at last focused their attention on the issue of Realism.[12]

5. Lettres Degas 1945, XVII; Degas Letters 1947, no. 26; Ronald Pickvance in 1986 Washington, D.C., p. 250.
6. Gustave Goetschy, 1881 review.
7. Entry in the diary of Theodore Robinson, 30 October 1892, Frick Library, New York. The authors thank Charles F. Stuckey of the Art Institute of Chicago and Michael Swicklik of the National Gallery of Art, Washington, D.C., for bringing this reference to their attention.
8. Jules Castagnary, 1874 review.
9. See the 1874 reviews of Castagnary, Émile Cardon, Ernest Chesneau, and Ariste (Jules Claretie).
10. Béliard's letter published in *Le Bien Public*, 9 April 1876; Edmond Duranty, *La nouvelle peinture*, reprinted in 1986 Washington, D.C., pp. 38–47.
11. For 1877, see the reviews of Robert Ballu, Jules Claretie, and Louis Leroy. For 1879, see those of Duranty, Henry Havard, Armand Silvestre, and Georges Lafenestre, and see also Pickvance in 1986 Washington, D.C., pp. 250ff.
12. Letter from Gustave Caillebotte to Camille Pissarro, 24 January 1881, in Marie Berhaut, *Caillebotte: sa vie et son oeuvre*, Paris: La Bibliothèque des Arts, 1978, pp. 25–26; Fronia E. Wissmann in 1986 Washington, D.C., pp. 337–52.
13. See Druick and Zegers in 1984–85 Boston, pp. xlix–l.
14. Edmond Duranty, "L'outillage dans l'art," *L'Artiste*, 1 July 1870, p. 11. Duranty also presented this thesis in "Le Salon de 1874," *Le Musée Universel*, 1874, IV, pp. 193–210, and in *La nouvelle peinture*.
15. For further details and sources, see Druick and Zegers in 1984–85 Boston, pp. xxix–li, lii, nn. 5, 6.

The Realist bias linking Degas's efforts to *present* as well as to *create* his work in a thoroughly modern way is indicated by the page in a notebook of 1879 in which he sketched cross sections of frame moldings with color notes and also recorded an address on rue Montmartre with the note "Bellet d'Arros/crayon voltaïque" (fig. 94). Bellet d'Arros was an inventor whose "crayon voltaïque"—an "electric pencil" permitting "the reproduction of a drawing in a more or less unlimited number of copies"—was reported two days after the opening of the 1879 exhibition in *La Nature*, a leading popular scientific weekly that Degas read (fig. 95). Related to his plans to launch an illustrated journal, Degas's interest in this new invention was informed by Duranty's theory that technical inventiveness is critical to pictorial invention.[13]

First advanced in 1870, Duranty's thesis was simple: historically, great moments in art had come on the heels of the invention of new mediums—for example, oil paint in the fifteenth century. Once the new medium passed into widespread use, true invention yielded to concern for technical perfection and, ultimately, to sterility. To create a new and vital art, Duranty contended, an artist needed materials as free from tradition as his ideas. "Today," he wrote somewhat optimistically in 1870, "we are possibly on the road to change in the look of art, but those who feel themselves drawn in this direction at the same time feel themselves shackled by its tools. They would like to have other colors, they would like instruments other than the broad and fine brush. They are experimenting with the knife and would try out the spoon if it seemed promising."[14] By 1876, Degas had, in Duranty's opinion, emerged as the primary inventor of "the new painting," wherein "everything is new or wants to be free." As Degas's notebooks and production attest, over the next five years he continued to explore new techniques and to revive old ones with a passion that proclaimed his Realist ambition.

Degas's fascination with technical invention is perhaps most clearly seen in his printmaking. Here he sought expressive freedom by pursuing unconventional approaches to traditional mediums and by making use of technological discoveries that involved both the direct and the photomechanical transfer of designs to create printing matrices. By July of 1876, when he told the critic Jules Claretie that he had discovered a "new printmaking technique," Degas's pursuit of new technical resources was at a fever pitch. "The man's crazes are out of this world," wrote fellow printmaker Marcellin Desboutin to a mutual friend. "He is now in the metallurgic phase of reproducing his drawings with a roller and is running all over Paris . . . trying to find the legion of specialists who will realize his obsession! . . . He talks only of metallurgists, lead casters, lithographers, planishers!" Degas's "discovery" was likely monotype, examples of which he showed at the 1877 group exhibition (see cat. nos. 160, 163, 174, 190). Claretie's review of that exhibition and Degas's notebooks of the period together indicate that he sought advice from the printing industry out of a desire to have his monotypes—and possibly etchings—serve as book illustrations for Ludovic Halévy's *Madame et Monsieur Cardinal* (see "Degas, Halévy, and the Cardinals," p. 280) and other contemporary Realist literature. This necessitated his finding a means to transfer images printed from low-yield matrices onto new printing matrices capable of producing large editions. The technical recipes and printers' names (Geymet, Gillot, and Lefman) recorded by Degas in his notebooks were associated with the latest inventions for making relief plates with precisely this function.[15]

Degas realized no book illustration projects. Also abandoned was his idea of 1879 to launch an illustrated journal to have been called *Le Jour et la Nuit*. The etchings he had made for *Le Jour et la Nuit*—some of which he included in the fifth group exhibition of 1880—indicate the problem. The artist's thoughts of financial gain were displaced by his consuming fascination with invention and process. The notebooks and the letters to Bracquemond and Pissarro document the obsession evident in such prints as *Leaving the Bath*, which Degas developed through twenty-two evolutionary states (fig. 96; see cat. nos. 192–194). The catalogue description Degas gave in 1880 to his etchings—"experiments and states of plates" ("essais et états de planches")—reflects his wish to present them as an artistic exposition paralleling the latest scientific findings published in *La Nature*. The series of states evokes both Muybridge's recent photographic analysis

Fig. 94. Page of a notebook used by Degas in Paris in 1878–79, bearing the name and address of Bellet d'Arros. Bibliothèque Nationale, Paris, Dc327d, Carnet 23, p. 9 (Reff 1985, Notebook 31)

Fig. 95. Anonymous, *The New Electric Pencil of MM. Bellet and Hallez d'Arros*. Wood engraving. Advertisement in *La Nature*, 12 April 1879, p. 189

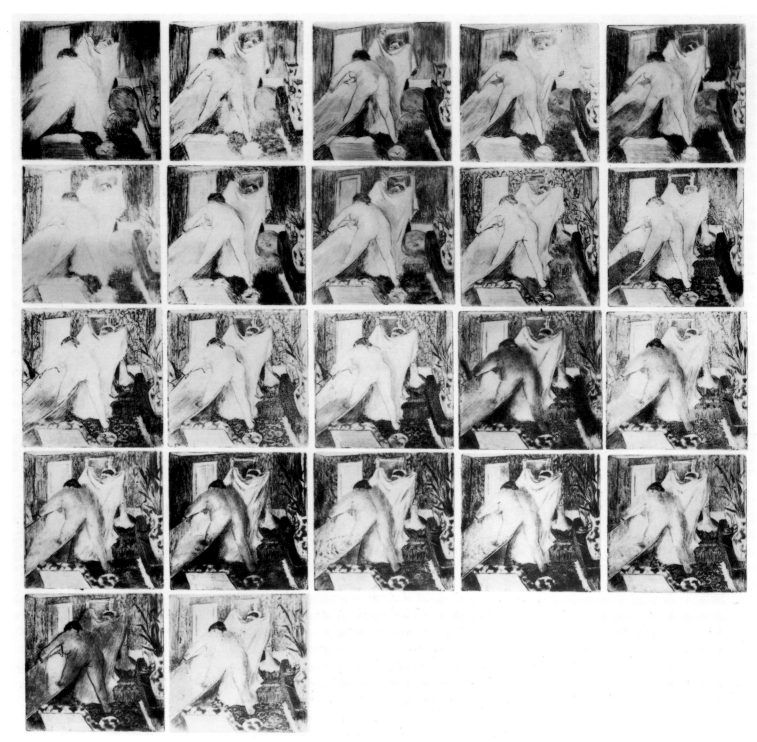

Fig. 96. Composite photograph of twenty-two successive states of *Leaving the Bath* (RS42), c. 1879–80. Drypoint and aquatint. See cat. nos. 192–194

of movement and the spirit of Darwin's evolutionary theory. Similarly, his use of the "crayon de charbon" (the carbon rod used in electric arc lamps) for drypoint attests to the fascination with new tools that he shared with Duranty. Although Degas appreciated the range of grays he could realize by scraping the printing plate with this unconventional instrument, more compelling, it seems, is the fact that in using the tool commonly known as the "crayon voltaïque" he pioneered a form of "electric pencil" just as modern as Bellet d'Arros's invention of the same name.[16]

While recent scholarship has focused on Degas's printmaking as the prime example of his interest in technical exploration and the revitalization of traditional mediums, to his contemporaries it was his more widely exhibited work in pastel, gouache, and dis-

temper that loudly signaled this particular Realist bent. Degas's explorations in both areas were, in fact, interconnected. From the very first, Degas used the pale, second impression of his monotypes as a literal base on which to build new works with the opaque color mediums. The impact of this activity on his painting was such that by 1877 Burty, in reviewing the third group exhibition, could observe that Degas had essentially abandoned oil for distemper ("peinture à la colle") and pastel. This was true for more than two-thirds of the work in color that Degas produced between 1876 and 1881.

Degas's sudden shift to the opaque mediums may have been stimulated by the exhibition and sale in 1875 of Émile Gavet's large collection of pastel by Millet, as well as the attention being paid to the recent work in pastels by Degas's friend Giuseppe De Nittis. Claretie observed that De Nittis was attracted to pastel because it permitted him to work quickly and because he dreamed of bringing "his modern sensibility" to a medium strongly associated with the eighteenth century.[17] Degas was even more susceptible to such attractions. Since they are either dry or quick-drying, pastel, gouache, and distemper allowed Degas to work more spontaneously than oil; and since they are opaque, they insured that he could readily and effectively make, and mask, changes to his compositions. They at once became the artist's means to quickly realize small-scale works that could be marketed less expensively than paintings and so yield the ready income his financial reversal had made necessary.

By 1879 collectors were, wrote Burty, fighting over the works that Degas came to refer to as his "articles."[18] Yet their attraction was not solely commercial. From the perspective of Duranty's theory of material invention, pastel, gouache, and distemper were mediums of considerable creative potential to which their traditionally perceived limitations provided the key. Distemper, for Duranty and others, was the "antique" medium that preceded—and was displaced by—the discovery of oil paint.[19] Its current use was largely inartistic, confined to the theater, where it continued to be used (as it had been for centuries) for the painting of stage sets. Pastel had enjoyed a brief revival in the 1830s and 1840s, but interest had waned by 1860. Considered inferior to oil in the hierarchy of mediums, pastel continued to be regarded as a medium for second-class talents, its "modern" application limited to portraiture, landscape, and still life. This was partly the result of the accepted view of pastel as inherently ephemeral—the prejudice reflected in Diderot's often quoted riposte to Maurice Quentin de La Tour: "Remember, pastelist, you are only powdery dust and to dust you will return."[20]

In these traditional assumptions Degas discovered new expressive potential for depicting the contemporary world of the Opéra and the café-concert. The fragility that continually led writers to discuss pastel in metaphors of fleeting beauty—the "powder of a butterfly's wings"[21]—nourished Degas's bittersweet vision of the onstage metamorphosis of homely young dancers into illusions of beauty as perfect and short-lived as the butterflies to which he was fond of likening them. Similarly, in using distemper, Degas played upon its associations with the fictive reality of stage flats to underscore the brilliant superficiality of the theatrical world. Often combining both mediums (fig. 97), the artist subtly evoked the inextricable mix of brashness and pathos he saw in the lives and work of female entertainers. His interest in the metaphorical associations of different mediums led him to use the "colored powder that one buys from *marchands d'apprêts pour fleurs*" to make the gouache he employed in painting fans.[22] There was both appropriateness and irony in painting these objects associated with fashionable women in the very pigments used for the artificial flowers that adorned their dresses and headwear.

Degas's readiness to depict the transient pleasures of fashionable life in mediums considered equally ephemeral may be a reflection of the revised view of the relative stability of oil paint. By the mid-1870s, there was alarming new evidence that the traditional confidence in the longevity of oil was misplaced. The concern Degas expressed in May 1876 about the yellowing of his paintings during drying and as a result of varnishing reflects the more widespread malaise. Just weeks earlier it had been reported that Manet's famous *Olympia* had significantly darkened and that many of the artist's more recent pictures had already become "heavy, opaque, and green."[23] Concern for posterity prompted scientific tests on the adverse effects of light on the pigments used by manu-

16. See 1984–85 Boston, nos. 32, 42, 43, 51. While Cassatt, Pissarro, and Raffaëlli likewise showed "états" of their prints destined for *Le Jour et la Nuit*, only Degas included the description "essai."
17. Jules Claretie, "Médaillons et profiles: J. de Nittis," *L'art et les artistes français*, Paris: Charpentier, 1876, pp. 415–16.
18. Burty, 1879 review; see Lettres Degas 1945, XI, XXXII (1879, misdated 1882); Degas Letters 1947, nos. 19, 41.
19. Duranty, "L'outillage dans l'art," p. 7.
20. See, for example, the entry for "Pastel" in Pierre Larousse, *Grand dictionnaire universel du XIXe siècle*, XII, Paris, 1874, p. 376.
21. Jules Claretie, "Un peintre de la vie parisienne," *La vie à Paris*, Paris: Victor Havard, 1881, p. 218.
22. Letter from Degas to Caillebotte, c. 1878, in Berhaut, no. 7.
23. Letter from Degas to Charles W. Deschamps, 15 May 1876, in Reff 1968, p. 90, and Jeanniot 1933, p. 167. On Manet, see Bertall, "L'exposition de M. Manet," *Paris-Journal*, 30 April 1876. We thank Charles F. Stuckey of the Art Institute of Chicago for this reference.

facturers and the role played by varnish in these changes. At the root of the problem, as Degas and others realized, was the painter's loss of the technical knowledge of his craft; while their forebears had supervised the preparation of their mediums, Degas and his contemporaries surrendered this responsibility to an industry more interested in immediate profit than in the manufacture of lasting materials.[24]

Less complicated in structure than oil paint, pastel could, it now appeared, be used with greater certainty. As Claretie observed in 1881, time had proven Diderot wrong: "La Tour and his powdery dust have outlived most of the great ambitious painters whose works—faded and cracked—have nothing of that exquisite freshness of the La Tours in the Musée de Saint-Quentin," which Degas loved to visit.[25] Similar claims of stability were advanced for gouache and distemper. Although gouache could be purchased ready-made in tubes, Degas occasionally preferred to make his own. Distemper demanded some expertise in mixing the powdered pigment with a heated solution of water and glue. In this activity, as well as in his attempt to use the still more durable and complex technique of tempera, Degas expressed a respect for traditional craft and a desire to master its secrets. A similar interest in reviving ancient techniques that promised unalterable color inspired the contemporary experiments in wax painting by Degas's acquaintances Jean-Charles Cazin and Gustave Moreau.[26]

More important to Degas than scientific sanction was the fact that in the absence of a vital tradition the opaque mediums naturally invited freedom of invention. He quickly learned to exploit the inherent flexibility of paper supports, adding and subtracting strips of paper as his ideas evolved (see fig. 97) and thus freeing himself of the need to conceive his compositions in standard formats. Similarly, he took full advantage of the different ways of handling pastel, sometimes drawing with the sticks, at other times creating tonal areas with a stump or with his fingers; often he worked with pastel and water, either wetting the stick or working the powdery pigment with brush and water to create fluid passages of color that he could blend with the better-adhering mediums of gouache and distemper. Degas's activity quickly fostered renewed interest in pastel. Reviewing the 1877 Salon, Louis Gonse conceded that the future of pastel lay beyond the doors of officialdom. Degas's efforts "to revive the medium by rejuvenating it" had produced pastels "not unworthy of the great tradition of La Tour and Chardin." But while their brilliance persuaded Gonse that Degas's association with the Impressionists was a masquerade, their physical construction alerted Arthur Baignères and others to the fact that Degas was indeed an "intransigent Impressionist" since he perversely sought to "avoid using customary techniques."[27] Indeed, Degas's wish to draw attention to his experimentation was evident at the 1879 exhibition, where his unusually detailed catalogue descriptions underscored the technical innovations evident in his entries. Elaborating on Baignères's objections, Havard described Degas's "unexpected combinations" of mediums as the product of a mind so obsessed with the "chemistry" of invention that it confused technical means with pictorial realization. Havard's dismissal of Degas's entries—like the frames housing them—as inconclusive "experiments" was a judgment Degas could have avoided if, in the words of Georges Lafenestre, he would only cease calling attention to his "new techniques." Clearly, as Duranty recognized, the impact of such richly textured matte surfaces could, like those of unvarnished oils, be "shocking" to conservative "French notions of decorum and polish."[28] However, Realist critics defended the perceived connection between Degas's "ragoût nouveau" and his modernity. In his review of 1880, Huysmans had special praise for Degas's ability to realize "new artistic pungency" from "new artistic techniques." These constituted a new "vocabulary," a new "instrument," which Degas, like the Goncourt brothers, had been forced to invent in order to fulfill the Realist goal "to render visible . . . the exterior of the human animal, in the milieu in which it moves, in order to clearly indicate the mechanism of its passions."

As Huysmans noted, Degas's affinities with the literature of the Goncourts and Zola sprang from a similar Realist "feeling for nature." Edmond de Goncourt himself had described Degas, following a visit to his studio in 1874, as "the one who has best been able, in transcribing modern life, to capture its soul." This was the goal Realist-Naturalist

24. See the contemporary articles in *La Chronique des Arts et de la Curiosité* in 1884 and 1889 as well as Anthea Callen, *Techniques of the Impressionists*, Secaucus: Chartwell Books, 1982.
25. Claretie, "Un peintre de la vie parisienne," p. 218; Havemeyer 1961, p. 265.
26. "Procédés nouveaux: couleurs à l'eau inaltérables," *Les Beaux-Arts Illustrés*, 25 February 1878, pp. 324–46. See Cazin's entries at the Salons of 1879, 1880, and 1881 and Moreau's at that of 1876.
27. Louis Gonse, "Les aquarelles, dessins et gravures au Salon de 1877," *Gazette des Beaux-Arts*, 1 August 1877, p. 162; Arthur Baignères, "Le Salon de 1879," *Gazette des Beaux-Arts*, 1 August 1879, p. 156.
28. 1879 reviews of Havard and Lafenestre; Edmond Duranty, "Eaux-fortes de M. Joseph Israels," *Gazette des Beaux-Arts*, 1 April 1879, p. 397.
29. Journal Goncourt 1956, II, p. 968; J. A. Anderson, "Critique d'art," *La Revue Moderne et Naturaliste*, 1879, pp. 17–21, and in the same periodical, Harry Alix, "L'art en 1880," 1880, pp. 271–75.

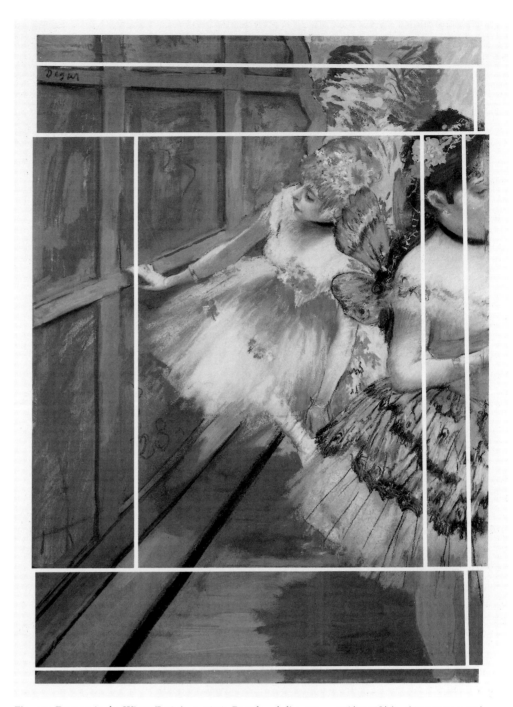

Fig. 97. *Dancers in the Wings* (L585), c. 1878. Pastel and distemper, 26¼ × 18⅝ in. (66.7 × 47.3 cm). Norton Simon Art Foundation, Pasadena. The white lines indicate the separate pieces of paper from which Degas built his composition.

writers prescribed for painting: the artist must disavow the superficial "dull realism" of the photograph and infuse his observations with ideas. Degas's composition, drawing, and subject matter convinced both champions and opponents of Realism that—even more than the Impressionists—his "bias toward modernism" firmly placed him among Realism's "school of thinkers."[29]

Degas acknowledged that the Goncourt brothers' novel *Manette Salomon* (1867) had influenced the "new perception" he brought to his art in the 1870s. Indeed, there are parallels between the Goncourts' writings and Degas's pictorial emphasis on the subjective quality of vision. When contemporary critics remarked on the arbitrariness conveyed by Degas's odd viewpoints, cropped forms, and tilting floors, they indicated

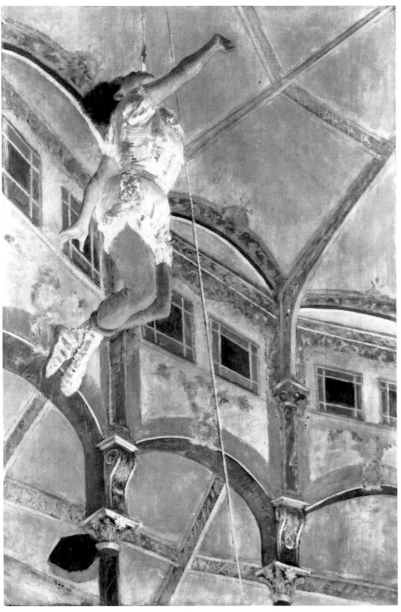

Fig. 98. *Mlle La La at the Cirque Fernando* (L522), 1879. Oil on canvas, 46 × 30½ in. (116.8 × 77.5 cm). The National Gallery, London

SATURDAY NIGHT AT THE VICTORIA THEATRE

Fig. 99. *Saturday Night at the Victoria Theater.* Wood engraving. *The Graphic*, 26 October 1872, p. 288

their recognition of Realist ideology. Some, like Baignères in 1876, saw in Degas's compositional devices the espousal of Impressionism's "passive" vision, the wish to adopt the camera's mechanistic mode of transmitting visual information "innocent" of intellectual organization. Indeed, Degas's compositions—like the Impressionists' brush-work—conveyed a message of spontaneity that belied thoughtful preparation. His trun-cation of forms and exaggerated perspectives (see fig. 98) evoked the fragmentation and distortions occasionally found both in contemporary photographs and in the reportorial glimpses of modern life recorded in the burgeoning French and English illustrated press; of these, *The Graphic*, which Degas had read while in New Orleans, was a prime exam-ple (see fig. 99). But while the Impressionists' rhetoric of spontaneity was widely accepted at face value—and their work criticized for lacking intelligence and objectivity[30]—Degas's intention was better understood. Even Baignères suspected that Degas's compositional methods were part of a strategy "to *appear* not to compose," and Armand Silvestre, Georges Rivière, and others signaled the "constant research" and the "process of syn-thesis" that informed Degas's seemingly casual view of contemporary life. The painter's notebooks confirm his desire to convey the appearance of immediacy through careful

study while resisting the temptation to "draw or paint *immediately.*" Mallarmé explained the compositional devices as reflecting the new "science" of painting that "pushed" traditional practices to their "utmost limits"; Degas had thus freed himself from the "hackneyed view of his subject" to create the "strange new beauty" to which critics responded according to their attitude toward Realism.[31] Jean de la Leude, for example, accused Degas in 1879 of cropping figures with a "murdering brush" that proved him guilty, like Zola, of the ugly dissection of reality. The following year, by contrast, Huysmans extolled Degas's daring in *Mlle La La at the Cirque Fernando* (fig. 98) to "make the ceiling of the Cirque Fernando incline completely to one side" and thus "convey the exact sensation of the eye that follows her."

Readiness to recognize a quasi-scientific truth in Degas's work came still more readily for his treatment of the human figure. From 1876 onward, critics seeking to praise the truth of Degas's keen analysis and telling synthesis of the human physiognomy frequently invoked comparison with Daumier, now recognized as the preeminent French "historian of our customs, of our appearance, and our race." But Degas's "research in pictorial shorthand"[32] was regarded as more pitiless than Daumier's, since his study of physiognomy was conducted in the harsh light of new scientific findings.

The need to transform the imprecise, traditional wisdom of Lavater and others into a "regulated science" had been the subject of Duranty's 1867 essay "Sur la physiono-mie."[33] In it he had outlined ways to refine the "grammar [of] modern observation" based on the analysis of the subject's physical, social, and racial characteristics. Not long after, Degas noted a similar ambition to "make of expressive heads (academic style) a study of modern feeling—it is Lavater, but a more relativistic Lavater, so to speak, with symbols of today rather than the past." This ambition was infused with the spirit of scientific investigation. Accordingly, Degas was convinced that only prolonged study would allow meaningful insight into the "customs of a people" and, true to the tenets of Realism, believed that "one can make art only of that to which one is accustomed." While visiting New Orleans he resisted painting his new surroundings, resolving instead to further study the Parisian world with which he was familiar.[34] The encyclopedic knowledge of the work and speech of laundresses and dancers with which Degas impressed Edmond de Goncourt in 1874 reflects his exhaustive observation of his subject, of "the special traits his profession prints on him," as advocated by Duranty. Degas's ability to mimic his subjects' movements attests as well to his application of the idea advanced in "Sur la physionomie" that through imitative behavior one is able to apprehend another person's underlying feelings.

Huysmans asserted in his review of 1880 that Degas observed the dancers so keenly that a "physiologist could make a meticulous study of each of their individual constitutions." Not only diehard Realists recognized the ideological bias. Three years earlier Bergerat, reviewing the third group exhibition, had discerned an ambition that was "above all ethnographic," that presumed the artist's role was to document contemporary "customs and society" for the future. Degas's physiognomic investigations indeed reflected the current related interests—shared by such friends as Comte Ludovic Lepic—in evolutionary theory and the scientific reconstruction of man's history. Lepic, the experimental printmaker who introduced Degas to monotype, was also an ardent amateur of French prehistory who, by 1874, had created several "reconstructions" of prehistoric man and animals for the recently founded ethnographic Musée de Saint-Germain.[35] Darwin's *Expressions of the Emotions in Man and Animals* (1872, translated into French in 1874) provided further support for the theory of evolution both by demonstrating analogies between animal and human expressions that argued a common origin and by explaining otherwise unaccountable human reactions as vestiges of earlier stages of man's evolution (see fig. 100). One of Degas's notebook sketches of café-concert singers made in 1877 (fig. 101)—a time when he was particularly close to Lepic—reflects the revived interest in the physiognomic practice of "making use of animals to explain man" that had found new scientific sanction in evolutionary theory. The head at the upper right has the suggestion of a simian ancestry—the singer's open mouth is as likely to emit a primal scream as to utter the raucous lyrics of a vulgar song. The other figures recall

30. Degas Letters 1947, no. 7; Richard Schiff, "Review Article," *Burlington Magazine*, December 1984, pp. 681–90.
31. Reviews of Baignères 1876, Rivière 1877, and Silvestre 1879 (24 April, *La Vie Moderne*); Reff 1985, Notebook 30 (BN, Carnet 9, pp. 196, 210); Stéphane Mallarmé, "The Impressionists and Édouard Manet" (1876), in 1986 Washington, D.C., pp. 31–33.
32. Edmond Duranty, "Daumier," *Gazette des Beaux-Arts*, May and June 1878, pp. 432, 440, 532, 538; Silvestre 1879 review.
33. *Revue Libérale*, 25 July 1867, pp. 499–523.
34. Reff 1985, Notebook 23 (BN, Carnet 21, p. 44); Lettres Degas 1945, II, III; Degas Letters 1947, nos. 4, 5.
35. See Duranty, "Le Salon de 1874," p. 194.

Fig. 100. Illustration for a review of Charles Darwin, *The Expression of Emotions in Man and Animals*. Engraving. *La Nature*, 4 July 1874, p. 75

Fig. 101. Page of a notebook used by Degas in 1877. Private collection, p. 11 (Reff 1985, Notebook 28)

rodents, in their skulls and features as well as in their hands held like the forepaws of animals standing on their hindquarters. All in all, their features show them to be neither very evolved nor very noble specimens of humanity; contemporary scientific studies of deformed and purportedly less evolved human types (see fig. 102) would have supported the traditional physiognomic reading of weakness, sensuality, and low intelligence in the recessive chin, prominent nose and mouth, and low forehead found in the two rodentlike figures, and of brutishness in the strong jaw of the other figure.

These were the general facial characteristics that Degas often used in the latter half of the 1870s in his depictions of prostitutes, café-concert singers, and, increasingly, dancers. He apparently saw in these subjects a sisterhood of types, reflecting the current thesis that physiognomic similarities exist among people involved in the same kind of work and raising the topical question of whether professions mold physiognomy or simply attract similar types. Huysmans recognized in Degas's various depictions of dancers an extended study of the "metamorphosis" of women in the work environment: through grueling practice the awkward young girls—"giraffes who could not bend, elephants whose hinges refused to fold"—were "broken in," finally to emerge as visions of grace pirouetting before the stage lights; in the end, too old to dance, they would become "dressing room attendants, palm readers, or walkers-on."[36] Degas actually evoked more graceful metaphors in depicting this evolution. A selection of pastels done in the late 1870s (fig. 103) suggests that he saw in the dancer's nightly activity the poignancy of the butterfly's life cycle: in the protective atmosphere of her dressing room the dancer sheds her drab street clothes and takes on a brilliant exterior (L497); awkwardly she emerges from her cocoon, barely stirring with new life (L644; see cat. no. 228); making last-minute adjustments, she prepares to take wing (L585); after a brief moment of glory (L572; see cat. no. 229), the curtain falls and the cycle ends abruptly (L575).

In their reviews of 1877, Paul Mantz, Georges Rivière, and others noted that in his presentation of these seeming "fragments" of modern life, Degas combined a "literary" with a "philosophic" talent to actually reveal "the essence of things." However, several reviewers also read in Degas's depictions of women a caricatural impetus that, under a veneer of "gentle" satire, was driven by cynicism and a "cruel" irony. Defenders like Armand Silvestre explained this in 1879 by picturing Degas as the quintessence of a modernity to which he "resigns himself . . . with a lighthearted philosophy and for

Portrait de l'Aztèque exhibé à Paris (D'après une photographie.)

Fig. 102. Portrait of the "Aztec" exhibited at the Paris Hippodrome in 1855. Wood engraving, after a photograph. Illustration for an article in *La Nature*, 2 January 1875, p. 65

36. 1880 review.
37. Review of 1 May 1879 by Silvestre; Theodore Massiac, "Causerie dramatique: les comédiens parisiens," *La Revue Moderne et Naturaliste*, 1880, pp. 276–82; Larousse, XVII, pt. 3, p. 1363.

Fig. 103. Pastels, late 1870s. Left to right, top to bottom: L497, private collection; L644 (cat. no. 228); L585, Norton Simon Foundation, Pasadena; L572 (cat. no. 229); L575, private collection

which he tries, by means of art, to console us." A similar "spirit that while apparently detached, bantering, and lighthearted belies well-concealed passions" was seen to characterize the theatrical pieces, novels, and short stories of Degas's close friend Ludovic Halévy. Both men shared the same *parisianisme*, that apparently nonchalant "way of seeing things as a Parisian sees them."[37] However, by 1880 critics showed signs of tiring of Degas's use of dance subjects as its principal form of expression. Even his friend Philippe Burty was warning that Degas's "ironic spirit will diminish him, if he persists with his dance classes at the Opéra."

Degas's entries at the sixth group exhibition can be seen as a response to this growing criticism. Abandoning his customary "young dancers," Degas presented instead a vision of "la vie moderne" at once less amusing, more aggressively Naturalist, and more

provocative than any of his entries to date. The works that riveted critical attention included two pastels sharing the title *Criminal Physiognomy* (fig. 104) and the wax sculpture *The Little Fourteen-Year-Old Dancer* (fig. 105; see cat. no. 227). His delay in putting the latter on view proved strategic since it forced critics to concentrate on the criminal physiognomies that set the stage for the sculpture's later—and much anticipated—arrival.

The criminal physiognomies were immediately recognized as portraits of Émile Abadie and two members of his murderous gang, whose exploits, apprehension, and subsequent trials had been sensationalized in the French press since early 1879.[38] Initial reports of three particularly brutal murders—including that of a widow whose newsstand was close to Degas's apartment—had been followed by the arrest of Abadie and Pierre Gille and their confession to one of the crimes. The public's initial shock at finding the authors of vicious, premeditated murder to be mere teenagers—Abadie was nineteen, and Gille seventeen—swelled to indignation with the disclosure that Abadie's "gang" abided by regulatory "statutes"—a cold-blooded code of crime written in a style described in the press as "genre *L'Assommoir.*" This reference to Zola's novel was disconcertingly apt. Abadie and Gille had, it was revealed, hatched their plots in the wings of the Ambigu Theater while working as walkers-on in the dramatization of *L'Assommoir*, which had premiered on 19 January 1879 (with Halévy[39]—and possibly Degas—in the audience). Abadie, Gille, and the other gang members thus presented the public with a sobering, real-life parallel to Zola's study of vice spawned by the interaction of hereditary traits and environment.

Study of the criminal mind was topical, and consequently the trial that began in August attracted "men of science" as well as the simply curious. That month *La Nature* presented the latest scientific findings suggesting that Darwin's theory gave new meaning to Duranty's description of criminals as the "savages of the civilized world." Investigation had shown that large heads, low foreheads, and prominent jaws characterized equally the skulls of prehistoric man and most contemporary murderers; by inference, the latter could be considered "living anachronisms," less evolved beings born with ferocious instincts appropriate to life in man's distant past. Abadie fit this image of the "born" murderer: his dark complexion, large head, low forehead, powerful jaw, high cheekbones, and full lips presented the "bestial, repellent physiognomy." However, the fair-complexioned Gille, with his almost girlish bearing, was disconcertingly innocent-looking; properly dressed, he would appear the elegant "dandy." Thus, he seemed to exemplify a kind of criminality that was not inborn but rather the result of illness or other external forces.[40]

The death sentence they both received created a split in public opinion: the "humanitarian press" called for mercy, citing extreme youth and bad upbringing as extenuating circumstances; conservative critics believed the murderers were constitutionally unregenerate and so deplored the presidential pardon granted in November. Scarcely had the debate died down when eighteen-year-old Michel Knobloch stepped forward to confess to having carried out another of the murders of early 1879 with Abadie, and implicated both Gille and a young soldier, Paul Kirail. In August 1880, when Abadie, Kirail, and Knobloch were put on trial and Gille was called to give testimony, Degas was among the crowd of spectators that filled the courtroom; he made notebook sketches of the defendants[41] and witnessed firsthand Abadie's scandalous behavior. Protected now by French law from the death sentence, the unrepentant Abadie brought to the courtroom the same cynical contempt for authority that he had dared to display in memoirs that, along with those of Knobloch, appeared excerpted in the newspapers the day the proceedings began. Their stories were of a youth spent in the company of "hooligans" who frequented public balls and cafés-concerts like the one on cours de Vincennes, where Abadie had first met Knobloch. Though Knobloch repented, blaming the influence of "bad company," he was condemned to death (his sentence was later commuted); Abadie was returned to prison to serve out his original sentence; and Kirail began a life of forced labor.

The Abadie affair was controversial. Conservatives called for stricter measures to protect society from criminals; more socially conscious criminologists posed the trou-

38. Details of the affair have been culled from articles in *Paris-Journal*, *Le Monde Illustré*, *L'Univers Illustré*, *Le Journal Illustré*, and *Le Voleur Illustré*.
39. "Les carnets de Ludovic Halévy" (edited by Daniel Halévy), *Revue des Deux Mondes*, 37, 15 February 1937, p. 821.
40. Duranty, "Sur la physionomie," p. 499; Jacques Bertillon, "Fous ou criminels?" *La Nature*, 23 August 1879, pp. 186–87. Descriptions of Abadie and Gille from *Paris-Journal*, 31 August 1879, and *Le Voleur*, 5 September 1879.
41. Reff 1985, Notebook 33 (private collection, New York, pp. 5v–6, 7, 10v–11, 15v, 16).
42. Reviews by Auguste Dalligny, Gustave Geffroy, and Gustave Goetschy.
43. Reviews by Comtesse Louise, Charles Ephrussi, and Paul Mantz.
44. Duranty, "Le Salon de 1874," p. 210; Huysmans, 1881 review.

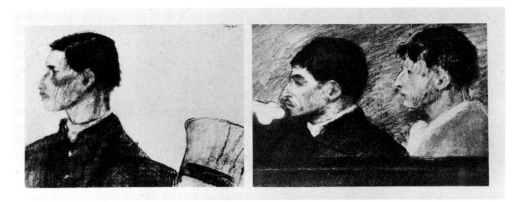

Fig. 104. *Criminal Physiognomy*, 1880. Pastels bearing the same title. Left: L638, 25¼ × 29⅞ in. (64 × 76 cm). Right: L639, 18⅞ × 24¾ in. (48 × 63 cm). Location unknown. Exhibited at the sixth Impressionist exhibition, 1881

bling question of how to stem "the early corruption of children thrown upon the dangerous streets of Paris." Degas's portraits allude to these tensions, while maintaining an appearance of detachment. He presents the criminals in strict profile, thus providing the maximum physiognomical information. Yet by introducing the tilted high hat into Abadie's portrait (fig. 104, L638), Degas suggests not only the gang leader's pride but the sometimes comic aspect of the court proceedings as well. Similarly, while the critics, struck by the "terrifying realism" of Degas's portrayals, commended the "singular physiologic soundness" with which he captured the "stains of vice" etched on "these animalistic foreheads and jaws," only the portraits of Abadie and the "sneaky" Kirail (fig. 104, L639, left) in fact conform strictly to the atavistic criminal stereotype.[42] And though some identified the third figure (fig. 104, L639, right) as Knobloch, his more regular features, blond coloring, and slightly feminine mien suggest—as Gustave Goetschy asserted— that Degas in fact depicted the innocent-looking Gille, emphasizing his distinction from the others coloristically. In so doing, Degas introduced the controversy into his portrait of modern crime; for if the others came to murder naturally, Gille's criminality laid greater responsibility on the doorstep of society.

Degas's portraits, like the trial, stripped away the attractive veneer of the popular theater and the café-concert to reveal their more sinister underside as a breeding ground for vice. The portraits thus underlined similar tensions in *The Little Fourteen-Year-Old Dancer*, which appeared halfway through the exhibition's run. Few reviewers shared Nina de Villard's discovery of the promise of beauty in the girl's features or her optimism regarding the eventual grace to emerge from the "cruel" discipline of her profession. Rather, the majority instantly recognized in the little dancer a kind of sister to Abadie, "a little Nana" who also inhabited the world of *L'Assommoir*. In her features, they read clearly "printed" signs of a "stock of evil instincts and vicious tendencies," a congenital predisposition to bestiality. Burdened by this heredity, her moral destiny seemed inevitable given her environment. Paul Mantz predicted that the "despicable promises" of vice in her face would soon flourish "on the espaliers of the theater."[43] Ironically, the very profession that would discipline and give physical grace to this yet unformed creature would also nourish all that was least disciplined and most unattractive in her. She thus embodied ambiguous potential, a physical and moral tension of which she seemed touchingly unaware in the innocence of her youth.

In his portraits of the criminals Degas subtly underscored the suggestion of uneasiness with modern life through his use of pastel: he portrayed contemporary "fleurs du mal" with the medium Quentin de La Tour had employed to depict the flower of the Ancien Régime. Degas's choice of medium for the dancer had even greater metaphoric resonance. Sculpture was, in the eyes of Duranty, Huysmans, and other Realist critics, the art form most inhibited by traditional materials.[44] Working with unorthodox substances—wax, clothing, and hair—Degas achieved an illusionism that was at once

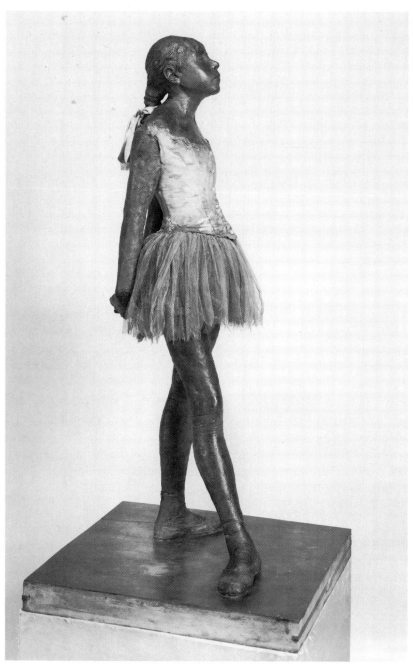

Fig. 105. *The Little Fourteen-Year-Old Dancer* (RXX), 1879–81. Wax, cotton skirt, satin hair ribbon, hair now covered with wax, height 37½ in. (95.2 cm). Collection of Mr. and Mrs. Paul Mellon, Upperville, Va.

frighteningly real and resolutely modern. While Huysmans's review linked Degas's technical innovations to an earlier tradition of religious sculpture, others detected a more immediate source of inspiration. From the insults heaped on *The Little Fourteen-Year-Old Dancer*, it is clear that the critics linked Degas's sculpture to the wax mannequins used in ethnographic displays such as those in the enormous and highly publicized ethnographic exhibition that had opened at the Palais de l'Industrie in February 1878. Incorporated in ambitious reconstructions such as the popular "ancient Peruvian habitation," these mannequins in native costume had drawn Duranty's criticism for being mere dolls, unconvincing in their gestures and untrue to national type.[45] Acknowledged, by contrast, as a serious "work of science," the *Dancer* too appeared to be a kind of ethnographic model. But as a "specimen" of French culture, the *Dancer* was clearly offensive. The point of Élie de Mont's complaint that she took after a "monkey, an Aztec"

45. Edmond Duranty, "Exposition des missions scientifiques," *La Chronique des Arts et de la Curiosité*, 23 February 1878, pp. 58–59.
46. Review of 19 April 1881.
47. "Les carnets de Ludovic Halévy" (edited by Daniel Halévy), *Revue des Deux Mondes*, 43, 15 January 1938, p. 398 (entry for 1 January 1882).

was elucidated in Henry Trianon's advice that in future Degas apply Darwinian evolutionary theory to aesthetic selection, choosing the best and most beautiful over the ugliest and least evolved. It was insulting to see the *Dancer* as a reflection of modern life. Trianon noted that she belonged in a museum of zoology, anthropology, or physiology rather than in an art gallery. De Mont wanted to see her pickled in a jar of alcohol, and the Comtesse Louise suggested that she be moved to the Musée Dupuytren, where examples of human pathology were exhibited.

Together *The Little Fourteen-Year-Old Dancer* and the studies of *Criminal Physiognomy* presented a rather bleak picture of contemporary French society. The perceptive young Gustave Geffroy regarded them as the work of a "philosopher" captivated by the tensions between the "deceptive exterior and the underside of Parisian life."[46] Even the less sympathetic Mantz conceded that they embodied an "instructive ugliness" that could be regarded as the "intellectual result" of Realism in the hands of a "moralist."

The 1881 group exhibition constituted the high-water mark of Degas's Realism. At the year's end his friend Halévy would finish a new novel, *L'abbé Constantin*, that deviated from his previous work in its undiluted optimism and that marked, he wrote, a "movement in the direction of duty and decency." Degas was indignant at this shift, "disgusted" by "so much virtue"; the painter would condemn him, Halévy confided to his journal, to forever create "things like *Madame Cardinal*, dry little things, satiric, irreverent, ironic, without heart or feeling."[47] Degas was not to change course so abruptly, nor would he ever follow his friend's lead. Nevertheless, over the course of the coming years he too gradually withdrew from the Realist world of the "famille Cardinal." Turning his attention away from the keen observation of Parisian life, Degas would seek to realize a vision which, though superficially related in subject to his work of the 1870s, was more intensely personal and introspective.

Chronology II: 1873–1881

1873

Dated works (after Degas's return from New Orleans): *Dancer Adjusting Her Slipper* (L325, essence, perhaps inscribed later); *Dancer* (III:156.1, pencil, Museum Boymans-van-Beuningen, certainly inscribed later).

by 9 April

Degas receives a payment of Fr 1,000 from Durand-Ruel. His uncle Eugène Musson writes from Paris to New Orleans: "Edgar has come back to us, enchanted by his voyage. . . . He is, as you say, a likable boy and one who will become a very great painter if God preserves his sight and puts a bit more lead in his head." In a letter to Tissot, Degas writes that he has abandoned his proposed participation at the Salon and that he is planning a visit to London.

> Journal, Durand-Ruel archives, Paris; Lemoisne [1946–49], I, p. 81; letter to Tissot, Bibliothèque Nationale, Paris; Degas Letters 1947, no. 7, p. 34.

Auguste De Gas sells his Italian assets to his brothers Henri and Achille in Naples, but retains his firm in Paris.

> Boggs 1963, p. 274.

25 April–7 May

Ernest Hoschédé, a collector, buys *The False Start* (fig. 69) from Durand-Ruel (stock no. 1121). The baritone Jean-Baptiste Faure acquires *At the Races in the Countryside* (cat. no. 95) and two racing scenes through Charles W. Deschamps, the manager of Durand-Ruel's gallery in London (stock nos. 1910, 1332, 2673). Encouraged by these sales, Deschamps exhibits three other works by Degas at Durand-Ruel's London branch.

> Journal, Durand-Ruel archives, Paris; exhibition catalogue cited in Flint 1984, p. 358.

14 June

Durand-Ruel buys from Degas *Orchestra Musicians* (cat. no. 98) and *Woman Ironing* (cat. no. 122) for a total of Fr 3,200 (stock nos. 3102, 3132). These are his last purchases from the artist during this period. Owing to an economic recession, Durand-Ruel is forced to abandon his support of the Impressionist group. As a result, Degas turns to Deschamps as his principal dealer for the two years to follow.

> Journal, Durand-Ruel archives, Paris (*brouillard* lists as 6 June).

28–29 October

During the night, the old Opéra on rue Le Peletier is destroyed by fire.

Degas meets Jean-Baptiste Faure, who commissions *The Dance Class* (cat. no. 130).

November

Auguste De Gas leaves for Naples, but is taken ill along the way. Degas joins him in Turin. In early December he writes to Faure from Turin: "Here I am in Turin, where an ill wind has brought me. My father was en route to Naples when he fell ill here. . . . I'm the one who had to leave immediately to look after him, and now I find myself tied down for some time to come, far from my painting, and my life, in the middle of Piedmont. I was anxious to finish your painting and to make your 'bagatelle.' [Arthur] Stevens was waiting for his two pictures. I wrote to him yesterday and I am writing to you today, hoping you will both forgive me." He returns to Paris by 8 December.

> Lettres Degas 1945, V, pp. 31–33; Degas Letters 1947, no. 10, pp. 36–37 (translation revised).

16 December

Degas buys Pissarro's "Terrains labourés près d'Osny" from Durand-Ruel.

> Journal, Durand-Ruel archives, Paris.

27 December

With Monet, Pissarro, Sisley, Morisot, Cézanne, and others, Degas forms the Société Anonyme Coopérative à Capital Variable des Artistes Peintres, Sculpteurs, Graveurs, etc. (the Société Anonyme des Artistes), devoted to free, nonjuried exhibitions, the sale of the works exhibited, and the publication of an art journal.

1874

Dated work: *Dancers Resting* (fig. 122).

12 February

Degas is visited at 77 rue Blanche by Edmond de Goncourt, who notes the next day in his journal: "Yesterday I spent my afternoon in the atelier of a strange painter named Degas. After many attempts, experiments, and thrusts in every direction, he has fallen in love with modern subjects and has set his heart on laundry girls and danseuses. I cannot find his choice bad. . . . This Degas is an original fellow, sickly, neurotic, and afflicted with eye trouble to the point of being afraid of going blind, but for those very reasons he is an excessively sensitive person who reacts strongly to the true character of things. Of all the men I have seen engaged in depicting modern life, he is the one who has most successfully rendered the inner nature of that life. One wonders, however, whether he will ever produce something really complete. I doubt it. He seems to have a very restless mind."

> Journal Goncourt 1956, II, pp. 967–68 (translation McMullen 1984, pp. 241–42).

16 February

Faure buys *Racehorses before the Stands* (cat. no. 68) from Durand-Ruel (stock no. 507/2052). Dissatisfied with six of his pictures owned by Durand-Ruel, Degas asks Faure to purchase them on his behalf, a transaction that takes place on 5 or 6 March. In exchange, Degas agrees to paint a number of works for Faure, who additionally commissions a few more.

> Journal, Durand-Ruel archives, Paris; Lettres Degas 1945, V, pp. 31–32 n. 1; Degas Letters 1947, "Annotations," no. 10, p. 261.

23 February

Death of Auguste De Gas in Naples. He leaves as his estate the firm in Paris, which subsists on credit.

> Rewald 1946 GBA, p. 121; Raimondi 1958, pp. 116, 263.

March

Degas recruits participants for the first exhibition of the Société Anonyme des Artistes. In a letter to Tissot, he writes: "I am getting really worked up and am running the thing with energy and, I think, a certain success. . . . The Realist movement no longer needs to fight with the others. It already *is*, it *exists*, it must show itself as *something distinct*, there must be a *salon of Realists*." Bracquemond (recruited by the critic Philippe Burty), Rouart, De Nittis, and Levert agree to join the group; Legros and Tissot refuse.

> Letter to Tissot, Bibliothèque Nationale, Paris; Degas Letters 1947, no. 12, pp. 38–39.

4 April

The partition of the movable effects of Auguste De Gas takes place at 10:00 A.M. at 4 rue de Mondovi. The property is divided equally among his five children. Present are the artist, his brother Achille, and their brother-in-law Henri Fevre. Thérèse Morbilli, in Naples, and René De Gas, in New Orleans, are represented by a notary. The total value of the inventoried effects amounts to Fr 4,918, less than the price paid by Faure for *The Dance Class* (cat. no. 130).

> Notarized inventory, private collection, Paris.

15 April

Opening of the *Première exposition* of the Société Anonyme des Artistes, at 35 boulevard des Capucines. Fewer than two hundred visitors are present at the opening. Degas exhibits ten works, of which

only three are for sale; the other seven are loans from Faure, Brandon, Mulbacher, and Rouart.

> 1986 Washington, D.C., pp. 93, 106.

April–June

Degas's work receives hostile reviews from Louis Leroy and Émile Cardon, but other critics, such as Philippe Burty (a friend), Ernest d'Hervilly, Armand Silvestre, and Jules-Antoine Castagnary, are laudatory. Jules Claretie writes in *L'Indépendance Belge*: "The most remarkable of these painters is M. Degas." This marks the beginning of a trend that will place the artist in an awkward position as regards his associates.

> [Philippe Burty], *La République Française*, 16 and 25 April 1874; E. d'H. [Ernest d'Hervilly], *Le Rappel*, 17 April 1874; Armand Silvestre, *L'Opinion Nationale*, 22 April 1874; [Jules-Antoine] Castagnary, *Le Siècle*, 29 April 1874; Ariste [Jules Claretie], *L'Indépendance Belge*, 13 June 1874; see 1986 Washington, D.C., p. 490.

15 May

The exhibition, plagued by bad press, poor attendance, and lack of sales, closes amid general disappointment. The Société Anonyme des Artistes is dissolved.

summer

Ballet Scene (L425, Courtauld Institute Galleries, London) is exhibited by Deschamps in London.

> Pickvance 1963, p. 263; Flint 1984, p. 359.

1875

Dated works: *Jules Perrot* (cat. no. 133); *Woman on a Sofa* (cat. no. 140).

28 February

Death of the artist's uncle Achille Degas. Degas travels to Naples for the funeral.

> Raimondi 1958, p. 116.

March

Achille Degas's will (dated 5 April) is probated in Naples. His brother Henri and their niece Lucie are left the movable property. Edgar and his brother Achille inherit the immovables, including a share of the Palazzo Degas and of the villa at San Rocco di Capodimonte, but the property cannot be divided or liquidated until the majority of Lucie Degas and until debts and annual life pensions are paid. (The estate will finally be settled only in 1909.)

> Boggs 1963, p. 275; will of Achille Degas, Archivio Notarile, Naples, L. Cortelli, notary, 1875, fol. 26; see cat. no. 145.

23 March

The painter Marco De Gregorio writes from Naples to Telemaco Signorini in Florence: "These last days I was visited by De Gas. . . . He will visit you when passing through Florence toward the end of the month. He is extremely enthusiastic about the Realist exhibition scheduled this year in Paris and has invited us to participate in the one planned for next year. . . . He appeared to me as an immensely perceptive and serious man; in the midst of all this, the fact that he is rich must help him considerably."

> Pietro Dini, *Diego Martelli*, Florence: Il Torchio, 1978, p. 150.

13 April

In a letter to De Nittis, then in London, the artist Marcellin Desboutin writes: "What is Degas up to? Nobody, not even his brother, has any news of him. Some say he is still in Naples, others claim he is at the festivities in Venice, your wife imagines he may be in London. . . . In any case, he has not gone through Florence yet. He had a letter addressed to my daughter there, but the day before yesterday I heard from Marie and she had not seen him at all!" Following his stay in Florence, Degas in fact stops in Pisa and Genoa.

> Pittaluga and Piceni 1963, pp. 353–54; Reff 1985, Notebook 26 (BN, Carnet 7, pp. 73, 79).

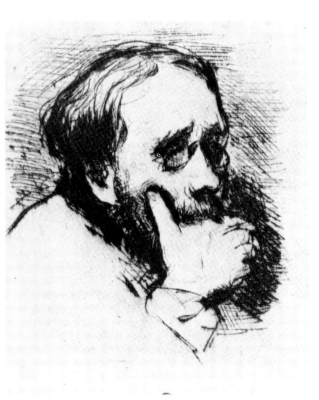

Fig. 106. Marcellin Desboutin, *Degas Reading*, engraved at Giuseppe De Nittis's 24 February 1875. Drypoint, 5¾ × 3⅝ in. (14.4 × 9 cm). Bibliothèque Nationale, Paris

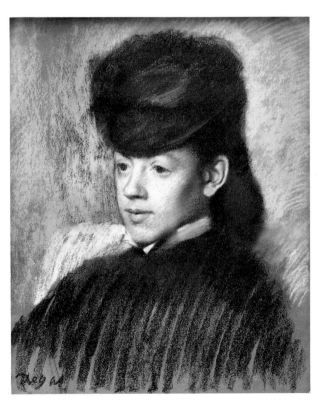

Fig. 107. *Mlle Malo (Mlle Mallot?)* (L444), c. 1875. Pastel, 20⅝ × 15¾ in. (52.2 × 41.1 cm). The Barber Institute of Fine Arts, The University of Birmingham

7 July

Degas writes to Thérèse Morbilli about conflicts in the Degas family in Naples and tells her that he is planning a holiday in Touraine.

Unpublished letter, National Gallery of Canada, Ottawa.

3 August

Informs Tissot of his plan to visit London briefly.

Letter, Bibliothèque Nationale, Paris; Degas Letters 1947, no. 15, p. 42.

19 August

Achille De Gas is attacked in front of the Bourse in Paris by Victor-Georges Legrand, the husband of Achille's former mistress, Thérèse Mallot. Achille fires a revolver twice, slightly wounding Legrand. On 24 September he is sentenced to six months in prison. On 20 November the sentence is commuted to one month in prison and payment of a fine of Fr 50.

Trial records, Archives, City of Paris; *Le Temps*, 26 September 1876.

autumn

The Rehearsal before the Ballet (L362, private collection) is shown at Deschamps's gallery in London.

Pickvance 1963, p. 265.

10 December

The question of Auguste De Gas's estate and his firm's large debts becomes pressing. The artist's uncle Henri Musson writes from Paris to New Orleans requesting that René De Gas repay the loan he received from the firm in 1872.

Rewald 1946 GBA, p. 121.

end of 1875

Members of the dissolved Société Anonyme des Artistes plan a second exhibition to be held in the spring of 1876.

1876

30 March

Opening of the *2e Exposition de peinture*, at Galerie Durand-Ruel, 11 rue Le Peletier. The exhibition catalogue lists twenty-two works by Degas, nearly all for sale. *The Absinthe Drinker* (cat. no. 172), listed as "Dans un café" and apparently not exhibited, is sent to London where Deschamps sells it to Henry Hill, a collector from Brighton. Evidently prompted by the need to sell as many works as possible, Degas also shows with his paintings photographs of works not in the exhibition.

Ronald Pickvance, "'L'absinthe' in England," *Apollo*, LXXVII:15, May 1963, pp. 395–96; Georges Rivière, *L'Esprit Moderne*, 13 April 1876.

April

The press is generally divided about Degas's selection, with Arthur Baignères calling him "the pontiff, I think, of the sect of intransigent Impressionists." There are, nevertheless, good reviews from Silvestre, Huysmans, Alexandre Pothey, Pierre Dax, and others.

Alexandre Pothey, *La Presse*, 31 March 1876; Armand Silvestre, *L'Opinion Nationale*, 2 April 1876; Arthur Baignères, *L'Écho Universel*, 13 April 1876; Pierre Dax, *L'Artiste*, 1 May 1876; Joris-Karl Huysmans, *Gazette des Amateurs*, 1876; see 1986 Washington, D.C., pp. 490–91.

In London, Deschamps exhibits four dance pictures (see cat. nos. 106, 124, 128, 129), all of which are bought by Hill. Again Deschamps also shows photographs of other works by Degas.

Pickvance 1963, p. 265 n. 82.

20 April

Degas moves from 77 rue Blanche. Desboutin writes to Mme De Nittis: "The very day before he would have been tossed out on the street, he managed (a truly lucky man) to find a more marvelous apartment and studio than anyone could have dreamed up for him, had they made a pattern based on the shape of his brain and the nature of his habits. There is a glass roof, as in a photographer's studio, perched above a small two-storey house. The view from up there would astound anybody, from the tight-laced bourgeois to

the Intransigents, the dancers or laundresses. . . . All this on my doorstep, between rue de Laval and place Pigalle, at 4 rue Frochot."

Pittaluga and Piceni 1963, pp. 357–58.

15 May

Degas informs Deschamps that he is sending him *Dancers Preparing for the Ballet* (fig. 109), advising great caution in the handling and varnishing of his recently completed works and requesting with desperate urgency Fr 7,000 owed to him.

Reff 1968, p. 90.

1 June

After receiving Fr 2,500, Degas thanks Deschamps, offers him *Portraits in an Office (New Orleans)* (cat. no. 115) and other works for sale, and tells him that the De Gas firm in Paris is to be liquidated. "You will be receiving my *Cotton* and a few small items that you must be sure to sell for me. . . . It will be necessary not only to proceed with our liquidation but also to earn enough money to get through the summer. . . . I have been quite shaken by the poor weather, but I hope that more moderate temperatures will soon arrive and that my sight will stabilize somewhat. What anguish I am experiencing again for my life and for my beloved art, which I will lose should the illness take the slightest turn for the worse. A hellish adventure! . . . I will soon be traveling to London with a small case of works."

Unpublished letter, Durand-Ruel archives, Paris.

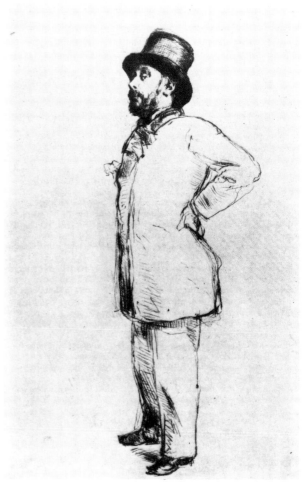

Fig. 108. Marcellin Desboutin, *Edgar Degas*, also called *Degas in a Hat*, 1876. Drypoint, 8¾ × 5¾ in. (22.8 × 14.5 cm). Bibliothèque Nationale, Paris

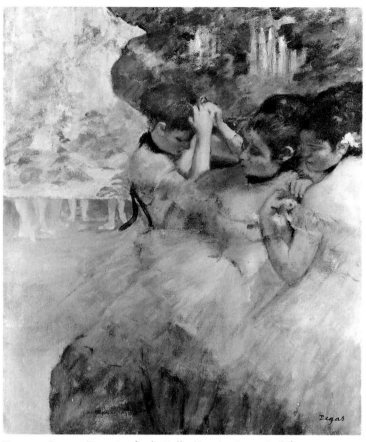

Fig. 109. *Dancers Preparing for the Ballet* (L512), 1875–76. Oil on canvas, 30 × 23⅜ in. (73.5 × 59.5 cm). The Art Institute of Chicago

June

Visits Naples with his brother Achille in a last attempt to raise funds from creditors. From Naples he appeals to Deschamps on 16 June for the money still owed to him. "Oh, the time one must spend on things other than one's livelihood, taking humiliating steps, attending interminable discussions that one cannot even understand, in order to defend one's name in matters of bankruptcy! I am now in Naples with my brother Achille to obtain our Neapolitan creditors' signature on a settlement that has been dragging on for six months. . . . Have ready, my dear Deschamps, the 4,500 francs that you still owe to me. Insure that I may *have them without fail* no later than a week after my return to Paris. . . . And my *Cotton*? Do your best *to set a price* for me, even if lower than the one I mentioned before. I need money, and I can't fuss over this any more. *And time presses more than ever.*" Degas returns to Paris at the end of the month.

Unpublished letter, Durand-Ruel archives, Paris.

4 July

The critic Jules Claretie writes to Mme De Nittis: "It so happens I met Degas yesterday, just back from Naples and going to the Gare de l'Est to wait for his brother, who is returning from some place or other. He told me about a new technique for engraving he had discovered! I told him what I thought of these useless little outbursts of vanity. I am going to write to Rossano."

Pittaluga and Piceni 1963, p. 339.

17 July

Degas is evidently very active producing monotypes and prints.

Letter from Desboutin to Mme De Nittis, in Pittaluga and Piceni 1963, p. 359; see "The First Monotypes," p. 257.

28 August

After a visit to Paris, René De Gas leaves for New Orleans, his debt still unpaid. On 31 August, Achille De Gas notifies Michel Musson in New Orleans that the bank has finally been closed and that René's failure to repay the loan has forced him, Edgar, and Marguerite to live on a bare subsistence in order to honor the bank's debts.

Rewald 1946 GBA, p. 122.

30 September

The poet Stéphane Mallarmé includes a flattering account of Degas in his article "The Impressionists and Édouard Manet," published in London.

Stéphane Mallarmé, "The Impressionists and Édouard Manet" (translated by George T. Robinson), *Art Monthly Review and Photographic Portfolio*, I:9, 30 September 1876, pp. 117–22.

1877

January

After two unsuccessful attempts, Degas has a work accepted at the annual Salon of the Société Béarnaise des Amis des Arts at Pau. He produces an etching for the catalogue (RS24).

Reed and Shapiro 1984–85, no. 24, p. 68.

Judgment is rendered in favor of the Banque d'Anvers, committing Degas and Henri Fevre to pay a total of Fr 40,000 in monthly installments.

Rewald 1946 GBA, pp. 122–23.

Fig. 110. *Woman Standing in the Street* (J216), 1876–77. Monotype, plate 6⅜ × 4⅝ in. (16 × 11.8 cm). Cabinet des Dessins, Musée du Louvre (Orsay), Paris (RF30020)

March

Degas writes to Faure reiterating his intention to finish his commissions as soon as he is relieved of his unending financial troubles. Plans for a third group exhibition are at an advanced state.

Lettres Degas 1945, XII, p. 40; Degas Letters 1947, no. 20, pp. 45–46.

4 April

Opening of the *3e Exposition de peinture*, at 6 rue Le Peletier. Degas exhibits three groups of monotypes and some twenty-three paintings and pastels that include café-concert scenes, *In a Café (The Absinthe Drinker)* (cat. no. 172; not listed in the 1877 catalogue), and *Mme Gaujelin* (fig. 25), prominently displayed on an easel.

Frédéric Chevalier, *L'Artiste*, 1 May 1877, pp. 329–33; Claretie 1877; see 1986 Washington, D.C., p. 492.

April

Although Georges Lafenestre and Charles Maillard publish unfavorable reviews, several critics praise the café-concert scenes and Claretie compares Degas's monotypes to Goya's. Claretie writes to De Nittis: "I saw the Impressionist exhibition. Degas shone. The rest is mad, truly mad and ugly." While Degas's realism is admired by many, Paul Mantz calls him "a cruel painter," but adds perceptively: "It is not exactly clear why M. Edgar Degas includes himself among the Impressionists. He has a distinct personality and stands apart in this group of would-be innovators." The same observation is also made, spitefully, by Charles-Albert d'Arnoux [Bertall]: "He has reserved a small chapel for himself, setting up his own separate altar, with its enthusiasts and its faithful. . . . Surely before long, like the high priest Manet, he will move on to opportunism and the Salon."

Pittaluga and Piceni 1963, p. 344, letter of 11 April; Paul Mantz, *Le Temps*, 22 April 1877; Bertall, *Paris-Journal*, 9 April 1877; see 1986 Washington, D.C., pp. 491–92.

21 May

In a letter to Mme De Nittis, Degas complains about his eyesight and about the behavior of Deschamps, from whom he has requested the return of *Portraits in an Office (New Orleans)* (cat. no. 115); he mentions the possibility of a two-day visit to London. He also gives her news of the Impressionist exhibition: "Our exhibition on rue Le Peletier went quite well. We covered our costs and made about sixty francs in twenty-five days. I had a small room all to myself, full of my wares. I sold only one, unfortunately. I am negotiating to sell that old oil portrait of a woman with a cashmere shawl on her knees [i.e., *Mme Gaujelin*, fig. 25]." In a somewhat uncharacteristic aside— Mme De Nittis not being among his closest friends—he tells her: "Living alone, without a family, is really too hard. I never would have suspected it would cause me so much suffering. Here I am now, getting old, in poor health, and almost penniless. I've really made a mess of my life on this earth."

Pittaluga and Piceni 1963, pp. 368–69.

August

Toward the end of the month, Degas visits the Valpinçons at Ménil-Hubert.

1 September

From Ménil-Hubert, he writes to Ludovic Halévy volunteering to help him with his comedy *La Cigale*, which features a fictitious "intentionist" painter (based partly on Degas) and his model, a laundress. *La Cigale* opens on 6 October at the Variétés.

Lettres Degas 1945, XIII bis, pp. 41–42; Degas Letters 1947, no. 22, pp. 46–47.

September

Having returned from Ménil-Hubert, Degas plans a trip to Fontainebleau with the painter Louis-Alphonse Maureau. Plans are cancelled, however, when Maureau has a severe attack of arthritis. At the same time, Degas's lease on his apartment on rue Frochot is due to expire. He writes to Halévy: "I am scouring the neighborhood.

Fig. 111. Study for *Mlle La La at the Cirque Fernando* (IV:255.a), dated 1879. Black chalk and pastel, 18½ × 12½ in. (47 × 31.8 cm). The Barber Institute of Fine Arts, The University of Birmingham

Where will Sabine and I lay our heads? I can't find anything decent." And, again: "I am looking in vain for a lodging for October." (Sabine Neyt was Degas's housekeeper.)

Unpublished letters to Ludovic Halévy, Bibliothèque de l'Institut, Paris.

16 September

Accompanied by Claretie, he visits the Neapolitan painter Federico Rossano. Following the visit, Claretie observes in a letter to De Nittis, "Degas seems to me to have calmed down."

Pittaluga and Piceni 1963, p. 347, letter of 21 September.

October

By the end of the month Degas has rented an apartment at 50 rue Lepic.

1878

January

The Société Béarnaise des Amis des Arts at Pau exhibits *Portraits in an Office (New Orleans)* (cat. no. 115).

February

Louisine Elder, the friend of Mary Cassatt who would later marry Henry Osborne Havemeyer and with him become a generous collector of the work of Degas, lends *Ballet Rehearsal* (fig. 130) to the

Eleventh Annual Exhibition of the American Water-color Society in New York; it is the first work by Degas to be exhibited in North America.

March

Probably through the intercession of Degas's friend Alphonse Cherfils, the Musée de Pau acquires *Portraits in an Office (New Orleans)*, the artist's first work to enter a public collection. On 19 March, in a telegram to the curator of the museum, Charles Lecoeur, Degas accepts the offer of a payment of Fr 2,000.

> Unpublished telegram to Lecoeur, Musée des Beaux-Arts, Pau. See cat. no. 115.

13 April

René De Gas deserts his family in New Orleans; he will later settle in New York. René's action results in a breach between him and Edgar that will take years to heal. The artist's unforgiving attitude offends his brother-in-law Edmondo Morbilli.

> Rewald 1946 GBA, pp. 124–25; Boggs 1963, p. 276.

15 October

Dr. Étienne Jules Marey (1830–1904), professor of natural history at the University of Paris, publishes "Moteurs animés: expériences de physiologie graphique" in *La Nature*. On 4 December, Gaston Tissandier presents a discussion of Muybridge's photographs ("Les allures du cheval") in the same publication. An entry in Degas's notebook from this period mentions *La Nature*.

> Reff 1985, Notebook 31 (BN, Carnet 23, p. 81).

December

Degas dates a study of a dancer (II:230.1, private collection, Paris).

1879

January

Degas attends performances at the Cirque Fernando, where he makes several studies for *Mlle La La* (fig. 98).

> Dated drawings: L525, 19 January (J. B. Speed Art Museum, Louisville); L524, 21 January; L523, 24 January (Tate Gallery, London); IV:255.a, 25 January (fig. 111).

March

Degas is active preparing the fourth group exhibition. His notebook contains ground plans of the rooms, projects for a poster, and lists of prospective artists.

> Reff 1985, Notebook 31 (BN, Carnet 23, pp. 33, 54, 64, 65 [plans], 39, 56, 58, 59 [poster], 92, 93 [artists]).

Adolf Menzel's *Supper at the Ball* (fig. 112), painted the previous year, is exhibited in Paris by Goupil et Cie. Both Degas and Duranty are very enthusiastic about it, but their admiration is not shared by Pissarro and Mary Cassatt. Degas makes a sketch and an oil copy from memory (fig. 113), while Duranty prepares a major article on Menzel, his last published work.

> Reff 1977, pp. 26–27; Reff 1985, Notebook 31 (BN, Carnet 23, p. 47); Lettres Pissarro 1980, no. 188, pp. 249–50; Edmond Duranty, "Adolphe Menzel," *Gazette des Beaux-Arts*, XXI:3, March 1880, pp. 201–17, XXII:2, August 1880, pp. 105–24.

3 March

Degas dates a portrait of Duranty (L518, private collection, Washington, D.C.).

3 April

Degas dates a portrait of Diego Martelli (fig. 147).

10 April

Opening of the *4me Exposition de peinture*, at 28 avenue de l'Opéra. Degas exhibits a group of twenty paintings and pastels as well as five fans.

April–June

The chorus of praise for his work is led by Alfred de Lostalot, who writes: "The honors fall, as always, to M. Degas . . . one of the few artists of our time whose works will endure." Conservative critics, however, are still perturbed by his unorthodox technique. Henry Havard notes perceptively: "His brain seems to be a furnace in which seethes a whole new kind of painting, as yet unborn." Disappointed by Degas's loyalty to the Impressionists, Bertall persists in baiting him: "We are inclined to think that M. Degas is feigning insanity. Isn't his independence leading him to sacrifice everything for love or friendship? In any case, M. Degas is making a name for himself that is heard everywhere. Perhaps one day, when he has become an opportunist, he will aim at chairing some group at the Institute."

> Henry Havard, *Le Siècle*, 27 April 1879; Bertall, *L'Artiste*, 1 June 1879, p. 398; see 1986 Washington, D.C., pp. 492–93.

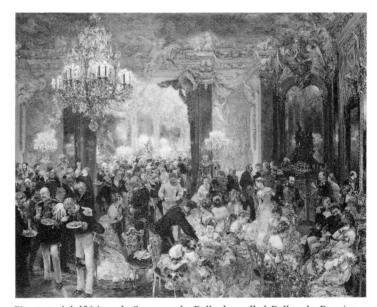

Fig. 112. Adolf Menzel, *Supper at the Ball*, also called *Ball at the Prussian Court*, 1878. Oil on canvas, 28 × 36 in. (71 × 90 cm). Nationalgalerie, Berlin

Fig. 113. *Supper at the Ball*, after Adolf Menzel (L190), 1879. Oil on panel, 18 × 26⅛ in. (45.5 × 66.5 cm). Musée d'Art Moderne, Strasbourg

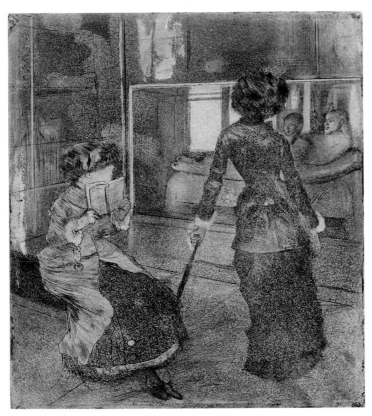

Fig. 114. *Mary Cassatt at the Louvre: The Etruscan Gallery* (RS51), 1879–80. Etching, aquatint, and drypoint, ninth state, 10½ × 9⅝ in. (26.7 × 24.5 cm). Cabinet des Dessins, Musée du Louvre (Orsay), Paris (RF4046D)

22–24 April

Two young men, Émile Abadie, a baker, and Pierre Gille, a florist, are arrested along with three accomplices for the murder of a woman in Montreuil. Under the headline "Moralité du théâtre naturaliste," *L'Événement* sarcastically points out that the two had acted as extras in *L'Assommoir* by Zola. The trial takes place in August 1879. Abadie and Gille are sentenced to death, but the sentence is commuted. After the conclusion of the trial, another accomplice, Michel Knobloch, confesses to having participated with Abadie and Paul Kirail in a different murder, and the case is reopened.

> Records of the Cour d'Appel de Paris, Archives de Paris, D.2V⁸89; Pierre Larousse, *Grand dictionnaire universel du XIXe siècle*, Paris, n.d., XVII (2nd supp.), pp. 4–5, under "Abadie, Gilles [sic], Knobloch, Kirail"; Émile Zola, *Correspondance* (general editor, B. H. Bakker), III, Montreal: Presses de l'Université de Montréal/Paris: Éditions du Centre National de la Recherche Scientifique, 1982, p. 318.

May

The second edition of *Le coffret de santal* by Charles Cros, with a poem—"Six tercets"—dedicated to Degas, is published.

11 May

In a letter to Félix Bracquemond, Degas mentions visits to printers and discussions about the publication of *Le Jour et la Nuit*, a journal that was to have been devoted to the graphic production of members of the Société Anonyme des Artistes.

> Lettres Degas 1945, XVIII, pp. 45–46; Degas Letters 1947, no. 27, pp. 50–51.

20 June

Henri Degas, the artist's last surviving uncle, dies in Naples. His share of the Neapolitan estate is inherited by Lucie Degas.

> Raimondi 1958, p. 117.

1880

Dated works: *The Violinist* (BR99, pastel, private collection, Zurich); *Fan: The Café-concert Singer* (cat. no. 211).

24 January

Le Gaulois announces the first issue of *Le Jour et la Nuit*, due to appear on 1 February, with prints by Degas, Mary Cassatt, Caillebotte, Pissarro, Jean-Louis Forain, Bracquemond, Jean-François Raffaëlli, and Rouart: "Initially, *Le Jour et la Nuit* will not appear at set intervals. Its price will vary between five and twenty francs, depending on the number of works that it contains. . . . The profits or losses will be divided among or sustained by the publication's contributors." However, *Le Jour et la Nuit* is not published.

> Tout-Paris [pseud.], "La journée parisienne: impressions d'un impressionniste," *Le Gaulois*, 24 January 1880; Charles F. Stuckey, "Recent Degas Publications," *Burlington Magazine*, CXXVII:988, July 1985, p. 466.

March

Degas and Caillebotte argue over the poster for the fifth group exhibition. Degas asks that it not list the names of the participating artists. In a letter to Bracquemond, he writes: "I had to give in to him and let them appear. When will we stop playing at being stars?"

> Lettres Degas 1945, XXIV, pp. 51–52; Degas Letters 1947, no. 33, p. 55 (translation revised).

1 April

Opening of the *5me Exposition de peinture*, at 10 rue des Pyramides. The catalogue lists for Degas eight paintings and pastels, two groups of drawings, a group of prints, and a sculpture, *The Little Fourteen-Year-Old Dancer* (see figs. 158–160), but his section of the exhibition is incomplete at the time of the opening. Some of the missing

Fig. 115. Jean-Louis Forain, *On the Lookout for a Star (Portrait of Degas)*, c. 1880. Pencil, 6¾ × 4 in. (17.2 × 10.2 cm). Collection of Mme Chagnaud-Forain, Paris

works are installed later, but *The Little Fourteen-Year-Old Dancer* and *Young Spartans* (cat. no. 40) are not shown at all.

April
Generally favorable reviews are led by Huysmans's admirable long notice (later reprinted in *L'art moderne*) and by Silvestre's perfunctory declaration: "As in previous years, Degas remains the incontestable and uncontested master. . . . Everything is so interesting that it is hard to praise it again without repeating oneself."

> Huysmans 1883, pp. 85–123; Armand Silvestre, *La Vie Moderne*, 24 April 1880, p. 262; see 1986 Washington, D.C., p. 494.

9 April
The writer Edmond Duranty dies. Degas and the writer Émile Zola are named executors of his will. Degas adds Duranty's portrait to the exhibition and through the remaining part of the year attempts to organize a sale to raise funds for Pauline Bourgeois, Duranty's companion.

> Lettres Degas 1945, XXIX, XXX, pp. 57–59; Degas Letters 1947, nos. 38, 39, pp. 61–62, "Annotations," no. 38, pp. 262–63; Crouzet 1964, p. 402; unpublished letter to Guillemet, 6 January [1881], Durand-Ruel archives, Paris; see "The Portrait of Edmond Duranty," p. 309.

In a letter, Mary Cassatt's mother blames Degas for the fact that *Le Jour et la Nuit* was never published.

> Mathews 1984, pp. 150–51.

August
The second Abadie trial takes place. Degas attends a session, making sketches of the murderers.

> Reff 1985, Notebook 33 (private collection, pp. 5v–7, 10v–11, 15v–16). See fig. 104.

September
A projected holiday at Croissy is delayed by work and by the refusal of his housekeeper, Sabine Neyt, to accompany him. In a letter to Halévy, he complains of having to constantly paint ballet scenes "for . . . that is the only thing people want from your unfortunate friend."

> Unpublished letters to Ludovic Halévy, Bibliothèque de l'Institut, Paris.

winter
Degas seeks additional art dealers to sell his work. On 23 December, Pissarro writes to Théodore Duret: "Degas has besieged [Adrien] Beugniet."

> Lettres Pissarro 1980, no. 83, pp. 140–41.

27 December
For the first time in over six years, Durand-Ruel buys a work from Degas, a pastel of jockeys (stock no. 648). Two more pastels, "Loge de danseuse" (fig. 116) and "Dans les coulisses: chanteuse guettant son entrée" (L715, private collection, Paris), are purchased by him in the months that follow (stock nos. 766, 800).

> Journal, Durand-Ruel archives, Paris.

1881

January
In the absence of Zola, who is busy with dress rehearsals for *Nana*, Degas organizes the Duranty sale. He solicits works from artists and contributes three works himself: a version of Duranty's portrait (L518, private collection, Washington, D.C.); *Woman with Field Glasses* (fig. 131); and a drawing of a dancer adjusting her slipper (Mr. and Mrs. Alexander Lewyt collection, New York, reproduced in *Les Beaux-Arts Illustrés*, III:10, 1879, p. 84). Zola writes the preface to the catalogue. The sale takes place on 28–29 January, but the results are disappointing. Degas buys one of Duranty's drawings by Menzel, *Head of a Worker, Lit from Below* (reproduced in Edmond Duranty, "Adolphe Menzel," *Gazette des Beaux-Arts*, XXII:2, August 1880, p. 107).

> Journal, Durand-Ruel archives, Paris.

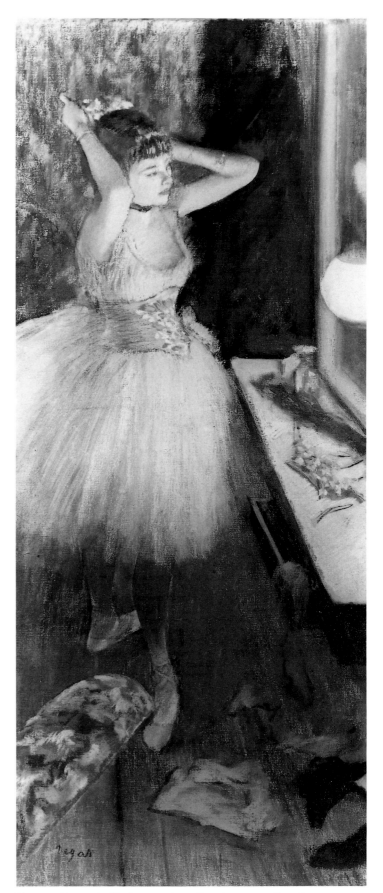

Fig. 116. *Dancer in Her Dressing Room* (L561), c. 1879. Pastel, 34⅝ × 14⅞ in. (87.9 × 37.7 cm). Cincinnati Art Museum

24 January

Degas and Caillebotte disagree on the nature of the exhibitions to be held by the Indépendants and the contributors recruited by Degas. Caillebotte writes a long letter to Pissarro criticizing Degas and advocating exhibitions restricted to the Impressionist group. He also notes: "Degas introduced disunity into our midst. Unfortunately for him, he has a bad character. He spends his time holding forth at the [Café de la] Nouvelle-Athènes or in society, when he would be much better occupied in doing more painting. No one denies that he is a hundred times right in what he says and that he talks about painting with infinite wit and good sense. (And isn't that the most evident part of his reputation?) But it remains true that the real argument of a painter is his painting and that if he were a thousand times more right in speaking, he would nevertheless be still more in the right in working. Today he says he needs to earn a living, but he will not grant the same need to Renoir and Monet. But before his financial losses, was he anything other than what he is today? Ask anyone who knew him, yourself first of all. No, this man has gone sour. He does not have the high rank his talent entitles him to, and he holds it against the entire world although he will never admit as much." As usual, Pissarro remains loyal to Degas; Caillebotte withdraws from the exhibition.

> Marie Berhaut, *Caillebotte: sa vie et son oeuvre*, Paris: La Bibliothèque des Arts, 1978, no. 22, pp. 245–46.

2 April

Opening of the *6me Exposition de peinture*, at 35 boulevard des Capucines. Degas's section of the exhibition contains four portraits, two of the three drawings entitled *Criminal Physiognomy* (fig. 104) based on the Abadie trial, and a *Laundress*. At the opening, there is again the empty case intended to contain *The Little Fourteen-Year-Old Dancer*; the sculpture finally makes its appearance in the exhibition by 16 April (see figs. 158–160).

April

Many reviews are published before *The Little Fourteen-Year-Old Dancer* is exhibited, and a number of critics are disconcerted by the paucity of works by Degas. The arrival of the sculpture unleashes a controversy in which only Huysmans, Claretie, Nina de Villard, and—unexpectedly—Paul de Charry recognize it as a masterpiece. Mantz renews his old charges of cruelty, and Albert Wolff delivers his most scathing attack to date: "He is the standard-bearer of the Indépendants. He is the leader; he is fawned upon at the Café de la Nouvelle-Athènes. And thus, to the end of his career, he will reign over a little circle; later, in a better life, he will hover . . . forever, like some sort of Father Eternal, God of failures."

> Huysmans 1883, pp. 225–57; Jules Claretie, *Le Temps*, 5 April 1881 (reprinted with slight changes in *La Vie à Paris: 1881*, Paris: Victor Havard, 1881, pp. 148–51); Villard 1881; Paul de Charry, *Le Pays*, 22 April 1881; Paul Mantz, *Le Temps*, 23 April 1881; Albert Wolff, *Le Figaro*, 10 April 1881; see also 1986 Washington, D.C., pp. 494–95; extracts of some of the reviews are included in Millard 1976, pp. 119–26.

Degas and Faure

cat. nos. 68, 95, 98, 103, 122, 130, 158, 159, 256

Degas formed his first serious contact with the art market in 1872, prior to his departure for New Orleans, when between January and September Paul Durand-Ruel bought eight paintings from him.[1] Durand-Ruel's considerable interest in Degas had actually led him to buy works by the artist from other sources as well, yet despite his efforts to sell the paintings in Paris, London, and Brussels, he succeeded in 1872 in disposing of only two works.[2] Degas's understandable disappointment was expressed in a letter to James Tissot in which he wrote: "I want to bring several pictures to London. . . . Durand-Ruel takes everything I do, but scarcely sells anything. Manet, always confident, says that he is saving us as a choice bit."[3]

In his own (occasionally inaccurate) memoirs, Durand-Ruel remarked about that period: "Degas . . . began to deliver a series of pastels and pictures to me which did not excite much interest at the time and that, over a number of years, I had a great deal of difficulty in selling, in spite of their very low price. Faure, whom I knew for a long time and with whom I was in contact during our stay in London, where we lived in neighboring houses on Brompton Crescent, bought some of these pictures from me— which I subsequently bought back."[4]

Jean-Baptiste Faure (1830–1914), a famous baritone, had established a reputation as a collector of works by Delacroix, Corot, and the Barbizon school. In a surprising reversal of taste, and with Durand-Ruel's help, he began buying on a considerable scale in 1873 paintings by Manet and the Impressionists, eventually assembling a vast collection of their work. His much-delayed return to the Opéra de Paris occurred while Degas was in the United States. And Degas's own return to Paris coincided with Faure's first purchases of his work, an important moment that marked the beginning of a difficult relationship in which Degas apparently behaved with less than customary rectitude. From that moment, and for a period that extended over several years, Faure became his most persistent patron and the bane of his existence, eventually owning eleven of Degas's paintings, the largest collection in France.[5]

The vexing question of the transactions between Degas and Faure has been dealt with briefly by Marcel Guérin, who consulted the Faure archives before they were destroyed in the Second World War, and more recently by Anthea Callen in an extensive unpublished dissertation on Faure as a collector.[6] According to Guérin:

The famous singer Faure was introduced to Degas by his friend Manet in about 1872. At that time he commissioned Degas to paint a picture of an examination or dance class at the Opéra (today in the Payne collection in New York), a first and very different version of the painting in the Camondo collection at the Louvre. . . . Degas delivered it to Faure in 1874 at the price of Fr 5,000—a high one for those days.

At the same time, Degas told Faure that he did not want to leave certain of his pictures at Durand-Ruel's for sale, as he was unhappy with them. Accordingly, Faure bought these pictures from Durand-Ruel for Fr 8,000 on 5 March 1874. They were: L'orchestre, Le banquier (possibly the portrait of Ruelle, the cashier employed by M. De Gas, senior, now part of the Raymond Koechlin bequest to the Louvre), Chevaux au pré, Sortie du pesage, Les musiciens, La blanchisseuse. Faure returned the six pictures to Degas and paid an additional Fr 1,500 in exchange for four large, very elaborate pictures, to be painted by Degas: Les danseuses roses, L'orchestre de Robert le Diable, Grand champ de courses, Les grandes blanchisseuses.

The first two canvases were delivered by Degas in 1876. (Robert le Diable is today in the South Kensington Museum.) . . . When the other two were still not delivered by the beginning of 1887, Faure lost patience and filed a suit against Degas. As a result Degas had to deliver the pictures.[7]

Insofar as Guérin's statements can be supplemented or corrected with evidence provided by Degas's correspondence or by the Durand-Ruel archives, the sequence of events appears to have been as follows.

On 25 April 1873, Faure purchased from Charles Deschamps, the manager of the London branch of Durand-Ruel, At the Races in the Countryside (cat. no. 95), with payments going to the London branch.[8] Two weeks later, on 7 May 1873, Faure bought two more racetrack scenes: Before the Race (fig. 87),[9] and "The Racecourse," no longer identifiable.[10] As for the first purchase, Durand-Ruel records indicate that the sale was made through Charles Deschamps, and the nature of the payments suggests the purchases were made in London, before Faure's return to Paris. Whether through Manet, Stevens, or, more probably, Deschamps or Durand-Ruel, the artist and Faure probably met not in 1872 but after April 1873, and at some point during 1873 Faure certainly commissioned from Degas the first of two ballet scenes he later owned. In December 1873, delayed by his father's sudden illness in Italy, the artist apologized to Faure from Turin for not having finished the picture and a "bagatelle"—

possibly a fan.[11] As Guérin has noted, the painting—The Dance Class (cat. no. 130)—was to be finished, not without difficulty, sometime later.[12]

On 15 or 16 February 1874, Faure bought from Durand-Ruel in Paris a fourth and final racetrack scene by Degas, Racehorses before the Stands (cat. no. 68), and it is probably around that time that the artist proposed to Faure the somewhat unusual strategy noted by Guérin: Faure was to redeem from Durand-Ruel six works that Degas wanted to repossess in exchange for new, larger compositions to be painted by the artist. All things considered, it would have been a hazardous scheme even for a less dilatory painter than Degas. This notwithstanding, on 5 or 6 March 1874, Faure paid Durand-Ruel Fr 8,800, nearly equivalent to the price paid by the dealer for the six works, and the artist recovered his paintings.[13] One of the pictures, recorded by Guérin as "Le banquier" but listed without a title in the Durand-Ruel archives, has been identified by Lemoisne as Sulking (cat. no. 85),[14] and it can be ascertained that the remaining five were Orchestra Musicians (cat. no. 98), the first version of The Ballet from "Robert le Diable" (cat. no. 103), Woman Ironing (cat. no. 122), Horses in the Field (L289), and very probably Leaving the Paddock (L107, Isabella Stewart Gardner Museum, Boston).[15]

The new compositions that Degas agreed to paint as substitutes entangled him in a protracted commitment that proved difficult to fulfill. In October 1874, when Faure threatened to leave the Opéra because of a proposed increase in admission prices for the performances of Adelina Patti, Degas expressed concern over the status of his arrangements with the singer in a letter to Deschamps, concluding: "Alas, that doesn't bode very well for the business of the paintings."[16] A subsequent letter to Deschamps written in early December 1874 establishes, however, that at least The Dance Class (cat. no. 130) was completed and delivered, but that Faure was becoming impatient about the remaining paintings.[17]

The account of the new paintings—five in number according to records in the Durand-Ruel archives, rather than four as listed by Guérin—is clouded by the absence of evidence about the date of delivery. Fortunately, the works are identifiable. In roughly chronological order, they are: Dancers (fig. 181), the second version of The Ballet from "Robert le Diable" (cat. no. 159), The Racecourse, Amateur Jockeys (cat. no. 157), Woman Ironing (cat. no. 256), and Women Ironing (fig. 232).[18] Of these, only Dancers is never mentioned by name in Degas's correspondence.

Degas's commitment to Faure could not have occurred at a worse moment. The

death of his father in February 1874, that of his uncle Achille in February 1875, and the great debts accumulated by his brother René precipitated the fall of the De Gas bank and placed the artist in the thankless position of having to paint for the art market at a moment when Paul Durand-Ruel, plagued by his own financial misfortunes, could no longer be of help. On the other hand, eager to establish a reputation, Degas wanted to supply Deschamps, his remaining dealer, with pictures for exhibition and sale in London, where prospects appeared more auspicious than in Paris. Degas's letters to Deschamps and to Faure brood relentlessly over this conflict, in which evidently the artist's immediate needs took precedence over Faure's commissions. Faure was frequently away, giving Degas a false sense of security that alternated with attacks of panic at the idea of the singer's return. From a letter to Tissot, written probably in 1874, it is clear that the artist intended to deliver the pictures to Faure, who at the time was in London, but had not succeeded in doing so: "My position in London is in no way assured. Faure will soon be back. His pictures have progressed very little so I should feel rather embarrassed in front of him. Therefore I hardly dare to idle around away from here. I was counting on having something ready for him when I went to London which I should have shown at Deschamps for glory(!). . . . They are not ready."[19]

As months, even years, passed, the tone of Degas's letters to Faure became increasingly apologetic about the paintings, explaining the causes for the delay. In a letter of 1876, written in connection with yet another of Faure's returns and his failure to deliver *The Ballet from "Robert le Diable"* (cat. no. 159) and *The Racecourse, Amateur Jockeys* (cat. no. 157), Degas wrote: "I have had to earn my wretched living in order to devote a little time to you; in spite of my anxiety about your return, it was necessary to do some small pastels. Please accept my apologies, if you still can."[20] And a year later, in a letter evidently written on 14 March 1877 in answer to an appeal from Faure, he replied:

I received your letter with great sadness. I prefer writing to seeing you.

Your pictures would have been finished a long time ago if I were not forced every day to do something to earn money.

You cannot imagine the burdens of all kinds which overwhelm me.

Tomorrow is the 15th. I am going to make a small payment and shall have a short respite until the end of the month.

I shall devote this fortnight almost entirely to you. Please be good enough to wait until then.[21]

From the absence of references to *The Ballet from "Robert le Diable"* (cat. no. 159) in the correspondence exchanged after 1876, it may be concluded that it was delivered during that year, and the same most probably applies to *Dancers* (fig. 181). Nevertheless, there still remained *The Racecourse, Amateur Jockeys, Woman Ironing* (cat. no. 256), and *Women Ironing* (fig. 232), as emerges from the correspondence of 1876 and 1877. During that period, Degas appears to have also exchanged works with Faure, as indicated by a letter from Pissarro uncovered by Theodore Reff.[22] It is surprising that there is no trace of further contact between Degas and Faure from 1877 to 1886, though one cannot imagine that Faure would not have continued to press the artist into finishing the paintings. In 1881, however, Faure, who was constantly buying and selling pictures, decided to dispose of three works by Degas—*Before the Race* (fig. 87), *The Ballet from "Robert le Diable,"* and *Dancers* (fig. 181), the latter two of which Degas had painted for him only a few years earlier.[23] Degas's own reaction to the sale is unknown, but one wonders if it had an effect on the delivery of the remaining paintings. In any event, by April 1882, when his financial standing had improved, Degas's apparent indifference to the question of his debt to Faure surprised friends such as Eugène Manet (see Chronology III, April 1882).

In 1887, the tone of the artist's letters had not changed. Answering yet another appeal from Faure on 2 January of that year, Degas still explained:

It is getting more and more embarrassing for me to be in your debt. And if I do not discharge my debt it is because it is difficult for me to do so. This summer I set to work again on your pictures, particularly the one of the horses, and I had hoped to finish it quickly. But a certain M[onsieur] B. saw fit to leave me saddled with having to produce a drawing and a picture that he had ordered from me. In full summer this dead loss of Fr 3,000 overwhelmed me. It was necessary to put aside everything of M. Faure's in order to make others that would enable me to live. I can only work for you in my spare moments, and they are rare.

The days are short; soon they will grow longer, and if I earn a little money I will be able to take up your work. I could go into longer explanations. The ones I give you are the simplest and the most irrefutable.

I beg you therefore to have a little more patience, as I must, to finish things which of necessity eat into my already limited time, without recompense, but which love and respect for my art will not let me neglect.[24]

According to Guérin, at this point Faure sued Degas for nondelivery of the paintings. However, no papers connected with a court case have been uncovered, suggesting that the litigation was settled out of court. Degas certainly delivered the works, for they appear later in Faure's collection. It is curious that, as events were about to develop, Faure, perhaps regretting his sale of the second version of *Robert le Diable* (cat. no. 159), purchased the first version (cat. no. 103) from Durand-Ruel on 14 February 1887.[25]

The final chapter in the story of Degas's connection with Faure unfolded in the early 1890s, when the collector disposed of all his works by Degas. On 2 January 1893, Faure sold to Durand-Ruel, with vastly increased valuations, five of the seven works he still owned: *Racehorses before the Stands* (cat. no. 68), *At the Races in the Countryside* (cat. no. 95), *The Racecourse, Amateur Jockeys* (cat. no. 157), *Woman Ironing* (cat. no. 256), and *Women Ironing* (fig. 232).[26] Then, one year later, on 31 March 1894, he gave up the early version of *The Ballet from "Robert le Diable"* (cat. no. 103).[27] Last, in mid-February 1898, came the sale of his one remaining work by Degas, *The Dance Class* (cat. no. 130), the earliest of his commissions.[28] When in 1902 Faure published the *Notice sur la collection J.-B. Faure* with a description of his remarkable holdings, Degas was the only major modern painter to be conspicuously absent from the catalogue.

1. In order of purchase, they were as follows: January, *Dance Class* (stock no. 943/979, "Le foyer de la danse," cat. no. 106) and *The Ballet from "Robert le Diable"* (stock no. 978, "L'orchestre de l'Opéra," cat. no. 103); April, *Before the Race* (stock no. 1332, fig. 87) and *Horses in the Field* (stock no. 1350, "Chevaux dans un pré," L289); June, "Mare with Colt" (stock no. 1724, unidentified); August, *Dance Class at the Opéra* (stock no. 1824, "La leçon de danse," cat. no. 107); and September, *At the Races in the Countryside* (stock no. 1910 "La voiture," cat. no. 95) and *Racehorses before the Stands* (stock no. 2052, "Avant la course," cat. no. 68). The price paid for *Dance Class* (cat. no. 106) is not recorded, but it was valued at Fr 1,000 when exchanged with Premsel and eventually sold to Brandon for Fr 1,200. The remaining seven pictures were sold by Degas for a total of Fr 8,100, with *Dance Class at the Opéra* (cat. no. 107), the highest-priced work, at Fr 2,500.
2. From the dealer Reitlinger, *The False Start* (stock no. 1128, "Courses au Bois de Boulogne," fig. 69) in February 1872, and "Le banquier" (stock no. 1156, possibly cat. no. 85) in March; from the collector Ferdinand Bischoffsheim, *Leaving the Paddock* (stock no. 1367, presumably L107, Isabella Stewart Gardner Museum, Boston). The only pictures sold by Durand-Ruel in 1872 were *Dance Class* (cat. no. 106), bought by Brandon, and *Dance Class at the Opéra* (cat. no. 107), bought in December 1872 by Louis Huth.
3. Degas, Paris, to James Tissot, London, undated, Bibliothèque Nationale, Paris. Marguerite Kay's English translation, dated "1873?" was published in Degas Letters 1947, no. 8, p. 35 (translation revised). From the evidence of the text, the date should be summer 1872, when the first version

of *The Ballet from "Robert le Diable"* (cat. no. 103) was sent by Durand-Ruel to London for exhibition.

4. "Mémoires de Paul Durand-Ruel," in Venturi 1939, II, p. 194.

5. According to Anthea Callen, Faure owned a total of sixteen works by Degas (actually he owned only eleven); see Anthea Callen, "Faure and Manet," *Gazette des Beaux-Arts*, LXXXIII:1262, March 1974, pp. 174–75 n. 5.

6. See Guérin's annotation in Lettres Degas 1945, pp. 31–32 n. 1; Degas Letters 1947, no. 10, "Annotations," p. 261; Callen 1971, passim and nos. 190–205; and Anthea Callen, "Faure and Manet," in *Gazette des Beaux-Arts*, LXXXIII:1262, March 1974, pp. 157–78.

7. Lettres Degas 1945, V, pp. 31–32 n. 1; Degas Letters 1947, "Annotations," no. 10, p. 261 (translation revised).

8. See Durand-Ruel journal (stock no. 1910, "La voiture"). Listed in Callen 1971 as no. 191, with the same identification.

9. *Before the Race* is recorded in the Durand-Ruel journal and stock book in 1872 and 1873, without a title, as stock no. 1332, and still retains the number inscribed on the back. When sold by Faure to Durand-Ruel in 1881 as "Jockeys," it was listed under deposit no. 3059 and stock no. 870 in the firm's *brouillard* (ledger) and appears also in the journal, without a title, and the stock book. It is catalogued in Callen 1971 under the latter incarnation as no. 201A "Jockeys," with the tentative proposal that it is the painting in the National Gallery of Art, Washington, D.C.

10. The unidentified "Racecourse" was given by Durand-Ruel the stock no. 2673 when it was brought from Brussels, as an exchange, on 15 March 1873. It appears listed with this number in the journal, the stock book, and the *brouillard* but was not catalogued by Anthea Callen.

11. Degas, Turin, to Faure, undated, but assigned by Guérin to December 1873 in Lettres Degas 1945, V, pp. 31–32; Degas Letters 1947, no. 10, pp. 36–37. Excerpts of the letter are cited in Chronology II, November 1873.

12. For this question, see "The Dance Class," p. 234.

13. The date is unclear. In the Durand-Ruel journal it appears as 5 March, while in the *brouillard* it is given as 6 March. The evidence that Faure did not keep the paintings is to be derived from the fact that Degas owned the works after 1874 and sold three of them a second time to Durand-Ruel: see cat. nos. 103, 85, 122. *Horses in the Field* (L289) was given by Degas to Tissot, who sold it to Durand-Ruel on 11 or 12 March 1890 (stock no. 2654); *Orchestra Musicians* (cat. no. 98), at one point owned by Bernheim-Jeune, was bought by Durand-Ruel on 11 October 1899 (recorded in the New York stock book, no. 2285); *Leaving the Paddock* (L107) was in the artist's studio at the time of his death.

14. See Lemoisne [1946–49], I, p. 83, and Reff 1976, p. 118. Listed in Callen 1971, no. 193, with the same identification. However, Henri Loyrette points out that proof is lacking to make such an identification (see cat. no. 85).

15. Two of the works, *Leaving the Paddock* and *Horses in the Field*, appear with the same identification, or tentative identification, in Callen 1971, nos. 200A and 203A. Reasons for the identification of *The Ballet from "Robert le Diable"* and *Orchestra Musicians* (Callen 1971, nos. 204A and 205A, unidentified) are given in the provenances of cat. nos. 103 and 98; the same applies to *Woman Ironing* (cat. no. 122), tentatively identified in Callen 1971, no. 202A, as *Woman Ironing* (cat. no. 258). Karen Haas at the Isabella Stewart Gardner Mu-

seum, Boston, generously agreed to unframe *Leaving the Paddock* and indicated that no stock number was inscribed on the back or on the frame.

16. Unpublished letter from Degas, Paris, to Charles Deschamps, London, 23 October 1874, Institut Néerlandais, Paris. The year can be inferred from the text of the letter.

17. Unpublished letter from Degas, Paris, to Charles Deschamps, London, dated only "Monday" but datable to December 1874 (a typescript of the letter was kindly provided to the author by John Rewald). For a discussion on the issue of dating the letter, see "The Dance Class," p. 234.

18. Identifiable from the record of the subsequent sale by Faure to Durand-Ruel listed in the firm's *brouillard*, journal, and stock book. Anthea Callen has identified four of the five works in Callen 1971, under nos. 195–98. Although she listed *Dancers* (fig. 181) as no. 199A, she did not propose an identification for it.

19. Degas, Paris, to James Tissot, London, dated only "Monday"; Bibliothèque Nationale, Paris. Degas Letters 1947, no. 14, pp. 41–42. On the evidence of the text, the letter must date from 1874.

20. Degas to Faure, postmarked (or dated by Guérin?) 1876, in Lettres Degas 1945, XI, p. 39; Degas Letters 1947, no. 19, p. 45 (translation revised).

21. Degas to Faure, postmarked March 1876, in Lettres Degas 1945, XII, p. 40; Degas Letters 1947, no. 20, pp. 45–46.

22. Letter from Camille Pissarro to Degas, dated 1876 by Janine Bailly-Herzberg, concerning a painting by Pissarro which Degas exchanged with Faure. See Lettres Pissarro 1980, no. 45, p. 101 n. 1.

23. Recorded in Durand-Ruel's *brouillard*, stock book, and journal as sold to the dealer on 28 February 1881 (stock nos. 869, 870, 871).

24. Degas to Faure, 2 January 1887, in Lettres Degas 1945, XCVII, pp. 123–24; Degas Letters 1947, no. 107, pp. 121–22 (translation revised).

25. Sale to Faure recorded in the Durand-Ruel journal, 14 February 1887 (stock no. 2981), mistakenly titled "Le concert, Le ballet de Guillaume Tell."

26. Recorded in the Durand-Ruel journal and stock book as sold to the dealer on 2 January 1893 (stock nos. 2564–2568). Degas's reaction to the sale is recorded in a letter to Henri Fevre: "After having owned my paintings for a long time people are beginning to sell them at a substantial profit. That doesn't put five francs in my pocket." See Fevre 1949, p. 97.

27. Sale recorded in the Durand-Ruel journal and stock book, 31 March 1894 (stock no. 2981).

28. Sale recorded in the Durand-Ruel stock book, 19 February 1898, as "Le foyer de la danse" (stock no. 4562).

122.

Woman Ironing

1873
Oil on canvas
21⅜ × 15½ in. (54.3 × 39.4 cm)
Signed lower left: Degas
The Metropolitan Museum of Art, New York.
 Bequest of Mrs. H. O. Havemeyer, 1929.
 H. O. Havemeyer Collection (29.100.46)

Lemoisne 356

During a visit to Degas's studio on 13 February 1874, Edmond de Goncourt admired several paintings of laundresses and ironers. He was later, in his published diary, to attribute the modernism of these works to the popularity of *Manette Salomon*, the novel he wrote in collaboration with his brother and which appeared in 1867.[1] The reverse was to occur with Émile Zola, who included descriptions of an ironers' shop in his novel *L'Assommoir*, first serialized in 1876 and subsequently published in 1877. According to Jules Claretie, writing in 1877, Degas, "like M. Zola, studied laundresses—and so thoroughly that the author of *L'Assommoir* said to him, 'In my writing I have quite simply described, in more than one place, some of your paintings.' And there, in a manner of speaking, was someone also working from nature."[2]

Even given the relatively confused chronology of the early paintings of ironers by Degas, it can be said with certainty that the New York *Woman Ironing* is one painting that Edmond de Goncourt could *not* have seen. Although the style gives no indication of a date shortly before or after the artist's voyage to New Orleans, it can be ascertained that the painting existed by 6 June 1873, when Degas sold it to Durand-Ruel for the rather large sum of Fr 2,000.[3] It is possible that this picture was the "Parisian Laundress" exhibited in Durand-Ruel's gallery in London in the winter of 1873–74, and it is known that in March 1874 it formed part of the group of six works Degas repossessed from Durand-Ruel with the help of Jean-Baptiste Faure. There is evidence that the white area around the arms was reworked, perhaps indicating that the artist's reason for reclaiming the painting may have been a slight dissatisfaction with his execution of it. Whatever the reasons for its return, it is almost certain that in 1876 Degas included it among the five ironers and laundresses that he contributed to the second Impressionist exhibition.

Despite the painting's modest dimensions, its subject is conveyed with an authority that defies size and with a restraint that rejects all concessions to sentimentality. It is the most economical as well as the no-

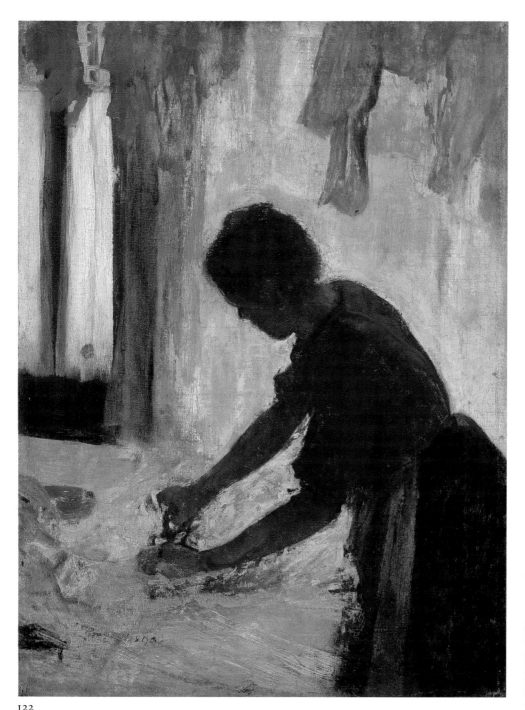

122

Fig. 117. *Woman Ironing* (III:269), c. 1873.
Charcoal, 16¾ × 12 in. (42.5 × 30.5 cm).
Private collection

that could well pass for a description of the painting in the Metropolitan Museum in New York.
3. Durand-Ruel journal (stock no. 3132); the stock number is stamped on the stretcher.

PROVENANCE: Bought from the artist by Durand-Ruel, Paris, 14 (or 6) June 1873, for Fr 2,000 (stock no. 3132, stamped on the stretcher); transferred to Durand-Ruel, London, winter 1873; returned to Durand-Ruel, Paris; bought back on behalf of the artist by Jean-Baptiste Faure, Paris, 5 or 6 March 1874, for Fr 2,000; resold by the artist to Durand-Ruel, Paris, 29 February 1892, for Fr 2,500 (stock no. 2039, inscribed on a label on the back); deposited with Bernheim-Jeune, Paris, 3 November 1893; returned to Durand-Ruel, Paris, 13 February 1894; sold to Durand-Ruel, New York, 4 October 1894 (stock no. 1204, inscribed on a label on the back); bought by H. O. Havemeyer, New York, 18 December 1894, for Fr 2,500; Mrs. H. O. Havemeyer, New York, 1907–29; her bequest to the museum 1929.

blest of Degas's early depictions of ironers, with a slightly tragic cast mitigated only by the wonderful effects of light. A charcoal study for the figure (fig. 117), squared for transfer, represents the ironer in the same size as she appears in *Woman Ironing* (which also retains matching traces of squaring). An unpublished pencil study in a French private collection, showing the composition almost exactly as it appears in the painting, gives every impression of being a compositional study for it. The drawing even includes corrections for cropping the design at the right and at the bottom that correspond to the solution eventually adopted in the painting.

1. See Journal Goncourt 1956, p. 968 n. 1, where it is established that the reference to *Manette Salomon*, lacking in the original diary, first appeared in the version of the journal published in 1891.
2. Jules Claretie, "Le mouvement parisien—L'exposition des impressionnistes," *L'Indépendance Belge*, 15 April 1877, p. 1. Theodore Reff, who did not subscribe to the idea of a direct influence of either Degas or Zola on each other, nevertheless published a particularly thorough analysis of Degas's ironers (Reff 1976, p. 168), citing a paragraph from Zola

EXHIBITIONS: (?) 1876 Paris, no. 49 (as "Blanchisseuse silhouette"); 1876, London, 168 New Bond Street, opened 3 November, *Seventh Exhibition of the Society of French Artists*, no. 80 (as "The Parisian Laundress"); 1915 New York, no. 26 (as 1880); 1930 New York, no. 56; 1944, Richmond, Virginia Museum of Fine Arts, 16 January–13 February, *Masterpieces of Nineteenth Century French Painting*, no. 22; 1977 New York, no. 14 of paintings, repr.; 1979 Edinburgh, no. 70, repr. (as before 1872); 1986 Washington, D.C., no. 26, repr. (color).

SELECTED REFERENCES: Havemeyer 1931, p. 112, repr.; Burroughs 1932, p. 142, repr.; Mongan 1938, p. 301; Lemoisne [1946–49], I, p. 87, II, no. 356 (as c. 1874); New York, Metropolitan, 1967, pp. 77–78, repr.;

Minervino 1974, no. 368; Erich Steingräber, "La repasseuse: Zur frühesten Version des Themas von Edgar Degas," *Pantheon*, XXXII, January–March 1974, pp. 51–53 n. 17, fig. 3; Reff 1976, pp. 166–68, 321 n. 68, fig. 118; Roberts 1976, fig. 30 p. 35 (as c. 1872 in text, but 1874 in caption); Moffett 1979, p. 10, fig. 16 (color); *The Realist Tradition: French Painting and Drawing 1830–1900* (exhibition catalogue by Gabriel P. Weisberg), Cleveland: Cleveland Museum of Art, 1980, p. 69; Keyser 1981, p. 40; 1984 Tübingen, under no. 88; Moffett 1985, pp. 72, 250, repr. (color) p. 73 (as c. 1874); Lipton 1986, pp. 117–18, 135, 140, 143, fig. 68; Weitzenhoffer 1986, p. 98, pl. 49.

The Rehearsal of the Ballet on the Stage

cat. nos. 123–127

When Degas scholars became aware of the existence of three very similar versions of the same composition representing an onstage ballet rehearsal, they began to try to place the works in logical sequence. There has never been any question that the largest of these, the Musée d'Orsay version—*Ballet Rehearsal on Stage* (cat. no. 123)—uncharacteristically painted in grisaille, is a work that Degas showed in the 1874 Impressionist exhibition and must therefore date from sometime before April of that year. However, there has always been less certainty about the date of the two somewhat smaller versions now in the Metropolitan Museum in New York.

Both works in the Metropolitan are on paper, and, as Ronald Pickvance has revealed, each is executed on top of a highly unusual ink drawing, one more finished than the other. The pictures were completed in different mediums: *The Rehearsal of the Ballet on the Stage* (cat. no. 124) was painted in essence—that is, oil paint diluted with turpentine—while *The Rehearsal on the Stage* (cat. no. 125) was finished in pastel and, possibly, some gouache.[1] So far there has been agreement on one point only: the pastel composition, more freely handled, has been considered by all to be the last work in the series. Lemoisne, sensitive to the stylistic differences between the essence and pastel versions, dated the essence painting c. 1876, tentatively recognizing it as a rehearsal subject exhibited by Degas in 1877, and placed the pastel somewhat later, c. 1878–79.[2] Lillian Browse decided on a shorter sequence of events, dating the essence painting c. 1874–75, closer to the Orsay version, and identifying the pastel as the work exhibited in 1877, hence dating it c. 1876–77.[3]

This speculative chronology was revised with most interesting results in 1963, when Pickvance published a seminal article on the dating of Degas's earliest dance subjects.[4] With reference to the three rehearsal pictures, he pointed out that George Moore had stated as early as 1891 that the New York essence version, then owned by Walter Sickert, was painted on top of a drawing that had been the rejected model for a proposed engraving to be published in the *Illustrated London News*. Pickvance connected the two New York compositions with Degas's known attempts in 1873 to establish a reputation in England, concluding that the more precise drawing underlying the essence painting was actually the model that Degas submitted for publication, while the freer ink drawing under the pastel was the copy he retained. Because the Orsay painting exhibits pentimenti showing several suppressed figures and, in Pickvance's opinion, a composition originally closer to the ink drawing under the essence *Rehearsal*, he reversed the accepted sequence of the pictures. He placed the essence painting first, in 1873, as the drawing initially conceived for the *Illustrated London News*; he believed the Orsay version came next, painted before April 1874 and with the benefit of a group of preparatory drawings executed specially for it; and he considered the last work of the three to be the pastel, executed on top of the presumed copy of the ink drawing and dated by him "no later than 1874."

The uncommon precision of the ink drawing under the essence version unquestionably suggests some relationship with the notion of a print.[5] The scenery and the figures are carefully outlined, and values are indicated in closely hatched lines. The detail is considerable: when the surface is examined under infrared light, even the nails on the ballet master's fingers are visible. The ink drawing under the pastel is quite different. It consists largely of outlines, ruled for the architecture, and in the rendering of some of the dancers, notably the two at the right, it is quite freely, even hesitantly, drawn. Only a few attempts at shading were made, as in the figure of the dance master and the dancers at the left. The quality and the character of this drawing indicate that it was not a copy, as Pickvance suggests, but, on the contrary, an earlier attempt at the composition that was taken up again and further elaborated in the more finished ink drawing under the essence painting.

If the ink drawings under the New York compositions are rightly considered to be unique experiments in the artist's work, rather less has been said about the equally unusual character of the Orsay painting. It is the only known grisaille in Degas's entire work, and no aesthetic reasons have been advanced for his choice. Painters, by tradition, used grisaille for models that were destined

for engraving, the absence of color allowing the engraver to focus on tonal values. As this tradition survived intact until the nineteenth century, it can only be concluded that the painting was supposed to perform this function; indeed, its exceptional nature can be explained only in these terms.

The numerous drawings connected with the three works, some twenty sheets ranging from sketches to fully realized essence or charcoal studies, deserve attention not least because they testify to the elaborate genesis of the composition. Many of these studies represent variations on the figures. The dancer farthest to the right, for instance, appears in two pencil drawings, once on a sheet with several other dancers (III:401) and a second time in conjunction with the dancer en pointe eventually placed next to her (IV:276.c). The dancer with both her arms raised behind her head was studied facing in one direction in pencil (IV:276.a) and facing in another in the magnificent essence drawing in this exhibition (cat. no. 127). There also appear to have been attempts at grouping the figures, implied by a sheet (IV:267) that shows on the recto an early experiment with an arrangement of the two dancers at the far left (one holding her arms behind her back, the other with her arm raised against the stage flat). On the verso of the same sheet, there is an alternative idea for the dancers at the center of the composition, one seated and the other tying her slipper.

As Pickvance has noted, a second, distinctive group of studies in charcoal highlighted with chalk represent six of the principal figures in the composition, carefully observed again under the same light as in the Orsay painting. Each drawing contains smaller or greater departures from the pencil, charcoal, or essence prototype, but in two instances the departures are significant and affect the sequence of the works. The dancer with her arms raised behind her head changed direction one more time and was finally positioned facing to her right (II:331). The original pose of the dancer en pointe, second from the right, was also changed. In an earlier charcoal drawing (III:115.1), her right hand touched her left shoulder; in the revised study (I:114), the arm was lowered to the position finally adopted in all three versions of the composition. The particular attention paid to light and the fact that this group of studies repeated the earlier group led Pickvance to conclude that they were executed sometime after the earlier drawings and specifically for the Orsay grisaille. Events seem to have evolved somewhat differently, however.

The ink drawing under the New York pastel, which Pickvance assumed to be a copy, has one telling peculiarity: the dancer en pointe, second from the right, was origi-

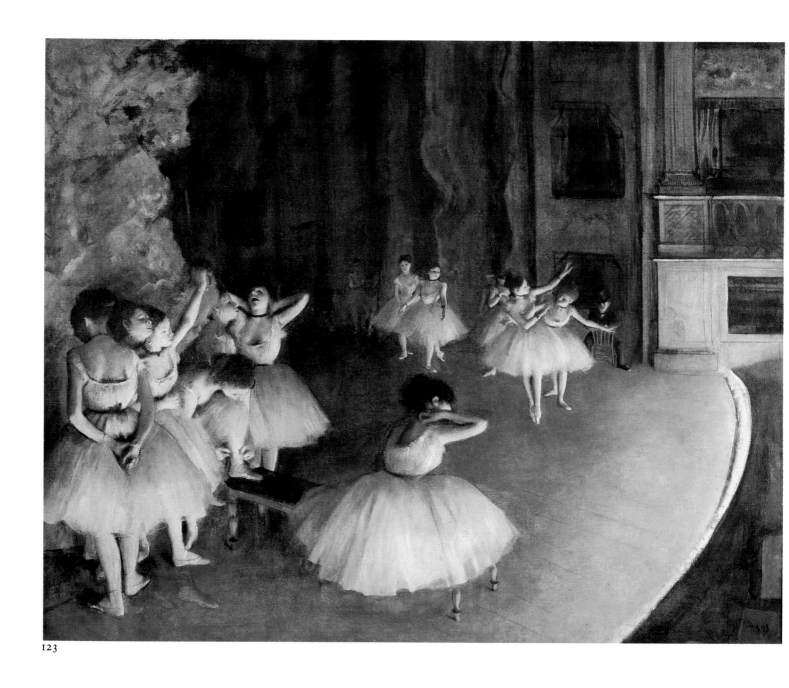

123

nally drawn with her right arm raised, as in the charcoal drawing (III:115.1) noted above, but was corrected in ink to follow the more elaborate drawing with the arm lowered (I:114). The ink composition under the essence painting shows the figure in the corrected pose, without a hint of alteration. Moreover, both ink compositions show a profile emerging from behind a stage flat near the dancer with both arms raised behind her head; this profile appears in only one of the presumed later drawings (IV:244). From the evidence, it is tempting to suggest a different sequence.

Various studies in pencil, charcoal, and essence were drawn for the figures. A first ink composition was begun, the one under the pastel, to map out the composition and try its effect as an engraving. The elaborate, sec-

ond series of charcoal-and-chalk drawings either existed at this stage or were prepared around this time. A second, more elaborate ink drawing followed, that under the essence painting, intended to simulate more fully the effect of the engraving. The composition was then painted in grisaille as the model for the engraving but was altered in the process. Various figures such as the ballet master and the seated man at the far right were eventually painted out, and the group of dancers to the left was slightly changed.

The questions that affect the chronology are really twofold and concern both the ink drawings and the finished works that covered them, two stages that did not occur simultaneously. The more finished ink drawing may well have been submitted by Degas to

the *Illustrated London News*, not necessarily to be engraved but as an example of how the engraving would look, and it would be interesting to know if this occurred during one of his supposed but undocumented trips to London in 1873–74. By April 1874, however, the finished grisaille painting already belonged to Gustave Mulbacher, which suggests that his permission for an engraving would have had to be sought. The attempt to publish, then, must have been made before this date. More problematic is the date at which the two ink drawings were painted over. The essence version, *The Rehearsal of the Ballet on the Stage* (cat. no. 124), is first documented in 1876, when it was exhibited and sold in London. The pastel, *The Rehearsal on the Stage* (cat. no. 125), belonged to Ernest

May, who apparently did not purchase works by Degas before 1878. A list of pictures Degas intended to show in a proposed exhibition on the theme of the dance, most probably in 1875, includes under no. 1 a "Répétition sur la scène" (Rehearsal on the Stage) and under no. 2 the curious note "id[em] en renversé."[6] This indicates that at least one of the rehearsal pictures, probably the essence version, existed by that date but gives no clue as to what the reversed version could have been.

The stylistic differences noted by Pickvance and others among the three versions suggest, indeed, that the pastel followed the essence painting. If so, one is tempted to reorder the sequence and place the grisaille first, in 1873–74, the essence painting soon afterward, perhaps in 1874, and the pastel after that. Whether in fact the pastel can also be dated 1874 remains to be seen.

1. Pickvance 1963, p. 260.
2. Lemoisne [1946–49], II, nos. 340, 400, 498.
3. Browse [1949], nos. 28, 30, 31.
4. See Pickvance 1963, pp. 259–63, for a discussion of the entire question.
5. The author has benefited greatly from examination reports on the two works in the Metropolitan Museum prepared at the National Gallery of Canada by Anne Maheux and Peter Zegers, Degas Pastel Project.
6. See Reff 1985, Notebook 22 (BN, Carnet 8, p. 203), where it is stated that the exhibition was planned for 1874. For arguments concerning the more likely date of 1875, see cat. no. 139.

123.

Ballet Rehearsal on Stage

1874
Oil on canvas
25⅝ × 31⅞ in. (65 × 81 cm)
Signed lower right: Degas
Musée d'Orsay, Paris (RF1978)

Lemoisne 340

Although it was exhibited in France only once—in 1874—before finally entering the collections of the Louvre in 1911 as part of the Camondo gift, this small painting was instrumental in establishing Degas's reputation as a supreme draftsman. Giuseppe De Nittis, who saw it at rue Laffitte when the first Impressionist exhibition was being hung, wrote some six weeks later to his friend Enrico Cecioni: "Since I am reviewing the works in my mind in order to describe them to you, I remember a drawing that must have been a dance rehearsal on the stage, illuminated from below, and I assure you that it is extremely beautiful. The muslin dresses are so diaphanous and the move-

ments so true that only seeing it could give you an idea; describing it is impossible."[1]

The opinion that the work was a drawing rather than a painting was shared by the critics. Philippe Burty called it in his review of the exhibition "a most remarkable drawing in bistre," and Ernest Chesneau noted: "There is nothing more interesting than this picturesque depiction of the play of light and shadow caused by the glow of stage footlights. M. Degas renders the scene with a charming and delightful attention to detail. He draws in a correct and precise manner, with the sole objective of scrupulous fidelity to the subject. . . . His color, in general, is a little muted."[2]

As the notion that Degas was not truly a colorist and that his genius was principally that of a draftsman originated in the mid-1870s, one wonders how much this work may have fostered it. As noted earlier, the monochrome treatment of the composition, the only such instance in the artist's work, is of course due to his intention to use the work as a model for an engraver.[3]

The thin layer of paint, made even more transparent by time, reveals changes to the composition. The group of dancers to the left was clearly altered, and the legs of certain dancers originally reached farther down into the foreground. To the right of the dancer with her arms raised behind her neck was a ballet master, seen from behind, in the act of rehearsing the pas de deux of the two dancers at the far right. At stage right, next to the seated figure, was another man slumped in his chair, his crossed legs stretched out in front of him. And the dancer in the center foreground, whose raised right arm has been slightly reduced in size, is seated on a bench that changed its position as the artist reworked the painting.

1. Letter from Giuseppe De Nittis, Paris, to Enrico Cecioni, 10 June 1874, published in Il Giornale Artistico, II:4, 1 July 1874, pp. 25–26 (reprinted in Pittaluga and Piceni 1963, pp. 302–04).
2. [Philippe Burty], "Exposition de la Société Anonyme des Artistes," La République Française, 25 April 1874, p. 4. Ernest Chesneau, "À côté du Salon, II, Lè plein air: Exposition du Boulevard des Capucines," Paris-Journal, 7 May 1874, p. 2.
3. See "The Rehearsal of the Ballet on the Stage," p. 225.

PROVENANCE: Bought (from the artist?) by Gustave Mulbacher, Paris, by April 1874; bought by Comte Isaac de Camondo, Paris, 24 May 1893, for Fr 21,000; his bequest to the Louvre, Paris, 1908; entered the Louvre 1911.

EXHIBITIONS: 1874 Paris, no. 60 (as "Répétition de ballet sur la scène"), lent by M. Mulbacher; 1907–08 Manchester, no. 172 (as 1874); 1924 Paris, no. 47; 1955 Paris, GBA, no. 56, repr.; 1969 Paris, no. 24; 1982, Prague, National Gallery, September–November, Od Courbeta k Cezannovi, no. 29; 1982–83, Berlin (G.D.R.), Nationalgalerie, 10 December–20 February, Von Courbet bis Cézanne: Französische Malerei, 1848–1886, no. 31, repr.; 1985, Peking, Palace

of Fine Arts, 9–29 September/Shanghai, Museum of Fine Arts, 15 October–3 November, La peinture française 1870–1920, no. 13, repr.; 1986 Washington, D.C., no. 25, repr. (color).

SELECTED REFERENCES: Léon de Lora [Louis de Fourcaud], "Exposition libre des peintres," Le Gaulois, 18 April 1874, p. 3; C. de Malte [Villiers de l'Isle-Adam], "Exposition de la Société Anonyme des Artistes Peintres, Sculpteurs, Graveurs et Lithographes," Paris à l'Eau-Forte, 59, 19 April 1874, p. 13; [Philippe Burty], "Exposition de la Société Anonyme des Artistes," La République Française, 25 April 1874, p. 4; Ernest Chesneau, "À côté du Salon, II, Le plein air: Exposition du Boulevard des Capucines," Paris-Journal, 7 May 1874, p. 2; Giuseppe De Nittis, "Corrispondenze: Londra," Il Giornale Artistico, II:4, 1 July 1874, p. 26; Alexandre 1908, repr. p. 29; Lemoisne 1912, pp. 57–58, pl. XXI (as 1874); Paris, Louvre, Camondo, 1914, pl. 32; Jamot 1914, pp. 454–55, repr.; Jamot 1918, p. 158, repr. p. 159; Lafond 1918–19, I, p. 45, repr.; Meier-Graefe 1923, p. 59; Rouart 1945, pp. 13, 70 n. 23; Lemoisne [1946–49], II, no. 340; Browse [1949], no. 28 (as 1873–74); Pickvance 1963, pp. 257, 263, fig. 20 (as 1874); Minervino 1974, no. 470, pl. XXVI (color); Reff 1985, pp. 7 n. 2, 9, 21, Notebook 22 (BN, Carnet 8, p. 203); Paris, Louvre and Orsay, Peintures, 1986, III, p. 193 (as 1874).

124.

The Rehearsal of the Ballet on the Stage

1874?
Essence with traces of watercolor and pastel over pen-and-ink drawing on paper, mounted on canvas
21⅜ × 28¾ in. (54.3 × 73 cm)
Signed upper left: Degas
The Metropolitan Museum of Art, New York.
 H. O. Havemeyer Collection. Gift of Horace Havemeyer, 1929 (29.160.26)

Lemoisne 400

This work is technically the more curious of the two versions of the composition in New York and the more difficult one to decipher. Anne Maheux and Peter Zegers have observed that the ink underdrawing was first covered with either watercolor or diluted gouache, and was then built up with more opaque layers of essence and, finally, oil paint. They have concluded that in certain areas, particularly visible in the hair of the ballet master and that of the seated dancer in the foreground, the design was reworked in detail in ink on top of the colored layer.[1] The ink underdrawing can be seen under infrared light, except for the area at the far left where the oil paint covers the paper thoroughly. This is unfortunate because the left part of the picture, showing two additional figures, is the very area in which the composition differs from the New York pastel

(cat. no. 125) and the Orsay grisaille (cat. no. 123). From the evidence, it is impossible to tell whether the dancer at the far left and a head appearing to her left were added in oil or formed part of the original design. It should be pointed out that a variation on the group at the far left occurs in the upper left section of *Orchestra Musicians* (cat. no. 98), which appears to have been repainted after March 1874.

Drawings are known for almost every figure in the picture and formed part of a large group of pencil or essence studies.[2] The second dancer from the right, however, is based on a charcoal-and-chalk study (I:114), and the dancer in position in the center background was adapted from a pencil-and-crayon study (I:328) in the Fogg Art Museum, Cambridge, Mass., that served also for a number of other compositions, notably *The Dance Class* (cat. no. 129).[3] The two double basses protruding in the foreground were not part of the original design but appear in two notebook sketches most closely connected with the Orsay grisaille.[4]

The cool tones of the painting are quite unlike those of the pastel version (cat. no. 125) and are particularly effective in suggesting the artificial effects of light on the stage.

1. These conclusions appear in an examination report prepared by Anne Maheux and Peter Zegers, Degas Pastel Project, National Gallery of Canada, Ottawa.
2. See "The Rehearsal of the Ballet on the Stage," p. 225.
3. In addition to these two drawings, the identifiable studies are as follows: ballet master (III:113); seated man at far left, said to have been posed for by James Tissot (III:164.1); first dancer from the right (III:401 and IV:276.c); fourth dancer from the right, in the background (IV:276.c); seated dancer at the center (presumably III:132.2); dancer with arms raised (cat. no. 127); dancer adjusting her slipper (III:163.2); profile emerging from behind stage flat (II:244); dancer with one arm raised (II:345); dancer at the far left (III:401).
4. See Reff 1985, Notebook 24 (BN, Carnet 22, pp. 26, 27). Theodore Reff, who dated the notebook 1868–73, has connected the drawings specifically to the essence painting (cat. no. 124) in New York. One of the drawings, however, represents the architecture as it appears only in the Orsay grisaille (cat. no. 123). For the possibility of the two New York rehearsal compositions' having been cut down, see cat. no. 125.

PROVENANCE: Sent by the artist to Charles W. Deschamps, 168 New Bond Street, London, before April 1876; sold to Captain Henry Hill, Brighton (Hill sale, Christie's, London, 25 May 1889, no. 29 [as "A Rehearsal"], for 66 guineas); bought by Walter Sickert, London; given to his second wife, Ellen Cobden-Sickert, London; left in the care of her sister, Mrs. T. Fisher-Unwin, London, by summer 1898; deposited by Mrs. Cobden-Sickert with Durand-Ruel, Paris, 4 January 1902 (deposit no. 10185, on the back, two Durand-Ruel labels: "Degas no. 10185/La répétition de ballet/moass" and "Répétition par Degas/ce tableau appartient à/Mrs. Cobden Sickert au soin de M. Fisher Unwin/11 Paternoster Bldgs/Londres"); returned to her in care of Boussod, Valadon et Cie, Paris, 25 January 1902; bought by Boussod, Valadon et Cie, 31 January 1902 (stock no. 27473, inscribed on the brace "B.V.C. 27473"), for Fr 75,373; [according to Walter Sickert's annotations in his copy of Jamot 1924, p. 84, now in the Institut Néerlandais, Paris, exchanged by him with Durand-Ruel for "Woman at the Window" (L385) and £800; according to the Durand-Ruel stock

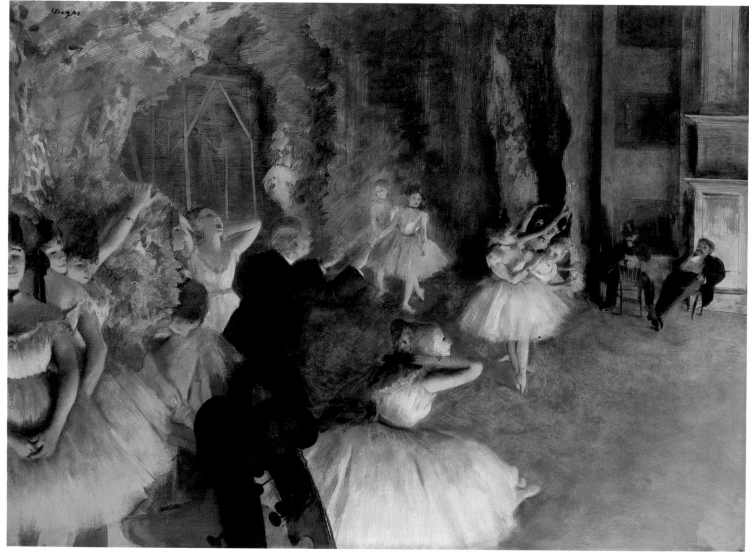

124

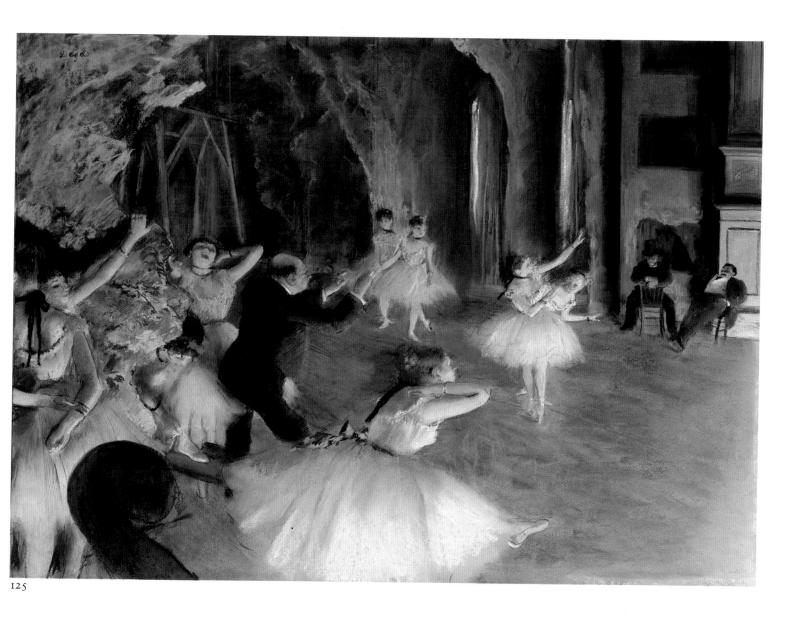

125

book, Walter Sickert bought "Woman at the Window" for Fr 10,000 on 18 February 1902]; sold by Boussod, Valadon et Cie to H. O. Havemeyer, New York, 7 February 1902, for Fr 82,845; Mrs. H. O. Havemeyer, New York, 1907–29; Horace Havemeyer, her son, New York, 1929; his gift to the museum 1929.

EXHIBITIONS: 1876 London, no. 130 (as "The Rehearsal"); (?)1877 Paris, no. 61, as "Répétition de ballet"; 1891–92, London, New English Art Club, Winter, *Seventh Exhibition*, no. 39 (as "Répétition"), lent by Mrs. Walter Sickert; 1898 London, no. 116, repr. (as "Dancers"), lent by Mrs. Unwin; 1900, Paris, Exposition Internationale Universelle, Grand Palais, *Exposition centennale de l'art français*, no. 210 (as "La répétition"), lent by Mrs. Cobden-Sickert; 1915 New York, no. 19 (as "Dancing Rehearsal") or no. 24 (as "The Rehearsal"), probably lent by Mrs. H. O. Havemeyer; 1930 New York, no. 58; 1937 Paris, Orangerie, no. 22, pl. XIII; 1947 Cleveland, no. 23; 1949 New York, no. 36; 1950–51 Philadelphia, no. 73, repr.; 1953, Kansas City, William Rockhill Nelson Gallery, 11–31 December, *Twentieth Anniversary Exhibition: 19th and 20th Century French Paintings*; 1958 Los Angeles, no. 26, repr.; 1977 New York, no. 13.

SELECTED REFERENCES: Alice Meynell, "Pictures from the Hill Collection," *Magazine of Art*, V, 1882, p. 82; Moore 1890, repr. p. 420; D.S.M. [Dugald Stuart MacColl], "Impressionism and the New English Art Club," *The Spectator*, LXVII:5, December 1891, p. 809; George Moore, "The New English Art Club," *The Speaker*, IV:5, December 1891, pp. 676–78; R. Jope-Slate, "Current Art: The New English Art Club," *Magazine of Art*, XV, 1892, p. 123; Frederick Wedmore, "Manet, Degas, and Renoir: Impressionist Figure-Painters," *Brush and Pencil*, XV:5, May 1905, repr. p. 260; Lafond 1918–19, II, p. 26 (as 1874); Jamot 1924, pp. 125 n. 6, 142–43, pl. 36 (as c. 1874); Havemeyer 1931, p. 123, repr. p. 122; Louise Burroughs, "Notes," *The Metropolitan Museum of Art Bulletin*, IV:5, January 1946, repr. facing p. 144, repr. (color, detail) cover; Huth 1946, p. 239 n. 22; Lemoisne [1946–49], I, pp. 91–92, II, no. 400 (as c. 1876); Browse [1949], pp. 55, 67, no. 30 (as c. 1874–75); Lettres Pissarro 1950, p. 239; Cooper 1954, pp. 61–62; Cabanne 1957, pp. 108, 112–13, 130, pl. 66 (as 1875, exhibited in 1877); Havemeyer 1961, pp. 259–60; Pickvance 1963, pp. 259–63, fig. 21 (as 1873); New York, Metropolitan, 1967, pp. 73–76, repr.; Reff 1976, pp. 284–85, 337 n. 36, fig. 200 (detail) (as c. 1873); Moffett 1979, p. 12, fig. 20; Moffett 1985, pp. 71, 250, repr. (color) pp. 71–72 (as 1873); Reff 1985, pp. 7 n. 2, 9 n. 7, 21 n. 6, Notebook 22 (BN, Carnet 8, p. 203), Notebook 24 (BN, Carnet 22, pp. 26, 27).

125.

The Rehearsal on the Stage

1874?
Pastel over brush-and-ink drawing on thin, cream-colored wove paper, laid on bristol board, mounted on canvas
21 × 28½ in. (53.3 × 72.3 cm)
Signed upper left: Degas
The Metropolitan Museum of Art, New York.
Bequest of Mrs. H. O. Havemeyer, 1929.
H. O. Havemeyer Collection (29.100.39)

Exhibited in New York

Lemoisne 498

Of the same size and of related design to the essence painting (cat. no. 124), this pastel was prepared with the help of the same studies but two. The second dancer from the right, en pointe, whose arm was slightly changed, follows a different version of the prototype appearing in a charcoal-and-chalk drawing (III:338.1); and the dancer with both arms raised behind her head was adapted from a pencil sketch (IV:276.a).

The sheet of paper on which the pastel was executed was fixed on a support, as was the essence version. In this instance, the support was fabric and the sheet was affixed with paper tape glued around the perimeter. However, part of the paper tape has peeled off, revealing that the drawing was trimmed by the artist, something that may have interesting implications in respect to the difference in design between the ink drawings and the grisaille painting at Orsay (cat. no. 123). Anne Maheux and Peter Zegers have pointed out that after the drawing was worked up in pastel, a number of details were redrawn in ink—notably the arm of the seated dancer in the foreground and some of the outlines of the faces.[1] This type of reworking, shared with the essence version, appears to be unique in Degas's work.

The Rehearsal on the Stage may be the work that was seen and admired by Paul Gauguin in Degas's studio in late summer 1879. According to a letter Gauguin wrote to Camille Pissarro on 26 September 1879, he returned to the studio to buy it but found it had been sold to the financier Ernest May.[2] As May bought this pastel about that time, it was possibly the work in question.[3] In any event, Gauguin admired Degas's composition enough to include elements from it as the decoration of a box he carved in 1884.[4]

1. These conclusions are contained in an examination report prepared by Anne Maheux and Peter Zegers, Degas Pastel Project, National Gallery of Canada, Ottawa.
2. For Gauguin's letter, see Lettres Gauguin 1984, I, p. 16.
3. See Merete Bodelsen, "Gauguin, the Collector,"

Burlington Magazine, CXII:810, September 1970, p. 590 n. 9. Bodelsen notes that May owned several pastels by Degas.
4. For Gauguin's sculpture, see Christopher Gray, *Sculpture and Ceramics of Paul Gauguin*, Baltimore: Johns Hopkins Press, 1963, p. 121, no. 8. Theodore Reff has pointed out that Gauguin might well have seen the Orsay grisaille version, which in his opinion is closer to the carving; see Reff 1976, pp. 267, 336 nn. 103, 104.

PROVENANCE: Ernest May collection, Paris (May sale, Galerie Georges Petit, Paris, 4 June 1890, no. 75 [as "Répétition d'un ballet sur la scène"], bought in); Georges May, his son, Paris; bought by Durand-Ruel, Paris, 25 January 1899, for Fr 47,000 (stock no. 4990, as "Répétition d'un ballet sur la scène, pastel, c. 1878–79"); transferred to Durand-Ruel, New York, January 1899 (stock no. 2117, on the back, a Durand-Ruel label: "Degas no. 2116/La leçon au foyer," actually the label for *Dance School* [L399, Shelburne Museum, Shelburne, Vt.], also bought from May, Paris, and recorded by Durand-Ruel, New York, as stock no. N.Y. 2116, the same day as *The Rehearsal on the Stage* [stock no. N.Y. 2117]; the labels were inadvertently interchanged); bought by H. O. Havemeyer, New York, 17 February 1899, for Fr 48,197; Mrs. H. O. Havemeyer, New York, 1907–29; her bequest to the museum 1929.

EXHIBITIONS: (?)1879 Paris, hors catalogue (according to Pickvance in 1986 Washington, D.C., pp. 264–65 n. 87); 1915 New York, no. 38 (as "The Ballet Rehearsal," 1875); 1930 New York, no. 143; 1949 New York, no. 36, repr. p. 8 (as 1876); 1952–53, New York, The Metropolitan Museum of Art, 7 November 1952–7 September 1953, *Art Treasures of the Metropolitan*, no. 147; 1977 New York, no. 18 of works on paper (as 1873–74), repr.

SELECTED REFERENCES: (?) Silvestre 1879, p. 38; Moore 1907–08, repr. p. 141; Geffroy 1908, p. 20, repr. p. 18 (as 1874); Lafond 1918–19, II, p. 26; Jamot 1924, pp. 142–43 (where confused with cat. no. 124, as c. 1874); Alexandre 1929, p. 483, repr. p. 479; Burroughs 1932, p. 144; Louise Burroughs, "Notes," *The Metropolitan Museum of Art Bulletin*, IV:5, January 1946, note facing p. 144; Huth 1946, p. 239 n. 22; Lemoisne [1946–49], I, pp. 91–92, II, no. 498 (as c. 1878–79); Browse [1949], no. 31 (as c. 1876–77); Cabanne 1957, p. 108; Havemeyer 1961, pp. 259–60; Pickvance 1963, p. 263 (as no later than 1874); New York, Metropolitan, 1967, pp. 76–77, repr.; Minervino 1974, no. 469; Reff 1976, p. 274, fig. 185 (detail) (as 1872–74); Reff 1977, [38ff.], fig. 70 (color); Moffett 1979, p. 12, fig. 19 (color); Moffett 1985, p. 71 (as 1873–74); 1986 Washington, D.C., pp. 264–65 n. 87; Weitzenhoffer 1986, pp. 133–34, pl. 93 (as c. 1872).

126.

Seated Dancer in Profile

1873
Essence drawing on blue paper
9 × 11½ in. (23 × 29.2 cm)
Vente stamp lower left
Cabinet des Dessins, Musée du Louvre (Orsay), Paris (RF16723)

Exhibited in New York

Vente III:132.3

For the central, seated figure in the three versions of *The Rehearsal*, Degas appears to have considered two different poses: one of a dancer scratching her back and the other of a dancer with her hand on her neck. There are essence studies of the model in both poses, but only the latter—the present drawing—was used.[1] As the drawing focused exclusively on the upper part of her body, Degas carried out additional, more detailed charcoal studies, heightened with white. In these, the dancer is observed under very specific conditions of light, illuminated from below, as if on stage. One of them (II:333) shows the figure seated, full-length, but with her back more erect and her head less dramatically tilted backward. A second study (fig. 118) represents only the dress, in considerable detail, and includes the dancer's feet, which do not appear in the other two drawings.

From a compositional sketch (IV:267), it would appear that at an early stage Degas intended to use the figure as part of a group that included a dancer adjusting her shoe. The scheme was evidently discarded, with the two dancers ultimately separated. As with most of the preparatory studies conceived for the project, Degas varied his use of prototypes for the different versions of the composition. The essence study, in combination with the study of the skirt, was followed in the dancer appearing in the two versions in the Metropoli-

Fig. 118. *Dancer in a Tutu* (III:83.2), 1873. Charcoal heightened with white, 9⅝ × 12¾ in. (24.4 × 32.4 cm). Cabinet des Dessins, Musée du Louvre (Orsay), Paris (RF16725)

126

Dancer with Arms behind Her Head

1873
Essence on commercially prepared green paper
24¼ × 17¾ in. (54 × 45 cm) (sight)
Private collection

Lemoisne 402

Degas observed his models' arms with an interest bordering on obsession, and few, if any, painters took greater delight in the emotion expressed by the movement or the outline of an arm. Degas was also interested in the expressive possibilities of the open mouth, a motif that enters his work early—for instance, in the drawing after a Roman model (cat. no. 8)—and persists in different guises as the yawn of a laundress or the singing of a café artist. Coupled with a strained movement of the arms, the effect of the open mouth can be ambiguous, as evocative of pain as it is of boredom.

The pose of the head, arms, and torso of this dancer, although observed from a model,

127

tan Museum (cat. nos. 124, 125). For the dancer in the Orsay grisaille version (cat. no. 123), the full-length charcoal drawing (II:333) was chosen instead.

Among the most powerfully evocative studies of a dancer at rest, the Louvre drawing also marks the first appearance of a pose that Degas examined again and again in the context of his later compositions of bathers. A woman in a related pose appears in the foreground of *Supper at the Ball* (fig. 112) by Adolf Menzel, painted in 1878, of which Degas was to make a copy in 1879 (fig. 113). From the evidence, it is impossible to determine whether Menzel knew one of the three versions of *The Rehearsal* or whether the similarity of the poses is a coincidence.[2]

1. For the alternative study with the dancer scratching her back, see III:132.2.
2. See Harald Keller, "Degas-Studien," *Städel-Jahrbuch*, new series, 7, 1979, pp. 287–88.

PROVENANCE: Atelier Degas (Vente III, 1919, no. 132.3, in the same lot with nos. 132.1 and 132.2, for Fr 5,500); Gaston Migeon, Paris; gift to the Louvre from the Société des Amis du Louvre 1931.

EXHIBITIONS: 1924 Paris, no. 107; 1969 Paris, no. 184; 1984 Tübingen, no. 93, repr. (color).

SELECTED REFERENCES: Lafond 1918–19, II, repr. before p. 37; Rivière 1922–23, I, pl. 23 (reprint edition 1973, pl. 40); Rouart 1945, p. 71 n. 28; Lemoisne [1946–49], II, under no. 400; Browse [1949], no. 28a, repr.; Pickvance 1963, p. 260 n. 53; Sérullaz 1979, repr. (color) p. 6.

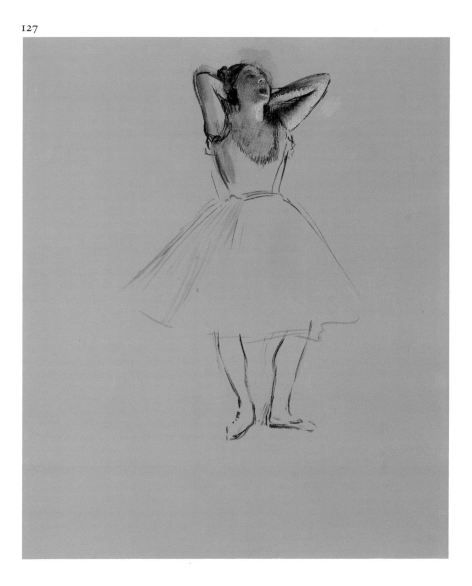

is in fact derived from one of the two crucified thieves in Mantegna's *Crucifixion* in the Louvre, a detail that attracted Degas enough to copy it twice.[1] His fascination with Mantegna is well known, and this is one of the rare examples when an old master is quoted so freely. Two other sheets show dancers in the same pose. One (IV:276.a), with two pencil studies of the torso of the same dancer, was used for the pastel version of *The Rehearsal on the Stage* (cat. no. 125); the other, a more finished sheet (II:331), was part of a group of six drawings executed for the Orsay version of the same painting (cat. no. 123). The drawing in this exhibition was used only for the oil in the Metropolitan Museum (cat. no. 124).

Degas adapted the pose for a nude in a monotype of a woman in her bathtub (J175).

1. See IV:99.c (Zurich, private collection) and a drawing in a Milan private collection (reproduced in 1984–85 Rome, under no. 6). See also cat. no. 27.

PROVENANCE: Bought from the artist in 1878 by Henry Lerolle (inscribed on verso: "Ce dessin a été acheté/ par Henri Lerolle à Degas lui-même [en même temps] que 'les femmes se coiffant' en 1878/Ceci s'est passé dans l'atelier de Degas/moi présente/ Madeleine Lerolle"); Madeleine Lerolle, his widow, Paris, from 1929; Hector Brame, Paris; Franz Koenigs, Haarlem. Private collection.

EXHIBITIONS: 1937 Paris, Orangerie, no. 82; 1938, Amsterdam, Paul Cassirer, *Fransche Meesters uit de XIXe eeuw*, no. 49, repr.; 1946, Amsterdam, Stedelijk Museum, February–March, *Teekeningen van Fransche Meesters 1800–1900*, no. 72; 1952 Amsterdam, no. 30; 1964, Paris, Institut Néerlandais, 4 May– 14 June/Amsterdam, Rijksmuseum, 25 June–16 August, *Le dessin français de Claude à Cézanne dans les collections hollandaises* (catalogue by Carlos van Hasselt), no. 186, repr.

SELECTED REFERENCES: Lafond 1918–19, II, repr. after p. 36; Rivière 1922–23, II, no. 69, repr. (reprint edition 1973, pl. 42); Lemoisne [1946–49], II, no. 402, repr.; Jean Leymarie, *Les dessins de Degas*, Paris: Fernand Hazan, 1948, no. 11, repr.; Claude Roger-Marx, *Degas, danseuses*, Paris: Fernand Hazan, 1956, no. 8, repr. cover.

128.

The Dance Class

1873
Oil on canvas
19 × 24⅝ in. (48.3 × 62.5 cm)
Signed lower right: Degas
The Corcoran Gallery of Art, Washington, D.C.
 William A. Clark Collection, 1926 (26.74)

Lemoisne 398

There are two quite different versions of this composition. One of them, *The Rehearsal* (fig. 119), in the Burrell Collection, Glasgow, was seen in Degas's studio in February 1874 by Edmond de Goncourt, as noted by Keith Roberts.[1] The other, the Corcoran Gallery painting exhibited here, was once considered a later work. However, Ronald Pickvance has demonstrated that it was painted after Degas's return from New Orleans in 1873, and before the Glasgow painting.[2] Thus it can be included among the two or three other major ballet subjects that Degas undertook in 1873.

The work is remarkable on several counts, not least in the ambitious attempt to group a very large number of figures, actually the largest to appear in any of Degas's compositions. The scene takes place in an unusual space, possibly the dance foyer of the old Opéra on rue Le Peletier, with a dimly lit chamber in the foreground opening at the side onto a more brightly illuminated rehearsal room. The left foreground is occupied by a spiral staircase, allowing for Degas's most bizarre design to date, composed exclusively of truncated figures. As in the few earlier ballet scenes, the emphasis is not on performance but on a moment of respite in the midst of a rehearsal. There is actually more movement here than in any of Degas's previous dance compositions. The air of informality touched off by the sequence of legs descending the staircase is maintained throughout much of the work, either in the poses of the dancers or in the introduction of charming subordinate elements—a red fan dropped on the floor or two pairs of pink slippers left on a bench. Whatever emotion is induced by the moody vibrations of light is held in check by the integration of the odd comic note—the dancer in the center, bending quite gracelessly, or the young woman in a red shawl biting her thumb in a gesture prefiguring that of an older and more cynical character in *Women on the Terrace of a Café in the Evening* (cat. no. 174).

Although numerous drawings doubtless served in the preparation of this work, surprisingly few can be traced.[3] Most of the identifiable studies were executed in essence, indicating—as Pickvance has pointed out—a date in the early 1870s, though they may have included more elaborate repetitions of one or two figures, studied in greater detail in charcoal and chalk.[4] The first dancer in the rehearsal room to the rear, with both her arms behind her back, appears on the extreme left in the Orsay *Ballet Rehearsal on Stage* (cat. no. 123), as does the bench, suggesting a certain proximity of the two works.

A slight ambiguity in the provenance of the work was raised by Paul Durand-Ruel's statement in his memoirs that he sold a "Répétition de danse," presumably this painting, to Walter Sickert and that "Senator Clark paid, already many years ago now, 80,000 francs. It's worth double that at least. I paid Degas 1,500 francs for it and sold it to Sickert for 2,000."[5] There appears to be no record of such a transaction in the Durand-Ruel archives, and one can only imagine that there was some confusion with *The Rehearsal on the Stage* (cat. no. 125), which was indeed owned by Sickert but not purchased from Durand-Ruel.

1. Keith Roberts, "The Date of Degas's 'The Rehearsal' in Glasgow," *Burlington Magazine*, CV:723, June 1963, pp. 280–81.
2. Pickvance 1963, p. 259.
3. The known drawings are as follows: bending dancer at the center (BR59); first dancer at the left (fig. 138); dancer with both arms raised just left of center (possibly III:145.1, but just as likely II:312); dancer in the far room with both arms behind her back (III:132.1, or possibly II:327). The second dancer from the right and the dancer at the center adjusting her shoulder strap appear on a sheet (III:212) that was cut into three pieces sometime after 1919; see 1984 Tübingen, nos. 96, 99, and 227, where the fragments are dated c. 1874.
4. As indicated in note 3, one of the dancers with her arms raised seems based on the charcoal drawing rather than the essence prototype. Pickvance, however, believes the charcoal drawing to date from a later period; see Pickvance 1963, p. 259 n. 34.
5. Venturi 1939, II, p. 195.

PROVENANCE: Sent by the artist to Charles W. Deschamps, London, by April 1876; bought by Captain Henry Hill, Brighton (Hill sale, Christie's, London, 25 May 1889, no. 28 [as "A Rehearsal"], for 60 guineas); bought by Montaignac for Michel Manzi, Paris; bought by Eugene W. Glaenzer and Co., New York; bought by Senator William A. Clark, Washington, D.C., 1903; his bequest to the museum 1926.

EXHIBITIONS: 1876 London, no. 131 (as "The Practising Room at the Opera House"); (?) 1877 Paris, no. 38; 1959, New York, Wildenstein and Co., 28 January–7 March, *Masterpieces of The Corcoran Gallery of Art*, p. 29; 1962, Seattle, Century 21 Exposition, 21 April– 4 September, *Masterpieces of Art*, no. 42, repr.; 1978 New York, no. 15, repr. (color); 1983–85, Washington, D.C., The Corcoran Gallery of Art, 1 October 1983–8 January 1984/Columbus, Ga., Columbus Museum of Arts and Sciences, 27 January–18 March/ Evanston, Northwestern University, Mary and Leigh Block Gallery, 18 May–15 July/Houston, The Museum of Fine Arts, 10 August–7 October/Tampa Museum, 28 October 1984–13 January 1985/Omaha, Joslyn Art Museum, 9 February–31 March/Akron Art Museum, 20 April–16 June, *La Vie Moderne: Nineteenth-Century Art from The Corcoran Gallery*, no. 41 (catalogue entry by Marilyn F. Romines), repr. (color) frontispiece; 1986 Washington, D.C., no. 45, repr. (color).

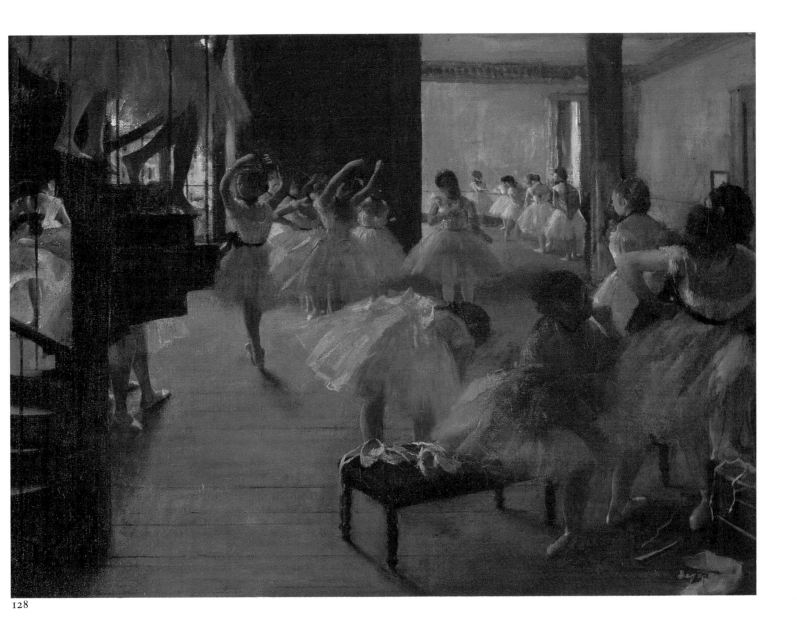

128

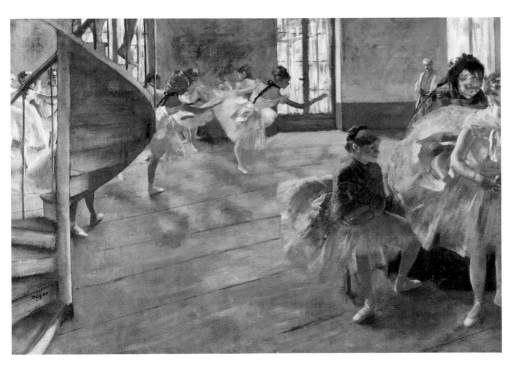

Fig. 119. *The Rehearsal* (L430), 1874. Oil on canvas, 23 × 33 in. (58.4 × 83.8 cm). The Burrell Collection, Glasgow

SELECTED REFERENCES: *The Echo*, 22 April 1876, cited in Pickvance 1963, p. 259 n. 36; *Illustrated Handbook of The W. A. Clark Collection*, Washington, D.C.: The Corcoran Gallery of Art, 1932, p. 32; Mongan 1938, p. 301; Venturi 1939, II, p. 195 (wrongly as a picture sold by Durand-Ruel to Walter Sickert); Rewald 1946, p. 233 (as c. 1873); Lemoisne [1946–49], II, no. 398 (as c. 1876); Browse [1949], no. 45 (as c. 1879–80); Cooper 1954, p. 61 nn. 4, 6 (wrongly as a picture owned by Walter Sickert); Pickvance 1963, pp. 259–65 (as 1873); Keith Roberts, "The Date of Degas's 'The Rehearsal' in Glasgow," *Burlington Magazine*, CV:723, June 1963, pp. 280–81; William Wells, "Degas' Staircase," *Scottish Art Review*, IX:3, 1964, pp. 14–17, repr. p. 15; Minervino 1974, no. 490; 1984 Tübingen, under no. 96; 1984–85 Washington, D.C., pp. 43–44, fig. 2.1 p. 44.

The Dance Class

cat. nos. 129–138

The series of six important compositions that Degas painted for Jean-Baptiste Faure began with a dance subject commissioned by Faure shortly after he met the artist in 1873. Although there has never been any doubt about the identification of the painting eventually delivered to Faure as *The Dance Class* (cat. no. 130), now in the Metropolitan Museum, there has been confusion about its date and its connection to the closely related and apparently earlier work (cat. no. 129) in the Musée d'Orsay. Published documentary evidence, chiefly a letter to Faure dating from December 1873, and the perplexing inclusion of seemingly the same painting belonging to Faure in the Impressionist exhibitions of both 1874 and 1876 have proved less than conclusive in settling the question. The only dated study directly connected with the paintings, an essence sketch of the ballet master Jules Perrot dated 1875 (cat. no. 133), emerged over the years as a perceptible obstacle to a logical chronology and to the dating of the Orsay painting before 1875. However, the publication of an X-radiograph of the Paris canvas in 1965 confirmed that it had been substantially altered, and George Shackelford demonstrated that the painting originally had several other principal figures, including a differently posed ballet master.[1]

Degas's correspondence suggests, in fact, that the sequence of events was somewhat different from what was previously thought. In the latter part of 1873, Degas began painting the Orsay canvas as the picture commissioned by Faure.[2] The work was probably finished, or almost finished, by 15 April 1874 in the form it had before he overpainted it, hence its inclusion in the catalogue of the

first Impressionist exhibition. The painting was not shown, however. Degas may have begun to alter it immediately, and perhaps had an idea about how he would change the composition. Sometime before November 1874, he had Jules Perrot pose for a drawing (fig. 121) to serve as the figure of a new ballet master. By November 1874, when matters became pressing, instead of continuing with complicated alterations to the Orsay painting Degas made the second version. In an unpublished, undated letter to Charles Deschamps, probably written shortly after 8 November 1874, Degas confirmed that he had delivered his picture to Faure: "The point was to release myself from Faure at any cost, as I told you, and only with the big work. The rest remains to be done—which he is already angry about. I really don't know how to do anything quickly, and I can still only do it with a prod in my back. I wish you were here every week to push me, then everything would go better."[3] It is likely that the first version was temporarily abandoned and taken up again only in 1875, when Degas made the dated essence drawing of Perrot specifically as a study for the picture. The Orsay *Dance Class* was finished by the spring of 1876, when it was exhibited in London at Deschamps's gallery, as pointed out by Ronald Pickvance.[4] It is ironic that, at the same time, Degas exhibited Faure's version of the composition in Paris.

1. 1984–85 Washington, D.C., pp. 45–58.
2. Lettres Degas 1945, V, p. 31 n. 1; Degas Letters 1947, no. 10, p. 36 n. 2, and "Annotations," p. 261.
3. Transcript of an undated letter from Degas to Charles W. Deschamps, kindly communicated to the author by John Rewald. The letter mentions various matters concerning Auguste Renoir and Arsène-Hippolyte Rivey, which links it closely to an unpublished letter from Degas to Deschamps dated 8 November 1874 that deals with the same questions; Institut Néerlandais, Fondation Custodia, Paris, inv. no. 1971-A.304.
4. Pickvance 1963, p. 259 nn. 37, 38.

129.

The Dance Class

Begun 1873, completed 1875–76
Oil on canvas
33½ × 29½ in. (85 × 75 cm)
Signed lower left: Degas
Musée d'Orsay, Paris (RF1976)

Lemoisne 341

Begun in 1873 but finished almost certainly only in 1875 or early 1876, this work is Degas's first attempt to paint a large canvas representing a group of dancers. The difficulties he encountered in orchestrating the figures have been analyzed by George Shackelford, who has shown how the artist altered the composition. At first, a younger dance master conducted the class, turning his back to the viewer, as in the drawing in the Art Institute of Chicago (cat. no. 131), and in the foreground, left of center, there was a dancer adjusting her shoe based on a drawing in the Metropolitan Museum (cat. no. 135). From X-radiographs, it may be concluded that Degas altered the dancer in the foreground twice before finally deciding on a figure loosely derived from the Louvre drawing (cat. no. 137). It is unclear at what stage the alterations occurred. A painted sketch dated 1874 (fig. 122) is certainly connected with the nearest group of dancers as it originally appeared in the painting, and the present figure of the ballet master is based largely on the essence sketch of Jules Perrot dated 1875 (cat. no. 133), but revised in light of an earlier study in the Fitzwilliam Museum (fig. 121).[1]

The handling of paint—light in application and almost translucent—is so confident as to make the efforts required to produce the work almost unnoticeable. Conceived in harmoniously subdued tones, the scene is ruled by a pale, uneven light which unexpectedly emphasizes a detail or dissolves outline and form. Alive with small, episodic incidents, the narrative suggests the end of a session and the exhaustion and relaxation that accompany the easing of tension. Almost none of the dancers pay attention to the old master—and none is more indifferent than the two towering above the others at the opposite ends of the room. In the background, the dancer adjusting her choker with an exasperated gesture becomes the echo of the one in the foreground scratching her back.

When Lillian Browse identified the figure of the ballet master as Jules Perrot she concluded that the scene in both the New York and the Paris versions was a reasonably accurate record of a dance class witnessed by Degas. Shackelford, who drew attention to

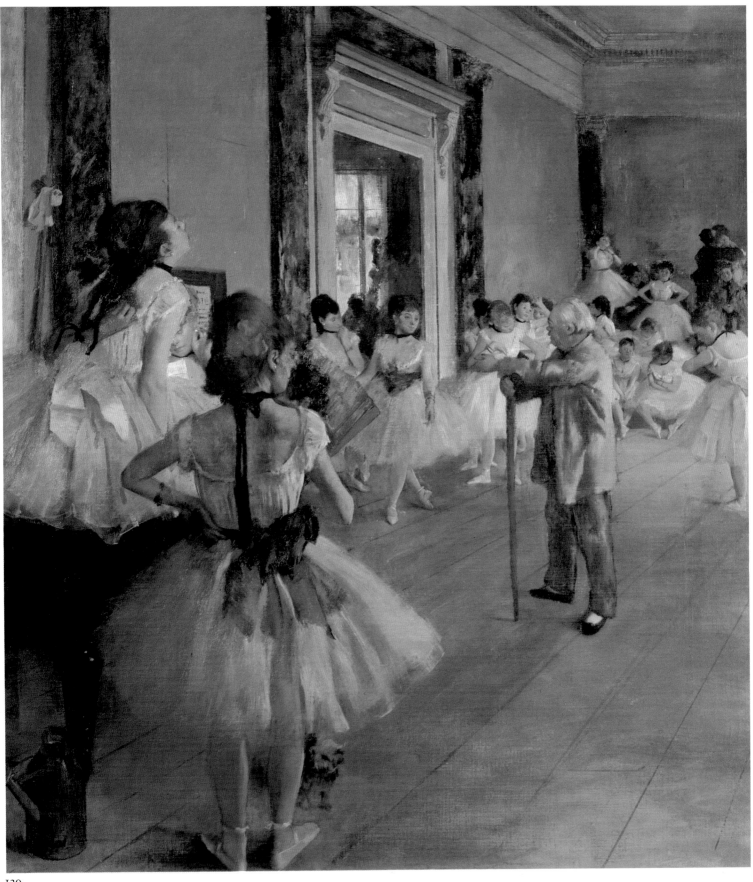

129

the improbability of a connection between Perrot and the Opéra in the 1870s, proposed instead the interesting hypothesis that in its final form *The Dance Class* is a genre portrait that may have been painted as a tribute to Perrot.[2]

1. Most of the drawings connected with the composition have been identified by Lemoisne and Shackelford. Lemoisne, however, has also associated a number of unrelated drawings. As far as can be ascertained, the related drawings are as follows: I:328 (Fogg Art Museum, Cambridge, Mass.) and II:332 (Detroit Institute of Arts), which served also for *Ballet Rehearsal on Stage* (cat. no. 123); III:112.3, all three dancers appearing on the sheet; III:115.1, rather than III:342.1 as proposed by Lemoisne, for the dancer touching her ear; IV:138.a; III:81.4, perhaps in association with III:166.1, for the dancer adjusting her shoulder strap; cat. no. 133 with fig. 121 for Perrot; and, more remotely, cat. nos. 136–138.
2. See "The Dance Class," p. 234.

PROVENANCE: Sent by the artist in spring 1876 to Charles W. Deschamps, London; bought by Captain Henry Hill, Brighton, before September 1876 (Hill sale, Christie's, London, 25 May 1889, no. 27 [as "Maître de ballet"], for 54 guineas [Fr 1,417]); bought by Goupil-Boussod et Valadon, Paris (stock no. 19884); bought by Michel Manzi, Paris, 3 June 1889, for Fr 4,000; bought by Comte Isaac de Camondo, Paris, April 1894, for Fr 70,000 (as "La leçon de danse"); his bequest to the Louvre, Paris, 1908; entered the Louvre 1911.

EXHIBITIONS: 1876 London, no. 127 (as "Preliminary Steps"); 1876, Brighton, Royal Pavilion Gallery, opened 7 September, *Third Annual Winter Exhibition of Modern Pictures*, no. 167 (as "Preliminary Steps"), lent by Captain Henry Hill; 1904, Paris, Musée National du Luxembourg, *Exposition temporaire de quelques chefs-d'oeuvre de maîtres contemporains, prêtés par des amateurs*, no. 17, lent by Comte Isaac de Camondo; 1924 Paris, no. 46; 1937 Paris, Orangerie, no. 21; 1948, Venice, XXIV Biennale di Venezia, 29 May–30 September, *Gli impressionisti* (catalogue by Rodolfo Pallucchini), no. 64, repr.; 1953–54 New Orleans, no. 75; 1955, Rome, Palazzo delle Esposizioni, February–March/Florence, Palazzo Strozzi, *Mostra de capolavori della pittura francese dell'ottocento*, no. 32, repr.; 1964–65 Munich, no. 81; 1969 Paris, no. 25; 1984–85 Washington, D.C., no. 10, repr. (color) (as c. 1875).

SELECTED REFERENCES: *The Echo*, 22 April 1876, *The Brighton Gazette*, 16 September 1876, cited in Pickvance 1963, p. 259 nn. 35, 36; "Art-notes from the Provinces," *Art Journal*, XXVIII, 1876, p. 371; Alice Meynell, "Pictures from the Hill Collection," *Magazine of Art*, V, 1882, p. 82; Hourticq 1912, p. 102, repr. p. 101; Lemoisne 1912, pp. 59–60, fig. xxii (as 1874); Paris, Louvre, Camondo, 1914; Jamot 1924, p. 102, pl. 35 (as 1874); Rivière 1935, repr. p. 117 (as 1872); Lemoisne [1946–49], II, no. 341; Browse [1949], no. 23 (as 1873–74); Pickvance 1963, pp. 259 nn. 37, 38, 265 n. 82, 266 (suggesting a date after April 1874); Reff 1968, p. 90 n. 43; Minervino 1974, no. 479; Paris, Louvre and Orsay, Peintures, 1986, III, p. 193 (as c. 1871–74); Sutton 1986, pp. 119–20, 126, 168, fig. 143 (color) p. 167; Weitzenhoffer 1986, pp. 130–31, pl. 87 (identifying the work with one offered by Durand-Ruel to H. O. Havemeyer in 1899).

130.

The Dance Class

1874
Oil on canvas
33 × 31¾ in. (83.8 × 79.4 cm)
Signed lower left: Degas
The Metropolitan Museum of Art, New York.
 Bequest of Mrs. Harry Payne Bingham, 1986

Lemoisne 397

It can reasonably be assumed that this work was painted largely in the autumn of 1874, when pressure on Degas from Jean-Baptiste Faure to deliver his commissioned works became increasingly difficult to ignore. In a way, the style of the painting alone reveals it as the earlier of the two versions of *The Dance Class*: the contrasts are bolder, the effects of light are more brilliant, and—most of all—there is a concern with the specific that brings the painting quite close to Degas's earliest ballet scenes and to *Portraits in an Office (New Orleans)* (cat. no. 115). In this respect, Mary Cassatt's repeated statements that in this work Degas surpassed Vermeer are not far removed from the voices that found *Portraits in an Office* infused with a seventeenth-century Dutch sensibility.[1]

The composition of the painting is more eccentric than either the original or the revised design of the related Orsay version (cat. no. 129), particularly in the extraordinary arrangement of the group in the foreground and the oppressive perspective, subverted by the sharply raised platform in the background. The center of the composition is psychologically, as well as technically, occupied by a dancer performing an arabesque for the ballet master at the far right. The figures behind her are more conspicuous than their counterparts in the Orsay version and include a number of dancers not appearing in the latter, notably a dancer leaning against the wall at a peculiar angle. The grouping of dancers to the left, clustered around an almost invisible piano, represents one of Degas's most dramatic and strange feats of composition. Two of the figures are like shadows of each other, two additional ones are virtually faceless, and another, a seated dancer, seems to float in mid-air.

Degas's claim to the dealer Charles Deschamps that he painted the work "d'un trait" (without a break)[2] is to an extent misleading, as pentimenti and X-radiography confirm changes to the composition. The principal dancer in the foreground, like the one behind her, originally looked straight down, and Degas changed the position of her legs twice before he settled on the final pose; the second dancer from the left was added after the group had already been painted; the dancer in arabesque was originally farther to the left, largely covering the figure immediately next to her; and the mirror extended farther into the background. A number of studies can be related to the composition, but fewer than might be expected.[3] The poster on the wall, a tribute to Faure, is for Rossini's opera *Guillaume Tell*, one of the singer's great successes.

1. "Col. Payne's Degas is more beautiful than any Vermeer I ever saw," cited in Weitzenhoffer 1986, p. 126. In 1915, in a letter to Mrs. H. O. Havemeyer in connection with attempts to organize an exhibition, Mary Cassatt wrote: "My one piece of advice is that you get the Colonel to lend his Degas, if you could get someone to lend a Vermeer for the Old Masters, it would show Degas' superiority."; Mary Cassatt, Grasse, 20 January 1915, to Louisine Havemeyer, Archives, The Metropolitan Museum of Art, New York.
2. Reff 1968, pp. 89–90.
3. III:157.2 (fig. 121) for Perrot; IV:138.a in association with III:166.1 for the dancer adjusting her shoulder strap.

PROVENANCE: Delivered by the artist to Jean-Baptiste Faure, Paris, autumn 1875; sold to Durand-Ruel, Paris, 19 February 1898, for Fr 10,000 (as "Le foyer de la danse"); transferred to Durand-Ruel, New York, 16 March 1898 (stock no. 1977); bought by Colonel Oliver H. Payne, New York, 4 April 1898; Harry Payne Bingham, his nephew, New York, from 1917; Mrs. Harry Payne Bingham, his widow, from 1955; her bequest to the museum 1986.

EXHIBITIONS: 1876 Paris, no. 37 (as "Examen de danse"), lent by Faure; 1915 New York, no. 33; 1921, New York, The Metropolitan Museum of Art, 3 May–15 September, *Loan Exhibition of Impressionist and Post-Impressionist Paintings*, no. 27; 1968, New York, The Metropolitan Museum of Art, Summer, *New York Collects*, no. 50; 1974–75 Paris, no. 17, repr. (color).

SELECTED REFERENCES: Grappe 1911, repr. cover and p. 21; Lemoisne 1912, p. 60 (as 1875); Meier-Graefe 1923, p. 56, pl. XVI (as 1872–73); Lemoisne [1946–49], I, pp. 92, 99, 102, II, no. 397 (as c. 1876); Degas Letters 1947, "Annotations," no. 10, p. 261 (as 1874); John Rewald, "The Realism of Degas," *Magazine of Art*, XXXIX:1, January 1946, repr. p. 13; Browse [1949], no. 23 (as c. 1874–76); Cabanne 1957, p. 98; Havemeyer 1961, pp. 263–64; Browse 1967, pp. 107–09, fig. 5; Minervino 1974, no. 488; 1984–85 Washington, D.C., pp. 52–53, fig. 2.8 (as c. 1876); Weitzenhoffer 1986, pp. 126–27, 130, fig. 79 (color) (as c. 1874).

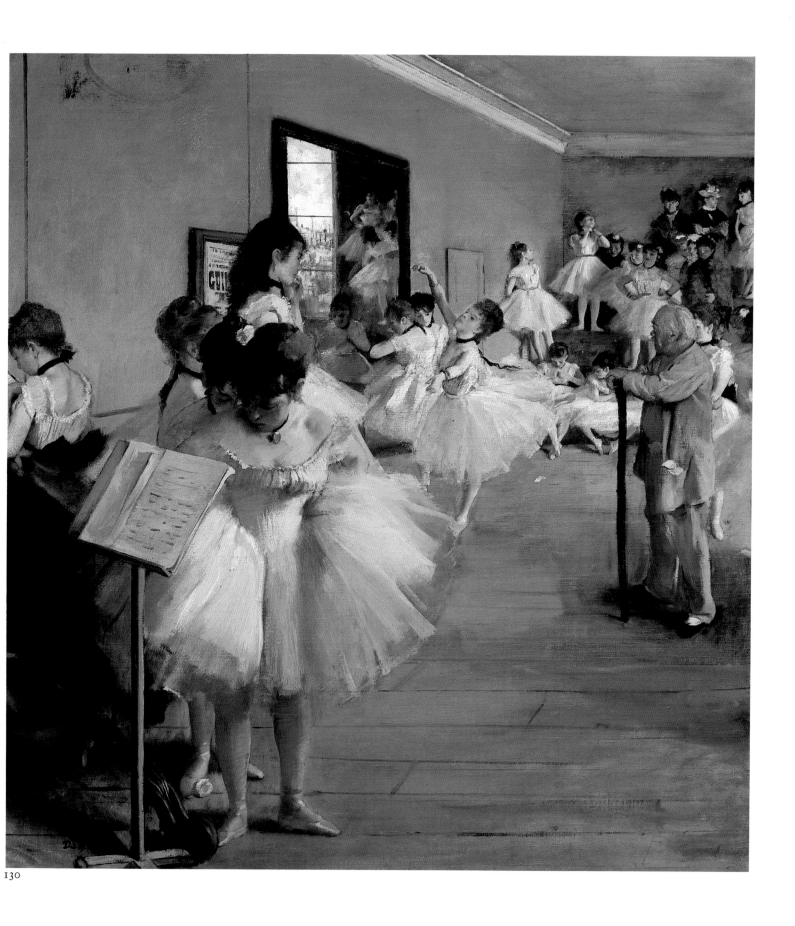

131

132

131.

Dance Master II

1873
Graphite and charcoal on faded, pale pink wove
 paper, squared in charcoal for transfer
16⅛ × 11¾ in. (41 × 29.8 cm) (irregular)
Vente stamp lower left; atelier stamp lower right
 and on verso. Inscribed in blue pencil lower
 right: 2284
The Art Institute of Chicago. Gift of Robert
 Sonnenschein II (1951.110a)

Vente IV:206.a

This and a cognate drawing (cat. no. 132)
were recognized by George Shackelford as
studies for the figure of the dance master
originally appearing in the Paris version of
The Dance Class (cat. no. 129).[1] The fact
that this drawing is squared for transfer
identifies it as the principal study used for
the figure, but the degree of finish alone
would indicate as much. As a virtuoso per-

formance, it equals the heights of Degas's
idol, Ingres, with the exception that it is not
ruled by a preconceived notion of ideal
form. On the contrary: few of the artist's
drawings reveal more eloquently his extraor-
dinary gift for extracting from a model the
telling detail that would bring a work to life
and give it an almost uncanny authenticity.

1. See "The Dance Class," p. 234.

PROVENANCE: Atelier Degas (Vente IV, 1918, no. 206.a,
in the same lot with no. 206.b [cat. no. 132], for
Fr 300). Robert Sonnenschein II, New Freedom, In-
diana; his gift to the museum 1951.

EXHIBITIONS: 1967 Saint Louis, no. 65, repr. (as
c. 1872); 1984 Chicago, no. 24, repr. (color) (as 1874);
1984–85 Washington, D.C., pp. 49–50, no. 11, repr.
p. 49 (as c. 1874).

SELECTED REFERENCES: Harold Joachim and Sandra
Haller Olsen, *French Drawings and Sketchbooks of the
Nineteenth Century, The Art Institute of Chicago*, Chi-
cago/London: University of Chicago Press, 1979, II,
no. 2F12.

132.

Dance Master I

1873
Watercolor and gouache with pen and black ink
 and touches of brown oil paint, over graphite
 and charcoal, on buff laid paper, laid down
17¾ × 10⅜ in. (45 × 26.2 cm) (irregular)
Vente stamp lower left; atelier stamp on verso,
 lower right
The Art Institute of Chicago. Gift of Robert
 Sonnenschein II (1951.110b)

Exhibited in Ottawa and New York

Lemoisne 367 bis

Although more informal in conception
than the related drawing (cat. no. 131), this
study is technically more complex, with the
underlying pencil outline covered with a
brush drawing, layers of watercolor and
gouache, and even touches of oil paint. The
order in which the two drawings were exe-
cuted is unclear and is unlikely ever to be

determined. Suzanne Folds McCullagh has proposed that the brush-and-ink study preceded the more finished pencil drawing.[1] George Shackelford, however, has reversed the order and considers the brush study to be second in the sequence, as a notation for the dance master's costume.[2] It is curious that in both drawings the artist had to revise the length of the legs.

In an earlier discussion of the two drawings, Jean Sutherland Boggs tentatively suggested that the model may have been Louis Mérante, the ballet master of the Opéra de Paris, commonly believed to be represented in *Dance Class at the Opéra* (cat. no. 107).[3] She noted that this study "runs close to broad caricature, but a caricature in which pathos rather than malice is combined with comedy."

1. 1984 Chicago, p. 59.
2. 1984–85 Washington, D.C., pp. 49–50.
3. 1967 Saint Louis, p. 106.

PROVENANCE: Atelier Degas (Vente IV, 1919, lot 206.b, in the same lot with no. 206.a [cat. no. 131], for Fr 300). Robert Sonnenschein II, New Freedom, Indiana; his gift to the museum 1951.

EXHIBITIONS: 1967 Saint Louis, no. 66, repr. (as c. 1872); 1984 Chicago, no. 23, repr. (color) (as 1874); 1984–85 Washington, D.C., pp. 49–50, no. 12, repr. p. 49 (as c. 1874).

SELECTED REFERENCES: Lemoisne [1946–49], II, no. 367 bis; Browse [1949], no. 40a, repr.; Boggs 1962, p. 127; Minervino 1974, no. 483; Reff 1976, p. 282, fig. 196 (as 1875–77); Harold Joachim and Sandra Haller Olsen, *French Drawings and Sketchbooks of the Nineteenth Century, The Art Institute of Chicago*, Chicago/London: University of Chicago Press, 1979, II, no. 2G1.

133.

Jules Perrot

1875
Essence on tan paper
19 × 11⅞ in. (48.1 × 30.3 cm)
Signed and dated lower right: Degas/1875
Philadelphia Museum of Art. The Henry P. McIlhenny Collection in memory of Frances P. McIlhenny (1986-26-15)

Lemoisne 364

The mistaken identification of this essence sketch as a portrait of the ballet master Ernest Pluque was rectified by Lillian Browse, who discovered that the figure represented Jules Perrot (1810–1892).[1] From 1830, when he made his debut as a classical dancer, until 1860, when he ostensibly retired, Perrot was perhaps the leading male dancer-choreographer of the Romantic era. As the partner of Marie Taglioni, he was the chief attraction of the Opéra de Paris until 1834, when dis-

agreements with the management led him to tour Europe with Carlotta Grisi. Except for a brief, unofficial return to the Opéra in 1841 to arrange Grisi's numbers in *Giselle*, and visits in 1847 and 1848, he performed in his own ballets abroad. Between 1842 and 1848, he was dancer-choreographer and ballet master at the London opera, and afterward he danced in Saint Petersburg, where he became ballet master in 1851. When he returned to Paris in 1861, the hoped-for reconciliation with the Opéra failed to take place.[2]

Nothing is known of the connection between Degas and Perrot beyond the notation of Perrot's Paris address, in 1879, in one of the artist's notebooks.[3] Degas certainly painted a portrait of Perrot, dated c. 1875–79 by Jean Sutherland Boggs, for which two related studies exist.[4] Ronald Pickvance has surmised that the two men may have met as

early as 1873, after Degas's return from New Orleans, but George Shackelford has proposed 1874 as a likelier probability.[5] Ivor Guest and Richard Thomson have recently shown that for Glasgow's *The Rehearsal* (fig. 119), known to have been finished by February 1874, the artist used an earlier photograph of Perrot (fig. 120), which may suggest that Perrot did not pose for Degas until later.[6]

A closely related charcoal drawing (fig. 121) in the Fitzwilliam Museum, Cambridge, England, shows Perrot from the same angle as in the essence study but with his arms and cane in a somewhat different position and his body defined by decidedly sinuous contours. The drawing is ruled for transfer and is inscribed with notes on color and light, indicating that Perrot wore the same red Russian shirt with his flannel suit as in the

133

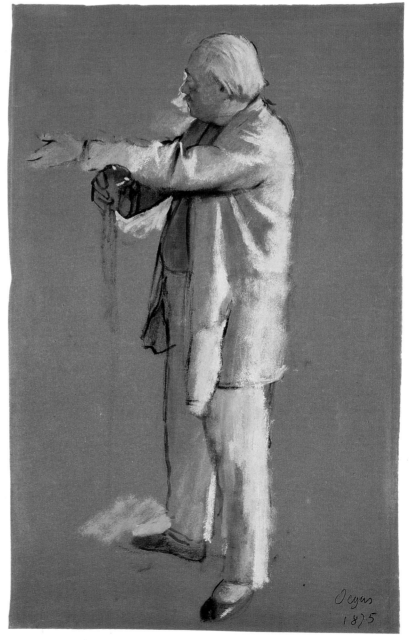

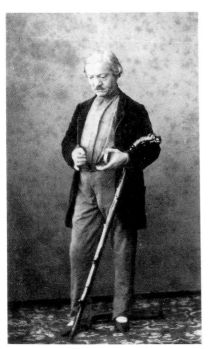

Fig. 120. C. Bergamasco, *Jules Perrot*, c. 1860. Photograph. Private collection

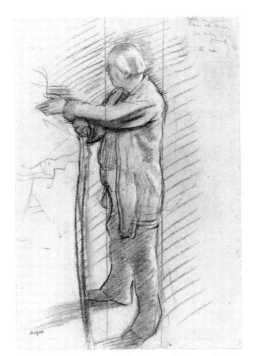

Fig. 121. *The Dancer Jules Perrot* (III:157.2), 1874. Charcoal and black chalk heightened with white, 19 × 12 in. (48.4 × 30.5 cm). Fitzwilliam Museum, Cambridge, England

Philadelphia sketch.[7] There is no doubt that the Fitzwilliam drawing served as a model for the figure of Perrot in New York's *The Dance Class* (cat. no. 130) and must therefore date from 1874. As the essence study is dated by the artist 1875, its relationship to the Fitzwilliam drawing and to the Orsay version of *The Dance Class* (cat. no. 129), formerly assumed to date from 1874, has been considered problematic. Browse concluded that the essence study was copied from the painting, and both Lemoisne and Shackelford have contemplated the possibility that Degas misdated it.

Théophile Gautier, who collaborated with Perrot on *Giselle* and admired him enormously, described him in his youth as large-chested and with unusually handsome, slender legs. At sixty-four, Perrot evidently retained tremendous presence and great elegance in the movements of his hands, but he was an aging man. By comparison with the Fitzwilliam drawing, the essence study presents a slightly idealized view of Perrot, with many of the precisely observed imperfections deleted. However, so many details are common to both works that it is exceedingly unlikely they were executed independently of each other at some distance in time. Consequently, either both were drawn during the same session in 1874 and the essence study was wrongly dated sometime after the event or, indeed, the essence study was executed in 1875, not from life but after the Fitzwilliam drawing—as suggested by Denys Sutton.[8] Given that the two works are al-

most the same size and that the notations on the Fitzwilliam drawing correspond to the colors in the essence study, it is highly probable that in 1875, when he reworked the Orsay canvas, Degas repeated the figure as a model to be used in the painting. That this was the case appears confirmed by the similarities shared exclusively by the painting and the essence study.

In a notebook dated 1877 but possibly begun slightly earlier, there are two pencil sketches that Degas made of Perrot in profile: facing right, as in the monotype *The Ballet Master* (cat. no. 150), and facing left, as in this work. From the evidence of the date of the notebook, they appear to have been drawn from memory, probably specifically for the monotype.[9]

1. Browse [1949], p. 54 and no. 24.
2. For biographical information on Perrot, see Guest 1984, and *Dance Index*, IV:12, December 1945, a number devoted to studies on Perrot.
3. Reff 1985, Notebook 22 (BN, Carnet 8, p. 210). Reff has dated the notebook 1867–74, though the notation of Perrot's address suggests it was in use until several years later. For Perrot's move in 1879 from his apartment on rue des Martyrs to 52 boulevard Magenta, see Guest 1984, pp. 337–38.
4. The related works are L367 bis (cat. no. 132) and III:157.3. See Boggs 1962, pp. 56–57, 127–28, pl. 92.
5. See Pickvance in 1979 Edinburgh, no. 16, and Shackelford in 1984–85 Washington, D.C., p. 52.
6. See Thomson in 1986 Manchester, p. 53. It is Guest, however, who first recognized that Perrot figured in the composition; see Guest 1984, p. 336.
7. The inscription may be rendered as "red reflection of the shirt on the neck, blue flannel trousers, rosy tints on the head."

8. Sutton 1986, p. 168.
9. Reff 1985, Notebook 23 (BN, Carnet 21, p. 41). See also cat. no. 175.

PROVENANCE: Eugene W. Glaenzer and Co., New York; bought by Boussod, Valadon et Cie, Paris, with profits to be shared with Glaenzer, for Fr 3,600, 8 December 1909 (as "Le maître de ballet [M. Mérante]"); bought the same day by J. Mancini, Paris, for Fr 4,000. Maurice Exsteens, Paris, by 1912. Petitdidier collection, Paris. Fernand Ochsé, Paris, by 1924. Paul Brame, Paris; César de Hauke, New York; Henry P. McIlhenny, Philadelphia; his bequest to the museum 1986.

EXHIBITIONS: 1914, Copenhagen, Statens Museum for Kunst, 15 May–30 June, *Fransk Malerkunst*, no. 703; 1924 Paris, no. 54; 1933 Northampton, no. 22; 1934, Cambridge, Mass., Fogg Art Museum, *French Drawings and Prints of the Nineteenth Century*, no. 20; 1935, Buffalo, Albright Knox Gallery, January, *Master Drawings*, no. 117, repr.; 1936 Philadelphia, no. 78, repr.; 1936, Cambridge, Mass., Fogg Art Museum, *French Artists of the 18th and 19th Century*; 1938, Boston, Museum of Modern Art, *The Arts of the Ballet*; 1947 Cleveland, no. 67, pl. LIII; 1947, Philadelphia Museum of Art, *Masterpieces of Philadelphia Private Collections*, no. 123; 1949, Philadelphia Museum of Art, "The Henry P. McIlhenny Collection" (no catalogue); 1958, Cambridge, Mass., Fogg Art Museum, *Class of 1933 Exhibition*; 1962, San Francisco, California Palace of the Legion of Honor, 15 June–31 July, *Henry P. McIlhenny Collection, Paintings, Drawings and Sculpture*, no. 17, repr.; 1967 Saint Louis, no. 73, repr. (shown in Philadelphia only); 1984, Atlanta, High Museum of Art, 25 March–30 September, *The Henry P. McIlhenny Collection: Nineteenth Century French and English Masterpieces*, no. 19, repr. (color); 1984–85 Washington, D.C., no. 13, repr. (color).

SELECTED REFERENCES: Lemoisne 1912, p. 60 (as Ernest Pluque); Rivière 1922–23, pl. xxvi (reprint edition 1973, pl. B); Mongan 1938, p. 295; Lemoisne [1946–49], II, no. 364; Browse [1949], no. 24 (as Jules Perrot); Boggs 1962, pp. 56–57, 127, pl. 93; Minervino 1974, no. 481; 1979 Edinburgh, under no. 16.

134.

Dancer in Profile Turned to the Right

c. 1873–74
Charcoal and pastel, squared, on pale pink laid paper, now faded
18⅜ × 12⅛ in. (46.5 × 30.8 cm)
Vente stamp lower right; atelier stamp on verso
Cabinet des Dessins, Musée du Louvre (Orsay), Paris (RF4645)

Exhibited in Paris

Vente III:341.1

In 1873, Degas had made an essence study on a blue ground of a dancer scratching her back (III:132.2) for possible use as the central figure in *The Rehearsal of the Ballet on the Stage* (cat. no. 124). The drawing was ultimately not used, but the artist returned to the same pose not long after for a dancer to be included in the foreground of the Orsay

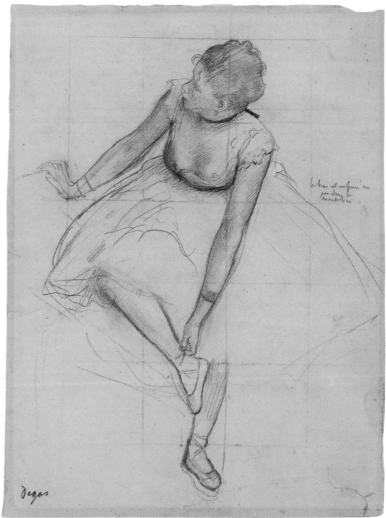

134 135

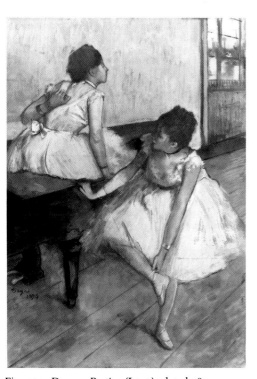

Fig. 122. *Dancers Resting* (L343), dated 1874.
Oil and gouache, 18⅛ × 12¾ in. (46 × 32.5 cm).
Private collection

version of *The Dance Class* (cat. no. 129). In the earlier drawing the dancer appeared graceful; for the new composition Degas chose a psychologically more affecting image, with the dancer almost convulsed by her action in this most informal of poses.

Squared for transfer, the study was also used for *Dancers Resting* (fig. 122), painted in 1874. However, George Shackelford, who has dated the drawing about 1874, has placed it chronologically between the two paintings and has concluded that it represents an elaboration of the dancer appearing in *Dancers Resting*.[1]

1. 1984–85 Washington, D.C., no. 15.

PROVENANCE: Atelier Degas (Vente III, 1919, no. 341.1, in the same lot with no. 341.2 [cat. no. 223], for Fr 2,850); bought at that sale by the Musée du Luxembourg, Paris; transferred to the Louvre 1930.

EXHIBITIONS: 1937 Paris, Orangerie, no. 84; 1969 Paris, no. 170; 1984–85 Washington, D.C., no. 15, repr. p. 56.

SELECTED REFERENCES: Rivière 1922–23, II, pl. 76 (reprint edition 1973, pl. 49); Cabanne 1957, p. 112, pl. 64; Valéry 1965, fig. 47; 1984–85 Paris, fig. 128 (color) p. 151; Sutton 1986, p. 168.

135.

Dancer Adjusting Her Slipper

1873
Graphite heightened with white chalk on now-faded pink paper
12⅞ × 9⅝ in. (33 × 24.4 cm)
Signed lower left: Degas
Inscribed center right: "le bras est enfoncé un/ peu dans la/mousseline" (the arm is depressed slightly in the muslin)
The Metropolitan Museum of Art, New York. Bequest of Mrs. H. O. Havemeyer, 1929. H. O. Havemeyer Collection (29.100.941)

Exhibited in New York

This drawing has considerable interest as the prototype for the dancer originally in the foreground, leaning on the piano, in *The Dance Class* (cat. no. 129). Between 1873 and 1874, Degas drew several studies of dancers adjusting their shoes, in different poses and from different angles, but none displaying quite the same mastery of the medium.[1] Jean Sutherland Boggs has shown that the model, unusually sensual for a dancer, is the same as the one who posed for a

241

related drawing in the Fogg Art Museum, Cambridge, Mass., *A Ballet Dancer in Position Facing Three-Quarters Front* (I:328).[2] As that drawing was one of the preparatory studies carried out in 1873 for *The Rehearsal of the Ballet on the Stage* (cat. no. 124), it can reasonably be surmised that *Dancer Adjusting Her Slipper* also dates from 1873.

Painted out of *The Dance Class*, where she was replaced with a figure derived from *Standing Dancer Seen from Behind* (cat. no. 137), the dancer survives, nevertheless, in the related *Dancers Resting* (fig. 122). In the latter, she is shown with the dancer scratching her back (cat. no. 134), very much in the same relationship as she would have had originally in *The Dance Class*.

1. See the sketch on a sheet detached from a notebook (Musée du Louvre, Paris, RF30011) and an essence study (L325), both related to *Dancers in a Practice Room* (L324, private collection, Paris). A drawing, once the property of Edmond Duranty, shows a dancer in the same pose. See Chronology II, January 1881.
2. 1967 Saint Louis, no. 71.

PROVENANCE: Mrs. H. O. Havemeyer, New York; her bequest to the museum 1929.

EXHIBITIONS: 1930 New York, no. 160; 1955 San Antonio, no number; 1960 New York, no. 84; 1967 Saint Louis, no. 71, repr.; 1977 New York, no. 16 of works on paper, repr. cover; 1980–81, Bordeaux, Galerie des Beaux-Arts, *Profil du Metropolitan Museum of Art de New York, de Ramses à Picasso*, no. 146.

SELECTED REFERENCES: Havemeyer 1931, p. 186; Walter Mehring, *Degas*, New York: Herrman, 1944, no. 25; Browse [1949], no. 20; René Huyghe, *Edgar-Hilaire-Germain Degas*, Paris: Flammarion, 1953, no. 31; Rosenberg 1959, no. 206, repr.; 1984–85 Washington, D.C., pp. 47–48, fig. 2.4 p. 47; Sutton 1986, p. 168, fig. 144.

136.

Seated Dancer

c. 1873
Graphite and charcoal heightened with white on pink wove paper, squared for transfer
16⅜ × 12⅞ in. (42 × 32 cm)
Signed lower right: Degas
The Metropolitan Museum of Art, New York.
 Bequest of Mrs. H. O. Havemeyer, 1929.
 H. O. Havemeyer Collection (29.100.942)

Lillian Browse has pointed out that this dancer, apparently rearranging her skirt, is actually tracing with her fingers the steps she is meant to memorize.[1] Her coiffure, arranged with a braid on the crown of her head, suggests she may be the same model that posed for *Seated Dancer in Profile* (cat. no. 126).

The drawing is squared, indicating it was intended for transfer, but no identically posed dancer appears in a painting. It is probable that the drawing was used only for a dancer with similarly posed legs and folded arms that appears in the background of the two versions of *The Dance Class* (cat. nos. 129,

136

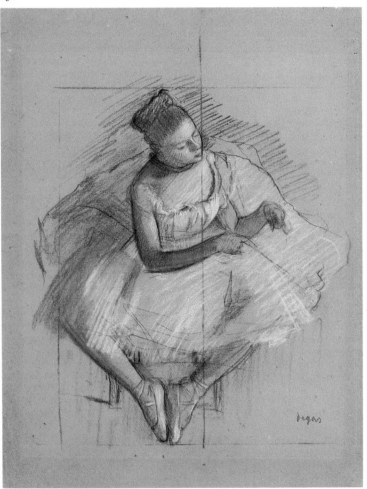

137

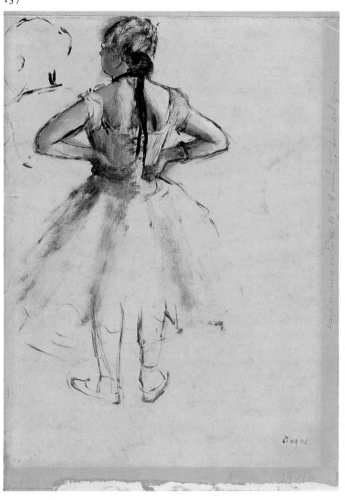

130). The pose of the legs is repeated on a sheet with six studies of dancers' legs (IV:138.a), all but one used in the Paris version (cat. no. 129) and probably executed to clarify details in the painting.

1. Browse [1949], no. 18, p. 341.

PROVENANCE: H. O. Havemeyer, New York; Mrs. H. O. Havemeyer, New York, from 1907; her bequest to the museum 1929.

EXHIBITIONS: 1922 New York, no. 13 of drawings; 1930 New York, no. 159; 1973–74 Paris, no. 34, pl. 63; 1977 New York, no. 17 of works on paper.

SELECTED REFERENCES: Havemeyer 1931, p. 186, repr. p. 187; Browse [1949], no. 18, repr. (as c. 1873).

137.

Standing Dancer Seen from Behind

c. 1873
Essence on pink paper
15½ × 11 in. (39.4 × 27.8 cm)
Signed lower right: Degas
Cabinet des Dessins, Musée du Louvre (Orsay), Paris (RF4038)

Exhibited in Ottawa

Maurice Sérullaz was the first to observe that this drawing is closely related to the dancer in the foreground holding a fan in *The Dance Class* (cat. no. 129) in the Musée d'Orsay and, hence, that it could not date from c. 1876 as previously thought.[1] There can be little doubt that the study belongs, along with *Two Dancers* (cat. no. 138) and several other essence studies, to a group of working drawings executed largely in 1873. Even though the poses are not identical, it is likely that Degas consulted this drawing when he decided to delete from the Orsay painting the figure based on *Dancer Adjusting Her Slipper* (cat. no. 135).

The term "dessin" (drawing) as used by Degas covered a wide range, and included essence paintings. He exhibited some of his drawings, a sign of the importance he attached to them, but these are seldom identifiable today. *Standing Dancer Seen from Behind* is one of the rare studies that was certainly shown in public. It was included along with a related drawing (L388, private collection, Paris) in the second Impressionist exhibition, in 1876, where it was seen by Huysmans. In the first of many enthusiastic reviews of the artist's work, he noted "two drawings on pink paper in which one ballerina, seen from behind, and another, adjusting her slipper, are carried off with an uncommon ease and vigor."[2]

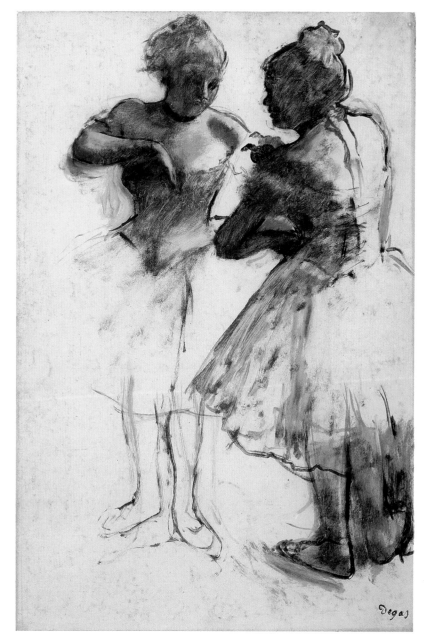

138

1. 1969 Paris, no. 168.
2. Joris-Karl Huysmans, *Gazette des Amateurs*, 1876. Reprinted in Huysmans 1883, p. 112.

PROVENANCE: Armand Guillaumin, Paris; Jack Aghion; Serghei Shchukin, Moscow (anonymous [Shchukin] sale, Drouot, Paris, 24 March 1900, no. 6 [as "Danseuse laçant son corset"]); bought by Comte Isaac de Camondo, Paris; his bequest to the Louvre, Paris, 1911; entered the Louvre 1914.

EXHIBITIONS: 1876 Paris, no. 51 (one of several drawings under the same number); 1937 Paris, Orangerie, no. 94 (as c. 1878); 1969 Paris, no. 168; 1976–77, Vienna, Graphische Sammlung Albertina, 10 November 1976–25 January 1977, *Von Ingres bis Cezanne: Aquarelle und Zeichnungen aus der Louvre*, repr. (color) cover.

SELECTED REFERENCES: Joris-Karl Huysmans, *Gazette des Amateurs*, 1876, reprinted in Huysmans 1883, p. 112; Paris, Louvre, Camondo, 1914, no. 218; Browse [1949], no. 32 (as c. 1876).

138.

Two Dancers

1873
Dark brown wash and white gouache on bright pink commercially coated wove paper now faded to pale pink
24⅛ × 15½ in. (61.3 × 39.4 cm)
Signed lower right: Degas
The Metropolitan Museum of Art, New York. Bequest of Mrs. H. O. Havemeyer, 1929. H. O. Havemeyer Collection (29.100.187)

Exhibited in New York

Lemoisne 1005

Dated 1889–95 by Lemoisne, 1878–80 by Moffett,[1] and c. 1880 by Shackelford,[2] this freely brushed drawing rightfully belongs to

the stock of figure drawings Degas executed in sepia wash on colored papers—usually pink—for his great rehearsal pictures of the mid-1870s. Browse dated it 1876,[3] but without taking into account that the two figures appear to the left and right of the ballet master in the Orsay *Dance Class* (cat. no. 129), begun in 1873. The two bent-armed women seen here, unlike the figures in most of Degas's working poses, reappear later only infrequently. The figure at the right looks into the mirror of the Metropolitan's version of *The Dance Class* (cat. no. 130) of 1874, while Degas may have used the figure at the left for *Dancer in Her Dressing Room* (L529, Oskar Reinhart Collection "Am Römerholz," Winterthur) of c. 1879–80. Degas made two fine pencil drawings of the figure at the left (II:332, Detroit Institute of Arts, and II:326), and there are notebook studies of the pose on the right.[4] Both figures appear on a fan of the late 1870s (BR72).

Shackelford observed that Degas may have drawn the two poses from the same model, "as if the dancer had been turned around to face herself."[5] There is indeed a peculiar quality of interior conversation evident in this drawing, much like that evoked by Picasso's 1906 drawings and painting *Two Women* (The Museum of Modern Art, New York).

GT

1. Moffett 1979, p. 12, no. 25.
2. 1984–85 Washington, D.C., p. 77.
3. Browse [1949], no. 33.
4. Reff 1985, Notebook 29 (private collection, p. 25), Notebook 30 (BN, Carnet 9, p. 1). Related drawings include II:91, III:81.4, and a drawing at the Louvre, cat. no. 137.
5. 1984–85 Washington, D.C., p. 77.

PROVENANCE: Presumably sold by the artist to Goupil-Boussod et Valadon, Paris; apparently bought, at an unknown date, from Boussod et Valadon by Mrs. H. O. Havemeyer, New York[1]; Mrs. H. O. Havemeyer, by 1922 until 1929; her bequest to the museum 1929.

1. Handwritten notes among Havemeyer papers in the archives of the Metropolitan Museum in New York indicate that a Degas drawing of "2 Dancers—on pink," presumably this work, was purchased through Boussod et Valadon, Paris.

EXHIBITIONS: 1922 New York, no. 90 (as "Deux danseuses," on pink paper), lent anonymously by Mrs. H. O. Havemeyer; 1930 New York, no. 162; 1947 Washington, D.C., no. 6; 1977 New York, no. 25 of works on paper.

SELECTED REFERENCES: Havemeyer 1931, p. 185; New York, Metropolitan, 1943, no. 53, repr.; Lemoisne [1946–49], III, no. 1005; Browse [1949], p. 347, no. 33, repr.; Minervino 1974, no. 1061; Moffett 1979, p. 12, pl. 25 (color); 1984–85 Washington, D.C., p. 77, repr.; 1987 Manchester, p. 113, fig. 148.

139.

Dancer Posing for a Photograph

1875
Oil on canvas, squared
25⅝ × 19¾ in. (65 × 50 cm)
Signed lower right: Degas
Pushkin Fine Art Museum, Moscow (3237)

Exhibited in Paris

Lemoisne 447

It has been demonstrated by Ronald Pickvance that *Dancer Posing for a Photograph* was exhibited in London in May 1875 and hence could not date from 1876 or 1878–79 as previously thought. Pickvance has dated it 1874, placing it logically in the sequence of ballet scenes connected with *The Dance Class* (cat. no. 128) of 1873.[1] The correspondence between Degas and Charles Deschamps, his dealer in London, allows in fact for a slightly more precise dating, simultaneously casting an interesting light on the pains Degas took to ensure the proper conservation of his works.

In a letter dated 15 May 1876 by Theodore Reff, Degas expressed his concern over the possible yellowing of *In a Café (The Absinthe Drinker)* (cat. no. 172) and *The Dance Class* (cat. no. 129) if glazed before being allowed to dry. He advised that his works should not be prematurely varnished, so as not to repeat the mishap experienced with "the little dancer in silhouette, which was done so much too soon that it is all yellow, and we could not remove the varnish completely."[2] This would indicate that the Mos-

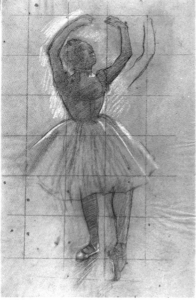

Fig. 123. *Study of a Dancer with Arms Raised* (III:338.2), 1874. Charcoal, 18 × 11¼ in. (45.7 × 28.6 cm). Private collection, New York

cow painting, surely the picture in question, was not dry when it reached London in late spring 1875 and, consequently, that it could not have been painted long before March of that year.

The work is the only known composition by Degas that could be recognized as the "Dancer in Front of a Looking Glass," which he listed in a notebook with a series of ballet scenes that he intended to show in an exhibition to be titled *Degas: dix pièces sur la danse d'Opéra* (Degas: Ten Works on Dance from the Opéra). If Reff's tentative identification is correct, it would follow that Degas's exhibition was not planned for early 1874, as Reff noted, but perhaps for 1875, when no Impressionist exhibition was held.[3] It is tempting to suppose that the title of the work, with its deliberately modern connotations, was an afterthought, as it appears for the first time as "at a photographer's studio—dancer" only in a list of works Degas drafted for the fourth Impressionist exhibition, in 1879.[4]

A study for the dancer (fig. 123), squared for transfer, represents her on the same scale as in the finished painting, which also retains traces of squaring. The pose is one Degas used often, in a variety of combinations, until relatively late in life. Performed by a dancer before a mirror in an apparently empty room, against the chilly light of the window, the movement becomes the miraculous expression of a concentrated examination of self.

Despite the artist's dazzling performance, recognized in 1875 by a British reviewer who called the picture "really a chef d'oeuvre in its way . . . by the hand of a thorough master," the work failed to sell.[5] It returned to Paris, where, as noted earlier, attempts to remove the varnish were made and where it formed part of the Doria collection before becoming the property of the famous Russian collector Serghei Shchukin.

1. Pickvance 1963, pp. 264–65.
2. Reff 1968, p. 90, and n. 44, where the picture is tentatively identified as *Danseuse posant chez le photographe* (Dancer Posing at the Photographer's Studio).
3. Reff 1985, Notebook 22 (BN, Carnet 8, p. 203).
4. Reff 1985, Notebook 31 (BN, Carnet 23, p. 67).
5. Pickvance 1963, pp. 264, 266. See also Reff 1968, where it is noted that the work was sold to Henry Hill after it was exhibited by Deschamps in November 1875. In fact, it was *Rehearsal before the Ballet* (L362) that was shown in London in November 1875 and subsequently purchased by Hill.

PROVENANCE: With Charles W. Deschamps, London, spring 1875. Hector Brame, Paris, by 1879; bought by Comte Armand Doria, Paris (Doria sale, Galerie Georges Petit, Paris, 4–5 May 1899, lot 137, repr., for Fr 22,000); bought by Durand-Ruel, Paris (stock no. 5192); deposited with Cassirer, Berlin, 8 September 1899; returned to Durand-Ruel, Paris, 29 December 1899 (stock no. 6212); bought by Serghei Shchukin, Moscow, 19 November 1902, for Fr 35,000; Shchukin collection, until 1918; to the Museum of

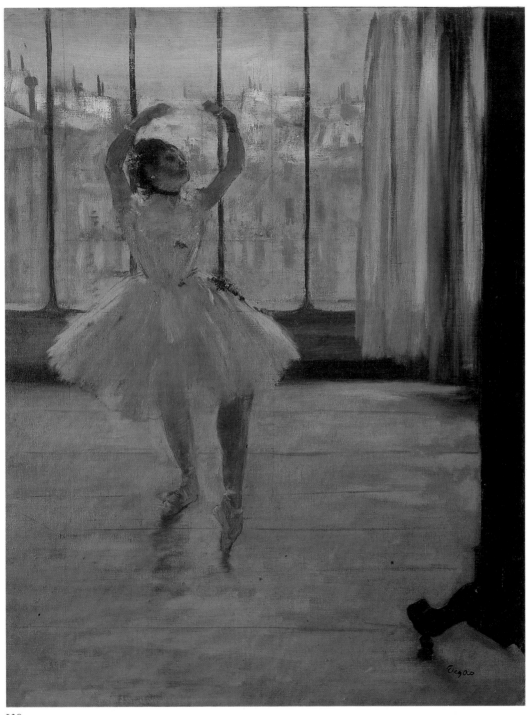

139

Western Art, Moscow, 1918; transferred to the Pushkin Museum 1948.

EXHIBITIONS: 1875, London, 168 New Bond Street, spring–summer, *Tenth Exhibition of the Society of French Artists*, no. 72 (as "Ballet Dancer Practising"); 1879 Paris, no. 72; 1902, Brussels, Société des Beaux-Arts, March–May, *Le Salon—9ème exposition*, no. 68; 1955, Moscow, Pushkin Museum, *Exhibition of French Art from the 15th to the 20th Century*, p. 30; 1956, Leningrad, Hermitage, *Exhibition of French Art from the 12th to the 20th Century*, p. 87, repr.; 1960, Leningrad, Hermitage, *Exhibition of French Art of the Second Half of the 19th Century from Soviet Art Museums Held in the State Pushkin Museum of Fine Arts*, p. 14; 1974–75, Leningrad, Hermitage/Moscow, Pushkin Museum, *Impressionist Painting on the Occasion of the Centenary of the First Impressionist Exhibition of 1874* (catalogue by Anna Grigorievna Barskain), no. 8, repr. (as 1874).

SELECTED REFERENCES: *The Echo*, 18 May 1875, *The Graphic*, 22 May 1875, cited in Pickvance 1963, p. 264 n. 73; Mauclair 1903, p. 389; Otto Grautoff, "Die Sammlung Serge Stschoukine in Moskau," *Kunst und Künstler*, XVII, 1918–19, repr. p. 85; Lafond 1918–19, II, p. 27, repr. before p. 37; Paul Ettinger, "Die modernen Franzosen in den Kunstsammlungen Moskaus," pt. I, *Der Cicerone*, XVIII:1, 1926, p. 23, repr. p. 26; Louis Réau, *Catalogue de l'art français dans les musées russes*, Paris: A. Colin, 1929, no. 763; Lemoisne [1946–49], II, no. 447 (as 1877– 78); Browse [1949], no. 43 (as 1878–79); Charles Sterling, *Great French Painting in the Hermitage*, New York: Abrams, 1958, p. 90, pl. 66 (erroneously as in the Hermitage); Pickvance 1963, pp. 264–65, fig. 18 (as 1874); Reff 1968, p. 90 n. 44; Minervino 1974, no. 505 (as 1877– 78?); *Die Gemäldegalerie des Pushkin Museums in Moskau* (by Irina Antonova), Moscow: Pushkin Museum, 1977, no. 97; *The Pushkin Museum of Fine Arts in Moscow: Painting* (compiled by Tatyana Sedova), Leningrad: Aurora Art Publishers, 1978, no. 75, repr.; Irina Kuznetsova and Evgenia Georgievskaya, *French Painting from the Pushkin Museum: 17th to 20th Century*, New York: Abrams/Leningrad: Aurora Art Publishers, 1979, no. 170, repr. (color) (as 1874); Reff 1985, Notebook 22 (BN, Carnet 8, p. 203), Notebook 31 (BN, Carnet 23, p. 67) (as 1874); Sutton 1986, p. 172, repr. (color) p. 173 (as c. 1877–79).

140.

Woman on a Sofa

1875
Essence, oil, and India ink over pencil on
 four pieces of pink paper joined together
19⅛ × 16¾ in. (48 × 42 cm)
Signed and dated upper right: Degas 1875
The Metropolitan Museum of Art, New York.
 Bequest of Mrs. H. O. Havemeyer, 1929.
 H. O. Havemeyer Collection (29.100.185)

Lemoisne 363

The careful rendition of the features of the
woman and the absence of a related version
in oil seem to confirm that this drawing had
an independent status and was not a study
for a more formal work. Certain technical
aspects of the portrait suggest that it may
have been developed in two stages. It proba-
bly began as a pencil drawing on a smaller
sheet of paper which was then enlarged
(somewhat less carefully than was custom-
ary for Degas) with additional strips of pa-
per at the bottom and sides, allowing the
artist to expand the design beyond the con-
fines of the original sheet and resume work
in a different technique. In its final form, it
was drawn largely with a brush in a combi-
nation of diluted oil paint, essence, and India
ink. The remarkably spirited style is recog-
nizably that of the similarly dated study of
the ballet master Jules Perrot (cat. no. 133).

The warm tone of the pink paper, won-
derfully put to use to set off the turquoise
trimmings of the dress, intensifies the pres-
ence of the informally posed sitter. The ulti-
mate effect is not so much that of a portrait
in the conventional sense as that of a digres-
sion on a theme or of a likeness captured
during a pause between sittings. Despite her
enormous dress, rather old-fashioned for
1875, the woman appears at ease, if slightly
aloof. Posed with an arm raised, rather like
a dancer holding onto a stage flat, she has a
kind of grace that is as attractive as it is un-
expected. On the surface, the sitter appears
to be a typical conservative bourgeoise from
Degas's circle. Her identity, however, re-
mains elusive.

PROVENANCE: Michel Manzi (d. 1915), Paris; Char-
lotte Manzi, his widow, Paris; bought by Mrs.
H. O. Havemeyer, New York, through Mary Cas-
satt, 5 December 1915; her bequest to the museum
1929.

EXHIBITIONS: 1922 New York, no. 108; 1930 New
York, no. 161; 1947 Washington, D.C., no. 14; 1960
New York, no. 88; 1974 Boston, no. 79; 1977 New
York, no. 19 of works on paper.

SELECTED REFERENCES: Wehle 1930, p. 55; New York,
Metropolitan, 1943, pl. 51; Lemoisne [1946–49], II,
no. 363; Boggs 1962, p. 48, fig. 82; Minervino 1974,
no. 389; Reff 1976, pp. 280–82, pl. 195 (color);
Weitzenhoffer 1986, p. 231.

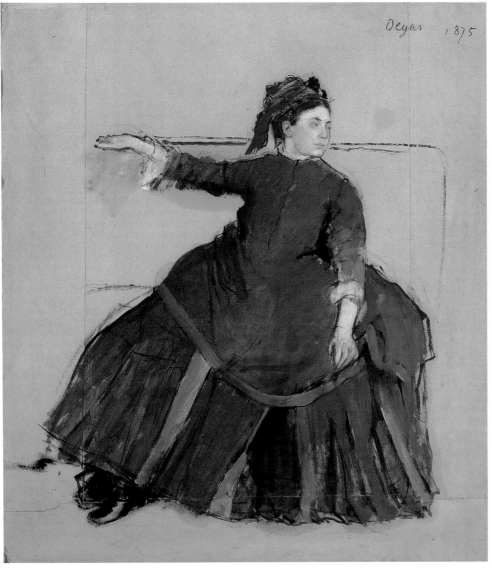

140

141.

Mme de Rutté

c. 1875
Oil on canvas
24½ × 19¾ in. (62 × 50 cm)
Signed lower right: Degas
Private collection, Zurich

Exhibited in Ottawa and New York

Lemoisne 369

Friedrich-Ludwig de Rutté (1829–1903), the
husband of the woman in this portrait, was
a Swiss architect from Bern who apparently
practiced architecture in Paris in the 1870s
before returning to his native city. His wife,
an Alsatian from Mulhouse, was the sister
of the painters Emmanuel and Jean Benner,
and his son Paul, also an architect, was born
in Paris in 1871. Degas probably met the
family in the late 1860s in the circle of paint-
ers around Emmanuel Benner. A former
student of Bonnat, Emmanuel Benner had a
studio he occasionally shared with Jean, his
twin brother, who spent long periods paint-
ing in Capri.

According to Paul de Rutté—as reported
by Lemoisne—Degas painted this portrait
about 1875 in Emmanuel Benner's studio on
23 rue de la Chaussée-d'Antin. The date
has been accepted by Jean Sutherland Boggs,
who has drawn a parallel between this por-
trait of Élise de Rutté and the earlier portrait
painted in New Orleans, *Woman with a Vase
of Flowers* (cat. no. 112). Boggs has noted
that the two works share a compositional
scheme. The sitter is physically separated

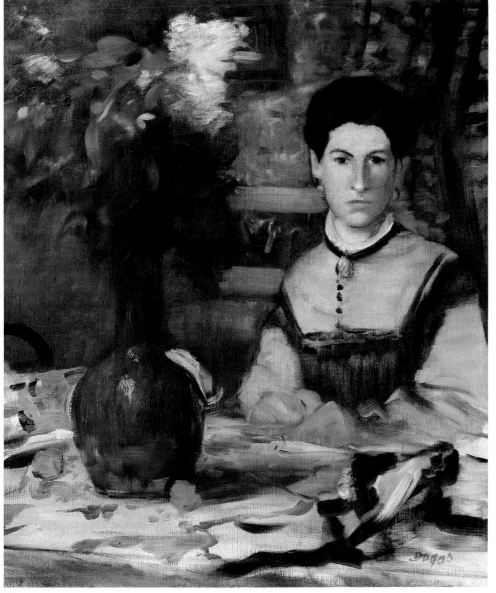

141

from the viewer by a barrier of accessories, and the foreground is dominated by a vase with flowers. She has emphasized, however, that in Mme de Rutté's portrait Degas was not "as concerned with the definition of the background, the shape of the table, the precise sculptural form of the vase; even her body is not so fully realized, and the hands are left undone. As a result, the painting's three-dimensional existence is not so forceful (nor as psychologically oppressive) as the *Woman with a Vase*."[1] The remarkably free and abridged treatment of the objects around Mme de Rutté acts as a foil for her solidly constructed, grave face.

1. Boggs 1962, p. 47.

PROVENANCE: Probably a gift of the artist to the sitter; Paul de Rutté, her son, Paris; (?) Mme Émile Couvreu, née Violette de Rutté, his sister; André de Würstem-

berger, her nephew; with Wildenstein and Co., London; bought by the present owner 1986.

EXHIBITIONS: 1931 Paris, Orangerie, no. 61, lent by Paul de Rutté.

SELECTED REFERENCES: Lemoisne [1946–49], II, no. 369; Boggs 1962, pp. 47–48, 59, 129; Minervino 1974, no. 394; Keyser 1981, p. 53.

Mme Jeantaud before a Mirror

c. 1875
Oil on canvas
29⅛ × 33½ in. (70 × 84 cm)
Signed lower right: Degas
Musée d'Orsay, Paris (RF1970–38)

Lemoisne 371

Berthe Marie Bachoux (1851–1929), a cousin of Vicomte Ludovic Lepic, an engraver,[1] married Charles Jeantaud on 1 February 1872.[2] The Jeantauds were part of the circle of friends around Degas in the early 1870s, and when they established themselves at 24 rue de Téhéran, near the artist's old friends the Henri Rouarts, Degas continued to see them. This portrait of Mme Jeantaud, originally dated 1874 and later c. 1875 by Lemoisne, was the first of two portraits Degas painted of her and certainly the more complex.

In more than one sense, the painting extends an idea that Degas touched on in *Dancer Posing for a Photograph* (cat. no. 139) of 1874. In that work, as in a later pastel, *At the Milliner's* (cat. no. 232), a reflection of the subject, invisible to the viewer, was implied by the action of the figure and the presence of a looking glass, seen from the back. In the portrait of Mme Jeantaud the notion is reversed: the sitter shows only her profile, and it is the reflection that provides the conventional, frontal view expected in a portrait. The multiplication of viewpoints was a concern increasingly expressed in Degas's notes and drawings of the late 1870s, but the confrontation of dissimilar images in *Mme Jeantaud before a Mirror* achieves a disturbing antithetical effect seldom observed in his other works.

Dressed in street clothes, Mme Jeantaud appears to stand poised for a brief glance in the mirror before going out. The suggested animation of her body, with her fashionable dolman still sweeping out behind her, may be said to be contradicted only by the languid droop of her right hand resting on her muff. In the reflection, however, where she is seen dimly against a flash of light emanating from a window behind her, the ambiguities multiply. She is seated, not standing, with her back erect, looking directly at the painter—or the viewer—rather than at herself, and her right hand is firmly lodged in the muff held in her lap.

The dramatic antithesis between the charm of Mme Jeantaud and her lugubrious reflection, ultimately beyond analysis, is reconciled pictorially in the extraordinary use of light, captured even by the pearl in the sitter's ear, the spontaneous, almost fiery application of paint, and the subtle

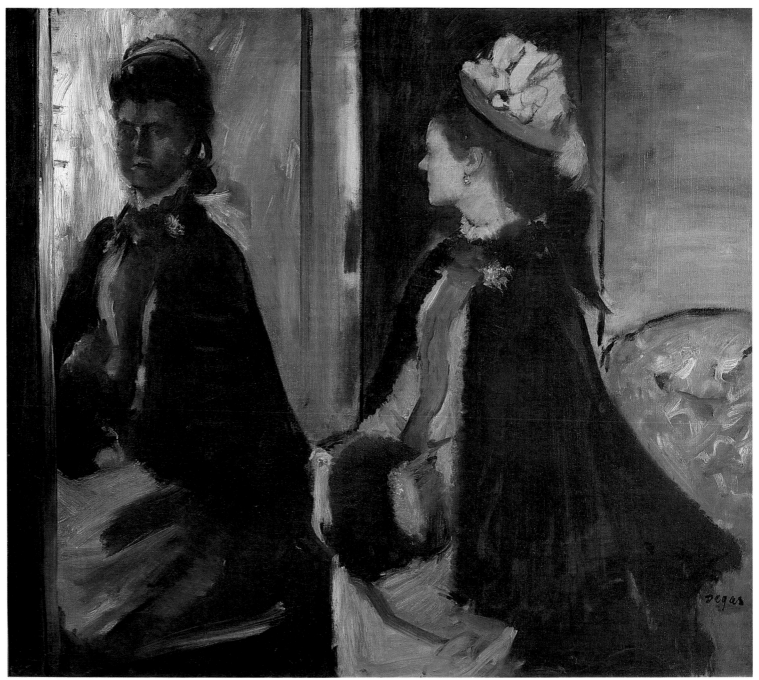

142

harmony of colors that dominates throughout—black, gray, blue gray, and blue, with violent shots of white in the armchair and the mirror. X-radiographs show that except for a slight correction in the line of the nose, the portrait was executed virtually without a break.

Around the time this portrait was painted, Mme Jeantaud also sat for Jean-Jacques Henner, with whom Degas shared another model, Emma Dobigny.[3] It would be difficult to find two pictures more indicative of the aesthetic gap that divided Degas from even the most idiosyncratic of artists connected with the Salon. In this context, it is perhaps revealing that Mme Jeantaud even-

tually sold her portrait by Degas but willed that by Henner to the Musée du Petit Palais. Degas himself painted her a second time, in about 1877 according to Lemoisne, in a more subdued composition (L440) of equally vigorous execution now in the Staatsgalerie Stuttgart.

Recently it has been proposed that *Mme Jeantaud before a Mirror* may have been exhibited in 1876 in the second Impressionist exhibition under the title "Modiste."[4] A brief description of the painting in Émile Porcheron's review of the exhibition appears to rule out the possibility.[5]

1. See "The First Monotypes," p. 257.
2. See cat. no. 100.

3. Juliette Laffon, *Musée du Petit Palais, Catalogue sommaire illustré des peintures*, Paris, 1882, no. 467, repr.
4. 1986 Washington, D.C., p. 161.
5. "We shall not mention the *Milliners*, who are obviously too ugly to be anything but chaste"; Émile Porcheron, "Promenades d'un flâneur: les impressionnistes," *Le Soleil*, 4 April 1876. Which of Degas's works was actually exhibited remains a tantalizing question, as it appears to have preceded by several years his first known paintings of milliners.

PROVENANCE: Mme Jeantaud, Paris; bought by Boussod, Valadon et Cie, Paris (shared half-interest with Wildenstein and Co.), 11 April 1907, for Fr 23,000 (as "Portrait d'une dame se reflétant dans une glace"); bought by Jacques Doucet (d. 1929), Paris, 18 April 1907; Mme Jacques Doucet, his widow, Neuilly-sur-Seine; Jean-Édouard Dubrujeaud, Paris; bequest of

Jean-Édouard Dubrujeaud, with life interest to his son, Jean Anglandon-Dubrujeaud, 1970; cession of life interest 1970.

EXHIBITIONS: 1912, Saint Petersburg, *Centennale de l'art français*, no. 176; 1917, Kunsthaus Zürich, 5 October–14 November, *Französische Kunst des 19. und 20. Jahrhunderts*, no. 89; 1924 Paris, no. 50, repr.; 1925, Paris, Musée des Arts Décoratifs, 28 May–12 July, *Cinquante ans de peinture française, 1875–1925*, no. 154; 1926, Amsterdam, Stedelijk Museum, 3 July–3 October, *Exposition rétrospective d'art français*, no. 41; 1928, Paris, Galerie de la Renaissance, 1–30 June, *Portraits et figures de femmes, d'Ingres à Picasso*, no. 56; 1931 Paris, Orangerie, no. 56, pl. VIII (incorrectly identified); 1932 London, no. 344 (402), pl. 125, lent by Mme Jacques Doucet; 1936, London, New Burlington Galleries, Anglo-French Art and Travel Society, 1–31 October, *Masters of French Nineteenth Century Painting*, no. 63; 1937 Paris, Palais National, no. 304; 1949 New York, no. 32, repr. (private collection), lent through César de Hauke; 1955, Rome, Palazzo delle Esposizioni, February–March/Florence, Palazzo Strozzi, *Mostra di capolavori della pittura francese dell'ottocento*, no. 31.

SELECTED REFERENCES: Lemoisne 1912, pp. 63–64, pl. xxiv; Lafond 1918–19, II, p. 14; Jamot 1924, pp. 52, 141–42, pl. 34; Lemoisne 1924, p. 98 n. 4; Rivière 1935, repr. p. 41; Lemoisne [1946–49], II, no. 371; Boggs 1962, p. 120; Minervino 1974, no. 393; Paris, Louvre and Orsay, Peintures, 1986, III, p. 197.

143.

Henri Rouart and His Daughter Hélène

1871–72
Oil on canvas
25 × 29½ in. (63.5 × 74.9 cm)
Private collection, New York

Exhibited in Ottawa and New York

Lemoisne 424

The son of a manufacturer of military equipment, Henri Rouart (1833–1912) belonged to a group at the Lycée Louis-le-Grand that included Degas, Ludovic Halévy,[1] and Louis Bréguet, the brother of the future Mme Halévy. At the time, Rouart's interests—always very diverse—were not yet so clearly directed to painting and music. Possessed of an inventive mind, he studied at the École Polytechnique, then embarked on a military career. In the early 1860s, he returned to his first passion, engineering, and, with his younger brother Alexis (1839–1911), successfully launched novel industrial projects that ranged from the first equipment for artificial refrigeration to engines propelled by gasoline. Until late in life he retained a demeanor that reminded people of both his former professions, as Daniel Halévy observed in his diary in August 1899: "Yesterday, Henri Rouart

came to call, an old friend of my father and of Degas . . . a former engineer, still military in his bearing, but at the same time gentle and charming."[2]

After graduation, Degas lost sight of Henri Rouart, but in 1870–71, during the Franco-Prussian War, chance assigned him to an artillery unit led by Rouart. The old friendship was renewed, and Degas discovered Rouart was now also an amateur landscape painter and about to start a collection of modern pictures. His more precocious brother Alexis, who collected lithographs and paintings by artists of the 1830s, was to share with Degas an interest not only in Daumier, Gavarni, and Delacroix, but also in Japanese prints.

It is difficult to exaggerate the friendship that united Degas and the Rouarts. He was closer to Henri, whom he convinced to join the Impressionists and exhibit with them, but discussed Ingres and Gavarni with Alexis. He saw both Rouarts regularly, and when Henri Fevre, Degas's brother-in-law, built adjacent houses on rue de Lisbonne for Alexis and Henri, Degas dined on Tuesdays with one Rouart family and on Fridays with the other. By 1906, the artist could truthfully acknowledge to his sister Thérèse that the Rouarts were his only family "in France."[3] Sad to say, he had the misfortune to outlive both brothers, see their collections sold, and witness the dispersal of his own works, in-

cluding *Dancers Practicing at the Barre* (cat. no. 165), the finest painting in Henri's collection, and *The Little Milliners* (fig. 207), owned by Alexis.

It is curious that Degas never painted a portrait of Alexis Rouart, who remains a shadowy figure, though a series of portraits of his brother and his family cover a period of over thirty years. The painting of Henri with his daughter Hélène, the first in the series, must have been begun in the relatively short period between the end of the war in 1871 and the artist's departure for New Orleans in October 1872. A date in the early 1870s, suggested by the age of the child—born in 1863—appears to belie the confident, luscious handling of the paint, reminiscent of Degas's work of the late 1870s, which has led Lemoisne, Jean Sutherland Boggs, and Theodore Reff to date the work c. 1877. Nevertheless, the scheme of the portrait, with the figures against a background parallel to the picture plane, is one Degas used only before his departure for New Orleans.[4] It occurs in *The Collector of Prints* (cat. no. 66), the portrait of James Tissot (cat. no. 75), and *Mme Théodore Gobillard* (cat. no. 87), all of which share an almost compulsive interest in the dynamic contrast generated by the placement of a figure against a background dominated by the interplay of rectangles.

Vigorous but somewhat uneven, the execution of this painting suggests an idea in

143

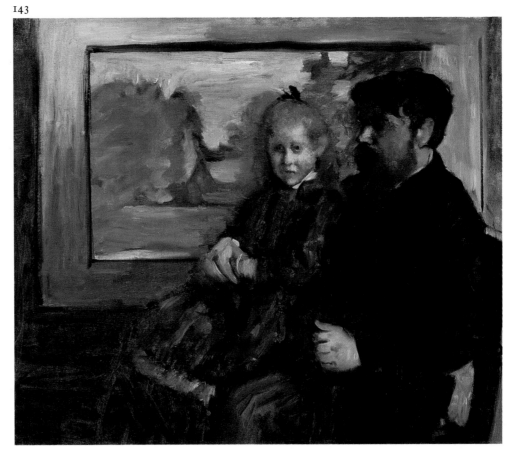

progress rather than a completed work, and it may be that it is indeed unfinished. The surprisingly broad brushwork of the left side of the composition is equaled only by that in *Laundresses Carrying Linen in Town* (fig. 336), an evidently unfinished work also commonly dated in the late 1870s but probably from about 1872. The asymmetrical composition of the Rouart portrait is a variation on an idea Degas experimented with in *Mme Théodore Gobillard*. Henri Rouart is seated in profile. The child, with eyes strangely focused in an otherwise blurred face, is already recognizable as the sitter for the great, later portrait in the National Gallery in London (fig. 192). Here, she sits rather uncomfortably on her father's knee. His right hand affectionately clasps her hands while his left arm, with fist clenched, rests on the armchair. The painting in the background appears to be the deliberately sketchy rendition of a landscape by Rouart and is certainly close to a painting by him published by Dillian Gordon.[5] The latter has also published a photograph of Hélène Rouart, which she has tentatively proposed as a possible model for the painting.[6] Despite the childish face, however, the photograph shows Hélène Rouart at a later, more mature stage and already in the costume of an adult.

1. See cat. nos. 166, 328, and "Degas, Halévy, and the Cardinals," p. 280.
2. Halévy 1960, p. 131; Halévy 1964, p. 102 (translation revised).
3. "I was able to arrive last Friday in time to go to dinner at the Rouarts', who are my family in France." Letter from Degas to Thérèse Morbilli of 5 December 1906, written after the artist's return from Naples, in the archives of the National Gallery of Canada, Ottawa.
4. Exceptions are the two portraits of Diego Martelli of 1879, cat. nos. 201, 202.
5. Dillian Gordon, *Edgar Degas: Hélène Rouart in Her Father's Study*, Portsmouth, 1984, p. 6, fig. 12.
6. Ibid., fig. 13.

PROVENANCE: Henri Rouart, Paris; Ernest Rouart, his son, Paris; Capitaine and Mme Bricka, daughter of Hélène Rouart (Mme Eugène Marin), Montpellier. Hector Brame, Paris. Feilchenfeldt, Amsterdam; private collection, New York.

EXHIBITIONS: 1931 Paris, Orangerie, no. 63, pl. IX, lent by Capitaine and Mme Bricka, Montpellier; 1947 Cleveland, no. 26, pl. XX; 1958 Los Angeles, no. 28, repr. p. 41; 1966, New York, The Metropolitan Museum of Art, *Summer Loan Exhibition, Paintings, Drawings and Sculptures from Private Collections*, no. 42; 1967, New York, The Metropolitan Museum of Art, *Summer Loan Exhibition, Paintings from Private Collections*, no. 28; 1978 New York, no. 16, repr.; 1984, London, The National Gallery, 11 April–10 June, *Degas: Hélène Rouart in Her Father's Study*, p. 4, fig. 1 p. 5.

SELECTED REFERENCES: Lemoisne [1946–49], II, no. 424; Meier-Graefe 1923, pl. XXXIII; Alexandre 1935, p. 159, repr.; Boggs 1962, pp. 45, 47, 67, 74, 128, pl. 87; Minervino 1974, no. 423; Reff 1976, p. 130, pl. 93.

144.

Henri Rouart in front of His Factory

c. 1875
Oil on canvas
25⅝ × 19¾ in. (65.1 × 50.2 cm)
The Carnegie Museum of Art, Pittsburgh. Acquired through the generosity of the Sarah Mellon Scaife Family (69.44)

Lemoisne 373

For reasons known only to Degas, all his portraits of Henri Rouart represent his friend in near-profile and always from the left.[1] Rouart's face in profile was manifestly expressive, a consideration not easily dismissed in any attempt to transfer a likeness favorably, and the artist was probably sensitive to the subtle variations he could experiment with in presenting an integral personality with—so to speak—only half the facts. The format of this portrait, with Rouart shown bust-length, follows an Italian fifteenth-century formula Degas knew well, but with an accomplished twist. The slightly bent sitter is placed completely off center, rather as if he were about to cross the field of the painting, dynamically framed by the schematic rendering of railway tracks converging dizzily, in perspective, behind his head.

As noted by George Moore, Degas's portraits almost always present the subjects in a setting characteristic of their interests.[2] Here, Rouart's factory becomes an extension of his personality.

144

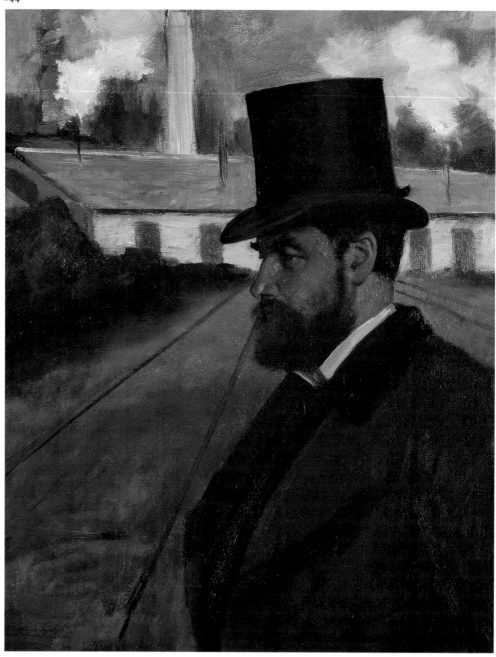

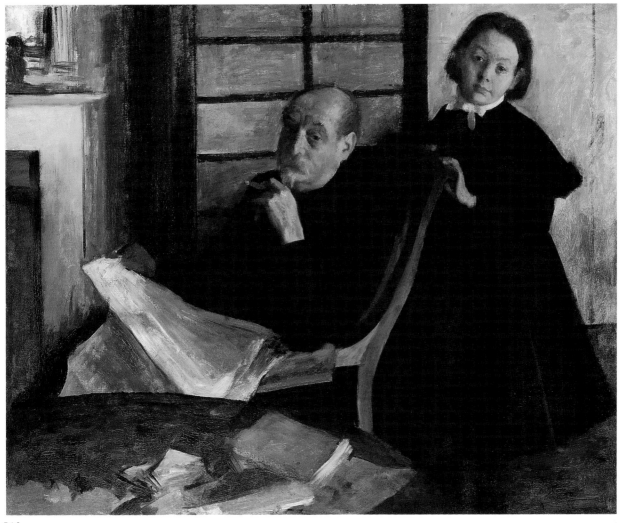

145

145.

Uncle and Niece (Henri Degas and His Niece Lucie Degas)

c. 1876
Oil on canvas
39¼ × 47¼ in. (99.8 × 119.9 cm)
The Art Institute of Chicago. Mr. and Mrs.
 Lewis Larned Coburn Memorial Collection
 (1933.429)

Lemoisne 394

1. See L293, L424 (cat. no. 143), L1176 (cat. no. 336), L1177 (fig. 306).
2. Moore 1890, p. 422.

PROVENANCE: Henri Rouart, Paris, probably a gift of the artist; Ernest Rouart, his son, Paris; Mme Ernest Rouart (née Julie Manet), his widow, Paris; Clément Rouart, her son, Paris. Private collection, Paris; Wildenstein and Co., Inc., New York; bought by the museum 1969.

EXHIBITIONS: 1877 Paris, no. 49 (as "Portrait de Monsieur H.R. . ."); 1924 Paris, no. 52; 1943, Paris, Galerie Charpentier, May–June, *Scènes et figures parisiennes*, no. 73; 1955 Paris, GBA, no. 62, repr.; 1960 Paris, no. 14, repr.; 1986 Washington, D.C., no. 47.

SELECTED REFERENCES: Jamot 1924, no. 49, p. 125 n. 4; Lemoisne [1946–49], II, no. 373; Agathe Rouart-Valéry, "Degas in the Circle of Paul Valéry," *Art News*, LIX:7, November 1960, p. 64, fig. 4 p. 39; Rewald 1961, p. 392, repr. p. 449; Boggs 1962, pp. 45, 93 n. 14, 128–29; Fred A. Myers, "New Accessions/ Degas," *Carnegie Magazine*, XLIV:3, March 1970, pp. 91–93, repr. facing p. 91 and detail on cover; Minervino 1974, no. 392.

When Hilaire Degas died in 1858, the perpetuation of the house of Degas in Naples was less than certain. Although his eldest son, Auguste, father of the artist, was married and established as a banker in Paris, none of Hilaire's three sons living in Naples showed an inclination for marriage. Finally, in 1862, at the relatively advanced age of fifty-two, Édouard Degas (1811–1870) married Candida Primicile Carafa, the sister of his brother-in-law, the Duca di Montejasi. Within a few years there were two children, René-George, who died young, and Lucie (1867–1909; fig. 124). Candida Degas died

Fig. 124. Raffaello Ferretti, *Lucie Degas*, c. 1882. Photograph. Private collection

in June 1869, and her husband followed her to the grave shortly afterward, in March 1870. In 1870, the children became the wards of Achille Degas, one of their uncles.

The death of Achille in 1875 left Lucie, at the age of eight, sole heiress to her father's estate and cobeneficiary, with her cousins, the brothers Edgar and Achille De Gas, of some of their uncle Achille's estate.[1] Orphaned again, as it were, she became the ward of her last surviving uncle, Henri Degas (1809–1879). Why she was not entrusted to the charge of an aunt or a cousin remains unclear, but the reasons must have been largely financial. Whatever life Lucie may have had in the dignified gloom of the Palazzo Degas with yet another bachelor uncle came to an end in 1879 with the death of Henri Degas, who left her the entire share of his estate. Aged twelve by then and the principal heiress to what had been the Degas fortune, Lucie changed guardians for the third time in three years when her cousins Thérèse and Edmondo Morbilli moved into the Palazzo Degas as her legal tutors. As subsequent events proved, the arrangement was less than ideal.[2]

It is probable that Degas met Lucie briefly for the first time in December 1873, when he brought his father to Naples. He no doubt saw her in March 1875, when he attended the funeral of his uncle Achille, and again in June 1876, when he returned to Naples in a failed attempt to raise money for his creditors in Paris. The double portrait of Henri Degas and his ward is known to have been painted in Naples, where it remained in Lucie's possession until her death.

Both Lemoisne and Jean Sutherland Boggs have dated the portrait to the time of Degas's visit of 1876, but recently Richard Brettell has proposed a more cautious date of 1875–78, with the death of Henri Degas as a terminus ante quem. It is probable that Uncle and Niece was not begun in 1875, when the commotion caused by Achille's death and the arrangements for Lucie's guardianship would have been scarcely conducive to so tranquil an interpretation of life in the Degas family. A date later than 1876 is equally improbable, since Degas did not visit Naples again until 1886, long after Henri's death. It is therefore likely that the work was begun and finished in 1876, when guardian and ward had settled into the routine of their existence, and that the portrait records one of the few peaceful moments in an otherwise stormy period of Lucie Degas's life.

The carefully constructed composition of Uncle and Niece has been admirably discussed by Boggs and Brettell, both of whom have pointed out the psychological implications of the scheme. Brettell has noted pen-

timenti in the arms and hands of the little girl, who had originally been holding her uncle's armchair more firmly, and the care with which the artist defined the relationship between the two sitters. The most striking aspect of the portrait is the extraordinary sense of immediacy it conveys. Henri Degas has been reading the newspaper, with Lucie looking over his shoulder, and they have been interrupted by the artist, whom they confront directly. The uncle, slightly weary, merely lifts his eyes for a moment; more self-consciously, the child strikes the semblance of a pose. Both react to the intruder, who captures them with the apparent informality of a photograph. In this respect, the work transcends conventional notions of portraiture and moves firmly into the realm of life caught in its unpredictable aspects. Brettell has suggested the composition approximates that of In a Café (The Absinthe Drinker) (cat. no. 172), a more obvious rendition of two solitary figures, unaware, in that instance, of the presence of an observer.

In conception, the Chicago painting is a type of experimental portrait imaginable only within the framework of an artist's immediate circle—family or friends. Degas's later attempt to convey an equal degree of life in the commissioned portrait of Mme Dietz-Monnin (L534), also in the Art Institute of Chicago, revealed to him, in full force, the tenuous nature of the relationship between sitter and portrait painter.

As Theodore Reff has pointed out, Lucie Degas posed a second time for the artist during a visit to Paris in 1881.[3] This time, it was not for a portrait but for a relief—The Apple Pickers (cat. no. 231).

1. For the complicated conditions of Achille Degas's will, see Boggs 1963, p. 275.
2. Following her marriage to her cousin Edoardo Guerrero, Lucie became estranged from the Morbillis and from Edgar Degas. The question of the inheritance left by Achille Degas, settled only after Lucie's death in 1909, was evidently one of the causes of the breach.
3. Reff 1976, pp. 249–51.

PROVENANCE: Degas family, Naples; Marchesa Edoardo Guerrero de Balde (née Lucie Degas), Naples; Signora Marco Bozzi (née Anna Guerrero de Balde), Lucie Degas's daughter, Naples; bought by Wildenstein and Co., New York, November 1926; Mrs. Lewis Larned Coburn, Chicago; her bequest to the museum 1933.

EXHIBITIONS: 1926, Venice, Pavillon de France, April–October, XVa Esposizione Internazionale d'arte nella città di Venezia, no. 16, fig. 104; 1929 Cambridge, Mass., no. 34, pl. XXII; 1932, The Art Institute of Chicago, Antiquarian Society, Exhibition of the Mrs. L. L. Coburn Collection: Modern Paintings and Water Colors, no. 6, repr.; 1933 Chicago, no. 289, fig. 289; 1933 Northampton, no. 17; 1934, The Art Institute of Chicago, 1 June–1 November, A Century of Progress, no. 204; 1934 New York, no. 1; 1934, Saint Louis, City Art Museum, April–May, "Paintings by French Impressionists" (no catalogue); 1936

Philadelphia, no. 24, repr.; 1949 New York, no. 35, repr.; 1951–52 Bern, no. 22, repr.; 1952 Amsterdam, no. 13, repr. (detail); 1984 Chicago, no. 26, repr. (color).

SELECTED REFERENCES: Kunst und Künstler, XXX, 1926–27, p. 40, repr. (as "Father and Daughter"); Manson 1927, pp. 11–13, 48, pl. 5; Daniel Catton Rich, "A Family Portrait of Degas," Bulletin of the Art Institute of Chicago, XXIII, November 1929, pp. 125–27, repr. cover; W. Hausenstein, "Der Geist des Edgar Degas," Pantheon, VII:4, April 1931, p. 162, repr.; Daniel Catton Rich, "Bequest of Mrs. L. L. Coburn," Bulletin of the Art Institute of Chicago, XXVI, November 1932, p. 68; Walker 1933, p. 184, repr. p. 179; Mongan 1938, p. 296; Masterpiece of the Month, Chicago: The Art Institute of Chicago, July 1941, pp. 188–93; Hans Grabar, Edgar Degas nach einigen und fremden Zeugnissen, Basel: Schwabe, 1942, repr. facing p. 60; Lemoisne [1946–49], II, no. 394; Raimondi 1958, p. 264, pl. 24; Paintings in the Art Institute of Chicago: A Catalogue of the Picture Collection, Chicago: The Art Institute of Chicago, 1961, p. 119, repr. p. 287; Boggs 1962, pp. 45–46, pl. 86; Boggs 1963, p. 273, fig. 32; Supplement to Paintings in the Art Institute of Chicago, A Catalogue of the Picture Collection (catalogue by Sandra Grung), Chicago: The Art Institute of Chicago, 1971, p. 27; Minervino 1974, no. 401; Koshkin-Youritzin 1976, p. 38; Keyser 1981, p. 55, pl. XIX; Sutton 1986, p. 278, fig. 270 p. 277.

146.

The Duchessa di Montejasi with Her Daughters Elena and Camilla

c. 1876
Oil on canvas
26 × 38½ in. (66 × 98 cm)
Private collection

Lemoisne 637

Degas's portrait of his aunt Stefanina and her two daughters Elena and Camilla is the last of his family portraits and probably the most arresting. Dramatically placed against a glistening blue-green background, Stefanina Primicile Carafa, Marchioness of Cicerale and Duchess of Montejasi, dominates the scene by virtue of her placement at the top of a pyramidal mound of black taffeta that is in turn centered in a square consisting of all but the left third of the canvas.[1] But the true basis of her commanding presence is her uncompromising expression of resignation and world-weary knowledge. In contrast, her daughters seem frivolous and gay. They are active (perhaps playing a piano[2]), while she is immobile (listening?); they seem carefree, while she is heavy with the weight of life. By separating the mother from the daugh-

146

ters Degas emphasized the differences rather than the similarities of the two generations portrayed.[3] As Jean Sutherland Boggs has written, Degas's sympathies now lie with the older generation, as they did not, for example, in the great family portrait of his youth, *The Bellelli Family* (cat. no. 20).[4]

It is not known for certain when Degas painted this portrait. The most useful clue is the black garb of the sitters, which has been interpreted by Paul Jamot, Jean Sutherland Boggs, and others as mourning dress.[5] Degas went to Naples, where his aunt lived, to look after his dying father in the winter of 1873–74. He returned in 1875 for the funeral of his uncle Achille, and visited again briefly in June 1876. However, the majority of writers on the painting subscribe to a date of 1881, too late to reflect events of the mid-1870s. Boggs has suggested that the women may have been in mourning again in 1879, when the duchess's sister Rosa-Adelaida, Duchessa Morbilli, and another brother, Henri Degas, died. But after 1876, Degas did not return to Naples until 1886. This last date, 1886, can be ruled out first on the evidence of style,

for the present painting has nothing in common, for example, with the 1886 portrait of Hélène Rouart (fig. 192), and second on account of the sisters' ages. In 1886, the duchess would have been sixty-seven, a plausible age for the woman portrayed here, but the daughters, Elena and Camilla, would have been thirty-one and twenty-nine respectively, too old for the young sisters in this portrait.

In a notebook he was to use in 1879, Degas wrote of doing a series of aquatints on mourning.[6] In this painting, he has made black more than a simple descriptive tool to characterize the sitters: he has made it the virtual subject of the work.[7] As worn by the duchess, the color is tragic; as worn by the daughters, it is striking and incongruous. Despite the temptation to associate this portrait with the notebook project, it should be remembered that even in a notebook dated by Reff as early as 1859–64, Degas had contemplated painting a portrait of Mme Paul Valpinçon in mourning dress, "which suited my aunt Laura [Bellelli] so well."[8] It is difficult to imagine that Degas was working in this portrait style even as late as 1879. The

Fig. 125. *The Duchessa di Montejasi* (BR53), 1868. Oil on canvas, 19¼ × 15½ in. (48.9 × 39.4 cm). The Cleveland Museum of Art

space of the present picture does not share the energetic diagonal movement of the 1879 portraits of Duranty (fig. 146 and L518) and Martelli (cat. nos. 201, 202), nor is the method of description or even the application of paint reminiscent of Degas's elliptical operations in the portrait of Mme Dietz-Monnin (L534, The Art Institute of Chicago). Instead, the closest analogies seem to lie in portraits of the early and mid-1870s, such as *Henri Rouart and His Daughter Hélène* (cat. no. 143) and *Uncle and Niece (Henri Degas and His Niece Lucie Degas)* (cat. no. 145, painted in Naples in 1876), both of which are lateral, almost narrative, compositions. There is more than a family resemblance between the faces of Henri Degas and his sister Stefanina: they are painted in very much the same manner. Thus, it seems logical to assume that the portrait of the duchess with her daughters was painted during the same stay in Naples. Degas evidently began his series on mourning some four years before he made those notes in his notebook, in the midst of the enormous losses he and his family had sustained over the previous year.

It should be noted that Paul Jamot considered the playing of music, rather than the effect of mourning, to be central to the meaning of this portrait. "As a psychologist as well as a painter, he [Degas] studied the effects of music on a given listener. With all the penetration of which he was capable, and without abandoning that dash of irony that he adds to all his most sympathetic curiosities, he created 'the portrait of the man or woman listening to music' [i.e., as a new class of portraiture]."[9]

Degas portrayed Elena and Camilla in a double portrait of about 1865 (L169, Wadsworth Atheneum, Hartford). Elena, who appears here on the right, was portrayed separately in 1875 in a portrait formerly in the Tate Gallery and now in the National Gallery, London (L327).[10] The duchess was painted by Degas about 1868 in a portrait now in the Mellon collection (BR 52), which was preceded by a life-size portrait head in oil (fig. 125). A related charcoal drawing formerly in the collection of T. Edward Hanley that was last sold publicly at the Palais Galliéra, Paris, in 1973, does not appear to be by Degas.

GT

1. Degas seems to have calculated the composition according to geometric formulas: the canvas is one and a half times as wide as it is tall, a standard format; the two figural groups, centered on the axes of their respective segments, divide the canvas according to the proportions of the "golden section" (a ratio of 1:16; i.e., the smaller part is to the larger part as the larger part is to the whole).
2. According to Henriot (*Catalogue de la Collection David Weill*, II, 1927, p. 231), Marcel Guérin was the first to suggest that the daughters are playing a piano.

3. The watercolor portrait of Mme Michel Musson and her daughters in the Art Institute of Chicago is an example of the opposite, a family group emoting in unison.
4. Boggs 1962, p. 59.
5. Jamot 1924, p. 60; Boggs 1962, pp. 58–59, 95 n. 45.
6. Reff 1985, Notebook 30 (BN, Carnet 9, p. 206).
7. The observation is Jacques Bouffier's.
8. Reff 1985, Notebook 18 (BN, Carnet 1, p. 96).
9. Jamot 1924, p. 60.
10. There is some dispute over the identity of the sitter in L327. Signora Bozzi, niece of Camilla Carafa, identified her aunt in the portrait (see Ronald Alley, *Tate Gallery Catalogues: The Foreign Paintings, Drawings and Sculpture*, London, 1959, p. 53). However, on the basis of photographs provided by Elena's nephew and Camilla's son, Signor Francesco Cardone di Cicerale, Boggs identified the portrait as that of Elena Carafa (Boggs 1962, p. 124).

PROVENANCE: Presumably given by the artist to the Duchessa Montejasi (née Stéphanie Degas), his aunt, Naples. With Vincent Imberti, Bordeaux, 1923; bought from him by David David-Weill, Paris, 1923; private collection.

EXHIBITIONS: 1924 Paris, p. 46, no. 64, repr. (as "Portrait de Mme de Rochefort [?] et de ses deux filles, Hélène et Camille [?]," c. 1881), lent by David Weill; 1931 Paris, Orangerie, no. 75, repr.; 1934, Venice, XIX Esposizione Biennale Internazionale d'Arte, May–October, *Il ritratto dell'800*, no. 6 (as "La Duchessa di Montejasi Cicerale con le sue figlie Elena e Camilla"), lent by David-Weill, Paris; 1952, Paris, Musée des Arts Décoratifs, March–April, *Cinquante ans de peinture française dans les collections particulières de Cézanne à Matisse*, no. 37, pl. I.

SELECTED REFERENCES: Jamot 1924, pp. 21, 58–60, 150, pl. 56 (as "Portrait de famille," 1881, David-Weill collection); Daniel Guérin, "L'exposition Degas," *Revue de l'Art*, April 1924, p. 286; Lemoisne 1924, p. 98, no. 4 (as "Portrait de Stéphanie Degas et de ses deux filles"); H. Troendle, "Die Tradition im Werke Degas," *Kunst und Künstler*, XXV, 1926–27, repr. p. 245 (as "Bildnis Mme de Rochefort und ihrer Töchter," 1881); Gabriel Henriot, *Catalogue de la Collection David Weill*, II, Paris: Braun et Cie, 1927, pp. 229–32, repr. p. 233 (as "Portrait de famille: La duchesse de Montijase [sic] et ses deux filles," c. 1881); Marcel Guérin, "Remarques sur des portraits de famille peints par Degas à propos d'une vente récente," *Gazette des Beaux-Arts*, June 1928, pp. 372–73 n. 1 (as formerly with Vincent Imberti and now in the David-Weill collection); Alexandre 1935, repr. p. 160; Grappe 1936, repr. p. 11; Lemoisne [1946–49], II, no. 637; Raimondi 1958, p. 264; Boggs 1962, pp. 58–59, 95, 124, pl. 114; Minervino 1974, no. 583.

147.

Woman with an Umbrella

c. 1876
Oil on canvas
24 × 19¾ in. (61 × 50.4 cm)
Vente stamp lower left
National Gallery of Canada, Ottawa (15838)

Lemoisne 463

Nothing is known about the circumstances surrounding the painting of *Woman with an Umbrella*, which came to light only at the time of Degas's death and was purchased at the third atelier sale by one of his friends, Denys Cochin. When the portrait was thoroughly examined for the first time in 1969 (see fig. 126), it was discovered that it was painted over an unfinished picture of a standing young woman in black, shown three-quarter length, left of the center of the canvas. She wears a white bonnet, white collar and cuffs, and except for the absence of an apron one could perhaps imagine her to be a nursemaid.[1] Her left arm, though scraped of paint, is still visible at the center of the coat of the woman with the umbrella, dividing it in two, almost as if it were a decorative element.

The second portrait was painted on top of a thin ground, directly, without preparatory drawings, in assured strokes of the brush that outlined the principal elements—the head, the erect body, and the firmly crossed arms. As Clement Greenberg has noted, if the pose and the manner of execution are faultlessly classical, the naturalism of the image is worthy of Goya.[2] The woman could never be considered beautiful and has

Fig. 126. X-radiograph of *Woman with an Umbrella* (cat. no. 147)

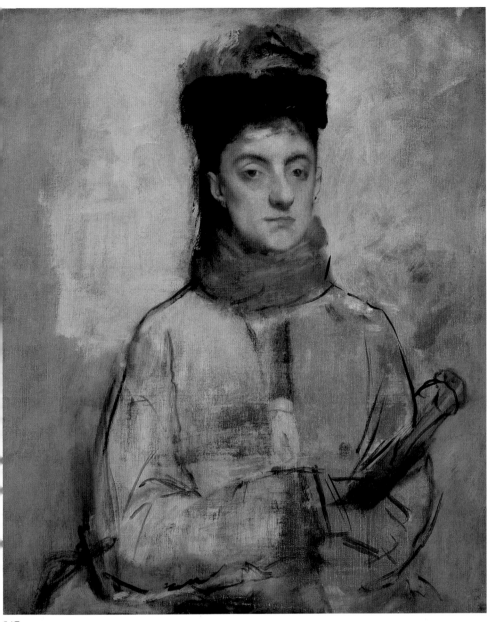

147

more than a share of that "pointe de laideur sans laquelle point de salut" (saving touch of ugliness) always appreciated by Degas.[3] The nose echoes the curiously constructed face, with oblong cheekbones and an unexpectedly round chin. The lips are shut with a defiant twist, and the eyes confront the viewer with a fixed, mesmerizing gaze. Elegant but morose, holding her umbrella as a kind of shield, she projects a frosty indifference to being anatomized in exact physical detail.

The portrait has been dated c. 1876 by Jean Sutherland Boggs and c. 1877–80 by Lemoisne. The style, remarkably Ingresque for so late a date, is of little assistance in dating the work; the costume would fit into any time slot in the late 1870s. The more probable date is about 1876, before Degas's portraits took the more complex formal turn that culminated in the late 1870s.

1. There is no apparent connection between this figure and the notes and drawing of a nursemaid appearing in one of Degas's notebooks for two projected compositions on the theme of birth and motherhood. See Reff 1985, Notebook 34 (BN, Carnet 2, pp. 8, 10, 11).
2. Clement Greenberg, "Art," The Nation, CLXVIII:18, 30 April 1949, p. 509.
3. See Degas's description of the women of New Orleans: "The women here are almost all pretty, and many, even in their attractiveness, have that saving touch of ugliness." Letter to Henri Rouart, 5 December 1872; Lettres Degas 1945, III, p. 28; Degas Letters 1947, no. 5, p. 27 (translation revised).

PROVENANCE: Atelier Degas (Vente III, 1919, no. 6, for Fr 7,000); bought by Baron Denys Cochin, Paris; with Hector Brame, Paris; with Paul Cassirer, Berlin. Arthur Sachs, Paris, by 1949. With Marianna Feilchenfeldt, Zurich; bought by the museum 1969.

EXHIBITIONS: 1931 Paris, Orangerie, hors catalogue; 1949 New York, no. 41, repr.; 1961, Paris, Musée

Jacquemart-André, summer–autumn, "Chefs-d'oeuvre des collections françaises" (no catalogue); 1962, Paris, Galerie Charpentier, Chefs-d'oeuvre des collections françaises, no. 25, repr.; 1964–65 Munich, no. 84, repr., lent by Mr. and Mrs. Arthur Sachs; 1975, Ottawa, National Gallery of Canada, 6 August–5 October, "Exploring the Collections: Degas and Renaissance Portraiture" (no catalogue, multigraph essay and checklist by Jean Sutherland Boggs); 1983, Vancouver Art Gallery, Masterworks from the Collection of the National Gallery of Canada, p. 48, repr. (color).

SELECTED REFERENCES: Lemoisne [1946–49], II, no. 463; Clement Greenberg, "Art," The Nation, CLXVIII:18, 30 April 1949, p. 509, reprinted in Clement Greenberg, The Collected Essays and Criticism (edited by John O'Brian), II, Chicago/London: University of Chicago Press, 1986, p. 302; Boggs 1962, p. 48, pl. 84; Jean Sutherland Boggs, The National Gallery of Canada, Toronto: Oxford University Press, 1971, pp. 61, 114, pl. xxiii (color); Minervino 1974, no. 461.

148.

Women Combing Their Hair

c. 1875
Oil on paper, mounted on canvas
12¼ × 18⅛ in. (32.3 × 46 cm)
Signed lower right: Degas
The Phillips Collection, Washington, D.C.
(0482)

Lemoisne 376

Sometime around 1878, Degas startled the Halévy family when he asked to be allowed to see Geneviève Halévy comb her hair.[1] It was a curious request to make and in more than one sense revealing of an interest in a theme that would become increasingly evident as years went by. There is little in Degas's early work to indicate this interest—perhaps a drawn copy of Botticelli's Birth of Venus of the late 1850s (IV:99.b), or drawings after a model with long flowing hair (Cabinet des Dessins, Musée du Louvre [Orsay], RF12262, RF12266) studied just before 1865 in anticipation of Scene of War in the Middle Ages (cat. no. 45). Possibly more revealing is a remark he made in a notebook used in 1868–74, where he confided, "I can readily call to mind the color of certain hair, for example, because I associate it with the color of gleaming walnut or of hemp, or indeed of horse chestnuts, real hair, with its shimmering flow and its lightness, or its coarseness and its weight."[2]

Somewhat unexpectedly, about 1875–76 the theme appears fully realized, in rapid succession, in Women Combing Their Hair, as a subsidiary motif in Peasant Girls Bathing in

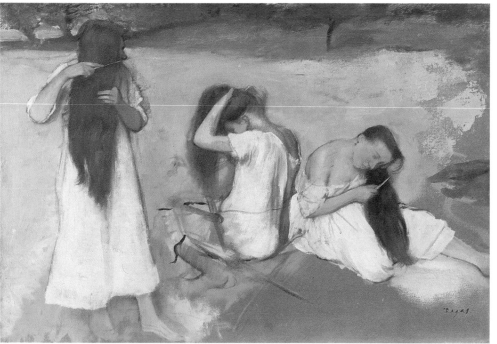

148

1949 New York, no. 33, repr.; 1950, New Haven, Yale University Art Gallery, 17 April–21 May, *French Paintings of the Latter Half of the 19th Century from the Collections of Alumni and Friends of Yale*, no. 6, repr.; 1958 Los Angeles, no. 25; 1959, New Haven, Yale University Art Gallery, *19th Century French Paintings*, no. 6, repr.; 1962 Baltimore, no. 40, repr.; 1977, Cincinnati, Taft Museum of Art, 24 March–8 May, *Best of 50* (no number), repr. (color); 1977–78, Memphis, Tenn., Dixon Gallery and Gardens, 4 December 1977–8 January 1978, *Impressionists in 1877*, no. 10, repr.; 1978 New York, no. 11, repr. (color).

SELECTED REFERENCES: Hertz 1920, pl. 8; Meier-Graefe 1920, pl. 38; Rouart 1945, pp. 13, 70 n. 24 (as "essence"); Lemoisne [1946–49], I, p. 86, II, no. 376; *The Phillips Collection: Catalogue*, Norwich, Conn., 1952, p. 27; Cabanne 1957, pp. 97, 111, pl. 56; Minervino 1974, no. 397; Roberts 1976, pl. 21 (color); Keyser 1981, p. 72, pl. vii; McMullen 1984, p. 275; 1984–85 Paris, fig. 111 (color) p. 132.

the Sea toward Evening (cat. no. 149), and as the central subject of *At the Seashore* (L406, National Gallery, London), in which a child has her hair combed by a nursemaid. Of these, *Women Combing Their Hair* is the most conspicuously studied, focusing exclusively on the movements of three figures, evidently painted from the same model in three different poses. The figure at the center can be safely considered the first expression of a prototype that Degas repeated in several versions, with the model nude, in the 1880s (see cat. nos. 284, 285). But the other two figures do not reappear in his later work except as remote echoes—for instance, in *Young Woman Combing Her Hair* (cat. no. 310), where the gesture of the figure at the left is reexamined but with entirely different results.

Some of the working process that underlies the painting is still visible and indicates it may have originated as a simple triple study of a woman combing her hair. The support, a sheet of paper, is of the same size and type as that used, for instance, in *Four Studies of a Jockey* (cat. no. 70), for some of the studies of women at the races (L260, L261), and in the individual sheets that make up *At the Seashore*. The figures, originally nude, were sketched in essence, quite freely, rather like the studies of women at the races. It seems reasonably certain that the idea to turn the work into a painting followed immediately after the original design. Though presumably drawn in the studio, the figures were placed in a semblance of narrative in a landscape, and their positions were slightly altered for compositional reasons. The woman at the center and the one at the left

were moved farther to the left, and it was in this final stage that the figures were dressed. Degas's emphasis was consistently on the upper part of the figures, with the arms and the hair observed with particular care. Parts of the landscape, apparently a beach by a river, were left unfinished, however, as were parts of the figures. The woman in the center is only partially covered by her clothes, and the figure still reveals a section of the previous, underlying nude.

As usual with Degas, the notion of "finished" and "unfinished" is an especially thorny question. Degas probably considered this work finished, as he did the even less complete *Laundresses Carrying Linen in Town* (fig. 336), which he exhibited in 1879. He signed the painting, possibly for its first owner, the artist, and later a friend, Henry Lerolle, but he appears never to have exhibited it.

1. Geneviève Halévy was the cousin of Ludovic Halévy and the widow of Georges Bizet, who had died in 1875. See George D. Painter, *Marcel Proust*, I, London: Chatto and Windus, 1959, p. 89.
2. Reff 1985, Notebook 22 (BN, Carnet 8, p. 4).

PROVENANCE: Bought from the artist in 1878 by Henry Lerolle (d. 1929), Paris; Madeleine Lerolle, his widow, Paris. With Carstairs, Carroll, New York, after 1936; bought by Duncan Phillips, Washington, D.C., 1940.

EXHIBITIONS: 1924 Paris, no. 56, repr.; 1931 Paris, Rosenberg, no. 27; 1935, Brussels, Palais des Beaux-Arts, *L'impressionnisme*, no. 15, repr.; 1936, London, New Burlington Galleries, Anglo-French Art and Travel Society, 1–31 October, *Masters of French Nineteenth Century Painting*, no. 62 (from the collection of the late Henry Lerolle); 1937 Paris, Orangerie, no. 23, pl. XIV; 1947 Cleveland, no. 27, pl. XXVII;

149.

Peasant Girls Bathing in the Sea toward Evening

1875–76
Oil on canvas
25⅝ × 37⅛ in. (65 × 81 cm)
Vente stamp lower left
Private collection

Lemoisne 377

The mood of this startling composition, simultaneously exuberant and somber, suggests a youthful, romantic intensity seldom observed in the artist's mature work, and the ritual aspect of the jubilant dance of the bathers, in a primal union with nature, sets the subject apart from almost anything else Degas painted.[1] The idea for a composition of this type seems to have arisen from a handwritten note in a notebook Degas used during the period 1868–72, in which he proposed to make "on a large scale, groups, in pure silhouette, at twilight."[2]

In a theme that preoccupied him from about 1856 to 1858, the artist attempted to convey the symbolic moment when Dante and Virgil entered Inferno. This work appears to reflect the opposite notion, entry into an almost ecstatic state of bliss, and it may not be entirely coincidental that the two figures holding each other by the hand distantly echo the pose of the models Degas used for his *Dante and Virgil* (fig. 11).[3] The lyrical passages in the background, with the tranquil-looking women quietly combing their hair or introspectively turning their backs to the sunset, are close in feeling and

Fig. 127. *Study of a Nude Girl* (IV:289.a),
c. 1875? Charcoal, 12¼ × 7⅝ in. (31 × 19.3 cm).
The British Museum, London

style to those in *Women Combing Their Hair* (cat. no. 148), in the Phillips Collection. The contrast between the still mood of the background and the flamboyant bathers in the foreground is echoed in the astonishingly free handling of paint, liquid and diaphanous nearly throughout but used sparingly, indeed almost brutally, in the bathers.

A drawing of a nude girl (fig. 127) in the British Museum served as the model for the figure at the left. The frenzied figure at the right, doubtless inspired by the standing nude at the center of *The Death of Sardanapalus* by Delacroix (now in the Louvre but during the 1870s and 1880s owned by Durand-Ruel), was also used for a pastel (L606) in the Sidney Brown collection in Baden, Switzerland.

According to the catalogues of the second and third Impressionist exhibitions, Degas exhibited the painting in 1876 and again in 1877. Although the shows were extensively reviewed, no mention of the picture appeared in print. As the artist frequently changed his mind about works to be exhibited, it is possible that he decided against showing it in 1876 after the catalogue was printed, hence its somewhat unusual inclusion one year later in the exhibition of 1877.

The remark of a critic who noted the absence of several of Degas's works nine days after the opening of the exhibition of 1876 lends some strength to this hypothesis.[4]

1. A different bathing scene in a monotype (J262) of decidedly comic cast, c. 1876, is in fact closely connected to the small, subsidiary figures appearing in the background of *At the Seashore* (L406, National Gallery, London).
2. See Reff 1985, Notebook 23 (BN, Carnet 21, p. 60). The author is grateful to Jean Sutherland Boggs for having drawn this notebook entry to his attention.
3. See in particular the nude studies IV:106.e and IV:116.b.
4. Émile Blémont [Émile Petitdidier], "Les impressionnistes," *Le Rappel*, 9 April 1876.

PROVENANCE: Atelier Degas (Vente III, 1919, no. 32, for Fr 5,500). Charles Vignier, Paris. Private collection. Sale, Sotheby Parke Bernet, London, 4 December 1984, no. 6, repr. (color); bought at that sale by present owner.

EXHIBITIONS: (?) 1876 Paris, no. 56 (as "Petites paysannes se baignant à la mer vers le soir"); 1877 Paris, no. 51 (as "Petites filles du pays se baignant dans la mer à la nuit tombante"); 1986 Washington, D.C., no. 27, repr. (color).

SELECTED REFERENCES: Lemoisne [1946–49], II, no. 377; Cabanne 1957, pp. 35, 111, 129, pl. 57; Minervino 1974, no. 396.

149

The First Monotypes

cat. nos. 150–153

A monotype is made by applying printer's ink or oil paint with a brush or rag on a metal plate and then printing the image on a sheet of dampened paper with the aid of a rolling press. Only one really good impression can be pulled, although a second, inevitably less richly textured, impression can also be obtained. It has frequently been stated that Degas, who preferred the phrase "dessin fait à l'encre grasse et imprimé" (drawing made with thick ink and then printed) to the term "monotype," first experimented with the process under the supervision of his friend Ludovic Lepic, an engraver, who had developed a system that allowed considerable variability in the inking of engraved plates. In a relatively short time, Degas created not only some of his most striking works but also some of the most innovative monotypes to be produced in modern times. From the evidence of the large number of surviving monotypes, he was clearly fascinated with the process, and it has been recorded on various occasions that he considered himself its inventor.[1]

Two options are open to the maker of monotypes: one, commonly known as the "dark-field manner," consists of completely covering the untouched plate with ink and then removing parts of the ink with a rag or an implement. With the second method, the "light-field manner," one simply draws on the plate with a brush and printer's ink. Degas used both methods, sometimes on the same plate, and with such different results as to seriously confuse the question of their date. He appears to have almost invariably pulled second impressions and in a few instances even attempted to obtain counterproofs. Eugenia Janis, whose analysis of the role of monotypes in Degas's work remains the essential text on the subject, has pointed out the artist's use of first impressions of monotypes for transfer lithographs and his extensive use of second impressions as a base for pastels. More recently, Sue Reed, Barbara Shapiro, Douglas Druick, and Peter Zegers have elaborated on the remarkably ingenious manner in which Degas used any image he produced, including the monotypes.

The chronology of the monotypes remains indefinite, in spite of the significant work of Denis Rouart, Eugenia Janis, and Françoise Cachin on the subject. It seems the first works were not begun as early as previously believed, and, paradoxically, many are probably dated later than they should be. The fixed points for a chronology of the works are few. Denis Rouart originally proposed 1875 as a tentative date for the earliest monotypes, which he believed to be the café-concert scenes, but now it is generally agreed that Degas's earliest monotype is *The Ballet Master* (cat. no. 150), dually signed "Degas" and "Lepic." This has been dated 1874–75 by Eugenia Janis on the assumption that a second impression of the monotype covered in gouache and pastel (fig. 130) existed in the summer of 1875 when it was allegedly purchased by Louisine Elder, the future Mrs. H. O. Havemeyer.[2] A dated bill of sale has been cited as evidence, but no such document appears to exist, and the earliest firmly established date for the pastel is 1878, when it was exhibited in New York.[3]

According to Mrs. Havemeyer's memoirs, she bought the pastel from a color shop in Paris on the advice of Mary Cassatt when she was "about sixteen years old"—that is, around 1871, clearly an impossibility.[4] There is no question that she could have acquired works of art in 1875 when she visited Paris, yet it is more likely that she bought the pastel in 1877 on a subsequent visit. This hypothesis is supported by her remark about a note of thanks Degas wrote to Mary Cassatt, difficult to imagine long before

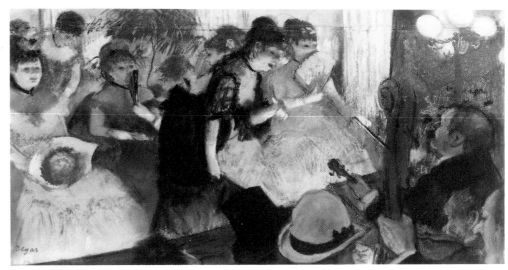

Fig. 128. *Cabaret* (L404), 1876–77. Pastel over monotype, 9½ × 17½ in. (24.1 × 44.5 cm). The Corcoran Gallery of Art, Washington, D.C.

1877,[5] and would also correspond with other evidence indicating that Degas did not actually begin producing monotypes until, most probably, the summer of 1876.

Jules Claretie, who saw Degas frequently and was not likely to be wrong about such things, mentioned in a letter of 4 July 1876 that the artist spoke to him "about a new printmaking process that he had discovered!"[6] As Claretie was the one critic who at the time of the exhibition of 1877 made a point of discussing Degas's monotypes and even recommended their publication, his voice has the ring of authority.[7] And in a well-known letter of 17 July 1876, Marcellin Desboutin, a close friend of Degas's, wrote about the artist's tremendous enthusiasm for printing: "Degas . . . is no longer a friend, a man, an artist! He's a zinc or copper *plate* blackened with printer's ink, and plate and man are flattened together by his printing press, whose mechanism has swallowed him completely!"[8]

The results of this intense activity were evident in the third Impressionist exhibition of 1877, to which Degas contributed three separate sets of monotypes, unfortunately not identified in the catalogue, as well as a number of works in pastel over monotype. Among the pastelized monotypes were *The Chorus* (cat. no. 160), *Women on the Terrace of a Café in the Evening* (cat. no. 174), *Cabaret* (fig. 128), *Café-concert at the Ambassadeurs* (L405, Musée de Lyon), *Woman Leaving Her Bath* (cat. no. 190)—always known or suspected to have figured in the exhibition—and, almost certainly, *Ballet (The Star)* (cat. no. 163). The catalogue also listed a "Cabinet de toilette" (no. 56) and "Femme prenant son tub le soir" (no. 46), which may be identified respectively as *The Toilette* (L547, Musée d'Orsay, Paris), variously dated from 1879 to 1885, and

Woman at Her Toilette (fig. 145), commonly dated 1885–90.[9]

Rouart, Janis, and Cachin have all observed that Degas's monotypes fall into certain thematic and stylistic groups and have dated them accordingly. It is a useful division for the purposes of dating, and for the sake of simplicity, it is retained here. One group, the café and café-concert scenes, has been dated by Rouart, Janis, and Cachin between roughly 1875 and 1880. From the evidence of the two scenes exhibited in 1877 and a few more small monotypes transferred by Degas as lithographs, generally dated 1876–77, the entire group can probably be dated 1876–77.[10] Another group of some forty monotypes (not counting second impressions), conceived by Degas as illustrations for *La famille Cardinal* by Ludovic Halévy and usually dated 1879–83, also belongs to a date prior to April 1877, when a number were shown in the third Impressionist exhibition and were reviewed by Jules Claretie.[11]

The group of brothel scenes, along with a few subjects aptly titled "scènes intimes" by Françoise Cachin, have been unanimously dated c. 1879–80 by Rouart, Janis, and Cachin. From the point of view of style, the series has been frequently and justly connected with the *Famille Cardinal* monotypes, and Cachin has even suggested that some of them may have been exhibited in 1877.[12] Jules Claretie, in his review of the exhibition of 1877, intimated as much.[13] The series should likely be reconsidered as belonging to the period 1876–77 and not separated from the *Famille Cardinal* group.

A number of monotypes that fall into small subgroups should be noted separately. The few portraits and busts, some connected with café-concert subjects, have in fact already been redated in part. The portrait of

Fig. 129. *Café-concert* (J25), 1876–77. Monotype, second impression, 8 × 16½ in. (20.3 × 41.9 cm). Mackenzie Art Gallery, Regina

Ellen Andrée (cat. no. 171), dated c. 1880 by Janis and Cachin, belongs more properly with that of Marcellin Desboutin (J233, Bibliothèque Nationale, Paris), dated by them 1876, which in turn carries a sequence of small monotypes, such as *The Jet Earring* (cat. no. 151), dated in the second half of the 1870s.[14] Three monotypes (two of them covered in pastel) of women leaving their bath, in spite of the varying dates in the late 1870s assigned by Janis and Cachin, are likely closely related and are at home in 1876–77, before the third Impressionist exhibition in which one of them figured.[15]

More enigmatic are a number of dark-field monotypes representing dance subjects and nudes in interiors. The dance subjects, few in number, were dated very late by Rouart, along with the nudes, c. 1890–95. Janis, followed by Cachin, moved them much earlier, to c. 1878–79, with one exception, *The Ballet Master* (cat. no. 150), which she dated c. 1874–75. On the basis of this monotype, Janis concluded that Degas may have employed the subtractive or dark-field method at the outset, and, owing to its relationship to works in other mediums, she suggested that in his earliest experiments he depended on subjects from his paintings.[16] This, indeed, happens to be true with most of the dark-field ballet subjects, which are variations on drawings. Hence, it is difficult to imagine why the small group of dance subjects should be separated by several years from a single, first experiment, *The Ballet Master*. It seems more likely that all are contemporary and thus to be placed among his early efforts.

Janis originally dated the group of dark-field nudes and "scènes intimes" 1880–85, but redated it 1877 on stylistic grounds.[17] The matter would not require attention if the group were not relatively mixed, containing scenes such as *The Fireside* (cat. no. 197), *The Tub* (cat. no. 195), and *Women by a Fireplace* (cat. no. 196), easily accommodated in 1876–77, along with the variety of stylistically different large nudes such as *Nude Woman Reclining on a Chaise Longue* (cat. no. 244), *Woman in a Bath Sponging Her Leg* (fig. 229), *Nude Woman Wiping Her Feet* (cat. no. 246), or the two versions of *Reader* (J139, J141). The question remains open, but calls for some comment. First, there appears to be a typological connection between the single nudes and the brothel scenes—both groups abounding in extravagant poses—that hints at a closer relationship than is generally noted.[18] Second, in several instances it is clear that the same plate was shared by a number of monotypes, perhaps suggesting contemporaneity. *Three Ballet Dancers* (J9, Clark Art Institute, Williamstown), *Cabaret* (fig. 128), *Nude Woman Reclining on a Chaise Longue* (cat. no. 244), and every oblong dark-field nude—all were obtained from the same plate.

Almost no attention has been paid to the sizes and formats of the plates Degas used, and the variety is greater than might at first be imagined. The largest plate, 21⅝ by 26¾ inches (55 by 68 centimeters), appears to have been used only three times, in every instance for a dark-field monotype: *The Ballet Master* (cat. no. 150); *The Dance Lesson* (L396, Joan Whitney Payson Gallery of Art, Portland, Me.), not recorded by Janis and Cachin; and, partially, *Ballet at the Paris Opéra* (L513, The Art Institute of Chicago).[19] The second largest, 22¾ by 16½ inches (58 by 42 centimeters), was used for four monotypes, all dark-field as well: the two impressions of *Ballet (The Star)* (cat. no. 163 and L601); *Women on the Terrace of a Café in the Evening* (cat. no. 174); the two impressions

of *The Tub*, called *Woman at Her Toilette* in its pastelized version (cat. no. 195 and fig. 145); and *The Fireside* (cat. no. 197).[20] That these large-format monotypes were made with pastels in mind, as Janis has proposed, is fairly evident from the record.

The most frequently used formats, however, were roughly 4¾ by 6¼ inches (12 by 16 centimeters) and 8¼ by 6¼ inches (21 by 16 centimeters), covering together over one third of Degas's entire output. A plate of the first format was used for some sixty monotypes, among which are many brothel scenes and nudes, a number of scenes from daily life, several café-concert scenes, a few landscapes, and a circus scene. The second format served for at least forty-seven monotypes—including one dancer, two café-concert subjects, twenty-eight nudes and brothel scenes, the portrait of Ellen Andrée, and four landscapes—most of which are assumed to be contemporary.

The production of such a large number of monotypes in a relatively short time is remarkable, as is the great stylistic difference that separates dark-field monotypes from the freely drawn light-field works. The difference ultimately may be ascribed less to the distance in time that might separate them than to the technique employed, doubtless determined by the final destination of the work. It is clear that during 1876–77, Degas was energetically trying to sell as many works as he could, and it cannot be entirely coincidental that so many of the monotypes were produced during that period. Whether as embryonic compositions to be finished as pastels or as proposed plates for publication, they all appear to have had some part in the artist's attempt to raise money with his work.

1. Rouart 1945, p. 62.
2. Janis 1967, p. 72 n. 9.
3. Weitzenhoffer 1986, p. 23. Frances Weitzenhoffer believes, however (p. 21), that Mrs. Havemeyer indeed bought the pastel in 1875 but without mentioning a bill of sale.
4. Havemeyer 1961, pp. 249–50. In fact, Louisine Havemeyer met Mary Cassatt only in 1874.
5. "Miss Cassatt told me Degas had written her a note of thanks when he received the money, saying he was sadly in need of it."; see Havemeyer 1961, p. 250. Frances Weitzenhoffer, in a different context, agrees that Cassatt and Degas may have first met only in 1877; see Weitzenhoffer 1986, p. 22.
6. Letter from Jules Claretie to Giuseppe and Léontine De Nittis, 4 July 1876, in Pittaluga and Piceni 1963, p. 339.
7. Claretie 1877, p. 1.
8. Letter from Marcellin Desboutin, Dijon, 17 July 1876, to Léontine De Nittis, in Pittaluga and Piceni 1963, p. 359 (translation, Reed and Shapiro 1984–85, p. xxix). Claretie's and Desboutin's letters have been cited as evidence of Degas's great interest in printmaking in general, but it is difficult to conceive of any other type of print he produced—aside from the monotype—as his dis-

covery. See Douglas Druick and Peter Zegers in 1984–85 Boston, pp. xxviii–xxix.

9. A critic noted in a review, "Why has M. Degas included in his contribution a squatting female *nude* that is scandalizing women viewers?" which is a reasonably close description of *The Toilette*; see Pothey 1877, p. 2. In fact, there are no other true candidates datable to 1877 for "Femme prenant son tub le soir" beyond the pastel in Pasadena (fig. 145).

10. For the dating of the lithographs, see Reed and Shapiro 1984–85, nos. 27, 28.

11. Claretie 1877, p. 1.

12. Cachin 1974, p. 83.

13. Claretie 1877, p. 1. See also "The Brothel Scenes," p. 296.

14. For the more recent redating of *Ellen Andrée*, see cat. no. 171.

15. See cat. nos. 190, 191.

16. 1968 Cambridge, Mass., no. 1.

17. Janis 1972, passim.

18. See cat. no. 181.

19. *The Dance Lesson* (L396) was dated c. 1876 by Lemoisne and c. 1879 by Lillian Browse (see Browse [1949], no. 40). Ronald Pickvance, however, has redated it about 1874 (see Pickvance 1963, p. 265). The monotype base suggests that Lemoisne's date was close to the mark, and the dependence of the figure of the dancer on a known drawing (fig. 123) appears to indicate that the work was among Degas's earlier monotypes.

20. It may be added that *Reclining Nude Holding a Cup* (L1229) gives every impression of being a pastelized monotype. The measurements, 16½ by 22¾ inches (42 by 58 centimeters), are those of the monotypes under discussion, but judging from the photographs published in Lemoisne [1946–49], III, no. 1229, and Vente II, no. 131, it is possible that the work was enlarged.

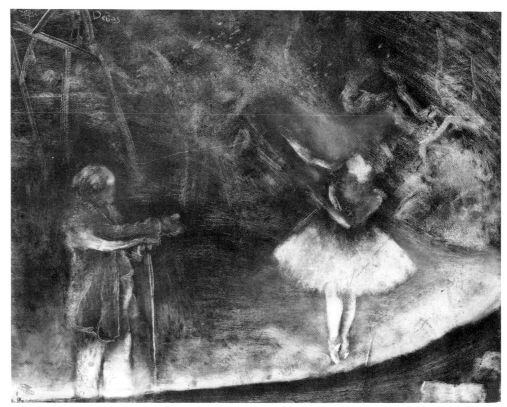

150

150.

The Ballet Master

1876
Executed in collaboration with the Vicomte
 Ludovic Lepic
Monotype heightened with white chalk or wash
Plate: 22¼ × 27½ in. (56.5 × 70 cm)
Signed on plate upper left: Lepic Degas
National Gallery of Art, Washington, D.C.
 Rosenwald Collection, 1964 (1964.B24.260)

Exhibited in Paris and New York

Janis 1/Cachin 1

The joint signature of Lepic and Degas at the upper left surely indicates—as maintained by Eugenia Janis—that this work was the artist's first attempt at a monotype, carried out with the assistance of Ludovic Lepic.[1] The plate is Degas's largest, and appears to have been used on only two other occasions.[2] It is possible that a large plate was chosen for practical reasons, to allow Degas to work on a familiar scale and in a relatively broad fashion. This hypothesis is confirmed, to an extent, by the simple composition, with only two figures, and by the size of the figures; the ballet master is similar in scale to his counterpart in the drawing that served as a model. Both the composition and the execution (in the dark-field manner) are rather awkward.

In conception the design is adapted from *The Rehearsal of the Ballet on the Stage* (cat. no. 124), where the dancer appears as part of the group to the right. The ballet master, precariously positioned in the monotype between the stage and the void below it, was derived from the charcoal study of Jules Perrot (fig. 121). The second impression of the monotype (fig. 130) was worked over with pastel and gouache into a composition with several additional figures.

1. Janis 1968, pp. xvii–xviii.
2. See "The First Monotypes," p. 257.

PROVENANCE: Ambroise Vollard, Paris; Henri Petiet, Paris; Lessing J. Rosenwald, Jenkintown, Pa., 1950; his gift to the museum 1964.

EXHIBITIONS: 1968 Cambridge, Mass., no. 1, repr.; 1982, Washington, D.C., National Gallery of Art, 7 February–9 May, *Lessing J. Rosenwald: Tribute to a Collector* (catalogue by Ruth Fine), no. 66, repr. p. 193; 1984–85 Washington, D.C., no. 17, repr.

SELECTED REFERENCES: Guérin 1924, p. 78; Janis 1967, p. 21 n. 13, fig. 45; Janis 1968, no. 1 (as c. 1874–75); Cachin 1974, no. 1 (as 1874); Sutton 1986, pp. 125–26.

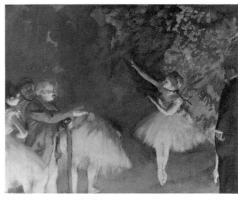

Fig. 130. *Ballet Rehearsal* (L365), 1876–77. Gouache and pastel over monotype, 21¾ × 26¾ in. (55.7 × 68 cm). The Nelson-Atkins Museum of Art, Kansas City

151

152

151.

The Jet Earring

c. 1876–77
Monotype in black ink on white laid paper
Plate: 3¼ × 2¾ in. (8.2 × 7 cm)
Sheet: 7 × 5¼ in. (18 × 13.2 cm)
Atelier stamp lower right corner, in margin
The Metropolitan Museum of Art, New York.
 Anonymous gift, 1959 (59.651)

Janis 243/Cachin 39

Seventeen monotypes of this size are known, occasionally in more than one impression, all but one representing busts of women or portraits.[1] There is every reason to think they were pulled from the same plate, and they are generally believed to be contemporary. Among them is a sketchy but convincing portrait of Marcellin Desboutin (J233, Bibliothèque Nationale, Paris), known only from a second impression; a fine head of an old man (J232, Museum of Fine Arts, Boston), possibly derived from an image in a publication; and busts of café-concert singers, women observed at cafés, and even a nursemaid. Some of the figures have sufficiently pronounced features to prompt Jean Adhémar to propose a number of identifications—Ellen Andrée, for example (RS27, J253), and, probably wrongly, the singer Thérésa (RS27).[2] It is not known if Degas had a particular reason for making these monotypes, which are attractive enough in their own right. But they do seem to have had a purpose; some of them, indeed, served as a transfer base for lithographs.[3]
 The woman in this monotype, recognizable by her black hat and long hair with a high chignon, appears in profile in another monotype of the same size (J244) and twice more, again in profile, on a larger sheet (J241). No identification has been proposed for her, but it may be noted that the profile views of her face remain consistent enough to suggest she may have been adapted from a photograph. The splendid head shown here is in an altogether different category from those in the other monotypes and is justly celebrated as one of Degas's more spellbinding images. The accent is on the rendition of the woman's lost profile, defined with an exceptionally pure outline and set off by the somber background. Eugenia Janis has shown that the especially fine effects were achieved by means of a combined monotype technique. The background and the hair were executed in the dark-field manner, and the outline and details of the face and the perfectly placed earring were painted with a brush in the light-field manner.[4] Janis dated the work 1877–80, a date accepted by Barbara Shapiro.[5] It seems, nevertheless, that a date of about 1876 would bring it more in line with its counterparts.[6]

1. The exception is a small landscape (J273).
2. Adhémar 1974, no. 44. For Thérésa (Emma Valadon), see cat. no. 175.
3. Reed and Shapiro 1984–85, nos. 27, 28.
4. 1968 Cambridge, Mass., no. 56.
5. 1980–81 New York, no. 28.
6. Sue Reed and Barbara Shapiro have dated the lithographs derived from the monotypes 1876–77; see Reed and Shapiro 1984–85, nos. 27, 28.

PROVENANCE: Atelier Degas (Vente Estampes, 1918, lot 281 [as "Buste de femme de profil perdu"]); bought by Marcel Guérin, Paris (his stamp, Lugt suppl. 1872b, lower right corner, in margin). Maurice Loncle, Paris (according to Helmut Wallach). Bought by the museum 1959.

EXHIBITIONS: 1960 New York, no. 99; 1968 Cambridge, Mass., no. 56, repr.; 1974 Boston, no. 92; 1977 New York, no. 1 of monotypes; 1980–81 New York, no. 28, repr. (as 1877–80).

SELECTED REFERENCES: Janis 1968, no. 243; Cachin 1974, no. 39, repr.

152.

At the Seashore

c. 1876
Monotype in black ink on white wove paper (formerly mounted by the artist on light-weight cardboard)
Plate: 4¾ × 6¾ in. (12 × 15.8 cm)
Sheet: 6½ × 6¼ in. (16.5 × 17.2 cm)
Atelier stamp lower left, in margin (and on verso of original mount removed in 1952)
Private collection

Janis 264/Cachin 181

Dated c. 1880 by Eugenia Janis and others, this monotype appears to belong to an earlier period, probably about 1876. In fact, there is every reason to assume that it is contemporary with another monotype, *The Bathers* (J262), dated c. 1875–80 by Janis, and that both are connected with related figures appearing in the painting *At the Seashore* (L406) in the National Gallery, London, generally

dated 1876–77 and certainly exhibited in the third Impressionist exhibition, of 1877.

Exceptionally fresh and luminous, this monotype is also one of the most charming works by the artist in this process, with the often melancholy theme treated with slightly comic overtones. As Janis has noted, the highly simplified figure may have been touched up in the area of the hat and the umbrella after the impression was pulled.

PROVENANCE: Atelier Degas (Vente Estampes, 1918, no. 300); bought by Gustave Pellet, Paris; by descent to Maurice Exsteens, Paris, from 1919; Marcel Guérin, Paris (his stamp, Lugt suppl. 1872b, lower left corner, in margin). With Gerald Cramer, Geneva; bought by present owner March 1952.

EXHIBITIONS: 1968 Cambridge, Mass., no. 61, repr. (as c. 1880); 1974 Boston, no. 103; 1985 London, no. 21, repr.

SELECTED REFERENCES: Janis 1968, no. 264; Cachin 1974, no. 181, repr.

153.

Factory Smoke

c. 1876–79
Monotype in black ink on white laid paper
Plate: 4¾ × 6¼ in. (11.9 × 16 cm)
The Metropolitan Museum of Art, New York. The Elisha Whittelsey Collection, The Elisha Whittelsey Fund (1982.1015)

Janis 269/Cachin 182

153

In a series of subjects that Degas listed in a notebook used from about 1877 to 1884 as being of interest to him, he wrote: "On smoke—people's smoke, from pipes, cigarettes, cigars; smoke of locomotives, tall chimneys, factories, steamboats, etc.; smoke confined in the space under bridges; steam."[1] Of course, smoke also captivated Monet, who in 1877 devoted a series of pictures to the smoke-filled interior of the Gare Saint-Lazare. Degas himself had included factory smokestacks and steamships somewhat unexpectedly in the backgrounds of *The Gentlemen's Race: Before the Start* (cat. no. 42) and *Horses in the Field* of 1871 (L289), and, more predictably, in *Henri Rouart in Front of His Factory* (cat. no. 144), *At the Seashore* (L406, National Gallery, London), and the small monotype *At the Seashore* (cat. no. 152).

Factory Smoke is the only work Degas devoted purely to the visual possibilities of smoke in the abstract, almost devoid of context. Monotype as a medium was ideally suited to capturing the impalpable quality of the subject. The image has "sentiment" (the effect Constable recognized in his studies of clouds) and should probably be read as the aesthetic reaction to a perceived phenomenon rather than as a visual metaphor of modern times.

Eugenia Janis has dated the work c. 1880–84. On the basis of Degas's notes on smoke, made in May 1879 or shortly afterward in connection with etchings planned for the proposed periodical *Le Jour et la Nuit*, a date of about 1879 or earlier appears more reasonable.

1. Reff 1985, Notebook 30 (BN, Carnet 9, p. 205); see also Reff 1976, p. 134.

PROVENANCE: Atelier Degas (Vente Estampes, 1918, no. 316, in the same lot with "Les deux arbres" [J273, C174]). César M. de Hauke; given by him to a private collector, London; bought by the museum 1982.

SELECTED REFERENCES: Janis 1968, no. 269; Cachin 1974, no. 182.

154.

Woman with Field Glasses

c. 1875–76
Oil on cardboard
18⅞ × 11⅞ in. (48 × 32 cm)
Signed twice, lower right: "Degas" (in white) and, again, "Degas" (in ochre)
Staatliche Kunstsammlungen Dresden, Gemäldegalerie Neue Meister, Dresden (Gal. Nr. 2601)

Withdrawn from exhibition

Lemoisne 431

This haunting figure seems to be Degas's final return to a motif that had preoccupied him since the mid-1860s (see cat. no. 74). The composition, with the figure shown full length, is known in three painted sketches—two smaller ones, in the Burrell Collection, Glasgow (fig. 131), and in a Swiss private collection (L269), and this slightly larger oil painting in Dresden. None are dated except for the Burrell version, inscribed by the artist on a piece of paper on the back "Degas vers 1865" (Degas c. 1865), but from the dress of the woman depicted, they possibly date from somewhat later.

The oil sketch in Switzerland (L269), inscribed with the sitter's name—Lyda—has led William Wells to tentatively propose that all the versions might represent the same model, Lydia Cassatt, Mary Cassatt's semi-invalid sister who settled in Paris in 1877, and that all the pictures date from c. 1874–80.[1] It is almost certain that the sitter is not Lydia Cassatt, but the question of her identity was tantalizingly raised as early as 1912 when Lemoisne noted that her face "through a whim of the artist, a bit paradoxical for those who knew the very beautiful woman whom he was thus hiding, is strangely masked by the two glittering lenses of the field glasses."[2] Richard Thomson has suggested that the pose may be derived from a classical representation of the goddess Pudicitia, and Degas certainly used it on at least one occasion for a drawing of a dancer.[3]

Indisputable is the notion that all the studies were in one manner or another related to a

figure to be integrated in a racing picture. The figure in the Burrell sketch was actually included in *At the Racetrack* (L184, Weil Enterprises and Investments Ltd., Montgomery) but was subsequently overpainted; such a figure was possibly also intended for *The Racecourse, Amateur Jockeys* (cat. no. 157), the large work painted for Faure, which may explain the necessity for this study, datable on the basis of the costume c. 1875–76.[4]

The existence of several versions of the figure and the artist's failure to use them in a painting inevitably raises questions. As the figure is unquestionably powerful—so powerful as to become emblematic of the very act of looking—it can be imagined that it defeated any attempt at successful integration within the broader context of a composition.

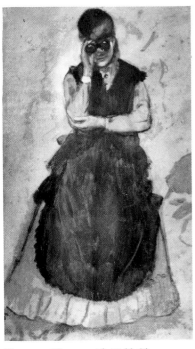

Fig. 131. *Woman with Field Glasses* (L268), c. 1865? Pencil and essence on paper mounted on canvas, 12⅜ × 7⅛ in. (31.4 × 18 cm) (paper). The Burrell Collection, Glasgow

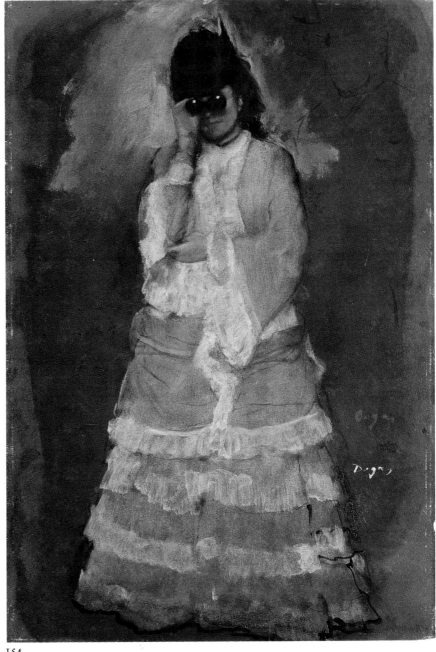

154

Isolated, standing by herself, the woman remains mysterious and not a little perverse as she reverses the common relationship between viewer and viewed.

It is interesting that all three sketches for *Woman with Field Glasses* were known in Degas's lifetime and enjoyed a certain reputation. The Burrell version was contributed by Degas to the Duranty sale of 1881, at which time, according to Ronald Pickvance, it may have been inscribed by the artist.[5] The version in Switzerland, said by Lemoisne to have belonged to Puvis de Chavannes, was certainly owned by A. Duhamel and, briefly, by Egisto Fabbri before becoming the private property of Joseph Durand-Ruel. The painting now in Dresden was given by Degas to James Tissot (see cat. no. 75), who eventually sold it to Paul Durand-Ruel, to the artist's great irritation.

1. William Wells, "Who Was Degas's Lyda?" *Apollo*, XCV:120, February 1972, p. 130.
2. Lemoisne 1912, p. 69.
3. 1987 Manchester, p. 69. For the drawing of the dancer, see IV:251.
4. An identical dress is worn by a figure in Eugène Giraud's *Le jardin de la marraine* of 1876. See also François Boucher, *Histoire du costume en Occident, de l'antiquité à nos jours*, Paris, 1965, fig. 1047 p. 393.
5. See 1979 Edinburgh, no. 2.

PROVENANCE: Given by the artist to James Tissot; bought by Durand-Ruel, Paris, 11 January 1897, for Fr 1,500 (stock no. 4012); bought by H. Paulus, 11 November 1897, for Fr 6,000. Woldemar von Seidlitz, Dresden, by 1907; bought by the museum 1922.

EXHIBITIONS: 1897, Dresden, May–June, *Internationalen Kunst-Austellung*, no. 122 (for sale); 1907, Dresden, *Moderne Kunstwerke aus Privatbesitz*, no. 16; 1964–65 Munich, no. 83.

SELECTED REFERENCES: Ernst Michalski, "Die neuerwerbungen der modernen Abteilung der Dresdner Gemäldegalerie," *Kunst und Künstler*, XXIII, 1924–25, p. 276, repr. p. 277; *Gemäldegalerie Neue Meister* (edited by Hans Joachim Neidhardt), 2nd edition, Dresden, 1966, p. 39, pl. 46; *Gemäldegalerie Neue Meister* (edited by Christa Freier), 4th edition, Dresden, 1975, p. 29, pl. 78; Lemoisne [1946–49], II, no. 431; 1967 Saint Louis, under no. 55; William Wells, "Who Was Degas's Lyda?" *Apollo*, XCV:120, February 1972, p. 130, pl. II (color); Minervino 1974, no. 425; 1979 Edinburgh, under no. 2.

155.

At the Races

c. 1876–77
Oil on canvas
19 × 24 in. (48.3 × 61 cm)
Signed lower left: Degas
Collection of Mr. and Mrs. Eugene Victor
 Thaw, New York

Exhibited in Ottawa and New York

Lemoisne 495

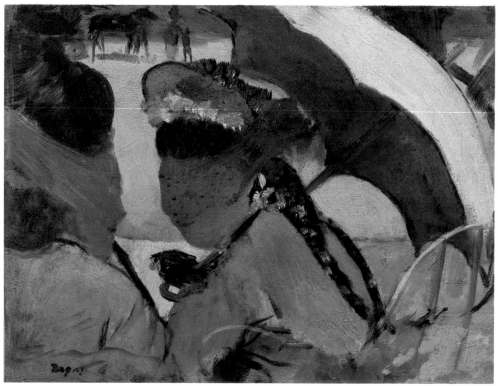

155

Although this small painting is assumed to represent a scene at the races, its focus, in fact, is on two spectators, chatting and unconcerned about the track. The artist's immediate, apparent concern is a formal one, expressed in the shapes of the headgear worn by the two women and the outlandish transformations it performs on them. The figure at the center has a coquettish hat terminating at the back in two speckled black ribbons, and her face is covered with a veil that successfully removes any suggestion of a physiognomy. The woman at the left, no less veiled, remains equally inaccessible, despite the hint of a profile. The wonderful white-and-green parasol, which figures also at the center of *At the Seashore* (L406, National Gallery, London), might appear under the circumstances to be a needless precaution. This is evidently not the case, to the advantage of the composition, which becomes toward the right a sequence of ever expanding curved segments.

Ronald Pickvance has connected the painting with monotypes by Degas in which the artist evokes the same half-whimsical mood. To these one may add the large, vigorous essence drawing on canvas of a woman with an umbrella (L414) in the Courtauld Institute, London, which may have provided the prototype for the central figure in this work. *At the Races* was given by Degas to his friend Marie Dihau, sister of the musician Désiré Dihau. It was dated c. 1878 by Lemoisne, but may date from slightly earlier, c. 1876–77.

PROVENANCE: Gift from the artist to Marie Dihau; bought by Durand-Ruel, Paris, 19 July 1922 (stock no. 12051); transferred to Durand-Ruel, New York, 1 December 1922 (stock no. 4764); bought by Étienne Bignou, in partnership with Alex. Reid and Lefevre Ltd., London, 12 February 1928. E. J. Van Wisselingh and Co., Amsterdam, 1931. (?) Marcel Guérin, Paris, 1931. Mr. and Mrs. Paul Mellon, Upperville, Va., by 1966; present owners.

EXHIBITIONS: 1928, New York, Durand-Ruel Galleries, 31 January–18 February, *Paintings and Pastels by Edgar Degas, 1834–1917*, no. 6; 1928, Glasgow/London, Alex. Reid and Lefevre Ltd., June, *Works by Degas*, no. 14; 1931, Amsterdam, E. J. Van Wisselingh and Co., 9 April–9 May, *La peinture française aux XIXe et XXe siècles*, no. 31; 1966, Washington, D.C, National Gallery of Art, 17 March–1 May, *French Paintings from the Collections of Mr. and Mrs. Paul Mellon*

and Mrs. Mellon Bruce, no. 49, repr.; 1974 Boston, no. 17 (as c. 1878); 1979 Edinburgh, no. 63, repr.; 1983 London, no. 13, repr. (color).

SELECTED REFERENCES: Lemoisne 1931, p. 289, fig. 57; Lemoisne [1946–49], II, no. 495; Cabanne 1957, p. 117, pl. 103 (as c. 1878); Rewald 1973, p. 429, repr. (color); Minervino 1974, no. 446; Lipton 1986, pp. 65–66, fig. 37.

156.

Two Studies of a Groom

c. 1875–77 ?
Essence heightened with gouache on tan paper,
 laid down, prepared with oil
9⅝ × 13½ in. (24.5 × 34.3 cm)
Vente stamp lower left
Cabinet des Dessins, Musée du Louvre (Orsay),
 Paris (RF5601)

Exhibited in Paris

Lemoisne 382

Degas's early studies of jockeys present a problem of dating and sequence that has been addressed, in part, by Ronald Pickvance.[1] It has been generally assumed that they cover a period from the mid-1860s to as late as 1878, and their chronology has been largely justified by the known or assumed date of paintings for which they may have served as studies. The various studies can be roughly divided into three groups: those appearing in Degas's notebooks; sheets

with individual pencil studies of jockeys; and the famous essence-and-gouache drawings, one of which, *Four Studies of a Jockey*, is included in this exhibition (cat. no. 70). The relevant notebook—no. 22 in Theodore Reff's catalogue—was dated c. 1867–74 by Reff.[2] The group of pencil studies of jockeys has for some time been dated c. 1878, though more recently Pickvance, who originally subscribed to a date in the 1870s, redated the studies 1866–68.[3] The essence-and-gouache studies have also been thought by Lemoisne to date from about 1866–72, a fairly broad range narrowed down by Pickvance to 1866–68.[4]

The interesting aspect of the question lies in the relationship between the various types of studies, a relationship that extends beyond the implications of their assumed near-contemporaneity. For instance, the groom on horseback on page 121 of Notebook 22 is certainly the first draft of the carefully drawn study of a jockey (IV:260.a) now in a New York private collection. Yet another sketch, on page 86 of the notebook, along with two studies of the same jockey on sheets that may have been detached from the notebook (IV:240.c, IV:240.e), led to an essence drawing showing the jockey reversed (L153). A pencil drawing of a jockey, his right hand on his hip, not included in the Degas atelier sales, is closely related to two of the three essence studies appearing on another sheet (fig. 86) and used as prototypes for the Boston *Racehorses at Longchamp* (cat.

no. 96). The unavoidable impression is that of a progressive development toward the brilliant essence-and-gouache studies, and that the latter indeed represented what Richard Brettell termed a "visual grammar of the horse race,"[5] as if by an Eadweard Muybridge in advance of his time.

This unusually spirited study on oiled paper formed part of a group with two other drawings of grooms on horseback.[6] Because of its relationship with the jockey and horse appearing at the far left of *Racehorses* (cat. no. 158) and the Orsay *Racecourse, Amateur Jockeys* (cat. no. 157), it has traditionally been assumed to be a preparatory study and, hence, to date (along with the other two drawings) from about 1875–78. As in the instances cited above, this study is related to a pencil drawing of a jockey (fig. 132) which did, in fact, serve for the paintings and was also dated c. 1878 until Pickvance ascribed it, with its counterparts, to a decade earlier, 1866–68.[7] Degas observed in a letter to Jean-Baptiste Faure in June 1876 that he would have to go to the races to refresh his memory before he could finish *The Racecourse*, and it might be claimed that his ink-and-gouache studies of jockeys were the result of a visit to the racetrack. This seems unlikely, as they appear conceived in the studio and were grouped on two of the three sheets with considerable concern for the overall appearance of the sheet, in a manner similar to the gouache studies of jockeys of the late 1860s.

Grooms do not figure frequently in Degas's drawings, but to those already mentioned above one may add a sketch on page 121 of Notebook 22. In this sheet from the Louvre, the figure on the left, riding a horse at full tilt, is peculiarly effective and the striking contrast between the dark rider and the white horse, as noted by Jean Sutherland Boggs, adds to the power of the image.[8] Variations on the theme of the rider atop a horse at full gallop occur in a gouache study of a jockey (L152) and in a small ink drawing in the Mellon collection.[9]

1. 1979 Edinburgh, under nos. 6, 7.
2. Reff 1985, Notebook 22 (BN, Carnet 8, passim).
3. 1968 New York, nos. 37–39; 1979 Edinburgh, no. 7.
4. 1979 Edinburgh, no. 6.
5. 1984 Chicago, no. 17, p. 49.
6. One drawing (L383) is in a private collection in Zurich; the other (L383 bis) is in the Sterling and Francine Clark Art Institute, Williamstown, Mass.
7. See Theodore Reff, "Works by Degas in the Detroit Institute of Arts," *Bulletin of the Detroit Institute of Arts*, LIII:1, 1974, p. 36, no. 13, repr.
8. 1967 Saint Louis, no. 77.
9. The Mellon drawing belongs with two other drawings of the same size, not included in the Degas atelier sales and reproduced by M. L. Bataille in "Zeichnungen aus dem Nachlass von Degas," *Kunst und Künstler*, XXVIII, July 1930, pp. 400–01.

PROVENANCE: Atelier Degas (Vente III, 1919, no. 153.2, in the same lot with no. 153.1 [cat. no. 69], for Fr 3,300); bought by Marcel Bing; his bequest to the museum 1922.

EXHIBITIONS: 1924 Paris, no. 92; 1931, Bucharest, Muzeul Toma Stelian, 8 November–15 December, *Desenul francez*, no. 103; 1964 Paris, no. 73; 1967 Saint Louis, no. 77, repr. text and cover (shown in Saint Louis only); 1969 Paris, no. 171.

SELECTED REFERENCES: Lafond 1918–19, I, p. 44; Rivière 1922–23, II, pl. 16 (reprint edition 1973, pl. 29); Jamot 1924, pl. 30; Rouart 1945, pp. 16, 71 n. 38; Lemoisne [1946–49], II, no. 382; Leymarie 1947, no. 13, pl. XIII; Cooper 1952, no. 3, repr.; Minervino 1974, no. 404.

Fig. 132. *Study of a Jockey* (III:128.1), 1866–68. Pencil, 12¾ × 9⅝ in. (32.4 × 24.5 cm). The Detroit Institute of Arts

156

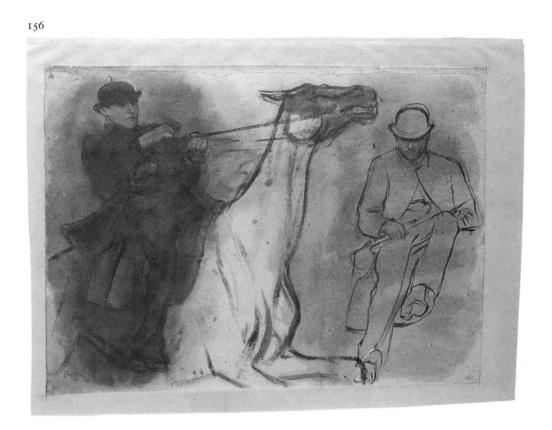

157.

The Racecourse, Amateur Jockeys

Begun 1876, completed 1887
Oil on canvas
26 × 31⅞ in. (66 × 81 cm)
Signed lower right: Degas
Musée d'Orsay, Paris (RF1900)

Exhibited in Paris

Lemoisne 461

This picture formed part of the group of five works that Degas undertook to paint for Jean-Baptiste Faure in 1874.[1] It proved the most difficult, requiring repeated alterations, and took over thirteen years to complete. The painfully long genesis of the painting can be traced, in part, through Degas's correspondence with the singer, even though at least one of the letters is somewhat uncertainly dated.

The earliest reference to the work, suggesting perhaps that it was not yet begun, occurs in an undated letter from Degas to Faure apparently written in June 1876, before the artist's failure to deliver the painting began to seriously affect the tone of the correspondence: "I received your friendly notice and am going to start right away on your *Courses* [The Racecourse]. Will you come here toward the end of next week to see how it is progressing? The unfortunate thing is that I shall have to go and see some real racing again, and I do not know if there will be any after the Grand Prix. . . . In any case you will be able to see something of your own next Saturday, 24 June, between 3 and 6 o'clock."[2]

Another letter to Faure, presumably written a few months later, indicates that the picture was in a very advanced state.[3] Although the second version of *The Ballet from "Robert le Diable"* (cat. no. 159) was almost certainly delivered in 1876, *The Racecourse* was evidently not finished, as shown by a letter of 31 October 1877 in which the artist promised again to complete the work within five days: "You will have *Les courses* on Monday. I have been at it for two days and it is going better than I thought."[4]

Nine years later the painting was no nearer completion, and the understandably angry Faure was not disposed to give it up. In a letter postmarked 2 July 1886, Degas asked for another delay: "I shall need a few more days to finish your big picture of the races. I have taken it up again and I am working on it. . . . A few days more and you will have it."[5]

The final known document, a letter from the artist dated 2 January 1887 in reply to a telegram from Faure, is yet another exhausted appeal for patience, but without promises

for an early delivery.[6] According to Guérin, following a lawsuit—or perhaps the threat of legal action—Degas surrendered the painting to Faure in 1887 along with one or perhaps two other works.[7] However, Faure did not retain the painting for long. Six years later, in 1893, he sold it to Durand-Ruel with four other works by Degas.

X-radiographs of *The Racecourse* confirm that the painting was reworked in several stages that marked the transition from a relatively symmetrical composition with a strong center to an emphatically asymmetrical one. Originally, a railing parallel to the picture plane ran across the foreground. Two figures (faintly legible in the radiograph) leaned on the railing or stood in front of it at the center of the picture in an arrangement reminiscent of that in the equally altered *At the Racetrack* (L184, Weil Enterprises and Investments Ltd., Montgomery). The figure to the left had a skirt, and may have been a woman with field glasses such as the one appearing in the Dresden painting of the subject (cat. no. 154). The carriage now at the right was introduced after the railing and the two figures were eliminated. In an earlier form of the composition, the carriage was slightly farther to the right; the hood was raised at a higher angle, and the rear background wheel showed entirely. After the repositioning of the carriage, however, the wheels were modified twice before the figure entering from the right was finally added. The mounted jockey immediately behind the carriage was at first identical to the jockey in pink and black in the related *Racehorses* (cat. no. 158) and to the one at the far right in *Racehorses at Longchamp* (cat. no. 96). However, in the final reworking the horse was turned to the left, thus covering the previously visible lower part of the adjoining jockey in red, and the rider was given a new pose adapted from an earlier drawing (fig. 133).

If, on the basis of the letters, it can be established that Degas worked on the composition in 1876, the fall of 1877, the summer of 1886, and, presumably, sometime after January 1887, it is difficult to establish the dates when the major alterations took place. The few related drawings add little light, proving only that Degas frequently relied on earlier studies. The horse at the center is unmistakably based on a much used drawing (IV:237.b) dating probably from the mid-1860s. The flying horse with rider to the left has no exact precedent but is in the last analysis derived from studies for *The Steeplechase* (fig. 67) and a related but less stretched-out horse in *The False Start* (fig. 69). Jean Sutherland Boggs has indicated (in private communication) that the landscape background is singularly evocative of the village of Exmes and could be loosely connected to

drawings in a notebook.[8] In quite a different vein, Siegfried Wichmann has pointed out the connection between the truncated wheels of the carriage in the painting and a related design in a Hiroshige woodcut.[9]

As it stands, the composition is among the most monumental—and original—racecourse scenes Degas ever conceived, with order and whimsy fused in almost perfect unison. Though set in the country, this is not a leisurely day at the races of the sort depicted in *At the Races in the Countryside* (cat. no. 95) but a full-scale event, with a wall of spectators somewhat incongruously assembled on the outskirts of a village where fields and trains coexist with an opti-

Fig. 133. *Study of a Jockey* (IV:274.2), 1866–68. Pencil, 12⅝ × 9½ in. (32 × 24 cm). Location unknown

mism characteristic of the machine age. The speeding jockey at the left, wittily echoing the movement of the train, counteracts the stately frieze of jockeys at the right, who, upon closer examination, reveal less than classical profiles and ears. And the spectators in the right foreground, reduced to an amusing meeting of hats, are drifters from a different, urban world, Degas's *modistes* of the early 1880s.

1. For the entire question of Faure's commissions, see "Degas and Faure," p. 221.
2. Lettres Degas 1945, XCV, p. 122; Degas Letters 1947, no. 104, p. 120 (translation revised). Dated by Degas only "Jeudi matin" (Thursday morning), the letter was given the date of 16 June 1886 by Marcel Guérin. As 16 June 1886 was a Wednesday, not a Thursday, Guérin probably made an error in

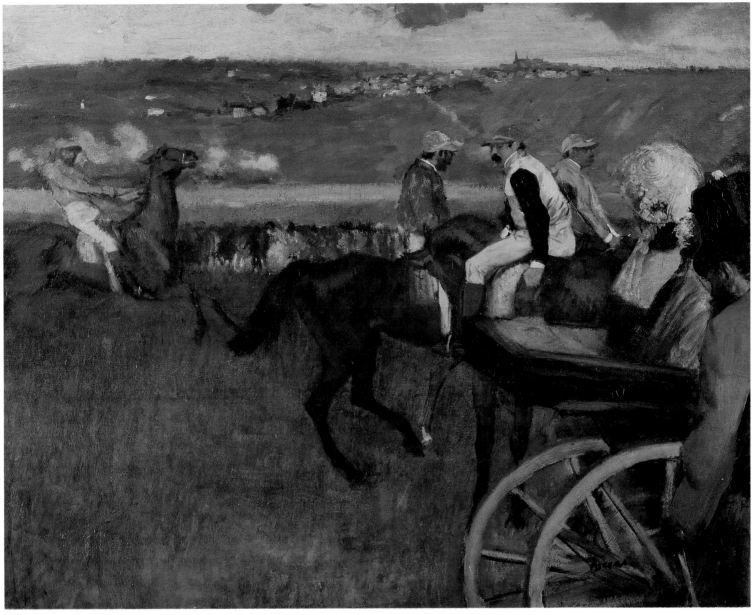

157

transcription. The one clue in the letter leading to a possible dating is Degas's own mention of "Samedi, 24 Juin" (Saturday, 24 June), which could have occurred in the relevant years only in 1876 and 1882 (in 1886, June 24 was a Thursday). The amiable tone of the letter suggests June 1876 as a likelier date than June 1882.

3. Lettres Degas 1945, XI, p. 39; Degas Letters 1947, no. 19, p. 45; dated 1876 by Marcel Guérin.

4. Lettres Degas 1945, XIII, pp. 40–41; Degas Letters 1947, no. 21, p. 46.

5. Lettres Degas 1945, XCVI, pp. 122–23; Degas Letters 1947, no. 105, p. 120 (translation revised).

6. Lettres Degas 1945, XCVII, pp. 123–24; Degas Letters 1947, no. 107, p. 121.

7. Lettres Degas 1945, V, pp. 31–32 n. 1; Degas Letters 1947, no. 10, p. 36 n. 2, and "Annotations," p. 261.

8. Reff 1985, Notebook 18 (BN, Carnet 1, p. 173).

9. Siegfried Wichmann, *Japonisme*, New York: Park Lane, 1985, pp. 249–50, fig. 661.

PROVENANCE: Commissioned from the artist by Jean-Baptiste Faure 1874; delivered to Faure 1887; bought by Durand-Ruel, Paris, 2 January 1893, for Fr 10,000 (stock no. 2567); bought by Comte Isaac de Camondo, Paris, 20 April 1893, for Fr 27,000; his bequest to the Louvre 1908; entered the Louvre 1911.

EXHIBITIONS: 1924 Paris, no. 63; 1926, Maison-Laffitte, Château de Maison-Laffitte, 20 June–25 July, *Les courses en France*; 1937 Paris, Orangerie, no. 27; 1951, Albi, Palais de la Berbie, *Toulouse-Lautrec, ses amis, ses maîtres*; 1951–52 Bern, no. 25; 1952 Amsterdam, no. 15; 1952 Edinburgh, no. 10; 1956, Warsaw, Muzeum Narodowe, 15 June–31 July, *Malarstwo Francuskie od Davida do Cézanne'a*, no. 35, repr.; 1956, Moscow/Leningrad, *French Painting from David to Cézanne*, no. 34, repr.; 1957, Paris, Musée du Louvre, Salle d'Auguste, Reception for the Queen of England at the Musée du Louvre (no catalogue); 1969 Paris, no. 29.

SELECTED REFERENCES: Frederick Wedmore, "Manet, Degas, and Renoir: Impressionist Figure-Painters," *Brush and Pencil*, XV:5, May 1905, repr. p. 259; Alexandre 1908, p. 32; Paul Gauguin, "Degas," *Kunst und Künstler*, X, 1912, repr. p. 334; Lafond 1918–19, II, p. 44, repr.; Paris, Louvre, Camondo, 1914, no. 166; Meier-Graefe 1920, pl. XXXIV; Jamot 1924, pl. 53; Rouart 1937, repr. p. 19; Lemoisne [1946–49], II, no. 461; Cabanne 1957, pp. 28–29, 117, pl. 104; Minervino 1974, no. 460, pl. XLV (color); Lipton 1986, pp. 19, 23, 26, 45–46, 62–63, fig. 15 pp. 24, 47; Sutton 1986, p. 120, fig. 131 (color) p. 156, fig. 133 (detail, color) p. 157; Paris, Louvre and Orsay, Peintures, 1986, III, p. 194.

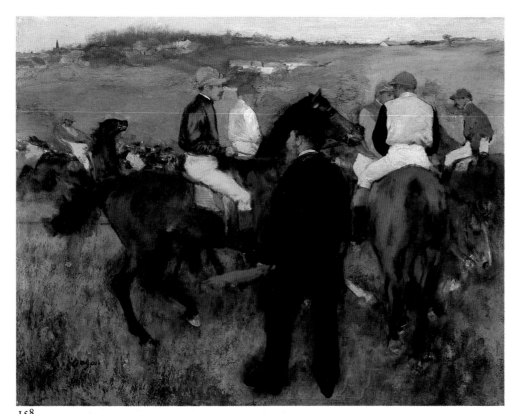

158

Fig. 134. *Patriarch Joseph of Constantinople and His Attendants*, detail after Benozzo Gozzoli, *The Journey of the Magi* (IV:91.b), dated 1860. Pencil, 10 × 12¾ in. (25.5 × 32.6 cm). Rijksmuseum, Amsterdam

158.

Racehorses

1875–78
Oil on panel
12⅝ × 15⅞ in. (32.5 × 40.4 cm)
Signed lower left: Degas
Private collection

Lemoisne 387

The numerous elements shared by this painting with the large canvas in the Musée d'Orsay (cat. no. 157) strongly imply a relationship beyond the merely casual, repeated exploration of motifs characteristic of the work of Degas. In a recent, detailed examination of *Racehorses*, Richard Thomson has discussed its friezelike conception in the context of Degas's study of Benozzo Gozzoli's fresco in the Palazzo Medici-Riccardi in Florence.[1] Indeed, one of the artist's copies, now in Amsterdam (fig. 134), has a particular relevance to the question: the scheme of its composition, with horsemen seen in profile and from the rear, is reminiscent of the solution adopted by Degas in *Racehorses* and in the Orsay painting. Both works are variations on a theme, with differently positioned but identical components—a leaping horse at the left, a principal horseman in profile, and jockeys seen from behind at the right. As might be expected, the same earlier drawings were used for both paintings, and

the horse appearing at the far right figures also in the Boston *Racehorses at Longchamp* (cat. no. 96).

Thomson's discussion includes the interesting discovery that *Racehorses* was substantially altered by the painter and that originally it had included a horse and jockey seen from behind at the center of the composition, as well as a fence to the left, which is still partly visible. Thomson concluded that the original work may have dated from the late 1860s but that it was transformed in the mid-1870s when Degas painted out the fence, replaced the central jockey and horse with the steward holding a flag, and added the jockeys on horseback at the far right.

The alterations noted by Thomson are similar to those that affected the Orsay painting. From the sequence of transformations in each painting, it would appear that *Racehorses* may have been altered first and that it served, if not as a sketch or a model, at least as a testing ground for the larger composition at Orsay. That this was the actual sequence is suggested by the pink-and-black mounted jockey to the right, apparently invented for *Racehorses* and then adopted also in the Orsay painting before its ultimate transformation.

After two failed experiments with racetrack scenes having a strong focus at the center, *Racehorses* was Degas's only composition of this type to leave his studio in this

form.[2] A later, vastly simplified reenactment of the design in a small oil painting on panel (L852, private collection, California) has an entirely different asymmetrical accent that nevertheless reveals its origins.[3]

1. 1987 Manchester, p. 99.
2. For another composition with figures in the center foreground, see *At the Racetrack* (L184, Weil Enterprises and Investments Ltd., Montgomery), discussed by Ronald Pickvance in 1979 Edinburgh, no. 10.
3. See Lemoisne [1946–49], III, no. 852, where it is wrongly identified as a pastel.

PROVENANCE: Bought from the artist by Durand-Ruel, Paris, 16 October 1891, for Fr 5,000 (stock no. 1865, as "Course de Gentlemen"); deposited with Heilbuth, Hamburg, 28 October 1891; returned 13 November 1891; deposited with Behrens, Hamburg, 22 February 1892; returned 29 February 1892; bought by Durand-Ruel, New York, 14 June 1892, for Fr 5,500; (?) bought by Lawrence, New York; (?) bought back from Lawrence, New York, by Durand-Ruel, New York, 8 February 1901 (stock no. 2494); transferred to Durand-Ruel, Paris, 2 February 1910 (stock no. 9237); deposited with Cassirer, Berlin, 30 September 1911. Edouard Arnhold, Berlin. Bührle collection, Zurich, 1958. Present owner.

EXHIBITIONS: (?) 1913, Berlin, Galerie Paul Cassirer, November, *Degas/Cézanne*, no. 23; 1976–77 Tokyo, no. 14 bis, repr. (color); 1978 New York, no. 12, repr. (color); 1987 Manchester, no. 50, repr. (color).

SELECTED REFERENCES: Moore 1907–08, repr. p. 140; Grappe 1911, p. 17; Gabriel Mourey, "Edgar Degas," *The Studio*, LXXIII:302, May 1918, repr. p. 129 (as 1875); Meier-Graefe 1920, pl. xii (as c. 1872); Walker 1933, p. 181, fig. 17 p. 183; Rivière 1935, repr. p. 139

(as 1872); Lemoisne [1946–49], II, no. 387 (as 1875–78); *Dr. Fritz Nathan and Dr. Peter Nathan, 1922–1972*, Zurich: Dr. Peter Nathan, 1972, no. 79, repr. (color); Minervino 1974, no. 434; Dunlop 1979, fig. 107 (color) p. 119 (as "Before the Start," c. 1875); Nicolaas Teeuwisse, *Vom Salon zur Secession*, Berlin: Deutscher Verlag für Kunstwissenschaft, 1986, pp. 223 (as bought by Arnhold in 1909), 306 n. 537 (with location unknown).

159.

The Ballet from "Robert le Diable"

1876
Oil on canvas
29¾ × 32 in. (76.6 × 81.3 cm)
Signed lower left: Degas
Trustees of the Victoria and Albert Museum, London (CAI. 19)

Lemoisne 391

In a letter to James Tissot in the summer of 1872, Degas wrote, in considerable anguish: "Certain parts of my *Orchestre* are not done well enough. At my urgent request Durand-Ruel promised not to send it [to London], and he deceived me."[1] The object of Degas's misgivings can easily be identified as the first version of *The Ballet from "Robert le Diable"* (cat. no. 103), which he sold to Durand-Ruel in January 1872 and which was subsequently sent to London for exhibition and possible sale.[2] The unsold painting remained a source of irritation to Degas until early March 1874, when Jean-Baptiste Faure made it possible for him to recover it along with five other works.[3] From the evidence available, he did not rework it, doubtless because in asking for a new version Faure gave him the opportunity to revise the composition altogether. Of all the paintings returned to Degas in early 1874, *Robert le Diable* can safely be said to have been nearest to Faure's personal interests, depicting, as it did, the most famous scene from an opera by Giacomo Meyerbeer, Faure's mentor and friend. It may be that Faure was ready to buy the first version—which, eventually, he also purchased in 1887—but that Degas refused to sell it for the reasons outlined to Tissot.

The second version of *Robert le Diable* was probably commissioned shortly before or during March 1874, when Degas and Faure discussed the return of his pictures from Durand-Ruel. Two years later, in 1876, when questioned by Faure (who had just returned to France) about the state of his commissions, Degas wrote to him, promising, "I am going to send *Robert le Diable* to you on Saturday and *Les courses* on Tuesday."[4] As no further reference to *Robert le Diable* appears in the subsequent correspondence between Degas and Faure, it has been reasonably concluded that unlike *The Racecourse, Amateur Jockeys* (cat. no. 157) mentioned in the letter, *Robert le Diable* was actually finished and delivered in 1876.

For the first version of *Robert le Diable*, Degas had chosen a vertical format rigidly divided into three parallel sections: the back of a row of seats, the spectators and the orchestra, and, finally, the stage. In the second version, Degas turned to a horizontal format, closer to the actual shape of the stage, and changed the lower part of the design by largely eliminating the seats in the foreground and placing the spectators and orchestra at an angle. The perception of the scene was thus substantially altered, with a

159

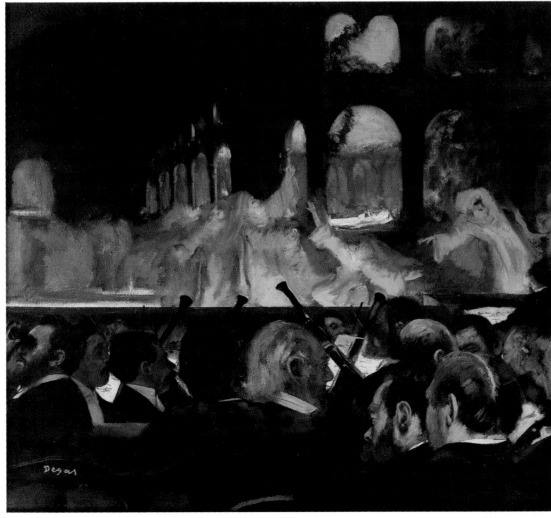

Fig. 135. Adolf Menzel, frontispiece for Heinrich von Kleist, *Der Zerbrochene Krug* (Berlin: A. Hofmann & Co., 1877). Wood engraving

new, emphatic suggestion that the viewer was part of the audience.

The foreground of the second *Robert le Diable* is unquestionably more finished, and there are subtle amendments throughout the picture. The ballet of the demonic nuns, based on the same drawings used for the first version, has been slightly spread out in a scene that is both more ghostly and more animated; Degas had obviously consulted notes he had made after the completion of the first version of the painting.[5] The figures in the foreground, larger than in the first version and containing several new faces, have been partly changed. The musician Désiré Dihau, third from the left, has retained his original position along with the figure immediately behind him, but Albert Hecht, with binoculars, has been moved to the far left, where he looks straight out of the picture, and Ludovic Lepic, not included in the first version, has been added as the bearded figure in profile, second from the right.

It has been argued by Margaretta Salinger that the conception of the first version of *Robert le Diable*, and by extension also the second, may have been influenced by Adolf Menzel's *At the Gymnase Theater* (Nationalgalerie, Berlin), painted in Paris in 1856–57.[6] In spite of Degas's documented admiration for Menzel, this does not appear to have been the case. An equally circumstantial argument could be made in connection with an en-

graved illustration by Menzel for Heinrich von Kleist's *Der zerbrochene Krug* (The Broken Pitcher), published in 1877 (fig. 135), which appears related to the bottom section of *Robert le Diable* of 1871. Jonathan Mayne has pointed out that the second version of the painting is the last in a series of works including *The Orchestra of the Opéra* (cat. no. 97) and *Orchestra Musicians* (cat. no. 98) in which Degas successively refined essentially the same formula.[7] To this series one might add *Ballet at the Paris Opéra* (L513, The Art Institute of Chicago), an example of the height of Degas's achievements in this genre.

1. Degas Letters 1947, no. 8, pp. 34–35 (translation revised). Letter dated "1873?" by Marguerite Kay, but datable to early summer 1872, when *Robert le Diable* was exhibited in Durand-Ruel's London branch at 168 New Bond Street.
2. See *brouillard*, Durand-Ruel archives, Paris. See also cat. no. 103.
3. See "Degas and Faure," p. 221.
4. Lettres Degas 1945, XI, p. 39; Degas Letters 1947, no. 19, p. 45.
5. For related drawings, see cat. nos. 104, 105. See also Reff 1985, Notebook 24 (BN, Carnet 2, pp. 9, 20, 21). Degas notes on p. 20, "at the apex of the arches the moonlight touches the columns very slightly—on the ground, the effect to be warmer and rosier than I had made it . . . the trees grayer . . . "; and on p. 21, "the nuns' figures more the color of flannel, but more blurred; in the foreground the arcades [illegible word] grayer and more blended in" On the significance of these notes, see also the differing views of Henri Loyrette (cat. no. 103), who links them to Degas's preparatory work for the first version of the painting.
6. New York, Metropolitan 1967, p. 67. For Menzel's illustration, see *Adolf von Menzel, das graphische Werk* (edited by Heidi Ebertshäuser), I, Munich: Rogner und Bernhard, 1976, pl. 681.
7. Mayne 1966, pp. 150–52.

PROVENANCE: Commissioned by Jean-Baptiste Faure 1874; delivered to Faure 1876; deposited with Durand-Ruel, Paris, 17 February 1881 (deposit no. 3057); bought by Durand-Ruel, Paris, 28 February 1881, for Fr 3,000 (stock no. 871); bought by Constantine Alexander Ionides, London, 7 June 1881, for Fr 6,000; his bequest to the museum 1900.

EXHIBITIONS: (?) 1876 Paris, no. 53 (as "Orchestre"); 1898, London, Guildhall, Corporation of London Art Gallery, 4 June–July, *Pictures by Painters of the French School*, no. 152.

SELECTED REFERENCES: Cosmo Monkhouse, "The Constantine Ionides Collection," *Magazine of Art*, VII, 1884, pp. 126–27, repr. p. 121; Moore 1890, p. 421, repr.; "The Constantine Ionides Collection," *Art Journal*, 1904, p. 286, repr.; Sir Charles J. Holmes, "The Constantine Ionides Bequest: Article II— Ingres, Delacroix, Daumier and Degas," *Burlington Magazine*, V, 1904, p. 530, pl. III; Richard Muther, *The History of Modern Painting*, revised edition, London: Dent/New York: Dutton, 1907, III, repr. (color) facing p. 118; Hourticq 1912, p. 99, repr.; Degas Letters 1947, no. 10, p. 36 n. 2, "Annotations," p. 261, and letter no. 19, p. 45 n. 1; Lettres Degas 1945, pp. 31–32 n. 1; no. XI, 39 n. 2; Lemoisne [1946–49], II, no. 391; Browse [1949], no. 9; Cooper 1954, pp. 60, 67; Pickvance 1963, p. 266; Rosine Raoul, "Letter from New York: Exhibitions on a Theme," *Apollo*, LXXVII:11, January 1963, p. 62 (reproducing a copy by Everett Shinn); Mayne 1966, pp. 148–56,

fig. 1; Browse 1967, p. 105, pl. 2; *Catalogue of Foreign Paintings, II, 1800–1900* (by Claus Michael Kauffmann), London: Victoria and Albert Museum, 1973, pp. 24–25, no. 58, repr. text and cover; Minervino 1974, no. 487, pl. XL (color); Reff 1985, p. 9, Notebook 24 (BN, Carnet 22, pp. 7, 9, 10, 11, 13, 15, 16–17, 19, 20, 21); Sutton 1986, p. 120, fig. 139 (color) p. 163.

160.

The Chorus

1876–77
Pastel over monotype on laid paper
10⅝ × 12¼ in. (27 × 31 cm)
Signed lower left: Degas
Musée d'Orsay, Paris (RF12259)

Exhibited in Paris

Lemoisne 420

In a conversation with Daniel Halévy, Degas identified the subject of this pastel as a scene from the opera *Don Giovanni*.[1] It was his only scene from an opera that did not include dancers, and it may be recognized as the finale of the chorus occurring in the first act in celebration of the engagement of Masetto and Zerlina. For want of a suitable baritone, *Don Giovanni* was not performed very often in Paris until the season of 1866. Then it was revived simultaneously at the Opéra and the Théâtre-Lyrique, becoming for Jean-Baptiste Faure, in the title part, one of his greatest triumphs. It was frequently performed afterward, and it might be noted that Ludovic Halévy's "Monsieur Cardinal," which Degas illustrated about the time this work was executed, takes place backstage during a performance of *Don Giovanni*.

Fig. 136. Honoré Daumier, *Crispin and Scapin*, also called *Scapin and Silvestre*, c. 1860. Oil on canvas, 24¼ × 32⅜ in. (60.5 × 82 cm). Musée d'Orsay, Paris

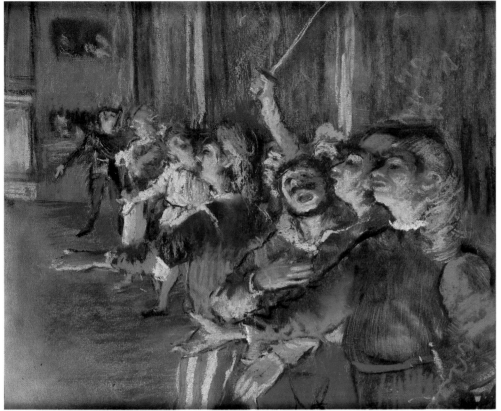

160

SELECTED REFERENCES: Chevalier 1877, p. 332; Jacques 1877, p. 2; Pothey 1877, p. 2; Paris, Luxembourg, 1894, p. 105, no. 1027; Bénédite 1894, p. 132; Grappe 1911, p. 51, repr.; Lafond 1918–19, I, repr. p. 51; Jamot 1924, p. 92; Lemoisne [1946–49], II, no. 420; Leymarie 1947, no. 32, repr.; Cabanne 1957, pp. 42–43; Janis 1968, no. 54, repr.; Minervino 1974, no. 416; Keyser 1981, pp. 41, 105, pl. xii (color); Paris, Louvre and Orsay, Pastels, 1985, no. 66.

161.

Dancer Onstage with a Bouquet

c. 1876
Pastel over monotype on laid paper
10⅝ × 14⅞ in. (27 × 38 cm)
Signed in pink pastel upper left: Degas
Private collection

Lemoisne 515

An examination of Degas's ingenious use of monotype as a base for pastels reveals that these works, more frequently than is generally assumed, underwent a remarkable series of metamorphoses. This enchanting composition, for example, began with a monotype. After having pulled one impression, however, Degas reworked the plate, touching up the dancer, changing the angle of her right arm, and adding a series of dancers in the background. He thus obtained a second, rather different monotype. He then produced a counterproof from the second monotype by facing it with a damp sheet of paper and running it through the press. In the end, all three impressions were used. The first one, exhibited here, was lightly touched up with pastel. The second impression, identified by Deborah Johnson, was enlarged with the addition of a strip of paper and reworked completely with pastel. The result was *The Ballet* (fig. 137).[1] The counterproof (L515 bis), also slightly touched up with color, was tentatively if erroneously connected with the first impression.[2]

In *Dancer Onstage with a Bouquet*, the monotype was created by wiping away the light areas—notably the dancer's skirt and bouquet—and giving texture and direction to the remaining surface. Pastel was applied sparingly in the background, allowing the monotype base to show through, and in the skirt and bouquet the white paper (now darkened) was used to simulate the glow of light, an effect now lost. The dancer's head, torso, and arms were carefully worked up in pastel to convey with maximum intensity the reflection of the footlights that brilliantly model her frame.

Degas himself used ballet scenes from the opera as the subject of several works.[2]

When shown in 1877 in the exhibition that marked Degas's emergence as the most fiercely realist of artists, the true—even picturesque—aspect of the scene struck several critics, one of whom remarked, "And the hideous chorus, bawling in full voice, aren't they real!"[3] As another critic noted, the group of singers, set in careful foreshortening along a conspicuous diagonal but with each figure carrying on in the most expressive disorder, is singularly alive.[4] The farcical aspect of the event and the dramatic lighting from below link the work to Daumier, whom Degas greatly admired, and perhaps more specifically to works of his such as *Crispin and Scapin* (fig. 136), which Durand-Ruel exhibited in 1878 and later sold to Degas's friend Henri Rouart.

The work originated as a monotype that was subsequently covered in pastel. No other impression of the monotype is known, but an untraced, presumably related monotype called "Choeur d'opéra" was listed without dimensions in the sale of prints by Degas of 22–23 November 1918.[5] The plate, of an unusual, almost square format, was also used for another pastelized monotype connected with the stage, *The Curtain* (L652, Mellon collection, Upperville, Va.), usually dated about 1881 but surely dating earlier, as well as for a sequence of dark-field monotypes of bathers and nudes, among them *Nude Woman Combing Her Hair* (cat. no. 247) and *The Washbasin* (cat. no. 248).

1. Halévy 1960, p. 113; Halévy 1964, p. 93.
2. See cat. no. 167. See also *Entrance of the Masked Dancers* (L527, Sterling and Francine Clark Art Institute, Williamstown, Mass.), identified by Alexandra Murphy in Williamstown, Clark, 1987, no. 56; and *Ballet Scene* (L470, private collection).
3. Pothey 1877, p. 2.
4. Jacques 1877, p. 2.
5. Vente Estampes, 1918, no. 186.

PROVENANCE: Gustave Caillebotte, Paris, by April 1877; deposited with Durand-Ruel, Paris, 29 January 1886 (stock no. 4692); consigned by Durand-Ruel with the American Art Association, New York, 19 February–8 November 1886; returned to Caillebotte 30 November 1886; his bequest to the Musée du Luxembourg, Paris, 1894; entered the Musée du Luxembourg 1896; transferred to the Louvre 1929.

EXHIBITIONS: 1877 Paris, no. 47 (as "Choristes"), lent by Gustave Caillebotte; 1886 New York, no. 67 (as "Chorus d'Opéra"); 1915, San Francisco, Panama-Pacific International Exposition, Department of Fine Art, French Section, summer, no. 24 (as "Les Figurants"); 1916, Pittsburgh, Carnegie Institute, 27 April–30 June, *Founder's Day Exhibition: French Paintings from the Museum of Luxembourg, and Other Works of Art from the French, Belgian and Swedish Collections Shown at the Panama-Pacific International Exposition, Together with a Group of English Paintings*, no. 22; 1916, Buffalo, Albright Art Gallery, 29 October–December, *Retrospective Collection of French Art, 1870–1910, Lent by the Luxembourg Museum, Paris, France*, no. 21; 1924 Paris, no. 171; 1949 Paris, no. 100; 1956 Paris; 1969 Paris, no. 171; 1970, Paris, Musée Eugène Delacroix, "Delacroix et l'impressionnisme" (no catalogue); 1985 Paris, no. 66.

This pastel has generally been dated 1878–80, too late for its style, and a date of about 1876 is probably more appropriate. The dancer is very close to one appearing in reverse in the reworked upper section of *Orchestra Musicians* (cat. no. 98), close enough to imply a connection. It might be supposed that a drawing existed, in reverse by comparison with the monotype. Indeed, a somewhat schematic study of this type was in the artist's atelier sale (III:259.2).

1. Deborah J. Johnson, "The Discovery of a 'Lost' Print by Degas," *Bulletin of Rhode Island School of Design*, LXVIII:2, October 1981, pp. 28–31.
2. 1968 Cambridge, Mass., no. 5.

162.

Dancer with a Bouquet Bowing

c. 1877
Pastel and gouache or distemper on paper, enlarged with five strips
28⅜ × 30⅝ in. (72 × 77.5 cm)
Signed lower left: Degas
Musée d'Orsay, Paris (RF4039)

Exhibited in Paris

Lemoisne 474

This pastel, touched up with gouache or distemper, represents the culmination of Degas's infatuation with effects induced by artificial light, but in an image that by comparison to *Dancer Onstage with a Bouquet* (cat. no. 161) is both startling and complicated. The general impression is that of a privileged angle of vision, one that permits a view of the stage seen by the audience as well as a glimpse of backstage activity visible only from the wings.[1] In the right background, lit from above, dancers and supernumeraries have assumed the pose for the ballet's finale. To the left, presumably hidden from the public by stage flats, other dancers are already preparing to leave the stage. Near the footlights, the prima ballerina takes a curtain call, glaringly lit from below, her harshly illuminated face frozen like a Japanese mask. It is an unforgettable face, both thrilling and horrific, that could have been shaped only on the stage.

Geneviève Monnier has remarked on the unusual shape of the work, almost square, which can be partly ascribed to the manner in which it was assembled.[2] Originally the image was smaller, some 15¾ by 23⅝ inches (40 by 60 centimeters), and contained only the principal dancer, her head touching the upper limit of the sheet. This was apparently first expanded with the addition of strips of paper at the right and at the top, resulting in a larger, asymmetrical design with the dancer in the left half of the composition. However, the work was further enlarged, in a second stage, at the top, to the left, and finally at the bottom. The pattern in which the added strips interlock leaves little doubt that this was the sequence followed, and the various additions indicate primarily a shift in emphasis in the composition.

Pentimenti and examination under infrared light show additional small but significant changes in the dancer that also may have been made in two stages. Her left arm was lowered by a fraction, the enormous bouquet was reduced in size, and her right leg was extended downward. The alterations to the arm and the bouquet were not made spontaneously and were first verified in a charcoal drawing (IV:165), obviously intended as a preparatory design. The study, on a sheet of the same size as the central, original portion of the pastel, shows the dancer on the same scale and in the same position as she appeared originally. The drawing was corrected, however: the dancer's arm was moved to a slightly different position, and the bouquet was made smaller. The only part of the drawing that was not revised is the right leg, indicating probably that the revisions tested in the drawing were carried out in the pastel prior to the addition of the strip of paper at the bottom and that the need for that strip became obvious only when Degas decided to extend the leg, perhaps in the ultimate phase of the work.

Very few of Degas's ballet scenes represent actual stage performances, and the scenery or costumes alone may evoke the event. With some exceptions, notably the two versions of *The Ballet from "Robert le Diable"* (cat. nos. 103, 159), the artist's frequent use of the same figures indicates that he seldom followed literally the actual production of a ballet, even if on occasion he borrowed elements from it. Theodore Reff has shown that in *Dancer at the Footlights* (BR77), the artist used elements from the stage set of the ballet *Yedda, Légende Japonaise.*[3] The same seems to apply to this pastel, in which the background figures in Hindu costume appear to be derived from the ballet scene in the third act of Massenet's opera *Le Roi de Lahore*, first performed in Paris on 27 April 1877. This is consistent with the date generally proposed for the work, about 1877–78, but allows little room for the recent suggestion that the dancer is a portrait

161

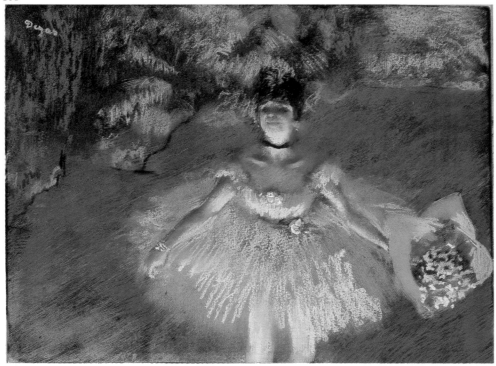

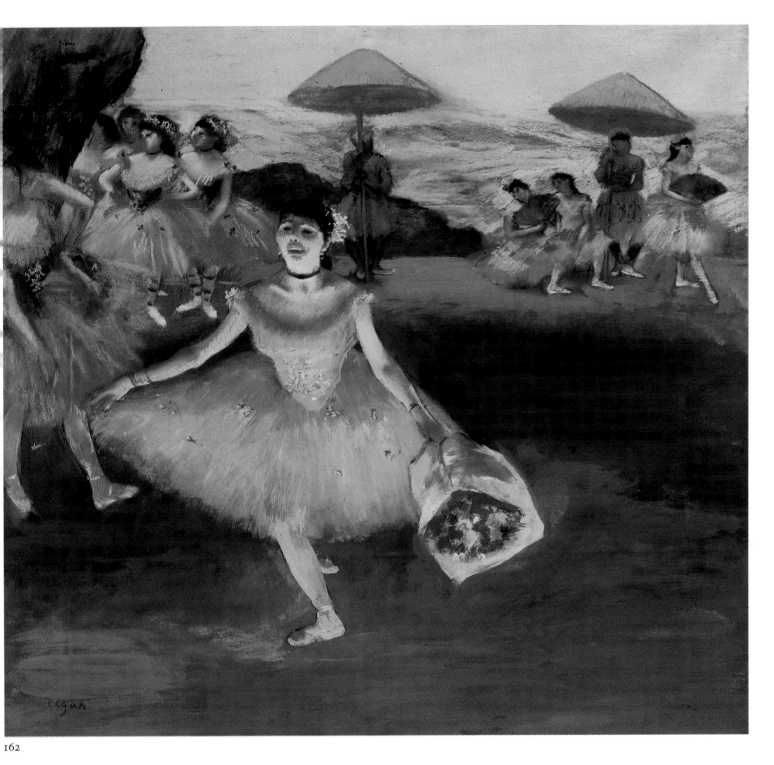

162

Fig. 137. *The Ballet* (L476), c. 1877–78. Pastel
over monotype, 15⅞ × 19⅞ in. (40.3 × 50.5 cm).
Museum of Art, Rhode Island School of Design,
Providence

of Rosita Mauri, who made her debut only in 1878, an identification hazardous under any circumstances in a face so distorted by light.[4] In 1892, the compiler of a sale catalogue assumed her to be one of the Cardinal girls, a tribute to the fame of Ludovic Halévy's short stories.[5]

A slightly smaller variant of the pastel (L475) in the Clark Art Institute, catalogued in Lemoisne as by Degas, is no longer believed to be by the artist.

1. See Lipton 1986, p. 95.
2. See Paris, Louvre and Orsay, Pastels, 1985, no. 52.
3. Brame and Reff 1984, no. 77.
4. The identification, made by Janet Anderson, is cited by Suzanne Folds McCullagh in 1984 Chicago, no. 41.
5. "The star steps back from the footlights, bowing and curtseying again and again . . . her mouth, opened wide, evinces the pleasure of her triumph—mere success isn't enough for Mlle Cardinal." See the Bellino sale catalogue, Galerie Georges Petit, Paris, 20 May 1892, no. 44.

PROVENANCE: A. Bellino, Paris (Bellino sale, Galerie Georges Petit, Paris, 20 May 1892, no. 44, repr. [as "Danseuses"], for Fr 12,500); bought by Comte Isaac de Camondo, Paris; his bequest to the Louvre 1908; entered the Louvre 1911.

EXHIBITIONS: 1924 Paris, no. 121; 1937 Paris, Orangerie, no. 89; 1949 Paris, no. 101; 1956 Paris; 1969 Paris, no. 179; 1985 Paris, no. 51, repr.

SELECTED REFERENCES: Lemoisne 1912, pp. 75–76, pl. XXX; Lafond 1918–19, I, repr. p. 57, II, p. 29; Paris, Louvre, Camondo, 1914, no. 216, p. 50, repr.; Jamot 1914, pp. 455–56; Meier-Graefe 1920, pl. XLIII; Jamot 1924, pl. 49; Lemoisne 1937, p. A, repr. p. D; Lassaigne 1945, p. 44, repr. (color); Rouart 1945, pp. 18, 72 n. 48, repr. p. 21; Lemoisne [1946–49], II, no. 474; Leymarie 1947, no. 31, pl. XXXI; Browse [1949], no. 56; Cabanne 1957, pp. 35, 41; Minervino 1974, no. 510; Roberts 1976, pl. 26 (color); Paris, Louvre and Orsay, Pastels, 1985, no. 51; Sutton 1986, pp. 179, pl. 168 (color) p. 185.

163.

Ballet (The Star)

1876–77
Pastel over monotype on laid paper
22⅞ × 16½ in. (58 × 42 cm)
Signed in the monotype upper left: Degas
Musée d'Orsay, Paris (RF12258)

Exhibited in Paris

Lemoisne 491

An appreciation of the realism of Degas's dancers was most briefly and felicitously expressed in 1877 by the young Georges Rivière, who, in a review of the third Impressionist exhibition, told his readers, "After having seen these pastels, you will never have to go to the Opéra again."[1] In a sense, it is curious that the dancers should have received that kind of notice, as this was the year in which Degas's café and café-concert scenes appeared in public for the first time, making an extraordinary impression and eclipsing almost everything else. The Star, or "L'étoile"—as the Orsay pastel has been known for almost a hundred years—is one of the series of pastelized monotypes that Degas started in the summer of 1876 and probably one of the four dance subjects exhibited in 1877.

That The Star was exhibited in 1877 is revealed by a reviewer who wrote under the pseudonym of Jacques, who, as impressed as was Rivière by the veracity of the scene, noted that "the prima ballerina, who bows, after a movement that has left her completely out of breath, swoops forward toward the footlights with such élan that if I were the conductor I would think about reaching out to support her." This sentiment was echoed by Louis de Fourcaud, who pointed out that in the work titled Ballet, "the dancer, with a look of rapture on her face, completes a sweeping bow, making her tutu stand out in the swirling movement."[2] Because two works entitled Ballet were shown by Degas in 1877, under nos. 39 and 57, it is likely that this work was one of them. It is equally probable that it was bought from the exhibition by Gustave Caillebotte, who already owned three pastelized monotypes by Degas.[3] It may well have been the single work Degas sold from the exhibition that he mentions in a letter of 21 May 1877 to Léontine De Nittis.[4]

Two decades later, when the Caillebotte bequest was finally exhibited at the Musée du Luxembourg, it was known among Degas's friends that he was unhappy to be represented in the museum by a handful of small pastels. In his diary entry for 27 February 1897, Daniel Halévy wrote of a discussion with Degas on the subject. The artist commented: "I did lots of women like that. . . . All of them are more or less rapid sketches. If you have to go to the Luxembourg, it is annoying to go in such impromptu style."[5] As Eugenia Janis was the first to note, several related monotypes of this subject were indeed covered by Degas with pastel, in itself a vivid testimony to his efforts to supply his dealers with small, perhaps rapidly executed works that pleased his public. The monotype under The Star is known in two impressions, and both are covered with pastel. The second pastelized impression, with dancers added in the foreground and background, is now in the Art Institute of Chicago (L601) and is different enough in effect not to immediately indicate its origins.[6] Yet another smaller, related

monotype known in two impressions, with the same dancer but shown at the left, resulted in two pastels (L492, Philadelphia Museum of Art, and L627).[7]

For The Star, Degas used one of his largest plates—in fact his second largest. A study for the dancer in the Art Institute of Chicago (II:336) was followed faithfully for the figure of the ballerina, shown in reverse in the monotype. The drawing has been dated c. 1878 but clearly precedes this work and should be dated 1873–74, as it seems connected with the preparatory studies for The Dance Class (cat. no. 130).[8]

The subsequent fame of this pastel, perhaps the most loved and certainly the most frequently reproduced of the artist's works, owes something to its location, in the Luxembourg, confirming Degas's fears for the effect his pastels were making there. Already in 1897, Daniel Halévy remarked on "that ballerina dancing all alone—grace and poetry embodied," a far cry from the sentiments voiced by the previous generation, who had admired its realism.[9] It is the magical aspect of the dancer's performance that has survived intact, overriding the work's singular novelty—the curious angle of vision, the vast expanse of stage left bare, the dancers in the wings, and, not least, the male figure, the star's "protector" waiting for her to finish her turn.

1. Georges Rivière, "L'exposition des impressionnistes," L'Impressionniste, 6 April 1877, p. 6.
2. See Jacques 1877, p. 2, and Léon de Lora [Louis de Fourcaud], "L'exposition des impressionnistes," Le Gaulois, 10 April 1877, p. 2.
3. It has been proposed by Richard Brettell that the picture exhibited in 1877 as Ballet was Ballet at the Paris Opéra, in the Art Institute of Chicago (L513); see 1986 Washington, D.C., p. 204. As the reviews mention only one dancer in Ballet and several appear in the foreground of the pastel in Chicago, the more probable identification remains The Star.
4. "I had a small room all to myself, full of my wares. I sold only one, unfortunately." See Chronology II, 21 May 1877.
5. See Halévy 1960, p. 113; Halévy 1964, p. 93.
6. For the Chicago version, see 1984 Chicago, no. 29.
7. For the Philadelphia pastel and its cognate, see Boggs 1985, pp. 8–9, 44 no. 3.
8. For the drawing, see 1984 Chicago, no. 40. This work was once with the Kleemann Galleries, New York, and the Harris Goldstein collection, Philadelphia, and appeared at the Parke-Bernet, New York, auction of 2 May 1956, no. 37. In addition to the transfer drawing (III:166.3) noted by Suzanne Folds McCullagh in 1984 Chicago, a study (III:151.2) of the same dancer in reverse is known.
9. Halévy 1960, p. 113; Halévy 1964, p. 93.

PROVENANCE: Bought (from the artist?) after April 1877 by Gustave Caillebotte, Paris; his bequest to the Musée du Luxembourg, Paris, 1894; entered the Luxembourg 1896; transferred to the Louvre 1929.

EXHIBITIONS: 1877 Paris, no. 39 (as "Ballet"); 1937 Paris, Orangerie, no. 88; 1956 Paris; 1969 Paris, no. 183.

SELECTED REFERENCES: Jacques 1877, p. 2; Paul Sébillot, "Exposition des impressionnistes," Le Bien Public, 7 April 1877, p. 2 (as "Ballerine qui salue le public");

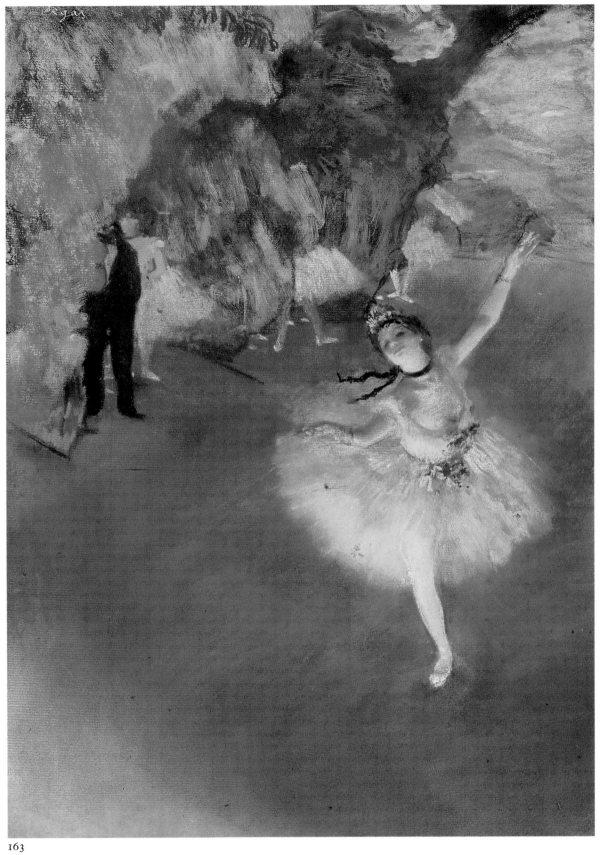

163

Léon de Lora [Louis de Fourcaud], "L'exposition des impressionnistes," *Le Gaulois*, 10 April 1877, p. 2; Paris, Luxembourg, 1894, p. 105, no. 1024; Bénédite 1894, p. 132; Jean Bernac, "The Caillebotte Bequest to the Luxembourg," *Art Journal* XV, 1895, pt. I, repr. p. 231, pt. II, p. 359; Marx 1897, repr. p. 324 (engraving by Nielsen); Woldemar von Seidlitz, "Degas," *Pan*, III:1, 1897, p. 58; Mauclair 1903, pl. 390; Karl Eugen Schmidt, *Französische Malerei des 19. Jahrhunderts*, Leipzig: E. A. Seemann, 1903, pl. 75; Pica 1907, repr. p. 414; Louis Hourticq, *Geschichte der Kunst in Frankreich*, Stuttgart: J. Hoffmann, 1912, p. 438; Gabriel Mourey, "Edgar Degas," *The Studio*, LXXIII:302, May 1918, repr. p. 131; Lafond 1918–19, I, p. 47, repr.; Meier-Graefe 1920, pl. XXXVIII; Rivière 1935, repr. frontispiece; Rouart 1945, pp. 54, 74 n. 81, repr. (detail) (as "Danseuse saluant") pp. 58–59; Lemoisne [1946–49], II, no. 491; Leymarie 1947, no. 26, pl. XXVI; Browse [1949], no. 55; Janis 1967, pp. 72–75, fig. 46; Janis 1968, no. 5; Cachin 1974, p. 281; Minervino 1974, no. 520, pl. XLII (color); Paris, Louvre and Orsay, Pastels, 1985, no. 65.

164.

Dancers at the Barre

c. 1873
Essence and sepia on green paper
18⅞ × 24⅝ in. (47.4 × 62.7 cm)
Signed in black chalk lower right: Degas
Trustees of the British Museum, London
(1968-2-10-25)

Exhibited in New York

Lemoisne 409

This essence study was one of twenty drawings selected by Degas for reproduction in the album *Degas: vingt dessins, 1861–1896,* where it was said to date from 1876. It has since been universally dated 1876–77, although the drawing belongs, along with other comparable studies, to the group of preparatory drawings executed in 1873 after the artist's return from New Orleans. A second, related essence composition (fig. 138) has a figure that was evidently a sketchy attempt at defining the dancer at the left in the British Museum sheet, along with a figure that Degas used in *The Dance Class* (cat. no. 128) of 1873, in the Corcoran Gallery of Art in Washington. A third essence drawing (III:212) of the same period, originally the same size as the British Museum study but subsequently divided into three separate sheets, must have belonged to the same group and clearly also served as a source for the Corcoran painting.[1]

The drawing in the British Museum has been assumed to be a preparatory study for *Dancers Practicing at the Barre* (cat. no. 165) in the Metropolitan Museum. This is true only inasmuch as the chance presence of two dancers on the same sheet later suggested to the artist the possibility of using them conjointly in a composition.[2]

Three drawings that can be dated 1873 appear connected to the essence study. One (III:83.3) is a charcoal-and-chalk variant of the dancer at the left; the other two (fig. 139 and IV:278.d) are related to the dancer at

the right and show her torso inclined at two different angles.

1. The drawing (III:212) was reproduced intact in the Degas atelier sale catalogue, though the three fragments—all privately owned—are each marked with the Vente stamp. See 1984 Tübingen, nos. 96, 99, 227, where they are dated c. 1874.
2. That Degas, indeed, used to advantage such chance encounters on a page is confirmed by *The Rehearsal* (fig. 154) in the Frick Collection, New York, and a study of a dancer connected with it (III:336.1). In addition to one of the figures, the drawing also provided a detail—the now famous unattached leg intruding into the composition.

PROVENANCE: Atelier Degas (Vente II, 1918, no. 338, for Fr 8,200); bought by Gustave Pellet, Paris. J. H. Whittemore, Naugatuck, Conn.; César M. de Hauke, New York; his bequest to the museum 1966.

EXHIBITIONS: 1935 Boston, no. 126; 1936 Philadelphia, no. 80, repr.; 1937 Paris, Orangerie, no. 85; 1951–52 Bern, no. 23; 1968, London, British Museum, 12 July–28 September, *César Mange de Hauke Bequest*; 1984 Tübingen, no. 103, repr. (color); 1987 Manchester, no. 48, fig. 78 (color).

SELECTED REFERENCES: Vingt dessins [1897], pl. 13; Lafond 1918–19, II, repr. after p. 36; Rivière 1922–23, pl. 86 (reprint edition 1973, pl. E [color]); Rouart 1945, p. 71 n. 28; Lemoisne [1946–49], II, no. 409 (as c. 1876–77); Browse [1949], no. 47; Cooper 1952, pp. 12–13, 16, no. 4, pl. 4 (color); Rosenberg 1959, p. 112, pl. 208; Minervino 1974, no. 496; John Rowlands, "Treasures of a Connoisseur: The de César [sic] Hauke Bequest," *Apollo*, LXXXVIII:77, July 1968, p. 46, fig. 9 p. 47 (as c. 1876).

164

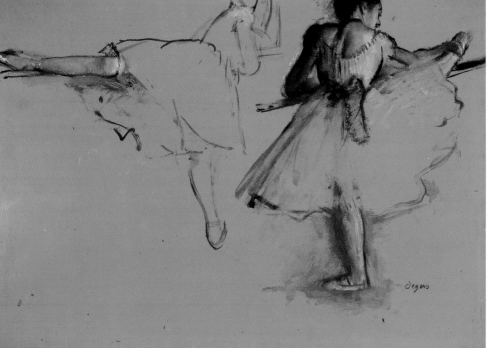

Fig. 138. *Two Studies of a Dancer* (III:213), 1873. Essence drawing, 15⅜ × 22½ in. (39 × 57 cm). Location unknown

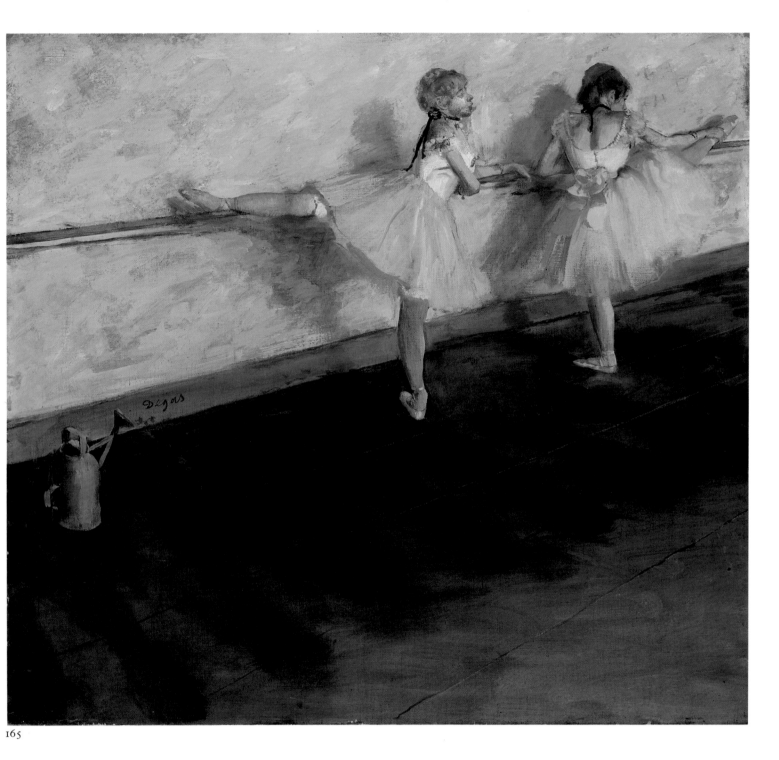

165

165.

Dancers Practicing at the Barre

1876–77
Oil colors freely mixed with turpentine on canvas
29¾ × 32 in. (75.6 × 81.3 cm)
Signed left of center: Degas
The Metropolitan Museum of Art, New York.
 Bequest of Mrs. H. O. Havemeyer, 1929.
 H. O. Havemeyer Collection (29.100.34)

Exhibited in New York

Lemoisne 408

The instant fame acquired by this picture at the time of the sale of Henri Rouart's collection in 1912 has overshadowed its true, subtle qualities—qualities that prompted George Moore in 1890 to consider it "perhaps . . . the finest of all" the artist's paintings devoted to the dance.[1] A century later, *Dancers Practicing at the Barre* appears more clearly to be the culmination of Degas's attempts in the mid-1870s to simplify his compositions. It is also one of the most happily phrased observations on the nature of rhythm, not only as the preeminent property of dance but also as a pervasive quality in nature.

The idea for the composition was suggested by the earlier essence study of two dancers (cat. no. 164) in the British Museum. Perhaps because the dancers in the study were each observed from a different angle, alternative studies were used for the painting. Degas drew the dancer at the left once more, from a model, elaborating on details of the torso, arms, and left leg, both in a pastel (II:234.1) and in a pencil study now in

Fig. 139. *Dancer at the Barre* (III:133.4), c. 1873? Charcoal, 12¼ × 7⅞ in. (31.1 × 20 cm). Cabinet des Dessins, Musée du Louvre (Orsay), Paris (RF4644)

the collection of Mr. and Mrs. William R. Acquavella. The dancer at the right was not entirely based, as one might expect, on the splendid prototype in the British Museum study but on one of the related drawings (fig. 139), where she is shown with her torso less bent to the right. As her right arm was not clearly defined in either the drawing or the British Museum study, the pose of the arm alone was examined separately on the Acquavella sheet.[2]

The resulting composition, audacious in its grouping of figures in the upper right quadrant, focuses attention completely on the two dancers performing their exercises in a sun-filled rehearsal room. One dancer, her back to the viewer, is entirely absorbed in her work; the other, equally wrapped up in herself, appears momentarily distracted. The rear wall shimmers with reflected light in contrast to the dusty floor, recently sprinkled with water in rhythmical patterns. To the left, a watering can is placed in such a way as to echo the movement of the dancer at the right, a deliberately established correspondence between animate and inanimate forms that Degas employed on other occasions.[3] In this instance, he came to regret it but was apparently denied permission to alter the composition by the owner of the work, Henri Rouart.[4]

In his earliest analysis of the painting, Paul-André Lemoisne concluded that *Dancers Practicing at the Barre* was shown in the Impressionist exhibition of 1877. Subsequently

he adopted an ambiguous stance on the subject, and doubt was expressed as recently as 1986 by George Shackelford.[5] Without discussing this painting, Georges Rivière reproduced a drawing of a related *Dancer at the Barre* (L421) with a review of the 1877 exhibition.[6] However, Paul Mantz in his review noted "the floor of the theater, where the spout of the watering can cleverly draws figure 8s in the dust," surely a reference to *Dancers Practicing at the Barre*.[7] This painting was certainly exhibited, and it is known that it was given by Degas to Henri Rouart as a replacement for an earlier work, now lost, which the artist wished to alter and destroyed in the process.[8]

1. Moore 1890, p. 423. At the Rouart sale, the picture fetched the highest price paid up to that date at public auction for the work of a living artist.
2. For a different dating of all the drawings connected with the painting, see Richard Thomson in 1987 Manchester, pp. 48–49.
3. See also *Woman in a Tub* (L766, private collection, California), where a jug in the foreground repeats the form of the bather.
4. Browse [1949], p. 353.
5. Lemoisne 1912, p. 71, as most probably exhibited; Lemoisne [1946–49], II, no. 421, indicating that the single *Dancer at the Barre* (L421) was shown; 1986 Washington, D.C., p. 204, noting that L421 was exhibited, and p. 217, where it is suggested that L408 may have been the work shown.
6. *L'Impressionniste*, 2, 11 April 1877, repr. p. 5. That there is no connection between the drawing reproduced by Rivière and the painting exhibited in 1877 is made clear by Rivière's monograph on Degas, in which he states: "In 1877, at the time of the publication of the periodical *L'Impressionniste*, a short-lived paper that lasted as long as the exhibition at 6 rue Le Peletier, Degas very kindly gave us a beautiful drawing, *Dancer at the Barre*, which we published in our first number." See Rivière 1935, p. 23.
7. Mantz 1877, p. 3.
8. Lettres Degas 1945, Paul Poujaud to Marcel Guérin, 11 July 1936, p. 256; Degas Letters 1947, p. 236.

PROVENANCE: Given by the artist to Henri Rouart, Paris (Rouart sale, Galerie Manzi-Joyant, Paris, 9–11 December 1912, no. 177, for Fr 478,000); bought by Paul Durand-Ruel as agent for Mrs. H. O. Havemeyer, New York; her bequest to the museum 1929.

EXHIBITIONS: 1877 Paris, no. 41; 1930 New York, no. 57; 1970, Boston, Museum of Fine Arts, 17 September–1 November, *Masterpieces of Painting in the Metropolitan Museum of Art*, p. 83, repr. (color); 1970–71, New York, The Metropolitan Museum of Art, 14 November 1970–14 February 1971, *Masterpieces of Fifty Centuries*, no. 376, repr.; 1977 New York, no. 15 of paintings, repr.

SELECTED REFERENCES: "Exposition des impressionnistes," *La Petite République Française*, 10 April 1877, p. 2; Mantz 1877, p. 3; Charles Bigot, "Causerie artistique: l'exposition des 'impressionnistes,'" *La Revue Politique et Littéraire* 44, 28 April 1877, p. 1047; Moore 1890, p. 423; Alexandre 1902, p. 10, repr. p. 5; Geffroy 1908, p. 20, repr. p. 21; Lemoisne 1912, pp. 71–72, pl. xxviii; *American Art News*, XI, 28 December 1912, p. 5; Charles Louis Borgmeyer, "The Master Impressionists," *The Fine Arts Journal*, Chicago, 1913, pp. 85, 87–88, 219, repr. p. 83; R. E. D.[Dell], "Art in France," *Burlington Magazine*, XXII:118, January

1913, p. 240; Moore 1918, p. 64; Lafond 1918–19, I, p. 150, repr. facing p. 150, II, p. 27; Havemeyer 1931, p. 120, repr.; Burroughs 1932, p. 144; Venturi 1939, II, pp. 131–33; Tietze-Conrat 1944, pp. 417ff., fig. 4 p. 416; Degas Letters 1947, pp. 235–36; Rouart 1945, pp. 10, 70 n. 13, repr. p. 11; Lemoisne [1946–49], I, pp. 93, 239 n. 118, II, no. 408; Browse [1949], pp. 32, 38, no. 46; Cabanne 1957, pp. 108, 116, no. 63, pl. 63; Halévy 1964, pp. 108, 111; Valéry 1960, p. 92; Havemeyer 1961, pp. 252ff., 257; Boggs 1964, pp. 2–3, fig. 2; New York, Metropolitan, 1967, pp. 78–81, repr.; Minervino 1974, no. 497; Reff 1976, pp. 277–78, 300, 337 n. 25, fig. 190 (detail); Charles S. Moffett and Elizabeth Streicher, "Mr. and Mrs. H. O. Havemeyer as Collectors of Degas," *Nineteenth Century*, 3, 1977, p. 25, fig. 4 p. 26; Moffett 1979, pp. 11–12, 16, fig. 21 (color); 1984 Tübingen, pp. 109 n. 184, 113 n. 287, 374, under no. 102; Moffett 1985, p. 74, repr. (color) p. 75; 1986 Washington, D.C., no. 46 (included in the catalogue but not exhibited); Weitzenhoffer 1986, pp. 208–09, fig. 147 (color).

166.

Portrait of Friends in the Wings (Ludovic Halévy and Albert Cavé)

1879
Pastel (and distemper?) on five pieces of tan paper joined together
31⅛ × 21⅝ in. (79 × 55 cm)
Signed in black pastel lower right: Degas
Musée d'Orsay, Paris (RF31140)

Exhibited in Paris

Lemoisne 526

Easily the most brilliant of the group Degas had met at the Lycée Louis-le-Grand, Ludovic Halévy (1834–1908) was the product of a prodigiously gifted family. Beginning in 1852, he pursued a career in public administration which culminated in the years 1861–65, when he acted as correspondence secretary to the Duc de Morny, the speaker of the legislative assembly and one of the most influential public figures during the Second Empire. At the same time Halévy showed considerable versatility, publishing short stories and plays and collaborating in 1855 with Jacques Offenbach on a musical comedy. With Hector Cremieux, and later with Henri Meilhac, another friend from the Louis-le-Grand days, he wrote librettos for Offenbach's operettas and established an unrivaled reputation in this field. In 1867, he left the civil service and began publishing enormously popular short stories in *La Vie Parisienne*, and in 1874, he surprised his admirers by producing the libretto for the opera *Carmen* by his cousin-in-law, Georges Bizet.

Albert Cavé (1832–1910) was a marginal,

if attractive, figure whose love for the stage and connection with both Ingres and Delacroix interested Degas. Born in Naples, he was the son of the painter Clément Boulanger. After his father's death, his mother, Marie-Élisabeth Blavot, a recognized painter in her own right, married Edmond Cavé, a government official in charge of the Fine Arts Directorate. Her son by Boulanger took Cavé's name and grew up knowing practically everyone connected with the arts. In 1852, shortly after his stepfather's death, he was given a position in the Ministry of the Interior, where he met the young Halévy, and subsequently became Director of Censorship. His instinct on matters relating to the stage was considered flawless, and although he appeared to have drifted through life with a minimum of effort, his advice was frequently sought. Degas, who objected to his idleness, was nevertheless fascinated by him.

On 15 April 1879, five days after the opening of the fourth Impressionist exhibition, Halévy noted in his diary: "Yesterday Degas exhibited a double portrait of Cavé and me on stage, standing in the wings, face to face. There I am, looking serious in a place of frivolity; just what Degas wanted."[1] This play of contrasts was given form in a highly unconventional double portrait with the two figures seen against the liveliest of blue-green stage flats. To the right, a rigid, vertical side scene occupies a third of the composition, partly concealing Cavé and subtly counteracting the sharp diagonals at the left. This remarkable placing of visual elements was first experimented with early in 1873 in *Cotton Merchants in New Orleans* (cat. no. 116), where a figure in profile also appears from behind a wall. The idea was further refined with even greater boldness in *Mary Cassatt at the Louvre: The Paintings Gallery* (cat. nos. 207, 208). There is a deliberately fastidious compositional touch in the angle of Halévy's umbrella, calculated to suggest spontaneity but far removed from it. It has long been recognized that Degas's masters in this instance were the great eighteenth-century Japanese printmakers, and echoes of their art can be found even in the background stage flat, which evokes a blurred memory of a field of irises in a Japanese screen.[2]

1. "Les carnets de Ludovic Halévy" (edited by Daniel Halévy), *Revue des Deux Mondes*, 37, 15 February 1937, p. 823.
2. Boggs 1962, p. 54. For the Japanese effects in *Cotton Merchants*, see Gerald Needham in *Japonisme: Japanese Influence on French Art 1854–1910* (exhibition catalogue), Cleveland Museum of Art, 1975; and Theodore Reff, "Degas, Lautrec, and Japanese Art," in *Japonisme in Art: An International Symposium*, Tokyo: Committee for the Year 2001, 1980, pp. 196–98.

166

PROVENANCE: Given by the artist to Ludovic Halévy, c. 1885 (according to Élie Halévy, cited in 1931 Paris, Orangerie, no. 136); Mme Ludovic Halévy, his widow, Paris, from 1908; Élie Halévy, her son, Paris; gift of Mme Élie Halévy to the Louvre, retaining life interest, 1958; entered the Louvre 1964.

EXHIBITIONS: 1879 Paris, no. 60 (as "Portrait d'amis, sur la scène"); 1924 Paris, no. 140, repr. (as c. 1880–82); 1930, Paris, Revue des Deux Mondes, *Cent ans de vie française* (catalogue not consulted); 1931 Paris, Orangerie, no. 136, repr. (as c. 1880–82); 1960 Paris, no. 26, repr.; 1965, Paris, Musée du Jeu de Paume, "Exposition temporaire" (no catalogue); 1966, Paris, Cabinet des Dessins, Musée du Louvre, *Pastels et miniatures du XIXe siècle*, no. 35; 1967–68 Paris,

no. 459, repr.; 1969 Paris, no. 188, fig. 10; 1969, Paris, Cabinet des Dessins, Musée du Louvre, "Pastels" (no catalogue); 1974, Paris, Cabinet des Dessins, Musée du Louvre, "Pastels, cartons, miniatures, XVI–XIXe siècles" (no catalogue); 1975 Paris; 1980–81, Paris, Cabinet des Dessins, Musée du Louvre, "Pastels et miniatures du XIXe siècle: acquisitions récentes du Cabinet des Dessins" (no catalogue); 1985 Paris, no. 76, repr. (color) p. 28.

SELECTED REFERENCES: Lemoisne 1924, repr. p. 100; Louis Gillet, "Cent ans de vie française à la Revue des Deux Mondes," *Gazette des Beaux-Arts*, III, January 1930, pp. 111–12; "Les carnets de Ludovic Halévy" (edited by Daniel Halévy), *Revue des Deux Mondes*, 37, 15 February 1937, p. 823; Rouart 1945, pp. 22,

72 n. 49; Lemoisne [1946–49], II, no. 526 (as 1879); Cabanne 1957, p. 42; Boggs 1962, pp. 54, 56, 59, 112, pl. 99 (as 1876); Minervino 1974, no. 567; Reff 1976, p. 183, fig. 128 (as 1879); Dunlop 1979, pp. 127, 166, fig. 158; Paris, Louvre and Orsay, Pastels, 1985, no. 76; Sutton 1986, p. 261, fig. 256 p. 260.

Degas, Halévy, and the Cardinals

cat. nos. 167–169

Ludovic Halévy's reputation as a writer was based not only on his success as a librettist but also on a series of related short stories of a satirical character published separately between 1870 and 1880 and eventually collected in 1883 under the title La famille Cardinal. As early as 1873, the first two stories about Pauline and Virginie Cardinal, two young dancers at the Opéra, and their parents were sufficiently notorious to be described in Larousse's Grand dictionnaire universel du XIXe siècle as "unhealthy."[1] As might be expected, Halévy's vivid sketches of life backstage inspired Degas, who made a series of monotype illustrations of the stories, his only project of that nature intended for publication.[2]

The corpus of monotypes mistakenly said to be connected with the printing in 1883 of La famille Cardinal has been dated about 1880–83, even though it has been suspected, on the basis of Degas's notebooks, that the artist embarked on the project in about 1877 or 1878.[3] There is reason to believe that in early 1877 the project was in fact already completed, as in the spring of that year Degas sent several of the monotypes to the third Impressionist exhibition, where they were admired by Jules Claretie, one of the reviewers:

M. Degas, a man of intellect, an acute, original, and profound observer of Paris life, is one of those artists who sooner or later achieve popular success through the more private successes of amateurs. He knows, and represents like no one else, life backstage at the theater, the rehearsal halls of the ballet, and the luscious appeal of young ballerinas, with their bouffant skirts. He has undertaken to illustrate Monsieur et Madame Cardinal [sic] by Ludovic Halévy. His drawings have extraordinary character: they are life itself. He is the equal of Gavarni and Goya. . . . In short, M. Degas has created scenes of Paris—its everyday life and its lowlife—which will one day astonish the public when a publisher decides to collect and

produce them in an album. This man's profound understanding of humankind will then be truly revealed. . . .[4]

The relatively complicated publishing history of the short stories collected in La famille Cardinal was the chief cause for the dates previously ascribed to the monotypes. "Madame Cardinal," written in one afternoon on 6 May 1870, appeared in La Vie Parisienne one week later. The second story, "Monsieur Cardinal," followed in November 1871. Both were signed with the pseudonym "A.B.C." Stimulated by their enormous success, Halévy in 1872 collected the two stories along with ten unrelated ones in a volume titled Madame et Monsieur Cardinal (Paris: Michel-Lévy, 1872). Issued under his real name, the volume was illustrated with twelve vignettes by Edmond Morin, only two of which—not all twelve as usually stated—related to the Cardinal stories. In December 1875, by which time Madame et Monsieur Cardinal had appeared in eighteen editions, Halévy published in La Vie Parisienne a third short story, "Les petites Cardinal."

Five years later, on 3 June 1880, Halévy noted in his diary: "I suddenly decided that I would finish off the Madame Cardinal series and produce a second volume with five previously unpublished chapters. I had many notes, though these were scattered and disorganized. In eight days, I had completed five chapters; of the last three, not one line had been written before. The drawings will be done by a young man, Henry Maigrot."[5] One month later, on 7 July 1880, the previously published "Les petites Cardinal," the five new Cardinal chapters, and six unrelated stories appeared together under the title Les petites Cardinal (Paris: Calmann-Lévy, 1880). As with the previous volume, the illustrations were restricted to one for each short story.

The success of Les petites Cardinal surpassed all expectations. In 1882, when Halévy published a highly sentimental novel, L'Abbé Constantin, he noted in his diary: "My friend Degas is furious with L'Abbé Constantin—'nauseated' would be a better word. He was insulting to me this morning."[6] Halévy actually never wrote another short story about the Cardinals, but in 1883 he published the eight Cardinal stories in one volume under the title La famille Cardinal, with illustrations by Émile Mas (Paris: Calmann-Lévy, 1883).

Inasmuch as Degas's monotypes illustrate specific episodes from the narrative, it is evident that they are linked to only three of the eight stories—"Madame Cardinal," "Monsieur Cardinal," and "Les petites Cardinal," all of which had been published by the end of 1875—and that the artist did not

illustrate the remaining five chapters written by Halévy in May–June 1880. Thus it is difficult to agree with Marcel Guérin and others that Degas intended the illustrations to be used in La famille Cardinal, the volume published in 1883, and it is just as difficult to suppose that they were considered for Les petites Cardinal, issued in 1880. It is more probable that in the summer of 1876, at the height of his interest in monotype, Degas conceived the idea of illustrating the three existing Cardinal stories in the event they were collected in a volume. That the project was at a fairly advanced stage and that a publication, probably a book, was contemplated are suggested by the existence of heliogravure reductions of one of the illustrations.[7] Guérin claimed that such was the case and that Halévy rejected the illustrations, an opinion confirmed by Mina Curtiss.[8] It has been assumed that Halévy failed to recognize their greatness, and there is evidence that he invariably chose mediocre illustrators for his works.[9] It is also true that in his illustrations Degas gave the narrator of the Cardinal stories Halévy's recognizable physiognomy, transmuting sketches published as fiction into autobiography. If for Degas—as for Flaubert—Art was a second Nature, a necessary reenactment of Nature, this unexpected pictorial device may have embarrassed Halévy. Whether the entire question was raised before or after Claretie's pointed remark of April 1877 about the monotypes deserving publication as an album remains to be determined.

When the portfolio of monotypes and drawings related to the project appeared as one lot in the 1918 sale of prints from the artist's estate, it was said to consist of thirty-seven monotypes, according to the catalogue, including eight retouched with pastel, thirty contretypes (actually, second impressions), and eleven drawings.[10] However, the portfolio was withdrawn from sale and most of its contents were deposited in 1925 with Durand-Ruel. On 17 March 1928, the portfolio was sold, again as one lot, for the extraordinary sum of Fr 408,500, at a sale organized by Marcel Guérin at which the principal buyers were Guérin himself, the publisher Auguste Blaizot, who also acquired the reproduction rights, and the collector David David-Weill. Seven monotypes and drawings accidentally removed from the portfolio before it had been left with Durand-Ruel were sold at auction separately on 25 June 1935.[11]

The monotype illustrations are all executed in the light-field manner. Although most of them are in black ink on white paper, at least nine impressions were substantially reworked with red, white, and black pastel.[12] Many of the illustrations refer to episodes in

the narrative, but there are also a number that are simply evocative of the backstage of the Opéra, with no specific relation to the text. It is evident throughout the series that Degas devoted several monotypes to one episode, working his way through varying compositions and refining visual effects. Viewed together, the sequences of illustrations showing the same scene from different angles, from a distance, and close up achieve a curious cinematic quality that would have been lost in a book. It could be claimed that Degas perhaps intended only the colored monotypes for publication, but this does not seem to have been the case considering the evidence of the one known engraved reproduction.[13] It was only in 1938 that thirty-one of the monotypes finally appeared, reproduced in engraved form in a limited edition of *La famille Cardinal* published by Blaizot. In the end, it was not the project Degas had in mind.

1. Pierre Larousse, *Grand dictionnaire universel du XIXe siècle*, IX, Paris, 1873, p. 30, "Halévy (Ludovic)." The entry also states that the short stories "belong to that genre of salacious literature, typical of the Second Empire, which has given us such an unfortunate reputation abroad."
2. The only other work of literature for which the artist agreed to provide an illustration was Mallarmé's proposed *Le tiroir de laque*, planned for 1887. Degas failed to deliver the etching, tentatively identified by Jean Adhémar as RS55. For the entire question of the project and Degas's participation, see Stéphane Mallarmé, *Correspondance*, III (edited by Henry Mondor and Lloyd James Austin), Paris, 1969, pp. 162, 227, 254, 256–57, 290; Henri de Régnier, "Mallarmé et les peintres," in *Nos rencontres*, Paris, 1931, pp. 202–03; and Janine Bailly-Herzberg, "Les estampes de Berthe Morisot," *Gazette des Beaux-Arts*, XCIII, May–June 1979, pp. 215–27.
3. Janis 1968, p. xxi (c. 1877); Pickvance in 1979 Edinburgh, p. 68 (c. 1877); Reff 1985, Notebook 27 (BN, Carnet 3, pp. 3–6); and Reff 1976, pp. 80, 185 (c. 1878); see later dating of cat. no. 167 to 1879–80 in Brame and Reff 1984, no. 96A.
4. Claretie 1877, p. 1.
5. "Les carnets de Ludovic Halévy" (edited by Daniel Halévy), *Revue des Deux Mondes*, 43, 1 January 1938, p. 117.
6. Ibid., 15 January 1938, p. 399.
7. Two proofs printed by Dujardin of *In the Corridor* are recorded in Janis 1968, no. 223, and Cachin 1974, no. 69.
8. Cited in Janis 1968, pp. xxi–xxii.
9. In a letter of 7 January 1886, Degas wrote to Halévy, "you . . . are such a good judge of everything that is not art. . . ." See Lettres Degas 1945, LXXXIX, pp. 114, 115 n. 1; Degas Letters 1947, no. 98, p. 113. According to Vollard, "Halévy could not understand Degas's talent but Mme Halévy, who admired him, encouraged him to prepare the drawings [i.e., the monotypes]. She assured Degas that she would persuade her husband, but failed." See René Gimpel, *Journal d'un collectionneur marchand de tableaux*, Paris: Calmann-Lévy, 1963, p. 37.
10. For Degas's own attempt to sell the Cardinal monotypes as a group to Paul Gallimard for Fr 80,000, see Gimpel, op. cit., p. 37.
11. Drouot, Paris, 25 June 1935, Edgar Degas estate,

167

Catalogue de sept croquis et impressions (monotypes) par Edgar Degas exécutés en partie pour l'illustration de l'ouvrage "Les petites Cardinal" par Ludovic Halévy.
12. There were eight colored impressions in the print sale of 1918. A ninth given by Degas to Halévy is recorded in Brame and Reff 1984, no. 96.
13. Nevertheless, the fact that the engraved work, *In the Corridor* (J223, C69), appears to be the only monotype in the series on beige rather than white paper may have a significance yet to be determined.

167.

Ludovic Halévy Finds Mme Cardinal in the Dressing Room

1876–77
Monotype in black ink on white laid paper heightened with red and black pastel
First of two impressions
Plate: 8¼ × 6¼ in. (21.3 × 16 cm)
Vente stamp in blue gray lower right margin
Graphische Sammlung, Staatsgalerie Stuttgart (D1961/145)

Janis 212/Cachin 65

There are two versions of this monotype, and second impressions are recorded for both.[1] One version, known until recently

only from the second impression, is partly heightened with pastel and is signed and inscribed "to my friend Halévy."[2] The second version, exhibited here, is more elaborately reworked in pastel and is probably the definitive image intended by Degas for publication.

The composition closely follows a paragraph in "Monsieur Cardinal" in which the narrator describes his visit backstage to a dressing room.

> I was looking for my worthy friend Mme Cardinal. The dressing room door was open, and I looked in. On hooks lining the walls, dressers were hanging up soiled gowns and red flannel hoopskirts. These were the chrysalises from which would emerge the sparkling butterflies of the *Don Giovanni* ballet. Three or four mothers were there, sitting on rattan chairs, talking, knitting, or dozing.
>
> In a corner I spied Mme Cardinal. Her two large white corkscrew curls perfectly framed her matriarchal face. With her snuffbox on her knees and her spectacles on her nose, she was reading a newspaper. I approached. Mme Cardinal, completely absorbed in her reading, did not see me coming.
>
> I dropped down on a little stool beside her.[3]

The artist's earliest attempt at illustrating the scene followed the text more literally. The picture shows the narrator seated next to Mme Cardinal, with the corner of a dressing table prominent in the foreground and two clearly defined dressers fluttering in the background.[4] In the two later versions, the narrator stands and the focus is on the two protagonists. The final image is more forceful and abstract, with all the subsidiary elements, such as the indistinct figure in the background and the red hoopskirt, reduced to a mere suggestion. The narrator has Halévy's features, identifiable from his portrait (cat. no. 166). Mme Cardinal is recognizable not only as the character created by Halévy, but also as a type of elderly stage mother included by Degas in two other, unrelated works—*The Rehearsal* (fig. 119) in Glasgow and *Dancers at Their Toilette (The Dance Examination)* (cat. no. 220) in Denver.

1. Janis 1968, nos. 212–214; Cachin 1974, under no. 65; Brame and Reff 1984, nos. 96, 96A.
2. Brame and Reff 1984, no. 96. There are several erased words in the margin, two still legible as "Halévy" and "croquis" (sketch), as well as the somewhat muddled inscription "Pour Madame Cardinal." The illustration, of course, is for "Monsieur Cardinal," and the inscription is not necessarily in Degas's hand.
3. Ludovic Halévy, *Madame et Monsieur Cardinal*, Paris: Michel-Lévy, 1872, pp. 30–31.
4. Catalogued and reproduced in Janis 1968, no. 215, as in black ink; Cachin 1974, under no. 65, as reworked in pastel, without a reproduction.

PROVENANCE: Atelier Degas (Vente Estampes, 1918, part of lot no. 201, not sold; sale, Degas estate, Lair-Dubreuil et Petit, Paris, 17 March 1928). Maurice Loncle, Paris. Bought by the museum 1961.

EXHIBITIONS: 1984 Tübingen, no. 131, repr. (color); 1984–85 Paris, no. 128, p. 403, fig. 266 (color) p. 411.

SELECTED REFERENCES: Ludovic Halévy, *La famille Cardinal*, Paris: Auguste Blaizot, 1938, repr. p. 1 (color engraving by Maurice Potin); Rouart 1945, pl. 7 (color); Christel Thiem, *Französischer Maler illustrieren Bücher*, Stuttgart: Staatsgalerie, 1965, under no. 44; Janis 1968, no. 212 (as c. 1880–83); Cachin 1974, under no. 65 (as c. 1880); Brame and Reff 1984, no. 96A (as 1879–80).

168.

Pauline and Virginie Conversing with Admirers

1876–77
Monotype in black ink on heavy China paper tipped onto heavy white wove paper
First of two impressions
Plate: 8½ × 6¼ in. (21.5 × 16 cm)
Sheet: 11⅜ × 7½ in. (28.9 × 19 cm)
Mount: 12¼ × 8¾ in. (31 × 22.2 cm)
Vente stamp in blue gray lower right margin; atelier stamp right corner of mount
Harvard University Art Museums (Fogg Art Museum), Cambridge, Massachusetts. Bequest of Meta and Paul J. Sachs (M14.295)

Janis 218/Cachin 66

168

In an episode of "Les petites Cardinal," the narrator remembers an event of ten years earlier, when Pauline and Virginie Cardinal were young. He was pursuing them in the company of three of their admirers: a painter (Degas? Lepic?), a senator, and the secretary of a foreign embassy.

> We were in a corridor. . . . In the old Opéra there were delightful corridors, with masses of nooks and crannies, dimly lit by smoky lamps. We caught the two young Cardinals in one of these corridors, and we asked them to grant us the pleasure of dining with us the next day at the Café Anglais. The girls were bursting to accept. "But mama would never consent," they said. "You don't know mama!" And suddenly, who should appear at the end of the corridor but the redoubtable lady herself. "So," she cried, "again you're letting my daughters in for a sound thrashing."[1]

In all three monotypes connected with the scene, Degas placed the dancers and the four men in the foreground, with Mme Cardinal as an indistinct presence at the end of the corridor. He revised the design at least twice. In a monotype of horizontal format and of greater compositional complexity (J220, C67), Mme Cardinal looms larger and the group, unaware of her presence, is more spirited.[2] In the work in this exhibition, the weight is more emphatically on the foreground and the dark figures of the men. In a very close variant (J219, C66), there is a slight shift in time: one of the admirers has turned around and has discovered the presence of Mme Cardinal.

1. Ludovic Halévy, *Les petites Cardinal*, Paris: Calmann-Lévy, 1880, pp. 6–7.
2. A previously unrecorded second impression of this monotype was sold anonymously in 1984, Nouveau Drouot, Paris, 24 October 1984, no. 57, repr.

PROVENANCE: Atelier Degas (Vente Estampes, 1918, part of lot no. 201, not sold; sale, Degas estate, Lair-Dubreuil et Petit, Paris, 17 March 1928). Paul J. Sachs, Cambridge, Mass.; bequeathed to the museum 1965.

EXHIBITIONS: 1961, Boston, Museum of Fine Arts, 4 May–16 July, *The Artist and the Book: 1860–1960*, with no. 71; 1965–67 Cambridge, Mass., no. 97, repr.; 1968 Cambridge, Mass., no. 49, repr.; 1974 Boston, no. 104; 1979 Northampton, no. 27, repr. p. 40; 1980–81 New York, no. 30, repr.

SELECTED REFERENCES: Ludovic Halévy, *La famille Cardinal*, Paris: Auguste Blaizot, 1938, repr. p. 66 (engraving by Maurice Potin); Janis 1968, no. 218 (as c. 1880–83); Cachin 1974, no. 66, repr. (as c. 1880); 1984–85 Paris, fig. 267 p. 412.

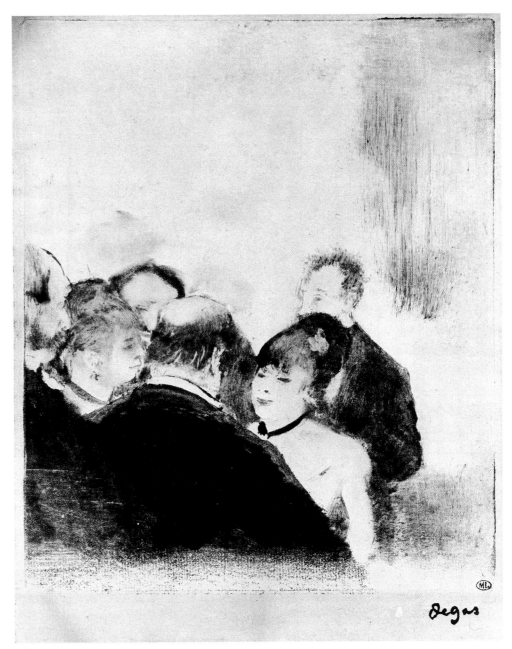

169

169.

The Cardinal Sisters Talking to Their Admirers

1876–77
Monotype in black ink on white laid paper
Second of two impressions
Plate: 8⅝ × 7 in. (21.8 × 17.7 cm)
Sheet: 10¼ × 7½ in. (26.1 × 19.1 cm)
Vente stamp in blue gray lower right margin; atelier stamp on mount
Cabinet des Dessins, Musée du Louvre (Orsay), Paris (RF30021)

Exhibited in Ottawa and New York

Janis 226/Cachin 72

There is ample evidence that whenever possible Degas printed a second impression of a monotype almost as a matter of principle, and the Cardinal series does not deviate from this pattern. Originally, there was an almost equal number of first and second impressions. But even if the artist frequently transformed a second impression into a pastel, he evidently never did so with the second impression of a monotype connected with the Halévy project. Notwithstanding the apparently generic nature of several illustrations for *La famille Cardinal*, it can be concluded that in the artist's mind they were specific to Halévy's narrative.

This second impression, obtained from an uncommonly well-inked plate, retains much of the vigor of the first without being as richly contrasted or as uniformly dark in the lower foreground. It is subtler and more delicate, but the humorous rendition of the middle-aged admirers, among whom Eugenia Janis has tentatively recognized Ludovic Lepic, remains unimpaired. Although the composition is not connected with an identifiable scene from the Cardinal stories, it represents a variation on the theme expressed in *Pauline and Virginie Conversing with Admirers* (cat. no. 168).

The first impression of this monotype was bound with *Ludovic Halévy Finds Mme Cardinal in the Dressing Room* (cat. no. 167) and four other monotypes in an exemplar of *La famille Cardinal* published by Blaizot, now in the Staatsgalerie Stuttgart.[1]

1. For the first impression, see Janis 1968, no. 226, and Cachin 1974, no. 72.

PROVENANCE: Atelier Degas (Vente Estampes, 1918, part of lot no. 201, not sold; sale, Degas estate, Lair-Dubreuil et Petit, Paris, 17 March 1928). Carle Dreyfus, Paris; his bequest to the Louvre 1952.

EXHIBITIONS: 1969 Paris, no. 195; 1985 London, no. 7, erroneously reproducing the first impression in the Staatsgalerie Stuttgart.

SELECTED REFERENCES: Valéry 1965, fig. 155 p. 239 (as 1880–90); Cachin 1974, no. 72 (as c. 1880).

170.

In the Omnibus

c. 1877–78
Monotype in black ink on white wove paper
Plate: 10⅞ × 11¾ in. (28 × 29.7 cm)
Musée Picasso, Paris

Exhibited in Paris

Janis 236/Cachin 33

A handful of Degas's monotypes are devoted to scenes from modern life that fall outside the broad, major themes forming the greater part of his output. Among these are two street scenes (J216 and J217), tentatively linked to the Cardinal family stories,[1] and *In the Omnibus*, which once belonged to Picasso. As Paris figures little in Degas's work, usually glimpsed only briefly through a window, it is not surprising to discover that in this monotype the artist chose the interior view of an omnibus or a cab; the bustle of the city is only suggested through the window by the presence of horses moving in the opposite direction.

The image is carefully edited, with the dark rectangular window frame subtly counterbalancing the horizontal format of the monotype. The figures—a veiled, pert young woman, of a type recognizable in other monotypes, and her unmistakably farcical-looking male companion—are slightly blurred, rather as if their proximity to the viewer prevented a clearer examination. By contrast, the horses in the background are energetically defined with a few bold strokes. A fairly large pastel by Giuseppe De Nittis of two women, one of them veiled, seen through the window of a cab appears to be related to the monotype and may actually have been inspired by it.[2]

1. See Janis 1968, nos. 216, 217. See also "Degas, Halévy, and the Cardinals," p. 280.
2. *In Fiacre* (Galleria G. De Nittis, Barletta), reproduced in Pittaluga and Piceni 1963, no. 527.

PROVENANCE: Atelier Degas (Vente Estampes, 1918, no. 202); bought by Gustave Pellet, Paris; by descent to Maurice Exsteens, Paris, from 1919; with Paul Brame, Paris. Pablo Picasso; Donation Picasso 1978.

EXHIBITIONS: 1924 Paris, no. 251; 1937 Paris, Orangerie, no. 206; 1948 Copenhagen, no. 106, repr.; 1951–52 Bern, no. 169, repr.; 1952 Amsterdam, no. 98; 1978 Paris, no. 41, repr.

SELECTED REFERENCES: Rouart 1948, pl. 12; Janis 1968, no. 236; Cachin 1974, no. 33, repr.

171.

Ellen Andrée

c. 1876
Monotype in brown-black ink on ivory wove paper, laid down on ivory laid paper
Plate: 8½ × 6¼ in. (21.6 × 16 cm)
Sheet: 9¼ × 7¼ in. (23.5 × 18.3 cm)
Atelier stamp on verso lower right
The Art Institute of Chicago. Mrs. Potter Palmer Memorial Fund (1956.1216)

Janis 238/Cachin 48

The transfer process required by monotypes does not lend itself readily to producing the exceptionally limpid effects achieved in this work, a rare and—as frequently noted—near-miraculous performance that has always been considered somewhat apart from the body of monotypes executed by Degas. In truth, the artist made few portraits in this medium, and only one, the very small *Portrait of a Bearded Man* (J232) in the Boston Museum of Fine Arts, can be said to share a few characteristics with this portrait in Chicago. Eugenia Janis has shown that the gentle gradation of tones in this work was the result of a highly varied application of ink, in some places diluted to a point that renders it barely perceptible, and that the more precise notations around the eyes and lips were probably details added with a brush after the plate was printed.

170

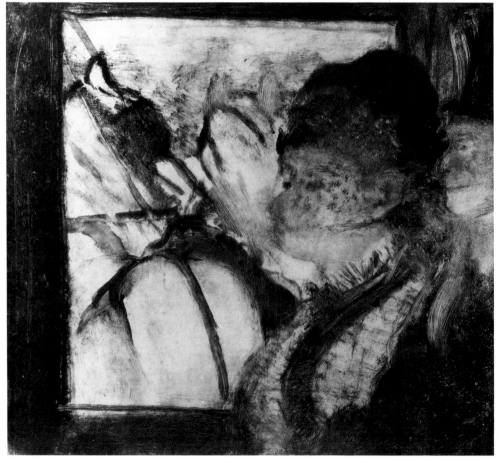

Françoise Cachin was the first to propose that the portrait may represent the actress Ellen Andrée, an identification now accepted. Although it is dated c. 1880 by Janis and Cachin, Suzanne Folds McCullagh has assigned it more sensibly to c. 1876, when Andrée posed with Marcellin Desboutin for *In a Café (The Absinthe Drinker)* (cat. no. 172).[1] On the basis of a resemblance with the woman in that painting, Jean Adhémar has recognized her also in a small monotype (J253) that Degas transferred to lithographic stone for *Four Heads of Women* (RS27).[2] Hélène Andrée (fig. 140), who changed her first name to Ellen for the stage, was a witty, lively woman of independent cast of mind who embarked at an early age on a career as a model before appearing in pantomimes at the Folies-Bergère.[3] She was a gifted comedian and had a natural manner on the stage,

Fig. 140. Franck [François de Villecholles], *Ellen Andrée*, c. 1878–80. Photograph. Private collection

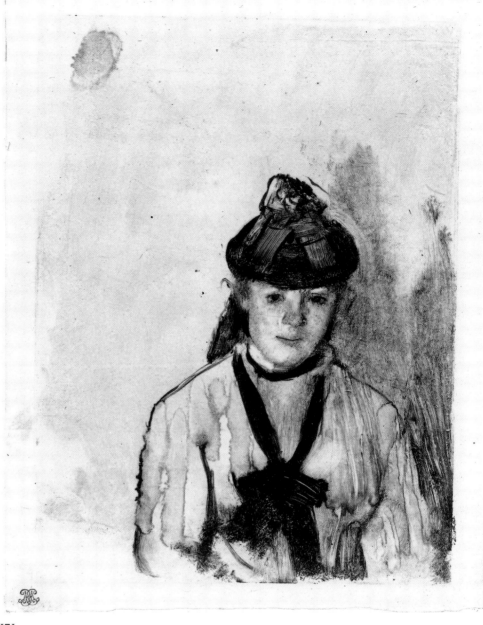

171

a quality that allowed her to make the transition to the legitimate theater. In 1887, after her marriage to the painter Henri Dumont, she joined André Antoine's first company and acted in his productions at the Théâtre-Libre, the temple of Naturalist theater.

In the mid-1870s, though still very young—she was at most about twenty—Ellen Andrée frequented the Café de la Nouvelle-Athènes and knew Degas, Halévy, Manet, and Renoir. About that time, she posed for the highly sensual nude in Henri Gervex's *Rolla* (which created a scandal in 1878 when it was rejected at the Salon) and for a portrait by Desboutin. She may also have been the model for *La prune*, by Manet, as suggested by Theodore Reff.[4] She certainly figures in several paintings and pastels by Manet, in Renoir's *La fin du déjeuner* of 1879 and *Le déjeuner des canotiers* of 1881, and in works by painters connected with the Salon, such as Alfred Stevens and Florent Willems.[5] Her own preferences were unequivocally on the side of Salon painters, and till the end she was unimpressed by the artists who had immortalized her. When appearing in 1921 in a play by Sacha Guitry and reminded by a journalist that she figured in several masterpieces, among them *The Absinthe Drinker*, she retorted: "so-called masterpieces!"[6]

Degas was sufficiently interested in Ellen Andrée to continue to see her after the late 1870s—when she still posed for him— probably because of her wit and no less for her association with the stage. Although somewhat intimidated by Manet, she was not afraid of Degas and left on record a few amusing details about his character—his frugal lunches eaten on a newspaper in his studio, his hatred of dogs, his sarcastic remarks—along with the unthinkable admission that she refused to accept one of his pastels of a dancer with the words: "Degas, my sweet, thank you very much, but she is too vile-looking."[7] As might have been expected, she was not very happy with her portrait in *The Absinthe Drinker*.[8] One would like to think, however, that this unusually moving, tenderly observed likeness pleased her.

285

1. For a discussion of the dating of this work, see 1984 Chicago, no. 28.

2. See Adhémar 1974, no. 44, where the lithograph is dated c. 1877–79. The first impression of the monotype was lost in the process of transfer to lithographic stone. A second impression was catalogued by Eugenia Janis (J253), who dated it c. 1878 (1968 Cambridge, Mass., no. 59). Janis's date should be adjusted to c. 1876–77, in line with the lithograph derived from it, redated 1876–77 by Sue Reed and Barbara Shapiro (Reed and Shapiro 1984–85, no. 27).

3. Ellen Andrée was not the daughter of the painter Edmond André, Manet's friend, as claimed by Rouart and Wildenstein, nor was she the sitter for a painting identified by them as her portrait, actually a portrait of Mlle André, the painter's daughter. See Denis Rouart and Daniel Wildenstein, *Édouard Manet*, Lausanne/Paris: La Bibliothèque des Arts, 1975, I, under no. 339, said to be a portrait of Ellen Andrée.

4. For Reff's tentative identification, see *Manet and Modern Paris: One Hundred Paintings, Drawings, Prints and Photographs by Manet and His Contemporaries* (exhibition catalogue by Theodore Reff), Washington, D.C.: National Gallery of Art, 1982, no. 18.

5. For Manet, Ellen Andrée posed for *La parisienne* of 1875–76 (Nationalmuseum, Stockholm), *Au Café* of 1878 (Oskar Reinhart Collection, Winterthur), and two pastels, *Tête de jeune fille* and *Jeune femme blonde aux yeux bleus* (Musée d'Orsay, Paris). She originally also posed for *Chez le père Lathuille* of 1879 (Musée des Beaux-Arts, Tournai), but was replaced by a different model. See Rouart and Wildenstein, op. cit., I, nos. 236, 278, 290, II, nos. 8, 9 of pastels. For Renoir, see François Daulte, *Auguste Renoir*, Lausanne: Éditions Durand-Ruel, 1971, I, nos. 288, 379. For a general account of Ellen Andrée's career as a model, see F.F. 1921, pp. 261–64.

6. F.F. 1921, p. 261.

7. F.F. 1921, p. 262.

8. "Degas! He has butchered me enough!" cited in F.F. 1921, p. 261.

PROVENANCE: Atelier Degas (Vente Estampes, 1918, no. 280); bought by Marcel Guérin, Paris (his stamp, Lugt suppl. 1872b, lower left corner, in margin). Otto Wertheimer, Paris; with M. Knoedler and Co., Paris. With Hammer Galleries, New York. Eugene V. Thaw–New Gallery, New York; bought by the museum 1956.

EXHIBITIONS: 1924 Paris, no. 236; 1931 Paris, Orangerie, no. 173, pl. XIII, lent by Marcel Guérin; 1968 Cambridge, Mass., no. 54, repr.; 1984 Chicago, no. 28, repr. (color).

SELECTED REFERENCES: Alexandre 1935, repr. p. 168; Janis 1968, no. 238; Cachin 1974, no. 48, repr.

172.

In a Café (The Absinthe Drinker)

1875–76
Oil on canvas
36¼ × 26¾ in. (92 × 68 cm)
Signed lower left: Degas
Musée d'Orsay, Paris (RF1984)

Lemoisne 393

A notebook Degas used in 1875–77 contains what seems to be the first reference to the work, the statement "Hélène et Desboutin dans un café. 90 c.–67 c.," indicating the size of the work and the name of the models, Ellen Andrée and Degas's good friend Marcellin Desboutin. On two other leaves in the same notebook are a sketch for the setting, the Café de la Nouvelle-Athènes, with notes on color and details, as well as a sketch for a shoe, presumably Ellen Andrée's. On another page is a list of five pictures to be submitted to the second Impressionist exhibition, among them "Dans un café"—this picture.[1] Degas evidently proposed to exhibit the painting, and the catalogue for 1876 actually lists it, again as "Dans un café," under no. 52. However, none of the reviews mention it, and the likelihood is that it was not finished on time. When it was completed, Degas must have sent it to London instead.

As Theodore Reff has pointed out, two weeks after the exhibition closed in Paris, Degas wrote about his "Intérieur de Café" in a letter of 15 May 1876 to Charles Deschamps.[2] The context of the letter suggests that the picture had been sent to London prior to a recent shipment of paintings and

that the work had just been finished. Indeed, the artist worried that it would yellow if not placed in the sun to dry.[3] As Ronald Pickvance has noted, the painting was sold in London to Henry Hill, who a few months later, in September 1876, lent it to the *Third Annual Winter Exhibition* in Brighton, as "A Sketch in a French Café."[4] The qualifying word, "sketch," probably appended to appease possible criticism of its very modern manner of execution, proved unnecessary, as a reviewer cited by Pickvance objected both to the "slap-dash" manner and the "very disgusting novelty of the subject"—the first mention of a topic that was to surface again.[5]

In the spring of 1877, the painting returned to France and appeared, hors catalogue, in the third Impressionist exhibition. This is confirmed by Frédéric Chevalier's review, in which he noted that one of the artist's "most strangely true-to-life drawings, done in a broad style, artless and sincere, shows a rather unsettling woman sitting at a table in a café. Beside her, an artist-etcher, whose modesty is as great as his considerable talent, withdraws into the background, no doubt to avoid being recognized."[6] Although it cannot be proved, it is likely that Degas made an effort to bring the painting back to Paris in 1877 (not having shown it in 1876) to have it viewed in its proper context with several recent scenes of modern life, notably *Women on the Terrace of a Café in the Evening* (cat. no. 174). Short of an attempt to sell the picture on behalf of Henry Hill, there seems to be no other reasonable explanation for its return. Following the exhibition the painting crossed the

Fig. 141. *Marcellin Desboutin*, also known as *Man with a Pipe* (D55), 1876–77. Lithograph, image 3¼ × 2⅞ in. (8 × 7.1 cm)

Fig. 142. Anonymous, *Ellen Andrée as Fanny in "La terre" by Zola*, 1902. Photograph. Private collection

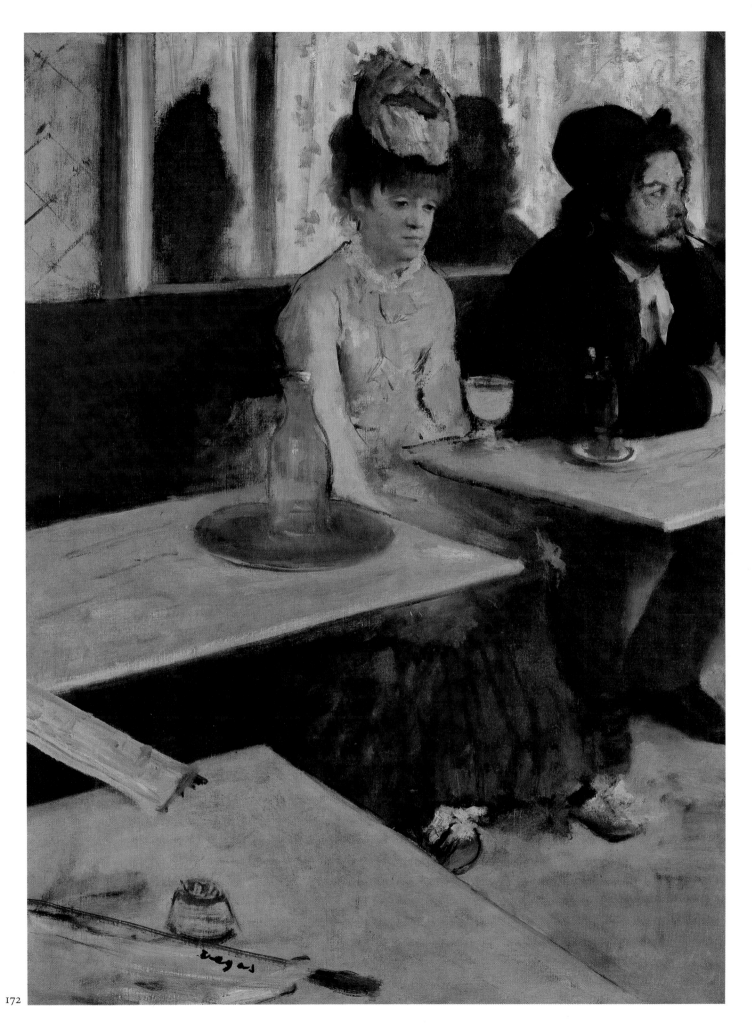

172

Channel once more, and it remained in Hill's collection until his death.

The reappearance of the painting at the Hill sale of 1892 and the subsequent clamor that surrounded its exhibition, as "L'Absinthe," in London in 1893 have been described in detail by the painter Alfred Thornton and by Ronald Pickvance, both of whom have shown the extent to which the event was symbolic for the emancipation of the modernist art movement in England.[7] The subject of the work was seen to be objectionable, and even George Moore found himself hopelessly explaining that the sitters for the painting were not pathological drunks: "The picture represents M. Deboutin [sic] in the café of the *Nouvelle-Athènes*. He has come down from his studio for breakfast, and he will return to his dry-points when he has finished his pipe. I have known M. Debouin a great number of years, and a more sober man does not exist."[8] Only Dugald S. MacColl maintained the argument above the level of the subject, referring to the work as the "inexhaustible picture, the one that draws you back, and back again."[9] However, this curious episode sufficiently marked the painting to lead a biographer of Desboutin as late as 1985 to point out that he did not drink.[10]

X-radiography suggests that Degas made surprisingly few alterations to the composition. The bottle in front of Ellen Andrée was changed slightly, the newspaper that connects the two tables was originally placed at a somewhat different angle, and Ellen Andrée's face may have been defined at first with greater precision. From the evidence, it is clear that the work was painted directly, without the benefit of preparatory drawings, and this may account for the great sense of spontaneity it conveys. Of course Degas knew his models, and this may have given him an added sense of confidence. Desboutin, whom he saw almost daily in 1876, appears in a related monotype (J233, Bibliothèque Nationale, Paris) used also for a lithograph (fig. 141), as well as in a portrait with another friend, Ludovic Lepic (L395, Musée d'Orsay, Paris). When questioned some forty-five years after the event, Ellen Andrée remembered only vaguely that she posed for "a café scene for Degas. I am sitting in front of an absinthe, Desboutin in front of a soft drink—what a switch! And we look like a couple of idiots."[11]

1. Reff 1985, Notebook 26 (BN, Carnet 7, pp. 68, 74, 87, 90).
2. See the letter (dated by Reff 1876) in Reff 1968, p. 90.
3. Reff 1968, p. 90.
4. Ronald Pickvance, "'L'absinthe' in England," *Apollo*, LXXVII:15, May 1963, pp. 395–96.
5. Ibid., p. 396.
6. Chevalier 1877, pp. 332–33.

7. Alfred Thornton, *The Diary of an Art Student of the Nineties*, London: Sir Isaac Pitman and Sons, 1938, pp. 22–33; Pickvance, op. cit., pp. 397–98.
8. George Moore, "The New Art Criticism," *Spectator*, 25 March, 1 and 8 April 1893, reprinted in Flint 1984, p. 291.
9. Dugald S. MacColl, "The Inexhaustible Picture," *Spectator*, LXX, 25 February 1893, reprinted in Flint 1984, p. 281.
10. "But Desboutin was abstemious, and, from that point to being a barfly, there is a range of behavior that false exaggeration and the frantic search for the picturesque do not excuse. Furthermore, Degas, in asking his friends to pose for his painting, only wished to show his aversion to alcoholism"; Bernard Duplaix, *Marcellin Desboutin, Prince des Bohèmes*, Moulins-Yzeure: Les Imprimeries Réunies, 1985, p. 60. For an earlier, similar defense, see Pickvance, op. cit., p. 398.
11. See F. F. 1921, p. 263.

PROVENANCE: Sent by the artist in spring 1876 to Charles W. Deschamps, London; bought by Captain Henry Hill, Brighton, before September 1876 (Hill sale, Christie's, London, 20 February 1892, no. 209 [as "Figures at a Café"], for £180); bought by Alexander Reid, Glasgow; bought by Arthur Kay, Glasgow; returned to Reid and repurchased by Kay, with *Dancers in the Rehearsal Room, with a Double Bass* (cat. no. 239), before February 1893; sold by Kay to Martin et Camentron, Paris, April 1893; bought by Comte Isaac de Camondo, Paris, May 1893, for Fr 21,000 (as "L'apéritif"); his bequest to the Louvre 1908; entered the Louvre 1911.

EXHIBITIONS: (?) 1876 Paris, no. 52 (as "Dans un café"); 1876, Brighton, Royal Pavilion Gallery, opened 7 September, *Third Annual Winter Exhibition of Modern Pictures*, no. 166 (as "A Sketch in a French Café"), lent by Captain Henry Hill; 1877 Paris, hors catalogue; 1893, London, Grafton Galleries, opened 18 February, *Paintings and Sculpture by British and Foreign Artists of the Present Day*, no. 258 (as "L'Absinthe"), lent by Arthur Kay; 1924 Paris, no. 59; 1931 Paris, Orangerie, no. 65; 1937 Paris, Orangerie, no. 25; 1945, Paris, Musée du Louvre, *Chefs d'oeuvre de la peinture*, no. 14; 1955, New York, Museum of Modern Art, spring, "15 Paintings by French Masters of the Nineteenth Century" (no catalogue); 1964–65 Munich, no. 82, repr. (color); 1969 Paris, no. 26; 1979 Edinburgh, no. 39, pl. 8 (color); 1983, London, The Courtauld Collection, April–August, on loan.

SELECTED REFERENCES: *Brighton Gazette*, 9 September 1876, p. 7; Chevalier 1877, pp. 332–33; [John A. Spender?], "Grafton Gallery," *Westminster Gazette*, 17 February 1893, p. 3; "L'absinthe," *The Times*, London, 20 February 1893, p. 8; "The Grafton Gallery," *The Globe*, 25 February 1893, p. 3; Dugald S. MacColl, "The Inexhaustible Picture," *Spectator*, LXX, 25 February 1893, p. 256; "The Grafton Gallery," *Artist*, XIV, March 1893, p. 86; [Charles Whibley?], [Review of Grafton Gallery exhibition], *National Observer*, 4 March 1893, p. 388; [John A. Spender], "The New Art Criticism: A Philistine's Remonstrance," *Westminster Gazette*, 9 March 1893, pp. 1–2; Dugald S. MacColl, "The Standard of the Philistine," *Spectator*, LXX, 18 March 1893, pp. 357–58; George Moore, "The New Art Criticism," *Spectator*, 25 March, 1 and 8 April 1893, reprinted in Flint 1984, p. 291; Arthur Kay, letter to *Westminster Gazette*, 29 March 1893; Charles W. Furse, "The Grafton Gallery, A Summary," *The Studio*, I:1, April 1893, pp. 33–34; Alfred L. Baldry, "The Grafton Galleries," *The Art Journal*, 1893, p. 147; Alexandre 1908, p. 32 (as "L'apéritif"); Lemoisne 1912, pp. 67–68, pl. XXVI; Jamot 1914, pp. 458–59, repr. facing p. 458; Paris, Louvre, Camondo, 1914, pl. 14; Lafond 1918–19, I, p. 44, II, repr. pp. 4–5; Meier-

Graefe 1920, pl. XL; Jamot 1924, pp. 98–99, 145, pl. 42; Lemoisne 1924, p. 98; Sascha Schwabacher, "Die Impressionister der Sammlung Camondo im Louvre," *Cicerone*, XIX:12, 1927, p. 371, repr.; Alfred Thornton, *The Diary of an Art Student of the Nineties*, London: Sir Isaac Pitman and Sons, 1938, pp. 22–33, repr. p. 27; Rewald 1946, repr. p. 305; Lemoisne [1946–49], II, no. 393; "15 Paintings by French Masters of the Nineteenth Century Lent by the Louvre and the Museums of Albi and Lyons," The Museum of Modern Art, *Bulletin*, XXII:3, Spring 1955, p. 7, repr. p. 18; Cabanne 1957, pp. 23, 98, 112, pl. 62 (color); Rewald 1961, p. 399, repr. p. 398; Ronald Pickvance, "'L'absinthe' in England," *Apollo*, LXXVII:15, May 1963, pp. 395–98, pl. iv (color) p. 397; Reff 1968, p. 90; Rewald 1973, pp. 399, 401, repr. p. 398; Reff 1977, fig. 30 and detail; Reff 1985, pp. 19–20, Notebook 26 (BN, Carnet 7, pp. 90, 87, 74, 68); Lipton 1986, pp. 42–48; Sutton 1986, pp. 210–11, fig. 196 (color) p. 209; Paris, Louvre and Orsay, Peintures, 1986, III, p. 194.

173.

Woman in a Café

c. 1877
Pastel over monotype in black ink
Plate: 5⅛ × 6¾ in. (13.1 × 17.2 cm)
Signed in pastel at left and bottom right: Degas
Private collection, New York

Exhibited in Ottawa and New York

Lemoisne 417

Not as well known as the related *Women on the Terrace of a Café in the Evening* (cat. no. 174), this pastel is also the least complex of the three works Degas devoted to the subject. The woman represented is recognizably a prostitute playing a game of solitaire as she waits for a client at the table of a café. The structure of the image is simple, allowing for sharp characterization of the single figure boldly placed at the center of the composition. The woman's face is carefully described but in an unreservedly amusing manner. She is very painted, there is more than a hint of the wanton about her, and her eyes are on the lookout as she spasmodically fingers the cards with her clawlike gloved hands. It is a sardonic but inspired image, very much in the tradition of Daumier.

The first known owner of the pastel was Carl Bernstein, a Berlin collector and cousin of Charles Ephrussi, publisher of the *Gazette des Beaux-Arts*. Ephrussi, whom Degas knew well, favorably reviewed the artist's contributions to the Impressionist exhibitions of 1880 and 1881. He owned at least two drawings of dancers by Degas and also bought, among other works, *General Mellinet and Chief Rabbi Astruc* (cat. no. 99) and *At the Milliner's* (fig. 210). Ephrussi's secretary, the poet Jules Laforgue, who subsequently

lived in Berlin and was close to the Bernsteins, was also enthusiastic about Degas and interested Max Klinger in his work. In the early 1880s, when the Bernsteins came to Paris, Ephrussi introduced them to modern French painting with notable results. They bought works by Manet, Monet, Morisot, Pissarro, Cassatt, and others, some of which were exhibited in Berlin in 1883. In addition to *Woman in a Café*, Bernstein owned two other small pastelized monotypes by Degas: *Cabaret Singer* (L539) and *At the Washbasin* (L1199, private collection).[1]

1. Charles Ephrussi was close enough to Degas to be invited to his housewarming dinner at the time the artist moved to 21 rue Pigalle. See Lettres Degas 1945, XX, p. 48; Degas Letters 1947, no. 29, p. 53. Degas had evidently accepted payments from him for a work, or works, which he had failed to deliver by April 1882. See Eugène Manet's letter in Chronology III, April 1882. For Ephrussi, without reference to Degas, see the fascinating account in Philippe Kolb and Jean Adhémar, "Charles Ephrussi (1849–1905), ses secrétaires: Laforgue, A. Renan, Proust, 'sa' Gazette des Beaux-Arts," *Gazette des Beaux-Arts*, CIII:1380, January 1984, pp. 29–41. For the Bernsteins as collectors, again without reference to Degas, see Nicholaas Teeuwisse, *Vom Salon zur Secession*, Berlin: Deutscher Verlag für Kunstwissenschaft, 1985, pp. 98–101, 103–04, 106–07.

PROVENANCE: [Probably Durand-Ruel, Paris, and Paul Cassirer, Berlin]; Carl Bernstein, Berlin; bought by Durand-Ruel, Paris, 22 October 1917 (stock no. 11097); bought by Durand-Ruel, New York, 6 November 1917; bought by Henry R. Ickelheimer, New York, 3 (or 10) November 1919; with M. Knoedler and Co., New York; present owner.

EXHIBITIONS: 1968 Cambridge, Mass., no. 15, repr.; 1982–83, Washington, D.C., National Gallery of Art, 5 December 1982–6 March 1983, *Manet and Modern Paris: One Hundred Paintings, Drawings, Prints and Photographs by Manet and His Contemporaries*, no. 24, repr.

SELECTED REFERENCES: Vollard 1924, repr. p. 4; Lemoisne [1946–49], II, no. 417; Janis 1967, p. 76, fig. 47; Janis 1968, no. 59; Cachin 1974, p. 281; Minervino 1974, no. 431; Jean-Jacques Lévêque, *Degas*, Paris: Siloé, 1978, p. 85, repr.; Sutton 1986, p. 211, fig. 199 (color) p. 212.

174.

Women on the Terrace of a Café in the Evening

1877
Pastel over monotype on white wove paper
16⅛ × 23⅝ in. (41 × 60 cm)
Signed upper right: Degas
Musée d'Orsay, Paris (RF12257)

Exhibited in Paris

Lemoisne 419

Prospective visitors to the opening of the third Impressionist exhibition were told by a newspaper a day in advance that Degas would show several "dessins" (drawings),[1] of which the most important was *Women on the Terrace of a Café in the Evening*. Though facing a good deal of competition from an uncommonly varied series of works that included several splendid café-concert scenes, the pastel attracted considerable attention and completely overshadowed *In a Café (The Absinthe Drinker)* (cat. no. 172), exhibited in the same room. The subject, prostitutes chatting on the boulevard, was undoubtedly considered sensational, but no less so than its rendition. Alexandre Pothey noted that "M. Degas appears to have thrown a challenge to the philistines," an idea echoed by Paul Mantz, who was convinced that for Degas "the idea of disconcerting the bourgeois is one of his most enduring preoccupations."[2] Pothey also wrote about the "terrifying realism" of these "painted, faded creatures, exuding vice, who cynically tell each other about their day's activities and accomplishments," but others found the work brilliantly satirical.[3] However, according to Daniel Halévy's diary, in old age Degas himself thought the pastel "rather on the cruel, cynical side."[4]

A slight sense of unease about the work can be detected as late as 1912 (by which time it had been exhibited at the Musée du Luxembourg for fifteen years) in Lemoisne's account of it: "The rendition of the women seems brutal. Degas's superb draftsmanship was perhaps sacrificed a little for the sake of exaggeratedly realistic effects and the demands of the composition."[5] The composition is, in truth, remarkable, with a carefully controlled architecture that gives the illusion of great informality. To the right, in a framed, perfect square, two women carry on a conversation. One of them is slumped in a chair while the other, leaning toward her across the table, in Georges Rivière's words, "clicks her fingernail against her teeth, saying, '*not even that*,'" her report of a client's lack of generosity.[6] To the left, another woman, cut in two by the foreground pillar, leans in the opposite direction, chatting with her neighbor. But there is no real narrative here. Instead, Degas offers a series of acute observations on human behavior.

1. "Échos et nouvelles," *Le Courrier de France*, 4 April 1877.
2. See Pothey 1877, p. 2, and Mantz 1877, p. 3. For other views, see Rivière 1877, p. 6, and the anonymous reviewer who saw in it, and other works, "small masterpieces of sharp and witty satire," *La Petite République Française*, 10 April 1877.
3. Pothey 1877, p. 2.
4. Halévy 1960, p. 113; Halévy 1964, p. 93.
5. Lemoisne 1912, pp. 73–74.
6. Rivière 1877, p. 6.

PROVENANCE: Gustave Caillebotte, Paris, by April 1877; deposited with Durand-Ruel, Paris, 29 January 1886 (deposit no. 4690); consigned by Durand-Ruel to the American Art Association, New York, 19 February–8 November 1886; returned to Caillebotte, 30 November 1886; his bequest to the Musée du Luxembourg, Paris, 1894; entered the Musée du Luxembourg 1896; transferred to the Louvre 1929.

EXHIBITIONS: 1877 Paris, no. 37, lent by Caillebotte; 1886 New York, no. 35; 1915, San Francisco, summer, Panama-Pacific International Exposition, Department of Fine Art, French Section, no. 23; 1916, Pittsburgh, Carnegie Institute, 27 April–30 June,

173

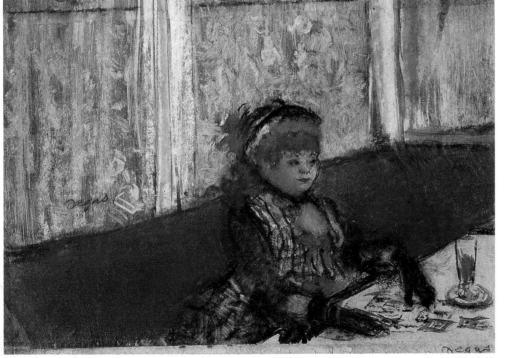

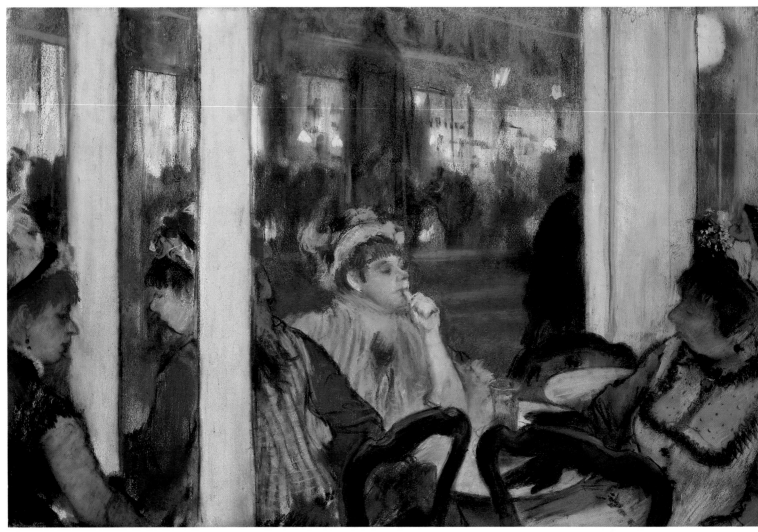

174

Founder's Day Exhibition: French Paintings from the Museum of Luxembourg, and Other Works of Art from the French, Belgian and Swedish Collections Shown at the Panama-Pacific International Exposition, Together with a Group of English Paintings, no. 21; 1916, Buffalo, Albright Art Gallery, 29 October–December, *Retrospective Collection of French Art, 1870–1910, Lent by the Luxembourg Museum, Paris, France*, no. 20; 1924 Paris, no. 120; 1949 Paris, no. 99; 1955, Paris, Musée National d'Art Moderne, *Bonnard, Vuillard et les Nabis (1888–1903)*, no. 52; 1956 Paris; 1969 Paris, no. 178; 1974, Paris, Cabinet des Dessins, Musée du Louvre, "Pastels, cartons, miniatures, XVI–XIXe siècles" (no catalogue); 1975–76, Paris, Cabinet des Dessins, Musée du Louvre, "Nouvelle présentation: pastels, gouaches, miniatures" (no catalogue); 1980–81, Paris, Cabinet des Dessins, Musée du Louvre, November 1980–19 April 1981, *Pastels et miniatures du XIXe siècle: acquisitions récentes du Cabinet des Dessins*, hors catalogue; 1985 Paris, no. 64, repr.

SELECTED REFERENCES: Jacques 1877, p. 2; Pothey 1877, p. 2; Rivière 1877, p. 6; "Exposition des impressionnistes," *La Petite République Française*, 10 April 1877, p. 2; Bénédite 1894, p. 132, repr. p. 131; Marx 1897, repr. p. 323; Mauclair 1903, p. 394, repr. p. 391; Lemoisne 1912, pp. 73–74, repr.; Lafond 1918–19, I, p. 53, repr.; Meier-Graefe 1920, pl. XLIV; Jamot 1924, pl. 45; Rouart 1937, repr. p. 18; Rouart 1945, pp. 56, 74 n. 83; Lemoisne [1946–49], I, pp. 88, 104, repr. (detail) facing p. 132, II, no. 419; Leymarie 1947, no. 29, pl. XXIX; Cabanne 1957, pp. 35, 43, 98, 113, pl. 69; Halévy 1964, p. 93; Valéry 1965, pl. 86; Janis 1968, no. 58; Cachin 1974, p. 281, repr.; Minervino 1974, no. 430; Koshkin-Youritzin 1976, p. 35; Keyser 1981, pp. 38, 46, 62, 101, pl. III (color); Hollis Clayson, "Prostitution and the Art of Later Nineteenth-Century France: On Some Differences between the Work of Degas and Duez," *Arts Magazine*, LX:4, December 1985, pp. 42–45, fig. 6 p. 44; Siegfried Wichmann, *Japonisme*, New York: Park Lane, 1985, p. 255, fig. 676; Paris, Louvre and Orsay, Pastels, 1985, no. 64.

175.

The Song of the Dog

c. 1876–77
Gouache and pastel over monotype on three
 pieces of paper joined
Image: 22⅝ × 17⅛ in. (57.5 × 45.4 cm)
Sheet: 24¾ × 20⅛ in. (62.7 × 51.2 cm)
Signed lower right: Degas
Private collection

Lemoisne 380

The fashion for café-concerts, which combined the attractions of pub and concert hall, emerged in Paris in the 1830s and quickly became an established feature of Parisian life, reaching a height of popularity in the 1870s. They usually presented quite a varied program, in a fairly ritualized format in three parts, with singers and comics appearing in the opening numbers. People were free to move about as they pleased, and drinks were served during the performance. In the summer, the outdoor café-concerts on the Champs-Élysées, such as the Alcazar-d'Été and the Café des Ambassadeurs, both of which opened in the early 1870s, were in great favor. They attracted huge audiences and, in the evening, a good many prostitutes. The performers were always witty and up to date, making the café-concert, in Gustave Coquiot's words, "in reality a school of sharp news reporting, of current commentary, celebrated and sung," an aspect of modern life Degas was not very likely to miss.[1]

Subjects inspired by the café-concert, principally singers in performance, appeared

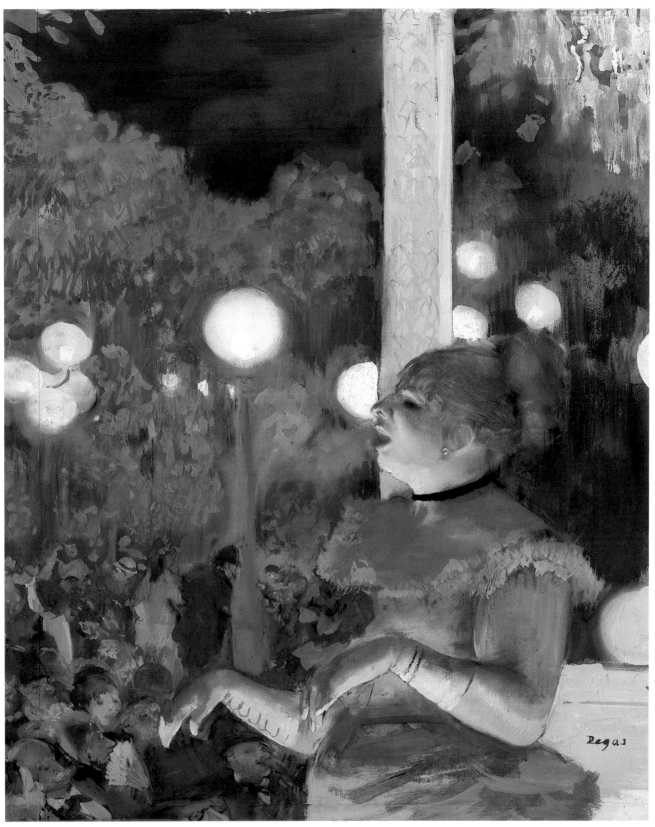

175

rather suddenly in Degas's work. In 1876–77, he produced a number of monotypes on the theme, some of which, reworked in pastel, were exhibited in 1877 with considerable success. As Douglas Druick and Peter Zegers have shown, *The Song of the Dog* began as a smaller monotype of the singer's head and torso, and was subsequently enlarged on three of the four sides with strips of paper to include the audience and a landscape.[2] The singer has been recognized as the famous Thérésa—her real name was Emma Valadon—who already in the late 1860s was said to command an annual salary of Fr 30,000.[3] In 1876–77, she was not quite forty, two years younger than Degas. In a letter of 1883 to the painter Henry Lerolle, Degas called her voice "the most natural, the most delicate, and the most vibrantly tender" instrument imaginable. Jeanne Raunay, herself a singer, shrewdly noted of Degas: "I don't believe that music alone, symphonic music, would have satisfied him. He needed words that he could hear, legs that he could see, human sounds, physiognomies that would move and interest him—in short, physical traits and features that, for him, complemented the melodic line."[4]

In *The Song of the Dog*, or "La chanson du chien," as it is popularly known, much is contained in the artist's rendering of the physical presence of the singer—her pleasant face luridly lit by the footlights, her stout body securely encased in her tight dress, and her graphic, pawlike gestures. Seen from the closest possible vantage point, she dominates her audience from the height of the stage, ridiculous but real, genuinely absorbed in her song. The background, hazy with light from the globes scattered in the garden, is no less keenly observed. A mustachioed old man has fallen asleep, a young woman peers from behind a cluster of heads, a waiter takes an order, and, in the background, a couple leaves during the performance.

In a Degas notebook once owned by Ludovic Halévy and inscribed in Halévy's hand with the date 1877, there are several sketches of Thérésa, including two showing her in the pose of *The Song of the Dog* (fig. 101).[5] There are numerous reasons to think that the notebook does indeed date from 1877, though at least two of the sketches in it appear to have served for pastelized monotypes exhibited in April 1877, which places something of a strain on the period of time during which Degas could have produced them.[6]

An additional pencil study (III:305) on an independent sheet of the same size as the notebook also exists. Degas repeated the composition in a lithograph of a narrower, upright format (RS25), and in 1888 George William Thornley reproduced the gouache in a lithograph that follows it closely.

1. Gustave Coquiot, *Les cafés-concerts*, Paris: Librairie de l'Art, 1896, p. 1.
2. See Druick and Zegers in 1984–85 Boston, pp. xxxv–xxxvi, xxxviii, fig. 19.
3. For more information about Emma Valadon (1837–1913), see Shapiro 1980, pp. 158–60.
4. Jeanne Raunay, "Degas: souvenirs anecdotiques," *La Revue de France*, XI:2, 15 March 1931, p. 269. The letter, first published by Jeanne Raunay, appears also in Lettres Degas 1945, XLVIII, pp. 74–75; Degas Letters 1947, no. 57, p. 76 (translation revised).
5. For the two closest sketches, see Reff 1985, Notebook 28 (private collection, p. 11); see also fig. 101. Two additional sketches appear on pp. 37 and 63 of the same notebook and certainly represent Thérésa. One of these was sketched again on a page in another notebook and has been identified by Theodore Reff as a study for *Women on the Terrace of a Café in the Evening* (cat. no. 174); see Reff 1985, Notebook 27 (BN, Carnet 3, p. 95) and Notebook 28 (private collection, pp. 37, 63); two of the caricatures of heads shown in the upper right corner of p. 7 in the latter notebook may have served as models for faces in the audience in *The Song of the Dog*.
6. See Reff 1985, Notebook 28 (private collection); the two bottom figures on p. 15 of this notebook are connected with the principal figures in *Café-concert at the Ambassadeurs* (L405, Musée des Beaux-Arts, Lyons) and *Cabaret* (fig. 128). The first of these pastels was shown in the third Impressionist exhibition and was described in detail in reviews.

PROVENANCE: Henri Rouart, Paris (Henri Rouart sale, Galerie Manzi-Joyant, Paris, 16–18 December 1912, no. 71, for Fr 50,100); bought by Durand-Ruel as agent for Mrs. H. O. Havemeyer, New York; Mrs. H. O. Havemeyer, to 1929; Horace O. Havemeyer, her son, New York, 1929–56; Doris Dick Havemeyer, his widow, New York (Havemeyer sale, Sotheby Parke Bernet, New York, 18 May 1983, no. 12, repr.). Present owner.

EXHIBITIONS: 1915 New York, no. 35 (as 1881); 1917, Paris, Galerie Rosenberg, 25 June–13 July, *Exposition d'art français du XIX siècle*, no. 25; 1936 Philadelphia, no. 36; 1941, New York, M. Knoedler and Co., 1–20 December, *Loan Exhibition in Honor of Royal Cortissoz and His 50 Years of Criticism in the New York Herald Tribune*, no. 23, lent by Mrs. Horace Havemeyer.

SELECTED REFERENCES: Hourticq 1912, p. 105, repr.; Lafond 1918–19, II, p. 37; Jamot 1924, p. 146, pl. 44; Vollard 1924, pl. 20 (as "The Song"); Havemeyer 1931, p. 381; Lemoisne [1946–49], II, no. 380; Havemeyer 1961, pp. 245–56; Minervino 1974, no. 414; Reff 1976, p. 283, fig. 187 (detail); Shapiro 1980, pp. 157–58, 160, 164 n. 21.

176.

Mlle Bécat at the Café des Ambassadeurs

Émilie Bécat, who had her hour of fame as a café-concert singer in the late 1870s before becoming briefly and unsuccessfully the owner of the Gaîté-Rochechouart, made her debut at the Café des Ambassadeurs in 1875. She had a strong voice but astonished her public chiefly with her extraordinary repertoire of movements and jumps, which made history as "le style épileptique." Her songs were undoubtedly on the outrageous side, enough to provoke in 1875 the intervention of censors and a well-organized defense by writers and journalists, such as Jules Claretie, one of Degas's friends.[1] Degas evidently enjoyed her performances enormously and recorded her in a number of notebook sketches and a few other works, including two lithographs.[2]

Mlle Bécat at the Café des Ambassadeurs forms part of a group of lithographs that are doubtless contemporary, or almost so, and represent the artist's earliest efforts in a new direction. Three of these contain several subjects on one sheet, including, again, Mlle Bécat (RS27, RS28, RS30). They were produced with the aid of monotypes datable to 1876—which indicates a date for Degas's first experiments in this unfamiliar medium. Three other lithographs are devoted to single figures, café-concert singers in performance. This one of Mlle Bécat, perhaps best known of the group and likely the most accomplished, has no known antecedent, though it relates to identifiable studies.

Degas's technical skill and the unconventional manner in which he brought about the splendid, complicated treatment of light in a nocturnal setting have been discussed by Theodore Reff and by Sue Reed and Barbara Shapiro, who have also noted that a lost monotype may have been the point of departure.[3] The lithograph, as they have shown, is nevertheless the result of extensive work in lithographic crayon that in some areas, notably the chandelier and the fireworks, has been scraped with a tool to brilliant effect. The composition contains a number of Degas's favorite motifs—the vertical architectural elements that recur in the contemporary *Women on the Terrace of a Café in the Evening* (cat. no. 174), and truncated double basses and hats in the foreground. An expanded impression of the lithograph was worked up in pastel in 1885 (cat. no. 264).

1. For Émilie Bécat, see Anne Joly, "Sur deux modèles de Degas," *Gazette des Beaux-Arts*, LXIX: 1180–81, May–June 1967, pp. 373–74; and Shapiro 1980, pp. 156–57, 163–64 n. 17.

2. For studies directly connected with the lithograph, see Reff 1985, Notebook 27 (BN, Carnet 3, pp. 89, 92, showing, respectively, the light globes and Émilie Bécat). Other sketches of Mlle Bécat, including one of her in a similar pose, appear in a notebook dated 1877–80 by Theodore Reff; see Reff 1985, Notebook 29 (private collection, pp. 13, 15).
3. Reff 1976, pp. 282–88; Reed and Shapiro 1984–85, no. 31.

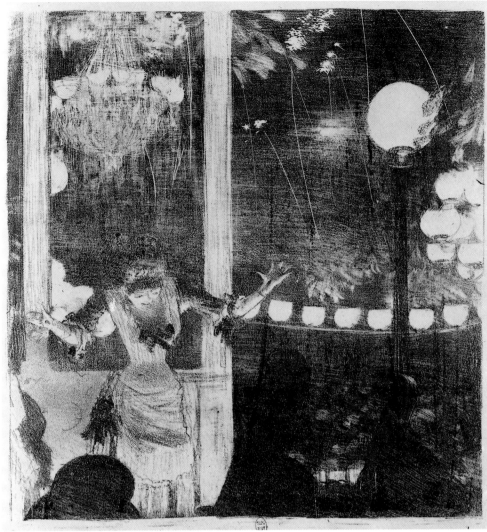

176b

176a.

Mlle Bécat at the Café des Ambassadeurs

1877–78
Lithograph on buff wove paper
Plate: 9 × 7⅝ in. (20.4 × 19.4 cm)
Sheet: 13½ × 10¾ in. (34.4 × 27.2 cm)
Atelier stamp lower right corner of sheet
National Gallery of Canada, Ottawa (23352)

Exhibited in Ottawa and New York

Reed and Shapiro 31/Adhémar 42

PROVENANCE: Atelier Degas (Vente Estampes, 1918, part of lots 115–28); bought by Henri A. Rouart, Paris, until 1944; Denis Rouart, his son, Paris, until 1968; with William H. Schab Gallery, Inc., New York; Donald H. Karshan, New York, by 1970; bought by the museum through Margo Schab 1979.

EXHIBITIONS: 1970, New York, City Center, 8 March–April/Indianapolis Museum of Art, November–December, *The Donald Karshan Collection of Graphic Art*; 1979–80 Ottawa; 1981, Ottawa, National Gallery of Canada, 1 May–14 June/Montreal Museum of Fine Arts, 9 July–16 August/Windsor, Ont., Windsor Art Gallery, 13 September–14 October, *La pierre parle: Lithography in France, 1848–1900*, no. 92 (catalogue by Douglas Druick and Peter Zegers).

SELECTED REFERENCES: Beraldi 1886, p. 153 (as "Chanteuse"); Alexandre 1918, repr. p. 18; Lafond 1918–19, II, pp. 38, 73; Delteil 1919, no. 49 (as c. 1875); Rouart 1945, pp. 66, 77 n. 10; *Lithographs by Degas* (exhibition catalogue by William M. Ittmann, Jr.), Saint Louis: Washington University, 1967, no. 3, repr.; Anne Joly, "Sur deux modèles de Degas," *Gazette des Beaux-Arts*, LXIX:1180–81, May–June 1967, p. 373 (as dated 1877); Joseph T. Butler, "The Donald Karshan Collection of Graphic Art," *Connoisseur*, CLXXIII:697, March 1970, repr. p. 227; Adhémar 1974, no. 42 (as c. 1877), repr.; Passeron 1974, pp. 64–68, 214; Reff 1976, pp. 287–88; Reed and Shapiro 1984–85, no. 31 (as 1877–78); Reff 1985, pp. 128–29, 132.

176b.

Mlle Bécat at the Café des Ambassadeurs

1877–78
Lithograph on buff-tan, moderately thin, smooth, wove paper
Plate: 9 × 7⅝ in. (20.4 × 19.4 cm)
Sheet: 13¾ × 10¾ in. (35 × 27.3 cm)
Bibliothèque Nationale, Paris (A.09141)

Exhibited in Paris

Reed and Shapiro 31a/Adhémar 42

PROVENANCE: Alexis Rouart, Paris, until 1911 (his stamp, Lugt suppl. 2187a); Henri A. Rouart, his son, Paris; acquired from him by the Bibliothèque Nationale 1932.

EXHIBITIONS: 1924 Paris, no. 211; 1974 Paris, no. 191, repr.; 1984–85 Boston, no. 31a, fig. 31.

SELECTED REFERENCES: Beraldi 1886, p. 153 (as "Chanteuse"); Alexandre 1918, repr. p. 18; Lafond 1918–19, II, pp. 38, 73; Delteil 1919, no. 49 (as c. 1875); Rouart 1945, pp. 66, 77 n. 10; *Lithographs by Degas* (exhibition catalogue by William M. Ittmann, Jr.), Saint Louis: Washington University, 1967, no. 3; *Inventaire du fonds français après 1800*, VI (catalogue by Jean Adhémar and Jacques Lethève), Paris: Bibliothèque Nationale, Département des Estampes, 1953, p. 111, no. 37; Anne Joly, "Sur deux modèles de Degas," *Gazette des Beaux-Arts*, LXIX:1181, May–June 1967, p. 373 (as dated 1877); Adhémar 1974, no. 42 (as c. 1877); Passeron 1974, pp. 64–68, 214; Reff 1976, pp. 287–88; Reed and Shapiro 1984–85, no. 31a (as 1877–78), repr.; Reff 1985, pp. 128–29, 132.

177.

Two Studies for Music Hall Singers

1878–80
Pastel and charcoal on gray paper
17⅞ × 22⅞ in. (45.2 × 58.2 cm)
Signed in charcoal lower left: Degas
Private collection, New York

Exhibited in New York

Lemoisne 504

This is the finest of several sheets of studies connected with a work on the theme of the café-concert. It appears that two women rather than one posed for all the drawings, in two different costumes—a chemise and a dress with black trimmings. In all the studies, they are shown as they perform a song. In a drawing once owned by Piero Romanelli (an acquaintance of Degas's) and now in a private collection in Chicago, the model in the chemise appears twice, with her right arm raised. In another drawing (III:335.1), she holds her left arm with the right. A third study in pastel (L507) shows the dressed model with her arms lowered. A final pastel study (L506), showing both models wearing the same dress, served for a finished pastel (L505) in the Corcoran Gallery of Art, Washington, D.C. The Corcoran work actually represents a sister act in a setting that is somewhat too well dressed with props, including

a chimneypiece, to easily pass for a café-concert stage.

In spite of a temptation to recognize in this study the same model observed from two different angles, the discrepancy in costume and in features is sufficiently pronounced to discourage such conjecture. Nevertheless, the figures hold the same pose, with shoulders hunched, palms turned upward in a hopeless gesture, appearing to ask the same plaintive question. The figure to the left, vigorous but more pathetic and moving than the other, also has more individualized features, recognizably those of one of the two models in the other drawings. The figure to the right, partly heightened with color, has more generalized facial characteristics, with carefully worked-out effects of light—including a reflection on the cheek—that contrast with the splendidly expressive hands emerging from a dark mass of erasures and corrections.

PROVENANCE: Boussod, Valadon et Cie, Paris; Albert S. Henraux, Chantilly, by 1922. With Paul Rosenberg, New York, 1956; Mrs. John Wintersteen, Philadelphia [acquired 1956?] (sale, Sotheby Parke Bernet, New York, 21 May 1981, no. 525, repr. [color]); bought at that sale by present owner.

EXHIBITIONS: 1924 Paris, no. 166, lent by Albert S. Henraux; 1932, Paris, Galerie Paul Rosenberg, 23 November–23 December, *Pastels et dessins de Degas*, no. 31; 1936, Paris, Bernheim-Jeune, for the Société des Amis du Louvre, 25 May–13 July, *Cent ans de théâtre, music-hall et cirque*, no. 26, lent by Albert S.

Henraux; 1937 Paris, Orangerie, no. 116, lent by Albert S. Henraux; 1958 Los Angeles, no. 31, lent by Mrs. John Wintersteen; 1966, San Francisco, California Palace of the Legion of Honor, 10 June–24 July/Santa Barbara Museum of Art, 2 August–4 September, *The Collection of Mrs. John Wintersteen*, no. 5, repr.; 1967 Saint Louis, no. 82, repr.

SELECTED REFERENCES: André Fontainas and Louis Vauxcelles, *Histoire générale de l'art français de la Révolution à nos jours*, Paris: Librairie de France, I, repr. p. 197; Rivière 1922–23, II, no. 90 (reprint edition 1973, pl. F [color]); Lemoisne [1946–49], II, no. 504; Cooper 1952, no. 13, repr. (color); Rosenberg 1959, pp. 116–17, pl. 224; Minervino 1974, no. 574; 1984–85 Washington, D.C., fig. 3.7.

178, 179.

At the Café des Ambassadeurs

One of Degas's most eccentric compositions, this is also his largest etching. As Eugenia Janis has shown, the idea originated with a small monotype (J31) now in the Saarland-Museum, Saarbrucken. The scene is actually viewed from behind the stage of the Café des Ambassadeurs through an opening in the wood enclosure of the garden. At the bottom and to the far right, elements of the palisade frame the image. Farther toward the center, the second dark vertical element is a tree, and beyond it and above is a striped awning. On the stage, dimly lit by a cluster of gaslights, a singer appears to be bowing to her public, while in the left foreground sits one of the "poseuses" who usually graced the stage during the performance of a singer.[1]

The etching is known in five states, of which the third and the fifth are the most successful. In the third state, the architecture dominates and accentuates the rhythm, the atmosphere is more mysterious, and the action of the performance emerges only dimly out of the darkness. This effect is particularly noticeable in the impression shown here (now in the Bibliothèque Nationale), pulled from a plate that was only partially wiped in the area of the gas globes. The noticeable difference in inking from impression to impression is a characteristic of prints produced in the Impressionist milieu which, as pointed out by Michel Melot, generally placed the individual qualities of each exemplar above the uniformity desirable in an edition.[2] In the fifth state, several elements have been altered and the scene emerges more clearly. The contrast between

177

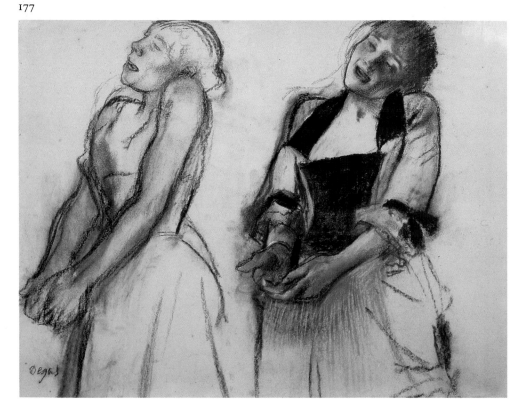

the background and the illuminated awning has been strengthened, the singer and the poseuse have been defined in more pronounced fashion, and the tree to the right has been expanded.

Dated too early by Loys Delteil—1875—the etching was assigned a date of about 1877 by Jean Adhémar and Michel Melot, situating it at the height of Degas's interest in café-concert subjects. Recently, however, Sue Reed and Barbara Shapiro have redated it 1879–80[3]—that is, at the time when Degas was at his most active in preparing etchings for the proposed publication *Le Jour et la Nuit*. As with most of the other etchings, one or at most a small number of impressions of each state is known. An impression of the third state was reworked by Degas in pastel in 1885 (cat. no. 265).

1. Gustave Coquiot wrote of the scene: "To get a true picture of this open bordello, we can only regret the disappearance—already in our time—of the 'poseuses' who, placed in a fanlike arrangement on the stage, remained seated throughout the program of vocal numbers" (*Des gloires déboulonnées*, Paris: André Delpeuch, 1924, p. 69).
2. See Melot in 1974 Paris, no. 187.
3. Reed and Shapiro 1984–85, no. 49.

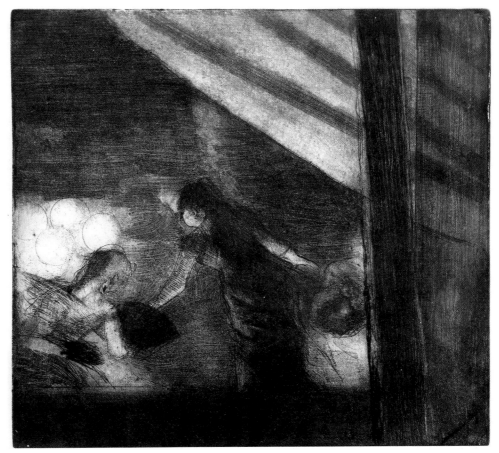

178

179

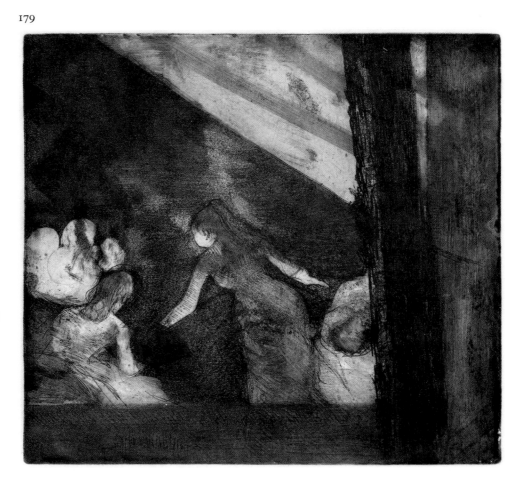

178.

At the Café des Ambassadeurs

1879–80
Etching, soft-ground etching, drypoint, and aquatint on pale buff laid paper, third state
Plate: 10½ × 11⅝ in. (26.6 × 29.6 cm)
Bibliothèque Nationale, Paris (A.09232)

Exhibited in Paris

Reed and Shapiro 49.III / Adhémar 30.II

PROVENANCE: Eugène Bejot (1867–1931), Paris; E. Bejot gift to the Bibliothèque Nationale 1931.

EXHIBITIONS: 1974 Paris, no. 187 (as second state, c. 1877); 1987, Paris, Bibliothèque Nationale, opened 10 September, *Hommage à Jean Adhémar* (no catalogue).

SELECTED REFERENCES: Delteil 1919, no. 27 (as c. 1875); Rouart 1945, pp. 64, 66, 74 n. 107; *Inventaire du fonds français après 1800*, VI (catalogue by Jean Adhémar and Jacques Lethève), Paris: Bibliothèque Nationale, Département des Estampes, 1953, p. 110, no. 25 (as second state); Adhémar 1974, no. 30.II (as c. 1877); Reed and Shapiro 1984–85, no. 49.III, repr. (as third state, Sterling and Francine Clark Art Institute, Williamstown, Mass.).

179.

At the Café des Ambassadeurs

1879–80
Etching, soft-ground etching, drypoint, and
 aquatint on wove paper, fifth state
Plate: 10½ × 11⅝ in. (26.6 × 29.6 cm)
Sheet: 12⅜ × 19⅝ in. (31.3 × 44.9 cm)
National Gallery of Canada, Ottawa (23969)

Exhibited in Ottawa and New York

Reed and Shapiro 49.V/Adhémar 30.III

PROVENANCE: Alexis H. Rouart, Paris. Donald H.
Karshan, New York, by 1970; with Margo Schab,
New York; bought by the museum 1981.

EXHIBITIONS: 1970, New York, City Center, 8
March–April/Indianapolis Museum of Art,
November–December, *The Donald Karshan Collec-
tion of Graphic Art*; 1984–85 Boston, no. 49.V, repr.

SELECTED REFERENCES: Delteil 1919, no. 27 (as c. 1875);
Rouart 1945, pp. 64, 66, 74 n. 107; Joseph T. Butler,
"The Donald Karshan Collection of Graphic Art,"
Connoisseur, CLXXIII:697, March 1970, repr. p. 227;
William M. Ittmann, Jr., "The Donald Karshan Print
Collection," *Art Journal*, XXIX:4, Summer 1970,
pp. 442–43, fig. 4; Adhémar 1974, no. 30.III (as
c. 1877); Reed and Shapiro 1984–85, no. 49.V, repr.

The Brothel Scenes

cat. nos. 180–188

No other aspect of Degas's work has dis-
concerted his admirers as much as the fifty
or so monotypes featuring brothel scenes.
Arsène Alexandre wrote a short passage in
1918 on the "realistic nudes in a certain series
that must be discussed, however delicate the
subject matter may be." Then, in the fol-
lowing decades, Camille Mauclair, and par-
ticularly Denis Rouart, put forth the idea of
a Degas haunted by sexuality.[1] The artist's
extreme reserve seems to have intrigued
some of his contemporaries, and Roy
McMullen recently came to the speculative
conclusion that Degas was likely impotent.[2]

All indications are that the artist had no
mistress following the 1870s, and, despite
his extraordinarily colorful language, he
surprised his models by his exemplary be-
havior toward them. Nevertheless, when
speaking to one of his models about the possi-
ble causes of his bladder condition, he admit-
ted, "it is true, I had the 'illness' [a venereal
disease] as did all young people, but I have
never led a wild life."[3] In any case, the cari-
catured verism of the monotypes, in which
Rouart found a "mixture of attraction and
fear toward the opposite sex,"[4] was inter-

preted quite differently by Eugenia Janis and
Françoise Cachin, whose important studies
shed new light on these works.[5]

However, some uncertainty continues to
surround the series. Although they are gen-
erally dated c. 1879–80, the monotypes appear
to belong to an earlier period, c. 1876–77,
and it is possible that Degas exhibited some
of them in April 1877. In his review of the
third Impressionist exhibition, Jules Claretie
compared some of the monotypes to Goya's
etchings, saying that "when I mention Goya,
I have my reasons. The horrors of war de-
picted by the Spanish master are no stranger
than the loves that Degas has undertaken to
paint and print. His etchings would make
eloquent translations of some of the pages
from *La fille Élisa*."[6] Nothing in Degas's
works except the brothel scenes could be
linked in this manner to Edmond de Gon-
court's *La fille Élisa*, which appeared on 20
March 1877, two weeks before the opening
of the exhibition, and inspired Degas to pro-
duce a few sketches the same year.[7]

The genesis of the series remains just as
uncertain. One hypothesis is that Degas was
inspired by Joris-Karl Huysmans's *Marthe:
histoire d'une fille*, published in Brussels in
September 1876, but the tragic naturalism of
this novel is inconsistent with the animation
and distinctive humor of the monotypes.[8] In
all likelihood, the series is not related to any
literary work, but rather owes its origin to
the masters of the first half of the century,
such as Guys and Gavarni, and to the dis-
covery of Japanese printmaking. Neverthe-
less, it is evident that a formal link, altered
to the point of being unrecognizable, does
exist between the brothel monotypes and
the earlier studies undertaken by Degas for
Scene of War in the Middle Ages (cat. no. 45),
in which we find the same profusion of
women, the same agitated poses, and the
same naturalism extending beyond the norm
of the academic nude. It is therefore not sur-
prising to find the true prototype for the
prostitute stretched out on her back in *Idle-
ness* (J102) in a study (cat. no. 47) for *Scene
of War*.

1. Alexandre 1918, p. 16.
2. McMullen 1984, pp. 268–69.
3. Michel 1919, p. 470.
4. Rouart 1945, p. 9.
5. See Janis in 1968 Cambridge, Mass., pp. xix–xxi;
 Nora 1973, passim; Cachin 1974, pp. 83–84; Hol-
 lis Clayson, "Prostitution and the Art of Later
 Nineteenth-Century France: On Some Differences
 between the Work of Degas and Duez," *Arts Mag-
 azine*, LX:4, December 1985, pp. 40–45. For a dis-
 cussion of Degas's alleged misogyny, see Broude
 1977, passim.
6. Claretie 1877, p. 1.
7. For sketches for *La fille Élisa*, see Reff 1985, Note-
 book 28 (private collection, pp. 26–27, 29, 31, 33,
 35, 45).
8. Reff 1976, pp. 181–82.

180.

The Name Day of the Madam

1876–77
Pastel over monotype on white wove paper
Plate: 10½ × 11⅝ in. (26.6 × 29.6 cm)
Musée Picasso, Paris

Exhibited in Paris

Lemoisne 549

The largest of Degas's brothel scenes, this
monotype was pulled from a plate almost
twice the size of the larger of the two for-
mats he commonly used in the series. It was
preceded by a different version on a smaller
scale, with the scene in reverse (J90, C100).
Yet another monotype on the same subject
(J88, C99) showing, with some variations, a
detail from the center of the composition,
almost certainly followed the large plate as
an independent though related design.

Renoir, who owned a monotype brothel
scene by Degas, remarked in a conversation
with Ambroise Vollard: "Any treatment of
such subjects is likely to be pornographic,
and there is always a desperate sadness
about them. It took Degas to give to the
Fête de la patronne [The Name Day of the
Madam] an air of joyfulness, and at the same
time the greatness of an Egyptian bas-relief."[1]
Picasso, to whom this monotype later be-
longed along with ten other brothel scenes
now in the Musée Picasso, was equally
moved by it. When showing the work with
some of his own etchings to the photogra-
pher Brassaï, he said: "It's the madam's name
day. A masterpiece, don't you think? See,
I've been inspired by it for a series of etch-
ings I am working on at the moment."[2] Pro-
duced during the period between March and
May 1971, Picasso's own variations on the
series frequently include Degas in the com-
position as an observer, sometimes in the act
of drawing or as a symbolic presence in the
form of a portrait hanging on the wall of the
salon.[3]

The subject is the nearest Degas ever came
to depicting an apotheosis of sorts, and it is
perhaps characteristic of his sense of humor
that he chose a brothel as the stage for a tragi-
comic if good-natured celebration.

1. Vollard 1936, p. 258.
2. Cited in Cabanne 1973, p. 147.
3. For Picasso's etchings, see Georges Bloch, *Pablo
 Picasso: catalogue de l'oeuvre gravé et lithographié
 1970–1972*, IV, Bern, 1979, nos. 1920–91.

PROVENANCE: Atelier Degas (Vente Estampes, 1918,
no. 212, for Fr 7,000); bought by Gustave Pellet, Pa-
ris; by descent to Maurice Exsteens, Paris, from 1919.
Pablo Picasso, 1958–73; Donation Picasso 1978.

EXHIBITIONS: 1924 Paris, no. 231; 1934, Paris, André
J. Seligmann, 17 November–9 December, *Réhabilita-
tion du sujet*, no. 82; 1937 Paris, Orangerie, no. 199;

1948 Copenhagen, no. 95; 1952 Amsterdam, no. 20; 1978 Paris, no. 42.

SELECTED REFERENCES: Alexandre 1918, p. 16; Lafond 1918–19, II, p. 72; Rouart 1945, pp. 56, 74 n. 84, repr. p. 60; Lemoisne [1946–49], II, no. 549 (as c. 1879); Rouart 1948, pl. 4 (color); Cabanne 1957, pp. 83 n. 60, 98, 113 (as 1879); Valéry 1965, fig. 154; Janis 1968, no. 89 (as c. 1878–79); Cachin 1974, under no. 99; Koshkin-Youritzin 1976, p. 36; Keyser 1981, p. 73; Sutton 1986, p. 253, repr.; *Eva und die Zukunft* (exhibition catalogue, edited by Werner Hofmann), Hamburger Kunsthalle, 1986, fig. 197A p. 280.

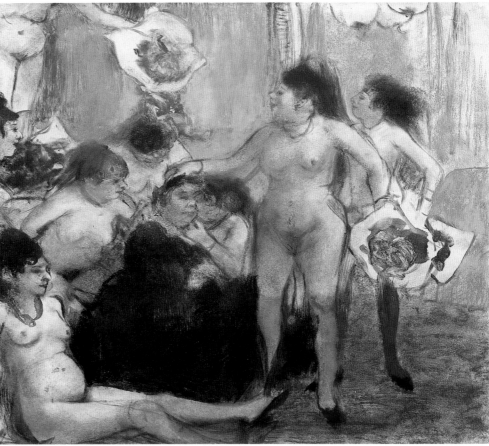

180

181.

In a Brothel Salon

1876–77
Monotype in black ink on white heavy laid paper
First of two impressions
Plate: 6¼ × 8½ in. (15.9 × 21.6 cm)
Atelier stamp on verso lower left
Musée Picasso, Paris

Exhibited in Ottawa

Janis 82/Cachin 87

181

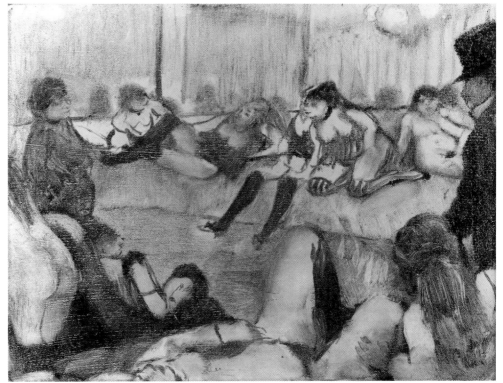

The image includes two sides of a salon paneled with mirrors as well as an elaborate foreground suggesting a third, invisible side. At the far left, the madam greets a client entering from the right. Between them, assembled along two horizontal tiers, are groups of dressed and undressed prostitutes in a variety of poses, some lying down, others seated, and still others caught in mid-movement.

In composition, this is the most ambitious of the monotypes in the series, and few, if any, convey with more ferocious intensity the degraded atmosphere of the brothel. The principal figure in the foreground, cut off in remarkable fashion, seems based on one used in a dark-field monotype, *Nude Woman Reclining on a Chaise Longue* (cat. no. 244).

A previously unknown second impression of the monotype appeared in an auction sale held in Bern in 1973.[1]

1. Kornfeld und Klipstein, Bern, Auction 147, *Moderne Kunst*, 20–21 June 1973, no. 147, repr.

PROVENANCE: Atelier Degas (Vente Estampes, 1918, no. 222, as "Salon de maison close"); bought by Ambroise Vollard, Paris. Maurice Exsteens, Paris; with Paul Brame, Paris; with Reid and Lefevre Gallery, London, 1958; Pablo Picasso, 1958–73; Donation Picasso 1978.

EXHIBITIONS: 1937 Paris, Orangerie, no. 192; 1951–52 Bern, no. 178; 1952 Amsterdam, no. 102; 1958 London, no. 11, repr.

SELECTED REFERENCES: Rouart 1948, pl. 34; Janis 1968, no. 82 (as c. 1879); Cachin 1974, no. 87 (as 1876–85); Reff 1976, pp. 181–82, fig. 126 p. 181.

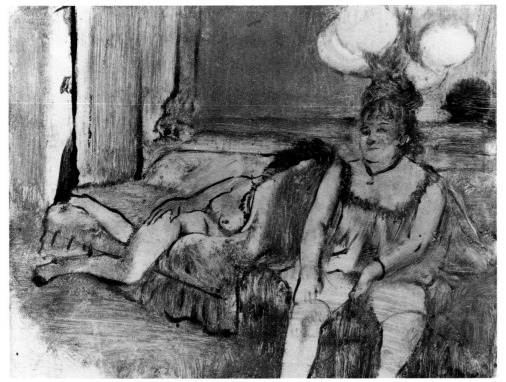

182

182.

Resting

1876–77
Monotype in black ink on China paper
Plate: 6¼ × 8¼ in. (15.9 × 21 cm)
Atelier stamp on verso lower left
Musée Picasso, Paris

Exhibited in Ottawa

Janis 83/Cachin 113

Imaginary or real, Degas's brothel scenes abound in shrewd psychological observations on individual behavior. In this monotype, one of the prostitutes has caught sight of an unseen interlocutor—the viewer—and automatically adjusts a stocking as she steadily holds his attention. She is past her prime, but, with a good deal of verve, she sports whatever is left of her looks. By contrast, another prostitute has collapsed on a sofa, though she may have just noticed the appearance of a client. The impending arrival, rendered with only a hand, a leg, and a profile visible beyond a door, is nevertheless presented with such deliberate casualness as to entirely steal a scene that otherwise might have been both more truculent and direct, if certainly less literary.

PROVENANCE: Atelier Degas (Vente Estampes, 1918, no. 221, one of sixteen monotypes in a lot); bought by Gustave Pellet, Paris; by descent to Maurice Exsteens, Paris, 1919; with Paul Brame, Paris; with Reid and Lefevre Gallery, London, 1958; Pablo Picasso, 1958–73; Donation Picasso 1978.

EXHIBITIONS: 1937 Paris, Orangerie, no. 196; 1948 Copenhagen, no. 86; 1952 Amsterdam, no. 101; 1958 London, no. 23, repr.; 1978 Paris, no. 45, repr.

SELECTED REFERENCES: Rouart 1948, pl. 33; Janis 1968, no. 83 (as c. 1879); Cachin 1974, no. 113, repr. (as 1876–85).

183

183.

Brothel Scene

1876–77
Monotype in black ink on white laid
 paper, heightened with pale ochre watercolor
Plate: 6⅜ × 8⅜ in. (16.1 × 21.5 cm)
Sheet: 8¼ × 10¼ in. (21 × 26.1 cm)
Signed in pencil lower right margin: Degas
Bibliothèque d'Art et d'Archéologie, Universités
 de Paris (Fondation Jacques Doucet), Paris
 (B.A.A. Degas 9)

Exhibited in Paris

Janis 68/Cachin 83

This monotype provides an interesting complement to *Resting* (cat. no. 182). The general elements of the two scenes are closely

related. The stress on bold contrasts and the broad handling of line are nevertheless very different. The foreground dominates; the woman turning her back to the viewer has been drawn in a contorted pose, with her sharply defined leg almost completely divorced from the rest of her body. Her head, with a rich cascade of black hair indicated by a few rapid strokes, is shown in lost profile in a grotesque recollection of the lovely head in *The Jet Earring* (cat. no. 151). More surprising, however, is the woman lying down in the background, reduced to a pair of black stockings and a head, perhaps the most ingeniously succinct representation in Degas's entire work.

PROVENANCE: Jacques Doucet, Paris; to the Fondation Doucet 1918.

EXHIBITIONS: 1924 Paris, no. 242.

SELECTED REFERENCES: Vollard 1914, pl. xvi; Maupassant 1934, repr. facing p. 34; Janis 1968, no. 68 (as c. 1879); Nora 1973, p. 30, fig. 2 (color) p. 31; Cachin 1974, no. 83, repr. (as "Scène de maison close," 1876–85).

184.

Waiting (second version)

1876–77
Monotype in black ink on China paper
Plate: 8½ × 6½ in. (21.6 × 16.4 cm)
Atelier stamp on verso lower left
Musée Picasso, Paris

Exhibited in New York

Janis 65 / Cachin 86

In the first impression of this monotype, improvised with the ease of a Japanese calligrapher, Degas drew the figures of the women only in outline. For the second impression, he reworked the plate. Shadows were added to the bodies, the treatment of the hair was elaborated, and the two women at the left were given stockings. In addition, parts of the background and most of the foreground were heavily inked. The resulting variant has richer tonalities, and the effects are more deliberate. Yet most of the figures have retained the vivid characteristics apparent in the first impression, particularly the woman at the far left, an arresting presence with covered bosom but parted legs, and the woman next to her, who, with her gesture, turns the viewer into a participant in the scene.

PROVENANCE: Atelier Degas (Vente Estampes, 1918, no. 221, one of sixteen monotypes in a lot); bought by Ambroise Vollard, Paris; Gustave Pellet, Paris; by

184

descent to Maurice Exsteens, Paris, 1919; with Paul Brame, Paris; with Reid and Lefevre Gallery, London, 1958; Pablo Picasso, 1958–73; Donation Picasso 1978.

EXHIBITIONS: 1948 Copenhagen, no. 84; 1958 London, no. 8, repr.; 1978 Paris, no. 44, repr.

SELECTED REFERENCES: Rouart 1948, pl. 40; Janis 1968, no. 65 (as c. 1879); Cabanne 1973, repr. p. 148; Cachin 1974, no. 86 (as 1876–85), repr.

185.

The Reluctant Client

1876–77
Monotype in black ink on off-white wove paper
Plate: 8¼ × 6¼ in. (21 × 15.9 cm)
Atelier stamp on verso lower left
National Gallery of Canada, Ottawa (18814)

Janis 86 / Cachin 96

The comic impact of this image is partly the result of the witty reversal of commonly held assumptions about the confident nature of males. To the amusement of four prostitutes, a confounded client has second thoughts or perhaps an attack of panic. The narrative

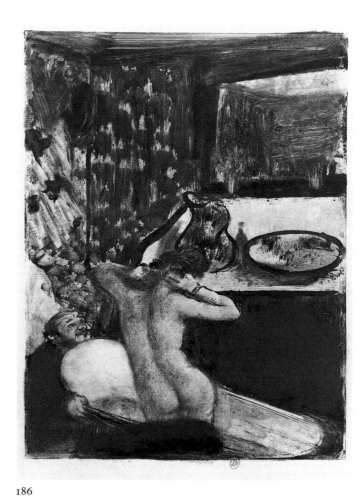

185 186

element is as evident as in *The Name Day of the Madam* (cat. no. 180), but the apparent informality of the composition is ruled by a pervasive sense of symmetry. The client and the prostitute, on the opposite sides of a cane (unexpectedly cast in the role of gravitational center), are mirror images of each other; and right and left of the prostitute are two seated figures that frame her in almost perfect unison. Degas's fundamentally satiric streak is nowhere more apparent than in the treatment of the client, at once pathetic and ridiculous, characterized in a few quickly jotted lines.

PROVENANCE: Atelier Degas (Vente Estampes, 1918, no. 221, one of sixteen monotypes in a lot); bought by Gustave Pellet, Paris; by descent to Maurice Exsteens, Paris, 1919; with Paul Brame, Paris; with Reid and Lefevre Gallery, London, 1958; W. Peploe, London (sale, Sotheby Parke Bernet, London, 27 April 1977, no. 279); bought at that sale by the museum 1977.

EXHIBITIONS: 1937 Paris, Orangerie, no. 198; 1948 Copenhagen, no. 87; 1951–52 Bern, no. 176; 1952 Amsterdam, no. 99; 1958 London, no. 30, repr.; 1979–80 Ottawa; 1980, Ottawa, National Gallery of Canada, 25 January–23 March/Montreal Museum of Fine Arts, 1 April–18 May/Saint Catharines, Ontario, Rodman Hall Art Centre, 30 May–30 June, "The Imprint of Genius: Five Centuries of Master Prints from the Collection of the National Gallery of Canada" (no catalogue, organized by Douglas Druick).

SELECTED REFERENCES: Maupassant 1934, repr. facing p. 48; Rouart 1945, pp. 56, 74 n. 84; Rouart 1948, pl. 32; Janis 1968, no. 86 (as c. 1879); Cachin 1974, no. 96 (as 1876–85); Koshkin-Youritzin 1976, p. 36.

186.

Admiration

1876–77
Monotype in black ink heightened with red and
 black pastel on white heavy laid paper
First of two impressions
Plate: 8½ × 6⅜ in. (21.5 × 16.2 cm)
Sheet: 12⅜ × 8⅞ in. (31.5 × 22.5 cm)
Signed in pencil lower left margin: Degas
Bibliothèque d'Art et d'Archéologie, Universités
 de Paris (Fondation Jacques Doucet), Paris
 (B.A.A. Degas 3)

Exhibited in Paris

Janis 184/Cachin 129

In *Admiration*, the theme of the voyeur follows a long tradition in Western art. Yet this modern transmutation of Susanna at her bath is not a moral discourse.[1] It is, rather, an ironic comment on the commerce of love as epitomized by the contrast between the very beautiful woman, abstractedly performing a charade, and the fawning, bedazzled admirer.

A second impression of the monotype, not recorded by Janis or Cachin, gives a better idea of a problem occasionally encountered by Degas when working directly, without the aid of preparatory drawings, in adjusting the relative proportions of his bathers to the bathtubs in which they take their poses.[2] In this first impression, the juncture between the nude and the edge of the tub has been covered with color to mask the discrepancy. The pose of the woman, with both her arms behind her neck, is one the artist studied persistently from every angle. A related pose was used for a pastel, *Woman at Her Toilette* (L749, private collection), generally dated 1885 but actually exhibited in 1880 in the fifth Impressionist exhibition under no. 39.[3]

1. For Degas's remarks on his subjects and Susanna and the Elders, see Pierre Borel's note in Fevre 1949, p. 52 n. 1. See also Halévy 1960, pp. 150–60; Halévy 1964, p. 119.
2. For the second impression, see Kornfeld und Klipstein, Bern, Auction 147, *Moderne Kunst*, 20–21 June 1973, no. 150, repr.
3. It has been tentatively suggested (1986 Washington, D.C., p. 322) that the work exhibited in 1880 was a pastelized monotype related to the brothel

series (L554, E. V. Thaw collection, New York). However, the reviews of Gustave Goetschy (Goetschy 1880, p. 2) and Armand Silvestre ("Exposition de la rue des Pyramides," *La Vie Moderne*, 24 April 1880, p. 262) make the identification certain.

PROVENANCE: Jacques Doucet, Paris; to the Fondation Doucet 1918.

EXHIBITIONS: 1924 Paris, no. 227.

SELECTED REFERENCES: Maupassant 1934, repr. facing p. 50; Marie Dormoy, "Les monotypes de Degas," *Art et Métiers Graphiques*, 51, 15 February 1936, repr. p. 37; Janis 1968, no. 184 (as c. 1877–80); Nora 1973, p. 30, fig. 2 (color) p. 31; Cachin 1974, no. 129, repr. (as c. 1880); Lipton 1986, pp. 170, 180, fig. 111 p. 171; Andrew Tilly, *Erotic Drawings*, New York: Rizzoli, 1986, p. 38, no. 12, repr. (color) p. 39.

187.

Two Women

c. 1879
Monotype in black ink on pale buff laid paper
Sheet: 9¾ × 11⅛ in. (24.9 × 28.3 cm)
Katherine Bullard Fund, Courtesy, Museum of
 Fine Arts, Boston (61.1214)

Janis 117/Cachin 122

There is no evidence that Degas was especially fascinated by lesbianism. As a theme, it never occurs in his painting and appears but twice in his monotypes. In the generation that preceded Degas, lesbianism had furnished subject matter to Honoré de Balzac, notably for his *La fille aux yeux d'or*; to a subtler degree to Jules Barbey d'Aurevilly, whom Degas knew; and above all to Charles Baudelaire for his *Lesbos* and *Femmes damnées*. As noted by Mario Praz half a century ago, Baudelaire in 1846 thought of giving the title "Les lesbiennes" to the collected edition of his poems.[1] But until Gustave Courbet, no true equivalent is found in painting—at least not in painting that qualifies as a truthful expression of human feeling—even though the occasional book illustration suggested the idea when representing the theme of sleep or friendship.[2]

In 1866, Courbet painted as a commission for Khalil-Bey, a Turkish diplomat living in Paris, his famous *Sleep* (fig. 143)—also known as *Les amies*—in every respect the greatest composition to depict the aftermath of lesbian love. Shortly after 1868, *Sleep* was bought by Jean-Baptiste Faure, Degas's future patron, and it is not an exaggeration to say that it furnished the idea for many variations by artists on the same theme, including somewhat less sensual depictions exhibited at the Salon in the last decades of the nineteenth century.[3]

Fig. 143. Gustave Courbet, *Sleep*, 1866. Oil on canvas, 53⅛ × 78¾ in. (135 × 200 cm). Musée du Petit Palais, Paris

Degas's opinion of Courbet, if it did not equal his admiration for Ingres, was very high indeed, and Courbet can be counted among the major influences on his work. Although not in fact indebted to *Sleep*, which Degas saw or could have easily seen in Faure's apartment, *Two Women* is a more animated if not quite as sumptuous variation on it. Eugenia Janis has drawn attention to the fact that Degas deliberately made one of the women darker, to suggest aggression.[4] But the idea of an exotic contrast in the proximity of pale and dark nudes, regardless of the relationship between them, was a favorite nineteenth-century device. Faint outlines of a human form at the right of the composition hint that at first it may have been quite different and that the dark area at the center, accordingly, could be the inadvertent result of Degas's attempt to partially wipe the plate—a stain that he used to the greatest advantage.

1. Mario Praz, *The Romantic Agony*, London: Oxford University Press, 1933, p. 333.
2. See, for instance, Achille Deveria's "Minna and Brenda" of 1837, an illustration for Walter Scott's *Pirate*, or Dante Gabriel Rossetti's frontispiece for his sister Christina's volume *Goblin Market*, published in 1862. For Deveria, see *Eva und die Zukunft* (exhibition catalogue, edited by Werner Hofmann), Hamburger Kunsthalle, 1986, p. 266, fig. 182c. Rossetti's engraving is reproduced in Gordon N. Ray, *The Illustrator and the Book in England from 1790 to 1914*, New York: Pierpont Morgan Library, 1976, p. 1862.
3. Examples include Georges Callot's *Sommeil*, exhibited at the Salon of the Société Nationale des Beaux-Arts in 1895, or the earlier, unintentionally comic *La vieille et les deux servantes* by Paul Nanteuil, exhibited at the Salon of the Société des Artistes Français in 1887.
4. 1968 Cambridge, Mass., no. 30.

PROVENANCE: Atelier Degas (Vente Estampes, 1918, no. 221, one of sixteen monotypes in a lot); Gustave Pellet, Paris, to 1919. Marcel Guérin, Paris (his stamp, Lugt suppl. 1872b, lower left corner, in margin). Bought by the museum 1961.

EXHIBITIONS: 1968 Cambridge, Mass., no. 30, repr.

SELECTED REFERENCES: Janis 1968, no. 117; Cachin 1974, no. 122.

187

188

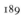

189

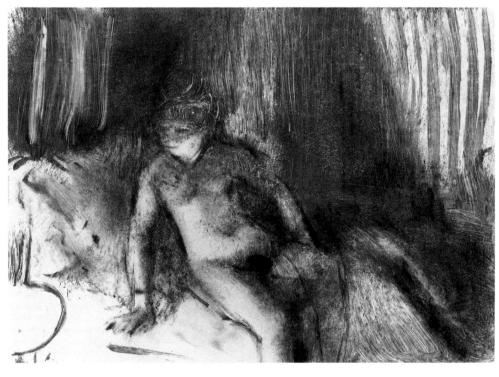

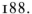

188.

Waiting

1876–77
Monotype in black ink on China paper
Plate: 4¾ × 6½ in. (12.1 × 16.4 cm)
Atelier stamp on verso lower left
Musée Picasso, Paris

Exhibited in New York

Janis 91/Cachin 101

Degas made several variations on the theme of the prostitute in bed awaiting her client.[1] In this one, the most provocative version, the staging of the scene is more deliberate and the outcome is more disturbing and more complex. The woman looks to her left, perhaps at the floor or at someone who has entered the room. Yet her body, with arms and legs invitingly parted, is positioned so as to unequivocally implicate the viewer, and her pubic area is the center of the composition. Nevertheless, the crude, flamboyant display of flesh is counterbalanced by the careful, almost scientific notation of the wretched paraphernalia associated with the prostitute's daily existence: the mirror on the wall, her black stockings and high-heeled shoes, the washbasin ready for use, an article of clothing left on an armchair.

Several etchings by Picasso testify to his admiration for this monotype.[2]

1. Janis 1968, nos. 92, 93, 95, 97, the last two with counterproofs.
2. Notably Bloch nos. 1988–89, 1992–95, in Georges Bloch, *Pablo Picasso: catalogue de l'oeuvre gravé et lithographié*, IV, Bern, 1979.

PROVENANCE: Atelier Degas (Vente Estampes, 1918, number unknown); bought by Gustave Pellet, Paris; by descent to Maurice Exsteens, Paris, 1919; with Paul Brame, Paris; with Reid and Lefevre Gallery, London, 1958; Pablo Picasso, 1958–73; Donation Picasso 1978.

EXHIBITIONS: 1937 Paris, Orangerie, no. 197; 1958 London, no. 16, repr.; 1978 Paris, no. 43, repr.

SELECTED REFERENCES: Maupassant 1934, repr. facing p. 48; Janis 1968, no. 91 (as c. 1878–79); Cachin 1974, no. 101 (as 1876–85).

189.

Waiting

c. 1879
Monotype in brown-black ink on white
 wove paper
Plate: 4¼ × 6⅜ in. (10.9 × 16.1 cm)
Sheet: 6⅜ × 7⅜ in. (16.3 × 18.8 cm)
The Art Institute of Chicago. Gift of
 Mrs. Charles Glore (1958.11)

Janis 103/Cachin 107

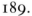

This small monotype forms part of a group of larger nocturnal scenes representing women resting, reading, getting in or out of bed, or perhaps playing with a small dog.[1] The scenes frequently include, or suggest the presence of, a bedside lamp that casts enough light to draw the essential elements of the subject out of the pervasive darkness. The women are always nude, though they may wear a bonnet or a choker, and appear to be enjoying a private moment in vast, heavily curtained beds.

By tradition, these monotypes have been considered ambiguous enough in subject to be marginally grouped, most probably wrongly, with the brothel scenes. However, their mild eroticism—amusing but never satirical—belongs to a different category, an apparently deliberate revival of a type of eighteenth-century imagery made fashionable not least by the Goncourt brothers. Were it not for the pronounced chiaroscuro effects, leading stylistically in quite a different direction, reminiscent especially of Rembrandt, some of these works could hang with reasonable comfort between amorous subjects by Fragonard, Moreau le Jeune, and Gabriel de Saint-Aubin.[2] Indeed, Degas's *Woman with a Dog* (J164, L746) makes sense only if placed next to Fragonard's *Young Girl Making Her Dog Dance on Her Bed*.[3] If this kinship is scarcely apparent in the monotypes, it becomes clearer in the pastelized impressions.

Waiting is known only as a monotype, and it is not easy to imagine how it might look as a pastel. The suggestive title was not chosen by the artist, but the work's compositional proximity to a different monotype, *Waiting for the Client* (J104), has led Eugenia Janis, followed by Françoise Cachin, to catalogue it with the brothel scenes. Nevertheless, it should be grouped with its counterparts such as *Woman Going to Bed* (J129, L747) or *Woman Turning Off Her Lamp* (J131, L744) among the artist's few attempts at traditional erotic imagery.

1. See *Woman Getting Up* (J167), *Woman Going to Bed*, which exists in several versions (J129, J134, J166), *Woman with a Dog* (J164), *Woman Turning Off Her Lamp* (J131), *Nude Woman Scratching Herself* (cat. no. 245), *Nude Woman Reclining on a Chaise Longue* (cat. no. 244).
2. For Degas's interest in the work of Moreau le Jeune, see Reff 1985, Notebook 26 (BN, Carnet 7, p. 91).
3. See Georges Wildenstein, *The Paintings of Fragonard*, London: Phaidon, 1960, no. 280.

PROVENANCE: Atelier Degas (Vente Estampes, 1918, no. 228); bought by Gustave Pellet, Paris; by descent to Maurice Exsteens, Paris, 1919; with Paul Brame, Paris; César M. de Hauke, Paris; acquired by the museum 1958.

EXHIBITIONS: 1937 Paris, Orangerie, no. 195; 1948 Copenhagen, no. 85; 1968 Cambridge, Mass., no. 26, repr.; 1979 Edinburgh, no. 95; 1984 Chicago, no. 46, repr. (color).

SELECTED REFERENCES: Rouart 1945, pp. 56, 74 n. 84; Rouart 1948, pl. 39; Janis 1968, no. 103, repr.; Cachin 1974, no. 107; Keyser 1981, pl. XXXI.

190.

Woman Leaving Her Bath

1876–77
Pastel over monotype on buff laid paper
6¼ × 8½ in. (16 × 21.5 cm)
Signed in black pastel lower right: Degas
Musée d'Orsay, Paris (RF12255)

Exhibited in Paris

Lemoisne 422

This enchanting small pastel over monotype has on occasion been wrongly identified. Lemoisne, who recognized it as a work loaned in 1877 to the third Impressionist exhibition by Gustave Caillebotte, its first owner, believed it to have been a reworked lithograph. Subsequently, and in spite of an admitted connection with the exhibition of 1877, the work was dated 1877–79.[1] In a recent publication, Geneviève Monnier has cleared the record and has ascribed it to 1876–77, the closest one could possibly get to a logical date.[2] Eugenia Janis has noted that at the right edge of the paper there is an exposed strip of monotype and has added that traces of Degas's fingerprints can be discerned. No other impression of the monotype under this pastel is known.

The composition, informal but rigorously constructed, represents a theme Degas repeated, with variations, though always maintaining the two interacting figures—a woman stepping out of her bath and a maid holding a dressing gown ready for her. The subject occurs in another pastelized monotype of the same size (L423, Norton Simon Museum, Pasadena), probably obtained from the same plate.[3] It also occurs in a monotype of vertical format included in this exhibition (cat. no. 191) and in an etching (cat. nos. 192–194) generally dated to the end of the 1870s. It is curious that no drawings are known to be connected with the compositions, though several later drawings represent a return to the theme. It could be supposed that, for Degas, the monotype process *was* a drawing process—implied by the terminology he used—but the absence of models is nevertheless surprising. In this composition, as in all the other versions, an armchair occupies a diagonal position in the foreground, a favorite motif frequently used by the artist. The partly open door to the right, however, does not appear in the other bathing scenes and adds a compositionally unexpected element as well as more than a hint of complicity between artist and viewer.

1. Janis 1968, no. 175; Cachin 1974, p. 282.
2. 1985 Paris, no. 63.
3. The measurements of the pastel have been mistakenly listed as 6¹¹⁄₁₆ by 11¹⁄₁₆ inches (17 by 28 centimeters) by Lemoisne, Janis, and Cachin. It actually measures 6¼ by 8½ inches (16 by 21.5 centimeters).

190

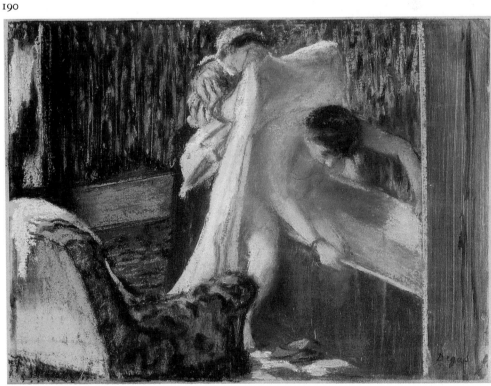

303

PROVENANCE: Gustave Caillebotte, Paris, by April 1877; his bequest to the Musée du Luxembourg, Paris, 1894; entered the Luxembourg 1896; transferred to the Louvre 1929.

EXHIBITIONS: 1877 Paris, no. 45; 1956 Paris; 1966, Paris, Cabinet des Dessins, Musée du Louvre, *Pastels et miniatures du XIXe siècle*, no. 37; 1969 Paris, no. 176; 1973–74, Paris, Cabinet des Dessins, Musée du Louvre, "Hommage à Mary Cassatt" (no catalogue); 1974 Paris, no. 194a, repr.; 1985 Paris, no. 63, repr.

SELECTED REFERENCES: Paris, Luxembourg, 1894, p. 105, no. 1028; Max Liebermann, "Degas," *Pan*, IV: 3–4, November 1898–April 1899, repr. p. 10; Moore 1907–08, repr. p. 98; Lafond 1918–19, I, repr. p. 113; Lemoisne [1946–49], II, no. 422 (as 1877); Pickvance 1966, pp. 17–21, repr.; Janis 1967, pp. 76–79, fig. 55; Janis 1968, no. 175 (as c. 1877–79); Cachin 1974, p. 282 (as 1877–79); Minervino 1974, no. 427; Paris, Louvre and Orsay, Pastels, 1985, no. 63.

191.

Woman Leaving Her Bath

1876–77
Monotype in black ink on off-white
 wove paper
Plate: 6⅜ × 4¾ in. (16.1 × 12 cm)
Sheet: 10 × 6⅞ in. (25.5 × 17.5 cm)
Signed in pencil lower right: Degas
Bibliothèque Nationale, Paris (A.09792)

Exhibited in Paris

Janis 176/Cachin 133

The smallest of three monotypes on the theme of a woman leaving her bath, this is also the only one of the group not to have been pastelized. As in the Orsay pastel (cat. no. 190), the figure is seen from the front. But the composition here is reversed, and the armchair has been replaced with a dressing table, viewed from behind, on which rest a jug and a washbasin. The work is exceptionally fine, and it was likely not destined for further improvement in pastel.

 The method used in inking the plate was a combination of the dark- and light-field manners, handled so confidently and imaginatively as to generate a range of tones hardly to be expected from so crude a process. The plate was covered with ink that was wiped away for the few light areas. What was left of the ink was worked up to an astonishing variety of textures by the most ordinary means: it was moved about vigorously for the lower part of the background wall, patted gently with the tips of the fingers for the pale gray of the bather, brushed more carefully for the bathtub, and punched with the tip of a hard brush for the floor. This done, the artist added the remaining details with a fine brush, drawing a few outlines,

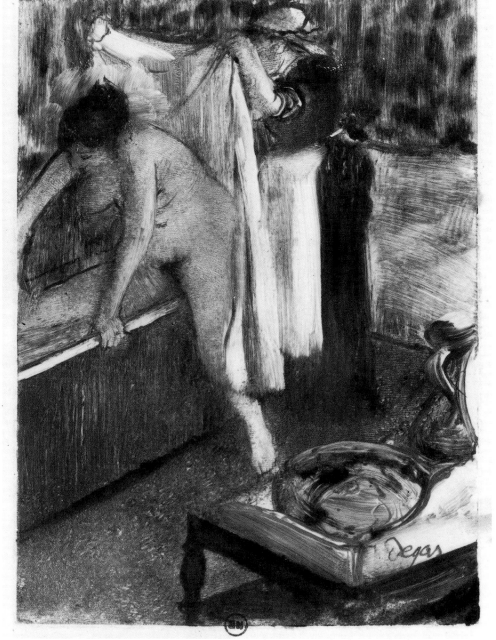

191

such as the edge of the bathtub, the contour of a hand, or the fold in the abdomen. In spite of the consciously rigorous structure of the work, one is captivated by the informal and true presentation of the image, with the bather gingerly testing the floor so as not to slip.

PROVENANCE: Dr. Georges Viau, Paris; acquired by the Bibliothèque Nationale 1943.

EXHIBITIONS: 1924 Paris, no. 235; 1974 Paris, no. 194; 1984–85 Paris, no. 135, p. 404, fig. 286 p. 431.

SELECTED REFERENCES: Rouart 1948, pl. 24; Janis 1968, no. 176 (as c. 1878–79); Cachin 1974, no. 133, repr. (as c. 1880).

192–194.

Leaving the Bath

From the closing of the fourth Impressionist exhibition in May 1879 to the spring of 1881, Degas devoted a large part of his energy toward planning the production of a publication—which he referred to as a journal—dedicated to prints and titled *Le Jour et la Nuit*.[1] The idea probably germinated during the exhibition in conversations with the engraver Félix Bracquemond.[2] Within days of closing the exhibition, Mary Cassatt and

Camille Pissarro joined the project, and subsequent correspondence between Degas and Bracquemond, all unfortunately undated, indicates a feverish interest in the subject. Degas was consulting printers, and all concerned were working on their plates.[3] However, there was also Degas's admission that it was "impossible for me, having to earn my living, to devote myself entirely to it as yet." Sometime after the end of June, he also revealed that he was busy nearly every day with sittings for a large portrait.[4] A final undated letter to Bracquemond on the subject of the journal notified his friend that the patience of the printer Salmon was at an end, that he expected the plates from the contributors within two days, and—somewhat alarmingly—that he, Degas, was "working on my plate, doing everything I can."[5]

The nature of the journal and the number of contributors, never clear from the correspondence, were only recently established when Charles F. Stuckey uncovered an article from *Le Gaulois* for 24 January 1880 announcing the appearance of the first issue of *Le Jour et la Nuit* on 1 February of that year.[6] With the date and a list of participants—including Cassatt, Caillebotte, Raffaëlli, Forain, Bracquemond, Pissarro, Rouart, and Degas—the article gave a full description of the future publication. It was, in effect, not a journal but a periodical collection of prints to be published at irregular intervals, without a text, at a price varying between five and twenty francs.[7]

The publication was never issued, and in a letter of 9 April 1880 to her son Alexander (Mary's brother), Katherine Cassatt did not conceal her opinion on the subject: "As usual with Degas when the time arrived to appear, he wasn't ready—so that 'Le Jour et la Nuit' . . . which might have been a great success has not yet appeared—Degas never is ready for anything—This time he has thrown away an excellent chance for all of them."[8] Nevertheless, there was some consolation for the artists, not mentioned by Mrs. Cassatt: her daughter, Bracquemond, Forain, Pissarro, Raffaëlli, and not least Degas were all exhibiting their etchings in the fifth Impressionist exhibition that had opened a few days earlier.

It is not certain what Degas had planned as his contribution to *Le Jour et la Nuit*. The single work known to have been undoubtedly connected with the project is *Mary Cassatt at the Louvre: The Etruscan Gallery* (fig. 114), his only etching to have been issued in an edition of one hundred and perhaps the one he was working on shortly before the printing session arranged with Salmon. But it is generally assumed that a number of etchings executed about 1879–80—among them *Leaving the Bath*, the splendid *Actress in Her Dressing Room* (RS50), *At the Café des Ambassadeurs* (cat. nos. 178, 179), and a few more—were the unusually interesting off-shoots of his commitment to the publication.

It has been pointed out in recent literature that nowhere in Degas's work are his complex method and his compulsive need to revise more readily apparent than in his prints. Successive states mercilessly record hesitations, changes, a highly expressive use of any means at his disposal, and a constant re-evaluation of the possibilities of the image. *Leaving the Bath* is known in twenty-two states—the largest number of any of his prints (see fig. 96). And each state marks minor adjustments or major alterations to the texture or intensity of a composition that remains otherwise substantially the same.[9]

According to legend, Degas began this etching during a visit to Alexis Rouart, when an ice storm prevented him from leaving.[10] The composition, related to that of three earlier monotypes but significantly smaller and of an uncommon square format, was established from the first state, and the following twelve states record very slight alterations to the design but major changes in emphasis. The walls of the room, the carpet, the armchair in the foreground, the water in the bathtub, the mantel seen in sharp perspective at the right—all were altered dramatically several times.

The three states included in this exhibition, each known in only one impression, are transitional phases in the evolution of the image. In the seventh state, the sharpness of the drawing and the contrasts of the blacks and whites are the most successful. In the fourteenth state, the previously crisp character of the bather was changed beyond recognition with the application of aquatint, the darkened flesh exploding like a cloud outside the confines of its former outlines. The mantel was also reworked, removing any sense of its structure; the side of the bathtub was given the same dark tonal value; and additional work in drypoint affected the interior of the bathtub and gave a greater sense of movement to the bathrobe held by the maid. In the eighteenth state, after two further major tonal transformations, individual components in the composition were determined with greater clarity. The mantel, an armchair in the background, and the bathtub assume discernible shapes; ripples in the water, introduced in the previous state, add an unexpectedly suggestive touch, as does a cup of chocolate on the mantel; and the bather, her body returned to its former lighter value, again becomes almost one with the bathrobe about to engulf her.

The last two states of *Leaving the Bath* indicate that the plate was so reworked that it was rendered useless. Sue Reed and Barbara Shapiro have shown that the small number of prints pulled from the plate rule out the possibility of its having been one of the etchings to be included in *Le Jour et la Nuit*.[11] In 1886, Henri Beraldi mentioned it among the eight prints by Degas that he listed in his guide, noting that the bather was a "femme du quartier Pigalle," thus insinuating she was a prostitute.[12] Eunice Lipton has argued that Degas's bathers were indeed prostitutes, and the unquestionable audacity of the design suggests as much.[13] This said, the scene—like all such scenes by Degas—is probably to be interpreted as an imaginary one. Paul Valéry remembered seeing in the studio at 37 rue Victor-Massé the props used for these compositions, "a basin, a dull zinc bathtub, stale bathrobes, . . . " and it has even been claimed that the great actress Réjane posed for a later variation of the motif, "playing the role" of the maid holding the peignoir.[14]

1. For the most detailed account of *Le Jour et la Nuit*, see Douglas Druick and Peter Zegers in 1984–85 Boston, pp. xxix–li.
2. Most of Degas's correspondence about the project—at least the surviving correspondence—was with Bracquemond, suggesting perhaps that the latter played a greater part than is generally assumed. At the end of December 1903, Degas would reproach him thus: "Have you forgotten the monthly review that we wished to launch in the old days?" See Lettres Degas 1945, CCXXXIII, p. 235; Degas Letters 1947, no. 255, p. 220.
3. Lettres Degas 1945, XVIII, p. 45, XIX, pp. 46–47, XXI, pp. 48–49, XXII, pp. 49–50; Degas Letters 1947, no. 27, pp. 50–51, no. 28, pp. 51–52, no. 30, p. 53, no. 31, p. 54.
4. Lettres Degas 1945, XXII, pp. 49–50, XIV, p. 42; Degas Letters 1947, no. 31, p. 54, no. 23, p. 47. The second letter, in the Bibliothèque Nationale, Paris, is on mourning paper, suggesting it was written not long after the death of Henri Degas, the artist's uncle, on 20 June 1879. The "large portrait" may have been that of Mme Dietz-Monnin (L534) now in the Art Institute of Chicago.
5. Lettres Degas 1945, XXIII, p. 50; Degas Letters 1947, no. 32, p. 55 (translation revised).
6. Charles F. Stuckey, "Recent Degas Publications," *Burlington Magazine*, CXXVII:988, July 1985, p. 466. The text of the article is reproduced in part in Chronology II, 24 January 1880.
7.
8. See letter from Katherine Cassatt, Paris, 9 April [1880], to Alexander Cassatt, in Mathews 1984, pp. 150–51.
9. For the most complete examination of the various states, see Reed and Shapiro 1984–85, no. 42.
10. See Delteil 1919, no. 39, and Marcel Guérin's note in Lettres Degas 1945, XXXII, p. 61 n. 1; Degas Letters 1947, no. 41, p. 64, and "Annotations," p. 264.
11. Reed and Shapiro 1984–85, no. 42.
12. Beraldi 1886, p. 153.
13. Eunice Lipton, "Degas' Bathers: The Case for Realism," *Arts Magazine*, LIV, May 1980, pp. 94–97.
14. Valéry 1965, p. 33; Valéry 1960, p. 19; Haavard Rostrup, "Degas of Réjane," *Meddeleser fra Ny Carlsberg Glyptotek*, XXV, 1968, pp. 7–13.

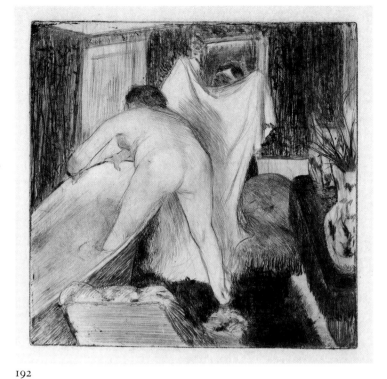

192

Leaving the Bath

1879–80
Drypoint and aquatint on pale buff, medium
 weight, moderately textured laid paper,
 seventh state
Plate: 5 × 5 in. (12.7 × 12.7 cm)
Sheet: 11¾ × 8½ in. (29.7 × 21.5 cm)
Inscribed in pencil in lower left margin: La Sortie
 de Bain
National Gallery of Canada, Ottawa (18662)

Reed and Shapiro 42.VII/Adhémar 49

PROVENANCE: Camille Pissarro (inscribed in pencil on
the verso: "Cette épreuve a appartenu au peintre C.
Pissarro"). Kornfeld und Klipstein, Bern (sale, Korn-
feld und Klipstein, Bern, *Moderne Kunst*, June 1974,
no. 179, repr.). With David Tunick, New York, 1975;
bought by the museum 1975.

EXHIBITIONS: 1979–80 Ottawa, fig. 11; 1984–85 Bos-
ton, no. 42.VII, repr.

SELECTED REFERENCES: Beraldi 1886, p. 153; Delteil
1919, no. 39; Rouart 1945, pp. 65, 74 n. 102; Adhé-
mar 1974, no. 49; Passeron 1974, p. 70; Reed and
Shapiro 1984–85, no. 42.VII, repr.

193

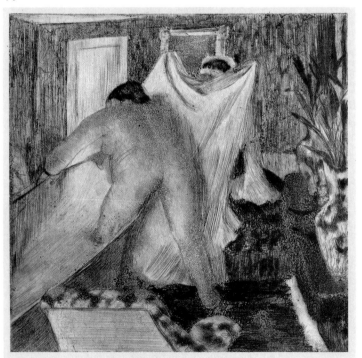

194

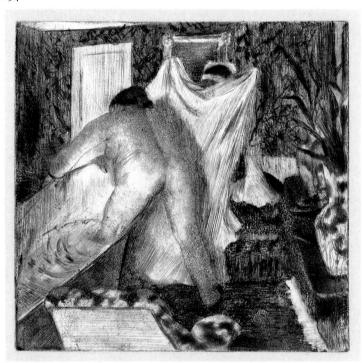

193.

Leaving the Bath

1879–80
Drypoint and aquatint on white, medium weight, moderately textured laid paper, fourteenth state
Plate: 5 × 5 in. (12.7 × 12.7 cm)
Sheet: 9¼ × 7 in. (23.5 × 17.9 cm)
Watermark: fragment of BLACONS
Faint trace of atelier stamp on verso
Sterling and Francine Clark Art Institute, Williamstown, Massachusetts (69.19)

Reed and Shapiro 42.XIV / Adhémar 49

PROVENANCE: Atelier Degas (Vente Estampes, 1918, part of lots 96–99). William Ivins, Jr., New York; with Lucien Goldschmidt, New York; bought by the museum 1969.

EXHIBITIONS: 1970 Williamstown, no. 51; 1975, Cleveland, Museum of Art, 9 July–31 August/New Brunswick, N.J., The Rutgers University Art Gallery, 4 October–16 November/Baltimore, The Walters Art Gallery, 10 December 1975–26 January 1976, *Japonisme: Japanese Influence on French Art, 1854–1910*, no. 55, repr.; 1978, Williamstown, Mass., Sterling and Francine Clark Art Institute, 23 May–30 July, *Manet and His Friends* (no catalogue); 1984–85 Boston, no. 42.XIV, repr.

SELECTED REFERENCES: Beraldi 1886, p. 153; Delteil 1919, no. 39; Rouart 1945, pp. 65, 74 n. 102; Adhémar 1974, no. 49; Passeron 1974, p. 70; Reed and Shapiro 1984–85, no. 42.XIV, repr.; Williamstown, Clark, 1987, no. 39, p. 57, repr.

194.

Leaving the Bath

1879–80
Drypoint and aquatint on pale buff, medium weight, moderately textured wove paper, eighteenth state
Plate: 5 × 5 in. (12.7 × 12.7 cm)
Sheet: 9¼ × 7⅛ in. (23.5 × 18.2 cm)
The Josefowitz Collection

Reed and Shapiro 42.XVIII / Adhémar 49

PROVENANCE: Atelier Degas (no stamp, sold or given away during the artist's lifetime). New York art market, 1984; present owner.

EXHIBITIONS: 1984–85 Boston, no. 42.XVIII.

SELECTED REFERENCES: Beraldi 1886, p. 153; Delteil 1919, no. 39; Rouart 1945, pp. 65, 74 n. 102; Adhémar 1974, no. 49; Passeron 1974, p. 70; Reed and Shapiro 1984–85, no. 42.XVIII, repr.

195

195.

The Tub

c. 1876–77
Monotype in black ink on white heavy laid paper
First of two impressions
Plate: 16½ × 21¼ in. (42 × 54.1 cm)
Sheet: no margins
Signed in pencil lower right: Degas
Bibliothèque d'Art et d'Archéologie, Universités de Paris (Fondation Jacques Doucet), Paris (B.A.A. Degas 4)

Exhibited in Paris

Janis 151 / Cachin 154

A pencil study of a nude drying herself (fig. 144) is one of the rare drawings that can be brought into direct relationship with a monotype of a bather by Degas, and the only one to indicate how he used the monotype process. It appears that the artist copied the drawing roughly on a plate, in reverse, as part of a scene of an interior. Two monotypes were pulled from the plate—the first impression, exhibited here, and a second impression, subsequently covered in pastel (fig. 145). It is evident from the first impression that the composition of the pastel was clearly thought out in advance and that each light area in the monotype corresponds to one that would be elaborated later—including the brightly lit wall behind the woman, the dressing table, the bed in the left fore-

Fig. 144. *Nude Woman Drying Herself* (III:347), c. 1876–77. Pencil heightened with white, 17 × 11 in. (43.3 × 28 cm). Ashmolean Museum, Oxford

Fig. 145. *Woman at Her Toilette* (L890), 1876–77. Pastel over monotype, 18 × 23¾ in. (45.7 × 60.3 cm). Norton Simon Foundation, Pasadena

ground, and even the mysterious spray of light at the far right that was intended as the base for a glittering starched petticoat in the pastel.[1] It is also apparent that when Degas made the pastel, he returned to the study drawn from the nude in order to define the figure more clearly.

Originally dated c. 1885 by Eugenia Janis along with other dark-field impressions, the monotype is part of a group she redated 1877.[2] The drawing (fig. 144) has been generally associated with the nudes of the late 1880s, but already some twenty years ago Jean Sutherland Boggs thought it stylistically inconsistent with the period and pointed out that it must have been one of the artist's earliest nudes from the beginning of the eighties.[3] The pastel, which belonged to Claude Monet, who seems to have acquired it in 1885, has been dated 1886–90 by Lemoisne, a date generally accepted.[4] However, the process and the nature of the monotype, as well as the fact that the pastelized impression was not expanded—as is usually the case with monotypes Degas reworked several years later—suggest a different chronology. The drawing, the monotype, and the pastel probably date from 1877 at the latest, and the stylistic similarity between the pastel and *Woman Leaving Her Bath* (cat. no. 190), exhibited in 1877, supports this hypothesis. It is quite possible, then, that the pastel is actually the unidentified "Femme prenant son tub le soir" exhibited in 1877 under no. 46.

1. A similar starched petticoat and Louis XVI bed appear conspicuously in the contemporary *Rolla*, by Henri Gervex, to whom, according to Vollard, Degas gave some advice. See Ambroise Vollard, *Degas: An Intimate Portrait*, New York: Dover, 1986, pp. 47–48.
2. See Janis 1972, passim, but without specific reference to this work.
3. 1967 Saint Louis, no. 131. Ronald Pickvance has dated the Ashmolean drawing (fig. 144) c. 1885, connecting it as well with the pastel nudes in the Pearlman collection (cat. no. 270) and the National Gallery of Art, Washington, D.C. (BR113); see 1969 Nottingham, no. 23.
4. Lemoisne [1946–49], III, no. 890.

PROVENANCE: Jacques Doucet, Paris; to the Fondation Doucet 1918.

EXHIBITIONS: 1924 Paris, no. 245.

SELECTED REFERENCES: Janis 1967, p. 80, fig. 44 p. 77; Janis 1968, no. 151 (as c. 1885); Cachin 1974, no. 154 (as c. 1882–85); 1984–85 Paris, fig. 287 p. 432.

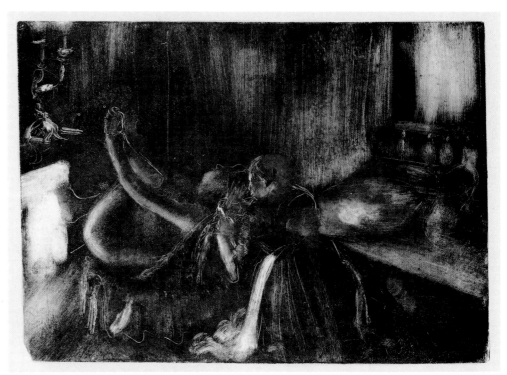

196

196.

Women by a Fireplace

c. 1876–77
Monotype in black ink
Plate: 10⅞ × 14⅞ in. (27.7 × 37.8 cm)
Sheet: 12⅞ × 19¼ in. (32.7 × 49.1 cm)
National Gallery of Art, Washington, D.C.
 Collection of Mr. and Mrs. Paul Mellon
 (1985.64.168)

Exhibited in Paris and Ottawa

A second impression of this composition, reworked in pastel and cut off at the left, was first recognized as a monotype by Eugenia Janis.[1] Her conclusion was confirmed when Barbara Shapiro published this magnificent first impression, which she dated with the dark-field monotypes about 1877–80.[2] From evidence discussed elsewhere in this catalogue,[3] it would seem that this work dates from slightly earlier, about 1876–77, and that it is contemporary with the monotypes of bathers leaving their bath (see cat. no. 190).

Women by a Fireplace appears to be the earliest instance of a scene by Degas with a maid combing the hair of her mistress, a subject that would become a preoccupation at a much later date. A contemporary painting, *At the Seashore* (L406, National Gallery, London), has a related theme, though it entirely lacks the sensual element central to the monotype.

The novelty of the design is all the more surprising as it has no true precedent in the artist's work and is unsupported by drawings. That there was some preparatory work—if not a drawing, a posed model, carefully observed—is nevertheless implied by the curious recurrence of the seated nude in a changed context, as a woman in a bathtub (fig. 229), known also in a second impression covered in pastel, *Woman in a Bath Sponging Her Leg* (cat. no. 251). Indeed, one is tempted to imagine that the bathtub scene preceded this monotype and that the whimsical pose of the nude in *Women by a Fireplace* is the result of a direct adaptation of a pose dictated by the composition of a monotype of a woman at her bath (fig. 229). The wonderful chiaroscuro effects, achieved with the strokes of a rag and the smudging of ink with the fingers, only partly model the figures and furnishings, which emerge as forms from the dark only with the help of assured contour lines quickly scratched in the plate with a sharp instrument.

1. Janis 1968, no. 161.
2. See Shapiro in 1980–81 New York, under no. 23.
3. See "The First Monotypes," p. 257.

PROVENANCE: Paul Mellon, Washington, D.C.; given by him to the museum 1985.

EXHIBITIONS: 1974 Boston, no. 102, fig. 7 (as "Après le bain," c. 1880, anonymous loan).

SELECTED REFERENCES: 1980–81 New York, pp. 99, 100 n. 2, fig. 51 p. 98.

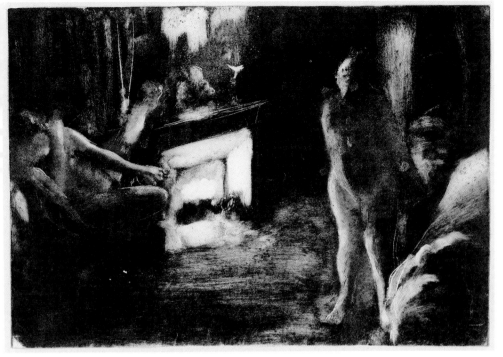

197

197.

The Fireside

c. 1876–77
Monotype in black ink on white heavy laid paper
Plate: 16⅝ × 23 in. (42.5 × 58.6 cm)
Sheet: 19¾ × 25⅜ in. (50.2 × 64.7 cm)
The Metropolitan Museum of Art, New York.
 Harris Brisbane Dick Fund; Elisha Whittelsey
 Collection; Elisha Whittelsey Fund; Douglas
 Dillon Gift, 1968 (68.670)

Janis 159/Cachin 167

The subject of this work, perhaps the strangest of all of Degas's monotypes, has never been satisfactorily explained. Unlike the two figures in *Women by a Fireplace* (cat. no. 196), united in a routine daily activity, each of the women in this composition appears engaged in some obscure performance. The figure to the right may be about to step into bed, and, like the women in a number of other monotypes, she is nude—except for her nightcap. Her pose, implying a wide range of meanings—from pain to private sexual practice— is related to the study of a wounded woman (cat. no. 48) drawn for but not used in *Scene of War in the Middle Ages* (cat. no. 45), a motif later studied again and realized also as a sculpture (cat. no. 349). The woman at the left is shown in one of the more extravagant poses devised by the artist, comparable in the 1870s only to that of a few figures appearing in his monotype brothel scenes. Though

it gives every sign of having been spontaneously invented, the figure may in fact have been inspired by another study for *Scene of War in the Middle Ages*—that of a woman with her legs splayed (cat. no. 47).

The interior, though not identical to that in *Women by a Fireplace*, recalls the same elements with an uncommon vigor—the armchair and the blazing fire, the sole source of light.

PROVENANCE: Gustave Pellet, Paris, until 1919; by descent to Maurice Exsteens, Paris, to at least 1937. César M. de Hauke. Private collection, Le Vésinet. Private collection, France; Hector Brame, Paris, 1968; bought by the museum 1968.

EXHIBITIONS: 1924 Paris, no. 250, lent by Maurice Exsteens; 1937 Paris, Orangerie, no. 207 (Exsteens collection); 1948 Copenhagen, no. 78; 1951–52 Bern, no. 171 (private collection, Le Vésinet); 1952 Amsterdam, no. 104 (private collection, Le Vésinet); 1955 Paris, GBA, no. 100 (no mention of lender); 1968 Cambridge, Mass., no. 37; 1977 New York, no. 3 of monotypes; 1980–81 New York, no. 23 (as c. 1877–80).

SELECTED REFERENCES: Guérin 1924, p. 78 (as "La cheminée"), repr. p. 79 (as "Le foyer," Pellet collection); Rouart 1945, pp. 56, 74 n. 83; Rouart 1948, p. 6, pl. 20; Cabanne 1957, pl. 71 (as "Deux femmes nues se chauffant," c. 1878–80); Henry Rasmusen, *Printmaking with Monotypes*, Philadelphia: Chitton, 1960, p. 26; Janis 1968, no. 159 (as c. 1880); Janis 1972, pp. 56–57, 66–67, fig. 17 p. 66; Nora 1973, p. 28; Cachin 1974, no. 167 (as c. 1880); Reff 1976, repr. (detail) p. 289; 1984–85 Paris, p. 399, fig. 279 p. 424.

The Portrait of Edmond Duranty

cat. nos. 198, 199

Edmond Duranty was born in Paris in 1833. His first name—actually Louis-Émile—and the identity of his father were, until the 1940s, the object of some confusion.[1] In 1856, Duranty turned to journalism and literature, joined the staff of *Le Figaro*, and issued with Champfleury the first number of *Le Réalisme*. His first and best-known novel, *Les malheurs d'Henriette Gérard*, published in installments in 1858, was followed by a number of less successful novels and collections of short stories. These included *Les combats de Françoise Du Quesnoy*, once said to have inspired Degas's *Interior* (cat. no. 84), and the novella *Le peintre Louis Martin*, in which Degas figures under his own name.[2] Nevertheless, it was as a journalist, principally a literary and art critic, that Duranty left his mark as one of the important apologists of the Realist movement and, later, of Naturalism.

A friend of Manet, Duranty met Zola and Degas along with most of the circle around the Café Guerbois in about 1865.[3] As no correspondence between Duranty and Degas appears to have survived, it is difficult to trace the progress of their friendship. Duranty wrote encouragingly if critically on Degas in his reviews of the Salons of 1869 and 1870 and later noted, "Degas is an artist of rare intelligence, preoccupied with ideas—which seems strange to most of his colleagues."[4] Duranty and Degas were evidently friends, sharing not only opinions but also a certain cast of mind touched with acid, but—as Marcel Crouzet has pointed out—by 1875 they had not yet reached the degree of closeness that would lead Duranty to name Degas an executor of his will, as he was later to do.[5] The extent to which Duranty and Degas shared an opinion, however, became obvious in 1876 when Duranty published *La nouvelle peinture* (The New Painting), a pamphlet on the group of artists exhibiting at the Durand-Ruel galleries. Ostensibly a review of the second Impressionist exhibition, the text was the first important document to outline the aesthetic principles of the Indépendants, but it so clearly sanctioned Naturalism and the position taken by Degas as to lead to the suspicion that Degas had dictated the text.[6] Identified only as "un dessinateur" (a draftsman), Degas was unequivocally given the credit Duranty believed he merited:

Thus, the series of new ideas that led to the development of this artistic vision took shape in the mind of a certain draftsman [Degas], one of our own, one of the new painters exhibiting in these galleries,

Fig. 146. *Edmond Duranty* (L517), 1879. Pastel and tempera, 39⅝ × 39½ in. (100.9 × 100.3 cm). The Burrell Collection, Glasgow

a man of uncommon talent and exceedingly rare spirit. Many artists will not admit that they have profited from his conceptions and artistic generosity. If he still cares to employ his talents unsparingly as a *philanthropist* of art, instead of as a businessman like so many other artists, he ought to receive justice. The source from which so many painters have drawn their inspiration ought to be revealed.[7]

Before his death on 9 April 1880, Duranty had only one more opportunity to print a paragraph about Degas, in a review of the Impressionist exhibition of 1879. He wrote: "The astonishing artist, Degas, is at this exhibition with all his brilliance, his whimsy, his caustic wit. He is a man apart, a man who is beginning to be very highly esteemed, and who will be particularly revered in the years to come, a man to whom twenty other painters who have been in contact with him owe their success. It is impossible even to be near the man without taking on some of his luster."[8] Following Duranty's death, Degas made every effort to organize a sale of works of art to raise money for his companion, Pauline Bourgeois, asking Fantin-Latour, Cazin, and others to help augment Duranty's own collection. Degas added three works himself, among them the small pastel version of Duranty's portrait.

From the evidence at hand, the evolution of Degas's great portrait of Duranty in his library (fig. 146), now in the Burrell Collection, Glasgow, was as brief as it was direct and consisted of three preliminary drawings of the same size. Two of these, in the Metropolitan Museum (cat. nos. 198, 199), are studies for the figure of Duranty and for the bookshelves in the background of the painting. The third drawing, another study of Duranty but with a more extensive foreground, was dated by Degas "Chez Duranty/

25 Mars 79," thus establishing that the painting was begun after that date. It has been convincingly demonstrated by Ronald Pickvance that the dated drawing was subsequently enlarged with a strip of paper and worked up by Degas into a pastel (L518, private collection, Washington, D.C.) that actually postdates the painting.[9] For the figure of Duranty in the painting, Degas certainly used the New York drawing (cat. no. 198), which corresponds in every respect, but he may also have used the dated drawing, prior to its transformation, to map out the foreground of the composition.

It is known from a list Degas drafted before the fourth Impressionist exhibition opened on 10 April 1879 that he intended to exhibit the portrait of Duranty, and the portrait is listed in the catalogue.[10] Probably because it was not completed until sometime after 10 April, the portrait, along with several other works announced in the catalogue, was not on view throughout the first part of the exhibition. As late as 26 April, it was not mentioned by the reviewer Alfred de Lostalot, one of Duranty's friends, in *Les Beaux-Arts Illustrés*, but confirmation that it was finished and exhibited by 1 May can be inferred from a line in a review by Armand Silvestre. Proof that it was on view when the exhibition closed on 10 May appears in Paul Sébillot's belated review, published on 15 May, where he tersely notes that the portrait has "great qualities."[11] Duranty's death a year later, nine days after the opening of the fifth Impressionist exhibition, prompted Degas to exhibit the portrait again. On that occasion it was admired by Huysmans, who wrote, partly inspired by *La nouvelle peinture*:

It goes without saying that M. Degas has avoided those idiotic backgrounds so dear to painters—the scarlet, olive-green, and pretty blue draperies, or the wine-colored, brownish green, and ash-gray blobs that are such shocking affronts to reality. Because, in fact, the person to be portrayed should be depicted at home, on the street, in a real setting—anywhere except against a polite backdrop of empty colors. Here we see M. Duranty surrounded by his prints and his books, seated at his table, with his slender, nervous fingers, his bright, mocking eye, his acute, searching expression, his wry, English humorist's air, his dry, joking little laugh—all of it recalled to me by the painting, in which the character of this strange analyst of human nature is so splendidly portrayed.[12]

1. See Crouzet 1964.
2. For Georges Rivière's views on *Les combats de Françoise Du Quesnoy* and alternative proposals of sources for *Interior*, see Reff 1976, pp. 202–15.
3. See Crouzet 1964, p. 335, where it is stated that Degas met Duranty in 1865.

4. Edmond Duranty, *Le pays des arts*, Paris: G. Charpentier, 1881, p. 335.
5. Crouzet 1964, p. 335.
6. For an analysis of the entire question, see Crouzet 1964, pp. 332–38.
7. Edmond Duranty, *La nouvelle peinture*, 1876, translation in 1986 Washington, D.C., p. 44.
8. Edmond Duranty, "La quatrième exposition fait par un groupe d'artistes indépendants," *La Chronique des Arts*, 8, 19 April 1879, p. 127.
9. Pickvance in 1979 Edinburgh, nos. 53–54.
10. Reff 1985, Notebook 31 (BN, Carnet 23, p. 68, under no. 4).
11. Silvestre 1879, p. 53, and Paul Sébillot, "Revue artistique," *La Plume*, 15 May 1879, p. 73.
12. Joris-Karl Huysmans, "L'exposition des Indépendants en 1880," reprinted in Huysmans 1883, p. 117.

198.

Study for *Edmond Duranty*

1879
Charcoal or dark brown chalk, with touches of white, on faded blue laid paper
12⅛ × 18⅝ in. (30.8 × 47.3 cm)
Vente stamp lower left; atelier stamp on verso upper right
The Metropolitan Museum of Art, New York. Rogers Fund, 1918 (19.51.9a)

Exhibited in Paris and New York

Vente II:242.2

Doubtless with Degas's work in mind, Edmond Duranty outlined in his essay on "the new painting" a summary of the aspirations of modern art: "What we need are the special characteristics of the modern individual—in his clothing, in social situations, at home, or on the street. The fundamental idea gains sharpness of focus. This is the joining of torch to pencil, the study of states of mind reflected by physiognomy and clothing. It is the study of the relationship of a man to his home, or the particular influence of his profession on him, as reflected in the gestures he makes: the observation of all aspects of the environment in which he evolves and develops."[1]

This statement could have been prompted by a number of Degas's recent portraits, including those of Mme Jeantaud (cat. no. 142) and Henri Rouart (cat. no. 144), but nowhere was the concept elaborated to a greater degree than in the portrait of Duranty himself and the contemporary portraits of Diego Martelli (cat. nos. 201, 202). Duranty, who six years earlier—at the age of forty—had impressed the very young George Moore as "a quiet elderly man who knew that he had

failed and whom failure saddened," is shown by Degas in his library among his books and manuscripts, the tools of his profession, his right arm resting on a large volume.² Giuseppe De Nittis, a great admirer of the painting, noted that Duranty is "sitting in a typical position. His finger presses his eyelids as if he wished in some way to narrow down his visual range, to focus it, in order to double its acuity."³ The drawing, supremely energetic though controlled throughout, is touched up with white highlights in the face and hands, conveying to a greater degree than the painting the idea of concentration, almost painful in its intensity.

1. Edmond Duranty, *La nouvelle peinture*, 1876, translation in 1986 Washington, D.C., pp. 43–44.
2. George Moore, *Reminiscences of the Impressionist Painters*, Dublin: Maunsell, 1906, p. 12. For a differently worded similar opinion, see George Moore, *Confessions of a Young Man*, New York: Brentano's, 1901, p. 79.
3. Joseph de Nittis [Giuseppe De Nittis], *Notes et souvenirs du peintre Joseph de Nittis*, Paris: Quantin, 1895, p. 192.

PROVENANCE: Atelier Degas (Vente II, 1918, no. 242.2, in the same lot as no. 242.1 [cat. no. 199], for Fr 8,000); bought at that sale by the museum.

EXHIBITIONS: 1919, New York, The Metropolitan Museum of Art [new acquisitions] (no catalogue); 1970, New York, The Metropolitan Museum of Art, *Masterpieces of Fifty Centuries*, no. 381, repr.; 1973–74 Paris, no. 31, repr.; 1977 New York, no. 27 of works on paper, repr.; 1979 Edinburgh, no. 52, repr.

SELECTED REFERENCES: Burroughs 1919, pp. 115–16; Rivière 1922–23 (reprint edition 1973, pl. 75); New York, Metropolitan, 1943, no. 52, repr.; Rewald 1946, repr. p. 342; Lemoisne [1946–49], II, under no. 517; Rich 1951, repr. p. 11; "French Drawings,"

The Metropolitan Museum of Art Bulletin, XVII:6, February 1959, repr. p. 169; Boggs 1962, p. 117; Jacob Bean, *100 European Drawings in The Metropolitan Museum of Art*, New York: The Metropolitan Museum of Art, 1964, no. 75, repr.; Reff 1976, p. 50, fig. 26; Reff 1977, p. 32, fig. 60 p. 33.

199.

Study of bookshelves for *Edmond Duranty*

1879
Charcoal or brown chalk, with touches of white, on faded blue laid paper
18½ × 12 in. (46.9 × 30.5 cm)
Vente stamp lower left; atelier stamp on verso lower right
The Metropolitan Museum of Art, New York. Rogers Fund, 1918 (19.51.9b)

Exhibited in Paris and New York

Vente II:242.1

Edmond Duranty's erudition was considerable, and in his journalistic career, working—sometimes simultaneously—for periodicals as diverse as *Paris-Journal* and the *Gazette des Beaux-Arts*, he wrote articles on topics that ranged from politics and archaeology to literature and art. Living in near penury, he slowly sold his more important books, and after his death the sale of his library raised only Fr 3,382.50. This drawing, one of De-

gas's rare still lifes and a study for the right side of the background in the portrait, represents the bookshelves in a state of relative disorder. In the finished painting, the shelves assumed a more regular, decorative quality.

PROVENANCE: Atelier Degas (Vente II, 1918, no. 242.1, in the same lot as no. 2422 [cat. no. 198], for Fr 8,000); bought at that sale by the museum.

EXHIBITIONS: 1919, New York, The Metropolitan Museum of Art [new acquisitions] (no catalogue); 1973–74 Paris, no. 32, pl. 60; 1977 New York, no. 27 of works on paper; 1979 Edinburgh, no. 53.

SELECTED REFERENCES: Burroughs 1919, p. 116; Jacob Bean, *100 European Drawings in The Metropolitan Museum of Art*, New York: The Metropolitan Museum of Art, 1964, no. 76, repr.

199

The Portrait of Diego Martelli

cat. nos. 200–202

In the course of his travels to Florence—likely during his longest visit, in the winter of 1858–59—Degas met a number of Florentine artists, mostly painters, but also a sculptor, Adriano Cecioni, belonging to the group commonly known as the Macchiaioli. He was closest to Telemaco Signorini, his exact contemporary, but over the years he met in Paris other members of the group such as Boldini, De Nittis, and Zandomeneghi, all of whom he knew well. It is unclear, however, when he first met Diego Martelli (1839–1896), a Florentine writer and art critic and the principal advocate of the group. During the late 1860s and early 1870s, there was considerable movement between Florence and Paris, with Signorini, Martelli, and other Macchiaioli spending periods of time in France; Degas himself visited Signorini in Florence in 1875. In the spring of 1878, at the time of the Exposition Universelle, Diego Martelli came to Paris for his fourth visit, an extended stay of some thirteen months. Through the circle of artists at the Café de la Nouvelle-Athènes he met Desboutin, already a Florentine by adoption, and Pissarro, who became a friend and from whom he purchased two landscapes.

The beginnings of Martelli's connection with Degas appear to have been more cautious. In a letter written on Christmas Day 1878 to Matilde Gioli, the wife of the painter Francesco Gioli, he mentioned friends in Paris, and Degas, "with whom I am in danger of becoming a friend, a man of wit and an artist of merit, threatened by blindness . . . and who consequently spends hours in a dark and desperate mood, matching the gravity of his condition."[1] In the spring of 1879, he saw a good deal of Degas, and it was at that time that the painter, more or less simultaneously with Federico Zandomeneghi, began a portrait of Martelli.[2]

In late March, Martelli wrote to Matilde Gioli again. He enclosed a poster, from Degas, of the fourth Impressionist exhibition, noted that the exhibition was due to open on 10 April, and told her that among the works exhibited would be two portraits of himself, one by Zandomeneghi and one by Degas.[3] Martelli left Paris in April, probably shortly after the exhibition opened. Once in Italy, he published a review of the exhibition in two successive issues of *Roma Artistica* and wrote his famous paper on Impressionism, eventually delivered on 16 January 1880 at the Circolo Filologico in Livorno.[4] When Martelli left Paris, Degas had in his studio two different portraits of him, one now in Edinburgh (cat. no. 201) and the other in Buenos Aires (cat. no. 202), neither of which Martelli was to see again. In the mid-1890s, Martelli regularly received news

of Degas from Zandomeneghi, and received as well a photograph by the "tiresome Degas" of Albert Bartholomé and Zandomeneghi posing as river gods in the park at Dampierre, but every effort he made to obtain his portrait from Degas failed.[5] In 1894, Zandomeneghi informed him that "a long time ago, I asked Degas tactfully for your portrait so that I could send it to you along with the one of you I did. Naturally Degas refused, first for the sake of refusing it, then because he remembered that Duranty disapproved of the foreshortening of the legs."[6] And in 1895, he warned him again: "Don't count on anything."[7]

Because of its freer style, the painting in Buenos Aires has long been assumed to be the full-scale study for the more finished painting in Edinburgh.[8] In recent years, however, Ronald Pickvance has shown that the works were two different, successive stages of the same project.[9] In addition to a highly finished charcoal-and-chalk study of Martelli's head (III:160.1, Cleveland Museum of Art), a number of preliminary drawings are known to be connected with the paintings. The most schematic are sketches in pencil in Notebook 31,[10] one of them a compositional study, page 25. An independent sketch (fig. 148) in the National Gallery of Scotland is also a compositional study on a sheet evidently detached from a notebook the same size as Notebook 31. Each of the two compositional studies relates to one of the paintings. The sketch on page 25 in Notebook 31, though drawn in haste, is unmistakably the preliminary design for the portrait in Edinburgh, while the detached sheet (fig. 148), with a horizontal composition, is close to the painting in Buenos Aires.

Three additional studies of Martelli also present variations. Two drawings squared for transfer, one in the Fogg Art Museum (III:344.2) and the other in a private collection in London (fig. 147), show Martelli seated and identically dressed and differ only in emphasis. In the London drawing, the feet are sketchy but the head and torso are carefully worked out and the outline of the sofa and the frame above it are indicated; like the preliminary study for Edmond Duranty's portrait, it is inscribed and dated "Chez Martelli/3 Avril 79/Degas"—which places it, as pointed out by Jean Sutherland Boggs, only seven days before the opening of the fourth Impressionist exhibition.[11] The full-length study in the Fogg, in which Martelli's head and arms are less defined, is more specific in the description of the lower part of his figure, particularly the feet. Finally, another squared study of Martelli (cat. no. 200) in the Fogg Art Museum, identified by Boggs as a study for the Buenos Aires version, shows him in the same pose, but only from the waist up and dressed in the waistcoat he wears in the Buenos Aires painting. In Pickvance's reconstruction of the sequence, the compo-

sitional study in Edinburgh (fig. 148) with the half-length study of Martelli in the Fogg (cat. no. 200) served for the painting in Buenos Aires, which, in his opinion, almost certainly preceded the portrait in Edinburgh. The compositional sketch in Notebook 31, with the full-length London and Fogg drawings (fig. 147 and III:344.2), followed closely as studies for the Edinburgh painting.

Despite the great disparity in style, it is difficult to think that the two paintings were not executed in rapid succession in the manner suggested by Pickvance. Martelli never returned to Paris, and there is no reason to suppose that the Buenos Aires version was painted several years later from drawings. It could be speculated that because Duranty had made a critical remark on the rendering of Martelli's legs in the Edinburgh version, Degas attempted a second portrait after Martelli's departure, omitting the legs, which may explain Martelli's curious request, through Zandomeneghi, for "his portrait" rather than for one of his portraits. But the evidence of the paintings themselves argues against it: the portrait in Edinburgh, so much more resolved, can only be the final version.

Other questions remain unanswered. If the drawing dated 3 April 1879 (fig. 147) gives a clue to the date when the Edinburgh version was begun, there is no clear indication when it was finished. Degas was evidently working on it at the same time he was painting Duranty's portrait and could scarcely have finished it for exhibition on 10 April. Both the Duranty and the Martelli portraits appear on the list Degas drafted in anticipation of the exhibition as well as in the printed catalogue.[12] Martelli himself was silent on the subject in his exhibition review—as he was on the subject of Zandomeneghi's portrait—possibly out of modesty or because he had not seen the painting exhibited. All other reviewers were equally silent, and, once again, there is only Armand Silvestre's word that by 1 May 1879, all of Degas's works were in the exhibition.[13] Which of the two portraits was ultimately exhibited remains in doubt.

1. Baccio M. Bacci, *L'800 dei macchiaioli e Diego Martelli*, Florence: L. Gonnelli, 1969, p. 116.
2. The Zandomeneghi portrait, doubtless the picture signed, dated, and inscribed "A Diego Martelli/Zandomeneghi 79," is now in the Galleria d'Arte Moderna, Florence.
3. Bacci, op. cit., p. 117, places the letter before a letter to Matilde Gioli dated 28 March 1879. The existence of the poster, however, suggests early April—before 9 April, when the poster was already prominently displayed throughout Paris.
4. For a recent reprint of the review, originally published on 27 June and 7 July 1879 in French, see Diego Martelli, *Les impressionnistes et l'art moderne* (edited by Francesca Errico), Paris: Vilo, 1979, pp. 28–33.
5. Letter from Zandomeneghi to Martelli, Paris, November 1895, in *Lettere dei macchiaioli* (edited by Lamberto Vitali), Turin: Einaudi, 1953, p. 313.

6. Letter from Zandomeneghi to Martelli, Paris, November 1894, in *Lettere dei macchiaioli*, op. cit., p. 304.
7. Letter from Zandomeneghi to Martelli, Paris, 31 August 1895, in *Lettere dei macchiaioli*, op. cit., p. 310.
8. Theodore Reff, however, has called the Buenos Aires painting "a second version"; see Reff 1976, p. 132.
9. See Pickvance in 1979 Edinburgh, p. 50 and nos. 55–60.
10. Reff 1985, Notebook 31 (BN, Carnet 23, pp. 24, 25, 27). In addition, Jean Sutherland Boggs and Theodore Reff have tentatively recognized in the same notebook on pages 1 and 3 studies for the head of Diego Martelli (see Boggs 1958, p. 242, fig. 40). The studies appear to be of an altogether different person.
11. 1967 Saint Louis, nos. 88, 89.
12. Reff 1985, Notebook 31 (BN, Carnet 23, p. 68, under no. 1).
13. Silvestre 1879, p. 53.

200.

Study for *Diego Martelli*

1879
Black chalk heightened with white chalk on buff wove paper, squared for transfer
17¾ × 11¼ in. (45 × 28.6 cm)
Vente stamp lower left
Harvard University Art Museums (Fogg Art Museum), Cambridge, Massachusetts. Bequest of Meta and Paul J. Sachs (1965.255)

Vente III:344.1

Presumably the earliest and certainly the most expressive of the three studies of Diego Martelli seated, this drawing was squared for transfer onto canvas for the portrait in Buenos Aires (cat. no. 202). Given that Mar-

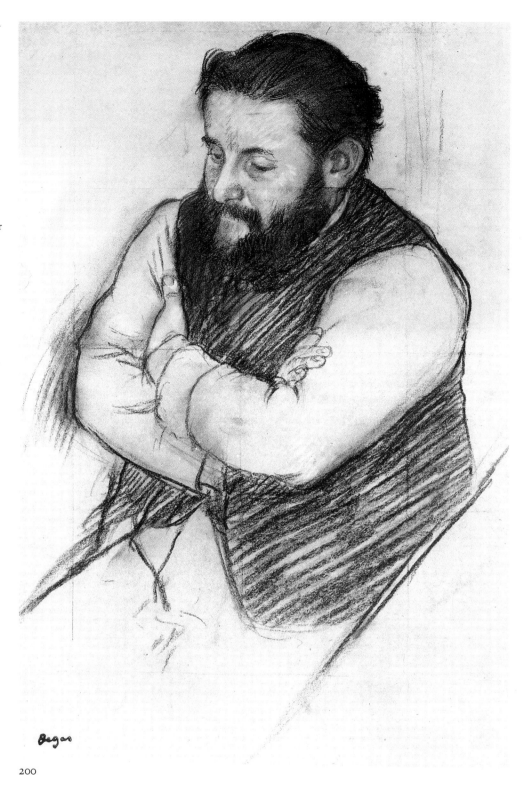

200

Fig. 147. Study for *Diego Martelli* (I:326), dated 3 April 1879. Charcoal heightened with white, 17¾ × 11½ in. (45 × 29 cm). Private collection, London

telli's head is inclined forward in the study in London and in the other study, in the Fogg Art Museum (fig. 147 and III:344.2), which differ in this respect from the painting in Edinburgh (cat. no. 201), it is likely that Degas used this drawing for the head in both the Edinburgh and the Buenos Aires portraits. As in the stylistically similar studies for the portrait of Edmond Duranty, the head is finished to a greater degree and has been touched up with white-chalk highlights.

There are slight revisions to the arms and a major adjustment to Martelli's waist, giving him a larger frame, consistent with his build as it appears in photographs of the period.

PROVENANCE: Atelier Degas (Vente III, 1919, no. 344.1, in the same lot with no. 344.2, for Fr 850). César M. de Hauke, New York; bought by Paul J. Sachs, 1929; his bequest to the museum 1965.

EXHIBITIONS: 1930, New York, Jacques Seligmann and Co., 27 October–15 November, *Drawings by*

Degas, no. 9; 1931 Cambridge, Mass., no. 17b; 1933 Northampton, no. 27; 1934, Cambridge, Mass., Fogg Art Museum, *French Drawings and Prints of the Nineteenth Century*, no. 22; 1936 Philadelphia, no. 82, repr.; 1940, Washington, D.C., Phillips Memorial Gallery, 7 April–1 May, *Great Modern Drawings*, no. 13; 1940, San Francisco, Golden Gate International Exposition, Palace of Fine Arts, *Master Drawings: An Exhibition of Drawings from American Museums and Private Collections*, no. 21, repr.; 1941, Detroit Institute of Arts, 1 May–1 June, *Masterpieces of 19th and 20th Century Drawings*, no. 24; 1943, Santa Barbara Museum of Art, *Master Drawings, Fogg Museum*; 1945, New York, Buchholz Gallery, 2–27 January, *Edgar Degas: Bronzes, Drawings, Pastels*, no. 69; 1947 Cleveland, no. 68, repr.; 1947, New York, Century Club, *Loan Exhibition*; 1947 Washington, D.C., no. 16; 1952, Richmond, Virginia Museum of Fine Arts, *French Drawings from the Fogg Art Museum*; 1955 Paris, Orangerie, no. 71, repr.; 1956, Waterville, Me., Colby College, Miller Library, 27 April–23 May, *An Exhibition of Drawings Presented by the Art Department, Colby College*, no. 31; 1960 New York, no. 91; 1965–67 Cambridge, Mass., no. 60, repr.; 1974 Boston, no. 85; 1979 Edinburgh, no. 59, repr.

SELECTED REFERENCES: Mongan 1932, p. 68, repr.; Cambridge, Mass., Fogg, 1940, p. 362, no. 673, fig. 349; Henry S. Francis, "Drawings by Degas," *Bulletin of the Cleveland Museum of Art*, XLIV, December 1957, p. 216; Rosenberg 1959, pp. xxiii, 110, pl. 205 (revised edition 1974, p. 148, pl. 269); Wick 1959, pp. 87–101; Boggs 1962, p. 123; Lamberto Vitali, "Three Italian Friends of Degas," *Burlington Magazine*, CV:723, June 1963, p. 269, fig. 27; Jean Leymarie, *Dessins de la période impressionniste de Manet à Renoir*, Geneva: Skira, 1969, p. 43, repr. p. 45; Vojtech and Thea Jirat-Wasiutynski, "The Uses of Charcoal in Drawing," *Arts Magazine*, LV:2, October 1980, p. 131, fig. 6 p. 130.

201.

Diego Martelli

1879
Oil on canvas
43½ × 39¾ in. (110 × 100 cm)
Vente stamp lower right
National Gallery of Scotland, Edinburgh
 (NG1785)

Exhibited in Paris

Lemoisne 519

Among Degas's greatest portraits, the Edinburgh version of *Diego Martelli* is also a striking example of his interest in unconventional angles of sight. At this time, perhaps not long before January 1879, he made notes about the construction of tiers all around his studio that would enable him to draw from both above and below the subject. He followed with the remark, "For a portrait, place the model at the lower level and work from the level above, in order to accustom yourself to retain the forms and expressions and never to draw or paint *immediately*."[1] The

high viewpoint in this portrait is no different from that in the Buenos Aires version (cat. no. 202) except for the extraordinary revelation of Martelli's legs, shown in sharp perspective, and the abruptly receding floor. The composition, however, is very different, with a clear break between Martelli and the table and a redistribution of the geometric forms in the background, where the curve of the sofa answers the curve of a mysterious framed object, perhaps a map of Paris.[2]

The still life on the table, easily the most inspired interpretation of the miscellanea scattered about a writer's person, is consistent with the artist's view of portrait painting as an exercise extending beyond the recording of mere physical traits. Martelli's slippers, lined with red, are the visual counterpart of another note Degas made: "Include all types of everyday objects positioned in a context to express the *life* of the man or woman— corsets that have just been removed, for example, and that retain the shape of the wearer's body."[3]

The correction in black outline at the juncture of Martelli's legs and the reworking of his left knee may have been prompted by Duranty's comments on the work.[4]

1. Reff 1985, Notebook 30 (BN, Carnet 9, p. 210).
2. See *Catalogue of Paintings and Sculpture*, 51st edition, Edinburgh: National Gallery of Scotland, 1957, p. 63, where the object is identified as a map. For Theodore Reff's discussion of the question, see Reff 1976, pp. 131–32.
3. Reff 1985, Notebook 30 (BN, Carnet 9, p. 208).
4. See "The Portrait of Diego Martelli," p. 312.

PROVENANCE: Atelier Degas (Vente I, 1918, no. 58, for Fr 30,500); bought by Dr. Georges Viau, Paris; bought by Paul Rosenberg and Co., Paris; with Reid and Lefevre, London, 1920; Mrs. R. A. Workman, London. With Knoedler and Co., London and New York, by 1930. With Reid and Lefevre, London; bought by the museum 1932.

EXHIBITIONS: 1879 Paris, no. 57; (?)1920, Glasgow, Alex Reid and Lefevre Galleries, January–February, no. 148; 1922, London, Burlington Fine Arts Club, summer, *French School of the Last Hundred Years*, no. 38; 1923, Manchester, Agnew and Sons Galleries, *Loan Exhibition of Masterpieces of French Art of the 19th Century*, no. 16; 1925, Kirkcaldy, Museum and Art Gallery, June, *The Kirkcaldy Art Inauguration Loan Exhibition*, no. 39; 1926–27, London, National Gallery, Millbank (Tate), on loan; 1930, Paris, Galerie Georges Petit, 15–30 June, *Cent ans de peinture française*, no. 14; 1930, New York, Knoedler Galleries, October–November, *Masterpieces by Nineteenth Century French Painters*, no. 4, repr.; 1931 Cambridge, Mass., no. 8, lent by Knoedler and Co. (as 1880); 1932 London, no. 347 (433); 1937 Paris, Palais National, no. 306; 1952 Amsterdam, no. 18; 1952 Edinburgh, no. 17, pl. X; 1979 Edinburgh, no. 60, pl. 13 (color).

SELECTED REFERENCES: Lemoisne 1912, p. 86; Lafond 1918–19, II, p. 15; Walter Sickert, "French Art of the Nineteenth Century—London," *Burlington Magazine*, XL:231, June 1922, p. 265; Coquiot 1924, p. 218, repr.; James B. Manson, "The Workman Collection: Modern Foreign Art," *Apollo*, III, 1926, p. 142, repr. (color); Lemoisne [1946–49], II, no. 519; *Catalogue of Paintings and Sculpture*, 51st edition, Edinburgh: Na-

tional Gallery of Scotland, 1957, p. 63; Boggs 1962, pp. 57, 123, pl. 102; Lamberto Vitali, "Three Italian Friends of Degas," *Burlington Magazine*, CV:723, June 1963, pp. 269–70; *The Maitland Gift and Related Pictures*, Edinburgh: National Gallery of Scotland, 1963, pp. 22–23, repr. p. 22; Minervino 1974, no. 556; Reff 1976, pp. 131–32, fig. 94; Piero Dini, *Diego Martelli*, Florence: Il Torchio, 1978, pp. 144–45, 155 nn. 64, 66; Reff 1985, Notebook 31 (BN, Carnet 23, pp. 1, 24, 25, 27, 68); Sutton 1986, p. 290, fig. 277 p. 287.

202.

Diego Martelli

1879
Oil on canvas
29¾ × 45⅝ in. (75.5 × 116 cm)
Signed lower right: Degas
Museo Nacional de Bellas Artes,
 Buenos Aires (2706)

Lemoisne 520

In composition, the portrait largely follows the diagrammatic sketch in Edinburgh (fig. 148), with two conspicuous exceptions: the sofa does not appear in the drawing, and the background wall recedes slightly to the right whereas in the drawing it recedes sharply to the left. For the portrait, Degas returned to a scheme he had used a decade earlier, particularly in the geometrically divided background, and he evidently adjusted the composition slightly after it had been blocked out. He extended the table to the left in order to connect it with Martelli's body, in the same relationship apparent in the drawing in the Fogg Art Museum (cat. no. 200), and covered part of the extreme right end of the blue sofa to avoid an exaggerated horizontal emphasis.

The handling of paint, brilliant and free for some of the background and in the still life with papers, pipe, pencil, inkstand, and Martelli's red skullcap, is tight and methodical in the figure and remaining accessories. The portrait does not, therefore, suggest a sketch or an unfinished work.

PROVENANCE: Atelier Degas (Vente II, 1918, no. 35, for Fr 17,500); bought by Dr. Georges Viau, Paris; Wildenstein et Cie, Paris; Jacques Seligmann, New York, by 1933; bought for the museum by the Asociación Amigos del Museo Nacional de Bellas Artes December 1939.

EXHIBITIONS: 1933 Northampton, no. 11; 1936 Philadelphia, no. 30, repr.; 1937 Paris, Orangerie, no. 31 1938 New York, no. 8; 1939–40 Buenos Aires, no. 41 1962, Buenos Aires, Museo Nacional de Bellas Artes, September–October, *El impresionismo francés en las colecciones argentinas*, p. 17, repr. (color); 1975–76, Munich, Haus der Kunst, 18 October 1975–

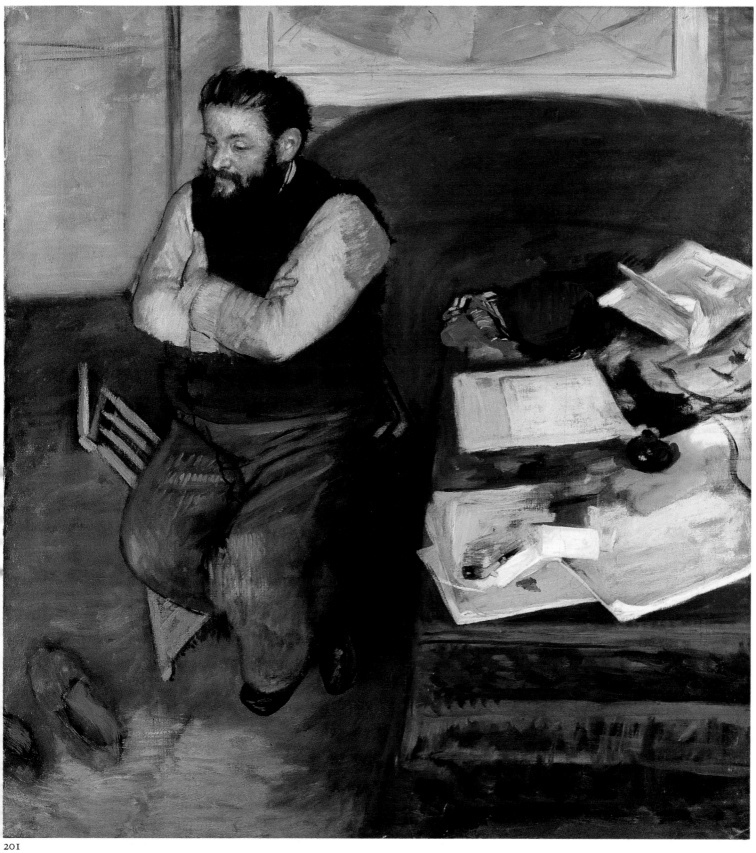

201

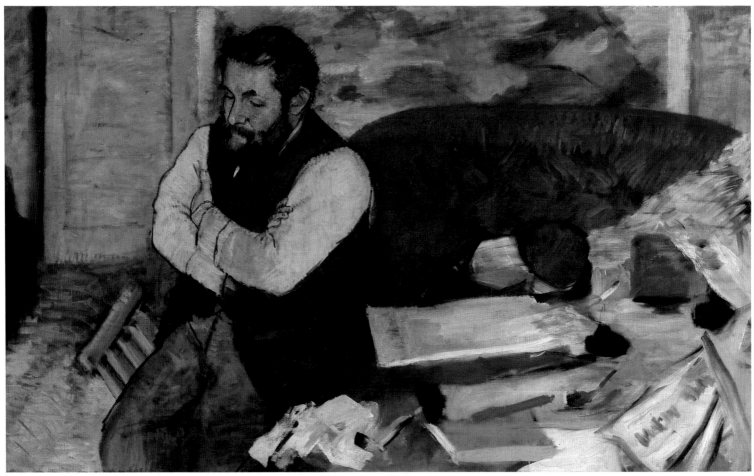

202

Fig. 148. Study for *Diego Martelli*, 1879. Pencil, 4⅜ × 6⅝ in. (11.1 × 16.8 cm). National Gallery of Scotland, Edinburgh

4 January 1976, *Toskanische Impressionen*, no. 15, repr.; 1984–85 Paris, no. 13, fig. 88 (color) p. 107.

SELECTED REFERENCES: Lafond 1918–19, II, p. 15; Coquiot 1924, p. 218; Fosca 1930, p. 377; *L'Amour de l'Art*, XIX, October 1938, repr. (color) cover; *Retrato de Diego Martelli* (edited by José M. Lamarca Guerrico), Buenos Aires: Francisco A. Colombo, 1940, passim; Julio Rinaldini, *Edgar Degas*, Buenos Aires: Poseidon, 1943, p. 28; Lassaigne 1945, p. 47; Lemoisne [1946–49], II, no. 520; Oscar Reuterswärd, "An Unintentional Exegete of Impressionism: Some Observations on Edmond Duranty and His 'La nouvelle peinture,'" *Konsthistorisk Tedskrift*, IV, 1949, p. 113, fig. 2; Boggs 1962, p. 123; Lamberto Vitali, "Three Italian Friends of Degas," *Burlington Magazine*, CV:723, June 1963, p. 269 n. 14; 1967 Saint Louis, p. 142; Minervino 1974, no. 557; Reff 1976, pp. 132, 317 n. 129; 1979 Edinburgh, under nos. 55–58, 60.

203.

Portraits at the Stock Exchange

c. 1878–79
Oil on canvas
39⅜ × 32¼ in. (100 × 82 cm)
Musée d'Orsay, Paris (RF2444)

Exhibited in Paris

Lemoisne 499

The name and address of Ernest May appear for the only time in one of Degas's notebooks dated 1875–78 by Theodore Reff.[1] It is likely that May and Degas met toward the end of this period, possibly through Gustave Caillebotte. In a letter to Caillebotte in early spring 1879 about the imminent fourth Impressionist exhibition, Degas wrote that they would meet next evening at Ernest May's for dinner.[2] According to Georges Rivière, Caillebotte and May were to provide part of the capital for *Le Jour et la Nuit*, the journal that Degas, Bracquemond, and others decided to publish shortly after the end of the exhibition of 1879.[3] Whether this is true or not, later in the year Degas acted as intermediary in May's purchase of a cartoon by Bracquemond, at which time he gave Bracquemond a brief but biting description of May: "I shall see him in a day or two. He is getting married, and is going to take a town house and arrange his little collection as a gallery. He is a Jew, and has organized a sale for the benefit of the wife of Monchot [sic], who went mad. He is a man who is throwing himself into the arts, you understand."[4]

May, a successful financier, was born in 1845 and was thus about ten years younger than Degas. The portrait that he commissioned from the sculptor François-Paul Machault was exhibited in plaster at the Salon of 1876 (no. 3445) and again, as a bronze, two years later (no. 4426). The sale organized to help Machault's wife was an obvious act of charity on behalf of someone May knew, exactly the sort of gesture Degas him-

self was to perform a year later for the widow of Edmond Duranty, and was not necessarily connected with his considerable interest in painting, which, over the years, led to a substantial collection. His earlier, perhaps more conservative streak had prompted him to buy a few old masters and the type of eighteenth-century pictures that would be seen in any nineteenth-century town house. About 1878, however, like Jean-Baptiste Faure, he began buying works by Manet and the Impressionists as well as a splendid series of early Corots that rivaled those in the Rouart collection.[5] During late 1879 and 1880, he purchased from Degas, through an unidentified dealer, *Dance School* (L399, Shelburne Museum, Shelburne, Vt.), *The Rehearsal on the Stage* (cat. no. 125), and *Dancers at Their Toilette* (cat. no. 220).

As Degas noted in his letter to Bracquemond, May married and moved to Faubourg Saint-Honoré, also spending some time at his country estate. Theodore Reff has shown that after May's first child, Étienne, was born on 29 May 1881, Degas attempted a pastel portrait of Mme May seated next to the baby's cradle (L656). The picture was left unfinished, though May kept it along with a study for Mme May's head (L657) and his own two portraits. In 1890, when he decided to dispose of a great part of his collection, the portraits were not included in the sale and he bought in *The Rehearsal on the Stage*.[6] A member of the Conseil des Amis du Louvre, in 1923 he willed his oil portrait by Degas, along with a series of Impressionist paintings, to the Louvre, and the collection entered the museum after his death in October 1925.[7]

There are two versions of this curious portrait: a smaller, compositionally simpler preparatory pastel (L392), and this oil painting—one hesitates to call it finished—in the Musée d'Orsay, generally dated 1878–79. In somewhat aberrant fashion, Lemoisne dated the pastel c. 1876, two to three years before the oil version, with the indication that it was exhibited in 1876 in the second Impressionist exhibition under no. 38 as "Portrait de M. E.M. . . ." Though admittedly identical, the initials used in 1876 stood for those of Eugène Manet, whose portrait (L339) Degas exhibited that year along with one of Manet's sister-in-law, Yves Gobillard-Morisot (cat. no. 87).[8] There is no reason to doubt that the pastel was executed shortly before the oil painting and thus should also be dated 1878–79. Indeed, as far as is known, there is no proof that Degas knew May as early as 1876–77.

It is probable that preparations for this portrait, never mentioned in Degas's correspondence, took place in late 1878 or early 1879. The pastel study is enlarged at the top

and bottom with two strips of paper, suggesting that at first Degas intended a horizontal composition with the figures cut off at the knees and the head of the figure at the extreme right touching the upper limit of the design. The final, vertical format was eventually adopted, but even this underwent transformations when translated to oil. The essential elements of the composition nevertheless appear in the pastel. Under the portico of the stock exchange, a deferential secretary or usher presents May with a document, likely a financial statement. Behind May, his companion—identified by Lemoisne as a M. Bolâtre, an associate of May's—leans forward to have a better look at the document.[9]

Degas retained this basic structure in the painting but expanded on it. All the figures were moved slightly upward, and the angle of vision was rendered more acute with the inclusion of Bolâtre's left foot in the compo-

203

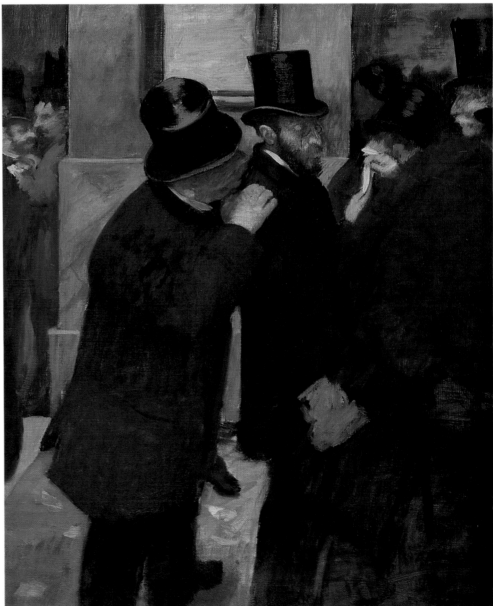

sition. Other figures, barely indicated in the pastel, were added in the left background, and two additional ones were introduced at the right, considerably animating the scene. From the very obvious pentimenti, it seems Degas added at the last the figure in the right foreground, with the head outside the confines of the painting, though he had second thoughts about it. Originally, the figure had an arm behind its back, and an attempt to change it was clearly abandoned, leaving a fairly large part of the composition unresolved.

The apparently chaotic but highly evocative composition is held firmly in place by the architectural elements, which astutely repeat the format of the painting. May, at the center and recognizably the focus of the work, is surrounded by figures from the hectic world of the stock exchange. But the faces of the secondary figures are either concealed or deliberately left vague so as not to dis-

tract attention from May. It comes as a surprise to discover that May was only thirty-four when he posed for the portrait, his long, pale, unruffled face appearing older than his years. It is a distinguished face that could well emerge from a painting by El Greco, whom Degas admired. There is no reason to think that Degas's anti-Semitism, intolerably pronounced many years later during the Dreyfus Affair, interfered with his perception of his sitter. Had this been the case, May would not have bequeathed the portrait to the Louvre. But something of Degas's sentiments about the stock exchange and the world of finance, a world he knew only too well, marks the grotesque figures in the left background.

According to the catalogues of the fourth and fifth Impressionist exhibitions, Degas exhibited this canvas both in 1879 and in 1880. This seems unusual for a work that was not for sale, and can be compared only to the second, unannounced appearance of Duranty's portrait in the exhibition of 1880, as a homage to him, a few days after his death. Ronald Pickvance has tentatively proposed that a reference by Louis Leroy, in a review of the 1879 exhibition, to a "man's hat, under which, after the most conscientious researches, I found it impossible to find a head," may have referred to this portrait.[10] It is more probable that Degas intended to exhibit the portrait in 1879, listed it in the catalogue, and then, either because it was not ready or because he undertook to change it, failed to show it. This would explain its presence in the exhibition of 1880, though not the critical silence that surrounded it.

1. Reff 1985, Notebook 27 (BN, Carnet 3, p. 34).
2. See Marie Berhaut, *Caillebotte: sa vie et son oeuvre*, Paris: La Bibliothèque des Arts, 1978, p. 243, where the letter is dated 1877. The likelier date of 1879 was proposed by Ronald Pickvance in 1986 Washington, D.C., pp. 247, 263 n. 26.
3. Rivière 1935, p. 75. However, if May was indeed one of the backers of the project it seems remarkable that Bracquemond should need an explanation of who he was. See the letter cited in note 4.
4. Lettres Degas 1945, XIX, pp. 46–47; Degas Letters 1947, no. 28, pp. 51–52 (translation revised).
5. See "Nécrologie: Ernest May," *Le Bulletin de l'Art Ancien et Moderne*, 724, January 1926, p. 16; M. Rostand, "Quelques amateurs de l'époque impressionniste" (unpublished thesis, École du Louvre, Paris, 1955).
6. See *Catalogue de tableaux anciens et modernes, aquarelles, pastels et dessins composant l'importante collection de M. E. May*, Paris: Galerie Georges Petit, 4 June 1890.
7. See "Donation May au Musée du Louvre," *L'Amour de l'Art*, March 1926, pp. 112–13.
8. The proof is to be found in a letter from Degas to Berthe Morisot, dating from April 1876 but misdated April 1874 in Morisot 1957, in which the artist asked Morisot's permission to exhibit the two portraits. See Morisot 1950, pp. 93–94; Morisot 1957, p. 97.
9. It has been suggested by Roy McMullen that Bolâtre is "whispering a tip into his ear," which is

most unlikely; see McMullen 1984, p. 301.
10. See Pickvance in 1986 Washington, D.C., p. 257 and no. 73.

PROVENANCE: Ernest May, Paris, from 1879; his bequest to the Musée du Louvre, retaining life interest, 1923; entered the Louvre 1926.

EXHIBITIONS: (?) 1879 Paris, no. 61 (as "Portraits, à la Bourse. Appartient à M. E.M. . . ."); 1880 Paris, no. 35; 1931 Paris, Orangerie, no. 69; 1946, Paris, Musée des Arts Décoratifs, *Les Goncourt et leur temps*, no. 593; 1952, Paris, Bibliothèque Nationale, opened 12 December, *Émile Zola*, no. 422; 1969 Paris, no. 30; 1979 Edinburgh, no. 49, pl. 11 (color); 1986 Washington, D.C., no. 73, repr. (color).

SELECTED REFERENCES: *Kunst und Künstler*, XXIV, 1925–26, repr. p. 400; Max J. Friedländer, "Das Malerische," *Kunst und Künstler*, XXVI, 1927–28, repr. p. 13; Rouart 1945, pp. 42, 73 n. 58; Lemoisne [1946–49], II, no. 499; Cabanne 1957, p. 113, pl. 72; Boggs 1962, pp. 54, 57, 59, 110, 123, pl. 101; Minervino 1974, no. 454; Paris, Louvre and Orsay, Peintures, 1986, III, p. 196; Sutton 1986, p. 216, pl. 204 p. 218.

204, 205.

Two Studies of Mary Cassatt at the Louvre and *Woman in Street Clothes*

Among the twenty-five works listed by Degas in 1879 in the catalogue of the fourth Impressionist exhibition were five objects related to the decorative arts—four fans and an *Essai de décoration, détrempe* (decorative scheme in distemper).[1] The *Essai de décoration* appears also on a draft list for the exhibition that contains an additional item of apparently decorative nature, a *Portrait sur abat-jour* (portrait on a lampshade), in the end not exhibited and therefore not discussed by any of the reviewers.[2] Lemoisne, along with a great many other scholars, assumed for some time that a pastel drawing inscribed "Portraits in a Frieze to Decorate an Apartment" (fig. 149) was the work exhibited, until Ronald Pickvance pointed out that the medium did not correspond and that *Portraits in a Frieze* was exhibited hors catalogue one year later in the fifth Impressionist exhibition.[3] The *Essai de décoration*, presumably lost, has thus far evaded identification, but it is generally believed that *Portraits in a Frieze* was in some manner related to the project. Furthermore, there are reasons to think that *Two Studies of Mary Cassatt at the Louvre* and *Woman in Street Clothes* (cat. nos. 204, 205) were also connected with the scheme.

The question of the nature of these works is complicated by the difficulty of naming the figures in the drawings. The ravishing *Woman in Street Clothes* has been recognized

by Pickvance as a portrait of the actress Ellen Andrée, and photographs of her support his interpretation.[4] *Portraits in a Frieze* represents three female figures in different costumes: one, standing to the left, so far unidentified; another, seated at the center, doubtless the American painter Mary Cassatt; and a third standing to the right, usually identified as Ellen Andrée on the strength of a closely related etching (RS40) identified by Arsène Alexandre in 1918.[5] Inasmuch as such matters can be judged, there is no similarity between the figures identified by Pickvance and Alexandre as Ellen Andrée, and it would be very difficult to claim they are the same person. There is almost universal agreement that *Two Studies of Mary Cassatt at the Louvre* does indeed represent Mary Cassatt, and her features are certainly recognizable in the figure facing the viewer. However, the possibility that the woman might be Ellen Andrée was raised because of the close relationship between this figure and the one appearing at the right in *Portraits in a Frieze* and in the etching: the women have the same profiles and wear the same costume. If Alexandre's identification of the etching is correct—and this appears highly doubtful—it follows that the related figures in both *Portraits in a Frieze* and *Two Studies of Mary Cassatt at the Louvre* represent Ellen Andrée.

More enigmatic is the relationship of the drawings to each other. All three show full-length figures against a neutral background and are executed in the same medium—charcoal and pastel—on gray paper. Pickvance has indicated that *Woman in Street Clothes* is the same height as *Portraits in a Frieze* and, hence, that the two might be related as studies for the same decorative scheme. Theodore Reff has concurred with this hypothesis.[6]

A possible connection with three or four additional works united by formal as well as conceptual links remains to be explored. One, *Woman Reading a Catalogue* (fig. 150), a preparatory drawing for the pastel and etched versions of *At the Louvre* (cat. nos. 206, 207, fig. 114), has already been associated with *Two Studies of Mary Cassatt at the Louvre* by Jean Sutherland Boggs.[7] A second, *Woman in a Mauve Dress and Straw Hat* (L651), possibly posed for by Ellen Andrée, has not been previously linked with the others but is the same size as *Woman Reading a Catalogue*. The third is the famous *Mary Cassatt at the Louvre* (L582, Philadelphia Museum of Art), a study for *At the Louvre* drawn on an entirely different scale but identical in size to *Two Studies of Mary Cassatt at the Louvre*. As with the previous group of works, all three drawings are in pastel on gray paper. Finally, there is an untraced work described in a sale catalogue of 1954: "Two studies of a seated woman; in the center, the same figure stand-

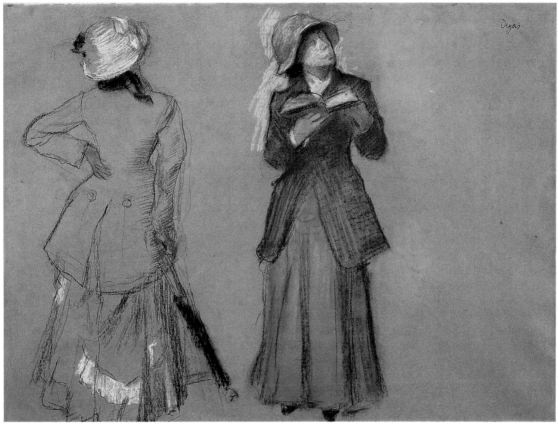

204

205

Fig. 149. *Portraits in a Frieze* (L532), 1879. Pastel, 19¾ × 25⅝ in. (50×65 cm). Collection of Dr. Herman J. Abs, Cologne

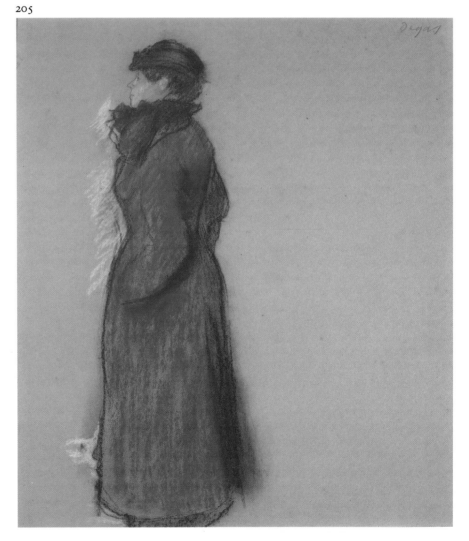

ing (Mary Cassatt?). Charcoal and pastel. H 61 cm; L 94 cm."[8] Larger than *Portraits in a Frieze*, the drawing may have been not unlike it.

All these works—except the lost drawing—share characteristics beyond type, technique, and size. They all represent women in street dress looking at something (probably works of art), consulting a book (likely a catalogue), or carrying a book. All could be visitors in a museum. Two of the figures were evidently used for the various versions of *At the Louvre* of 1879–80 (cat. nos. 206, 207; fig. 114), but any of the other figures could have served equally well. In this light, it is tempting to consider them as a stock of figures assembled for some unrealized or lost composition with visitors in a museum and eventually used for *At the Louvre* (cat. no. 206).

In a notebook of 1859–64, Degas twice stated ideas for decorative projects, an allegorical scheme with figures half life-size for a library and "Portrait of a Family in a Frieze." For the latter, he added: "Proportions of the figures barely one meter. There could be two compositions, one of the family in town, the other in the country."[9]

Portraits in a Frieze appears to be the much later realization of such an idea, though one wonders to what extent the term "portrait" can be understood in the common sense of the word. Despite the inscription, the figures in *Portraits in a Frieze* preclude a satisfactory interpretation. The frieze either represents Mary Cassatt twice, in two different costumes, a curious device for a portrait, or joins Mary Cassatt with Ellen Andrée—a less than likely association.

1. 1879 Paris, no. 67.
2. Reff 1985, Notebook 31 (BN, Carnet 23, p. 68). The curious *Portrait sur abat-jour* appears listed under no. 19 on p. 67 of Notebook 31.
3. 1979 Edinburgh, no. 68.
4. Ibid., no. 69.
5. Alexandre 1918, p. 14. Alexandre's identification was adopted by all later scholars; however, the drypoint was listed in the Vente Estampes, no. 141, as "Femme debout, au livre." The similarity between the etching and a sculpture by Degas, *The Schoolgirl* (RLXXIV), has led Theodore Reff to tentatively propose that Ellen Andrée also posed for the sculpture, which he dated 1881; see Reff 1976, p. 260. However, according to Jeanne Fevre, the artist's niece, the model for the sculpture (and, hence, for the drawings connected with it in Notebook 34 [BN, Carnet 2, passim]) was her sister Anne Fevre, who also posed for *The Apple Pickers* (cat. no. 231); see Jeanne Fevre's unpublished, undated letter, Archives, Musée du Louvre, Paris, kindly communicated to the author by Henri Loyrette.
6. See Pickvance in 1979 Edinburgh, no. 69; Reff, in Brame and Reff 1984, no. 104.
7. See Boggs in 1967 Saint Louis, nos. 86, 87.
8. Drouot, Paris, 20 December 1954, no. 70.
9. Reff 1985, Notebook 18 (BN, Carnet 1, pp. 123, 204).

204.

Two Studies of Mary Cassatt at the Louvre

c. 1879
Charcoal and pastel on gray wove paper
18¾ × 23¾ in. (47.8 × 63 cm)
Signed in black pastel upper right: Degas
Private collection, U.S.A.

Brame and Reff 105

PROVENANCE: Harris Whittemore, Naugatuck, Conn.; transferred to J. H. Whittemore Co., Naugatuck, Conn., 1926 (sale, Parke-Bernet, New York, 19–20 May 1948, no. 84). Siegfried Kramarsky, New York; private collection.

EXHIBITIONS: 1935 Boston, no. 125; 1939, Boston, Museum of Fine Arts, 9 June–10 September, *Art in New England: Paintings, Drawings, Prints from Private Collections in New England*, no. 158; 1944–45, Washington, D.C., National Gallery of Art, 19 November 1944–8 May 1945, *French Drawings from the French Government, the Myron A. Hofer Collection, and the Harris Whittemore Collection*, no. 68; 1947 Washington, D.C., no. 17, repr.; 1959, New York, Columbia University, at M. Knoedler and Co., 13 October–7 November, *Great Master Drawings of Seven Centuries*, no. 72, repr.; 1967 Saint Louis, no. 87, repr.; 1978 New York, no. 9, repr. (color).

SELECTED REFERENCES: Brame and Reff 1984, no. 105.

205.

Woman in Street Clothes

c. 1879
Pastel on gray wove paper
18⅞ × 17 in. (48 × 43 cm)
Signed in blue pencil upper right: Degas
Collection of Walter M. Feilchenfeldt, Zurich

Brame and Reff 104

PROVENANCE: Duc de Cadaval, Pau; Paul Rosenberg, New York; present owner.

EXHIBITIONS: 1976–77 Tokyo, no. 29, repr. (color); 1979 Edinburgh, no. 68, repr.; 1984 Tübingen, no. 135, repr. (color).

SELECTED REFERENCES: Thomson 1979, p. 677, fig. 94; Brame and Reff 1984, no. 104 (as 1878–80).

206.

At the Louvre

c. 1879
Pastel on seven pieces of paper joined together
28 × 21¼ in. (71 × 54 cm)
Vente stamp lower right
Private collection

Lemoisne 581

Louisine Havemeyer implied in her memoirs, quite unintentionally, that Degas and Mary Cassatt knew each other as early as 1874 or 1875, or even earlier.[1] The supposition remains unfounded, though it is certain that the two had met by 1877 when Degas invited Mary Cassatt to exhibit with the Impressionists, a proposal that bore fruit only in 1879. It is unfortunate for students of the Impressionist movement that in later life, when her sentiments for Degas were decidedly ambivalent, Mary Cassatt destroyed her letters from the artist, who did not save his correspondence from her, either.

As a painter, Cassatt was frequently associated with Degas by critics, an opinion she never altogether rejected, and Degas's respect for her work was common knowledge. In return, her admiration was unqualified and she did everything she could to further his work among her American acquaintances. She had character and determination along with talent and great natural elegance, qualities likely to have attracted him, but it must have been a fairly odd relationship between two testy, opinionated people. As friends, they were close enough that Degas would introduce her to his family—his sister Thérèse, his brother René, his niece Lucie Degas, and the children of Marguerite Fevre. At the time of Degas's death, when Cassatt was over seventy, she courageously stepped into the midst of family squabbles and helped reunite the Fevres with the Degas. Nevertheless, this did not prevent her from reacting sharply when the Louvre purchased *The Bellelli Family* (cat. no. 20), at a time when she thought money should be spent on the war effort.[2]

As friends and colleagues, Degas and Cassatt appear to have been closest about 1879–80, when they collaborated on Degas's proposed publication *Le Jour et la Nuit* and Cassatt posed for a number of his works. She has been recognized, for example, in this splendid pastel, in the two etchings derived from it, and in some of the figures in *Portraits in a Frieze* (cat. nos. 204, 205; fig. 149).

It should be stated at the outset that the unconfirmed but long-known traditional identification of Cassatt in this pastel has been substantiated by her own words. In a letter to Louisine Havemeyer of 7 December

1918, she wrote: "I posed for the woman at the Louvre leaning on an umbrella."[3] Though the work is admittedly unconventional, no one has doubted that it is a portrait. As such, it belongs to the series of Degas's "psychological" portraits of the late 1870s representing friends in settings typical of their calling. Jean Sutherland Boggs has observed that these works are among Degas's most memorable and has noted the artist's tendency during this period to "present things in bold, self-contained shapes, which have expressive silhouettes, and in addition to compose clearly but unexpectedly with them."[4]

The most revealing comparison is probably with *Portrait of Friends in the Wings* (cat. no. 166). Both works depict their subjects in appropriate settings—Halévy backstage at the theater, Cassatt at the museum—and in both instances the main figure is set off by a companion. In *At the Louvre*, Mary Cassatt is observed from behind a catalogue by another visitor, probably her sister Lydia, who anticipates the viewer's curiosity about her. The scene might belong to a genre painting were it not for the absence of metaphorical elements.

The most provocative aspect of the work is the artist's decision to represent his sitter from behind. Boggs has connected this pose with Duranty's observation in *La nouvelle peinture* about the significant interpretations to be derived from the simple view of a person's back.[5]

That other choices were open to Degas is made plain by the contemporary studies of Mary Cassatt in the surviving *Portraits in a Frieze*, as well as, perhaps, in the untraced large drawing of the same type said to show her in three poses, standing and seated.[6] In

Fig. 150. *Woman Reading a Catalogue* (III:150.2), 1879. Charcoal and pastel, 19 × 12¼ in. (48 × 31 cm). Location unknown

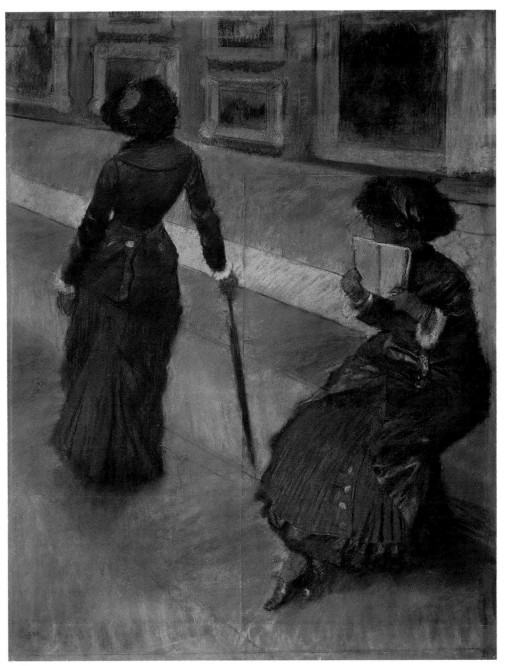

206

fact, it can hardly be denied that a relationship between the figures in *At the Louvre* and *Portraits in a Frieze* exists, and the process that led to the work is of some interest to the argument. *At the Louvre* consists of seven pieces of paper joined in such a way as to inadvertently reveal the sequence in which the composition was assembled. Originally there was only one, smaller sheet, measuring some 24⅜ by 19¾ inches (62 by 50 centimeters)—that is, roughly the same size as *Portraits in a Frieze*—with the two figures side by side at a certain distance from each other. However, the sheet was cut vertically in two, and the fragments were then repositioned in a different relationship to each other. The section containing the seated woman was placed lower, partly overlapping the section containing

Mary Cassatt and covering half of her umbrella. As the resulting arrangement was no longer rectangular, two blank fragments were inserted at the upper right, above the seated woman, and at the lower left, below Mary Cassatt. Finally, three additional horizontal strips of paper were added at the bottom, to the left (a thin strip), and at the top to obtain a more pronounced vertical composition.

This additive process occurs in a number of other works, notably *Dancer with a Bouquet Bowing* (cat. no. 162), and is highly revealing of Degas's exceptional sense of composition and supreme attention to detail. Normally, however, it applies to works that began with an identifiable core—a figure or a preexisting composition—which was then enlarged on one or several sides. *At the Louvre* is uncharacteristic inasmuch as

it cannot be said to have such a core. It began with a friezelike arrangement, which was then turned into a composition with a sharply diagonal twist. The further permutations of the figures in two subsequent, etched compositions, *Mary Cassatt at the Louvre: The Etruscan Gallery* (fig. 114) and *Mary Cassatt at the Louvre: The Paintings Gallery* (cat. nos. 207, 208), indicate that once released from the frieze format they were set in a different relationship that was revised repeatedly until the two figures almost merged into one.

Lucretia Giese has observed that a canceled notation about a portrait of Mary Cassatt appears in a list of works Degas proposed to send to the exhibition of 1879, and indeed the work is absent from the catalogue printed for the exhibition.[7] The withdrawn work was not *Portraits in a Frieze*, listed separately, and it was probably not the portrait now in Washington, D.C. (cat. no. 268), generally dated later, though the fact that Cassatt disliked it may have been good enough reason to withdraw it from the list. This leaves the two etched variations, which appear to have been executed toward the end of 1879 if not in early 1880, and, finally, this pastel, *At the Louvre*, most likely the work Degas wished to exhibit.[8]

Two principal drawings are associated with *At the Louvre*, and both are central to its elaboration. One is the famous pastel sketch of Mary Cassatt (L582, Philadelphia Museum of Art), which was closely followed in the finished work. The other is a charcoal-and-pastel study of Lydia Cassatt (fig. 150). From one of Degas's notebooks, used by the artist from about 1879, Theodore Reff has reproduced a sketch Degas made at the Louvre that is evidently connected with the wall of pictures appearing behind the two women, and there are additional, related sketches in the same notebook.[9] A pencil drawing (IV:250.b, Mellon collection, Upperville, Va.) of the two women in a compositional arrangement similar to that of the pastel is a preparatory study for the etching *Mary Cassatt at the Louvre: The Etruscan Gallery* and certainly postdates the pastel.

1. See "The First Monotypes," p. 257.
2. Cassatt's negative reaction to the purchase is recorded in an unpublished letter written to Paul Durand-Ruel from Grasse on 5 May 1918; Durand-Ruel archives, Paris.
3. Mary Cassatt, Grasse, 7 December 1918, to Louisine Havemeyer; Archives, The Metropolitan Museum of Art, New York.
4. Boggs 1962, p. 53.
5. 1967 Saint Louis, p. 136.
6. The drawing appeared in an anonymous sale, Drouot, Paris, 20 December 1954, no. 70, where it was described as "Two studies of a seated woman; in the center, the same figure standing

(Mary Cassatt?). Charcoal and pastel. H 61 cm; L 94 cm." See also cat. nos. 204, 205.
7. Giese 1978, p. 47. For Degas's list, see Reff 1985, Notebook 31 (BN, Carnet 23, p. 67), where the work is tentatively identified as *Mlle Cassatt au Louvre*.
8. For the date of the two etchings, see Reed and Shapiro 1984–85, nos. 51, 52.
9. See Reff 1976, p. 133, and Reff 1985, Notebook 33 (private collection, pp. 1, IV, 9).

PROVENANCE: Atelier Degas (Vente I, 1918, no. 126, for Fr 30,500); bought at that sale by Jeanne Fevre, the artist's niece, Nice (Fevre sale, Galerie Charpentier, Paris, 12 June 1934, no. 93, repr.); bought by Maurice Exsteens, Paris. Sale, Sotheby's, New York, 15 May 1984, no. 8, repr. (color); bought by present owner.

EXHIBITIONS: 1939, New York, M. Knoedler and Co., 9–28 January, *Views of Paris*, no. 29 (as c. 1875); 1960 New York, no. 32, repr. (as "Mary Cassatt at the Louvre").

SELECTED REFERENCES: Lafond 1918–19, II, repr. before p. 17 (as "La promenade au Louvre"); Rivière 1935, repr. (color) p. 61; Lemoisne [1946–49], II, no. 581 (as 1880); Rewald 1961, repr. (color) p. 438; Boggs 1962, p. 51, fig. 111; Minervino 1974, no. 575; Reff 1976, pp. 132–35, repr. p. 133; Giese 1978, pp. 43–45, fig. 5 p. 45; 1984–85 Boston, p. xxxvi, fig. 17 p. xxxvii, and pp. 168–70, no. 51, fig. 1 p. 169.

207, 208.

Mary Cassatt at the Louvre: The Paintings Gallery

Degas's admiration for Japanese prints is well documented, and it is known that at the time of his death over fifteen drawings by Hiroshige, two triptychs by Utamaro, sixteen albums of prints—among them two by Sikenobu—and numerous loose sheets by Hokusai, Utamaro, Shunsho, and others were sold along with a framed print by Kiyonaga that once hung above his bed. His fascination with Japanese art at times took an obvious form, as in the fans noted by critics in 1879 for their Oriental appearance, but most of all it affected his approach to composition. If the pastel *At the Louvre* (cat. no. 206) was dominated, with considerable bravura, by a forced perspective in the Japanese manner, this effect was emphasized to its limit in a reprise of the composition, *Mary Cassatt at the Louvre: The Paintings Gallery*.

It has often been observed that *The Paintings Gallery* is the most consciously Japanese of all Degas's works and that its very shape was determined by *hashira-e* prints designed for hanging on pillars in Japanese houses.[1] Indeed, that shape is accentuated in Degas's print by a marble pillar in the foreground that occupies one quarter of the composition.

Fig. 151. Study for *Mary Cassatt at the Louvre* (IV:249.a), 1879. Pencil, dimensions recorded in Vente IV as 11½ × 10⅝ in. (29 × 27 cm). Location unknown

The figures are identical to those appearing in a related print, *Mary Cassatt at the Louvre: The Etruscan Gallery* (fig. 114), and are exactly the same size but positioned differently: that of Mary Cassatt, more emphatically a silhouette, was reversed and placed immediately behind the foreground figure. Some twenty states for the etching in this exhibition are known, the second largest number recorded for a print by Degas, showing substantial changes to the tonal and textural effects of the design but only one significant shift in composition. At first, the pillar at the left was narrower, and the decision to expand it to its final width was reached only in the seventh state. A drawing of almost the same height, known only from photographs (fig. 151), played a part in the elaboration of the print and shows the two figures in the same compositional relationship and the pillar the same size as it had been in the first six states.

The sequence in which *The Paintings Gallery* and *The Etruscan Gallery* were executed has never been clear, but it has been cogently argued that *The Paintings Gallery* came second.[2] This can be inferred to an extent from what is known of the genesis of the two works. The preparatory sketch (IV:250.b) for the two figures in *The Etruscan Gallery* has survived in the Mellon collection.[3] On the verso, the drawing retains the marks of its transfer onto the plate. From these traces, it is evident that it was transferred only once and that the transfer was for *The Etruscan Gallery*. However, both recto and verso contain a vertical line drawn in pencil that clearly marks the original position of the marble pillar in *The Paintings Gallery*. There are only two possible interpretations for the line: either it was there from the beginning and was intended for but not used in *The Etruscan*

322

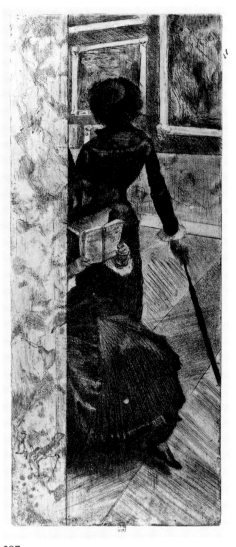

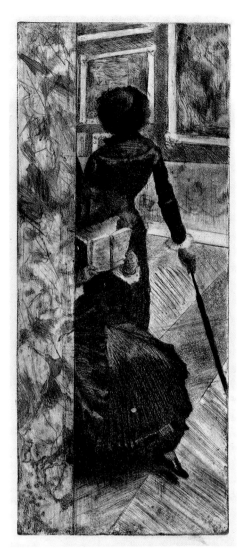

207

208

1. Colta Feller Ives, *The Great Wave: The Influence of Japanese Woodcuts on French Prints*, New York: The Metropolitan Museum of Art, 1974, pp. 36–37.
2. See Reed and Shapiro 1984–85, no. 52, and Ronald Pickvance, "Degas at the Hayward Gallery," *Burlington Magazine*, CXXVII:988, July 1985, p. 476.
3. It has been proposed that the drawing was prepared with the help of scaled photographs of *At the Louvre*. Although this may have been the case with other works, it does not seem to apply here: the drawing is tentative and sketchy, with false starts and revisions in the contours, scarcely a possibility if it was simply traced from a model. The fact that the figures are squared appears to indicate that they were drawn by conventional means.
4. See Michel Melot in 1974 Paris, nos. 197–200.
5. See 1889, Paris, Galerie Durand-Ruel, 23 January–14 February, *Exposition des peintres-graveurs*, under Degas, no. 104, "Lithographie, 6 exemplaires, 100 fr.," and no. 105, "Lithographie, 3 exemplaires, 200 fr." The Durand-Ruel archives record under "pictures received on deposit" for 1882–84 a group of four lithographs and one engraving left by Degas and returned to him unsold on 31 October 1883.
6. Beraldi 1886, p. 153.

207.

Mary Cassatt at the Louvre: The Paintings Gallery

1879–80
Etching, soft-ground etching, aquatint, and drypoint, on China paper, fifteenth–sixteenth intermediate state
Plate: 12 × 5 in. (30.5 × 12.6 cm)
Bibliothèque Nationale, Paris (A.09167)

Exhibited in Paris

Reed and Shapiro 52.XV–XVI/Adhémar 54.X

PROVENANCE: Alexis Rouart, Paris (his stamp, Lugt suppl. 21872); Henri A. Rouart, his son, Paris. Marcel Guiot, Paris; acquired from him by the Bibliothèque Nationale 21 June 1933.

EXHIBITIONS: 1974 Paris, no. 199, repr.

SELECTED REFERENCES: Alexandre 1918, p. 13; Lafond 1918–19, II, p. 70; Delteil 1919, no. 29; Rouart 1945, pp. 64–65, 74 n. 100; *Inventaire du fonds français après 1800*, VI (catalogue by Jean Adhémar and Jacques Lethève), Paris: Bibliothèque Nationale, Département des Estampes, 1953, p. 110, no. 27 (as tenth state, c. 1876); Adhémar 1974, no. 54.x; Colta Feller Ives, *The Great Wave: The Influence of Japanese Woodcuts on French Prints*, New York: The Metropolitan Museum of Art, 1974, pp. 36–38; Reed and Shapiro 1984–85, no. 52.XV–XVI (intermediate state, reproducing an exemplar in a private collection); Ronald Pickvance, "Degas at Hayward Gallery," *Burlington Magazine*, CXXVII:988, July 1985, p. 476.

Gallery, which is not very likely, or it was added after the fact as a test for *The Paintings Gallery*, the more probable explanation. If the latter applies, it can be concluded that *The Paintings Gallery* came second in the sequence of etchings.

The states included in this exhibition represent two slightly different moments in the long evolution of the print. As Michel Melot has pointed out, the artist's insistence on continually altering the image led on occasion to almost illegible plates.[4] In the intermediate state between the fifteenth and sixteenth states (cat. no. 207), slight modifications were made to the texture, chiefly in an attempt to harmonize the highlights on Mary Cassatt's dress. It was a minor adjustment, recorded in two known impressions. The immediately succeeding state, the sixteenth, shows extensive work on the pillar, producing a more pronounced decorative effect. This was first enhanced and then dissolved altogether in the subsequent three states. Only one impression of the sixteenth state is known, that in the Art Institute of Chicago (cat. no. 208).

The large number of states and the small number of impressions recording them have been cited as convincing evidence of Degas's relative lack of interest in printmaking as a financially rewarding enterprise. His etchings were evidently collected by his admirers, but there is scarce proof of their being sold on any scale. After the exhibition of 1880, there is a record of only one exhibition, at Durand-Ruel's in 1889, to which Degas submitted prints, ostensibly for sale, and there is evidence that although the artist did attempt to sell prints, his efforts were unsuccessful.[5] Beraldi noted as early as 1886 that Degas's etchings were "essais" (test pieces)—the word Degas used in the 1880 exhibition catalogue—and that they sometimes served as a working base for his pastels.[6] This is known to have been the case, and several of these, including *Mary Cassatt at the Louvre: The Paintings Gallery* (cat. no. 266), now also in Chicago, found their way to Durand-Ruel's listed as "eau-forte—impression rehaussée" (etching—touched-up proof).

Mary Cassatt at the Louvre: The Paintings Gallery

1879–80
Etching, soft-ground etching, aquatint, and drypoint on ivory wove Japanese tissue, sixteenth state
Plate: 12 × 5 in. (30.5 × 12.6 cm)
Sheet: 13⅜ × 6⅞ in. (34 × 17.5 cm)
Atelier stamp on verso, lower left
The Art Institute of Chicago. Gift of Walter S. Brewster (1951.323)

Exhibited in Ottawa and New York

Reed and Shapiro 52.XVI / Adhémar 54.XV

PROVENANCE: Atelier Degas. Walter S. Brewster, Chicago; his gift to the museum 1951.

EXHIBITIONS: 1964, University of Chicago, 4 May–12 June, *Etchings by Edgar Degas* (catalogue by Paul Moses), no. 31, repr.; 1979 Edinburgh, no. 117, repr.; 1984 Chicago, no. 52, repr. (color).

SELECTED REFERENCES: Alexandre 1918, p. 13; Lafond 1918–19, II, p. 70; Delteil 1919, no. 29; Rouart 1945, pp. 64–65, 74 n. 100; Adhémar 1974, no. 54.xv; Colta Feller Ives, *The Great Wave: The Influence of Japanese Woodcuts on French Prints*, New York: The Metropolitan Museum of Art, 1974, pp. 36–38; Reed and Shapiro 1984–85, no. 52.xvi, repr.; Ronald Pickvance, "Degas at Hayward Gallery," *Burlington Magazine*, CXXVII:988, July 1985, p. 476.

Fan: Dancers

1879
Watercolor and silver and gold paint on silk
7½ × 22¾ in. (19.1 × 57.9 cm)
Signed upper right: Degas
The Metropolitan Museum of Art, New York.
 Bequest of Mrs. H. O. Havemeyer, 1929.
 H. O. Havemeyer Collection (29.100.555)

Lemoisne 566

Degas's works include twenty-five fans, whose importance has for a long time been underestimated; they are the subject of a recent study by Marc Gerstein.[1] With the exception of three of these fans, painted about 1868–69, Degas's output spans the period 1878–85, especially around 1879—the year in which he was enthusiastically planning, for the exhibition of the Indépendants, a room that would be devoted entirely to fans painted by Pissarró, Morisot, Forain, and Félix and Marie Bracquemond.[2] In the end, only Pissarro and Forain joined Degas, who showed five fans. This would be the only time that Degas would exhibit his fans.

In an undated letter to Paul Durand-Ruel, correctly assigned by Lionello Venturi to late 1912, Mary Cassatt made arrangements for the disposal of her portrait by Degas (cat. no. 268), along with a fan by the artist. She wrote: "In my opinion, the fan is the most beautiful one that Degas painted. I imagine it is unquestionably valuable—I have

thought twenty-five thousand—in view of the fact that it belongs to the period of the 'dancers at the bar.' It was exhibited in 1879."[3]

The fan was duly recorded in Durand-Ruel's stock book as a deposit from Cassatt on 13 January 1913 (deposit no. 11640), and the same source indicates that it was returned to her, unsold, on 3 June of the same year. It is evident that Durand-Ruel's return of the fan was related to the price being asked, because Cassatt wrote to the dealer on 11 March 1913: "Perhaps I was asking too much for the fan. I was basing myself on the price of the fan at the Alexis Rouart sale, which I believe sold for 16,000 without the commission? I don't find the price too high, but I know that no one here would appreciate it, and that is why I wish to part with it, even for less than my asking amount."[4]

More than four years later, in December 1917, Cassatt offered the fan, with a nude (cat. no. 269) and a portrait of a woman (L861) by Degas—both now in the Metropolitan Museum—to Louisine Havemeyer for the sum of $20,000.[5] At the beginning of February 1918, as the works still remained in Cassatt's empty apartment on rue de Marignan, she asked Ambroise Vollard to remove them so they could be packed up by the Dupré firm.[6] These works, the fan included, were again deposited with Durand-Ruel, and on 13 March 1918 she followed up with a letter asking him to dispatch them to the United States.[7] Marc Gerstein has shown that the fan was bought by Louisine Havemeyer, noting that Cassatt had repre-

209

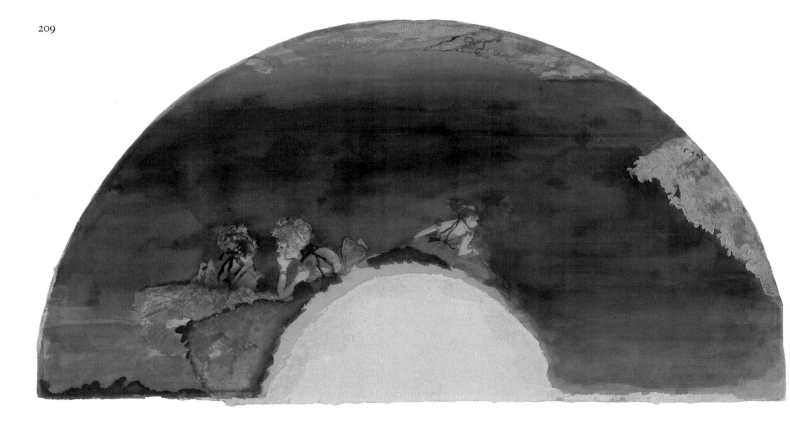

210

sented it in her *Young Woman in Black* of 1883 (now in the Peabody Institute, Baltimore).[8]

With an immense, almost bare stage and dancers at rest clustered at the center, this composition is one Degas repeated in a related fan, *Dancers Resting* (L563, Norton Simon Museum, Pasadena), that contains an additional figure. The present version is stronger, with broader effects and a more pronounced burlesque element. Cassatt's remark that it figured in the fourth Impressionist exhibition indicates that it was one of the two fans exhibited under nos. 80 and 81. As her name does not appear as a lender in the exhibition catalogue, it must be assumed that it was given to her by Degas sometime after May 1879.

1. Gerstein 1982, passim.
2. See *Lettres Degas* 1945, XVII, p. 44; *Degas Letters* 1947, no. 26, p. 49.
3. Venturi 1939, II, p. 129.
4. Ibid., p. 132.
5. See letter from Mary Cassatt, Grasse, to Louisine Havemeyer, 28 December 1917, in Mathews 1984, p. 330.
6. See letter from Mary Cassatt, Grasse, to Paul Durand-Ruel, 9 February 1918, in Venturi 1939, II, p. 136.
7. See letter from Mary Cassatt to Paul Durand-Ruel, 13 March 1918, in Venturi 1939, II, p. 137; deposit book, 31 October 1909–1926, Durand-Ruel archives, Paris.
8. Gerstein 1982, pp. 105–18. According to Frances Weitzenhoffer, Mrs. Havemeyer bought the fan in 1917; see Weitzenhoffer 1986, p. 238. However, she seems to have acquired it only after March 1918.

PROVENANCE: Mary Cassatt, Paris, by 1883; deposited with Durand-Ruel, Paris, 13 January 1913 (deposit no. 11640, inscribed on a label on verso: "Degas no. 11640/Danseuses/éventail"); returned to Mary Cassatt 3 June 1913; redeposited with Durand-Ruel, Paris, 8 March 1918 (deposit no. 11924, inscribed on a label on verso: "Degas no. 11924/Éventail:/Danseuses"); bought from Mary Cassatt by Mrs. H. O. Havemeyer, New York; transmitted to Mrs. H. O. Havemeyer by Durand-Ruel 1919; Mrs. H. O. Havemeyer, New York, from 1919; her bequest to the museum 1929.

EXHIBITIONS: 1879 Paris, no. 80 or 81; 1922 New York, no. 87 or 89 of drawings; 1930 New York, no. 164; 1977 New York, no. 2 of fans, repr.

SELECTED REFERENCES: Havemeyer 1931, p. 185; Lemoisne [1946–49], II, no. 556; Minervino 1974, no. 547; Gerstein 1982, p. 110, fig. 2 p. 111; 1986 Washington, D.C., p. 268; Weitzenhoffer 1986, pp. 238, 242.

210.

Fan: The Ballet

1879
Watercolor, India ink, and silver and gold
 paint on silk
6⅛ × 21¼ in. (15.6 × 54 cm)
The Metropolitan Museum of Art, New York.
 Bequest of Mrs. H. O. Havemeyer, 1929.
 H. O. Havemeyer Collection (29.100.554)

Lemoisne 457

The most overtly Japanese of all Degas's designs, this fan was painted in monochrome in imitation of lacquer on a black ground. In

this respect, it is a unique experiment in the artist's oeuvre. The stage, to the left, was sprinkled with silver powder and painted with thin washes of simulated silver paint, actually tin, less apt to tarnish. The same silvery paint was used in greater concentration for the large stage flat to the right and for other areas. The dancers were left in black, with outlines and highlights drawn in gold-colored paint obtained from brass powder.[1] The mottled design with stylized patterns on the stage flat, the irregular form on which the principal dancers move, and the abrupt transitions from one plane to another are greatly indebted to Japanese precedents, as is the general conception of the work. The figures, however, are part of Degas's known repertoire. The main dancer to the left appears also in the Orsay *Ballet (The Star)* (cat. no. 163), and her counterpart to the right is the dancer performing an arabesque for Jules Perrot in *The Dance Class* (cat. no. 130).

Recently it has been proposed that the fan was loaned by the dealer Hector Brame to the Impressionist exhibition of 1879 and that it may have been one of the fans singled out by the critic Paul Sébillot as "a very curious Japanese fantasy."[2] It is known that the fan belonged to Brame in 1891, at which date it was sold to Durand-Ruel, who in turn sold it to the Havemeyers.[3] Yet the fan is one of the very few to have been folded. It seems highly unlikely that Degas would have exhibited it after it was folded, and it appears just as improbable that it would have been

211

mounted and used by Brame, Durand-Ruel, or Mrs. Havemeyer. If indeed the fans owned by Brame in 1879 and 1891 are the same, it is possible that sometime between those dates it was the property of a different, unidentified owner who was responsible for the mounting.

1. An analysis of the metallic paints was carried out in 1986 by Barbara H. Berrie and Gary W. Carriveau at the National Gallery of Art, Washington, D.C. By means of X-ray fluorescence spectroscopy, they established that the gold-colored area contains predominantly copper and zinc and that tin was substituted for silver.
2. Gerstein 1982, p. 110, and 1986 Washington, D.C., no. 76. See also Paul Sébillot, "Revue artistique," *La Plume*, 15 May 1879, p. 73.
3. The provenance of the work was established by Marc Gerstein; see Gerstein 1982, p. 110.

PROVENANCE: Hector Brame, Paris, possibly in 1879 and certainly by 1891; bought by Durand-Ruel, Paris, 22 December 1891, for Fr 250 (stock no. 1963); bought by H. O. Havemeyer, New York, 19 September 1895, for Fr 1,500; Mrs. H. O. Havemeyer, New York, from 1907; her bequest to the museum 1929.

EXHIBITIONS: (?)1879 Paris, no. 77, lent by Hector Brame; 1922 New York, no. 87 or 89 of drawings; 1930 New York, no. 163; 1977 New York, no. 1 of fans; 1986 Washington, D.C., no. 76.

SELECTED REFERENCES: Havemeyer 1931, p. 185; Lemoisne [1946–49], II, no. 457; Minervino 1974, no. 542; Gerstein 1982, p. 110, fig. 1 p. 111; Weitzenhoffer 1986, p. 242.

211.

Fan: The Café-concert Singer

1880
Watercolor and gouache on silk mounted
on cardboard
12⅛ × 23⅞ in. (30.7 × 60.7 cm)
Signed and dated in black China ink
lower left: Degas 80
Kupferstichkabinett der Staatlichen Kunsthalle,
Karlsruhe (1976-1)

Lemoisne 459

The only known fan by Degas to represent a café-concert scene, this is also his only dated fan. The subject matter is an extension of a theme that preoccupied him throughout the later 1870s. Here it is treated with the greatest elegance, suggesting only distantly the boisterous atmosphere of evenings at the Ambassadeurs and the Alcazar-d'Été. The larger part of the fan is filled by the dark night sky and the foliage of the café garden, scintillatingly lit by gaslight, with the singer, seen from behind, asymmetrically placed to the right side of the composition. Götz Adriani has shown how the column dividing the image vertically is placed so as to create a careful geometric ratio of two to one.[1] It has been suggested that the singer may be Mlle Dumay (or Demay),[2] though the angular position of the arm is more reminiscent of "le style épileptique" of Mlle Bécat (see cat. no. 176).[2]

1. 1984 Tübingen, no. 122.
2. *Jahrbuch der Staatlichen Kunstsammlungen in Baden-Würtemberg*, XIV, 1977, p. 172.

PROVENANCE: Ernest-Ange Duez, Paris (Duez sale, Galerie Georges Petit, Paris, 12 June 1896, no. 273, for Fr 500); bought by Durand-Ruel, Paris (stock no. 3839); deposited with Cassirer, Berlin, 28 September–20 December 1898; loaned to the New Gallery, London, 1 December 1905; deposited with Bernheim-Jeune, Paris, 10 October 1906; transferred to Durand-Ruel, New York, 1912 (stock no. N.Y. 3554); bought by William P. Blake, 12 October 1912, for Fr 4,000; deposited by Blake with Durand-Ruel, New York, 18 September 1919 (stock no. N.Y. 7790); returned to William P. Blake, 29 December 1919; by descent to J. M. Blake, New York; bought by Durand-Ruel, New York, 3 March 1937 (stock no. N.Y. 5346); bought by Sam Salz, New York, 20 September 1940; returned to Durand-Ruel, New York, 3 February 1942 (stock no. N.Y. 5478). Sale, Palais Galliéra, Paris, 29 November 1969, no. 5. Anne Wertheimer, Paris. Bought by the museum 1976.

EXHIBITIONS: 1898, Berlin, Bruno and Paul Cassirer Gallery, autumn, *Ausstellung von Werken von Max Liebermann, H. G. E. Degas, Constantin Meunier*, no. 69; (?)1906, London, New Gallery, International Society of Sculptors, Painters, and Gravers, January–February, *Pictures and Sculpture at the Sixth Exhibition*, hors catalogue; 1909, Brussels, Société "Les Arts de la Femme," inaugurated 31 March, *Exposition rétrospective d'éventails*, no. 125, lent by Durand-Ruel; 1983, Karlsruhe, Staatliche Kunsthalle, 10 September–20 November, *Die französischen Zeichnungen, 1570–1930* (catalogue by Johann Eckart von Borries and Rudolf Theilmann), no. 75, repr.; 1984 Tübingen, no. 122, repr.; 1984, Stuttgart, Staatsgalerie, Graphische Sammlung, 1 July–2 September/Zurich, Museum Bellerive, 12 September–4 November,

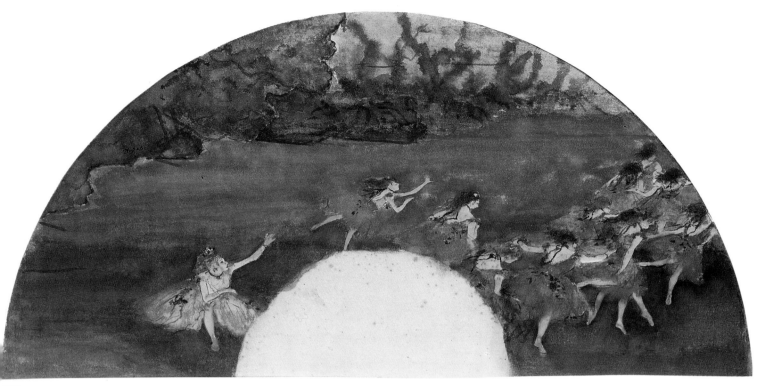

212

Kompositionen im Halbrund: Fächerblätter aus vier Jahr-hunderten (catalogue by Monika Kopplin), no. 70, repr.

SELECTED REFERENCES: Lemoisne [1946–49], II, no. 459; Minervino 1974, no. 541; Staatliche Kunsthalle, Karlsruhe, "Neuerwerbungen 1976," *Jahrbuch der Staatlichen Kunstsammlungen in Baden-Würtemberg*, XIV, 1977, pp. 170, 172, pl. 21; Monika Kopplin, *Das Fächerblatt von Manet bis Kokoschka: Europäische Traditionen und Japanische Einflüsse* (Ph.D. dissertation), Cologne, 1980/Saulgau, 1981, pp. 88–89, pl. 95; Gerstein 1982, pp. 110, 112, 114, pl. 7.

212.

Fan: The Farandole

1879?
Gouache on silk, mounted on cardboard,
 with some silver and gold
12 × 24 in. (30.7 × 61 cm)
Signed in black China ink upper left: Degas
Private collection, Switzerland

Exhibited in Paris

Lemoisne 557

The farandole is an old Provençal dance in which long human chains are formed by linking hands. *La Farandole* is also the title of a ballet in three acts on a Provençal theme by Gille, Mortier, and Mérante, to music by Théodore Dubois, performed at the Opéra de Paris beginning in December 1883.[1] It is known that Degas saw the ballet, paired with the opera *Rigoletto*, on 3 June 1885, and it is quite possible that he saw earlier performances.[2] The traditional title of the fan should perhaps be linked to the ballet rather than to the Provençal dance, even though Degas's composition is most likely not connected with any specific event witnessed on the stage.

The sweeping view from a high vantage point is characteristic of many of Degas's fans, but in this instance the effect is enhanced by the unusually large number of dancers included in the design. To the right, the corps de ballet, like dragonflies in flight across the stage, is shown in a curved formation that gently counterposes the rounded shape of the fan. To the left, the leading ballerina, based on a figure who also appears in the background of *The Star* (L598) in the Art Institute of Chicago, holds the stage alone with a melodramatic wave of the arm. As noted by Jean Sutherland Boggs, there is considerable humor in the rendition of the dancers and the drawing is as free and uninhibited as it is formal and controlled in the artist's paintings of the same period.[3]

The fan has generally been dated 1879 or 1878–79. If a connection with the ballet *La Farandole* is allowable, a date shortly after 1883 would be more appropriate.

1. For an illustration showing two scenes from the ballet, see *L'Illustration*, LXXXII:2130, 22 December 1883, p. 388.

2. Information kindly supplied to the author by Henri Loyrette, who compiled a record of Degas's attendance at the Opéra for the years 1885–87.
3. 1967 Saint Louis, p. 150.

PROVENANCE: Mme de Lamonta collection, Paris (sale, Mme X [de Lamonta] estate . . . , Drouot, Paris, 13 February 1918, no. 77, for Fr 8,000); bought by Gustave Pellet, Paris; by descent to Maurice Exsteens, Paris, 1919; Klipstein and Kornfeld, Bern, by 1960; to present owner.

EXHIBITIONS: 1933 Paris, no. 1654; 1937 Paris, Orangerie, no. 186; 1938, London, The Leicester Galleries, *The Dance*, no. 77; 1939 Paris, no. 20, lent by Exsteens; 1948–49, Paris, Galerie Charpentier, *Danse et Divertissements*, no. 75; 1951–52 Bern, no. 30; 1952 Amsterdam, no. 23; 1955 Paris, GBA, no. 86, repr.; 1960, Bern, Klipstein und Kornfeld, 22 October–30 November, *Choix d'une collection privée, Sammlungen G.P. und M.E.*, no. 15, repr.; 1965, Bregenz, Künstlerhaus Palais Thurn und Taxis, 1 July–30 September, *Meisterwerke der Malerei aus Privatsammlungen im Bodenseegebiet*, no. 30b, pl. 10; 1967 Saint Louis, no. 95, repr.; 1984 Tübingen, no. 117, repr. (color); 1984, Stuttgart, Staatsgalerie, Graphische Sammlung, 1 July–2 September/Zurich, Museum Bellerive, 12 September–4 November, *Kompositionen im Halbrund: Fächerblätter aus vier Jahrhunderten* (catalogue by Monika Kopplin), no. 64, repr. (color).

SELECTED REFERENCES: Rivière 1935, repr. p. 155; Rouart 1945, p. 70 n. 22; Lemoisne [1946–49], II, no. 557; Minervino 1974, no. 549; Monika Kopplin, *Das Fächerblatt von Manet bis Kokoschka: Europäische Traditionen und Japanische Einflüsse* (Ph.D. dissertation), Cologne, 1980/Saulgau, 1981, pp. 63, 79–80, 85, pl. 83; Terrasse 1981, no. 301, repr.; Gerstein 1982, pp. 110ff., pl. 3; Siegfried Wichmann, *Japonisme*, New York: Park Lane, 1985, p. 162, fig. 407 (color) p. 163.

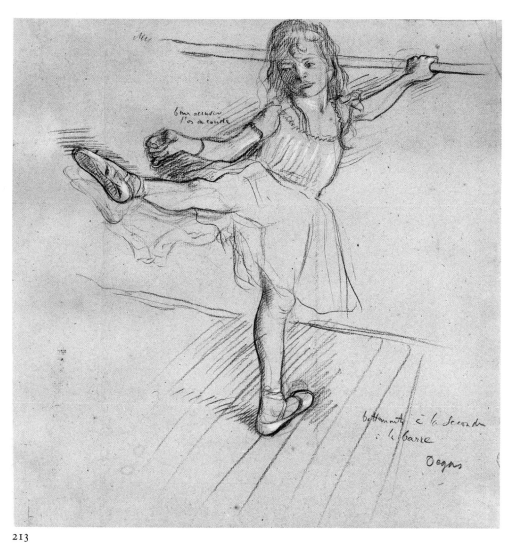

213

1. Browse [1949], nos. 76, 78 (fig. 152).
2. For a contemporary account of training in the be-
ginners' class of the Academy of Music, see
"L'école de danse à l'Académie de Musique: la
classe des petites," *L'Illustration*, LXXI:1829, 16
March 1878, pp. 172–73, with twelve illustra-
tions. A description of a posing session attended
by Degas in Lepic's studio in 1881 has been given
by Georges Jeanniot: "The next day we actually
saw [Rosita] Maury and her friend [Mlle Sanla-
ville] arrive with two young dancers. The ballet
positions were demonstrated by the two students
of the corps de ballet, while the two stars posed
for the heads. Life contains these surprises."
Jeanniot 1933, p. 153.
3. Browse [1949], no. 76; Pickvance 1963, p. 258
n. 24.
4. Havemeyer 1961, p. 252.

PROVENANCE: Bought from the artist by H. O. Have-
meyer, New York; Mrs. H. O. Havemeyer, New
York, from 1907; her bequest to the museum 1929.

EXHIBITIONS: 1922 New York, no. 24 of drawings;
1930 New York, no. 158; 1947, San Francisco, Cali-
fornia Palace of the Legion of Honor, 8 March–
6 April, *19th Century French Drawings*, no. 88; 1977
New York, no. 24 of works on paper; 1984 Tübingen,
no. 116, repr.

SELECTED REFERENCES: Havemeyer 1931, p. 186; New
York, Metropolitan, 1943, no. 54; Browse [1949],
pp. 59, 68, 364, no. 77, repr.; Havemeyer 1961, p.
252; Linda B. Gillies, "European Drawings in the
Havemeyer Collection," *Connoisseur*, CLXXII:693,
November 1969, pp. 148, 153, repr.

213.

Little Girl Practicing at the Barre

1878–80
Black chalk heightened with white chalk on
 pink laid paper
12⅛ × 11½ in. (31 × 29.3 cm)
Signed in pencil lower right: Degas
Inscribed in black chalk above left: "bien accuser/
 l'os du coude" (emphasize the elbow bone),
 and below right: "battements à la seconde/à la
 barre" (battements in second position at the
 barre)
The Metropolitan Museum of Art, New York.
 Bequest of Mrs. H. O. Havemeyer, 1929.
 H. O. Havemeyer Collection (29.100.943)

Exhibited in Paris and Ottawa

This very young dancer, at the most eight
or nine years old, also appears in two other
drawings first published by Lillian Browse.[1]
All three have inscriptions that explain or
correct the design, and all three were osten-
sibly executed during the same session, per-
haps in the beginners' class at the Academy
of Music.[2] As Ronald Pickvance has pointed
out, a misreading of the inscription "dessin
de Degas" (drawing by Degas) in Henri
Rouart's hand on one of the drawings, the
only one not signed, led to the faulty con-
clusion that the model's name was "Dugés."[3]

Although much of the effect of the drawing
rests on the compelling youth of the model,
with her touchingly large head and—as
Browse has pointed out—bony, unformed
knees, it is a fairly dispassionate examina-
tion of a pose Degas studied on several occa-
sions in the late 1870s. Characteristically,
Degas noted above the girl's right arm:
"bien accuser l'os du coude" (emphasize the
elbow bone). Louisine Havemeyer, who ob-
tained the drawing from Degas, drew atten-
tion to its relationship to the pastel *Dancers
at the Barre* (L460, private collection), which
she then owned.[4] A more developed study
of the same pose, drawn from a slightly older
dancer, appears in *Dancer at the Barre* (fig. 152),
and variations occur in three other drawings
(L460 bis, III:372, II:220.b).

Fig. 152. *Dancer at the Barre*, 1878–80.
Charcoal, 12 × 9½ in. (30.5 × 24.1 cm).
Fitzwilliam Museum, Cambridge,
England

214.

Dancer Resting

1879
Pastel and gouache or distemper on laid paper,
 with strips added top and bottom, mounted on
 cardboard
23⅝ × 25¼ in. (59 × 64 cm)
Signed lower right: Degas
Private collection

Exhibited in Paris

Lemoisne 560

An interest in the bodies of seated dancers
resting, only occasionally studied before by
Degas, appears in his work about 1878.
The firmly dated study (inscribed "Dec. 78")
of the fifteen-year-old Melina Darde seated
on the floor (II:230.1, private collection, Pa-
ris) and a host of studies of dancers observed
from every angle—resting, tying their slip-
pers, pulling at their stockings, or collaps-
ing with exhaustion—formed the stock from
which he drew figures for numerous new
ballet scenes, almost exclusively concerned

with the dance class, that begin to appear
about 1878–79. In the finished pastels and
paintings, the dancers are shown singly or
in pairs absorbed in their occupation; these
are unquestionably Degas's most moving
inventions, but also the first to attract unfa-
vorable criticism at the Impressionist exhibi-
tion of 1880, where the representation of
their prematurely wasted bodies brought
forth remarks prefiguring those that greeted
The Little Fourteen-Year-Old Dancer (cat.
no. 227) in 1881.

It is somewhat uncharacteristic that in this
pastel Degas concentrates on a single dancer,
with the compositionally unorthodox indi-
cation of a second dancer outside the field of
vision. The work is a variation of a different
pastel on a related subject, *Two Dancers*
(fig. 153), which shows both dancers in a
more abrupt, expressive design that figured
in the exhibition of 1880 with *Dancers at
Their Toilette* (cat. no. 220) and startled even
well-disposed critics such as Charles Eph-
russi. In the present version the drawing is
stronger, with the volumes more carefully

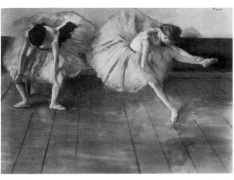

Fig. 153. *Two Dancers* (L559), c. 1879. Pastel and
gouache, 18⅛ × 26¼ in. (46 × 66.7 cm). Shelburne
Museum, Shelburne, Vt.

defined and with a degree of finish that Degas
affected in some works around 1878–80. The
young dancer, shown absorbed in massaging
her left foot, an act far removed from the
magic illusions of the stage expected from
Degas, slightly resembles the adolescent
Marie van Goethem, whom Degas repre-
sented in *The Little Fourteen-Year-Old Dancer*.

214

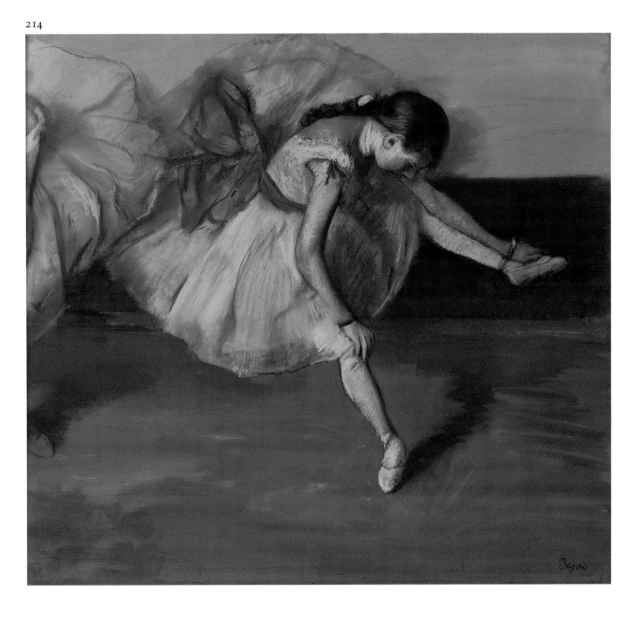

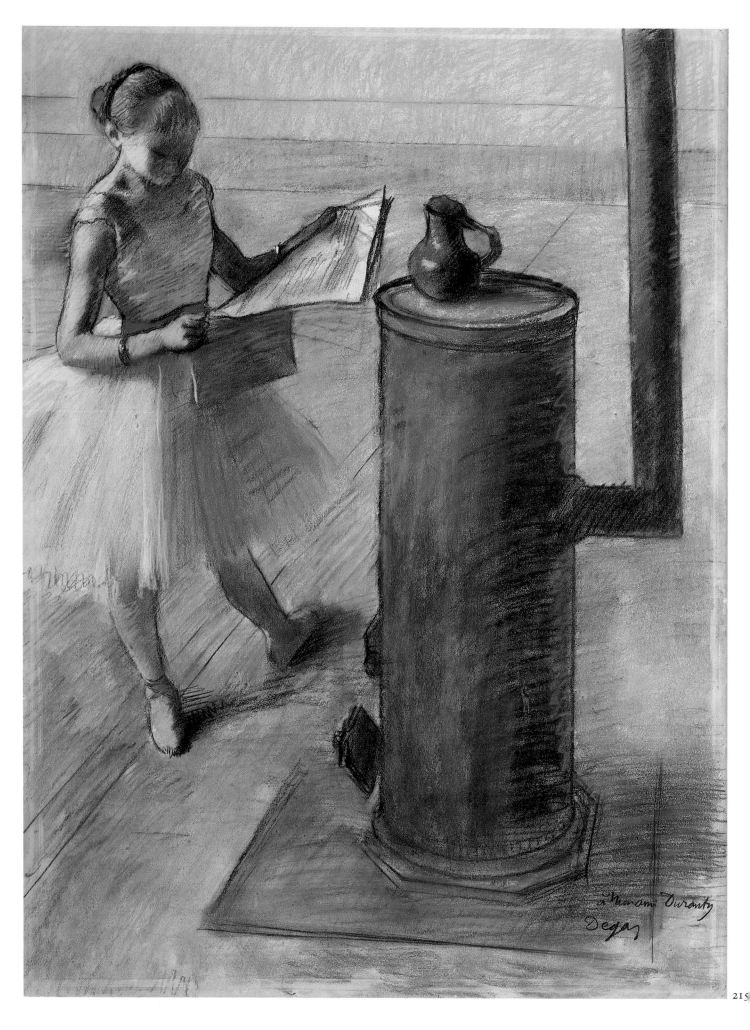

à Monsieur Duranty

Degas

It would be inappropriate to call this work a simple pastel, as it is technically more complex than that. Denis Rouart has explained that Degas sometimes steamed his pastels, afterward rubbing the moist powder on the surface of the paper with a brush. This appears to have occurred in *Dancer Resting*, in which parts of the background wall and the floor were clearly handled differently from the figure and were also reworked with gouache or distemper.

PROVENANCE: Durand-Ruel, Paris; bought by Jules-Émile Boivin, Paris; Mme Jules-Émile Boivin, his widow, Paris, 1909–19; Madeleine-Émilie Boivin (Mme Alphonse Gérard), her daughter, Paris; present owner.

EXHIBITIONS: 1924 Paris, no. 116; 1955 Paris, GBA, no. 87; 1960 Paris, no. 26, repr.

SELECTED REFERENCES: Lemoisne 1924, pp. 102–03 n. 1; Lemoisne [1946–49], II, no. 560; Pierre Cabanne, *Degas Danseuses*, Lausanne: International Art Book, 1961, repr. (color) p. 3 (as c. 1879); Minervino 1974, no. 739.

215.

Dancer Resting

c. 1879–80
Pastel and black chalk on off-white wove paper, laid down
30⅛ × 21⅞ in. (76.5 × 55.5 cm)
Inscribed and signed bottom right: à mon ami Duranty/Degas
Private collection

Lemoisne 573

When in 1880 the writer Edmond Duranty died, Degas organized a sale to raise money for his companion, Pauline Bourgeois. For the sale he contributed three works of his own—a drawing of a dancer, a version of *Woman with Field Glasses* (fig. 131), and, aptly, a portrait of Duranty (L518).[1] The fourth and last work by Degas in the sale was this pastel of a dancer, his gift to Duranty, inscribed in his hand. The prices obtained at the sale were very low, and it is indicative of the artist's cast of mind that instead of buying back any of his own works he bought a drawing by Adolf Menzel, whom both he and Duranty admired very much.

There is something touching about Degas's giving Duranty, one of the most erudite of his friends, a pastel of a dancer reading. The subject does not occur again in any of his developed works, though it might appear as a detail of a larger composition.[2] Figures immersed in their newspapers dominate the foreground of both *Portraits in an Office (New*

Orleans) (cat. no. 115) of 1873 and *The Dance Class* (cat. no. 219) of eight years later, but the serenity of the moment achieved in this pastel is unparalleled in Degas's work. The approach evident here is very much that of Degas at the very end of the 1870s—the view from a slightly elevated point, the rather self-conscious composition, and the admirable directness of observation, a faculty that Duranty would have appreciated. That faculty, so nearly resembling a science, is nevertheless worn lightly, and all the precise notations of the dancer's anatomy, or the season (winter), or the time (morning) are tempered by the free handling of pastel, riotously applied on the stove.

As Charles Millard noted in his catalogue entry on the work, the pastel may have been posed for by Marie van Goethem and should be dated late 1879 or early 1880, shortly before Duranty's death.[3] The work subsequently belonged to another of Degas's friends, Henri Rouart, and while it was in the Rouart collection it was reproduced as a lithograph, by George William Thornley, in 1888.

1. See "The Portrait of Edmond Duranty," p. 309, and Chronology II, 9 April 1880.
2. A dancer reading a letter figures in two studies (III:115.3, III:342.1) as well as in the Orsay *Dance Class* (cat. no. 129). Another study, full length, appears in a later sheet with several dancers (IV:284.6).
3. See Charles Millard in *The Impressionists and the Salon (1874–1886)* (exhibition catalogue), Los Angeles: Los Angeles County Museum of Art, 1974, no. 16.

PROVENANCE: Given by the artist to Edmond Duranty, Paris (Duranty sale, Drouot, Paris, 28–29 January 1881, no. 17, as "Danseuse"); bought by Alphonse Portier, Paris; bought by Durand-Ruel, Paris, 12 February 1881, for Fr 200 (stock no. 816); bought the same day by Henri Rouart, Paris, for Fr 350 (Henri Rouart sale, Galerie Manzi-Joyant, Paris, 16–18 December 1912, no. 76, for Fr 37,000); bought by Alfred Strolin, Paris (sale, Drouot, Paris, *Collection de M. Alfred Strolin, ayant fait l'objet d'une mesure de séquestre de guerre*, 7 July 1921, no. 42, repr., as "Pendant le repos," for Fr 204,000); bought by Durand-Ruel, Paris. With M. Knoedler et Cie, New York; Mrs. Peter A. Widener, Philadelphia, by 1970; Sari Heller Gallery, Ltd., Beverly Hills, by 1974. Sold, Christie's, New York, 15 November 1983, no. 50, repr. Private collection.

EXHIBITIONS: 1922, London, The Leicester Galleries, January, *Paintings, Pastels and Etchings by Edgar Degas*, no. 55; 1970, Philadelphia Museum of Art, 7 July–30 August, *Private Collections: Mr. and Mrs. Henry Clifford; Mr. and Mrs. Louis C. Madeira; Mrs. John Wintersteen; Mr. and Mrs. Jack L. Wolgin* (no catalogue); 1983, San Diego Museum of Art, *Selections from San Diego Private Collections*.

SELECTED REFERENCES: Thornley 1889; Lemoisne [1946–49], II, no. 573; Browse [1949], no. 79; Minervino 1974, no. 768; *The Impressionists and the Salon (1874–1886)* (catalogue entry by Charles Millard), Los Angeles: Los Angeles County Museum of Art, 1974, no. 16, repr. and cover (color) (included in the catalogue but withdrawn from the exhibition).

216.

The Violinist

c. 1877–78
Chalk, charcoal, heightened with white, and gray wash on buff wove paper
18⅞ × 12 in. (47.9 × 30.5 cm)
Vente stamp lower left; atelier stamp on verso
Museum of Fine Arts, Boston. William Francis Warden Fund (58.1263)

Exhibited in New York

Vente III:161.1

In the Impressionist exhibition of 1879, Degas exhibited no fewer than three (probably recent) compositions of dancers practicing with a violinist. He had included rehearsal violinists in his earliest paintings on dance subjects—*Dance Class* (cat. no. 106) and *Dance Class at the Opéra* (cat. no. 107)—but in subsequent compositions music figured only by implication, in the dancers' movements or in fragments of musical instruments cannily intruding in a design. In the group of works shown in 1879, the violinist was given extraordinary prominence in the foreground as a presence of equal or almost equal importance to the dancers. In a sense, these later compositions are an affecting scrutiny of contrasts and are as much about music as they are about dance. The dancers, usually shown as a group, follow the music, while the musician, an isolated presence functioning in a different realm, appears divorced from the events surrounding him.

This study of a jovial elderly violinist is one of a series of such studies made from at least three different models. It is the liveliest of the series, not only because of the astonishing degree of personality it projects but also because the quick, alternative notations for the position of the arms and legs are so evocative of movements associated with performance. The same model, in a more solemn mood, appears also in a related, less animated drawing (III:161.2, Clark Art Institute, Williamstown), intended to record more precise notations for the violin and the hands. Nevertheless, Degas studied the hands and violin again, from a different model, on a sheet in a private collection in Minneapolis (III:164.2). As noted by Peter Wick, a synthesis of the three studies served for the more severe-looking violinist in the foreground of *The Rehearsal* (fig. 154), although that figure retains little of the exuberant vitality of the musician in the Boston drawing.[1]

Both Wick and Jean Sutherland Boggs[2] have dated the drawing about 1879. An earlier date, of about 1877–78, perhaps 1878 for the series of related drawings, seems more probable.

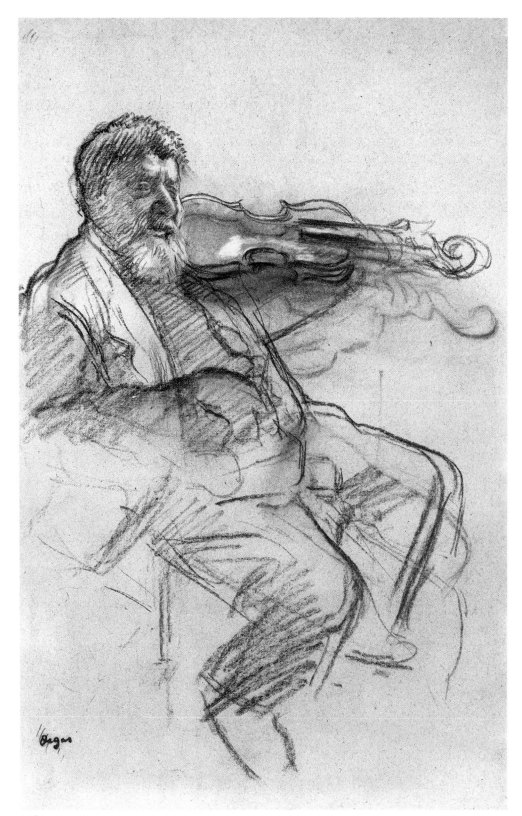

216

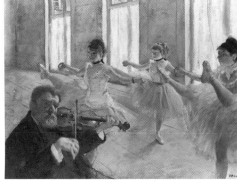

Fig. 154. *The Rehearsal* (L537), c. 1878–79.
Oil on canvas, 18¾ × 24 in. (47.6 × 61 cm).
The Frick Collection, New York

1. Wick 1959, pp. 87–101.
2. 1967 Saint Louis, no. 96.

PROVENANCE: Atelier Degas (Vente III, 1919, no. 161.1).
Marcel Guérin, Paris. Bought by the museum 1958.

EXHIBITIONS: 1958, New York, Charles E. Slatkin
Galleries, 7 November–6 December, *Renoir, Degas*,
no. 23, pl. XIX; 1960 New York, no. 93; 1967 Saint
Louis, no. 96, repr.; 1970 Williamstown, no. 25,
repr.; 1974 Boston, no. 83.

SELECTED REFERENCES: Lemoisne 1931, p. 290, fig. 62;
Denis Rouart, *Degas, Dessins*, Paris: Braun, 1948,
no. 3; Browse [1949], under no. 35; Wick 1959,
pp. 92–93, 97, 99 n. 4; Williamstown, Clark, 1964,
I, p. 83, fig. 66; 1979 Edinburgh, under no. 22.

217.

The Violinist, study for *The Dance Lesson*

c. 1878–79
Pastel and charcoal on green paper, squared for
 transfer, with letterpress printing on verso
15⅜ × 11¾ in. (39.2 × 29.8 cm)
Vente stamp lower left; atelier stamp on verso
 lower right
The Metropolitan Museum of Art, New York.
 Rogers Fund, 1918 (19.51.1)

Exhibited in New York

Lemoisne 451

A nervous and succinct charcoal drawing in
the Minneapolis Institute of Art (fig. 155)
records Degas's first attempt to capture this
violinist as he performs. In this beautiful,
more elaborate study in the Metropolitan Mu-
seum, the musician is in almost the same pose
but observed with greater penetration. His
enormously moving, pathetic head is described
in unsparing detail, down to the vainly parted
remnants of hair, and his arms grasp the vio-
lin with a greater sense of surrender to the
music. As Peter Wick has observed, the way
the model holds his fingers indicates he was
likely a café or theater player.[1]

Worked up in pastel and squared for trans-
fer, the drawing served as a reference for the
violinist in *Portrait of a Dancer at Her Lesson
(The Dance Lesson)* (cat. no. 218), as well as
for *The Violinist* (BR99), dated 1880, where
he appears alone, somewhat tidied up, and
certainly younger. Theodore Reff has called

the latter a study and placed it in the se-
quence leading to the figure in *Portrait of a
Dancer at Her Lesson*, but it was more likely
conceived as an independent work.[2] The Met-
ropolitan's drawing has been dated c. 1877–
78 by Lemoisne and Douglas Cooper, c. 1879
by Jean Sutherland Boggs, and 1882–84 by
Lillian Browse.[3] A date around 1878, after
The Violinist (cat. no. 216) in Boston, seems
more likely. It is curious that the drawing
was executed on the back of a bookseller's
advertisement; all the books on the list seem
to date from before 1878.

1. Wick 1959, pp. 87–101.
2. Brame and Reff 1984, under no. 99.
3. Lemoisne [1946–49], II, no. 451; Browse [1949],
 no. 100; Cooper 1952, no. 11; Boggs in 1967 Saint
 Louis, p. 154.

PROVENANCE: Atelier Degas (Vente II, 1918, no. 171,
for Fr 4,500); bought at that sale by the museum.

EXHIBITIONS: 1919, New York, The Metropolitan
Museum of Art, May, *Recent Accessions* (no cata-
logue); 1922 New York, no. 60a of drawings; 1977
New York, no. 22 of works on paper, repr.

SELECTED REFERENCES: Burroughs 1919, p. 115; Le-
moisne [1946–49], II, no. 451 (as c. 1877–78);
Browse [1949], no. 100 (as c. 1882–84); Cooper
1952, p. 18, no. 11, pl. 11 (color) (as c. 1877–78);
Wick 1959, p. 97, fig. 10 p. 100; 1967 Saint Louis,
p. 154; Minervino 1974, no. 504; Brame and Reff
1984, under no. 99.

217

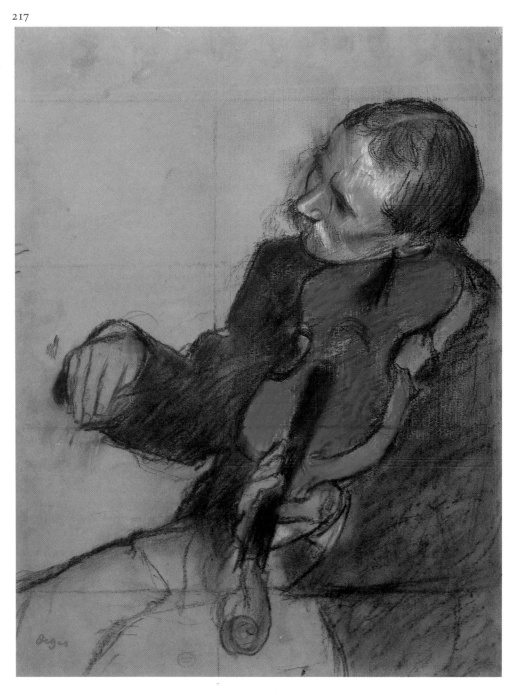

Fig. 155. *The Violinist* (IV:247.b), c. 1879. Char-
coal, 12⅝ × 9½ in. (32 × 24 cm). Minneapolis
Institute of Art

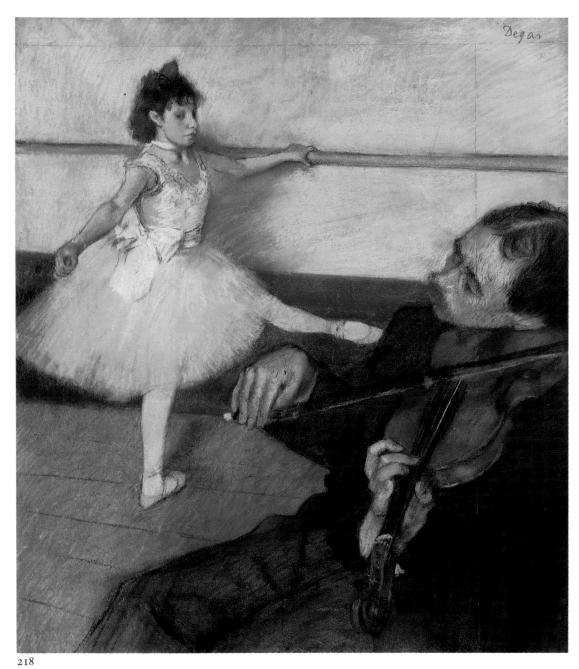

Fig. 156. *Dancer at the Barre* (II:352), c. 1879. Charcoal heightened with white, 17⅞ × 11½ in. (45.5 × 29 cm). Eugene Chesrow Trust, Chicago

218

218.

Portrait of a Dancer at Her Lesson (The Dance Lesson)

c. 1879
Black chalk and pastel on three pieces of wove paper joined together
25⅜ × 22⅛ in. (64.6 × 56.3 cm)
Signed upper right: Degas
A partially legible inscription in graphite in the artist's hand at the upper right reads: 9c à droite/3c en haut/. . . coté pour . . . / refaire . . .
The Metropolitan Museum of Art, New York. Anonymous Gift, 1971. H. O. Havemeyer Collection (1971.185)

Exhibited in New York

Lemoisne 450

An interesting anecdote about this work was related by Ambroise Vollard, who claimed to have been present when the events took place. According to Vollard, the painter Gustave Caillebotte, at the time of his death in 1894, bequeathed a painting to Renoir, to be chosen before his collection went to the Louvre. After considering one of Caillebotte's own works, Renoir was persuaded by Caillebotte's brother to take one by Degas. Renoir, however, according to Vollard, "soon tired of seeing the musician forever bending over his violin, while the dancer, one leg in the air, awaited the chord that would give the signal for her pirouette. One day, when Durand-Ruel said to him: 'I have a customer for a really finished

Degas,' Renoir did not wait to be told twice but, taking down the picture, handed it to him on the spot. When Degas heard of it, he was beside himself with fury, and sent Renoir back a magnificent painting that the latter had once allowed him to carry off from his studio. . . . I was with Renoir when the painting was thus brutally returned to him. In his anger, seizing a palette knife, he began slashing at the canvas."[1] Part of the painting was saved, but Renoir mailed the shreds of canvas to Degas with a note cryptically inscribed with only one word: "Enfin" (Finally!).

The pastel indeed belonged to Caillebotte, who probably bought it from—or after—the Impressionist exhibition of 1879.

334

In 1886, he lent it, along with *Women on the Terrace of a Café in the Evening* (cat. no. 174) and *The Chorus* (cat. no. 160), to the sale exhibition organized by Durand-Ruel at the American Art Association in New York. It is possible that Caillebotte was ready to dispose of the works, but an annotated exhibition catalogue in the Durand-Ruel archives suggests otherwise.[2] Caillebotte died on 24 February 1894. By 31 March, Renoir, who had owned the work less than a few weeks, deposited it with Durand-Ruel, ostensibly with the idea of selling it. On 13 May 1895, Durand-Ruel returned the pastel to Renoir, but three years later, having found in the Havemeyers prospective clients, he purchased it and dispatched it to New York in the shortest possible time.

Compositions with single dancers observed with such precision are uncommon for Degas, and this alone is sufficient to identify this pastel as the "Portrait de danseuse, à la leçon" (Portrait of a Dancer at Her Lesson) that was exhibited in 1879. Despite the violinist's overwhelming presence, it is the dancer who dominates. She is no longer a child, but is not yet an adult, and her expression—worried and attentive—is emphasized at the expense of anything her awkward body may convey. She is drawn delicately, almost cautiously, in contrast to the powerfully and more freely outlined musician. Lillian Browse has indicated that the dancer is shown as she performs her "grands battements en avant," but the ungainly posture of her raised right leg and the absence of studies for this pose suggest that the composition underwent a transformation. Erased lines under the pastel hint that originally the dancer was conceived with her right leg raised sideways, farther to the left, in a variant grand battement or developpé similar to that of the dancers appearing in a contemporary pastel (L460, private collection) and in the background of *The Dancing Lesson* (cat. no. 221) in the Clark Art Institute. The suggestion is that the leg was moved forward for compositional reasons at a fairly early stage, when the artist decided to include the violinist in the design. The added strips of paper at the top and to the right argue for such an interpretation, as does the different handling of the two figures. If this was the case, it is likely that a study of almost certainly the same model (fig. 156) and two differently posed studies (II:220.b, L460 bis) played a part in the conception of the work.

Lemoisne and Moffett have proposed a date of 1877–78 for the pastel, but Browse believed it to have been executed as late as 1882–84. Recently, on the basis of *The Violinist* (BR99), dated 1880, Theodore Reff has proposed 1880 as a firmer date.[3]

1. Vollard 1936, pp. 19–20. Jeanne Baudot, a friend of Renoir, gave a somewhat different account of the events. Following an illness that forced him to stop working, Renoir "after many hesitations, finally resigned himself to accept Fr 45,000 [for the pastel] from Durand-Ruel." See Jeanne Baudot, *Renoir, ses amis, ses modèles*, Paris: Éditions Littéraires de France, 1949, p. 23. From Julie Manet's diary, it is clear that the incident between Degas and Renoir took place at the beginning of November 1899, almost a year after Renoir sold the pastel. See Manet 1979, pp. 279, 282.
2. The catalogue is priced throughout. Against the three works owned by Caillebotte the word "sold" appears. As the works were not sold in New York, it can only be concluded that "sold" actually meant "not for sale."
3. Lemoisne [1946–49], II, no. 450; Browse [1949], no. 101; Moffett 1979, p. 11.

PROVENANCE: Gustave Caillebotte, Paris, probably bought in 1879 at the fourth Impressionist exhibition; deposited with Durand-Ruel, Paris, 29 January 1886 (deposit no. 4691); consigned by Durand-Ruel to the American Art Association, New York, 19 February–8 November 1886; returned to Caillebotte, 30 November 1886; bequeathed by Caillebotte to Auguste Renoir, Paris, 1894; deposited by Renoir with Durand-Ruel, Paris, 13 March 1894 (deposit no. 8398); returned to Renoir, 13 May 1895; bought by Durand-Ruel, Paris, 12 December 1898, for Fr 5,000 (stock no. 4879); transferred to Durand-Ruel, New York, 31 December 1898 (stock no. N.Y. 2071); bought by H. O. Havemeyer, New York, 3 January 1899, for Fr 27,750; Mrs. H. O. Havemeyer, New York, 1907–29; Horace Havemeyer, her son, New York; given to the museum 1971.

EXHIBITIONS: 1879 Paris, no. 74; 1886 New York, no. 63; 1975–76, New York, The Metropolitan Museum of Art, December 1975–23 March 1976, *Notable Acquisitions 1965–1975*, p. 91, repr.; 1977 New York, no. 23 of works on paper.

SELECTED REFERENCES: Max Liebermann, "Degas," *Pan*, IV:3–4, November 1898–April 1899, repr. p. 196; Moore 1907–08, repr. p. 103; Geffroy 1908, p. 20, repr. p. 22; Lafond 1918–19, II, p. 31, repr. before p. 37; Alexandre 1929, pp. 483–84, repr. p. 480; Lemoisne [1946–49], I, p. 116, II, no. 450; Browse [1949], no. 101 (as c. 1882–84); Wick 1959, p. 97; 1967 Saint Louis, p. 154; Minervino 1974, no. 503; Moffett 1979, p. 11, pl. 22 (color); *The Crisis of Impressionism 1878–1882* (exhibition catalogue by Joel Isaacson), Ann Arbor: The University of Michigan Museum of Art, 1979, pp. 34 (as 1878–82), 88 (as 1879), repr. p. 35; Brame and Reff 1984, under no. 99 (as 1880); Weitzenhoffer 1986, p. 133, fig. 90.

219.

The Dance Class

1881
Oil on canvas
32⅛ × 30⅛ in. (81.6 × 76.5 cm)
Signed lower left: Degas
Philadelphia Museum of Art. Purchased for the
 W. P. Wilstach Collection (W'37-2-1)

Lemoisne 479

Mary Cassatt's attempts in 1880 to persuade her brother to buy a work by Degas were defeated less by Alexander Cassatt's lack of enthusiasm than by a succession of unanticipated difficulties. It is curious that although Alexander Cassatt and his family spent the summer of 1880 in France and certainly met Degas, he appears not to have seen any paintings by the artist. Perhaps for this reason, commissioning a work was out of the question for fear that Degas might paint, in the words of Alexander's mother, Katherine Cassatt, "something so eccentric you might not like it."[1] Failure to secure for Alexander Cassatt the first version of *Fallen Jockey* (see cat. no. 351) or *Horseback Riding* (L117), however, was followed by the tentative proposal of a picture with dancers—the work that was to become the present *Dance Class*, now in the Philadelphia Museum of Art.

The vicissitudes of this painting, the second of Degas's works to cross the Atlantic (the first was *Ballet Rehearsal*, fig. 130), are partly chronicled in the Cassatt correspondence, where clues to the changes made to the painting are also found. In late 1880, the composition was clearly finished in the form it had before Degas altered it but, as usual, he was unhappy with the results. On 10 December of that year, Mrs. Cassatt informed her son that Degas was unwilling to part with it because "he says he must repaint it all merely because a small portion was washed out."[2] Four months later, the question of the painting was still unresolved. On 18 April 1881, Mr. Cassatt wrote to his son that he would not hear from his sister "until she can tell you that she has the Degas in hand—
. . . Degas still keeps promising to finish the picture you are to have & although it does not require more than two hours of work it is still postponed—However he said today that want of money would compel him to finish it at once—You know he would not sell it to Mame [Mary Cassatt], & she buys it from the dealer—who lets her have it as a favor and at a less price than he would let it go to anyone not an artist."[3]

If Mr. and Mrs. Cassatt underestimated the extent to which Degas reworked the painting, they had the satisfaction of knowing two months later that on 18 June 1881,

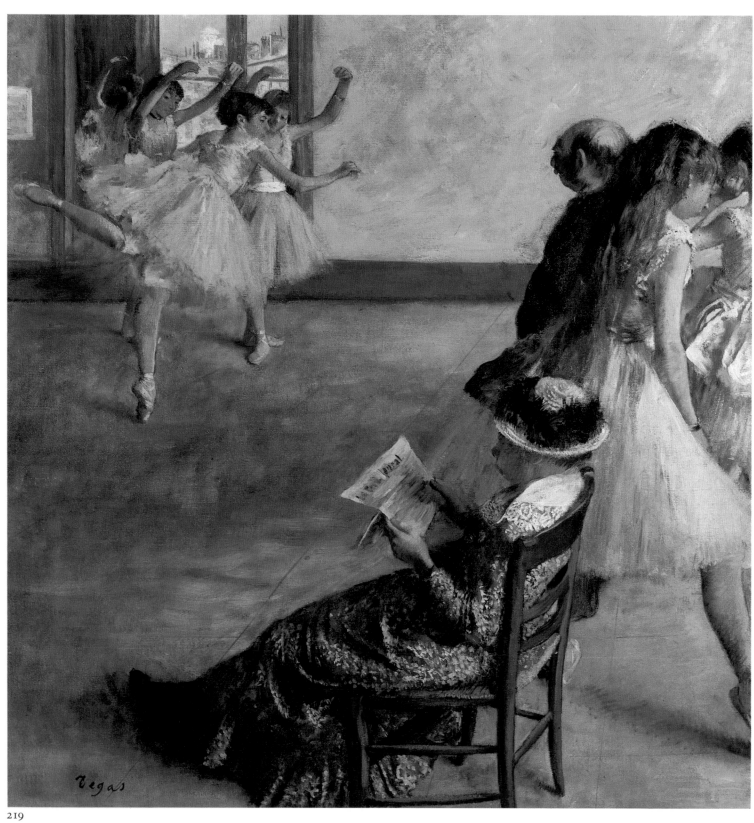

219

Degas had delivered the work to Durand-Ruel.[4] There were further difficulties with the price being asked by the dealer, shipping, and duty to be paid, but the picture, along with a Monet and a Pissarro, arrived safely in Philadelphia in September.[5]

It was only after the death of Alexander Cassatt, when concern over the dispersal of his pictures prompted her to discuss the matter with her friend, Louisine Havemeyer, that Mary Cassatt again mentioned *The Dance Class*. In a letter of 18 April 1920, she described it as a "girl reading seated on a bench, the same model as the one who posed for the statue and bust of her, a very fine classic group of dancers, one of Degas's best." In a subsequent letter, on 28 April, she gave further particulars, noting, "I wanted the picture which then had a large figure of a dancer in the foreground but he changed it substituting the girl in blue reading the paper."[6]

The extent to which the picture was reworked is visible in X-radiographs. In the background, the dancer en pointe was originally slightly more to the right, with her arm extended before her, as she appears in the study for the figure (L479 bis). In the foreground, in the place now occupied by the seated woman, was a seated dancer adjusting her shoe, seen from the left in a pose that appears to have duplicated that of a dancer in a study (L600) formerly in the Wadsworth collection. Near her left foot, at the lower edge of the canvas, slightly left of center, was a watering can.

The principal dancer in the right foreground was roughly in the same location in which she appears now, but somewhat higher and in a different pose. Whether she was actually transformed only once or twice is not entirely clear from the X-radiograph, but the trace of an alternative pose for her left arm suggests that she may indeed have been altered twice. Originally, the dancer was posed in a manner close to that of the dancer on the left in *Two Dancers in the Dressing Room* (BR89, National Gallery of Ireland, Dublin), but with her head raised as in *Dancers, Pink and Green* (cat. no. 307), dated 1894, and *Two Dancers in Green Skirts* (cat. no. 308). The bow of her sash, which protruded considerably behind her, and her left arm, visible to the naked eye in a large pentimento, completely covered the ballet master, who did not form part of the original composition. In a subsequent stage, the dancer appears to have had her left arm raised, with her hand touching her left shoulder. This pose is nearly identical to that of the dancer appearing in a black-chalk-and-pastel drawing in the National Gallery of Art, Washington, D.C., dated c. 1878 by George Shackelford but possibly executed somewhat later, specifically as a study for the Philadelphia paint-

ing.[7] The dancers in the foreground were based in their ultimate form on an elaborate black-chalk-and-pastel drawing (L480, private collection), clearly contemporary with the Washington sheet.

In its reworked form, the painting can be firmly dated late spring 1881 rather than 1878, as believed by Lemoisne, or c. 1880, as proposed by Lillian Browse. The work evidently already existed in its previous form in December 1880 and may have dated from slightly earlier, perhaps 1879. Some of the studies used for the painting date from considerably earlier: the two dancers in the background with their arms raised en couronne are based on drawings II:312 and III:218, one of which (II:312) Degas probably used in *The Dance Class* (cat. no. 128) in the Corcoran Gallery. No study has been uncovered for the woman in blue, which suggests that she was painted directly from the model, the young Marie van Goethem, who was hardly the right age required for the figure, but who also likely posed at the time for the last details of *The Little Fourteen-Year-Old Dancer* (cat. no. 227). Pentimenti to the left of her shoe indicate that at first her legs extended farther to the left and that both her feet were shown.

The composition obviously preoccupied Degas, who painted several variants on the theme in different formats—upright (L587), rectangular (L588, National Gallery, London), and horizontal (L703). In all, the background figures are related to those in the Philadelphia painting, but the large figure in the right foreground is of a standing dancer adjusting her shoe. As the compositions of all three are more resolved than the design originally under the painting in Philadelphia, they certainly must postdate it. A fourth painting (L1295), originally perhaps contemporary with this work but extensively repainted at a much later date, may have been an early, abandoned attempt toward the composition.

1. Mathews 1984, p. 155.
2. Ibid.
3. Mathews 1984, p. 161.
4. Recorded in the "Grand Livre," Durand-Ruel archives, Paris.
5. Mathews 1984, p. 162.
6. Mary Cassatt, letters to Mrs. H. O. Havemeyer dated 18 April and 28 April 1920. Archives, The Metropolitan Museum of Art, New York.
7. 1984–85 Washington, D.C., no. 29, repr. p. 90.

PROVENANCE: Painted for Alexander Cassatt; delivered by the artist to Durand-Ruel, Paris, 18 June 1881, for Fr 5,000 (stock no. 1115, as "Le foyer de la danse"); delivered by Durand-Ruel the same day to Mary Cassatt, Paris, for Fr 6,000; Alexander Cassatt, Philadelphia, 1881–1906; Lois Cassatt, his widow, Philadelphia, to 1920; Mrs. W. Plunkett Stewart, their daughter, to 1931; Mrs. William Potter Wear, her daughter; Mrs. Elsie Cassatt Stewart Simmons, her daughter; bought by the Commissioners of Fairmount Park for the W. P. Wilstach Collection 1937.

EXHIBITIONS: 1886 New York, no. 299 (as "Repetition of the Dance"); 1893, Chicago, World's Columbian Exposition, *Loan Collection: Foreign Masterpieces Owned in the United States*, no. 39 (as "The Dancing Lesson"); 1902–03, Pittsburgh, Carnegie Institute, 5 November 1902–1 January 1903, *A Loan Exhibition (Seventh Annual Exhibition)*, no. 41; 1934, Philadelphia Museum of Art, 27 October–5 December, *Impressionist Figure Painting*; 1936 Philadelphia, no. 35, repr.; 1937 Paris, Orangerie, no. 30, pl. XIX; 1936 Philadelphia, no. 35, repr.; 1947 Cleveland, no. 36, pl. XXXIX (as "Ballet Class"); 1948, New York, Paul Rosenberg and Co., *Loan Exhibition of 21 Masterpieces by 7 Great Masters*, no. 8; 1950–51 Philadelphia, no. 75; 1955, Sarasota, The John and Mable Ringling Museum of Art, *Director's Choice*, no. 25; 1958 Los Angeles, no. 29, repr.; 1960 New York, no. 26, repr.; 1962 Baltimore, no. 42, repr.; 1969, The Minneapolis Institute of Arts, 3 July–7 September, *The Past Rediscovered: French Painting 1800–1900*, no. 23, repr.; 1979 Edinburgh, no. 21, pl. 7 (color) (as 1880); 1979 Northampton, no. 2, repr.; 1985 Philadelphia.

SELECTED REFERENCES: Ambroise Vollard, *Degas: An Intimate Portrait*, New York: Greenberg, 1927, pl. 26; Lemoisne 1937, repr. p. B (as "Pendant la leçon de danse"); "Portfolio of French Painting," *The Pennsylvania Museum Bulletin*, XXXIII:176, January 1938, repr. cover; *Sixty-second Annual Report of the Philadelphia Museum of Art* . . . , Philadelphia, 1938, repr. p. 12; Lemoisne [1946–49], II, no. 479 (as "Classe de ballet [Salle de danse]," c. 1878); Browse [1949], no. 98 (as c. 1880); Cabanne 1957, pp. 44, 98, 114, pl. 78 (color) (as c. 1878); Minervino 1974, no. 529; Thomson 1979, p. 677, fig. 97; Boggs 1985, pp. 11–13, 40–41 nn. 21–32, 44–45, no. 4, repr. (color) p. 10 (as c. 1880); Sutton 1986, p. 178, fig. 163 (color) p. 181.

220.

Dancers at Their Toilette (The Dance Examination)

c. 1879
Pastel and charcoal on heavy gray wove paper
25 × 19 in. (63.4 × 48.2 cm)
Signed lower right: Degas
Denver Art Museum. Anonymous gift (1941.6)

Lemoisne 576

This famous pastel was one of two very different works on the subject of ballet that Degas contributed to the Impressionist exhibition in 1880, where it was noticed by Charles Ephrussi and Joris-Karl Huysmans. Both entranced and repelled by it, Ephrussi nevertheless commended the "audacity of the foreshortening [and] the astonishing strength of the drawing." Huysmans, less qualified in his admiration, gave an extended account of the work, concluding: "What truth! What life! See how realistic these figures are, how accurately the light bathes the scene. Look at the expressions on

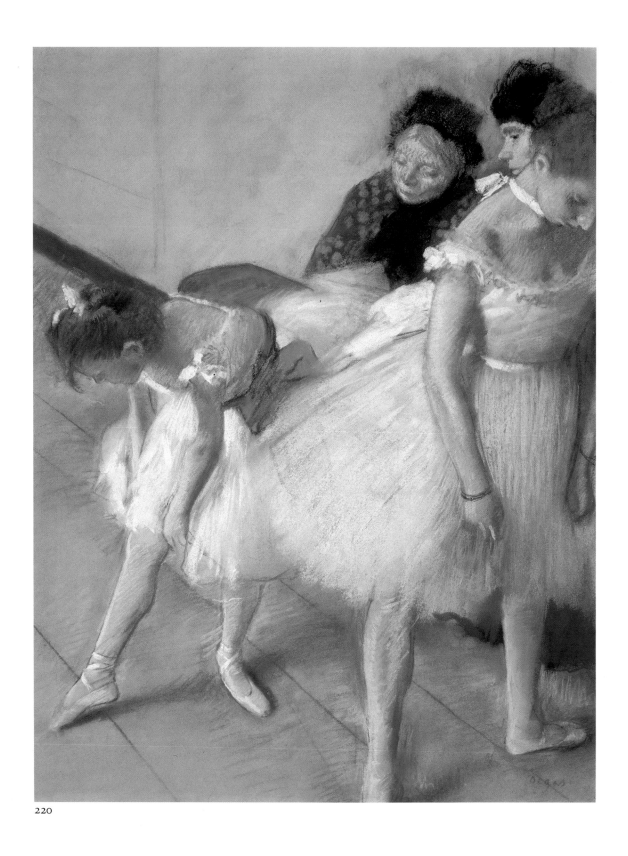

220

these faces, the boredom of painful mechanical effort, the scrutiny of the mother whose desires are whetted whenever the body of her daughter begins its drudgery, the indifference of the friends to the familiar weariness. All these things are noted with analytical insight at once subtle and cruel."[1]

Although Huysmans, as a novelist, may have been inclined to reinvent the scene for himself, he agreed with Ephrussi that the artist's distortions were unusually effective. Indeed, both authors noted, independently, what they observed as the dislocated, clown-like movements of the dancers.[2]

The origins of the composition can probably be traced to the group at the far right in *The Rehearsal* (fig. 119) in Glasgow, finished by February 1874. There Degas introduced the theme of the mother preparing her daughter for rehearsal. In the Denver work, the motif was developed into an extremely refined composition dominated by strong diagonals that underline the peculiarly high angle of vision. Faint traces under the pastel indicate changes in the design that are not entirely intelligible, as well as, in part, the sequence in which the figures were built up. At first, Degas intended the floor to rise at a more acute angle, and the dancer to the left, though in the same location and pose, was

seated on the bench, which was subsequently moved farther into the background. Behind that dancer, there was probably a different figure, evidence of which is still visible above the head of the old woman. The woman and the inquisitive bystander with a plumed hat were evidently introduced after the figure in the background was eliminated. The dancer to the right was added last, partly covering the seated dancer and the figure behind her.[3] The extraordinary concentration of heads in the upper right corner of the composition, with limbs unfolding below like segments of a half-open fan, is so unusual and at the same time so casual as to invest the design with the tenor of an observed incident. The whole is psychologically convincing, with the relationships clearly defined. The dancer to the right flexes her leg as she waits for someone to adjust the back of her dress; the figure behind her is temporarily distracted by the dancer to the left; the old woman is absorbed in her newspaper.

The ingenious grouping of figures is all the more remarkable as it apparently evolved without the aid of preliminary drawings. The dancer adjusting her stocking is of a type Degas observed repeatedly, but she has no direct antecedent; indeed, she is closer in spirit to a different type of seated dancer that he included in a pastel (L542, The Metropolitan Museum of Art, New York).[4] The old woman was posed for by Sabine Neyt, Degas's housekeeper, who sat for the stage mothers in some other works (including the painting in Glasgow, fig. 119). No study of her in this pose is known, though a related drawing (II:230.1) was used for a different pastel (fig. 163). The dancer to the right, the most forceful of the figures, was developed directly in the composition, as shown by pentimenti around her back and right leg. Degas must have been pleased with her, because he adapted the pose for the portrait of one of the Mante sisters in the two versions of *The Mante Family* (L971; L972, Philadelphia Museum of Art).

The application of pastel is less consistent than a first glance would suggest. The seated dancer was drawn lightly, with assured strokes, frequently permitting the paper to show through; the face of the old woman was realized with tightly organized vibrant hatched lines in flesh tones and blue that anticipate the evolution of Degas's later style; and the solidly constructed dancer to the right, defined very much in terms of light and shade, was built up to a considerable degree of finish.

1. Charles Ephrussi, "L'exposition des artistes indépendants," *Gazette des Beaux-Arts*, XXI:4, May 1880, p. 486; Huysmans 1883, pp. 113–14 (translation in 1986 Washington, D.C., p. 323).
2. Ephrussi, op. cit., p. 486; Huysmans 1883, p. 114.

3. Some of these conclusions were reached on the basis of an examination and report of condition carried out in 1984 by Anne Maheux and Peter Zegers, Degas Pastel Project, National Gallery of Canada, Ottawa.
4. However, the seated dancer in the pastel in the Metropolitan Museum is clearly derived from the well-known study dated December 1878 of Melina Darde seated (II:230.1).

PROVENANCE: Ernest May, Paris (May sale, Galerie Georges Petit, Paris, 4 June 1890, lot 76, as "Danseuses à leur toilette," for Fr 2,550). Bernheim-Jeune, Paris; bought by Durand-Ruel, Paris, 26 March 1898, for Fr 10,000 (stock no. 4589); transferred to Durand-Ruel, New York, 22 December 1898 (stock no. N.Y. 4589); bought by H. O. Havemeyer, New York, 31 December 1898–9 January 1899; Mrs. H. O. Havemeyer, New York, 1907–29; Horace Havemeyer, her son, New York, until 1941; anonymous gift to the museum 1941.

EXHIBITIONS: 1880 Paris, no. 40 (as "Examen de danse"), lent by Ernest May; 1898 London, no. 117 (as "Dancers at Their Toilet"); 1949 New York, no. 54, repr.; 1953–54 New Orleans, no. 76; 1958 Los Angeles, no. 39, repr. (color); 1960 New York, no. 31, repr.; 1961, Richmond, Virginia Museum of Fine Arts, 13 January–5 March, *Treasures in America*, p. 78, repr.; 1962 Baltimore, no. 45, repr. cover; 1965, New York, Wildenstein and Co., 28 October–27 November, *Olympia's Progeny*, no. 28, repr.; 1986 Washington, D.C., no. 92, repr. (color).

SELECTED REFERENCES: Charles Ephrussi, "L'exposition des artistes indépendants," *Gazette des Beaux-Arts*, XXI:4, May 1880, p. 486; Joris-Karl Huysmans, "L'exposition des indépendants en 1880," reprinted in Huysmans 1883, pp. 113–14; Frederick Wedmore, "Modern Art at Knightsbridge," *The Academy*, 1359, 21 May 1898, p. 560; Thomas Dartmouth, "International Art at Knightsbridge," *The Art Journal* [XVII], 1898, repr. p. 253; Lafond 1918–19, I, repr. p. 69, II, p. 27; Meier-Graefe 1923, pl. 36 (as "Danseuses s'habillant," c. 1876); Havemeyer 1931, p. 384, repr. p. 389; Rivière 1935, repr. p. 99; Lemoisne [1946–49], II, no. 576 (as 1880); Browse [1949], no. 102 (as c. 1882); *European Art: The Denver Art Museum Collection*, Denver: Denver Art Museum, 1955, no. 73, p. 28, repr. p. 30; Minervino 1974, no. 761, pl. XLVI (color); Weitzenhoffer 1986, p. 133, pl. 91 (as 1880).

221.

The Dancing Lesson

c. 1880
Oil on canvas
15½ × 34¾ in. (39.4 × 88.4 cm)
Signed upper right: Degas
Sterling and Francine Clark Art Institute, Williamstown, Massachusetts (562)

Lemoisne 820

Both Lemoisne and Lillian Browse supposed that Degas's remarkable horizontal compositions with dancers belonged to the 1880s. Lemoisne concluded that they followed the artist's equally singular experiments with horizontal racetrack scenes, which he dated in the second half of the 1870s.[1] George Shackelford demonstrated, however, that one of the ballet scenes, *The Dance Lesson* (fig. 218) in the Mellon collection, was exhibited in the Impressionist exhibition of 1880, and that the composition, based on a drawing in a notebook, had been elaborated by about 1878.[2] He therefore dated this work—stylistically closest to the Mellon painting—about 1880.

The unusual format of the painting, over twice as wide as it is high, is one Degas experimented with in monotypes as early as 1876, notably in a work covered with pastel (L513, The Art Institute of Chicago), dating from 1876–77.[3] What distinguishes the ballet scenes of the end of the 1870s is an altogether new approach to composition. As Shackelford has pointed out, almost invariably they are based on a module that includes one or several large figures in the foreground, counterbalanced by a vast open space leading, in perspective, to dancers in the distance who are greatly diminished in size.[4] This compositional device is observed with an emphatic diagonal cast in the Williamstown painting, in which the transition from shadow to light reflects the perspectival effects of the design. The handling of light is, indeed, unusually fine and is reminiscent of works from the earlier 1870s. Dancers are seen against the light or more elaborately lit from two sides, as is the central dancer holding a resplendently colorful fan.

Degas's particularly careful preparations for this work are indicated by the number of important pastel drawings that served for the movements of the individual dancers. In almost every instance, these show that the general plan of the painting and the manner in which the figures were to be lit were determined before the painting was begun. One study, *Dancer with a Fan*, is included in this exhibition (cat. no. 222). There are two others (L822, L884 bis) for each of the seated dancers at the right. Formerly dated 1885

and c. 1886 by Lemoisne, these studies include elaborate indications about light, closely followed in the painting, as well as, in one instance (the study of the girl smoothing her stocking), about the positioning of the floor, the wall, and the bench. A fourth drawing of the same size (L821) is a study for the dancer at the barre at the far left. The two dancers by the windows at the center were based on existing drawings (II:220.b, II:352 [fig. 156]) not necessarily connected with this project at the outset.

Alexandra Murphy has recently observed that Degas altered slightly, if significantly, the format of the composition while the work was in progress. He removed the canvas from the stretcher, expanded the stretcher by three-eighths of an inch (one centimeter) at the top and three-quarters of an inch (two centimeters) at the bottom, and retacked the margins.[5] She surmised that the operation may have been carried out partly to ensure that the left foot of the second dancer from the right did not touch the edge of the painting. In addition, examination under infrared light has revealed several pentimenti in the lower right quadrant. The figure of the dancer seated at the far right, identical in origin to that in a drawing (fig. 157) in the Johnson Collection in the Philadelphia Museum of Art, was completely altered.[6] Beside her there was an unidentified object, rather like a rectangular box, that was subsequently removed. The legs of the dancer smoothing her stocking changed position several times: her left leg was moved farther to the right, and her right leg was altered four times. The problem evidently required an additional drawing (III:371) that settled the dancer in the pose finally chosen for the painting.

The Dancing Lesson, by tradition, was a commission executed for J. Drake del Castillo, a member of the Chamber of Deputies for Indre-et-Loire, and his address, 2 rue Balzac, appears in a notebook dated 1880–84 by Theodore Reff.[7] Drake del Castillo was in some way connected with Paul Lafond, Degas's friend and biographer, and his wife, who occasionally stayed at 2 rue Balzac when visiting Paris in the early 1890s.[8]

1. See cat. no. 304.
2. 1984–85 Washington, D.C., pp. 85–91.
3. 1984 Chicago, no. 31.
4. 1984–85 Washington, D.C., p. 85.
5. See Alexandra Murphy in Williamstown, Clark, 1987, no. 44.
6. Communicated to the author by Alexandra Murphy.
7. Reff 1985, Notebook 34 (BN, Carnet 2, p. 2).
8. The address, "Madame Lafond/chez Mr. Drake/del Castillo/2 rue Balzac," appears on the envelope of a letter from Degas, postmarked 25 October 1894, published in Sutton and Adhémar 1987, p. 171 (where, however, the envelope is not described).

PROVENANCE: J. Drake del Castillo, Paris; bought by Boussod, Valadon et Cie, Paris, 10 January 1903, for

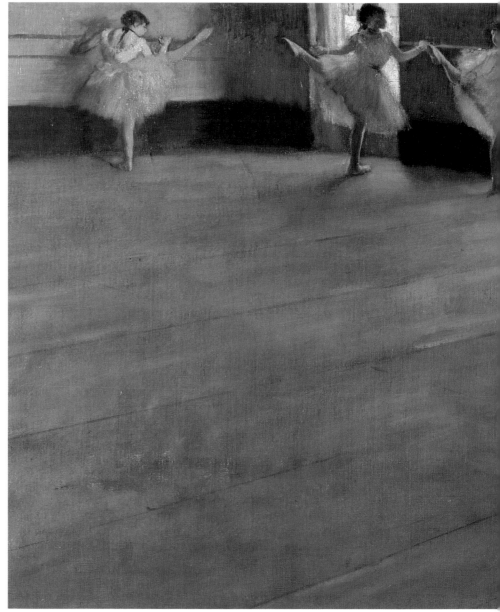

221

Fr 30,000 (stock no. 27863, as "Le foyer de la danse"); bought the same day by Eugene W. Glaenzer and Co., New York, for Fr 60,000; bought back by Boussod, Valadon et Cie, Paris, 30 June 1906 (stock no. 28847); bought by Georges Hoentschel, Paris, the same day, for Fr 65,000. [Samuel Courtauld, London, according to Lemoisne]. Galerie Barbazanges, Paris; bought by M. Knoedler and Co., Paris, 1924; bought by Robert Sterling Clark, New York, 1924; his gift to the museum 1955.

EXHIBITIONS: 1913, Ghent, Exposition Universelle et Internationale de Gand, Groupe II, *Beaux-Arts: oeuvres modernes*, no. 121 (as "La répétition de danse"), lent by Georges Hoentschel; 1914, London, Grosvenor House, *Art français: exposition d'art décoratif contemporain 1800–1885*, no. 24 (as "Leçon de danse"), lent by Hoentschel; 1956, Williamstown, Sterling and Francine Clark Art Institute, opened 8 May, *French Painting of the Nineteenth Century*, no. 101, repr.; 1959 Williamstown, no. 3, pl. XVIII; 1970 Williamstown, no. 7; 1979 Northampton, no. 3, repr.; 1984–85 Washington, D.C., no. 32, repr. (color) (as c. 1880).

SELECTED REFERENCES: Lemoisne [1946–49], III, no. 820 (as 1885); Browse [1949], no. 116 (as c. 1883); *French Painting of the Nineteenth Century*, Williamstown, Mass.: Sterling and Francine Clark Art Institute, n.d. [after 1962], n.p., no. 36, repr.; Minervino 1974, no. 819; Kirk Varnedoe, "The Ideology of Time: Degas and Photography," *Art in America*, LXVIII:6, Summer 1980, p. 105, fig. 12 (color) p. 106; *List of Paintings in the Sterling and Francine Clark Art Institute*, Williamstown, Mass.: Sterling and Francine Clark Art Institute, 1984, p. 12, fig. 257; Boggs 1985, p. 13, fig. 6; Williamstown, Clark, 1987, no. 44, repr. (color) p. 61 and cover.

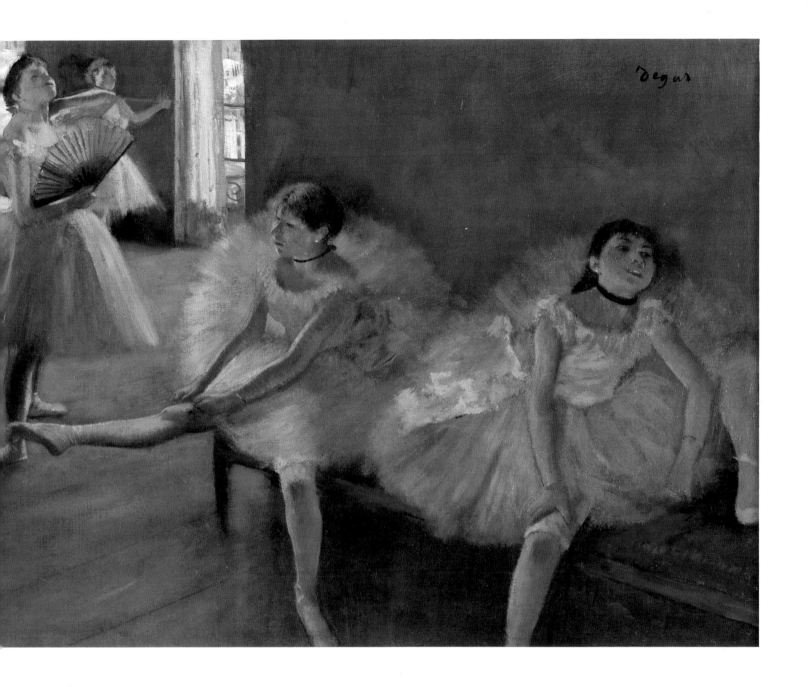

Fig. 157. *Dancer Resting* (L659), c. 1880. Charcoal heightened with white, 18¼ × 24⅛ in. (46.4 × 61.3 cm). John G. Johnson Collection, Philadelphia Museum of Art

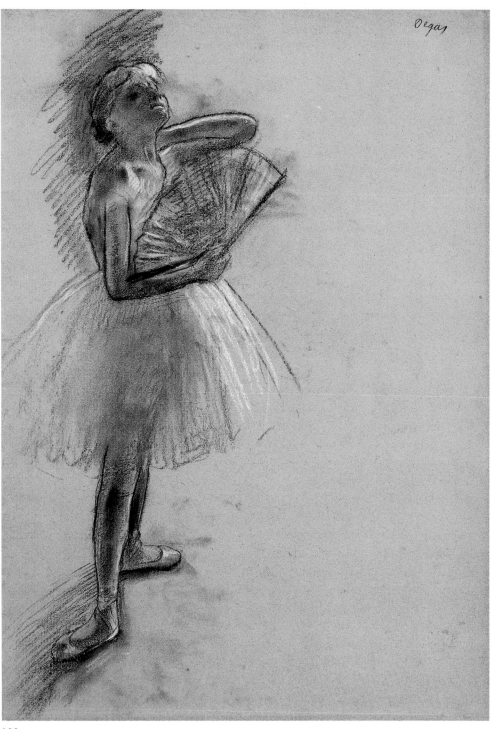

222

pression the subject is reacting to the gaze directed toward her. She is young and almost alarmingly thin, but with the fan unfolded before her she has the manner of an adult perfectly aware of the arsenal of meanings she could convey with a movement of her wrist. If her left arm is in the familiar pose of the tired dancer rubbing her neck, there is more than a hint that she is striking an attitude—indeed, that with a toss of her head she almost defies the viewer.

PROVENANCE: H. O. Havemeyer, New York, probably bought from the artist with *Little Girl Practicing at the Barre* (cat. no. 213); Mrs. H. O. Havemeyer, New York, 1907–29; her bequest to the museum 1929.

EXHIBITIONS: 1930 New York, no. 155, repr.; 1977 New York, no. 33 of works on paper (as 1880–82).

SELECTED REFERENCES: Havemeyer 1931, p. 185, repr. p. 187; Lemoisne [1946–49], III, no. 823 (as 1885); Browse [1949], no. 117, repr. (as c. 1883); Minervino 1974, no. 821.

The Little Fourteen-Year-Old Dancer

cat. nos. 223–227

Marie van Goethem, who posed for *The Little Fourteen-Year-Old Dancer* (cat. no. 227, fig. 158), turned fourteen in 1878.[1] That date and the title of Degas's most important sculpture—the only one to be exhibited in his lifetime—represent the sole clues to a possible date for its genesis. The stages through to its completion are marked by a number of drawings datable to the end of the 1870s, separately examined below, and by a wax model of the dancer nude that preceded the final work (fig. 158). There are no references to the sculpture in Degas's known correspondence from that period, and no sketches in his notebooks. As Theodore Reff has pointed out, a notebook used by the artist between 1880 and 1884 contains Marie van Goethem's address, and also refers to a Mme Cusset (actually Cussey), a merchant of doll's hair, probably connected with the wig assembled for the statue.[2]

It is almost certain, however, that by the end of March 1880, the *Little Dancer* was largely finished and probably looked as it did a year later when it was finally seen in public. Degas listed it in the catalogue of the 1880 Impressionist exhibition under the title retained for the exhibition of 1881, and it is known that in 1880 he went as far as installing the glass case in which it was to be shown.[3] On 6 April 1880, however, a sympathetic critic, Gustave Goetschy, told his readers: "Everything M. Degas produces interests me so keenly that I delayed by one day the

222.

Dancer with a Fan

c. 1880
Charcoal and pastel heightened with white chalk on greenish paper
24 × 16½ in. (61 × 41.9 cm)
Signed upper right: Degas
The Metropolitan Museum of Art, New York. Bequest of Mrs. H. O. Havemeyer, 1929. H. O. Havemeyer Collection (29.100.188)

Exhibited in New York

Lemoisne 823

This large, expressive drawing used for the central figure in *The Dancing Lesson* (cat. no. 221) is one of the identifiable studies linked to the finished composition. This said, it should be noted that in the drawing the dancer is at least twice as large as she appears in the painting, considerably enhancing her dramatic impact and bestowing a sense of immediacy absent in the painted version.

The drawing is one of the few representations of a dancer in repose that gives the im-

publication of this article to tell you about a wax statuette that I hear is marvelous and that represents a fourteen-year-old dancer, modeled from life, wearing real dance slippers and a bouffant skirt composed of real fabric. But M. Degas isn't an 'Indépendant' for nothing! He is an artist who produces slowly, as he pleases, and at his own pace, without concerning himself about exhibitions and catalogues. All the worse for us! We will not see his *Dancer* [cat. no. 227], nor his *Young Spartans* [cat. no. 40], nor a number of other works he has announced."[4]

What prevented Degas from showing the statue remains unknown—perhaps his customary last-minute hesitations or simply a matter of adjusting a detail. According to Renoir, a change of detail did occur at some point in the history of the work, though not necessarily at this time. In a conversation with Ambroise Vollard, he intimated that several people had remarked on how summarily the mouth had been rendered and that as a result Degas had changed it—for the worse.[5]

As in the previous year, on 2 April 1881 *The Little Fourteen-Year-Old Dancer* was announced for the sixth Impressionist exhibition and the empty glass case was set up again. From the sequence of reviews, many published before the work was actually included in the exhibition, it can be determined that the *Little Dancer* was finally seen only shortly before 16 April, and its original appearance can be partly determined from the reviews. The dancer was dressed in a real bodice, tutu, stockings, and ballet shoes; on her head was a wig with a pigtail tied with a leek-green ribbon, and she wore a similar ribbon around her neck.[6] The wax body was tinted to simulate flesh, but already at that time it was being said that the polychromy was slightly defective. Charles Ephrussi, one of the reviewers, expressed the wish that "the work had been more finished, that the color of the wax had been better blended, without those dirty blotches that spoil the overall appearance."[7]

The astonishing effect of the statue has been analyzed in considerable detail by John Rewald, Charles Millard, and Theodore Reff.[8] The exhibition reviews of 1881 were unanimous in admitting that it was an extraordinary work, even if they disagreed on its relative merits. Paul Mantz, who had heard of the *Little Dancer* while it was in the making, had to admit that no amount of warning could have possibly prepared the viewer for the realism of the work. Ephrussi's statement, "This is a truly modern effort, an essay in realism in sculpture," was followed by Joris-Karl Huysmans's lengthier comment, prefaced with the words: "The fact is that at one fell swoop, M. Degas has overthrown the

traditions of sculpture, as he has for a long time been shaking up the conventions of painting."[9] And like Ephrussi, Huysmans concluded that the work was "the only truly modern initiative that I know of in sculpture."[10]

Critics were quick to link the work with polychrome sculpture of the past. But it is curious that the negative criticism focused not on the novelty of the materials but on a moral issue raised by the physical aspect of the dancer. Mantz noted her expression of "brutish insolence" and asked, "Why is her forehead, as are her lips, so profoundly marked by vice?" words echoed by Henry Trianon, who described her as "the archetype of horror and imbecility."[11] Even Jules Claretie, who had been very much affected by the work, remarked that "the pug-nosed vicious face of this scarcely pubescent girl, a blossoming street urchin, remains unforgettable."[12]

The most remarkable aspect of the statue was its extraordinary naturalism, achieved by highly unusual means in a unique combination of the artificial with the real—wax, with hair and cloth. The choice of wax as the basic medium may have been dictated by convenience or by force of habit; indeed, as far as is known, most of Degas's sculpture was made of wax. However, it appears that in this work Degas aimed at a certain quality of surface that only wax could provide and that he wished to retain.

The renewal of interest among Degas's contemporaries in the wax sculpture of the past was related to the ongoing argument about the use of color in sculpture that culminated with the exhibitions of polychrome sculpture in Dresden in 1883 and in Berlin in 1886. In France, enthusiasm for wax focused on the work of Antoine Benoist, whose well-known colored-wax portrait of Louis XIV, complete with a wig of real hair, was on display at Versailles, and on a now almost completely forgotten polychrome wax head of a woman in the Musée Wicar at Lille, once ascribed to the circle of Raphael. The fame of the head at Lille in the latter part of the nineteenth century can scarcely be exaggerated. Several studies were devoted to it, including a major article by Louis Gonse, a friend of Duranty's. As early as 1859, in a discussion of the Lille head, Jules Renouvier had encouraged the use of wax as a medium by stating that "wax can lend itself to developments in polychrome sculpture that have been only timidly attempted thus far." Even more notable is the fact that Renouvier defended the naturalistic effects obtained in wax sculpture by claiming that in certain circumstances, "art becomes more affecting by approximating reality more than academic rules allow it."[13]

When the new Musée Rétrospectif opened its doors in Paris in 1864, one of its sections was devoted to wax sculpture. Private collectors began to acquire wax sculpture—Alfred-Émilien de Nieuwekerke, the Surintendant des Beaux-Arts, for example. Other collectors closer to Degas were Philippe Burty and Charles de Liesville, a friend of Duranty's.[14] Burty, on seeing the wax head at Lille in 1866, had pronounced it "the most astonishing wonder that one could hope to see" and enlisted Henry Cros, a young sculptor with a marked interest in new materials, to execute a copy for Alexandre Dumas fils. Cros followed this work with painted wax medallions and busts, among them one of Burty's daughter.[15] Reviews indicate that most wax sculpture shown at the Salon, Cros's included, was well received until 1879, when the controversy unleashed by Désiré Ringel's *Demi-monde*, again a moral issue, prefigured the events that surrounded the exhibition of *The Little Fourteen-Year-Old Dancer*.[16]

Thus Degas's work expressed a mood and an aesthetic that were current at the time. The advocates of polychrome sculpture were known to Degas, and Burty was a friend of several years' standing. There is no known link between Cros and Degas, but their names were mentioned together in Huysmans's review of 1881, and Charles Cros, the sculptor's brother, dedicated a poem to Degas in 1879. It is not surprising, therefore, that Nina de Villard, Charles Cros's mistress, wrote in her review of the *Little Dancer*, "Standing before this statuette I experienced one of the sharpest artistic sensations of my life; for a long time after, I dreamt of it."[17]

Degas's insistence on wax as the only possible material for the *Little Dancer* was tested in 1903 when the possibility of casting it arose in connection with its proposed sale. Louisine Havemeyer's memoirs leave no doubt that her intention to buy the work was prompted by a visit to Degas's apartment in the spring of 1903. In later life, she recollected:

During another visit to Degas, I had an opportunity to look around the apartment. I found a little vitrine containing the model of a horse and the remains of his celebrated statue of "La Danseuse."
. . . As I looked into the little vitrine, I remember how faded the gauze was and how wooly the dark hair appeared, but nevertheless I had a great desire to possess the statue, and as soon as I met Durand-Ruel afterward I requested him to interview Degas and find out if the statue could not be put together again for me. The answer came—"it might and it might not be done. There were hopes and there

343

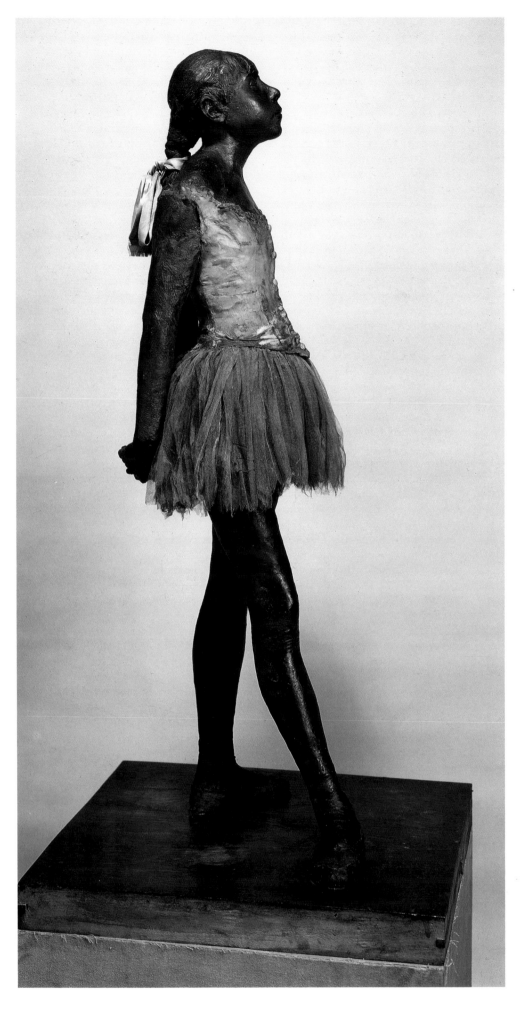

were doubts!" There would be work Degas could no longer see to do, that would have to be entrusted to another, but above and beyond other considerations, the statue was past for him and far away from his present line of thought . . . and so after much hesitation and a great deal of advice, I finally abandoned the idea.[18]

Before negotiations broke down, Mary Cassatt, who had accompanied Mrs. Havemeyer during her visit to Degas, wrote to Paul Durand-Ruel in late 1903: "I have just received a letter from Mrs. Havemeyer about the statue. She will have nothing but the original, and she tells me that Degas, on the pretext that the wax has blackened, wants to do it all over in bronze or plaster with wax on the surface. What an idea, what does it matter that the wax is blackened? The price seems reasonable, which is what I wrote to her. It is Degas who is not. Couldn't you arrange it, she wants the statue so much."[19]

Throughout the summer and fall of 1903, Degas was preoccupied with his sculpture. In an undated letter to his friend Louis Braquaval, written shortly after 19 July 1903, he informed him that he would not visit him at Saint-Valéry because "I must finish this sculpture, though I really ought to stop at my age. I shall work until I drop, and I'm feeling steady enough on my legs, in spite of having just reached 69."[20] In a letter of September 1903 to Alexis Rouart, he observed: "I am still here, in this studio, after doing some wax figures. Old age would be sad without work."[21] If the letters may only indicate a renewed interest in sculpture in general, it is clearer from other sources that the wax statue of the little dancer was very much on Degas's mind. A letter from Bartholomé to Paul Lafond, dating from the same period, mentions a visit from Degas, who wanted advice on repairs to a wax sculpture "that was going to go to America." And discussions about the possibility of Bartholomé's supervising the casting of the work are certainly suggested by Degas's letter to Bartholomé datable 1903 that begins: "My dear friend, and perhaps caster. . . ."[22]

Nothing came of the project, however, and the *Little Dancer* was cast in bronze only in 1921. It is interesting to speculate on the alterations made to the statue, possibly to facilitate its casting. The ballerina's hair is covered with wax, indicating that either the critics who commented on the work in 1881 were mistaken or that it was subsequently

Fig. 158. *The Little Fourteen-Year-Old Dancer* (RXX), 1879–81. Wax, cotton skirt, satin hair ribbon, height 37½ in. (95.2 cm). Collection of Mr. and Mrs. Paul Mellon, Upperville, Va.

modified. It has been suggested that the alterations were made after the artist's death and were required for the casting process, though photographs of the *Little Dancer* taken after it was found in Degas's apartment show unmistakably that it was already in that condition (figs. 159, 160). It is therefore possible that the alterations were made by Degas himself in 1903 in anticipation of casting that year.

The drawings connected with the work constitute a particular problem of dating. The studies can be divided into two principal groups. One set consists of two sheets that are more distantly associated with the work than the other group. These show Marie van Goethem dressed or nude from five different angles in a pose related to that of the statue, though she has her arms in front of her chest and, where she is clothed, is adjusting her shoulder strap.[23] Five other sheets contain twelve—not sixteen as is sometimes stated—full-length studies of Marie dressed or nude in the general pose she assumed for the sculpture.[24] An additional drawing related to the latter group has four studies of her head, torso, and arms, and there is also a sheet containing five studies of only her feet.[25]

The studies, highlighted with chalk or pastel, are absolutely assured. In almost every instance, the layout on the sheet is unusually careful. The paper used, sometimes green or pink, appears to be from the same stock that served for *Portraits in a Frieze* (see cat. nos. 204, 205), and six of the nine sheets are very large. How the artist himself regarded them may be inferred from the fact that he sold three of the larger sheets to collectors he knew—Jacques Doucet, Roger Marx, and Louisine Havemeyer.

Rewald was the first to propose that the studies of the model adjusting her dress predate the others and may indicate that at an early stage Degas intended to represent the sculptured figure in a different pose.[26] His hypothesis was accepted by Lillian Browse but received little general support.[27] Lately, however, George Shackelford concluded that at least one of the two studies, *Two Dancers* (cat. no. 225), dates from about 1880, a year or two after the dates he assigned to the other drawings.[28] The second group of studies, showing the model with her arms behind her back, has been analyzed by Ronald Pickvance, who proposed a sequence if not a date. Based on differences he noted between the nude studies and the nude sculpture, he concluded that the drawings preceded the waxes in a specific order and that the ones of Marie van Goethem dressed followed the nude wax sculpture as studies for the final, dressed version of the statue.[29]

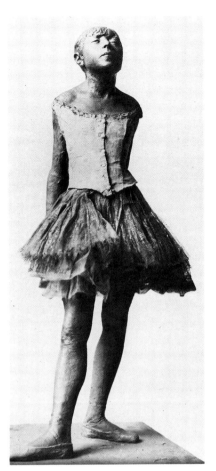

Fig. 159. Photograph taken in 1919 of *The Little Fourteen-Year-Old Dancer* (see fig. 158)

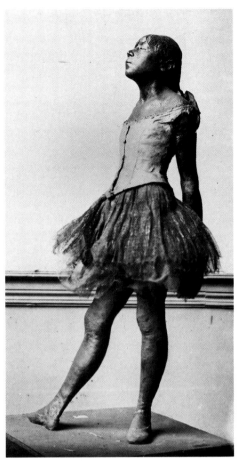

Fig. 160. Photograph taken in 1919 of *The Little Fourteen-Year-Old Dancer* (see fig. 158)

1. For details about Marie van Goethem, see cat. no. 223.
2. Reff 1985, Notebook 34 (BN, Carnet 2, p. 228).
3. Mantz 1881, p. 3.
4. Goetschy 1880, p. 2. Charles Millard has proposed that in 1880, Degas intended to exhibit the nude version of *The Little Fourteen-Year-Old Dancer*; see Millard 1976, p. 9. For a similar view, see also 1986 Florence, no. 73.
5. "That dancer, in wax. . . . There was a mouth, a simple indication of one, but such modeling! Unfortunately, after hearing people say, 'But you have forgotten to make the mouth!' he changed it." Cited in Vollard 1924, p. 63. John Rewald has suggested that Renoir may have had the nude version in mind; see Rewald 1956, pp. 17–18.
6. Joris-Karl Huysmans noted that the fabric bodice was covered with wax and that the color of the ribbons was "porreau," that is, leek-green—confirmed by Nina de Villard, who also described the ribbons as green. Paul Mantz alone added that the dancer wore "a blue ribbon around her waist" as well. See Huysmans 1883, p. 227; Villard 1881, p. 2; Mantz 1881, p. 3.
7. C.E. [Charles Ephrussi], "Exposition des artistes indépendants," *La Chronique des Arts et de la Curiosité*, 16 April 1881, p. 127. Paul Mantz also noted "stains, spots, and scaly patches that M. Degas made on the flesh," suggesting they were deliberate; see Mantz 1881, p. 3.
8. Rewald 1956, pp. 16–20; Millard 1976, pp. 27–29, 60–65; Reff 1976, pp. 239–48.
9. C.E. [Charles Ephrussi], op. cit., p. 127; Huysmans 1883, p. 226.
10. Huysmans 1883, p. 227.
11. Mantz 1881, p. 3; Henry Trianon, "Sixième exposition de peinture par un groupe d'artistes," *Le Constitutionnel*, 24 April 1881, p. 2.
12. Claretie 1881, p. 150.
13. Jules Renouvier, "La tête de cire du Musée Wicar à Lille," *Gazette des Beaux-Arts*, III:6, 15 September 1859, pp. 340–41. For the Lille head, see also Louis Gonse, "Musée Wicar, objets d'art: la tête de cire," *Gazette des Beaux-Arts*, XVII:3, March 1879, pp. 193–205.
14. See Paul Mantz, "Musée Rétrospectif: la Renaissance et les temps modernes," *Gazette des Beaux-Arts*, XIC:4, October 1865, pp. 343–44; see also Spire Blondel, "Les modeleurs en cire," *Gazette des Beaux-Arts*, XXVI:5, November 1882, p. 436.
15. Philippe Burty, "Exposition des beaux-arts à Lille," *Gazette des Beaux-Arts*, XXI:4, October 1866, pp. 389–90. For Henry (or Henri) Cros, who in 1879 was doing a series of mural decorations for the museum of pathology at the Salpêtrière in Paris, see Maurice Testard, "Henry Cros," *L'Art Décoratif*, XVIII, 1908, pp. 149–55; see also Henry Roujon, *La Galerie des Bustes*, Paris: Hachette, 1909, pp. 293–98; Léonce Bénédite, "Henry Cros 1840–1907," in preface to the catalogue for the retrospective exhibition in 1922, Paris: Société du Salon d'Automne, 1922, pp. 369–76; and Henry Hawley, "Sculptures by Jules Dalou, Henry Cros and Medardo Rosso," *Bulletin of*

the Cleveland Museum of Art, LVIII:7, September 1971, pp. 201–05, 209 nn. 5–16. A sitting for the portrait of Madeleine Burty (who subsequently married Charles Haviland, a collector of works by Degas) was described in Edmond de Goncourt's diary entry for 10 December 1872; see Journal Goncourt 1956, pp. 923–24.

16. For wax sculpture in the latter part of the nineteenth century, see Spire Blondel, "Les ciriers modernes," *L'Artiste*, I, 1898, pp. 225–34; for Désiré Ringel, see Antoinette Le Normand Romain's chapter on polychromy in *La sculpture française au XIXe siècle* (exhibition catalogue), Paris: Grand Palais, 1986, p. 155.

17. See Villard 1881, p. 2. For Charles Cros's connection with Nina de Villard and Degas, see Louis Forestier, *Charles Cros, l'homme et l'oeuvre*, Paris: Lettres Modernes Minard, 1969, pp. 54–67, 124–29, 170–71, 279–81.

18. Havemeyer 1961, p. 255.

19. Letter from Mary Cassatt, Mesnil-Beaufresne, Tuesday [1903], to Paul Durand-Ruel. The original letter is in a French private collection, a transcript in the Durand-Ruel archives, Paris. Translation in Mathews 1984, p. 287.

20. Unpublished letter from Degas, Paris, Wednesday, to Louis Braquaval, datable 1903 from Degas's statement about his age.

21. Letter from Degas, Paris, Monday [September 1903], to Alexis Rouart, who wrote the date on the letter; see Lettres Degas 1945, CCXXII, p. 234; Degas Letters 1947, no. 254, p. 219 (translation revised).

22. Letter from Degas, Paris, Friday, to Bartholomé. Marcel Guérin, who published the letter, included it with the correspondence for 1888. However, the letter can be dated 1903 on the basis of an Ingres exhibition mentioned in the text, recognizable as "Portraits dessinés par Ingres," held that year at the Galerie Bulloz, Paris, in connection with the publication of Henry Lapauze's *Les portraits dessinés de J.-A.-D. Ingres*, Paris: J. E. Bulloz, 1903. See Lettres Degas 1945, CI, p. 127; Degas Letters 1947, no. 112, p. 125.

23. See cat. no. 225 and fig. 161.

24. See III:386 and IV:287.1, showing the model nude; and L586 bis, L586 ter (cat. no. 224), and III:277, showing her dressed.

25. See III:149 and cat. no. 223.

26. Rewald 1956, p. 17.

27. Browse [1949], no. 92.

28. 1984–85 Washington, D.C., pp. 73–78.

29. 1979 Edinburgh, p. 64 and nos. 74, 77.

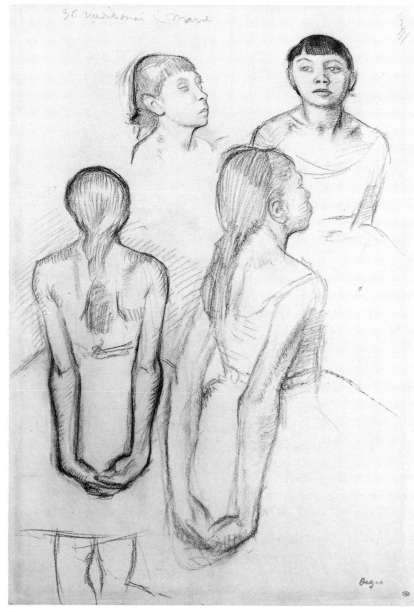

223

223.

Four Studies of a Dancer

1878–79
Chalk and charcoal, heightened with gray wash and white, on buff wove paper
19¼ × 12⅝ in. (49 × 32.1 cm)
Inscribed in graphite upper left: 36 rue de Douai Marie
Vente stamp lower right; atelier stamp on verso
Cabinet des Dessins, Musée du Louvre (Orsay), Paris (RF4646)

Exhibited in Paris

Vente III:341.2

This study, inscribed with a name and address—the same as that appearing in a notebook used by Degas between 1880 and 1884—identified Marie van Goethem as the model for *The Little Fourteen-Year-Old Dancer* (cat. no. 227).[1] As Charles Millard has established, Marie was one of three daughters—all ballet students—of a Belgian tailor and a laundress.[2] The name of the eldest daughter, Antoinette, later a supernumerary, appears as a prospective model in a notebook used by Degas until the early 1870s.[3] The youngest daughter, Louise-Joséphine, who became a dancer at the Opéra and performed until 1910, subsequently claimed that it was she who posed for the *Little Dancer*.[4] Marie, born on 17 February 1864, would have been fourteen in 1878.

Unfortunately, there are few descriptions of Marie van Goethem outside of the splendid visual records of her left by Degas. A small item published in a newspaper on 10 February 1882, when she was one week short of eighteen, states: "Mlle Van Goeuthen [sic].—Fifteen years old. Has a sister

who is a supernumerary and another at the ballet school.—Poses for painters.—Therefore frequents the *Brasserie des Martyrs* and *Le Rat Mort*."[5] The discrepancy between Marie's real age and that noted in the newspaper is interesting. It could be an editorial mistake, but it may also suggest that she was not truthful about her age, in which case an attempt to attach the date of 1878 to the first idea for the *Little Dancer* could prove misleading. Blanche Mante, also a young dance student and several years Marie's junior, remembered her as having beautiful long hair which she wore hanging down her back when dancing. But Millard has suspected, probably rightly, that it was Louise-Joséphine whom Mlle Mante remembered.[6] From the evidence of the drawings, Marie van Goethem also had a wonderful head of hair, shown in all its beauty in *The Dance Class* (cat. no. 219) in Philadelphia. Her face, no less than her angular body, had an interesting structure, though it was not necessarily beautiful by the standards of 1880.

In these four studies, as in the other studies directly related to the project, the dancer is shown in the pose adopted for the statue. The study at the lower right duplicates to some degree a study appearing at the center of a different sheet (L586 bis, private collection). The presence of the name and address on the drawing has suggested, with some reason, that it may have been the first in the sequence of studies of Marie in this pose in dance costume.

1. "Marie, 36 rue de Douai/Van Gutten." See Reff 1985, Notebook 34 (BN, Carnet 2, p. 4).
2. Millard 1976, pp. 8–9 n. 26.
3. "Vanguthen Boulevard [de] Clichy. Antoinette petite blonde/12 ans." See Reff 1985, Notebook 22 (BN, Carnet 8, p. 211). Reff dates the notebook 1867–74.
4. Pierre Michaut, "Immortalized in Sculpture," *Dance*, August 1954, pp. 26–28, cited in Millard 1976, pp. 8–9 n. 26.
5. "Paris la nuit: le ballet de l'Opéra," *L'Événement*, 10 February 1882, p. 3. The note cannot refer to Antoinette van Goethem, too old in 1882 to pass for fifteen, or to Louise-Joséphine who, born on 18 July 1870, was not yet twelve years old. The text of the note was also used in 1887 by the anonymous author of a book on dancers at the Opéra (Un vieil abonné [An old subscriber], *Ces demoiselles de l'Opéra*, Paris: Tresse et Stock, 1887, pp. 265–66). For both, see Coquiot 1924, p. 76; Millard 1976, p. 8 n. 26; and Shackelford in 1984–85 Washington, D.C., p. 69.
6. See Browse [1949], p. 62, and Millard 1976, pp. 8–9 n. 26.

PROVENANCE: Atelier Degas (Vente III, 1919, no. 341.2, in the same lot with no. 341.1 [cat. no. 134], for Fr 2,850); bought at that sale by the Musée du Luxembourg, Paris; transferred to the Louvre 1930.

EXHIBITIONS: 1937 Paris, Orangerie, no. 84; 1952, London, Arts Council Gallery, 2 February–16 March, *French Drawings from Fouquet to Gauguin*, no. 49; 1952–53 Washington, D.C., no. 157; 1959–60 Rome, no. 182; 1964 Paris, no. 71, repr.; 1969 Paris, no. 186, pl. XIX; 1984–85 Washington, D.C., no. 19, repr.

SELECTED REFERENCES: Rivière 1922–23, I, pl. 36 (reprint edition 1973, pl. 63); Browse [1949], no. 94; Rosenberg 1959, p. 113, pl. 213; Millard 1976, pl. 27; Reff 1976, pp. 245, 333 nn. 17, 18, fig. 161; Keyser 1981, pl. XXXVII; 1984 Chicago, p. 97, fig. 42-2.

224.

Three Studies of a Dancer in Fourth Position

1879–80
Charcoal and pastel with stump, over graphite, heightened with white chalk, on buff laid paper
18⅞ × 24¼ in. (48 × 61.6 cm)
Signed in black pastel lower left: Degas
The Art Institute of Chicago. Bequest of Adele R. Levy (1962.703)

Exhibited in Ottawa and New York

Lemoisne 586 ter

There are no true precedents in Degas's earlier work for multiple studies, from different angles, of a model holding strictly the same pose. Richard Thomson has observed that in an early drawing after the classical *Borghese Gladiator*, Degas was careful to study the sculpture from three different angles,[1] and over the years he seems to have maintained the same interest in an anatomical model (attributed to Edmé Bouchardon) of which he owned a cast.[2] Degas's increasing fascination with mirror images, documented in a notebook used in the late 1870s[3] and very much in evidence in the repetitive motifs of some of his later compositions, has been cited as a possible reason for the multiplicity of views of Marie van Goethem, seen from every imaginable point of view as she holds her pose.[4]

That hypothesis, attractive as it is, does not appear completely convincing when applied to this particular set of drawings. In fact, there may have been a simpler reason for them. From the beginning of the eighteenth century, when Bouchardon made a famous series of such studies (now in the Louvre), until the later nineteenth century, drawings of this type served a special function in the evolution of a sculpture: far from being the initial study toward it, they usually followed the making of the first modeled sketches.[5] Thus they were not the first projection on paper of something that had not yet taken form in three dimensions, but rather a refining tool that gave the sculptor the opportunity to take a second, more analytical look at the model before proceeding with the final sculpture. Whether Degas deliberately adopted the procedure cannot be proved, but it is unlikely that he was unaware of it, and the drawings associated with *The Little Fourteen-Year-Old Dancer* (cat. no. 227), whatever their status within the sequence, do correspond closely to the practice. What distinguishes them from the usual productions of this type is their quality and the complete absence of pedantry.

224

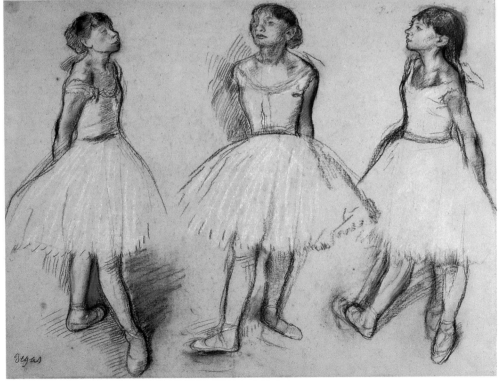

The drawing in the Art Institute of Chicago, one of the finest of the group, is related to one on a sheet of the same size in a private collection (L586 bis) that represents Marie van Goethem in three views from the back. Erasures and subtle changes in both drawings indicate the effects the artist strove for. In the Chicago sheet, corrections affect mostly the pose of the legs, though the right arm of the figure in the center, erased and covered with a shadow, indicates it was pushed farther behind the model's back. In the related drawing, it is principally the posture of the arms that underwent revision. In two of the three studies on the sheet, Marie van Goethem originally held her arms behind her back with her elbows farther apart, but then she adjusted her pose, probably at the request of the artist, with her arms held closer together.

1. 1987 Manchester, p. 82, no. 112 p. 85.
2. See the drawings in Reff 1985, Notebook 8 (private collection, pp. 2v, 3v, 43) and Notebook 9 (BN, Carnet 17, p. 18), as well as IV:123.b, IV:123.c, IV:182.a, IV:182.b.
3. Reff 1985, Notebook 30 (BN, Carnet 9, p. 65).
4. George Shackelford (1984–85 Washington, D.C., pp. 73–78) cites as a precedent van Dyck's triple portrait of Charles I of England. However, this is not a portrait in the traditional sense but is a set of studies painted specifically as a guide for the sculptor Gianlorenzo Bernini.
5. For Bouchardon's studies and the role of preparatory drawings in sculpture, see *La sculpture: méthode et vocabulaire*, Paris: Imprimerie Nationale, 1978, pp. 22–41. For a later manifestation of the practice, see the case of Paul Dubois's *Eve* of 1873, reproduced by Anne Pingeot in *La sculpture française au XIX siècle* (exhibition catalogue), Paris: Grand Palais, 10 April–28 July 1986, pp. 61–64.

PROVENANCE: Roger Marx (d. 1913), Paris (Marx sale, Galerie Manzi-Joyant, Paris, 11–12 May 1914, no. 124, repr.); bought by Durand-Ruel, Paris, for Fr 10,070 (stock no. 10552); bought by R. Bunes, 28 February 1921, for Fr 26,000. [? Bibliothèque d'Art et d'Archéologie, Paris, according to Lemoisne.] Adele R. Levy, New York; her bequest to the museum 1962.

EXHIBITIONS: 1961, New York, The Museum of Modern Art, 9 June–16 July, *The Mrs. Adele R. Levy Collection: A Memorial Exhibition*, no. 14, repr.; 1979 Edinburgh, no. 76, repr.; 1984 Chicago, no. 42, repr. (color); 1984–85 Washington, D.C., no. 20, repr.

SELECTED REFERENCES: Marx 1897, repr. (detail) pp. 321, 323; Rewald 1944, pp. 21, 62, repr.; Lemoisne [1946–49], II, no. 586 ter; Browse [1949], no. 91; Harold Joachim and Sandra Haller Olsen, *French Drawings and Sketchbooks of the Nineteenth Century, The Art Institute of Chicago*, Chicago: University of Chicago Press, 1979, II, 2F2.

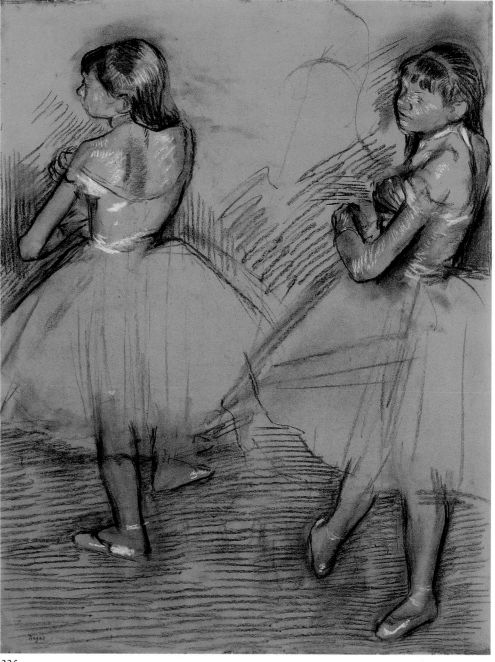

225

225.

Two Dancers

c. 1879
Charcoal and white chalk on green commercially coated wove paper, which retains its original color
25⅛ × 19¼ in. (63.8 × 48.9 cm)
Signed lower left: Degas
The Metropolitan Museum of Art, New York. Bequest of Mrs. H. O. Havemeyer, 1929. H. O. Havemeyer Collection (29.100.189)

Exhibited in New York

Lemoisne 599

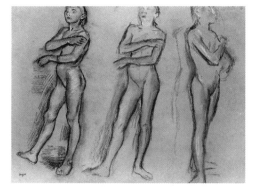

Fig. 161. *Three Studies of a Nude* (III:369), c. 1879. Charcoal, 18⅞ × 25⅝ in. (48 × 65 cm). Private collection

Even among Degas's surviving works of sculpture, there are examples that show he modeled the same subject again and again, making adjustments or expanding a theme. From the evidence, it would appear that of all his major works, *The Little Fourteen-Year-Old Dancer* (cat. no. 227) had the least difficult genesis, with a clear progression from the nude modeled version to the dressed one he exhibited. This is somewhat difficult to imagine, however, and it is not unreasonable to suppose that other modeled sketches, now lost, may have existed.

Two fine studies of the model, Marie van Goethem, adjusting her shoulder strap are the only indication that Degas may have entertained a different idea for the sculpture. In addition to this sheet, in which she appears in her ballet dress, there is a drawing of almost exactly the same size, also on green paper, in which she is shown nude in three different views of the same pose (fig. 161).[1] The effect of each drawing is quite different. The nude version, vigorous and direct, can easily be accepted as the analysis of a model for a sculpture. In the one exhibited here, the dancer is seen from above, from an angle that is stylistically consistent with the artist's preoccupations in the late 1870s but far from common in a drawing purporting to be a study specifically related to a sculpture. Thus the relationship of the drawing to the sculpture remains vague, and it may well be that it was simply executed in the course of studying the model for the interesting points of view it offered.

The pose, with one arm raised and the head turned slightly to the side, is one Degas had examined periodically since the early 1870s, notably in an earlier study of two dancers in the Metropolitan Museum (cat. no. 138).[2] About 1878–79, Degas took a new interest in the motif and in one instance included a dancer of this type, apparently based on an earlier drawing, in a fan (BR72) painted for Louise Halévy and subsequently exhibited in 1879.[3]

1. Seldom exhibited and reproduced, it was nevertheless included in Rivière 1922–23, I, pl. 35.
2. See 1984–85 Washington, D.C., p. 77, fig. 3.4, and 1987 Manchester, p. 113, fig. 148 p. 112.
3. Among many drawings of various dates, one might cite two that certainly precede the Metropolitan drawing (cat. no. 138). These are III:81.4 and III:166.1. The fan appeared in the fourth Impressionist exhibition under no. 78.

PROVENANCE: Possibly the drawing that was bought from the artist for Fr 500 by Durand-Ruel, Paris (stock no. 2184, as "Danseuses," drawing), 26 January 1882, and sold by Durand-Ruel for Fr 800 to M. Deschamps, 31 August 1882; possibly the same "Danseuses" sold by Deschamps for Fr 800 to Durand-Ruel, Paris (stock no. 567), 30 June 1890, which was then sent to New York on 29 November 1893, arrived at Durand-Ruel, New York, 12 December 1893 (stock no. N.Y. 1105), and was sold to H. O. Havemeyer,

New York, 16 January 1894; Mrs. H. O. Havemeyer, from 1907; her bequest to the museum 1929.

EXHIBITIONS: 1922 New York, no. 60 (as "Deux danseuses, vues de dos," on green paper), no lender given; 1930 New York, no. 156; 1977 New York, no. 31 of works on paper.

SELECTED REFERENCES: Havemeyer 1931, p. 185, repr. p. 187; *Hilaire-Germain Edgard* [sic] *Degas, 1834–1917: 30 Drawings and Pastels* (introduction by Walter Mehring), New York: Erich S. Herrmann, 1944, pl. 16; Lemoisne [1946–49], II, no. 599; Browse [1949], p. 369, no. 92; 1984–85 Washington, D.C., p. 70, fig. 3.1.

226.

Nude Study for *The Little Fourteen-Year-Old Dancer*

1878–80
Bronze
Height: 28½ in. (72.4 cm)
Original: red wax with black spots. National Gallery of Art, Washington, D.C. Collection of Mr. and Mrs. Paul Mellon. See fig. 162

Rewald XIX

There has never been any doubt that the nude version of *The Little Fourteen-Year-Old Dancer* is the model for the dressed version (cat. no. 227) and that, as such, it preceded it. About one-fourth smaller than the final

226

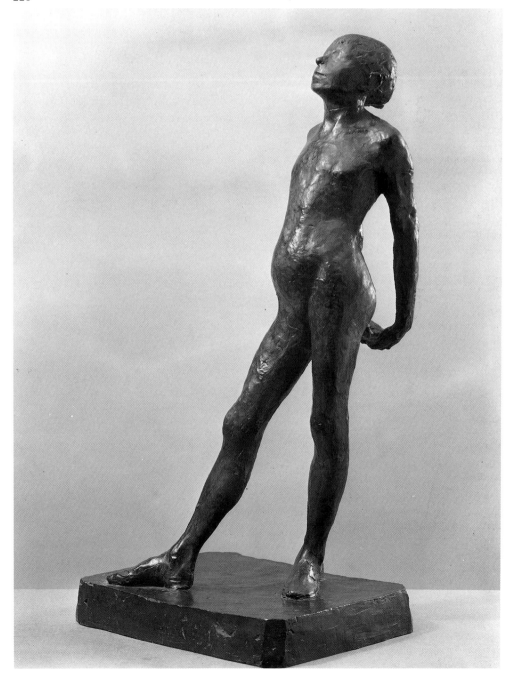

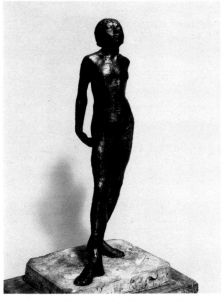

Fig. 162. Nude study for *The Little Fourteen-Year-Old Dancer* (RXIX), 1878–80. Wax, height 14¾ in. (37.5 cm). National Gallery of Art, Washington, D.C. Collection of Mr. and Mrs. Paul Mellon

work and modeled with less regard for detail, the sculpture is a vigorous final draft that anticipates, with unexpectedly different results, the pose, proportions, and general effect of the dressed *Little Dancer*.

Marks on the wax model—visible also in the bronze version—and a comparison with the nude studies of Marie van Goethem (fig. 161) have led Charles Millard and Ronald Pickvance to suggest that the wax model (fig. 162) underwent a number of transformations.[1] Noting that in the drawings Marie van Goethem holds a slightly different pose, Pickvance proposed that at some point during its final stage the statue was altered in three ways: the arms were pulled farther back from the body, the right leg was moved, and the head was tilted back a bit more, resulting in a crack at the level of the neck.[2]

Devoid of her stage costume, the dancer seems younger than in the final work. The body, clearly that of an adolescent, is firmly planted on its large feet, and the arms echo in their curve the forward thrust of the yet unformed torso, an effect that was attenuated in the ultimate version. The small size of the wax model, along with the term "statuette" used to describe the work in the catalogues of the 1880 and 1881 Impressionist exhibitions, has led to the tentative suggestion that the nude wax study may have been exhibited in the fifth Impressionist exhibition, of 1880.[3] However, Gustave Goetschy's description of the work that was expected at the exhibition, clearly the dressed version, rules out the possibility.[4]

1. Millard 1976, p. 9; 1979 Edinburgh, no. 75.
2. Millard was the first to point out that the right leg had been displaced. See Millard 1976, p. 9.

3. See 1986 Florence, under no. 73.
4. Goetschy 1880, p. 2.

SELECTED REFERENCES: Lemoisne 1919, repr. p. 112 (wax original); Janneau 1921, repr. p. 352 (unidentified bronze cast); Bazin 1931, p. 294, fig. 69 (unidentified bronze cast); Rewald 1944, no. XIX, reprs. pp. 57–60, details pp. 60–61 (bronze cast A/56, The Metropolitan Museum of Art, New York, as 1879–80); Rewald 1956, no. XIX, plates 30, 31 (unidentified bronze cast, as 1879–80); Minervino 1974, no. S37; Millard 1976, pp. 8–9, figs. 23, 24 (wax original, as 1878–80); Reff 1976, p. 239, fig. 158 (bronze cast A/56, The Metropolitan Museum of Art, New York); 1986 Florence, no. 56, repr. (bronze cast S/56, Museu de Arte, São Paulo); 1987 Manchester, no. 69, fig. 108 (bronze cast, National Gallery of Scotland, Edinburgh).

A. *Orsay Set P, no. 56*
Musée d'Orsay, Paris (RF2101)

Exhibited in Paris

PROVENANCE: Acquired thanks to the generosity of the heirs of the artist and of the Hébrard family 1930; entered the Louvre 1931.

EXHIBITIONS: 1931 Paris, Orangerie, no. 37 of sculptures; 1964 Paris, no. 103; 1969 Paris, no. 241; 1984–85 Paris, no. 32, p. 189, fig. 154 p. 178.

B. *Metropolitan Set A, no. 56*
The Metropolitan Museum of Art, New York.
 Bequest of Mrs. H. O. Havemeyer, 1929.
 H. O. Havemeyer Collection (29.100.373)

Exhibited in Ottawa and New York

PROVENANCE: Bought from A.-A. Hébrard by Mrs. H. O. Havemeyer 1921; her bequest to the museum 1929.

EXHIBITIONS: 1922 New York, no. 101; 1945, New York, Buchholz Gallery, 3–27 January, *Edgar Degas: Bronzes, Drawings, Pastels*, no. 13; 1977 New York, no. 9 of sculptures.

227.

The Little Fourteen-Year-Old Dancer

1879–81
Bronze, partly tinted, cotton skirt, satin hair ribbon, wooden base
Height: 37½ in. (95.2 cm)
Original: wax, cotton skirt, satin hair ribbon, hair now covered with wax, wooden base. Collection of Mr. and Mrs. Paul Mellon, Upperville, Virginia. See figs. 158–160

Rewald XX

No work of sculpture by Degas suffered so much in translation to bronze as did *The Little Fourteen-Year-Old Dancer*. The unusually complex combination of materials was an evident difficulty. Whether contact between Degas and the Adrien Hébrard foundry existed as far back as 1870, as stated by Thiébault-Sisson, is open to question.[1] But in 1903 a proposal was considered, then abandoned, to cast the work, and three other sculptures actually were cast in plaster during the artist's lifetime, probably under his supervision.

Louisine Havemeyer's second attempt to purchase the wax *Little Dancer* in 1918 generated correspondence that throws some light on the otherwise confusing history of the casting, generally believed to have taken place in 1922 or 1923 but actually carried out in 1921. Unfortunately for Mrs. Havemeyer, her attempted negotiations occurred while Degas's estate was being divided, with all the complications attending such divisions. The *Little Dancer* was in a lot jointly owned by Jeanne Fevre, the artist's niece, and her brother Gabriel. It was René de Gas's plan to remove the waxes (not included in the posthumous sales) from the artist's studio and entrust them to Albert Bartholomé for cleaning and restoration. Mrs. Havemeyer's agent was Durand-Ruel, but she relied on Mary Cassatt to help her with the negotiations because of Cassatt's friendship with Jeanne Fevre. Throughout the entire episode, Cassatt attempted to prevent the casting of the *Little Dancer* and advised Jeanne Fevre to resist the idea, hoping that Mrs. Havemeyer would buy what she called a "unique piece."

The exact condition of the work in 1917 remains problematic. As has been noted, Mrs. Havemeyer claimed in her memoirs that in 1903 she had seen the "remains" of the sculpture, suggesting there had been extensive damage. However, her memory was almost certainly colored by the subsequent descriptions of the work in Paul Lafond's monograph of 1918–19, where it was

claimed that at the time of the artist's death the *Little Dancer* was a ruin and that "its arms were broken off from the body and lying pitifully at its feet."[2] Despite Lafond's closeness to the artist, there are reasons to doubt his statement. However defective Degas's armatures were, it would have been virtually impossible for the arms to fall off. It is clear, nevertheless, that the weight of the arms caused a break at the shoulder level and that both arms were partly detached but held in place by the armature. As Charles Millard has noted, this is visible in the earliest photographs of the sculpture (figs. 159, 160), and indeed the break in the left arm is noticeable in the bronze cast.[3]

René de Gas's decision to turn over all of the sculpture to Bartholomé was certainly made by early 1918, and a letter from Mary Cassatt of 9 February of that year shows that she had advised Jeanne Fevre to oppose the idea and "to take legal action, rather than give in to it."[4] By mid-March, photographs of the works had already been taken—Vollard showed a set to Renoir, who admired them very much—and Mary Cassatt was still hoping that the waxes would remain untouched.[5] In early May 1918, the matter was still not resolved. According to a letter of 6 May written by Degas's friend the sculptor Paul Paulin to Paul Lafond immediately following the first atelier sale, "René, the brother, is still disposed toward making an important gift to the State. Bartholomé had some doubts about the intentions of the niece. Bartholomé was entrusted with restoring the sculptures, and asked for carte blanche. Mlle Fevre did not want to give it to him, she didn't even want to hear speak of him. That spoiled things, and there was a question of litigation. . . ."[6]

Three days later, on 9 May 1918, Mary Cassatt informed Mrs. Havemeyer that the sculptures would be cast and that she had a letter from Jeanne Fevre "with the account of how their hands were forced by the press, under the instigation of a sculptor friend of Degas who needs to wrap himself in Degas's genius, not having any of his own."[7] On 25 June she wrote again, adding a postscript to the letter a day later: "Now as to the statue George D.R. [Durand-Ruel] took on himself to write me that the heirs would not sell, but it is not the case they are perfectly willing to sell it to you as a *unique* piece, there has been no objection as to not having it reproduced, the statues are in a place of safety and will not be cast until after the war. The founder advised Mlle Fevre to accept an offer of 100,000 fcs I think 80,000 might be accepted. You will have to think it over, I only wish that I could see it again and especially that you could. The sculpture

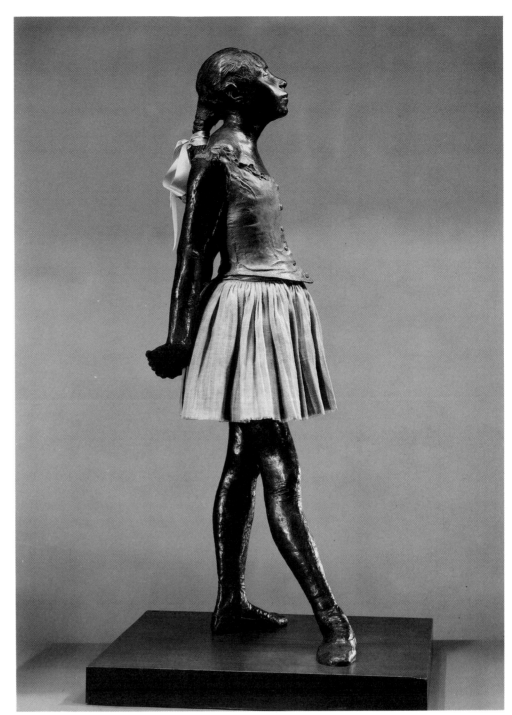

227

has made a great sensation. It is more like Egyptian sculpture."[8]

In the weeks to follow, Vollard was consulted about the purchase, and he thought the price rather high.[9] Then negotiations came to a standstill, to be reopened a year later.

Arrangements for casting the seventy-two Degas sculptures, not including the *Little Dancer*, were apparently made during 1919, when Albino Palazzolo, a highly skilled caster (formerly at Hébrard's) who had cast Rodin's *Thinker*, was called from Italy to undertake the work.[10] To what degree he

rather than Bartholomé was responsible for restoring and preparing the waxes is a question that remains only partially answered.[11] By November 1919, negotiations for the sale of the wax *Little Dancer* were open again, and on 8 December Mary Cassatt wrote to Mrs. Havemeyer: "As to the Degas 'danseuse' Hébrard who is to cast it says it is in perfect condition and only needs cleaning and a new skirt. As to the price it has not yet been fixed but every time it is mentioned it gets dearer. I think casting it will be difficult because the bodice is glued to the statue and this may make it difficult."[12] In another

letter of 8 December with a postscript dated 10 December, Mary Cassatt wrote that the Fevres had finally "decided on the price for the danseuse, 500,000 fcs!" In addition, she noted: "Now they give you a month to get an answer to me, and then if you do not accept the statue will be cast not in bronze but in something as much like the original wax as possible. As a unique thing and in the original it is most interesting, but 25 copies in . . . wax takes away the artistic value in my opinion, they don't think of that. What would Degas have thought of this?"[13]

In May 1921, the wax *Little Dancer* reappeared in public for the first time since Degas exhibited it in 1881.[14] Palazzolo had already taken a mold from it, and while an exhibition of the completed seventy-two bronzes was in progress at Hébrard's, the first bronze cast was already under discussion. On 4 June 1921, Mary Cassatt wrote to Jeanne Fevre: "Before leaving Paris last Thursday I saw the exhibition of your uncle's bronzes. M. Durand said that the large dancer has just been cast and that the result surpassed even M. Hébrard's expectations. He has not yet decided how the skirt will be done—whether it will be in muslin or bronze."[15] With this knowledge in mind, Mrs. Havemeyer abandoned the idea of buying the wax and opened new negotiations for the bronze in the latter part of 1921, when a second bronze was cast. On 6 January 1922, Mary Cassatt, who had still not seen the bronze, wrote again to Jeanne Fevre, telling her that "Mrs. Havemeyer had acquired the first cast of the large dancer and the Durand-Ruels had the second! I have not been able to see the statue enough to judge the reproduction, but I heard from others that it was admirable."[16]

In the casting, the most conspicuously disturbing aspects of the original wax were subdued: the translucent quality of the surface was lost, and the fabric was reduced to the skirt and the hair ribbon—almost always pink rather than the original green. Jeanne Fevre made the ballet skirts worn by some of the bronze *Little Dancers*, and at least one exemplar, that owned by the late Henry McIlhenny (now in the Philadelphia Museum of Art), was sold with a replacement skirt. Nevertheless, the careful patina duplicated with considerable effect the hue of the wax, the bodice, and the slippers.

The exact number of bronze casts of the *Little Dancer* issued by Hébrard is unknown, but it has been generally assumed, as in the case of the other bronzes, that the edition was intended to number twenty-two: twenty for sale, one for Hébrard, and one for the Degas heirs. However, as Mary Cassatt mentioned in a letter of December 1918 and another to Durand-Ruel in January 1920,

twenty-five casts were proposed.[17] Some two decades ago, not long after the rediscovery of the original waxes in storage at Hébrard's, two previously unknown plaster casts of the *Little Dancer*, patinated in imitation of the original wax, were also uncovered. Even more recently, another set of bronzes, marked MODÈLE and containing yet another exemplar of the *Little Dancer*, was found in storage at Hébrard's. That set, now in the Norton Simon Museum, Pasadena, is generally closest to the original waxes and, indeed, most of the individual pieces retain the defects of armature—not visible in the *Little Dancer*—still apparent in the waxes but corrected in the edition of bronzes issued by Hébrard for sale. The Pasadena bronzes clearly served in Hébrard's foundry as the model for the patina used in the other bronzes as they were issued over the years.[18] The two plaster exemplars, which remain understudied, are now in the Mellon collection and in the Joslyn Art Museum, Omaha. Exactly where they fit in the sequence of casts remains unclear.

1. François Thiébault-Sisson, "À propos d'une exposition: Degas, ou l'homme qui sait," *Le Temps*, 19 April 1924.
2. Lafond 1918–19, II, p. 66.
3. Millard 1976, p. 32 n. 29.
4. Letter from Mary Cassatt, Grasse, 9 February 1918, to Paul Durand-Ruel, cited in Venturi 1939, II, p. 136.
5. One of the photographs (fig. 160), published in Lemoisne 1919, p. 112, shows the fissure around the left arm.
6. Letter from Paul Paulin to Paul Lafond, 6 May 1918, published in Sutton and Adhémar 1987, p. 180.
7. Unpublished letter from Mary Cassatt, Grasse, 9 May 1918, to Louisine Havemeyer, Archives, The Metropolitan Museum of Art, New York.
8. Unpublished letter from Mary Cassatt, Grasse, 25 June 1918, to Louisine Havemeyer, Archives, The Metropolitan Museum of Art, New York.
9. Unpublished letter from Mary Cassatt, Grasse, 4 August 1918, to Louisine Havemeyer, Archives, The Metropolitan Museum of Art, New York.
10. Millard 1976, p. 31 n. 27.
11. Correspondence suggests that Bartholomé had something to do with the waxes, though he did not prepare them for casting; that task was undertaken by Palazzolo. For Palazzolo's role, see Jean Adhémar, "Before the Degas Bronzes," *Art News*, 54:7, November 1955, pp. 34–35, 70. For a thorough discussion of the entire question, see Millard 1976, pp. 30–31 nn. 23–28.
12. Unpublished letter from Mary Cassatt, Paris, 8 December 1919, to Louisine Havemeyer, Archives, The Metropolitan Museum of Art, New York. It is curious that in an undated telegram preserved in an envelope with letters dated 14 November 1919 and 8 December 1919, Mary Cassatt informed Mrs. Havemeyer: "Statue Bad Condition" (Archives, The Metropolitan Museum of Art, New York).
13. Unpublished letter from Mary Cassatt, Paris, 8 December 1919, to Louisine Havemeyer, Archives, The Metropolitan Museum of Art, New York.
14. See Thiébault-Sisson, op. cit., where it is stated that the wax was exhibited at the Orangerie and, hence, not at Hébrard's, as is usually believed.

15. Unpublished letter from Mary Cassatt, Mesnil-Beaufresne, 4 June [1921], to Jeanne Fevre, Brame archives, Paris. The year of the letter can be inferred from the reference to the exhibition held by Hébrard in May–June 1921. In the same letter, Mary Cassatt refers to Hébrard's project of casting a set of Degas sculptures in terra-cotta to be given to the Musée du Petit Palais. No such set is known to exist.
16. Unpublished letter from Mary Cassatt, Grasse, 6 January [1922], to Jeanne Fevre, Brame archives, Paris. The year of the letter can be established with the help of letters in the same collection dating from 23 December [1921] and 21 January [1922], all of which discuss the forthcoming Degas exhibition due to open in New York on 26 January—actually held at the Grolier Club 26 January–28 February 1922.
17. Cited in Venturi 1939, II, p. 138.
18. Palazzolo remembered that the casting of all the sets of bronzes was completed only in about 1932. See Jean Adhémar, "Before the Degas Bronzes," *Art News*, 54:7, November 1955, p. 70.

SELECTED REFERENCES: Goetschy 1880, p. 2; Henry Havard, "L'exposition des artistes indépendants," *Le Siècle*, 3 April 1881, p. 2; Gustave Goetschy, "Exposition des artistes indépendants," *La Justice*, 4 April 1881, p. 3, and *Le Voltaire*, 5 April 1881, p. 2; Auguste Daligny, "Les indépendants: sixième exposition," *Le Journal des Arts*, 8 April 1881, p. 1; Jules Claretie, "La vie à Paris: les artistes indépendants," *Le Temps*, 5 April 1881, p. 3; C. E. [Charles Ephrussi], "Exposition des artistes indépendants," *La Chronique des Arts et de la Curiosité*, 16 April 1881, pp. 126–27; Élie de Mont, "L'exposition du Boulevard des Capucines," *La Civilisation*, 21 April 1881, pp. 1–2; Bertall [Charles-Albert d'Arnoux], "Exposition des peintres intransigeants et nihilistes," *Paris-Journal*, 22 April 1881, pp. 1–2; Paul de Charry, "Les indépendants," *Le Pays*, 22 April 1881, p. 3; Mantz 1881, p. 3; Villard 1881, p. 2; Henry Trianon, "Sixième exposition de peinture par un groupe d'artistes," *Le Constitutionnel*, 24 April 1881, pp. 2–3; Claretie 1881, pp. 150–51; Comtesse Louise, "Lettres familières sur l'art," *La France Nouvelle*, 1–2 May 1881, pp. 2–3; [Charles Whibley?], "Modern Men: Degas," *National Observer*, 31 October 1891, pp. 603–04 (reprinted in Flint 1984, pp. 277–78); Paul Gsell, "Edgar Degas, statuaire," *La Renaissance de l'Art Français*, I, December 1918, pp. 374, 376 (erroneously as exhibited in 1884), repr. p. 375 (original wax); Lafond 1918–19, II, pp. 64–66; Lemoisne 1919, pp. 111–13, repr. p. 112; Blanche 1919, p. 54; Thiébault-Sisson 1921; Meier-Graefe 1923, p. 60 (erroneously as exhibited in 1874); Bazin 1931, figs. 70 p. 294, 71 (detail) p. 295; Rewald 1944, no. XX, repr. pp. 60–61, 68–69 (details), pp. 63–65 (bronze cast, The Metropolitan Museum of Art, New York), 66 (original wax); Rewald 1956, no. XX, plates 24–29 (unidentified bronze cast); Havemeyer 1961, pp. 254–55; Millard 1976, pp. 8–9, 27–29, 119–26, passim, pl. (color) facing p. 62 (original wax); Reff 1976, pp. 239–48, figs. 157 (color), 162 (detail) (bronze cast, The Metropolitan Museum of Art, New York); 1979 Edinburgh, no. 78, repr. (bronze cast, Robert and Lisa Sainsbury collection, University of East Anglia, Norwich); McMullen 1984, pp. 327, 329, 333–36, 338–40, 343–44, 347; Lois Relin, "La 'Danseuse de quatorze ans' de Degas son tutu et sa perruque," *Gazette des Beaux-Arts*, CIV:1390, November 1984, pp. 173–74, fig. 1 (original wax); 1984–85 Paris, fig. 155 p. 180 (color, bronze cast, Musée d'Orsay, Paris), fig. 157 p. 183 (color, plaster cast, Joslyn Art Museum, Omaha); 1984–85 Washington, D.C., pp. 65–83, no. 18, repr. (color) p. 64 (original wax), p. 134 (bronze cast HER-D, Virginia Museum of Fine Arts, Richmond).

1986 Florence, pp. 57–61, no. 73, repr. (color, bronze cast, Museu de Arte, São Paulo); Sutton 1986, p. 187, pl. 169 p. 186 (bronze cast, Norton Simon Museum, Pasadena); Weitzenhoffer 1986, pp. 242–43, 256, pl. 166 (color, bronze cast, The Metropolitan Museum of Art, New York); 1987 Manchester, pp. 80–86, no. 72, fig. 110 (bronze cast, Robert and Lisa Sainsbury collection, University of East Anglia, Norwich).

A. *Orsay cast*
Musée d'Orsay, Paris (RF2132)

Exhibited in Paris

PROVENANCE: Acquired thanks to the generosity of the heirs of the artist and of the Hébrard family 1930; entered the Louvre 1931.

EXHIBITIONS: 1931 Paris, Orangerie, no. 73 of sculptures; 1969 Paris, no. 242; 1986 Paris, no. 87, repr.

B. *Metropolitan cast*
The Metropolitan Museum of Art, New York.
 Bequest of Mrs. H. O. Havemeyer, 1929.
 H. O. Havemeyer Collection (29.100.370)

Exhibited in Ottawa and New York

PROVENANCE: Bought from A.-A. Hébrard by Mrs. H. O. Havemeyer, New York, 1922; her bequest to the museum 1929.

EXHIBITIONS: 1977 New York, no. 10 of sculptures; 1981, Indianapolis Museum of Art, 22 February–29 April, *The Romantics to Rodin*, no. 105, repr.

228.

Dancer Leaving Her Dressing Room

c. 1879
Pastel and gouache on wove paper, with strip of laid paper added at top
20⅜ × 11⅞ in. (52 × 30 cm)
Signed lower left: Degas
Private collection

Lemoisne 644

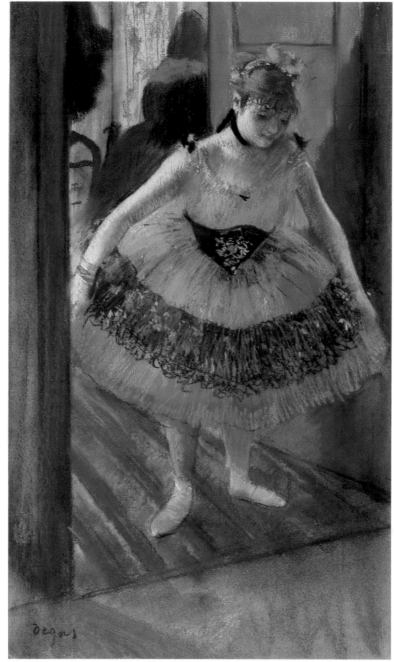

228

There are relatively few works by Degas on the theme of the dancer in her dressing room preparing to go on stage, each apparently dating from the late 1870s. In a very fine etching (RS50) of c. 1879–80—another known version of which was enhanced with pastel (BR97, private collection, New York)—as well as in a pastel (fig. 116), the dancer is shown in front of a mirror, arranging her hair. Two other pastels include a dresser putting the last touches on the dancer's costume in the presence of a third person, the dancer's protector. In one of these (fig. 163), the action takes place in the foreground, whereas in the other (L529, Oskar Reinhart Collection, Winterthur), exhibited by Degas in the spring of 1879, the ballerina is seen in the distance through a half-open door.

According to Lillian Browse, *Dancer Leaving Her Dressing Room*, another variation on the same theme, depicts a dancer looking at herself in the mirror.[1] However, it quite obviously represents a dancer who, having completed her toilette, is about to leave her dressing room and pauses indecisively at the door, as though either to gather up her skirt before crossing the threshold or to cast one last glance at her costume. The refined interaction of lines and the ambiguities present in the composition, no doubt the reason for Browse's interpretation, are explained in part by the lighting. Emanating from an invisible source inside the dressing room, a soft light bathes the scene and outlines the body of the dancer, ashen by contrast in the gaslight. In the foreground, the

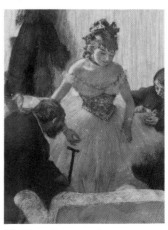

Fig. 163. *Dancer in Her Dressing Room* (L497), c. 1880. Pastel, 23¼ × 17¾ in. (59 × 45 cm). Private collection

diagonal shadow of the left wall repeats the bottom edge of the door, while the contour of the dancer's shadow on the right takes on the form of the dresser in black in the background. This interplay is also pursued in the colors, more limited in range than one might first believe. The blue green of the dancer's skirt is picked up in the more muted and subtle coloring of the shadows, the orange ochre of the door reappears in the floral ornaments, and the red spangles on the skirt echo the only garish element, the scarf wrapped around the dresser's neck. An area reworked in black pastel above the dancer's right shoulder, in which Browse believed she detected a third person, may in fact conceal an initial attempt at the silhouette of a male figure.[2]

The pastel, at one time in Henri Rouart's collection, was one of the fifteen works by Degas reproduced in lithographic form by George William Thornley in 1888–89. Lemoisne dated it c. 1881.[3] Browse suggested a slightly earlier date, c. 1878–79.[4] The fact that the pastel was purchased without the involvement of Durand-Ruel would suggest that it was acquired by Rouart before Durand-Ruel resumed relations with Degas at the end of 1880.

1. Browse [1949], no. 62.
2. Ibid.
3. Lemoisne [1946–49], II, no. 644.
4. Browse [1949], no. 62.

PROVENANCE: Acquired by Henri Rouart probably before December 1880 (Rouart sale, Galerie Manzi-Joyant, Paris, 16–18 December 1912, no. 73, as "Danseuse sortant de sa loge," bought in by the Rouart family, for Fr 31,000); Ernest Rouart, son of Henri Rouart, Paris; Mme Eugène Marin (née Hélène Rouart), sister of Ernest Rouart, Paris. With Arthur Tooth and Sons, Ltd., London, 1939. With M. Knoedler and Co., New York; acquired by Edward G. Robinson, Beverly Hills, before 1941; Gladys Lloyd Robinson and Edward G. Robinson, until 1957; acquired in 1957 through M. Knoedler and Co. by Stavros Niarchos, Paris; private collection.

EXHIBITIONS: 1939, London, Arthur Tooth and Sons, Ltd., 8 June–1 July, "La Probité de l'Art," Drawings, Pastels and Watercolours, no. 52; 1941, Los Angeles County Museum of Art, July–1 August, Collection of Mr. and Mrs. Edward G. Robinson, no. 9; 1953, New York, Museum of Modern Art, March–14 April/ Washington, D.C., National Gallery of Art, 10 May–14 June, Forty Paintings from the Edward G. Robinson Collection, no. 9; 1956–57, Los Angeles County Museum of Art, 11 September–11 November/San Francisco, California Palace of the Legion of Honor, 30 November 1956– 13 January 1957, The Gladys Lloyd Robinson and Edward G. Robinson Collection, no. 12; 1957–58, New York, Knoedler Gallery, 3 December 1957–18 January 1958/Ottawa, National Gallery of Canada, 5 February–2 March/Boston, Museum of Fine Arts, 15 March–20 April, The Niarchos Collection, no. 11, repr.; 1958, London, Tate Gallery, 23 May–29 June, The Niarchos Collection, no. 12, repr.; 1959, Kunsthaus Zurich, 15 January–1 March, Sammlung S. Niarchos, no. 12.

SELECTED REFERENCES: Thornley 1889; Alexandre 1912, p. 28, repr. p. 23; Charles Louis Borgmeyer,

The Master Impressionists, Chicago: The Fine Arts Press, 1913, repr. p. 81; Dell 1913, p. 295; Frantz 1913, p. 185; Lemoisne [1946–49], II, no. 644 (as "Danseuse sortant de sa loge," c. 1881); Browse [1949], no. 62 (as "La loge de danseuse," c. 1878–79); Minervino 1974, no. 774.

229.

The Green Dancer (Dancers on the Stage)

c. 1880
Pastel and gouache on heavy wove paper
26 × 14¼ in. (66 × 36 cm)
Signed in black chalk lower left: Degas
Thyssen-Bornemisza Collection, Lugano, Switzerland

Lemoisne 572

As Eunice Lipton has pointed out, both in this work and in Dancer with a Bouquet Bowing (cat. no. 162), there is a dichotomy between the foreground of the composition (the performance seen by the audience) and the background of dancers in offstage poses visible only from the wings.[1] Yet there is a pronounced difference between the two pastels. Here the downward-plunging view is intended to suggest a view from a box near the proscenium arch, an angle of sight the artist had experimented with in less mystifying fashion as early as 1876–77 in Ballet (The Star) (cat. no. 163).

The dramatic possibilities of such a view were fully exploited, nevertheless, only in this pastel. In the background, behind stage flats, dancers in orange and red are restlessly waiting for their cue to come on stage but are contained within a rigorous horizontal frieze. In the foreground, a fragment of the performance is visible—a frantic rush of dancers in green thrown along a steep diagonal and suggesting a good deal more than is shown. In the center, a ballerina in arabesque flings her limbs wildly at improbable

angles; next to her is the leg of another dancer, the rest of her body left to the imagination; and in the lower foreground, a costume, without a body, disappears from the field of vision in a flutter of gauze and sequins. This is Degas's most flamboyant interpretation of movement on the stage, as well as his most challenging attempt at projecting the viewer into the midst of a performance.

The evolution of the composition can be traced to The Star and the variations on it that were executed probably about 1877. The earliest of these, a gouache or distemper Dancer Bowing (L490, Rothschild collection, Paris) was conceived like The Star but differs in the pose of the dancer, who performs an arabesque with a bouquet in her right hand. The dancer was prepared with some care in three studies—one for the entire figure (IV:281), one for the head with part of the left arm (IV:283.b), and one for the upper part of the body on a sheet containing other studies of dancers as well (IV:269).

The pose must have fascinated Degas, because he followed it up in another series of studies in which the dancer remains essentially the same but with her head shown in different positions. A separate study of the head in three positions (fig. 164), now in the Louvre, appears to have served in the preparation of the drawings. The first of these was probably a drawing, also in the Louvre (fig. 165), showing the dancer with her head turned toward the left. There are various revisions to the figure, indicating considerable search for the right movement, and in the margins are two additional studies of the right arm as well as one of the head, shown in a more pronounced profile view that corresponds to one of the heads in the other Louvre sheet. The drawing was followed by a study of the dancer looking down (III:276), used for Arabesque (L418, Musée d'Orsay), and yet another with the dancer looking to the right (III:182).

The Green Dancer was prepared with the aid of two of the sheets from this stock of

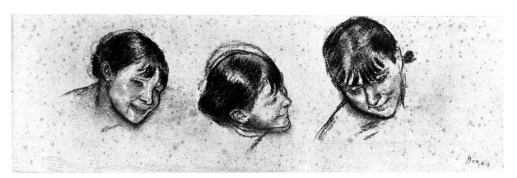

Fig. 164. Three Studies of a Dancer's Head (L593), c. 1879–80. Pastel, 7⅛ × 22⅜ in. (18 × 56.8 cm). Cabinet des Dessins, Musée du Louvre (Orsay), Paris (RF4037)

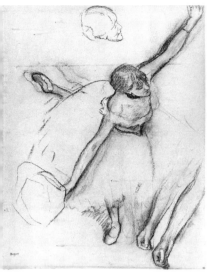

Fig. 165. *Dancer with a Bouquet* (III:398), c. 1879–80. Charcoal with white highlights, 24 × 18⅛ in. (60.9 × 46.1 cm). Cabinet des Dessins, Musée du Louvre (Orsay), Paris (RF4649)

drawings—the Louvre's dancer (fig. 165) and one of the studies (IV:269) connected with the Rothschild *Dancer Bowing*. The latter contained a clearer description of the dancer's left arm as well as a figure used for the dancer in the left background of the Thyssen pastel.

The work has been dated 1877–79 by Götz Adriani, c. 1879 by Lemoisne and Denys Sutton, and as late as 1884–88 by Lillian Browse. The appearance among the background dancers of a figure with her left hand on her shoulder, clearly adapted from a study of Marie van Goethem (fig. 239) used for *The Singer in Green* (cat. no. 263), places the pastel in the period in which Degas worked on *The Little Fourteen-Year-Old Dancer* (cat. no. 227), probably about 1880.

The pastel appears to have been much admired in the 1880s, and Max Klinger wrote enthusiastically about it in 1883.[2] Douglas Cooper and Ronald Pickvance have noted that *The Green Dancer* belonged to Walter Sickert and was exhibited twice in England—in 1888 and 1898. Pickvance, who has cited some of the reviews of 1888, has suggested that in the later 1890s the pastel changed hands and became the property of Ellen Sickert's sister, Mrs. Fisher-Unwin, whose name appears as the lender to the exhibition of 1898.[3] However, Ellen Sickert is recorded in the Durand-Ruel archives as the owner in 1902, and it is possible that Mrs. Fisher-Unwin simply handled the loan of the work on behalf of her sister.

1. Lipton 1986, pp. 95–96.
2. See Max Klinger in *Von Courbet bis Cézanne: Französische Malerei 1848–1886* (exhibition catalogue), Berlin (G.D.R.): Nationalgalerie, 1982, p. 146.
3. 1979 Edinburgh, no. 29.

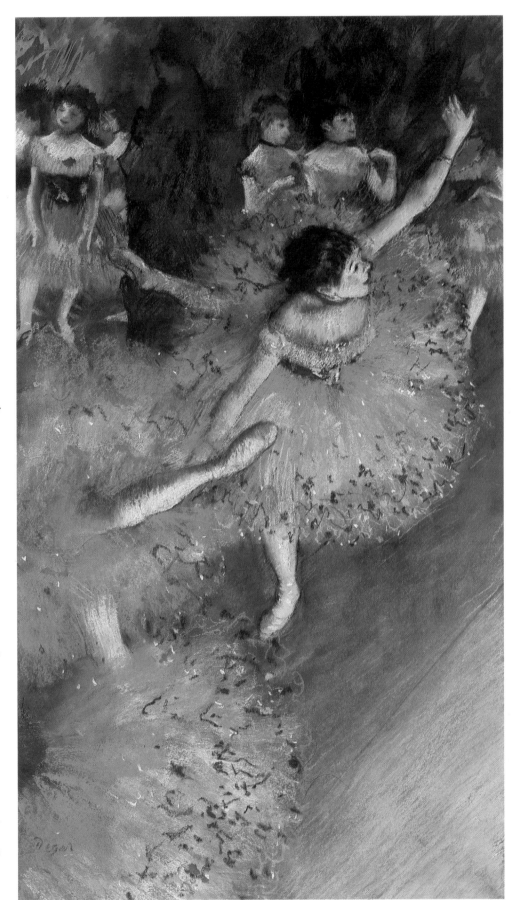

229

PROVENANCE: Walter Sickert, London; given to his second wife, Ellen Cobden-Sickert, London; left in care of her sister, Mrs. T. Fisher-Unwin, London, by summer 1898; bought from Mrs. Cobden-Sickert by Durand-Ruel, Paris, 5 March 1902, for Fr 20,084.55 (stock no. 7005, as "Danseuse verte"); sold to Lucien Sauphar, Paris, 24 April 1902, for Fr 30,000. With Bernheim-Jeune et Cie, Paris; bought by Durand-Ruel, Paris, 2 May 1908, for Fr 20,000 (stock no. 8658); bought by Charles Barret-Decap, Paris, 13 June 1908, for Fr 25,000; Reid and Lefevre Gallery, London, by 1928; William A. Cargill, Bridge of Weir (Cargill sale, Sotheby's, London, 11 June 1963, no. 15, repr.); bought by Arthur Tooth and Sons, Ltd., London; Norton Simon, Pasadena (Simon sale, Sotheby Parke Bernet, New York, 6 May 1971, no. 30, repr.). Baron Heinrich Thyssen-Bornemisza, Lugano.

EXHIBITIONS: 1888, London, New English Art Club, Spring Exhibition, no. 18 (as "Danseuse verte"); 1898 London, no. 144, repr. (as "Dancers"), lent by Mrs. Unwin; 1903, Paris, Bernheim-Jeune et Fils, April, Exposition d'oeuvres de l'école impressionniste, no. 15 (as "Danseuses vertes"), lent by Lucien Sauphar; 1928, Glasgow/London, Alex. Reid and Lefevre Ltd., Works by Degas, no. 6, repr.; 1976–77 Tokyo, no. 28, repr.; 1979 Edinburgh, no. 29, pl. 5; 1984 Tübingen, no. 107, repr. (color); 1984–86, Tokyo, The National Museum of Modern Art, 9 May–8 July/Kumamoto Prefectural Museum, 20 July–26 August/London, Royal Academy of Arts, 12 October–19 December/Nuremberg, Germanisches Nationalmuseum, 27 January–24 March 1985/Düsseldorf, Städtische Kunsthalle, 20 April–16 June/Florence, Palazzo Pitti, 5 July–29 September/Paris, Musée d'Art Moderne de la Ville de Paris, 23 October 1985–5 January 1986/Madrid, Biblioteca Nacional, 10 February–6 April/Barcelona, Palacio de la Vierreina, 7 May–17 August, Modern Masters from the Thyssen-Bornemisza Collection, no. 8, repr. (color).

SELECTED REFERENCES: Moore 1907–08, repr. p. 150; Albert André, Degas: pastels et dessins, Paris: Braun, 1934, pl. 19; Lemoisne [1946–49], II, no. 572 (as c. 1879); Browse [1949], no. 168 (as c. 1884–86); Cooper 1954, p. 62; Ronald Pickvance, "A Newly Discovered Drawing by Degas of George Moore," Burlington Magazine, CV:723, June 1963, p. 280 n. 31; Minervino 1974, no. 731; Reff 1976, p. 178, pl. 125 (as c. 1879); Thomson 1979, p. 677, pl. 96; Lipton 1986, pp. 95–96, 105, 109, 115, fig. 59 pp. 96, 109; Sutton 1986, pl. 179, p. 172 (color) p. 189 (as 1879).

230.

At the Ballet

c. 1880–81
Pastel on paper
21⅝ × 18⅞ in. (55 × 48 cm)
Signed lower right: Degas
Private collection, France

Withdrawn from exhibition

Lemoisne 577

Nowhere in the formal expression of Degas's ideas are his departures from convention more evident than in his handling of foregrounds. These always convey a sense of immediacy, or of the unexpected, and invariably place the viewer in relation to the subject. It might be argued that this formal question exerted an almost tyrannical hold on Degas, but the results of his experiments are never less than provocative. The origins of this pastel can be traced to one such experiment, a pastel in the Rhode Island School of Design (fig. 137), generally dated about 1878, in which Degas added by rather elaborate means a woman holding a fan in the foreground of a ballet scene. The formula was used again in a lithograph (RS37) but was developed only later, probably about 1880.

The immediate forerunner of At the Ballet is a charcoal-and-pastel study (fig. 166) of a woman in a box at the Opéra holding a fan and opera glasses. She is seen from above her left shoulder as though the viewer were standing next to her, Richard Thomson has noted.[1] The drawing is in effect a giant foreground, with a small opening at the upper left corner showing lightly sketched dancers performing on the stage. This extreme if compelling solution to the compositional experiment was amended in At the Ballet, where only the woman's hands are retained, the balustrade of the loge is lowered, and the ballet on the stage is given a larger share of the composition. The effect of the hands divested of a body is even more powerful, particularly that of the flexed right hand as it emerges from behind the speckled red-and-blue feather fan. The dancers, seen from the stage box, were composed with the aid of two large drawings that are sometimes connected with those posed for by Marie van Goethem (fig. 167; L579). It has been said that an interest in photography may have been responsible for the very specific sensibility expressed in this pastel, but it is difficult to imagine photography of the period being even remotely as ingenious.[2]

Datable about 1880–81, At the Ballet was followed by two other variations on the subject prepared with the aid of alternative studies of the hand holding the opera glasses

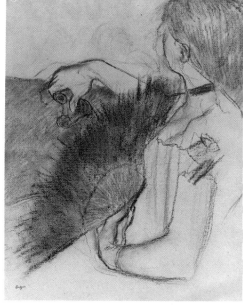

Fig. 166. At the Theater, Woman with a Fan (L580) c. 1880. Charcoal and pastel, 28⅜ × 18⅞ in. (72 × 48 cm). Private collection

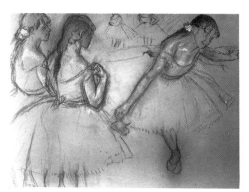

Fig. 167. Dancers on the Stage (L578), c. 1880. Charcoal and pastel, 18⅛ × 23⅝ in. (46 × 60 cm). Location unknown

(IV:134.a, Bern; IV:134.b). One, in the Johnson Collection at the Philadelphia Museum of Art (L828), includes the profile of the woman. The other (L829, Armand Hammer collection) is of more eccentric design. It reveals the figure more completely and implies the presence of a second woman, invisible except for a hand holding opera glasses.

1. 1987 Manchester, p. 77.
2. For the link with photography, see La douce France/Det ljuva Frankrike (exhibition catalogue), Stockholm: Nationalmuseum, 1964, no. 29.

PROVENANCE: Una, 39 avenue de l'Opéra, Paris; bought by Durand-Ruel, Paris, 13 December 1892, for Fr 3,000 (stock no. 2533, as "Au théâtre"); deposited with Charles Destrée, Hamburg, 15 December 1892; returned to Durand-Ruel, Paris, 7 January 1893; private collection of Joseph Durand-Ruel, Paris; private collection.

EXHIBITIONS: 1905 London, no. 55; 1913, São Paulo, Exposition d'art français de São Paulo, no. 914; 1925, Paris, Galerie Rosenberg, 15 January–7 February, Les grandes influences au XIX siècle d'Ingres à Cézanne,

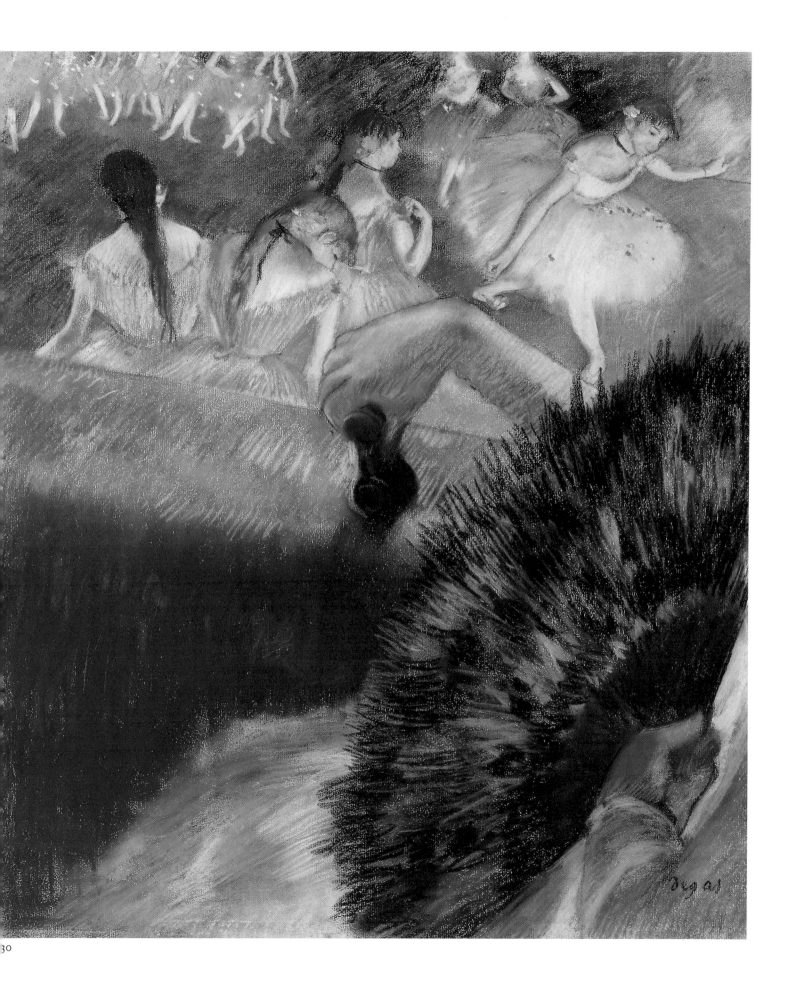

no. 15; 1939–40 Buenos Aires, no. 43; 1940–41 San Francisco, no. 33, repr.; 1943, New York, Durand-Ruel Galleries, 1–31 March, *Pastels by Degas*, no. 1; 1947, New York, Durand-Ruel Galleries, 10–29 November, *Degas*, no. 14; 1964, Stockholm, Nationalmuseum, 7 August–11 October, *La douce France/Det ljuva Frankrike, Mästarmålingar från tre sekler ur collections Wildenstein, Durand-Ruel, Bernheim-Jeune*, no. 29, repr.

SELECTED REFERENCES: Lafond 1918–19, II, repr. before p. 37; Lemoisne [1946–49], II, no. 577 (as 1880); Minervino 1974, no. 765; 1984 Tübingen, under no. 159; 1984–85 Boston, under no. 37; Boggs 1985, pp. 15–16, fig. 8; 1987 Manchester, p. 77, fig. 103.

231.

The Apple Pickers

1881–82
Bronze
17¾ × 18¾ in. (45.1 × 47.6 cm)
Original: red wax on wood. National Gallery of Art, Washington, D.C. Collection of Mr. and Mrs. Paul Mellon

Rewald I

Despite its unique status as the only surviving relief by Degas, this work attracted little attention until relatively recently. In the 1970s, Theodore Reff and Charles Millard discussed the work in the context of a larger, now lost, clay relief known only from a somewhat inaccurate account given by Bartholomé to Lemoisne shortly after Degas's death. According to Lemoisne, Bartholomé remembered "having seen him make, very early in his career, before 1870, a large bas-relief in clay, absolutely charming, representing, half life-size, young girls picking apples. But the artist did nothing to preserve his work, which later on literally crumbled to dust."[1] Independently from Lemoisne, Vollard reported Renoir as having said, "Why, Degas is the greatest living sculptor! You should have seen a bas-relief of his . . . he just let it crumble to pieces . . . it was as beautiful as an antique."[2]

A connection between this work and the lost relief was established as early as 1921 when the founder Hébrard, probably at Bartholomé's instigation, named the bronze "La cueillette des pommes" (The Apple Picker).[3] In 1944, when John Rewald catalogued the wax relief, he placed it earliest in the sequence of sculptures by Degas and, following Bartholomé's account, dated it c. 1865, though he concluded it was probably "a replica on a smaller scale" of the lost work.[4] Subsequently, Michèle Beaulieu also cited Bartholomé as a reason for dating it before 1870, but considered the possibility that the wax relief may have been a sketch for the larger work.[5]

In 1970, in the first extensive discussion of the subject, Theodore Reff redated the lost relief 1881.[6] He demonstrated that the artist had used as one of his models his cousin Lucie Degas, who visited France in 1881, and linked the work to drawings and to notes, measurements, and sketches in Degas's notebooks of the period (see fig. 168).[7] Furthermore, he proposed that several studies of a young boy climbing a tree are connected to a figure which, though absent from the wax relief, may have appeared in the larger work. Reff's interpretation was further developed by Charles Millard, who followed his suggestions for a hypothetical reconstruction of the lost relief more consistent with Bartholomé's description. Noting that the subject of the wax version was "sufficiently unclear to make it doubtful that anyone seeing it would think of children picking apples," he concluded that it was executed several years after the clay relief, certainly not before 1890, as a record of the lost work, but that it incorporated only some of the features of the original. In addition, he speculated that the wax relief may have been altered at some point by the replacement of a section at the far left.

A hitherto unnoticed contemporary account of the relief, perhaps the large version, appears in an undated letter from Jacques-Émile Blanche to an unnamed friend, probably Henri Fantin-Latour, written on 8 December 1881, immediately after a visit to Degas's studio: "I had just returned from the exhibition of the Courbet sale, where I met Degas. He told me he found it difficult to leave those pictures, which are, nonetheless, a rebuke to his own art, which he has spent his life perfecting and distilling. . . . He then talked on brilliantly for a while, after which he led me into his studio, where he showed me a new sculpture he had made. In it, a young girl, half reclining in a coffin, is eating fruit. To one side is a mourner's bench for the child's family—for this is a tomb."[8]

From the description there can scarcely be any doubt that the relief was conceived as a funerary decoration rather than a rural genre piece, and it may be inferred that it was incomplete when Blanche saw it, containing only the central figure sitting on (rather than in) the sarcophagus and the bench to the right, apparently without the seated girls. The work may have been connected with the recent death of Marie Fevre, the daughter of the artist's sister Marguerite, noted in a letter written by Thérèse Morbilli a day after her arrival in Paris with Lucie Degas in June 1881.[9] One of Degas's notebooks contains notes on the artist's family tomb at the Montmartre cemetery that might have been made in connection with the project.[10]

Another notebook contains, along with studies Reff has associated with the relief, the curious proposal to carry out "in aquatint a series on *mourning* (different blacks, black veils of deep mourning floating about the face, black gloves, mourning carriages, equipment and paraphernalia of undertaking establishments, coaches similar to Venetian gondolas)."[11]

Given its proposed destination, the composition is a very odd one, with its stress on life continuing joyfully around the grave of a dead girl. In that context, one may perhaps explain it as symbolic of the concept of resurrection, with the girl eating fruit a personification of the deceased Marie Fevre. It is known that around the time Degas worked on the relief, he was interested in obtaining photographs of sculpture by Andrea and Luca della Robbia—the medallions from the Ospedale degli Innocenti, and the Cantoria in the Opera dell'Duomo, Florence.[12] Yet, except for the format, superficially like a panel from the Cantoria, there is little in Degas's relief to connect it to such precedents. Rather, it appears to continue into modern times the spirit of the Etruscan funerary sculpture Degas studied and drew at the Louvre.

1. Lemoisne 1919, p. 110.
2. Ambroise Vollard, *Renoir: An Intimate Record*, New York: A. A. Knopf, 1925, p. 87.
3. A.-A. Hébrard, *Exposition des sculptures de Degas*, 1919, no. 72.
4. Rewald 1944, no. 1.

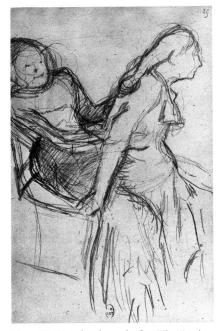

Fig. 168. Notebook study for *The Apple Pickers*, 1881. Pencil, 6½ × 4¼ in. (16.4 × 10.7 cm). Bibliothèque Nationale, Paris, Dc327d, Carnet 2, p. 25 (Reff 1985, Notebook 34)

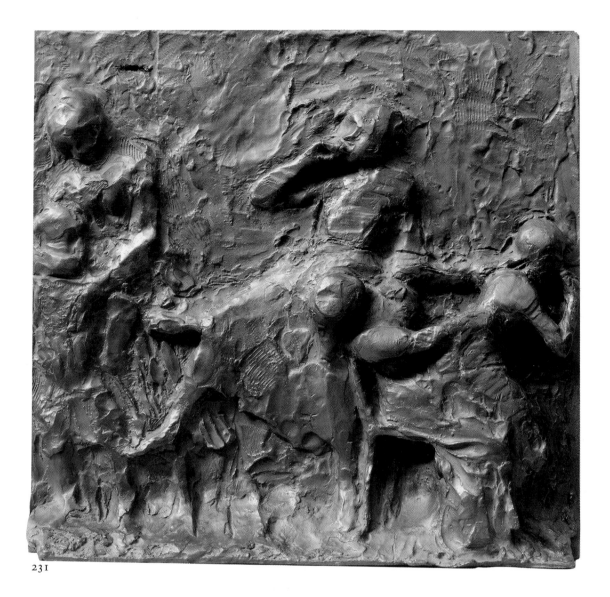

231

5. Beaulieu 1969, p. 369.
6. Theodore Reff, "Degas' Sculpture, 1880–1884," *Art Quarterly*, XXXIII:3, Autumn 1970, pp. 278–88; Reff 1976, pp. 249–56.
7. For related drawings (all cited in Reff 1976, pp. 251–54), see Reff 1985, Notebook 30 (BN, Carnet 9, pp. 212–13, 190, 186, 184), Notebook 34 (BN, Carnet 2, pp. 15, 21, 25, 29, 37, 43, 45); IV:156; and BR100, which—as pointed out by Reff—may be connected to an unexecuted painting.
8. Unpublished letter, Archives, Musée du Louvre, Paris. It is dated only "Thursday evening," but can be dated 8 December 1881 because of the reference to the exhibition of the first Courbet sale, which took place that day.
9. Undated letter from Thérèse Morbilli, Paris, to Edmondo Morbilli, Naples [June 1881], published in part in Boggs 1963, p. 276. Because of a reference to the sale of a painting for Fr 5,000, most likely *The Dance Class* (cat. no. 219), delivered at that price to Durand-Ruel on 18 June 1881, the letter can be dated 19 June 1881. It says: "We arrived yesterday morning. . . . Marguerite . . . is extremely unhappy over the death of her Marie."

Simone Célestine Marguerite Marie Fevre, an unrecorded child, died at age five and was buried on 29 November 1880 in the Degas family tomb; archives, Montmartre cemetery.

10. Reff 1985, Notebook 32 (BN, Carnet 5, p. 4).
11. Reff 1985, Notebook 30 (BN, Carnet 9, p. 206).
12. For Degas's notes on the photographs, see Reff 1985, Notebook 34 (BN, Carnet 2, p. 6).

SELECTED REFERENCES: Rewald 1944, no. I, repr. p. 33 (bronze cast A/37, The Metropolitan Museum of Art, New York, as 1865–81); Rewald 1956, pp. 14, 141, no. I, pl. 1 (unidentified bronze cast, as 1865–81); Beaulieu 1969, p. 369 (as before 1870); Minervino 1974, no. S72; Millard 1976, pp. 4, 15–18, 24, 65–66, 81–82, 90–92, fig. 38 (bronze cast A/37, The Metropolitan Museum of Art, New York, as c. 1881–82/83); Reff 1976, pp. 249–56, fig. 163 p. 249 (bronze cast A/37, The Metropolitan Museum of Art, New York, as 1881); Reff 1985, Notebook 30 (BN, Carnet 9, pp. 212–13, 190, 186, 184), Notebook 34 (BN, Carnet 2, pp. 1, 15, 21, 25, 29, 223); 1986 Florence, no. 37, repr. (bronze cast S/37, Museu de Arte, São Paulo).

A. *Orsay Set P, no. 37*
Musée d'Orsay, Paris (RF2136)

Exhibited in Paris

PROVENANCE: Acquired thanks to the generosity of the heirs of the artist and of the Hébrard family 1930; entered the Louvre 1931.

EXHIBITIONS: 1931 Paris, Orangerie, no. 72 of sculptures; 1969 Paris, no. 225; 1984–85 Paris, no. 80, p. 207, fig. 205 p. 203.

B. *Metropolitan Set A, no. 37*
The Metropolitan Museum of Art, New York.
 Bequest of Mrs. H. O. Havemeyer, 1929.
 H. O. Havemeyer Collection (29.100.422)

Exhibited in Ottawa and New York

PROVENANCE: Bought from A.-A. Hébrard by Mrs. H. O. Havemeyer 1921; her bequest to the museum 1929.

EXHIBITIONS: 1922 New York, no. 28 of bronzes; 1977 New York, no. 11 of sculptures.

III
1881–1890

Gary Tinterow

Fig. 169. Barnes (Dieppe)?, *Edgar Degas*, c. 1885. Photograph, modern print from a glass negative in the Bibliothèque Nationale, Paris

The 1880s: Synthesis and Change

The author wishes to thank Anne M. P. Norton, Susan Alyson Stein, and Guy Bauman for their help with this essay.

1. "The 'Impressionists,'" *The Standard*, London, 13 July 1882, p. 3.
2. Letter from Caillebotte to Pissarro, 24 January 1881, cited in Marie Berhaut, *Caillebotte: sa vie et son oeuvre*, Paris: La Bibliothèque des Arts, 1978, no. 22, p. 245.
3. Degas's statement to the young Alexis Rouart, cited in Lemoisne [1946–49], I, p. 1.

At the beginning of the 1880s, the extent of Degas's fame was such that a London newspaper heralded him as "the chief of the [Impressionist] school."[1] He was in fact a significant force in the Société Anonyme des Artistes that sponsored the Impressionist exhibitions in Paris, and he used these exhibitions brilliantly as a platform for himself. At the 1881 exhibition he asserted the power of his wit, the acuity of what Douglas Druick has termed his "scientific Realism" (see p. 197), and the vigor of his art with his sensational *Little Fourteen-Year-Old Dancer* (figs. 158–160). He was worldly and influential, and in constant contact with a large number of artists, so much so that Degas's colleagues were bothered by his politicking. Caillebotte, for one, complained in a letter to Pissarro that Degas spent the day "holding forth at the [Café de la] Nouvelle-Athènes or in society."[2]

At the end of the 1880s, his Société Anonyme des Artistes disbanded, Degas had virtually fulfilled the wish that he had pronounced for himself, "to be illustrious and unknown."[3] He had long since abandoned the Salon, had refused to exhibit in the art pavilion at the 1889 World's Fair, and had repeatedly declined to participate in either the Paris exhibitions of the Artistes Indépendants or the important annual exhibitions in Brussels organized by Les XX. Because Degas after 1886 simply would not contribute to group exhibitions, the display of just two or three of his works in a dealer's gallery became an event noted by most of the art journals in Paris. Confident of his talent and secure in his stature, Degas had withdrawn by the end of the 1880s to a much smaller world of close friends, his self-chosen surrogate family of writers, artists, and collectors, in order better to indulge his passions: the incessant making of works of art, constant attendance at the Opéra, the rereading of favorite books in order to extract new meanings, and the dogged pursuit of paintings, drawings, and prints to add to his collection.

Any division of time is arbitrary, but the units used to measure it often take on genuine significance. The 1880s—or more particularly the nine years between the sixth Impressionist exhibition in 1881 and the famous tilbury trip in Burgundy in 1890 that gave birth to the landscape monotypes—were for Degas a momentous decade, a palpable period of time. The boundaries are well marked. He began the period as an artist in his prime, a man in his late forties with a capacity for work and a stepped-up production of finished works of art that was outdistanced only by the enormous debt with which his father and brothers had encumbered him. He ended the decade as an affluent confirmed bachelor moving into a three-floor apartment that was enormous but necessary for his growing collection of works by French masters old and new: Ingres and Delacroix, Corot and Courbet, Gauguin and Cézanne. In the early 1880s, Degas was eager to sell as much as he could, mostly through Durand-Ruel; in the late 1880s, he sold only selectively, to a large group of dealers—Boussod et Valadon, Bernheim-Jeune, Hector Brame, and Ambroise Vollard, in addition to Durand-Ruel—all of whom fought competitively and paid dearly for the privilege of buying from him. At the beginning of the decade, Degas was the favored artist of Edmond Duranty, the Naturalist critic who was not only a spokesman in the 1870s for many of Degas's aesthetic views but also a vigorous proponent of his art. By the end of the decade, Symbolist critics such as Félix Fénéon and G.-Albert Aurier were writing about his work enthusiastically.

To suggest that in nine years Degas had relinquished his position as a conspicuous presence in the Paris art world in order to slip into comfortable obscurity, had passed

from serious indebtedness to affluence, and had converted from Naturalism to Symbolism is to oversimplify the complex changes that in fact occurred gradually, without giving any evidence of the roots or explaining the causes. But it is undeniable that in the 1880s Degas remade his life and his art through a great number of conscious decisions—some active, others passive—coincidentally just at the time when other artists of his generation, most notably Monet and Renoir, were also self-consciously attempting to redefine their art as well. Within the confines of this short essay, one can only trace very broadly the order of events against the background of Degas's milieu. But to identify some of the most significant changes in Degas's art in the 1880s, to discuss the patterns of sale and exhibition of his work, and to suggest the depth and spread of his influence seem nonetheless to be important steps toward a new appraisal of the period.

The first person to grapple with Degas's art of the 1880s and to attach a measure of importance to its proper ordering was Paul-André Lemoisne, the author of a massive four-volume catalogue of Degas's work that includes nearly 1,500 paintings and pastels. The enormous body of documentation that he assembled has been the basis of all studies of Degas since the publication of the catalogue just after the Second World War. His accomplishment is all the more impressive when one considers the difficulty in ordering works that are not dated by the artist. Degas's work in the 1880s is especially problematic in this regard. Of the more than four hundred works that Lemoisne assigned to the period, only twenty-one are inscribed with dates. (Three of these inscribed dates escaped Lemoisne's notice, whereas the inscription on another work, L815, is probably incorrect; see Chronology III, 1885.) Three additional dated paintings and pastels have come to light since the publication of Lemoisne's catalogue, and there are as well one dated lithograph and one dated drawing from the 1880s. (All works dated by Degas in the 1880s are noted in the Chronology.)

The lack of dated works is a large obstacle, but the problem of establishing a chronology for the period has been compounded by Lemoisne's seeming inability to discern subtle currents of change in Degas's art and practice. By ignoring these currents, he proposed a confused chronology that today is untenable. He saw the 1880s as the high point of Degas's work, but for him it was a plateau with little relief to the terrain. He wrote: "The years between 1878 and 1893 deserve special attention because they represent the apogee of Degas's career, the period in which he creates, easily and powerfully, a magnificent series of masterpieces. However, the manner in which Degas conceived his art did not change: the subjects that interest him are more or less identical, with the addition only of the milliners and the nudes. Although the originality of his groupings and his *mise-en-page* are more marked, his method of composition is for all that still the same."[4]

Degas's art was of course evolving, just as quickly as it had at any point in his career, but the evolution was largely unrecognized by Lemoisne. The result in his catalogue is chaos. Many of the jockey scenes, for example, are placed near the beginning of the decade, whether they were brilliant in color and animated in composition, such as the Clark Art Institute's *Before the Race* (cat. no. 236, dated correctly c. 1882 by Lemoisne), or muted brown in tonality and elegiac in mood, such as the pastel in the Hill-Stead Museum in Farmington which bears the inscribed date "86" (L596, dated by Lemoisne c. 1880). Because, for example, *Three Jockeys* (cat. no. 352) repeats the composition of a highly finished pastel that would appear to date from c. 1883 (L762, dated by Lemoisne 1883–90), Lemoisne gives the same date to both, even though the handling and palette of *Three Jockeys* is manifestly close to that of the pastels, such as *Dancers* (cat. no. 359), executed at the very end of Degas's career, about 1900.

Hundreds of works of the 1880s were assigned dates by Lemoisne that are contradicted by the evidence of dealers' stock books, early exhibition and auction catalogues, and the letters or diaries of Degas's contemporaries. Granted, little of this documentary information was available to Lemoisne when he assembled his catalogue in the 1930s and 1940s. But the more serious flaw in his catalogue derives from his misunderstanding of the central feature of Degas's method in the 1880s—his habit of repeating successful

4. Lemoisne [1946–49], I, p. 109.
5. One indication of the problems posed by Lemoisne's dates is that some two dozen works originally intended for this section of the catalogue have in the course of writing been redated out of the decade.
6. All works that Degas is known to have sold or exhibited in this period are indicated in Chronology III.
7. "Exposition des impressionnistes," *La Petite République Française*, 10 April 1877, p. 2 (translation 1986 Washington, D.C., p. 217).
8. F.-C. de Syène [Arsène Houssaye], "Salon de 1879," *L'Artiste*, May 1879, p. 292.

compositions over a period of years (or decades), with differing palettes, differing kinds of handling and degrees of finish, and differing relationships between figures and the surrounding space. Lemoisne notes the obvious repetition of subjects and motifs, and groups similar compositions together, but he interprets the later variants, which often exhibit looser drawing and a sketchier finish, as studies preparatory to the earliest work. Lemoisne thus stands the chronology of Degas's work on its head.[5] The most egregious error of Lemoisne's dating is his suggestion that *Fallen Jockey* (cat. no. 351) is a study made in the mid-1860s for *The Steeplechase* (fig. 316), which Degas exhibited in the Salon of 1866. In fact, *Fallen Jockey* is a great synthetic statement of the 1890s exhibiting all the features that are today considered characteristic of the artist's late work.

Fascinating patterns and correspondences emerge if, ignoring Lemoisne, one constructs a skeletal chronology of the dated works of the 1880s and fleshes it out with the approximately 150 works that are firmly datable by their known dates of sale, descriptions in dated correspondence, or public exhibition in the period.[6] The most important discovery resulting from this exercise is that the modalities of Degas's approach to style appear much more consistent than Lemoisne's catalogue suggests. Although the changes in his art viewed over any length of time are dramatic, the shifts no longer seem capricious. Working very much like Picasso at the beginning of the twentieth century, Degas seems continually to have found for himself interesting pictorial problems, which he then resolved in numerous solutions, each equally viable. Once an idea was exhausted he would leave it, only to return years later to the same format, or composition, or figural group, with new paints on his palette and changed ideas in his head, to produce wholly new variations on old themes.

In the early 1880s, through about 1884, Degas was still working very much along the course that he had set for himself upon returning from New Orleans in 1873. His compositions were packed with accessories and figures—whether dancers, racehorses, or milliners—and generally they included at least one figure brought startlingly close to the picture plane and therefore cropped. The vantage point was generally very high, looking down with a *japonisant* bird's-eye view. Degas's angle was shockingly novel, and theatrical. His pictures were always clever and often humorous. Remarks about paintings made in the 1870s apply equally to works, such as the milliners, of the early 1880s: "So many little masterpieces of clever and accurate satire,"[7] to quote a critic of 1877, or "Parisian wit and Impressionist veracity set off by a fanciful Japanese touch,"[8] to quote a critic of 1879. His use of color was local and intense: the dancers' ribbons, the jockeys' silks, the milliners' feathers were all bright in hue—cardinal red, sky blue, canary yellow, pistachio green—yet despite their strong color, rarely did they suffuse the work with a dominant tonality. Degas's preference for pastel grew stronger, and by about 1882 he had given up the dangerously unstable mixtures of distemper, gouache, and dry pigments that were prevalent in the experimental years of the 1870s. His innovative approach notwithstanding, throughout the 1870s and into the early 1880s he respected the physical integrity of what he described. Flesh was always flesh-colored, light was northern and cool. His humans all have faces, with features brilliantly conceived to convey with a single expression generations of breeding, whether high or—more typically—low.

By the early 1880s, most of the subjects that Degas had established in the 1870s were common currency. Milliners, laundresses, dancers, and café-concert singers appeared widely in popular illustration and in the novels of the Naturalist writers. Artists like Jean-François Raffaëlli and Jean-Louis Forain collaborated with writers like Edmond de Goncourt, Zola, and Huysmans on books such as *Croquis parisiens*, published in 1880, or *Les types de Paris*, published in 1889, in which characters remarkably close to the inhabitants of Degas's world are interpreted for an audience broader than Degas's. Images of young working women—depicted by artists since the seventeenth century as potentially available for sexual favors—were exploited by Degas in a fashion that is almost ironic: he diffused the sexuality of the sensational imagery to render it barely perceptible. To quote the critic Geffroy on the milliners, Degas "retained this taste for the surprises of the street, for encounters at corners and at half-open doors, [in his pictures] of

Fig. 170. Édouard Manet, *Woman Bathing*, c. 1878–79. Pastel, 21¾ × 17¾ in. (55 × 45 cm). Musée d'Orsay, Paris

dark and brittle milliners who adjust their hats with a grace learned in the outlying districts . . . pictures [nonetheless] of grand, simplified gestures, in rich and matte colors, of overwhelming sumptuousness."[9] In the early 1880s, Degas continued to investigate the human race as a scientific Realist, but he colored the evidence with a panoply of luxurious color, and suffused the results with charm.

Toward the mid-1880s, Degas markedly shifted the course of his art. He simplified his compositions, made the depicted space more shallow, brought his viewpoint down to near eye-level, and focused his attention on a single figure or figural group. He concentrated on human form with a point of view that he had ignored since the 1860s, when he had copied the Italian masters extensively. Humor and anecdote, with the notable exception of a work like *The Morning Bath* (cat. no. 270), is conspicuously absent. It is almost as if Degas, clarifying his art, heeded the remarks made by Armand Silvestre apropos the most classical, if not classicizing, of Degas's entries to the fourth Impressionist exhibition, the relief-like *Laundresses Carrying Linen in Town* (fig. 336), because it was this aspect of his art that he emphasized at mid-decade: "The considered mastery in this picture, whose power is indefinable . . . is the most eloquent protest against the confusion of colors and complication of effects that is destroying contemporary painting. It is a simple, correct, and clear alphabet thrown into the studio of the calligraphers whose arabesques have made reading unbearable."[10]

Degas's new classicizing style is most evident in the series of large pastel nudes. In them, the figure dominates. Indeed the compositions are so cropped that there is room for little else. Compared to the pastels of milliners of 1882, the colors are muted even in the most colorful of the series, such as *After the Bath* (fig. 171; cat. no. 253), and *Nude Woman Having Her Hair Combed* (cat. no. 274). The technique is straightforward and

9. Gustave Geffroy, *La vie artistique*, Paris: E. Dentu, 1894, p. 161.
10. Armand Silvestre, "Le monde des arts: les indépendants— les aquarellistes," *La Vie Moderne*, 24 April 1879, p. 38.
11. Adam 1886, p. 545.

simple: most of the pastels of the period are worked on store-bought academy boards, as opposed to the assemblages of pieced paper common to the 1870s and early 1880s. The more brusquely worked nudes, such as the bather in the Burrell Collection in Glasgow (fig. 183) and the 1885 *Woman Bathing in a Shallow Tub* in New York (cat. no. 269), are almost monochromatic. Paul Adam, reviewing the nudes exhibited in the 1886 Impressionist exhibition, noted that Degas "uses bituminous tones monotonously," but added that "very beautiful drawing predominates."[11] It seems certain that Degas suppressed his palette at mid-decade in order to focus attention on the strength of his line. And his decision to do so was probably a reaction to the high-keyed palettes of Monet, Renoir, and Pissarro at the time. Sickert wrote that he had "never forgotten some words . . . [that] Degas let fall in 1885 about the direction that was being taken in

Fig. 171. *After the Bath*, c. 1883–84 (cat. no. 253)

painting at the time, and his attitude toward that direction. 'They are all exploiting the possibilities of color. And I am always begging them to exploit the possibilities of drawing. It is the richer field.'"[12] Abandoning his scientific sensibility, in his nudes he distilled and consolidated his art toward a new synthetic classicism based on line.

One issue regarding Degas's nudes that is often overlooked is their relation to the work of Édouard Manet. Manet is the only artist with whom Degas maintained a truly competitive relationship. They were both prickly about their artistic debts to one another, yet there can be no doubt that each contributed equally to the other's aesthetic, even if the balance did shift over the years. It is evident that in the 1870s, Manet based his pastels of women bathing and his scenes of the café-concert on Degas's treatments of these subjects shown in the 1877 Impressionist exhibition. On the other hand, the experience of seeing Manet's nudes in large scale (see fig. 170) may well have prompted Degas to move his *scènes intimes* out of the monotype format and onto large boards. Because Degas was no longer an intimate of Manet's at the end of his life, he may not have seen Manet's nudes until after the latter's death in 1883, either at the atelier sales or at the home of Berthe Morisot and Eugène Manet. It thus seems significant that the earliest of Degas's bathers to approach the size of Manet's probably date from 1883–84, such as *After the Bath* or the pastel in the Burrell Collection dated 1884. Probably there was a feeling of release included in Degas's remorse at the loss of his colleague, and perhaps mixed in as well was a desire to take his own imagery back for himself. Certainly the suite of nudes that Degas exhibited in the 1886 exhibition was a repudiation, conscious or not, of Manet's aesthetic. Geffroy, writing in 1894, compared Degas's nudes to those of earlier French painters, including Manet's *Olympia*, and concluded: "Degas had another comprehension of life, a different concern for exactitude before nature. There is certainly a woman there [in Degas's pictures], but a certain kind of woman, without the expression of a face, without the wink of an eye, without the décor of the toilette, a woman reduced to the gesticulation of her limbs, to the appearance of her body, a woman considered as a female, expressed in her animality, as if it were a matter of a superior illustration in a zoological textbook."[13] For his part, Degas virtually confirmed Geffroy's analysis when he reflected to Sickert: "Perhaps I looked on women too much as animals."[14]

Synthesis was the key word among those critics who could see past the provocative imagery of the so-called animalistic nudes Degas exhibited in 1886. Mirbeau spoke for many when he observed that "there is wonderful power of synthesis and abstract line in them such as no other artist of our time that I know of can produce."[15] Huysmans singled out Degas's line and characterized it as "ample and fundamental."[16] And Fénéon went to the heart of the matter by pinpointing the cumulative observations that Degas synthesized in his drawing. "The line of this cruel and wise observer elucidates, through difficult and wildly elliptical foreshortenings, the mechanics of movement. In a moving being, [Degas's] line registers not only the essential gesture, but the smallest and most distant myological repercussions. From this comes the definitive unity of his drawing. It is an art of Realism, however it does proceed from a direct vision; once one catches oneself watching, the native spontaneity of the observation is lost. Hence Degas does not copy from nature. He accumulates a multitude of sketches, from which he takes the irrefutable veracity that he confers on his work. Never have pictures shown less of the painful image of the 'model' who has 'posed.'"[17] It was the strong and almost independent contours of Degas's nudes that impressed not just critics, but also the younger generations of artists working in Paris at the time. Gauguin summed it up in an uncharacteristically simple statement: "Drawing had been lost, it needed to be rediscovered. When I look at these nudes, I am moved to shout—it has indeed been rediscovered."[18]

Toward the end of the decade, Degas's style evolved further. But because his works were infrequently exhibited between 1886 and 1891, and because he dated only two works at the end of the 1880s—one in 1887 and one in 1890—it is difficult to determine precisely when the shift occurred. Yet the signs of change are unmistakable. In some genres, such as in his pictures of jockeys, he retained the clarity of his earlier style, but reinvigorated it with a new enthusiasm for accuracy fueled by Muybridge's photographs (see "Degas and Muybridge," p. 459). Similarly, in the pictures of dancers his

12. Walter Sickert, "Post-Impressionists," *The Fortnightly Review*, DXXIX, 2 January 1911, p. 87.
13. Geffroy, op. cit., pp. 167–69.
14. Sickert 1917, p. 185.
15. Mirbeau 1886, p. 1 (excerpted in 1986 Washington, D.C., p. 453). See also Mirbeau's article of 1884 in which he describes Degas's "violent and cruel synthesism" (Octave Mirbeau, "Notes sur l'art: Degas," *La France*, 15 November 1884, p. 2)
16. Huysmans 1889, p. 25.
17. Fénéon 1886, p. 263.
18. Words reportedly written in 1903, one month before Gauguin's death, recorded in "Degas von Paul Gauguin," *Kunst und Künstler*, X, 1912, p. 341 (translation 1984 Tübingen, p. 83).
19. Sickert 1917, p. 185.
20. Félix Fénéon, "Calendrier de janvier," *La Revue Indépendante*, February 1888; reprinted in Fénéon 1970, I, p. 95.
21. Richard Kendall, "Degas's Colour," in *Degas 1834–1917*, Manchester: Manchester Polytechnic 1985, pp. 23–24
22. G.-Albert Aurier, "Les symbolistes," *Revue Encyclopédique*, 1 April 1892; reprinted in Aurier Oeuvres posthumes, Paris, 1893, pp. 293–309; cited in John Rewald, *Post-Impressionism: From van Gogh to Gauguin*, 3rd rev. ed., New York: The Museum of Modern Art, 1978, p. 483.
23. Maurice Denis, "L'époque du symbolisme," *Gazette des Beaux-Arts*, XI, 1934, pp. 175–76. (Instead of copying nature, Denis writes, Symbolist art is to be constructed by two means: "the objective deformation, which depends on a purely aesthetic and decorative conception, on technical principles of color and of composition; and the subjective deformation, which brings into play the personal feeling of the artist, his soul, his poetry. . . .")
24. Jeanniot 1933, p. 158.

line is more insistent, the color stronger, and the composition expressed with a resolution revealing the cumulative mastery of his means. But in the bathers, he pushed his interests of mid-decade to new extremes, as if unfettered by any consideration other than the exigencies of pictorial construction. His figures are now models posing frankly in the studio, not women seen "through the keyhole"[19] washing in their homes. Any suggestion of anecdote or humor is gone, replaced by a more profound exploration of the expressive properties of form, line, color, and feeling.

The essential development in Degas's nudes of the late 1880s was the fusion of color with drawing. With pastel he was able to apply color in a linear manner, not so much to delineate form as to model it. In *Nude Woman Combing Her Hair* (cat. no. 285), for example, the figure is modeled with thin overlapping strokes of lime green and apricot orange—colors not usually associated with flesh—as opposed to the pale pink with dark brown shadows that Degas used in his earlier nudes. In the nudes of the late 1880s, the long strokes of color perform much the same function as did Seurat's dots and result in similar kinds of optical blendings—although by this time Degas's colors were acutely unnatural. Whereas most observers felt that Degas had subdued color to favor line in the nudes exhibited in 1886, they found it hard to deny that color in works such as *Woman Stepping into a Bath* (cat. no. 288) and *Nude Woman Drying Herself* (cat. no. 289) now carried an importance equal to that of line and was applied in an equally independent manner. A short notice in dense prose by Fénéon in 1888 stressed (in contrast to his review of the 1886 exhibition) the importance then accorded to Degas's mastery of color. Some measure of Degas's enjoyment of paradox is revealed by Fénéon's rhetorical rejoinder: "But he rejects this prestige [of a colorist], and quickly adds: I want to be only a draftsman."[20]

As Richard Kendall has shown, many of the most sophisticated, coloristically, of the late pastels have a tonal substructure drawn by Degas the draftsman beneath their brilliant surfaces finished by Degas the colorist.[21] Such a procedure is unthinkable in the work of an Impressionist like Monet or a committed colorist like Cézanne. Curiously, it is not unlike the way Seurat would first work out his figures and compositions in subtly shaded drawings in black and white before developing his paintings in color. And it is exactly analogous to Degas's practice of first establishing tonal relationships in his black-and-white monotypes before reworking them in colored pastel. Sometime in the later 1880s, Degas adopted a similar method in his painting as well. The *Nude Woman Drying Herself* in Brooklyn (cat. no. 255) is an example of a painting left unfinished by Degas after he had laid in the tonal structure but before he had applied the color.

With his high-keyed, antinaturalistic palette and strong, abstracting line Degas approached Symbolism at the end of the decade. It is debatable whether he ever adopted dream imagery in his later work. It is equally uncertain whether Degas's pictures embrace a central "Idea," which Gauguin and the theorist G.-Albert Aurier insisted was critical for true Symbolist art—although Aurier did cite Degas's "expressive synthesis" as proto-Symbolist.[22] But at the very least it is true that he allowed his imagination an increasingly large role in his work. A drawing such as that of the nude on horseback in Rotterdam (cat. no. 282) was clearly made from memory, a memory refreshed perhaps by his early drawings, all the more powerful because of it. Similarly, *Dancers, Pink and Green* (cat. no. 293) is not a transcription of a real event in the wings of a theater, but rather a translation in a new language from Degas's own work of the 1870s. Having long forsaken his interest in depicting the world as he saw it, Degas sometime before 1890 set out to paint a world that he knew through experience. Following this method, he developed an expressive style that conforms precisely to the Symbolist principles defined by Gauguin's follower Maurice Denis, in which flat, decorative surfaces marked by bold outlines are emphasized and worked in vivid colors rarely before seen—electric blue, hot pink, chrome yellow, dark purple.[23] Jeanniot recorded Degas's having said that: "It is all very well to copy what one sees, but it is much better to draw what one remembers. A transformation results in which imagination collaborates with memory. You will reproduce only what is striking, which is to say, only what is necessary. That way, your memories and your fantasies are liberated from the tyranny of nature."[24]

Durand-Ruel, the principal dealer and for some time principal patron of the artists who participated in the Impressionist exhibitions, purchased only three pictures of nude bathers (out of several hundred) from Degas throughout the course of the 1880s. That the dealer could virtually ignore the most important series of Degas's works during this period raises an interesting question regarding the relationship between the artist's subjects, his choice of style, and his market. As one might expect, Degas was highly sensitive to market conditions, and yet, at the same time, he could be immune to commercial influence. Throughout the 1880s (albeit less so at the end), Degas fabricated works of art for quick sale, while working simultaneously on pictures so ambitious or difficult that he could never have seriously entertained the hope of finding buyers for them.

Degas met Paul Durand-Ruel in the early 1870s, when the latter was shifting the base of his stock from the work of the Barbizon school, still quite salable, to that of the young urban Realists, Manet, Monet, Renoir, Pissarro, Tissot, and Degas. Durand-Ruel first purchased pictures from Degas in January 1872.[25] That same year, as Michael Pantazzi has shown, the artist complained that "Durand-Ruel takes everything I do, but scarcely sells anything."[26] Degas did not wait long before taking matters in his own hands, arranging a complicated buy-back deal with the collector Jean-Baptiste Faure, whereby Faure in 1874 depleted Durand-Ruel of his stock of Degas's pictures in return for the promise of larger and "better" paintings to be delivered directly to Faure (see "Degas and Faure," p. 221). Indeed the paintings finally delivered, thirteen years later, such as *Woman Ironing* (cat. no. 256), were large and crammed with visual detail; but because Degas felt obliged to live up to the commission, they appear to have been painted with a heavy hand. And because they remained in Degas's studio too long, they are overworked and lack the spontaneity of his independent work. The arrangement with Faure is surprising because of Degas's active role (it ended, badly, in 1887, with recriminations on both sides), but it turns out to be just the first documented instance of Degas's manipulative relations with his dealers and collectors.

Little is known of Durand-Ruel's involvement with Degas in the late 1870s. Financial setbacks for the gallery, and for the French nation, necessarily slowed activity, and what transactions there were are now obscured by missing stock books. Starting with December 1880, however, documentation is complete, revealing to a certain extent Degas's pattern of sale. Evidently, at least once a month, when he was in the city, Degas would put together a package of works that he was ready to release, usually amounting to about Fr 1,000 in value. Degas would summon Durand-Ruel, who seems generally to have bought whatever he was offered.[27] If Durand-Ruel hesitated, Degas became annoyed: "*One* delays coming to see the pastel, [therefore] I am sending it to you. You will get another (of horses) and the little *Course* (in oils) with a background of mountains. Please send me some money *this afternoon*. Try and give me half the sum each time I send you something. Once my fortunes are restored I might well keep nothing for you and so free myself completely from debt."[28] Sometimes the package would be a mixed lot, such as the large pastel, the pastel drawing, and the two fans (one being cat. no. 211), sold on 12 April 1883. At other times Degas would sell a large suite of works, such as the twelve drawings of dancers (probably among them cat. no. 222) sold on 25 January 1882. Durand-Ruel automatically doubled the amount he paid Degas to establish the retail price of the work, and this markup rarely varied. However, when Durand-Ruel bought works by Degas from other dealers, or collectors, or at auction, he altered the markup percentage to suit market conditions. Discounts were generally not granted, for as a rule Durand-Ruel's "prix demandé" in the 1880s was very close to the sum received. But there was a fair amount of trading of other kinds. The gallery would accept a work by one artist in exchange for a work by another artist, and it often acted as an agent at auction for Degas and for Mary Cassatt—buying pictures or drawings for them against future payment in cash or art. Occasionally in the 1880s, Durand-Ruel paid Degas half of the purchase price upon delivery, but usually he credited the full amount to Degas's account, against which Degas made constant withdrawals. Guérin's assertion that Degas used Durand-Ruel as a banker is substantiated by the unpublished correspondence in the Durand-Ruel archives as well as by their account books. In the

25. See Chronology I, January 1872.
26. Letter from Degas to Tissot, [summer 1872], Bibliothèque Nationale, Paris; Degas Letters 1947, no. 8, p. 35.
27. Total value in francs of recorded sales by Degas to Durand-Ruel and to Boussod et Valadon:

	Durand-Ruel	Boussod et Valadon	Total
1881	9,000		9,000
1882	14,650		14,650
1883	6,875		6,875
1884	6,880		6,880
1885	6,525		6,525
1886	5,600		5,600
1887	800	4,000	4,800
1888	4,800	3,200	8,000
1889	1,350	2,400	3,750
1890	10,300	10,800	21,100

The figures for Durand-Ruel are taken from the journal and the stock books. The totals noted in the gallery's "grand livre" differ slightly. The Boussod et Valadon figures derive from Rewald 1986.
28. Letter from Degas to Durand-Ruel, [13 August 1886], Lettres Degas 1945, XCVI bis, p. 123; Degas Letters 1947, no. 106, p. 121.
29. Letter from Degas to Durand-Ruel, summer 1884, Lettres Degas 1945, LXVII, p. 94; Degas Letters 1947, no. 76, p. 94.
30. Letter from Degas to Bracquemond, [April/May 1879], Lettres Degas 1945, XVI, p. 43; Degas Letters, 1947, no. 25, p. 48.
31. See the description of collectors of Degas's work in Octave Mirbeau, "Notes sur l'art: Degas," *La France*, 15 November 1884, p. 2, reprinted in Gary Tinterow, "A Little-Known Article by Octave Mirbeau," *Burlington Magazine*, March 1988.
32. John House, "Impressionism and Its Contexts," in *Impressionist and Post-Impressionist Masterpieces: The Courtauld Collection*, New Haven: Yale University Press, 1987, pp. 18–19 n. 17, letter from Monet to Durand-Ruel, 3 November 1884; reprinted in Daniel Wildenstein, *Monet: biographie et catalogue raisonné*, Lausanne/Paris: La Bibliothèque des Arts, 1979, II, no. 527, p. 256.

first half of the 1880s, Degas withdrew on average Fr 485 three times a month or more. He either sent individuals to Durand-Ruel for payment ("Cher Monsieur, my maid will go and fetch a little money from you"[29]), or demanded that money be sent to him wherever he happened to be—the Grand Hôtel at Paramé, for instance, where he stayed in August 1885. Degas's account with Durand-Ruel was often overdrawn, and at the end of the year he often had an outstanding balance. To cite but one year, in 1882 he sold to Durand-Ruel art worth Fr 14,650, and received from him Fr 17,950 in cash. Degas seems to have been on cordial terms with Durand-Ruel, but they were never friends. Unlike Monet, who trusted Durand-Ruel as an adviser and relied on him to develop marketing strategies, Degas kept him at a distance. He always called him "Monsieur."

Degas was conscious of commercial pressures as early as the late 1860s, when he still aspired to success at the Salon. By the 1880s, he seems clearly to have distinguished between his commercial output—his fabricated "articles"[30]—and the rest of his art. The majority of works purchased by Durand-Ruel in the 1880s were, not surprisingly, pictures of racecourse scenes and dancers, Degas's "articles." Domestically scaled and highly finished, they seemed to have been designed for the apartments and town houses of Degas's "collectors"—rich merchants, industrialists, and the occasional artist, intellectual, and aristocrat.[31] Degas had ceased painting monumental pictures when he renounced the Salon, after 1870; he did not work routinely on a large scale until the 1890s. The relatively few large works that he began in the 1880s, such as the Brooklyn *Nude Woman Drying Herself* (cat. no. 255), the Chicago *Millinery Shop* (cat. no. 235), and the London portrait of Hélène Rouart (fig. 192), remained in his studio for many years. Not until he left his large apartment in 1912 did he consider selling the Chicago millinery shop picture, though it is highly unlikely that Durand-Ruel would have purchased it much earlier.

John House has drawn attention to Durand-Ruel's attempts to influence the size and level of finish of paintings by the Impressionists he represented. A letter of 1884 in which Monet objected to Durand-Ruel's pressure outlines the issue precisely: "As far as the finish is concerned, or rather the 'lèche' [degree of polished execution] which the public wants, I will never agree."[32] There is no record suggesting that Durand-Ruel sought to influence Degas similarly, but there is evidence that Degas obliged the expectations of the market. Two examples of many may be cited. On 25 January 1882, Degas sold twelve drawings to Durand-Ruel. They are all of a piece—drawn on colored papers, worked up with pastel and chalk, and conspicuously signed. They are sufficiently spontaneous to give an indication of the creative process, yet sufficiently finished to be pleasing in themselves. Clearly, drawings such as these, quite different from the working drawings of the same period found in Degas's studio at his death, gratified buyers; ten of the twelve were sold in the course of the year. In 1885, Degas sold a number of prints to Durand-Ruel—etchings, lithographs, and monotypes—which he had reworked with pastel in order to make them more substantial and thus more attractive commercially, among them *At the Café des Ambassadeurs* (cat. no. 265). These pictures, being small, portable, jewellike, and yet affordable, were sent by Durand-Ruel to the exhibition of material from his gallery that he organized in New York in 1886. Throughout the early 1880s, there was a direct relationship between the purchase from Degas of a number of like works—"articles"—and the planning of a promotional exhibition or sale in London, Paris, Brussels, or New York.

Degas's commercial works can be distinguished from the rest of his oeuvre primarily by their degree of finish. In the 1880s he worked simultaneously in two styles—one commercial, the other distinctly not. Several examples at mid-decade reveal this tendency clearly, and one could argue that it persisted throughout the remainder of his career. In 1884 and 1885, Degas made eight pastels of scenes from the farce *Les Jumeaux de Bergame*, seven of which are identical in style, typified by *Harlequin* (fig. 237). Drawing is precise, colors are intense, and the surface is richly worked to elicit a variety of textural effects. Over the years, Degas sold all but one of these pastels, and most of them were quickly resold. In contrast, the one pastel in the series that Degas did not sell but rather presented as a wedding present to his friend Hortense Valpinçon (cat. no. 260), is

worked quite differently. The drawing is supple, forms are developed by the cumulative effect of lines rather than by contour lines, and color is soft and suggestive rather than declamatory. It is less finished, or "licked," but, to use Degas's description of the freely painted *Cotton Merchants in New Orleans* (cat. no. 116), "better art."[33]

The series of nude bathers offers another instance of Degas's duality of style. The *Woman Bathing in a Shallow Tub* in Paris (cat. no. 271), characteristic of Degas's most polished art, is uniformly layered with pastel that was applied with precision. Forms are smoothly modeled and details are carefully delineated. Dated 1886, *Woman Bathing in a Shallow Tub* was sold immediately to Émile Boussod, even before it was shown in the Impressionist exhibition that spring. The *Woman Bathing in a Shallow Tub* in New York (cat. no. 269), from the same series, is in a quite different style. The figure is ungainly and angular, unlike the Paris nude which is beautifully soft and curved. Its only accessory, the porcelain pitcher, serves to underscore the nude's blunt figure. The drawing in the New York pastel is raw, and much of the paper is left exposed. The near monochromy of the New York bather makes the subtle hues of the Paris bather seem rainbowlike in comparison. It is not surprising then that the New York pastel, dated 1885, was not sold by the time it was shown in the 1886 exhibition, and it is absolutely fitting that this sketchiest, most difficult, and least commercial of the suite of nudes should have been acquired by another artist, Mary Cassatt. She was sensitive to the pastel's special qualities, and in letters to Louisine Havemeyer she continually deemed it superior to almost any other nude by Degas (see cat. no. 269).

Durand-Ruel and Degas apparently had a special arrangement in the early 1880s, for in more than one letter Degas announces that he is sending to the gallery collectors who had sought to purchase works directly from him. Yet the arrangement could not have been exclusive, since Degas sold at the same time to other dealers such as Alphonse Portier, or a man named Clauzet, on rue de Châteaudun.[34] By 1887 Durand-Ruel, once again in precarious financial condition, could ill afford to patronize Degas, and his purchases gradually diminished. More important, Durand-Ruel seems to have spurned Degas's more avant-garde works, such as his nudes. Degas sold these to other dealers, including Theo van Gogh, Vincent's brother, who about this time had set up his mezzanine gallery at Boussod et Valadon and taken up the slack from Durand-Ruel. Van Gogh bought not only from Degas but also invested heavily in Monet, for example, seriously threatening Durand-Ruel's control of the Impressionist market. More significant to Degas's reputation and influence than his financial dealings was the fact that van Gogh's gallery became the meeting place of younger painters and critics, who had already begun to perceive Durand-Ruel as slightly old guard. Since Degas did not exhibit his recent work publicly between 1886 and 1891, his admirers congregated at such galleries as van Gogh's.

Degas's decision to withdraw from his highly visible and active role within the Parisian artistic community came, ironically, during the years in which his influence on the work of younger painters was most pervasive. Degas had always directly encouraged his artist friends—Cassatt and Bartholomé are the two most obvious beneficiaries in the 1880s—but he taught by example rather than by instruction. Unlike, say, Pissarro, Degas had no students. Although he never accepted the role or appellation of *maître*, both Gauguin and Seurat attested to the importance of his art for their own, and his influence on Forain, Raffaëlli, and the young Toulouse-Lautrec was paramount. His caustic humor and acerbic remarks notwithstanding, Degas was (except with Manet) always generous to the artists who borrowed freely from his bank of subjects and images, and extended his support even to minor practitioners, such as De Nittis, Zandomeneghi, Boldini, and Sickert. Degas went so far as to supply Sickert, in September 1885, with photographs of his paintings (in pastel-colored mats and painted frames) to show to art students in London.[35] The gruff Degas may well have received more artists in his studio than is commonly thought.

It is not possible here to track Degas's numerous sources of inspiration or to properly chart his pervasive influence. Yet the juxtaposition of merely a few pictures by Cézanne, Degas, Puvis de Chavannes, Seurat, and Renoir (figs. 172–177) suffices to convey

33. Letter from Degas to Tissot, 18 February 1873, Bibliothèque Nationale, Paris; Degas Letters 1947, no. 6, p. 29.
34. Letter from Degas to Bracquemond, 13 May 1879, and letter from Degas to Durand-Ruel [December 1885?], Lettres Degas 1945, XVIII and LXXVIII, pp. 45, 102; Degas Letters 1947, nos. 27, 87, pp. 50, 102.
35. Letter from Degas to Ludovic Halévy [September 1885], Lettres Degas 1945, LXXXV, p. 109 Degas Letters 1947, no. 94, p. 108.

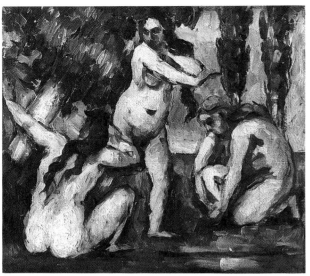

Fig. 172. Paul Cézanne, *Three Bathers*, c. 1874–75. Oil on canvas, 8⅝ × 7½ in. (22 × 19 cm). Musée d'Orsay, Paris

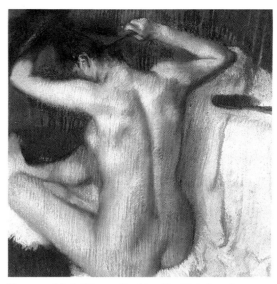

Fig. 175. *Nude Woman Combing Her Hair* (L848), c. 1884–86. Pastel, 21⅝ × 20½ in. (55 × 52 cm). The Hermitage Museum, Leningrad

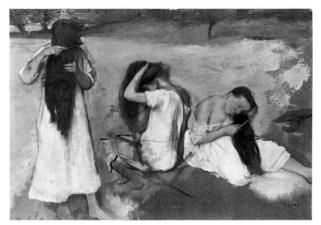

Fig. 173. *Women Combing Their Hair*, c. 1875 (cat. no. 148)

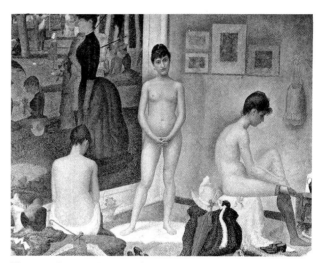

Fig. 176. Georges Seurat, *The Models* (*Les poseuses*), c. 1887–88. Oil on canvas, 78¾ × 98⅜ in. (200 × 250 cm). The Barnes Foundation, Merion Station, Pa.

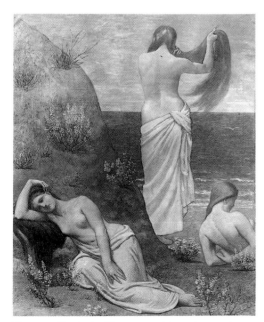

Fig. 174. Puvis de Chavannes, *Young Women by the Seashore*, 1879. Oil on canvas, 80¾ × 60⅝ in. (205 × 154 cm). Musée d'Orsay, Paris

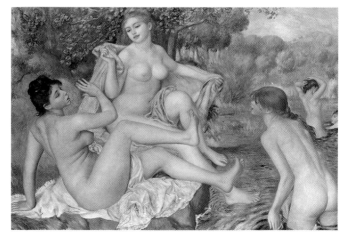

Fig. 177. Auguste Renoir, *Bathers*, 1887. Oil on canvas, 45¼ × 66⅞ in. (115 × 170 cm). Philadelphia Museum of Art

the nexus of artistic creation in Paris in the 1880s. These artists exploited common sources, and mutual influence was rife. Renaissance and Baroque art, for example, was invoked simultaneously by Renoir, Degas, and Seurat, albeit to quite differing effects. Hitherto, it has been difficult to assess the interchange among artists accurately because basic premises about Degas's chronology were false; Degas's contribution has gone largely unrecognized, and Degas studies have, accordingly, lagged far behind those devoted to his contemporaries. With a new chronology in place, Degas's development may be better understood, revealing his pivotal role as a catalyst in the evolution of modernism. Seeing his art with fresh eyes better enables us to appreciate Blanche's assertion that Degas, who was his favorite artist, "bridged two epochs; he bound the past to the most immediate present."[36] Now, with hindsight, it can be said that during the 1880s Degas anticipated many of the most important developments of the future as well.

36. Blanche 1919, p. 287.

Chronology III

Note

The Chronology for this section is disproportionately longer than those of the other sections because there is more known about Degas's activities in this decade than in any other. First, some forty percent of Degas's published correspondence dates from this period. Second, it was in these years that works by Degas found their way to numerous exhibitions throughout Europe and in New York. But more important, two new sources of information—one regarding the marketing of his work and, concurrently, his finances, the other regarding his habitual attendance at the Opéra—have been made available to the organizers of this exhibition.

The records of Degas's principal dealer in the 1880s, Durand-Ruel, happen to be completely intact for this period, whereas, for example, the books for the 1870s are incomplete. Since in the 1890s Degas seems to have preferred to sell his recent work to Ambroise Vollard (whose stock books for Degas have not been located) in addition to other dealers, the Durand-Ruel ledgers for the 1880s constitute an unparalleled resource. They provide a highly detailed picture of the selling of Degas's work: the precise dates when works of art left the artist's hands, the intervals at which he preferred to sell, the prices he realized, and the kinds of objects he sold (recent works versus older works; pastels rather than paintings; pastelized monotypes, etchings, and lithographs rather than drawings). The Durand-Ruel accounts have been published here—for the first time so extensively—thanks to the generosity of Caroline Durand-Ruel Godfroy, who provided access to the archives, and as a result of the patience and diligence of Henri Loyrette and Anne Roquebert, who transcribed the information over many months. The matching of specific works by Degas with the descriptions and inventory numbers recorded in the ledgers for the 1880s was largely accomplished, when possible, by myself with Anne M. P. Norton and Susan Alyson Stein. Our colleagues in Paris confirmed many of our hunches and made suggestions, as did members of the Durand-Ruel staff. The Boussod et Valadon stock books, first published by John Rewald in 1973 (and revised in 1986), have been similarly exploited in this Chronology.

It was also Henri Loyrette who found in the Archives Nationales, Paris, the registers of the Opéra de Paris that season subscribers signed in order to gain access to the stage and *foyers* during any given performance. These records enable one to determine on which nights Degas passed through to the stage, and although one cannot deduce from that whether he stayed for the entire performance, or passed instead directly to the wings, and while one cannot know when he attended performances without signing the register, the records do indicate, at the least, precisely when Degas was in Paris. The registers prior to 1885 are missing, but from 1885 onward, Degas's known attendance at the Opéra is here published in full, also for the first time.

GT

1881

18 April

Mary Cassatt's father writes to his son Alexander that Degas is still reworking *The Steeplechase* (fig. 316), which Alexander had hoped to acquire. He reports that the painting requires no more than two hours of work, yet "it is still postponed. However, [Degas] said to-day that want of money would compel him to finish it at once." (Degas never completed his revision of the painting.)

Mathews 1984, p. 161; also in Weitzenhoffer 1986, p. 27.

18 June

Degas sells "Le foyer de la danse" (cat. no. 219) to Durand-Ruel for Fr 5,000 (stock no. 1115); it is resold immediately to Mary Cassatt's brother for Fr 6,000. (This is the first sale to Durand-Ruel since the preceding February, when Degas sold "Dans les coulisses, chanteuse guettant son entrée" [L715] for Fr 600 [stock no. 800].)

Journal, Durand-Ruel archives, Paris.

Degas's sister Thérèse Morbilli and her ward, Lucie de Gas, arrive in Paris for an extended visit. The next day, in a letter to her husband, Thérèse writes about her brother: "He has become a famous man, you know. His pictures are greatly sought after." In another letter, of 4 July, she complains about financial difficulties: "I cannot possibly borrow more money from Edgar. . . . Life is too difficult around him. He earns money but never knows how much he has. Marguerite has lent me 100 francs for day-to-day needs, as I didn't have the courage to ask Edgar."

Guerrero de Balde archives, Naples; Boggs 1963, p. 276.

8 July

Degas sells "Femme dans une loge" (fig. 178) to Durand-Ruel for Fr 500 (stock no. 924). (The work was previously exhibited in the 1880 Impressionist exhibition.)

Journal and stock book, Durand-Ruel archives, Paris.

28 August

Asks Durand-Ruel to call on him. Among other things, he wishes to show him a "laundress" that he has just finished. (The reference may be to L685 [cat. no. 256], L276 [cat. no. 258], or L846 [cat. no. 325], though L846 seems much later and L685 presumably was still unfinished in 1881.)

Unpublished letter, Durand-Ruel archives, Paris.

13 October

Sells "Coin de salon" (unidentified) to Durand-Ruel for Fr 1,500 (stock no. 1923). Two days later he sells a pastel, "Femme faisant sa toilette" (unidentified), for Fr 800 (stock no. 1926). (This marks the first mention of a bather in the Durand-Ruel account books.)

Journal and stock book, Durand-Ruel archives, Paris.

11 November

Plans are under way for another group exhibition, to be held in 1882. Gauguin, who has found rooms for the exhibition, writes to Pissarro: "I think that, if Degas doesn't throw a stick in the spokes, this is a superb opportunity to hold our exhibition (in the light, day and night)."

Lettres Gauguin 1984, no. 18, p. 23.

26 November

Eadweard Muybridge gives a demonstration of his photographic proof of "true" animal motion at the studio of the painter Ernest Meissonier. In attendance are many of the notable academic artists of the day, including Bonnat, Cabanel, Détaille, and Gérôme. Degas is not present. (The previous September, Muybridge gave a similar demonstration to scientists gathered at the home of Étienne Jules Marey. It is thought that Degas was aware in 1879 of the first French publications relating the discoveries of Muybridge, but it was not until after the publication of *Animal Locomotion* in 1887 that he was able to assimilate fully the implications of Muybridge's work into his own.)

See "Degas and Muybridge," p. 459.

8 December

Degas attends the public viewing before the first auction sale of the contents of Courbet's studio, where he meets the painter Jacques-Émile Blanche (1861–1942).

Unpublished letter from Blanche, probably to Fantin-Latour, Musée d'Orsay, Paris.

1882

Dated works: *The Little Milliners* (fig. 207); *At the Milliner's* (cat. no. 232); *At the Milliner's* (fig. 179).

25 January

Degas sells a dozen studies of dancers to Durand-Ruel for a total of Fr 2,450 (stock nos. 2170–2181). The group includes works such as L865, L822, probably L821, and possibly L823 (cat. no. 222). The

Fig. 178. *The Box at the Opéra* (L584), 1880. Pastel, 26 × 20⅞ in. (66 × 53 cm). Private collection

next day, Degas sells two more works, both "Danseuses" (unidentified, listed as "aq. pastel"), for Fr 500 apiece (stock nos. 2183, 2184); one may well have been L599 (cat. no. 225).

Journal and stock book, Durand-Ruel archives, Paris.

28 January

Sells "Portrait de Mlle X" (i.e., Mlle Malo, fig. 107) to Durand-Ruel for Fr 400 (stock no. 2164).

Journal and stock book, Durand-Ruel archives, Paris.

1 February

Crash of the Catholic bank Union Générale, with grave ramifications for Durand-Ruel.

Venturi 1939, I, p. 60.

1 March

Opening of the *7me Exposition des artistes indépendantes* (the Impressionist exhibition), at 251 rue Saint-Honoré. Degas pays his dues as a member of the Société Anonyme des Artistes, but refuses to participate in the exhibition. (According to Berthe Morisot's husband, Eugène Manet, one newspaper decided that the exhibition was "decapitated" as a result of the absence of Degas and Mary Cassatt. Cassatt subsequently explains to Eugène Manet that Degas had removed himself because of hostility directed at him by Gauguin.[1] In a letter of 14 December 1881 to Pissarro, Gauguin had threatened to resign from the Société to protest Degas's promotion of his own protégés [mostly Italians, like Federico Zandomeneghi and Giuseppe De Nittis, but especially Jean-François Raffaëlli, who was French] at the expense of those whom Gauguin deemed to be true Impressionists.[2] Caillebotte had once written to Pissarro: "It is not possible to have an exhibition with Degas. . . . Degas is . . . the only one who put us on bad terms.")[3]

1. Morisot 1950, p. 110; Morisot 1957, p. 112.
2. Rewald 1973, p. 465; see also Roskill 1970, p. 264.
3. Venturi 1939, I, p. 60.

6 March

Sells a drawing of a dancer to Durand-Ruel for Fr 600 (stock no. 2247). One week later sells a pastel, "Sur la scène" (unidentified), for Fr 400 (stock no. 2258); Pissarro buys it from Durand-Ruel in April for Fr 800.

Journal and stock book, Durand-Ruel archives, Paris.

16 March

Degas informs his cousin Lucie in Naples that he has found a young girl "of your proportions" to substitute for her in a "bas-relief" for which she has posed in Paris (cat. no. 231).

Raimondi 1958, pp. 276–77; Reff 1976, p. 250.

14 April

Sells "Danseuses, baisser du rideau" (L575; see fig. 103) to Durand-Ruel for Fr 800 (stock no. 2281).

Journal and stock book, Durand-Ruel archives, Paris.

2 May

Degas writes to Henri Rouart about the opening of the Salon: "An astonishing Whistler, excessively subtle but of a quality! Chavannes, noble, a bit of a rehash, has the bad taste to show himself perfectly dressed and proud, in a large portrait of himself, done by Bonnat, with a fat dedication on the sand where he and a massive table, with a glass of water are posing (style Goncourt). Manet, stupid and fine, knows a trick or two without impression, deceptive Spanish, painter; . . . in a word you will see. Poor Bartholomé is ruffled and is asking naïvely to have his two works back."

Lettres Degas 1945, XXXIII, pp. 62–63; Degas Letters 1947, no. 42, p. 65.

3 June

Sells "Les modistes" (fig. 207) to Durand-Ruel for Fr 2,500 (stock no. 2421).

Journal and stock book, Durand-Ruel archives, Paris.

15 June

Degas gives a small housewarming party for himself at his apartment at 21 rue Pigalle, "9 o'clock promptly"; the attire is "redingote" rather than the more formal "habit." His housekeeper, Sabine Neyt, has died, perhaps before the move. Zoé Closier is hired as the new housekeeper.

Lettres Degas 1945, XCII, p. 120 (incorrectly dated 1886 by Guérin; Degas refers in this letter to Thursday, 15 June, which in the 1880s occurred only in 1882). Unpublished invitation from Degas to Durand-Ruel, Durand-Ruel archives, Paris ("We will be few. Don't mention it to anyone"); Mc-Mullen 1984, pp. 373, 407.

27 June

From Naples, Edmondo Morbilli writes to his wife, Thérèse (Edgar's sister), in Paris: "As for René's desire to have me come to Paris, in the hope that I could reconcile him with Edgar, please tell him not to be sorry that I cannot and do not want to come, for Edgar has displayed a complete lack of understanding, with the result that I despair of ever convincing him through serious arguments! It is only because I consider him very stubborn that I can let you go ahead and see him again without hard feelings. If I had taken him seriously, I would have had to ask you to break off all relations with him, even though he's your brother. Edgar is probably doing some good painting, I don't dispute that, but as to the rest, we must always think of him as a child, so as not to be angry with him."

Unpublished letter, Bozzi collection (not Bozzi Archives), Naples; see Chronology II, 13 April 1878.

summer

Exhibition organized by Durand-Ruel at White's Gallery, 13 King Street, London. Included are four works by Degas: "At the Milliner's" (cat. no. 233), "Jockeys and Horses in Action" (unidentified), "La loge" (fig. 178), and "Dancers" (either L652, Mellon collection, Upperville, Va., or L575, private collection, Boston).

The Standard, London, 13 July 1882, p. 3; see also Cooper 1954, p. 23.

15 July
Sells two more large pastels to Durand-Ruel: "Dame essayant un chapeau" (cat. no. 232) and "Chapeaux nature morte" (fig. 179)— the former for Fr 2,000, the latter for Fr 800 (stock nos. 2508, 2509).

Journal and stock book, Durand-Ruel archives, Paris.

end of July
Visits the Halévys at Étretat. Writes to Blanche that "the weather is fine, but more Monet than my eyes can stand."

Lettres Degas 1945, XXXIX, p. 67; Degas Letters 1947, no. 48, p. 70; see also Reff 1985, Notebook 35 (BN, Carnet 4, p. A).

5 August
From Étretat, writes to his close friend Albert Bartholomé (1848–1928) that Blanche has sent him the review in the London *Standard* about the Durand-Ruel exhibition, "where I was flattered in a few courteous and pinched lines."

Lettres Degas 1945, XL, p. 69; Degas Letters 1947, no. 49, p. 71.

9 September
Degas is in Switzerland, near Geneva, at the Hôtel Beauséjour, Veyrier. (Annotations in a notebook indicate that he also visits Geneva, Zurich, and Ouchy.)

Lettres Degas 1945, XLI, p. 69; Degas Letters 1947, no. 50, p. 71; Reff 1985, Notebook 35 (BN, no. 4, pp. 103, 105, 107).

November
Death of Mary Cassatt's sister Lydia, who is thought to have posed for the seated figure in *At the Louvre* (cat. no. 206).

10 December
Sells "Le départ" (cat. no. 236) to Durand-Ruel for Fr 2,500 (stock no. 2648). When Henry Lerolle and his wife buy the painting in January 1883, they initiate a lifelong friendship with Degas.

Journal and stock book, Durand-Ruel archives, Paris; Lettres Degas 1945, LII, pp. 77–78; Degas Letters 1947, no. 61, pp. 78–79.

29 December
Sells "Femmes regardant la mer" (L879) to Durand-Ruel for Fr 1,200 (stock no. 2669).

Journal and stock book, Durand-Ruel archives, Paris.

1883

Dated work (August 1883): *Hortense Valpinçon* (cat. no. 243).

Refuses to have a one-man show at Durand-Ruel (unlike Pissarro, Monet, Renoir, and Sisley).

Rewald 1961, p. 604.

14 February
Sells "Course de gentlemen" (cat. no. 42) to Durand-Ruel for Fr 5,200 (stock no. 2755).

Journal and stock book, Durand-Ruel archives, Paris.

April
Exhibition at Dowdeswell and Dowdeswells', 133 New Bond Street, London, organized by Durand-Ruel. On view and for sale are seven works by Degas: "Courses de gentlemen" (cat. no. 42),

Fig. 179. *At the Milliner's* (L683), dated 1882. Pastel, 25⅝ × 19⅝ in. (65 × 50 cm). Private collection

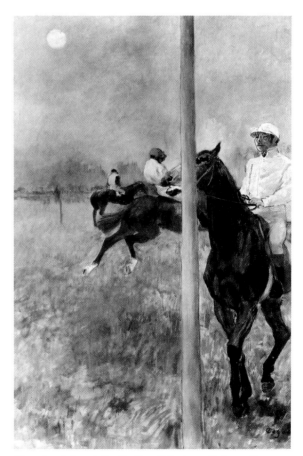

Fig. 180. *Jockeys before the Race* (L649), c. 1878–79. Essence, 42½ × 29⅛ in. (108 × 74 cm). The Barber Institute of Fine Arts, The University of Birmingham

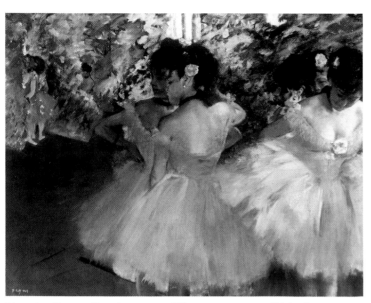

Fig. 181. *Dancers* (L617), c. 1876. Oil on canvas, 23 × 28½ in. (58.4 × 72.4 cm). Hill-Stead Museum, Farmington, Conn.

£400; "Chapeaux" (fig. 179), £60; "Femme dans une loge" (fig. 178), £50; "Femmes appuyées sur une rampe" (L879), £120; "La danseuse" (L574), £50; "Les danseuses" (unidentified), £50; and "Le départ jockeys" (fig. 180), £140. The reviews are favorable; the London *Academy* calls Degas "the chief painter of the Impressionist school."[1] Pissarro comments in a letter to Durand-Ruel: "Degas finds himself chief of the Impressionists; if he only knew! Anathema!"[2]

 1. *The Academy*, London, 28 April 1883, p. 300; see also Cooper 1954, p. 25.
 2. Lettres Pissarro 1980, p. 200; see also Venturi 1939, II, pp. 11–12.

12 April

Sells a pastel, "La conversation" (L774, Staatliche Museen zu Berlin), to Durand-Ruel for Fr 1,000 (stock no. 2800); a drawing, "Croquis de trois femmes" (fig. 149), for Fr 300 (stock no. 2801); and two fans (one of them BR73), for Fr 75 each (stock nos. 2802, 2803).

 Journal and stock book, Durand-Ruel archives, Paris; Gerstein 1982, pp. 105–18.

30 April

Death of Manet, the former leader of Degas's generation of painters. Degas writes to Bartholomé just before the end: "Manet is done for. . . . Some newspapers, they say, have already taken care to announce his approaching end to him. His family will I hope have read them before he did."

 Lettres Degas 1945, XLIV, p. 71; Degas Letters 1947, no. 53, p. 73.

9 May

Pissarro commends Huysmans's *L'art moderne* to his son Lucien: "You will also be very pleased to find in reading the book that you are not alone in your enthusiasm for Degas, who is without a doubt the greatest artist of the period."

 Lettres Pissarro 1980, no. 145, pp. 203–04; Pissarro Letters 1980, p. 31.

23 May

Sells three fans, all entitled "Scène d'opéra: danseuses," to Durand-Ruel for Fr 75 each (stock nos. 2823–2825). (One is certainly L567; the other two may be L556 [Kornfeld collection, Bern] and L564.)

 Journal and stock book, Durand-Ruel archives, Paris.

August

At Ménil-Hubert with the Valpinçons, Degas makes studies for a portrait of Hortense (see cat. no. 243).

16 October

Increasingly conscious of the loss of friends through death, Degas writes to Henri Rouart in Venice: "On Saturday we buried Alfred Niaudet [a cousin of Mme Ludovic Halévy with whom Rouart, Halévy, and Degas had been at school]. Do you remember the guitar soirée at the house, nearly a year and a half ago? I was counting up the friends present; we were twenty-seven. Now four have gone. The Mlles Cassatt were to have come, one of them [now] is dead."

 Lettres Degas 1945, XLV, pp. 71–72; Degas Letters 1947, no. 54, p. 73.

3 December

"The Ballet" (fig. 181) is included in the Pedestal Fund Art Loan Exhibition in New York, lent by Erwin Davis (see fig. 182).

4 December

Degas writes to Lerolle, encouraging him to go hear his latest infatuation, the chanteuse Thérésa, at the Alcazar. In jest, he proposes her for a role in Gluck's *Orfée et Euridice*.

 Lettres Degas 1945, XLVIII, p. 75; Degas Letters 1947, no. 57, p. 76; see cat. nos. 175, 263.

Fig. 182. Anonymous, "The Opening of the Art Loan Exhibition in Aid of the Bartholdi Pedestal Fund at the Academy of Design Last Monday" (detail). Engraving. *The Daily Graphic*, New York, 10 December 1883

1884

Dated works: *Woman Bathing in a Shallow Tub* (fig. 183); *Mme Henri Rouart* (L766 bis, pastel, Staatliche Kunsthalle, Karlsruhe); *Jockeys* (L767); *Before the Race* (fig. 291); *Nude Woman Drying Herself* (fig. 195); *Program for the Soirée Artistique* (RS54, lithograph).

Huysmans publishes *À rebours*. Conceived as a rejection of his earlier Naturalist tenets, it comes to be seen as a manifesto of the new Symbolist spirit. In it Huysmans lavishes praise on the work of Moreau and Redon.

January

Degas resumes selling to Durand-Ruel after a hiatus of eight months. On 3 January, he sells a pastel of a jockey for Fr 500 (stock no. 3149) and four drawings of dancers for Fr 75 each (stock nos. 3150–3153; Durand-Ruel returns three of them to the artist). On 27 January, he sells two drawings of dancers for Fr 100 and Fr 200 respectively (stock nos. 3188, 3189). On 29 January, he sells a pastel of a dancer (possibly L616, Shoenberg collection, Saint Louis, or L821) for Fr 300 (stock no. 3191).

Journal and stock book, Durand-Ruel archives, Paris.

Having always been disappointed by Manet's search for official honors, Degas complains that his retrospective exhibition should be held "anywhere but in those official galleries" of the École des Beaux-Arts.

Jacques-Émile Blanche, *Manet*, Paris: F. Rieder et Cie, 1924, p. 57.

In settling Édouard Manet's estate, Berthe Morisot and Eugène Manet give Degas Manet's *Departure of the Folkestone Boat* (fig. 184). He writes to them: "You wanted to give me a great pleasure and you have succeeded in doing so. May I also tell you that I deeply feel the many delicate meanings conveyed in your gift."

Morisot 1950, p. 121; Morisot 1957, p. 123.

8 January

Degas informs Mme de Fleury, the sister of Mme Bartholomé, of a portrait he has completed of M. and Mme Bartholomé in street clothes. (The portrait cannot be identified with certainty, although it may be *Conversation*, cat. no. 327, which the artist could have repainted much later.)

Lettres Degas 1945, L, p. 76; Degas Letters 1947, no. 59, p. 77.

4–5 February

Degas has Durand-Ruel bid for him on three works by Manet at the sale of the contents of Manet's studio: *Leaving the Bath*, 1860–61, ink (RWII, no. 362, private collection, London); *Portrait of H. Vignaux*, c. 1874, ink (RWII, no. 472, Baltimore Museum of Art); *The Barricade*, lithograph. Degas pays Fr 147 for the three works.

16 February

Sells two drawings (possibly L579, L586 bis) to Durand-Ruel for a total of Fr 800 (stock nos. 2974, 2975).

Journal and stock book, Durand-Ruel archives, Paris.

6 March

Sells two unidentified pastels of dancers to Durand-Ruel for Fr 300 each (stock nos. 3219, 3220).

Journal and stock book, Durand-Ruel archives, Paris.

9 April

Sells "Chevaux de courses" (L767, private collection) to Durand-Ruel for Fr 2,500 (stock no. 3231).

Journal and stock book, Durand-Ruel archives, Paris.

31 May

Sells "Chanteuse" (unidentified, listed as "dessin rehaussé") to Durand-Ruel for Fr 80 (stock no. 3264).

Journal and stock book, Durand-Ruel archives, Paris.

30 June

Sells a painting, "Chevaux de courses" (unidentified), to Durand-Ruel for Fr 700 (stock no. 3284).

Journal and stock book, Durand-Ruel archives, Paris.

16 August

Degas is at Ménil-Hubert visiting the Valpinçons. In a letter to Bartholomé he writes, listless and depressed: "Is it the country, is it the weight of my fifty years that makes me as heavy and as disgusted as I am? They think I am jolly because I smile stupidly, in a resigned way. I am reading *Don Quixote*. Ah! happy man and what a beautiful death. . . . Ah! where are the times when I thought myself strong. When I was full of logic, full of plans. I am sliding rapidly down the slope and rolling I know not where, wrapped in many bad pastels, as if they were packing paper."

Lettres Degas 1945, LIII, pp. 78–79; Degas Letters 1947, no. 62, pp. 80–81.

August–October

Intending to stay at Ménil-Hubert for the usual two or three weeks, Degas continually delays his return home. He makes short trips to Paris and other places, but does not go back to his studio until late October. He works on a life-size bust of Hortense Valpinçon, to which he eventually adds arms and legs. Owing to negligent, improvised preparations, it disintegrates almost immediately. An attempt to cast it in plaster fails.

Millard 1976, pp. 12–13.

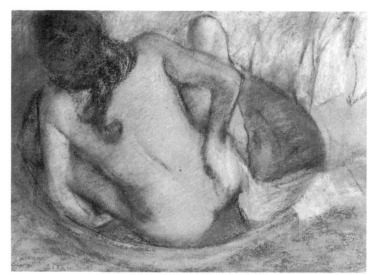

Fig. 183. *Woman Bathing in a Shallow Tub* (L765), dated 1884. Pastel, 17¾ × 25⅝ in. (45 × 65 cm). The Burrell Collection, Glasgow

Fig. 184. Édouard Manet, *The Departure of the Folkestone Boat*, 1869. Oil on canvas, 24¾ × 39¾ in. (63 × 101 cm). Oskar Reinhart Collection, "Am Römerholz," Winterthur

21 August

Death of Giuseppe De Nittis in Paris. Announcing the news to Ludovic Halévy, Degas writes of "this strange and intelligent friend." He attends the funeral in Paris and returns to Ménil-Hubert. (De Nittis was much influenced by Degas, but closer in sensibility to the more fashionable Tissot. Degas painted his wife [L302, Portland Art Museum, Oregon] and son [L508].)

Lettres Degas 1945, LVI, p. 82; Degas Letters 1947, no. 65, p. 83.

early autumn

From Ménil-Hubert, Degas in his usual financial difficulties writes optimistically to Durand-Ruel: "Ah well! I shall stuff you with my products this winter and you for your part will stuff me with money. It is much too irritating and humiliating to run after every five franc piece as I do." Durand-Ruel is himself still suffering from a serious slump.

Lettres Degas 1945, LXVII, p. 94; Degas Letters 1947, no. 76, p. 94.

21 October

From Ménil-Hubert, Degas posts a letter of condolence to De Nittis's widow—"How can one bear such a thing?" He informs her that he is finally returning to Paris, and explains his motive in sculpting a portrait bust of Hortense Valpinçon: "As one grows old, one tries to give back to people the good they have done to you, and to love them in turn. . . . I wanted to leave in [Paul Valpinçon's] house something from me that would touch him and that would always remain in the family."

Pittaluga and Piceni 1963, p. 370.

late October

Visits the Halévys at Dieppe, staying at rue de la Grève.

Lettres Degas 1945, LXVIII, p. 95; Degas Letters 1947, no. 77, p. 95.

29 November

Resumes selling to Durand-Ruel after a hiatus of six months. Sells "Danseuse et arlequin" (L1033) for Fr 200 (stock no. 586); Lerolle acquires it on Christmas eve for Fr 400.

Journal and stock book, Durand-Ruel archives, Paris.

13 December

Sells "Danseuses devant la rampe" (unidentified, listed as "tableau pastel," probably cat. no. 259) to Durand-Ruel for Fr 600 (stock no. 593).

Journal and stock book, Durand-Ruel archives, Paris.

14 December–31 January

Two paintings are lent by M. Cotinaud to an exhibition, *Le sport dans l'art*, at Galerie Georges Petit, Paris: "Départ de course de Gentlemen-Riders" (cat. no. 42) and "Start" (unidentified).

Annotated exhibition catalogue, Durand-Ruel archives, Paris.

1885

Dated works: *Mlle Sallandry* (fig. 185); *Mlle Bécat at the Café des Ambassadeurs* (cat. no. 264); *At the Café des Ambassadeurs* (cat. no. 265); *Woman Bathing in a Shallow Tub* (cat. no. 269); *Nude Woman Pulling On Her Chemise* (fig. 186); *Harlequin* (fig. 237). *After the Bath* (L815, pastel, Norton Simon Museum, Pasadena) is inscribed "85," but the picture appears to be much later and so the inscription is probably unreliable.

Death of Michel Musson (1812–1885), one of Degas's maternal uncles. (He is the most prominent figure in *Portraits in an Office*, cat. no. 115. His daughter Estelle married and divorced the painter's brother René. Two years before his death Michel adopted the two surviving children of that marriage, both of whom retained the name Musson. He died where he had always lived, in New Orleans.)

Rewald 1946, pp. 124–25.

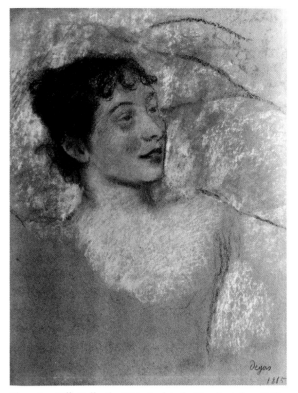

Fig. 185. *Mlle Sallandry* (L813), dated 1885. Pastel, 29½ × 23⅝ in. (75 × 60 cm). Private collection

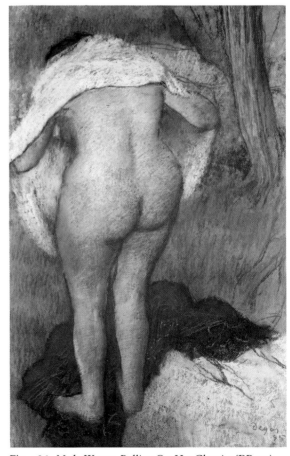

Fig. 186. *Nude Woman Pulling On Her Chemise* (BR113), dated 1885. Pastel, 31½ × 20⅛ in. (80 × 51.2 cm). National Gallery of Art, Washington, D.C.

shortly before 5 January

Degas writes to Manet's putative son Léon Leenhoff. Wanting to share in a tribute to Manet, he agrees to attend the banquet at Père Lathuille's to mark the anniversary of Manet's retrospective exhibition held at the École des Beaux-Arts the year before.

Unpublished letter, Pierpont Morgan Library, New York.

Degas taunts Durand-Ruel by telling him that he is selling a group of drawings to the dealer Clauzet, rue de Châteaudun, but asks Durand-Ruel for more money nonetheless. (The previous year, Degas had asked the dealer Alphonse Portier [1841–1902] to collect a pastel—presumably a work sold to him by the artist.)

Lettres Degas 1945, LXX, LXXIX, pp. 97, 103; Degas Letters 1947, nos. 79, 88, pp. 97, 103.

27 January

Sells "Arlequin et danseuse" (pastel) to Durand-Ruel for Fr 500 (stock no. 616). (This is almost certainly L817 [fig. 237] or possibly L771, both completed during the winter of 1884–85; see cat. no. 260.)

Journal and stock book, Durand-Ruel archives, Paris.

21 February

Degas attends a performance of Donizetti's *La Favorite* at the Opéra.

Archives Nationales, Paris, AJ13 (see headnote, Chronology III).

26 February

Sells "Danseuses" (pastel, unidentified) to Durand-Ruel for Fr 1,000 (stock no. 645).

Journal and stock book, Durand-Ruel archives, Paris.

6 March–15 April

Delacroix exhibition at the École des Beaux-Arts.

March–April

At the Opéra: *Rigoletto*, 2 March; *Le Tribut de Zamora*, 16 March; *L'Africaine*, 21 March; *Rigoletto* and *Coppélia*, 27 March; fragments of *Rigoletto*, *Coppélia*, *La Korrigane*, and *Guillaume Tell*, 1 April; *Rigoletto* and *La Korrigane*, 8 April; *Faust*, 13 April; *Hamlet*, 24 April.

Archives Nationales, Paris, AJ13.

27 April

Sells three pastels to Durand-Ruel: "Tête de femme" (unidentified) for Fr 800, "Course" (possibly L850) for Fr 600, and "Chevaux" (unidentified) for Fr 600 (stock nos. 663–665).

Journal and stock book, Durand-Ruel archives, Paris.

9 May

At the Opéra: *Faust*.

Archives Nationales, Paris, AJ13.

18–30 May

Sales at the Hôtel Drouot of the collection of Comte de la Béraudière. Degas buys a small painting by Ingres, *Oedipus and the Sphinx* (fig. 187), for Fr 500.

Annotated sale catalogue, Frick Art Reference Library, New York.

30 May

Sells two pastels of bathers entitled "Femme à sa toilette" to Durand-Ruel: L883 (private collection, New York) for Fr 600, and another (unidentified) for Fr 400 (stock nos. 682, 683). (These are the last nudes to be purchased by Durand-Ruel in the 1880s.)

Journal and stock book, Durand-Ruel archives, Paris.

spring

Eugène Manet complains to his wife Berthe Morisot, "Degas has a seat at the Opéra, gets high prices, and does not think of settling his debts to Faure and Ephrussi."

Morisot 1950, p. 111; Morisot 1957, p. 113.

In an undated letter to Pissarro, Gauguin once again airs his resentment of Degas, fueled essentially by disagreement over the relative merits of certain younger painters (for example, Raffaëlli versus Guillaumin): "Degas's conduct becomes more and more absurd. . . . You may well believe me, Degas has greatly harmed our move-

ment. . . . You will see that Degas is going to end his days more unhappy than the others, wounded in his vanity for not being the first and only one."

Lettres Gauguin 1984, no. 79, pp. 106–07; Rewald 1973, p. 493.

May–June

At the Opéra: *L'Africaine*, 4 May; *Faust*, 9 May; *Rigoletto* and *Coppélia*, 11 and 20 May; *Rigoletto* and *La Farandole*, 3 June; *Coppélia* and *La Favorite*, 5 June; probably attends the dress rehearsal of Reyer's opera *Sigurd*; *Sigurd*, 15, 22, and 26 June.

Lettres Degas 1945, LXXXII, p. 106; Degas Letters 1947, no. 91, p. 105; Archives Nationales, Paris, AJ13.

June

Durand-Ruel exhibits Impressionist works in Brussels, at the Hôtel du Grand Miroir. Three pastels by Degas are included, "Tête de femme" and two "Chevaux de courses" (all unidentified); all three, apparently, are sold in Brussels, since their return to Paris was not recorded.

Deposit book, Durand-Ruel archives, Paris.

7–10 June

Monet writes to Durand-Ruel about a Degas he hopes to buy from the dealer Portier (almost certainly a pastel of a bather, fig. 145). He evidently plans to exchange a work of his for the Degas, and asks Durand-Ruel for advice and permission.

Venturi 1939, I, p. 292.

19 June

Sells "Danseuses" (L716 bis, private collection, Paris) to Durand-Ruel for Fr 1,000 (stock no. 692).

Journal and stock book, Durand-Ruel archives, Paris.

Fig. 187. Jean-Auguste-Dominique Ingres, *Oedipus and the Sphinx*, c. 1826–28. Oil on canvas, 6⅞ × 5⅜ in. (17.5 × 13.7 cm). The National Gallery, London

Fig. 188. *Fan: Ballet Scene from the Opera "Sigurd"* (L595), 1885. Pastel on silk, 11⅝ × 23⅜ in. (29.5 × 59.4 cm). Private collection, New York

27 June

Sells three pastelized prints to Durand-Ruel: "Blanchisseuses" (no doubt a proof of RS48) for Fr 100; "Danseuses" (sold Sotheby's, New York, 9 May 1979, lot 114, a proof of the seventh state of RS47) for Fr 75; and "Chanteuse" (cat. no. 265) for Fr 50 (stock nos. 697–699). All three are sent by Durand-Ruel to the 1886 exhibition in New York.

Journal and stock book, Durand-Ruel archives, Paris.

July–August

At the Opéra: *Sigurd*, 1 July; *Les Huguenots*, 3 July; *Sigurd*, 15 and 27 July; *Sigurd*, 10 and 14 August; *Les Huguenots*, 17 August; *Sigurd*, 19 August; *L'Africaine*, 21 August.

Archives Nationales, Paris, AJ13.

summer

This is probably when Degas makes drawings from Act II, Scene 1, of *Sigurd*, set against dolmens in an Icelandic forest (see fig. 188). In his devotion to the diva Rose Caron, he attends nearly all the performances of *Sigurd*. In September he writes to Bartholomé: "Divine Mme Caron, I compared her, speaking to her in person, with the figures [in the paintings] of Puvis de Chavannes, which were unknown to her. The rhythm, the rhythm . . ." To Halévy he writes of her expressive arms: "If you see them again you will cry out: 'Rachel, Rachel' [the great actress of Delacroix's epoch]."

Reff 1985, Notebook 36 (The Metropolitan Museum of Art, New York, pp. 17ff); Lettres Degas 1945, LXXXIV, LXXXV, pp. 108–10; Degas Letters 1947, nos. 93, 94, pp. 107–09.

20 August

Sells "L'orchestre" (cat. no. 103) to Durand-Ruel for Fr 800 (stock no. 732), the last sale to him for a year.

Journal and stock book, Durand-Ruel archives, Paris.

22 August–12 September

Degas visits the Halévys at Dieppe. While there, he becomes friendly with the young English painter Walter Sickert, whom Whistler had already sent to Degas in Paris on another occasion. (Sickert later remembered Degas "always humming with enthusiasm airs from the *Sigurd* of Reyer.") Working in Blanche's studio, Degas records in a group portrait in pastel the intersection in Dieppe of six friends: Albert Cavé, Ludovic and Daniel Halévy, Henri Gervex, Blanche, and Sickert (see figs. 189, 190).

Sickert 1917, p. 184.

During the course of this stay, the photographer Barnes captures Degas's parodic staging of Ingres's *Apotheosis of Homer*, in which Degas casts himself as Homer (fig. 191).

Lettres Degas 1945, LXXXVI, p. 112; Degas Letters 1947, no. 95, p. 110.

late August

Degas stops at Paramé near Saint-Malo as part of an excursion to Mont Saint-Michel. Perhaps he sees a performance of *Les Jumeaux*

Fig. 189. Barnes (Dieppe), *Friends at Dieppe*, 1885. Photograph, modern print from a glass negative in the Bibliothèque Nationale, Paris. From left to right, last two rows: Marie Lemoinne, Ludovic Halévy, Walter Sickert, Jacques-Émile Blanche, two unidentified women, and Albert Cavé; also standing (at left) Rose Lemoinne and (at right) Catherine Lemoinne, Daniel Halévy (?), and Degas; seated, Élie Halévy, two unidentified women, and Mme Blanche (?), the painter's mother

Fig. 190. *Six Friends at Dieppe* (L824), 1885. Pastel, 45¼ × 28 in. (115 × 71 cm). Museum of Art, Rhode Island School of Design, Providence. Left to right, top to bottom: Walter Sickert, Daniel Halévy, Ludovic Halévy, Jacques-Émile Blanche, Henri Gervex, and Albert Cavé

de Bergame, produced at the Casino de Paramé in 1885 (see cat. no. 260). In a letter to Durand-Ruel from Paramé, he asks for money to be sent to him and instructs his dealer as to where a "simple white frame" can be found in his studio to be used on a jockey picture. (Degas and Pissarro, among the Impressionists, were the most committed to the novel use of plain white or pastel-colored frames.)

> Lettres Degas 1945, LXXVII, LXXX, pp. 101, 104–05; Degas Letters 1947, nos. 86, 89, pp. 101, 103–04.

September

Gauguin too is in Dieppe in September; he encounters Degas and is deliberately disagreeable.

> Roskill 1970, p. 264.

September–December

At the Opéra: *Guillaume Tell*, 12 and 18 September; *Sigurd*, 19 September; *Coppélia* and *La Favorite*, 21 September; *Sigurd*, 23 and 28 September; *Hamlet*, 30 September; *Guillaume Tell*, 3 October; *La Favorite* and *La Korrigane*, 7 October; *Guillaume Tell*, 12 October; *La Juive*, 14 and 17 October; *Sigurd*, 23 October; *Guillaume Tell*, 26 October; *La Juive*, 2 November; *Les Huguenots*, 4 November; *Robert le Diable*, 9 November; *La Juive*, 13 November; *Sigurd*, 16 November; *Rigoletto* and *Coppélia*, 20 November; *La Juive*, 23 November; *Sigurd*, 25 November; *Le Cid*, 30 November; *La Juive*, 7 December; *Le Cid*, 14 December; *La Favorite* and *La Korrigane*, 16 December; *Le Cid*, 25 December; *Robert le Diable*, 26 December.

> Archives Nationales, Paris, AJ13.

early December

Gauguin, writing to his wife, gives some indication of the improving demand for Degas's work: "Sell rather the drawing by Degas; . . . he alone [of the artists Gauguin collected] sells well." (He refers most probably to *Dancer Adjusting Her Slipper* [L699], which Degas had given to Gauguin in exchange for the latter's *Still Life with Mandolin*.)

> Lettres Gauguin 1984, no. 90, p. 118; unpublished note by Degas, private collection.

Fig. 191. Barnes (Dieppe), *Apotheosis of Degas*, 1885. Photograph, modern print from a glass negative in the Bibliothèque Nationale, Paris. A parody of Ingres's *Apotheosis of Homer*, in the Musée du Louvre, Paris

1886

Dated works: *Jockeys* (L596, pastel, Hill-Stead Museum, Farmington, Conn.); *Mlle Salle* (L868, pastel, private collection); *Study of Hélène Rouart* (L866, pastel, Los Angeles County Museum of Art); *Hélène Rouart* (L870, pastel, private collection); *Hélène Rouart* (L870 bis, pastel, private collection; *Hélène Rouart* (L871, pastel, private collection); *Woman Bathing in a Shallow Tub* (cat. no. 271). (For the portrait in oil of Hélène Rouart, see fig. 192.)

Jean Moréas publishes *Manifeste du symbolisme*, a declaration of independence from Realism and Naturalism.

Octave Mirbeau publishes the novel *La calvaire*, in which the character of an artist, Eugène Lirat, is based on Degas.

by 5 January

After a stopover in Geneva to see his brother Achille, Degas is in Naples to negotiate the sale of his share of the Neapolitan property to his cousin Lucie (fig. 193), soon to come of age.

> Lettres Degas 1945, LXXXIX, XC, pp. 114–19; Degas Letters 1947, nos. 98, 99, pp. 113–17.

7 January

Degas writes to Bartholomé from Naples: "I wish I were already back. Here I am nothing more than an embarrassing Frenchman."

> Lettres Degas 1945, LXXXVIII, p. 113; Degas Letters 1947, no. 97, p. 112.

Fig. 192. *Hélène Rouart* (L869), 1886. Oil on canvas, 63⅜ × 47¼ in. (161 × 120 cm). The National Gallery, London

30 January

Back in Paris, attends *Sigurd* at the Opéra.

> Archives Nationales, Paris, AJ13.

February–March

At the Opéra: *Robert le Diable*, 3 February; *Le Cid*, 5 February; *La Favorite* and *Les Jumeaux de Bergame*, 12 February; *Sigurd*, 15 February; *Faust*, 7 March; *Les Huguenots*, 10 March; *Sigurd*, 15 March; *Les Huguenots*, 29 March; *Robert le Diable*, 31 March.

> Archives Nationales, Paris, AJ13.

March

Plans advance for the Impressionist exhibition, despite Degas's obstinate insistence on the inclusion of his friends and the rejection of others. Pissarro writes to his son Lucien about Degas's reaction to Seurat's *A Sunday Afternoon on the Island of La Grande-Jatte* (fig. 194), which the young artist intended to exhibit. "Degas is a hundred times more loyal. I told Degas that Seurat's painting was very interesting. 'I would have noted that myself, Pissarro, except that the painting is so big!' Very well—if Degas sees nothing in it so much the worse for him."

> Lettres Pissarro 1950, p. 101; Pissarro Letters 1980, p. 74.

5 March

In a letter to his son Lucien, Pissarro vents his frustration with Degas, who is insisting that the upcoming Impressionist exhibition be held from 15 May to 15 June. "The exhibition is completely blocked. . . . We shall try to get Degas to agree to showing in April, if not we will show without him. . . . Degas doesn't care, he doesn't have to sell, he will always have Miss Cassatt and not a few exhibitors outside our group, artists like Lepic."

> Lettres Pissarro 1950, p. 97; Pissarro Letters 1980, p. 71.

April

Zola publishes *L'Oeuvre*, which appeared previously in installments in *Gil Blas*. In it, Zola paints an unflattering portrait of a modern painter who fails to realize his ambitions; the character is a composite of several Impressionist painters. Four years later, Daniel Halévy asks Degas if he has read *L'Oeuvre*; he replies that he has not, and calls Zola's method puerile.

> Halévy 1960, p. 47; Halévy 1964, p. 41.

April–May

Twenty-three works by Degas are exhibited in New York in an exhibition entitled *Works in Oil and Pastel by the Impressionists of Paris*, shown first at the American Art Galleries (10 April) and later at the National Academy of Design (25 May). Durand-Ruel has organized the exhibition, his first in America, as a promotional effort, yet the artists he represents prefer to keep their best work for the upcoming Impressionist exhibition in Paris. Among the important works included are *The Dance Class* (cat. no. 219), lent by Alexander Cassatt, and one of the two versions of *The Ballet from "Robert le Diable"* (L294 or L391; see cat. nos. 103, 159), but the majority of the works by Degas are smaller items such as pastelized etchings and monotypes, and colored drawings such as *Dancer with Red Stockings* (cat. no. 261). The critical reception varies greatly. Some works are sold from the exhibition.

> Venturi 1939, I, pp. 77–78; *The Critic*, New York, 17 April 1886, pp. 195–96; *The Mail and Express*, New York, 21 April 1886, p. 3; *The Tribune*, New York, 26 April 1886, p. 3.

At the Opéra: *Sigurd*, 5 April; *L'Africaine*, 7, 12, and 16 April; *Sigurd*, 28 April; *L'Africaine*, 5 May; *Le Cid*, 7 May; *L'Africaine*, 8 May; *Guillaume Tell*, 10 May; *Rigoletto* and *Coppélia*, 14 May; *Henri VIII*, 17 May; *Sigurd*, 21 May; *La Juive*, 26 May.

> Archives Nationales, Paris, AJ13.

15 May

Opening of the *8me Exposition de peinture* (the last Impressionist exhibition), at 1 rue Laffitte, in which Seurat's *A Sunday Afternoon on the Island of La Grande-Jatte* (fig. 194) is the greatest novelty. As be-

Fig. 193. Montalba (Naples), *Lucie Degas at Nineteen*, 1886. Photograph, vintage print. Private collection, Naples

The milliners are praised for their color, drawing, and handling, but the nudes create a sensation. Almost every review focuses on the bathers, overshadowing even Seurat's spectacular entry. The frank ugliness of some of the nudes and the squalor of their surroundings are appalling to some critics, exciting to others. The notion of Degas's misogyny is formulated for the first time by the critics of this exhibition.

> 1986 Washington, D.C., pp. 430–34, 452–54, 495–96; see also Thomson 1986.

summer

Sometime after the closing of the Impressionist exhibition, Degas and Cassatt exchange pictures: Degas gives Cassatt his *Woman Bathing in a Shallow Tub* (cat. no. 269) and Cassatt gives Degas her "Study" now known as *Girl Arranging Her Hair* (fig. 297). (Both pictures were included in the group exhibition at 1 rue Laffitte.) Degas prominently displays the Cassatt in his sitting room, where it is to be seen in photographs taken in the 1890s (see fig. 196).

> Vollard 1924, pp. 42–43; letter from Cassatt to Louisine Havemeyer, 12 December 1917, Archives, The Metropolitan Museum of Art, New York; Mathews 1984, pp. 329–30.

June–August

At the Opéra: *Henri VIII*, 9 June; *La Favorite* and *La Korrigane*, 25 June; *Sigurd*, 26 July; *Guillaume Tell*, 2 August; *La Juive*, 23 August.

> Archives Nationales, Paris, AJ13.

13 August

Degas sends a pastel to Durand-Ruel, because the dealer has delayed fetching it from the artist's studio. The Durand-Ruel stock books show the purchase in August and September of two racecourse scenes in pastel and another in oil, for Fr 800, Fr 800, and Fr 2,500 (stock nos. 830, 851, 867). These are the first sales to Durand-Ruel after a hiatus of one year. Degas reprimands his dealer rudely for not paying quickly enough: "Please send me some money *this afternoon*. Try to give me half the sum each time I send you something. Once my fortunes have been restored, I might well keep nothing for you and so free myself completely from debt. At the moment I am horribly embarrassed. It is for that reason that I was anxious to sell this particular pastel to someone other than you, so as to be able to keep all the money."

> Lettres Degas 1945, XCVI bis, p. 123; Degas Letters 1947, no. 106, p. 121.

fore, only artists who did not exhibit at the Salon could participate in the Impressionist exhibition. Monet, Renoir, Caillebotte, and Sisley disqualify and decline to exhibit.

Degas evidently exhibits only ten of the fifteen works he has listed in the catalogue. The listed works are: "Femme essayant un chapeau chez sa modiste" (cat. no. 232); "Petites modistes" (fig. 207); "Portrait" (*Portrait of Zacharian*, L831, private collection); "Ébauche de portraits" (not shown, possibly *Six Friends at Dieppe*, fig. 190); "Têtes de femme" (not shown, undoubtedly the *Mlle Salle*, L868, private collection); and a group of ten untitled nudes under the heading "Suite de nus de femmes se baignant, se lavant, se séchant, s'essuyant, se peignant ou se faisant peigner." Seven of the ten nudes are identifiable in the various reviews: *Woman Bathing in a Shallow Tub* (fig. 183); *Woman Bathing in a Shallow Tub* (cat. no. 269); *The Morning Bath* (cat. no. 270); *Woman Bathing in a Shallow Tub* (cat. no. 271); *Nude Woman Drying Herself* (fig. 195); *Nude Woman Pulling On Her Chemise* (fig. 186); and a pastel of bathers, out of doors, with a dog (very likely L1075, private collection; L1075 closely resembles the pastel described in reviews, but modern photographs seem to indicate that it is a work that was substantially revised by Degas, perhaps around 1900, and so the identification remains speculative until further examination is possible).

Fig. 194. Georges Seurat, *A Sunday Afternoon on the Island of La Grande-Jatte*, 1884–86. Oil on canvas, 81½ × 121¼ in. (207 × 308 cm). The Art Institute of Chicago

Fig. 195. *Nude Woman Drying Herself* (BR82), dated 1884. Pastel, 19⅝ × 19⅝ in. (50 × 50 cm). The Hermitage Museum, Leningrad

September–October
 At the Opéra: *Guillaume Tell*, 10 September; *Faust*, 1 October; *Guillaume Tell*, 6 October; *La Favorite* and *Les Deux Pigeons*, 18 October; *Le Freischutz* and *Les Deux Pigeons*, 22 October; *Rigoletto* and *Les Deux Pigeons*, 29 October.
 Archives Nationales, Paris, AJ13.

20 October
 Sells a "Danseuse" (possibly L735, The Metropolitan Museum of Art, New York) to Durand-Ruel for Fr 500 (stock no. 882). On 30 October he sells another "Danseuse" (listed as "tableau") for Fr 500 (stock no. 887).
 Journal and stock book, Durand-Ruel archives, Paris.

25 October
 Vincent van Gogh notes "a very nice Degas" at the gallery where his brother works, Boussod et Valadon, 19 boulevard Montmartre. (The Boussod et Valadon ledgers show no trace of a Degas in the gallery at this time, but it is possible that some of the accounts on the advanced artists represented by Theo were kept apart from those of the main gallery.)
 Rewald 1986, p. 13.

November
 At the Opéra: *Faust*, 2 November; *Le Freischutz* and *Les Deux Pigeons*, 12 November; *Faust*, 19 November; *La Juive*, 22 November.
 Archives Nationales, Paris, AJ13.

Having split with Seurat and Signac, Gauguin turns to Degas for collegial support. Pissarro writes to his son Lucien that "Gauguin has become intimate with Degas once more, and goes to see him all the time—isn't this seesaw of interests strange?"
 Lettres Pissarro 1950, p. 111; Pissarro Letters 1980, p. 81; see also Roskill 1970, p. 264.

11 November
 Sells "Danseuses sous un arbre" (L486, Norton Simon Museum, Pasadena) to Durand-Ruel for Fr 500 (stock no. 890). Henry Lerol[l] buys it on 22 November (see fig. 216).
 Journal and stock book, Durand-Ruel archives, Paris.

December
 At the Opéra: *L'Africaine*, 8 December; *Patrie*, 20 and 29 December.
 Archives Nationales, Paris, AJ13.

1887

Dated work (the last work but one that Degas dated in the 1880s): *Portrait of a Woman (Rosita Mauri?)* (cat. no. 277).

Death of Bartholomé's wife Périe. Bartholomé abandons painting and dedicates himself to sculpture, in which endeavor he is greatly encouraged by Degas.

Publication of *Animal Locomotion* by Eadweard Muybridge; Degas presumably obtains a copy.
 See "Degas and Muybridge," p. 459.

2 January
 Degas writes an irritated letter to Faure: "I received the other day on an *open* telegram your request for a reply to your last letter. It is getting more and more embarrassing for me to be in your debt. . . . I was necessary to put aside everything of M. Faure's in order to make others that would enable me to live. I can only work for you in my spare moments, and they are rare. . . . Accept, my dear M. Faure, my sincere regards."
 Lettres Degas 1945, XCVII, pp. 123–24; Degas Letters 1947, no. 107, pp. 121–22; see "Degas and Faure," p. 221.

25 January
 Pissarro is considering selling a Degas pastel in his possession in order to raise desperately needed cash, but is reluctant to do so lest Degas take offense and retaliate. However, when Paul Signac tells him it could be worth Fr 1,000 he decides to see the dealer Portier. Later, in conversation with Pissarro, Portier states his conviction that because Monet, Renoir, Pissarro, and others will contribute to the Exposition Internationale at Galerie Georges Petit rather than to their own group shows, Degas's Société Anonyme des Artistes will be finished. (In fact, the 1886 exhibition of the Société was the last.)
 Lettres Pissarro 1950, pp. 132, 139–40; Pissarro Letters 1980, pp. 98, 103–04.

31 January
 Degas sells "Convalescente" (cat. no. 114) to Durand-Ruel for Fr 800 (stock no. 919). (This is the only sale to the dealer this year.)
 Journal and stock book, Durand-Ruel archives, Paris.

February–May
 At the Opéra: *Patrie*, 14 February; *Sigurd*, 16 February; *Rigoletto* and *Les Deux Pigeons*, 2 March; *Les Huguenots*, 12 March [?]; *Sigurd*, 14 March; *Aïda*, 16 and 30 March; *Sigurd*, 3 April; *Aïda*, 27 April; *La Favorite* and *Les Deux Pigeons*, 29 April; *Faust*, 9 May; *Sigurd*, 20 May; *Le Prophète*, 25 May.
 Archives Nationales, Paris, AJ13.

5–6 May
 Two "pastels of racehorses and jockeys by Degas" are on view at Moore's Art Gallery, New York (nos. 96 [unidentified] and 97 [BR111, The Carnegie Museum of Art, Pittsburgh]). They are auctioned, and one sells for $400. (Durand-Ruel had organized the sale in an attempt to improve the American market for his pictures. The results were mixed—the works by Degas sold cheaply, while landscapes by Monet fetched over $1,000 apiece.)
 Montezuma, "My Notebook," *Art Notebook* 17, June 1887, p. 2; *New York Times*, 7 May 1887, p. 5.

July

At the Opéra: *Le Prophète*, 8 and 25 July.

Archives Nationales, Paris, AJ13.

22 July

First recorded purchase of a Degas by Theo van Gogh for Galerie Boussod et Valadon: "Femme accoudée près d'un pot de fleurs" (cat. no. 60), bought directly from the artist for Fr 4,000. (Over the next three years, van Gogh will acquire several dozen paintings and pastels by Degas, either directly from the artist or from other dealers, collectors, and auctioneers.)

Rewald 1986, p. 89.

August–December

At the Opéra: *Le Cid*, 5 August; *Robert le Diable*, 17 August; *Aïda*, 26 August and 12 September; *Rigoletto* and *Les Deux Pigeons*, 21 September; *Guillaume Tell*, 23 September; *Les Huguenots*, 26 September; *Aïda*, 5 October; *Le Prophète*, 12 October; *Aïda*, 17 October; *Don Juan*, 26 and 31 October; *Faust*, 4 November; *Don Juan*, 11 and 16 November; *Rigoletto* and *Coppélia*, 9 and 23 December.

Archives Nationales, Paris, AJ13.

1888

According to Theo van Gogh's address book, Degas moves from 21 rue Pigalle to 18 rue de Boulogne (now rue Ballu) sometime between 1888 and 1890 (see 29 April 1890).

Ronald de Leeuw and Fieke Pabst, "Le carnet d'adresses de Theo van Gogh," in *Van Gogh à Paris* (exhibition catalogue), Paris: Réunion des Musées Nationaux, 1988, p. 356, no. 64.

Durand-Ruel, whose business has recovered from the financial disasters of 1882–84, opens a gallery in New York.

Venturi 1939, I, p. 82.

January

Works by Degas are shown at Galerie Boussod et Valadon in a small show arranged by Theo van Gogh. Among them are: *The Splinter* (L1089, private collection); *The Bath* (fig. 197); *Woman Leaving Her Bath* (cat. no. 250); *Nude Woman Kneeling* (L1008); and *The Tub* (fig. 247). On view at Durand-Ruel this month: "Rampe de danseuses" (cat. no. 259); "Le baisser du rideau" (L575; see fig. 103); and a pastel of a dancer vertiginously balanced in an arabesque penchée (either L591, or L735, The Metropolitan Museum of Art, New York).

Félix Fénéon, "Calendrier de janvier," *La Revue Indépendante*, February 1888; reprinted in Fénéon 1970, I, pp. 95–96.

28 March

At the Opéra: *Aïda*.

Archives Nationales, Paris, AJ13.

April

"Le foyer de la danse" (cat. no. 107) is shown at the Glasgow International Exhibition.

Four lithographs by the engraver George William Thornley after works by Degas, three "danseuses" and one "femme à la toilette" (all unidentified), are shown at Galerie Boussod et Valadon. Fénéon writes an appreciative review in the May issue of *La Revue Indépendante*. (Thornley executed fifteen lithographs in colored ink after Degas. The full portfolio was published in April 1889.)

Félix Fénéon, "Calendrier d'avril," *La Revue Indépendante*, May 1888; reprinted in Fénéon 1970, I, p. 111; see also Reed and Shapiro 1984–85, pp. lvii, lxxi n. 11.

18 April

For the first time since January 1887 Degas sells a work to Durand-Ruel, "La mère de la danseuse," for Fr 1,500 (stock no. 1584). Durand-Ruel sells it on 8 June to Paul-Arthur Chéramy. (This work is not readily identified; it does not appear to be one of the versions of *The Mante Family* [L971, private collection; L972, Philadelphia Museum of Art].)

Journal, Durand-Ruel archives, Paris.

Fig. 196. *Élie Halévy and Mme Ludovic Halévy in Degas's Living Room*, c. 1896–97. Photograph, modern print from a glass negative in the Bibliothèque Nationale, Paris. On the wall is Mary Cassatt, *Girl Arranging Her Hair* (fig. 297)

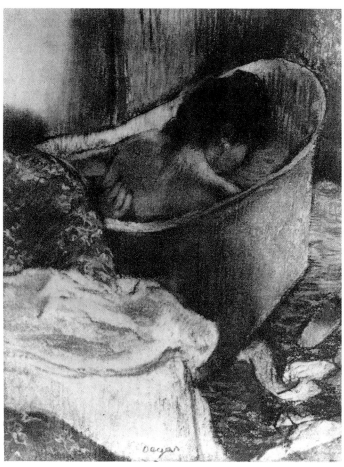

Fig. 197. *The Bath* (L1010), c. 1883–86. Pastel, 15 × 11 in. (38 × 28 cm). Location unknown

April–June

At the Opéra: *Henri VIII*, 30 April; *Sigurd*, 1 and 13 June.

Archives Nationales, Paris, AJ13.

6 June

At the Pertuiset sale, Degas buys Manet's *The Ham* (RWI, no. 351, Glasgow Art Gallery) and *A Pear* (RWI, no. 355).

8 June

Sells a painting, "Courses" (cat. no. 237), to Theo van Gogh for Fr 2,000.

Rewald 1986, p. 89.

9 July

Sells "Quatre chevaux de course" (L446) to Theo van Gogh for Fr 1,200. (Degas is working passionately on his sculpted horses. He writes to Bartholomé: "I have not done enough horses.")

Rewald 1986, p. 89. Lettres Degas 1945, C, p. 127; Degas Letters 1947, no. III, p. 124.

10 July

Pissarro writes to his son Lucien: "Monet's recent paintings did not impress me. . . . Degas is even more severe; he considers these paintings to have been made to sell. Besides, he always maintains that Monet made nothing but beautiful decorations."

Lettres Pissarro 1950, pp. 171–72; Pissarro Letters 1980, p. 127.

August

Vincent van Gogh writes to Émile Bernard about the virility of Degas's art: "Degas's painting is vigorously masculine and impersonal precisely because he has accepted the idea of being personally nothing, but a little notary with a horror of sexual sprees. He looks at the human animals who are stronger than he is and are screwing and screwing, and he paints them well, precisely because he himself has no pretentions about screwing."

Lettres de Vincent van Gogh à Émile Bernard (edited by Ambroise Vollard), Paris, 1911, no. ix, p. 102; The Complete Letters of Vincent van Gogh, Greenwich, Conn.: New York Graphic Society, 2nd edition, 1959, III, p. 509 (translation revised).

6 August

Degas sells "Danseuses" (possibly L783, Ny Carlsberg Glyptotek, Copenhagen) to Durand-Ruel for Fr 500 (stock no. 1699). On 20

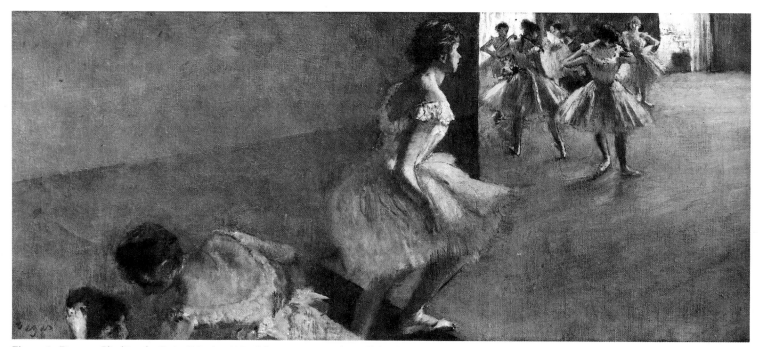

Fig. 198. *Dancers Climbing the Stairs* (L894), 1888. Oil on canvas, 15⅜ × 35⅜ in. (39 × 90 cm). Musée d'Orsay, Paris

Fig. 199. Anonymous, *Charles Haas, Mme Émile Straus, Albert Cavé, M. Émile Straus*, c. 1888. Photograph. Location unknown

August, he sells two more paintings, "Danseuses montant l'escalier" (fig. 198) for Fr 2,000 and "Danseuse" (unidentified, listed as "tableau") for Fr 500 (stock nos. 2112, 2113).

Journal and stock book, Durand-Ruel archives, Paris.

August

At the Opéra: *Aïda*.

Archives Nationales, Paris, AJ13.

August

Degas is in Cauterets. He has arrived there via Pau, where he joined Paul Lafond before going to Lourdes and then to Cauterets. It is his first "cure" at Cauterets, conveniently situated near Pau, where Lafond and their friend Alphonse Cherfils live. (Lafond is the curator of the museum at Pau, which earlier had purchased *Portraits in an Office (New Orleans)*, cat. no. 115; he was one of the first to write a book on Degas after his death. Cherfils was a collector; his son Christian dedicated a volume of poems entitled *Coeurs* to Degas the following year.)

Degas is amused by meeting the rich and famous at Cauterets, and sends reports back to entertain his friends. Among his distractions is a Pulchinello theater set up on the esplanade.

Lettres Degas 1945, CIII, CIV, CV, pp. 129–31; Degas Letters 1947, nos. 114, 115, 116, pp. 126–28.

8 August

From Cauterets Degas writes to Thornley with concerns regarding the reproductions Thornley has been making of his work. Degas wishes to take Thornley's drawing after *At the Milliner's* (cat. no. 233)

to the house of Henri Rouart in order to correct the drawing in front of the original. Degas cautions him: "You were in too much of a hurry, my dear Mr. Thornley. Matters of art must be done at leisure." (See fig. 200.)

Lettres Degas 1945, CXXI, p. 153 (incorrectly as 28 April); Degas Letters 1947, no. 133, p. 147.

summer

Four Thornley lithographs after works by Degas and one drawing by Degas are included in an exhibition at the Nederlandsche Etsclub, Amsterdam. The five works are listed in the catalogue as having been lent by Boussod et Valadon. On 4 September Pissarro writes to his son Lucien: "Theo van Gogh told me that my etchings, Degas's drawings, your woodcuts and the Seurat have created a sensation at The Hague." (He was mistaken about the city.)

Reed and Shapiro 1984–85, pp. lviii, lxxi n. 16; Lettres Pissarro 1950, p. 175; Pissarro Letters 1980, pp. 130, 388 (Additional Notes, c).

30 August

From Cauterets, Degas writes to Mallarmé saying he has quite neglected Mary Cassatt, so much so that he no longer has her address.

Unpublished letter, Bibliothèque Littéraire Jacques Doucet, Paris, MVL3283[2].

September–October

At the Opéra: *Faust*, 21 September; *La Favorite* and *La Korrigane*, 22 October.

Archives Nationales, Paris, AJ13.

22 October

Sells "Jockey" (fig. 201) to Durand-Ruel for Fr 300 (stock no. 2159); it is purchased by Mary Cassatt for her brother Alexander on 18 December 1889.

Journal and stock book, Durand-Ruel archives, Paris.

November

At the Opéra: *Faust*, 9 November; *Roméo et Juliette*, 28 November.

Archives Nationales, Paris, AJ13.

Fig. 200. George William Thornley, *At the Milliner's*, after Degas, 1888. Lithograph, blue ink on off-white paper, 9⅜ × 10¾ in. (23.4 × 27.1 cm). The Art Institute of Chicago

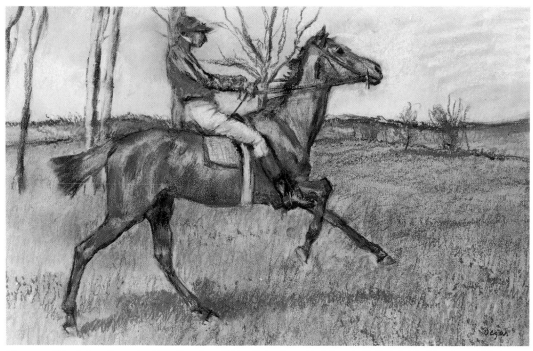

Fig. 201. *The Jockey* (L1001), 1888. Pastel, 12¾ × 19⅝ in. (32.4 × 48.8 cm). Philadelphia Museum of Art

13 November

Theo van Gogh writes to Gauguin: "Degas is so enthusiastic about your works that he is speaking about them to a lot of people, and he is going to buy the canvas representing a spring landscape." (The Gauguin in question may have been *Two Breton Girls in a Meadow* [W249], although the identification has been disputed. Degas's admiration for Gauguin's work endured despite the younger artist's obdurate behavior.)

> Paul Gauguin: 45 lettres à Vincent, Théo et Jo van Gogh (edited by Douglas Cooper), [The Hague/Lausanne], 1983, no. 8 n. 1, p. 67; The Complete Letters of Vincent van Gogh, Greenwich, Conn.: New York Graphic Society, 2nd edition, 1959, III, T3a, p. 534.

November

In a letter to the artist Émile Schuffeneker, Gauguin asks that his etchings by Degas be sent to him at Arles. (He evidently kept them with him for the remainder of his life, for he painted one of them, *The Little Dressing Room* [RS41], in the background of his 1901 *Still Life with Sunflowers* [fig. 202].)

> Lettres Gauguin 1984, no. 180, p. 281.

winter 1888–89

Degas writes eight sonnets that take as their subjects some of the people and things that preoccupied him in his painting: horses, dancers, singers. Their tone varies from the playful to the magisterial. Some are titled, such as "Pur sang" (Thoroughbred); others carry dedications that reveal the artist's intention, such as those dedicated to the dancer Mlle Sanlaville, the singer Rose Caron, and the parrot belonging to Mary Cassatt. The sonnets remain unpublished until 1918, but manuscript copies evidently circulate among the artist's friends. Mallarmé mentions them in a letter of 17 February 1889 to Berthe Morisot: "His own poetry is taking up his attention, for—and this will be the notable event of this winter—he is on his fourth sonnet. In reality, he is no longer of this world; one is perturbed before his obsession with a new art in which he is really quite proficient."

Mallarmé goes on to cite the works by Degas on view at Boussod et Valadon: "This does not prevent him from exhibiting, on the boulevard Montmartre, next to the incomparable landscapes of

Monet, marvelous works—dancing girls, bathing women, and jockeys." (For the sonnet dedicated to Mlle Sanlaville, see cat. no. 262.)

> Lafond 1918–19, pp. 127–38; Degas Sonnets 1946; Morisot 1950, p. 145; Morisot 1957, p. 147.

3 December

At the Opéra: *Roméo et Juliette*.

> Archives Nationales, Paris, AJ13.

Fig. 202. Paul Gauguin, *Still Life with Sunflowers*, 1901. Oil on canvas, 30¼ × 25⅝ in. (76.8 × 65.1 cm). Jointly owned by The Metropolitan Museum of Art, New York, and Joanne Toor Cummings

Fig. 203. Conte Giuseppe Primoli, *Degas Leaving a Public Urinal*, 1889. Photograph, modern print from a glass negative in the Bibliothèque Nationale, Paris

8 December
Degas writes to the Belgian critic Octave Maus, who has asked him to exhibit with Les XX in Brussels; he declines the request, and will do so again the following year.

Lettres Degas 1945, CVI, p. 132; Degas Letters 1947, no. 117, p. 129.

1889
Huysmans's *Certains* is published, with a long chapter on the nudes exhibited by Degas at the 1886 Impressionist exhibition.

4 January
At the Opéra: *Roméo et Juliette*.

Archives Nationales, Paris, AJ13.

23 January–14 February
Two lithographs by Degas are shown in Durand-Ruel's *Exposition des peintres-graveurs*. In his preface to the catalogue, Philippe Burty praises the "renaissance of black and white."

Venturi 1939, I, p. 83.

10 March
The artist Odilon Redon (1840–1916) writes in his journal: "But Degas is an artist. He is one, very exultant and free. Coming from Delacroix (of course without his lyricism and his passion!) what a science of juxtaposed tones, exalted, wanted, premeditated, for impressive aims! He is a Realist. Perhaps he will be dated by *Nana*. It is Naturalism, Impressionism, the first stage of the new style. But this proud man will be credited for having all his life held out for liberty. . . . His name, more than his oeuvre, is a synonym of character, it is about him that the principle of independence will always be discussed. . . . Degas would have the right to have his name inscribed high on the temple. Respect here, absolute respect."

Odilon Redon, *À soi-même: journal (1867–1915)*, Paris: H. Floury, 1922, pp. 92–93; *To Myself: Notes on Life, Art and Artists*, New York: George Braziller, 1986, pp. 79–80.

5 April
Degas sells two works to Durand-Ruel: "Danseuse bleue" for Fr 500 and "Danseuse rouge" for Fr 250 (both unidentified; stock nos. 2308, 2309).

Journal and stock book, Durand-Ruel archives, Paris.

April
At the Opéra: *Roméo et Juliette*, 10 April; *La Favorite* and *La Korrigane*, 29 April.

Archives Nationales, Paris, AJ13.

13 April
G.-Albert Aurier (under the pseudonym Luc Le Flaneur) mentions in *Le moderniste* that works by Degas are on view at Boussod et Valadon: "dancers, jockeys, races, exquisite feminine movements." On 11 May, he writes again that at Theo van Gogh's (Boussod et Valadon) there are "some little dancers, some naughtiness in the wings, some jockeys and some horses."

Luc Le Flaneur, "Enquête des choses d'art," *Le Moderniste*, 13 April–11 May 1889, in *Van Gogh: A Retrospective* (edited by Susan Alyson Stein), New York: Hugh Lanter Levin Associates, 1986, pp. 176–78.

16 April
Degas sells "Danseuses, contrebasses" (unidentified painting, listed as 22 × 16 cm) to Theo van Gogh for Fr 600.

Rewald 1986, p. 89.

spring
Exposition Internationale in Paris; construction of the Eiffel Tower is completed. Degas refuses to exhibit in the fine arts pavilion.

Jeanniot 1933, p. 174.

May
Sells two pictures to Theo van Gogh: "Deux danseuses" (unidentified, listed as 22 × 16 cm) on 14 May for Fr 1,200 and "Danseuse bleue et contrebasse" (unidentified) on 23 May for Fr 600.

Rewald 1986, p. 89.

25 May
The pioneering collection of Henry Hill of Brighton is sold at Christie's, London. Included in it are six works of the 1870s by Degas, nos. 26–31: "A 'Pas de deux'" (mistitled, cat. no. 106), 43 gns, 1 s.; "Maître de Ballet" (cat. no. 129), 56 gns, 14 s.; "A Rehearsal" (cat. no. 128), 63 gns; "A Rehearsal" (cat. no. 124), 69 gns, 6 s.; "A Rehearsal" (L362, private collection), 61 gns, 19 s.; and "Ballet Girls" (L425, Courtauld Institute Galleries, London), 64 gns, 1 s.

Christie's, London, 25 May 1889, "Modern Pictures of Henry Hill, Esq."; Pickvance 1963, p. 266.

13 June
Writes to Bartholomé that he is working on his sculpture *The Tub* (cat. no. 287).

Lettres Degas 1945, CVIII, p. 135; Degas Letters 1947, no. 119, p. 132 (the reference is incorrectly related by Guérin to *The Little Fourteen-Year-Old Dancer*, cat. no. 227).

26 June
At the Opéra: *La Tempête*.

Archives Nationales, Paris, AJ13.

10 July
Degas's sister Marguerite Fevre and her family sail from Le Havre for Buenos Aires. Degas writes to Lafond the following month: "They expect to be happier there than here, and from the bottom of my heart, I hope they will be."

Sutton and Adhémar 1987, p. 163.

Fig. 204. Giovanni Boldini, *Edgar Degas*, 1883. Black crayon, 11¼ × 8 in. (29 × 20 cm). Private collection

25 July

Thanks the Italian photographer Conte Giuseppe Primoli (1851–1927) for his instantaneous photograph of the top-hatted Degas leaving a public urinal (fig. 203). He points out that "if it were not for the person going in, I would have been caught buttoning my trousers like a fool, and the whole world would be laughing."

Lamberto Vitali, *Un fotografo fin de siècle: il conte Primoli*, Turin: Einaudi, 1968, p. 78.

2 August

At the Opéra: *La Tempête* and *Henri VIII*.

Archives Nationales, Paris, AJ13.

29 August

From Cauterets, Degas writes to the fashionable Italian portrait painter Giovanni Boldini (1845–1931) concerning their planned trip to Spain. Jokingly he wonders whether Boldini will travel incognito. He suggests that they meet in Bayonne, "and set off immediately for Spain without any wait in Bonnat's country." (See fig. 204.)

Lettres Degas 1945, CXI, CXII, pp. 139–41; Degas Letters 1947, nos. 122, 123, pp. 134–36 (letters given in reverse chronology by Guérin).

early September

From Pont-Aven, Gauguin writes to Bernard: "You know how I esteem the work of Degas, and yet I feel that there is something he lacks—a heart that is moved." (On 17 January 1886, Degas had written to Bartholomé from Naples: "Even this heart of mine has

something artificial. The dancers have sewn it into a bag of pink satin, pink satin slightly faded, like their dancing shoes.")

Lettres de Gauguin à sa femme et à ses amis (edited by Maurice Malingue), Paris: Éditions Bernard Grasset, 1946, LXXXVII, p. 166; Paul Gauguin, *Letters to His Wife and Friends* (translated by Henry J. Stenning), Cleveland/New York: World Publishing, 1949, no. 87, p. 124 (translation revised); Lettres Degas 1945, XC, p. 118; Degas Letters 1947, no. 99, p. 116.

8 September

In the company of Boldini, Degas reaches Madrid. He notes the price of the journey in his notebook. He writes to Bartholomé inviting him to join them. Having arrived at 6:30 A.M., he is at the Prado by 9:00, and plans to see a bullfight the same day. He intends to tour Andalusia and "set foot in Morocco."

Reff 1985, Notebook 37 (BN, Carnet 6, p. A); Lettres Degas 1945, CXIV, pp. 143–44; Degas Letters 1947, no. 125, pp. 138–39.

18 September

Degas is in Tangiers. He writes to Bartholomé, recalling that "Delacroix passed here," and adds that he will return to Paris via Cadiz and Granada.

Lettres Degas 1945, CXV, p. 145; Degas Letters 1947, no. 126, p. 140.

30 October–11 November

Some early works by Gauguin, as well as paintings and drawings from his personal collection (by Degas, Guillaumin, Manet, Cassatt, Forain, Cézanne, Pissarro, Sisley, and Angrand), are shown by the Copenhagen Art Society, *Scandinavian and French Impressionists* (no catalogue).

Merete Bodelsen, "Gauguin, the Collector," *Burlington Magazine*, CXII:810, September 1970, p. 602.

November–December

At the Opéra: *Roméo et Juliette*, 2 November; *Le Prophète*, 20 November; *La Tempête* and *Lucie de Lammermoor*, 14 December.

Archives Nationales, Paris, AJ13.

17 December

Sells three drawings to Durand-Ruel, all of dancers, at Fr 300, Fr 200, and Fr 100 respectively (stock nos. 2589–2591).

Journal, Durand-Ruel archives, Paris.

1890

Dated work (July 1890): *Gabrielle Diot* (fig. 205).

This is apparently the year in which Degas writes his charming letter to Lepic requesting a dog that he could offer to Mary Cassatt. "It is a young [male] dog that she needs, so that he may love her." (This letter is one of the few evidences of a continuing warm relationship between Degas and Cassatt.)

Lettres Degas 1945, CXIX, p. 151; Degas Letters 1947, no. 131, p. 145.

17 January

Degas sells "Danseuse avant l'exercice" (unidentified, listed as 62 × 48 cm) to Theo van Gogh for Fr 1,050. (It appears that Theo brought his sister Wil along with him to Degas's studio. Theo wrote to his brother: "[Degas] trotted out quite a number of his things in order to find out which of them she liked best. She understood those nude women very well." Vincent then wrote Wil to tell her how lucky she was to have visited Degas in his home.)

Rewald 1986, pp. 52–90; *Verzamelde Brieven van Vincent Van Gogh*, Amsterdam/Antwerp: Wereldbibliotheek, 1954, p. 286 (letter T28, dated 9 February 1890); p. 180 (letter W20, mid-February 1890); *The Complete Letters of Vincent van Gogh*, Greenwich, Conn.: New York Graphic Society, 2nd edition, 1959, III, pp. 467, 564 (letter T28, dated 9 February 1890; letter W20, mid-February 1890).

31 January

Sells two portraits to Durand-Ruel: "Portrait de femme" (L923) for Fr 1,600 and "Portrait d'homme" (unidentified) for Fr 400 (stock nos. 2630, 2631).

Journal and stock book, Durand-Ruel archives, Paris.

8 March

Sells four paintings, none of them recent (for example, L133, "Portrait de M. Roman"), to Theo van Gogh for a total of Fr 5,000.

Rewald 1986, p. 90.

by 18 March

In a letter to Monet, Degas agrees to subscribe Fr 100 toward the purchase of Manet's *Olympia* for its eventual exhibition in the Louvre.

Degas Letters 1947, no. 127, p. 141.

March

At the Opéra: *Ascanio*, 21 and 26 March.

Archives Nationales, Paris, AJ13.

26–28 March

Auction sale in Paris of Baron Louis-Auguste Schwiter's collection. (According to an unpublished note by Degas, Delacroix's portrait of Schwiter [fig. 206] was acquired at this sale by the dealer Montaignac, who sold it to Degas in June 1895, in exchange for three pastels that the artist appraised at Fr 12,000.)

Unpublished note by Degas, private collection.

29 April

Degas writes to Bartholomé that he has just spent his first night in his new apartment, presumably 18 rue de Boulogne. He adds that he has visited the Japanese exhibition at the École des Beaux-Arts, which opened on 25 April, and that on Saturday he dined with Mary Cassatt at the Fleurys', the family of Bartholomé's late wife, Périe.

Lettres Degas 1945, CXX, pp. 151–52; Degas Letters 1947, no. 132, pp. 145–46.

April–May

At the Opéra: *Ascanio*, 30 April; *Salammbô* (with Rose Caron), 4 May.

Archives Nationales, Paris, AJ13.

9 May

Sells "Ancien portrait d'homme assis tenant son chapeau" (L102, c. 1861–65, Musée des Beaux-Arts, Lyons) to Theo van Gogh for Fr 2,000.

Rewald 1986, p. 90.

May

Goes to Brussels, perhaps among other reasons to see Rose Caron again in *Salammbô*.

Lettres Degas 1945, CXX, pp. 151–52; Degas Letters 1947, no. 132, pp. 145–46.

June

At the Opéra: *Coppélia* and *Zaïre*, 2 June; *Le Rêve* and *Zaïre*, 9 June.

Archives Nationales, Paris, AJ13.

10 June

Sells "Étude d'anglaise" and "Étude de femme" to Theo van Gogh for Fr 1,000 each (each listed as 40 × 32 cm, possibly L951 bis and L952).

Rewald 1986, p. 90.

2 July

Sells "Danseuses, orchestre" (unidentified) to Durand-Ruel for Fr 500 (stock no. 570). On 16 July, he sells "Trois danseuses" (L1208) for Fr 800 (stock no. 596). On 17 July, he sells "Danseuses répétition" (unidentified) for Fr 1,500 (stock no. 597).

Journal and stock book, Durand-Ruel archives, Paris.

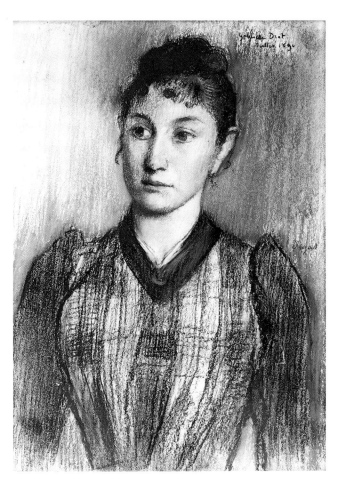

Fig. 205. *Gabrielle Diot* (L1009), dated 1890. Pastel, 24 × 17⅜ in. (61 × 44 cm). Art market, Hamburg

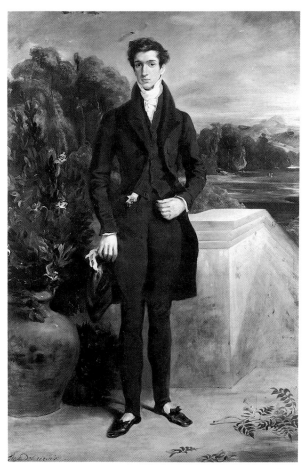

Fig. 206. Eugène Delacroix, *Baron Schwiter*, 1826–30. Oil on canvas, 85¾ × 56½ in. (218 × 143.5 cm). The National Gallery, London

29 July

Vincent van Gogh dies of a self-inflicted gunshot wound. (There is
no record of Degas's reaction to the news. At some point, probably
in the 1890s, he acquired from Vollard van Gogh's *Two Sunflowers*
[1887, F376, Kunstmuseum Bern] in exchange for "deux petits cro-
quis de danseuses," as well as an 1887 *Still Life* [F382, The Art In-
stitute of Chicago] and a drawing.)

> *Paul Gauguin: 45 lettres à Vincent, Théo et Jo van Gogh* (edited by Douglas
> Cooper), [The Hague/Lausanne], 1983, no. 34, p. 253 n.; unpublished
> note by Degas, private collection.

August

Degas is at Cauterets for his health. At nearby Pau he sees Lafond and
spends three days with Cherfils before going on to see his brother
Achille in Geneva.

> Lettres Degas 1945, CXXIV, CXXV, pp. 154–57; Degas Letters 1947,
> nos. 136, 137, pp. 148–51.

20 August

Sells "Tête de femme, étude" (L370) to Durand-Ruel for Fr 500
(stock no. 649).

> Journal, Durand-Ruel archives, Paris.

3 September–18 October

"Avant le départ," a pastel, is lent by Durand-Ruel, New York, to
the Interstate Industrial Exposition in Chicago (no. 95).

15 September

At the Opéra: *L'Africaine.*

> Archives Nationales, Paris, AJ13.

12 October

Theo van Gogh is hospitalized at the sanatorium run by Dr. Blanche,
the father of Jacques-Émile Blanche. Now that his association with
Boussod et Valadon is terminated, he can no longer purchase works
from Degas. He dies in Utrecht on 25 January 1891. For a short
time, Maurice Joyant attempts to maintain the gallery's ties with
advanced painters—staging, for example, a Morisot retrospective
in 1892—but before his departure in 1893, Joyant succeeds in buying
only two works by Degas, neither directly from the artist.

> Rewald 1986, pp. 73–90.

232

232.

At the Milliner's

1882
Pastel on pale gray wove paper (industrial wrap-
 ping paper, stamped on verso: OLD RELIABLE
 BOLTING EXPRESSLY FOR MILLING); adhered to
 silk bolting in 1951
29¾ × 33¾ in. (75.6 × 85.7 cm)
Signed and dated in black chalk upper right:
 1882/Degas
The Metropolitan Museum of Art, New York.
 Bequest of Mrs. H. O. Havemeyer, 1929.
 H. O. Havemeyer Collection (29.100.38)

Exhibited in New York

Lemoisne 682

This work is perhaps the best known of the group of pastels in the milliner series. Durand-Ruel bought it from the artist in July 1882, presumably not long after it was completed, and sold it three months later to a client of the gallery, Mme Angello, who consented to lend it to the eighth Impressionist exhibition, in 1886, where it was joined by *The Little Milliners* (fig. 207). It was enthusiastically noted by most reviewers of the exhibition, but curiously, it was not discussed in any depth: Huysmans neglected it entirely,[1] Octave Mirbeau mentioned only "two milliners' interiors,"[2] and Félix Fénéon at the end of his review cited "two pictures of milliners in their shops."[3] Of the French critics of the 1886 exhibition, only Jean Ajalbert departed from the majority, who spoke primarily of the deeply saturated color and of the simplicity of the background: "A woman is trying on a hat before a mirror, which obliquely conceals the milliner from view. She has admired this hat for a long time in the shopwindow, or envied it on another woman. She forgets herself in scrutinizing her new head; she imagines it with some alterations, a ribbon, a pin. . . . What a natural pose, what truth there is in this incomplete toi-

lette, hastily done in order to run to the milliner's."[4] George Moore referred to the pastel in 1888 when he wrote of the "fat, vulgar woman" of whom "you can tell exactly what her position in life is."[5] But when the dealer Alexander Reid exhibited the pastel in London in January 1892, and when its new owner, the well-known Glaswegian collector T. G. Arthur, lent it later that year to the Glasgow Institute of the Fine Arts, it aroused much more interest; its anecdotal qualities fascinated Anglo-Saxon observers.

Seeing *At the Milliner's* again in London, George Moore commented on it at greater length,[6] and an anonymous contributor to the Glasgow *Herald* was moved to write a subtle appreciation:

It is subdued in colour, is in every way unobtrusive, and yet it asserts itself with quiet persistence. How do we explain this? Something of it is due to the novelty of the grouping. The lady trying on a hat in front of the cheval mirror is not a *grande dame*, incapable of raising her arms to her head, but an energetic woman who relies on her own "fixing" and her own judgment; the *modiste . . .* remains timidly in the background. The artist, in fact, cuts her off behind the upright looking-glass, and concentrates attention on the purposeful purchaser, whose sturdy form is accentuated against a terracotta background. It is all delightfully unstudied, which means, of course, that what seems to be a "snap shot" is the result of felicity afore-thought.[7]

This critic, like Ajalbert, thus identified the two most striking features of the picture: the extraordinary slicing of both the composition and the shopgirl by the cheval glass, and the unusual attire of the client trying on a hat. Even though Degas by 1882 had often exploited the expressive possibilities of the eccentric cropping of a figure, the shopgirl blocked by her mirror—treatment cruel or comic, depending on one's point of view—still seemed novel, and it is noteworthy that the critic for the Glasgow *Herald* associated the cropping with a "snap shot" aesthetic.

Commentators have since been unanimous in their interpretation of the subordinated shopgirl: she is shown by Degas to be no more important than the mirror, reduced to the status of a two-handed hat stand. The role of the client, however, has been subject to a wide range of readings. From Moore's fat and vulgar woman to Lemoisne's view that the picture is "nothing other than a charming portrait,"[8] a disagreement seems to derive from the woman's incongruous style of clothing. Her olive-brown street dress is baggy in the jacket, wrinkled at the skirt, and topped with a cape sufficiently loose and unfitted to remind the viewer that she is not wearing the kind of sumptuous costume that one would expect in a painting by James Tissot or Alfred Stevens. Yet only women of bourgeois households, kept women, or upper-class ladies could afford the considerable investment that a trip to the milliner's entailed, however "hasty" a trip it was (to follow Ajalbert's interpretation). The answer to the question of the client's status may in fact lie with the identity of the model, a female artist of substantial means who evidently favored fancy hats.

Mary Cassatt, who arranged for the pastel to be sold to Louisine Havemeyer, told Mrs. Havemeyer that she had posed for the picture.[9] About 1882, Cassatt also served as the model for another pastel, *At the Milliner's*, now at the Museum of Modern Art in New York (fig. 208). When asked by Mrs. Havemeyer whether she often posed for Degas, she admitted to doing so "only once in a while when he finds the movement difficult, and the model cannot seem to get his idea."[10] It was probably for the sake of discretion and propriety that she sought to mini-

Fig. 209. Mary Cassatt, *Self-Portrait*, c. 1878. Gouache, 23½ × 17½ in. (59.8 × 44.5 cm). The Metropolitan Museum of Art, New York

mize her role in his work. Cassatt in fact was closely associated with Degas during the late 1870s and early 1880s, frequently accompanying him on his daily rounds as he gathered material for his pictures of everyday life.

Even if the features are those of Cassatt, it still is not certain that the client in *At the Milliner's* is portrayed in Cassatt's own clothes. Degas may well have invented a costume for his friend, just as he may have also for Ellen Andrée in *In a Café (The Absinthe Drinker)* (cat. no. 172). In Cassatt's own *Self-Portrait* in gouache, probably made about 1878 (fig. 209), she wears a bonnet much like the one in this picture, but her day dress is extravagant in comparison to the brown frock seen here. Thus we cannot know for certain whether Degas meant to reveal through her costume something about Cassatt's personality, so that the picture would assume the status of a portrait, or whether he intended rather to represent a fictive character, for whom Cassatt simply served as a convenient model.

1. Huysmans 1889, pp. 22–25.
2. Mirbeau 1886, p. 1.
3. Fénéon 1886, p. 264.
4. Ajalbert 1886, p. 386.
5. George Moore, *Confessions of a Young Man*, London: S. Sonnenschein, 1888 (1959 edition, p. 45; reprinted in Flint 1984, p. 66).
6. Moore 1892, pp. 19–20.
7. *The Glasgow Herald*, 20 February 1892, p. 4.
8. Lemoisne [1946–49], I, p. 123.
9. Havemeyer 1961, p. 258.
10. Ibid.

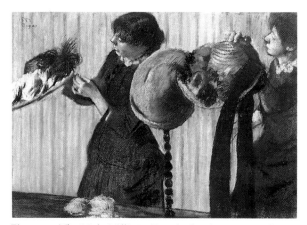

Fig. 207. *The Little Milliners* (L681), dated 1882. Pastel, 19 × 27 in. (48.3 × 68.6 cm). The Nelson-Atkins Museum of Art, Kansas City

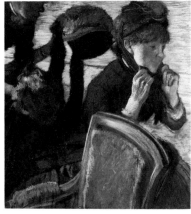

Fig. 208. *At the Milliner's* (L693), c. 1882. Pastel, 26⅜ × 26⅜ in. (67 × 67 cm). The Museum of Modern Art, New York

PROVENANCE: Sold by the artist to Durand-Ruel, Paris, 15–16 July 1882, for Fr 2,000 (stock no. 2508); acquired by Mme Angello, 45 rue Ampère, Paris,

o–12 October 1882, for Fr 3,500 or Fr 4,000; Mme Angello, Paris, 1882 until at least summer 1886. With Alexander Reid, London and Glasgow, by late 1891; acquired by T. G. Arthur, Glasgow, January 1892, for £800; with Martin et Camentron, 32 rue Rodier, Paris, by at least 1895; deposited by Camentron with Durand-Ruel, Paris, 13–19 March 1895 (deposit no. 8637); acquired by Durand-Ruel, Paris, 27–28 May 1895, for Fr 15,000 (stock no. 3317); acquired by Durand-Ruel, New York, 12 January 1899 (stock no. 2097); acquired by H. O. Havemeyer, New York, 24 January 1899; H. O. Havemeyer, 1899–1907; Mrs. H. O. Havemeyer, New York, 1907–29; her bequest to the museum 1929.

EXHIBITIONS: 1886 Paris, no. 14 (as "Femme essayant un chapeau chez sa modiste," pastel), lent by Mme A.; 1891–92, London, Mr. Collie's Rooms, 39B Old Bond Street, December 1891–January 1892, *A Small Collection of Pictures by Degas and Others*, no. 19, lent by Alexander Reid; 1892, Glasgow, La Société des Beaux-Arts (Alexander Reid's gallery, an expanded version of the exhibition at Mr. Collie's Rooms), February (no catalogue); 1892, Glasgow Institute of the Fine Arts, *31st Exhibition of Works of Modern Artists*, no. 562, lent by T. G. Arthur; 1930 New York, no. 145; 1949 New York, no. 60, repr. p. 44; 1974–75, New York, The Metropolitan Museum of Art, 12 December 1974–10 February 1975, *The H. O. Havemeyers: Collectors of Impressionist Art*, no. 10; 1977 New York, no. 34 of works on paper.

SELECTED REFERENCES: Ajalbert 1886, p. 386; Jules Christophe, "Chronique: rue Laffitte, no. 1," *Journal des Artistes*, 13 June 1886, p. 193; Rodolphe Darzens, "Chronique artistique: exposition des impressionnistes," *La Pléiade*, May 1886, p. 91; Fénéon 1886, p. 264; Henry Fèvre, "L'exposition des impressionnistes," *La Revue de Demain*, May–June 1886, p. 154; Marcel Fouquier, "Les impressionnistes," *Le XIXe Siècle*, 16 May 1886, p. 2; Geffroy 1886, p. 2; Hermel 1886, p. 2; Labruyère, "Les impressionnistes," *Le Cri du Peuple*, 17 May 1886, p. 2; Mirbeau 1886, p. 1; Jules Vidal, "Les impressionnistes," *Lutèce*, 29 May 1886, p. 1; George Moore, *Confessions of a Young Man*, London: S. Sonnenschein, 1888 (1959 edition, p. 45; reprinted in Flint 1984, p. 66); Moore 1890, p. 424; *The Glasgow Herald*, 20 February 1892, p. 4; D. S. MacColl, "Degas and Monticelli," *The Spectator*, 2 January 1892 (reprinted in *Confessions of a Keeper*, New York: MacMillan Co., 1931, pp. 130–31); Moore 1892, p. 19; Hourticq 1912, repr. p. 109; Lafond 1918–19, II, p. 46, repr. after p. 44; Havemeyer 1931, p. 127, repr. p. 126; Burroughs 1932, p. 142 n. 6; Rewald 1946, repr. p. 391; Lemoisne [1946–49], I, p. 123, repr. (detail) facing p. 148, II, no. 682; S. Lane Faison, Jr., "Édouard Manet: The Milliner," *Bulletin of the California Palace of the Legion of Honor*, XV:4, August 1957, n.p., repr.; Havemeyer 1961, pp. 257–58; Rewald 1961, repr. p. 524; Ronald Pickvance, "A Newly Discovered Drawing by Degas of George Moore," *Burlington Magazine*, CV:723, June 1963, p. 280 n. 31; Ronald Pickvance, *A Man of Influence: Alex Reid, 1854–1928*, Edinburgh: Scottish Arts Council, 1967, p. 10; New York, Metropolitan, 1967, pp. 81–82, repr.; 1967 Saint Louis, p. 170; Rewald 1973, p. 524 repr.; Minervino 1974, no. 586; Alice Bellony-Rewald, *The Lost World of the Impressionists*, London: Weidenfeld and Nicholson, 1976, repr. p. 207; Reff 1976, pp. 168–70, 322 n. 92, fig. 119 (color) p. 169; Reff 1977, p. 39, fig. 70 (color) p. 38; Meyer Schapiro, *Modern Art*, New York, 1978, pp. 239–40, fig. 2 p. 245; 1979 Edinburgh, p. 63, under no. 72; Moffett 1979, pp. 10, 12, pl. 15 (color); Theodore Reff, "Degas, Lautrec and Japanese Art," in *Japonisme in Art: An International Symposium*, Tokyo: Kodansha International Ltd., 1980, pp. 198–200, repr. p. 198; S[amuel] Varnedoe, "Of Surface

Similarities, Deeper Disparities, First Photographs, and the Function of Form: Photography and Painting after 1839," *Arts Magazine*, LVI, September 1981, pp. 114–15, repr.; Novelene Ross, *Manet's Bar at the Folies Bergères and the Myth of Popular Illustration*, Ann Arbor, 1982, p. 47; McMullen 1984, p. 377; 1984 Chicago, p. 133; 1984 Tübingen, p. 377, under no. 141; Gruetzner 1985, pp. 36–37, 66, fig. 35; Moffett 1985, pp. 76–77, repr. (color), 250–51; Lipton 1986, p. 155, fig. 97; Thomson 1986, p. 190; 1986 Washington, D.C., pp. 430–31, 443–44, fig. 6 p. 435; Weitzenhoffer 1986, pp. 133, 255, pl. 94; *Modern Europe* (introduction by Gary Tinterow), New York: The Metropolitan Museum of Art, 1987, pp. 7, 24, pl. 10 (color).

233.

At the Milliner's

1882
Pastel on gray heavy wove paper
29⅞ × 33⅜ in. (75.9 × 84.8 cm)
Signed lower right in black chalk: Degas
Thyssen-Bornemisza Collection, Lugano, Switzerland

Lemoisne 729

The most splendid of Degas's milliner pictures, this was the first of the series to be shown in public, at a small exhibition organized by Durand-Ruel in London in July 1882.[1] Although the exhibition, at 13 King Street, St. James's, apparently received little notice in the press, an anonymous critic did write a perceptive appreciation: Degas's "skill as a colourist and as one who can suggest—we can hardly say who can elaborately paint texture—is shown better in another design, the astonishing picture of two fashionable young women trying on bonnets in a milliner's shop. Half of the design is occupied by the milliner's table, on which lies a store of her finery. Silk and feather, satin and straw, are indicated swiftly, decisively, with the most brilliant touch."[2]

Degas set off the two figures in this composition with a strong diagonal—the table with its lush cornucopia of trimmed hats in coral, blue, and white—much as in *The Milliner* (cat. no. 234) and *The Millinery Shop* (cat. no. 235). With an inventive twist, he achieved the same effect by means of an armchair in the picture now in the Museum of Modern Art, New York (fig. 208), and with a small sofa in a pastel in the Annenberg collection (fig. 210). Evidently Degas based the series structurally on this steep diagonal *repoussoir*, thereby enabling him to create, by jarring overlaps, a wedge-shaped space in which the figures can operate. In this work, however, the depth of space is made more suggestive by the gilt-framed mirror on the back wall that brings into view

a gleaming reflection of the daylight traversing the store window. Although writers have speculated that virtually every one of the milliner pictures presupposes a viewpoint through the shop window, it seems likely that only two works, this pastel and another *At the Milliner's* (fig. 179),[3] can justify the assertion. Here Degas describes the hats, rendered with "a finely sustained harmony and energetic and lively drawing,"[4] with such tantalizing materiality that one is reminded that he proposed to the retailer Georges Charpentier that he publish an edition of Zola's *Au Bonheur des Dames* with genuine samples of goods pasted in as illustrations.[5]

1. As noted by Ronald Pickvance (1979 Edinburgh, p. 63). Douglas Cooper was one of the first to stress the importance of this exhibition, in his introduction to *The Courtauld Collection* (Cooper 1954, p. 23), noting a review in the London *Standard* of 13 July 1882. The review unquestionably identifies this work, L729. It must have been sent to London by Paul Durand-Ruel, presumably soon after he bought it. However, there is no clear reference to the purchase of this picture in the Durand-Ruel stock books. Nor is there any mention in the stock books of its having been sent to London in 1882, while on the other hand there is a clear entry when another pastel (L683, stock no. 2509 [fig. 179]) was sent to Dowdeswell and Dowdeswells' in London on 13 March 1883 (valued at Fr 1,500) and returned to Paris on 27 July 1883. It may be that Durand-Ruel borrowed L729 on consignment from Degas, or perhaps Henri Rouart had already purchased it and lent it to Durand-Ruel. Pickvance claimed that this work was "certainly the first pastel of milliners to have been bought from Degas by his dealer Durand-Ruel" (ibid.). In actual fact, the first milliner recorded in the gallery's stock books is *The Little Milliners* (fig. 207), bought from Degas on 5 June 1882. *The Little Milliners* bore the Durand-Ruel stock no. 2421, cost Fr 2,500, and was sold for Fr 3,000 on 10 July 1883 to Alexis Rouart, who lent it to the eighth Impressionist exhibition in 1886.
2. *The Standard*, London, 13 July 1882, p. 3; reprinted in 1886 New York (where the article is incorrectly dated 1883).

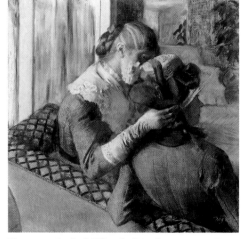

Fig. 210. *At the Milliner's* (L827), 1882–84. Pastel, 27½ × 27½ in. (70 × 70 cm). Collection of Mr. and Mrs. Walter H. Annenberg

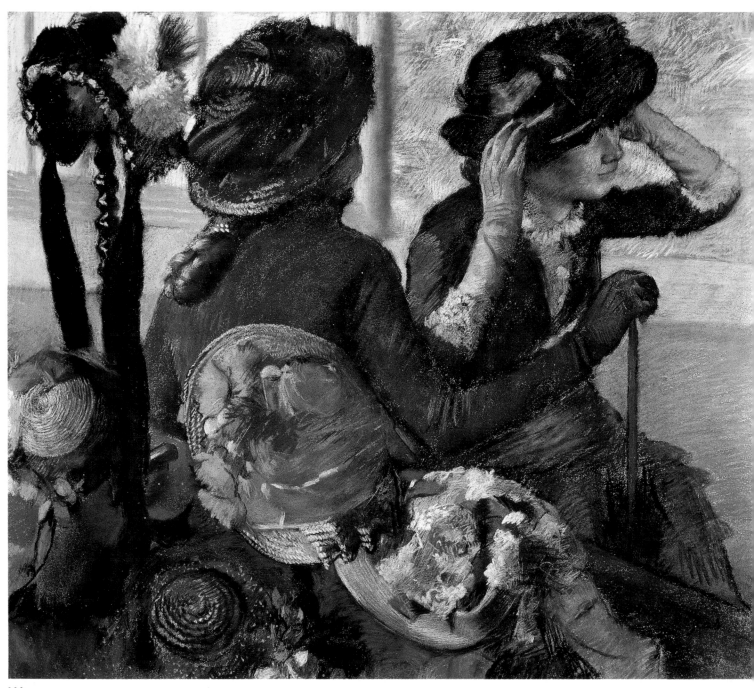

233

3. George Moore first described this work in an article in *The Magazine of Art* (XIII, 1890, p. 424).
4. Alexandre 1912, p. 26.
5. Morisot 1950, p. 165; Morisot 1957, p. 167.

PROVENANCE: Possibly with Durand-Ruel, Paris, 1882.[1] Henri Rouart collection, Paris, by 1888,[2] until 1912 (Rouart sale, Galerie Manzi-Joyant, Paris, 16–18 December 1912, no. 70, repr., for Fr 82,000); acquired by M. Chialiva, perhaps as agent for Ernest Rouart, his son; Ernest Rouart, Paris, by 1924 until at least 1937; Mme Ernest Rouart, his widow, Paris, until the early 1950s; possibly with Sam Salz, New York; Robert Lehman, New York, by 1953, until 1975; Lehman heirs, 1975–78; bought by Thomas Gibson Fine Art Ltd., London, 1978; bought by the present owner 1978.

1. Durand-Ruel organized the 1882 exhibition at White's Gallery, London, but in neither the stock books nor the journal is the purchase or transfer of this work mentioned. See note 1 above.
2. Possibly acquired directly from the artist; see preceding footnote and note 1 above. A letter from Degas to Thornley of 28 August 1888 cites Rouart as the owner at this time (Lettres Degas 1945, CXXI, p. 153; Degas Letters 1947, no. 133, p. 147, mistakenly dated 28 April).

EXHIBITIONS: 1882, London, White's Gallery, 13 King Street, St. James's, July (no catalogue known); 1924 Paris, no. 148, repr., lent by Ernest Rouart; 1934, Paris, Chez André J. Seligmann, 17 November–9 December, *Réhabilitation du sujet*, no. 85, lent by Ernest Rouart; 1937 Paris, Orangerie, no. 110, pl. XXII, lent by Ernest Rouart, as engraved by Thornley; 1979 Edinburgh, no. 72, pl. 14 (color); 1984 Tübingen, no. 141, repr. (color) p. 33; 1984–86, Tokyo, The National Museum of Western Art, 9 May–8 July 1984/Kumamoto Prefectural Museum, 20 July–26 August 1984/London, Royal Academy, 12 October–19 December 1984/Nuremberg, Germanisches Nationalmuseum, 27 January–24 March 1985/Düsseldorf, Städtische Kunsthalle, 20 April–16 June 1985/Musée d'Art Moderne de la Ville de Paris, 23 October 1985–5 January 1986/Madrid, Biblioteca Nacional, Salas Pablo Ruiz Picasso, 10 February–6 April 1986/Barcelona, Palacio de la Vierreina, 7 May–17 August 1986, *Modern Masters from the Thyssen-Bornemisza Collection*, no. 9, repr. (color).

SELECTED REFERENCES: Anon. [Frederick Wedmore?], "The 'Impressionists,'" *The Evening Standard*, London, 13 July 1882, p. 3; Thornley 1889, repr.; Alexandre 1912, p. 26, repr. p. 18; Lafond 1918–19, II, p. 46, repr. facing p. 46; Meier-Graefe 1920, pl. 76; Meier-Graefe 1923, pl. LXXV; Jamot 1924, pl. 59 p. 151; Lemoisne 1937, p. A, repr. p. B, as Rouart collection; Lemoisne [1946–49], I, pp. 123, 146, repr. (detail) facing p. 110, III, no. 729 (as c. 1883); Wilhelm Hausenstein, *Degas*, Bern: Scherz Kunstbücher, 1948, pl. 43; Fosca 1954, repr. (color) p. 79; *Great Private Collections* (edited by Douglas Cooper), London: Weidenfeld and Nicholson, 1963, repr. p. 83, as Robert Lehman collection; Valéry 1965, pl. 87; Minervino 1974, no. 602; Erika Billeter, "Malerei und Photographie–Begenung zweier Medien," *du*, 10, 1980, p. 49; Terrasse 1981, no. 414, repr.; McMullen 1984, repr. p. 294; Lipton 1986, p. 155, fig. 98 p. 156.

234.

The Milliner

c. 1882
Pastel and charcoal on gray laid paper now discolored to buff (watermark: MICHALLET) mounted on dark brown wove paper
18¾ × 24½ in. (47.6 × 62.2 cm)
Signed lower right (obscured): Degas; re-signed in black chalk upper right: Degas
The Metropolitan Museum of Art, New York. Purchase, Rogers Fund and Dikran G. Kelekian Gift, 1922 (22.27.3)

Exhibited in New York

Lemoisne 705

Humor is implicit in almost all of Degas's representations of milliners, but in no other work is the visual pun so straightforwardly funny as in this pastel. Degas adopted for his milliner a pug-nosed girl with high cheekbones reminiscent of Marie van Goethem, the model for *The Little Fourteen-Year-Old Dancer* (cat. no. 227), and placed her in an exaggerated but nonetheless unselfconscious pose of absorbed creativity. According to Berthe Morisot, Degas once proclaimed his "liveliest admiration for the intensely *human* quality of young shopgirls,"[1] and by that he may have meant an elemental character that other observers of his work—such as Edmond de Goncourt—identified as animal-like.[2] But human or animal, this particular young shopgirl is compared by the artist with an inanimate hat stand in the form of a dummy's head, and she emerges

234

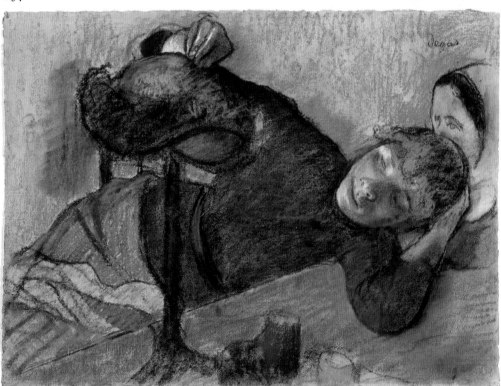

the superior being. Degas took pains to describe carefully the dummy's head, and seemed to delight especially in the bright blue eyes of the unseeing stand staring fixedly at the hat it may soon wear.

This work, rarely reproduced and practically ignored in the literature on Degas, is notably fresh and well preserved. Degas used a fine sheet of heavy laid paper that survived his manipulations without being cut up, extended, or pasted down, and applied a light layer of pastel and chalk that retains the traces of his deft and confident execution. The dramatic lighting of the young girl's face—it is lit almost from below—shows that Degas's interest in such effects, beginning in the late 1860s, continued at least into the early 1880s.

1. Valéry 1965, p. 202; Valéry 1960, p. 84.
2. See Journal Goncourt 1956, II, p. 968 (entry for Friday, 13 July 1874), where he characterizes Degas's dancers as little monkey-girls.

PROVENANCE: Earliest whereabouts unknown. Roger Marx, Paris, until 1913 (Marx sale, Drouot, Paris, 11–12 May 1914, no. 122, repr., for Fr 12,000); bought at that sale by Dikran Khan Kelekian, Paris and New York, 1914–22 (Kelekian sale, American Art Association, New York, 30 January 1922, no. 125, for $2,500); bought at that sale by the museum with a partial gift of funds from the former owner, 1922.

EXHIBITIONS: 1921, New York, The Metropolitan Museum of Art, 3 May–15 September, *Loan Exhibition of Impressionist and Post-Impressionist Paintings*, no. 36 (as "La modiste"), lent anonymously, as formerly in the Roger Marx collection; 1977 New York, no. 35 of works on paper.

SELECTED REFERENCES: Manson 1927, p. 49, pl. 65; Lemoisne [1946–49], II, no. 705 (as c. 1882); Minervino 1974, no. 592; Lipton 1986, p. 153.

235.

The Millinery Shop

c. 1882–86
Oil on canvas
39⅛ × 43½ in. (100 × 110.7 cm)
The Art Institute of Chicago. Mr. and Mrs.
 Lewis Larned Coburn Memorial Collection
 (1933.428)

Lemoisne 832

The Millinery Shop is the largest and proba-
bly the last of Degas's treatments of the
theme in the 1880s. Although he returned
to the subject again in the 1890s, borrowing
compositional strategies and gestures from
earlier pictures,[1] the milliners dating from
the relatively short span of 1882 to about
1886 form an exceptionally cohesive unit of
work, of which this picture can be seen as
the terminus.

Simplifying radically the dense composi-
tions of the great pastels made about 1882,
with paired figures and numerous hats
crowded close to the picture plane (such as
L693 [fig. 208], L729 [cat. no. 233], L683
[fig. 179]), Degas took as his point of depar-
ture for this painting a single figure creating
a hat, much like the figure in the pastel *The
Milliner* (cat. no. 234), now in the Metro-
politan Museum. Degas was clearly fasci-
nated by the image of a woman linked to a
table at the fulcrum of her bent elbow and
explored it in several of the milliner pictures.
In one, *The Conversation at the Milliner's*, a
pastel of about 1882 (L774, Staatliche Mu-
seen zu Berlin), Degas placed three figures
leaning over tables, extending themselves
from their hips to their heads; in another
pastel, dating most probably from the mid-
1890s, *Two Women in Brown Dresses* (L778),
the figures are bent so dramatically that
their heads nearly rest on the table's surface.
In the three preparatory works for the fig-
ure in *The Millinery Shop* (L834, L835,
L833; see figs. 211, 212), Degas reversed the
direction of the milliner from that in L705
(cat. no. 234), switched her identity from
shopgirl to client, and adjusted her posture
accordingly from an improper lean to a suit-
ably erect carriage.

Examinations at the Art Institute of Chi-
cago have revealed beneath the present fig-
ure indications that Degas had originally
painted a customer virtually identical to that
in a preparatory pastel, L834 (fig. 211). Hat-
ted and gloved, dispassionately inspecting a
detail of a hat, the figure fills the page of the
study in a manner consistent with the milli-
ner pictures of about 1882. However, Degas
departed from these studies in making the
painting. The format of the canvas provided
a more open and spacious composition than

the studies allowed, necessitating in turn ad-
justments such as the inordinate lengthening
of the woman's right arm. The most import-
ant change evident in the final painting of
the canvas seems to have developed in the
course of work on the last preparatory draw-
ing, L833 (fig. 212). In this drawing, Degas
inserted the hat and stand close to the figure's
head, crowding the composition unhappily.
The artist must have sensed a redundancy in
the hat on the stand next to the client's hat,
and then perhaps turned back to an earlier
study, L835, to scratch out the hat on her
head. In the final painting, the client has lost
her hat; she seems to have simultaneously
lost her status as a consumer and returned to
the role of hatmaker, surrounded by her at-
tributes—the hat displayed like a crown
above her head, and the bouquet of hats on
stands that beg for equal attention much as
do the flowers in *Woman Leaning near a Vase
of Flowers* (cat. no. 60).

There is, in fact, curiously little in the
way of clues to help the viewer ascertain the
role of the seated woman. Her dress, a sober
olive wool skirt with a tunic top and narrow
fur *col militaire*, conforms to the drab cloth-
ing the clients wear in other milliner pictures;
and she wears gloves, which no other shop-
girl does. But to a remarkable degree women
are defined by their hats in the milliner series,
and the absence of one on the seated woman's
head seems sufficient to establish her as a *petite
commerçante*. Some writers have further
interpreted the figure's mouth to be pursed
around a pin she is about to place on the
hat,[2] thus firmly establishing her activity;
indeed she may be wearing sewing gloves.

This painting is surpassed in size in the
1880s only by *Nude Woman Drying Herself*
(cat. no. 255) and by the portrait *Hélène
Rouart* in the National Gallery in London
(fig. 192), with which it shares a certain
similarity in handling, in addition to a com-
mon scale. Although the palettes differ,
Degas's technique of modeling in the faces
is close enough to suggest that the two pic-
tures were executed at approximately the
same time. Since four pastel studies for the
portrait of Hélène Rouart are inscribed with
the date 1886 (see Chronology III), it seems
reasonable to conclude that the present pic-
ture was finished sometime in the winter of
1885–86.

1. For example, Degas used the composition of this
 painting as the basis for *The Milliner* (L1023) of
 c. 1895, adding a second milliner, but otherwise
 retaining a similar deep space and disposition of
 table and hat stands. Other late milliners include
 L1315 and its related works: L1316, L1110, L1319,
 L1317, and L1318 (cat. no. 392).
2. 1984 Chicago, p. 131. Brettell suggests (p. 134)
 that since the portrait of Diego Martelli (cat.
 no. 201) of 1879 is identical in size to *The Millinery
 Shop*, the two paintings may have been begun
 simultaneously. It seems unlikely, however, that

the preparatory works (L834, L835, L833) were
made any earlier than the winter of 1881–82, and
it is difficult to imagine that Degas began work on
the painting much earlier than the drawings.

PROVENANCE: Sold by the artist to Durand-Ruel, Par-
is, for Fr 50,000 (as "L'atelier de la modiste," 100 ×
110 cm, stock no. 10253), 22 February 1913; sent to
Durand-Ruel, New York, 13 November 1917, re-
ceived in New York 1 December 1917 (stock
no. 4114), remaining until 1932; bought for either
$35,000 or $36,000 from Durand-Ruel Gallery, New
York, by Mrs. Lewis Larned Coburn, Chicago, 19
January 1932;[1] bequeathed to the museum in 1932;
accessioned in 1933.

1. The 1932 acquisition date given in the Durand-
 Ruel stock books contradicts a signed loan receipt,
 dated 23 January 1930, for the loan of a "Millinery
 Shop, 1882" from Mrs. L. L. Coburn to the Art
 Institute of Chicago (loan no. 7730). The cata-
 logue for the 1984 Chicago exhibition (no. 63,
 p. 134) states that Mrs. Coburn acquired the work
 in 1929.

EXHIBITIONS: (?)1886 New York, no. 69 (as "Mo-
diste");[1] 1932, The Art Institute of Chicago, Anti-
quarian Society, 6 April–9 October, *Exhibition of the
Mrs. L. L. Coburn Collection: Modern Paintings and
Water Colors*, no. 9, p. 38, repr.; 1933 Chicago, no.
286, pl. 53; 1933 Northampton, no. 8, repr.; 1934,
The Art Institute of Chicago, 1 June–1 November,
*A Century of Progress: Exhibition of Paintings and Draw-
ings*, no. 202; 1934, Toledo Museum of Art, Novem-
ber, *French Impressionists and Post-Impressionists*, no. 1;
1935–36, Springfield, Mass., Springfield Museum of
Art, December 1935–January 1936, *French Painting:*

Fig. 211. *At the Milliner's* (L834), c. 1882–86.
Pastel, 18⅛ × 23⅝ in. (46 × 60 cm). Location
unknown

Fig. 212. *At the Milliner's* (L833), c. 1882–86.
Pastel, 19¼ × 25¼ in. (49 × 64 cm). Location
unknown

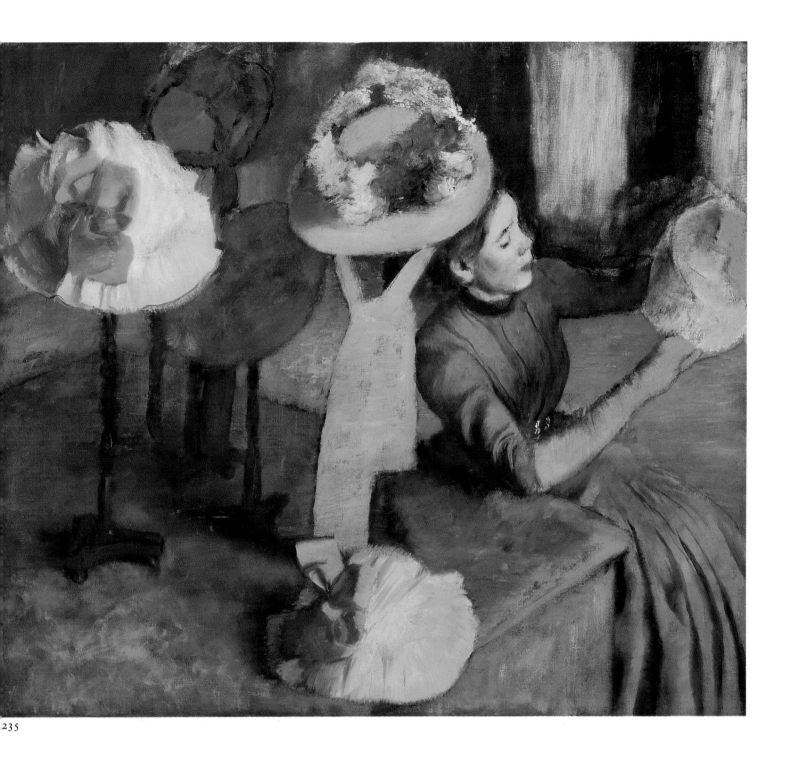

235

Cézanne to the Present, no. 1; 1936 Philadelphia, no. 40, repr.; 1941, Worcester, Mass., Worcester Art Museum, 22 February–16 March, *The Art of the Third Republic: French Painting 1870–1940*, no. 4 repr. and repr. (color) cover; 1947 Cleveland, no. 38, pl. XXX; 1950–51 Philadelphia, no. 74, repr.; 1974 Boston, no. 20, pl. II (color); 1978 Richmond, no. 14; 1980, Albi, Musée Toulouse-Lautrec, 27 June–31 August, *Trésors impressionnistes du Musée de Chicago*, no. 8, repr.; 1984 Chicago, no. 63, repr. (color).

. It is highly unlikely that this was the "Modiste" exhibited in 1886 at the National Academy of Design, New York, as suggested by Huth, and subsequently by Brettell and McCullagh (1984 Chicago, no. 63). There is no mention of this work in the

Durand-Ruel stock books until 1913, and it was they, rather than Degas himself, who arranged for the loan of works to the 1886 exhibition in New York. The "Modiste" exhibited in New York was probably a drawing that cannot today be identified with certainty; it was catalogued under "Works in Pastel and Watercolor."

SELECTED REFERENCES: *The Fine Arts*, XIX, June 1932, p. 23, repr.; Daniel Catton Rich, "Bequest of Mrs. L. L. Coburn," *Bulletin of the Art Institute of Chicago*, XXVI:6, November 1932, repr. p. 69; Mongan 1938, pp. 297, 302, pl. II, A; Huth 1946, p. 239, fig. 8 p. 234 (identifies this work as among those included in the 1886 National Academy of Design exhibition, New York); Rewald 1946, repr. p. 390 (as possibly

having been exhibited at the eighth Impressionist exhibition); Lemoisne [1946–49], III, no. 832 (as c. 1885); Rich 1951, pp. 108–09, repr. (color); Chicago, The Art Institute of Chicago, *Paintings in the Art Institute of Chicago: A Catalogue of the Picture Collection*, 1961, p. 121, repr. (color) p. 336; John Maxon, *The Art Institute of Chicago*, New York: Harry N. Abrams, 1970, pp. 89–90, 280, repr. (color) p. 89; Minervino 1974, no. 635, pl. IL (color); *Toulouse-Lautrec: Paintings* (exhibition catalogue by Charles F. Stuckey), The Art Institute of Chicago, 1979, p. 309, fig. 2; Keyser 1981, pp. 99, 101, pl. XLV; *Manet* (exhibition catalogue), New York, The Metropolitan Museum of Art, 1983, p. 486, fig. a; Lipton 1986, p. 153 fig. 95, p. 154, fig. 95 p. 162.

Before the Race

Degas made racing pictures sporadically during the 1860s and 1870s, but he stepped up production noticeably in the 1880s. He may have seen them as particularly marketable, and that notion, combined with Durand-Ruel's new solvency, appears to have provided him with the incentive to begin painting groups of closely related variants of a given picture once he had found a successful composition.

The Clark Art Institute's finely painted oil on panel (cat. no. 236) appears to have been the prototype for three other panels: one in the collection of Mrs. John Hay Whitney (cat. no. 237), one in the Walters Art Gallery in Baltimore (fig. 213), and one formerly in the collection of A. A. Pope at the Hill-Stead Museum in Farmington (L896 bis).[1] The Hill-Stead panel is the most dissimilar of the variants and was probably the last to be made. The Clark and Walters panels are identical in size and extremely close in the disposition of figures, notwithstanding the changes in cropping or the different jockeys inserted for variety at the right of each of the two pictures. But the similarities stop there, for the two paintings are altogether unlike in handling. Where the Clark picture is a richly painted *morçeau de peinture*, the Walters picture is drawn with thin veils of paint barely masking the wooden support. In the Clark picture, Degas painted with particular pleasure the brightly colored racing silks of the jockeys, using techniques he had developed in the 1860s for reflective satins, while in the Walters picture the silks are only summarily indicated, with little distinction.

The panel in the Whitney collection is composed somewhat differently. The figures are slightly smaller and the landscape deeper; the scene, centered on the panel, therefore appears less immediate. Yet the handling is once again rich, fluid, and satis-

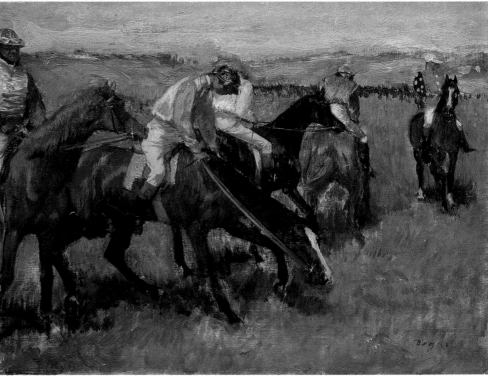

236

fying. The sheen of the horses' coats vies for attention with the shimmering shirts worn by the jockeys, the turf is rendered with great tactility, and the landscape is noted economically but convincingly. Owing to the paper laid on the surface of the Whitney panel, Degas could not introduce the effects of translucency that he used in the landscape of the Clark panel, and the palette of the Whitney picture is tawnier and more restrained. The Clark panel was sold in 1882 and was probably painted in that year; the Whitney panel was sold in 1888 and could have been painted anytime between 1882 and 1888. The Walters panel, being slightly more summary in execution, may have been painted later, perhaps toward the end of the decade.

Degas made outline drawings of the entire composition, to scale, for the Walters, Whitney, and Hill-Stead paintings (Vollard 1914, pl. LXXXIV [fig. 214], for BR110 [fig. 213]; III:178.2 [fig. 215] for L679; and III:230 for L896 bis). There are as well individual studies for many of the figures and horses.[2] No compositional study for the Clark painting is known today.

The Whitney panel figured among the pictures by Degas that Theo van Gogh bought for his gallery at Boussod et Valadon. Van Gogh acquired it in June 1888 and sold it in August 1889. Degas sold the Clark panel to Durand-Ruel in December 1882, and they in turn sold it to the Salon painter Henry Lerolle in January 1883. Degas was astonished at Lerolle's purchase, and flat-

Fig. 213. *Before the Race* (BR110), c. 1888–90. Oil on panel, 10⅜ × 13¾ in. (26.4 × 34.9 cm). Walters Art Gallery, Baltimore

Fig. 214. *Before the Race*, c. 1888–90. Pencil. Location unknown. From Vollard 1914, pl. LXXXIV

Fig. 215. *Jockeys at the Start* (III:178.2), c. 1882–88. Pencil, 13 × 19⅝ in. (33 × 50 cm). Location unknown

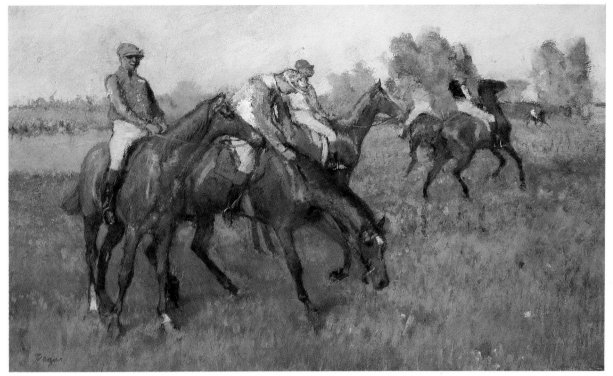

237

tered. He wrote of it to Mme Bartholomé: "In agreement with his [Lerolle's] wife, who is said to manage him, he has just, at a moment like this, bought a little picture of mine of horses, belonging to Durand-Ruel. And he writes admiringly of it to me (style Saint-Simon), wishes to entertain me with his friends . . . [even though] most of the legs of the horses in his fine picture (mine) are rather badly placed."[3] Lerolle continued to buy pictures by Degas and maintained an amicable relationship with the irascible painter. When Renoir painted Lerolle's daughters in 1897, he included the Clark panel and a pastel of dancers (L486, Norton Simon Museum, Pasadena) in the background (fig. 216). On seeing the Renoir, Julie Manet commented: "The background, with Degas's little Dancers in pink with their plaits, and the Races, is lovingly painted."[4]

1. These were followed by an oil and two pastels in which Degas reversed the principal figure of the horse with the outstretched neck: L761 (oil), L762 (pastel), and L763 (cat. no. 352).
2. Drawings for L702 include IV:377 and III:94.2 for the horse with its head lowered, and III:130.2 and III:131.1 for the jockey seated on it. Drawings for L679 include IV:202.b for the jockey and the horse with its head lowered, and IV:217.a, IV:217.b, and IV:244.b for the horse and jockey at the far right.
3. Lettres Degas 1945, LII, pp. 77–78; Degas Letters 1947, no. 61, pp. 79–80.
4. Quoted in Renoir (exhibition catalogue by John House and Anne Distel), London and Boston: Arts Council of Great Britain and the Museum of Fine Arts, Boston, 1985, p. 266.

236.

Before the Race

1882
Oil on panel
10½ × 13¾ in. (26.5 × 34.9 cm)
Signed lower right in black: Degas
Sterling and Francine Clark Art Institute, Williamstown, Massachusetts (557)

Lemoisne 702

PROVENANCE: Bought from the artist by Durand-Ruel, Paris, 10–12 December 1882, for Fr 2,500 (stock no. 2648, as "Le départ"); bought by Henry Lerolle, 10 January 1883, for Fr 3,000; Lerolle collection, Paris, 1883–1929; Mme Henry Lerolle, his widow, 1929 until at least 1936. With Hector Brame, Paris, 1937; bought by Durand-Ruel, New York, 3 June 1937, for Fr 30,000 (stock no. 5381, as "Chevaux de courses")[1]; bought by Robert Sterling Clark, 6 or 15 June 1939; Clark collection, New York, 1939–55; their gift to the museum 1955.

1. Jacques Seligmann is often listed as an owner at this time; however, the Durand-Ruel stock books indicate the direct transfer of this work from Brame, to Durand-Ruel, to R. S. Clark (between 1937 and 1939).

EXHIBITIONS: 1924 Paris, no. 45, repr. (as "Le départ d'une course [La descente de mains]"), lent by Henry Lerolle; 1931 Paris, Rosenberg, no. 28 (as "Avant la course," 1875), lent by Mme Henry Lerolle; 1933 Paris, no. 108 (as c. 1872–74), lent by Mme Lerolle; 1934, Paris, Chez André J. Seligmann, 17 November–9 December, Réhabilitation du sujet, benefit for the Foch Foundation, no. 84 (as "Les jockeys"), lent by Mme Lerolle; 1936, London, New Burlington Galleries, Anglo-French Art and Travel Society, 1–31 October, Masters of French Nineteenth Century Painting, no. 68 (as 1885), from the collection of the late Henri [sic] Lerolle; 1937 Paris, Orangerie, no. 35, pl. XII

(as "Avant la course [La descente de main]," c. 1882, bought by Lerolle in 1884 from Durand-Ruel, lent by private collector); 1956, Williamstown, Mass., Sterling and Francine Clark Art Institute, 8 May–, Exhibit 5: French Painting of the Nineteenth Century, no. 99, repr.; 1959 Williamstown, no. 1, pl. XVI (as c. 1882); 1968 New York, no. 10, repr. (as c. 1882); 1970 Williamstown, no. 6 (as c. 1878–80); p. 5 notes that L702 appears in the background of Renoir's portrait of the Lerolle sisters [fig. 216]); 1987, Williamstown, Sterling and Francine Clark Art Institute, 20 June–25 October, Degas in the Clark Collection (by Rafael Fernandez and Alexandra R. Murphy), no. 52, repr. (color) p. 67 and repr. (color, detail) p. 21.

SELECTED REFERENCES: Lafond 1918–19, II, p. 42, repr. after p. 44; Jamot 1924, p. 140, pl. 30a (as c. 1872–74); Lemoisne 1924, p. 96, repr. (as. c. 1874); Lemoisne [1946–49], I, p. 121, II, no. 702 (as c. 1882); François Daulte, "Des Renoirs et des chevaux," Con-

Fig. 216. Pierre Auguste Renoir, Yvonne and Christine Lerolle at the Piano, 1897. Oil on canvas, 28¾ × 36¼ in. (73 × 92 cm). Musée de l'Orangerie, Paris

naissance des Arts, 103, September 1960, pp. 32–33, fig. 14 (color); Sterling and Francine Clark Art Institute, French Paintings of the Nineteenth Century, Williamstown, Mass., 1963, no. 34, repr.; List of Paintings in the Sterling and Francine Clark Art Institute, Williamstown, Mass., 1972, p. 32, no. 557, repr. (as c. 1882); Minervino 1974, no. 694; Dunlop 1979, no. 171, p. 180, repr. (as 1882); William R. Johnston, The Nineteenth Century Paintings in the Walters Art Gallery, Baltimore, 1982, pp. 134–35 (compared with BR110 [fig. 213], with differences cited in the cropping, color, etc.); List of Paintings in the Sterling and Francine Clark Art Institute, Williamstown, Mass., 1984, p. 12, fig. 255.

237.

Before the Race

1882–88
Oil on paper, laid on cradled panel
12 × 18¾ in. (30.5 × 47.6 cm)
Signed lower left: Degas
Collection of Mrs. John Hay Whitney

Exhibited in New York

Lemoisne 679

PROVENANCE: Sold by the artist to Goupil–Boussod et Valadon, Paris, 8 June 1888, for Fr 2,000; bought by Paul Gallimard, Paris, for Fr 2,400, 5 August 1889; Gallimard collection, Paris, 1889 until sometime before 1927 (according to Manson 1927). With Reid and Lefevre, London, 1927; bought by M. Knoedler and Co., New York, 23 March 1927; bought by John Hay Whitney, New York, May 1928; Whitney collection, New York, 1928–82; to present owner.

EXHIBITIONS: 1903, Paris, Bernheim-Jeune et Fils, April, Exposition d'oeuvres de l'école impressionniste, no. 14, lent by Paul Gallimard; 1904, Brussels, La Libre Esthétique, 25 February–29 March, Exposition des peintres impressionnistes, no. 27; 1908, London, New Gallery, January and February, Eighth Exhibition of the International Society of Sculptors, Painters and Gravers, no. 69; 1910, Brighton, Public Art Galleries, 10 June–31 August, Exhibition of the Work of Modern French Artists, no. 111; 1912, Paris, L'Hôtel de la Revue "Les Arts," June–July, Exposition d'art moderne (maison Manzi, Joyant et Cie), no. 114; 1914, Copenhagen, Statens Museum for Kunst, 15 May–30 June, Art français du XIXe siècle, no. 69, lent by Paul Gallimard; 1942, Art Association of Montreal, 5 February–8 March, Loan Exhibition of Masterpieces of Painting, no. 66, p. 47 (as "Chevaux de course," Whitney collection); 1960–61, London, Tate Gallery, 16 December 1960– 21 January 1961, The John Hay Whitney Collection, no. 18 (as "Avant la course," c. 1881–85); 1983, Washington, D.C., The National Gallery of Art, 29 May–3 October, The John Hay Whitney Collection, no. 12, p. 38, repr. p. 39 (as "Before the Race," 1881–85).

SELECTED REFERENCES: Louis Vauxcelles, "Collection de M. P. Gallimard," Les Arts, no. 81, September 1908, p. 21, repr. p. 26 (as "Les courses"); Arsène Alexandre, "Exposition d'art moderne à l'Hôtel de la Revue 'Les Arts,'" Les Arts, August 1912, repr. p. IV; Lemoisne [1946–49], II, no. 679 (as c. 1881–85); Rewald 1973 GBA, Appendix I (a reprint of excerpts from the ledger of Goupil–Boussod et Valadon; identifies "Courses, 31 × 47" as L679; revised in Rewald

1986, p. 89); Minervino 1974, no. 697; William R. Johnston, The Nineteenth Century Paintings in the Walters Art Gallery, Baltimore, 1982, p. 134 (discussed in relation to L702 [cat. no. 236]).

238.

Study of a Jockey

c. 1882–84
Charcoal on blue-gray laid paper now discolored to buff
19¾ × 12⅞ in. (50 × 32.5 cm)
Vente stamp lower left
Ashmolean Museum, Oxford (1977.27)

Exhibited in Paris

Vente III:98.2

Both this drawing and Study of a Nude on Horseback (cat. no. 282) are studies made in the artist's maturity based on poses established early in his career. The figure of this mounted jockey appeared as early as 1860–62 in one of the artist's first racecourse scenes, At the Races: The Start (fig. 51), and was placed prominently in the foreground of The Gentlemen's Race: Before the Start (cat. no. 42), which Degas began in 1862 but continued to rework well into the 1880s. It is

quite possible that he made this drawing in the process of revising The Gentlemen's Race, although more probably it was made in preparation for the figure in two pastels of the mid-1880s—L850 (private collection) and L889 (fig. 217).

Perhaps one of the reasons Degas was loathe to release The Gentlemen's Race to the man who commissioned it, Jean-Baptiste Faure, was that it represented to him an invaluable source in the manufacture of new jockey scenes; drawings such as this one could have been made from the early painting in order to serve as a repertory of poses for future use. All the same, this incisive work has none of the rotelike qualities of a copy. By shifting the contours, moving the arm, making the jockey's lean more acute, and modifying the knee, Degas invested the drawing with a particularly heightened sense of observed detail.

PROVENANCE: Atelier Degas (Vente III, 1919, no. 98.2 [as "Jockey (Profil)"], for Fr 800); acquired by Durand-Ruel, Paris (stock no. 11453). Percy Moore Turner, London, until no later than 1952; John N. Bryson, by 1966, until 1976; his bequest to the museum 1976.

EXHIBITIONS: 1967 Saint Louis, no. 102, repr. p. 160 (as "Jockey in Profile"), John Bryson collection; 1979 Edinburgh, no. 14, p. 16 repr.; 1982, New Brunswick, N.J., Rutgers University, Jane Voorhees Zimmerli Art Museum, 12 September–24 October 1982/ Cleveland Museum of Art, 16 November 1982–

Fig. 217. Before the Race (L889), c. 1882–84. Pastel, 25¼ × 21⅝ in. (64 × 55 cm). Museum of Art, Rhode Island School of Design, Providence

238

9 January 1983, *Dürer to Cézanne: Northern European Drawings from the Ashmolean Museum*, no. 109, p. 134, repr. p. 135; 1983 London, no. 24, repr.; 1986, Oxford, Ashmolean Museum, 11 March–20 April/ Manchester City Art Gallery, 30 April–1 June/Glasgow, Burrell Collection, 7 June–13 July, *Impressionist Drawings from British Public and Private Collections*, no. 19, p. 60, pl. 33.

SELECTED REFERENCES: Paul-André Lemoisne, *Degas et son oeuvre*, Paris: Éditions d'Histoire d'Art, 1954, p. 185, repr. between pp. 120 and 121 (as Percy Moore Turner collection); Christopher Lloyd, "Nineteenth-Century French Drawings in the Bryson Bequest to the Ashmolean Museum," *Master Drawings*, XVI:3, Autumn 1978, pp. 285, 287 n. 6, pl. 35.

239.

Dancers in the Rehearsal Room, with a Double Bass

c. 1882–85
Oil on canvas
15⅜ × 35¼ in. (39 × 89.5 cm)
Signed lower left: Degas
The Metropolitan Museum of Art, New York.
 Bequest of Mrs. H. O. Havemeyer, 1929.
 H. O. Havemeyer Collection (29.100.127)

Lemoisne 905

More than any other group in the artist's oeuvre, the frieze-format rehearsals constitute a genuine series. For over twenty years, Degas elaborated—in a style gradually evolving from a precise rendering of observed detail to an expressive notation of linear rhythm and suffused color—a fixed set of dancers placed in an oblong rehearsal room, who appear, disappear, or are reproduced in reverse images of themselves in an unending stream of contrapuntal variation. Nowhere is Degas's system of additive invention more evident than in this group. Although he adopts a similar method in his pictures of jockeys, it is only in the dance pictures that one feels one enters a world totally inhabited by creatures of one man's imagination—a world not unlike that created by a powerful novelist.

This painting is probably the second in the series of over forty horizontal rehearsal pictures. It was preceded by *The Dance Lesson*, in the Mellon collection (fig. 218), which can be dated 1879 on the basis of a thumbnail sketch in a notebook Degas is known to have used in 1878–79.[1] The sketch, which George Shackelford believes to be a rapid notation taken from a composition already in progress,[2] differs from the Mellon painting in the number of figures, the presence of a violin case on the floor, and the curious placement of a bull's-eye window on the long wall at the left. Otherwise the essential features of the entire series are present: the long wall that rushes precipitously back into space, providing a foil for one, two, or three principal figures in front; the pocket of space where the room widens, with two tall French windows illuminating a group of dancers limbering up before a rehearsal, or cooling off afterward; the chair; and the bench, which was to become the locus for many of Degas's late dancers.

Whereas the Mellon picture bears the traces of Degas's revising and rethinking of a new compositional format, the Metropolitan's picture shows few pentimenti and no drastic changes: X-radiography and infrared reflectography show a work that appears to have been painted in virtually a single cam-

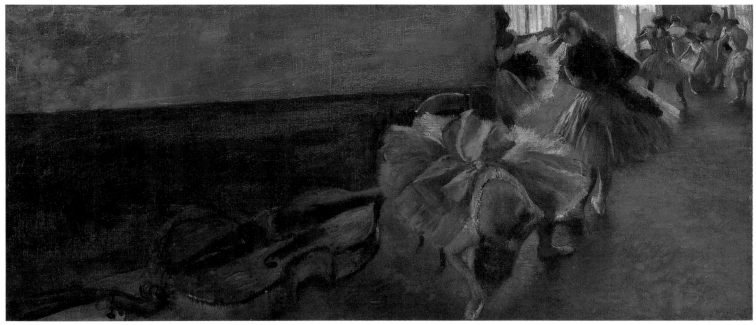

239

paign with only minor revisions, despite George Moore's assertion in 1892 that the painting had recently been retouched by Degas.[3] The lithograph drawn after it in 1889 (fig. 219) shows the picture as it appears today.

Theodore Reff has proposed revising the date of this picture to 1879 from Lemoisne's date of 1887, citing as evidence the 1879 notebook sketch for the Mellon picture. However, the Metropolitan's picture fits more comfortably among the paintings that Degas produced toward the mid-1880s; its palette, in particular, reveals affinities with other works of the mid-1880s. The tawny tonality, relieved occasionally by accents of bright color, is close to that of Chicago's *Millinery Shop* (cat. no. 235) and significantly removed from the cool palettes of the Mellon picture and *The Dancing Lesson* in the Clark Art Institute (cat. no. 221), both of which do seem to date from 1879–80. The Metropolitan's picture is equally removed from both the

variant in Detroit (L900), which is later, and the frieze-format painting of a rehearsal in the National Gallery of Art (cat. no. 305) that Degas sold in 1892. The drawings for the Metropolitan's painting (cat. nos. 240, 242) seem to have been made between 1882 and 1885;[4] they are similar in handling to the milliners in pastel and their related drawings of 1882.

A closely related oil sketch, perhaps made as an independent work rather than as a preparatory sketch, also exists (L902).

1. Reff 1985, Notebook 31 (BN, Carnet 23, p. 70).
2. 1984–85 Washington, D.C., p. 86.
3. Moore 1892, p. 19.
4. The other drawings that Degas seems to have made for this picture include L907, L906, II:219.1, III:357.1, L909, II:351, III:150.1, III:254, III:358.2, III:358.1, II:355, L911, and L912.

PROVENANCE: Earliest whereabouts unknown. With Alexander Reid, Glasgow, by 1891, until 1892; bought by Arthur Kay, London, 1892, until 1893; with Martin et Camentron, Paris, until May 1895; bought by Durand-Ruel, Paris, 27–28 May 1895, for Fr 8,000

(stock no. 3318); transferred to Durand-Ruel, New York, 20 November 1895 (stock no. 1445); arrived in New York 4 December 1895; bought by E. F. Milliken, 23 March 1896, for $6,000; Milliken collection, New York, 1896–1902 (Milliken sale, American Art Association, New York, 14 February 1902, no. 11 [as "Les coulisses"], for $6,100); bought by Durand-Ruel, New York, as agent for H. O. Havemeyer; H. O. Havemeyer, New York, 1902–07; Mrs. H. O. Havemeyer, New York, 1907–29; her bequest to the museum 1929.

EXHIBITIONS: 1891–92, London, Mr. Collie's Rooms, 39B Old Bond Street, December 1891–January 1892, *A Small Collection of Pictures by Degas and Others*, no. 20, lent by Alexander Reid; an expanded version of the exhibition traveled to Glasgow, La Société des Beaux-Arts, February 1892 (no catalogue known); 1893, London, Grafton Galleries, February, *First Exhibition, Consisting of Paintings and Sculpture by British and Foreign Artists of the Present Day*, no. 301a (lent anonymously by Arthur Kay); 1896–97, Pittsburgh, Carnegie Art Galleries, 5 November 1896–1 January 1897, *First Annual Exhibition*, no. 86, lent by E. F. Milliken; 1930 New York, no. 54; 1946, Newark Museum, 9 April–15 May, *19th Century French and American Paintings from the Collection of The Metropolitan Museum of Art*, no. 13; 1958–59, Pittsburgh, Museum

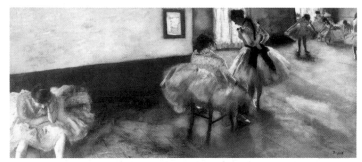

Fig. 218. *The Dance Lesson* (L625), c. 1879. Oil on canvas, 15 × 34⅝ in. (38 × 88 cm). Collection of Mr. and Mrs. Paul Mellon, Upperville, Va.

Fig. 219. Anonymous, *Dancers in the Rehearsal Room with a Double Bass*, after Degas, 1889. Transfer lithograph. Cabinet des Estampes, Bibliothèque Nationale, Paris

of Art, Carnegie Institute, 5 December 1958–8 February 1959, *Retrospective Exhibition of Paintings from Previous Internationals, 1896–1955*, no. 1, repr.; 1961, Corning, N.Y., Corning Museum of Glass, 15 July–15 August, *300 Years of Ballet* (no catalogue); 1963, Little Rock, Arkansas Arts Center, 16 May–26 October, *Five Centuries of European Painting*, repr. p. 47; Ronald Pickvance, *A Man of Influence: Alex Reid, 1854–1928*, Edinburgh: Scottish Arts Council, 1967, no. 23, repr. p. 32; 1972, Munich, Haus der Kunst, 16 June–30 September, *World Cultures and Modern Art*, no. 742; 1977 New York, no. 16 of paintings; 1978 New York, no. 40, repr. (color); 1978 Richmond, no. 12; 1979 Edinburgh, no. 26, pl. 4 (color); 1984–85 Washington, D.C., no. 30, repr. p. 90 (as c. 1885); 1987 Manchester, no. 75, fig. 116 (as c. 1879–85).

SELECTED REFERENCES: Moore 1892, p. 19; Anon. [J. A. Spender?], "Grafton Gallery," *Westminster Gazette*, 17 February 1893, p. 3 (reprinted in Flint 1984, pp. 279–80); "The Grafton Gallery," *Globe*, 25 February 1893, p. 3 (reprinted in Flint 1984, p. 280); "The Grafton Gallery," *Artist*, XIV, 1 March 1893, p. 86 (reprinted in Flint 1984, p. 282); Arthur Kay, letter to the editor, *Westminster Gazette*, 29 March 1893 (reprinted in Arthur Kay, *Treasure Trove in Art*, Edinburgh/London: Oliver and Boyd, 1939, pp. 28–30, repr. facing p. 32); Havemeyer 1931, p. 119; Tietze-Conrat 1944, pp. 416–17, fig. 1 p. 414; Lemoisne [1946–49], III, no. 905 (as 1887); Browse [1949], pp. 67, 377–78, no. 118, repr.; Havemeyer 1961, p. 259; Ronald Pickvance, "L'absinthe in England," *Apollo*, LXXVII:15, May 1963, p. 396; New York, Metropolitan, 1967, pp. 84–85, repr.; Minervino 1974, no. 836; Reff 1976, pp. 21, 137, 151; Reff 1977, p. 39, fig. 71 (color); Moffett 1979, p. 12, pl. 18 (color); 1984 Chicago, pp. 62, 146, 149; 1984 Tübingen (1985 English edition, pp. 383, under no. 162, 385, under no. 172); 1984–85 Boston, p. lix, fig. 37 (the lithograph after the painting); 1984 Chicago, pp. 62, 146, 149; 1984–85 Paris, fig. 134 (color) p. 159; Paris, Louvre and Orsay, Pastels, 1985, p. 80, under no. 73; Reff 1985, I, pp. 21 n. 8, 151, Notebook 31 (BN, Carnet 23, p. 70); Weitzenhoffer 1986, p. 257.

Drawings for Ballet Pictures

cat. nos. 240–242

Unlike the stock figures Degas drew for his ballet pictures of the 1870s (see, for example, cat. nos. 127, 138), which he used and reused in different contexts over a long period of time, the drawings for the ballet pictures of the 1880s seem to have been made expressly for each new picture, regardless of how often the pose had been used before. These drawings were often done on a relatively large scale before being reduced for inclusion in the meticulously painted canvases. Many of them therefore convey a monumentality often lacking in the final pictures, and also a freedom and certainty of expression rarely matched in the paintings.

240

240.

Study of a Bow

c. 1882–85
Pastel and charcoal on blue-gray laid paper
9¼ × 11¼ in. (23.5 × 30 cm)
Vente stamp lower left appearing vertically
Musée d'Orsay, Paris (RF30015)

Exhibited in Paris

Lemoisne 908 bis

Perched on the back of a dancer like an enormous blue butterfly, this extravagant bow was made as a preparatory study for *Dancers in the Rehearsal Room, with a Double Bass* (cat. no. 239). In his execution of the principal figure of the painting, Degas followed the design of the bow quite closely, though he changed its color from pale blue to yellow. The figure itself is related to many other pastel studies of a seated dancer doubled over to tie the laces of her slipper. Degas evidently considered this pose one of his most successful: he integrated it into a number of pastels beginning about 1879 and included it repeatedly in the horizontal pictures of rehearsals painted from then through the mid-1880s.[1] He seems to have made a new pastel study of the dancer for every painting; some of these were gifts that he signed and dedicated to friends. None, however, is as ravishing as this brilliantly rendered study of the bow.

After the artist's death, the drawing was stamped with Degas's signature in such a way that the left side became the bottom.

Consequently, the work has often been reproduced in the wrong direction.

1. The pose appears in *L'attente* (L698, Norton Simon Museum, Pasadena) and at about the same time in L530 (fig. 236), L531, L658, L661, BR86, and BR76. It is also included in several other horizontal pictures of rehearsals: L900 (Detroit Institute of Arts), L941 (cat. no. 305), and L1107 (fig. 289). Related studies of the seated dancer include L599 bis, L600, L699, L826, L826 bis, L903, L904, L906, L907, L908, L913, BR 90, and BR125. There are as well a number of pastels and paintings of the 1890s and early 1900s that include the pose, most notably the Cleveland *Frieze of Dancers* (L1144), where the position is examined from four viewpoints.

PROVENANCE: Atelier Degas (Vente III, 1919, no. 403, for Fr 280); bought by Marcel Guérin, Paris. Carle Dreyfus, Paris, until 1952; his bequest to the Louvre 1952.

EXHIBITIONS: 1953, Paris, Cabinet des Dessins, Musée du Louvre, April–May, *Collection Carle Dreyfus: léguée aux Musées Nationaux et au Musée des Arts Décoratifs*, no. 98; 1962, Mexico City, Universidad Nacional Autónama de Mexico, Museo de Ciencias y Arte, October–November, *100 Años de Dibujo Francés, 1850–1950*, no. 23; 1967–68, Paris, Orangerie des Tuileries, 16 December 1967–March 1968, *Vingt ans d'acquisitions au Musée du Louvre, 1947–1967*, no. 460 (stating erroneously that Carle Dreyfus acquired this work at the third atelier sale); 1969 Paris, no. 213; 1974, Paris, Musée du Jeu de Paume, 8 July–29 October, *Présentation temporaire* (no catalogue); 1983, Paris, Palais de Tokyo, 9 August–17 October, *La nature-morte et l'objet de Delacroix à Picasso* (no catalogue).

SELECTED REFERENCES: Lemoisne [1946–49], III, no. 908 bis (as an 1887 study for L907); Paris, Louvre and Orsay, Pastels, 1985, p. 80, no. 73 (as 1887).

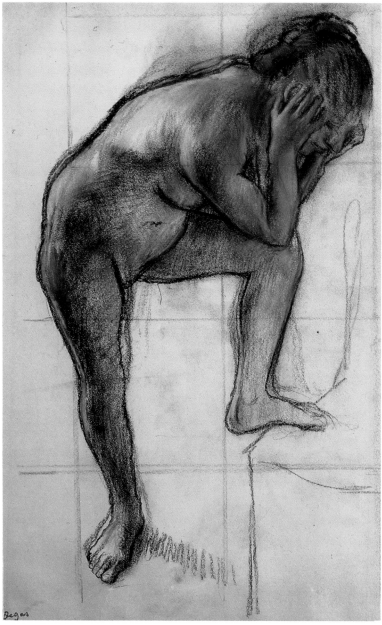

241

ing of the torso and legs, to the emphatic, repeated contour of the figure as a whole. In the 1880s, these contours became increasingly important to Degas as he more frequently constructed his pictures in his "additive" mode, inserting preexisting figures, like strongly outlined silhouettes, into a number of predetermined compositions.

1. See the discussion of the appearance, disappearance, and reappearance of this figure in 1984–85 Washington, D.C., pp. 91–97.

PROVENANCE: Atelier Degas (Vente II, 1918, no. 178, for Fr 6,000); bought by Dr. Georges Viau, Paris; Viau collection, 1918–42 (Viau sale, Drouot, Paris, 11 December 1942, no. 59, pl. VI, for Fr 300,000); acquired at that sale by the Louvre.

EXHIBITIONS: 1932 London, no. 828 (969), pl. CC, repr., lent by Dr. Georges Viau; 1936 Philadelphia, no. 84, repr. p. 136, lent by Dr. Georges Viau; 1939 Paris, hors catalogue; 1964 Paris, no. 69, pl. XVIII; 1969 Paris, no. 223; 1974, Paris, Musée du Jeu de Paume, 8 July–29 October, *Présentation temporaire* (no catalogue).

SELECTED REFERENCES: Lemoisne [1946–49], II, no. 615 (as c. 1880–85); Minervino 1974, no. 874; 1984–85 Washington, D.C., p. 92, fig. 4.3 p. 95; Paris, Louvre and Orsay, Pastels, 1985, no. 71, p. 77, repr. p. 78.

Fig. 220. *Studies of Two Dancers* (III:223), c. 1882–85. Charcoal heightened with white, 18⅛ × 23⅝ in. (46 × 60 cm). The High Museum of Art, Atlanta

241.

Nude Dancer with Her Head in Her Hands

c. 1882–85
Pastel and charcoal on robin's-egg blue wove paper, squared for transfer
19½ × 12⅛ in. (49.5 × 30.7 cm)
Vente stamp lower left
Musée d'Orsay, Paris (RF29.346)

Exhibited in Paris

Lemoisne 615

Degas probably made this drawing and a second one (fig. 220) in preparation for *In a Rehearsal Room*, at the National Gallery of Art, Washington, D.C. (cat. no. 305). Although the dancer is not visible in the painting, a figure like her was originally placed just to the left of the seated dancer pulling on her stockings.[1] Another figure in the same pose appears in the *Ballet Rehearsal* at the Yale University Art Gallery in New Haven (fig. 289), but drawings for that figure (III:88.1, III:124.1, and another at the Narodni Muzej in Belgrade) make it clear that Degas employed a different model for that picture, even though the figures and their poses, disposition, and relative size conform almost precisely to the painting in Washington.

Degas achieves in his drawing a figure of almost monumental stature, despite the ungainliness of the pose and the difficult twist of the torso. In rendering the work, Degas employed a variety of techniques that he had recently perfected in his large-scale pastels, from the softly highlighted stumping in the face and hands, to the striated hatch-

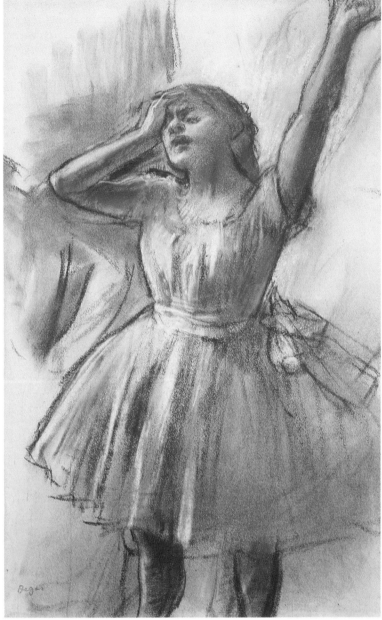

242

color—electric blue in the bodice, orange red in the hair, and purple in the skirt and shadows.

color—electric blue in the bodice, orange red in the hair, and purple in the skirt and shadows.

PROVENANCE: Atelier Degas (Vente II, 1918, no. 175, for Fr 12,200); bought back at that sale by René de Gas, the artist's brother, Paris, 1918–21; his estate until 1927; by inheritance to Roland Nepveu De Gas, Paris, 1927, until at least 1943. Hal Wallis, Los Angeles, by 1958; L. A. Nicholls, England, until 1959 (sale, Sotheby's, "Collection of a Gentleman" [L. A. Nicholls] London, 25 November 1959, no. 54, repr., for £8,400); bought at that sale by M. Knoedler and Co., New York; bought by John D. Rockefeller III, 27 October 1960; Rockefeller collection, New York, 1960–68; bought by Hirschl and Adler Galleries, Inc., New York, 1968; acquired by the Kimbell Foundation 1968.

EXHIBITIONS: 1943, Paris, Galerie Charpentier, May–June, Scènes et figures parisiennes, no. 67 (label on verso indicates R. Nepveu De Gas as lender); 1958 Los Angeles, no. 62, anonymous loan; 1967 Saint Louis, no. 130, p. 198, repr. p. 197, from a private collection, New York; 1973, New York, Hirschl and Adler Galleries, Inc., 8 November–1 December, Retrospective of a Gallery, Twenty Years, no. 32, repr. (color); 1978 New York, no. 41, repr. (color).

SELECTED REFERENCES: Lafond 1918–19, II, repr. after p. 34; Rouart 1945, repr. p. 75; Lemoisne [1946–49], III, no. 910 (as 1887); Fort Worth, Kimbell Art Museum, Catalogue of the Collection, 1972, pp. 198–200, repr. (color) p. 199; Minervino 1974, no. 835.

243.

Hortense Valpinçon

August 1883
Black chalk on buff wove paper
13 × 10¾ in. (33 × 27.3 cm)
Inscribed lower right: Hortense/Ménil-Hubert/ août 1883
The Metropolitan Museum of Art, New York. Bequest of Walter C. Baker (1972.118.205)

242.

Dancer Stretching

c. 1882–85
Pastel on pale blue-gray laid paper
18⅜ × 11¾ in. (46.7 × 29.7 cm)
Vente stamp lower left
Kimbell Art Museum, Fort Worth (AP68.4)

Lemoisne 910

Dancer Stretching is the most extraordinary of the drawings associated with the horizontal or frieze-format rehearsals. Degas included the figure in the Metropolitan's Dancers in the Rehearsal Room, with a Double Bass (cat. no. 239), although there she is barely visible, having been placed in the far corner of the room. With an almost perverse twist, the artist relegated to a second-ary position one of his most expressive figures. Curiously, her pose does not recur in any of his pictures. It is possible that Degas had intended to place the figure in the foreground of a composition, and then decided against it, just as he had removed a dancer with her head in her hands (cat. no. 241) from the foreground of the rehearsal now in the National Gallery of Art in Washington (cat. no. 305).

The singular gesture of this dancer cannot be traced in earlier pictures. She neither yawns nor exclaims, but by pressing her right hand to her forehead she expresses the unmistakable pain and fatigue experienced by dancers after long hours of rehearsal. Degas makes the sensation of pain all the more acute through the dramatic use of chiaroscuro, with the highlights in deeply saturated

Hortense Valpinçon was among Degas's special joys during his visits to her parents' country house at Ménil-Hubert. Having portrayed her as a child (see cat. no. 101), he watched her mature and remained friends with her until the end of his life. Even after her father Paul's death, Hortense—then a married woman with children of her own— continued to invite Degas to stay with her family in Normandy.

Degas's project for his visit in the summer of 1883 was a portrait of Hortense. He executed this exquisite drawing, as pure as an antique cameo or a Renaissance medal,[1] in addition to several other works that the sitter recalled: a pastel of Hortense seated out of doors (possibly L857); another work on paper (private collection, not in Lemoisne or Brame and Reff); a pastel variant of this drawing, L722 (fig. 221; see note 3); and

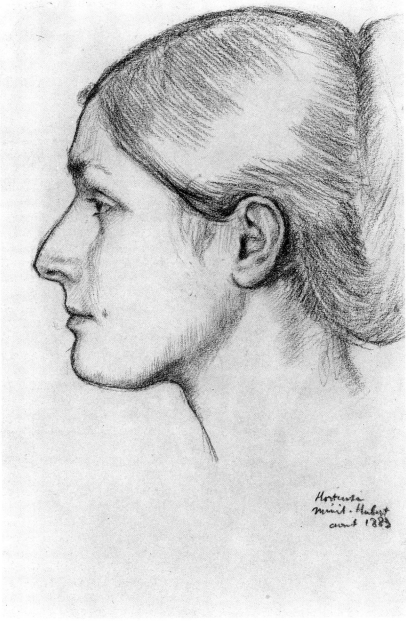

243

The bizarre *mise-en-page* was involuntary and involved no prior design by the artist. On the contrary: there was no *mise-en-page* at all.[2]

According to further remarks in this interview, Degas kept the drawing in his bedroom and gave it to Hortense only about 1907. Degas's maid Zoé is quoted by her as saying at the time, "Take it, Madame, it still looks like you."[3]

1. The comparison is made by Jean Sutherland Boggs, in 1967 Saint Louis, p. 176.
2. Barazzetti 1936, 190, p. 3.
3. Barazzetti 1936, 191, p. 1. From other remarks by Hortense cited there, it is tempting to deduce that the pastel L722 (fig. 221) was made in 1907, at the time of the gift of the drawing. However, Boggs believes that the style of execution indicates a date in the 1880s for the pastel as well.

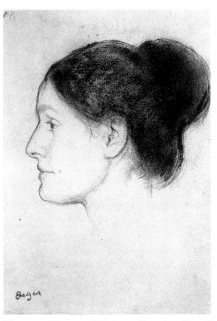

Fig. 221. *Hortense Valpinçon* (L722), 1883. Pencil and pastel, 11⅜ × 6⅜ in. (29 × 16 cm). Collection of Mr. and Mrs. Paul Mellon, Upperville, Va.

PROVENANCE: The artist until c. 1907; his gift to Hortense Valpinçon (Mme Jacques Fourchy), c. 1907; M. and Mme Jacques Fourchy, Paris, c. 1907 until at least 1924; presumably by descent to Raymond Fourchy, their son, Paris. Walter C. Baker, New York, by 1960 until 1972; his bequest to the museum 1972.

EXHIBITIONS: 1960, New York, The Metropolitan Museum of Art, June–September, *The Walter C. Baker Collection of Drawings* (no catalogue); 1967 Saint Louis, no. 113, p. 176, lent by Walter C. Baker, New York; 1973–74 Paris, no. 33, repr.; 1977 New York, no. 38 of works on paper.

SELECTED REFERENCES: Barazzetti 1936, 190, p. 3, 191, p. 1; Lemoisne [1946–49], III, p. 410, under no. 722; Claus Virch, *Master Drawings in the Collection of Walter C. Baker*, New York: The Metropolitan Museum of Art, 1962, no. 104, pp. 58–59; Reff 1976, pp. 265–66, fig. 180 p. 265.

perhaps other works now lost. Fifty-three years later, in 1936, Hortense described the making of this drawing and several others to an interviewer, who re-created the scene in vivid detail:

His little friend having grown to young womanhood, it was only natural that Degas should want to capture the pretty profile the purity of which delighted his artist's eye. He sketched it on a blank page with a sharp pencil [sic] stroke that dug deeply into the paper. Drawing, Degas used to say, is a way of feeling. He followed the profile, outlined the forehead, and began a second time—a first, half-erased line tells us so—to draw the imperceptibly hooked bridge of the nose, its delicate flare at the fine nostril, and the resolutely bold chin. The slightly protruding lower lip is holding back a smile that is smoldering underneath, ready to burst forth, while the limpid eyes are somewhat sad. "Don't play the victim," Degas would tell the girl, who with her stillness was becoming melancholy. With the point of his pencil, he suggested the texture of the mole at the corner of her mouth, which led him to say as he watched the glistening young face: "You are a sweet young thing." He sketched the delicate neck and tiny ear, and behind it the big bun of hair. Arriving at the edge of the paper, he found he could not get all the hair in; the bun was truncated at the side of the page. "How tedious, there's no more paper," Degas grumbled. "I'll have to start over again."

Monotypes of Nudes

cat. nos. 244–252

Degas's monotypes have long been thought
to fall outside the ongoing current of his
work as a whole. When they finally emerged
from the obscurity of his portfolios to be
sold at the atelier sales in 1918–19, their
strange, unfamiliar beauty caused a stir
among critics and connoisseurs, many of
whom were uncertain how they related to
his better-known prints, pastels, and paint-
ings. Arsène Alexandre wrote in 1918:
"There were, during Degas's lifetime, only
a few rare individuals, discerning people
who were not slaves to prevailing opinions,
who grasped the significance and appreciated
the original beauty of these distinctive
works. His monotypes represent one area of
his work in which he was most free, most
live, and most reckless. He did not rely on
any precedent, even from among his other
works, and was not hampered by any rule."[1]
With hindsight, a perspective enhanced
by Eugenia Janis's comprehensive exhibition
of the monotypes at the Fogg Art Museum in
Cambridge, in 1968, these works no longer
appear completely isolated from the rest of
the artist's oeuvre; indeed, one can now
point to almost as many interconnections as
differences. A case in point is provided by
the dark-field monotypes of nude women
caught at intimate moments, reposing indo-
lently in unspecified interiors or intently
washing themselves (see cat. nos. 195–197,
244–252). These works seem to derive from
the brothel monotypes of 1876–77 (cat.
nos. 180–188); they relate as well to etchings
of about 1879, such as *The Little Dressing
Room* (RS41) and the remarkable *Leaving
the Bath* (RS42), of which Degas made
twenty-two different states (see cat. nos.
192–194); and ultimately they lead to the
large pastels of bathers that Degas worked
in the 1880s.

Despite the now obvious links with these
works in other mediums, the precise dating of
the dark-field monotypes has remained un-
certain. Most recent writers have assigned
them to the 1880s on account of their affini-
ties with the pastels, following a general
tendency to associate all nudes with this
decade of production.[2] However, there is
good reason to believe that not all of them
date from as late as the 1880s. An important
element in sketching a chronology was the
inclusion in the 1877 Impressionist exhibi-
tion of two scenes of women bathing. At
least one of them, *Woman Leaving Her Bath*
(cat. no. 190), was a pastel over monotype.
It has been suggested by Michael Pantazzi
that the other work shown then, "Femme
prenant son tub le soir," was a pastel now in
the Norton Simon Museum, Pasadena

(fig. 145), and that it was drawn over a sec-
ond impression of *The Tub* (cat. no. 195), a
monotype now in the Fondation Jacques
Doucet, Paris.[3] If the Doucet monotype
does indeed date from 1877 or earlier, then
it is arguable that monotypes drawn in a
similar style—typified by broad highlights
punctuating dark planes, and features occa-
sionally delineated with a wiry line—date
from about 1877 as well.[4] Following this
hypothesis, one could construct a group of
bathers made before the 1880s that are dis-
tinguished by clearly articulated spatial rela-
tionships, by the kinds of incidental detail
that Degas was careful to include, and by a
mordant, comic touch in the drawing of the
nudes. This last characteristic would fall in
line with a general tendency toward carica-
ture in Degas's work of the late 1870s.

The monotypes of nudes in this section of
the catalogue are perceptibly different and do
not seem consistent with Degas's style of
the 1870s. With the exception of *Nude Woman
Wiping Her Feet* (cat. no. 246), they do not
rely on humor for their effect. They repre-
sent instead, in Janis's words, "gigantic nudes
without faces, backlighted by a window, re-
clining under the fierce illumination of an
oil lamp or a fireplace, reading, emerging
from a bathtub or seated on the edge of a
bed . . . not personages but palpitatingly
expressive physical presences that block the
light or seem to absorb their dark, inky inte-
riors."[5] This physicality brings them closer
to the large pastels of bathers. Unlike the
monotypes assigned to 1876–77, these mono-
types are more remarkable for their ambigu-
ity than for their descriptive passages. As
Janis suggests, "their strikingly modern lack
of anecdote makes it difficult to believe that
they coincide with Degas's urbane represen-
tations of modern life from the late 1870s
and early 1880s."[6]

In order to date these works convincingly,
the most important connection to be consid-
ered is the link between the dark-field
monotypes of nudes and the series of large
pastels of women bathing that Degas made
between 1884 and 1886, culminating in the
"suite de nus" shown at the 1886 Impres-
sionist exhibition. The women depicted in
the large pastels of bathers and in the mono-
types of nudes are all of a similar type. They
are single women—when a bed is visible it
is a single bed—and although men are never
present, in contrast to *Admiration* (cat. no.
186), their uninhibited nudity suggests
that they are available for sex. The figures
in the pastels and monotypes share a com-
mon scale and are all viewed at very close
range. Because Degas cropped the composi-
tions tightly around the figures, they appear
large in proportion to their surroundings,
occupying nearly all the available space.

Since several of the large pastels are dated
1884 and 1885, and others, though undated,
were exhibited in 1886, their dates are rela-
tively certain. How then are the monotypes
related to the large pastels? It is reasonable
to assume that they preceded them. For one
thing, there are very few preparatory draw-
ings for the pastels, which suggests that the
monotypes may in some manner have served
in their stead. It seems certain, as Janis has
written, that Degas initially used the mono-
type as a vehicle for composing an entire
sheet at once.[7] Heretofore he had built up
compositions by assembling in a predeter-
mined, fictive space figures that he had first
developed in drawings. With monotype,
working with printer's ink on a zinc or cop-
per plate, Degas could compose in an organic
rather than additive manner and easily erase
or revise what he had done. When he printed
the monotype, he had the structure of his
image in place, as if he had made a photo-
graphic print which he could then tint with
colors. The experience of working in mono-
type seems to have been important to the
development of the larger pastels of bathers
because in both the nude figure was made
the primary element around which the space
and accessories have been fitted. This new,
synthetic approach became crucial to his
working method for the rest of his career.

The consistent style of the black-and-
white monotypes in this section[8] suggests
that they were made over a relatively short
period of time, probably before the series of
large pastels was begun in 1884, but not as
early as 1876–77. As usual, Degas printed
more than one impression of each of these
monotypes in order to have a spare work
for coloring with pastel. But since he did
not immediately rework the second impres-
sions, their chronology is more compli-
cated. Some of these reworked monotypes,
such as *Woman in a Bath Sponging Her Leg*
(cat. no. 251), seem to have preceded the
large bathers (if the palette and handling are
reliable indicators) while others evidently
remained untouched in his portfolios much
longer. *Woman Leaving Her Bath* (cat. no. 250),
for example, was probably reworked about
1886–88, after many of the large pastels of
bathers had already been made and exhib-
ited. Thus the pastelized monotypes must
have been made before, during, and after
the series of large pastels of bathers. Inter-
estingly, Degas made each one of the ver-
sions in pastel more particular and concrete
in the description of every detail; in this re-
gard, they are close to the large pastels. Many
of these pastelized monotypes are ravishing
pictures, but in making them Degas sacri-
ficed the poetic suggestiveness of his work
in black and white in order to achieve the
prosaic specificity that he wanted.

1. Alexandre 1918, pp. 18–19.
2. Janis dated all the monotypes of nudes to the 1880s in her catalogue (Janis 1968), but later redated them to 1877 (see Janis 1972).
3. See "The First Monotypes," p. 257.
4. See, for example, cat. nos. 196 and 197.
5. Eugenia Parry Janis, "The Monotypes," in 1984–85 Paris, p. 399.
6. Ibid., p. 400.
7. Ibid.
8. With the possible exception of *Nude Woman Reclining on a Chaise Longue* (cat. no. 244), which has characteristics of both the earlier and later nudes.

244.

Nude Woman Reclining on a Chaise Longue

c. 1879–83
Monotype in black ink on ivory heavy laid paper
First of two impressions
Plate: 7⅞ × 16¼ in. (19.9 × 41.3 cm)
Sheet: 8¾ × 16½ in. (22.1 × 41.8 cm)
Inscribed in monotype upper left: Degas/à/Burty
The Art Institute of Chicago. Clarence Buckingham Collection (1970.590)

Janis 137/Cachin 163

As Eugenia Janis has noted, the inscription of this monotype to Philippe Burty was not merely a gesture of friendship from the artist to a great collector of prints, but homage to a man who in the 1850s and 1860s had been one of the chief propagandists for the revival of etching in France.[1] At the heart of that revival was a renewed appreciation of Rembrandt's tonal prints, and at the heart of this stunning nude is a tribute to Rembrandt's etching *Negress Lying Down* (fig. 222).

Degas's assimilation of Rembrandt's art into his own extends from the 1857 *Portrait of Tourny* (RS5; see "The Etched Self-Portrait of 1857," p. 71), where he portrayed his friend

in the style of Rembrandt's *Self-Portrait at a Window*, to the *Nude Woman Having Her Hair Combed* of the mid-1880s (cat. no. 274), where he alludes to the Rembrandt *Bathsheba* that his father's acquaintance La Caze had bequeathed to the Louvre. Degas's appreciation of the Dutch master was thus a complex matter, initiated in family experiences and in the enthusiasms of a young art student, influenced by the rediscovery of Dutch painting by amateurs, critics, and art historians (Burty and Thoré-Bürger are but two), and developed through the eyes of a mature artist assessing the greatness of another. Here Degas

Fig. 222. Rembrandt, *Negress Lying Down*, 1658. Etching, drypoint, and burin, second state. Plate 3⅛ × 6¼ in. (8 × 15.8 cm); sheet 3¼ × 6⅜ in. (8.2 × 16 cm). The Art Institute of Chicago

Fig. 223. *Nude Woman Reclining* (L752), c. 1888. Pastel over monotype, 13 × 16⅞ in. (33 × 43 cm). Private collection, New York

does not actually copy Rembrandt, but rather takes Rembrandt's print as a kind of challenge: to achieve, with a modern subject (the contemporary courtesan), in a modern idiom (the startling bird's-eye point of view, the radical foreshortening), and in a newly invented medium (the monotype), an analogous image demonstrating an equal mastery of the subtleties of chiaroscuro. It goes without saying that Degas rose to his self-imposed challenge and created here a tonal work of infinite subtlety, from the globe of the oil lamp, brightest at its center and darkest at its chimney, to the ghostly reflections in the mirror above the daybed, to the dim highlights caressing the indolent bather's arm, breasts, belly, and thighs.

Degas used the second impression of this monotype to create a wholly independent work in pastel (fig. 223). He made it half again as large, extending the composition vertically to include the entire bath sheet (only just visible in the right hand of the bather in the monotype) and much of the wall above the couch (he chose not to include a mirror). Richard Brettell aptly describes the difference between these two works in terms of Degas's treatment of the nude: the bather in the pastel is "leaner, more defined, and harder than the model in the monotype. The pastel is athletic, the monotype sensual."[2]

1. Janis 1972, p. 61.
2. Richard Brettell in 1984 Chicago, p. 144.

PROVENANCE: Gift of the artist to Philippe Burty, Paris, c. 1879–83. With Durand-Ruel, Paris. Gustave Pellet, Paris, until 1919; by descent to Maurice Exsteens, Paris, 1919 until at least 1937. With Hector Brame, Paris; with Paul Brame, Paris, 1958–60; bought by Eberhard Kornfeld, Bern, October 1960, sold to Walter Neuerberg, Cologne, October or November 1960, until 1970 (consigned by him for sale Klipstein und Kornfeld, Bern, Auction 108, May 1963, no. 247, pl. 37, but withdrawn; sold, Kornfeld und Klipstein, Bern, Auction 137, June 1970, no. 318, pl. 24); bought at that sale for the museum by Mr. Kovler of Kovler Gallery, Chicago.

EXHIBITIONS: 1937 Paris, Orangerie, no. 208, lent by Maurice Exsteens; 1948 Copenhagen, no. 76, from a private collection; 1960, Bern, Klipstein und Kornfeld, 22 October–30 November, *Choix d'une collection privée: Sammlungen G.P. und M.E.*, no. 23, repr.; 1968 New York, no. 24, repr; 1984 Chicago, pp. 142–44, no. 68, repr. (color).

SELECTED REFERENCES: Guérin 1924, p. 78 (as "La lettre"), repr. p. 80 (as "Femme à la lampe," Pellet collection); Rouart 1948, pl. 19 (as "Nu couché"); Pickvance 1966, p. 18, fig. 1 p. 17; Janis 1967, p. 80, fig. 40 p. ; Janis 1968, no. 137 (as c. 1885); Janis 1972, pp. 56–57, 59–61, fig. 8 p. 60; Nora 1973, pp. 28–30, fig. p. 29; Cachin 1974, no. 163 (as c. 1885); Terrasse 1983, p. 33, fig. 6.

244

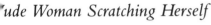

245

45.

ude Woman Scratching Herself

1879–83
onotype in black ink on cream-colored heavy
laid paper (sheet pasted to museum mount)
st of two impressions
te: 10⅞ × 14⅞ in. (27.6 × 37.8 cm)
eet: 14 × 20⅛ in. (35.5 × 51 cm)
ustees of the British Museum
(1949-4-11-2425)

is 135/Cachin 164

his dark-field monotype sometimes known
Le sommeil would seem to be a virtuosic
prise of J137 (cat. no. 244), only more
ring in its summary description of form,
ore exaggerated in its anatomical ellisions,
d therefore more abstract in appearance
d mysterious in meaning. The figure, pil-
ws, and crumpled sheets—so many dips
d curves—were made by wiping away
e ink in an almost rhythmic fashion, as a
eans of emphasizing similarities within the
age (the pillow on the right, for example,
d the arch of the figure's back, or the
uble curve of the two pillows and the
ape of the nude's two breasts). Although
egas gives us no clues regarding the loca-
on of this scene or the identity of the figure,
e can only assume that the coarse gesture
scratching and the uninhibited nudity were

meant to suggest a prostitute in a brothel.
The figure is closely related to the weary in-
habitants of the small brothel monotypes,
such as J72, J73, and J74, who lounge in
their quarters with equal ennui.

True to his habitual procedure, Degas
made the pastelized version of this work
(L753, J136)—based on a weak second im-
pression of this monotype—more logical
and less evocative. In it, the bed and sheets
are clearly indicated, the alcove has been de-
fined, and the nude has been given a right
arm.

While the subject would tie this mono-
type to the work of the late 1870s, the rela-
tively large scale of the figure and its size in
relation to the depicted space argue for a date
closer to 1883. The pastelized version seems
to date from about 1883 as well.

Degas may also have pulled a counterproof
of this monotype, since this composition, in
reverse, seems to have been the basis of an
exceptional landscape by the artist (fig. 224)
in which he transformed the figure of a re-
cumbent nude into the hills and dales of a
verdant landscape near the sea.[1]

1. The observation was made by Jean Sutherland
Boggs in conversation with the author. Richard
Thomson has suggested, less convincingly, that a
drawing for the Metropolitan Museum's *Nude
Woman Having Her Hair Combed* (cat. no. 274) un-
derlay the landscape (1987 Manchester, p. 111).

Fig. 224. *Landscape* (BR134), c. 1892. Pastel over
monotype, 18⅛ × 21½ in. (46 × 54.6 cm). Galerie
Jan Krugier, Geneva

PROVENANCE: Atelier Degas (Vente Estampes, 1918,
no. 239, for Fr 940); bought at that sale by Gustave
Pellet, 1918, until 1919; Campbell Dodgson, London
(former Keeper of the Department of Prints and
Drawings, British Museum), until 1949; his bequest
to the museum 1949.

EXHIBITIONS: 1985 London, no. 20, p. 54, repr. p. 55
(as c. 1883–85).

SELECTED REFERENCES: Guérin 1924, repr. p. 79 (as
Pellet collection); Janis 1967, p. 80, fig. 42 p. 77; Janis
1968, no. 135 (as c. 1883–85); Cachin 1974, no. 164,
repr. (as c. 1885); Keyser 1981, pp. 73–76, pl. XXXIV
(as c. 1885); Sutton 1986, p. 238, fig. 222 p. 235.

246

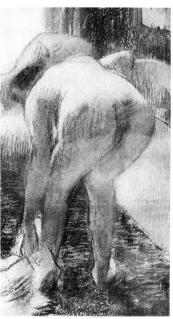

Fig. 225. *Nude Woman Wiping Her Feet* (L836), c. 1884–86. Pastel over monotype, 17¾ × 9½ in. (45 × 24 cm). Private collection, Paris

246.

Nude Woman Wiping Her Feet

c. 1879–83
Monotype in black ink on cream-colored heavy laid paper
First of two impressions
Plate: 17¾ × 9⅜ in. (45.1 × 23.9 cm)
Sheet: 21⅞ × 14⅜ in. (55.5 × 36.5 cm)
Cabinet des Dessins, Musée du Louvre (Orsay), Paris (RF4046B)

Exhibited in Ottawa and New York

Janis 127/Cachin 158

"Do you know how we pose at Degas's?" a model asked the critic Gustave Coquiot one evening at a dance hall. "As women who dump themselves in the tub and who wash their hind ends."[1] All the indignation and surprise that gave birth to this remark is epitomized by this monotype. It is a tour-de-force of its kind, the most sensational and comical of the bather monotypes. With an impressive economy of means—just a few wipes with his fingers and his cloth pad and a few touches with something sharp—Degas perpetrated an image that violated al-most every taboo concerning decency and privacy. The bather is seen not as she mig[ht] present herself to someone else, nor as she might see herself reflected in a mirror; rathe[r] she is shown from a vantage point that coul[d] only be obtained by a voyeur or a familiar. As Degas was to remark to George Moore about his bathers in general, "It's the hum[an] animal taking care of its body . . . [seen] a[s] if you looked through a keyhole,"[2] and this human animal is caught in a cruelly unflat-tering position. But it could also be said th[at] for all his sarcasm, Degas still had sympat[hy] for his subject and softened the assault wit[h] a broadly comic approach.

Degas made two impressions of this monotype. The second, fainter impression was reworked with pastel, presumably at a later date (fig. 225). Characteristically, he made the setting in the pastel more specifi[c] (adding a mirror over the bathtub and an armchair behind the bather's head) and made the pose of the figure more credible anatomically (bending the legs of the bathe[r]

at the knee and articulating her arms at the elbow). And as with some of his other pas-telized monotypes, by adding an anecdotal a[s]pect that is fundamentally at odds with the monumentality of the image, he deprived the composition of much of its strength.

Degas first used a bending figure seen from behind in an earlier monotype of a brothel scene (J67, Musée Picasso, Paris). He incorporated a similar figure in a num-ber of pastels in and about 1885, one of which is dated 1885 and was exhibited in the 1886 Impressionist exhibition (fig. 186)[.]

And he used the pose in a charcoal and pastel drawing, L837, which was reproduced in Vollard's album of reproductions of drawings by Degas.[4]

1. Coquiot 1924, p. 199.
2. George Moore, *Confessions of a Young Man*, London: S. Sonnenschein, 1888 (Montreal: McGill-Queen's University Press, 1972, p. 318).
3. L1075, L1076 (ex Vollard collection), and L1077 (ex Vollard collection).
4. Vollard 1914, pl. LIX.

PROVENANCE: Earliest whereabouts unknown; Comte Isaac de Camondo, Paris, until 1908; his bequest to the Louvre 1908; entered the Louvre 1911.

EXHIBITIONS: 1969 Paris, no. 206 (as c. 1890).

SELECTED REFERENCES: Paris, Louvre, Camondo, 1914, no. 230 (as c. 1890–1900); Lafond 1918–19, II, p. 72; Paris, Louvre, Camondo, 1922, no. 230; Janis 1967, p. 80, fig. 48 p. 78 (as c. 1885); Janis 1968, no. 127 (as c. 1880–85); Nora 1973, p. 28, fig. 1 p. 30; Cachin 1974, no. 158, repr. (as c. 1882–85).

247.

Nude Woman Combing Her Hair

c. 1879–83
Monotype in black ink on buff heavy laid paper
First of two impressions
Plate: 12⅜ × 11 in. (31.3 × 27.9 cm)
Sheet: 19½ × 13¾ in. (49.4 × 24.9 cm)
Atelier stamp on verso
Cabinet des Dessins, Musée du Louvre (Orsay), Paris (RF16724)

Exhibited in Paris

Janis 156/Cachin 168

Leaning with her knee against the end of a chaise longue, a young woman combs her hair, holding it aloft against the light that floods through the glass curtains of the window behind her. As the scene is drawn with great precision, despite the difficulties imposed by the dark-field manner, Degas seems to have sought to invest the work with exceptional detail as a foil to the shadowy composition. As a matter of course, the contours and silhouettes were carefully worked, but most extraordinary are details such as the highlight delineating the bather's left jaw, or the glint of light caught by her earring, or the teeth of the comb and the fingers of the hand that holds it.

Degas first broached the motif of a woman combing her hair in a painting of about 1875 now in the Phillips Collection in Washington, *Women Combing Their Hair* (cat. no. 148), and afterward returned to the subject repeatedly in the 1880s and 1890s (see cat. nos. 284, 285, 310). It allowed him to exploit two highly charged objects of sensual desire: the female nude and luxuriant hair. Extravagantly long undone hair had become, by the mid-nineteenth century, synonymous with sexuality in the nudes of most academic painters and sculptors. In Clésinger's marble of 1847, *Woman Bitten by a Snake* (Musée d'Orsay, Paris), and in Cabanel's painting of 1863, *The Birth of Venus* (fig. 251), the abundant hair of the figures was just as important to the eroticism of the works as the breasts and hips of the models. Courbet used hair as a potent symbol, so much so that he was able to eroticize, for example, his *Portrait of Jo* (The Metropolitan Museum of Art, New York) simply by depicting Jo Heffernan running her fingers through her red hair—even though she is fully clothed. Puvis de Chavannes, whose work Degas admired almost as much as he did Courbet's, painted many compositions of women adjusting huge manes of hair or having their hair combed, and in these pictures, cool and detached in sentiment, hair is used as an almost intellectual expression of sensuality. With Degas, sexuality is typically more veiled. Although this nude is chaste and modest—she would not know that we are watching—there can be no doubt that Degas arranged her cascades of hair for our pleasure and further underscored her sexuality by emphasizing her hips and marking her *mons veneris*.

Degas pulled a second impression of this monotype and reworked it with pastel (L799, private collection). It conforms closely in appearance to this work, with one exception: the end of the chaise longue was converted to a pouf.

PROVENANCE: Atelier Degas (Vente Estampes, 1918, no. 247, for Fr 3,100); bought at that sale by Jeanne Fevre, the artist's niece, Paris, 1918, until 1930 (sale, Drouot, Paris, 11 December 1930, no. 65, as "La toilette [La chevelure]"); bought at that sale by the Société des Amis du Louvre.

EXHIBITIONS: 1937 Paris, Orangerie, no. 210; 1969 Paris, no. 209; 1985 London, no. 17, repr.

SELECTED REFERENCES: Alexandre 1918, no. 171, repr. p. 17; Guérin 1924, p. 78; Leymarie 1947, no. 39, pl. XXXIX; Janis 1967, p. 79 n. 31; Janis 1968, no. 156, repr. (as c. 1884); Nora 1973, p. 28; Cachin 1974, no. 168, repr. (as 1880–85).

247

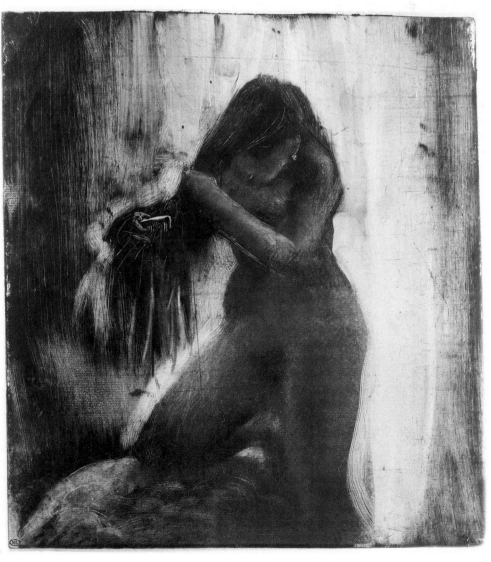

248.

The Washbasin

c. 1879–83
Monotype in black ink on pale buff heavy laid
 paper
First of two impressions
Plate: 19 × 14 in. (48.2 × 35.3 cm)
Sheet: 12⅜ × 10¾ in. (31.5 × 27.3 cm)
Atelier stamp on verso
Sterling and Francine Clark Art Institute,
 Williamstown, Massachusetts (1962.39)

Janis 147/Cachin 156

This work, one of the most charming of the dark-field monotypes of bathers, is specifically related to earlier, smaller format monotypes in which prostitutes bathe while male clients avidly observe their actions (see cat. no. 186). But in line with the general development of Degas's work in the 1880s, the figure here has assumed a larger place within the composition and the anecdotal element has been suppressed. We the viewers now take the place of the onlooking clients, and the artist focuses our attention not on a comic scene but on the lovely, lithe back of the bather—always a subject of interest to Degas—and on the light that streams in from the window at the left, bouncing off the marble washstand and porcelain basin and illuminating the perfume bottles beneath the mirror. As a subtlety, Degas has indicated the barely perceptible reflection of the bather's back in the mirror, and as a sociological clue he has placed within view the young woman's hairpiece.

It is not known whether Degas made a second impression of this monotype, but he did make a counterproof of it by pressing a sheet of paper on its surface while the ink was still wet. This explains both the paleness of this print (it gave up much of its ink to the counterproof) and the puzzling double platemark at the margins (made by running this sheet through the press a second time with its counterproof). Degas reworked the counterproof with pastel (fig. 226) and also made another pair of monotypes (J149, Fondation Jacques Doucet, Paris, and L1199, J150) based on the counterproof (a mirror image of the present work). Pastels of a woman adjusting her hair at her dressing table, such as L983 (fig. 248), relate closely to this constellation of images, all of which seem to date to the mid-1880s. Degas used them as inspiration for new works in the 1890s, such as L966 bis, and Mary Cassatt may have thought of them in 1891 when she made her aquatints of a bather with her peignoir gathered at her waist, looking like a modern-day Venus de Milo.

PROVENANCE: Atelier Degas (Vente Estampes, 1918, no. 245, for Fr 835); bought at that sale by Ambroise Vollard, Paris. Dr. Herbert Leon Michel, Chicago, until 1962; bought from him by the museum in 1962.

EXHIBITIONS: 1965, Williamstown, Sterling and Francine Clark Art Institute, May, *Exhibit 29: Curator's Choice*, no. 10, repr.; 1968 Cambridge, Mass., no. 36, repr. (as c. 1880–85); 1970 Williamstown, no. 53;

248

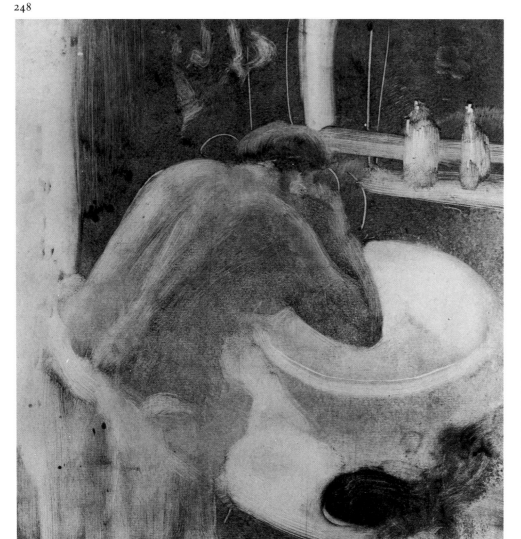

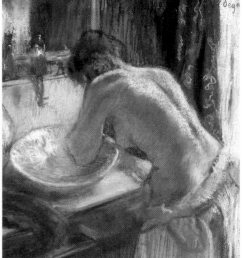

Fig. 226. *The Washbasin* (L966), c. 1884–86. Pastel over monotype, 12¼ × 10⅝ in. (31 × 27 cm). Private collection

1974 Boston, no. 105; 1981 San Jose, no. 54, repr. n.p.; 1984, Williamstown, Sterling and Francine Clark Art Institute, 7 April–28 May, *Degas: Prints and Drawings* (no catalogue); 1987, Williamstown, Sterling and Francine Clark Art Institute, 20 June–25 October, *Degas in the Clark Collection* (by Rafael Fernandez and Alexandra R. Murphy), no. 55, p. 69 repr. (as c. 1880–85).

SELECTED REFERENCES: Janis 1968, no. 147 (as c. 1880–85); Cachin 1974, no. 156 (as c. 1882–85).

249.

Woman Leaving Her Bath

c. 1879–83
Monotype in black ink on pale buff heavy laid
 paper
First of two impressions
Plate: 11 × 14¾ in. (28 × 37.5 cm)
Inscribed in monotype lower right: Degas à son
 ami Michel Levy [partially obscured with
 blue ink]
Private collection

Janis 121/Cachin 161

In making this work, Degas first covered a
copper or zinc plate with heavy printer's
ink. He then wiped the plate with a rag,
vertically to indicate the window at the left,
and diagonally to create the bathtub at the
right. To make the bather, he manipulated
the ink with his fingers, adding ink for the
shadows, taking it away for the highlights.
With a pointed instrument, he scratched in
the faucets over the bathtub, defined the
chair and the robe, and formed the precise
contours of the bather's back, head, arms,
and hands. He carefully scratched in his sig-
nature and an inscription to a friend. Then,
satisfied with his shadowy scene, he placed
a sheet of ribbed paper over the plate, and ran
the sandwich through the press. He lifted
the paper off the plate, replaced it with an-
other sheet, and repeated the printing.

Degas saved the second printed sheet for
later work. It was a paler version (since
most of the ink was absorbed by the first
sheet), and was probably too faint to be leg-
ible on its own. Sometime later, about 1886–
88, he completely reworked this second
impression to make a picture in pastel (cat.
no. 250). In doing so, he was careful to cor-
rect the anatomy of the bather, lengthening
and straightening her torso and providing
elbows for her otherwise jointless, doughy
arms. Similarly, he made some of the fur-
nishings of the room more precise: the mir-
ror has a frame, the window its curtains.

Although it lacks the specificity of the pas-
tel and the allure of its strong coloring, the
monotype has a haunting, mysterious quali-
ty. The rich surface of this impression and
the dramatic contrast between its dense sha-
dows and brilliant highlights indicate that it
was generated in the first printing. It is a
self-sufficient work, created as a private im-
age of delectation and destined for a specific
individual. The bather is faceless, her figure
too imprecise to provoke an erotic response,
but perhaps the very notion of the violation
of privacy implicit in this image was suffi-
cient to convey a sexual charge. The recipi-
ent of this monotype, an artist named Henri
Michel-Lévy, was the subject of a portrait
by Degas (L326, Calouste Gulbenkian Mu-

seum, Lisbon) notable for its air of brood-
ing, brutal sexuality—the man stares down
the observer while a lay figure, dressed in a
woman's street costume, lies crumpled at
his feet.

PROVENANCE: Gift of the artist to Henri Michel-Lévy,
c. 1879–83. César de Hauke, Paris, by 1958; Mrs.
Elsa Essberger, Hamburg, by at least 1968; by de-
scent to present owner.

EXHIBITIONS: 1958 Los Angeles, no. 96, repr. p. 85
(as c. 1880), lent by César de Hauke, Paris; 1968
Cambridge, Mass., no. 32, repr., lent by Mrs. Elsa
Essberger, Hamburg.

SELECTED REFERENCES: Janis 1968, no. 121 (as c. 1880–
85); Janis 1972, pp. 56–57, 59, fig. 5 p. 57; Cachin
1974, no. 161 repr. (as c. 1882–85).

250.

Woman Leaving Her Bath

c. 1886–88
Pastel over monotype on buff laid paper
 mounted on canvas
Second of two impressions
11 × 15 in. (28 × 38 cm)
Signed lower left: Degas
Collection of Mr. and Mrs. Thomas Gibson

Lemoisne 891

It is not known precisely when Degas made
the monotype (cat. no. 249) that served as
the base for this work, nor is it known
when he reworked it with pastel. What is
certain is that this pastel was exhibited at
Theo van Gogh's gallery at Boussod et Va-
ladon in January 1888 (see Chronology III),
where it was seen and described by Félix
Fénéon:

> The pertinacious and never vain efforts of
> this cool visionary are dedicated to finding
> the line that will reveal his figures unfor-
> gettably and give them a life that is both
> definitive and stamped with genuine mo-
> dernity. He delights in shielding his work
> from the comprehension of the passer-by
> and concealing its austere, unblemished
> beauty, imagining deceptive foreshorten-
> ings that alter proportions and suppress
> shapes; . . . already standing to leave the
> bath, another [bather], with golden yel-
> low hair, arms outstretched, takes hold of
> a peignoir; the water, still splashing, re-
> flects the red walls; at her groin, shadows
> darken to green.[1]

The work may have been consigned by
the artist directly to Theo van Gogh (al-
though it does not appear in the Boussod et
Valadon stock books), and it was probably
completed not long before it was exhibited

in 1888. The hot colors of the wall hangings
and the broad facture (the blue pastel shadows
in the peignoir may even have been worked
wet with a brush) support a date about 1886–
88. Furthermore, the stiff, straightened back
of this bather in pastel links the work to
Degas's nudes of the mid-1880s, in contrast
to the elastic and often lissome bodies of the
nudes in the monotypes of the 1870s and
early 1880s. Presumably, the artist continued
to turn to his stock of monotypes for re-
working with pastel many years after he
had begun them.

Gauguin too saw this work when it was
exhibited in 1888. In addition to five works
by Degas,[2] van Gogh displayed in his gallery
a painting by Gauguin, *Two Bathers* (Wil-
denstein 215; private collection, Buenos Aires),
that was painted in Brittany in 1887 and was
no doubt inspired by the nudes bathing out
of doors that Degas had exhibited at the 1886
Impressionist exhibition (BR113 [fig. 186],
and another pastel, reworked later, L1075).
Gauguin was a leading disciple of Degas's in
the 1880s, and each of them owned and
copied works by the other.[3] The younger
artist, fiercely competitive, nevertheless
could only have been flattered by the juxta-
position of his bathers with Degas's. At this
time the two artists, for different reasons
and with different results, were interested in
truncated figures and motifs and asymmet-
rical compositions. Both used inelegant pos-
tures and abrupt foreshortenings, making of
them something beautiful and bold. Gauguin,
for his part, copied this pastel in a notebook
(fig. 227).[4]

There is a drawing, L892, related to this
pastel. Since the figure in the study has the
same stiff, straight back parallel to the upper
edge of the picture as the figure in the pas-
tel, the drawing must relate to the finished
pastel rather than to the monotype under-
neath it. The style of the study is consistent
with Degas's work of 1886–88. Much later,
sometime in the late 1890s, Degas made a
bold and free charcoal drawing (fig. 228)
after the pastel or, more probably, of the
study; this drawing on tracing paper bears a
dedication to Mme Charpentier. It was not
catalogued by Lemoisne, nor did it figure in
the atelier sales.

G. W. Thornley made a colored litho-
graph after this pastel, which he published
in 1889.[5]

1. *La Revue Indépendante*, February 1888, reprinted in
 Fénéon 1970, I, pp. 95–96.
2. L1089, L876 (fig. 247), L1008, L1010 (fig. 197),
 and the present work.
3. See Reff 1976, pp. 262–64.
4. There are sufficient discrepancies between Gau-
 guin's copies and the original works by Degas to
 suggest that Gauguin's notes were made from
 memory. In particular, the figure in the copy of
 L731 is reversed, and the drawings at the upper

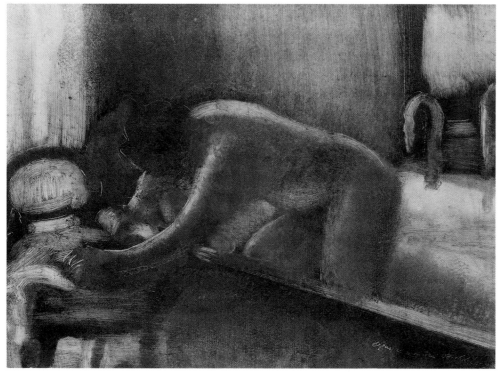

249

250

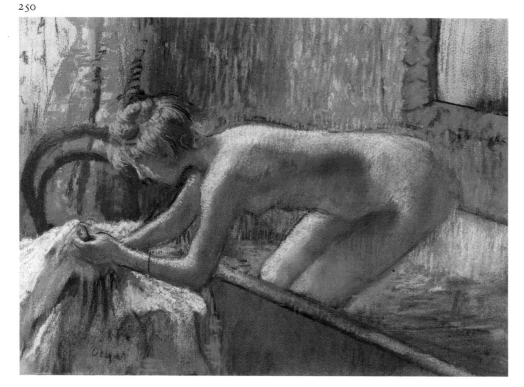

Fig. 227. Paul Gauguin, Sheet of studies after Degas, February 1888. Pencil on paper, 6¼ × 4¼ in. (15.9 × 10.8 cm). Album Brillant, Cabinet des Dessins, Musée du Louvre (Orsay), Paris (RF30273)

Fig. 228. *Woman Leaving Her Bath*, c. 1898. Pastel and charcoal on paper, 17 × 20 in. (43.2 × 50.8 cm). Location unknown. Previously unpublished

and lower right are too summary to identify with known works by Degas. The works copied are L891, L1010 (fig. 197), L1008, L731, and the unidentifiable work (which may be a reworking of one of Gauguin's own poses of bathers, such as the pose at the bottom left of Wildenstein 215, cited above). Three of the identifiable works are known to have been on view at Boussod et Valadon in early 1888.

5. Thornley 1889.

PROVENANCE: With Goupil–Boussod et Valadon, Paris, 1888; subsequent whereabouts unknown. Georges Bernheim, by 1913; half share acquired, with Bernheim, by Durand-Ruel, Paris, 20 May 1913 (stock no. 10333). Dr. Georges Viau, Paris, before 1918. With Galerie Barbazanges, Paris, 1921; sent on deposit to Durand-Ruel, New York, 10–16 March 1921 (deposit no. 12380); bought by Durand-Ruel, Paris, 29 March 1921, for Fr 2,500 (stock no. 4652); bought by Mrs. G. D. [sic] Maguire, New York, 16 April 1930, for Fr 5,000; Mrs. Ruth Swift Maguire, New York, 1930–49; Mrs. Ruth Dunbar Sherwood, her daughter, 1949 until after 1960; Tom Denton, New Mexico; Gerald Peters, Santa Fe, N.M., until 1983; bought by Eugene V. Thaw, New York, late 1983; bought by present owner, 9 February 1984.

EXHIBITIONS: 1888, Paris, Boussod et Valadon, January (no catalogue known); 1937 New York, no. 6, repr., lent by Mrs. R. S. Maguire; 1949 New York,

no. 76, lent by the estate of Mrs. Ruth Swift Maguire; 1960 New York, no. 68A, lent by Mrs. R. Dunbar Sherwood; 1985, London, Thomas Gibson Fine Art Ltd., 4 June–12 July, *Paper*, n.p., repr.

SELECTED REFERENCES: Félix Fénéon, "Calendrier de janvier," *La Revue Indépendante*, February 1888, reprinted in Fénéon 1970, I, pp. 95–96. Thornley 1889, repr.; Lafond 1918–19, II, repr. following p. 52 (as G. Viau collection); Lemoisne [1946–49], III, no. 891 (as c. 1886–90); Janis 1968, no. 122, repr. (as 1886–90); Minervino 1974, no. 931.

251.

Woman in a Bath Sponging Her Leg

c. 1883–84
Pastel over monotype on off-white laid paper
Second of two impressions
7¾ × 16⅛ in. (19.7 × 41 cm)
Signed in brown chalk lower left: Degas
Musée d'Orsay, Paris (RF4043)

Exhibited in Paris

Lemoisne 728

To make this pastel, Degas took as his point of departure a second, paler impression of a monotype (fig. 229) that shows a hunched, frog-faced, rubber-jointed woman taking a daytime bath in a well-appointed room. There is a mirror above the bath, and the tub itself is fed through swan-neck faucets that are served by interior plumbing—still very much a luxury in 1880s Paris. The animal-like qualities that the artist gives to the bather in the monotype link her to the women in some of his brothel monotypes (see cat. nos. 180–188); that affinity, coupled with the fact that the setting is more elegant than the woman occupying it, would seem to indicate that this monotype too represents a brothel scene.

The pastel conveys a quite different impression. The bather is younger, and she holds her well-shaped head high above her slim shoulders. Degas straightened her extended leg and corrected the position of her left arm. The room is now more simply furnished: the walls are hung with a nondescript wallpaper or chintz; there is no mirror; and the tub, without faucets and in the middle of the room, has no plumbing. The hoop-back chair has been replaced by a mass-produced bentwood chair, and a simple chest of drawers marks the corner. The environment here is less sophisticated, and the woman in turn appears more honest: perhaps she is a young working woman or a model—certainly not the figure of ridicule portrayed in the original monotype.

The monotype base was probably made about 1879–83. The slightly comic atmosphere ties it to the late 1870s, as does the bird's-eye point of view. It is dedicated to a friend of Degas's, a minor Neapolitan artist, Federico Rosanno, whom Degas refers to in letters thought to have been written in 1879 or 1880.[1] The present work, on the other hand, probably dates to about 1883–84. Its pleasantly soft and light tonalities, the pale flesh color of the bather's skin, and the rather straightforward approach to the simple fact

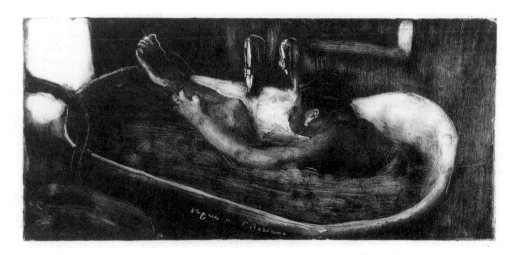

Fig. 229. *Woman in a Bath Sponging Her Leg* (J119), 1879–83. Monotype, 7⅞ × 16⅞ in. (20 × 42.9 cm). Private collection

251

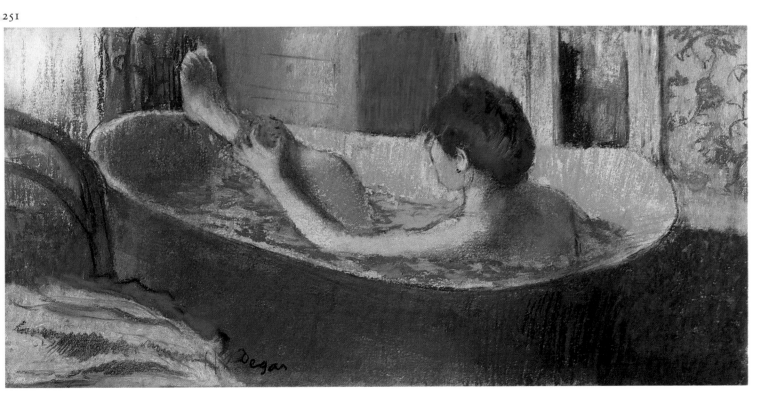

of a woman bathing relate it to a constellation of works commonly dated to the mid-1880s, many of which are pastelized monotypes.[2]

Lemoisne's claim that it was exhibited in the 1886 Impressionist exhibition is unsubstantiated: not a single reviewer described it.[3]

1. Lettres Degas 1945, XVI, p. 43, XXII, p. 49; Degas Letters 1947, no. 25, p. 48, no. 31, p. 54. The association was made by Janis (1968 Cambridge, Mass., no. 31).
2. Examples include L730, L747, J144, J145, L966 (fig. 226), L1199, L799, and L717 (cat. no. 253), in addition to a closely related pastel L1010 (fig. 197).
3. Lemoisne [1946–49], III, p. 412.

PROVENANCE: Earliest whereabouts unknown. Bought from Guyotin, a *commissaire-priseur*, by Durand-Ruel, Paris, 9 March 1893, for Fr 1,200 (stock no. 2693); sold to M. Manzini, 47 rue Taitbout, Paris, 13 March 1893, for Fr 2,600; bought on the same day by Comte Isaac de Camondo (Camondo Notebook, Archives, Musée du Louvre, Paris); Camondo collection, Paris, 1893–1908; his bequest to the Louvre 1908; entered the Louvre 1911; first exhibited 1914.

EXHIBITIONS: 1969 Paris, no. 202 (as c. 1883).

SELECTED REFERENCES: Paris, Louvre, Camondo, 1914, p. 44, no. 224; Lafond 1918–19, I, repr. p. 58; Meier-Graefe 1920, pl. 74; Paris, Louvre, Camondo, 1922, p. 50, no. 224; Meier-Graefe 1923, pl. LXXIV; Paris, Louvre, Pastels, 1930, no. 25; Lemoisne [1946–49], III, no. 728 (as c. 1883); Paris, Louvre, Impressionnistes, 1958, no. 92; Paris, Louvre, Peintures, 1959, no. 641, pl. 222; Janis 1967, pp. 21 n. 10, 26 n. 28, 72 n. 6, 79, fig. 56 p. 29; Janis 1968, no. 120 (as c. 1883); Janis 1972, p. 65; Paris, Louvre, Impressionnistes, 1973, p. 143, repr. p. 32; Minervino 1974, no. 889, pl. XLVII (color); Terrasse 1974, repr. p. 79; Paris, Louvre and Orsay, Pastels, 1985, no. 56, p. 65 repr.

252.

Woman Standing in Her Bath

c. 1879–83
Monotype in black ink on cream-colored heavy laid paper, slightly discolored
First of two impressions
Plate: 15 × 10⅝ in. (38 × 27 cm)
Sheet: 20⅜ × 13⅞ in. (51.7 × 35.3 cm)
Cabinet des Dessins, Musée du Louvre (Orsay), Paris (RF4046)

Exhibited in Ottawa and New York

Janis 125/Cachin 157

In this work Degas revels in light and its reflections, just as he exploits light in such black-and-white lithographs as *Mlle Bécat at the Café des Ambassadeurs* (cat. no. 176). But where the light in *Mlle Bécat* is largely artificial, here it is direct sunlight that illuminates the scene. Almost blinding in intensity as it burns through the glass curtains, the light softens as it fills the room, bouncing off the

peignoir draped on the chair at the right and pooling on the surface of the bathwater at the left. While most of the dark-field bather monotypes are distinguished by sharp contrasts of light and shade, here Degas masterfully employs a middle tone, giving a sense of three-dimensionality to the figure and the furnishings that elsewhere appear relatively flat.

Degas had used the pose of a stepping bather in an early pastelized monotype (L423, Norton Simon Museum, Pasadena), which in turn is very close to a black-and-white monotype (cat. no. 191) as well as to a pastelized monotype (cat. no. 190) that was shown by the 1877 Impressionist exhibition. Presumably all three works were made by 1877, and they offer instructive

contrast to the present work, which must be later. The earlier monotypes depict rooms whose depth is defined by the sharp diagonal line that Degas habitually used in the late 1870s to structure space. The furnishings and décor are precisely catalogued, and the figures are small in relation to the space they occupy. In contrast, the space implied in the present work is not nearly as deep and the diagonal thrust of the bathtub's rim is mitigated by the strong vertical of the window. The furnishings are only summarily indicated, and the figure assumes a more important place. In other monotypes of this later group (for example cat. no. 246), the figure swells in proportion to the depicted space to assume monumental and sometimes even grotesque pro-

252

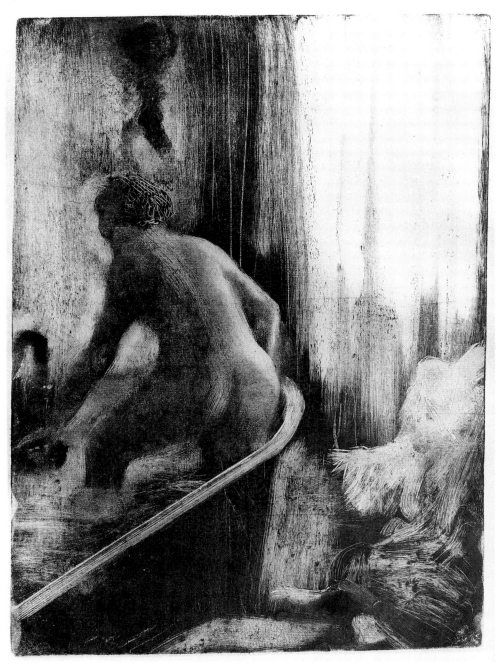

portions. The pastelized versions of these monotypes tend to give even greater prominence to the figure. Since the pastel bathers shown in the 1886 Impressionist exhibition are all very large in comparison to the depicted space, monotypes such as the present work most probably fall between the two known termini, 1877 and 1886.

PROVENANCE: Earliest whereabouts unknown; Comte Isaac de Camondo, Paris, until 1908; his bequest to the Louvre 1908; entered the Louvre 1911.

EXHIBITIONS: 1924 Paris, no. 248 (as between 1890–1900); 1969 Paris, no. 207 (as c. 1883); 1986, New York, The Brooklyn Museum, 13 March–5 May/ Dallas Museum of Art, 1 June–3 August, *From Courbet to Cézanne*, fig. 120.

SELECTED REFERENCES: Paris, Louvre, Camondo, 1914, no. 229 (as c. 1890–1900); Paris, Louvre, Camondo, 1922, no. 229; Guérin 1924, p. 78; Rouart 1948, pl. 16; Janis 1967, p. 79; Janis 1968, no. 125 (as c. 1880–85); Cachin 1974, no. 157, repr. (as c. 1882–85).

253.

After the Bath

c. 1883–84
Pastel and wash (possibly over monotype) on buff wove paper, extended with strip at bottom
20½ × 12⅝ in. (52 × 32 cm)
Signed in black chalk lower right: Degas
Durand-Ruel collection

Lemoisne 717

This work occupies a key position transitional between the pastelized monotypes begun in the mid-1870s and largely completed by the early 1880s[1] and the large-format nudes that Degas began in the mid-1880s[2] and continued working on for ten years. Its size falls neatly between the average sizes of the two groups, and its date probably lies about midway between the two periods in question. It may in fact have been the point of departure for the entire series of large nudes that culminated in the works shown at the Impressionist exhibition of 1886.

The figure in this picture is probably the first bather by Degas to stand more or less upright and be fully visible to the observer. The earlier nudes, worked in monotype, tend to be crouching or stooping, bent over, or immersed in a tub; the images are so closely cropped that one feels the figures would break out of the frame if they were to fully extend themselves. This work also appears to be one of the first of the bathers to be executed in a new, larger scale: the earlier monotype bathers never exceeded forty-five

centimeters (about 18 in.) in either direction, whereas this sheet is about one-and-a-half times larger than the largest monotype bather. It is not as imposing in size as the bathers exhibited in 1886, but the figure possesses a kind of integrity that could properly be characterized as classical. The figure, evidently studied from life (see cat. no. 254), moves within a convincing and well-defined space of medium depth that, contrary to the monotypes, does not oppress or circumscribe her but rather appears to be agreeably generous. The pink-and-green wall coverings seem to have been designed to reflect her pink flesh color with its green undertones, and the drapes seem to have been parted expressly to reveal her handsome, robust physique. The whole is suffused with a clear light of sufficient strength to render even the shadowed details quite legible.

This work may be more closely related to the monotypes than was previously thought, since the pose of the figure is almost identical to that in L719 (fig. 230), a pastel thought to have a monotype base. Eugenia Janis has suggested that the base Degas used may have been a second impression of the monotype J125 (cat. no. 252), but she allows that the number of discrepancies between the two images is large enough to cast doubt on her proposal.[3] Indeed, it may be that the present work shares a previously unrecognized monotype base with the pastel L719. Examination of photographs (the present location of L719 is unknown) indicates that the figures in the two works are virtually the same size, and that in addition to the strip of paper added at the bottom, the present work may bear a plate mark, which would have been necessitated by the conversion of the squarish format of L719 to the vertical format here. Future examination of *After the Bath* may shed further light on the interdependence of these works.

Other related works include the life drawing (cat. no. 254) and additional sketches noted in the entry for that work. Degas also made another pastel, L718 (fig. 231), showing the same figure sponging her leg in a room with a similarly unmade bed at the extreme left, only this time there is a shallow tub and the slipper chair has been turned around. Degas obviously delighted in the utility of this figure, equally at home in or out of a tub, shallow or deep, and poised precariously, like many of his dancers, in mid-movement.

1. Such as L422 (cat. no. 190) and L423, Norton Simon Museum, Pasadena.
2. See, for example, cat. nos. 269 and 271.
3. Janis 1967, p. 79 n. 34.

PROVENANCE: Earliest whereabouts unknown. Mme Paul Aubry, 16 boulevard Maillot, Paris, until 1895; bought by Durand-Ruel, Paris, 1 October 1895, for Fr 4,500 (stock no. 3415); Durand-Ruel collection, Paris, from 1895; Mme Georges Durand-Ruel collection, Neuilly-sur-Seine; by descent to M. and Mme Charles Durand-Ruel, Paris, until 1986; to present owner.

EXHIBITIONS: (?)1903–04, Weimar;[1] 1905 London, no. 52 (as "After the Bath," pastel, 1883), no lender given; 1924 Paris, no. 145, pp. 77–78, repr. p. 79 (as "Femme nue, debout dans son cabinet de toilette, se frottant après son bain," 1883), lent by Georges Durand-Ruel; 1934, Paris, Galerie Durand-Ruel, 11 May–16 June, *Quelques oeuvres importantes de Corot à Van Gogh*, no. 9 (as 1883); 1937 Paris, Orangerie, no. 120, lent by Durand-Ruel; 1939–40 Buenos Aires, no. 42, I, p. 60, II, repr. p. 46; 1940–41 San Francisco, no. 32, repr. p. 82; 1941, Worcester Art Museum, 22 February–16 March, *The Art of the Third Republic: French Painting 1870–1940*, no. 5, repr.; 1941, The Art Institute of Chicago, 10 April–20 May, *Masterpieces of French Art Lent by the Museums and Collectors of France*, no. 43; 1947, New York, Durand-Ruel Galleries, 10–29 November, *Degas*, no. 20; 1960 Paris, no. 36, repr.; 1964, Stockholm, Nationalmuseum, 7 August–11 October, *La douce France/Det Ljuva Frankrike*, no. 30, repr.; 1970, Kunstverein Hamburg, 28 November 1970–24 January 1971, *Französische Impressionisten: hommage à Durand-Ruel*, no. 12, repr.; 1974, Paris, Galeries Durand-Ruel, 15 January–15 March, *Cent ans d'impressionnisme: hommage à Paul Durand-Ruel, 1874–1974*, no. 17, repr.

1. According to the Durand-Ruel deposit book, the work was sent to an exhibition in Weimar, 3 December 1903–4 March 1904.

SELECTED REFERENCES: Pica 1907, p. 416, repr.; Moore 1907–08, p. 144, repr.; Grappe 1908, p. 12, repr.; Lemoisne 1912, repr. facing p. 100; Jamot 1918, repr. p. 163; Lafond 1918–19, II, repr. (color) facing p. 52; Jamot 1924, pp. 107 n. 2, 152, pl. 64; Vollard 1924, repr. facing p. 20; Grappe 1936, repr. p. 49; Lemoisne [1946–49], III, no. 717 (as 1883); Minervino 1974, no. 895.

254.

Standing Bather

c. 1883–84
Charcoal, pastel, and watercolor on off-white laid paper
12⅛ × 9⅜ in. (30.8 × 23.8 cm)
Vente stamp lower right
The Metropolitan Museum of Art, New York. Rogers Fund, 1918 (19.51.3)

Brame and Reff 112

Degas brought this drawing—a preparatory study for a larger pastel—to a higher degree of finish than almost any other drawing of a bather. He selected a fine sheet of paper, tested his stick of charcoal at the right margin, and drew the outlines of the figure. He began tentatively at the shoulders, and initially sketched them much wider, but as he became sure of what he wanted, he drew a strong contour along the desired profile. He repeated the same procedure in defining the

bather's right arm, but the rest of the figure was completed with little revision. Degas abandoned most of his studies of bathers at just that stage of summary execution. In this instance, however, he carried on, not only adding touches of color to indicate the environment—here it is bright sky-blue pastel—but also making a pale gray wash, perhaps with charcoal or a warm-gray chalk, and meticulously painting in the shadows. Over this he drew the broader cross-hatching in charcoal and the rather unexpected, largely imperceptible touches of color. The hot shadow on the face is readily visible, but the moss-green shadow on the bather's back next to her left elbow, the touches of pink on either side of the small of her back, and the faint highlight on the crest of her left shoulder are subtleties that reveal more about Degas's fanatic sense of observation than about the bather herself.

This drawing is closely related to several pastels and a sculpture (RLIX) of a bather holding an identical pose—raising the knee in order to sponge it—but it is not entirely certain for which of these the present drawing served as a study. Brame and Reff have catalogued it as a study for *After the Bath* (cat. no. 253),[1] but whereas there is some indication of a deep tub in this drawing, there is no tub at all in that pastel. The composition of L719 (fig. 230), with its deep tub, is closest to the composition suggested by this drawing, but that work seems to have been completed about 1894,[2] whereas the drawing conforms to Degas's technique around 1883–84. The bather in L718 (fig. 231) also corresponds to the bather in this drawing, but there is a shallow tub in that work rather than the deep one seen here, and the style of execution seems to indicate a date about 1890. It is of course possible that Degas used this drawing as the basis for all three pastels, but since there are, in addition, other more summary sketches of figures in the same pose (III:135.1, III:135.3, III:142.4, III:110.2, II:172), it is difficult to determine the precise relationship between these studies and the finished works.

1. Brame and Reff 1984, p. 122.
2. The chronology of L719 is complicated by its monotype base, which was probably made several years earlier than the pastelized surface.

PROVENANCE: Atelier Degas (Vente II, 1918, no. 222.2), for Fr 2,700 (along with another drawing, II:222.1); bought at that sale by the museum.

EXHIBITIONS: (?)1922 New York, no. 49 (as "Après le bain: femme s'essuyant le genou gauche"); 1977 New York, no. 40 of works on paper.

SELECTED REFERENCES: Burroughs 1919, pp. 116–17; Brame and Reff 1984, no. 112 (as 1883–86).

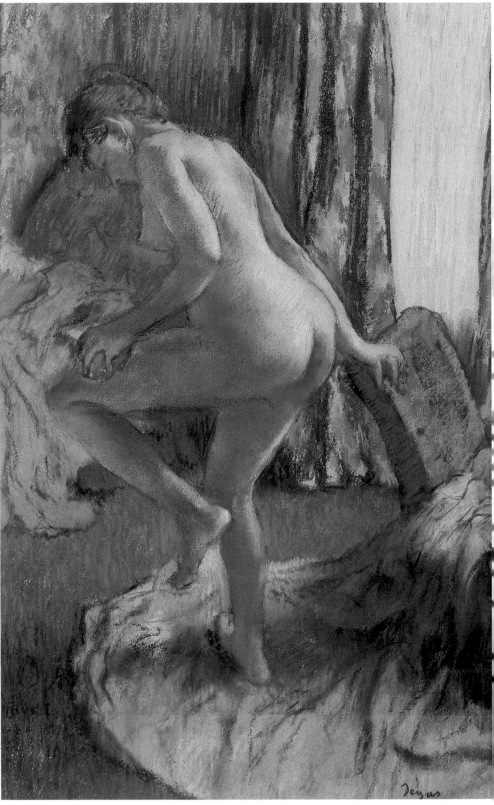

253

255.

Nude Woman Drying Herself

c. 1884–92
Oil on canvas
59 × 84⅜ in. (150 × 214.5 cm)
Vente stamp lower right
The Brooklyn Museum, New York.
 Carl H. DeSilver Fund (31.813)
Lemoisne 951

This outsized, probably unfinished, painting is difficult to date conclusively for the same reason that Degas's dark-field monotypes of bathers resist definite dating: because Degas never applied the superficial layer of color, one cannot rely on the palette for clues. It possesses the same sense of scale as the monotypes, and indeed the composition happens

254

Fig. 230. *Woman Sponging Her Knee* (L719), c. 1894. Pastel (over monotype?), 15 × 11 in. (38 × 28 cm). Location unknown

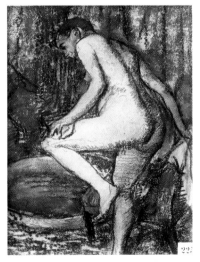

Fig. 231. *Woman Sponging Her Knee* (L718), c. 1890. Pastel and charcoal, 12¼ × 9⅞ in. (31 × 25 cm). Location unknown

to be a reversed variant of a dark-field monotype (cat. no. 195) that Degas made sometime in the late 1870s or early 1880s. Like the monotype, it is monochrome and its execution is summary. But unlike the monotype, it was drawn nearly life-size on an enormous canvas that enabled the artist to realize the scale that was always implicit, but never actually achieved, in the work on paper.

This canvas is larger than all but two other paintings by Degas, *The Bellelli Family* (cat. no. 20) and *The Daughter of Jephthah* (cat. no. 26), both of which are early works unrelated in conception or ambition to this *Nude Woman Drying Herself.* The size of this picture, however, can be related to a general tendency on Degas's part, beginning in the mid-1880s, to work in oils on larger canvases—for example, the portrait of Hélène Rouart in the National Gallery, London (fig. 192), or the Chicago *Millinery Shop* (cat. no. 235). Taking that tendency into account, this painting would date to about 1884–86; the subject is certainly consistent with the artist's preoccupation with bathers at this time. The strength of the forms and the vigor of Degas's application of the primary layer of paint also lend support to a date in the mid-1880s, as do such characteristics as the independence of the nude from the environment and the energy with which she rubs herself dry.

However, *Nude Woman Drying Herself* also relates to a group of three other inordinately large paintings of the 1890s (each measuring 59 × 71 in., or 151 × 180 cm): *Four Dancers* (fig. 271), *Fallen Jockey* (cat. no. 351), and *Dancer with Bouquets* (L1264, Chrysler Museum, Norfolk, Va.). To this group, one could also add the Cleveland *Frieze of Dancers* (L1144, 27⅝ × 80 in., 70 × 200 cm), as well as an enormous unfinished pastel of bathers at the Musée des Arts Décoratifs, Paris (fig. 314, 63¾ × 76 in., 162 × 193 cm). Each of these related works—all finished in the second half of the 1890s—constitutes a synthetic summary of Degas's most important themes. This bather, with her tub, towel, unmade bed, and bright window, has all the makings of a quintessential bather, just as the Basel *Fallen Jockey* (cat. no. 351) reflects, in a most laconic fashion, Degas's final and dark thoughts on the jockeys that had given him so much pleasure as a young man. Although it is entirely possible that these paintings were conceived independently, together they create a synoptic dictionary of Degas's subjects. This, plus their common scale, leads one to wonder whether they were intended to form a decorative ensemble, destined perhaps to hang on the walls of Degas's studio or in some future museum dedicated to his work and his collection of other masters.

255

While some may consider this painting finished— a work executed *en camaïeu*—it is more likely that it was abandoned at a preparatory stage, perhaps because Degas found that the imagery had achieved a kind of self-sufficiency. If indeed it was abandoned, then the work serves as an important document of Degas's late painting technique. Here we learn that the artist prepared his paintings with an underdrawing in sepia paint, probably thinned with turpentine, that provided a tonal armature for the composition, much in the way that the monotypes served as a kind of photographic negative for the subsequent works in pastel. Degas's underpainting indicates structural relationships by defining areas of light and shade, extending in this work even to subtleties such as the semi-translucency of the towel under the bather's left arm. Contours have been added with the artist's lithe and fluent brush only in such critical areas as the face, breast, and left leg of the bather. Had the artist completed the work, it might have resembled *Four Dancers* (fig. 271), which seems to have a

similar tonal wash underneath the surface layer of paint, and which displays the same markedly calligraphic, somewhat detached contours in the drawing of the face and limbs.

PROVENANCE: Deposited by the artist with Durand-Ruel, Paris (deposit no. 10256, as "Femme au tub"), 22 February 1913; Atelier Degas (Vente I, 1918, no. 57, for Fr 5,700); bought at that sale by Marcel Bing, Paris. Yamanaka and Co., New York; bought by the museum 30 December 1931.

EXHIBITIONS: 1937 Paris, Orangerie, no. 34; 1937, New York, The Brooklyn Museum, October, *Leaders of American Impressionism*, no. 2; 1944–45, New York, The Brooklyn Museum, November 1944–January 1945, *European Paintings from the Museum Collection* (no catalogue); 1954 Detroit, no. 69.

SELECTED REFERENCES: Rivière 1922–23, I, pl. 43 (as Marcel Bing collection, Paris); Lemoisne [1946–49], III, no. 951 (as c. 1888); H. Wegener, "French Impressionist and Post-Impressionist Paintings in the Brooklyn Museum," *The Brooklyn Museum Bulletin*, XVI:1, Fall 1954, p. 12; Minervino 1974, no. 934.

256.

Woman Ironing

Begun c. 1876, completed c. 1887
Oil on canvas
32 × 26 in. (81.3 × 66 cm)
Signed lower left: Degas
National Gallery of Art, Washington, D.C.
 Collection of Mr. and Mrs. Paul Mellon
 (1972.74.1)

Lemoisne 685

"If it is finished, I shall set to work on the *Laundress*."[1] Thus wrote Degas to his sorely tested friend and patron Jean-Baptiste Faure in June 1876, reporting on his intentions of completing a promised racecourse picture (see cat. no. 157). The *Laundress* to which he referred was no doubt this painting of a woman ironing that had been commissioned by Faure, a singer at the Opéra and perhaps the most important patron of French painting of his day. Although the circumstances regarding this commission are not fully known (see "Degas and Faure," p. 221), one can surmise that there is a direct relationship

424

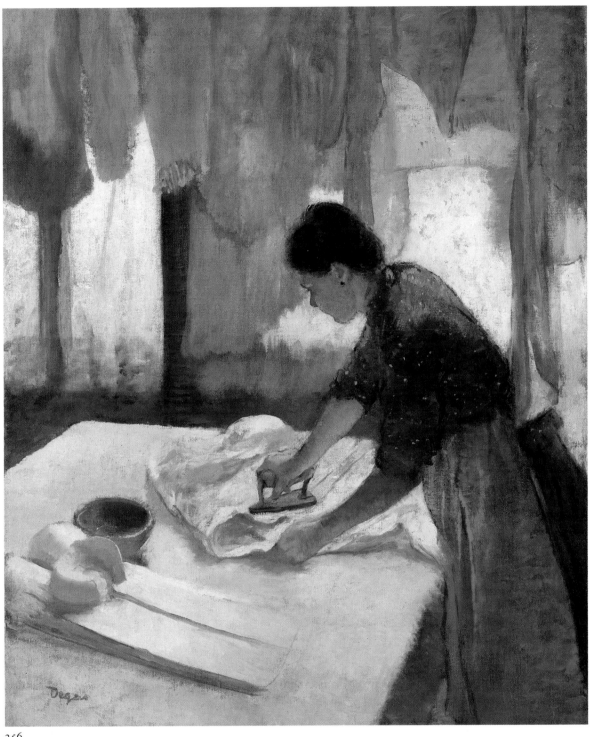

256

between the genesis of this picture and Faure's purchase—at Degas's request—of the smaller *Woman Ironing*, in the Metropolitan Museum in New York (cat. no. 122), from Durand-Ruel in 1874. Degas regretted the premature sale of several of his early works and sought to have them back. Faure obliged him by buying, among other pictures, the little *Woman Ironing*, and turning it over to the artist. Two years later Degas exhibited that same *Woman Ironing* at the 1876 Impressionist exhibition, but otherwise he kept it in his possession and out of view until February 1892, when he sold it back to

Galerie Durand-Ruel. It was perhaps his unwillingness to release the small *Woman Ironing* that provoked the creation of this larger version for Faure; the sale of the small picture to Durand-Ruel in 1892 may also have precipitated the creation of a third variant, now in Liverpool (cat. no. 325). In fact, Degas may have traced from the New York picture (or from a study now lost) the silhouette of the laundress to make a drawing (fig. 117)[2] that he squared, perhaps in order to enlarge it one and a half times to make the present painting.

Although Degas retained the basic com-

position of the New York painting in making this second version, the underlying conception was changed markedly. The dramatic chiaroscuro that was the raison d'être for the New York painting was almost entirely abandoned. Here Degas lit the laundress with light directed from the windows as well as with light reflected from the worktable. While she remains in half-shadow, her flesh is naturalistically colored and her dress carefully described, the dotted blue blouse with rosy shadows serving as a foil to the mauve apron. The room in which the laundress works is much larger and airier than

in the early picture, and also more easily understood: for example, Degas discriminated between the window at the right and the narrow, glazed double door at the left, whereas he deliberately left these areas vague in the New York painting. The laundry, no more than limp sheets of humid linen in the New York picture, with an occasional recognizable cuff, is here sorted out as a crisp shirt, just ironed and folded, another shirt in the works, and a panoply of colored clothing—coral, ochre, and blued white—hanging to dry on the line above. All these carefully delineated accessories lessen the elemental impact of the New York picture—a statement about a faceless woman working monotonously in a damp and cramped environment—to produce here a charming and somewhat anecdotal image (with a generous gesture the artist has given this laundress an earring). Degas obviously enjoyed the play of light filtering through translucent cloth, and achieved it with the full effect of transparency gained by his technique of scraping and glazing. Indeed the entire painting, lovely as it is, seems somewhat forced and even contrived, as if Degas had been attempting to compensate for the great delay in its delivery. Guérin wrote (and there is no evidence to contradict him) that this work was not given to Faure until sometime after 1887, which is to say at least twelve years after Faure entered into his initial agreement with the artist.[3] This date appears to be consistent with the manner in which it is painted—there are parallels both in scale and in handling with *The Millinery Shop* (cat. no. 235).

Degas also made for Faure another work depicting a laundry scene, *Women Ironing* (fig. 232). Like the present work, it was one in a continuum of variations on a similar theme that Degas was loathe to let leave his studio (see cat. no. 257).

1. Lettres Degas 1945, XCV, p. 122; Degas Letters 1947, no. 104, p. 120. Anthea Callen recognizes in this remark a reference to this picture, but she accepts Guérin's erroneous dating of the letter to 1886 (Callen 1971, p. 51). Degas refers in the letter to a Saturday, 24 June; Michael Pantazzi, in preparation for this catalogue, noted that that combination of day and date occurred in 1871, 1876, 1882, and 1893. Degas and Faure had not established relations by 1871, and by 1893 Faure was already selling this painting. Thus 1876 and 1882 are the only possible dates for this letter, and the amicable tone of the letter suggests 1876.
2. The only other surviving drawing related to the three versions of this laundress in silhouette is an unpublished sketch in a French private collection. Its small size and manner of execution suggest that it was a copy of the New York painting that Degas made in a notebook or on a scrap of paper. Michael Pantazzi, however, thinks otherwise; see cat. no. 122.
3. Lettres Degas 1945, V, pp. 31–32 n. 1; Degas Letters 1947, p. 261, Annotations, Letter 10. Guérin may have had access to Faure's papers, which no

longer exist. Apart from the misdating of some letters and the omission of the New York *Woman Ironing* from the list of works Faure had bought in 1874 in order to return them to the artist, Guérin's account of the affairs between Degas and Faure seems accurate and has withstood intensive examination in Callen 1971.

PROVENANCE: Commissioned from the artist by Jean-Baptiste Faure in 1874, but not delivered until c. 1887; Faure collection, Paris, c. 1887, until 1893; sold to Durand-Ruel, Paris, 2–3 January 1893, for either Fr 5,000 or Fr 8,000 (stock no. 2564); bought by James F. Sutton, 16 January 1893, for either Fr 15,000 or Fr 18,000 (sale, American Art Association, New York, 25–30 April 1895, no. 164, for $1,750); bought at that sale by Durand-Ruel in partnership with Goupil-Boussod et Valadon (Durand-Ruel stock no. 3326 [one-third]; Goupil–Boussod et Valadon stock no. 23902 [two-thirds]); Durand-Ruel collection, Paris, from 5 November 1898; Georges Durand-Ruel collection, by 1924; Mme Georges Durand-Ruel collection, Neuilly-sur-Seine, by 1932; Mme Jacques Lefébure, her niece, Paris, until 1967; bought by Wildenstein and Co., New York, 1967, and sold immediately to Mr. and Mrs. Paul Mellon, Upperville, Va.; their gift to the museum 1972.

EXHIBITIONS: 1905 London, no. 68 (as "The Ironer," 1882); 1907–08 Manchester, no. 176; 1924 Paris, no. 68 (as "Repasseuse à contre-jour," 1882), lent by Georges Durand-Ruel; 1932 London, no. 349 (456), lent by Mme Durand-Ruel, Paris; 1934, Paris, Galeries Durand-Ruel, *Quelques oeuvres importantes de Corot à Van Gogh*, no. 8; 1936 Philadelphia, no. 39, repr. p. 91, lent by Durand-Ruel, Paris and New York; 1937 New York, no. 10, repr.; 1937, Toronto, The Art Gallery of Ontario, 15 October–15 November, *Trends in European Paintings from the XIIIth to the XXth Century*, no. 37, repr.; 1940, New York, Durand-Ruel Galleries, 27 March–13 April, *The Four Great Impressionists: Cézanne, Degas, Renoir, Manet*, no. 7, lent by Durand-Ruel, private collection; 1947, New York, Durand-Ruel Galleries, 10–29 November, *Degas*, no. 7, private collection; 1986, Naples, Museo di Capodimonte, 4 December 1986–8 February 1987/Milan, Pinacoteca di Brera, March–May, *Capolavori impressionisti dei musei americani*, p. 40, no. 15, repr. (color) p. 41.

SELECTED REFERENCES: Théodore Duret, "Degas," *The Art Journal*, London, July 1894, xxxiii, repr. p. 204; Lemoisne 1912, pp. 95–96, pl. XL (as "Repasseuse à contre-jour," 1882, Durand-Ruel collection); Lafond 1918–19, II, p. 48; Jamot 1924, p. 151, pl. 60; Grappe 1936, p. 45, repr. (Georges Durand-Ruel collection); Mongan 1938, p. 301; John Rewald, "Depressionist Days of the Impressionists: A Fortieth Anniversary," *Art News*, XLIII:20, 1–14 February 1945, repr. p. 13 (installation photograph from 1905 London, Grafton Galleries exhibition); Lemoisne [1946–49], II, no. 685 (as 1882, erroneously listed as "peinture à l'essence sur carton"); Paul-André Lemoisne, *Degas et son oeuvre*, Paris, 1954, pl. 6 (color) p. 129; New York, Metropolitan, 1967, p. 78; Callen 1971, pp. 51–52, 165, no. 198 (as "La repasseuse à contre-jour," 1886–87, catalogued as Jean-Baptiste Faure acquisition, with subsequent provenance; listed incorrectly as The Art Gallery of Ontario); Minervino 1974, no. 597; John Walker, *National Gallery of Art, Washington*, New York, 1974, p. 487, fig. 785 (color); National Gallery of Art, *European Paintings: An Illustrated Summary Catalogue*, Washington, D.C., 1975, p. 100, no. 2633, repr. p. 101; Reff 1976, p. 83, fig. 57; Reff 1977, p. 31, fig. 56 (color); Eunice Lipton, "The Laundress in Late 19th Century French Culture: Imagery, Ideology and Edgar Degas," *Art History*, 3, 1980, pp. 295–313, pl. 44; 1984–85 Paris, fig. 96 (color) p. 117; Lipton 1986, p. 141, fig. 87.

257.

Women Ironing

c. 1884–86
Oil on unprimed canvas
30 × 31⅞ in. (76 × 81 cm)
Signed upper right: Degas
Musée d'Orsay, Paris (RF1985)

Lemoisne 785

The image of this pair of laundresses, caught unawares like Degas's bathers, is as durable in the artist's oeuvre as the silhouette of a single laundress. He made four variations of this composition over a period of at least a dozen years;[1] and although the size and format of the three versions in oil are close,[2] the approach to the subject and the methods of handling are sufficiently varied as to make them three wholly independent pictures, each conveying a distinctive impression and mood.

The present work, a variant painted in the 1880s after a prototype of the 1870s (fig. 232), exhibits characteristics of both periods of Degas's work. The broad comedy of the

Fig. 232. *Women Ironing* (L686), c. 1876, reworked c. 1887. Oil on canvas, 31⅛ × 28¾ in. (79 × 73 cm). Private collection

Fig. 233. *Women Ironing* (L687), c. 1884–85. Oil on canvas, 32¼ × 29½ in. (82 × 75 cm). Norton Simon Art Foundation, Pasadena

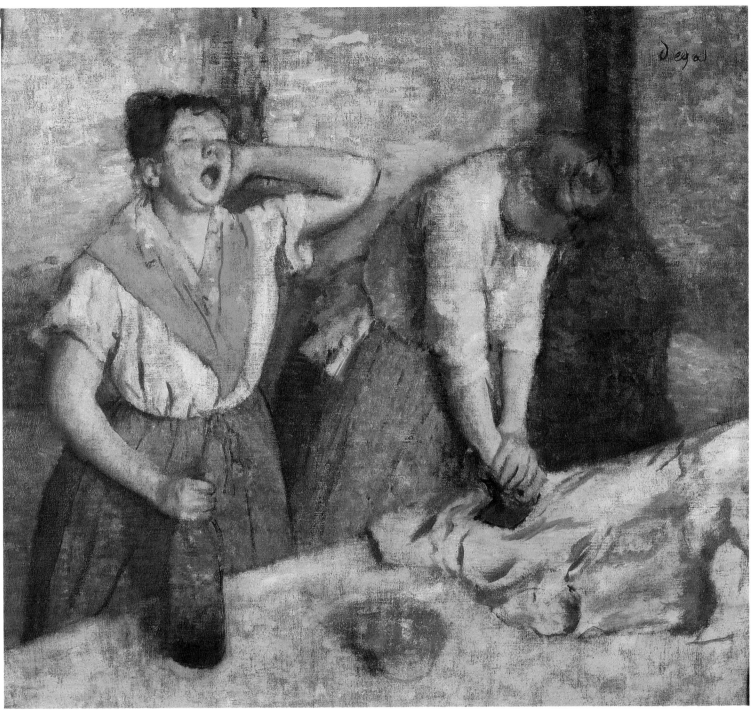

257

Fig. 234. *Women Ironing* (L786), c. 1891. Pastel, 23¼ × 29⅛ in. (59 × 74 cm). Private collection

scene would seem to link it to work of the mid-1870s, such as some of the brothel monotypes, and the general placement of the figures is reminiscent of genre scenes of this period, such as *In a Café (The Absinthe Drinker)* (cat. no. 172). However, other formal elements point to a date around the mid-1880s. The proximity of the figures to the foreground is characteristic of works in the series of milliners and bathers of about 1882–86. And Degas's evident interest in rendering palpable the various textures he describes—the flesh of the yawning laundress's stout arm, the scratchy wool shawl she wears (contrasted with the enameled surface of the bowl of water), the starched

linen shirt that the other laundress is pressing—is equally characteristic of works of the mid-1880s, especially the artist's pastels. Certain descriptive passages in particular, such as the folds of the shirt or the modeling of the flesh, are very close to analogous passages in works dated by the artist 1885. Regardless, however, of its precise relationship to other works, what is certain is its virtually unique place within Degas's hugely varied technical practices: it may be the only finished painting by the artist executed on unprimed canvas (even more unusual is its particularly coarse weave—Degas always preferred fine linen). Doubtless the artist sought a richly textured effect reminiscent

of his contemporaneous pastels, and he accomplished it here by dragging dry, pasty paint across the rough fabric, resulting in a lively, chalky surface that still retains its vibrant color since the work, like his pastels, was never varnished.

The audacious gesture of the yawning woman is perhaps the most striking element of this picture. George Moore wrote: "It is one thing to paint washerwomen amid decorative shadows, as Teniers would have done, and another thing to draw washerwomen yawning over the ironing table in sharp outline upon a dark background."[3] In the same article, Moore remarks how tellingly a single gesture can epitomize a life, and in this instance it is as true of the joyless activity of the figure at right as it is of the comic figure at left about to take a swig of wine. Paul Jamot describes her as "a plump gossip who . . . is filling her distended cheek with a yawn fit, as they say, to unhinge her jaw." Noting her unconscious vulgarity, Jamot traces Degas's cruel wit in "the somewhat distorted face, the screwed-up eyes . . . barely bigger than the two black holes of the nostrils under her potato nose."[4]

It is impossible to date the different versions of this composition with certainty. However, the following hypothetical chronology seems tenable. The canvas formerly in the Durand-Ruel collection (fig. 232) was probably the first to be painted: it was commissioned in 1874 by Jean-Baptiste Faure (see "Degas and Faure," p. 221) and included among the works exhibited in the 1876 Impressionist exhibition (as no. 41). The critic Alexandre Pothey saw it and described it in a review: "Degas shows us two laundresses: one presses on her iron with movement that seems quite accurate; the other yawns and stretches her arms. It is powerful and true, like a Daumier."[5] Nevertheless, Faure did not yet own the painting in 1876: his name did not appear as owner in the exhibition catalogue, and in a letter dated by Guérin to 1877, Degas promised only then to finish "les blanchisseuses" that he owed to Faure.[6] Thus, either the artist intended to give Faure another painting, or he wanted to alter the painting he had exhibited in 1876 before delivering it. And in fact Degas did rework the painting (fig. 232), but probably not until the middle of the 1880s: he removed the linen hanging on a line behind the two workers and the flue of the stove behind the laundress on the right. It seems that Degas painted out these details and repainted the face of the yawning laundress before handing the painting over to Faure sometime after the latter's threat of a lawsuit in January 1887.[7] Before doing so, it seems that he copied it in the present painting, formerly in the Camondo collection and now in the Musée

d'Orsay. This second version, painted in the style characteristic of the early and mid-1880s, retains some features of the primary version that are no longer visible in the earlier painting. While the two variants are very similar in the presentation of the figures, the pictures ultimately convey quite different attitudes toward the subject. The high point of view of the Durand-Ruel painting reduces the proportions of the figures and thus makes our perceptions more detached and less immediate than with the Orsay painting. This almost clinical objectification of the subject is characteristic of Degas's approach in the 1870s, while the strong presence of the figures in the Orsay painting is equally characteristic of Degas's work in the 1880s. Degas went on to make a third version of the composition (fig. 234). The vigorous contours and the summary modeling of this late variant denote a work of the 1890s, perhaps around the spring of 1891, when Degas sold the painting now in the Musée d'Orsay to Durand-Ruel.

The version now in the Norton Simon Museum (fig. 233) was the last of the works to leave the studio (in 1902)[8] and it is least like the others. In some respects it is the work most characteristic of the mid-1880s, with its straightforward rather than oblique viewpoint, its large-scale laundresses taking up much of the depicted space, and its almost idealized—rather than caricatural—figural style. Some of the passages, however, seem inconsistent with Degas's style in the 1880s (for example, the hatching or striation over some of the contours), and since it remained with the artist until late in his life, it could have been retouched by him at almost any point.

1. L785 (the present picture); L686 (fig. 232); L687 (fig. 233); L786 (fig. 234).
2. L786 (fig. 234), the picture in charcoal and pastel, is smaller and more insistently horizontal.
3. Moore 1890, pp. 423–24. He refers either to this work or to the related work, L686 (fig. 232).
4. Paul Jamot, "Degas," in La peinture au Musée du Louvre, école française: XIXe siècle (troisième partie), Paris: L'Illustration, [1929], p. 71.
5. Alex[andre] Pothey, "Chronique," La Presse, 31 March 1876. Hollis Clayson refers to this review, without quoting from it, in 1986 Washington, D.C., p. 158 n. 12. Ronald Pickvance is credited with the identification of L686 (fig. 232) as the picture seen in the 1876 exhibition, in the sale catalogue for this painting: Christie's, London, 30 November 1987, lot no. 80.
6. Lettres Degas 1945, XIII, p. 41; Degas Letters 1947, no. 21, p. 46.
7. One might argue that the late delivery of the Faure painting puts into question the date of the Orsay painting, for if the latter was indeed completed by 1886, Degas should have been able to give it to Faure to redeem his obligation, whereas in fact he did not release it until 1891. However, it is clear that it was Degas's practice to keep the paintings destined for Faure separate from the rest of his work. (See cat. nos. 157, 159.)

8. Sold by Degas to Durand-Ruel for Fr 15,000 on 18 October 1902 (stock no. 7184).

PROVENANCE: Acquired from the artist by Durand-Ruel, Paris, 7–9 March 1891, for Fr 4,000 (stock no. 854, as "Les repasseuses"); bought by Paul Gallimard, Paris, 23 March 1891, for Fr 6,000; bought by Michel Manzi, Paris, or with Galerie Manzi–Joyant, 1893; bought by Comte Isaac de Camondo, November 1893, for Fr 25,000 (Camondo notebook, Archives, Musée du Louvre, Paris); Camondo collection, Paris, 1893–1908; his bequest to the Louvre 1908; entered the Louvre 1911; first exhibited in 1914.

EXHIBITIONS: 1937 Paris, Orangerie, no. 42, pl. XXIV; 1945, Paris, Musée du Louvre, July, Chefs-d'oeuvre de la peinture, no. 93 (c. 1884); 1946, Paris, Musée des Arts Décoratifs, Les Goncourt et leur temps, no. 594 (as c. 1884); 1969 Paris, no. 31.

SELECTED REFERENCES: Moore 1890, pp. 423–24 (describes either this work or L686, fig. 232); Pica 1907, pp. 404–18, repr. p. 417; Alexandre 1908, p. 32, repr. p. 24; Grappe 1908, repr. p. 13; Lemoisne 1912, p. 94, compared with L686; Jamot 1914, pp. 457–58; Paris, Louvre, Camondo, 1914, no. 168; Lafond 1918–19, I, p. 10, repr., II, p. 47; Meier-Graefe 1920, pl. 79; Paris, Louvre, Camondo, 1922, pp. 35–36, no. 168, pl. XXXVII (as c. 1884); Meier-Graefe 1923, pl. LXXIX; Paris, Louvre, Peintures, 1924, p. 76; Henri Focillon, La peinture aux XIXe et XXe siècles: du réalisme à nos jours, Paris: Librairie Renouard, 1928, repr. p. 187; Paul Jamot, La peinture au Musée du Louvre: école française. XIXe siècle, Paris: L'Illustration [1929], pp. 69–71, pl. 52 p. 73; Walker 1933, p. 179, fig. 4 p. 175; Lemoisne [1946–49], III, no. 785 (as c. 1884); Paris, Louvre, Impressionnistes, 1958, pp. 49–50, no. 93; Paris, Louvre, Peintures, 1959, p. 13, no. 642, pl. 223; Werner Hofmann, The Earthly Paradise: Art in the Nineteenth Century, New York, 1961, p. 425, pl. 174; Pool 1963, p. 43, pl. 41 (color); Minervino 1974, no. 624, pl. XLVIII (color); Broude 1977, pp. 105, 106, fig. 23; Linda Nochlin, Realism, New York, 1979, p. 157, repr. p. 156; Eunice Lipton, "The Laundress in Late Nineteenth Century French Culture: Imagery, Ideology and Edgar Degas," Art History, III, September 1980, p. 38; McMullen 1984, repr. p. 375; 1984–85 Paris, fig. 37 (color) p. 37, repr. (color, detail) p. 36; Lipton 1986, pp. 142–43, repr. p. 143, fig. 89; Paris, Louvre and Orsay, Peintures, 1986, III, p. 194.

258.

Woman Ironing

c. 1882–86
Oil on canvas
25½ × 26¼ in. (64.8 × 66.7 cm)
Vente stamp lower right
Reading Public Museum and Art Gallery, Reading, Pennsylvania (76–45–1)

Lemoisne 276

Like most of the pictures of laundresses, this little-known work seems to have roots in the 1870s. It shares the workaday mood and monochrome veil of paint of the Woman Ironing (L361, formerly Mme Jacques Doucet collection) that Lemoisne dates to 1874—only the watermelon-red shirt of the

258

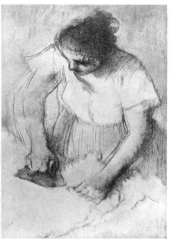

Fig. 235. *Woman Ironing* (L277), c. 1882–86. Pastel. Location unknown

laundress relieves the drab olives and browns of the painting. But the vigorous pastel that served as a study for this painting (fig. 235)[1] could not date before 1882–86, when Degas made similar studies for the pictures of milliners (see, for example, the studies for *The Millinery Shop*, cat. no. 235). And the transformations that resulted when the ideas in the study were transferred to canvas are typical of Degas's strategies in the 1880s: the figure is made more remote by the seemingly endless table at which she works, and she is further isolated from the viewer by the sheets of hanging linen. While one tends to associate the bird's-eye perspective and the diagonalized space with Degas's work around 1879, in fact these devices persisted well into the 1880s and can be found in all the other series of this decade, such as the milliners, the bathers, the dancers, and the visits to the museum. However, there is a new element here, and that is the artist's willingness to attempt to extract sufficient pictorial interest from one expressive figure, as opposed to his preferred method in the 1870s of building compositions with, and conveying meaning through, multiple figural groups.

1. There is a copy of this work in the Whitworth Art Gallery, Manchester (D.40.1925), accepted as authentic by Ronald Pickvance ("Drawings by Degas in English Public Collections: 2," *Connoisseur*, CLVII: 633, November 1964, p. 162, repr. p. 163), but rejected as a forgery by Richard Thomson (*French 19th Century Drawings in the Whitworth Gallery*, Manchester: University of Manchester, 1981, p. 13).

PROVENANCE: Atelier Degas (Vente II, 1918, no. 6 [as "Blanchisseuse repassant du linge"], for Fr 7,000); bought by M. Pellé (Gustave Pellet?); Henry K. Dick, Ithaca, N.Y., by 1949; Martha B. Dick, his niece, Reading, Pa., by 1954 until 1976; her bequest to the museum 1976.

EXHIBITIONS: 1949 New York, p. 47, no. 21 (as 1871), repr. p. 20, lent by Henry K. Dick.

SELECTED REFERENCES: Guérin 1931, p. 17; Lemoisne [1946–49], II, no. 276 (as c. 1870–72); Callen 1971, p. 169, no. 202A (in which this painting is erroneously proposed as one of the six paintings sold by Durand-Ruel to Jean-Baptiste Faure on 5 March 1874, for Fr 8,000, and subsequently returned to the artist); Minervino 1974, no. 366.

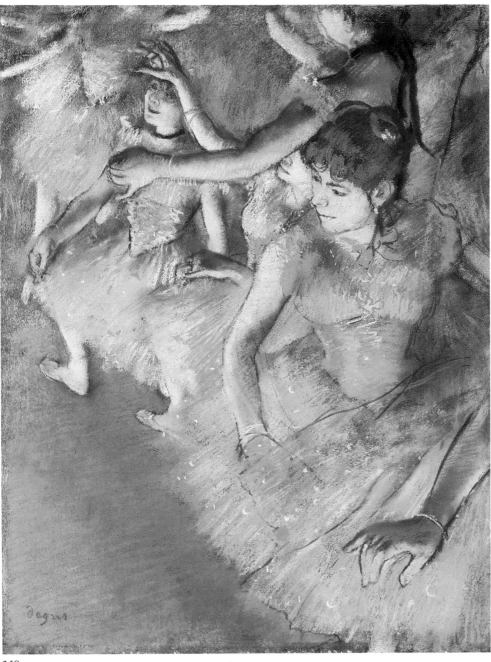

259

259.

Dancers on the Stage

c. 1882–84
Pastel on laid paper, extended with strip at top
25½ × 20 in. (64.8 × 50.8 cm)
Signed in brown chalk lower left: Degas
Dallas Museum of Art. Lent by Mrs. Frank Bartholow

Lemoisne 720

No other dance scene by Degas is so dramatically packed with such a variety of figures and poses, nor does any other picture evoke so convincingly the actuality of performers seen from very close quarters. Although Degas did not include a ballet patron in this picture, his vantage point is that of the privileged viewer who lurks among the stage flats to keep an eye on his protégée.[1]

While there are no closely analogous ballet works in Degas's oeuvre, there are parallels to be drawn between this work and pictures with different subjects. The crowding of the composition is similar to the effect one finds in some of the milliners, especially *At the Milliner's* (cat. no. 233), and the modeling of the figures, carefully executed and highly finished, is also comparable. But curiously, the closest analogy may be with Degas's contemporaneous jockey scenes. The wedge-shaped group of dancers here is organized along the same lines as the mounted jockeys in *Before the Race* (L757) of about 1883–85. In both works, one senses that the figures have been added one over the next, like so many silhouettes, cut out and rearranged. And common to both is the steep recession that follows the diagonal axis.

The yellow harmony seen in this picture occurs rarely in Degas's work, and it is unusual for him to outline contours in this particular brown chalk. Every indication suggests that this is a virtually unique tour de force. While other pastels of dancers on the stage are arranged along a diagonal axis in a similar fashion, Degas had never before dared such a profusion of drawn limbs: here there are no fewer than eleven arms. Félix Fénéon remarked after seeing this work at Durand-Ruel in January 1888: "This mass radiating in a tangle of arms and legs is like an image of an epileptic Hindu god."[2]

1. The observation is George Shackelford's, in 1984–85 Washington, D.C., p. 38.
2. Félix Fénéon, "Calendrier de janvier," *La Revue Indépendante*, February 1888, reprinted in Fénéon 1970, I, p. 96.

PROVENANCE: (Possibly Durand-Ruel stock no. 593, bought from the artist for Fr 600 on 13 December 1884, sold to Peter Coats for Fr 1200 on 25 April 1885). With Durand-Ruel, Paris, by 1888; Dr. George Viau, Paris, by 1918. [?Wilhelm Hansen, Copenhagen] With Winkel and Magnussen, Copenhagen. With Galerie Barbazanges, Paris, until March 1921; acquired by Durand-Ruel, Paris, 12 March 1921 (stock no. 2378); transferred to Durand-Ruel, New York (stock no. 4650) and sold to F. H. Ginn, 15 December 1925; Mr. and Mrs. Frank H. Ginn, Cleveland, 1925 until at least 1936; Mr. and Mrs. William Powell Jones, Gates Mills, Ohio, by 1947. Mr. and Mrs. Algu Meadows, Dallas, by 1974 until 1982; by descent to Mr. and Mrs. Frank Bartholow, Dallas.

EXHIBITIONS: 1888, Paris, Galeries Durand-Ruel, January (no catalogue); 1936 Philadelphia, no. 42, repr. lent by Mr. and Mrs. Frank H. Ginn, Cleveland; 1947 Cleveland, no. 39, repr. frontispiece, lent by Mr. and Mrs. William Powell Jones, Gates Mills, Ohio; 1949 New York, no. 64, repr. p. 48, lent by Mr. and Mrs. William Powell Jones; 1974, Dallas Museum of Fine Arts, 5 June–7 July, *The Meadows Collection*, no number; 1976–77 Tokyo, no. 36, repr. (color); 1978, Dallas Museum of Fine Arts, 24 January–26 February, *Dallas Collects: Impressionist and Early Modern Masters*, no. 12, lent anonymously by Mr. and Mrs. Algur Meadows; 1984–85 Washington, D.C., no. 8, repr. (color) frontispiece.

SELECTED REFERENCES: Félix Fénéon, "Calendrier de janvier," *La Revue Indépendante*, February 1888, reprinted in Fénéon 1970, I, p. 96; Lafond 1918–19, II, repr. facing p. 26 (as G. Viau collection); Hoppe 1922, pp. 51–52, repr. p. 53 (as Winkel and Magnussen collection); Jamot 1924, pp. 62, 152; Lemoisne [1946–49], III, no. 720 (as 1883); Browse [1949], p. 374, no. 111 (as c. 1884–86); Rich 1951, repr. p. 26; Browse 1967, p. 112, fig. 16 p. 114; Minervino 1974, no. 796; Anne R. Bromberg, "Looking at Art: France in the 19th Century," *Dallas Museum Art Bulletin*, Summer 1986, pp. 11–13, no. 10, repr. p. 12.

260.

Harlequin

1884–85
Pastel on paper, extended with strip at right
18 × 31 in. (45.7 × 78.7 cm)
Signed and inscribed lower left: à mon amie
 Hortense/Degas
Hart Collection

Exhibited in New York

Lemoisne 818

One tends to think of Degas's depictions of the ballet as generic—rehearsals in unidentified spaces for nameless ballets, or fleeting pauses behind unspecified décors—but there are in fact a number of readily identifiable ballets within Degas's oeuvre. Aside from *La Source* (see cat. no. 77) and *Robert le Diable* (see cat. nos. 103, 159), the identifiable ballets include *La Farandole* (see cat. no. 212), the ballet from *Sigurd* (L594; L595; fig. 188), the ballet from *L'Africaine* (L521), the ballet *Yedda* (BR77), a ballet from *Don Giovanni* (L527, Clark Art Institute, Williamstown),[1] and possibly the ballet from *Le Roi de Lahore* (see cat. no. 162).[2] The present pastel is among a suite of seven works (plus a later reprise and two studies)[3] that call for identification on account of the careful description of the costumes from the commedia dell'arte. The costume worn here and in each of the other related works is that of Harlequin; it appears just as it was defined by Riccoboni in 1731: "pieces of red, blue, yellow, and green . . . cut in triangles, and arranged next to one another from head to toe; there is a small hat that barely covers the shaven head; little pumps without heels, and a flat black mask without eyes, but with only two quite small holes to see through."[4]

Lillian Browse identifies the ballet depicted here as *Les Jumeaux de Bergame*,[5] a farce about two brothers—both Harlequins from Bergamo—who arrive in Paris and accidentally fall in love with the same woman. Harlequin Senior is at first unaware of his beloved's new suitor, but when he hears someone serenading her outside her house, he attacks the interloper, who turns out to be his brother, Harlequin Junior. Naturally there is another girl on hand, so that everyone can marry at the finale. The original play was written by Jean-Pierre Claris de Florian in 1782; adapted as a ballet by Charles Nuitter and Louis Mérante with music by Théodore de Lajarte, it premiered in Paris on 26 January 1886. Degas apparently did not attend the gala opening night, but he did see a performance on 12 February 1886, when he signed the register at the door through which he gained entry to the stage and the *foyers* behind it. He also attended rehearsals. There is, as proof, a torn fragment of a note in Degas's hand on stationery of the Théâtre National de l'Opéra, dated 23 July 1885, in which the artist describes Mérante rehearsing the dancers for their roles.[6] This could explain why one of the pastels in the suite is dated 1885 (fig. 237)—as evidently there were rehearsals well be-fore the January premiere. However, a further complication develops when one learns that another pastel, L1033, was bought from Degas by Durand-Ruel on 29 November 1884, and that another, BR123, was bought by them on 30 April 1885, from a different dealer, St. Albin, who in turn must have owned it for at least a few weeks before selling it. Thus, Degas seems to have executed at least some of the Harlequin pastels in the winter of 1884–85, many months before he is known to have attended rehearsals.

It is possible that another production, also called *Les Jumeaux de Bergame*, may have been the inspiration for Degas's Harlequin suite. In 1875, William Busnach wrote a comic opera in one act closely following Florian's play and set to music by Charles Lecocq. In the eleventh scene of Busnach's libretto there is a moment in which Harlequin Senior unwittingly beats his brother with a bat—precisely what Degas describes in the present pastel. (The brother is huddled under what must be a cape; one of his hands emerges from it pathetically.) The operatic version of *Les Jumeaux de Bergame* does not figure in the programs of either the Opéra or the Opéra Comique between 1875 and 1889, but there were of course other theaters where it could have been performed and where Degas might have seen it. In the summer of 1885, for example, a production of either the opera or the new ballet was mounted at the Casino de Paramé on the Normandy coast, where Degas is known to have stopped (see Chronology III).

260

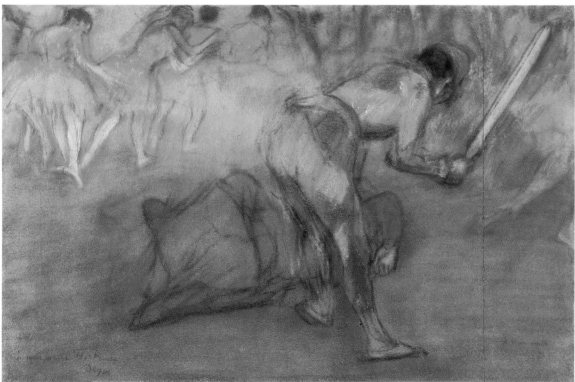

Regardless of which version he saw (both had ballet scenes in them), the story clearly caught the artist's fancy. No other staged piece had given rise to as many pictures by him as *Les Jumeaux de Bergame*, and it appears that it was the slapstick or vaudevillian character of the work that appealed most. In five of the seven pastels, Degas shows Harlequin Senior behaving aggressively with his stick, and to heighten the irony of one brother threatening another, he emphasized the hips of the women playing Harlequin *en travesti*. Thus, what Degas actually depicts is a kind of charade in the form of a farce about courtship and love; it is only too fitting that the sardonic artist, past fifty and morose about his own bachelorhood, should have given this pastel to his beloved Hortense Valpinçon for her wedding to Jacques Fourchy in 1885.

1. Identified by Alexandra R. Murphy as the "Trio des masques" in the first act (Williamstown, Clark, 1987, no. 56, p. 70).
2. Browse [1949], p. 56.
3. The others in the series are L771, L806, L817 (fig. 237), L1032 bis, L1033, and BR123; sometime in the 1890s, Degas took up the theme again for L1111, which was preceded by two studies, L1112 and L1113. There is also a related sculpture, RXLVIII (cat. no. 262).
4. L. Riccoboni, *Histoire du théâtre italien*, Paris, 1731, quoted by François Moureau, "Theater Costumes in the Work of Watteau," in *Watteau: 1684–1721* (exhibition catalogue), Washington, D.C.: National Gallery of Art, 1984, p. 507.
5. Browse [1949], p. 58.
6. Marcel Guérin refers to this letter, without publishing it, in the French edition of the Degas Letters (Lettres Degas 1945, p. 103 n. 2), but the reference is omitted in the English edition (Degas Letters 1947, p. 103). Part of the note has been torn away; the remaining portion reads as follows:

> 23 July 85/at the Opéra, in the Cupola, rehearsal of the short ballet "Les Jumeaux de Bergamme," by Florian, the music of M. de Lajarte, the ballet master Mérante.
>
> Mlle Sanlaville and Mlle Alice Biot play the two harlequins, Mlle Bernay and Mlle Gallay the two women, Rosette—Bernay, and Nérine—Gallay.
>
> The two men are in green[?] breeches . . . black stockings . . . shoes . . . where they will dance.
>
> To the left near a window the 2 violins, a desk . . . on the bench—facing the stage a large mirror in front of which are two curtains that are drawn when the dancers look at themselves too often.
>
> Mérante rehearses the mimed scenes with the 4 actors.—then the dancers depart and then begins the divertissement that follows the . . . Mérante made them act it out again . . .

(Unpublished note, private collection, Paris.)

PROVENANCE: Gift from the artist to Hortense Valpinçon, 1885, on the occasion of her marriage to Jacques Fourchy; M. and Mme Jacques Fourchy, Paris, from 1885 until at least 1924; Raymond Fourchy, their son, Paris, by 1937 until 1981; consigned by his heirs for sale, Sotheby's, London, 1 April 1981, no. 8a, repr.; bought at that sale by an agent for the present owner.

EXHIBITIONS: 1924 Paris, no. 151 (as "Scène de ballet [Arlequin]," c. 1885), lent by Mme J. Fourchy; 1937 Paris, Orangerie, no. 126, lent by Raymond Fourchy; 1975, Paris, Galerie Schmit, 15 May–21 June, *Exposition Degas*, no. 28, repr. (color), p. 57.

SELECTED REFERENCES: Lemoisne [1946–49], III, no. 8 (as 1885); Minervino 1974, no. 831.

261

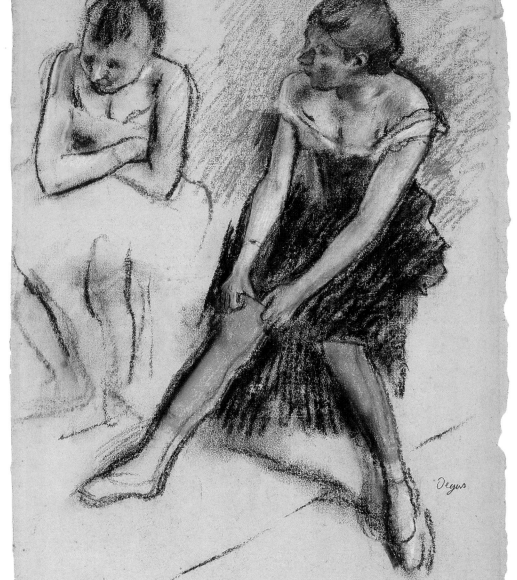

261.

Dancer with Red Stockings

c. 1884
Pastel on pink laid paper, now faded
29⅞ × 23⅛ in. (75.9 × 58.7 cm)
Signed lower right: Degas
The Hyde Collection, Glens Falls, New York (1971.65)

Exhibited in New York

Lemoisne 760

When this pastel—seemingly a casual study tossed off by the artist—was shown in New York in 1886, several reviewers considered the exhibition of such a patently unfinished work a provocation. One writer, acknowledging its merits, believed nevertheless that such works should rather be exhibited someplace "where only artists, students, or critics would see them, for such persons only do they concern."[1] Other critics appreciated the realism of Degas's dancer studies and sensed that the fragmentary nature of

some of the works contributed to the impression of spontaneity and hence truthfulness. The art critic for the New York *Mail and Express* was transported to the stage of a French theater: "One is in a *pays des cocotte[s]*, and actresses; the genius of Degas, especially, revels *dans les coulisses*. Here are ballet coryphées in every state of deshabille, dancing, dressing, drawing on their stockings, rapidly sketched in charcoal on variously tinted papers, with a dab of occasional color, doubtless *la note qui chante*! The utter homeliness and want of grace of the models console us for the scanty memoranda the artist gives of their charms."[2]

Degas seems to have excerpted the two figures on this sheet from a pastel of about 1879–80 of dancers at rest (fig. 236). But, as was usual for him at that period, he was not content merely to reproduce poses he had

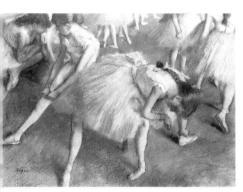

Fig. 236. *Before the Ballet* (L530), c. 1879–80. Pastel, 19⅝ × 25⅝ in. (50 × 65 cm). Private collection

developed elsewhere. Instead, he once again adopted a different point of view, as if moving around the models from above. The principal figure in this work is oriented more toward the viewer, even if her head is turned away; we look down into her lap, so that her spindly legs appear more splayed than in the larger pastel. The second figure, with arms crossed, is only loosely related to her counterpart. In the earlier work, straddling the bench and bent over, she appears to be waiting patiently. Here, her back straightened but her eyes downcast, she appears to be suffering more from the cold than from boredom.

Both figures seem caught in a state of undress, made overt by the glimpse of décolletage and made sexual by the sensational red stockings. The figure at the right, in particular, is seen in a transitional state: partially clad in her street clothes, she still has her dancing slippers on. Degas seems to have delighted in this ambiguity or imprecision, for he declined to make her costume more specific, and even neglected to draw the legs of the bench on which the dancers presumably sit.

The light in this work is particularly well observed. Rendered with a pale blue chalk, it strikes just the edge of the cheek of the figure at the left, before falling on the figure at the right, whose head is turned to receive it.

1. "The Impressionist Pictures: The Art Association Galleries," *The Studio: Journal of the Fine Arts*, no. 21, 17 April 1886, p. 249.
2. "The Impressionists: II," *The Mail and Express*, New York, 21 April 1886, p. 3.

PROVENANCE: An entry in the Durand-Ruel stock books indicates that Durand-Ruel, Paris, sent this work to Durand-Ruel, New York, 19 February 1886; it was returned (after the close of the 1886 New York exhibition) to Durand-Ruel, Paris, 11 August 1886 (stock no. 451, as "Danseuse tirant son bas"). Possibly with Boussod et Valadon, Paris (photo credit, Alexandre 1918). Ernest Chausson, Paris, by 1918; Mme Ernest Chausson, his widow, Paris, until 1936 (Chausson sale, Drouot, Paris, 5 June 1936, no. 6, repr. [as "La danseuse aux bas rouges"], for Fr 30,000); bought at that sale by M. Bacri; Lord Ivor Spencer Churchill, London, by 1937; bought by Paul Rosenberg, New York, 25 November 1944; bought by Charlotte Hyde (Mrs. Louis F. Hyde), 2 December 1944.

EXHIBITIONS: 1886 New York, no. 50 (as "Danseuse Pulling on Her Tights"); 1935, Brussels, Palais des Beaux-Arts, "L'impressionnisme" (no catalogue); 1937 Paris, Orangerie, no. 134 (as "Danseuse aux bas rouges," c. 1885), lent by Lord Ivor Churchill, London; 1949 New York, no. 66 (as "Dancer with Red Stockings," 1883), lent by Mrs. Louis F. Hyde.

SELECTED REFERENCES: "The Impressionists: II," *The Mail and Express*, New York, 21 April 1886, p. 3; Arsène Alexandre, "Essai sur Monsieur Degas," *Les Arts*, 1918, no. 166, p. 8, repr. (as "Étude aux crayons de couleurs," photo Goupil); Lafond 1918–19, II, repr. (color) after p. 24 (as "Danseuses aux bas rouges," Mme Chausson collection); Lemoisne [1946–49], III, no. 760 (as c. 1883–85); Browse [1949], p. 407, pl. 222 (as c. 1900); Minervino 1974, no. 806; James K. Kettlewell, *The Hyde Collection Catalogue*, Glens Falls, N.Y., 1981, no. 75, p. 161, repr. (color) p. 160 (as c. 1883–85).

262.

Dancer in the Role of Harlequin, erroneously called *Dancer Rubbing Her Knee*

1884–85
Bronze
Height: 12¼ in. (31.1 cm)
Original: red-brown wax. Collection of Mr. and Mrs. Paul Mellon, Upperville, Virginia

Rewald XLVIII

When this work was exhibited for the first time, in 1921 at Galerie Hébrard, it was incorrectly titled *Dancer Rubbing Her Knee*. Presumably the generic title was invented because the founder who edited the bronzes,

Hébrard, was unaware of the relationship of the original wax to Degas's series of seven pastels depicting scenes from *Les Jumeaux de Bergame* (see cat. no. 260). Since one of the pastels was sold by Degas in late 1884, and since the pastel to which this work directly corresponds is dated 1885 (fig. 237), one can safely assume that Degas modeled the original wax over the course of the winter of 1884–85.[1] The close correlation with a dated picture makes this sculpture one of the very few that can be confidently assigned to a specific period.

The dynamic twist of the pose and the strength it suggests would place the work in the mid-1880s even without the supporting evidence of related pictures. Several writers, including Charles Millard,[2] have noticed that a characteristic feature of Degas's sculpture of the 1880s is the appearance of movement, which the artist sought to express synthetically with ever-increasing accuracy. Here Degas has captured the moment in which a nimble female dancer in the male role of Harlequin Senior, poised with her feet planted in an exaggerated fourth position, is about to pantomime "her" discovery that the lout "she" has just attacked with a baton is Harlequin Junior, "her" brother. The contrapposto of the figure and the expectant lean forward are somehow sufficient to convey the high drama of the moment.

Both the original wax and the subsequent bronze cast exhibit the smooth, compact surface of the artist's more finished works. It seems, however, that Degas could not leave alone even so successful a piece as this figurine, for the back and right arm appear to have been reworked, most probably at a later date, and then left unfinished. The figure no longer has the baton it may once have held—the founder, perhaps assisted by Degas's friend Bartholomé, made the object look like a handkerchief or scarf. Notwith-

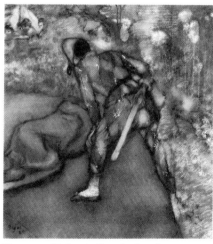

Fig. 237. *Harlequin* (L817), dated 1885. Pastel, 24¾ × 22 in. (63 × 56 cm). The Art Institute of Chicago

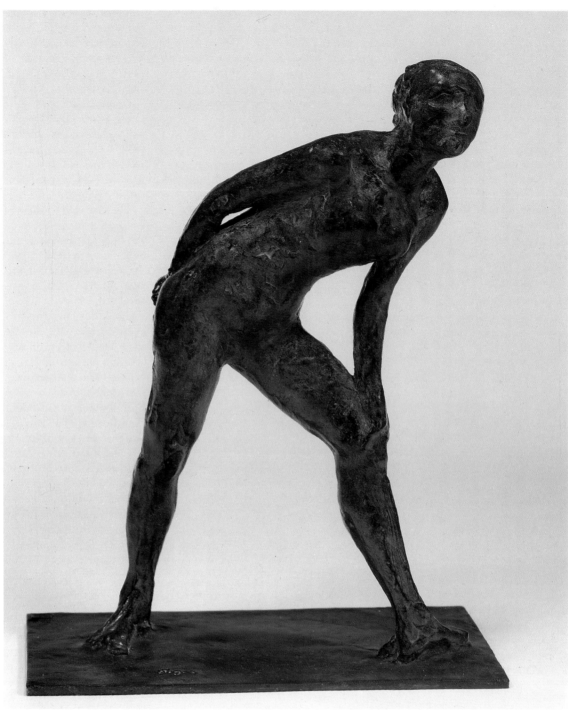

262

standing the lack of detail in the face, the large eye sockets, big cheeks, and smile confer upon it an uncanny resemblance to that of Mlle Marie Sanlaville (see fig. 238), the première danseuse who danced the role of Harlequin Senior in the 1886 production of the ballet *Les Jumeaux de Bergame*. Degas obviously knew Sanlaville well; he dedicated one of his eight sonnets to her:

Tout ce que le beau mot de pantomime dit
Et tout ce que la langue agile, mensongère,
Du ballet dit à ceux que percent le mystère
Des mouvements d'un corps éloquent et
 sans bruit.

Qui s'entêtent à voir en la femme qui fuit,
Incessante, fardée, arlequine, sévère,
Glisser la trace de leur âme passagère,
Plus vive qu'une page admirable qu'on lit,

Tout, et le dessin plein de la grâce savante,
Une danseuse l'a, lasse comme Atalante:
Tradition sereine, impénétrable aux fous.

Sous le bois méconnu, votre art infini
 veille:
Par le doute et l'oubli d'un pas, je songe à
 vous,
Et vous venez tirer d'un vieux faune
 l'oreille.[3]

1. There is a sheet of two drawings related to this sculpture (IV:75). The drawings show a dancer from two different angles in precisely this same pose, wearing Harlequin's pants but with a woman's rounded hips.
2. Millard 1976, pp. 106–07.
3. Degas Sonnets 1946, no. 6, pp. 35–36.

SELECTED REFERENCES: 1921 Paris, no. 27; Havemeyer 1931, p. 223, Metropolitan 39A; Paris, Louvre, Sculptures, 1933, p. 68, no. 1744, Orsay 39P; Rewald 1944, no. XLVIII (as 1882–95), Metropolitan 39A; Borel 1949, n.p., repr., wax; Rewald 1956, no. XLVIII, Metropolitan 39A; Minervino 1974, no. 27; 1976 London, no. 27; Millard 1976, pp. 24, 67–68 71, 107, figs. 76, 80, wax (as 1885–90); 1986 Florence, no. 39, p. 192, fig. 39 p. 136.

Fig. 238. René Gilbert, *Portrait of Mlle Sanlaville of the Opéra*, etching after his pastel exhibited at the Salon of 1883. From *Gazette des Beaux-Arts*, XXVII, 1883, facing p. 466

A. *Orsay Set P, no. 39*
Musée d'Orsay, Paris (RF2091)

Exhibited in Paris

PROVENANCE: Acquired thanks to the generosity of the heirs of the artist and of the Hébrard family, Paris, by the Louvre 1930.

EXHIBITIONS: 1931 Paris, Orangerie, no. 27; 1956, Yverdon, Switzerland, Hôtel de Ville, 4 August–17 September, *100 sculptures de peintres: Daumier à Picasso*, no number; 1969 Paris, no. 277; 1984–85 Paris, no. 36 p. 189, fig. 161 p. 184.

B. *Metropolitan Set A, no. 39*
The Metropolitan Museum of Art, New York.
 Bequest of Mrs. H. O. Havemeyer, 1929.
 H. O. Havemeyer Collection (29.100.411)

Exhibited in Ottawa and New York

PROVENANCE: Bought from A.-A. Hébrard, Paris, by Mrs. H. O. Havemeyer late August 1921; Havemeyer collection, New York, 1921–29; her bequest to the museum 1929.

EXHIBITIONS: 1922 New York, no. 64; 1925–27 New York; 1930 New York, under Collection of Bronzes, nos. 390–458; 1974 Dallas, no number, n.p. fig. 14; 1977 New York, no. 33 of sculptures.

263.

The Singer in Green

c. 1884
Pastel on light blue laid paper
23¾ × 18¼ in. (60.3 × 46.3 cm)
Signed in purple chalk lower right: Degas
The Metropolitan Museum of Art, New York.
 Bequest of Stephen C. Clark, 1960 (61.101.7)

Exhibited in New York

Lemoisne 772

When this pastel was sold at public auction in Paris in 1898, the catalogue included a remarkable description: "Skinny and with the graceful moves of a little monkey, she has just sung her ribald verses and, with a gesture that conceals an entreaty behind her smile, is inviting applause. The harsh glare of the footlights marks her protruding shoulders and the working-class contours of her face with shadows that are searching and sometimes brutal: a joyful flower whose special beauty cloaks the scent of poverty."[1] With her small eyes, high cheeks, and low brow, the young woman looks like Marie van Goethem, the model for *The Little Fourteen-Year-Old Dancer* (cat. no. 227), and also resembles the girl in *The Milliner* (cat. no. 234). Evidently these were the features that signified for the artist a working-class background, whence came the performers of the popular cafés-concerts. But Degas's depiction is more than generic or class-bound, for the gesture of the hand lightly tapping the shoulder, carefully developed in a preparatory drawing (fig. 239), is unmistakably the specific trademark of Thérésa (Emma Valadon, 1837–1913), the queen of the café-concert in the 1870s and 1880s and one of Degas's favorite performers (see cat. no. 175).[2] By the time this pastel was made, Thérésa was already a plump woman who wedged herself uncomfortably into her costumes,[3] so that Degas could not have meant to portray her specifically here. Yet as a souvenir *portrait-carte* of 1865 attests (fig. 240), Thérésa once had the thin waist and skinny arms of the figure in *The Singer in Green*, and in Degas's synthesis of an imaginary but quintessential singer of the café-concert he drew heavily on the special charms of the star of the Alcazar. On 4 December 1883, the artist wrote to his friend Henry Lerolle urging him to "go right away to hear Thérésa at the Alcazar. . . . She opens her big mouth and there emerges the most natural, the most delicate, the most vibrantly tender voice imaginable."[4]

This pastel is not mentioned in the Durand-Ruel archives before 1898, when it was bought at the Laurent sale.[5] Since then it has been called *The Singer in Green*—despite the absence of a pure green in the singer's costume.

The vivid, virtually acidic yellow, turquoise, and orange are characteristic of the saturated hues and complementary colors that artists in Degas's circle began to experiment with in the mid-1880s, and evocative as well of the cheap *confection* in which the singer would have appeared. The generalized setting seems to refer to the parklike environs of the summer cafés-concerts; otherwise there are no clues to the locale, as there are in *The Song of the Dog* (cat. no. 175) or in Degas's etchings and lithographs (see cat. nos. 264, 265) As with *The Milliner* (cat. no. 234), Degas worked on a fine sheet of paper and drew

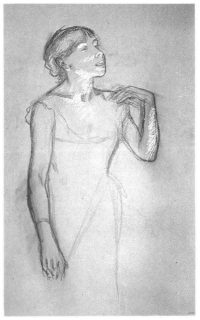

Fig. 239. *Café-concert Singer* (III:393), c. 1884. Charcoal and white chalk, 18⅞ × 12⅝ in. (48 × 32 cm). Private collection

Fig. 240. Étienne Carjat, *Thérésa*, 1865. Portrait-carte. Bibliothèque Nationale, Paris

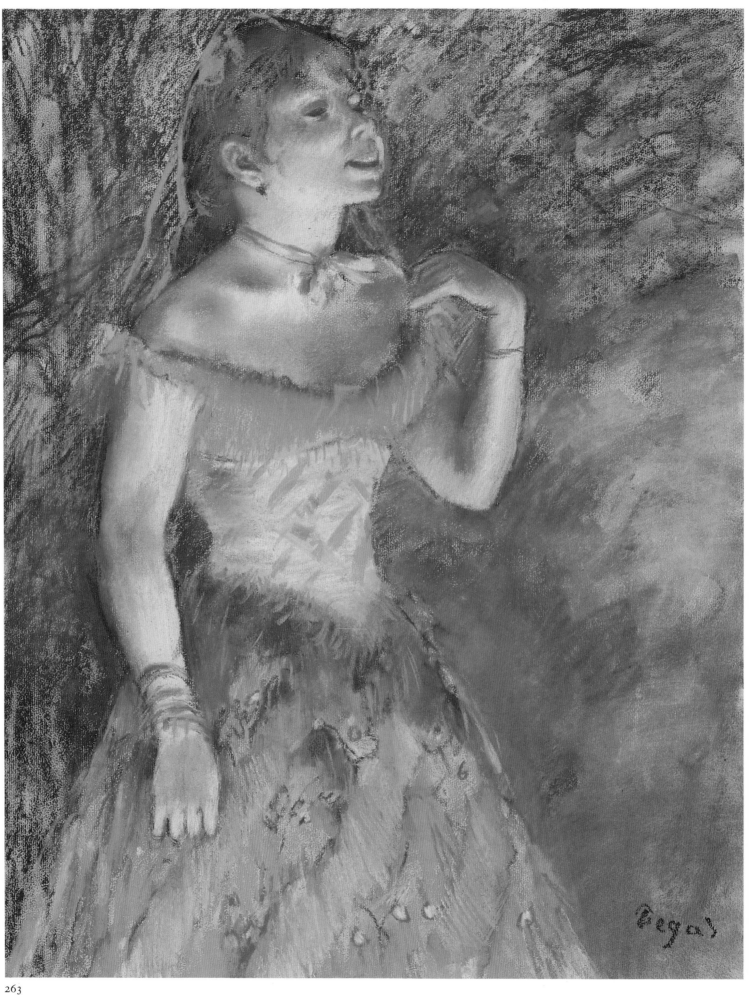

263

surely, with little revision. Only the arms and profile betray signs of reworking; otherwise the technique is as dazzling in its confidence as it is bold in color, and the work itself is remarkably fresh.

1. The author of these remarks is unknown. "Catalogue de tableaux modernes, pastels et dessins par Chéret, Dantan, Degas, Détaille et de Neuville, Gauguin, Lebourg, Maurin, Sisley et Wilette; sculptures par Rodin et Campagne dépendant de la collection de M. X . . . [Laurent]. Vente Hôtel Drouot, Salle 6, le jeudi 8 décembre 1898 à 3 h.," no. 4.
2. First identified by Michael Shapiro in "Degas and the Siamese Twins of the Café-Concert: The Ambassadeurs and the Alcazar d'Été," *Gazette des Beaux-Arts*, XCV, April 1980, pp. 159–60.
3. Louisine Havemeyer describing Thérésa as she appears in *The Song of the Dog* (cat. no. 175), in Havemeyer 1961, pp. 245–46.
4. Lettres Degas 1945, XLVIII, p. 75; Degas Letters 1947, no. 57, p. 76.
5. The work was not, as suggested in Huth 1946, p. 239, exhibited in New York in 1886; entries in the Durand-Ruel ledgers identify no. 57 of that exhibition, "Chanteuse," as an etching (stock no. 699, probably RS49 [see cat. nos. 178, 179]) that was bought from Degas on 27 June 1885, the same day as the pastelized etching "Blanchisseuse" (RS48), which was also shown in the 1886 New York exhibition.

PROVENANCE: Earliest whereabouts unknown. Laurent collection, Paris, until 1898 (sale, Drouot, Paris, "Collection de M. X" [Laurent], 8 December 1898, no. 4, for Fr 8,505); bought at that sale by Durand-Ruel, Paris (stock no. 4874, as "La chanteuse verte"), 1898–1906; sent on consignment to Paul Cassirer, Berlin, 18 October–18 November 1901; bought from Durand-Ruel by A. A. Hébrard, 3 February 1906, for Fr 15,000. With Alexandre Berthier, Prince de Wagram, Paris, until 1908; bought by Durand-Ruel, Paris, 15 May 1908, for Fr 18,861 (stock no. 8675); bought by M. P. Riabouschinsky, 17 April 1909, for Fr 20,000; Riabouschinsky collection, Moscow, 1909–c. 1918–19; probably nationalized with his collection 1918/19; State Tretyakov Gallery, Moscow, until 1925; Museum of Modern Art, Moscow, 1925–33; bought by M. Knoedler and Co., New York, 1933; bought by Stephen C. Clark, New York, 1933–60; his bequest to the museum 1960.

EXHIBITIONS: 1899, Dresden, Kunst Salon Ernst Arnold, spring, *Frühjahrs-Ausstellung*, no. 7 (as "Sängerin"); 1903, Vienna, Secession, *Entwicklung des Impressionismus in Malerei u. Plastik*, no. 52 (as "Im Café-concert"); 1905 London, no. 69 (as "The Music Hall Singer in Green," pastel), no lender listed; 1936, New York, The Century Club, 11 January–10 February, *French Masterpieces of the Nineteenth Century* (foreword by Augustus V. Tack), no. 16, repr., lent by Stephen C. Clark; 1936 Philadelphia, no. 44, repr., lent anonymously; 1937 New York, no. 3, repr. p. 96; 1941 New York, no. 39, fig. 42; 1942, New York, Paul Rosenberg and Co., 4–29 May, *Great French Masters of the Nineteenth Century: Corot to Van Gogh*, no. 3, repr. p. 15; 1946, New York, The Century Association, 6 June–28 September, *Paintings from the Stephen C. Clark Collection*, unnumbered checklist; 1954, New York, M. Knoedler and Co., 12–30 January, *A Collector's Taste: Selections from the Collection of Mr. and Mrs. Stephen C. Clark*, no. 8, repr.; 1955, New York, Museum of Modern Art, 31 May–5 September, *Paintings from Private Collections*, p. 8; 1958, New York, The Metropolitan Museum of Art, summer, *Paintings from Private Collections*, no. 41; 1959, New York, The Metropolitan Museum of Art,

summer, *Paintings from Private Collections*, no. 29; 1960, New Haven, Yale University Art Gallery, 19 May–20 June, *Paintings, Drawings and Sculpture Collected by Yale Alumni*, no. 188, repr. p. 182; 1960, New York, The Metropolitan Museum of Art, 6 July–4 September, *Paintings from Private Collections*, no. 31; 1977 New York, no. 46 of works on paper, repr.

SELECTED REFERENCES: Georges Grappe, *Edgar Degas*, Berlin [1909], p. 38; Hourticq 1912, repr. p. 104; Lemoisne 1912, pp. 101–02, pl. XLIII; Lafond 1918–19, I, repr. p. 7, II, p. 38; Iakov Tugendkhol'd, *Edgar Degas*, Moscow, Z. I. Grzhebin, 1922, repr. p. 8; Jamot 1924, p. 153, pl. 66; Vollard 1924, repr. facing p. 84; Ternovietz, "Le Musée d'Art Moderne de Moscou," *L'Amour de l'Art*, 6th year, 1925, repr. p. 464 (as the Riabouschinsky collection); Moscow, Musée d'Art Moderne, *Catalogue illustré*, 1928, p. 37, no. 128; L. Réau, *Catalogue de l'art français dans les musées russes*, Paris, 1929, p. 102, no. 771; Arthur Symons, *From Toulouse-Lautrec to Rodin with Some Personal Impressions*, New York: Alfred H. King, 1930, p. 118; Mongan 1938, pp. 296–97; Huth 1946, p. 239; Lemoisne [1946–49], III, no. 772 (as 1884); Browse [1949], p. 42; Fosca 1954, repr. (color) p. 71; *Metropolitan Museum Bulletin*, XX, October 1961, repr. p. 43 (annual report); New York, Metropolitan, 1967, pp. 82–83, repr. p. 82; Minervino 1974, no. 616; Reff 1976, pp. 67, 69, 310 n. 87, fig. 41 (color) p. 66; Reff 1977, repr. (color) cover; Moffett 1979, p. 12, pl. 27 (color); Shapiro 1980, p. 160; Robert C. Williams, *Russian Art and American Money, 1900–1940*, Cambridge, Mass., 1980, p. 34; McMullen 1984, p. 363; 1984–85 Paris, fig. 89 (color) p. 109; Moffett 1985, pp. 11, 78, 82, 251, repr. (color and color detail) pp. 78–79.

Etchings and Lithographs Reworked with Pastel

cat. nos. 264–266

In 1885, perhaps in anticipation of an exhibition, Degas reworked with pastel a number of black-and-white etchings and lithographs that he had executed between 1877 and 1880. The subjects of the prints he chose to rework, with the exception of *Mary Cassatt at the Louvre: The Paintings Gallery* (cat. no. 266), were drawn from the world of the café-concert and the theater: *Actresses in Their Dressing Rooms* (BR97, private collection, New York), *Mlle Bécat at the Café des Ambassadeurs* (cat. no. 264), *Mlle Bécat* (L372, art market, New York),[1] *Two Performers at a Café-Concert* (L458), and *At the Café des Ambassadeurs* (cat. no. 265).

The prints stemmed from the period at the end of the 1870s when Degas was consumed with the possibilities of manufacturing images—in monotype, lithography, and etching, or often by combining several of these media—and equally possessed with the artistic potential inherent in dramatic ef-

fects of artificial lighting. A number of these works seem to have been intended for his unrealized journal *Le Jour et la Nuit*, to which he and his friends Pissarro, Cassatt, and Bracquemond would have contributed black-and-white etchings of scenes taken from daily occurrences in Paris and its environs. Degas was far more interested in nightlife than in daytime scenes, and in choosing theatrical subjects he availed himself of the places in Paris with the latest in advanced methods of lighting.

Degas's representations of these scenes exerted an enormous influence on the work of Forain, Seurat, and Toulouse-Lautrec, who not only took up his subject matter but also adopted his interest in artificial light. Seurat in particular made a suite of drawings (one of which is reproduced as fig. 241) that appear to have been inspired by Degas's lithographs and monotypes of Mlle Bécat.

1. It is possible that this pastel over lithograph was the "Chanteuse en scène" that Degas exhibited hors catalogue at the sixth Impressionist exhibition; if so, it dates to 1881 rather than 1885. Huysmans identified Bécat and provided a fairly close description of the work: "singers on stage holding out paws that twitch like those of the stupefied Barbary apes in Saxony . . . and in the foreground, like an enormous five, the neck of a cello . . ." (Huysmans 1883, p. 225). This description could also apply to L404 (fig. 128) and L405, but it seems unlikely that Degas would have exhibited these two works again in 1881 after having included them in the 1877 Impressionist exhibition. Huysmans mentioned "drawings and sketches," and thus could equally have described lithographs such as RS26, RS30 (the basis for L372), or RS31 (cat. no. 176, the basis for BR121, cat. no. 264).

264.

Mlle Bécat at the Café des Ambassadeurs

1885
Lithograph reworked in pastel, on three pieces of paper joined together
9 × 7⅞ in. (23 × 20 cm)
Signed and dated lower right: Degas/85
Collection of Mr. and Mrs. Eugene Victor Thaw, New York

Exhibited in Ottawa and New York

Brame and Reff 121

This work, signed and dated by the artist "85" but drawn over a lithograph of c. 1877–78 (cat. no. 176), is virtually a compendium of sources of light, both natural and artificial. Although barely visible, the moon is present, breaking through the clouds just to the left of its man-made surrogate, the large globe of a streetlamp. At the far right and

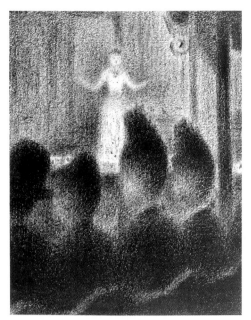

Fig. 241. Georges Seurat, *At the "Concert Européen,"* c. 1887–88. Conté crayon and gouache, 12¼ × 9⅜ in. (31.2 × 23.7 cm). The Museum of Modern Art, New York

264

far left, Degas included grapelike clusters of gas lamps, linked by a string of lamps in the shape of Japanese lanterns that had been installed at Les Ambassadeurs only in 1877.[1] Prominent in the lithograph but suppressed in this pastel is a large crystal chandelier reflected in the mirror behind the performer, while dancing above her head are the bursts of fireworks—pink and blue in the pastel, but brilliant white in the lithograph—that punctuated the end of an act.[2] The performer, Mlle Émilie Bécat, was famous for her animated, pantomime-like performances, and Degas repeatedly sought, in notebook studies and in the lithograph *Mlle Bécat at the Café des Ambassadeurs: Three Motifs* (RS30), to capture an essential gesture evocative of the senseless ditties she had made famous: *Le turbot et la crevette, La rose et l'hippopotame,* and *Mimi-bout-en-train.* For this pastel, Degas enlarged the sheet of the lithograph, adding strips of paper at the right and at the bottom, and colored the forms with a subdued pink-and-green harmony. He invented

a column at the far right, similar to the columns on the stage, but more important, he replaced the top hats of the male observers at the lower left corner and the almost invisible scrolls of the double basses at the right of the lithograph with a group of female spectators. In every other representation of the café-concert, Degas depicted exclusively or largely male audiences; he enjoyed, as did Daumier before him, the juxtaposition of female performers with male observers. Yet women evidently numbered significantly in the audiences of the cafés-concerts: Daudet described the visitors as "local shopkeepers with their ladies and misses."[3] And in the world Degas depicted in the mid-1880s, few men are to be seen.

Émile Bernard reinterpreted this work in a painting of 1887, and in a black-and-white lithograph (Josefowitz collection, Lausanne).

1. *The Crisis of Impressionism: 1878–1882* (exhibition catalogue, edited by Joel Isaacson), Ann Arbor: University of Michigan Museum of Art, 1979, p. 92.
2. According to Flaubert's description in *L'éducation sentimentale* of 1869, quoted in Reed and Shapiro 1984–85, p. 97.
3. Alphonse Daudet, *Fromont jeune et Risler aîné*, Paris: G. Charpentier, 1880, p. 368; quoted in Shapiro 1980, p. 153.

PROVENANCE: Bought from the artist by Clauzet, rue de Châteaudun, Paris; Mr. and Mrs. Walter Sickert, London, by May 1891; Mrs. Fisher Unwin, Walter Sickert's sister-in-law, London, by 1898; Mrs. Cobden-Sickert, by 1908; with M. Knoedler and Co., New York; Mrs. Ralph King, Cleveland, by 1947; Mr. and Mrs. Robert K. Schafer, Mentor, Ohio, until May 1982; bought by David Tunick, New York, May 1982; bought by present owner October 1982.

EXHIBITIONS: 1898 London, no. 119, repr. (as "Café chantant"), lent by Mrs. Fisher Unwin; 1908, London, New Gallery, January–February, *Eighth Exhibition of the International Society of Sculptors, Painters and Gravers,* no. 87, lent by Mrs. Cobden-Sickert; 1947 Cleveland, no. 44, pl. XLVI (as "At the Music Hall/Au café-chantant"), lent by Mrs. Ralph King, Cleveland; 1983 London, no. 26, repr. (color), (as "Aux Ambassadeurs: Mlle Bécat"); 1984–85 Boston, no. 31b, pp. 94–97, repr. (color) p. 96 (as "Mlle Bécat at the Café des Ambassadeurs"); 1985, New York, Pierpont Morgan Library, 3 September–10 November 1985/Richmond, Va., Virginia Museum of Fine Arts, 17 February–13 April 1986, *Drawings from the Collection of Mr. and Mrs. Eugene Victor Thaw, Part II,* no. 46, pp. 68–69 repr. (color).

SELECTED REFERENCES: Lettres Pissarro 1950, p. 239, Pissarro Letters 1980, p. 376, undated fragment of a letter (May 1891, according to Brame and Reff, and Pickvance) from Lucien to Camille Pissarro, which mentions seeing at Sickert's house, "the little Degas lithograph retouched with pastels that we saw some time ago at Clauzet's"; Brame and Reff 1984, no. 121 (as 1877–85).

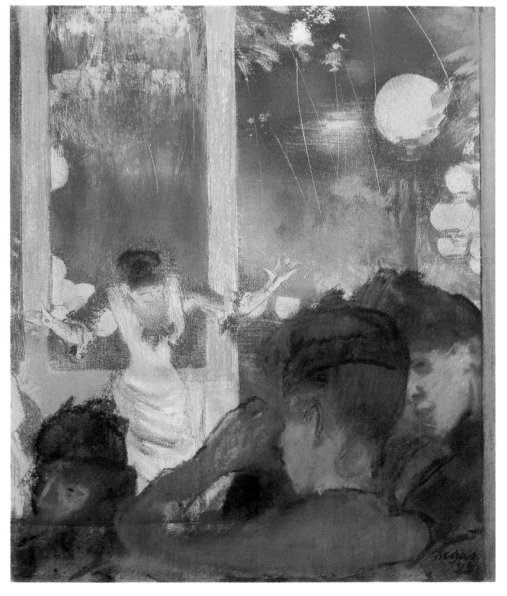

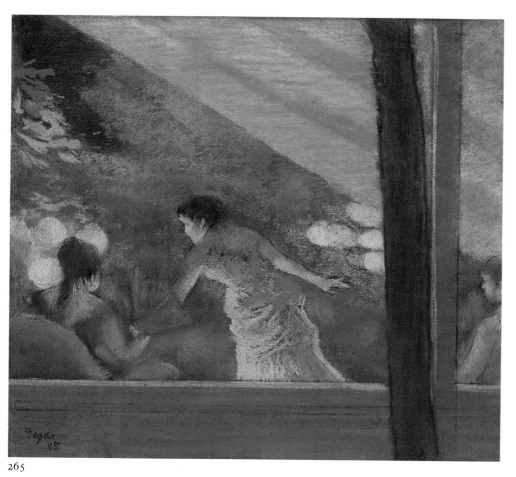

265

Fig. 242. Henri de Toulouse-Lautrec, *Jane Avril at the Café des Ambassadeurs*, 1894. Color lithograph, sheet 23⅝ × 16⅞ in. (60 × 43 cm), image 11⅞ × 9½ in. (30.1 × 24.2 cm). The Art Institute of Chicago

265.

At the Café des Ambassadeurs

1885
Pastel over etching on buff laid paper
10⅞ × 11⅝ in. (26.5 × 29.5 cm)
Signed and dated in pencil lower left: Degas/85
Musée d'Orsay, Paris (RF4041)

Exhibited in Paris

Lemoisne 814

Degas took the third state of an etching of 1879–80, the largest in his oeuvre, RS49 (see cat. nos. 178, 179), as the basis for this pastel.[1] The etching was based on a small monotype, J31, and both relate to a lithograph, RS26, in which Degas glimpsed a view from behind a singer standing under the gold-and-white striped awning of the Café des Ambassadeurs, here tinged with shrimp-colored reflections from the performer's dress. In the etching, her figure is cut at the knees by the latticework balustrade of the stage; in the pastel, the balustrade appears as a solid parapet. Otherwise, Degas chose in this instance not to make any substantial changes in the composition; rather, he took the opportunity to clarify forms that remained ambiguous in the etching. Thus the narrow tree trunk, climbing

not quite perpendicularly next to a stage column and green with moss, is recognizable in the pastel while obscure in the etching. Degas included in the pastel the back of an armchair for the performer seated at the left—in this detail bringing the pastel closer to the monotype—and added a figure at the right; both are women waiting their turn to sing, seated in a formation known as "la corbeille." Degas further defined in this work the globes of the gas lamps and added leaves at the left, sapped of their color and made pale blue by the strong stage lights, to suggest a setting of a warm summer's evening; the sky glows in phosphorescent blue and green. Nine years later, Toulouse-Lautrec adopted a similar composition for his color lithograph *Jane Avril at the Café des Ambassadeurs* (fig. 242).[2]

1. Until 1967, it was assumed that this pastel had been done over a monotype base, a more characteristic procedure for Degas during the period from the late 1870s to mid-1880s. See Janis 1967, p. 71 n. 3.
2. First noted in Reed and Shapiro 1984–85, p. 79.

PROVENANCE: Bought from the artist by Durand-Ruel, Paris, 27 June 1885, for Fr 50 (stock no. 699, as "Chanteuse"); bought by an unidentified client through Goupil–Boussod et Valadon, 21 January 1888, for Fr 100; Comte Isaac de Camondo, Paris,

c. 1888–1908; his bequest to the Louvre 1908; entered the Louvre 1911.

EXHIBITIONS: 1886 New York, no. 57 (as "Singer of the Concert Café"); 1949 Paris, no. 102; 1956 Paris; 1969 Paris, no. 210.

SELECTED REFERENCES: Paris, Louvre, Camondo, 1914, no. 220; Lafond 1918–19, II, repr. between pp. 34 and 37; Meier-Graefe 1920, pl. 80; Paris, Louvre, Camondo, 1922, no. 220; Meier-Graefe 1923, repr. pl. LXXX; Lemoisne [1946–49], III, no. 814 (as 1885); Paris, Louvre, Pastels, 1930, no. 22; Janis 1967, p. 71 n. 3; Minervino 1974, no. 633; 1984–85 Boston, p. 156, fig. 2 p. 154; Paris, Louvre and Orsay, Pastels, 1985, no. 54, pp. 63–64, repr. p. 63.

266

266.

Mary Cassatt at the Louvre: The Paintings Gallery

1885
Pastel over etching, aquatint, drypoint, and *crayon voltaïque*, on tan wove paper
Plate: 12 × 5 in. (30.5 × 12.7 cm)
Sheet: 12⅜ × 5⅜ in. (31.3 × 13.7 cm)
Signed and dated in black chalk lower left: Degas/85
The Art Institute of Chicago. Bequest of Kate L. Brewster (1949.515)

Exhibited in Ottawa

Lemoisne 583

Degas made fewer changes in working this etching with pastel than he did with the preceding prints in this group. It may well be that in developing the twenty-three states of the etching in 1879–80, Degas finally exhausted his otherwise enormous resources of invention (see cat. nos. 207, 208). While he accented a brown ostrich feather on

Mary Cassatt's hat in this pastel, and created a fussier hat for her sister Lydia (seated on the bench reading from the Louvre's printed catalogue), almost every other detail was simply colored in over a proof intermediate between the twelfth and thirteenth states. The composition remains nonetheless a tour-de-force of descriptive rendering, from the marbleized pilaster, to the herringbone oak floor, *faux-marbre* wainscoting, and gilt frames, not to mention the silk, satin, lace, and feathers of the ladies' costumes—effects all heightened by the additional coloring. One curious change that did occur was in the working of Lydia's dress: sharply rendered in the etching, with a smartly pleated skirt and a stylish metal button, here it becomes strangely indistinct and nondescript. Perhaps some connection may be made with the fact that Lydia had died three years earlier, in November 1882.

PROVENANCE: Earliest whereabouts unknown. Ivan Shchukin (brother of Sergei Shchukin), Paris, until 1900; bought by Durand-Ruel, Paris, 28 December 1900, for Fr 2,200 (stock no. 6183, as "Au Louvre," pastel); Durand-Ruel collection, Paris, 1900–26; deposited with Galerie Durand-Ruel, Paris, 2 October 1923 (deposit no. 6183, as "Au Louvre," 1885, watercolor); bought by Galerie Durand-Ruel (reconstitution of stock), 26 April 1926 (stock no. 12490, as "Au Louvre"); Kate L. Brewster, Chicago, until 1949; her bequest to the museum 1949.

EXHIBITIONS:[1] 1905 London, no. 49 (per Durand-Ruel archives, Paris, as "Visitors in the Louvre Museum," 1880); 1964, University of Chicago, Renaissance Society, 4 May–12 June, *An Exhibition of Etchings by Edgar Degas*, no. 31; 1984 Chicago, no. 53, pp. 117–19, repr. p. 117 and back cover (color).

1. It is tempting to identify this work with no. 38 of the 1886 New York exhibition, but the Durand-Ruel archives clearly indicate that the exhibited work (stock no. 475) was a drawing, perhaps BR105 (cat. no. 204).

SELECTED REFERENCES: Lemoisne [1946–49], II, no. 583 (as 1880); Cachin 1974, no. 54 (erroneously described as a "reproduction touched with pastel"); Minervino 1974, no. 576; Giese 1978, pp. 43, 44 n. 9, 47, fig. 6 p. 46; Thomson 1985, pp. 13–14, fig. 13 p. 58.

267.

The Visit to the Museum

c. 1885
Oil on canvas
32 × 29¾ in. (81.3 × 75.6 cm)
Vente stamp lower right
National Gallery of Art, Washington, D.C. Collection of Mr. and Mrs. Paul Mellon (1985.64.11)

Lemoisne 465

This painting and its variant in Boston (fig. 243) are closely connected to the pastels, lithographs, and etchings depicting a woman traditionally identified as Mary Cassatt at the Louvre,[1] but they constitute nonetheless a group apart. Except for the etching reworked with pastel (cat. no. 266), the works on paper were all executed about 1879–80, whereas the two paintings were done probably about 1885. The paintings are marked by a greater freedom of handling: the Washington painting in particular has a richly applied surface that describes in a generalized manner a great variety of materials and textures, such as the blurred gilt frames, the light-softened forms of the indistinguishable paintings they contain, the parquet floor, and the crisp, lively, exquisitely rendered silhouette of the female visitor. If legend has revealed Mary Cassatt and her sister as the protagonists of the works on paper, the woman in this painting has escaped identification. The fact that she stands in the Grande Galerie of the Louvre is undeniable—the paired pink scagliola columns are visible at the far right—but Degas deliberately demurs on the character of this female type. The English painter Walter Sickert reported that Degas had told him that with this painting "he wanted to give the idea of that bored and respectfully crushed and impressed absence of all sensation that women experience in front of paintings."[2]

Sickert came to know Degas well during the summer of 1885. Although they had met two years earlier, it was only then, in Dieppe, that they cemented their friendship. Sickert saw this picture one day when Degas "was glazing a painting with a flow of varnish by means of a big flat brush. As he brought out the background in a few undecided strokes, suggesting frames on the wall, he said with irrepressible merriment, 'Il faut que je donne avec ça un peu l'idée des Noce de Cana.' [With this I must give a bit of the idea of (Veronese's) *The Marriage at Cana*.]" This must have occurred in Degas's studio in

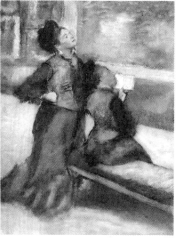

Fig. 243. *The Visit to the Museum* (L464), c. 1885. Oil on canvas, 36⅛ × 26¾ in. (91.8 × 68 cm). Museum of Fine Arts, Boston

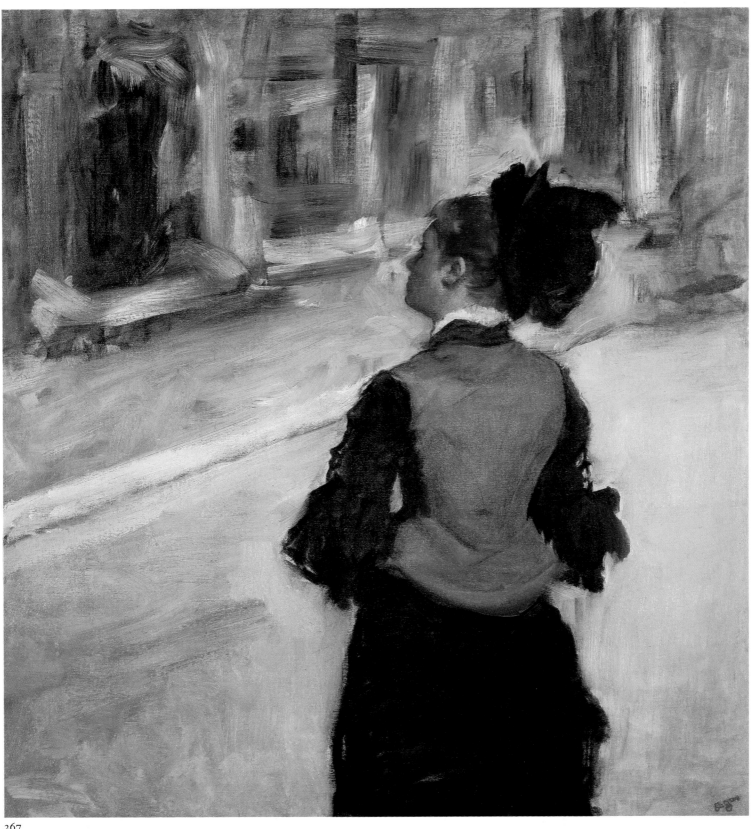

267

Paris, and since Sickert mentions a studio on several floors, it could only be the studio on rue Victor-Massé, where Degas moved in 1890. That he saw this painting rather than the version in Boston seems certain since he wrote that it represents a lady drifting in a picture gallery, and in the Boston picture there are two ladies.

One of the exhibits by Degas in the 1886 exhibition of modern French painting in New York was entitled "Visit to the Museum" (no. 38). Both this picture and the Boston picture have been proposed in an effort to identify that catalogue number, but the Durand-Ruel ledger "Tableaux remis en dépôt" clearly indicates that the work sent to New York for that exhibition was a drawing, possibly BR105 (cat. no. 204).

1. L532, L581, L582, L583, BR105, RS51, RS52 (see cat. nos. 204, 206–208, 266, and figs. 114, 149).
2. Sickert 1917, p. 186.
3. Ibid.

PROVENANCE: Atelier Degas (Vente II, 1918, no. 20, for Fr 21,100); bought by M. Tiguel. Mme Friedmann, Paris; Mme René Dujarric de la Rivière, her daughter, Boulogne, by 1960 until 1972; bought by Wildenstein and Co., New York, 1972; bought by Mr. and Mrs. Paul Mellon, February 1973; Mellon collection, Upperville, Va., 1973–85; their gift to the museum 1985.

EXHIBITIONS: 1955 Paris, GBA, no. 73, p. 20, repr. (as "La visite au musée"), no lender listed; 1960 Paris, no. 19, repr. (as 1877–80), no lender listed (according to label on reverse, lent by Mme René Dujarric de la Rivière); 1978 Richmond, no. 10; 1986, Washington, D.C., National Gallery of Art, 20 July–19 October, *Gifts to the Nation: Selected Acquisitions from the Collections of Mr. and Mrs. Paul Mellon*, no number, n.p. pamphlet (introduction by J. Carter Brown).

SELECTED REFERENCES: Sickert 1917, p. 186; Lemoisne [1946–49], II, no. 465 (as c. 1877–80); Giese 1978, p. 43, fig. 2 p. 44; 1984 Chicago, p. 118.

268

268.

Mary Cassatt

c. 1884
Oil on canvas
28⅛ × 23⅛ in. (71.5 × 58.7 cm)
The National Portrait Gallery, Smithsonian Institution, Washington, D.C. Gift of the Morris and Gwendolyn Cafritz Foundation and Regents' Major Acquisitions Fund, Smithsonian Institution (NPG.84.34)

Lemoisne 796

After Mary Cassatt and Degas had collaborated feverishly on their unrealized journal *Le Jour et la Nuit* in 1879–80 and then abandoned that project, they still continued to work together: in 1882, Cassatt took the trouble to pose for several of Degas's millinery scenes (see cat. no. 232), and Degas,

for his part, continued to encourage Cassatt in her work. Sometime after the 1886 Impressionist exhibition, he acquired one of her strongest paintings, *Girl Arranging Her Hair* (fig. 297). Degas accorded the picture a place of honor in his apartment throughout the 1890s (see fig. 196)—probably until he had to move in 1913.[1] Cassatt kept this portrait until the same year.

Considering the intensity of the friendship between the two artists, it is surprising to read of the absolute revulsion Cassatt had for this painting toward the end of her life. In letters written in 1912 and 1913, when she wanted to sell it, she criticized it in the strongest possible terms: "I do not want to leave it with my family as being [a picture] of me. It has some qualities as art, but it is so painful and represents me as such a re-

pugnant person, that I would not want it known that I posed for it."[2] What is it about this portrait that could have provoked such antipathy? Cassatt's biographer, Adelyn Breeskin, suggested that "Degas may very well have chosen this pose especially to shock her sense of propriety; . . . a lady was not meant to sit forward, with elbows on knees, conspicuously holding cards."[3] Yet surely it was not simply the improper posture of Cassatt in this painting that was so disturbing to her, but rather the character she was made to impersonate. For as Richard Thomson has observed, Degas may have painted Cassatt here as a fortune-teller.[4] In Paris during the latter part of the nineteenth century, fortune-tellers apparently were as common as they were disreputable, and no self-respecting bourgeoise would even admit

o receiving such a person in her home, let
alone impersonate one in an artist's studio.
Degas did not take pains to draw the tarot
cards carefully, and for this reason they have
sometimes been interpreted as photographs.
But to date only Thomson's reading of the
subject of the painting, made deeper by his
assertion that fortune-tellers were often pro-
curesses or prostitutes, begins to explain the
almost pathological aversion to the painting
by Cassatt late in life. What must have been
intended as a joke grew repellent as Cassatt's
attitude toward Degas hardened.

Since Cassatt's overriding concern while
selling the painting was to avoid recogni-
tion—she wanted it sold to a foreigner, and
with her name not attached to it—the like-
ness in the portrait must have been telling.
It would seem that Degas began the picture
as part of his series of portraits of individuals
seen in their own rooms, such as Michel-
Lévy in his studio (L326, Calouste Gulbenkian
Museum, Lisbon), Duranty in his study,
and Martelli in his room (cat. nos. 201, 202).
Thus the setting may be Cassatt's own studio,
for the studded leather chairs do not appear
elsewhere in Degas's works. However, Degas
largely effaced these details, substituting a
bamboo ballroom chair for the broadbacked
chair on which Cassatt was seated, and in so
doing began to transform the painting from
a portrait to a genre piece far removed from
Cassatt's highborn sensibilities.

If the subject of this genre-portrait is in-
deed a "repugnant person," to use Cassatt's
words, why then did she keep the painting
for so long? Since Cassatt evidently destroyed
Degas's letters to her and since her letters to
him have not survived, there is little hope of
answering the question—or of bringing to
light even the most elementary facts about
their friendship and collaboration.

1. See Chronology III, summer 1886, and fig. 196.
2. Letters from Cassatt to Durand-Ruel, of late 1912
and April 1913, in Venturi 1939, II, pp. 129–31.
According to Cassatt, this painting is not only un-
signed but unfinished.
3. Adelyn Dohme Breeskin, *Mary Cassatt: A Cata-
logue of the Graphic Work*, Washington, D.C.:
Smithsonian Institution Press, 1979, p. 15.
4. Thomson 1985, pp. 11–12. This interpretation was
first suggested in print by Marguerite Rebatet in
her caption for "La tireuse de cartes," in *Degas*,
Paris: Pierre Tisné, 1944, pl. 63.

PROVENANCE: Presumably a gift from the artist to
Mary Cassatt; Cassatt collection, Paris (?) c. 1884–
1913; bought by Ambroise Vollard, April 1913, until
at least 1917. Wilhelm Hansen, Copenhagen, 1918–
23. Acquired, possibly through Galerie Barbazanges,
Paris, by Kojiro Matsukata, 1923; Matsukata collec-
tion, Paris, Kobe, and Tokyo, 1923–51; bought by
Wildenstein and Co., New York, November 1951;
bought by André Meyer, early 1952; Meyer collec-
tion, New York, 1952–80 (Meyer sale, Sotheby
Parke Bernet, New York, 22 October 1980, no. 24,
repr., for $800,000); acquired by Galerie Beyeler,
Basel; acquired by the museum 1984.

EXHIBITIONS: 1913, Berlin, Cassirer, November,
Degas/Cézanne, no. 5; 1917, Kunsthaus Zürich, 5
October–14 November, *Französische Kunst des XIX.
und XX. Jahrhunderts*, no. 90, repr. (as "Portrait de
femme," Coll. A.V. [Ambroise Vollard]); 1920, Co-
penhagen, Ny Carlsberg Glyptotek, 27 March–19
April, *Degas–Udstilling*, no. 7 (as "Sittande dam"),
lent by Wilhelm Hansen; 1924 Paris, no. 58 (as "Miss
Cassatt assise, tenant des cartes"), lent by Kojiro
Matsukata; 1960 New York, no. 41, repr. (as "Por-
trait de Mary Cassatt," c. 1884), lent by Mr. and
Mrs. André Meyer; 1962, Washington, D.C., Na-
tional Gallery of Art, 9 June–8 July, *Exhibition of the
Collection of Mr. and Mrs. André Meyer*, p. 20, repr.;
1966, New York, M. Knoedler and Co., 12–29 Janu-
ary, *Impressionist Treasures from Private Collections in
New York*, no. 6, repr.

SELECTED REFERENCES: Jacques Vernay, "La triennale:
exposition d'art français," *Les Arts*, 154, April 1916,
p. 28 repr. (as "Étude de femme"); Karl Madsen,
*Malerisamlingen Ordrupgaard, Wilhelm Hansen's Sam-
ling*, Copenhagen, 1918, p. 32, no. 70 (as "Siddende
Dame"); Lafond 1918–19, II, p. 17; Leo Swane, "De-
gas: Billederne pa Ordrupgaard," *Kunstmuseets Aars-
skrift 1919*, Copenhagen, 1920, repr. p. 73; Hoppe
1922, p. 33, repr. p. 31 (as "Sittande dam," Wilhelm
Hansen collection, Ordrupgaard); Venturi 1939, II,
pp. 129–31; Lemoisne [1946–49], III, no. 796 (as
c. 1884); Boggs 1962, pp. 51, 112, pl. 113 (as c. 1880–
84); Adelyn D. Breeskin, *Mary Cassatt: A Catalogue
Raisonné of the Oils, Pastels, Watercolors, and Drawings*,
Washington, D.C.: Smithsonian Institution, 1970,
p. 13, repr.; Rewald 1973, p. 516, repr.; Minervino
1974, no. 608; Nancy Hale, *Mary Cassatt*, Garden
City, N.Y.: Doubleday, 1975, repr. between pp. 120
and 121; Broude 1977, pp. 102–03, 105, fig. 12 (de-
tail) p. 102; Giese 1978, p. 45, fig. 13 p. 49; Dunlop
1979, pp. 168–69; Thomson 1985, pp. 11–13, 16,
fig. 7 p. 55.

269.

Woman Bathing in a Shallow Tub

1885
Charcoal and pastel on pale green wove paper
now discolored to warm gray (adhered to silk
bolting in 1951)
32 × 22 in. (81.5 × 56 cm)
Signed and dated in black chalk upper left:
Degas/85
The Metropolitan Museum of Art, New York.
Bequest of Mrs. H. O. Havemeyer, 1929.
H. O. Havemeyer Collection (29.100.41)

Exhibited in New York

Lemoisne 816

"Degas's art is after all for the very few. I
cannot believe that many would care for the
nude I have. Those things are for painters
and connoisseurs."[1] Mary Cassatt, who
wrote these words in 1913 about this pastel,
often overestimated the public disdain—
which she perceived as omnipresent—for
modern art. Her opinion may have been
formed by her memory of the critical re-
sponse to this work when it was shown at
the eighth Impressionist exhibition in 1886.

Doubtless the common response was hostile
and rude, but even the more sophisticated
and otherwise sympathetic reviewers used
brutal language to describe the nudes in
general and this work in particular. Henry
Fèvre's damning praise was typical: "M.
Degas lays bare for us, with the great,
sweeping shamelessness of the artist, the
bloated, doughy, modern flesh of the prosti-
tute. In the shady boudoirs of registered
houses, where ladies fill the utilitarian social
role of love's main sewers, fat, heavy-jowled
women wash themselves, brush themselves,
soak themselves, and wipe their backsides in
washbasins as big as troughs."[2] Félix Fénéon,
who applauded the realism of the nudes, was
careful to note the ungainliness of this
figure: "A bony spine becomes taut; fore-
arms, leaving the fruity, pearlike breast,
plunge straight down between the legs to
wet a washcloth in the tub water in which
the feet are soaking."[3] Of the nudes that
were exhibited, this one's pose is perhaps
the most awkward and unconventional, which
suggests that the work as a whole may have
been intended as a deliberately anticlassical—
hence modern—statement.

Certainly the finish of the pastel is uncon-
ventional; it was worked in a manner that
contrasts markedly with the precision with
which the milliners were executed and with
the luxuriant color of the bathers as a group.
Degas seems to have drawn the figure first
in charcoal, and then made no attempt to
cover the contours. The paper, once pale
though now darkened to a medium gray,
supplied the predominant tone for the flesh;
Degas used his pale pink chalk sparingly,
and was only slightly more liberal with the
complementary pea-green pastel that pro-
vides the undertone. Otherwise, the work
seems relatively colorless. Only in the
working of the bath sheet thrown over the
armchair did the artist allow himself a rich
application of pigment, smudging and
stumping the white with blue reflections of
the cool northern light, and creating, with
an odd chestnut-colored chalk, shadows
that are almost sculptural in their effect. In
other areas, he turned the thin application of
pastel to particular advantage; he reserved
the uncolored paper to provide, for exam-
ple, the reflection of light on the water in
the tub, and used the paper's grainy texture
to modify the cobalt-blue shadow cast by
the bather's legs. Similarly, the paper itself
provided the mid-tone for the blue-and-
white pitcher in the lower right corner.

Degas studied the geometry for this tenu-
ously balanced pose in two highly animated
drawings, IV:288.a and III:82.2 (fig. 244).
They describe the position of the bather al-
most in profile, although one of them is in
reverse.[4] On one, IV:288.a, Degas drew lines

443

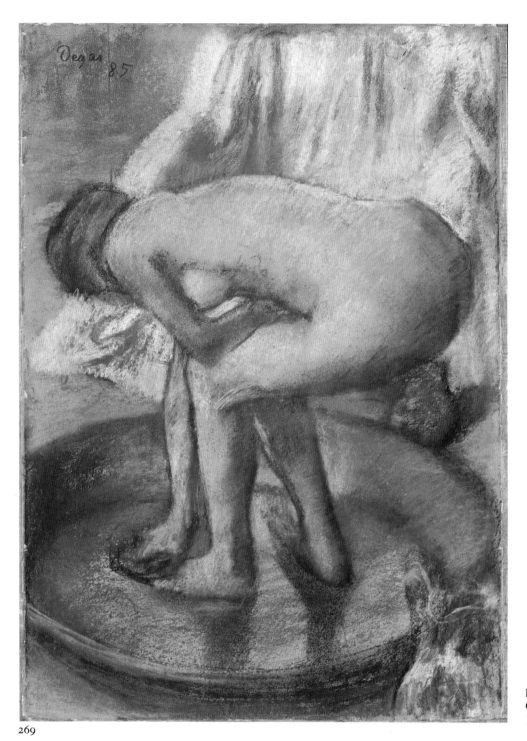

269

exhibition (1886), at which both works were shown. Mary Cassatt, Paris, c. 1886–1918/19; bought by Louisine Havemeyer, along with two other works by Degas, for a total of $20,000 (offer made in letter from Mary Cassatt to Louisine Havemeyer, 28 December 1917, Archives, The Metropolitan Museum of Art[2]); owing to the war, deposited by Cassatt with Durand-Ruel, Paris (no. 11925), from 8 March 1918 until 9 May 1919 when it was shipped to New York; Mrs. H. O. Havemeyer, New York, 1919–29; her bequest to the museum 1929.

1. According to Vollard, Degas proposed that Cassatt exchange her painting, then on exhibit at the first Impressionist exhibition, for the best of his "nudes." Obviously, Vollard confused the first Impressionist exhibition with the last, but his statement would otherwise appear to be correct (Vollard 1924, pp. 42, 43).
2. Letter reprinted in Mathews 1984, p. 330 (the other two works were L566 [cat. no. 209] and L861).

EXHIBITIONS: 1886 Paris, one of nos. 19–28; 1921, New York, The Metropolitan Museum of Art, 3 May–15 September, *Loan Exhibition of Impressionist and Post-Impressionist Paintings*, no. 32 (as "The Bather"), lent anonymously; 1922 New York, no. 47 (as "Femme au tub, s'essuyant"), no lender given; 1930 New York, no. 146; 1977 New York, no. 42 of works on paper.

Fig. 244. *Study of a Bather* (III:82.2), c. 1885. Colored crayons, 9 × 11¾ in. (23 × 30 cm). Location unknown

along the principal axes—from the head through the arm to the knee, from the knee to the rump, and from the knee to the left foot—and concluded, in notes to himself written on the sheet, that all three axes should be equally long, each measuring forty-seven centimeters (which is very close to their length in the finished pastel). On the other (fig. 244)—which, incidentally, looks like a counterproof but was probably drawn directly—he determined that the axes from the head to the hip and the hip to the right foot were to be forty-five centimeters long.

1. Mary Cassatt to Louisine Havemeyer, in an undated letter, probably of April 1913 (on deposit at The Metropolitan Museum of Art, New York).
2. Henry Fèvre, "L'exposition des impressionnistes," *La Revue de Demain*, May–June 1886, p. 154.
3. Fénéon 1886, p. 262 (translation McMullen 1984, p. 377).
4. These two drawings, in addition to a third (IV:288.b), all bear carefully noted measurements, which may be a sign that Degas was working on a sculpture. If he made such a sculpture, it presumably disintegrated or was destroyed.

PROVENANCE: Acquired from the artist by Mary Cassatt,[1] in exchange for her *Girl Arranging Her Hair* (fig. 297) after the close of the eighth Impressionist

SELECTED REFERENCES: Fénéon 1886, p. 262; Hermel 1886, p. 2; Mirbeau 1886, p. 1; Havemeyer 1931, p. 132; Burroughs 1932, p. 145 n. 16; Lemoisne [1946–49], III, no. 816 (as 1885); New York, Metropolitan, 1967, repr. p. 88; Minervino 1974, no. 911; Moffett 1979, p. 13, pl. 29 (color); 1984–85 Paris, fig. 123 (color) p. 145; Paris, Louvre and Orsay, Pastels, 1985, p. 68, under no. 59; Thomson 1986, pp. 187–88, fig. 1 p. 187; 1986 Washington, D.C., pp. 430–34, 443–44; Weitzenhoffer 1986, pp. 238, 255, pl. 158.

270.

The Morning Bath

1885–86
Pastel on buff wove paper affixed to original
 pulpboard mount
26⅜ × 20½ in. (67 × 52.1 cm)
Signed in blue chalk lower left: Degas
The Henry and Rose Pearlman Foundation

Lemoisne 877

'The chef d'oeuvre is the short-legged lump of human flesh who, her back turned to us, grips her flanks with both hands. The effect is prodigious. Degas has done what Baudelaire did—he has invented un frisson nouveau. Terrible, too terrible, is the eloquence of these figures. Cynicism was one of the great means of eloquence of the middle ages, and from Degas' pencil flows the pessimism of the early saint, and the scepticism of these modern days."[1] George Moore, who had a penchant for exaggeration, struck the precise tone of what in fact was a unanimous chorus of derision for the unlucky subject of this pastel. This was the one bather most discussed by the reviewers of the 1886 Impressionist exhibition, apparently because of the uncompromising realism of the banal scene, with few concessions to beauty or taste. That the work later acquired the subtitle 'La boulangère' (The Baker's Wife) is indicative of the way in which the subject was interpreted. Jean Ajalbert, writing in 1886, went so far as to dream of her minuscule

husband, and of the difficulty she would have had first in squeezing her ample form into a corset, and then in shoving the entire ensemble onto a public bus.[2]

Shocking as the scene may have been to viewers at the exhibition, the subject and the setting were by no means new to Degas. Eight or nine years earlier, he had executed several monotypes of women bathing, two of which he colored with pastel and exhibited in the 1877 Impressionist exhibition (see cat. no. 190). Somewhat later, he made a series of larger monotypes of bathers in cramped bedrooms, their zinc tubs crowded next to their beds, their washstands close by (see, for example, cat. nos. 195, 246, 247, 249, 252). Those monotypes of bathers are closely related to the monotypes of brothel scenes; indeed, the interiors portrayed in the

two groups are almost indistinguishable from one another. The setting and mood of *The Morning Bath* seem to derive from one of the bather monotypes (cat. no. 195), which also exists in a pastelized version (fig. 145). A drawing that Degas had made for that monotype (fig. 144) may have served as the point of departure for the figure here. Although the position of the arms is different, the carriage of the figure is the same; the neatly observed shadow along the spine, the distinctive dimple of the bather's buttocks, and the position of the feet—even the highlight on the top of the right foot—are common to both. Finally, both the drawing and the present pastel were executed with strong and elegant contours. Paul Adam wrote: "The characteristic line of Ingres, whose student Degas once was, is revealed

270

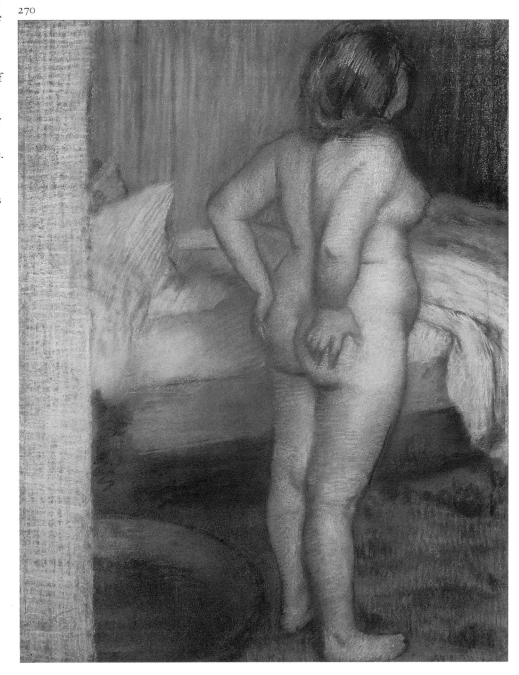

Fig. 245. *Nude Woman Stretching* (BR157), 1890s. Pastel, 30¾ × 19¾ in. (78.1 × 50.1 cm). Private collection

445

to be pure, confident, and rare under the pencil as it inscribes this fat bourgeoise ready for bed."[3]

That Adam regards the figure as a woman going to bed, while Ajalbert sees her as just waking up typifies the difficulty of ascribing specific contexts to Degas's bathers. While most of the reviewers, for example, saw in this nude a *petite bourgeoise*, perhaps a baker's or butcher's wife,[4] Fénéon called her a *maritorne*, a slattern.[5] Yet if she is a slattern, she is a healthy one. Degas gave her a glowing complexion, with none of the gray, green, or yellow tints that cast a pall over many of the other bathers. Her hands are reddened—Mirbeau noted her "short, chubby hand, ensconced in a layer of fat"[6]—but her gesture is robust. Huysmans remarked that "she stretches with the rather masculine motion of a man who lifts the tails of his jacket as he warms himself in front of a chimney."[7] The winglike symmetry of this gesture clearly attracted Degas: he adapted it for other bathers (cat. no. 274), for dancers (cat. nos. 307, 308), and for related sculptures (RXXI, RXXII, RXXIII, RLII [cat. no. 309]). He also took it up again for a late bather (fig. 245), though in this last instance he made the pose more expressive—pulling the head back, arching the spine, and bringing the hands higher. The color in the late variant is hot and exotic: the walls are turquoise, the chair deep gold, and the rug ultramarine and dark red.

Degas worked this pastel in a typical manner for the mid-1880s. It is drawn on commercially prepared academy board (pulpboard as opposed to the mosaics of joined paper he preferred in the 1870s and 1890s). The principal features were blocked in with chalk that he applied broadly and then rubbed or stumped; details or highlights were afterward made in the topmost layer, with short, parallel strokes. Every inch of the support is covered with a layer of pastel—in contrast to *Woman Bathing in a Shallow Tub* (cat. no. 269)—and there are very few pentimenti: only the lost profile and the contour of the left arm were subjected to revision.

1. [George Moore], *The Bat*, London, 25 May 1886, p. 185.
2. Ajalbert 1886, p. 386.
3. Adam 1886, p. 545.
4. Both Moore and Huysmans, in the 1880s, referred to this woman as a butcher's, not a baker's, wife (*une bouchère*). Moore retailed the following story regarding the alleged model for this picture: "Degas more than once drew a creature as short-legged and as bulky, and the model he chose was the wife of a butcher in rue La Rochefoucauld. The creature arrived in all her finery, the clothing she wore when she went to Mass on Sunday, and her amazement and her disappointment are easily imagined when Degas told her that he wanted her to pose for him naked. She was accompanied by her husband, and knowing her to be not exactly a Venus de Milo, he tried to dissuade Degas. Degas assured

the butcher that the erotic sentiment was not strong in him" (George Moore, *Hail and Farewell, I: Ave*, London, 1911, pp. 143–44; cited in Gruetzner 1985, p. 34).
5. Fénéon 1886, p. 262.
6. Mirbeau 1886, p. 2.
7. Huysmans 1889, p. 24.

PROVENANCE: Earliest whereabouts unknown. Probably in the collection of J. and G. Bernheim-Jeune in 1910, until at least 1919 (sale, Drouot, Paris, *Tableaux modernes . . . provenant de la collection "L'art moderne"* [Lucerne], 20 June 1935, no. 7, repr. [as "Femme à son lever"], for Fr 22,000); bought at that sale by M. Clerc (per annotated sale catalogue); with Galerie Bernheim-Jeune, Paris. David-Weill collection, Paris, by 1947. Henry and Rose Pearlman collection, New York, by 1966.

EXHIBITIONS: 1886 Paris, one of numbers 19–28; 1910, Paris, Bernheim-Jeune, 17–28 May, *Nus*, no. 26 (as "La boulangère"); 1974, New York, The Brooklyn Museum, 22 May–29 September, *An Exhibition of Paintings, Watercolors, Sculpture and Drawings from the Collection of Mr. and Mrs. Henry Pearlman and the Henry and Rose Pearlman Foundation*, no. 9, repr. (color) (as c. 1886); 1986 Washington, D.C., no. 141, repr. p. 454 (color); 1986, New York, The Metropolitan Museum of Art, 13 May–2 December, "Selections from the Collection of Mr. and Mrs. Henry Pearlman" (no catalogue).

SELECTED REFERENCES: Adam 1886, p. 545; Ajalbert 1886, p. 386; Fénéon 1886, p. 262; Mirbeau 1886, p. 2; [George Moore], *The Bat*, London, 25 May 1886, p. 185; Huysmans 1889, p. 24; Vollard 1914, repr. (color); *L'Art moderne et quelques aspects de l'art d'autrefois: cent soixante-treize planches d'après la collection privée de MM. J. et G. Bernheim-Jeune*, Paris: Bernheim-Jeune, 1919, I, pl. 52; Coquiot 1924, repr. p. 184; Lemoisne [1946–49], III, no. 877 (as c. 1886); Pickvance 1966, p. 19, fig. 7 p. 21; Minervino 1974, no. 925; Gruetzner 1985, pp. 34–35, fig. 34 p. 66; Christopher Lloyd and Richard Thomson, *Impressionist Drawings from British Public and Private Collections*, Oxford: Phaidon Press/Art Council, 1986, p. 47, fig. 48 p. 46; Thomson 1986, p. 189, fig. 5.

271.

Woman Bathing in a Shallow Tub

1886
Pastel on heavy wove paper
23⅞ × 32⅝ in. (60 × 83 cm)
Signed and dated in blue chalk lower right: Degas/86
Musée d'Orsay, Paris (RF4046)

Exhibited in Paris

Lemoisne 872

This nude, a figure of fragile beauty, struck by a soft, blond, early morning light, was particularly well received at the 1886 Impressionist exhibition. Huysmans characteristically projected his own preconceived, misogynistic interpretation onto the figure: he called her "plump and well stuffed"[1] and emphasized the strain of her gesture (whereas, in fact, one could as easily have highlighted the figure's integral and classical qualities, harking back to the Louvre's *Crouching Aphrodite*, said to be after Doidalsas). Geffroy, in a parallel vein, wrote that Degas "has hidden nothing of her froglike appearance, of the fullness of her breasts, the heaviness of her lower parts, the twisting of her legs, the length of her arms, the stunning apparition of paunches, knees, and feet unexpectedly foreshortened."[2] But other critics who mentioned this pastel stressed it beauty and finesse. Mirbeau found in it "th loveliness and power of a gothic statue."[3] And Maurice Hermel, after characterizing the bathers series as "anatomical problems solved by an astonishing draftsman and rendered poetic by a colorist of the first rank," wrote an enthusiastic appreciation deserving of repetition: "The pose is admirably true to life, the line of the back and curve of the thigh superb, the left foot exquisite; the robust, supple contours express the fullness o

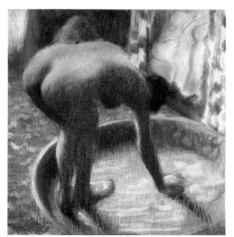

Fig. 246. *Woman Bathing in a Shallow Tub* (L1097), c. 1885–86, reworked 1890s(?). Pastel, 28 × 27⅛ in. (71 × 69 cm). Hiroshima Museum of Art

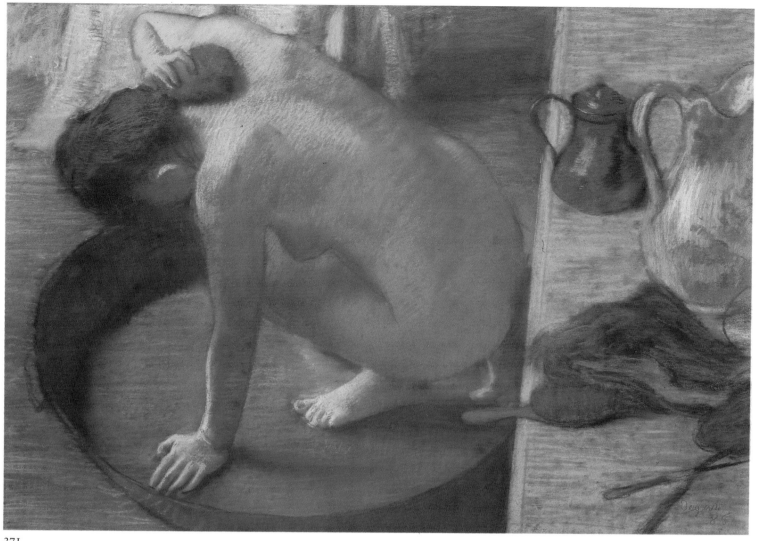

271

the body; the streaking of the colors conveys all the nuances of the skin in light and shadow; the accessories, washstand, draperies, and reflections of water on metal are all as masterfully executed as could be."[4]

The pastel is one of seven that Degas executed in the mid-1880s of a woman in a shallow tub: three works—L738 (fig. 293), L765 (fig. 183), and L766—depict a figure sitting or kneeling in the tub, while four others—L1097 (fig. 246),[5] L876 (fig. 247), L816 (cat. no. 269), and L872 (the present work)—show her standing or squatting, with one arm extended either for balance or to sop up water with a sponge. Although Degas never exhibited them together, the last four can be seen as a subseries within the larger group of bathers; a similar-looking model was used for all four, and in them she performs a similar activity. Placed in sequence (i.e., figs. 246, 247, cat. no. 269, and the present work), the pastels look like four consecutive frames of film: the camera circles the bather while she gathers the last drops of water in her sponge, and then comes

in for a close-up as she shifts her weight, steadies herself with her left hand, and lifts her right arm to squeeze the sponge out on her shoulder. The utensils of the bather's toilette—her attributes—come into focus

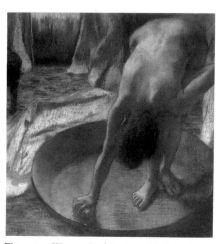

Fig. 247. *Woman Bathing in a Shallow Tub* (L876), c. 1885–86. Pastel, 27½ × 27½ in. (70 × 70 cm). Hill-Stead Museum, Farmington, Conn.

with the close-up in the present work, and the viewer can thus anticipate what will happen next: having dried herself with the peignoir at the upper left, she will brush her hair, insert her hairpiece, and then put on a

Fig. 248. *Woman before a Mirror* (L983), c. 1885–86. Pastel, 19¼ × 25¼ in. (49 × 64 cm). Hamburger Kunsthalle

447

hat that is presumably just outside our field of vision. Degas in fact depicted this last, anticipated scene in a pastel of about this date (fig. 248).

Such sequential—almost calibrated—imagery is a distinctive feature of Degas's work from the early and mid-1880s until the end of his career. It relates to notes that he jotted in a notebook about 1879–80: "do some simple operations/like drawing a profile that would not move, while moving oneself, up/or down/same for a complete figure/a piece of furniture, a whole room/ In short, study from all perspectives a figure or an object, anything at all."[6] In retrospect, with Cubism, Futurism, and other analytical movements of modern art behind us, Degas's ambitions now seem commonplace, but in their time they were remarkably advanced. Granted that the young Seurat was working in an equally analytic fashion, and that Monet would later exploit serial imagery—nevertheless no French painter of the epoch was as close to the full realization of sequential images. On the international scene, only photographers such as Marey and Muybridge were working on parallel projects, and they for scientific rather than artistic reasons.

Muybridge's work on animals in motion coincided closely with Degas's development of a new grammar of representation, and although Degas knew some examples of Muybridge's early experiments, he could not have seen the full corpus of *Animal Locomotion*, with its studies of the human figure, until its publication in 1887 (see "Degas and Muybridge," p. 459). Thus, this instance seems to reflect a case of parallel development—a "mysterious coincidence," to use Baudelaire's description of his relationship to Edgar Allan Poe—as opposed to the example of the direct influence of Muybridge on Degas's jockey studies of the late 1880s.

Observing this work, one teeters over the bather, and this results in a dramatically intrusive viewpoint, different from that of most of the other bather pastels of the mid-1880s. Degas uses the marble tabletop at the right to crop the composition, just as he used the door frame at the left of *The Morning Bath* (cat. no. 270). Here, however, he exploits the perspectival distortion resulting from his nearly overhead viewpoint to shift the tabletop from its normal horizontal position to a seemingly vertical one—a shift no less striking than those effected by Cézanne in his contemporaneous still lifes. And just as Cézanne, in his paintings, established formal relationships among disparate objects through visual rhymes and color harmonies, so Degas sets up his still life at the right: the water pitcher and its handle echo the figure of the nude and her arm; the smaller copper

pot nestles neatly beside the pitcher handle; and the hairpiece, the little copper pot, the nude's henna hair, and her sponge act as common referents against which other colors can be compared.

The cool tonality of this work is similar to that of the *Woman Bathing in a Shallow Tub*, in the Metropolitan Museum (cat. no. 269), although here Degas has covered the paper support entirely with pastel. The hand and foot in the tub are rendered with a particularly exquisite refinement; one is reminded that it was around this same period that Degas redrew and repainted a hand and a foot in the painting *Mlle Fiocre in the Ballet "La Source"* (cat. no. 77; see the later drawings L 1108 and L 1109).

The pose of this bather derives from a crouching figure in *Semiramis Building Babylon* (cat. no. 29) and in a preparatory drawing for that painting in the Louvre (cat. no. 31). A comparison of the early drawing with this pastel reveals that Degas lost none of the purity of his line in the intervening twenty-five years, but rather gained an extraordinary ability to invest his figures with a lifelike sense of movement.

1. Huysmans 1889, p. 24.
2. Geffroy 1886, p. 2.
3. Mirbeau 1886, p. 1.
4. Hermel 1886, p. 2.
5. The surface of L1097 has the appearance of a pastel of the early 1890s, though the composition is one of the mid-1880s; Degas may have reworked it later. L1098, in the Burrell Collection in Glasgow, appears to be considerably later than L1097, perhaps as late as 1900.
6. Reff 1985 (BN, Carnet 9, Notebook 30, p. 65).

PROVENANCE: Probably acquired from the artist by Émile Boussod (Galerie Goupil–Boussod et Valadon), Paris, 1886. Bought by Comte Isaac de Camondo, March or April 1895, for Fr 14,000 (Camondo notebook, Archives, Musée du Louvre, Paris); Camondo collection, Paris, 1895–1908; his bequest to the Louvre 1908; entered the Louvre 1911; first exhibited 1914.

EXHIBITIONS: 1886 Paris, perhaps no. 19 or no. 20, lent by M. E.B. [Émile Boussod?]; 1924 Paris, no. 158; 1949 Paris, no. 103, repr.; 1956 Paris; 1969 Paris, no. 211; 1975 Paris; 1983, Paris, Palais de Tokyo, 27 May–17 October, "La nature-morte et l'objet de Delacroix à Picasso" (no catalogue).

SELECTED REFERENCES: Fénéon 1886, p. 262; Geffroy 1886, p. 2, reprinted in [Octave Maus], "Les Vingtistes Parisiens," *L'Art Moderne*, 6e année, 26, 27 June 1886, p. 202; Hermel 1886, p. 2; Mirbeau 1886, p. 1; Huysmans 1889, p. 24; Lemoisne 1912, pp. 107–08, pl. XLVI; Jamot 1914, pp. 456–57; Paris, Louvre, Camondo, 1914, no. 222, pl. 52; Lafond 1918–19, I, repr. p. 54; Emil Waldman, *Die Kunst des Realismus und des Impressionismus*, Berlin, 1927, pp. 63, 97, repr. p. 477; Paul Jamot, *La peinture du Musée du Louvre: école française, XIXe siècle*, Paris: *L'Illustration*, 1929, p. 72, pl. 55 p. 77; Fosca 1930, VI, repr.; Huyghe 1931, p. 275, fig. 17; Grappe 1936, repr. p. 53; Lemoisne [1946–49], III, no. 872 (as 1886); Leymarie 1947, no. 40, pl. XL; Arnold Hauser, *The Social History of Art*, New York, 1952, repr. between pp. 120 and 121; P.-A. Lemoisne, *Degas et son oeuvre*, Paris, 1954, pl. 5 (color); Pickvance 1966, p. 19, fig. 6 p. 21; Paris,

Louvre, Impressionnistes, 1973, p. 143, repr. p. 32; Minervino 1974, no. 920, pl. LIII (color); Alan Bowness, *Modern European Art*, London (1972) 1977, p. 84, no. 83, repr. (color); Broude 1977, p. 105, fig. 1 p. 106; A. Lefébure, *Degas*, Paris, 1981, repr. (color) p. 58; H. Adhémar, et al., *Chronologie impressionniste, 1863–1905*, Paris, 1981, no. 238, repr.; Pierre-Louis Mathieu, "Huysmans: inventeur de l'impressionnisme," *L'Oeil*, December 1983, p. 42, repr. (color) p. 38; Françoise Cachin in 1983, New York, The Metropolitan Museum of Art, *Manet*, p. 434, fig. p. 433; 1984 Chicago, p. 164 fig. 77–1; McMullen 1984, p. 275, repr. p. 277; 1984–85 Paris, p. 46, fig. 125 (color) p. 148; Paris, Louvre and Orsay, Pastels, 1985, p. 68 no. 59, repr.; Lipton 1986, p. 182, fig. 123 p. 183; Thomson 1986, pp. 188–89, p. 188 fig. 2.

272, 273

Nude Woman Drying Her Foot

In both of these pastels, which are close in size, Degas's principal interest lay in examining what could be done with a bather doubled up, snaillike, drying her foot. The bather's torso is pressed hard against her leg in both works, her back rounded, and her right arm extended parallel to her left leg. Turning the Paris bather (cat. no. 273) clockwise ninety degrees results in a figure similar to the New York bather (cat. no. 272). In other important respects, however, the poses are quite different. The Paris bather is stooped over in an embryonic position, as if hugging herself, and she is all curves. The New York bather has, seemingly, too many limbs; they sprout from the center, making her figure almost arachnoid.

The poses that Degas has wrought in these pictures are so abstracted that one is reminded of Ingres's sinuous but arbitrarily distorted nudes. But where Ingres distorts anatomy in order to heighten the erotic appeal, Degas is relentlessly faithful to the imperfections of the model. The nudes are neither sensuous nor appealing. The flesh is not healthy, but pasty. The strong contours in chestnut-colored chalk emphasize the bilious tone of the bather's complexion, which is relieved only slightly by the pale pink chalk used for the highlights. The bather in the New York pastel is flabby, and her elbows and face are red from exposure—a Zola-like clue pointing to a rough life. Such details, as well as the close cropping of the figures within narrowly confined rooms, convey a sense of the mean and circumscribed lives these women lead, whether or not they are prostitutes.[1] In the Paris pastel, Degas seems further to imply some sort of waiting presence in the form of the open-armed armchair, which in turn is contrasted with the small wooden side chair on which she sits. He establishes a

272

272.

Nude Woman Drying Her Foot

c. 1885–86
Pastel on buff wove paper affixed to original
 pulpboard mount
19¾ × 21¼ in. (50.2 × 54 cm)
Signed in blue chalk lower left: Degas
The Metropolitan Museum of Art, New York.
 Bequest of Mrs. H. O. Havemeyer, 1929.
 H. O. Havemeyer Collection (29.100.36)

Exhibited in New York

Lemoisne 875

PROVENANCE: Bought, probably from Galerie Goupil–
Boussod et Valadon,[1] by Mrs. H. O. Havemeyer,
New York, by 1915, until 1929; her bequest to the
museum 1929.

1. Label on verso indicates that the work passed
 through Goupil et Cie (Boussod Valadon et Cie
 Successeurs), Paris.

dialogue between the two chairs, leading us
to wonder, as well, whether a top-hatted
man is hidden behind the door frame at the
right.

The blue, yellow, and green harmonies in
the two pastels are typical of many of the
bathers, but the hues here are higher keyed.
Degas worked the Paris pastel more richly
than the New York work: the upholstered
chair is a particularly bright and dense gold,
a color picked up again in the signature at
the right.

Although Lemoisne and others have sug-
gested that one or both of these pastels were
included in the 1886 Impressionist exhibi-
tion, neither was described by any of the
critics in their reviews.

1. As Eunice Lipton argues (Lipton 1986, p. 169 and
 passim).

EXHIBITIONS: 1915 New York, no. 37 (as "After the
Bath," 1887; annotated copy of this catalogue indi-
cates that the bather is "drying her foot"), no lender
given; 1922 New York, no. 48 (as "Après le bain:
femme s'essuyant le pied gauche"); 1930 New York,
no. 148; 1977 New York, no. 47 of works on paper.

SELECTED REFERENCES: Havemeyer 1931, p. 128, repr.
p. 129; Burroughs 1932, p. 145 n. 17; Lemoisne
[1946–49], III, no. 875 (as 1886); New York, Metro-
politan, 1967, pp. 89–90, repr. p. 89; Minervino
1974, no. 926; 1986 Washington, D.C., pp. 430,
443; Weitzenhoffer 1986, p. 255; 1987, Williamstown,
Sterling and Francine Clark Art Institute, 20 June–
25 October, *Degas in the Clark Collection* (by Rafael
Fernandez and Alexandra R. Murphy), fig. H, p. 13.

273

273.

Nude Woman Drying Her Foot

c. 1885–86
Pastel on buff heavy wove paper
21⅜ × 20⅝ in. (54.3 × 52.4 cm)
Signed in yellow chalk lower right: Degas
Musée d'Orsay, Paris (RF4045)

Exhibited in Paris

Lemoisne 874

PROVENANCE: Comte Isaac de Camondo collection, Paris, until 1908; his bequest to the Louvre 1908; entered the Louvre 1911; first exhibited 1914.

EXHIBITIONS: 1924 Paris, no. 157; 1937 Paris, Orangerie, no. 135; 1949 Paris, no. 104; 1956 Paris; 1969 Paris, no. 212.

SELECTED REFERENCES: Lemoisne 1912, pp. 105–06, pl. XLV; Jamot 1914, pp. 450–51, 457, repr. p. 451; Paris, Louvre, Camondo, 1914, no. 221, p. 43; Lafond 1918–19, I, repr. p. 59; Meier-Graefe 1920, p. 83; Paris, Louvre, Camondo, 1922, no. 221, p. 49; Meier-Graefe 1923, pl. LXXXII; Jamot 1924, pl. 71b p. 154; Paul Jamot, *La peinture au Musée du Louvre*, Paris, 1929, III, repr. p. 72; Paris, Louvre, Pastels, 1930,

no. 23; Lemoisne [1946–49], III, no. 874 (as 1886); G. Carandente, "Edgar Degas," *I maestri del colore*, 144, Milan: Fratelli Fabbri Editori, 1966, pl. XVI (color); Monnier 1969, p. 368; Minervino 1974, no. 927; Terrasse 1974, pp. 60–61, fig. 3 (color); Paris, Louvre and Orsay, Pastels, 1985, no. 58, p. 67 repr.

Nude Woman Having Her Hair Combed

c. 1886–88
Pastel on light green wove paper, now discolored
to warm gray, affixed to original pulpboard
mount
29⅛ × 23⅞ in. (74 × 60.6 cm)
Signed in orange chalk lower right: Degas;
obscured by the artist and re-signed in black
chalk at left: Degas
The Metropolitan Museum of Art, New York.
Bequest of Mrs. H. O. Havemeyer, 1929.
H. O. Havemeyer Collection (29.100.35)

Exhibited in New York

Lemoisne 847

There can be little doubt that Degas intended to exhibit this work at the eighth Impressionist exhibition, in 1886. It is large in format, highly finished, and exquisitely worked, and would seem to belong to the series of bathers that created such a sensation at the exhibition. Degas evidently anticipated its inclusion, for he took pains to describe his nudes in the catalogue as "women bathing, washing themselves, drying themselves, toweling themselves, combing their hair or having it combed," and the present work is the only pastel of the mid-1880s of a woman having her hair combed. However, not one of the reviewers of the exhibition (and they were many) described a work even remotely resembling this picture. Thus, just as Degas listed *The Little Fourteen-Year-Old Dancer* (cat. no. 227) in the catalogue of the 1880 Impressionist exhibition and did not exhibit it—the empty case serving as the butt of many jokes—so too, apparently, did he decide not to exhibit *Nude Woman Having Her Hair Combed*.[1] Either he was unable to finish it before the exhibition opened[2]—which is easily understandable in view of the meticulous, time-consuming technique of this particular work—or else he deliberately excluded it, for reasons yet to be discovered.

The degree of finish in this work exceeds that of nearly all the nudes of the mid-1880s, with the exception of *Nude Woman Combing Her Hair* (cat. no. 285). Degas began with the nude, the servant, and the chaise longue, outlining the forms with charcoal and chalk, and then filling them in with broad planes of color that were stumped or smeared greenish gold for the chaise and a medium flesh color for the figure; the peignoir was probably left in reserve. The wall hangings, matching the upholstery of the chaise, were also blocked in at this point. Having established his zones of color and general structure, Degas set to work on each aspect of the composition with remark-

able enthusiasm. Whereas, for example, he drew much of *Woman Bathing in a Shallow Tub* (cat. no. 269) with only four chalks (the tin tub is expressed with two blues, a white, and a black), here he worked the wall hangings and the chaise with three different tones of olive-gold pastels, in addition to a dark olive-green for shadows, black chalk or charcoal for definition, and a contrasting orange for texture, the last drawn mainly in parallel strokes perpendicular to the direction in which the underlying color had been applied. Similarly, he worked the maid's coral-colored bodice in contrasting tones, one coarsely applied over the other, and did the same for the rug, beginning with a rose-red base (now faded) over which he drew roughly parallel green strokes, crossed perpendicularly with strokes of turquoise and blue.[3] The bather's peignoir and the maid's apron were worked differently: Degas steamed or soaked his sticks of Prussian-blue pastel to make the smudged shadows; over the shadows, he used a brush to apply a thin wash made of white pastel;[4] he then reworked the surface with coarser highlights in white and, finally, added a few touches of bright blue in the shadows.

The true tour de force, however, is the nude. The figure—who resembles Marie van Goethem, the model for *The Little Fourteen-Year-Old Dancer*—is beautifully proportioned, and supremely refined in execution. Degas rendered it with countless strokes of pastel, each subtly nuanced to bring the body into relief. There is no known drawing for the figure, and the numerous pentimenti in the thighs, the feet, the right shoulder, and the profile of the face suggest that it was in large part developed directly on the work, or at least substantially modified to accommodate the demands of the

composition. Degas seems to have been especially concerned with the geometry of the composition, for he created a structure uncharacteristic for the eighties. To be sure, he included a strong diagonal element, the chaise longue, which establishes the depth of space for the scene. But in an unusual departure from his normal practice, he conspicuously counterbalanced the diagonal line of gold upholstery (extended at the left by the wall covering) with the white peignoir which, puddled at the feet of the bather, drapes across the chaise and melds visually with the white apron of the maid. Degas thus created a symmetrical X-shaped compositional device and poised the nude precisely at the point of intersection of the two diagonals. In so doing, he generated a shallow but persuasive space that flows convincingly around the bather, radiant in her pool of white light.

The pose of the bather, seen in a three-quarter view, seated amid drapery and dreamily self-absorbed while being waited upon by a servant, is reminiscent of Rembrandt's *Bathsheba with King David's Letter* (fig. 250) at the Louvre. Even though the present pastel was not exhibited in the 1886 Impressionist exhibition, the suite of bathers as a whole elicited comparisons with the Rembrandt.[5] It was common for reviewers to cite artistic precedents—the obvious quotations made by Manet in his work encouraged the practice—and Rembrandt's painting (given to the Louvre by La Caze, a friend of Degas's family) was one of the most famous old-master nudes in Paris. As Ian Dunlop has observed, Degas's *Nude Woman Having Her Hair Combed* "seems to have been conceived in much the same light as the Rembrandt: both nudes are absorbed in their thoughts and appear to be oblivious of any onlooker

Fig. 249. George William Thornley, *Nude Woman Having Her Hair Combed*, after Degas, 1888. Lithograph, red ink on off-white paper, 9¾ × 7⅝ in. (23.8 × 19.6 cm). The Art Institute of Chicago

Fig. 250. Rembrandt, *Bathsheba with King David's Letter*, 1654. Oil on canvas, 55⅞ × 55⅞ in. (142 × 142 cm). Musée du Louvre, Paris

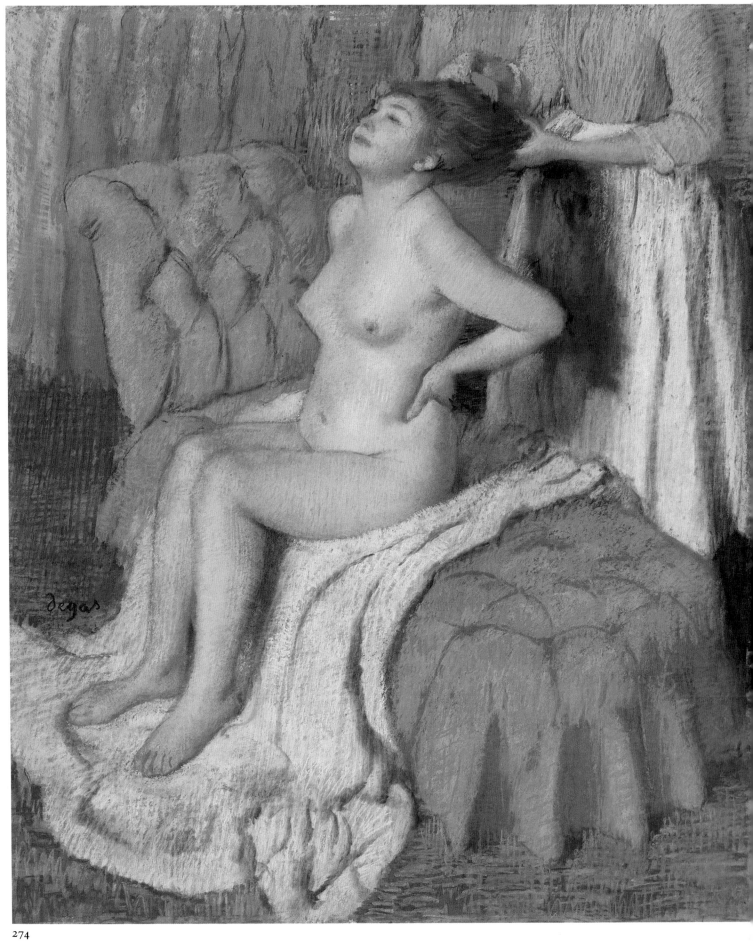

274

except their attendants, who go about their business in unselfconscious fashion."[6]

Compared with Degas's other bathers of the mid-1880s, the nude in this pastel is portrayed in quite flattering terms. The remarks about animality and misogyny in which the contemporary reviewers reveled certainly do not apply here. Rather more apt is Eunice Lipton's assertion that Degas's bathers are essentially women portrayed as they saw themselves, enjoying private moments of narcissistic pleasure.[7] The woman in this scene is enveloped in luxury and comfort; there is no cheap zinc tub, no tacky wallpaper, nor any other indicator of a squalid brothel environment to undercut the picture's beauty. Herein may lie a clue as to why Degas did not exhibit this work with the other bathers: the nude was too refined, and the classical connotations were too apparent to provide the "frisson nouveau"[8] that Degas hoped to achieve with this series.

1. Jamot (1924, pp. 153–54) and Lemoisne ([1946–49], III, p. 488) speculated that it *was* included in the 1886 exhibition, and most writers subsequently concurred. Ronald Pickvance (in a letter of 1964 in the archives of the Metropolitan Museum) suggests that it was not exhibited. Richard Thomson (1986, pp. 187–90) recently stated that it was not exhibited, although the catalogue for the exhibition *The New Painting* (1986 Washington, D.C., p. 443) does not exclude the possibility.
2. Since G. W. Thornley reproduced the pastel in a lithograph made in 1888 (fig. 249), it must have been completed by that date. Indeed, it may have already belonged to Boussod et Valadon, which published Thornley's suite of lithographs and exhibited them. There is a Boussod et Valadon label affixed to the back of the pastel.
3. Theodore Reff attributes Degas's use of "cross-hatched complementary colors" in this work to the influence of Delacroix (Reff 1976, p. 310 n. 87). While complementary color harmonies were a significant aspect of Delacroix's technique, more important was his espousal of a modified Rubensian colorism—something Degas did not adopt at the time. In this pastel, every form is colored locally, and the local color is as strictly observed as it would be in a painting by Ingres—even if the colors themselves are broken. For example, the blue rug, though mixed with other colors, throws no reflections on the gold chaise, and the maid's white apron catches no color from either the adjacent chair or her blouse. Thus there is no interaction among the different zones of color, and such interaction was the key feature of Delacroix's mature technique.
4. This was observed by Peter Zegers and Anne Maheux.
5. Geffroy 1886, p. 2.
6. Dunlop 1979, p. 190.
7. Eunice Lipton, "Degas' Bathers: The Case for Realism," *Arts Magazine*, LIV:9, May 1980, p. 97. The description of this pastel in the catalogue of the 1914 Roger Marx sale, p. 66, states that the nude "gives herself up to the care of a servant girl . . . who is combing her mistress's luxuriant tresses."
8. The phrase is used by George Moore, writing anonymously in *The Bat* (London), 25 May 1886, p. 185.

PROVENANCE: Probably acquired from the artist by Galerie Goupil–Boussod et Valadon (Theo van Gogh), Paris, c. 1888; probably sold to M. Dupuis, Paris, c. 1888–90 (Dupuis sale, Drouot, Paris, 10 June 1891, no. 13, for Fr 2,600)[1]; acquired at that sale by Mayer (probably Salvador Meyer). Roger Marx, Paris, after 1891, until 1913 (Marx sale, Galerie Manzi-Joyant, Paris, 11–12 May 1914, lot no. 125, repr., for Fr 101,000); bought by Joseph Durand-Ruel as agent for Mrs. H. O. Havemeyer (on deposit with Durand-Ruel, Paris [no. 11710], 19 May 1914); Mrs. H. O. Havemeyer, New York, 1914–29; her bequest to the museum 1929.

1. The many omissions in the Boussod et Valadon stock books (noted by Rewald 1973 GBA, p. 76, and Rewald 1986, p. 78) make it impossible to confirm the earliest provenance of this work. Yet Rewald has established that all the modern pictures included in the Hôtel Drouot sale of 10 June 1891 came from the Dupuis estate; and Dupuis bought almost exclusively from Theo van Gogh at Boussod et Valadon.

EXHIBITIONS: 1909, Paris, Bernheim-Jeune et Cie, 3–15 May, *Aquarelles et pastels de Cézanne, H.-E. Cross, Degas, Jongkind, Camille Pissarro, K.-X. Roussel, Paul Signac, Vuillard*, no. 48; 1915 New York, no. 22; 1930 New York, no. 147; 1974–75, New York, The Metropolitan Museum of Art, 12 December 1974–10 February 1975, "The H. O. Havemeyers: Collectors of Impressionist Art," no. 6; 1977 New York, no. 43 of works on paper, repr.

SELECTED REFERENCES: Thornley 1889, repr.; Lafond 1918–19, I, repr. p. 23; Jamot 1924, pp. 153–54, pl. 69; Huyghe 1931, fig. 29 p. 279; Havemeyer 1931, p. 130, repr. p. 131; Burroughs 1932, p. 145 n. 15, repr.; Mongan 1938, p. 302, pl. II.C; Rewald 1946, repr. p. 393; Lemoisne [1946–49], I, p. 121, repr. facing p. 120, III, no. 847 (as c. 1885); Cooper 1952, pp. 22–23 (English edition), no. 22, repr. (color), pp. 23–24 (German edition), no. 22, repr.; Cabanne 1957, pp. 55, 119, pl. 127 (color); Havemeyer 1961, pp. 261–62; Rewald 1961, repr. p. 525; Pool 1963, p. 44, pl. 45; Denys Sutton, "The Discerning Eye of Louisine Havemeyer," *Apollo*, LXXXII, September 1965, p. 235, pl. XXV (color) p. 233; Pickvance 1966, p. 21, pl. V (color) p. 22; New York, Metropolitan, 1967, pp. 86–88, repr. p. 87; Theodore Reff, "The Technical Aspects of Degas's Art," *Metropolitan Museum Journal*, IV, 1971, p. 144, fig. 3 (detail) p. 145; Rewald 1973, repr. p. 525; Rewald 1973 GBA, p. 76; Minervino 1974, no. 918, pl. LI (color); Reff 1976, pp. 33 n. 19, 274–76, 310 n. 87, pl. 186 (color) p. 275; Broude 1977, p. 95 n. 1; Charles S. Moffett and Elizabeth Streicher, "Mr. and Mrs. H. O. Havemeyer as Collectors of Degas," *Nineteenth Century*, III, Spring 1977, pp. 23–25, repr.; Moffett 1979, p. 13, pl. 30 (color); Eunice Lipton, "Degas's Bathers: The Case for Realism," *Arts Magazine*, LIV, May 1980, p. 97, fig. 14; Keyser 1981, p. 81; Shapiro 1982, p. 16, fig. 12 p. 18; 1984–85 Boston, no. lxxi n. 14; 1984–85 Paris, repr. (color, detail) p. 7, fig. 45 (color) p. 49; Gruetzner 1985, p. 36, fig. 36 p. 66; Moffett 1985, pp. 80, 251, repr. (color) p. 81; Thomson 1985, p. 15, fig. 36 p. 66; Lipton 1986, pp. 181–82, fig. 122 p. 181; Rewald 1986, p. 78; Thomson 1986, pp. 187, 190; Weitzenhoffer 1986, pp. 217–18, 255, pl. 152; 1987 Manchester, p. 111, fig. 147 (inverted).

275.

Reclining Bather

1886–88
Pastel on buff wove paper
18⅞ × 34¼ in. (48 × 87 cm)
Signed lower left in black pastel: Degas
Musée d'Orsay, Paris (Récupération no. 50)

Exhibited in Paris

Lemoisne 854

This bather is perhaps the most expressive of Degas's nudes of the mid-1880s, and is the only bather of the period whose pose suggests that there may have been some act of violation. Presumably she is only resting after her bath; perhaps she is lazily drying herself on the peignoir draped on the floor. Yet we wonder how she came to be lying in that position, and cannot help noting that the way in which she draws her left arm over her face suggests a form of defense. Had Degas simply placed her left arm behind her head rather than in front of her face, he would have arrived at a variation of the time-tested pose of the *gisante*, the reclining nude who makes direct eye contact with the viewer while displaying herself. From the nudes of the great Venetians, to Goya's *Nude Maja*, to Alexandre Cabanel's 1863 *Birth of Venus* (fig. 251), it was a pose long familiar to artists. In this picture, Degas shows both breasts—something rare in his work—but the pose is not made any the more inviting by it. This bather is too vulnerable-looking to be unabashedly erotic, and because she is actively hiding her face, she limits the observer's experience to furtive voyeurism. She is not willingly exposing herself or proffering her charms; therefore we are embarrassed intruders. The ambiguity of this work, compared to the conventionality of a painting such as Cabanel's, attests (if testimony is necessary) to Degas's relentless search for new means of expression and his refusal to rely on pat formulas.

When Degas did exploit a device from another picture—whether his own or that of an old master—he invested it with new meaning. This pose, for example, seems to derive from the supine figure of a vanquished nude at the lower right of *Scene of War in the Middle Ages* (cat. no. 45). When the drawing for that figure (cat. no. 57) is reversed, the position of the legs and feet fall more or less into line with those of the pastel, and the position of the arms is analogous if not identical. That androgynous nude, which appears to have been posed for by a male model, hides its face not in modesty but rather in a desperate attempt to avoid being trampled by a horse. The drawing in turn harks back to the copy Degas made in 1855 of David's

453

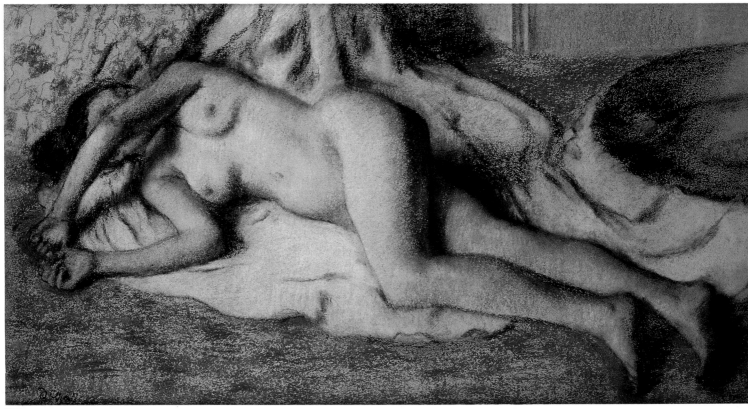

275

Death of Joseph Bara (L8), which depicts the last moments of a thirteen-year-old revolutionary volunteer. Thus Degas transforms the nature and meaning of a figure, even while retaining certain essential characteristics of pose and gesture.

So convincing is Degas's realization of the figure and his evocation of space that this nude, along with several other bathers of the mid-1880s, reminded Paul Jamot of sculpture: "They have the solidity, the precision, the fullness, and the volume of sculpture, and this too confirms an impression of seriousness, of gravity, remote from all frivolous ulterior motives."[1] It is densely worked yet subtly modeled, in a high-keyed scheme of complementary colors: red and

green, blue and yellow. Sometime in the mid-1890s, Degas made a new version of this pastel (fig. 252) that is nearly identical in pose—only the décor and the position of one foot were changed—but more vibrant in palette and more strident in the application of the pastel.

This picture still retains its original green painted frame presumably designed by Degas; few such frames have survived.

1. Jamot 1924, p. 107.

PROVENANCE: Probably bought from the artist by Galerie Goupil–Boussod et Valadon (Theo van Gogh), Paris, c. 1888; probably bought by M. Dupuis, Paris, c. 1888–90 (Dupuis sale, Drouot, Paris, 10 June 1891, no. 14, for Fr 1,600 [Fr 1,680. 10 with commission and taxes])[1]; bought by Durand-Ruel,

Paris (stock no. 1013); bought by Henry Lerolle, 20 avenue Duquesne, Paris, 28 July 1891, for Fr 2,500 (Fr 6,000 with a Courbet, "Femme nue torse"); Lerolle collection, Paris, 1891–1929; Mme Henry Lerolle, his widow, until at least 1933. With Arthur Tooth and Sons, Ltd., London, by 1938. Unknown collection, France; confiscated during the Second World War; recovered by the Commission de Récupération Artistique, 19 December 1949 (no. 50); entered the Cabinet des Dessins, Musée du Louvre, 23 December 1949.

1. The many omissions in the Boussod et Valadon stock books (noted by Rewald 1973 GBA, p. 76, and Rewald 1986, p. 78) make it impossible to confirm the earliest provenance of this work. Yet Rewald has established that all modern pictures included in the Hôtel Drouot sale of 10 June 1891 came from the Dupuis estate; in turn, Dupuis bought almost exclusively from Theo van Gogh, at Boussod et Valadon.

Fig. 251. Alexandre Cabanel, *The Birth of Venus*, 1863. Oil on canvas, 51⅛ × 88½ in. (130 × 225 cm). Musée d'Orsay, Paris

Fig. 252. *Reclining Bather* (L855), c. 1895. Pastel, 18⅞ × 32⅝ in. (48 × 83 cm) Private collection, New York

EXHIBITIONS: 1933, Paris, Chez André J. Seligmann, 18 November–9 December, *Exposition du pastel français du XVIIe siècle à nos jours*, no. 68, lent by H. Lerolle; 1937 Paris, Orangerie, no. 121, from a private collection; 1938, London, Arthur Tooth and Sons, Ltd., 3–26 November, *Fourth Exhibition "La flèche d'or": Important Pictures from French Collections*, no. 21, repr. (as 1884); 1966, Paris, Cabinet des Dessins, Musée du Louvre, May, *Pastels et miniatures du XIXe siècle*, no. 39; 1969, Paris, Cabinet des Dessins, Musée du Louvre, *Pastels* (no catalogue); 1974, Paris, Cabinet des Dessins, Musée du Louvre, *Pastels, Cartons, Miniatures, XVIe–XIXe siècles* (no catalogue); 1975 Paris; 1985 Paris, no. 90.

SELECTED REFERENCES: Hourticq 1912, repr. p. 110 (as Lerolle collection); Jamot 1924, pp. 107, 152–53, pl. 65; Lemoisne 1937, repr. p. C; "Exhibitions of Modern French Paintings," *Burlington Magazine*, December 1938, p. 282, pl. A (as with Messrs. Arthur Tooth and Sons, Ltd., London); Lemoisne [1946–49], III, no. 854 (as c. 1885); Valéry 1965, fig. 72; Minervino 1974, no. 916; 1984–85 Paris, p. 48, fig. 47 (color) p. 53 (as exhibited at Boussod et Valadon in 1888); Paris, Louvre and Orsay, Pastels, 1985, no. 90, pp. 92–93, p. 92 repr.

276.

Portrait of a Woman (Mme Bartholomé?)

c. 1885–88
Bronze
Height: 4⅝ in. (11.8 cm)
Original: undefinable matter, containing plaster, olive-brown color. Collection of Mr. and Mrs. Paul Mellon, Upperville, Virginia

Rewald XXIX

This small bust, exceptional even within the great variety of Degas's surviving sculptures, was catalogued at the 1922 Grolier Club exhibition as a portrait of Mme Barthélemy (meaning, no doubt, Mme Bartholomé, the first wife of Degas's great friend the sculptor Albert Bartholomé). That is how the work was known until 1976, when Charles Millard suggested that the woman portrayed was Rose Caron, the singer greatly admired by Degas (see cat. no. 326).[1] Millard linked the bust to a passing reference Degas made in a letter to Bartholomé (dated by Millard to 1892): "The moment I return I intend to pounce upon Mme Caron. You should already reserve a place for her among your precious bits of plaster."[2] Since it was about this time that Degas made his portrait head of Mlle Salle (RXXX and RXXXI), a dancer at the Opéra, and since the artist's infatuation with Caron's singing is known to have been intense, Millard's attribution seemed plausible. However, the resemblance to Caron is slight: none of the many photographs of Caron gives any indication of the high cheekbones and prominent jaw that Degas emphasized here. Furthermore, the date of

1892 is inconsistent with the style of the bust. It is difficult to believe that Degas would have worked on such a small scale in 1892, and the high level of finish puts it much closer to *Dancer in the Role of Harlequin* (cat. no. 262) of 1884–85 or the horses of about 1888 than to the roughly finished dancers or bathers of the early 1890s. Degas's letter of 1892 could, however, refer to a portrait of Caron that no longer survives, perhaps one of the seventy-five to one hundred works found in the studio that were too damaged to be cast in bronze.

Jean Sutherland Boggs has suggested that the sitter is more probably Périe Bartholomé.[3] Indeed, the resemblance of this work to the portrait-figure modeled by Bartholomé in 1888 for his wife's tomb is striking (see fig. 253). From the long nose and prominent ears to the knot of hair and the frilled collar, this bust bears such a remarkable similarity to the figure on Bartholomé's tomb of his wife that the question of influence arises. Degas may have wished to record Périe's features after her premature death in 1887 and perhaps he worked on his little sculpture while Bartholomé worked on his tomb, but it is equally possible that Degas made the portrait of Périe during her life and that Bartholomé took *it* as his model. One should remember that Bartholomé was a painter until his wife's death and that it was Degas who encouraged him to work in clay

276

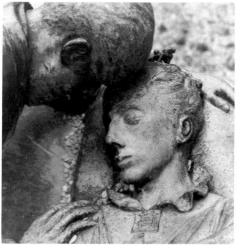

Fig. 253. Albert Bartholomé, *Tomb of Périe Bartholomé*, 1888–89. Bronze. Bouillant cemetery, near Crépy-en-Valois

as a distraction from his grief. Certainly Bartholomé never again made a work as original as his portrait of Périe, and this in itself may be further confirmation of the influence of Degas.

In Degas's bust, the absence of the plinth is a shockingly modern development. Even a generation later, when Brancusi used a hand to support the head in his versions of the *Portrait of Mlle Pogany* and *Muse*, he nevertheless extended the neck to provide a surrogate plinth.[4] With the sole exception of

455

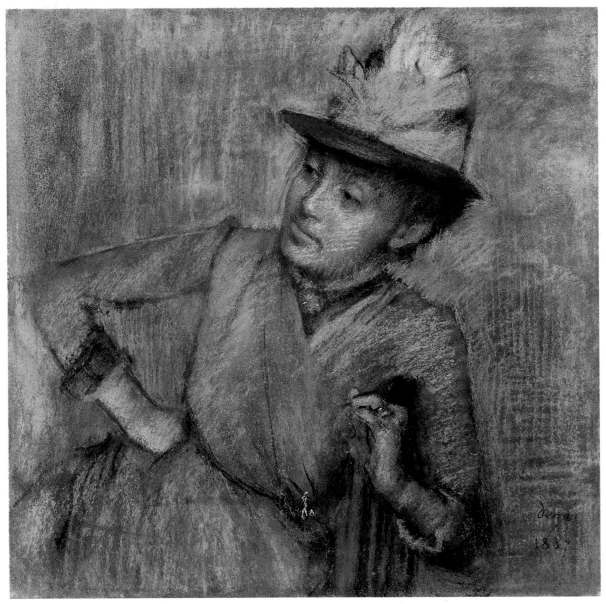

277

Medardo Rosso, no sculptor contemporary with Degas achieved the unstudied informality or unexpected novelty of this small yet great work.

1. Millard 1976, pp. 11–12.
2. Lettres Degas 1945, CLXXV, p. 196; Degas Letters 1947, no. 188, p. 185 (translation revised).
3. In conversation with the author.
4. Millard 1976, p. 111.

SELECTED REFERENCES: 1921 Paris, no. 71; R. R. Tatlock, "Degas Sculptures," XLII, March 1923, p. 153; Bazin 1931, p. 301, fig. 74 p. 295; Havemeyer 1931, p. 223, Metropolitan 62A; Paris, Louvre, Sculptures, 1933, p. 72, no. 1788, Orsay 62P; Rewald 1944, no. XXIX (as 1882–95), Metropolitan 62A; Rewald 1956, no. XXIX, Metropolitan 62A; Michèle Beaulieu, "Une tranquille sensualité," Les Nouvelles Littéraires, 3 July 1969, p. 9; Minervino 1974, no. S 71; 1976 London, no. 71; Millard 1976, pp. 11–12, 108–09, 111, fig. 121, wax (as 1892); 1986 Florence, repr. p. 205, no. 62, fig. 62 p. 159; Paris, Orsay, Sculptures, 1986, p. 136.

A. *Orsay Set P, no. 62*
Musée d'Orsay, Paris (RF2135)

Exhibited in Paris

PROVENANCE: Acquired thanks to the generosity of the heirs of the artist and of the Hébrard family, Paris, by the Louvre 1930.

EXHIBITIONS: 1931 Paris, no. 71; 1969 Paris, no. 281; 1984–85 Paris, no. 85 p. 207, fig. 210 p. 204.

B. *Metropolitan Set A, no. 62*
The Metropolitan Museum of Art, New York. Bequest of Mrs. H. O. Havemeyer, 1929. H. O. Havemeyer Collection (29.100.417)

Exhibited in Ottawa and New York

PROVENANCE: Bought from A.-A. Hébrard, Paris, by Mrs. H. O. Havemeyer late August 1921; her bequest to the museum 1929.

EXHIBITIONS: 1922 New York, no. 39 (as a portrait of Mme Barthélemy); 1925–27 New York; 1930 New York, under Collection of Bronzes, nos. 390–458; 1974 Dallas, n.p., fig. 20; 1977 New York, no. 57 of sculptures; 1978 Richmond, no. 51.

277.

Portrait of a Woman (Rosita Mauri?)

1887
Pastel on wove paper, affixed to original pulpboard mount
19¾ × 19¾ in. (50 × 50 cm)
Signed and dated lower right: Degas/1887
Private collection

Lemoisne 897

So strong is the personality conveyed in this portrait, and so engaging the expression, that writers have naturally long been eager to identify the seated woman. The work was catalogued simply as *Femme assise* in the 1918 sale of Degas's atelier. Jean Sutherland Boggs notes the resemblance between this sitter and the figure known as "Mlle S., première danseuse à l'Opéra" in another

pastel, L898.[1] According to Lillian Browse, "Mlle S." may have been Mlle Rita Sangalli, an Italian dancer born in Milan in 1849, who had left the Opéra de Paris by 1887, the year this pastel was made.[2] Boggs, finding Sangalli an unlikely possibility, mentions both Mlle Salle and Mlle Sanlaville as candidates for this pastel and for L898.[3] But the most likely possibility is suggested by the name inscribed in a modern hand on the back of the cardboard support: Rosita Mauri. Mauri made her debut at the Opéra in Gounod's *Polyeucte* in 1878. At that time she was

Fig. 254. Montalba (Naples), *Rosita Mauri*, c. 1880. Portrait-carte (detail). Bibliothèque de l'Opéra, Paris

perceived, according to Browse, as a newcomer and a rival to the former star dancer Léontine Beaugrand.[4] In 1880, she created the star role of Yvonette in *La Korrigane*, which proved to be one of her most popular roles, and in 1885 she starred in *Les Deux Pigeons*. Degas saw both ballets many times (see Chronology III), but Mauri is not mentioned in any of the surviving letters by Degas. Illustrations and photographs of the 1880s show that Mauri had the wide-set almond-shaped eyes and eyebrows of the woman portrayed here, as well as the same aquiline nose, high cheeks, and rounded jaw (see fig. 254). But lacking in this portrait is one of Mauri's most distinctive features, her long black hair. A critic for *Le Figaro* wrote in a review of *Les Deux Pigeons*: "By good fortune, we find [Mauri] again in the second act, with her magnificent black tresses flowing over her shoulders, whose whiteness

emerges from a fire-colored bodice."[5] Degas did in fact paint a star ballerina who closely resembles Mauri, dancing with long hair (L469),[6] but the identification of the dancer in that work as well as in the present portrait must necessarily remain speculative.

Degas's technique in this work is typical of his pastel portraits of the 1880s. The face is carefully worked up, with green shadows beneath the skin tone and hatched white highlights above, while the remainder of the figure is only summarily depicted. In her dress and hands, Degas relied for effect more on the contours and flat-colored shapes than on the precisely modeled relief such as he achieved in her face. And these shapes appear to have been deliberately chosen to convey a sense of the sitter's personality, in a manner somewhat analogous to that described by Charles Henry's theory of the Scientific Aesthetic of 1885, upon which Seurat had relied so heavily. Degas has exploited every opportunity for an angle, from the torque of the woman's torso to the sharp bend of her elbow, from the crossover fastening of the dress to the pert aigrette of her hat, positioned like an exclamation point above her face. The dynamic twist of the sitter's pose and her alert expression indicate a lively and interested individual.

1. Boggs 1962, p. 130.
2. Browse [1949], pp. 57, 351.
3. Boggs 1962, p. 130; see also fig. 238.
4. Browse [1949], p. 57.
5. Quoted (in English translation) in Browse [1949], pp. 62–63.
6. Browse rejects this identification (Browse [1949], p. 358, note to no. 58), but the resemblance to contemporary photographs of Mauri is striking. See cat. no. 162; see also 1984 Chicago, p. 95, for the identification of other works by Degas that feature Mauri.

PROVENANCE: Atelier Degas (Vente I, 1918, no. 169, for Fr 7,600); bought at that sale by Simon Bauer, Paris; bought indirectly by Paul Rosenberg and Co., New York, October 1973, until 1979 (Rosenberg sale, Sotheby's, London, 3 July 1979, no. 2, for £55,000); bought at that sale by Gallery Umeda, Osaka; private collection, Osaka; Art Salon Takahata Ltd., Osaka, until May 1983 (sale, Christie's, New York, 17 May 1983, no. 9, repr.); bought at that sale by present owner.

EXHIBITIONS: 1962, Buenos Aires, Museo Nacional de Bellas Artes, September–October, *El impressionisme frances en las coleccionés argentinas*, p. 20; 1974 Boston, no. 30 (as "Seated Woman [Rosita Maury?]," 1887), lent by Paul Rosenberg and Co.; 1978 New York, no. 39, repr. (color) (as "Portrait de Rosita Maury, première danseuse à l'Opéra," 1887), lent anonymously by Alexandre P. Rosenberg, Paul Rosenberg and Co., New York.

SELECTED REFERENCES: Lemoisne [1946–49], III, no. 897; Boggs 1962, pp. 65–66, 130, pl. 129 (as "Mlle Salle or Mlle Sanlaville [?] Seated"); Minervino 1974, no. 660.

278.

The Battle of Poitiers, after Delacroix

c. 1885–89
Oil on canvas
21½ × 25⅝ in. (54.5 × 65 cm)
Collection of Barbara and Peter Nathan, Zurich

Brame and Reff 83

Degas was a voracious copyist of the old masters. His selection of works to copy was wide-ranging and highly sophisticated. While his lessons from the old masters were concentrated during his early years in Italy, he continued to copy—albeit sporadically—later in life. Theodore Reff, who has studied Degas's copies systematically, dates nearly all the drawn copies to the period between 1853 and 1861, and the copies in oil to the later 1860s.[1] There are, however, important exceptions of copies made during Degas's maturity, and they are exceptional not only for their dates, which fall outside his years of apprenticeship, but also for the kinds of works copied: a copy after a painting by Menzel (see figs. 112, 113),[2] painted in 1879; the present copy after Delacroix, which Reff dates to 1880; a copy after Mantegna (BR144), done in 1897; and another after Delacroix, *The Fanatics of Tangier* (BR143), most probably executed in 1897 as well. Thus, three of these four later copies were made from nineteenth-century pictures, whereas the overwhelming majority of Degas's earlier copies were taken from Italian paintings of the fifteenth and sixteenth centuries: the copy after Mantegna falls neatly into the pattern of the earlier copies.

Degas had copied a few works by Delacroix in his youth, and although the extensive color notes with which he annotated the copies demonstrate his interest in Delacroix's painting method, these early copies were for the most part executed in crayon or pencil.[3] The single early copy after Delacroix in oil, *The Entry of the Crusaders into Constantinople*, c. 1859–60 (BR35), reveals how much Degas's approach to the older painter changed in the twenty years between that copy and the present one. In the 1860s, Degas was first and foremost a draftsman, and it was as a draftsman that he looked at Delacroix. Despite the fidelity with which he rendered Delacroix's harmony of blue greens and reddish browns in *The Entry of the Crusaders*, he was just as interested in capturing the nervous, flickering brushwork as in conveying the tonal balance of the picture. By the 1880s, his use of color had become more structural than descriptive, and this altered the focus of his copying. In *The Battle of Poitiers*, Degas completely sub-

jugates line to color, apparently in order to better understand the role of color in establishing the composition. Against the morass of fighting figures, punctuated by their brilliant scarlet robes, only the figure of King John stands out, by virtue of his golden tunic. Degas seems to have deliberately exaggerated Delacroix's coloristic approach to pictorial organization by simplifying the composition and palette—eliminating, for example, the greens of the landscape, and merely suggesting Delacroix's battalions with a few swaths of brown paint. He further imposed his own vision on Delacroix's scene by omitting the clues that articulate the landscape and create the sense of deep space, and organized the composition instead in the parallel bands that he had employed in the landscapes of many of his jockey scenes.

It was Delacroix's sketch for *The Battle of Poitiers* (fig. 255) that Degas copied (the copy is identical in size), and not the enormous definitive version commissioned for the palace at Versailles. The sketch had been purchased at auction in 1880 by an art dealer, Hector Brame, who sometimes handled works by Degas. It is possible, as Reff has suggested, that Degas had access to the work in Brame's gallery.[4] However, it is equally possible that Degas made his copy while the sketch was publicly exhibited, either at the École des Beaux-Arts in 1885, or at the Exposition Universelle of 1889; he

also may have seen it, though only briefly, when it was auctioned at the Hôtel Drouot in 1880, or in 1889 when Durand-Ruel purchased it. Since the gallery sold the sketch that year to Henry Walters of Baltimore, Degas's copy could not have been made any later. The fluent handling and the particular palette of Degas's copy point to a date later, rather than earlier, in the 1880s.

Degas's interest in and affinities with Delacroix were noticed as early as 1880, when Huysmans stated that "no other painter after Delacroix—whom he has studied closely and who is his true master—has understood as M. Degas has the marriage and adultery of colors."[5] In the latter half of the 1890s, Degas actively pursued works by Delacroix for his own collection; when he died, he owned 13 paintings and over 200 drawings, watercolors, and pastels by the master, in addition to lithographs and etchings. They represented every aspect of his career, including a sketch for *The Battle of Nancy*, which is similar in composition to *The Battle of Poitiers*. It is tempting to wonder why Degas did not buy the Delacroix sketch for himself when it was sold in 1889.

1. Reff 1963, pp. 241ff; Reff 1964; "Addenda to Degas's Copies by Theodore Reff," *Burlington Magazine*, CVII:747, June 1965, pp. 320ff.; Reff 1971.
2. See Chronology II, March 1879, and figs. 112, 113.
3. *Entombment*, partial copy, Reff 1985, Notebook 13

(BN, Carnet 16, p. 53); *Massacre at Chios*, partial copy, Notebook 16 (BN, Carnet 27, p. 36); *Pietà*, partial copy, Notebook 16 (BN, Carnet 27, p. 35) *Mirabeau and Dreux Brézé*, Notebook 18 (BN, Carnet 1, p. 53); *Attila*, drawing formerly in the Fevre collection; *Christ on the Lake of Gennesaret*, Notebook 16 (BN, Carnet 27, p. 20A); *Ovid among the Scythians*, Notebook 18 (BN, Carnet 1, p. 127). Color notes, references, and copies of signatures: Notebook 12 (BN, Carnet 18, p. 109); Notebook 14 (BN, Carnet 12, p. 1); Notebook 15 (BN, Carnet 26, p. 6); Notebook 18 (BN, Carnet 1, p. 53A); Notebook 19 (BN, Carnet 3, p. 15); Notebook 27 (BN, Carnet 3, p. 43).
4. Reff 1976, p. 67.
5. Huysmans 1883, p. 120.

PROVENANCE: Atelier Degas (inventory no. 525, not included in the atelier sales); René de Gas, his brother, Paris, 1917–27 (René de Gas estate sale, Drouot, Paris, 10 November 1927, no. 78, for Fr 7,000);[1] bought at that sale by M. Aubry. Lucas Lichtenhahn, Basel, until 1947; E. G. Bührle, Zurich, 1947–56; E. G. Bührle Foundation Collection, Zurich, 1956–73; bought by present owner 1973.

1. "Revue des ventes: succession de René de Gas," *Gazette de l'Hôtel Drouot*, XXXVI:119, 12 November 1927, p.1.

EXHIBITIONS: 1949, Kunsthalle Basel (Öffentliche Kunstsammlung), 3 September–10 November, *Impressionisten*, p. 20, no. 45, lent from a private Swiss collection; 1951–52 Bern, no. 3, lent by Sammlung Bührle, Zurich; 1953, Kunsthaus Zürich, January–April, *Falsch oder Echt*, no number; 1958, Kunsthaus Zürich, 7 June–30 September, *Sammlung Emil G. Bührle: Festschrift zu Ehren von Emil G. Bührle zur Eröffnung des Kunsthaus-Neubaus und Katalog der Sammlung Emil G. Bührle*, no. 154, p. 103.

278

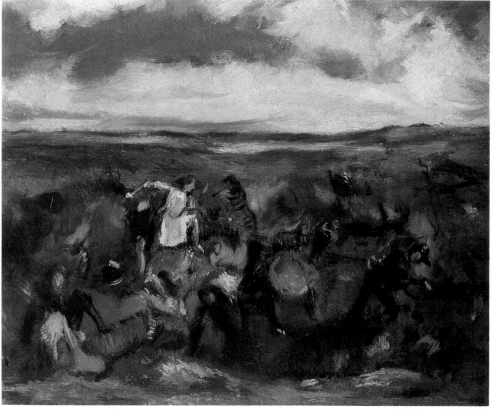

Fig. 255. Eugène Delacroix, sketch for *The Battle of Poitiers*, 1829–30. Oil on canvas, 20¾ × 25½ in. (52.8 × 64.8 cm). Walters Art Gallery, Baltimore

SELECTED REFERENCES: Phoebe Pool, "Degas and Moreau," *Burlington Magazine*, CV, June 1963, p. 255; Reff 1963, p. 251; Gerhard Fries, "Degas et les maîtres," *Art de France*, Paris, IV, 1964, p. 353; Reff 1964, p. 255; Reff 1976, p. 67, fig. 39 p. 64; Reff 1977, fig. 62 (color); Lee Johnson, *The Paintings of Eugène Delacroix*, Oxford: Clarendon Press, 1981, I, p. 137, no. 140; Brame and Reff 1984, no. 83 (as c. 1880).

Degas and Muybridge

cat. nos. 279–282

In 1872, at the suggestion of Leland Stanford of Palo Alto, the British photographer Eadweard Muybridge began to devise methods whereby the movement of the horse could be analyzed by stop-action photography.[1] Advance and premature news of this development was published in Paris (without documentation) by Gaston Tissandier in *La Nature* in 1874. Four years later, Muybridge's techniques were sufficiently refined and his body of work sufficiently advanced for Tissandier to publish plates of a walking horse, a trotting horse, a cantering horse, and a galloping horse in the 14 December 1878 number of *La Nature*. The response of the scientific community and of academic artists was quick and, on the whole, enthusiastic.[2] *L'Illustration* followed with an article devoted to Muybridge, and Étienne Jules Marey, a physicist who had conducted parallel experiments, almost immediately altered his approach to accommodate Muybridge's discoveries. Degas no doubt followed these developments avidly,[3] and may even have been aware of the illustrated lecture Muybridge gave at the studio of the painter Ernest Meissonier in November 1881 (see Chronology III). But there is no indication of any immediate change in Degas's approach to drawing horses; indeed, in reworking *The Steeplechase* (fig. 316) in the early 1880s and painting *Fallen Jockey* (cat. no. 351) in the 1890s, he held fast to an antiquated but expressive mode of depiction.

It is only after the publication of Muybridge's *Animal Locomotion* in 1887 that one finds clear evidence of Degas's interest. He copied two frames of a plate in volume nine of *Animal Locomotion*, "Annie G. in Canter," (see figs. 256, 257, and cat. no. 279). He made at least six wax models of horses (RVI, RIX, RXI, RXIII, RXIV, RXVII; see cat. nos. 280, 281) that reflect Muybridge's work; three of these illustrate the photographer's revolutionary observation that at a gallop, the horse's four feet are off the ground when they are tucked beneath the animal rather than when they are extended. He also made a highly finished pastel, *The Jockey*, now in Philadelphia (fig. 201),[4] and an unfinished pastel (L1002), both of which derive from a photograph and reflect the pose of one of his modeled horses (RVI). Since the Philadelphia pastel was bought from Degas by Durand-Ruel on 23 October 1888, one can determine that Degas had access to Muybridge's 1887 edition of *Animal Locomotion* quite soon after its publication. That he was excited by this is made clear by his remark in a letter of 1888 to Bartholomé:

"I have not done enough horses."[5] That he was incorporating Muybridge's conclusions in his work is made evident by the new, highly sophisticated representation of movement that he invested in poses he had already developed in earlier paintings and pastels, and perhaps even in other sculptures that have not survived.

It was not for lack of imagination or from an unwillingness to undertake personal study that Degas used Muybridge's photographs. His attentiveness to direct observation is constantly borne out by his paintings, pastels, notebooks, and sketches. One drawing of the mid-1880s (IV:213.a, Museum Boymans-van Beuningen, Rotterdam) bears Degas's notation that the "right foot comes off the ground first," and in an earlier letter to his patron Faure he used as an excuse for not finishing a racecourse scene the need to see personally some races, which he could not attend owing to the end of the season.[6] Nonetheless, he found something useful in the photographs, and seems to have employed them in the same resourceful fashion as he did his trove of figure drawings that were constantly exploited for new applications.

1. See Anita Ventura Mozley, *Eadweard Muybridge: The Stanford Years* (exhibition catalogue), Stanford University Museum of Art, 1972; Van Deren Coke, *The Painter and the Photograph*, Albuquerque: University of New Mexico, 1972; Scharf 1968; and Millard 1976, pp. 21–23, nn. 76–83. See also Scharf's important article "Painting, Photography, and the Image of Movement," *Burlington Magazine*, CIV:710, May 1962, pp. 186–95, as well as Ettore Camesasca's "Degas, Muybridge e Altri," in 1986 Florence.
2. Although inevitably there was conservative dissent as well. Ernest Meissonier reputedly resisted the photographs before converting to the role of propagandist, and the *Gazette des Beaux-Arts* published a hostile review of Muybridge's work in 1882 (Georges Guéroult, "Formes, couleurs et mouvements," *Gazette des Beaux-Arts*, XXV, 1882, pp. 178–79).
3. He wrote in a notebook of c. 1878–79 to remind himself of the magazine *La Nature* and jotted down the address of the publisher (Reff 1985, Notebook 31 [BN, Carnet 23, p. 81], cited in Millard 1976, p. 21 n. 77). Paul Valéry was probably the first to point out the relationship to Muybridge (Valéry 1946, pp. 64–66).
4. See Boggs 1985, pp. 19–23. Degas sold the work for Fr 300 to Alexander Cassatt, with Mary Cassatt and Durand-Ruel as intermediaries.
5. Lettres Degas 1945, C, p. 127; Degas Letters 1947, no. III, p. 124.
6. Lettres Degas 1945, XCV, p. 122; Degas Letters 1947, no. 104, p. 120, which dates to 1876, not 1886 as Guérin suggests. See cat. no. 256, n. 1.

279.

Horse with Jockey in Profile

c. 1887–90
Red chalk on off-white thin wove paper
11⅛ × 16⅜ in. (28.3 × 41.8 cm)
Vente stamp lower left
Museum Boymans-van Beuningen, Rotterdam (FII22)

Exhibited in Ottawa and New York

Vente III:130.1

This spirited red-chalk drawing is one of several that the artist is known to have made after photographs by Eadweard Muybridge.[1] In this instance, the artist misinterpreted Muybridge's photographs and positioned the front legs incorrectly. Degas pulled a counterproof of it, presumably soon after it was drawn, and reworked it with pastels (IV:335.b). The present drawing may well have been strengthened by Degas after it was transferred.

1. Aaron Scharf (1968) identified Muybridge's "Annie G. in Canter" (fig. 256) as the source for L665 (fig. 257), its counterproof L665 bis, and the present drawing. Another drawing, III:229, was adapted from Muybridge's "Daisy Trotting," and appears reversed as III:196; drawings III:244.a, IV:203.c, and IV:219.a were taken from "Elberon Trotting."

PROVENANCE: Atelier Degas (Vente III, 1919, no. 130.1, for Fr 1,350); bought at that sale by Henry Fèvre, Paris, 1919–25 (sale, Drouot, Paris, collection X [Henry Fèvre], 22 June 1925, no. 40, repr., for Fr 2,500); bought at that sale by H. Haim, Paris. S. Meller, Paris. With Paul Cassirer, Berlin, until 1927; bought by Franz Koenigs, Haarlem, 1927, until 1940; acquired, with the Koenigs collection, by D. G. van Beuningen April 1940; his gift to the museum 1940.

EXHIBITIONS: 1946, Amsterdam, Stedelijk Museum, February–March, *Teekeningen van Fransche Meesters van 1800–1900*, no. 56; 1949–50, Paris/Brussels/Rotterdam, no. 198; 1951–52 Bern, no. 98 (as c. 1881–85); 1952, Paris, Bibliothèque Nationale, 20 February–20 April, *Musée Boymans de Rotterdam: dessins du XVe au XIXe siècle*, no. 135 (as 1881–85); 1967 Saint Louis, no. 107, repr. p. 167 (as 1887–90); 1969 Nottingham, no. 24, pl. XIII; 1984 Tübingen, no. 152, repr. (as 1887–88).

SELECTED REFERENCES: "Degas," *Arts and Decoration*, XI:3, July 1919, repr. p. 114; Lemoisne [1946–49], II, under 674 bis.; Jean Vallery-Radot, "Dessins de Pisanello à Cézanne," Musée Boymans, *Art et Style*, 23, 1952, repr.; Rosenberg 1959, p. 114, fig. 217; Aaron Scharf, "Painting, Photography and the Image of Movement," *Burlington Magazine*, CIV:710, May 1962, p. 191, fig. 13 p. 195; C. C. van Rossum, *Ruiter en paard*, Utrecht, 1962, pl. 20; Rotterdam, Boymans, 1968, pp. 68–69, no. 73, repr.

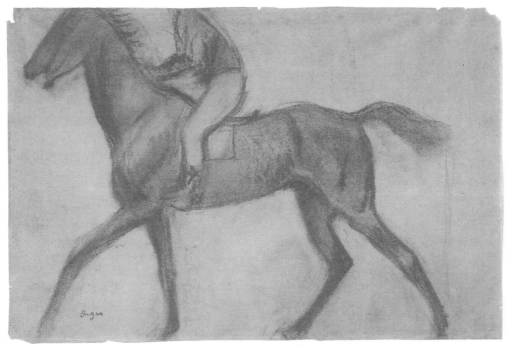

279

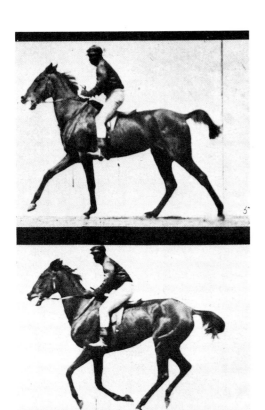

Fig. 256. Eadweard Muybridge, "Annie G. in Canter." Photograph from *Animal Locomotion*, 1887, IX, plate 621, nos. 5, 11

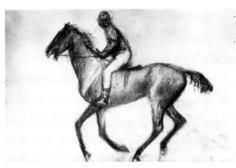

Fig. 257. *Jockey Seen in Profile* (L665), c. 1887–90. Pastel, 10⅝ × 13 in. (27 × 33 cm). Location unknown

280.

Horse Balking, erroneously called *Horse Clearing an Obstacle*

1888–90
Bronze
Height: 11⅜ in. (28.4 cm)
Original: yellow wax; piece of wire showing in the tail. Collection of Mr. and Mrs. Paul Mellon, Upperville, Virginia

Rewald IX

Charles Millard has demonstrated that this sculpture, originally modeled in wax, was based on frames in a sequence of photographs by Muybridge of a horse jumping (fig. 258). Millard has also suggested that, far from being a three-dimensional replica of the planar image presented by Muybridge, it is a complex synthesis of movement interwoven with ever-finer suggestions of space engaged by the figure. "It combines forward, backward, rising, and twisting motions in the closest approximation of a centripetal spiralling movement possible with a four-legged animal."[1] Indeed, so intent was Degas on creating a strongly dynamic pose that he altered the horse's position in such a way as to sacrifice verisimilitude for expressiveness. The horse's front legs are positioned as if to clear an obstacle, but the back legs are spread apart and braced as if to rear. (Other photographs by Muybridge of rearing horses may have been used for the back legs; see, for example, fig. 259.) A running horse about to clear an obstacle would have to break

its gait before jumping in order to arrive at the position indicated in this sculpture. So it is a moment of hesitancy or balking that Degas ultimately chose to depict, and not—as was formerly thought—the motion of a horse jumping. Several other of his sculpted horses of the 1880s reveal a similar quality. *Horse with Head Lowered, Rearing Horse,* and *Prancing Horse* (RXII, RXIII [cat. no. 281], RXVI) all depict frisky horses that are in a sense misbehaving, and one may assume that Degas found in their movements something more vivid than mere walking, running, or even jumping.

The surface of this work is moderately well finished, but it seems that Degas's primary interest was in the horse's movement, not the specifics of its anatomy. In contrast, the animal in *Rearing Horse* is keenly described. Degas made several drawings of horses in similar poses (for example, IV:216.c and IV:259.b, the latter probably a reworked counterproof of the former). A horse in such a pose appears in two horizontal paintings, *Racehorses* (BR111, The Carnegie Museum of Art, Pittsburgh) and *At the Races* (L503, E. G. Bührle Foundation Collection, Zurich), both of which probably date to c. 1887–90. A mounted horse in an identical pose is included as well in a pastel in the Pushkin Fine Art Museum in Moscow, *Racehorses* (L597), which Lemoisne dates to

c. 1880 but which surely belongs to the late 1880s or early 1890s. In all these, the horse is rearing rather than jumping a hurdle.

The original wax is supported from the base to the lower neck of the horse by a small rod. The armature is visible where it extends from the end of the tail.

1. Millard 1976, p. 100. Millard chose two frames from plate 640 in volume nine of Muybridge's 1887 corpus. However, Degas could have used any number of frames from plates 636–646, and may well have made a composite figure from many of them.

SELECTED REFERENCES: 1921 Paris, no. 43; Janneau 1921, repr. p. 355; Havemeyer 1931, p. 223, Metropolitan 48A; Paris, Louvre, Sculptures, 1933, p. 70, no. 1760, Orsay 48P; Rewald 1944, no. IX (as 1865–81), Metropolitan 48A; John Rewald, "Degas Dancers and Horses," *Art News,* XLIII:11, September 1944, repr. p. 22; Paris, Louvre, Impressionnistes, 1947, p. 133, no. 298, Orsay 48P; Rewald 1956, no. IX, Metropolitan 48A; Beaulieu 1969, p. 372; Minervino 1974, no. S43; Tucker 1974, p. 152, figs. 145, 146; 1976 London, no. 43; Millard 1976, pp. 21, 23, 59, 100–02, fig. 66, wax (as 1881–90); 1986 Florence, pp. 78, 197–98, repr. no. 48, fig. 48 p. 145; Paris, Orsay, Sculptures, 1986, p. 133.

A. *Orsay Set P, no. 48*
Musée d'Orsay, Paris (RF2107)

Exhibited in Paris

PROVENANCE: Acquired thanks to the generosity of the heirs of the artist and of the Hébrard family by the Louvre 1930.

EXHIBITIONS: 1931 Paris, Orangerie, no. 43; 1969 Paris, no. 233; 1984–85 Paris, no. 93 p. 209, fig. 218 p. 212.

B. *Metropolitan Set A, no. 48*
The Metropolitan Museum of Art, New York. Bequest of Mrs. H. O. Havemeyer, 1929. H. O. Havemeyer Collection (29.100.424)

Exhibited in Ottawa and New York

PROVENANCE: Acquired from A.-A. Hébrard by Mrs. H. O. Havemeyer late August 1921; her bequest to the museum 1929.

EXHIBITIONS: 1922 New York, no. 36; (?)1923–25 New York; (?)1925–27 New York; 1930 New York, under Collection of Bronzes, nos. 390–458; 1974 Dallas, no number, n.p., fig. 6; 1977 New York, no. 20 of sculptures.

280

Fig. 258. Eadweard Muybridge, "Daisy, the Leap." Photograph from *Animal Locomotion,* 1887, IX, plate 640, no. 6

281

1. The drawings show rearing horses from different aspects. For example, from behind: III:98.1; a tracing from it, III:90.c; a counterproof of the tracing, IV:375.a; III:89.2; its counterproof, IV:375.b. From the front: IV:214.b. A related horse appears in the pastel L597 (Pushkin Fine Art Museum, Moscow).

SELECTED REFERENCES: Lemoisne 1919, p. 111, repr. p. 110, wax; Janneau 1921, repr. p. 355; 1921 Paris, no. 44; Havemeyer 1931, p. 223, Metropolitan 4A; Raymond Lécuyer, "Une exposition au Musée de l'Orangerie: Degas portraitiste et sculpteur," *L'Illustration*, 4619, 12 September 1931, repr. p. 40, Orsay 4P; Paris, Louvre, Sculptures, 1933, p. 70, no. 1761, Orsay 4P; Rewald 1944, no. XIII (as 1865–81), Metropolitan 4A; Paris, Louvre, Impressionnistes, 1947, p. 133, no. 299, Orsay 4P; Borel 1949, repr. n.p.;

Fig. 259. Eadweard Muybridge, "Rearing Horse." Photograph from *Animal Locomotion*, 1887, IX, plate 652, no. C

281.

Rearing Horse

1888–90
Bronze
Height: 12⅛ in. (30.8 cm)
Original: red wax. Collection of Mr. and Mrs. Paul Mellon, Upperville, Virginia. See fig. 260

Rewald XIII

This sculpture has been assigned dates ranging from the 1860s to the 1890s, but its strong stylistic affinity with *Horse Balking* (cat. no. 280) can be used to date the work to the late 1880s, a period when the artist was passionately engaged in making horse sculptures.

Like *Horse Balking*, this work may have been based on one of Muybridge's photographs. In the same volume of *Animal Locomotion* in which Degas found pictures of leaping horses, there is a page of horses en-

gaged in miscellaneous activities; one of the photographs shows a dappled horse, unmounted, rearing as if in fright (fig. 259). The position of the horse in that photograph and in Degas's *Rearing Horse* are almost identical. While Degas does not provide a pretext for the action of the horse, the glaring eyes set in a tensely drawn head and the seemingly swift, well-integrated rise of the body convincingly suggest fright. Indeed, this horse's head is more finely rendered and more expressively satisfying than any other by Degas. The finish of the wax (and consequently the bronze) is not as meticulous as in some of the classically inspired horses of the 1870s, such as *Horse Walking* (RIV), but the slightly textured surface adds to the work's naturalism (see fig. 260).

There are drawings of rearing horses dating from the mid-1870s, and others as late as about 1900, when Degas included a turning horse in a similar stance in *Three Jockeys* (cat. no. 352).[1]

Fig. 260. *Rearing Horse* (RXIII), c. 1888–90. Red wax, height 12¼ in. (31 cm). Collection of Mr. and Mrs. Paul Mellon, Upperville, Va.

Rewald 1956, no. XIII, Metropolitan 4A; Beaulieu 1969, p. 373; Minervino 1974, no. S44; 1976 London, no. 44; Millard 1976, pp. 23, 100 (as 1881–90); Boggs 1986, pp. 22–23; 1986 Florence, p. 174, no. 4, fig. 4 p. 103; Paris, Orsay, Sculptures, 1986, p. 133; Rewald 1986 (revised introduction originally published in Rewald 1944), p. 125, fig. 30 p. 124; Weitzenhoffer 1986, p. 241, fig. 164, Metropolitan 4A.

A. *Orsay Set P, no. 4*
Musée d'Orsay, Paris (RF2108)

Exhibited in Paris

PROVENANCE: Acquired thanks to the generosity of the heirs of the artist and of the Hébrard family by the Louvre 1930.

EXHIBITIONS: 1931 Paris, Orangerie, no. 44; 1937 Paris, Orangerie, no. 229; 1969 Paris, no. 237, repr.; 1972, Paris, Musée Bourdelle, June–September, *Centaurs, chevaux et cavaliers*, no. 253; 1973, Paris, Musée Rodin, 15 March–30 April, *Sculptures de peintres*, no. 45, repr.; 1984–85 Paris, no. 90, p. 208, fig. 215 p. 210.

B. *Metropolitan Set A, no. 4*
The Metropolitan Museum of Art, New York. Bequest of Mrs. H. O. Havemeyer, 1929. H. O. Havemeyer Collection (29.100.426)

Exhibited in Ottawa and New York

PROVENANCE: Acquired from A.-A. Hébrard by Mrs. H. O. Havemeyer late August 1921; her bequest to the museum 1929.

EXHIBITIONS: 1922 New York, no. 38 (Bronze no. 4 erroneously given as no. 41); (?)1923–25 New York; 1930 New York, p. 39, under Collection of Bronzes, nos. 390–458; 1974 Dallas, no number; 1974–75, New York, The Metropolitan Museum of Art, 12 December 1974–10 February 1975, *The H. O. Havemeyers: Collectors of Impressionist Art*, no. 8; 1975 New Orleans; 1977 New York, no. 21 of sculptures.

282.

Study of a Nude on Horseback

c. 1890
Charcoal on off-white laid paper
12¼ × 9¼ in. (31 × 24.9 cm)
Vente stamp lower right
Museum Boymans-van Beuningen, Rotterdam (FII129)

Vente III:131.2

This study of a nude on a horse holds a virtually unique place among Degas's later drawings. There is only one other drawing of a rider in which Degas placed such an emphasis on the nude figure, an unpublished study of about 1863–65 for *Scene of War in the Middle Ages* (fig. 261), which may have served as a point of departure for the present drawing. And while the artist continually sought, from early drawings such as the

one of 1865 to his work in the 1890s, to capture every rhythm and inflection of a rider's shoulders and back, nowhere else does he define so carefully the precise foreshortening of the right arm, the forward tilt of the back, the twist of the spine, or the extension of the sinewy, lithe leg. Even though Degas was already an accomplished draftsman in the 1860s, the extraordinary freedom and assurance of this drawing in comparison to the earlier one is striking.

For all its impressive sculptural impact, this figure decidedly lacks the kind of anecdotal characterization that gives the Ashmolean's drawing of a jockey (cat. no. 238) its charm. As Jean Sutherland Boggs has noted, Degas's drawings of this period show two somewhat contradictory influences: photography and sculpture.[1] The appearance of a great many studies of nude figures—primarily of dancers—toward the end of the 1880s and well into the twentieth century seems to coincide with the publica-

Fig. 261. *Nude on Horseback*, study for *Scene of War in the Middle Ages* (cat. no. 45), c. 1863–65. Charcoal, 14 × 8⅞ in. (35.5 × 22.5 cm). Cabinet des Dessins, Musée du Louvre (Orsay), Paris

282

tion of Muybridge's photographic studies of nudes, and this drawing in particular may have been occasioned by the numerous nudes on horseback in volume nine of Muybridge's corpus.

Degas first used this pose, reversed, in 1865, in *Scene of War in the Middle Ages* (cat. no. 45), repeated it in *Before the Race* (fig. 87) about 1873, inserted it in *Racehorses at Longchamp* (cat. no. 96), and included it again in *Four Jockeys* (L446)—reversing each time the direction of the rider. But it is closest to the horse and rider in a small painting of about 1890, *Jockey* (L986), and a small painting in charcoal and oil on panel, *Jockey Seen from Behind* (BR126, De Chollet collection). Also about 1890, Degas reversed the figure for inclusion in *Four Jockeys* (L762). A similar figure was included in *Before the Start* (L761) and in *Three Jockeys* (cat. no. 352). Drawings of the pose in the same direction include IV:216.d (c. 1890) for the horse and IV:224.e (c. 1890) for the clothed rider and horse. Reversed drawings include III:114.2 (1870s), IV:237.c (1870s), and IV:245.b (c. 1890). Dated to 1882–84 by Theodore Reff,[2] this nude study fits more securely in the group of works made about 1890.

1. 1967 Saint Louis, pp. 162–64.
2. Theodore Reff, "An Exhibition of Drawings by Degas," *Art Quarterly*, Fall–Winter 1967, p. 261.

PROVENANCE: Atelier Degas (Vente III, 1919, no. 131.2, repr., for Fr 750); bought at that sale by Dr. Georges Viau, Paris. With Paul Cassirer, Berlin, 1928; bought by Franz Koenigs, Haarlem, 1928, until 1940; acquired, with the Koenigs collection, by D. G. van Beuningen April 1940; his gift to the museum 1940.

EXHIBITIONS: 1946, Amsterdam, Stedelijk Museum, February–March, *Teekeningen van Fransche Meesters, van 1800–1900*, no. 62; 1967 Saint Louis, no. 106, p. 166 repr. (as c. 1887–90); 1969 Nottingham, no. 25, repr. cover (as c. 1887–90); 1984 Tübingen, no. 149, repr. (as 1884–88).

SELECTED REFERENCES: Eugenia Parry Janis, "Degas Drawings," *Burlington Magazine*, CIX, July 1967, p. 413, fig. 45 p. 415; Theodore Reff, "An Exhibition of Drawings by Degas," *Art Quarterly*, Fall–Winter 1967, p. 261 (relates this work to III:107.3, and suggests that both drawings date to 1882–84); Rotterdam, Boymans, 1968, no. 82, repr.

283.

Landscape with Cows

c. 1888–92
Pastel (possibly over monotype) on off-white laid paper
10¼ × 13⅞ in. (26 × 35.5 cm)
Signed lower left in pencil: Degas
Private collection

Lemoisne 633

283

This landscape, protected by two cows, one brown and the other black, is remarkable for its structural and seasonal clarity. As convincing as the anatomy of the cows is the fringed distant horizon or the hillock along which the trees grow. The white sky, the rhythm of the artist's strokes of fresh green pastel through which the paper is visible, the yearning of the trees, even the twitch of the cow's tail fill the work with a sense of the expectations, if not also with some of the melancholy, of spring.

It is because there is some suggestion of a light black monotype under the multilayered pastel that the cataloguer at Sotheby's in 1983 was led to assume that this work, like other landscapes by Degas from the Havemeyer collection in the same sale, had at least its genesis at that famous session in Jeanniot's studio at Diénay in 1890.[1] In fact, it may have been the first of the series that led to the flatter, more abstract, more obviously imagined landscapes. Lemoisne, who could never have seen it because it went in the 1890s to the United States—a country he never visited—dates it earlier and somewhat indecisively as 1880–90. Eugenia Janis does not help us place the work, because she correctly does not include it in her catalogue of the monotypes. We are therefore left somewhat uncertain about its date. But this fresh pastel surely reflects Degas's incipient interest in landscape, an interest that he would develop from 1890 in a more subjective way. JSB

1. See "Landscape Monotypes," p. 502.

PROVENANCE: Bought by H. O. Havemeyer, New York, from Galerie Durand-Ruel, 16 January 1894, until 1907; Mrs. H. O. Havemeyer, 1907–29; Mr. and Mrs. Horace Havemeyer, her son, New York, 1929–56; Mrs. Horace Havemeyer, New York, 1956–82 (Havemeyer sale, Sotheby's, New York, 18 May 1983, no. 3, repr.); bought at that sale by present owner.

SELECTED REFERENCES: Havemeyer 1931, p. 388; Lemoisne [1946–49], II, no. 633 (as 1880–90); Minervino 1974, no. 647.

284, 285

Nude Woman Combing Her Hair

These pastels are two in a series of pictures of women in various positions combing or drying their hair—seated on the floor or in a chair, or poised on the edge of the tub. Common to all of them is an emphasis on the gesture of the woman with upraised arms arranging her hair.[1] It is a gesture that first appears in a relatively early scene of bathers *Women Combing Their Hair* (cat. no. 148), of c. 1875, after which it is removed to the artist's more private world of monotypes.[2] It reappears in the early 1880s in pictures of dancers, then in milliners,[3] and again, about 1883, in the form of a corseted woman arranging her hair before her dressing table

(L749, private collection, Detroit). Degas clearly regarded the works in this series as forming part of his suite of nudes, since one of the categories he included in the catalogue of the 1886 Impressionist exhibition was "women combing their hair" (although none of the seven exhibited works—out of the ten he listed in the catalogue—fell into this category).

More specifically, these two pastels are part of a group of three pictures—a primary work and two nearly identical variants—that Degas made in the mid-to-late 1880s. During this period, the artist often made multiple versions of a given composition; this group includes works in three different sizes and formats. The first to be made (and the smallest) was undoubtedly the work now in Leningrad (fig. 175). In it, Degas selected a square format, adopted a low viewpoint, and ignored the possibility of a rapport between the figure and the armchair, which he took up in the two variants. The emphasis is on anatomy and structural clarity, and this, combined with the naturalistic coloration of the flesh, indicates a date of 1884–86. In the second and largest of the pastels, now in the Taubman collection (cat. no. 284), Degas gives the figure generous space and views her from above, adopting the vantage point characteristic of pastels of bathers of 1886–88, such as *Nude Woman Having Her Hair Combed* (cat. no. 274). Like the woman having her hair combed, the nude here is ample in figure (the model is heavier than the one in the Leningrad pastel) and the pink-and-white tonality of her flesh radiates health. As in many of the pastels of bathers of 1885–86, the contours are strongly drawn. But here Degas uses his line to make a beautiful, sensuous, and appealing nude, one that is ravishing in a way that the nudes exhibited in 1886 are not.

Degas returned to the composition, about 1888, in the pastel now in New York (cat. no. 285). In this third and last variant, he deliberately set up a contrast to the earlier nude in the Taubman collection (cat. no. 284), his point of departure. First and foremost, he developed a new technique for applying pastel. While a number of late pastels are thickly encrusted with pigment, no other work by Degas was made in quite the same way. The artist applied so many successive layers that the pigment became burnished by the very application of pastel, and the underlying paper was rubbed so much that its fibers were loosened and now project from the surface like so many little hairs. Degas began the work in his usual manner, drawing the outline of the figure with dark chalk or charcoal on a store-bought academy board. He established the composition with little revision—only the right arm and left breast show signs of hesitation—since he had the earlier nude as his guide. He seems to have smudged a middle tone over most of the sheet, a flesh color under the figure, and pale green elsewhere. He then obliterated this tone with insistent, repeated, parallel strokes in audacious, antinatural chartreuses and greens, the complementary colors that are exactly opposite the predominant pinks of the earlier nude.

Since the thirteenth century, artists had been modeling forms with parallel strokes of paint in three tones of the same color—light, dark, and middle intensity—and Cennini, about 1400, had prescribed in his artist's handbook the use of green as a secondary tone for flesh, already by then a time-honored practice. In the late nineteenth century, no one except Seurat had deliberately inverted traditional technique to the extent that Degas did in this work—and only van Gogh among the younger painters had achieved a comparable method of modeling flesh not with tone or shadow, but with arbitrarily chosen color. It is nothing short of extraordinary that Degas was able to juxtapose and mix so many closely valued pastels without obtaining a muddy or lackluster effect, and it appears that he was able to do so only by fixing the intervening layers with a sprayed adhesive. Beyond this, he achieved vibrancy and intensity through the use of complementary pairs—pink and chartreuse in the flesh, orange and blue in the wall coverings, and red and green in the upholstered chair and rug. It seems certain that in this respect he was following the example set by Seurat in the immediately preceding years.

The advantage of the pose is that it afforded Degas the opportunity to focus on the female back, an aspect of human architecture that fascinated him. He admired dancers for their backs, preferred certain models on account of their backs,[4] and displayed anatomical sophistication in these works by discriminating among subtle changes in the position of the shoulder blades, spine, nape of the neck, and coccygeal region. And can it be coincidental that these violin-shaped backs are reminiscent of the nudes of the revered Ingres, whose Valpinçon *Bather* (fig. 262) the young Degas not only copied[5] but personally obtained from its owner (the father of his friend Paul) for the retrospective exhibition of his work that the old artist had arranged in 1855 at the Exposition Universelle?

1. For example, L848 (fig. 175), L935, L936, L1003, L1283, L1284, and L1306 (cat. no. 314).
2. J178, J184 (cat. no. 186), J185, J192, and, tangentially, J156 (cat. no. 247) and J173.
3. Especially L709, L780, and L781 (Courtauld Institute, London).
4. See Jeanniot 1933, p. 155.
5. Reff 1985, Notebook 2 (BN, Carnet 20, p. 59).

Fig. 262. Jean-Auguste-Dominique Ingres, *Bather*, called *The Valpinçon Bather*, 1808. Oil on canvas, 57½ × 38⅜ in. (146 × 97.5 cm). Musée du Louvre. Paris

284.

Nude Woman Combing Her Hair

1886–88
Pastel on paper mounted on cardboard
31 × 26 in. (78.7 × 66 cm)
Signed in brown chalk upper right: Degas
Collection of Mr. and Mrs. A. Alfred Taubman

Exhibited in New York

Lemoisne 849

PROVENANCE: Earliest whereabouts unknown; Mrs. Ernest Chausson, Paris, widow of Degas's friend the composer (Chausson sale, Drouot, Paris, 5 June 1936, no. 7, for Fr 5,800); bought at that sale by Durand-Ruel (stock no. N.Y. 5313); bought by Mrs. Herbert C. Morris, Philadelphia, 9 March 1945, for $15,000. (Sale, Christie's, New York, 31 October 1978, no. 10, repr.); bought at that sale by present owner.

EXHIBITIONS: 1924 Paris, no. 160, repr.; 1931 Paris, Rosenberg, no. 30; 1935, Brussels, Palais des Beaux-Arts, June–September, *L'impressionnisme*, no. 15; 1936 Philadelphia, no. 45; 1947, Philadelphia Museum of Art, May, *Masterpieces of Philadelphia's Private Collections* (Philadelphia Museum of Art Bulletin, XLII, no. 2), no. 24, repr. p. 83.

SELECTED REFERENCES: Lafond 1918–19, I, p. 21, repr.; Lemoisne 1924, p. 105, repr.; Lemoisne [1946–49], III, no. 849 (as c. 1885); Minervino 1974, no. 914.

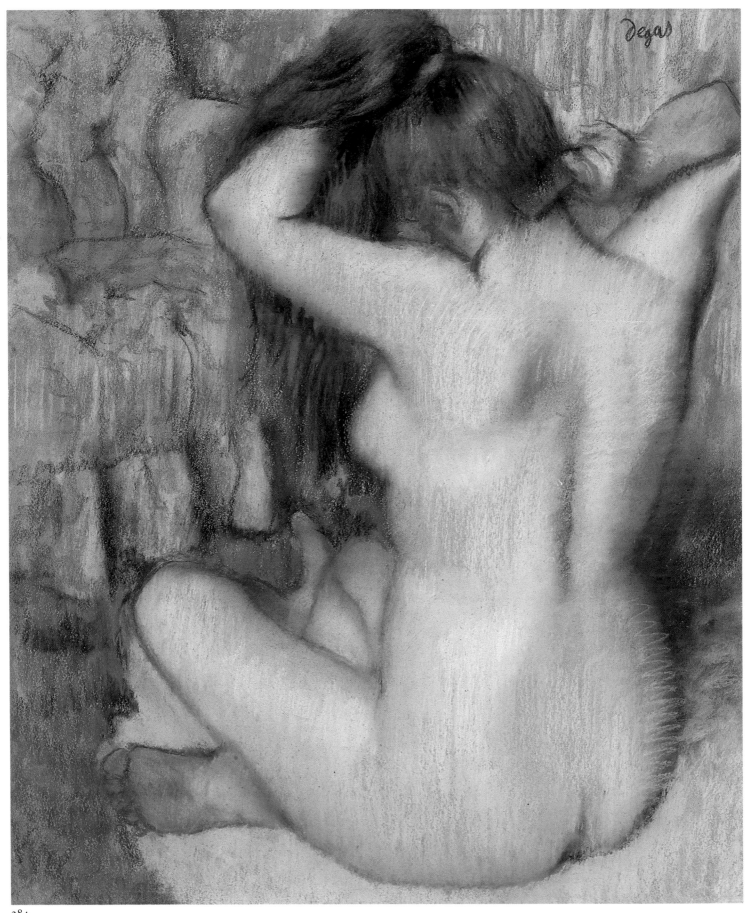

284

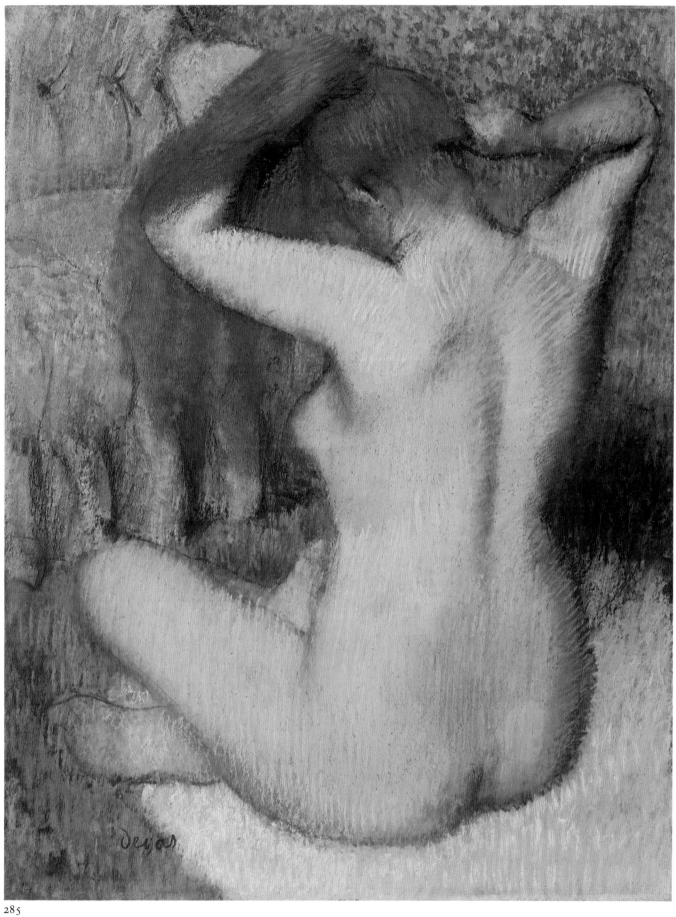

285

285.

Nude Woman Combing Her Hair

c. 1888–90
Pastel on light green wove paper now discolored
to warm gray, affixed to original pulpboard
mount
24⅛ × 18⅛ in. (61.3 × 46 cm)
Signed in brown chalk lower left: Degas
The Metropolitan Museum of Art, New York.
Gift of Mr. and Mrs. Nate B. Spingold, 1956
(56.231)

Exhibited in New York

Brame and Reff 115

PROVENANCE: Bought from the artist by Durand-
Ruel, Paris, 27 February 1891, for Fr 2,000 (stock
no. 838); bought by Paul Gallimard, 3 March 1891.
Jos Hessel, Paris, 1894, until after 1937. Private col-
lection, Paris. With Sam Salz, New York, until 1950;
bought by Mr. and Mrs. Nate Spingold, New York,
30 April 1950, until 1956; their gift to the museum,
retaining life interest, 1956.

EXHIBITIONS: 1929, Paris, Galerie de la Renaissance,
15–31 January, Oeuvres des XIXe et XXe siècles,
no. 127, lent by Jos Hessel; 1937 Paris, Palais Natio-
nal, no. 310, lent by Jos Hessel; 1947, Paris, Galerie
Alfred Daber, 19 June–11 July, Grands maîtres du XIXe
siècle, no. 10; 1960, New York, The Metropolitan
Museum of Art, 24 March–19 June, The Nate and
Frances Spingold Collection, unnumbered pamphlet;
1965, Waltham, Mass., Dreitzer Gallery, Spingold
Theater, Brandeis University, 11–16 June, Nate B.
and Frances Spingold Collection (no catalogue); 1977
New York, no. 45 of works on paper.

SELECTED REFERENCES: Tristan Bernard, "Jos Hessel,"
La Renaissance, XII:1, January 1930, p. 19, repr.;
New York, Metropolitan, 1967, p. 89, repr.; Brame
and Reff 1984, no. 115 (as c. 1885).

286.

Nude Woman Drying Her Arm

c. 1887–89
Pastel and charcoal on off-white wove paper,
discolored at the edges
12 × 17½ in. (30.5 × 44.5 cm)
Signed lower left: Degas
The Metropolitan Museum of Art, New York.
Bequest of Mrs. H. O. Havemeyer, 1929.
H. O. Havemeyer Collection (29.100.553)

Exhibited in New York

Lemoisne 794

This work is one in a large group of variants
that Degas presumably made sometime after
the 1886 Impressionist exhibition but before
the end of the decade. It is based on a coun-
terproof that was taken from a drawing in
the opposite direction (fig. 263), which in
turn derives from a drawing (L791) that De-
gas had squared, possibly for transfer to yet
another work. There is even a tracing of the
present work that Degas seems to have made
before he added the final pastel coloring to
this sheet (IV:163). This system of reversing
images and producing copies is similar to the
process of making monotypes, only it is dry
(chalk and pastel) rather than wet (printer's
ink). Although the chronology of the mono-
types remains unclear, it is generally thought
that Degas abandoned his "dessins faits à
l'encre grasse et imprimés" early in the 1880s
and did not take them up again—with the
possible exception of the Nude Torso (J158)—

until the early 1890s, when he made his se-
ries of landscape monotypes. If so, it may be
that in the interim he used counterproofing
and tracing as substitutes for making mono-
types. Evidently, his desire to replicate and
multiply images did not abate when he put
his monotype plates away; there are, for ex-
ample, eighteen related variants of the pre-
sent work.[1]

Although Degas's pastelized monotypes
tend to be dense and richly colored, his
"impressions rehaussées" are often only
lightly touched. This particular work
amounts to little more than a colored draw-
ing, for the modeling is largely effected by
the fluid underdrawing in charcoal. Light
applications of pale violet and yellow pastel
(complementary colors) give the flesh its
hue, while the towel and peignoir on which
the bather sits are shaded by an aquamarine
chalk, meant no doubt to reflect the clear
light of day. Degas did allow himself dense
colors in the rug and wall coverings, but
otherwise the work is made as if it were an
exercise in eliciting the effects of transparen-
cy from an opaque medium with as little
color as possible.

1. The variants range over a period of several years
and fall into four groups of closely related works,
with three additional loosely related works. First:
L793 (fig. 263); its counterproof, the present work,
L794; a tracing made from the latter, IV:163; and a
related work, L795. Second: L791; its counter-
proof, IV:364; and a related work, II:385. Third:
L790; its counterproof, L795 bis; and its tracing,
IV:355. Fourth: L794 bis; its counterproof, L789;
and three related works, II:301, III:192, and IV:169.
Three additional works: I:249, II:363, and IV:291.

286

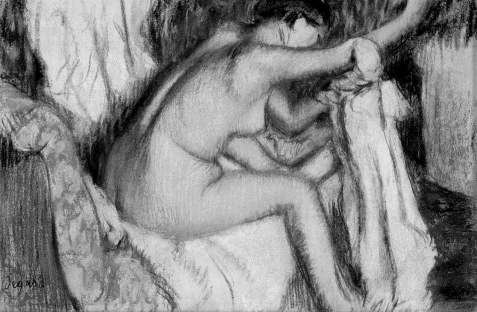

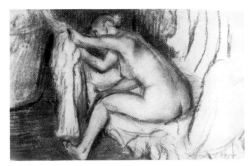

Fig. 263. Nude Woman Drying Her Arm (L793),
c. 1887–89. Charcoal heightened with pastel,
12¼ × 19⅝ in. (31 × 50 cm). Private collection,
Paris

PROVENANCE: Bought from the artist by Durand-Ruel, Paris, 25 November 1898, for Fr 2,000 (stock no. 4828, as "Sortie du bain"); sold to E. F. Milliken, New York, 19 July 1899, for Fr 5,000; bought by James S. Inglis, New York, 1899, until 1908; his estate 1908–10 (Inglis sale, American Art Association, New York, 10 March 1910, no. 63, repr.); bought at that sale by Durand-Ruel, New York, for $2,500 (*American Art Annual*, VIII, 1910–11, p. 363), as agent for Mrs. H. O. Havemeyer; Mrs. H. O. Havemeyer, New York, 1910–29; her bequest to the museum 1929.

EXHIBITIONS: 1930 New York, no. 150; 1977 New York, no. 41 of works on paper.

SELECTED REFERENCES: Pica 1907, repr. p. 412; Meier-Graefe 1923, pl. LXXXVIII; Havemeyer 1931, p. 132; Lemoisne [1946–49], III, no. 794 (as c. 1884); New York, Metropolitan, 1967, p. 90 repr.; Minervino 1974, no. 902.

287.

The Tub

1888–89
Bronze
Height: 8½ in. (21.6 cm)
Original: brownish red wax figure in lead basin covered with white plaster, the basin surrounded by cloth resting on a wooden plank. National Gallery of Art, Washington, D.C. Collection of Mr. and Mrs. Paul Mellon (1985.64.48). See fig. 264.

Rewald XXVII

In the letter to Bartholomé that Guérin dates to 1888, in which Degas wrote "I have not done enough horses," he added: "The women must wait in their basins."[1] The artist was referring most probably to the present sculpture. In a progress report postmarked 13 June 1889, he mentioned the work again to Bartholomé: "I have worked the little wax a great deal. I made a base for it with rags soaked in a more or less well-mixed plaster."[2] Since, according to Charles Millard, the base would have been among the finishing touches,[3] the sculpture must have been near completion by the summer of 1889.

Singled out by Millard as the "most wholly original" of all Degas's sculpted works,[4] *The Tub* occupies a position of importance parallel to that of *The Little Four-teen-Year-Old Dancer* (cat. no. 227). Like the dancer, it is large in size, monumental in its proportions, and suitable for exhibition—though it was not seen outside the artist's studio until after his death. Like the dancer, a large part of its effect in the original depends on its polychromy and on the inclusion of materials foreign to sculpture; the lead tub, the white plaster for the water, the dark red wax for the flesh, and the real sponge held in the bather's hand all contributed to

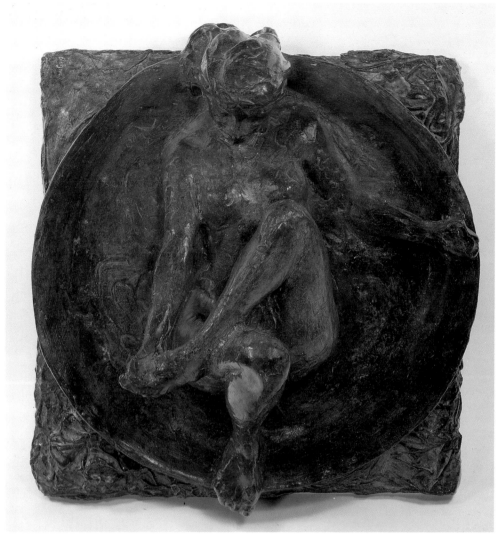

287

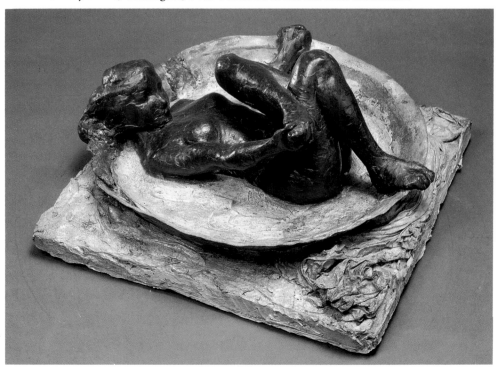

Fig. 264. *The Tub* (RXXVII), 1888–89. Brownish red wax figure in lead basin covered with white plaster, the basin surrounded by cloth resting on a wooden plank, 9½ × 16½ in. (24 × 42 cm). National Gallery of Art, Washington, D.C. Collection of Mr. and Mrs. Paul Mellon

the realism of the piece (see fig. 264). (Unfortunately, this crucial aspect of the work was misunderstood by the founder who, in patinating the posthumous bronze casts, chose not to imitate the variety of colors and textures of the original work. As a result, it is the least successful of the translations into bronze.) Finally, as with the dancer, Degas wished to shock the observer with the lifelike accuracy of the bather's anatomy and with the convincing texture of the fleshlike wax. Both works carry with them overtones of the Pygmalion myth, which had recently been revived in the ballet *Coppélia*. And in the doll-like nature of both there is latent more than a little of the erotic and voyeuristic appeal of Madame Tussaud's and the Musée Grévin.

Of all Degas's surviving sculptures, *The Tub* is the only work that begs to be seen directly from above. It is also the work most integrated with its base. The function of bases in general—their relationship to the sculpture and to the viewer—had become an issue in the Salons of the 1880s and 1890s. Rodin's sinking of the base of his *Eve* into the floor at the Salon of 1899 was symptomatic of the wish of some avant-garde sculptors to eliminate an extraneous element and focus attention on the work itself. A different solution, the integration of the figure with its base, had been essayed by various sculptors throughout the nineteenth century, using as precedents classical Venuses reclining on a couch and medieval funerary *gisants*. Giovanni Dupré's *Dead Abel* (1842), Auguste Clésinger's *Woman Bitten by a Snake* (1847), Alexandre Schoenewerk's *The Maid of Tarentum* (1872), and Augustin Préault's *Ophelia* (1842–46) all drew upon these historical sources and were certainly known to Degas when he began work on *The Tub*. Charles Millard argues that Barye's *Bear Playing in Its Trough* (1833) may have encouraged Degas in the development of *The Tub*, and that a curious wax figure by Gustave Moreau of the infant Moses lying in his basket was "the most meaningful of the modern sources."[5] However, it could also be said that the examples by Préault and Clésinger, whose sensual figures are played off against and circumscribed by the supporting ground, defined for Degas the challenge of finding in a modern, everyday situation some pretext for a recumbent nude bound in a logical manner to its base.

Regardless of the specific source, Degas's solution was brilliant. The bather's pose, delightful in its geometric complexity and satisfying in its self-evident logic, is perfectly natural. The figure is beautifully rendered, with smooth skin pulled over an exaggeratedly feminine body, and the face—so rarely defined in Degas's sculptures—is almost captivating.

There are no known studies by Degas for the figure, but there is an undated drawing by Zandomeneghi, published by Millard, of a model holding an identical pose.[6] Presumably it was made after the sculpture.

1. Lettres Degas 1945, C, p. 127; Degas Letters 1947, no. III, p. 124 (translation revised). Millard (1976, p. 20 n. 72) does not believe that Degas was thinking of this work when writing this sentence because of his use of the plural, "les femmes." However, given Degas's constant use of *bons mots* and circumlocutious phrasing in his letters, it seems an entirely natural way for him to refer to this work.
2. Lettres Degas 1945, CVIII, p. 135; Degas Letters 1947, no. 119, p. 132 (translation revised). Guérin (n. 3) incorrectly relates this letter to *The Little Fourteen-Year-Old Dancer* (cat. no. 227).
3. Millard 1976, p. 10.
4. Ibid., p. 69.
5. Ibid., pp. 75, 80, figs. 93, 94.
6. Ibid., pp. 82–83 n. 56, fig. 96.

SELECTED REFERENCES: Lemoisne 1919, p. 115, repr. p. 109, wax; Royal Cortissoz, "Degas as He Was Seen by His Model: Intimate Notes on the Artist during His Last Phase," *New York Tribune*, 19 October 1919, repr. p. 1, wax (as "Seated Figure"); 1921 Paris, no. 56; Janneau 1921, repr. p. 353; Bazin 1931, fig. 72, p. 295, wax; Havemeyer 1931, p. 223, Metropolitan 26A; Paris, Louvre, Sculptures, 1933, p. 71, no. 1773, Orsay 26P; Alexandre 1935, repr. p. 172, Orsay 26P; Rewald 1944, no. XXVII (as 1882–95), Metropolitan 26A; Rewald 1956, no. XXVII, Metropolitan 26A; Fred Licht, *Sculpture 19th and 20th Centuries*, Greenwich, Conn.: New York Graphic Society, 1967, p. 322, no. 138, n.p. fig. 138; Jack Burnham, *Beyond Modern Sculpture: The Effects of Science and Technology on the Sculpture of This Century*, New York: George Braziller, [1968], pp. 22–23, p. 22 fig. 2; Beaulieu 1969, p. 380; Minervino 1974, no. S56; 1976 London, no. 56; Millard 1976, pp. 9–10, 20 n. 72, 24, 38, 63, 68, 69, 75, 80, 82–83 n. 56, 107–08, 114, fig. 92, wax (as 1889); Reff 1976, pp. 291–92, p. 291 fig. 209, Metropolitan 26A; Rewald 1986 (revised introduction originally published in Rewald 1944), p. 145, fig. 35 p. 144; 1986 Florence, repr. p. 94, fig. 26 p. 125, p. 186, no. 26 repr., Paris, Orsay, Sculptures, 1986, p. 134.

A. *Orsay Set P, no. 26*
Musée d'Orsay, Paris (RF2120)

Exhibited in Paris

PROVENANCE: Acquired thanks to the generosity of the heirs of the artist and of the Hébrard family by the Louvre 1930.

EXHIBITIONS: 1931 Paris, Orangerie, no. 56; 1960–61, Paris, Musée National d'Art Moderne, 4 November 1960–23 January 1961, *Les sources du XXe siècle: les arts en Europe, 1884–1914*, no. 108 (as c. 1886); 1969 Paris, no. 289; 1976–77 Tokyo, no. 94; 1984–85 Paris, no. 86, p. 207, fig. 211 p. 205; 1986 Paris, no. 219, p. 359, repr.

B. *Metropolitan Set A, no. 26*
The Metropolitan Museum of Art, New York. Bequest of Mrs. H. O. Havemeyer, 1929. H. O. Havemeyer Collection (29.100.419)

Exhibited in Ottawa and New York

PROVENANCE: Acquired from A.-A. Hébrard by Mrs. H. O. Havemeyer late August 1921; her bequest to the museum 1929.

EXHIBITIONS: 1922 New York, no. 32; 1925–27 New York; 1930 New York, under Collection of Bronzes, nos. 390–458; 1974 Dallas, no number, fig. 19; 1974 Boston, no. 50, fig. 6; 1975 New Orleans; 1977 New York, no. 34 of sculptures.

288.

Woman Stepping into a Bath

c. 1890
Pastel and charcoal on blue laid paper mounted at perimeter on backing board
22 × 18½ in. (55.7 × 46.8 cm)
Signed in red chalk upper left: Degas
The Metropolitan Museum of Art, New York. Bequest of Mrs. H. O. Havemeyer, 1929. H. O. Havemeyer Collection (29.100.190)

Exhibited in New York

Lemoisne 1031 bis

Degas's fascination with the image of a figure stepping over an obstacle apparently dates back to his student days, when he planned a painting of the wife of King Candaules climbing into bed (BR8, c. 1855–56) and copied a figure scrambling over a riverbank from an engraving by Marcantonio Raimondi after Michelangelo (fig. 265). About 1860–62, he adopted the pose for an exquisite nude study of a woman climbing into a chariot (fig. 266), originally intended for (but finally not included in) *Semiramis Building Babylon* (cat. no. 29; see also cat. no. 34). Some thirty years later, he worked on a group of bathers who step into a deep tub with the same effortful movement as that of the figure from Marcantonio and the climbing figure in *Semiramis*. The present work is one of seven pastels in which this wide-hipped and faceless woman appears, but it towers above the others because of the brilliant resolution that Degas has brought to the pose and the high level of execution with which it is realized.

In the constellation of works directly related to this pastel,[1] and in an analogous group of works that feature an unmade bed in addition to the tub[2] (culminating in the Chicago *Morning Bath*, cat. no. 320), Degas made the action of the figure much more kinetic. In those works, the woman actively pushes with one leg, or balances with the other; in each case, there is a sense of extension or strain as she turns in contrapposto. Here, however, she lets her arms bear her weight. This slight shift in the pose decreases the dynamism, but it allowed Degas to splay the woman's figure laterally across the sheet, not at all unlike the manner in which Frans Snyders would extend, in an

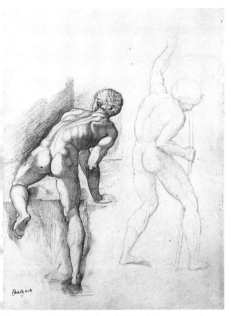

Fig. 265. *Male Bather* (IV:84.b), copy after Marcantonio Raimondi's engraving after Michelangelo's *Battle of Cascina*, 1857. Pencil, 11¾ × 7⅞ in. (30 × 20 cm). The Detroit Institute of Arts

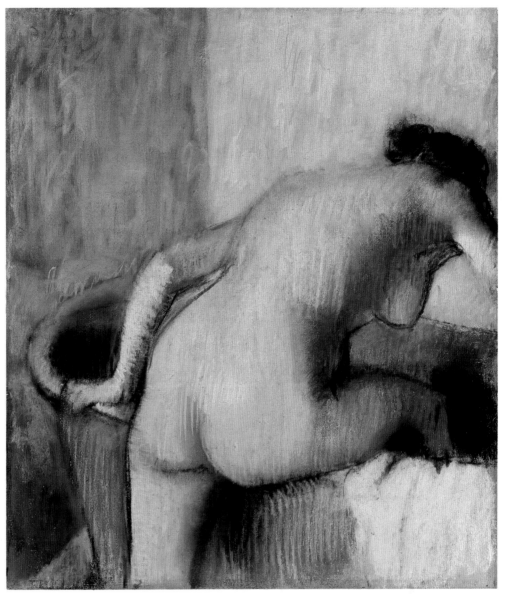

288

Fig. 266. *Nude Woman Seen from Behind, Climbing into a Chariot*, study for *Semiramis Building Babylon*, c. 1860–62. Charcoal, 11¼ × 6⅛ in. (28.5 × 15.5 cm). Cabinet des Dessins, Musée du Louvre (Orsay), Paris (RF15486)

emblematic way, an animal across a hunting scene by Rubens. Thus, despite the strong diagonal of the tub and the receding plane of the left-hand wall, the bather herself unifies the composition, turning it into a single cohesive whole. Degas omitted any descriptive or narrative details—there is no wallpaper, no picture on the wall, no maid—in order to focus the viewer's attention squarely on the monumental figure of the nude.

Also contributing to the cohesiveness of the composition is Degas's pastel technique. With his chalk he traversed every outline—whether of the tub, the bather, or the join at the corner of the room—in order to mitigate the disjuncture that the contours would otherwise create. Reading from the top of the composition to the bottom, the chestnut-colored wall at the left and the yellow wall at the right are unified by the orange chalk scrawled over both; the same orange chalk is drawn over the bather's left shoulder, softening the contour, just as the purple

chalk that modifies the interior of the blue zinc bathtub has been drawn over the top of the bather's right thigh. In knitting the image together, Degas relied on some interesting coloristic ploys. For example, he colored the bottom-left portion of the tub with purple pastel over blue, while just to the right of the bather's leg he reversed himself and drew blue over purple. The dark green shadows in the bather's hair and the lime green undertone of her skin also vary from the expected.

Degas probably began this work, which is drawn on a fine piece of blue laid paper, by outlining the figure in chalk and scumbling in a base color for the background. He seems to have pulled a counterproof of the drawing before working further on the sheet, because a pastel—catalogued among the "impressions rehaussées de couleurs" in the fourth atelier sale (IV:330, L1032)—reverses the pose precisely. Although the size of this work differs from that of the counterproof, the internal measurements are identical.

471

Louisine Havemeyer purchased this pastel of her own accord at the Hayashi sale in New York in 1913. When Mrs. Havemeyer's good friend and adviser Mary Cassatt learned of the purchase, she approved, though grudgingly: she preferred *her* bather (cat. no. 269) to all others.[3] Mrs. Havemeyer had announced her independence the year before by buying, without consulting Cassatt, the Rouart *Dancers Practicing at the Barre* (cat. no. 165) for the highest sum any contemporary work had ever fetched at auction. From that moment, she relied solely on her own judgment in evaluating works by Degas.

1. L1031 (private collection, New York), L717 (cat. no. 253), L718 (fig. 231), L719 (fig. 230), BR112 (cat. no. 254), J125 (cat. no. 252), L731, L731 bis, L732, L732 bis, L734.
2. L1028 (cat. no. 320), L1029 (cat. no. 337), and related studies: L1030, L1030 bis, L1030 ter, L1029 bis.
3. Letter from Mary Cassatt to Louisine Havemeyer, n.d., Archives, The Metropolitan Museum of Art, New York.

PROVENANCE: Earliest whereabouts unknown. Tadamasa Hayashi collection and estate, Tokyo and Paris, until 1913 (Hayashi sale, American Art Association, New York, 8–9 January 1913, no. 85, repr. for $3,100); bought at that sale by Durand-Ruel as agent for Mrs. H. O. Havemeyer; Mrs. H. O. Havemeyer, New York, 1913–29; her bequest to the museum 1929.

EXHIBITIONS: 1930 New York, no. 152; 1977 New York, no. 48 of works on paper.

SELECTED REFERENCES: "Der Kunstmarkt—von den Auktionen," *Der Cicerone,* V, 1913, p. 192; Havemeyer 1931, p. 133; Lemoisne [1946–49], III, no. 1031 bis (as c. 1890); Regina Shoolman and C. E. Slatkin, *Six Centuries of French Master Drawings in America,* New York: Oxford University Press, 1950, pp. 188–89, pl. 106; Havemeyer 1961, p. 261; New York, Metropolitan, 1967, pp. 90–91, repr. p. 90; Minervino 1974, no. 947, pl. LII (color); Klaus Berger, *Japonismus in der Westlichen Malerei, 1860–1920,* Munich: Prestel-Verlag, 1980, p. 70, fig. 50; Moffett 1985, p. 80, repr. (color) p. 251; Paris, Louvre and Orsay, Pastels, 1985, p. 92, under no. 89; *Modern Europe* (introduction by Gary Tinterow), New York: The Metropolitan Museum of Art, 1987, p. 25, pl. 11 (color).

289.

Nude Woman Drying Herself

c. 1890
Pastel on paper
21⅝ × 28 in. (55.5 × 70.5 cm)
Vente stamp lower left
Philadelphia Museum of Art. The Henry P. McIlhenny Collection in memory of Frances P. McIlhenny (1986-26-16)

Exhibited in Ottawa

Lemoisne 886

Degas's pictures of women drying themselves present us with the most energetic of his bathers. The movement of the figures is always vigorous, and the feeling of concentration and self-absorption always intense. The bather in this pastel, for example, wipes her left hip with deliberation and noticeable exertion. The impression of physical strain derives from the emphasis placed on the muscularity of the figure: Degas has carefully lighted her left side in a way that brings out the muscles of the upper arm and has twisted the body so as to introduce folds in the flesh under the left breast—folds that highlight the sheet of muscles underneath.

The extraordinary sense of corporeality in this pastel could well be the result of Degas's contemporaneous work in sculpture. There are two surviving waxes of figures in this same pose, RLXIX (cat. no. 381) and RLXXXI, and the latter is particularly close to the pastel. There may also have been other similar waxes, now lost: after having completed the inventory of Degas's atelier, Joseph Durand-Ruel wrote in 1919 that a large number of the artist's waxes had fallen to pieces and that "it is only the later ones that now exist."[1]

289

This pastel seems to have been made at the same time as *Woman Stepping into a Bath* (cat. no. 288). Both pastels are manifestly studio pieces, with no attempt made to disguise the plain surroundings or rationalize the settings. Both concentrate on a single movement, and both are realized with veils of pastel, one scumbled over the other, that set up vibrant harmonies of golden orange, lime green, and pink. The nude in each of these works is made up of daringly raw patches of yellow, white, pink, and green that together create a more vivid impression of human skin than do the flesh tones of the more conventional nudes of the early 1880s.

1. Letter from Durand-Ruel to Royal Cortissoz, 7 June 1919, published by Cortissoz in "Degas as He Was Seen by His Model: Intimate Notes on the Artist during His Last Phase," *New York Tribune*, 19 October 1919, section IV, p. 9.

PROVENANCE: Atelier Degas (Vente I, 1918, no. 132, for Fr 20,000); bought at that sale by Dr. Georges Viau; Georges Viau, Paris, 1918–42 (Viau sale, Drouot, Paris, 11 December 1942, no. 70, pl. XIII, for Fr 650,000); bought at that sale by Étienne Bignou. With A. Lenars et Cie, Paris, until May 1950; bought by Reid and Lefevre, London, 1 May 1950; bought by James Archdale, Birmingham, 15 December 1950, until 1962; bought by Reid and Lefevre, London,

6 April 1962; bought by Henry P. McIlhenny, 1962; McIlhenny collection, Philadelphia, 1962–86; his bequest to the museum 1986.

EXHIBITIONS: 1950, London, Lefevre Gallery, May–June, *Degas*, no. 7, repr. p. 8; 1951–52 Bern, no. 43, lent by James Archdale, Esq., Birmingham; 1952 Edinburgh, no. 23, pl. VIII, lent by J. Archdale, Esq.; 1953, City of Birmingham Museum and Art Gallery, July–September, *Works of Art from Midland Houses*, no. 125; 1962, London, Lefevre Gallery, February–March, *XIX and XX Century French Paintings*, no. 7, repr. p. 9; 1962, San Francisco, The California Palace of the Legion of Honor, 15 June–31 July, *The Henry P. McIlhenny Collection*, no. 19, repr.; 1977, Allentown, Pa., Allentown Art Museum, 1 May–18 September, *French Masterpieces of the 19th Century from the Henry P. McIlhenny Collection*, p. 60, repr. p. 61; 1979, Pittsburgh, Museum of Art, Carnegie Institute, 10 May–1 July, *French Masterpieces of the 19th Century from the Henry P. McIlhenny Collection* (no catalogue); 1984, Atlanta, High Museum of Art, 25 May–30 September, *The Henry P. McIlhenny Collection: Nineteenth Century French and English Masterpieces*, no. 23, p. 58, repr. (color) p. 59; 1985 Philadelphia; 1986, Boston, Museum of Fine Arts, 26 June–31 August, "Masterpieces from the Henry P. McIlhenny Collection" (no catalogue).

SELECTED REFERENCES: Lemoisne [1946–49], III, no. 886 (as c. 1886); Cooper 1952, pp. 12, 25, no. 25; Minervino 1974, no. 924.

290, 291

Fourth Position Front, on the Left Leg

While the majority of Degas's dance sculptures capture fleeting moments of movement or disequilibrium, this work is notable for the perfect balance of the figure and the dancer's seemingly effortless control over her body. The graceful carriage and extraordinary poise of the figure suggest links with a number of comparable works—two figures of the *Spanish Dancer* (RXLVII, RLXVI), two figures of the *Dancer Moving Forward, Arms Raised* (RXXIV, RXXVI), and *Dancer Ready to Dance, the Right Foot Forward* (RXLVI). These works presumably were made during the mid-to-late 1880s, or at least after *The Little Fourteen-Year-Old Dancer* (cat. no. 227, completed in 1881) and before the *Dressed Dancer at Rest, Hands on Her Hips* (cat. no. 309, associated with pastels and paintings of 1894).

Degas made two other closely related sculptures of a woman in this pose, RXLIII and RXLIV. The order in which the three works were made cannot be determined, but

290

291

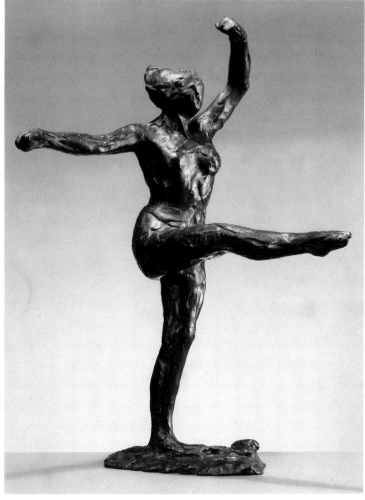

they all appear to date from the same period. The two others are practically identical in size (22½ in. or 57.4 cm high), and the same model seems to have posed for both. The present work is smaller by a third, and the proportions of the figure are not the same—Degas obviously used a different model. It is uniformly more summary in description than the two larger works, but the dancer's attitude is more perfectly executed: her back is absolutely straight, and her right leg is precisely parallel to the floor. In one variant (RXLIV), the dancer's right leg is lifted slightly above the horizontal; in the other variant (RXLIII), the dancer has lost her balance—she is leaning backward and her raised leg is far too high (perhaps the result of an accident in the artist's studio, or perhaps an intentional effect).

As handsome as the bronze casts of this work are, comparison between the original wax and the subsequent bronzes, first made by Hébrard between 1919 and 1921, reveals the inevitable differences in quality. In the case of the present work, much of the texture of the original wax has been lost. Degas's habit of building form by applying successive layers of material left scaly surfaces, like bark, on a number of his wax models, including this one. In the bronze cast of this work, the scalelike accretions are much less pronounced, and therefore one gets a poorer sense of how the model was made. Hébrard did attempt to simulate the color of the original wax in the patina of the bronze, but since the wax continued to oxidize, it is now darker than the cast.

290.

Fourth Position Front, on the Left Leg

c. 1883–88
Yellow-brown wax
Height: 16 in. (40.6 cm)
Musée d'Orsay, Paris (RF2770)

Exhibited in Paris

Rewald LV

PROVENANCE: Atelier Degas; Degas's heirs to A.-A. Hébrard, Paris, 1919 until c. 1955; consigned by Hébrard with M. Knoedler and Co., New York; bought by Paul Mellon 1956; his gift to the Louvre 1956.

EXHIBITIONS: 1955 New York, no. 53; 1969 Paris, no. 270.

291.

Fourth Position Front, on the Left Leg

c. 1883–88
Bronze
Original: yellow-brown wax. Musée d'Orsay, Paris (RF2770). See cat. no. 290
Height: 16 in. (40.6 cm)

Rewald LV

SELECTED REFERENCES: 1921 Paris, no. 9; Havemeyer 1931, p. 223, Metropolitan 6A; Paris, Louvre, Sculptures, 1933, p. 67, no. 1726, Orsay 6P; Rewald 1944, no. LV (as 1896–1911), Metropolitan 6A; Rewald 1956, no. LV, Metropolitan 6A; Paris, Louvre, Impressionnistes, 1958, p. 220, no. 440, wax; Pierre Pradel, "Nouvelles acquisitions: quatre cires originales de Degas," La Revue des Arts, 7th year, January–February 1957, pp. 30–31, fig. 5 p. 31, wax; Minervino 1974, no. S9; 1976 London, no. 9; Millard 1976, pp. 35, 106 (as after 1890); 1986 Florence, p. 175, no. 6 repr., fig. 6 p. 105; Paris, Orsay, Sculptures, 1986, p. 127.

A. Orsay Set P, no. 6
Musée d'Orsay, Paris (RF2073)

Exhibited in Paris

PROVENANCE: Acquired thanks to the generosity of the heirs of the artist and of the Hébrard family by the Louvre 1930.

EXHIBITIONS: 1931 Paris, Orangerie, no. 9 of sculptures, p. 132; 1984–85 Paris, no. 69 p. 196, fig. 194 p. 198.

B. Metropolitan Set A, no. 6
The Metropolitan Museum of Art, New York. Bequest of Mrs. H. O. Havemeyer, 1929. H. O. Havemeyer Collection (29.100.400)

Exhibited in Ottawa and New York

PROVENANCE: Bought from A.-A. Hébrard by Mrs. H. O. Havemeyer late August 1921; her bequest to the museum 1929.

EXHIBITIONS: 1922 New York, no. 18; 1930 New York, under Collection of Bronzes, nos. 390–458; 1974 Dallas, no number; 1977 New York, no. 47 of sculptures.

292.

Nude Dancer with Upraised Arms

c. 1890
Black chalk on buff wove paper
12⅞ × 9⅜ in. (32.7 × 23.6 cm)
Vente stamp lower left
Den Kongelige Kobberstiksamling, Statens Museum for Kunst, Copenhagen (8524)

Exhibited in Ottawa

Vente IV:141.b

This superb, spirited drawing is related to a sheet of approximately the same date with two dancers in a similar pose (III:374), which in turn served as a study for an unfinished pastel (L845). What interested Degas in all three works was the curve of the arms and the obscuring of half of the dancer's face. The articulation of the joints at shoulder, elbow, and wrist obviously fascinated him, and here especially he sought to make the contour of the dancer's rib cage rhyme with the contour of her left arm. The revisions and repeated contours do not, as in Renoir's drawings, betray an insecurity in realizing the desired image, but rather reveal his experimentation with a number of different possibilities from which he could choose the definitive pose. The sense of continuous movement that results from this experimentation seems to coincide with Degas's interest in Muybridge's photography—this kind of drawing becomes quite common only from the late 1880s onward. It may also reflect an awareness of Marey's chronophotographs, but since Degas seems not to have borrowed identifiable motifs from Marey, the extent of influence is more difficult to trace than in the case of Muybridge.

In choosing this specific pose for the dancer, Degas (as he often did in the late 1880s) referred back to his early work. Just as his Study of a Nude on Horseback (cat. no. 282) refers to a similar study for Scene of War in the Middle Ages (fig. 261, c. 1863–65), so does this work refer to the figure with upraised arms in Young Spartans (cat. no. 40, c. 1860–62), and its preparatory drawings (one in the Detroit Institute of Arts and another in the Robert Lehman Collection at the Metropolitan Museum). As Richard Thomson has recently shown, Degas adapted the pose from Ingres's Archangel Raphael of 1847, which the young artist had copied as an exercise in 1855.[1]

This drawing presents the same fluid and almost calligraphic line as Study of a Nude on Horseback, and conveys a similar impression of corporeality—evidence that they were probably both made at about the same time.

1. 1987 Manchester, pp. 35–37.

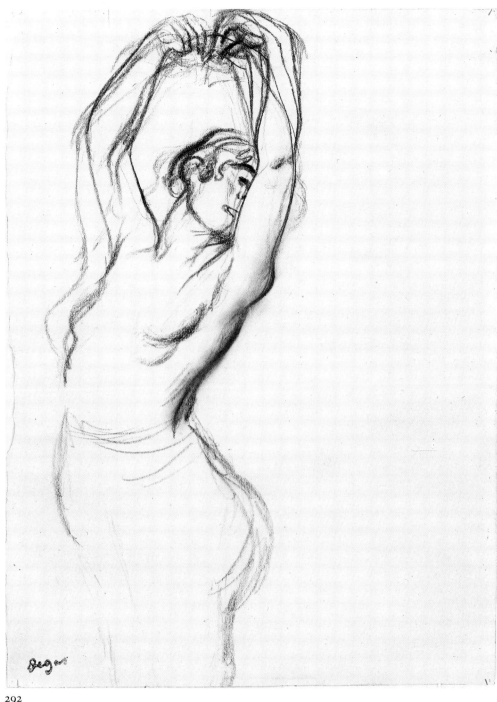

292

PROVENANCE: Atelier Degas (Vente IV, 1919, no. 141.b, repr., for Fr 700); bought at that sale by Jens Thiis, for the museum.

EXHIBITIONS: 1939, Copenhagen, Statens Museum for Kunst, May, *Franske Haandtegninger fra det 19. og 20. Aarhundrede*, no. 25; 1948 Copenhagen, no. 116; 1967, Copenhagen, Statens Museum for Kunst, 2 June–10 September, *Hommage à l'art français* (compiled by Hanne Finsen), no. 41, repr.; 1984 Tübingen, no. 202 (as 1895–1900).

SELECTED REFERENCES: Kaj Borchsenius, *Franske Tegninger i Dansk Eje*, Copenhagen, 1944, repr. p. 11; Erik Fischer and Jorgen Sthyr, *Seks Aarhundreders Europaeisk Tegnekunst*, Copenhagen, 1953, p. 102, repr.

293.

Dancers, Pink and Green

c. 1890
Oil on canvas
32⅜ × 29¾ in. (82.2 × 75.6 cm)
Signed lower right in red: Degas
The Metropolitan Museum of Art, New York.
 Bequest of Mrs. H. O. Havemeyer, 1929.
 H. O. Havemeyer Collection (29.100.42)

Lemoisne 1013

This painting, together with a later version in the Musée d'Orsay, *Dancers in Blue* (cat. no. 358), and a third variant, L880 (fig. 267), is poised midway between Degas's horizontal

rehearsals begun around 1879 and the series of dancers behind the stage flats of the late 1890s. The dancers' poses derive indirectly from the early rehearsals and relate specifically to an even earlier painting of about 1875, *Three Dancers in the Wings* (fig. 268), and to a pastel of the late 1870s, *Before the Ballet* (L500, Corcoran Gallery of Art, Washington, D.C.). At the same time, these pictures announce the artist's new interest in depicting close groups of figures repeating similar poses, and they prefigure his new and highly subjective treatment of color and space.

The genesis of this composition followed a now familiar course in Degas's oeuvre. First he painted *Three Dancers in the Wings* as part of a group of ballet scenes taken from backstage,[1] in a project parallel to his series of illustrations for *La famille Cardinal* (see "Degas, Halévy, and the Cardinals," p. 280). It was lightly and loosely painted, a mere sketch in comparison to some of the jewellike paintings of the mid-1870s; its palette is little more than a warm grisaille relieved by a few touches of bright green. For the dancers, Degas relied on his stock of drawings on pink paper, such as *Standing Dancer Seen from Behind* (cat. no. 137). Then, some fifteen years afterward, he took up the composition again in *Dancers in the Wings* (fig. 267), a densely worked, hotly colored painting of the same size. The horizontal format suggested a narrative approach, so in this later version he added the performing dancers at the left. Thus, the artist imparted a new twist to the story: during a performance, while two dancers execute a pas de deux at center stage, dancers waiting in the wings risk missing their cues as they dally with a top-hatted ballet patron.

At about the same time, around 1890, Degas painted *Dancers, Pink and Green*. Taking the horizontal painting L880 as a basis, he adapted the composition to a format that is almost square. In so doing, he concentrated attention on the activity of the waiting dancers, perceived more as a block than as individuals—two interlocking pairs of superimposed dancers, and a fifth dancer at the right whose back and arm rhyme visually with those of the adjacent figure. The performing dancers have been removed to the background, barely visible between the two pairs of dancers in the foreground. But one essential narrative element in the earlier pictures has been retained: the slim and slightly ominous shadowlike profile of a male patron. The inclusion of this figure adds a suggestion of menace to an unguarded moment of waiting and preparation.

Dancers, Pink and Green is another significant example of Degas's attempt to imitate in oil the complex multilayered pastel tech-

nique he developed in the 1880s. Although he had in the 1870s deliberately compared oil paint and pastel in the two versions of *The Rehearsal* (cat. nos. 124, 125), the mediums in those works were thinly and inconspicuously applied. Here, the paint film is thick and pasty. Degas scumbled color onto the canvas, and then in many areas, such as in the scenery and in the flesh of the dancers, reapplied a contrasting or complementary color: orange over blue, pink over green. The second color was often dragged across the surface with a fairly dry brush, so that small areas of the contrasting ground could remain visible. By working in this manner, Degas inverted the normal effects of oil paint, which are predicated on its ability to render deep color through the use of glazes. For these works, he mixed his colors with white to render them opaque like pastels. By applying the colors thickly, and in layers, he approximated pastel technique, even going so far as to model some of the paint with his fingers, just as he would manipulate his pastel. Degas was, of course, not alone in creating such rich textural effects: concurrently, Monet and Pissarro were both experimenting with similar methods. Many of the avant-garde artists at this time were at least conscious of the renewed interest in systematic color theories—which Seurat was exploiting most fully—and this interest may explain in part why Degas reduced his palette in this picture to just a few colors, expressed in complementary pairs.

The technique Degas employed in this picture dictated more than the effects of light, color, and texture; it determined the space as well. By concentrating on the surface of the picture (even to the extent of var-

nishing the painting selectively, where he wanted more saturated color), he negated the sense of deep space that one finds in the works of the 1870s and early 1880s. The composition here recedes in planes aligned with the surface plane, and not along the steep diagonal on which he had formerly organized his pictures. Thus, even though the composition of *Dancers, Pink and Green* is punctuated by receding verticals—the supports of the stage flats and the tree trunks painted on them, which serve the same function as the forest of columns in *Dancers Exercising* (L924, Ny Carlsberg Glyptotek, Copenhagen)—the result is nevertheless a compressed, planar space, woven in a tapestry-like tissue of vibrant color. Even the distant view at the right toward the stack of balconies in the theater interior here reads as a flat pattern of gold and red.

There is only one existing drawing (fig. 269) that is related to this painting; it would appear to date from the early 1880s and was used for the dancer at the left with her legs in fourth position. On the same sheet is a sketch for the dancer in the second rank whose head is obscured in the painting.

The densely worked surface of this painting might lead one to conclude that it betrays several campaigns of work. Indeed, owing to the close connection between the composition and pictures of the 1870s, one could speculate that it was begun then and finished later, in the 1890s. However, examinations with X-radiographs indicate the contrary: Degas made no substantial revisions to the painting, and although it seems to have been worked in layers, they probably were applied consecutively during one period of work, presumably sometime about 1890.

1. Other pictures in this group include *Dancers Preparing for the Ballet* (fig. 109), *Dancers Backstage* (L1024, National Gallery of Art, Washington, D.C.), and *Before the Ballet* (L500, Corcoran Gallery of Art, Washington, D.C.).

PROVENANCE: Earliest whereabouts unknown. Mrs. H. O. Havemeyer, New York, by 1917, until 1929; deposited by her with Durand-Ruel, New York, 8 January 1917, and returned 21 December 1917 (deposit no. 7844); bequeathed by Mrs. H. O. Havemeyer to the museum 1929.

EXHIBITIONS: 1928, New York, Durand-Ruel, 20 March–10 April, *French Masterpieces of the Late XIX Century*, no. 7, lent anonymously; 1930 New York, no. 55; 1952, Hempstead, N.Y., Hofstra College, 26 June–1 September, *Metropolitan Museum Masterpieces* (no catalogue); 1954, West Palm Beach, Fla., Norton Gallery and School of Art, December 1954/ Coral Gables, Fla., Lowe Gallery, University of Miami, January 1955/Columbia, S.C., Columbia Museum of Art, February 1955, *Take Care* (no catalogue); 1960, Old Westbury, N.Y., *Fourth Annual North Shore Arts Festival*, 13–22 May, *Art of the Dance* (no catalogue [?]); 1972, Tokyo, National Museum, 10 August–1 October/Kyoto, Municipal Museum, 8 October–26 November, *Treasured Masterpieces of the Metropolitan Museum of Art*, no. 97; 1977 New York, no. 18 of paintings; 1978 Richmond, no. 18; 1978 New York, no. 45, repr. (color); 1986, Naples, Museo di Capodimonte, 3 December 1986–8 February 1987/Milan, Pinacoteca di Brera, 4 March–3 May 1987, *Capolavori impressionisti dei musei americani*, no. 17, repr. (color).

SELECTED REFERENCES: Havemeyer 1931, p. 118 repr.; Lemoisne [1946–49], III, no. 1013 (as 1890); Browse [1949], pp. 59, 396, no. 180, repr.; Havemeyer 1961, p. 259; New York, Metropolitan, 1967, pp. 85–86, repr. p. 86; Minervino 1974, no. 855; 1977, Paris, Cabinet des Dessins, Musée du Louvre, *La collection Armand Hammer*, n.p., under no. 42; Buerger 1978, p. 21; Theodore Reff, "Edgar Degas and the Dance," *Arts Magazine*, LIII:3, November 1978, pp. 145–47, fig. 2 p. 146; Moffett 1979, pp. 12–13, pl. 26 (color); Moffett 1985, pp. 82, 251, repr. (color) p. 83; Weitzenhoffer 1986, p. 255.

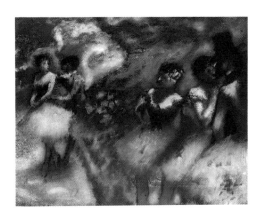

Fig. 267. *Dancers in the Wings* (L880), c. 1890. Oil on canvas, 19⅝ × 24 in. (50 × 61 cm). Location unknown

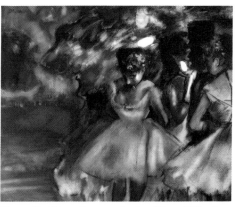

Fig. 268. *Three Dancers in the Wings* (BR91), c. 1875. Oil on canvas, 21½ × 25½ in. (54.6 × 64.8 cm). Location unknown

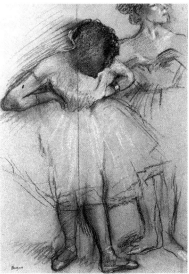

Fig. 269. *Two Dancers* (III:209.2), early 1880s. Charcoal, 18⅛ × 12¼ in. (46 × 31 cm). Private collection, New York

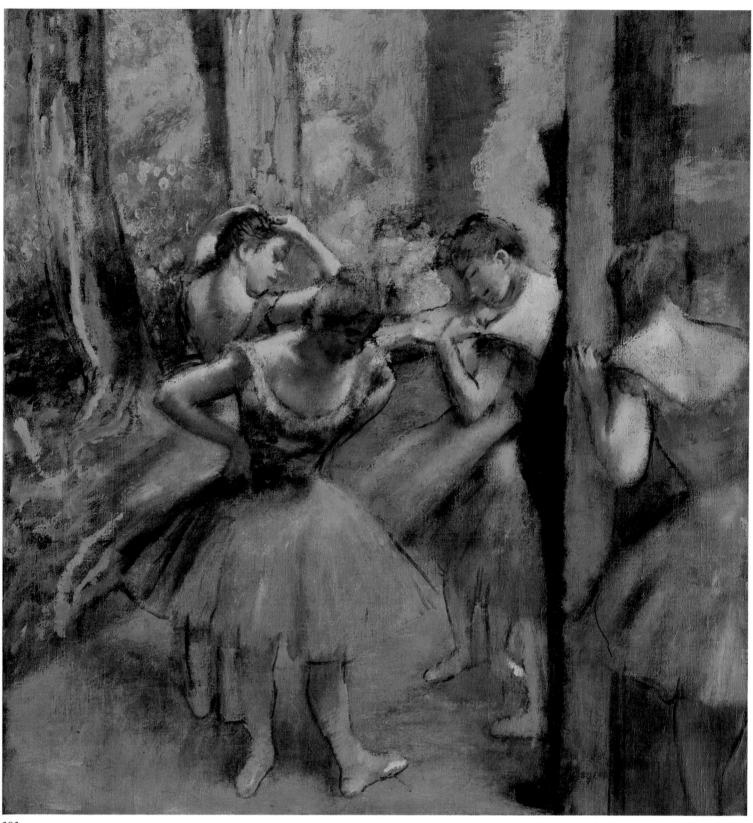

293

IV
1890–1912

Jean Sutherland Boggs

Fig. 270. Attributed to Albert Bartholomé, *Degas in His Studio*, c. 1898. Photograph printed from a glass negative in the Bibliothèque Nationale, Paris

The Late Years: 1890–1912

In making an assessment of the character of the late works of Edgar Degas, two elements so important in evaluating his work in the 1870s and 1880s are missing. We do not have the evidence of his notebooks, which he seems to have stopped keeping about 1886. And, because he essentially withdrew from exhibiting his work, we do not have the same spirited reviews by critics to evaluate. This might appear to be balanced by the survival of more correspondence from this period than from earlier years, but the letters are often perfunctory; or by a greater number of personal accounts by his contemporaries, but these concentrate on the aging man rather than on the work of the artist. In addition, the knowledge of his deteriorating eyesight has encouraged the incorrect assumption that he gave up oil painting for pastel and two-dimensional work for modeling in wax.[1] But Degas continued to paint, at least through 1896, and he drew until he stopped working entirely.

One problem is that of establishing when the late work begins. This must be an arbitrary choice. In writing a book twenty-five years ago on Degas's portraits, I chose the year 1894, a perfectly sensible date when he had reached the age of sixty.[2] For this exhibition we have selected 1890, which also has its virtues, as the following commentaries on the exhibited works will make clear. More surprising is the problem of deciding when the late work ends. Obviously, because of Degas's failing eyesight, it did not extend until his death in 1917. The dealer Ambroise Vollard, who is often inaccurate about dates, records Degas as still drawing in 1914.[3] We know from the evidence of Alice Michel that he was working with difficulty in 1910.[4] Étienne Moreau-Nélaton, a great collector and connoisseur who bequeathed his magnificent collection to the Louvre, admired a pastel that he described Degas as "fencing" with in 1907.[5] The last dated work is from 1903.[6] We know that Degas was still at the peak of his form in 1899.[7] Evidence suggests that he was less active in the twentieth century and certainly must have stopped work completely when he had to move his studio and living quarters from rue Victor-Massé in 1912.

In thinking about the work of Degas in these late years, it is difficult to ignore the intrusion of the spirit of the aging man; and one must confess his late work is unavoidably serious, without any of the wit or humor of the 1870s. Nevertheless, it is a joy to begin a consideration of it with 1890, knowing that Degas entered these years with a certain abandon, seeing and hearing Rose Caron in *Sigurd* for the twenty-ninth recorded time, and making the carefree trip by horse and carriage into Burgundy with his great friend the sculptor Albert Bartholomé. But in the twenty-seven years before he died, there was a deterioration in body and mind and morale, only too well described in the often grumpy letters and in the records of acquaintances and friends. It is endearing that on occasion he admitted that his physical troubles could be emotional.[8] It is also even possible that, perhaps only for protection, he exaggerated his problems with his sight. Vollard, after all, tells the story of Degas's excusing himself to an old friend because of his blindness and then pulling out his watch to check the time.[9] Because his aging into what some have romantically described as a "blind Homer" has been thoroughly chronicled,[10] I will not attempt here to deal with his life. Many of the details are in the Chronology, and others can be found in the commentaries on individual works.

One fact about which there is general agreement by writers on the late work is Degas's increasing indulgence in the abstract elements of his art. Color becomes more intense and often seems to dominate his paintings and pastels. It is significant that as

1. The question of Degas's eyesight is to be thoroughly addressed in an article by Richard Kendall scheduled for publication in *Burlington Magazine* in the spring of 1988.
2. Boggs 1962, pp. 73–79.
3. Vollard 1936, pp. 235–36.
4. Michel 1919, p. 464.
5. Moreau-Nélaton 1931, p. 267.
6. L1421, São Paulo, Museu de Arte. See "The São Paulo Bather," p. 600.
7. See "The Russian Dancers," p. 581.
8. In August 1904, Degas wrote to Paul Poujaud to ask his advice about where he should go to recover from gastrointestinal influenza and added, "My tongue is still coated, my head hot and heavy, my morale low. Gastrology is a mental illness"; Lettres Degas 1945, CCXXXVI, p. 237; Degas Letters 1947, no. 257, p. 221.
9. Ambroise Vollard, *Degas: An Intimate Portrait*, New York: Dover, 1986, p. 22.
10. McMullen 1984, pp. 402–66; Jean Sutherland Boggs, "Edgar Degas in Old Age," for "Artists and Old Age: A Symposium," *Allen Memorial Art Museum Bulletin*, XXXV:1–2, 1977–78, pp. 57–67.

late as 1899 Degas should have described the production of his Russian Dancers as an "orgy of color."[11] His love of color may also have explained his continuing passion for the work of Delacroix, which he was buying. Waldemar George, writing about an exhibition of the late work at Vollard's in 1936, remarked on "the most surprising results. His tones—false, strident, clashing, breaking into shimmering fanfares . . . without any concern for truth, plausibility, or credibility."[12] Line also increased in vigor and expressive power. In reminding himself and others of what Ingres had said to him as a youth about line, Degas kept alive his concept of line as a way of seeing form.[13] George also commented on his line working independently of his color: "a fat line, mobile, supple, elastic, completely autonomous."[14] In addition, the very texture of Degas's work seems an immediate expression of the will of the man himself—often emphasized by his working directly with his hands, leaving a fingerprint like a signature on his monotypes, paintings, and sculpture. This concern might help us understand his paying what may have been his final tribute to Ingres when, in 1912, at the age of seventy-eight, he visited the retrospective exhibition of the other artist's work and stroked the canvases with his fingers.[15] In this interest in and reliance on abstraction, there is a willfulness and a turning to what Degas himself described as "mystery" in art.[16]

In the first phase of the late work, from about 1890 through 1894, it seems as if this sense of mystery is fed by visions of the Near East—Persian miniatures, and *The Thousand and One Nights*, which Degas professed to read constantly and which he wanted to buy in the new and expensive English edition.[17] Even his admiration for Delacroix and his memory of having in 1889 reached Tangiers, where Delacroix had passed,[18] may have encouraged his addiction to the Arabic tradition in art. He loved rugs, and said that one of his pastels of a milliner's shop was inspired by an Oriental rug he had seen in a shop on place Clichy.[19] In his nudes, there is a sensuality—as in the caress of the line along the buttocks of the lithograph *Nude Woman Standing Drying Herself* (cat. no. 294)—that a European might find exotic. His tendency to indulge his nudes (cat. nos. 310–320) with surroundings enriched by portable fabrics, sumptuous in pattern and color, but to leave their bodies chastely unadorned makes them worthy of the admiration of a pasha. Degas painted and drew these works with great restraint, as if a potentate's discriminating taste could control their size and his indulgence in color and texture. These nudes often arouse the most delicate *frisson* as they turn away from us, their hair heavy and their slender necks vulnerably exposed.

Since Degas's landscape monotypes (cat. nos. 298–301) are small, exquisite, and essentially artificial, it is logical that he should have produced them at this time, sometimes enhancing them with pastel.[20] The very fact that Degas exhibited them in the only one-man exhibition he authorized during his lifetime makes them in fact a manifesto in which he was announcing his intention of devoting his work to what one critic described as the "delightfully fanciful"[21] rather than to the measurable and "scientific." But as Howard Lay points out, the landscape monotypes were consistent with the conclusions of Henri Bergson in 1889 and William James in 1890 about the nature of perception.[22]

There are four ways in which the landscape monotypes are important, aside from the fact that they are the creations of Degas's imagination rather than reproductions of what he saw. One is their suggestion of a state of flux, which Degas explained by his having seen landscapes from moving trains. Another is the unimportance of gravity and equilibrium, which normally provide a sense of stability. A third is the elimination of the human dimension by not including people and by not using a perspective that would make us feel part of the created space—estranging us, in fact. The last significant point about the landscape monotypes is their ambiguity. Often, there are allusions to sensations, such as atmosphere and sound, that obscure visual comprehension. And furthermore, there are instances—for example, in the monotype in the British Museum (cat. no. 300)—where it is not clear whether the upper color field is sea or sky. Denis Rouart, a grandson of Degas's great friend Henri Rouart and a painter and curator who wrote the pioneering works on the techniques and monotypes of Degas, has suggested that in these landscapes the artist "abandons all accidental precision and limits [himself] to evo-

11. Manet 1979, p. 238.
12. Waldemar George, "Oeuvres de vieillesse de Degas," *La Renaissance*, 19th year, nos. 1–2, January–February 1936, p. 4.
13. Halévy 1960, pp. 57–59; Halévy 1964, p. 50.
14. George, op. cit., p. 3.
15. Halévy 1960, p. 139; Halévy 1964, p. 107.
16. Halévy 1960, p. 132; Halévy 1964, p. 103.
17. Lettres Degas 1945, Appendix III, p. 277; Halévy 1964, p. 65.
18. Lettres Degas 1945, CXV, to Bartholomé, 18 November 1889, p. 145; Degas Letters 1947, no. 126, p. 140.
19. Jeanniot 1933, p. 280.
20. See "Landscape Monotypes," p. 502.
21. R.G. in "Choses d'art," *Mercure de France*, V, December 1892, p. 374.
22. Howard G. Lay, "Degas at Durand-Ruel 1892: The Landscape Monotypes," *The Print Collector Newsletter*, IX:5, November–December 1978, pp. 145–46.
23. Denis Rouart, "Degas, paysage en monotype," *L'Oeil*, 117, September 1964; *9 Monotypes by Degas* New York: E. V. Thaw & Co., 1964, n.p.
24. See "Interiors, Ménil-Hubert," p. 506.
25. See "Photography and Portraiture," p. 535.
26. Newhall 1956, pp. 124–26.
27. Eugenia Parry Janis in 1984–85 Paris, p. 473, describes them as Symbolist "oceans of unknowable darkness."
28. See "After the Bath," p. 548.
29. See "The Dancer in the Amateur Photographer's Studio," p. 568.

cation stripped of particularized meaning."[23] In a sense, Degas asserts the significance of the artist while leaving the spectator enchanted but vaguely uneasy.

Degas was capable of apparent contradictions. In the same year, 1892, in which he was making many of the landscape monotypes, he was worried about applying principles of perspective in painting certain rooms at Ménil-Hubert, the Normandy château of his friends the Valpinçons (see cat. nos. 302, 303).[24] Yet though he clearly defines the boxlike spaces—painted with a solidity foreign to the translucent monotypes—he excludes people here as well, from these rooms he clearly cherishes. In a painting in the National Gallery of Art in Washington of dancers in a rehearsal room (cat. no. 305), the room is as significant as the billiard room at Ménil-Hubert, equally measured, equally opaque. Although there are dancers present, they seem less important than the space, except to explain Degas's nostalgia for it. In these works, with their increasing sense of melancholy and isolation, Degas was preparing, in a different way from in the monotypes, for the direction of his work in the mid-1890s.

"Exquisite" is a word that can be aptly applied to most of Degas's works in the early 1890s: exquisite in conception, in execution, in their allusions, in the relationships they suggest with the art of some of his contemporaries such as Mallarmé, exquisite in their ability to give pleasure—and exquisite also in their capacity to probe gently but almost sadistically into loneliness and pain. By the midpoint in the decade, perhaps encouraged by the honest eye of the camera, Degas confronted loneliness and pain more boldly, conveying both alienation and anguish in works—whether portraits or landscapes, dancers or bathers—of great visual and emotional power.

The key to Degas's work from 1895 to 1900 is his interest in taking photographs or having them taken for him.[25] When he acquired his Kodak, he pestered his friends to pose. He did not abdicate to this mechanical machine his role as an artist, collaborating with his friend Tasset on developing, enlarging, and retouching his prints.[26] He also preferred to work indoors at night, when he would use lamps to provide a rich and dramatic chiaroscuro, producing prints one could describe as Rembrandtesque. He posed his sitters as high-handedly as if he were a director in the theater or of films. By their nature not as abstract as his paintings and drawings, these photographs nevertheless seem to belong to the theater, having a strong sense of what would be effective on the stage. Finally, whether he intended it or not, Degas produced composite photographs through double exposures of a startling complexity and ambiguity.[27]

Among the photographs attributed to Degas is a bromide print, now in the Getty Museum, of a nude (cat. no. 340) which is clearly related to three oil paintings that can be dated fairly securely to 1896.[28] There is no evidence that the photograph was made before rather than after the paintings. Nevertheless, the coincidence is so great it seems certain that these three remarkable and expressive paintings—one gently sensual (fig. 310), one a bather in a film of red paint (cat. no. 342) as vulnerable as the nudes on the scarlet bed in Delacroix's *The Death of Sardanapalus*, one like a resurrection from a bathtub tomb (cat. no. 341)—were all stimulated in their dramatic range by this small and poignant photograph.

Even more mysterious than the Getty photograph are three glass collodion negatives of a dancer (cat. no. 357, and figs. 322, 323), found among the archival material that the painter's brother René gave to the Bibliothèque Nationale in 1920.[29] Through solarization, the glass plates have turned red-orange and green. The positions of the dancers in at least three pastels (cat. no. 360, and figs. 325, 326), in a number of drawings, and in the large painting *Four Dancers* in Washington (fig. 271) are certainly based on these photographic plates.

Even the red orange and green of the tiny glass plates seem to have been carried over to the *Four Dancers*; other hues are found, but oranges and greens predominate. In addition to the possible photographic derivation of *Four Dancers*, there is another aspect of the painting that is important in this middle phase of Degas's late work. It is undoubtedly a creation inspired by the theater, and Degas's works of this period, which were usually larger and bolder than those of the early 1890s, were normally theatrical, as his portrait photographs most movingly were.

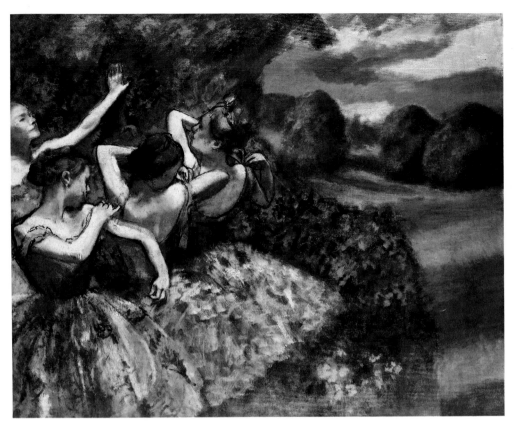

Fig. 271. *Four Dancers* (L1267), c. 1896–98. Oil on canvas, 59 × 71 in. (150 × 180 cm). Chester Dale Collection, National Gallery of Art, Washington, D.C.

Degas's works in the late 1890s possessed the artificiality as well as the scale and carrying power of the theater. His colors became stronger and harsher, his handling richer, and his line more brutal. His spaces are the unreal spaces of the stage, even when they are the empty streets of Saint-Valéry-sur-Somme (cat. nos. 354–356). His bodies are energetic, but more frenetically so. It could have been because of the dancers of the late 1890s that Paul Valéry was reminded, in writing *Degas Danse Dessin*, of a statement by Stéphane Mallarmé: "A danseuse is not a woman dancing, because she is not a woman and she does not dance."[30] Degas's androgynous dancers rest, wait, rehearse, acknowledge applause, but only rarely in this period do they perform. Their bodies have lost the articulation that makes movement possible. When they do move, like the Russian Dancers (see cat. nos. 367–371), it is as a group. Thrust into the glamorous world of the theater, they sadly recall the aspirations of the young dancers in his earlier work.

After 1900, the excitement of Degas's color does not diminish. His line may even increase in expressive force. The spaces continue to be theatrical and ambiguous, our own equilibrium somewhat threatened. But the great change is in the bodies. These aging figures struggle wearily with the fragility of their limbs and the weight of their torsos. Although only shades of the bathers and dancers produced in the 1870s and 1880s, they still possess a fierce will that makes them struggle against infirmities, never quite succumbing to the intensity of the color or line with which Degas suffused his drawings and canvases.

The late work of Degas has always bothered critics, who have tended to avoid it rather than to confront its meaning. It was easy, mistakenly, to ignore it as the work of an increasingly senile artist—his deterioration obvious from his intolerant, anti-Semitic stand on the Dreyfus Affair—or one whose failing eyesight could explain his distortion of visual imagery. Degas's melancholy might have been acceptable had it been expressed as charmingly passive, like the melancholy in most of the late paintings of his contemporary Monet. Somehow, it was never understood why an artist who in his works some twenty years earlier had placed so much emphasis on the individual in a social environment and on the possibility of human perfectibility, who had responded to vitality with

30. Valéry 1965, p. 27; Valéry 1960, p. 17. See also Stéphane Mallarmé, *Oeuvres complètes*, Paris: Gallimard, 1945, p. 304.
31. Valéry 1965, p. 165; Valéry 1960, p. 74 (translation revised).
32. Odilon Redon, *À soi-même, journal (1867–1915)*, Paris: José Corti, 1979, p. 96.
33. Halévy 1960, p. 91.

animation and wit in works of discretion and understatement, should have raised his painter's voice and spoken loudly in color and line about loneliness, anguish, frustration, and futility. But what was also not understood was that he spoke as well about the effort, even in the dying, to exert the human will. And he spoke with his own will, which, in spite of physical frailties, expressed itself cogently, boldly, valiantly.

The significance of Degas's convictions about the human will is contained in a story about the younger painter Jean-Louis Forain trying to persuade him to install a telephone. As Forain was talking, his telephone rang and he got up to answer it. Degas scoffed: "*It rings, and you have to run.*"[31] Degas had never run—after a telephone or after any fashion. As Redon had written in his journal in 1889, the life of Degas was a monument to independence.[32] Because of that independence, through his work he continues to call— and it is we who respond to what Daniel Halévy described as "his implacable will."[33]

Chronology IV

Note
The author would like to thank her colleagues Henri Loyrette and
Gary Tinterow for having provided her with unpublished docu-
ments, and Michael Pantazzi for having perceptively guided her to
material that crossed his desk. John Stewart at the National Gallery
of Canada has given help with transcriptions.

1890

26 September

With Albert Bartholomé, Degas begins a trip by horse and carriage
to the Jeanniots in Burgundy, where he makes his first landscape
monotypes.

> Lettres Degas 1945, CXXVIII, p. 159; Degas Letters 1947, no. 140, p. 153;
> Jeanniot 1933, p. 290; see "Landscape Monotypes," p. 502.

October

Degas is offended by the publication of personal details about his
family in an article by George Moore in the *Magazine of Art* and re-
fuses to see Moore again. Whistler (to whom Degas has had to
apologize for a cruel statement about him quoted by Moore) writes:
"That's what comes, my dear Degas, of letting those vile studio-
crawling journalists into our homes!"

> Halévy 1964, pp. 58–59; Moore 1890, p. 422; "Letters from the Whistler
> Collection" (edited by Margaret Macdonald and Joy Newton), *Gazette des
> Beaux-Arts*, CVIII, December 1986, p. 209.

22 October

Goes to *Sigurd*, with Rose Caron (see cat. no. 326) as Brunehilde—
his twenty-ninth recorded attendance at this opera by Ernest Reyer,
which he will see and hear eight more times in 1890 and 1891. Caron
has returned to Paris after three years with the Théâtre de la Mon-
naie in Brussels.

> Archives Nationales, Paris, AJ13 (see headnote to Chronology III); Eugène
> de Solenière, *Rose Caron*, Paris: Bibliothèque d'Art et de la Critique, 1896,
> pp. 37, 39.

26 October

Writes an affectionate and self-analytical letter to Évariste de Valernes
in Carpentras.

> Lettres Degas 1945, CLVII, pp. 177–80; Degas Letters 1947, no. 170,
> pp. 170–72.

4 December

Attends a dinner given by the lawyer and collector Paul-Arthur
Chéramy at the Café Anglais. Reyer is on the host's right, Degas
on his left, and Mme Caron across the table.

> Fevre 1949, pp. 125–26 n. 1.

1891

Sends a telegram on a Friday to Bartholomé urging him to attend
a Buddhist mass at the Musée Guimet to be read by two Buddhist
priests. "The little goddess, who knows how to dance, will be
invoked."

> Lettres Degas 1945, CLXIII, p. 188; Degas Letters 1947, no. 176, p. 178.

21 January

After a performance of *Sigurd*, Degas dines at the Halévys' with
Jacques-Émile Blanche, Jules Taschereau, and Henri Meilhac, a
playwright and collaborator of Ludovic Halévy. He talks of Ingres
and Gauguin.

> Halévy 1960, pp. 56–62; Halévy 1964, pp. 49–52.

6 July

Writes to Valernes that he is planning a series of lithographs of
nudes and dancers.

> Lettres Degas 1945, CLIX, pp. 182–84; Degas Letters 1947, no. 172,
> pp. 174–75; see "Lithographs: Nude Women at Their Toilette," p. 499.

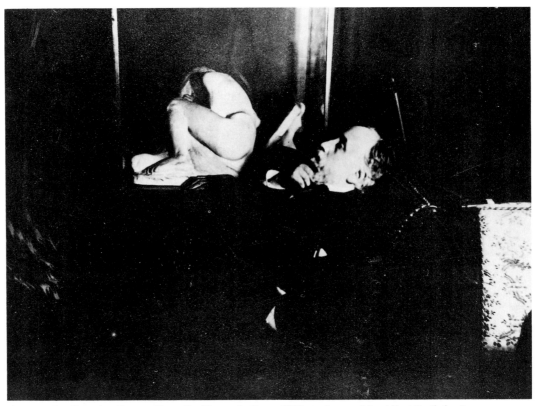

Fig. 272. Attributed to Degas, *Degas Looking at the Statue "Fillette pleurant," by Albert Bartholomé*
(T58), c. 1895–1900. Photograph printed from a glass negative in the Bibliothèque Nationale, Paris

Fig. 273. Attributed to Degas, *Degas, with Mme Ludovic Halévy (?) Reading the Newspaper* (T37), c. 1890–95. Photograph, modern print. The Metropolitan Museum of Art, New York

1 August
Writes to Ludovic Halévy that on the previous Thursday he was at a dinner given by Chéramy at Chez Durand, where he met Bertrand, the codirector of the Opéra.
Lettres Degas 1945, CLXII, p. 187; Degas Letters 1947, no. 175, pp. 177–78.

26 August
At the Opéra attends Verdi's *Aïda* for the tenth recorded time since 1887.
Archives Nationales, Paris, AJ13.

September
Writes to Halévy that he dined on Saturday at Albert Cavé's with Mme Howland and Charles Haas. On Friday is at the Rouarts' before seeing a revival of the play *La Cigale*, by Meilhac and Halévy, and on Monday will have the painter Jean-Louis Forain and his wife to dinner.
Lettres Degas 1945, CLXVII, p. 190; Degas Letters 1947, no. 180, p. 180.

Henri de Toulouse-Lautrec (1864–1901) writes to his mother: "Degas has encouraged me by saying my work this summer wasn't too bad."
Henri de Toulouse-Lautrec, *Lettres 1871–1901*, Paris: Gallimard, 1972, no. 127, p. 152; *Unpublished Correspondence of Henri de Toulouse-Lautrec*, London: Phaidon, 1969, no. 125, p. 135.

2 September
Goes to *Robert le Diable* (see cat. nos. 103, 159), which he will have seen at the Opéra six recorded times since 9 November 1885.
Archives Nationales, Paris, AJ13.

26 October
Although he is reputed to dislike Wagner's music, sees *Lohengrin* at the Opéra, with Caron singing the role of Elsa, and will see it again on 22 July 1892.
Archives Nationales, Paris, AJ13; Eugène de Solenière, *Rose Caron*, Paris: Bibliothèque de l'Art et de la Critique, 1896, p. 39.

1892
29 February
Sees *Guillaume Tell* by Rossini at the Opéra for the twelfth recorded time.
Archives Nationales, Paris, AJ13.

25 March
Leaves Paul Lafond in Pau to visit his "unfortunate" brother Achille in Geneva.
Unpublished letter to Bartholomé, 26 March 1892, National Gallery of Canada, Ottawa.

28 March
Sees Valernes in Carpentras, to which he has gone by way of Grenoble, Valence, and Avignon.
Fevre 1949, p. 94.

13 April
Death of Eugène Manet, brother of Édouard Manet, husband of Berthe Morisot, and father of Julie. Degas had seen him in agony earlier in the day.
Fevre 1949, p. 98.

27 June
Attends Gounod's *Faust* at the Opéra for the eleventh recorded time since 13 April 1885.
Archives Nationales, Paris, AJ13.

27 August
Has been painting two canvases of the billiard room at Ménil-Hubert, where he has been staying with the Valpinçons. Was to go by Tours, Bourges, Clermont-Ferrand, and Valence to Carpentras.
Lettres Degas 1945, CLXXII, pp. 193–94; Degas Letters 1947, no. 185, p. 183; Fevre 1949, p. 102; see "Interiors, Ménil-Hubert," p. 506, and cat. no. 302.

September

An exhibition of landscapes by Degas is held at Durand-Ruel; it is the first of only two exhibitions in his lifetime known to have been devoted to his work alone.

> See "Landscape Monotypes," p. 502.

October

Wears a curious contraption to strengthen his eyes.

> Lettres Degas 1945, CLXXIV, p. 195; Degas Letters 1947, no. 187, pp. 184–85; Halévy 1964, p. 67.

1893

Ambroise Vollard opens a small gallery.

March

In a Café (The Absinthe Drinker) (cat. no. 172), owned in Great Britain since it was first exhibited there in 1876, is shown at the Grafton Galleries in London and arouses a sensational dispute about its morality.

> Flint 1984, pp. 8–11.

23 May

Witness, with Puvis de Chavannes, at the marriage of Marie-Thérèse Durand, daughter of Paul Durand-Ruel, to Félix-André Aude.

> Archives, Eighth Arrondissement, Paris.

31 August

Visits his sister Thérèse and her ailing husband Edmondo Morbilli at Interlaken, Switzerland, and plans to stop at the Jeanniots at Diénay on his way back to Paris.

> Lettres Degas 1945, CLXXVI, pp. 196–97; Degas Letters 1947, no. 189, p. 189.

15 September

Witness, with Puvis de Chavannes, at the marriage of Jeanne Marie Aimée Durand, daughter of Paul Durand-Ruel, to Albert Édouard Louis Dureau.

> Archives, Eighth Arrondissement, Paris.

October

Writes to an unidentified woman about the death on 13 October of his brother Achille: "You haven't forgotten my poor Achille. You were hospitable and good to him in bad times. And remember how your husband went out at six in the morning to wait for him to be released from prison, that time he fired the revolver. He married in America, twelve years ago, and lived in Switzerland afterward. But in 1889 he had a slight stroke, two years after another which left him half-paralyzed. He had to stay in bed for two years, losing his speech and perhaps some of his reason. He has just died here after being back for two weeks. His wife insisted that nobody be invited to the funeral, and I have had to observe this restriction."

> Unpublished letter, n.d., Archives of the History of Art, The Getty Center for the History of Art and Humanities, Los Angeles, no. 860070.

4 November

At Degas's urging, Durand-Ruel opens an exhibition of the work of Gauguin. Degas buys *The Moon and the Earth* (fig. 274), one of Gauguin's most famous works.

> Wildenstein 1964, no. 499, pp. 202–03.

1894

Dated works: *Racehorses in a Landscape* (cat. no. 306), *Dancers, Pink and Green* (cat. no. 307), *Young Girl Braiding Her Hair* (cat. no. 319), and possibly also *Woman with a Towel* (cat. no. 324).

Fig. 274. Paul Gauguin, *The Moon and the Earth*, 1893. Oil on canvas, 44⅛ × 24⅜ in. (112 × 62 cm). The Museum of Modern Art, New York

Fig. 275. Paul Gauguin, *The Day of the God*, 1894. Oil on canvas, 27½ × 35⅞ in. (70 × 91 cm). The Art Institute of Chicago

17 March
Goes to see the collection of the critic Théodore Duret before its sale. Afterward, dines at Berthe Morisot's with Mallarmé, Renoir, Bartholomé, Paule and Jeannie Gobillard (daughters of Yves Gobillard-Morisot and nieces of Berthe Morisot), and Julie Manet.
> Manet 1979, p. 30; see cat. nos. 87–91, 332, 333.

19 March
At the Duret sale of works by Degas and his artist friends, Degas attacks Duret: "You glorify yourself as having been one of our friends. . . . I won't shake hands with you. Besides, your auction will fail."
> Halévy 1960, pp. 115–16; Halévy 1964, p. 94.

25 April
At the sale of the collection of the painter Millet, buys El Greco's *Saint Ildefonso* (fig. 276). He notes: "the painting that was over Millet's bed for a long time, bought at the sale after his wife's death."
> Harold E. Wethey, *El Greco and His School*, Princeton: Princeton University Press, 1962, II, no. X-361, p. 239; unpublished notes, private collection.

31 May
By telegram, invites Mallarmé, Renoir, and Berthe Morisot to dinner.
> Unpublished telegram, Bibliothèque Littéraire Jacques Doucet, Paris, MLL3284.

October
Death of Paul Valpinçon.

3 October
Writes to Halévy asking him to see a Creole actress named Schampsonn, "who has posed for me quite simply."
> Lettres Degas 1945, CLXXX, pp. 199–200; Degas Letters 1947, no. 194, pp. 188–89.

7 November
Julie Manet sees at Camentron's gallery a beautiful pastel by Degas of a woman at a milliner's trying on a hat before a cheval glass (cat. no. 232), and also horses and dancers. She reports that Degas has bought two of the three known parts of Manet's large *Execution of the Emperor Maximilian* (National Gallery, London), hoping to reunite them.
> Manet 1979, p. 50.

December
Death of Edmondo Morbilli.
> Fevre 1949, p. 92.

22 December
After a closed court-martial, Alfred Dreyfus is convicted of treason and sentenced to loss of military rank and to life imprisonment. Degas presumably supports the verdict.

1895

Degas buys one of Gauguin's great works, *The Day of the God* (fig. 275).
> 1984 Chicago, p. 189.

18 February
Writes to Durand-Ruel that he has bought eight works at the Gauguin sale for Fr 1,000.
> Unpublished letter, Durand-Ruel archives.

March
Dates a charcoal-and-pastel drawing of Alexis Rouart (fig. 304) made in preparation for the double portrait with his father (cat. no. 336).

2 March
Berthe Morisot dies, having referred to Degas in her final letter to her daughter Julie Manet.
> Morisot 1950, pp. 184–85; Morisot 1957, p. 187.

Fig. 276. El Greco, *Saint Ildefonso*, c. 1603–05. Oil on canvas, 44½ × 25¾ in. (112 × 65 cm). National Gallery of Art, Washington, D.C.

June
Obtains Delacroix's portrait *Baron Schwiter* (fig. 206) from the dealer Montaignac (who had bought it at the Schwiter sale in March 1890) in exchange for three of his pastels worth Fr 12,000.
> Unpublished notes, private collection.

11 August
Writes the first of several letters from Mont-Dore to Tasset, the color merchant and framer (of the firm Tasset et Lhote) who is helping him with the development and enlargement of his photographs.
> Newhall 1956, pp. 124–26.

18 August
At Mont-Dore, hoping for a cure from bronchitis, writes to his cousin Lucie Degas Guerrero de Baldo asking for a statement about his financial affairs in Naples.
> Lettres Degas 1945, CXCI, p. 207; Degas Letters 1947, no. 206, pp. 194–95.

late August
After Mont-Dore, spends five days at Saint Valéry-sur-Somme, where his family has gone since as early as 1857 (see Chronology I, 11 November 1857).
> Fevre 1949, p. 96.

Fig. 277. *Mme Ludovic Halévy and Her Son Daniel* (T16), c. 1895. Photograph, modern print. The Metropolitan Museum of Art, New York

29 September

Writes to Ludovic Halévy: "One fine day, I shall burst in on you, with my camera in hand."

Lettres Degas 1945, CXCIII, p. 208; Degas Letters 1947, no. 208, pp. 195–96.

October

His sister Marguerite dies in Buenos Aires. Degas arranges to have her body brought back to France and buried in the family vault in Montmartre cemetery.

Halévy 1960, pp. 79–81; Halévy 1964, pp. 69–71.

20 November

Julie Manet visits Degas; Mallarmé, Renoir, and Bartholomé are also there for dinner, served by Zoé.

Manet 1979, pp. 72–73.

29 November

Renoir takes Julie Manet to Degas's studio. She finds him modeling a nude in wax. Degas is also at work on a bust of Zandomeneghi, which has not survived. They go on to Vollard's to see an exhibition of the work of Cézanne. Degas embraces Julie when they part.

Manet 1979, pp. 73–74.

22 December

Degas shows his recent acquisitions to young Daniel Halévy, including works by Delacroix, van Gogh, and Cézanne. He says, "I buy, I buy. I can't stop myself."

Halévy 1960, p. 86; Halévy 1964, p. 73.

28 December

Undertakes a long photographic session after dinner at the Halévys'.

Halévy 1960, pp. 91–93; Halévy 1964, pp. 82–83; see "Photography and Portraiture," p. 535.

Fig. 278. Unidentified couple, c. 1895. Photograph, modern print. The Metropolitan Museum of Art, New York

Fig. 279. Jean-Auguste-Dominique Ingres, *Jacques-Louis Leblanc*, 1823. Oil on canvas, 47⅝ × 37⅝ in. (121 × 95.6 cm). The Metropolitan Museum of Art, New York

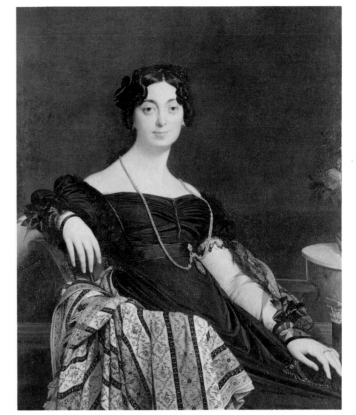

Fig. 280. Jean-Auguste-Dominique Ingres, *Mme Jacques-Louis Leblanc*, 1823. Oil on canvas, 47 × 36½ in. (119.4 × 92.7 cm). The Metropolitan Museum of Art, New York

1896

The Caillebotte bequest is accepted for the Musée du Luxembourg; included in it are seven works by Degas.

Through Vollard, Degas exchanges two small sketches of dancers for "Two Heads of Dried Sunflowers" by van Gogh.

> Unpublished notes, private collection.

January

Buys from Vollard "Three Pears" and "Green, Yellow, and Red Apples" by Cézanne for Fr 100 each.

> Unpublished notes, private collection.

1 January

Julie Manet writes to Mallarmé: "We have been told by M. Renoir that the photographs of M. Degas are a success and exhibited at Tasset's."

> *Documents Stéphane Mallarmé* (edited by Carl Paul Barbier), IV, Paris: Libraire Nizet, 1973, p. 427.

2 January

On rue Mansart, Degas delivers an informal speech to Daniel Halévy: "Taste! It doesn't exist. An artist makes beautiful things without being aware of it."

> Halévy 1960, p. 96; Halévy 1964, p. 85.

23 January

Durand-Ruel buys for Degas portraits of Jacques-Louis Leblanc (fig. 279) and Mme Leblanc (fig. 280) by Ingres at auction at Hôtel Drouot, Paris, no. 47, for Fr 3,500 and Fr 7,500 respectively. Bartholomé writes to Paul Lafond on 7 March: "Perhaps you have seen something in the papers about the sensation of his collecting career: the purchase of two portraits, of M. and Mme Leblanc, by Ingres."

> Archives, The Metropolitan Museum of Art, New York; letter from Bartholomé to Lafond, in Sutton and Adhémar 1987, p. 172.

Bartholomé adds: "After the [collecting of] walking sticks, it was photography, and now paintings, with an intensity that I am afraid worries Durand-Ruel, and that worries me for his future. His disinterestedness is all very fine, as is his idea of a museum. But will it catch on with other collectors as he believes? And one must eat."

> Letter from Bartholomé to Lafond, private collection.

In acquiring these paintings by Ingres, Degas reminds himself in a notebook of his having been taken to see them in 1855 in the house of a son of M. and Mme Leblanc, rue de la Vieille-Estrapade.

> Unpublished notes, private collection.

20 February

Writes to Julie Manet that Durand-Ruel will lend one small room for the posthumous exhibition of 300 of the works of her mother, Berthe Morisot.

> Degas Letters 1947, no. 209, p. 196.

2 March

On the first anniversary of Berthe Morisot's death, her daughter Julie Manet finds Degas working with Monet and Renoir on the hanging of the memorial exhibition of her mother's work at Durand-Ruel.

> Manet 1979, p. 77.

4 March

Degas hangs the drawings in Berthe Morisot's exhibition himself.

> Manet 1979, p. 77.

5 March

Death of Évariste de Valernes.

6 March

Goes to Valernes's funeral in Carpentras. (Bartholomé later writes to Lafond that Degas has left for Cauterets suddenly, "at the news of the death of M. de Valernes.")

> Sutton and Adhémar 1987, p. 173.

May

Visits "M. Ramel, brother of the second Mme Ingres," and lists eighteen works by Ingres that he has seen in their house.

Unpublished notes, private collection.

25 May

Writes to Henri Rouart congratulating him on his children and regretting his own celibacy.

Lettres Degas 1945, CXCIV, p. 209; Degas Letters 1947, no. 211, p. 197; see cat. no. 336.

20 June

Mrs. Potter Palmer of Chicago buys *The Morning Bath* (cat. no. 320) from Durand-Ruel.

28 July

Writes to Alexis Rouart: "Everything is long for a blind man who wants to pretend that he can see."

Lettres Degas 1945, CXCVIII, p. 212; Degas Letters 1947, no. 214, p. 199.

November

Buys *Saint Dominique* by El Greco (Museum of Fine Arts, Boston) from Zacharie Astruc for Fr 3,000.

Unpublished notes, private collection.

5 November

First Annual Exhibition opens at the Carnegie Institute Art Gallery in Pittsburgh, with two works by Degas.

18 November

Visits the exhibition of the work of his friend Jeanniot. Later the same day, shows the Halévys his enlarged photographs of Charles Haas (fig. 300), Ernest Reyer, Du Lau, and Mme Howland (fig. 301).

Halévy 1960, pp. 99–100; Halévy 1964, p. 87; see "Photography and Portraiture," p. 535.

Fig. 282. René De Gas, *Degas and His Niece at Saint-Valéry-sur-Somme*, c. 1900. Photograph printed from a glass negative in the Bibliothèque Nationale, Paris

Fig. 281. Paul Helleu, *Alexis Rouart*, 1898. Etching, 21¼ × 16⅜ in. (54 × 41.5 cm). Sterling and Francine Clark Art Institute, Williamstown

1897

February

The Caillebotte bequest is exhibited in the Musée du Luxembourg.

Lettres Pissarro 1950, p. 432; Pissarro Letters 1980, p. 307.

10 February

Julie Manet goes with Paule Gobillard to see Degas, who is not feeling well.

Manet 1979, p. 124.

20 March

Invites the painter Louis Braquaval (1854–1919) and his wife to dinner with René De Gas and his family (the first written record of a reconciliation with René).

Unpublished letter, private collection; see cat. no. 335.

16 August

Visits the Musée Ingres at Montauban with Bartholomé, perhaps for several days.

Lettres Degas 1945, CXCVIII, CXCIX, CCVII, pp. 211–12, 217; Degas Letters 1947, nos. 214, 216, 223, pp. 198, 200, 203–04.

November–December

Because of his anti-Semitism, Degas becomes increasingly estranged from the liberal and bourgeois—and partly Jewish—Halévy family.

15 November

Writes to Mme Halévy of trouble with his lungs; hopes to have dinner with the Halévys on Thursday, the 19th.

Lettres Degas 1945, CCVIII, p. 218; Degas Letters 1947, no. 225, pp. 204–05.

25 November

Zola publishes his first article in *Le Figaro* supporting Dreyfus.

1987–88 New York, p. ix.

Daniel Halévy writes in his journal: "Last night, chatting among ourselves at the end of the evening—until then the subject [the

Dreyfus Affair] had been proscribed, as Papa was on edge, Degas very anti-Semitic—we had a few moments of delightful gaiety and relaxation."

Halévy 1960, pp. 127; Halévy 1964, p. 100.

1 December

Degas finds an excuse to avoid a dinner at the Halévys' in a letter to Mme Halévy: "I must beg you to excuse me tomorrow, my dear Louise. Young Mme Alexis Rouart has actually recovered her health and with it her knack for friendship. She has so very kindly asked me for dinner on Thursday to continue with *Candide* that I cannot refuse. Do forgive me."

Letter from Degas to Louise Halévy, Bibliothèque de l'Institut, Paris, no. 352.

8 December

Julie Manet and Paule Gobillard run into Degas at the Louvre, where he talks to them of painting and the works in the Louvre. Degas may then have introduced Julie to her future husband, Ernest Rouart, whom she describes as "his pupil M. Rouart." They go on to the Mallarmés'.

Manet 1979, pp. 143–44.

13 December

Zola's pamphlet *Letter to Youth* calls on young intellectuals to rally in support of Dreyfus.

1987–88 New York, p. ix.

23 December

Degas dines for the last time at the Halévys'. Daniel Halévy later writes: "One last time Degas dined with us. Who the other guests were I don't remember. Doubtless, young people who didn't care what they said. Degas remained silent. Conscious of the threat that hung over us, I watched his face attentively. His lips were closed; he looked upwards almost constantly, as though cutting himself off from the company that surrounded him. Had he spoken it would no doubt have been in defense of the army, the army whose traditions and virtues he held so high, and which was now being insulted by our intellectual theorizing. Not a word came from those closed lips, and at the end of dinner Degas disappeared.

"The next morning my mother read without comment a letter addressed to her and, hesitating to accept its significance, she handed it in silence to my brother Élie. My brother said, 'It is the language of exasperation.'"

Lettres Degas 1945, CCX, p. 219; Degas Letters 1947, no. 227, pp. 205–06; Halévy 1960, pp. 127–28; Halévy 1964, pp. 100–101.

The letter in question, probably written on 23 December 1897, is almost certainly the following: "Thursday—It is going to be necessary, my dear Louise, to give me leave not to appear this evening and I might as well tell you right away that I am asking it of you for some time to come. You couldn't imagine that I would have the courage to be gay all the time, to make small talk. I can no longer laugh. In your goodness you thought that these young people and I could mix with each other. But I am a burden to them, and they are even more unbearable to me. Leave me in my corner, where I will be happy. There are very good moments to remember. If I let our affection, which goes back to your childhood, suffer greater strain, it will be broken.—Your old friend, Degas."

Unpublished letter, private collection.

1898

André Méllerio writes of the twenty reproductions of the drawings of Degas exhibited at Boussod, Manzi, Joyant et Cie (published as *Degas: vingt dessins, 1861–1896*) that "the technique used by M. Manzi for these reproductions warrants real attention" and that since "the works of M. Degas, even his lesser drawings, are fetching increasingly enormous sums," such a publication "will help

perpetuate and further disseminate the essence, the very core of this artist."

André Méllerio, "Expositions: un album de 20 reproductions," *L'Estampe et l'Affiche*, II, 1898, p. 82.

January

Buys a "still life with glass and serviette" by Cézanne (Kunstmuseum Basel) from Vollard for Fr 400.

Unpublished notes, private collection.

20 January

Julie Manet records in her journal anti-Semitic statements by both Renoir and Degas. Of Degas, she writes: "We went to invite M. Degas to join us, but we found him so worked up against the Jews that we went our way without asking anything of him."

Manet 1979, p. 150.

22 April

Degas attends the funeral of Gustave Moreau at the Church of La Trinité in Paris and walks with Comte Robert de Montesquiou to the burial at Montmartre cemetery.

Mathieu 1976, p. 185; Robert de Montesquiou, *Altesses sérénissimes*, Paris: Librairie Félix Juven [1907].

May

Buys for Fr 200 a painting by Cézanne of green pears, which he describes as "relined—without doubt, a fragment of a picture."

Unpublished notes, private collection.

June

Degas sees the two portraits of Mme Moitessier by Ingres, the standing version (now in the National Gallery of Art, Washington, D.C.) and the seated (National Gallery, London), and makes the following notes: "There are two painted portraits, one standing facing us, with bare arms, a black velvet dress on a reddish ground, some flowers in her hair, belonging to her daughter, Mme la Comtesse de Flavigny, 9 rue de la Chaise, where I just saw it in June 1898. Mme de Flavigny, still in mourning for her mother, dead the past year, received me, and we chatted about the portrait. She quite naturally found the arms too fat, and I wanted to persuade her that they are right like that. She alerted her sister Mme de Bondy, who owns the other, the seated version, and I was able to see it in her absence, 42 rue d'Anjou (to see it with difficulty, the hôtel is for sale, and the interior turned completely upside down) (flowered dress, fine composition, less finished than the other, and more modern)."

Unpublished notes, private collection.

Fig. 283. *Odette De Gas, the Artist's Niece(?)* (T55), c. 1900. Photograph printed from a glass negative in the Bibliothèque Nationale, Paris

22 August
Writes to Henri Rouart that he is at Saint-Valéry-sur-Somme. (He may have been staying with Braquaval or with his brother René.)
> Lettres Degas 1945, CCXIX, p. 224; Degas Letters 1947, no. 237, p. 210; see "Late Landscapes at Saint-Valéry-sur-Somme," p. 566.

10 September
Death of Stéphane Mallarmé.

3 November
Julie Manet visits Degas, who teases her about marriage and mentions Ernest Rouart. She finds "ravishing" a wax of a nude on which he is working.
> Manet 1979, p. 202.

22 December
Attends a reception at the Rouarts' for Yvonne Lerolle, who is to marry their son Eugène. Degas tells Julie Manet, "I found Ernest for you . . . now it's up to you to carry on."
> Manet 1979, p. 207.

27 December
Attends the wedding of Yvonne Lerolle and Eugène Rouart.
> Manet 1979, p. 208.

28 December
Is one of fifteen at a dinner party at Julie Manet's.
> Manet 1979, p. 208.

1899
28 January
Julie Manet asks Degas for a drawing to be used in a publication of Mallarmé's poems. He refuses because the publisher is a Dreyfusard.
> Manet 1979, p. 213.

26 March
Drafts a letter to an unknown person, angry about persistent requests to exhibit his works.
> Lettres Degas 1945, CCXIII, p. 227; Degas Letters 1947, no. 240, p. 212.

25 April
Julie Manet writes that on a visit to the Hôtel Desfossés to see a collection to be auctioned the next day, Degas has spoken to her of Ernest Rouart as "a young man to marry."
> Manet 1979, p. 228.

6 June
Julie Manet and Ernest Rouart dine at Degas's. At the end of the evening, Julie writes: "I thought about it all, and told myself that Ernest is the one for me."
> Manet 1979, p. 233.

29 June
Julie Manet sees Degas at the exhibition of the Chocquet collection at Galerie Georges Petit; he praises Ernest Rouart.
> Manet 1979, pp. 236–37.

1 July
At the Chocquet sale, buys two works by Delacroix. After the sale, takes Julie Manet and one of the Gobillard sisters to his studio and shows them three pastels of Russian dancers on which he has been working.
> Manet 1979, pp. 237–38; see "The Russian Dancers," p. 581.

19 September
Dreyfus is pardoned, a judgment Degas presumably does not accept.

16 November
Julie Manet writes in her journal of quarrels between Renoir and Degas, now reconciled.
> Manet 1979, p. 279.

toward 1900
Facing with distrust the exhibition *Centennale d'art français* proposed for the Grand Palais, still under construction, to complement the Exposition Universelle, Degas writes to Lafond: "I want to know whether the Pau museum has been asked to lend its picture of the cotton market [cat. no. 115] to this 'Concentration.' I want to prevent this loan about which I was not consulted." The museum, of which Lafond was the curator, nevertheless lends the painting. In addition, Mrs. Sickert lends her *Rehearsal of the Ballet on the Stage* (cat. no. 124).
> Sutton and Adhémar 1987, p. 175.

1900
The second version of *The Ballet from "Robert le Diable"* (cat. no. 159) is bequeathed by C. A. Ionides to the Victoria and Albert Museum, London.

16 March
Writes to Louis Rouart, son of Henri, in Cairo telling him that Julie Manet and his brother Ernest, already looking married, had come to dinner with Alexis Rouart.
> Lettres Degas 1945, CCXXIV bis, pp. 228–29; Degas Letters 1947, no. 244, pp. 214–15.

30 April
Invites Maurice Tallmeyer (an anti-Dreyfus journalist who had been at the same hotel at Mont-Dore in 1897) to dinner at 7:30 at his place with Forain and Mme Potocka (née Pignatelli d'Aragon), a famous beauty.
> Lettres Degas 1945, CCXXV, p. 229; Degas Letters 1947, no. 245, p. 215.

31 May
Attends the double wedding of Julie Manet and Ernest Rouart and of Jeannie Gobillard and Paul Valéry at the church of Saint-Honoré d'Eylau.
> Agathe Rouart Valéry, *Paul Valéry*, Paris: Gallimard, 1966, p. 59; Manet 1979, p. 289.

1901
Fourteen years after the death of his first wife, Albert Bartholomé remarries. His second wife is Florence Letessier, a model described by Degas in a letter to his sister Thérèse as "quite young."
> Unpublished letter, National Gallery of Canada, Ottawa.

There is some estrangement between Bartholomé and Degas afterward. Degas writes to Lafond: "He asked me to be a witness: I knew nothing about it before everybody else. You have often heard me quote the Russian proverb: 'silver in the beard, devil in the heart.'"
> Sutton and Adhémar 1987, p. 176.

January
In his annual New Year's letter to Suzanne Valadon, whom he always calls Maria, Degas writes: "That she-devil of a Maria, what talent she has."
> Degas Letters 1947, no. 251, p. 218.

28 August
Writes to Joseph Durand-Ruel of a "Blanchisseuse" (possibly L216, Neue Pinakothek, Munich) that he has finished and which Durand-Ruel will recognize.
> Lettres Degas 1945, CCXXXI bis, p. 234; Degas Letters 1947, no. 252, p. 218.

9 September
Toulouse-Lautrec dies at his mother's château at Malromé. Degas seems to have been relatively indifferent to Lautrec, much as the other artist admired and imitated his work.

1902

30 September

Bartholomé writes to Lafond about the growing estrangement between him and Degas: "Degas is as rude as ever in order to show that he has not changed. He always made a great fuss about coming to dinner at Auteuil [a suburb of Paris to which Bartholomé had moved], but the last time I saw him he said very naïvely, 'I need air. I take walks. Yesterday I was at Auteuil.'"

> Letter from Bartholomé to Lafond, private collection.

1903

Dated work: *Woman at Her Toilette* (fig. 335).

> See "The São Paulo Bather," p. 600.

8 May

Death of Paul Gauguin on Hiva Oa in the Marquesas Islands.

September

Writes to Alexis Rouart that he has done some figures in wax, adding: "With no work, what a sad old age!"

> Lettres Degas 1945, CCXXXII, p. 234; Degas Letters 1947, no. 254, p. 219.

13 November

Death of Pissarro, from whom Degas had been estranged since the Dreyfus Affair.

30 December

Writes a short, sentimental letter to Félix Bracquemond, referring to their efforts to start a periodical of prints, *Le Jour et la Nuit*, and hoping that they will see each other again "before the end."

> Lettres Degas 1945, CCXXXIII, p. 235; Degas Letters 1947, no. 255, p. 220.

1904

May

Daniel Halévy visits Degas, who has been ill with intestinal grippe for two months. He is shocked to "see him dressed like a tramp, grown so thin, another man entirely."

> Halévy 1960, pp. 131–32; Halévy 1964, p. 103.

3 August

Writes to Hortense Valpinçon, whom he intends to visit at Ménil-Hubert for a short stay.

> Degas Letters 1947, no. 256, p. 220.

10 August

Writes to Durand-Ruel that he is "working like a galley slave" and that Durand-Ruel would see new things very far advanced. Complains that he has grown old without learning how to make money. Needs Fr 3,500 from Durand-Ruel to settle a bill with Brame, presumably for the purchase of works of art.

> Lettres Degas 1945, CCXXXIV, pp. 235–36; Degas Letters 1947, no. 258, pp. 221–22.

August

Spends time at Pontarlier, where he has gone by way of Épinal, Gérardmer, Alsace, Munster, Colmar, Belfort, Besançon, and Ornans. On 28 August, writes to Durand-Ruel asking for Fr 400, half of which he intends to send to Naples. Plans to make trips from Pontarlier and return by Nancy. (He has gone to Pontarlier for gastritis, which he described in a letter at the beginning of August to Paul Poujaud as being a mental illness.)

> Lettres Degas 1945, CCXXXIX, p. 239; CCXXXV, p. 236; CCXXXVI, p. 237; Degas Letters 1947, no. 261, p. 223, no. 259, p. 222, no. 257, p. 221.

27 December

Writes to Alexis Rouart: "It is true, my dear friend, you put it well, you are my family."

> Lettres Degas 1945, CCXXXVII, p. 238; Degas Letters 1947, no. 262, p. 223 (translation revised).

1904–05

Makes portraits in pastel of M. and Mme Louis Rouart (L1437–L1444, L1450–L1452) and the young Mme Alexis Rouart with her son and daughter (see cat. nos. 390, 391).

> Lemoisne [1946–49], I, p. 163.

1905

February

In an exhibition arranged by Durand-Ruel at the Grafton Galleries in London, thirty-five of Degas's works are shown along with those of Boudin, Cézanne, and the Impressionists.

21 April

Writes to his sister Thérèse in Naples from the country house of Henri Rouart at La Queue-en-Brie, where he has spent several days. He intends to tour the neighborhood.

> Unpublished letter, National Gallery of Canada, Ottawa.

1906

18 April

Writes to his sister Thérèse that he is relieved that she and his other Neapolitan relatives were not affected by the eruption of Vesuvius.

> Unpublished letter, National Gallery of Canada, Ottawa.

12 July

Alfred Dreyfus is completely rehabilitated, but Degas's attitude does not change.

September

Writes to his niece Jeannie Fevre that he must go to Naples and may stop to see her in Nice.

> Reff 1969, no. 10, p. 288 (BN, Ms. Nova, Acq. Fr. 24839, fol. 159).

22 October

Death of Cézanne, whose works Degas admires and of which he owns seven canvases and a watercolor.

late October

Goes to Naples.

5 December

Has returned from Naples in time to have dinner with the Rouarts—"my family in France"—on Friday. Writes Thérèse that between Marseilles and Lyons his pocket was picked of Fr 1,000, and he believes he was drugged first.

> Unpublished letter to Thérèse Morbilli, National Gallery of Canada, Ottawa.

1907

February

The dentist Paul Paulin makes his second bust of Degas in Degas's studio.

> Letter from Paulin to Lafond, 7 March 1918, in Sutton and Adhémar 1987, p. 179.

6 August

Writes to Alexis Rouart that he is working on drawings and pastels. He is no longer tempted to take trips, but when it grows dark (about 5:00 P.M.), he takes a tram to Charenton or some other place. On Sunday, he is to go see Henri Rouart, who is recovering. He himself suffers from pains in his kidneys.

> Lettres Degas 1945, CCXLIII, pp. 241–42; Degas Letters 1947, no. 268, pp. 226–27.

26 December

The collector and writer Étienne Moreau-Nélaton visits Degas in his studio. Degas, who is working on a pastel of a bather, talks

about his collecting. They go together to Lésin, on rue Guénégaud, who mounts Degas's drawings and has the secret of the fixative given to Degas by Luigi Chialiva (1842–1914).

Moreau-Nélaton 1931, pp. 267–70.

1908
May

Calls on the Halévys to view the body of Ludovic, whom he had not seen since 1897 because of their differences over the Dreyfus Affair.

Halévy 1960, pp. 134–35; Halévy 1964, pp. 104–05.

21 August

Writes to Alexis Rouart that he wants to do sculpture: "Soon one will be a blind man."

Lettres Degas 1945, CCXLV, p. 243; Degas Letters 1947, no. 270, p. 227.

November

Death of Célestine Fevre, a daughter of his sister Marguerite, at La Colline-sur-Loup, near Nice (see fig. 24).

18 November

Degas has dinner with the Bartholomés (see fig. 284). Bartholomé writes to Lafond: "He was well and in charming good humor."

1909

The painter's cousin Lucie dies in Naples.

late May

Is presumed to have attended performances of the first appearance of Diaghilev's company in Paris after its opening on 19 May.

1910
11 March

Writes to Alexis Rouart: "I do not finish with my damned sculpture."

Lettres Degas 1945, CCXLVIII, pp. 244–45; Degas Letters 1947, no. 273, p. 229.

4 August

Writes to Mme Ludovic Halévy: "My dear Louise—Thank you for your kind letter. One of these days, you will discover me on your doorstep.—Affectionately, Degas."

Unpublished notes, private collection.

1911
April

A one-man show (his second) is held at the Fogg Art Museum at Harvard University. Among the twelve works are *Interior* (cat. no. 84) and *Racehorses at Longchamp* (cat. no. 96).

May

Goes to a large exhibition of the work of Ingres at Galerie Georges Petit.

Halévy 1960, pp. 138–39; Halévy 1964, p. 107.

June

While visiting the Rouarts at La Queue-en-Brie, Degas sees his first airplane. Has lunch with Mme Ludovic Halévy, M. and Mme Daniel Halévy, and Mme Élie Halévy at Sucy-en-Brie. Élie, Daniel's brother and a distinguished historian, refuses to come down to lunch because he has never forgiven the painter for his anti-Dreyfus stand.

Halévy 1960, pp. 139–41; Halévy 1964, pp. 107–08. (Both Mme Daniel Halévy and Mme Élie Halévy described the episode to this author.)

1912

Death of Henri Rouart.

His rue Victor-Massé apartment (where he has lived since 1890) is to be demolished, and Degas must move. With the help of friends, in particular Suzanne Valadon, he finds another apartment, at 6 boulevard de Clichy. Is depressed over the forced move.

12 July

Writes to his Fevre nieces to announce the death of his sister Thérèse in Naples.

Fevre 1949, p. 113.

29 July

Sends money to Naples to help pay for the funeral expenses of Thérèse.

Unpublished letter, National Gallery of Canada, Ottawa.

3 December

Mary Cassatt writes to Mrs. Havemeyer of visiting Degas's Fevre nieces but finding only "the Comtesse" (presumably Anne, Vicomtesse de Caqueray) at home. They live near Nice "in a most romantic valley," ignorant, until she explains it to Anne, of the value of their uncle's work.

Unpublished letter, Archives, The Metropolitan Museum of Art, New York, C34.

10 December

Goes to the sale of Henri Rouart's collection; his *Dancers at the Barre* (cat. no. 164) sells for Fr 478,000. Daniel Halévy encounters Degas

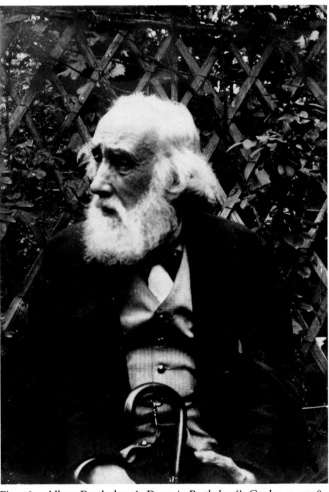

Fig. 284. Albert Bartholomé, *Degas in Bartholomé's Garden*, c. 1908. Photograph, modern print. Bibliothèque Nationale, Paris

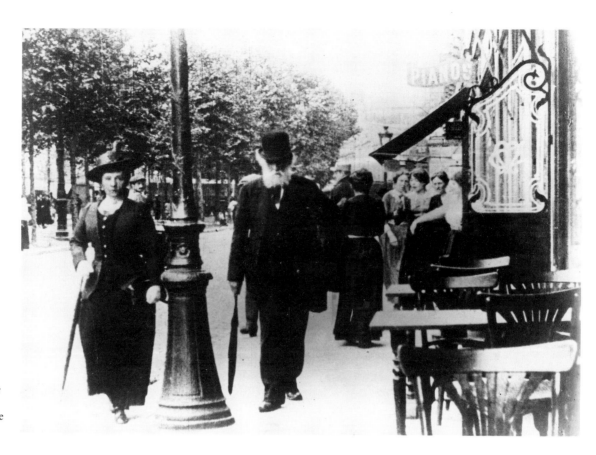

Fig. 285. Sacha Guitry, *Degas in the Streets of Paris*, 1912–14. Photograph, modern print. Bibliothèque Nationale, Paris

at the auction (apparently he has not seen him for some time). Halévy hears a voice say "Degas is here," and "there was Degas . . . sitting motionless like a blind man." He and Degas walk away from the auction house, and Degas says, "You see, my legs are good. I walk well. But since I moved, I no longer work. . . . I let everything go. It's amazing how indifferent you get in old age."

Halévy 1960, pp. 141–48; Halévy 1964, pp. 108–11.

13 December

Daniel Halévy sees Degas again at an exhibition of the Rouart drawings that will be sold. At noon, the gallery is closed. "Degas goes out first and we all follow him. Is it an apotheosis or a funeral? Not out of indifference, but out of consideration, everyone leaves him to his vague and grandiose solitude. He departs alone."

Halévy 1960, pp. 148–49; Halévy 1964, p. 111.

1913

The museum in Frankfurt buys *Orchestra Musicians* (cat. no. 98) from Durand-Ruel.

11 September

Mary Cassatt writes to Mrs. Havemeyer that she is expecting a Fevre niece of Degas's, whom she has urged to come to Paris to see his condition. She says he is "immensely changed mentally but in excellent physical health."

Unpublished letter, Archives, The Metropolitan Museum of Art, New York, B92.

4 December

Mary Cassatt writes to Mrs. Havemeyer that Degas is "a mere wreck."

Unpublished letter, Archives, The Metropolitan Museum of Art, New York, C48AB.

1915

17 November

René de Gas writes to Lafond: "Thank you for your interest in the health of dear Edgar. Unhappily, I cannot tell you anything encouraging. Considering his age, his physical state is certainly not bad; he eats well, does not suffer from any infirmity except his deafness, which is increasing and makes conversation very difficult. . . . When he goes out, he can hardly walk farther than place Pigalle; he spends an hour in a café and returns painfully. . . . He is admirably looked after by the incomparable Zoé. His friends rarely come to see him because he hardly recognizes them and does not talk with them. Sad, sad end! Still, he is going gradually without suffering, without being beset by anxieties, indeed surrounded by devoted care. That is the main thing, is it not!"

Letter, private collection; cited in part in Sutton and Adhémar 1987, p. 177.

1916

Jeanne Fevre, at Mary Cassatt's urging, comes to nurse her uncle.

summer

Visits the Bartholomés at Auteuil.

1917

13 September

Paulin writes to Lafond that Bartholomé "added in his letter that he had seen Degas before leaving, that he was more beautiful than ever, like an old Homer with his eyes looking into eternity." Paulin goes on: "I myself went to see him before leaving again. Zoé and Mlle Lefèvre [sic] are always there. He does not go out. He dreams, he eats, he sleeps. When he was told that I was there, it seemed that

he remembered me and said 'show him in.' I found him seated in an armchair, draped in a generous bathrobe, with that air of the dreamer we have always known. Does he think of something? We cannot tell. But his pink face seems narrower; it is now framed by long thinning hair and a great beard, both of a pure white, giving him great presence. I need not tell you that I did not stay long. We shook hands, and said we would see each other soon. That is all."

Letter, private collection.

27 September
Degas dies from cerebral congestion.

28 September
After a short service at the nearby Church of Saint-Jean-l'Évangéliste, Degas is buried in the family vault at Montmartre cemetery, next to the tomb of Mme Moitessier (whose portraits by Ingres he had admired in June 1898). On a sunny day in wartime Paris, about one hundred people attend, including Bartholomé, Bonnat, Cassatt, Joseph and Georges Durand-Ruel, Jeanne Fevre, Forain, Gervex, Louise Halévy, Lerolle, Monet, Raffaëlli, Alexis and Louis Rouart, Sert, Vollard, and Zandomeneghi.

Mathews 1984, p. 328.

Lithographs: Nude Women at Their Toilette

cat. nos. 294–296

On 6 July 1891, Degas wrote to Évariste de Valernes, "I am hoping to do a set of lithographs, a first series on nude women at their toilette, and a second on nude dancers."[1] It has always been quite reasonably assumed that six lithographs of bathers (RS61–RS66), including *Nude Woman Standing Drying Herself* (cat. no. 294) and *After the Bath* (cat. nos. 295, 296), were the result, though Richard Brettell has suggested an earlier date for the first print (cat. no. 294).[2]

Certainly Degas had earlier been attracted, in other mediums—oil, pastel, drawing, and perhaps wax sculpture—to the idea of a female nude seen from behind, long hair hanging down and body arched as she dries or sponges her hip or the upper part of a leg. These earlier studies seem to have culminated in the three lithographs.

Richard Thomson has recently suggested that the source for the figure in these lithographs was the *Entry of the Crusaders into Constantinople*, a work by Delacroix in the Louvre: "Thirty years later [after having made a copy of the Delacroix] he returned to the grieving woman at the lower right, . . . retaining her broad back and tumbling hair, but changing her setting from the melodramatic to the domestic."[3]

1. See cat. no. 58. See also Lettres Degas 1945, CLIX, p. 182; Degas Letters 1947, no. 172, p. 175 (translation revised), incorrectly dated December instead of July.
2. 1984 Chicago, p. 170, no. 78. Brettell relates this print to the light-field monotypes of ten years earlier—which are even less securely dated—though he suggests the later date of 1890–91 in his caption for the work.
3. 1987 Manchester, p. 124.

294.

Nude Woman Standing Drying Herself

1891
Transfer lithograph, crayon, tusche, and scraping on white laid paper
Image: 13 × 9⅝ in. (33 × 24.5 cm)
Sheet: 16¾ × 11⅞ in. (42.5 × 30 cm)
Signed in pencil lower left: Degas
Print Department, Boston Public Library. Albert H. Wiggin Collection

Reed and Shapiro 61.IV

Degas made a preliminary drawing of this subject that shows that he had thought of making the nude smaller in relation to the room in which she stands drying herself behind a chaise longue.[1] Although he did eventually enlarge the figure, and merely suggests the room with strokes of rich ornament on the wall—emphasizing the purity of her body—the intimacy of a boudoir scene remains.

The sensuality of the lithograph is created by an enjoyment of the contours, the play of the blackness of the lithographic ink—often dryly applied—against the white of the paper. The bather's breast is somewhat indefinite, essentially concealed by the black shadow and protected by the arm. Her right hip, however, juts out provocatively, and the buttocks are rendered with a certain tenderness.

Degas's obvious pleasure in the contours of the body and in its sensuality must have been inspired by Ingres. In the beginning of 1891 (22 January), at dinner at the Halévys', he described a meeting with Ingres during which the older artist had said, "Draw lines, young man, draw lines; whether from memory or from nature."[2] On that occasion, Degas also quoted some of the older artist's aphorisms, including, "Form is not in the contour; it lies within the contour" and "Shadow is not an addition to the contour but makes it." This lithograph seems to illustrate Degas's acceptance of Ingres's advice.

In the preliminary drawings and in the various states of the lithograph, there is an increasing emphasis on the model's beautiful head of hair, which flows downward as she leans to dry her hip, the towel over her wrist echoing in white the downward movement

294

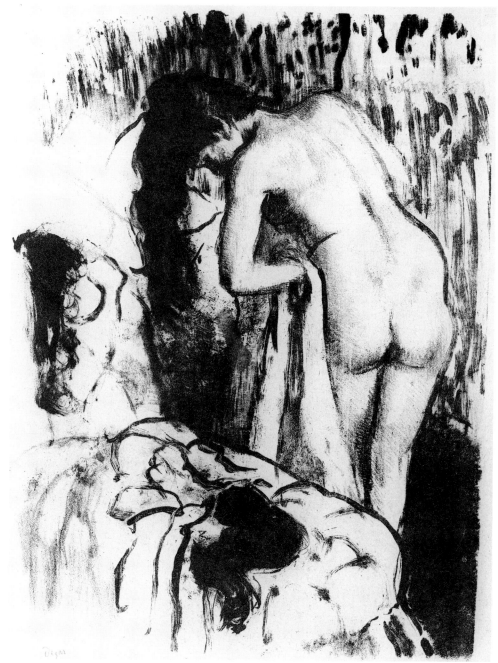

of the hair.[3] Two hairpieces, one hanging on the back of the chaise and one curled on the seat, appear almost animate.

There is a particular poignancy in the contrast between the weight of the woman's abundant black hair and the youthfulness of her tenderly rendered body—as if some of the bather's energy were pouring out from her hair.

1. III:384.
2. Halévy 1960, pp. 57, 59; Halévy 1964, p. 50.
3. II:318; II:316; III:327.1, Clark Art Institute, Williamstown; II:321; III:262.

PROVENANCE: Albert Henry Wiggin, New York (Lug suppl. 2820a, not stamped); his gift to the Boston Public Library 1941.

SELECTED REFERENCES: Delteil 1919, no. 65.III/IV; E. W. Kornfeld and Richard H. Zinser, *Edgar Degas Beilage zum Verzeichnis der graphischen Werkes von Loy Delteil*, Bern: Kornfeld und Klipstein, 1965, repr. n.p.; 1967 Saint Louis, pp. 30–31, nos. 18, 19; Adhé mar 1974, no. 63; Reed and Shapiro 1984–85, pp. LXV–LXXII, no. 61.IV.

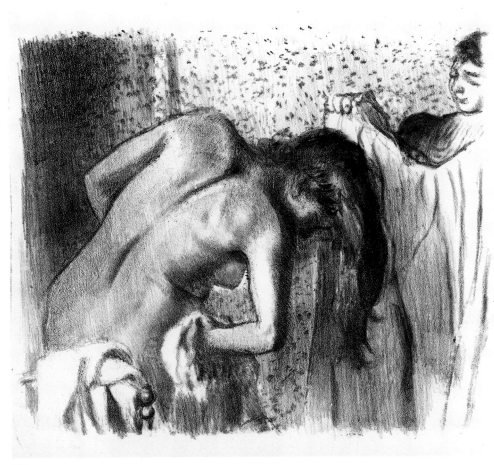

295

296

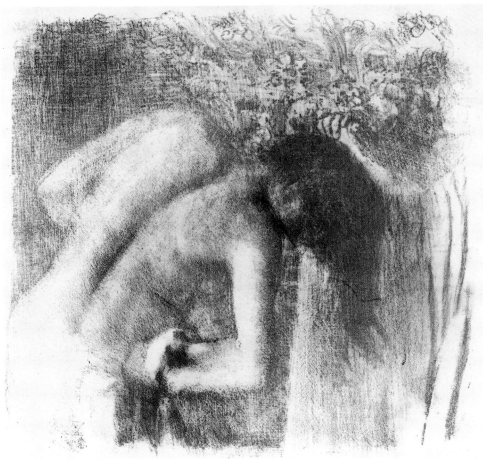

295.

After the Bath, large plate

1891–92
Transfer lithograph, crayon, and scraping on off-white heavy smooth wove paper
Sheet: 12½ × 17½ in. (31.7 × 44.6 cm)
Image maximum: 11⅞ × 12⅞ in. (30.2 × 32.7 cm)
Atelier stamp at right of plate mark, lower right
The Art Institute of Chicago. Clarence Buckingham Collection (1962.80)

Reed and Shapiro 66.III

Degas here achieves a greater monumentality than in *Nude Woman Standing Drying Herself* (cat. no. 294) by showing less of the model's

Fig. 286. *The Toilette after the Bath* (L1085), c. 1891 Charcoal and pastel, 15 × 13⅜ in. (38 × 34 cm). The Burrell Collection, Glasgow

body and by having it dominate the space. In the Burrell Collection in Glasgow, there is a charcoal and pastel drawing (fig. 286) in which a maidservant, as solemn-featured as an acolyte, holds up a towel for the bathing figure. Degas seems in that drawing to have begun with a more concentrated composition and then, as was his custom, to have patched on additional pieces of paper to the sheet so that more of the nude is seen and the space around her is amplified. The rendering of the hair is particularly luxuriant.

In the third state of *After the Bath*, the hair is as rich as in the drawing but the background ornament is smaller and more repetitive and the maid's expression is gentler and more attentive.

PROVENANCE: With Louis Carré, Paris, 1919. With Richard Zinser, New York; acquired by the museum 1962.

EXHIBITIONS: 1967, Saint Louis, Steinberg Hall, Washington University, 7–28 January/Lawrence, The Museum of Art, The University of Kansas, 8 February–4 March, *Lithographs by Edgar Degas* (catalogue by William M. Ittman, Jr.), no. 15, repr.; 1984 Chicago, no. 81, repr.; 1984–85 Boston, no. 66.III, repr.

SELECTED REFERENCES: Delteil 1919, no. 64; E. W. Kornfeld and Richard H. Zinser, *Edgar Degas: Beilage zum Verzeichnis der graphischen Werkes von Loys Delteil*, Bern: Kornfeld und Klipstein, 1965, repr. n.p.; Passeron 1974, pp. 70–74; Reed and Shapiro 1984–85, pp. XLV–LXIX.

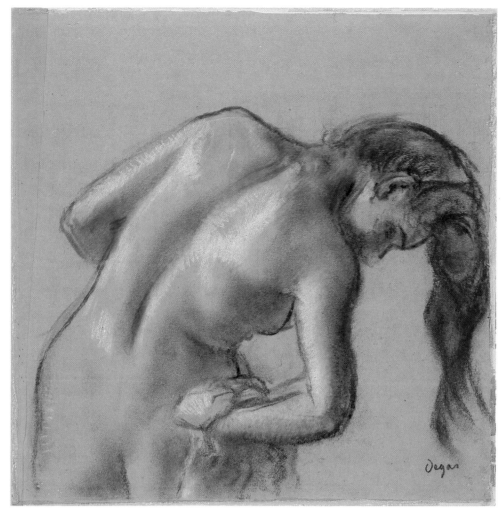

297

296.

After the Bath, large plate

1891–92
Transfer lithograph, crayon, and scraping on off-white laid paper
Image: 12 × 12⅜ in. (30.5 × 31.5 cm)
Sheet: 16⅞ × 19⅛ in. (42.9 × 48.7 cm)
National Gallery of Canada, Ottawa (23117)

Reed and Shapiro 66.V

In the fifth and final state of *After the Bath*, the handling is broader, as if to exploit the innate roughness of the lithographic stone, though Degas actually used transfer papers. There are almost no contours as the forms merge into each other and into space. There seem to be memories of the wallpaper in the Burrell Collection drawing (fig. 286) as the wall bursts into flower in the upper right. Unlike in the more realistic Burrell drawing, here the maidservant's hand, holding up a towel like Saint Veronica's veil, appears disembodied; the fingers, poised in a gesture of benediction, release an aura of light above the bather's hair. Beneath the hand, the bather's profile is lost in shadow, the hair, shortened and rough, hardly distinguished

in form and texture from the towel. The sense of mystery, which other commentators acknowledge,[1] is heightened by the barely visible though compassionate features of the maidservant's face.

1. Sue Welsh Reed and Barbara Stern Shapiro in 1984–85 Boston, p. 248.

PROVENANCE: Auguste Clot, Paris; Louis Rouart, Paris; David David-Weill, Paris (sale, Drouot, Paris, 25–26 May 1971, no. 53); Barbara Westcott, Rosemont, N.J.; with David Tunick, 1971; bought by the museum 1977.

EXHIBITIONS: 1979 Ottawa; 1981, Ottawa, National Gallery of Canada, 1 May–14 June/Montreal Museum of Fine Arts, 9 July–16 August/Windsor Art Gallery, 13 September–14 October, "La pierre parle: Lithography in France 1848–1900" (organized by Douglas Druick and Peter Zegers; no catalogue), no. 493.

SELECTED REFERENCES: Delteil 1919, no. 64; E. W. Kornfeld and Richard H. Zinser, *Edgar Degas: Beilage zum Verzeichnis der graphischen Werkes von Loys Delteil*, Bern: Kornfeld und Klipstein, 1965, repr. n.p.; Passeron 1974, pp. 70–74; Reed and Shapiro 1984–85, pp. lxv–lxix.

297.

Bather Drying Herself

c. 1892
Pastel and charcoal, heightened with white chalk, on tracing paper
10⅜ × 10⅜ in. (26.4 × 26.4 cm)
Signed lower right: Degas
The Metropolitan Museum of Art, New York. Bequest of Stephen C. Clark, 1960 (61.101.18)

Exhibited in New York

Lemoisne 856

At one point in his preoccupation with the lithograph *After the Bath* (cat. nos. 295, 296), it seems that Degas made a tracing of the bather alone, eliminating the setting and the maid and giving more emphasis to the figure's contours and anatomy.[1] The strong line of the forehead and nose gives more emphasis to the profile than in any state of the lithograph. The white chalk with charcoal on the yellow tracing paper seems faintly lavender in hue, and gives the drawing an unexpectedly stylish (for the 1890s) color scheme that Degas occasionally affected, in spite of his reputed antipathy to Art Nouveau

style.[2] The bather's hair is magnificently drawn, from the tiny curls at the nape of the neck to the purplish brown tresses rendered with a sure sense of space, fading out with fainter, rougher strokes of pastel.

1. All other related drawings seem to show the maidservant. See III:177.1; III:334.2, British Museum, London; IV:356.
2. Halévy 1960, pp. 94–97; Halévy 1964, pp. 84–85.

PROVENANCE: Albert S. Henraux, Paris; Stephen C. Clark, New York; his bequest to the museum 1960.

EXHIBITIONS: 1924 Paris, no. 161; 1977 New York, no. 44 of works on paper.

SELECTED REFERENCES: Lemoisne [1946–49], III, no. 856 (as c. 1885).

Landscape Monotypes

cat. nos. 298–301

Degas had always painted or drawn occasional landscapes, but he was normally so caustic about his Impressionist colleagues' painting out of doors that it was a surprise to his friends when he announced that he had succumbed to landscape painting. At dinner at the Ludovic Halévys' in September 1892, as Halévy's son Daniel faithfully recorded, he told the gathering that he had finished twenty-one landscapes in monotype.[1] He presumably also said, though Daniel does not mention this, that they were being shown at Durand-Ruel that month.

Degas remarked that the monotypes had grown out of his travels that summer. Actually, he had begun the landscapes on his famous trip by horse and carriage—a white horse and a tilbury—in October 1890, when he went with the sculptor Albert Bartholomé (1848–1928) to visit their mutual friend, the artist Pierre-Georges Jeanniot (1848–1934), at his large estate, Diénay par Is-sur-Tille, in the Côte d'Or region of Burgundy. Degas wrote highly amusing daily reports to Ludovic Halévy and his wife, Louise, on their progress.[2] When they arrived at Diénay, it became clear that Jeanniot had a printing press and all the tools to entice Degas to make monotypes. Later, Jeanniot described Degas working on a copper (or zinc) plate with colored oil paints which he applied with a brush, and probably his fingers, wiping away much of the paint with a pad he had made himself.[3] "We gradually saw emerging on the surface of the metal a valley, a sky, white houses, fruit trees with black branches, birches and oaks, ruts filled with water from a recent downpour, orange-colored clouds scudding across a turbulent sky above the red-and-green earth. . . . All these things emerged without apparent effort, as if he had the model in front of him."[4] Jeanniot added, "Bartholomé recognized the places they had passed in the tilbury with the white horse." Degas used the old press to transfer the paint from the plate to wet China paper and, as Jeanniot reported, he pulled three or four proofs (though two is more probable), each of course paler than the proof preceding it, and hung them up to dry. Then he used pastel to give the monotypes more structure, recalling in the landscapes what Jeanniot described as the "unexpectedness of the antitheses and the contrasts."[5]

Jeanniot and Bartholomé, accustomed to Degas's earlier work and attitudes, seized rather unexpectedly on the scant realism in these scenes of nature that, in their view, he had created so miraculously from memory. This was in spite of the fact that Jeanniot was later to record Degas as having said, "Reproduce only what has struck you—that is, the essential; in that way your memories and your imagination are liberated from the tyranny that nature holds over them."[6]

When almost two years later Degas talked to the Halévys about his upcoming exhibition of landscapes, Ludovic Halévy perceptively asked, "What kind are they? Vague things?" To which the artist replied, "Perhaps." Halévy continued to question him: "A reflection of your soul? . . . Do you like that definition?" Degas replied, "A reflection of my eyesight. We painters do not use such pretentious language."[7]

The landscapes are indeed vague. They go a long way toward abstraction. Although Degas traveled incessantly in the two years he was apparently producing these monotypes—to Carpentras, Geneva, Dijon, Pau, Cauterets, Avignon, Grenoble, and Lausanne, as well as in Normandy—his sources are difficult to identify. Names of specific locations have been attached to the monotypes, but without much conviction. Another characteristic is a suggestion of a state of flux, for which Degas prepared the Halévys: "They are the fruit of my travels this summer. I would stand at the door of the coach, and as the train went along I could see things vaguely. That gave me the idea of doing some landscapes."[8] He later wrote to his sister Marguerite in Argentina that they were "paysages imaginaires" (imaginary landscapes).[9]

In showing the monotypes at Durand-Ruel, Degas had the first of two one-man exhibitions in his lifetime; he seems to have lent the works himself. Durand-Ruel had shown Degas's work widely in group exhibitions in the British Isles, Europe, and North America, but most often works he had bought from the artist. When Paul Durand-Ruel was asked by the British dealer D. C. Thomson about the exhibition of landscapes, he wrote somewhat nervously: "M. Degas's exhibition consists of only a few small landscapes in pastel and watercolor that he has authorized me to show to certain collectors. They are not of enough significance to form an exhibition in the true sense of the word; M. Degas would doubtless not approve one in any case."[10] Only after the exhibition, it seems, did the dealer acquire any of the landscapes for his own stock.

Earlier, however, Durand-Ruel had decided to interest the Ministry of Fine Arts in the exhibition and wrote on 10 September 1892 to Henry Roujon, a friend of Mallarmé' who was Surintendant des Beaux-Arts: "I am writing to ask you, in the event that you have a free moment and are interested, to come to one of my galleries, on rue Lafitte, to see a very unusual exhibition of 25 pastels and watercolors by Degas. It is a series of landscapes. As you know, Degas never exhibits, and it is a signal event to have been able to persuade him to show a collection of new works."[11] Writing this letter must have made Durand-Ruel even more nervous than acknowledging the existence of the exhibition to D. C. Thomson; it was Roujon who had offered to acquire a work by Degas for the Luxembourg museum. Degas, offended by Roujon's condescension and his power, had refused, and stormily wrote to Ludovic Halévy: "They have the chessboard of the Fine Arts on their table. . . . They move this pawn here, that pawn there. . . . I am not a pawn, I do not want to be moved!"[12] It was to be 1972 before a monotype landscape by Degas entered the Louvre (cat. no. 299).

The principal Symbolist review, Mercure de France, did acknowledge the exhibition in December: "At the Durand-Ruel gallery, a series of landscapes by Degas, not studies, but delightfully fanciful scenes, recalled from the imagination."[13]

But the only thorough review was by Arsène Alexandre, in Paris of 9 September 1892. He begins by emphasizing the rarity of the event. "This is one of the most extraordinary happenings of the season. M. Degas is exhibiting. Though that is not quite the correct way to put it, because M. Degas is not exhibiting and will not, ever, exhibit. But put simply, in a corner of Paris that I will not name and that M. Degas would prefer to be left unknown, there are some twenty new works by him. . . . " After discussing the character of the artist, he says of the exhibition, "There are only landscapes here, very small ones, executed with an exquisite skill and restraint. M. Degas has brought together in these works feelings and reminiscences about nature that he conveys with great poignancy and power."

Alexandre perceptively comments on individual works, though only one is identifiable—"A faraway volcano, unknown to any geographer, belching a blue column of smoke and ash"—*Vesuvius*, a pastel over monotype in the Kornfeld collection, Bern (L1052, J310). Although Alexandre did not have the advantage of Jeanniot's description of Degas working with monotype and we must remember that Durand-Ruel in November would describe the works to Thomson as "pastel and watercolor," he was fascinated by the "cuisine"—the artist's craft. "It is unusually difficult, in these landscapes, to discover the secrets of the 'recipe,' the artful and exciting mix of materials for which M. Degas has a penchant. Everything imaginable happens here: watercolor is treated and brushed on like oil paint, then mixed with gouache, reworked and accented with pastel, sometimes touched up and dabbed with a wad of cloth, at other times squiggled

with the tips of his fingers, like a child making patterns in the mud."

Finally, Alexandre decides that Degas must understand nature very well to have produced these works: "To achieve such results, even *to attempt* such a subject, one must have meditated at length on nature, at its very heart, to have studied the trees leaf by leaf, the grass blade by blade. . . . In a word, one must know nature fully and deeply to be able to portray it, and to express it, even a little."[14]

No one has written more eloquently about the landscapes since.[15]

1. Halévy 1964, p. 66.
2. Lettres Degas 1945, CXXVIII, CXXIX–CXXXI, CXXX–CXLI, CXLIII–CXLV, CXLVII–CLIV; Degas Letters 1947, nos. 140, 142–44, 146–54, 156–58, 160–67 (26 September–19 October 1890) (translation revised).
3. Jeanniot 1933, pp. 291–93; quoted in Janis 1968, p. xxv.
4. Janis 1968, p. xxv.
5. Ibid., p. xxvi.
6. Jeanniot 1933, p. 158.
7. Halévy 1964, p. 66.
8. Ibid.
9. Fevre 1949, p. 102 (letter of 4 December 1892, in which Degas refers to a small exhibition of twenty-six landscapes).
10. Letter to D. C. Thomson, London, 16 November 1892, Durand-Ruel archives, Paris; Sutton 1986, p. 295.
11. Durand-Ruel archives, Paris.
12. Degas Letters 1947, Appendix, "Notes on Degas, Written Down by Daniel Halévy, 1891–1893," entry for 19 February 1892, p. 248.
13. R.G. in "Choses d'art," *Mercure de France*, V, December 1892, p. 374. The notice ended, rather improbably, "un peu à la manière de Corot" (a little in the style of Corot).
14. Arsène Alexandre, "Chroniques d'aujourd'hui," *Paris*, 9 September 1892.
15. There is, however, a useful review of the exhibition, dated 25 November 1892, in a short-lived Montreal periodical. See Philip Hale, "Art in Paris," *Arcadia*, I, no. 16, 15 December 1892, p. 326.

298

298.

Landscape

1890–92
Monotype in oil colors heightened with pastel
Plate: 10 × 13⅜ in. (25.4 × 34 cm)
Signed lower left in red: Degas
The Metropolitan Museum of Art, New York.
 Purchase, Mr. and Mrs. Richard J. Bernhard
 Gift, 1972 (1972.636)

Exhibited in New York

Lemoisne 1044

The identification of the monotypes that were made in October 1890 at Diénay, the Jeanniot estate in Burgundy, as well as those among the twenty-one, twenty-five, or twenty-six monotypes (the number varies[1]) that Degas was to show two years later at Galerie Durand-Ruel, is a matter of conjecture. He made about fifty monotypes at that time. One pair of cognates is generally assumed to reflect his trip to Burgundy, particularly because in the earlier version there is the suggestion of an emerging landscape structure, as Jeanniot had described in the first monotype Degas made at Diénay.[2] In addition, the first of those two landscapes (L1055, J279) was bought by Durand-Ruel in June 1893, not long after the exhibition, and sent to his New York gallery, where it was sold to Denman W. Ross in November 1894.[3]

Because of the nature of the Ross bequest to the Museum of Fine Arts, Boston, the earlier version cannot be lent. It is, as Barbara Stern Shapiro has observed, warmer in color than the one in this exhibition, vibrates more chromatically, and is probably therefore an autumnal version.[4] The second of the pair, the present version, is more delicate, more achingly beautiful. Shapiro points out that Degas "dabbed and pulled at the ghostlike inks to diminish the effect of vegetation. A palette of cool pastels was lightly scumbled over the pale streaky monotype design; the pastel work served as a subtle cover rather than as a vehicle for the articulation of the terrain."[5] Eugenia Parry Janis, who has written the most basic work on the monotypes, agrees about the abstraction achieved here. She notes that "the most dramatic spatial effect is not in the view represented but rather in the optical vibration set up between the two layers of color."[6]

It is not always easy to separate the color monotype from the pastel. Monotype can be recognized in the blue-gray sky, the white mist or cloud layer, the brown that barely covers the paper in the foreground, the bit of blue under the mountain in the distance, and the green under the grass. Sometimes Degas exposed the paper, as in the white stream. With pastel, he used a turquoise blue on the mountain at the left, mottled a clearer, more intense blue over the mountaintop at the right, chose a vivid emerald green for the strokes of the grass, applied greens, blues, and purples on the tops of the nearest mounds of earth, and dabbed a grass-green-like moss on the tops of the mounds, as if to save them from prettiness. There is a quiet lavender between the mounds.

With an instrument like the end of a brush, he burnished fine strokes to indicate horizontal lines through the sky. At the right, he produced vertical lines in the sky and diagonal slashes against the hill to suggest rain. He incised other lines horizontally across the grass to the left of the stream, and introduced small strokes in the mountain and some zigzagging below and above the lavender between the mounds.

It is a scene of spring. The blue hills are wonderfully tender. The sky seems to drip into the white mist. It could be the landscape about which Alexandre wrote in 1892, recalling "the sadness of grayish blue mornings, wan and unreal."[7] This is a beautiful, gossamer world, essentially uninhabited and far from reality. As Douglas Crimp has written, the monotypes are "landscapes in which Degas supplanted the visible world with the visionary."[8]

1. It seems unlikely that the figures given casually by the artist, or remembered casually by his friends, can be trusted.
2. Janis 1968, p. xxv.
3. Ibid., p. xxvii.
4. 1980–81 New York, no. 31, p. 112.
5. Ibid., no. 32, pp. 112–14.
6. Janis 1968, p. xxvi.
7. Arsène Alexandre, "Chroniques d'aujourd'hui," *Paris*, 9 September 1892.
8. Crimp 1978, p. 93.

PROVENANCE: With Durand-Ruel, Paris and New York. With Kennedy Galleries, New York, 1961; H. Wolf 1963; Edgar Howard; bought by the museum 1972.

EXHIBITIONS: 1961, New York, Kennedy Galleries, *Five Centuries of Fine Prints*, no. 278a, p. 42, repr.; 1974 Boston, no. 107; 1977 New York, no. 5 of monotypes; 1980–81 New York, no. 32.

SELECTED REFERENCES: Lemoisne [1946–49], III, no. 1044; Janis 1968, no. 285; Cachin 1974, p. lxviii; Minervino 1974, no. 959; *The Metropolitan Museum of Art, Notable Acquisitions, 1965–1975*, New York: The Metropolitan Museum of Art, 1975, p. 193; Reff 1977, pp. 42, 43, fig. 77.

299.

Landscape, called Burgundy Landscape

1890–92
Monotype in color on laid paper
11⅞ × 15¾ in. (30 × 40 cm)
Signed and inscribed in red crayon lower left: À
 Bartholomé, Degas
Cabinet des Dessins, Musée du Louvre (Orsay),
 Paris (RF35720)

Exhibited in Paris

Cachin 201

Because this landscape is dedicated to Bartholomé, Degas's staunch companion on the tilbury trip into Burgundy, it is tempting to think that Degas gave it to the sculptor at the time he was experimenting with monotype in the Jeanniot home at Diénay, their destination.[1] It may be partly because its austerity is not offset by pastel, which Barbara Stern Shapiro has described as "diminishing the effect of vegetation," that this monotype seems so earthy.[2] One can sense, to quote Jeanniot, "ruts filled with water from a recent downpour," "the red-and-green earth," and "orange-colored clouds" which—somewhat browner than described— seem to have descended on the earth.[3] The thin black, almost hatched storm clouds gather in the sky to the right above the uneven dark purple contour of a hill bursting over the horizon. Degas appears to have plowed up the red soil with the coarse bristles of his brush.

Although Degas had said at one time that nothing in his work should appear to be accidental,[4] we cannot help feeling that chance played its role in the form of the orange cloud lying on the earth. Degas was, to a significant extent, beginning to accept improvisation, while still controlling his work with absolute mastery.

1. The dedication of this monotype, untouched by pastel, argues against the assumption made by Howard G. Lay ("Degas at Durand-Ruel, 1892: The Landscape Monotypes," *The Print Collector's Newsletter*, IX:5, November–December 1978, p. 143) that a landscape monotype without pastel was "probably unfinished."
2. 1980–81 New York, no. 32, pp. 112–14.
3. Janis 1968, p. xxv.
4. He said, for example, to George Moore: "No art was ever less spontaneous than mine"; Moore 1890, p. 423.

PROVENANCE: Albert Bartholomé, until 1928; Dr. Robert Le Masle, Paris; his bequest to the Louvre.

EXHIBITIONS: 1985 London, no. 26, repr.

SELECTED REFERENCES: Philip Hale, "Art in Paris," *Arcadia*, I, no. 16, 15 December 1892, p. 326; Geneviève Monnier, "Un monotype inédit de Degas, Cabinet des Dessins," *La Revue du Louvre et des Musées de France*, 23rd year, I, 1973, p. 39, repr.; Cachin 1974, no. 201; Sérullaz 1979, repr. (color) p. 27.

299

300.

Landscape, called *Cape Hornu near Saint-Valéry-sur-Somme*

1890–92
Monotype in oil colors on heavy white laid paper
Plate: 11⅞ × 15¾ in. (30 × 40 cm)
Sheet: 12⁷⁄₁₆ × 16⁵⁄₁₆ in. (31.6 × 41.4 cm)
Trustees of the British Museum, London
 (1949-4-11-2424)

Janis 295

In the 1985 Arts Council of Great Britain
exhibition *Degas Monotypes*, Anthony Grif-
fiths pointed out that "there is no reason to
think that he went [to Saint-Valéry-sur-
Somme] in the '90s and many reasons to
think he did not."[1] The title of this mono-
type is one that has been imposed on one of
Degas's imaginary landscapes. The forms
could suggest brown cliffs against a gray
sea, but there is no evidence that this is a
specific, identifiable place. The landscape is
so ambiguous that the gray could be water
or sky; the green, grass or water. *Cape Hornu*
has a mood that is more than simply visual;
it seems to evoke other sensations—of the
weather, and even of sound. It has something
in common with the theater flats Degas was
painting in the 1890s as backgrounds for
some of his dancers.[2]

300

1. 1985 London, no. 24, p. 62. Actually, Degas did
 go to Saint-Valéry-sur-Somme in the 1890s, but
 after producing these monotypes.
2. Paul Lafond (Lafond 1918–19, II, p. 62) observed
 the relationship between Degas's landscapes and
 his theater flats.

PROVENANCE: Campbell Dodgson, London; his be-
quest to the museum 1949.

EXHIBITIONS: 1985 London, no. 24.

SELECTED REFERENCES: Janis 1968, no. 295; Cachin
1974, no. 192, repr. (color).

301

301.

Landscape

1890–92
Monotype in oil colors on wove paper
Plate: 11½ × 15½ in. (29.2 × 39.4 cm)
Collection of Phyllis Lambert, Montreal

Janis 309

Of all the landscapes in the exhibition, this one is the most abstract and the most foreboding. Although Degas's vision includes the wonderful and mysterious rose, purple, and gold colors of the earth, and the relief of untouched paper, in the center there arises a strangely conical form—not quite a tree, not quite a tornado cloud—which vaguely threatens us.

PROVENANCE: Maurice Exsteens, Paris; with Paul Brame and César de Hauke, Paris, 1958.

EXHIBITIONS: 1968 Cambridge, Mass., no. 78.

SELECTED REFERENCES: Cachin 1974, no. 190.

Interiors, Ménil-Hubert

cat. nos. 302, 303

There was always a special place in Degas's heart for his schoolfriend Paul Valpinçon, his wife, and their daughter Hortense (cat. nos. 60, 61, 95, 101, 243). Visits to their château Ménil-Hubert in Normandy (near Gacé, in the department of Orne) were a regular part of his life. In August 1892, he found himself complaining to his friends, as he had in the past, that he was staying on unwillingly because he had trapped himself into beginning a work of art.

On Saturday 27 August 1892, he wrote to Bartholomé, "I wanted to paint, and I set about doing billiard interiors. I thought I knew a little about perspective. I knew nothing at all, and thought I could replace it through a process of perpendiculars and horizontals, measuring angles in space, just through an effort of will. I kept at it."[1]

The three oil paintings he did of interiors—two of the billiard room, the other perhaps his own bedroom—seem the antithesis of the thin, open imaginary landscapes in monotype that he had been doing at the same time. The interiors are real, with, as Theodore Reff has shown, some works of art that are identifiable.[2] The interest in perspective provides a measurable link between the spectator and that space, and the handling of the oil paint has a richness of texture and color that makes the monotype landscapes seem translucent.

Degas felt an affection for the house and the people who occupied it—people with whom he could perform a stately dance outside the château on a summer's day (see fig. 287). Because he had moved around constantly both as a child and as an adult, he must have envied the stability of the Ménil-Hubert household. He must also have savored its settled domesticity, for this was a time when he was as nearly domesticated as he would ever become. He had moved into a three-storey apartment on rue Victor-Massé in the Ninth Arrondissement in 1890, and had taken a great interest in its furnishing and decoration—looking for rugs, wall coverings, and, as always, the printed handkerchiefs with which Julie Manet tells us he used to ornament his dining room. On 20 November 1895, after having dined with him, she wrote, "His dining room is hung with yellow handkerchiefs, and on top of them are the drawings of Ingres."[3] Degas was prepared to entertain. This would have made him even more appreciative of the settled rooms in this house of a friend.

1. Lettres Degas 1945, CLXXII, pp. 193–94; Degas Letters 1947, no. 185, p. 183 (translation revised).
2. Reff 1976, pp. 141–43, identifies an eighteenth-century tapestry at the right, *Esther Swooning before Ahasuerus*, and Giuseppe Palizzi's *Animals at a Watering Place*, c. 1865, on the back wall.
3. Manet 1979, p. 72.

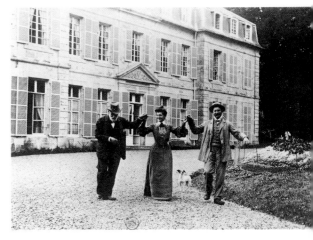

Fig. 287. Anonymous, *M. and Mme Fourchy (née Hortense Valpinçon) with Degas at Ménil-Hubert*, c. 1900. Photograph printed from a glass negative in the Bibliothèque Nationale, Paris

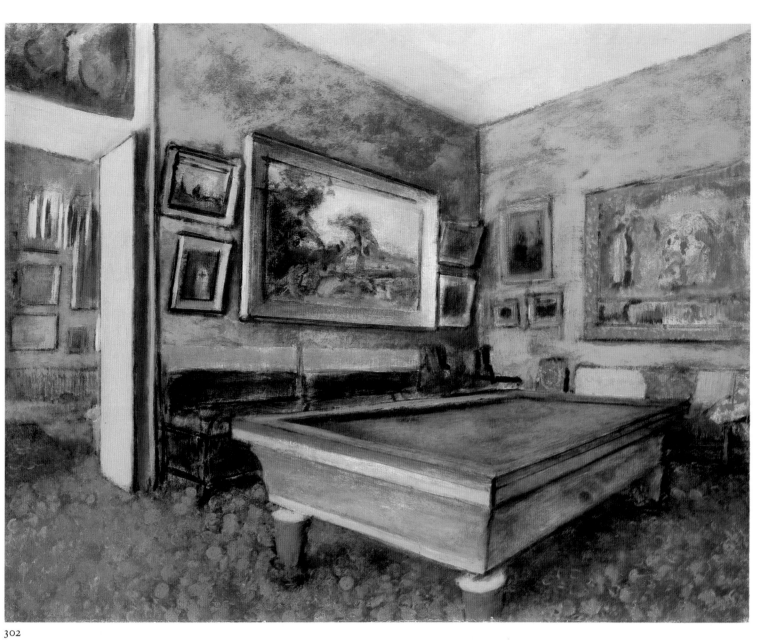

302

302.

The Billiard Room at Ménil-Hubert

1892
Oil on canvas
25⅝ × 31⅞ in. (65 × 81 cm)
Vente stamp lower right
Staatsgalerie Stuttgart (2792)

Lemoisne 1115

Degas did two versions of *The Billiard Room at Ménil-Hubert*. One of them is in a private collection in Paris; the other is the present work. The viewer's first impression is that the painting is somewhat subdued, but we are soon struck by its integrity.

Layers of color are revealed under the upper layers of paint—pure yellow under the wood of the billiard table, brown under the blue-and-rose coin-stippled rug, and a light green under the dark of the velvet benches by the table. There are surprising effects with color—such as the rose wall of the room glimpsed through the door, the blueish cast to the billiard table, and the blue gray of the door, the doorframe, and the ceiling.

The paintings and other works on the walls are handled with great intimacy, even to their frames. The difference, for example, between the density of framed paintings and the tapestry at the right is clearly defined. Thin white curtains cover some of the pictures in the next room. The billiard table unifies the space but curiously does not dominate it.

The Billiard Room is like the monotype landscapes in that it is uninhabited and therefore evokes a spatial experience of its own. But it is full of the potential for human drama.

PROVENANCE: Atelier Degas (Vente II, 1918, no. 37, for Fr 13,000); Charles Comiot, Paris; private collection, Switzerland; with Nathan Gallery, Zurich; bought by the museum 1967.

EXHIBITIONS: 1933 Paris, no. 110.

SELECTED REFERENCES: François Fosca, "La collection Comiot," *L'Amour de l'Art*, April 1927, p. 111, repr. p. 110; Barazzetti 1936, 192, p. 1; Lemoisne [1946–49], III, no. 1115; Degas Letters 1947, no. 185, p. 183; "Staatsgalerie Stuttgart Neuerwerbungen 1967," *Jahrbuch der Staatlichen Kunstsammlungen in Baden-Württemberg*, V, 1968, pp. 206–07, fig. 7; Minervino 1974, no. 1157; Reff 1976, pp. 140–43, fig. 105; Stuttgart, Staatsgalerie, 1982, p. 75.

303.

Interior at Ménil-Hubert

1892
Oil on canvas
13 × 18⅛ in. (33 × 46 cm)
Signed lower right: Degas
Private collection, Zurich

Exhibited in Ottawa and New York

Lemoisne 312

Interior at Ménil-Hubert shows us a smaller and gentler space than that of *The Billiard Room* (cat. no. 302). It is probably a guest bedroom—Theodore Reff suggests it is the painter's[1]—charmingly but informally decorated with wallpaper, pictures, a mirror reflecting other pictures, and a towel rack. It makes Ménil-Hubert seem a most hospitable place.

Although Degas had not until this time painted interiors except as backgrounds for his sitters or as settings for dramas, the rooms in which the Bellelli family (see cat. no. 20) or Mme Edmondo Morbilli (see cat. no. 94) are placed, or in which *Interior* (cat. no. 84) or *The Song Rehearsal* (cat. no. 117) are set, show his sensitivity to the character of such spaces.

Degas's paintings of the unoccupied rooms at Ménil-Hubert may have made him partic-

ularly ready in 1894[2] to buy and to treasure the painting by Delacroix, now in the Louvre (RF2206), of the tentlike room of the Comte de Morny, with its pictures hanging on the striped walls and its Roman lamp suspended high above a settee. His own work here perhaps inspired his collecting of other masters rather than being the result of their influence.

1. Reff 1976, p. 141.
2. Letter to the author from Philippe Brame, 22 April 1987, confirms the date of purchase.

PROVENANCE: Atelier Degas (Vente II, 1918, no. 31, for Fr 13,700); Charles Comiot, Paris; Mr. and Mrs. Saul Horowitz, New York.

EXHIBITIONS: 1937 Paris, Orangerie, no. 46; 1955 Paris, GBA, no. 54 bis.

SELECTED REFERENCES: François Fosca, "La collection Comiot," *L'Amour de l'Art*, April 1927, p. 111; Lemoisne [1946–49], II, no. 312 (as 1872–73); Minervino 1974, no. 347; Reff 1976, pp. 91–92, 141, pl. 60 (color) (as 1892).

Reflections on Horses and Dancers at Sixty

cat. nos. 304–309

When he was about sixty and contemplating the two subjects by then most often associated with his name—horses and riders, and the dance—Degas was often reflective. In the very act of reflection, he seemed to cast a spell on his horses and dancers. Their responses are slower. They appear to live in twilight, and whether it is in a field or on the stage, any animation is apt to be more optical and illusory than measurable.

Degas seemed to look back to his earlier art, creating genealogies on particular themes. Sometimes, such traditions had their sources in artistic traditions of the past—like the echoes of Benozzo Gozzoli in the Whitney landscape *Hacking to the Race* (cat. no. 304). More often, they are found in his own earlier work—as in the Thyssen *Racehorses in a Landscape* (cat. no. 306), a pastel (fig. 291), or a painting (L767) of 1884. He even established new sequences, as with the pastel *Dancers, Pink and Green* (cat. no. 307), dated 1894, which begat the larger oil painting *Two Dancers in Green Skirts* (cat. no. 308), which in turn produced the sculpture *Dressed Dancer at Rest, Hands on Her Hips* (cat. no. 309). This sense of continuity was obviously important to Degas.

303

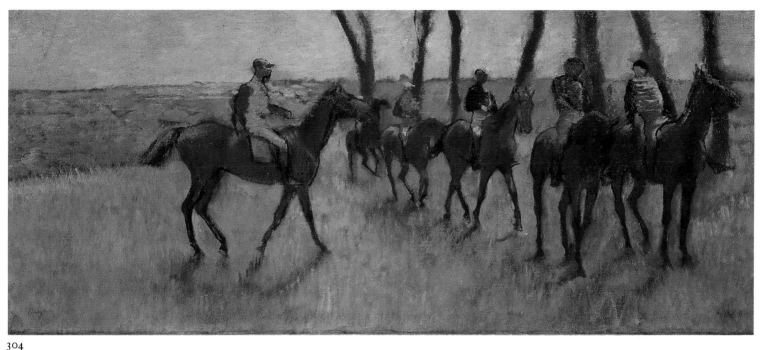

304

304.

Hacking to the Race

c. 1895
Oil on canvas
15½ × 35 in. (39.4 × 89 cm)
Vente stamp lower left
Collection of Mrs. John Hay Whitney

Exhibited in New York

Lemoisne 764

Hacking to the Race is probably the last of a group of nine known jockey scenes that Degas executed in a panoramic format slightly wider than a double square.[1] This format, an obvious choice for the rolling landscapes and high horizons favored by Degas, was first used by him in the late 1870s and subsequently taken up by several avant-garde painters in the 1880s. Van Gogh adopted it for the series of double squares he painted in Auvers in 1890, and before him Pissarro had made a series of overdoors in a similar format that van Gogh probably saw in his brother's gallery. Although the shape was commonly used for marine pictures, it is similar to that of Daubigny's many views of the environs of Paris. Thus, it was a format laden with associations when Degas took it up for his jockeys and dancers.

As John Rewald has noted, the friezelike arrangement of the horses on parade—they are probably hacking to the race—is reminiscent of Benozzo Gozzoli's *Journey of the Magi* (Palazzo Medici-Riccardi, Florence), which Degas had copied about 1860 (fig. 288), and adapted for one of his early scenes of horseback riding (L118, Detroit Institute of

Arts).[2] But the positions of the horses' legs derive from a more contemporary source—the photographs of Eadweard Muybridge. At least four of the six horses are taken directly from Muybridge, and the transverse view of the line of five horses may have been suggested by the photographer's head-on shots taken from a slight diagonal.

This work has generally been assigned to the 1880s, but a date of c. 1895 seems more likely in view of what we now know. Certainly the painting must date to later than 1887, the year Muybridge's corpus appeared.[3] The drawings for the individual figures—fluent summary sketches that capture the carriage but not the character of the jockeys—seem to date to the first half of the 1890s.[4] But the elegiac mood and the carefully syncopated movement of the horses suggest affinities with Degas's dancers of the mid-1890s, especially the *Frieze of Dancers* in Cleveland (L1144).[5] The emphasis is no longer on bright silks or a brilliant sky, but on the subtly articulated limbs of the horses, rhythmically echoed by the line of poplars—themselves perhaps a reference to Monet's serial views of poplars painted in 1891–92.

GT

1. The others are: L446, L502, L503, L596, L597, L597 bis, L761, BR111.
2. John Rewald, *The John Hay Whitney Collection* (exhibition catalogue), Washington, D.C.: National Gallery of Art, 1983, p. 40. Rewald also associates the painting with Muybridge's photographs.
3. See "Degas and Muybridge," p. 459.
4. III:107.3, III:108.2, III:99.2, IV:378.b, III:129.1.
5. Noted by George Shackelford in 1984–85 Washington, D.C., pp. 102–04.

Fig. 288. *The Journey of the Magi*, detail after Benozzo Gozzoli, *The Journey of the Magi* (IV:91.c), c. 1860. Pencil, 10⅜ × 12 in. (26.2 × 30.5 cm). Harvard University Art Museums (Fogg Art Museum), Cambridge, Mass.

PROVENANCE: Atelier Degas (Vente I, 1918, no. 102); bought at that sale by Jacques Seligmann, Paris, for Fr 33,000 (Seligmann sale, American Art Association, New York, 27 January 1927, no. 41); bought at that sale by Rose Lorenz, agent, for $11,800; Helen Hay Whitney collection, from 1927; by inheritance to John Hay Whitney, until 1982; to present owner.

EXHIBITIONS: 1960 New York, no. 39, repr.; 1983, Washington, D.C., National Gallery of Art, 29 May–3 October, *The John Hay Whitney Collection*, no. 13, pp. 40–41, repr. (color) (as 1883–90); 1987 Manchester, no. 90, p. 141, pl. 128, p. 99 (color) (as c. 1895).

SELECTED REFERENCES: Étienne Charles, "Les mots de Degas," *La Renaissance de l'Art Français et des Industries de Luxe*, April 1918, p. 3, repr. (as "Esquisse d'un tableau de courses"); Lemoisne [1946–49], III, no. 764 (as c. 1883–90); Minervino 1974, no. 710; 1984–85 Washington, D.C., pp. 102–04, fig. 4.9.

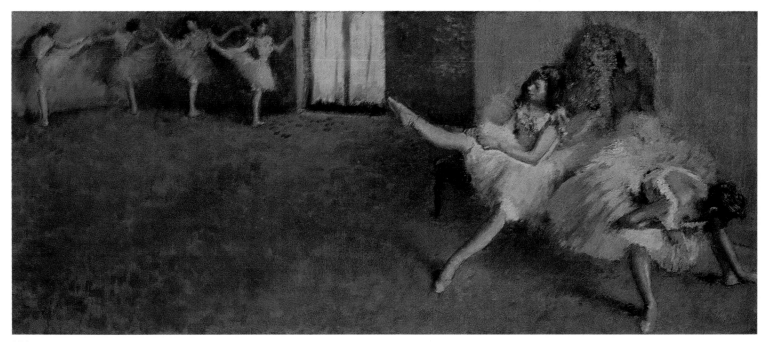

305

305.

In a Rehearsal Room

1890–92
Oil on canvas
15¾ × 35 in. (40 × 89 cm)
Signed in black lower left: Degas
National Gallery of Art, Washington, D.C.
 Widener Collection (1942.9.19)

Lemoisne 941

Degas's friezelike compositions of dance classes, all about the same size, bridged the 1880s, from their introduction at the end of the seventies until their demise in the nineties. *In a Rehearsal Room*, it is proposed, was painted between 1890 and 1892. Durand-Ruel bought it from the artist on 17 May 1892; normally, Degas sold works to his dealer not long after he had produced them.[1]

One in the series of works that George Shackelford brought together in 1984–85 in his exhibition *Degas: The Dancers*, in Washington,[2] this painting shows the ballerinas trapped in a melancholy spell. There are fewer dancers here—only six—than in the other frieze compositions, the result, as Shackelford demonstrated by X-radiograph, of Degas's having painted out two figures near the bench (see cat. no. 241). Although in all the works the floor is a significant element—Paul Valéry found Degas's floors "often admirable"[3]—the floor in this painting is the most open and uninterrupted. Indeed, the dancers can be seen as forming an animated frame for it. This treatment of space is particularly unlike that in *The Dancing*

Lesson (cat. no. 221) in the Clark Art Institute, in which the young dancer with a fan is the center of the painting. Even the work that is closest to the Washington canvas, the *Ballet Rehearsal* at Yale (fig. 289),[4] has fussier genre details, such as the bulletin board and the post that bisect the picture with more energy than do any of the architectural elements in the Washington painting. Degas's clearing of the space has a certain ruthless simplification that suggests his work of the nineties.

For the dancers in this painting, Degas used, as he often did, stock poses. Some are undoubtedly based on earlier drawings—as was the dancer at the barre nearest the window or the dancer with her leg outstretched on the bench.[5] The figures are so close to those in the *Ballet Rehearsal* that it is often difficult to tell which of the roughly contemporary studies were intended for which painting. One drawing, which must be for the Washington canvas, is a charcoal nude study of the two figures on the bench (fig. 290). The left arm of the figure with the lifted leg is bent like that of the dancer in the Washington painting rather than straight as in the *Ballet Rehearsal*. It is a surprisingly abrupt drawing, with harsh definition of the contours by heavy lines or raking shadows, not without a relationship to the small lithograph *Three Nude Dancers at Rest* (RS59) that it has been assumed Degas made about 1891–92.[6] A drawing of the dressed dancer on the right (II:217.1) could be considered a study for either the Yale or the Washington

Fig. 289. *Ballet Rehearsal* (L1107), c. 1890. Oil on canvas, 14⅛ × 34½ in. (38 × 90 cm). Yale University Art Gallery, New Haven

Fig. 290. *Study of Seated Nude Dancers* (III:248), c. 1890–92. Charcoal, 13⅜ × 18½ in. (34 × 47 cm). Location unknown

painting; only the inward slant of the right leg indicates that it was made for the latter. Again it is charcoal, a drawing in which Degas was exploring solutions. Although transitional, these drawings illustrate the direction of his style at the beginning of the nineties.

If we compare the figures in the Yale painting with those in the exhibited work, we find that the dancers at the barre in the Washington picture are slightly less articulated and less defined, without the same sprightly contours and indications of features. The Washington dancers are creatures of light and shadow rather than bone. The biggest difference in the figures on the bench is that in the Washington painting the lifted leg is higher, silhouetted cleanly against the floor and wall. It appears to be the focus of the painting, as if its spirited animation were the antithesis of everything else in the work. *In a Rehearsal Room* seems almost the expression of yearning for the optimism of earlier dance compositions, where Degas conveyed the sense of will and the possibility of perfection in the young dancers as transcending their effort and exhaustion.

Finally, there is the melancholy mood, established by the figures and the space they occupy, but particularly by the color and the handling of paint. The violets and blues on the floor express sadness; the blues in the shadows of the tutus and in the fabric on the wall intensify the atmosphere of poignancy. Even the pink of the tights serves to accentuate the passivity of the other colors. The paint is handled beautifully, dappling the floor gently and changing the tutu of the

dancer on the right into some strange luminous flower, without its being subordinated to the definition of either floor or tutu. Although there are figures in the room, the density of the enclosed interior space and the sense of emptiness are close to that in *The Billiard Room at Ménil-Hubert*, of 1892 (cat. no. 302).

1. The dated works in this exhibition, when compared with the dates of their acquisition by Durand-Ruel from the artist, confirm this.
2. See 1984–85 Washington, D.C., no. 35, pp. 93–95, with an X-radiograph of *In a Rehearsal Room*, reproduced p. 97, fig. 4.4. Shackelford dates it c. 1885 but indicates repainting.
3. Valéry 1965, p. 21; Valéry 1960, p. 42.
4. Lemoisne dates this c. 1891.
5. II:220.b; 1967 Saint Louis, no. 122; III:81.1.
6. Richard Thomson (1987 Manchester, p. 88, fig. 117 p. 89) dates the lithograph after 1900.

PROVENANCE: Bought from the artist by Durand-Ruel, Paris, 17 May 1892 (stock no. 2228); bought by P. A. B. Widener, Philadelphia, 3 February 1914 (stock nos. 3853, N.Y. 3741); Joseph E. Widener, Philadelphia.

EXHIBITIONS: 1905 London, no. 51 (as "Ballet Girls in the Foyer"); 1981 San Jose, no. 66; 1984–85 Washington, D.C., no. 35 (as c. 1885).

SELECTED REFERENCES: Lafond 1918–19, I, repr. p. 6; anon., *Paintings in the Collection of Joseph Widener at Lynnewood Hall*, Elkins Park, Pa.: privately printed, 1931, p. 212; Lemoisne [1946–49], III, no. 941 (as 1888); Browse [1949], p. 377, pl. 116a (as c. 1884–86); Minervino 1974, no. 842; Kirk Varnedoe, "The Ideology of Time: Degas and Photography," *Art in America*, LXVIII:6, Summer 1980, pp. 100, 105, repr. (color) pp. 106–07.

306.

Racehorses in a Landscape

1894
Pastel on tracing paper
19¼ × 24¾ in. (48.9 × 62.8 cm)
Signed and dated in black chalk lower left:
 Degas/94
Thyssen-Bornemisza Collection, Lugano,
 Switzerland

Lemoisne 1145

Degas must have been in a reflective mood in 1894, perhaps because it was the year of his sixtieth birthday. In this pastel, he more or less repeated the composition he had used for one pastel (fig. 291) and one oil (L767) produced exactly a decade before. Just as he had distinguished those works from each other by the landscape background and the color of the jockeys' silks, he found similar features differentiating this work from the earlier versions.

Instead of the literal, descriptive pasture and hills in daylight of the earlier works, Degas chose a scene in which the lighting is almost theatrical[1]—rose and blue on the mountaintops above a deep blue shadow, and rose and violet through the greens of the grass. The mountains and even the pasture loom up and dominate the horses and riders. Clearly, this landscape had been influenced by the monotypes he had made two or three years earlier. Although less important than their natural surroundings, the jockeys are dressed in silks the color of aniline dyes—shiny intense pinks and blues, oranges and greens, which seem to grow as naturally as flowers in the landscape setting. They can remind us of the Mogul miniatures that we know Degas had admired over thirty years before.[2]

Degas did not hesitate to reuse motifs. He often repeated figures he had used in other compositions. His fidelity to this particular arrangement of horses and riders is nevertheless unusual. And his dating of all three versions is rarer still. It is tempting to think that these were among the works he referred to in his letters as "articles" intended for a market eager for his racetrack scenes; certainly they were bought by Durand-Ruel immediately. This one may even have been intended for the husband of Mary Cassatt's friend Louisine Havemeyer, who bought it in 1895.[3]

1. Denys Sutton writes: "It possesses a dreamy quality which would make an ideal setting for *Pelléas and Mélisande*" (Sutton 1986, p. 151).
2. Reff 1985, Notebook 18 (BN, Carnet 1, pp. 197, 235, 241).
3. Weitzenhoffer 1986, p. 102.

PROVENANCE: Bought from Degas by Durand-Ruel, Paris, 18 August 1894 (stock no. 3116); bought from

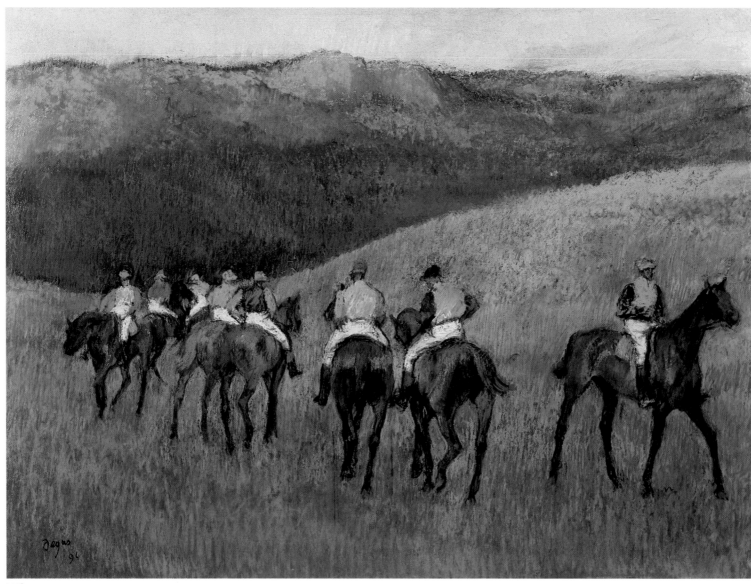

306

Durand-Ruel by Horace Havemeyer, New York, 30 March 1895, for $2,700 (stock nos. 3116, N.Y. 1376); by descent to Mrs. James Watson-Webb, New York; by descent to Mr. and Mrs. Dunbar W. Bostwick, New York; Andrew Crispo Gallery, New York; Baron H. H. Thyssen-Bornemisza, Lugano.

EXHIBITIONS: 1922 New York, no. 72; 1936 Philadelphia, no. 53, pl. 105; 1960 New York, no. 62, repr.; 1984 Tübingen, no. 192, repr. (color) p. 72.

SELECTED REFERENCES: Grappe 1911, repr. p. 36; Meier-Graefe 1923, pl. XC; Lemoisne [1946–49], III, no. 1145; Minervino 1974, no. 1164; Gunther Busch, "Ballett und Gallopp im Zeichentrick," *Welt am Sonntag*, 8 April 1984, repr. (color); Sutton 1986, pp. 150–51, pl. 132 (color) p. 156; Weitzenhoffer 1986, p. 102, pl. 53 (color).

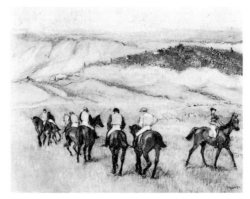

Fig. 291. *Before the Race* (L878), dated 1884. Pastel, 19¾ × 24¾ in. (50 × 63 cm). Private collection

307.

Dancers, Pink and Green

1894
Pastel
26 × 18½ in. (66 × 47 cm)
Signed and dated lower right: Degas 94
Private collection

Exhibited in New York

Lemoisne 1149

In dating this pastel 1894, Degas was not reworking an old idea, as he had in the Thyssen racehorse scene (cat. no. 306), but starting a new one. Although in the past he had painted and drawn dancers from behind, it was usually in a class and not on the stage. Here, he captures the excitement of a ballet in the theater—two performers waiting beside an exuberantly painted flat to go on stage, the dancer at the right turning to her companion and gesturing that they must wait still.

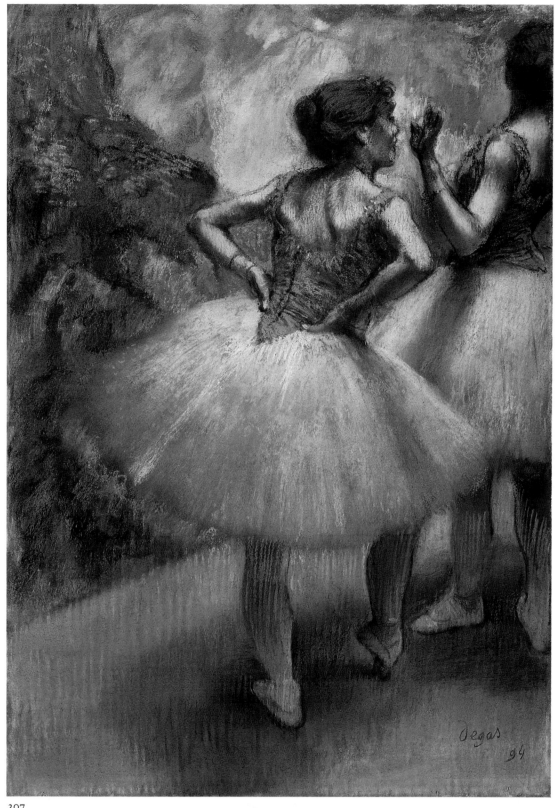

307

Springing from their green silk bodices, their gauze tutus are an enchanting peppermint pink with a border of green faintly bluer than their tops. A slightly deeper rose and green are to be found in the shadows and on the floor.

Since any surviving drawings related to this composition seem to be worked up like the later oil version (cat. no. 308), it is possible that Degas developed the pastel from his original drawing. There is an immediacy in the realistic angularity of the arms and the shoulder blades and the way the fabric pulls at the seam in the bodice that would substantiate this. The hair is also meticulously drawn. Degas used color and the strokes of his pastel to convey the radiant aura of a theatrical performance.

PROVENANCE: H. O. Havemeyer, New York; by descent to present owner.

SELECTED REFERENCES: Lemoisne [1946–49], III, no. 1149; Minervino 1974, no. 1068.

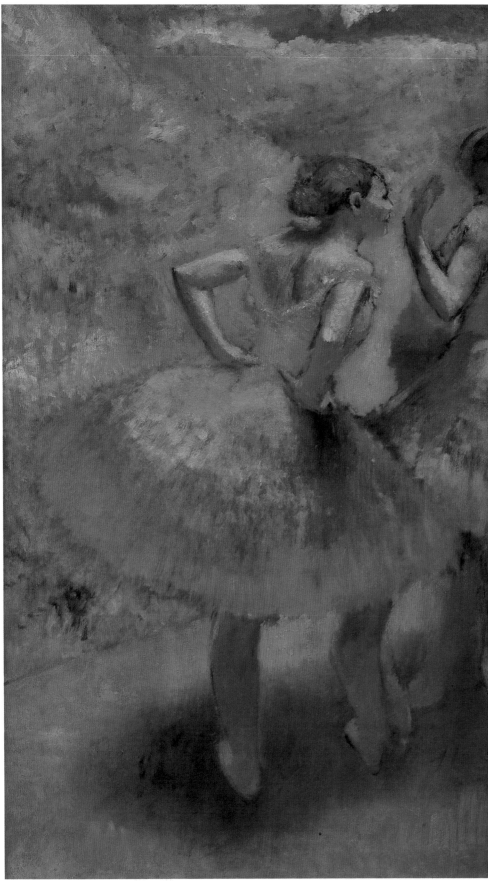

308

308.

Two Dancers in Green Skirts

1894–99
Oil on canvas
55⅛ × 31½ in. (140 × 80 cm)
Vente stamp lower left
Collection of Mr. and Mrs. Herbert Klapper,
 New York

Exhibited in Ottawa and New York

Lemoisne 1195

This is an oil version of *Dancers, Pink and Green* (cat. no. 307) and over four times as large. Lemoisne dates it to a year after the pastel, though it is difficult to be certain exactly where it would fall between 1894 and 1899. The generosity of its scale could indicate a later date.

In this instance, Degas made several drawings in which he rounded the hair of the dancer on the left into a bun (fig. 292).[1] He also rounded her features and her limbs, making them more traditionally beautiful. He pulled back the right arm so that it would not have the same self-confident angle as the left, and revealed the curve of the breast. Drawings of the two dancers together show Degas working on the rhythmic relationship of the contours of the bodies.[2]

In this painting, through color, which may have mellowed with age, Degas transports us to a world that contains less of the excitement of the theater than it does of the seduction of fantasy. His brushstrokes are as bold as the total conception of the work.

Fig. 292. *Standing Dancer* (III:335.2), c. 1895. Charcoal, 18⅞ × 13 in. (48 × 33 cm). Location unknown

1. Others are L1196; III:402; IV:152; 1958 Los Angeles, no. 65.
2. I:311; IV:161.

PROVENANCE: Atelier Degas (Vente I, 1918, no. 100); bought at that sale by Jos Hessel, Paris, for Fr 38,500; bought by Durand-Ruel, New York, 21 March 1921 (stock no. D 12386); Orosdi; bought from Orosdi estate by Durand-Ruel, New York, 19 April 1927 (stock no. N.Y. 5023); bought by Albright Art Gallery, Buffalo, 27 February 1928; sold to Matignon Art Galleries, New York, 1942, in exchange for *Rose Caron* (cat. no. 326); with J. K. Thannhauser, New York. With Hammer Galleries, New York. Sale, Christie's, New York, 16 May 1984, no. 28, repr. (color); bought by present owner.

EXHIBITIONS: 1928, Buffalo Fine Arts Academy, Albright Art Gallery, June–August, *Selection of Paintings*, no. 13 (as "Two Dancers in Green Skirts"); 1968, New York, Hammer Galleries, November–December, *40th Anniversary Loan Exhibition: Masterworks of the XIXth and XXth Century*, repr. (color); 1985, New York, Wildenstein, 13 November–20 December, *Paris Cafés*, repr. (color) p. 79.

SELECTED REFERENCES: Lemoisne [1946–49], III, no. 1195 (as 1895).

309.

Dressed Dancer at Rest, Hands on Her Hips

c. 1895
Bronze
Height: 16⅞ in. (42.9 cm)
Original: brown wax. Collection of Mr. and Mrs. Paul Mellon, Upperville, Virginia

Rewald LII

Degas represented in three works of sculpture a dancer in the same position as the dancer on the left in the pastel *Dancers, Pink and Green* (cat. no. 307) and the oil painting *Two Dancers in Green Skirts* (cat. no. 308).[1] Two, not in this exhibition, are nude (RXXII and RXXIII). More interesting in relation to the pastel and in particular to the painting, to which it is closer, is the third sculpture, which is clothed. As in the canvas, the dancer's tutu is long and full, bouncing up at the back. To support it, Degas stuffed his wax with corks.[2] Working with his fingers, he used tiny pieces of wax to catch the light and produce a flickering effect. Even in sculpture he found a material and technique equivalent to paint or pastel to suggest the shimmering light of the theater. At the same time, the illusion does not extend to the body of the dancer, which is angular, or to her face, which is brutally modeled.

1. Michèle Beaulieu (1969 Paris, no. 256) suggests the relationship to cat. nos. 293 and 358, as well as to L1015, L1016, L1017 (Art Institute of Chicago), L1018, and L1019.
2. Millard 1976, p. 37, no. 59.

SELECTED REFERENCES: 1921 Paris, no. 23; Paris, Louvre, Sculptures, 1933, no. 1750; Rewald 1944, no. LII (as 1896–1911); 1955 New York, no. 50; Rewald 1956, no. LII; Beaulieu 1969, p. 375 (as 1890), fig. 8 p. 373, Orsay 51P; Minervino 1974, no. S23; 1976 London, no. 23; Millard 1976, p. 37 n. 59; Reff 1976, pp. 241–42, fig. 159, Metropolitan 51A; 1986 Florence, no. 51, p. 200, pl. 51 p. 148.

A. *Orsay Set P, no. 51*
Musée d'Orsay, Paris (RF2087)

Exhibited in Paris

PROVENANCE: Acquired thanks to the generosity of the heirs of the artist and of the Hébrard family 1930.

EXHIBITIONS: 1931 Paris, Orangerie, no. 23 of sculptures; 1969 Paris, no. 258 (as 1890); 1984–85 Paris, no. 74 p. 189, fig. 199 p. 201.

B. *Metropolitan Set A, no. 51*
The Metropolitan Museum of Art, New York. Bequest of Mrs. H. O. Havemeyer, 1929. H. O. Havemeyer Collection (29.100.392)

Exhibited in Ottawa and New York

PROVENANCE: Bought from A.-A. Hébrard by Mrs. H. O. Havemeyer 1921; her bequest to the museum 1929.

EXHIBITIONS: 1922 New York, no. 63; 1930 New York, under Collection of Bronzes, nos. 390–458; 1974 Dallas, no number; 1977 New York, no. 44 of sculptures (dated by Millard as after 1890).

309

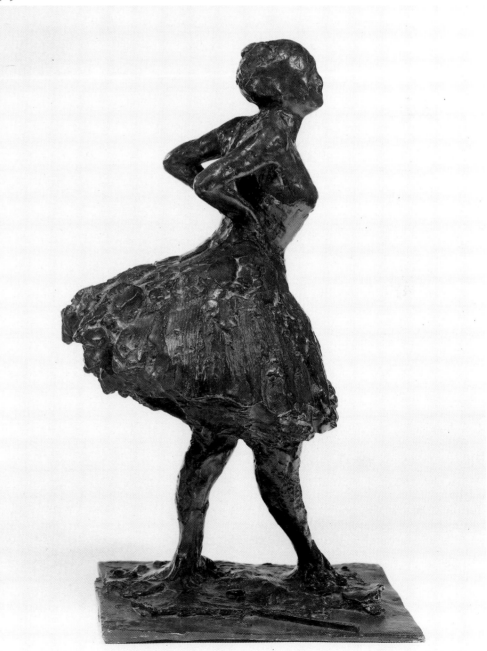

Bathers

cat. nos. 310–320

Degas did not make the kind of public statement about his bathers in the 1890s that he had in 1886, when he described his contribution of a group of nudes to the last of the Impressionist exhibitions. Nevertheless, nude women bathers continued to represent a large proportion of his work—about a third. Although he could still have said what he had observed to George Moore, "These women of mine are honest, simple folk, unconcerned by any other interests than those involved in their physical condition,"[1] he now used the bathers' bodies and gestures to express more than their status. And although it was at this time that he is recorded as having said at the Halévys' "At last I shall be able to devote myself to black and white, which is my passion,"[2] in fact, except for the lithographs and a few drawings in charcoal, these pastels and paintings are remarkable for the intensity of their color.

Degas continued the practice he also must have employed in the eighties of asking his nude models to move freely around the studio—in which a bathtub had been placed—until they took a pose that he wanted to "seize."[3] As some explanation of the settings for these paintings and pastels of bathers, there is a story of the inspection by Mme Ludovic Halévy of the painter's new apartment on rue Victor-Massé in 1890. Mme Halévy's son Daniel described her reaction: "Mama said to Degas in speaking of his new apartment, 'It's charming, but do remove your dressing room from your picture gallery. It spoils the whole thing.'" Degas replied firmly, "No, Louise. It is convenient to me where it is, and I don't put on airs, do I? In the morning, I bathe."[4] The perfectly natural relationship for Degas between the act of bathing and the enjoyment of works of art is the basis of these compositions.

On the other hand, Alice Michel, who modeled for Degas twenty years later, in 1910, remembers in the middle of his untidy studio "a bathtub, which he used in posing models for his 'bathers.'"[5]

Eunice Lipton, in her provocative book *Looking into Degas: Uneasy Images of Women and Modern Life*, argues with conviction that "bathtubs, then, in late nineteenth-century France, far from being ordinary accoutrements of middle-class life, were a sign of the prostitute."[6] She points out that the "upholstered chair covered with a towel or dressing gown, a tub, a dressing table, a water pitcher, a bed" reinforce this association. But she sees an ambiguity in these bathers, as she does in all the work of Degas. "Because of the absence of explicit sexual gestures and complex narratives, . . . the prostitute has

metamorphosed into any working woman, or even middle-class woman."[7] One reason may be that although Degas may indulge in richness of texture and color in fabrics that would not seem inappropriate in a brothel, his bathtubs are chastely bare, without the skirts with which it was customary to adorn them in brothels. In the same way, the bathers are bare, and without affectations. Only in the nineteenth century must their nudity have been explained by prostitution. Degas was in fact pursuing something more essential.

The collector and writer Étienne Moreau-Nélaton, who visited Degas more than ten years later, remarked on the pieces of material in the studio—the sumptuous orange, "une étoffe rose saumon," which Degas begged him not to move.[8] Although some of the fabrics and specific pieces of material are familiar to us from Degas's works of the eighties, some are new, the result presumably of his shopping for the rue Victor-Massé apartment. In general, it can be said that they are used more abstractly and often more ambiguously than were his props a decade earlier.

1. Moore 1890, p. 425.
2. Degas Letters 1947, "Notes on Degas, Written Down by Daniel Halévy 1891–1893," p. 247. Halévy dates the incident Saturday 14 February 1892.

310

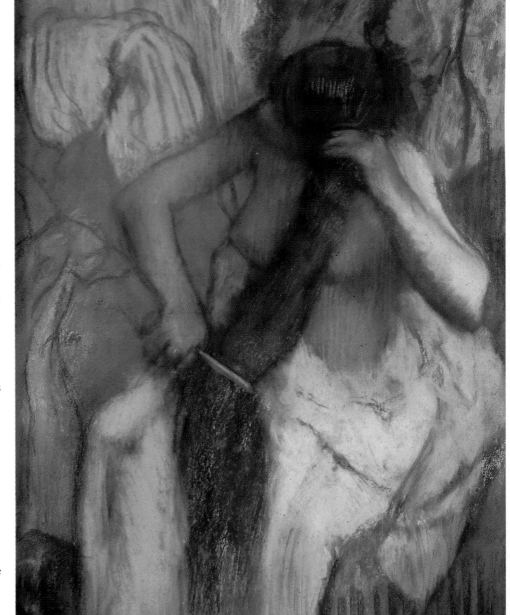

The story may be apocryphal; Mina Curtiss omitted it from her careful edition of Halévy's *My Friend Degas*; see Halévy 1964.
3. Michel 1919, pp. 457–78, 623–39.
4. Halévy 1960, p. 39; Halévy 1964, p. 37.
5. Michel 1919, p. 458.
6. Lipton 1986, p. 169.
7. Ibid., p. 182.
8. Moreau-Nélaton 1931, p. 268.

310.

Young Woman Combing Her Hair

c. 1890–92
Pastel on beige paper mounted on heavy wove
 paper
32½ × 23⅜ in. (82 × 57 cm)
Vente stamp lower left
Musée d'Orsay, Paris (RF1942-13)

Exhibited in Paris

Lemoisne 930

Degas, who had always given great emphasis to the image of women combing their hair, seems here to have found in it a reflection of sound. The bather combs her hair as if the comb were a bow. She cups her ear with the other hand as if listening.

The nudity of the figure is somewhat concealed by the hennaed hair between her breasts and by the white towel over the lower part of her body. Nevertheless, the drawing of the breasts is both so sculptural and so chaste that it inevitably suggests early fifth-century Greek sculpture. Even the roughness of the hatching on the torso reminds us of the resistance of stone. On the other hand, the pastel breaks into a panoply of color behind the figure—a yellow green that is an extension of the chaise longue, what appears to be a pink towel with blue shadow, and some reddish fabric continuing the color of the young woman's hair. Blue shadows on a white towel in the upper left become more intensely turquoise in some fabric in the upper right. This background not only relieves the stonelike severity of the figure, it also dissolves into an organic vortex of color that competes with the figure and supports the musical analogy.

PROVENANCE: Atelier Degas (Vente I, 1918, no. 128); bought at that sale by Dr. Georges Viau, for Fr 20,000; Viau collection, 1918–42 (sale, Drouot, Paris, first Viau sale, 11 December 1942, no. 69, pl. XII); bought at that sale by the Louvre.

EXHIBITIONS: 1945, Paris, Louvre, *Nouvelles acquisitions des Musées Nationaux*, no. 80; 1949 Paris, no. 105; 1956 Paris (no catalogue); 1969 Paris, no. 219, repr. (color) cover; 1969, Paris, Louvre, Cabinet des Dessins, December, "Pastels" (no catalogue); 1974, Paris, Louvre, Cabinet des Dessins, June, "Pastels, cartons, miniatures, XVIe–XIXe siècles" (no catalogue); 1975, Paris, Louvre, Cabinet des Dessins, "Pastels du XIXe siècle" (no catalogue); 1975–76, Paris, Louvre, Cabinet

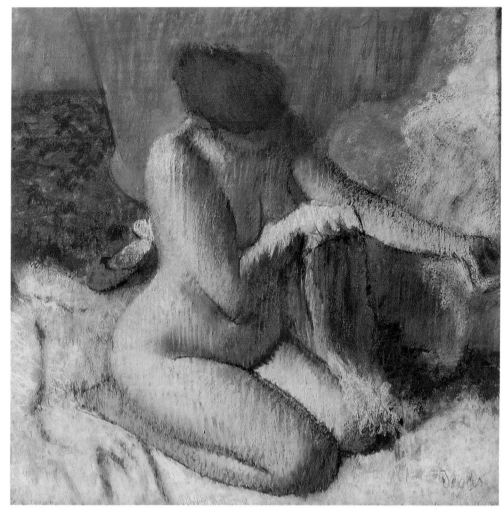

311

des Dessins, "Nouvelle présentation: pastels, gouaches, miniatures" (no catalogue); 1985 Paris, no. 89.

SELECTED REFERENCES: Germain Bazin, "Nouvelles acquisitions du Musée du Louvre," *Revue des Beaux-Arts de France*, 1943, pt. III, repr. p. 139; Lemoisne [1946–49], III, no. 930 (as c. 1887–90); Paris, Louvre, Impressionnistes, 1947, no. 75; Minervino 1974, no. 939, pl. LV (color); Paris, Louvre and Orsay, Pastels, 1985, no. 89, p. 92, repr. p. 91.

311.

After the Bath

c. 1895
Pastel on wove paper, with additional strip at top
27⅝ × 27⅝ in. (70 × 70 cm)
Signed in black chalk lower right: Degas
Musée du Louvre, Paris. Gift of Hélène and
 Victor Lyon (RF31343)

Exhibited in Paris

Lemoisne 1335

In some ways, this pastel seems a denial by the artist of the round tub he had enjoyed drawing in his bathers of the eighties. It is

Fig. 293. *Woman in a Tub* (L738), 1884–86. Pastel, 27½ × 27½ in. (68 × 68 cm). The Tate Gallery, London

based on *Woman in a Tub* (fig. 293), customarily dated between 1882 and 1885, which appears to have been shown in the last Impressionist exhibition.[1] The earlier work was once owned by Degas's friend the painter Henry Lerolle and is now in the Tate Gallery in London. In the Tate pastel, a nude in an almost identical position sits in a

flat circular tub, which emphasizes the unusual roundness of the forms. The tub also contains the body most reassuringly.

In making the later work, Degas stayed remarkably close to the original conception, but he placed the bather on a towel on the floor. She is therefore not protected by the tub. And indeed there is less sense of a defined intimate interior. He has opened up the space around the figure, particularly above her head, and he has been even less specific about the details. Only a preparatory drawing (L1334) indicates that there is probably an elongated tub behind the bather. Degas compensates for his suppression of literal description by the intensity of the color, though it is still in stylized patches, and by the abstract play of pastel. The nude herself also seems more generalized, her features lost in shadow—perhaps not quite a goddess, but hardly a particular individual.

One might suspect that Degas made *After the Bath* for someone who had enjoyed the earlier pastel in Lerolle's house. This does not seem to have been the case, however, since Degas sold *After the Bath* to Durand-Ruel in June 1895, and it did not find a buyer until the following May.

1. Thomson 1986, p. 189, fig. 4 p. 188.

PROVENANCE: Bought from the artist by Durand-Ruel, Paris, 11 June 1895; bought by Mr. Von Seidlitz 2 May 1896, for Fr 4,300 (stock no. 3344); Von Seidlitz collection, Dresden; Max Silberberg, Breslau (sale, MM. S . . . and S . . . [Silberberg], Paris, Galerie Georges Petit, 9 June 1932, no. 6, repr.); bought at

that sale by Schoeller, for Fr 110,000; Victor Lyon, Paris; gift of Hélène and Victor Lyon to the Louvre, reserving rights for their son Édouard Lyon, 1961; entered the Louvre 1977.

EXHIBITIONS: 1914, Dresden, April–May, *Exposition de la peinture française du XIXe siècle*; 1937 Paris, Orangerie, no. 158, pl. XXIX; 1978, Paris, Louvre, "Donation Hélène et Victor Lyon" (no catalogue).

SELECTED REFERENCES: Grappe 1911, p. 18; Lemoisne [1946–49], III, no. 1335 (c. 1898); Minervino 1974, no. 1042; Anne Distel, "La donation Hélène et Victor Lyon, II: peintures impressionnistes," *La Revue du Louvre et des Musées de France*, XXVIII:5–6, 1978, pp. 400, 401, 406, no. 64, repr. (color); 1984–85 Paris, fig. 120 (color) p. 141; Paris, Louvre and Orsay, Pastels, 1985, p. 86, no. 83.

312.

Nude Woman Drying Her Feet

c. 1895
Pastel
18⅛ × 23¼ in. (46 × 59 cm)
Vente stamp lower left
Collection of Muriel and Philip Berman, Allentown, Pennsylvania

Exhibited in Ottawa and New York

Lemoisne 1137

One view of the body in motion that interested Degas, as he watched his models moving around his studio, was looking down at the back of a bather as she leaned forward to

dry her lower limbs. In his most daring performance with this pose—a charcoal and pastel drawing (fig. 294)—the bather is freestanding and seems to bow, holding her towel with the flourish of a matador.[1] By contrast, in this pastel in the Berman collection, Degas drew a bather supporting herself on the edge of the tub and curling around herself as if she were a dormouse.

Degas surrounded the bather with yellow drapery, a patterned rug, and a blue tub, to make the scene more intimate still. He used the pastel calligraphically, but with particular vibration on the model's back, where the white and black strokes of pastel spill over the contours of her body. The energy is therefore highly abstracted, reaching a fluid resolution in the shining white towel, with its blue shadows, about the bather's legs.

1. A preparatory study for *Le petit déjeuner après le bain* (L1150 and L1151, Tel Aviv Museum).

PROVENANCE: Atelier Degas (Vente II, 1918, no. 63, for Fr 7,100); Charles Comiot, Paris; Yolande Mazuc, Caracas; with Wildenstein, New York; Mr. and Mrs. Morris Sprayregen, Atlanta. Sale, Sotheby Parke Bernet, New York, 14 November 1984, no. 17; bought at that sale by present owner.

EXHIBITIONS: 1949 New York, no. 82, p. 65, lent by Wildenstein; 1956, New York, Wildenstein, November, *The Nude in Painting*, no. 29; 1960 New York, no. 59, lent by Mr. and Mrs. Morris Sprayregen.

SELECTED REFERENCES: François Fosca, "La collection Comiot," *L'Amour de l'Art*, April 1927, p. 113, repr. p. 111; Lemoisne [1946–49], III, no. 1137 (as c. 1893); Jean Crenelle, "The Perfectionism of Degas," *Arts*, XXXIV:7, April 1960, p. 40, repr.

312

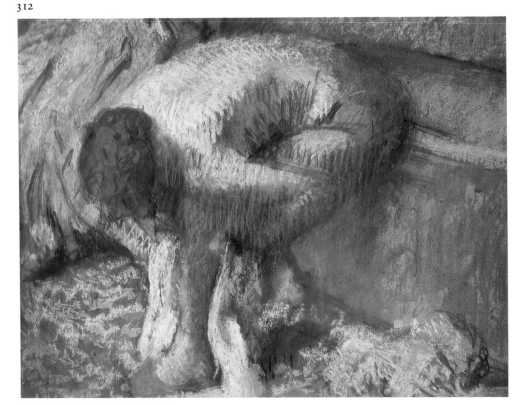

Fig. 294. *Breakfast after the Bath* (L1152), c. 1895. Charcoal and pastel, 31½ × 20⅞ in. (80 × 53 cm). Private collection

313.

Nude Woman Lying on Her Stomach

c. 1895
Pastel over monotype in black ink on off-white
 laid paper
16⅛ × 12¼ in. (41 × 31 cm)
Vente stamp lower left
Private collection, France

Lemoisne 1401

Seldom in his search for what seems to have been a visual equivalent for energy did Degas ever succumb to the attractions of complete relaxation as he did in this pastel. To that end, he made drawings of a youthful figure lying on her stomach in serenity and self-absorption (fig. 295). The drawings show Degas working through the emphases in her contours toward an impression of total indolence.[1] In the pastel, he placed the figure in an interior with reddish wallpaper and a mirror reflecting the light of the kerosene lamp on the table beside her. The pastel, which conveys the richness of light and shadow in the room, comes to even greater life in indicating, with vibrating strokes, the almost iridescent surface of her skin. The small composition is full of visual intensity that arouses in us a sympathy for, and even envy of, the resting girl.

There are two problems connected with this pastel. One is the date. Lemoisne proposes about 1901, which seems late for a work as small and as specific in detail as this one. Eugenia Parry Janis, in her catalogue of the Degas monotypes, brings up another problem in describing the work as a pastel over monotype and then dating it almost twenty years earlier, c. 1880–85.[2] The vibrant handling of the pastel suggests that it must be later; hence, a date of c. 1895 is proposed here. Janis considers the work to be a cognate of Nude Woman Lying on a Divan (fig. 296), which is a monotype covered with pastel that includes the same elements—lamp, mirror, divan, and a reclining nude figure. Nevertheless, if similar monotypes exist under both pastels, Degas must have used the pastel much later here than he did for what may be its cognate and applied it so heavily that the monotype itself is barely visible. That this is not an impossibility is suggested by the size of the drawings of the recumbent figure. These are substantially bigger than the finished pastel, indicating that Degas was working on the composition again at a later time when, because of his bad eyesight, he was more comfortable working on a larger scale.

1. L1402 (fig. 295), L1403, III:171, III: 249.
2. Janis 1968, no. 162.

313

Fig. 295. Young Woman Lying on a Chaise Longue (L1402), c. 1895. Pastel and pencil, 14⅛ × 22½ in. (36 × 57 cm). Private collection

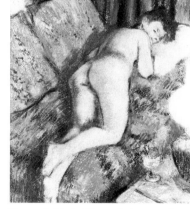

Fig. 296. Nude Woman Lying on a Divan (L921), c. 1885. Pastel over monotype, 15 × 11 in. (38 × 28 cm). Location unknown

PROVENANCE: Atelier Degas (Vente II, 1918, no. 194); bought at that sale by Nunès et Fiquet, Paris, for Fr 6,000; by descent to present owner.

EXHIBITIONS: 1955 Paris, GBA, no. 162.

SELECTED REFERENCES: Lemoisne [1946–49], III, no. 1401; Janis 1967, p. 81, fig. 47; Janis 1968, no. 162; Minervino 1974, no. 1046.

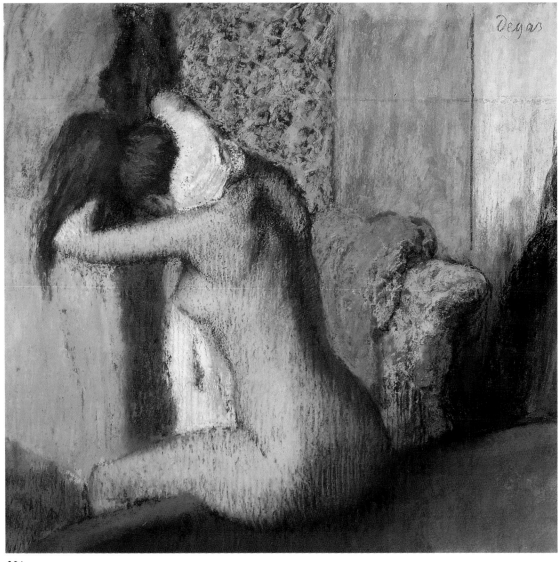

314

314.

After the Bath, Woman Drying Her Neck

c. 1895
Pastel on wove paper, with strip added at top
24½ × 25⅝ in. (62.2 × 65 cm)
Signed upper right: Degas
Musée d'Orsay, Paris (RF4044)

Exhibited in Paris

Lemoisne 1306

There are ambiguities in the handling of space in this pastel of a nude drying her neck. The tub on which she sits is not consistently defined. The predominantly white vertical strip on the far right, separated by a dark stroke from a thinly painted blue-gray strip, could indicate a window. The patterned yellow-and-green material might be a curtain or wallpaper. Between the tub and the wall, there is undoubtedly the patterned back of a chair or a chaise longue with some orange material thrown over it, but the rest of this piece of furniture is lost behind the nude's body. There are other mysteries, such as the flowing orange at the left, perhaps a curtain, and the dark brown vertical break that seems to make a visual pun on the bather's hair. The work is full of puzzles, but it is so strong and so luminous in color that we are not distracted by them.

The contours of the spare body are hard beneath the radiant strokes of pastel that explode luminously in a disciplined hatching over the shadows. Denis Rouart has described the work as layered—a "pastel of one layer superimposed over another."[1] Because the bather's back is turned, we are not apt to think of her as an individual, though we do seem to feel the pull of the hair against the fragile neck.

1. Rouart 1945, p. 40 (illustration caption).

PROVENANCE: Bought from the artist by Durand-Ruel, Paris, 24 May 1898 (stock no. 4682); bought by Comte Isaac de Camondo, 7 September 1898, for Fr 10,000 (stock no. 4682); his bequest to the Louvre 1908; entered the Louvre 1911.

EXHIBITIONS: 1914, Dresden, April–May, *Exposition de la peinture française au XIXe siècle*; 1937 Paris, Palais National, no. 242; 1949 Paris, no. 107; 1969 Paris, no. 221.

SELECTED REFERENCES: Paris, Louvre, Camondo, 1914, no. 226, p. 44; Meier-Graefe 1923, pl. XCIII; Lemoisne 1937, repr. p. D; Rouart 1945, repr. p. 40; Lemoisne [1946–49], III, no. 1306 (as c. 1901); Monnier 1969, p. 366, fig. 1; Monnier 1978, p. 77, repr. (color) p. 76; Siegfried Wichmann, *Japonisme: The Japanese Influence on Western Art since 1858*, London: Thames and Hudson, 1981, repr. p. 26; Paris, Louvre and Orsay, Pastels, 1985, no. 57, pp. 65–66, repr. p. 66 and cover (color).

315.

The Breakfast after the Bath

c. 1895
Pastel and brush on tracing paper, several pieces joined
47⅝ × 36¼ in. (121 × 92 cm)
Signed in orange crayon lower right: Degas
Private collection

Lemoisne 724

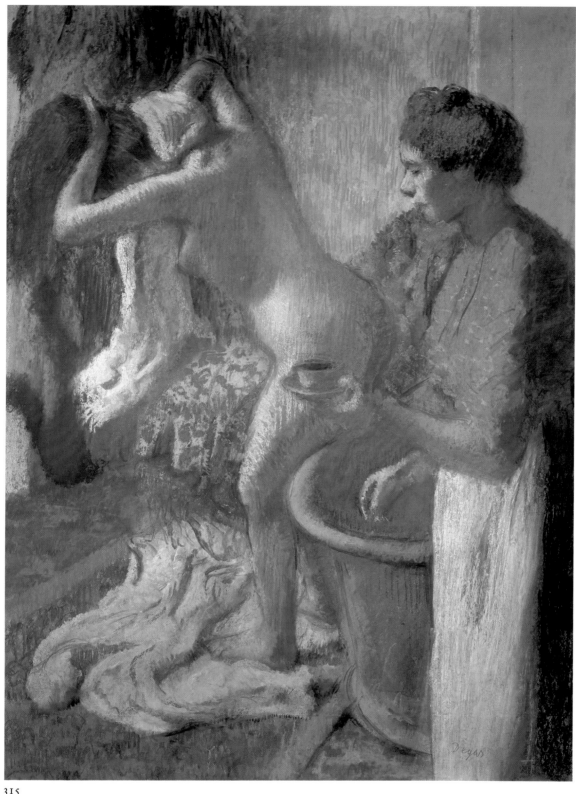

315

The very size of *The Breakfast after the Bath* reveals the ambitions Degas must have had for it. It is among the largest of his pastels. In the stock books of Durand-Ruel and in the exhibitions to which that firm sent the work, it was consistently dated 1883.[1] This misconception could have resulted from the resemblance it bears to a pastel of a bather, undoubtedly of 1883 (cat. no. 253). The similarity is in the energetic angle of the torso of the bather. Nevertheless, any comparison with the elegant feet and gestures of the earlier nude and with the light that caresses that body reveals how clumsily flat-footed this bather is. This work is also six times as large. And instead of the thin application of pastel that reveals the delicacy of the charcoal drawing in the earlier work, Degas has drawn, painted, and rubbed on so many irregular layers of pastel that here there is a rich, unbroken web of color. In spite of the presence of the green-and-yellow upholstered chaise that also appears frequently in Degas's pastels of nudes in the previous decade, *The Breakfast after the Bath* clearly belongs to the 1890s.

This bather is a mass of energy which the vibrantly applied colors of her flesh—predominantly pinks and greens—do not contradict. In the kind of gesture Degas always

loved, she holds out her heavy and luxuriant hair with the left hand while she dries her neck with the right. A touch of rose at the top of her spine inevitably hints that her neck could be as vulnerable as those of the bathers in the lithographs of 1891 (cat. nos. 294–296). Nevertheless, the action is wholesome and the soft flow from the luminously blue-shadowed towel fulfilling and distracting as we are led from it to the pool of the towel on which she stands. In a setting of almost Oriental splendor, even if it was based on the contents of the artist's studio on rue Victor-Massé, Degas balances this virago with the quiet figure of the maidservant, who has the dignity of a column but is at the same time subservient, at least to the passing of the years. Almost ritualistically, she holds out a blue cup that casts an equally blue shadow on her mistress's jutting hip.

1. Stock nos. 10949 (1917), N.Y. 4137 (1917), N.Y. 4717 (1922).

PROVENANCE: With Ambroise Vollard, Paris; bought by Galerie Paul Rosenberg, Paris (photo no. 1407, also nos. 1203 [2] and 3002); bought by Galerie Durand-Ruel, Paris, 16 March 1917, for Fr 75,000 (stock no. 10949); sent to Durand-Ruel, New York, 29 December 1917 (stock no. N.Y. 4137); bought by H. W. Hughes, 18 January 1921, for $30,000 (stock no. N.Y. 4137); bought by Durand-Ruel, New York, 3 January 1922 (stock no. N.Y. 4717); bought by Leigh B. Block, Chicago, 23 June 1949; bought from him at an unknown date by Marlborough International Fine Art, London; bought by The Lefevre Gallery, London, June 1978; bought by present owner December 1979.

EXHIBITIONS: 1917, Paris, Galerie Paul Rosenberg, 25 June–13 July, *Exposition d'art français du XIXe siècle*, no. 30, lent by Georges Bernheim; 1928, New York, Durand-Ruel, 31 January–18 February, *Exhibition of Paintings and Pastels by Edgar Degas*, no. 23 (as 1883); 1936 Philadelphia, no. 49, repr. p. 101 (as 1890?), lent by Durand-Ruel, Paris and New York; 1937 New York, no. 16, repr.; 1943, New York, Durand-Ruel, 1–31 March, *Pastels by Degas*, no. 5; 1945, New York, Durand-Ruel, 10 April–5 May, *Nudes by Degas and Renoir*, no. 6; 1947, New York, Durand-Ruel, 10–29 November, *Degas*, no. 21; 1949 New York, no. 63, p. 59, repr. p. 56, lent by Durand-Ruel; 1979, London, The Lefevre Gallery, 15 November–15 December, *Important XIX and XX Century Paintings*, no. 5, repr. (color).

SELECTED REFERENCES: Vollard 1914, pl. VII; Meier-Graefe 1923, pl. LXXXVI (as c. 1890); Edward Alden Jewell, *French Impressionists and Their Contemporaries Represented in American Collections*, New York: Hyperion, 1944, repr. p. 168; Lemoisne [1946–49], III, no. 724; Daniel Catton Rich, "Degas," *American Artist*, 22–27 October 1954, repr. p. 23; Daniel Catton Rich, *Edgar-Hilaire-Germain Degas*, New York: Abrams, 1966, p. 100, pl. 19 (color); Minervino 1974, no. 891; Dunlop 1979, p. 193, fig. 187 (color) p. 201.

316.

Nude Woman Drying Herself

c. 1895
Charcoal on tracing paper mounted on cardboard
25⅞ × 14⅝ in. (65.8 × 37 cm)
Vente stamp lower left
Von der Heydt-Museum, Wuppertal
(KK 1961/63)

Withdrawn from exhibition

Vente II:269

Degas made many drawings, one work of sculpture, and four pastels of a woman sitting on a chair by a bathtub, holding up her left arm while she dries herself under her breast. In this drawing from Wuppertal, she raises her arm so that it hides her face as she dries herself with a luxuriant towel. Degas used charcoal on tracing paper, presumably tracing other drawings as he worked toward the most effective conception. His drawing style is strong and shows no concern about leaving evidence of earlier thoughts or imperfections. The work's rhythms are descriptive—the limp softness of the towel, the short broken strokes like caresses in the hair, the crosshatching to suggest flesh. Degas looks down at the nude with a certain tenderness, emphasized by the dark shadows under her ear and above her breast. To these indications of vulnerability, he adds the gesture of the raised hand—almost one of greeting—which makes the woman a touchingly valiant figure.

316

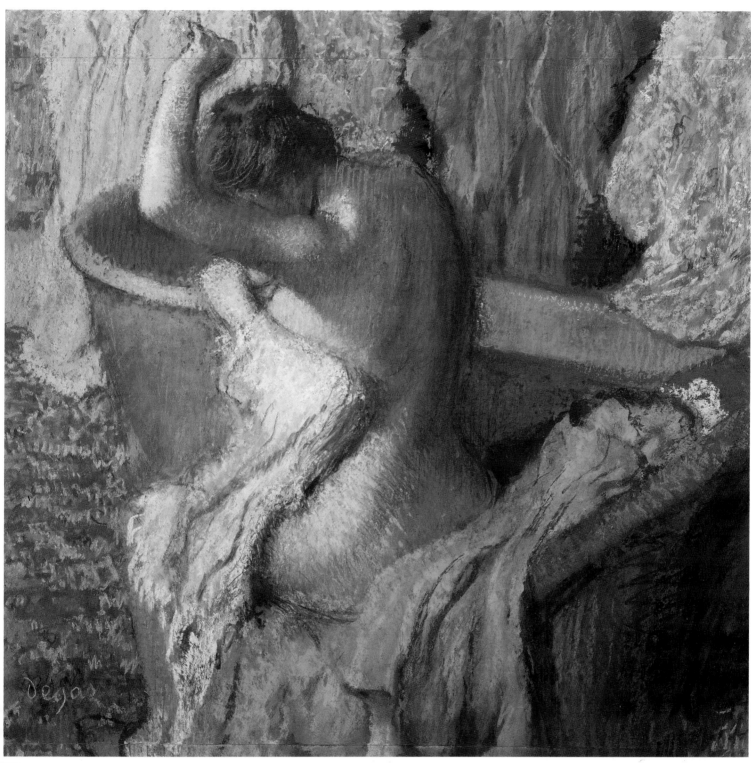

317

317.

Seated Bather Drying Herself

c. 1895
Pastel on wove paper, with strips added at top
 and bottom
20½ × 20½ in. (52 × 52 cm)
Signed twice lower left in green (obscured) and
 in yellow: Degas
Collection of Robert Guccione and Kathy Keeton

Lemoisne 1340

PROVENANCE: Atelier Degas (Vente II, 1918, no. 269); bought at that sale by Ambroise Vollard, Paris, for Fr 1,450; Tanner; Dr. Eduard Freiherr von der Heydt, Ascona; his gift to the museum 1955.

EXHIBITIONS: 1948, Venice, *Biennale XXIV*, no. 72; 1967 Saint Louis, no. 135, repr. p. 202.

SELECTED REFERENCES: *Verzeichnis der Handzeichnungen Pastelle und Aquarelle* (by Hans Günter Aust), Wuppertal: Von der Heydt-Museum, 1965, no. 43, repr.

Through studying the figure and the composition in drawings such as the charcoal from Wuppertal (cat. no. 316), Degas arrived at this sumptuous pastel, which he signed with a particular flamboyance. He changed the position of the body slightly, particularly by reducing the action in the raised hand. Although the movement through the body is a spiraling one, the figure seems more quietly resolved than in the strong charcoal

523

drawing. With less emphasis on realism in the rendering of the body, the woman seems more youthful as well. But the sense of vulnerability has survived, here in particular contrast with the deep (and now diagonally placed), intensely blue tub and the rich fabrics on the wall, chair, and floor. This was a period in which Degas was enamored with *The Thousand and One Nights*;[1] the intensity of the color in this pastel makes it nearly as exotic.

1. Halévy 1964, pp. 65–66.

PROVENANCE: Bought from the artist by Durand-Ruel, Paris, 7 January 1902 (stock no. 6887); bought by Peter Fuller, Brookline, Mass., 8 July 1925 (stock no. 12387); Fuller family, Brookline and Boston, 1925–81 (sale, Sotheby Parke Bernet, New York, 21 May 1981, no. 526); bought by present owners.

EXHIBITIONS: 1905 London, no. 56 (as "After the Bath," pastel, 1899) or no. 70 (as "The Bath," pastel, 1890); 1928, Boston Art Club, *Fuller Collection*, no. 5; 1935 Boston, no. 21; 1937, Boston, Institute of Modern Art, *Boston Collections*; 1939, Boston, Museum of Fine Arts, 9 June–10 September, *Art in New England: Paintings, Drawings, and Prints from Private Collections in New England*, no. 39, pl. XIX.

SELECTED REFERENCES: Moore 1907–08, repr. p. 104; Max Liebermann, *Degas*, Berlin: Cassirer, 1918, repr. p. 24; Lemoisne [1946–49], III, no. 1340 (as 1899); Minervino 1974, no. 1043.

318.

Woman Seated in an Armchair, Drying Under Her Left Arm

c. 1895
Bronze
Height: 12⅝ in. (32 cm)
Original: brown wax. National Gallery of Art, Washington, D.C. Collection of Mr. and Mrs. Paul Mellon

Rewald LXXII

Degas had made many drawings and pastels of a nude seated in an armchair washing or drying under her left arm. Of these, *Nude Woman Drying Herself* (cat. no. 316) is particularly sensitive, and *Seated Bather Drying Herself* (cat. no. 317) is probably the most resolved and the most radiant. It was natural to have used the same pose in sculpture as well. Working on a small scale, which made visitors to his studio compare his wax figures to dolls, Degas modeled brown wax over an unorthodox type of armature and gave it additional resilience by incorporating corks and pieces of wood. These are still visible on the back of the original wax model, now in the Mellon collection. Degas was as experimental in sculpture as he was in monotype or pastel and, indeed, in painting. The impressionistic way he worked the wax with any tool at hand, including his fingers, makes the fabric of the bathrobe tossed over the chair—the same rounded, tufted chair as in the pastel—as informal as it had been in

the works on paper. The concept of a seated figure and the way the broken surfaces of the wax catch the light suggest that Degas may have been looking at the work of the Italian sculptor Medardo Rosso, who had made a seated portrait in wax of the painter's great friend Henri Rouart in 1894.[1]

The body of the bather is, however, more solid, more defined, and more classically integrated than one by Medardo Rosso would have been. In fact, in spite of the clumsy way she sits with her legs and feet apart, she seems to belong, quite naturally, to the tradition of the classical nude. Charles Millard sees a relationship here to Greek terra-cotta figurines.[2] The bather's lifted left arm is less poignant than in the two-dimensional works, perhaps the result of breaks, though it is not unlike that in the Wuppertal drawing (cat. no. 316). *Woman Seated in an Armchair* offers surprises if examined directly from the front or the rear. The chair becomes a throne, and the woman's gesture, otherwise so feminine and so poignant, becomes authoritarian, even consular.

1. Millard 1976, pp. 77–78.
2. Ibid., figs. 134, 135.

SELECTED REFERENCES: 1921 Paris, no. 60; Paris, Louvre, Sculptures, 1933, no. 1777; Rewald 1944, no. LXXII (as 1896–1911), pp. 140–42, Metropolitan 43A; 1955 New York, no. 68; Rewald 1956, no. LXXII, Metropolitan 43A; Beaulieu 1969, p. 38 (as 1883); Minervino 1974, no. S60; 1976 London, no. 60; Millard 1976, pp. 109–10, fig. 134; 1986 Florence, no. 43 p. 194, pl. 43 p. 140.

318, METROPOLITAN

A. *Orsay Set P, no. 43*
Musée d'Orsay, Paris (RF2124)

Exhibited in Paris

PROVENANCE: Acquired thanks to the generosity of the heirs of the artist and of the Hébrard family 1930.

EXHIBITIONS: 1931 Paris, Orangerie, no. 60 of sculptures; 1969 Paris, no. 286 (as 1884); 1984–85 Paris, no. 77 p. 207, fig. 202 p. 202.

B. *Metropolitan Set A, no. 43*
The Metropolitan Museum of Art, New York.
 Bequest of Mrs. H. O. Havemeyer, 1929.
 H. O. Havemeyer Collection (29.100.415)

Exhibited in Ottawa and New York

PROVENANCE: Bought from A.-A. Hébrard by Mrs. H. O. Havemeyer 1921; her bequest to the museum 1929.

EXHIBITIONS: 1922 New York, no. 29; 1930 New York, under Collection of Bronzes, nos. 390–458; 1974 Boston, no. 46; 1974 Dallas, no number; 1975 New Orleans, no number; 1977 New York, no. 59 of sculptures (dated by Millard as after 1895).

319.

Young Girl Braiding Her Hair

1894
Pastel on gray heavy wove paper
24 × 18⅛ in. (61 × 46 cm)
Signed and dated in dark green chalk upper
 right: Degas/94
Collection of Mr. and Mrs. Bernard H. Mendik,
 New York

Lemoisne 1146

Degas dated so few of his works that it is natural to speculate about his motive when he did. There is no reason to assume some association with the subject of this pastel to explain the dating; even the fact that it went on the market right away argues against it. It is more likely that he undertook a subject and almost immediately achieved the realization of it. There was no need to explore it further; the date records his satisfaction.

Young Girl Braiding Her Hair is a work of intimate genre. The room does not possess the untidiness of the corners of Degas's studio. Nor does it suggest the kind of cultivated taste reflected, for example, in the works of art in the guest bedroom at Ménil-Hubert (see cat. no. 303). Although the elements of this room are humble, they are not simple, and they make claims on our attention with their intense play of color, pattern, and texture. They tend to overwhelm the frail figure of the girl standing in her chemise and gently braiding her hair, disciplining

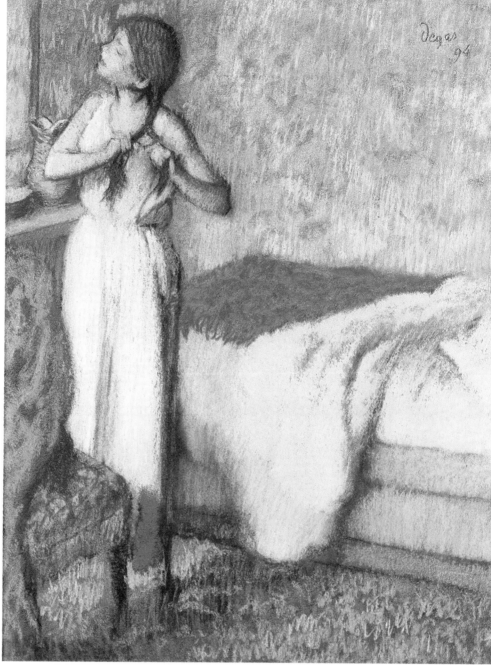

319

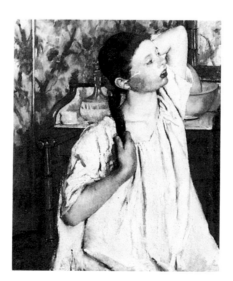

any wild beauty it might have possessed. The lift of her chin should suggest a certain courage, but principally she invites tenderness for her lack of grace, affectation, or animation in the oppressive room.

It is possible that Degas was consciously making a variation on an oil painting by Mary Cassatt, *Girl Arranging Her Hair* (fig. 297), which was exhibited in the 1886 Impressionist exhibition and which he had acquired for his collection that year. Although Cassatt's young girl is seated and shown only half-length, she holds her long braid and is

Fig. 297. Mary Cassatt, *Girl Arranging Her Hair*, 1886. Oil on canvas, 29½ × 24½ in. (75 × 62.3 cm). National Gallery of Art, Washington, D.C.

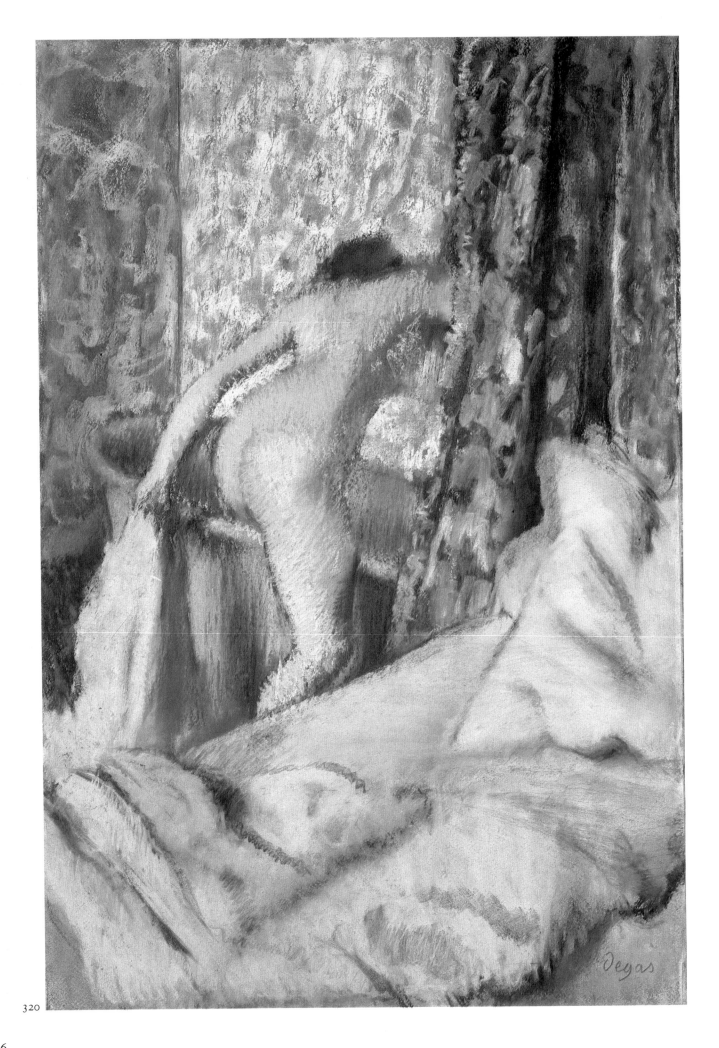

320

placed against a background of a washstand and flowered wallpaper. Furthermore, she is homely and somewhat coltish, which may have aroused in Degas the compassion he reveals here.

PROVENANCE: Tadamasa Hayashi, New York (estate sale, American Art Association, New York, 1913, no. 87, repr.); bought at that sale by Durand-Ruel, New York, and Bernheim, Paris (stock no. N.Y. 3602; stock no. 10260); bought by Bernheim, Paris, 14 May 1919, for Fr 20,000; Mme P. Goujon, Paris. With Wildenstein, New York; present owner.

EXHIBITIONS: 1924 Paris, no. 174; 1939 Paris, no. 32; 1955 Paris, GBA, no. 143, repr. p. 30; 1956, Paris, Bibliothèque Nationale, *Paul Valéry*, no. 679; 1960 Paris, no. 48; 1961, Paris, Musée Jacquemart-André, summer, *Chefs-d'oeuvre des collections particulières*, no. 49; 1962, Paris, Galerie Charpentier, *Chefs-d'oeuvre des collections françaises*, no. 29.

SELECTED REFERENCES: Lemoisne [1946–49], III, no. 1146; Minervino 1974, no. 1166.

320.

The Morning Bath

c. 1895
Pastel on off-white laid paper, mounted on board
26¼ × 17¾ in. (66.8 × 45 cm)
Signed lower right: Degas
The Art Institute of Chicago. Potter Palmer Collection (1922.422)

Exhibited in Ottawa

Lemoisne 1028

This great pastel was bought by Mrs. Potter Palmer of Chicago in 1896, evidence of the interest in Degas that Mary Cassatt had aroused among her compatriots and friends. John Walker, the former director of the National Gallery of Art in Washington, was so impressed by the vigor of Degas's drawing for the pastel that he saw in it the influence of Michelangelo (see fig. 265).[1] More recently, Richard Brettell pointed out the relationship of the energetic pose to one of Degas's works of sculpture, *Dancer Looking at the Sole of Her Right Foot* (cat. no. 321).[2] Certainly the pastel nude has the same dense, concentrated force.

If we knew only the drawing or a black-and-white photograph of this pastel, its color and scale would be surprising. We would expect the body, with its contrapposto, to be heroically large rather than modest in size. We would be unprepared to have its power emphasized, in an almost contradictory manner, by the harmony of the limpid blues and greens. These become most intense in the blue of the curtain at the right, which casts a blue reflection on the bather's skin. The bed in the vast foreground is invitingly serene.

Although Eunice Lipton has suggested that this pastel shares "all the traces of prostitutional display—the drapes . . . the towel, even part of the bed,"[3] it seems too chaste in color to make this a certainty.

Richard Brettell has observed:

In the end, as one stands before *The Morning Bath*, the sheer brilliance of Degas's technique triumphs. The pastel is fully worked and layered. The wall behind the woman glows with separate applications of yellow, red-orange, blue, green, and pale pink. Sometimes, these colors were laid on directly; sometimes, they were crumbled, dissolved in a rapidly drying medium, and "painted" on the paper. Degas worked into the pastel with liquid solvents, using both brushes and various stumps; he also "etched" fine lines into the thick layers of pastel with knives and needles. His handling of the body of the nude is even more spectacular; it virtually glows as it receives all the morning light and every color in the rest of the pastel. Only the bed in the foreground, with its sleight-of-hand lines and thinly applied areas of powder blue, lilac, and pale green, is technically simple. Degas was a master technician; his fascination with his materials and their expressive potential—with the alchemy of art—establishes him as one of the great experimentalists in the history of modern art.[4]

1. Walker 1933, figs. 2, 3, pp. 176–78.
2. 1984 Chicago, p. 161.
3. Lipton 1986, p. 174, fig. 117.
4. 1984 Chicago, p. 160.

PROVENANCE: Bought from the artist by Durand-Ruel, Paris, 16 December 1895 (stock no. 3636); bought by Mrs. Potter Palmer, Chicago, 20 June 1896, for Fr 5,000 (stock no. 3636); her bequest to the museum; entered the museum 1922.

EXHIBITIONS: 1933 Chicago, no. 287; 1934, The Art Institute of Chicago, 1 June–1 November, *A Century of Progress*, no. 203; 1936 Philadelphia, no. 43, repr.; 1984 Chicago, no. 76, repr. (color).

SELECTED REFERENCES: Daniel Catton Rich, "A Family Portrait of Degas," *Bulletin of the Art Institute of Chicago*, XXIII, November 1929, p. 76, repr.; Lemoisne [1946–49], III, no. 1028 (as c. 1890); Rich 1951, pp. 116–17, repr.; *Paintings in the Art Institute of Chicago: A Catalogue of the Picture Collection*, Chicago: The Art Institute of Chicago, 1961, p. 121; Minervino 1974, no. 946; Lipton 1986, p. 174, fig. 117; Sutton 1986, p. 239, pl. 230 (color) p. 240.

321.

Dancer Looking at the Sole of Her Right Foot

1895–1910
Bronze
Height: 19⅛ in. (48.6 cm)
Original wax destroyed

Rewald IL

We know from some of his letters and the reports of his friends that Degas was working at sculpture in the nineties, though a date cannot be firmly established for any of the works. Nevertheless, the closeness of this dancer to the nude in the Chicago pastel *The Morning Bath* (cat. no. 320) suggests that the sculpture, like the pastel, was probably made before 1896.[1]

This is the boldest of the three bronzes that Degas devoted to this theme—full of energy and possessing great compositional interest from whatever angle it is viewed. It clearly suffered in casting, which probably resulted from Degas's use of unorthodox armatures.

The British sculptor William Tucker, in comparing the sculpture of Degas with that of Rodin, has written of this figure: "In the Degas sculpture, the figure is articulated, not as with Rodin from the ground upward, but from the pelvis outward, in every direction, thrusting and probing with volumes and axes until a balance is achieved. From what we know of Degas's methods—primitive and insubstantial armatures, modeling wax eked out with tallow and pieces of cork—an actual physical balance in the model was as much a consideration as the illusioned balance of the figure."[2]

1. As pointed out by Richard Brettell, 1984 Chicago, p. 161, fig. 76-1.
2. Tucker 1974, p. 154, p. 153 figs. 148, 149.

SELECTED REFERENCES: 1921 Paris, no. 33 or 34; Paris, Louvre, Sculptures, 1933, no. 1750; Rewald 1944, no. IL (as 1896–1911), Metropolitan 69A; 1955 New York, no. 57 or 58; Rewald 1956, no. IL, Metropolitan 69A; Beaulieu 1969, p. 375 (as 1890–95), fig. 9 p. 374, Orsay 69P; Minervino 1974, no. S33; Tucker 1974, p. 154, figs. 148, 149 p. 153; 1976 London, no. 33; Millard 1976, pp. 18 n. 66, 71, 107; 1984 Chicago, p. 161, fig. 76-1; 1986 Florence, no. 69 p. 208, pl. 69 p. 166.

A. Orsay Set P, no. 69
Musée d'Orsay, Paris (RF2098)

Exhibited in Paris

PROVENANCE: Acquired thanks to the generosity of the heirs of the artist and of the Hébrard family 1930.

EXHIBITIONS: 1931 Paris, Orangerie, no. 34 of sculptures; 1969 Paris, no. 264 (as 1890–95); 1984–85 Paris, no. 48 p. 190, fig. 173 p. 188.

321

322

322.

Dancer Looking at the Sole of Her Right Foot

1895–1910
Green wax
Height: 18⅛ in. (46 cm)
Musée d'Orsay, Paris (RF2771)

Exhibited in Paris

Rewald LX

PROVENANCE: Atelier Degas; his heirs to A.-A. Hébrard, Paris, 1919, until c. 1955; consigned by Hébrard to M. Knoedler and Co., New York; acquired by Paul Mellon from M. Knoedler and Co. 1956; his gift to the Louvre 1956.

EXHIBITIONS: 1955 New York, no. 56; 1969 Paris, no. 262 (as 1890–95); 1986 Paris, no. 62.

B. *Metropolitan Set A, no. 69*
The Metropolitan Museum of Art, New York.
Bequest of Mrs. H. O. Havemeyer, 1929.
H. O. Havemeyer Collection (29.100.376)

Exhibited in Ottawa and New York

PROVENANCE: Bought from A.-A. Hébrard by Mrs. H. O. Havemeyer 1921; her bequest to the museum 1929.

EXHIBITIONS: 1922 New York, no. 67; 1930 New York, under Collection of Bronzes, nos. 390–458; 1974 Dallas, no number; 1977 New York, no. 61 of sculptures (dated by Millard as 1900–1912).

322, 323

Dancer Looking at the Sole of Her Right Foot

The figure here is somewhat more tentative than in the other version of the same subject (cat. no. 321) and has suffered the loss of part of an arm. The cast retains Degas's handling of the wax in a painterly, expressive way, and the play of light and shadow on the bronze is consequently particularly beautiful.

From Alice Michel, one of the models who posed for him in 1910, we gather that Degas was still making sculpture at that time, but excruciatingly slowly; he was quite willing to begin again when one of his waxes fell apart. Michel describes the model assuming this pose: "Standing on her left foot, her knee slightly bent, she lifted her other foot in a vigorous backward movement. To hold her right foot in this pose, she caught her toe with her right hand, then turned her head so that she could see the sole of her foot and lifted her left elbow high to regain her balance."[1]

1. Michel 1919, p. 459.

SELECTED REFERENCES: 1921 Paris, no. 32; Bazin 1931, p. 296; Paris, Louvre, Sculptures, 1933, no. 1749; Rewald 1944, no. LX (as 1896–1911), Metropolitan 67A; 1955 New York, no. 56; Rewald 1956, no. LX, Metropolitan 67A; Beaulieu 1969, p. 375 (as 1890–95), fig. 9 p. 374, Orsay 67P; Minervino 1974, no. S32; Tucker 1974, p. 154, figs. 148, 149 p. 153; 1976 London, no. 32; Millard 1976, pp. 18 n. 66, 69, 71, 107, fig. 125, Orsay 67P; 1986 Florence, no. 67 p. 207, pl. 67 p. 164.

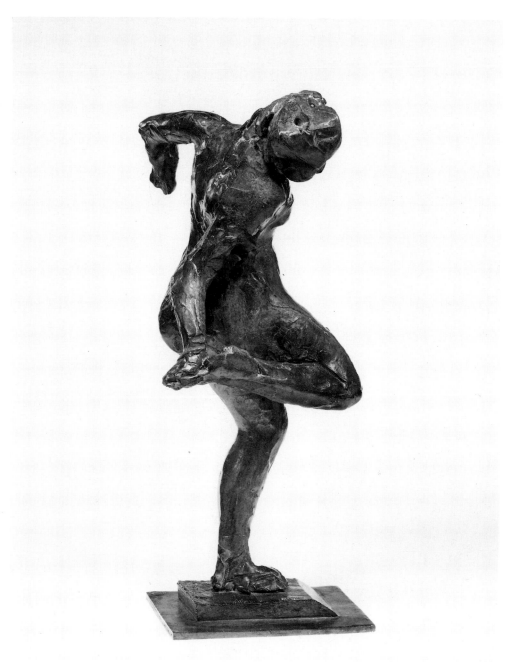

323

323.

Dancer Looking at the Sole of Her Right Foot

1895–1910
Bronze
Height: 18¼ in. (46.4 cm)
Original: green wax. Musée d'Orsay, Paris
 (RF2771). See cat. no. 322

Rewald LX

A. *Orsay Set P, no. 67*
Musée d'Orsay, Paris (RF2096)

Exhibited in Paris

PROVENANCE: Acquired thanks to the generosity of the heirs of the artist and of the Hébrard family 1930.

EXHIBITIONS: 1931 Paris, Orangerie, no. 32 of sculptures; 1984–85 Paris, no. 43 p. 190, fig. 168 p. 186; 1986 Paris, p. 137, no. 63.

B. *Metropolitan Set A, no. 67*
The Metropolitan Museum of Art, New York.
 Bequest of Mrs. H. O. Havemeyer, 1929.
 H. O. Havemeyer Collection (29.100.376)

Exhibited in Ottawa and New York

PROVENANCE: Bought from A.-A. Hébrard by Mrs. H. O. Havemeyer 1921; her bequest to the museum 1929.

EXHIBITIONS: 1922 New York, no. 67; 1923–25 New York; 1925–27 New York; 1930 New York, under Collection of Bronzes, nos. 390–458; 1974 Dallas, no number; 1977 New York, no. 64 of sculptures (dated by Millard as 1900–1912).

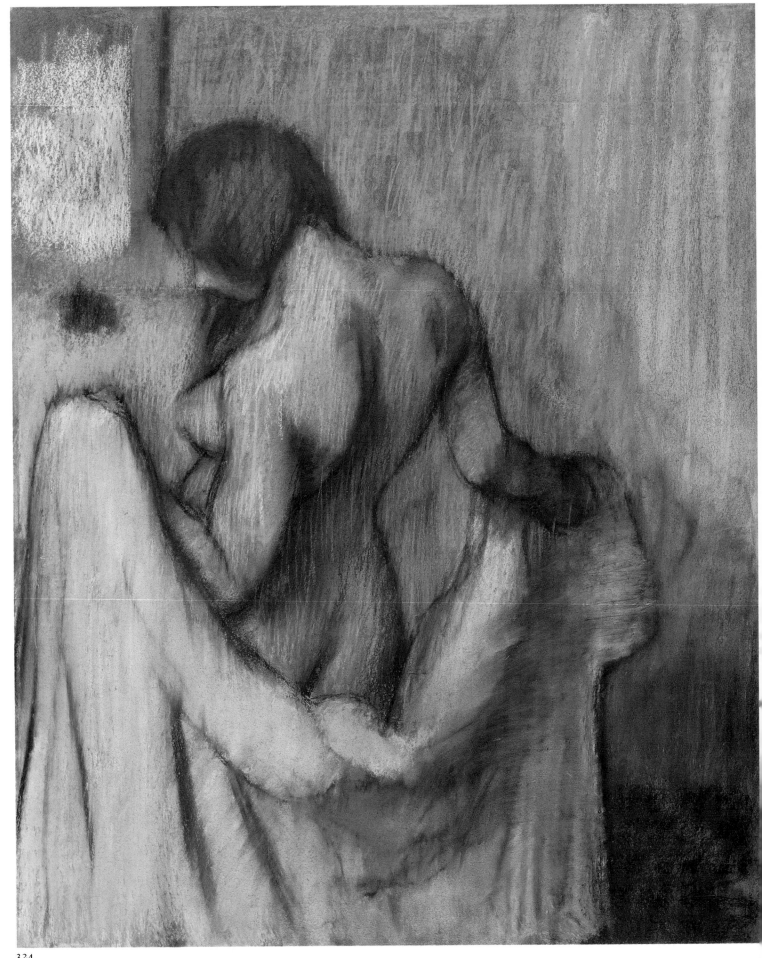

324

324.

Woman with a Towel

1894 or 1898?
Pastel
37¾ × 30 in. (95.9 × 76.2 cm)
Signed and dated upper right: Degas/9[?]
The Metropolitan Museum of Art, New York.
 Bequest of Mrs. H. O. Havemeyer, 1929.
 H. O. Havemeyer Collection (29.100.37)

Exhibited in New York

Lemoisne 1148

This work has the bare elements of a genre-like setting—gilt-framed mirror, mantelpiece with an ultramarine object on it, green-and-orange wallpaper—rather like the pastel *Young Girl Braiding Her Hair* (cat. no. 319). The figure, however, has nothing in common with the standing figure in the chemise in that work. This one is heroically and energetically muscular, her body twisted in contrapposto, emphasized by charcoal or black-chalk contours drawn over the pastel. The nipple of her breast is smudged. Degas has drawn strokes of pink over the flesh and placed a blue shadow on her rump. She holds her large, faintly lavender-tinted towel, with its robin's-egg-blue shadows, with a flourish, enhanced—it has been pointed out—by the variety of means with which Degas applied the pastel.[1] He worked the right portion of the towel with a sharp instrument such as the end of a paintbrush handle, making rather rough horizontal strokes, and used a wet brush to smear the folds and contours. The left contour was softened with a tampon, sponge, or bristle brush. All this gives the towel a decisive movement. Very different is the head, which is bowed. Glowing red hair falls over the young woman's face, somewhat like that of the figure on the right in *The Coiffure* from Oslo (cat. no. 345), though its elfin profile is barely visible.

Degas dated this work, as he had *Young Girl Braiding Her Hair*, but there is considerable difference of opinion about the reading of the second digit. Traditionally, the date has been read as 1894, the same date as the other pastel, not by any means an impossibility; but Charles S. Moffett has proposed 1898.[2]

1. These comments on technique are drawn from the examination report made by Anne Maheux and Peter Zegers, Pastel Project Conservators, National Gallery of Canada.
2. 1977 New York, no. 52.

PROVENANCE: Bought from the artist by Durand-Ruel, Paris, 25 February 1901 (stock no. 6226); bought by H. O. Havemeyer, New York, 22 April 1901, for Fr 10,000 (stock no. 6226); bequeathed by Mrs. H. O. Havemeyer to the museum 1929.

EXHIBITIONS: 1915 New York, no. 39 (as "After the Tub," 1895); 1922 New York, no. 34 (as "La sortie du bain"); 1930 New York, no. 149; 1977 New York, no. 52 of works on paper, repr. (as 1898).

SELECTED REFERENCES: Havemeyer 1931, p. 131 (as 1894); Lemoisne [1946–49], III, no. 1148 (as 1894); New York, Metropolitan, 1967, p. 91, repr. (as 1894); Minervino 1974, no. 1015.

Genre

cat. nos. 325–327

Genre was rare in Degas's late work; it was too rooted in specific times and places, too concerned with exactitude in defining the niceties of social distinctions to be of great interest to him as he grew older and was drawn toward more universal themes. When he did attempt genre, it was in a nostalgic spirit, frequently with reference to his work of the past.

325.

Woman Ironing

c. 1892–95
Oil on canvas
31½ × 25 in. (80 × 63.5 cm)
Vente stamp lower right
Walker Art Gallery, Liverpool (WAG6645)

Exhibited in Ottawa and New York

Lemoisne 846

There were times when Degas thought of laundresses with a certain licentious humor—for example, in the notebook in which at the Halévys' in 1877 he had made a drawing, across two pages, of the composer Ernest Reyer tempting one of four laundresses with what Degas identified in the inscription as "une troisième loge," which can be interpreted as an invitation to share his box at a theatrical performance.[1] Eunice Lipton has suggested that "perhaps 'troisième loge' is metaphorical, implying a third place in his [Reyer's] amorous life."[2] *Woman Ironing*, from the Walker Art Gallery in Liverpool, is far removed from that earlier heretical parody of a Judgment of Paris. Instead, it carries on the tradition of Degas's image of a laundress seen in profile, with form and features barely visible against the backlight of a window and the reflected light of a wall, which he had first developed in the early seventies in paintings such as the Metropolitan's *Woman Ironing* (cat. no. 122).

In the twenty-year span we are assuming between the Metropolitan's painting and Liverpool's, Degas painted the *Woman Ironing* now in the National Gallery of Art in Washington (cat. no. 256). In that composition, he converted the image into something with a greater sense of scale, which was not just a matter of choosing a larger canvas. The laundress is more nobly proportioned and more at ease, and there is a wonderful soothing serenity in the pinks, lavenders, and blues. It was nearly a decade later that Degas painted the Liverpool work, using a canvas the same size as that in Washington but, by strengthening the body and eliminating the softening distraction of laundry hanging in the background, making the woman a sturdier and more independent figure, removed from the humidity, if not the heat, of such an establishment.

This late painting of a laundress, though less ingratiating than the figure in the Washington canvas, is not without an aura of femininity. In the ambiguous planes of the freely painted walls, window, and floor of the room are touches of pink that give the composition a feminine tenderness. Some almost lavender brushstrokes of paint on the wall beside the laundress's profile spill gently onto her sleeve. Her dark gray apron has a charming rose tie, the lips of her shadowed face are faintly pink, and her splendid bared arms reflect a rose light. Although Degas is gentle in painting the wisp of hair falling over her forehead, his use of harsh broken lines of black paint emphasizes and strengthens the contours of the arm and back.

Woman Ironing is not simply a painting in rose and golden light. What is shocking about it, and at the same time gives it physical substance, is the striking fabric—green, with gold and rich black—painted with energetic freedom and heavy impasto. The cloth is both alien to, and yet the reason for, the action and the painting. Its force is strengthened by the diagonal line of the ironing board—itself unique in Degas's work, his other laundresses having worked at tables. The dignity of the ironer raises the work above genre to an expression of simple, austere nobility.

Gary Tinterow, in investigating Degas's work in the eighties for this exhibition, has proposed that the picture, which Lemoisne dates c. 1885,[3] must have been painted in the nineties. Tinterow's proposal is defensible in terms of its color and handling and its strange fusion of shadow and substance—a quality that permeates, for example, *Two Dancers in Green Skirts* (cat. no. 308), which must have been painted after 1894.

1. Reff 1985, Notebook 28 (private collection, pp. 4–5).
2. Lipton 1986, p. 140.
3. Ronald Pickvance (1979 Edinburgh, no. 70, p. 63) essentially agrees with Lemoisne in stating: "The initial design could have been dated from the early 1870s, the reworking could have been done a decade or so later."

PROVENANCE: Atelier Degas (Vente I, 1918, no. 32); Dr. Georges Viau, Paris, from at least 1925 until September 1930[1]; bought back in half-shares by Jacques Seligmann and Wildenstein and Co., New York, 27 September 1930; remained in New York until transferred to Wildenstein and Co., London, 1937; bought by the Hon. Mrs. Peter Pleydell-Bouverie, 27 November 1942 (sale, Sotheby's, London, 30 July 1968, no. 13); bought at that sale with the aid of the National Art Collections Fund.

1. César M. de Hauke, New York, is often indicated as the owner at this time, but a letter from Germain Seligmann of 28 December 1968, cited in *Foreign Catalogue*, Walker Art Gallery, Liverpool, 1977, denies that he owned the work.

EXHIBITIONS: 1937, New York, Jacques Seligmann Gallery, 22 March–17 April, *Courbet to Seurat*, no. 7, Dr. Georges Viau collection; 1942, London, National Gallery, February–March, *Nineteenth Century French Paintings*, no. 37, lent by the Hon. Mrs. Pleydell-Bouverie; 1952 Edinburgh, no. 22 (as c. 1885), lent by the Hon. Mrs. Pleydell-Bouverie; 1954, London, Tate Gallery, 26 January–25 April, *The Pleydell-Bouverie Collection*, no. 15, repr. cover; 1963, London, 19 April–19 May, *Tate Gallery, Private Views, Works from the Collection of Twenty Friends of the Tate Gallery*, no. 152; 1970, London, Lefevre Gallery, 4 June–4 July, *Edgar Degas 1834–1917* (foreword by Denys Sutton), no. 10, p. 40, repr. p. 41; 1979 Edinburgh, no. 70, p. 63, repr.; 1979, London, Royal Academy, 17 November 1979–16 March 1980, *Post Impressionism*, no. 61, p. 63, repr.

SELECTED REFERENCES: Waldemar George, "La collection Viau," *L'Amour de l'Art*, September 1925, p. 365, repr.; Lemoisne [1946–49], III, no. 846 (as c. 1885); Hugh Scrutton, "Estate Duty Purchase and the Auction Room: The Technique under the Finance Act, 1930," *Museums Journal*, 68, December 1968, p. 113, fig. 47; Minervino 1974, no. 638; *Foreign Catalogue*, Liverpool: Walker Art Gallery, 1977, I, no. 6645, pp. 51–52, II, repr. p. 59; Richard Cork, "A Postmortem on Post-Impressionism," *Art in America*, LXVIII, October 1980, p. 92, repr. p. 93.

326.

Rose Caron

c. 1892
Oil on canvas
30 × 32½ in. (76.2 × 86.2 cm)
Vente stamp lower left
Albright-Knox Art Gallery, Buffalo, New York. Charles Clifton, Charles W. Goodyear, and Elisabeth H. Gates Funds, 1943 (43.1)

Lemoisne 862

When Gary Tinterow, the author of Chapter III of this catalogue (on Degas's work in the 1880s), proposed dating this painting of Rose Caron in the 1890s—as opposed to Lemoisne who dates it 1885–90—he also suggested that it is a "genre portrait." Indeed, Rose Caron in this painting is presumably portrayed not as she appeared in life but as she appeared to her contemporaries on the stage at the Opéra de Paris or in Brussels at the Théâtre de la Monnaie—the quintessential operatic lyric soprano with a strong dramatic sense. The *Nouveau Larousse illustré* records that "a warm, vibrant, well-placed voice is combined with a fine stage presence in this great lyric-dramatic artist."[1]

Although this is certainly not a conventional portrait, Rose Caron's features—long straight nose, small mouth, and small eyes enhanced by eyelining and darkened brows—seem close to those in an engraving of the singer published in *L'Illustration* on 18 October 1890 (fig. 298). Her head, with its high cheekbones and pointed jaw, could have seemed to her contemporaries exotically "Aztèque."

Degas was, of course, infatuated with Caron, at least from the time he attended the dress rehearsal on 12 June 1885 of the first performance in Paris of *Sigurd* by his friend Ernest Reyer.[2] (He may have seen her earlier in Brussels.) In addition to hearing her thirty-seven documented times in the role of Brunehilde in *Sigurd* and twice in Reyer's *Salammbô*, he would have seen her between 1885 and 1891 as Agathe in Weber's *Le Freischutz*, Chimène in Massenet's *Le Cid*, and Catherine in Saint Saëns's *Henri VIII*. When she returned from Brussels in 1890, she must have been the reason that Degas, in spite of his reputed dislike of Wagner, went to *Lohengrin* on 26 November 1891 and 22 July 1892 to hear her sing Elsa.

Degas was not only enamored of Caron on the stage. He seems to have felt it a privilege to be invited to dine with her, and not to have been too disappointed, when he complimented her for being as graceful as a Puvis de Chavannes, that she had never heard of the artist.[4] He confirmed his admiration about 1889 in writing a sonnet to her as he wrote one to a very different woman,

325

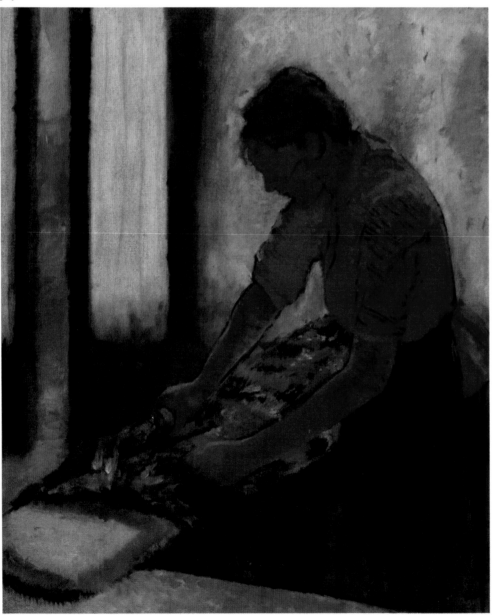

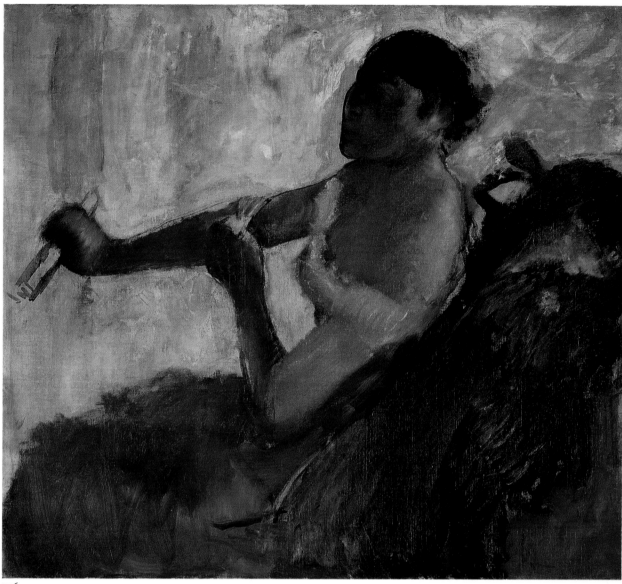

326

L'ILLUSTRATION

SAMEDI 18 OCTOBRE 1890

Fig. 298. *Mme Rose Caron*. Engraving.
L'Illustration, 18 October 1890

his colleague and friend Mary Cassatt, and another to the dancer Marie Sanlaville. The poem is not to Rose Caron, but to "Madame Caron, Brunehilde de Sigurd":

Ces bras nobles et longs, lentement en fureur,
Lentement en humaine et cruelle tendresse,
Flèches que décochait une âme de déesse
Et qui s'allaient fausser à la terre d'erreur;

Diadème dorant cette rose pâleur
De la reine muette, à son peuple en liesse;
Terrasse où descendait une femme en détresse,
Amoureuse, volée, honteuse de douleur;

Après avoir jeté sa menace parée,
Cette voix qui venait, divine de durée,
Prendre Sigurd ainsi que son destin voulait;

Tout ce beau va me suivre encore un bout de
* vie . . .*
Si mes yeux se perdaient, que me durât l'ouïe,
Au son, je pourrais voir le geste qu'elle fait.[5]

(The poet, describing in classic sonnet style the haughty Norse warrior-goddess with her long arms, eloquent gestures, and powerful effect on all who follow her and love her, concludes with a moving tribute to Caron's "divine" voice: "This beauty will remain with me to the end of my days. Though my eyes fail me, may my hearing continue strong, for in that voice I shall forever see what my eyes cannot.")

Not long after Caron first appeared in *Sigurd* in Paris in 1885, Degas declared his enthusiasm for the opera in drawings, particularly in a notebook that is now in the Metropolitan Museum, and in two fans (fig. 188) and one painting that show draped maidens with their arms stretched upward against an Icelandic landscape of trees and dolmens.[6] The portrait of Caron in Buffalo is more apt to suggest the later opera by Reyer in which she appeared—*Salammbô*—to which Degas

was less devoted, at least in his recorded attendance.

Salammbô is based on the romantic novel by Flaubert set in ancient Carthage. Although in the painting Caron is not wearing a costume from the opera, she sits on an extravagant feather wrap draped over a chair and, with a troubled, shadowed face and superb gestures, pulls on her right glove. She could easily be on the operatic stage, playing the role of the Carthaginian priestess. The loosely painted strokes of pink and gold, with occasional touches of a pale and acid green, transport her, and us, to the theater and a romantic past.

1. Vol. II, p. 516.
2. Lettres Degas 1945, LXXXII, p. 106; Degas Letters 1947, no. 91, p. 105.
3. Information on Rose Caron is from Eugène de Solenière, *Rose Caron*, Paris: Bibliothèque d'Art et de la Critique, 1896. On Degas's attendance at the Opéra, see Archives Nationales, Paris, AJ13, "entrées personnelles, porte de communication."
4. Lettres Degas 1945, LXXXIV, to Bartholomé, p. 108; Degas Letters 1947, no. 93, p. 107.
5. Degas Sonnets 1946, no. VII, pp. 37–38.
6. Reff 1985, Notebook 36 (Metropolitan Museum, 1973.9); a drawing in the Museum Boymans-van Beuningen, Rotterdam (FII53); fans (L594, L595 [fig. 188]), in private collections; and L975.

PROVENANCE: Atelier Degas (Vente III, 1919, no. 17); bought at that sale by Dr. Georges Viau, Paris, for Fr 8,000; Viau collection, 1919–30; André Weil and Matignon Art Galleries, New York, 1939; bought by the museum 1943.

EXHIBITIONS: 1931 Paris, Orangerie, hors catalogue; 1938, Amsterdam, Stedelijk Museum, July–September, *Hondert Jaar fransche Kunst*, no. 107, repr. (as "Rose Caron," dated 1890); 1939 Paris, no. 46, lent by Dr. Georges Viau; 1947 Cleveland, no. 47a, pl. XL; 1948 Minneapolis, no. 27; 1949 New York, no. 74, repr. p. 66; 1954, Buffalo, Albright Art Gallery, 16 April–30 May, *Painters' Painters*, p. 42, no. 30, repr.; 1954 Detroit, no. 74, repr.; 1957, Montclair, N.J., Montclair Art Museum, 2–27 October, *Master Painters*, no. 15; 1958, Houston, The Museum of Fine Arts, 10 October–23 November, *The Human Image*, no. 52, repr.; 1958 Los Angeles, no. 54; 1960, Houston, The Museum of Fine Arts, 20 October–11 December, *From Gauguin to Gorky*, no. 17, repr.; 1960 New York, no. 48, repr. (as 1886); 1961, Pittsburgh, Carnegie Institute, Museum of Art, 10 January–19 February, "Paintings from the Albright Art Gallery Collection" (no catalogue); 1961, New Haven, Yale University Art Gallery, 26 April–24 September, *Paintings and Sculpture from the Albright Art Gallery*, no. 14; 1962 Baltimore, no. 49, repr. p. 43; 1968, Baltimore Museum of Art, 22 October–8 December, *From El Greco to Pollock: Early and Late Works by European and American Artists*, p. 81, pl. 60; 1968, Washington, D.C., National Gallery of Art, 19 May–21 July, *Paintings from the Albright-Knox Art Gallery*, p. 17, repr.; 1972, New York, Wildenstein and Co., 2 November–9 December, *Faces from the World of Impressionism and Post-Impressionism*, no. 23, repr. (as c. 1885); 1978 New York, no. 36, repr. (color); 1986, Houston, The Museum of Fine Arts, 10 October 1986–25 January 1987, *The Portrait in France 1700–1900* (by Mary Tavenor Holmes and George T. M. Shackelford), no. 40, pp. 112–13, 137, repr. (color) p. 31.

SELECTED REFERENCES: "Degas," *Arts and Decoration*, XI:3, July 1919, p. 114 (regarding the atelier sale); *Annuaire de la Curiosité et des Beaux-Arts*, 1920, p. 43 (listed as "Jeune femme assise mettant des gants," erroneously giving the name of the atelier sale purchaser as M. Gradt, for Fr 8,200); Waldemar George, "La collection Viau: I, la peinture moderne," *L'Amour de l'Art*, September 1925, p. 364, repr. p. 367; Claude Roger-Marx, "Edgar Degas," *La Renaissance*, XXII:4, August 1939, p. 52, repr.; Lemoisne [1946–49], III, no. 862 (as "Femme assise tirant son gant," 1885–90); *Catalogue of the Paintings and Sculpture in the Permanent Collection* (edited by A. C. Ritchie), Buffalo: Albright Art Gallery, 1949, I, pp. 78, 193, no. 36, repr. p. 79; Boggs 1962, pp. 64–65, 69, 112, pl. 122; Minervino 1974, no. 670; Millard 1976, pp. 11–12, fig. 123; Stephen A. Nash et al., *Albright-Knox Art Gallery: Painting and Sculpture from Antiquity to 1942*, New York: Rizzoli, 1979, pp. 216–17, repr. p. 217, pl. 10 (color) p. 26.

327.

Conversation

c. 1895
Oil on canvas
19¼ × 22 in. (49 × 60 cm)
Signed lower right: Degas
Yale University Art Gallery, New Haven. Gift of Mr. and Mrs. Paul Mellon, B.A. 1929 (1983.7.7)

Lemoisne 864

In this painting, called *Conversation*, now at Yale, Degas once more turned back to an earlier work for inspiration. This time, it was to the puzzling canvas in the Metropolitan Museum from the late sixties, *Sulking* (cat. no. 85). In that work, a couple are in an office in positions that could suggest estrangement. As Theodore Reff has shown, the racing print behind them, *Steeplechase Cracks*, after the picture by the English painter J. F. Herring, unites them, if not very serenely. He admits that *Sulking* is a work that possesses a certain ambiguity.[1] And the later painting is unquestionably ambiguous.

The earlier composition has been rethought. The man is physically closer to the young woman than was his predecessor in *Sulking*, and there seems to be at least a complicity, if not necessarily a sympathy, between them. The landscape also provides a mellower background than Herring's *Steeplechase Cracks* for what appears to be a moment of meditation rather than conversation. The light on the woman's face and hand becomes the focus of our contemplation; related to the white on the man's shirtfront, it draws them closer together. The canvas itself has been repainted by Degas. This is particularly apparent in the head of the man, which is evasive in its features and feeling.

Lemoisne believed that *Conversation*, though finished in 1895, was begun in 1884 as the work Degas mentioned when he wrote to Mme de Fleury that her sister, Périe, and Périe's husband, Albert Bartholomé, had posed for "an intimate portrait" and were "represented in their town attire."[2] That identification seems eccentric, particularly because Degas was so attentive to Bartholomé after his invalid wife's death in 1887, and it is strange that he would have wanted to provoke sad memories of their marriage in 1895, the year Lemoisne dates the completion of *Conversation*. On the other hand, about 1895 Degas made a posthumous portrait of his friend the singer Lorenzo Pagans (fig. 299), in which he resurrected the ghost of his own father, dead for nearly twenty years.[3] It could have been in the same spirit that he perhaps recalled Mme Bartholomé in *Conversation*.

Any features that might identify Mme Bartholomé in the painting, such as those we find on the reclining figure on her tomb made by her husband (fig. 253), are difficult to detect in competition with her great hat, the hand covering her chin, and the light olive-green bustle that seems added like a plume to her brown skirt. The identification of Bartholomé also presents problems. The bald head and the long nose are features found even in the photograph of him in 1888 looking down at the terra-cotta model of his wife that he had made for her tomb.[4] By 1890, when Manzi painted Bartholomé and Degas in their tilbury on the ride into Burgundy[5] or caricatured them with himself looking at a bust of Lafond, the beard had lengthened. By the period of the unveiling of Bartholomé's *Monument to the Dead* at the Père-Lachaise cemetery in 1899, it was still longer, and it was white. In the Yale painting, the beard is shorter, which the de-

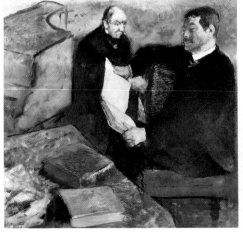

Fig. 299. *Pagans and Degas's Father* (L345), c. 1895. Oil on canvas, 32 × 33 in. (81.3 × 83.8 cm). Private collection

327

sire to reveal the touch of white on the shirt could explain. But the mustache seems to merge indistinguishably into the beard, whereas in all the other portraits of Bartholomé it is nattily distinct. This leaves us in a quandary about whether this is indeed Bartholomé. We can only speculate that *Conversation* might have been intended to bring back the spirit of Périe de Fleury Bartholomé to console her aging husband—a memorial perhaps even more tender than Bartholomé's tomb for her, in which he showed himself embracing his wife.

1. Reff 1976, p. 120, p. 316 n. 89.
2. Lettres Degas 1945, L, p. 76; Degas Letters 1947, no. 59, p. 77.
3. See Boggs 1962, p. 56, for a discussion of the work, and Boggs 1985, pp. 25, 27, for a redating of it.
4. For photographs of Albert Bartholomé and his wife, of Bartholomé and the tomb of his wife, and of Manzi's painting and caricature, see 1986 Florence, pp. 50–54 in the article by Thérèse Burollet, "Un'amicizia paradossale . . . quella di Edgar Degas et dello scultore Albert Bartholomé."
5. See "Landscape Monotypes," p. 502.

PROVENANCE: Atelier Degas (Vente I, 1918, no. 59); bought at that sale by Dr. Georges Viau, for Fr 22,500; Viau collection, 1918–42 (first Viau sale, Drouot, Paris, 11 December 1942, no. 90). Mr. and Mrs. Paul Mellon, Upperville, Va.; their gift to the museum 1983.

SELECTED REFERENCES: Lemoisne [1946–49], III, no. 864 (as a later replica of L335, c. 1885–95); Reff 1976, p. 120, fig. 87 p. 316, no. 89 (refers to Lettres Degas 1945 and Degas Letters 1947, 8 January 1884).

Photography and Portraiture

cat. nos. 328–336

Absorbed as Degas had been in portraiture in his early years, it was clearly of less interest to him as he grew older. By the nineties, his greater devotion to the general than the particular made portraits rather improbable subjects for him. The exceptions were usually in the medium of photography.

Most of what we know of Degas as a photographer comes from the book *My Friend Degas* by Daniel Halévy (1872–1962), a son of the painter's old friends Ludovic and Louise Halévy (see cat. nos. 166, 167). Daniel Halévy tells us that sometime about 1895, Degas "acquired a camera and used it with the same energy he put into everything."[1] His camera was probably a handheld George Eastman Kodak, introduced in 1889, that could use rolled film. Degas rejected the new technology and continued to use glass plates and a tripod, and indeed much of the paraphernalia of earlier photography, because in the nineties he was no longer interested in the instantaneity of a snapshot. Eugenia Parry Janis has pointed out: "Whether consciously or not, Degas pursued effects resembling older, more primitive manifestations of camera work: a subject's stillness; the controllable art of posing, and most interesting of all, perhaps, the strange unearthly illumination of da-

guerreotype and calotype, which was the first and perhaps finest expression of this early photographic sensibility."[2] Although some of Degas's photographs were indeed made in daylight and it was said on at least one occasion that he photographed at night because he was otherwise occupied during the day,[3] he explained a decided preference for night to the Halévys: "Daylight is too easy. What I want is difficult—the atmosphere of lamps or moonlight."[4]

It was at the Halévys' house that he made some of his finest photographs of that family, and their relatives and friends. Three of the noblest are individual photographs of Ludovic (cat. no. 328), Louise (cat. nos. 329, 330), and Daniel (cat. no. 331), each sitting in an armchair in which it was possible to relax in reasonable comfort before Degas's camera and lights. It has been estimated by the various sitters that they had to be still for between two minutes (Daniel—always generous)[5] and fifteen (Paul Valéry—more impatient).[6] Degas expressed in these photographs his love of the Halévys, from whom he would soon be severed by his own implacable unwillingness to believe in the innocence of Captain Alfred Dreyfus, an issue that divided much of France.

Degas did take photographs of people outside the Halévy circle, at least outside their house. Among these portraits are the profile figure of Charles Haas (fig. 300) standing in a garden and the proud figure of Mme Meredith Howland against a rug (fig. 301). Daniel Halévy tells us of Degas's indignant account of Mme Howland's reactions to the two photographs. He asked Halévy, "Isn't it beautiful? But she won't see it. She'll let her dog lick it. She's a beast. The other day I showed her my beautiful Haas. 'It's all mottled,' she said. 'You'll have to touch it up!'"[7] Indeed, Degas's prints and presumably his plates often did have surface imperfections. His devotion to experimentation and discovery became stronger in his later work and militated against perfection of finish.

Exceedingly complex photographs were made at the Halévys' on an evening about which Daniel gave his now famous description of Degas's working method. It was after dinner at his parents' house. Also present were Jules Taschereau (an uncle) and his daughter Henriette, and Mme Alfred Niaudet (an aunt) and her two daughters, Mathilde and Jeanne. Degas went to his studio to fetch his camera and returned:

> From then on, the pleasure part of the evening was over. Degas raised his voice, became dictatorial, gave orders that a lamp be brought into the little salon and that anyone who wasn't going to pose should leave. The duty part of the evening be-

gan. We had to obey Degas's fierce will, his artist's ferocity. At the moment, all his friends speak of him with terror. If you invite him for the evening, you know what to expect: two hours of military obedience.

In spite of my orders to leave, I slid into a corner, and silent in the dark I watched Degas. He had seated Uncle Jules, Mathilde, and Henriette on the little sofa in front of the piano. He went back and forth in front of them, running from one side of the room to the other with an expression of infinite happiness. He moved lamps, changed the reflectors, tried to light the legs by putting a lamp on the floor—to light Uncle Jules's legs, those famous legs, the slenderest, most supple legs in Paris, which Degas always mentions ecstatically.

"Taschereau," he said, "hold onto that leg with your right arm, and pull it in there, there. Then look at that young person beside you. More affectionately—still more—come—come! You can smile so nicely when you want to. And you, Mlle Henriette, bend your head—more—still more. Really bend it. Rest it on your neighbor's shoulder." And when she didn't follow his orders to suit him, he caught her by the nape of the neck and

posed her as he wished. He seized hold of Mathilde and turned her face toward her uncle. Then he stepped back and exclaimed happily, "That does it."

The pose was held for two minutes—and then repeated. We shall see the photographs tonight or tomorrow morning, I think. He will display them here looking happy—and really at moments like that he is happy.

At half-past eleven everybody left; Degas, surrounded by three laughing girls, carried his camera, as proud as a child carrying a gun.[8]

The photograph (fig. 302) ended in a double exposure, as did several others Degas made at that time (fig. 303). One problem is knowing whether this effect was intentional or accidental.[9] Certainly Degas did acknowledge he had failures, as when he told Julie Manet on 29 November 1895 that after a session of photographing Renoir and the Mallarmés, "I am sorry, the photographs are all spoiled, I was afraid to tell you."[10] However, the effects of the double exposure were so provocative that, having arrived at one or two by accident, Degas could have pursued the others intentionally.

If we view the photograph that Daniel Halévy describes Degas taking as a horizon-

tal work, we can see Henriette Taschereau, Mathilde Niaudet, and Jules Taschereau seated on the small sofa in front of the piano, and we can admire one outstretched knee of M. Taschereau's famous legs. He is doing as Degas ordered—holding onto his right leg with his arm and smiling at his niece. Henriette leans on her cousin's shoulder as Degas had placed her, and Mathilde faces her uncle as Degas had insisted. It is disconcerting, however, to discover that the pictures on the wall hang sideways, and that a double portrait of Jeanne Niaudet and her mother is superimposed across the shoulders of this seated group.

What do these departures from conventional photography represent? In the illusive play with reality and the abstract animation of the spaces, the photographs could anticipate Analytical Cubism. In their flouting of convention and their suggestion of action, they could, as has been proposed, prefigure Futurism. The strangeness of juxtapositions and particularly the disorientation in space seem to suggest Surrealism. But the affinity now most frequently proposed for these photographs is with the contemporary Symbolist movement. Both Eugenia Parry Janis and Douglas Crimp support this point of view.

In these works, there is a sense of physical beauty that may be elusive but is also lingering. The space is mysterious but compelling and unforgettable. There is a play of different levels of reality in the disposition of the three-dimensional sitters—phantoms though they may seem—against the pictures on the walls, and a sense of shift and change, which is not that of actual movement but which the artist has created abstractly. Janis suggests the connections with Symbolist poetry by pointing to Degas's friendships with the Symbolist poets Émile Verhaeren and Stéphane Mallarmé, both of whom he photographed.[11] Crimp sees a photograph such as that of the Taschereaus and the Niaudets—"caught in the complex web of the photographic medium . . . transformed into a hallucinatory, spectral image"—as sympathetic and completely consistent with the nature of Symbolist poetry.[12]

1. Halévy 1964, p. 81.
2. 1984–85 Paris, pp. 468–69.
3. Halévy 1960, p. 78; Halévy 1964, p. 69.
4. Ibid.
5. Halévy 1960, p. 93; Halévy 1964, p. 83.
6. Valéry 1965, p. 81; Valéry 1960, p. 40.
7. Halévy 1960, p. 83; Halévy 1964, p. 73.
8. Halévy 1960, pp. 91–93; Halévy 1964, pp. 82–83.
9. Terrasse 1983, p. 43.
10. Manet 1979, p. 73.
11. 1984–85 Paris, pp. 475–76.
12. Crimp 1978, p. 91.

Fig. 300. *Charles Haas*, c. 1895. Photograph printed from a glass negative in the Bibliothèque Nationale, Paris

Fig. 301. *Mme Meredith Howland*, c. 1895. Photograph printed from a glass negative in the Bibliothèque Nationale, Paris

Fig. 302. *Henriette Taschereau, Mathilde Niaudet, Jules Taschereau, Jeanne Niaudet, and Mme Alfred Niaudet* (T17), 1895. Photograph, double exposure, modern print. The Metropolitan Museum of Art, New York

Fig. 303. *Mathilde Niaudet, Jeanne Niaudet, Daniel Halévy, Henriette Taschereau, Ludovic Halévy, and Élie Halévy* (T18), 1895. Photograph, double exposure, modern print. The Metropolitan Museum of Art, New York

328

328.

Ludovic Halévy

c. 1895
Gelatin silver print
3⅛ × 3 in. (8.1 × 7.8 cm)
The J. Paul Getty Museum, Malibu
(86.XM.690.3)

Ludovic Halévy, who was born the same year as Degas, would have been sixty-one in 1895, the year this photograph was presumably taken. He was not by any means as active as his friend. His writing of librettos and fiction was over.

In the photograph, the patterns of the antimacassar and, in particular, of the flowered screen suggest Degas's enjoyment of ornament in other contemporary works, such as the pastel *Young Girl Braiding Her Hair* (cat. no. 319) of 1894. The picture shows Halévy to have aged and mellowed considerably since Degas had thought of him in terms of *La famille Cardinal* almost twenty years before.[1] He is very much the handsome man of letters, member of the Academy since 1884, and paterfamilias, as he leans back, a book on his lap, against the antimacassar of his chair. There may be a certain hauteur implied in his arched eyebrows, but the photograph is a flattering portrait. It makes us realize the tragedy that the break between the painter and writer over the Dreyfus Affair in 1897 would mean for them both.

1. See "Degas, Halévy, and the Cardinals," p. 280; see also cat. nos. 166, 167.

PROVENANCE: Ludovic Halévy; Mme Joxe-Halévy; François Braunschweig; his heirs; bought by the museum.

SELECTED REFERENCES: 1984–85 Paris, p. 466, no. 140 p. 486, fig. 322 p. 469.

329

330

329.

Mme Ludovic Halévy

c. 1895
Gelatin silver print
15⅞ × 11⅝ in. (40.3 × 29.5 cm)
The J. Paul Getty Museum, Malibu
(86.XM.690.1)

Louise Bréguet Halévy was a friend of De-
gas's younger sister Marguerite and one of
the few women he called by her first name.
She came from a distinguished family of
physicists, engineers, and instrument
makers descended from Abraham Louis
Bréguet (1747–1823), the great Swiss clock-
maker. Degas had been at the Lycée Louis-
le-Grand with a great-grandson of the
clockmaker, Louis Bréguet, who was a
brother of Louise.

From his letters, it is clear that Degas re-
spected and admired Louise Halévy, whom
Henri Loyrette speculates he may have
loved when he was a young man (see cat.
no. 20). At one time, according to one of
her two sons, Daniel, he said to Mme Ha-
lévy, "Louise, I would like to do your por-
trait; your features are extremely linear,"[1]
but he never drew or painted a portrait of

her. It was only in photography that he
tried to capture her mature beauty. It seems
to have been in the year that his sister Mar-
guerite died in Buenos Aires that he made
two photographs of her—this, and one called
The Developer,[2] or *Mme Ludovic Halévy, Re-
clining* (T15). Degas romantically used the
chiaroscuro created by the lamps in the Ha-
lévy house at 22 rue de Douai to show only
half of her beautiful face and to make her
veined hand wonderfully moving. She
seems relaxed, but her hand reveals certain
tensions. Her face is sad, as if she could be
mourning the loss of her old friend Mar-
guerite De Gas Fevre. She may also be an-
ticipating the consequences of the Dreyfus
Affair on the friendships of the Halévy family.

1. Halévy 1964, p. 53.
2. A reference to the fact that Mme Halévy some-
times developed his films. Degas ended a letter of
29 September 1895 to her husband: "Greetings to
Louise the developer"; Lettres Degas 1945, CXCIII,
p. 208; Degas Letters 1947, no. 208, pp. 195–96.

PROVENANCE: Galerie Texbraun, Paris; bought by the
museum 1986.

EXHIBITIONS: 1984–85 Paris, no. 141 p. 486, fig. 323
p. 470.

330.

Mme Ludovic Halévy

c. 1895
Gelatin silver print
15¾ × 11⅜ in. (40.1 × 28.7 cm) (sight)
Collection of Mme Joxe-Halévy, Paris

In the enlarged portrait photograph of Lou-
ise Bréguet Halévy (cat. no. 329), Degas of-
fers us a tantalizing glimpse, through the
shadows, of a few objects—a photograph, a
lamp—in the Halévy apartment. This sec-
ond enlargement focuses in a Rembrandt-
esque fashion on Mme Halévy's face and
hand.

PROVENANCE: Ludovic Halévy; Daniel Halévy; by
descent to present owner.

SELECTED REFERENCES: Halévy 1964, repr. facing
p. 49, cropped print, Mme Joxe.

331

331.

Daniel Halévy

c. 1895
Gelatin silver print
15⅞ × 11⅞ in. (40.2 × 30.2 cm)
Collection of Mme Joxe-Halévy, Paris

Terrasse 13

When at Dieppe in 1885 Degas persuaded the English photographer Barnes to record a tableau vivant of his own apotheosis, he had arranged behind him the three daughters of Jean Lemoinne, publisher of the influential *Journal des Débats*, and the two young sons of Ludovic and Louise Halévy—Élie, aged fifteen, and Daniel, aged thirteen—kneeling or crouching at his feet (fig. 191). Presumably then, he regarded both Halévy boys with equal affection. Ten years later, however, it was clear that he had a special disciple in the younger son, Daniel (1872–1962), and it is likely that Élie (1870–1937), who was to become a distinguished historian, had probably already begun to regard the painter's political conservatism with distaste. Daniel uncritically idolized the painter and was to express his admiration of him in

the essays that were to make up his book *My Friend Degas*. By 1895, he was already keeping the journal entries that would form its core. He was also sufficiently influenced by Degas to have bought a landscape at the sale of Gauguin's works in February of that year (see cat. no. 356).

It is appropriate that Degas should have made an idealized portrait photograph of this young man. He placed him in the same setting and armchair he had used for his mother, a chair in which the sitter could relax. Again there is a strong play of shadow, which dramatizes the figure of Daniel. His expression is thoughtful and, with his raised eyebrows, his hand covering his lips, agreeably sardonic. In this print, the sense of the painter's affection for Daniel is clearly expressed.

PROVENANCE: Ludovic Halévy; Daniel Halévy; by descent to present owner.

SELECTED REFERENCES: Halévy 1964, repr. facing p. 48, Mme Joxe; Terrasse 1983, no. 13.

332.

Mallarmé and Paule Gobillard

c. 1896
Gelatin silver print
11½ × 14½ in. (29.2 × 37 cm)
Musée d'Orsay, Paris (PHO1986-83)

Terrasse 11

When the parents of Paule and Jeannie Gobillard died (their mother was Berthe Morisot's sister, Mme Théodore Gobillard),[1] the two Gobillard girls were established in a separate apartment of their own on rue de Villejust.[2] Until her death in March 1895, their aunt Berthe Morisot Manet kept a protective eye on them. This was also true of certain family friends—among them the poet Stéphane Mallarmé, who had a daughter Geneviève somewhat older than they. When Berthe Morisot contemplated her approaching death in a letter to her daughter Julie Manet,[3] she wrote that she hoped Julie would join her Gobillard cousins in that apartment, as she later did. Because Paule Gobillard was the eldest, Mallarmé referred to her as "notre Demoiselle Patronne."[4] Renoir's filmmaker son, Jean, in his biography of his father, tells us that "Paule became so wrapped up in playing the part of big sister that she never married."[5] In fact, she turned to painting.[6] From Julie Manet's journal, it is clear that the three girls responded to the opportunities given them to know some of the finest minds from the worlds of painting, poetry, and music in Paris. They also enjoyed entertaining. As Jean Renoir wrote, "'The little Manet girls,' as they were called, carried on the family tradition. . . . Whenever I have an opportunity to go and see my old friends, I feel as if I were breathing a more subtle air than elsewhere."[7]

It was at one of their soirées in 1895 that Degas took the solemn photograph of Mallarmé sitting twisted in a light chair looking toward Paule Gobillard, who sits unconventionally with her arms propped on two chairs (one the back of Mallarmé's), her arms held together as if for support. Her great puffed sleeves and simple coiffure seem to emphasize the classic beauty of her head. Behind Paule Gobillard, we see the bottom of a vertical painting by Édouard Manet, the uncle of her cousin Julie. The Manet canvas was painted in 1880 and bought at the posthumous sale of the artist's works in 1884 by Julie's parents. Although Degas showed less than half of the painting *Jeune fille dans un jardin*, or *Marguerite [Guillemet] at Bellevue*,[8] there may be some hint of the protective presence of Marguerite Guillemet in the garden at Bellevue, floating above and between Paule Gobillard and Stéphane Mallarmé.

332

Gobillard under a painting by Manet/Photograph taken by Degas in 1896/rue Villejust/and enlarged by Tasset/P. V." [translation]); by descent to their son François Valéry; bought by the museum 1986.

SELECTED REFERENCES: Terrasse 1983, no. 11; Françoise Heilbrun and Philippe Néagu, *Chefs-d'oeuvre de la collection photographique*, Paris: Philippe Sers et R.M.N., 1986, no. 150.

333.

Renoir and Mallarmé

1895
Gelatin silver print
15¼ × 11½ in. (38.9 × 29.2 cm) (sight)
Bibliothèque Littéraire Jacques Doucet, Paris

Terrasse 12

A photograph that seems seminal to Degas's evolution as a photographer, this was taken in the apartment that Julie Manet shared with her Gobillard cousins. It is of the painter Auguste Renoir and the poet Stéphane Mallarmé, who were probably friends through the late Berthe Morisot, in

333

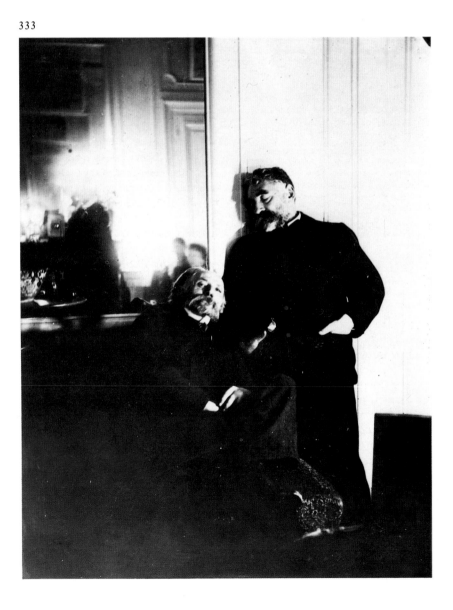

Mallarmé gently refers to the photograph in the first stanza of his "Vers de circonstance":

Tors et gris comme apparaîtrait
Miré parmi la source un saule
Je tremble un peu de mon portrait
Avec Mademoiselle Paule.[9]

(Twisted and gray
Like a willow midst a brook
I tremble a little before this likeness
Of myself with Mademoiselle Paule.)

1. See cat. nos. 87–91.
2. Julie Manet's parents had bought the ground-floor apartment at 40 rue de Villejust (now rue Paul-Valéry) in 1883, but Berthe Morisot had moved out when her husband died. The Gobillard-Morisots seem to have lived three floors above.
3. Morisot 1950, pp. 184–85; Morisot 1957, p. 187, letter dated 1 March 1895.
4. The first line of one of his "Dons de fruits glacés," no. XXXIV of 1898, *Mallarmé: oeuvres complètes*, Paris: La Pléiade, 1945, p. 124.
5. Jean Renoir, *Renoir, My Father*, London: Collins, 1962, p. 268.
6. Her niece, Agathe Rouart Valéry, kindly provided information on her career, including two catalogues: *Dames et demoiselles: Blanche Hoschédé, Jeanne Baudot, Paule Gobillard*, Paris: Durand-Ruel, 1966, and *Paule Gobillard 1867–1946*, New York: Hammer Galleries, 1981.
7. Renoir, op. cit., p. 269.
8. The identification of the painting was made by Karen Herring, National Gallery of Canada Research Assistant for the Degas exhibition.
9. Mallarmé, op. cit., no. XXXII of 1896, p. 124.

PROVENANCE: Given by the artist to Paul Valéry, who married Jeannie Gobillard, Paule's sister, in 1900 (Valéry wrote in the margin: "Mallarmé and Paule

whose former home at 40 rue de Villejust Degas photographed them. Both men acted as guardians to her daughter and nieces. Renoir is seated, and Mallarmé stands by a fireplace over which there is a mirror indistinctly reflecting Mme Mallarmé and their daughter Geneviève in the lower right corner and Degas with his camera at the left. Although Paul Valéry, to whom Degas gave a print of this photograph, pointed out that the mirrored reflections were "like phantoms," and the picture session imposed strains on the sitters, he was impressed by the fine likeness of Mallarmé: "This masterpiece of its kind involved the use of nine oil lamps . . . and a fearful quarter hour of immobility for the subjects. It has the finest likeness of Mallarmé I have ever seen, apart from Whistler's admirable lithograph."[1]

More recently, the ambiguity of the work has been emphasized. Douglas Crimp has written: "Suspended in the specular infinitude that is this photograph, its author is reduced to a specter. Degas has included himself in his photograph only to disappear, in a way that cannot but remind us of Mallarmé's own self-effacement in the creation of his poetry."[2]

1. Valéry 1965, p. 81; Valéry 1960, p. 40.
2. Crimp 1978, p. 95.

PROVENANCE: Paul Valéry, who wrote in the margin: "This photograph was given me by Degas, whose ghostly reflection and camera appear in the mirror. Mallarmé is standing beside Renoir, who is sitting on the sofa. Degas had required them to hold the pose for fifteen minutes, by the light of nine oil lamps. The location is the fourth floor, no. 40 rue de Villejust. In the mirror can be seen the shadowy figures of Mme Mallarmé and her daughter. The enlargement is by Tasset" (translation); bequeathed by Paul Valéry to the Bibliothèque Littéraire Jacques Doucet, Paris.

EXHIBITIONS: 1984–85 Paris, no. 143 p. 486, fig. 337 p. 480.

SELECTED REFERENCES: Valéry 1965, p. 69; Crimp 1978, pp. 94–95, copy print from The Metropolitan Museum of Art, New York, repr. p. 94; Dunlop 1979, p. 210, copy print from The Metropolitan Museum of Art, New York, fig. 193 p. 209; Terrasse 1983, no. 12, pp. 38–39, 121, print, Bibliothèque Littéraire Jacques Doucet, fig. 12 p. 63; 1984–85 Paris, pp. 473–81, no. 143 p. 486, fig. 337 p. 481, print, Bibliothèque Littéraire Jacques Doucet.

334.

Paul Poujaud, Mme Arthur Fontaine, and Degas

c. 1895
Gelatin silver print
11⅝ × 15⅞ in. (29.4 × 40.5 cm)
Inscribed in another hand in violet ink on verso:
Paul Poujaud, 13 rue Solférino
The Metropolitan Museum of Art, New York
(1983.1092)

Terrasse 9

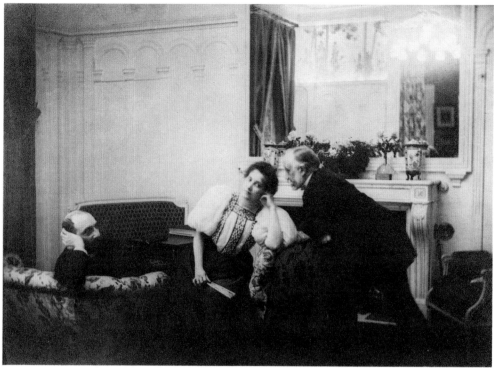

334

Degas occasionally ventured forth into polite bourgeois society, as when he frequented the salon of Mme Arthur Fontaine, whom he photographed in her sitting room with their friend the lawyer Paul Poujaud. Marcel Guérin describes Paul Poujaud as "a lawyer . . . known for his artistic culture and sure taste. He knew all the leading musicians and all the great painters of the period. His judgment and opinions carried great weight, and his influence was considerable. He belonged to the type of 'Dilletante,' was an excellent conversationalist and used to recount in the most vivid manner his memories of a whole life devoted to art."[1] Guérin believed that this photograph had been taken in the salon of the composer Ernest Chausson (1855–1899), a brother-in-law of Mme Fontaine (another of her sisters had married Henry Lerolle).

Degas also had young friends who had become the fashionable recorders of that and an even more aristocratic contemporary society—Giovanni Boldini (1845–1931), Paul Helleu (1859–1927), and Jacques-Émile Blanche (1861–1942). In the mannered poses into which he manipulated Paul Poujaud, Mme Fontaine, and himself in this photograph, Degas may have been gently satirizing these younger artists' work. In the exaggeration of the poses and, in particular, in the diagonal energy of his own body, he also anticipates the histrionics of early films. Although Degas often had difficulty in achieving perfect prints of his photographs, this enlarged silver print has a satiny surface and a precision of detail that enhance the sophisticated image.

1. Degas Letters 1947, Appendix, "Three Letters from Paul Poujaud to Marcel Guérin," p. 233.

PROVENANCE: Paul Poujaud (though an attestation of François Valéry at Bieures, 25 May 1983, states that it was given by Degas to Paul Valéry); Paul Valéry; François Valéry; bought from Alhis Matheos, Basel, by the museum 1983.

SELECTED REFERENCES: Lettres Degas 1945, p. 248, pl. XXII (as "Salon de Chausson"); Lemoisne [1946–49], I, p. 218, repr. p. 219a, a print in the collection of A. S. Henraux; Terrasse 1983, no. 9, p. 35, repr. p. 60, a print in the collection of M. and Mme Marc Julia.

335.

René De Gas

1895–1900
Gelatin silver print
14 × 10 in. (35.6 × 25.4 cm)
Bibliothèque Nationale, Paris

Exhibited in Paris

Terrasse 52

Although Degas had been fond of his brother René, the youngest member of his family, in their early years (see cat. no. 2), and was clearly proud of him when he visited him and his other brother Achille in New Orleans in the winter of 1872–73,[1] he was deeply offended when René deserted his blind wife, their cousin Estelle Musson. As late as 1882, Degas's cousin Edmondo Mor-

335

Henri Rouart and His Son Alexis

1895–98
Oil on canvas
36¼ × 28¾ in. (92 × 73 cm)
Vente stamp lower right
Neue Pinakothek, Munich (13681)

Exhibited in Paris

Lemoisne 1176

In 1895, the same year he probably photographed his old school friend Ludovic Halévy, Degas began making studies for a painting of another of their classmates at the Lycée Louis-le-Grand, Henri Rouart,[1] in one more portrait, this time with Henri's son Alexis. Although this painting, which is now in Munich, seems completely different from a photograph in its scale, in the texture of the opaquely applied paint, and in its unusual color, there may have been a photographic source for it.

In writing on 11 August 1895 to his friend Tasset, who developed and enlarged his photographs, Degas asked him to treat several negatives. Three were of a subject he described as "an elderly invalid in black skullcap; behind his armchair a friend standing."[2] This may have been the source for the composition of this painted portrait, in which it is frightening to sense the pathos—both in the inadequacy of the son and in the son's physical domination over his father, who was suffering from gout. The painting seems far removed from the romanticized photographs Degas had made the same year of Ludovic Halévy and his son Daniel (cat. nos. 328, 331).

We have another record of Henri Rouart at this time. Paul Valéry had been introduced into the Rouart household by one of their sons in 1893 or 1894 and became a frequent visitor. He wrote in *Degas Danse Dessin*:

> In M. Rouart himself . . . I was awed by the amplitude of a career in which nearly all the virtues of character and intelligence had been combined. He was untroubled by ambition, by envy, by any thirst for appearances. True value was all he cared for, and he could appreciate it in several kinds. Among the first connoisseurs of his time, a man who admired—and made early purchases of—the works of Millet, Corot, Daumier, Manet . . . and El Greco, he owed his fortune to machine construction, to inventions which he carried through from the purely theoretical to the technical and thence to the stage of industrial application. This is no place for the gratitude and affection I owe to M. Rouart. I will only say that he is among the

billi was refusing in a letter to his wife Thérèse, the sister of the estranged brothers, to come to Paris to request a reconciliation.[2] Eventually—at least by 20 March 1897, when Degas invited the painter Louis Braquaval and his wife to dinner with René and his family—that reconciliation did occur.[3] One suspects that the death of their brother Achille in October 1893 and of their sister Marguerite two years later may have encouraged it.

Degas made at least two other photographs of his journalist brother, who was an editor of the conservative newspaper *Le Petit Parisien*. These show René seated at a desk and displaying a certain air of cold calculation (T53, T54). In this photograph, however, there are no defenses and no protection. René, who had always been improvident or unfortunate with money, clearly suffered with the years. His suit is coarse, his hands clumsy. His expression suggests the complete vulnerability of this man who in 1895 would have been only fifty. We are not surprised to know that by 1901 he would have changed the spelling of his name from De Gas to de Gas, which suggests noble origin,

and would enjoy moving to a more fashionable quarter when the inheritance of a small fortune from his painter brother made it possible for him to do so.

As Eugenia Parry Janis has pointed out, this photograph of René was taken in Degas's studio with the same curtain and rope against which the painter himself posed for a profile portrait in a smock, a photograph which is often attributed to his friend Bartholomé (fig. 270).[4] Ironically, Degas seems more energetic than his brother, who was eleven years younger.

1. Lettres Degas 1945, III, to Henri Rouart, 5 December 1872, p. 25; Degas Letters 1947, no. 5, p. 24.
2. Guerrero de Balde archives, Naples, 27 June 1882, published in Boggs 1963, p. 276.
3. Unpublished letter, private collection, Paris.
4. 1984–85 Paris, p. 482.

PROVENANCE: René De Gas; his gift to the Bibliothèque Nationale, Paris, 1920?

SELECTED REFERENCES: Terrasse 1983, no. 52, pp. 101, 122, repr. p. 90; 1984–85 Paris, p. 482, fig. 338 p. 481.

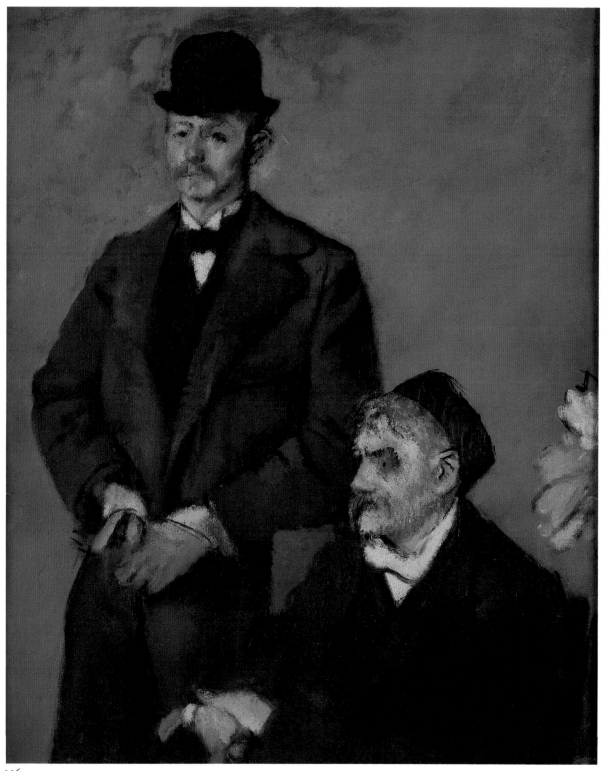

336

men who have left an impress on my mind. His researches into metallurgy and mechanics, as an inventor of thermodynamic machinery, went side by side with an ardent passion for painting; he was as much at home with it as an artist, and indeed practiced it himself as a true painter. But owing to his modesty, his own output, with its curious preciseness, remains almost unknown, the possession only of his heirs.[3]

Clearly, Rouart was much more imposing and personally integrated in 1895 than Degas's portrait suggests. Valéry was aware of the deep affection of the painter and Rouart for each other, but "was always struck by the contrast between two men so remarkable in their different ways."[4]

In painting Henri Rouart with his son Alexis, as he had once painted him with his daughter Hélène (cat. no. 143), Degas must have been aware of those differences, if only

of those he was to express the following year in a letter to Rouart: "You will be blessed, O righteous man, in your children and your children's children. During my cold, I am meditating on the state of celibacy, and a good three-quarters of what I tell myself is sad. I embrace you."[5]

Leading to the double portrait of Henri and his son Alexis, Degas had made a charcoal-and-pastel drawing of Alexis, a work he dated very precisely March 1895 (fig. 304).

Fig. 304. *Alexis Rouart* (BR139), dated March 1895. Charcoal and pastel, 23⅛ × 16 in. (58.8 × 40.5 cm). Private collection

Fig. 305. Paul Cézanne, *The Man with the Pipe*, c. 1892–95. Oil on canvas, 28¾ × 24 in. (73 × 60 cm). Courtauld Institute Galleries, London

Fig. 306. *Henri Rouart* (L1177), dated 1895. Pastel and charcoal, 23⅝ × 17¾ in. (60 × 45 cm). Location unknown

To us, Alexis's ill-fitting hat and coat combined with his mustache irresistibly suggest Charlie Chaplin. Someone interested in the most advanced of the arts in early 1895, however, might have been reminded of the workingmen's suits and hats of the card-players and gardeners in the current exhibition of the work of Cézanne at Vollard's gallery on rue Laffitte. (Cézanne, after all, had a particular interest in a man and his hat and had even painted himself in his bowler.) Compared with Cézanne's rustic figures, such as *The Man with the Pipe* (fig. 305), Alexis Rouart does not dominate his clothes in a macho fashion and does not have the protection of a clay pipe. His body is unequal to the great overcoat—drawn with a few abrupt, extended zigzags of charcoal—his hands seek each other for support, and his mustache is revealed as pale with a reddish tinge. Nicely understated is the mobility and indecisiveness of the face—brows at different levels, eyes of different sizes, asymmetrical mustache, mouth at an angle—its paleness emphasized by the strokes of red chalk on the nose and the modeling of the right side of the face. In a curious way, this drawing of Alexis is beautifully disciplined, while inviting our sympathy for this son of Henri Rouart.

That same year, 1895, Degas dated another pastel-and-charcoal drawing for the Munich painting, this time of Henri Rouart seated, with the headless form of Alexis faintly indicated behind him (fig. 306). Henri Rouart, though aged and undoubtedly arthritic, seems as full of vigorous life—or at least the past enjoyment of it—as his son seems repressed. His body flows into his shapeless suit and is dominated by his energetically modeled head. His mustache grows more

generously than his son's. We see more of his hair, which curls over his brow. He frowns with the kind of creative energy that made Valéry so much admire him. Behind him the sage-green wallpaper breaks into flower, the precedent for the yellow flower that is so surprising in the painting.

The double portrait, which grew out of two such drawings, has gone beyond individual portraiture to a statement of physical and intellectual decline in the individual, and from generation to generation. Both Henri and Alexis seem helpless and weak, their ineffectuality revealed even by the gloves in Alexis's hands.

What happened to Degas's characterization of Henri Rouart between the drawing and the painting? Consciously or unconsciously, he may have projected some of his own physical decline onto the figure of Henri Rouart. There is no reason to believe that Rouart possessed such agonized eyes as Degas gave him here. It is also possible that he was thinking of the sitter for his photograph of "an elderly invalid in black skullcap," which, since he mentions another photograph taken at Carpentras, is probably of his old friend the painter Évariste de Valernes, whom he often visited there and who was to die in 1896. Degas may have projected onto Rouart some of the characteristics of the dying Valernes.

It is in this work, rather than in the drawing, that Degas aged his friend so brutally and even gouged his eyes with red paint. It is an expressive painting about the indignity of age and the indignity of youth: the son stands as if he were already at his father's funeral. Degas, possibly more than they, was troubled by the seeming loss of control by individuals over their destiny. In this

work, which was perhaps executed as much as three years after the drawings, he reveals how haunted he was by the specter of age.

1. See cat. nos. 143, 144.
2. Newhall 1956, p. 125.
3. Valéry 1965, p. 14; Valéry 1960, pp. 8, 9.
4. Valéry 1965, p. 16; Valéry 1960, p. 10.
5. Lettres Degas 1945, CXCIV, p. 209; Degas Letters 1947, no. 211, p. 197.

PROVENANCE: Atelier Degas (Vente I, 1918, no. 17); bought by Jacques Seligmann, Paris, for Fr 13,500 (sale, American Art Association, New York, 27 January 1921, no. 44). With Justin Thannhauser, Lucerne and New York; bought by the museum 1965.

EXHIBITIONS: 1949 New York, no. 83, repr. p. 22; 1960 New York, no. 63, repr.

SELECTED REFERENCES: Lemoisne [1946–49], III, no. 1176; Boggs 1962, pp. 74–75, 128–29, pl. 140; Minervino 1974, no. 1174; Sutton 1986, p. 301, pl. 288 p. 304.

Oil Paintings of the Nude

cat. nos. 337–342

Although Degas is often thought of as having turned almost exclusively to pastels in his last years, in fact he did produce a surprisingly large number of oil paintings. These have not been omitted in major retrospectives of his work, such as the exhibition in Paris in 1924 or in Philadelphia in 1936, but they have seldom played a large role in the literature. One reason may be that they are not easy to understand and to like, almost a terrifying contradiction of what his work had been in the seventies. There is ambiguity, often a suggestion of hostility, certainly an admission of the irrational, and a denial of human perfectibility. This can be

perceived even in the paintings of the nudes.

Elements of the pastel nudes of this same period are here. There are the extravagant fabrics, the long bathtub in settings Mme Halévy would have found surprising,[1] and a pyrotechnic brilliance of color. But the image of the bathtub becomes more ominous in the oils. Even in the pastels, there is little indication of actual water to be enjoyed by the bathers, as there was in some of the works of a decade before. But in these oils, the emptiness of the tub and its very largeness seem to give it a symbolic meaning, at times almost that of a tomb. Predictably, the handling of paint is broader than in the vibrantly applied pastels. The colors are also more generalized, without the same fracturing of hues. The palette and the mood change from one work to another, most obviously in the three compositions Degas based on the same crouching figure (cat. nos. 341, 342; fig. 310), but on the whole the oils are more assertive and less seductive than the pastels. Their format is almost invariably horizontal.

1. See "Bathers," p. 516.

337.

The Bath

c. 1895
Oil on canvas
32 × 46¼ in. (81.3 × 117.5 cm)
Vente stamp lower right
The Carnegie Museum of Art, Pittsburgh. Acquired through the generosity of Mrs. Alan M. Scaife, 1962 (62.37.1)

Lemoisne 1029

The relationship of this painting to the pastel *The Morning Bath*, in the Art Institute of Chicago (cat. no. 320), has been recorded. In his standard catalogue raisonné of the artist's work, Lemoisne places the painting directly after the pastel. Richard Brettell has also remarked on their relationship.[1] It is true that in both works a nude figure is shown getting into a tub, her face turned away or indistinct. There is also a background of patterned paper, and the foreground is taken up by a heavily canopied

unmade bed. It may have been an exercise on Degas's part to have worked two very different variations on the scheme—in the oil choosing a horizontal composition, using colors that are as hot as the others are cool, and working boldly with the paint, particularly in the almost pointillist disks on the background wall.[2] It was not something he did without preparation, for there are many drawings that show his studies of the movement of the figure. Nevertheless, he apparently wanted an effect more immediate and more savage than in the highly refined pastel.

The orange-canopied bed recalls those in late medieval paintings of fifteenth-century Flanders. It is also like those we see today in the Chambre des Povres in the fifteenth-century Hôtel-Dieu at Beaune. According to Erwin Panofsky, the canopied beds in paintings such as the wedding portrait of the Arnolfinis by Jan van Eyck in the National Gallery in London, or the *Annunciation* by Rogier van der Weyden in the Louvre were "nuptial rooms" of great sacramental significance, which makes the bed in this painting an ironic reminder of a more solemn age.[3]

337

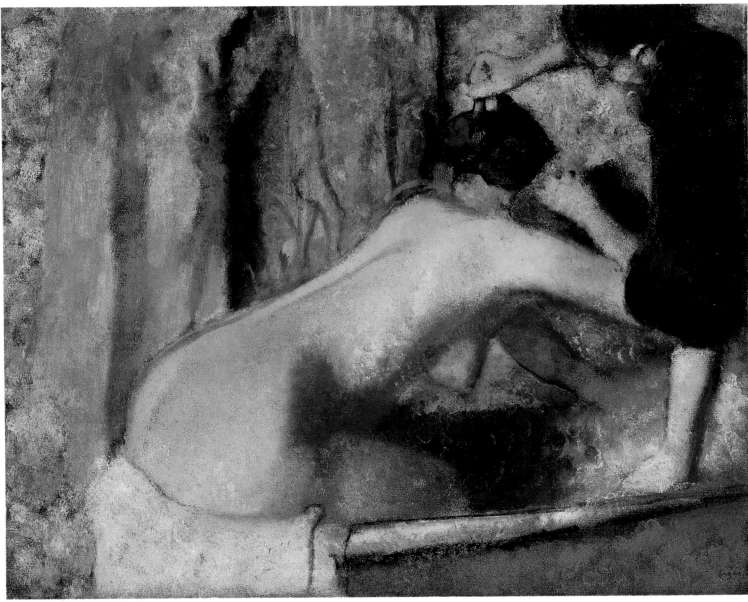

338

1. 1984 Chicago, p. 161.
2. Denis Rouart (Rouart 1945) in his captions for re-
 productions of the painting, pp. 48, 49 (detail),
 describes the medium as "peinture à l'huile, travail
 au pouce" (oil, worked with the thumb).
3. Erwin Panofsky, *Early Netherlandish Painting*,
 Cambridge, Mass.: Harvard University Press,
 1953, I, pp. 203, 254.

PROVENANCE: Atelier Degas (Vente I, 1918, no. 39);
bought at that sale by Ambroise Vollard, Paris, for
Fr 10,100; with Durand-Ruel, Paris, 1918 (stock
no. 11296); with Sam Salz, Inc., New York (possibly
bought 6 May 1940, stock no. 11301).

EXHIBITIONS: 1955 Paris, GBA, no. 129, repr. p. 50;
1960 Paris, no. 45.

SELECTED REFERENCES: Rouart 1945, p. 44, repr. (de-
tail) pp. 48, 49; Lemoisne [1946–49], III, no. 1029 (as
c. 1890); F. A. Myers, "The Bath," *Carnegie Maga-
zine*, October 1967, p. 285, repr.; *Catalogue of Paint-
ing Collection*, Pittsburgh: Museum of Art, Carnegie
Institute, 1973, p. 50, pl. 38 (color); Minervino 1974,
no. 948; Reff 1976, p. 278, fig. 192 (detail) p. 279;
1984 Chicago, p. 161, fig. 76.2 p. 162; *Collection
Handbook*, Pittsburgh: Museum of Art, Carnegie In-
stitute, 1985, p. 90 (entry by Paul Tucker), repr. (col-
or) p. 91; Sutton 1986, p. 242, pl. 224 (color) p. 236.

338.

Woman at Her Bath

c. 1895
Oil on canvas
28 × 35⅜ in. (71 × 89 cm)
Vente stamp lower right
The Art Gallery of Ontario, Toronto (55/49)

Lemoisne 1119

One of the paintings that seem to have em-
erged from a series of drawings of a woman
sitting on the edge of a bathtub sponging or
drying her neck is *Woman at Her Bath*, a
work showing the artist's indulgence in ex-
otically beautiful colors. Particularly start-
ling are the violet and rose towels against
the mottled green-and-orange wall and the
orange glow on the flesh as if it were reflected
from the tub below. Degas introduced into
the work a maidservant who solemnly pours
water on the bather's vulnerable neck. In
the spareness of the body, there are abrupt
contours which draw our eyes, as the figure
of the maidservant also does, relentlessly
back to the picture plane. In its decorativeness
and sensuous enjoyment of color, *Woman at
Her Bath* goes a long way toward anticipat-
ing the later work of Pierre Bonnard.

PROVENANCE: Atelier Degas (Vente I, 1918, no. 73); bought by Danthon, for Fr 33,800; George Willems sale, Galerie Petit, Paris, 8 June 1922, no. 6, repr.). Sold in "diverses collections," Cassirer, Berlin, 20 October 1932, for DM 15,600. Robert Woods Bliss, Washington, D.C., 1949. Earl Stendahl, Hollywood, Calif., 1956; bought by the museum 1956.

EXHIBITIONS: 1959, London, Ontario, London Public Library and Art Museum, 6 February–31 March, *French Painting from the Impressionists to the Present*, repr.

SELECTED REFERENCES: Le vieux collectionneur (The Old Collector), "Les ventes," *Revue de l'Art Ancien et Moderne*, LXII:340, December 1932, p. 418, repr. p. 415; Lemoisne [1946–49], III, no. 1119 (as c. 1892); Jean Sutherland Boggs, "Master Works in Canada: Edgar Degas, Woman in a Bath," *Canadian Art*, July 1966, p. 43, repr. (color) p. 44; Minervino 1974, no. 998.

339.

After the Bath, Woman Drying Herself

c. 1895
Oil on canvas
30 × 33 in. (76.2 × 83.8 cm)
Vente stamp lower right
The Henry and Rose Pearlman Foundation

Lemoisne 1117

The dating of Degas's works is imprecise. However, it seems to have been sometime about 1894, the year he dated the pastel *Young Girl Braiding Her Hair* (cat. no. 319) and possibly the pastel nude in the Metro-politan Museum (cat. no. 324), that he made another pastel of a nude, *Woman Drying Herself* (fig. 307), now in the National Gallery of Scotland in Edinburgh. The Edinburgh pastel is close to the other dated works in the twist of the body and the lankness of the hair. However, Degas carried the composition forward to this much harsher painting of the nude, in which he used oil sparingly on the canvas, with a resulting texture unlike the density of the pastel.

There are transitional drawings (L1118; fig. 308) leading up to this work. The position of the figure had always been a curious one—a young nude woman leaning across the back of a chaise longue covered by a towel or sheet while she dries her back with her left hand. But as Degas pursued the idea

339

Fig. 307. *Woman Drying Herself* (L1113 bis), c. 1894. Pastel, 25⅝ × 24¾ in. (65 × 63 cm). National Gallery of Scotland, Edinburgh

Fig. 308. *After the Bath, Woman Drying Herself* (III:290), c. 1895. Charcoal heightened with white, 36¼ × 30¾ in. (92 × 78 cm). Location unknown

through the large charcoal drawing with white highlights (fig. 308), he made the model's position more uncomfortable, almost cutting her head away from her body. In many of his late nudes, the neck seems a vulnerable place; but in this drawing and here it is lost as a transition between the shoulders and the disembodied head. Broad brushstrokes of vermilion paint above the shoulders and arms dramatize the severance, which the black line falling like a strand of hair seems to mourn. The position of the woman's body is itself strained enough to indicate pain,[1] as with her right hand (unlike that of the nude in the Edinburgh pastel) she dries her stomach. Although this could be interpreted as a scene of agony depicting a figure whose contours are as austere as those of a medieval wooden saint, and although the colors are otherwise strong and boldly applied— the background with large disks of pink, orange, yellow-green, and dark blue paint, the bath a green blue, the towel a fresher

turquoise with dashes of red—the canvas is handled with such dryness that it possesses a fundamental restraint.

1. Eunice Lipton (Lipton 1986, pp. 177–78) writes: "It seems quite likely that the contorted bodies . . . represent women who are experiencing intense physical pleasure."

PROVENANCE: Atelier Degas (Vente I, 1918, no. 98); bought by Durand-Ruel, Paris, for Fr 11,500; with Ambroise Vollard, Paris; A. de Galea, Paris.

EXHIBITIONS: 1924 Paris, no. 73; 1960 New York, no. 56, repr.; 1962 Baltimore, no. 51, repr.; 1966, New York, The Metropolitan Museum of Art, *Summer Loan Exhibition*, no. 44; 1967, Detroit Institute of Arts, no. 27, repr. p. 54; 1968, New York, The Metropolitan Museum of Art, summer, *New York Collects*, no. 54; 1970, Hartford, Conn., Wadsworth Atheneum, spring and fall, *Impressionism, Post-Impressionism, and Expressionism: The Mr. and Mrs. Henry Pearlman Collection*, no. 31; 1971, New York, The Metropolitan Museum of Art, 1 July–7 September, *Summer Loan Exhibition*, no. 34; 1974, New York, The Brooklyn Museum, *An Exhibition of Paintings, Watercolors, Sculpture and Drawings from the Collection of Mr. and Mrs. Henry Pearlman and the Henry and Rose Pearlman Foundation*, no. 10.

SELECTED REFERENCES: Lemoisne [1946–49], III, no. 1117 (as c. 1892); Minervino 1974, no. 994; Lipton 1986, p. 215 n. 32.

After the Bath

cat. nos. 340–342

In 1896 or 1897, Degas's friend the Italian painter and publisher Michel Manzi (1849–1915) issued a volume of reproductions of drawings by Degas on which he had worked in collaboration with the artist in Manzi's rue Forest studio.[1] Number 19 of the twenty reproductions is of a drawing (fig. 309), which is dated 1896 in that portfolio. This pastelized drawing is clearly a study for three paintings (fig. 310; cat. nos. 341, 342) that have in common a figure of a nude reclining on the back of a chaise longue in a position as awkward and strained as the nude in *After the Bath* in the Pearlman collection (cat. no. 339), but even more contorted. In recent years, a bromide photograph (cat. no. 340) has been discovered (once in the collection of Sam Wagstaff, now in the J. Paul Getty Museum, Malibu) which shows the nude placed somewhat more gracefully in the same position, her head cut off by the black shadow. The photograph has been attributed to Degas.[2]

Whether the idea began for Degas with the photograph or with the drawing, whether indeed he was the photographer, it is undoubtedly true that the figure itself is a poignant blend, as both Eugenia Parry Janis and Eunice Lipton have written, of eroticism and anguish. Janis has commented about the model:

She seems to writhe in pain. The lines of her shoulders and spine are more comparable to the agonized torsos of the damned in Rodin's *Gates of Hell* than to most other nudes drawn by Degas. . . . The head has succumbed to deep shadow. The psychic pain expressed through the body, twisted into an agitated shadow pattern, and the awkwardly projecting knees and elbows are strikingly reminiscent of Degas's *early interpretations of the nude* [as in *Scene of War in the Middle Ages*, cat. no. 45]. . . . At the same time, despite the anguish conveyed, there is a strange eroticism in this figure; but this is not a depiction of desire in the usual sense. We are moved, as always with Degas's conception of sexuality, by our privileged access to a private "performance."[3]

Lipton, who believes such works by Degas are of "women who are experiencing intense physical pleasure,"[4] sees the relationship of these nudes to a Persian miniature of lovers that Degas had copied in a tracing of

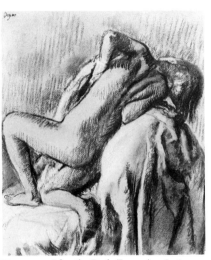

Fig. 309. *After the Bath* (L1232), 1896. Pastel and charcoal, 15⅜ × 13 in. (39 × 33 cm). Private collection

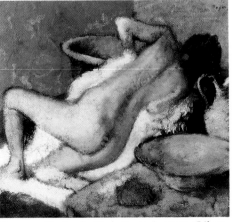

Fig. 310. *Study of a Nude* (L1233), 1896. Oil on canvas, 30¼ × 32⅝ in. (77 × 83 cm). Private collection

340

3. 1984–85 Paris, p. 473.
4. Lipton 1986, p. 178.
5. Ibid., p. 179.
6. Paul Gauguin, *Lettres de Gauguin à sa femme et à ses amis* (edited by Maurice Malinque), Paris: Grasset, 1946, no. CXXXIV, p. 237, Tahiti, 8 December 1892.
7. Jeanne Baudot, the painter and a protégée of Renoir's, in *Renoir: ses amis, ses modèles* (Paris: Éditions Littéraires de France, 1949, p. 67), tells of Degas's making use of a model whom Renoir had dismissed because she was pregnant; it could have been for this painting, though Baudot states it is for one in which the figure is "couchée sur le ventre" (lying on her stomach).

340.

After the Bath

1896
Bromide print
6¾ × 4⅞ in. (16.5 × 12 cm)
The J. Paul Getty Museum, Malibu
(84.XM.495.2)

Terrasse 25

This exquisite bromide print has become so much a part of the history of three major paintings[1] that it takes self-discipline to think of it as a separate image. Very much like the props that Degas used in his paintings and pastels of bathers and even in the portrait photograph of his brother René (cat. no. 335) are what appear to be an unstable screen, a heavy swag of patterned fabric on the right, a paisley shawl over the seat of the chaise, and a plain white towel over its back. These suggest that the photograph could have been taken in the painter's studio. Degas required great skill to pose the model in a strained position that would convey the desired combination of anguish and ecstasy, and to devise lighting that would illuminate her arched nude body so that the shadows along her spine would fall like the stroke of a brush.

1. See "After the Bath," p. 548.

PROVENANCE: Sam Wagstaff, New York; bought by the museum 1984.

EXHIBITIONS: 1978, Washington, D.C., Corcoran Gallery of Art, 4 February–26 March/Saint Louis Art Museum, 7 April–28 May/New York, Grey Art Gallery, New York University, 13 June–25 August/Seattle Art Museum, 14 September–22 October/Berkeley, University Art Museum, 8 November–31 December/Atlanta, High Museum, 20 January–5 March, *A Book of Photographs from the Collection of Sam Wagstaff*, p. 126.

SELECTED REFERENCES: Jean Sutherland Boggs, "New Acquisition: Museum Acquires Late Degas Painting," *Freelance Monitor*, 1, October–November 1980, p. 33, fig. 9; Terrasse 1983, no. 25, pp. 45–46, 122; 1984–85 Paris, pp. 472–73, fig. 334 p. 478; Boggs 1985, p. 32, fig. 23 p. 34; Lipton 1986, p. 216 n. 36.

a reproduction some thirty years before. She suggests: "Ecstasy is the subject of both."[5]

Faced with such convictions that these works represent some form of autoeroticism, it is not unwise to remember Gauguin's description in 1892 of his *The Spirit of the Dead Watching*, now in the Albright-Knox Gallery, Buffalo. He wrote to his wife from Tahiti, "I painted a nude of a young girl. In that position, a trifle can make it indecent."[6]

It is not impossible, moreover, that in the three works by Degas, the young girl could be pregnant.[7] In the three paintings, there is undoubtedly an undercurrent of sensuality, but also an ambiguity and a youthfulness that keep them remarkably restrained. And what the three paintings also reveal, in their different colors and in the variations of their handling, is how much Degas loved to paint in oil and how he could exploit it in a great decorative and emotional range. In addition, he used space and certain domestic symbols—sheets, towels, bathtubs, basins, a sponge—in a highly evocative way. The works have a tenderness and a sense of something young that is either threatened or lost.

It has not been possible to borrow one of the three related paintings, *Study of a Nude* (fig. 310), for the exhibition. It is the smallest of the three, the one with the most uncomplicated visual appeal, and the most sensual. The nude gives the greatest sense of her enjoyment of the position she has assumed, her soft flesh caressed by the towel. Although the sponge, the basin, and the ewer could be considered visual metaphors, associating the figure with another Passion, in fact they are so beautifully painted and so tactile in their appeal that the effect is to increase the sensuality of the work rather than to evoke any sense of agony. Indeed, the sponge seems to emphasize the softness of the nude's exquisitely painted rump. Only the falling mass of hair suggests that hers could be a covert act.

Although all of these works can safely be dated c. 1896, it seems difficult to find any clues to their chronological sequence.

1. Vingt dessins [1897], no. 19.
2. See *A Book of Photographs from the Collection of Sam Wagstaff*, New York: Gray Press, 1978, p. 126; Terrasse 1983, no. 25, pp. 45–46, repr. p. 75.

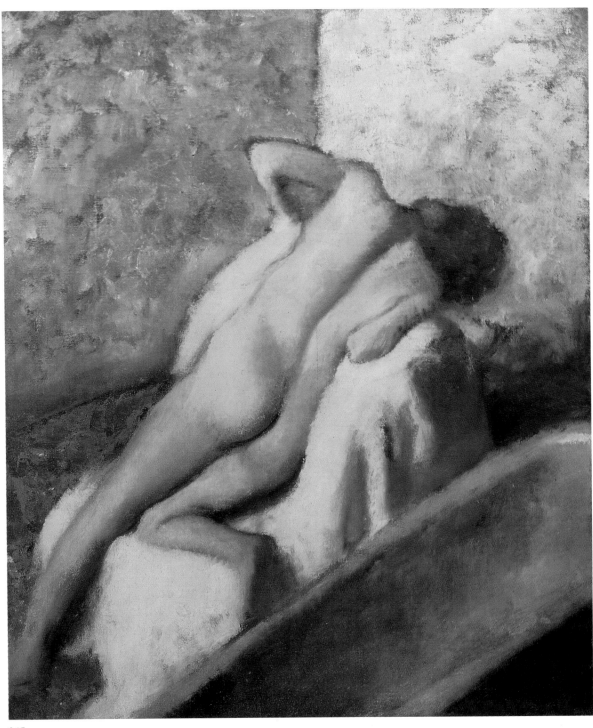

341

341.

After the Bath

1896
Oil on canvas
45⅝ × 38¼ in. (116 × 97 cm)
Vente stamp lower right
Private collection, Paris

Lemoisne 1234

Ambroise Vollard was never Degas's official agent—Paul Durand-Ruel was—but he did buy works by Degas from Durand-Ruel and perhaps occasionally from the artist

himself. His taste, which was revealed in those acquisitions and in his publication of an album of indifferent photographic reproductions of the works of Degas in 1914, ran toward the more extreme examples of the artist's late works.[1] This was consistent with his championing of Cézanne and the young Picasso. When Degas was still living, Vollard bought the smallest (fig. 310) of three related nudes, including this painting and the Philadelphia *After the Bath* (cat. no. 342). At the sale of the contents of the artist's studio after his death, he acquired

this canvas, the largest of the three. Unlike the small painting, it is still in the hands of a member of the family of one of Vollard's heirs.

In this work, Degas chose a vertical format, unusual for his late oil paintings and for his nudes. He also decided to change the position of the left leg, probably to give a greater diagonal sweep to the large figure in this sizable canvas. He arrived at the position of the nude through a drawing (fig. 311) that is surprisingly rhythmic and very softly feminine. In the painting, however, he made

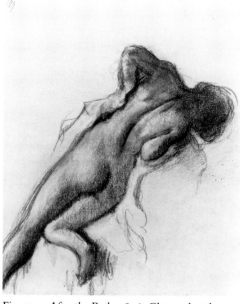

Fig. 311. *After the Bath*, 1896. Charcoal and pastel, 11⅜ × 9¼ in. (29 × 23.5 cm). Collection of Philippe Boutan-Laroze, Paris

the figure harder and crisper to a point where it almost becomes sexually ambiguous and could, like the photograph of the figure, remind Eugenia Parry Janis of Degas's

drawings for *Scene of War in the Middle Ages* (cat. nos. 46–57).[2] It also seems remarkably chaste, like the nudes of Northern painters such as Bouts and Memling, whose works Degas could have studied on his trip to Brussels in 1890.

The mood of the painting is established by the intense cobalt blue of the wall at the left. With the bathtub placed like a sarcophagus in the foreground, and the earthy orange tones of the rug, the hair, and some accents on the flesh, the blue seems to lift the figure from its tomb as if in a form of exaltation.

1. Vollard 1914. Degas had signed the drawings.
2. 1984–85 Paris, p. 473. See 1967 Saint Louis, p. 70, on the sexual ambiguity of certain figures in *Scene of War in the Middle Ages*.

PROVENANCE: Atelier Degas (Vente I, 1918, no. 88); bought by Ambroise Vollard, Paris, for Fr 15,500; by descent to present owner.

EXHIBITIONS: 1925, Paris, Musée des Arts Décoratifs, 28 May–12 July, *Cinquante ans de peinture française 1875–1925*, no. 31, lent by Ambroise Vollard; 1937 Paris, Orangerie, no. 53; 1976–77 Tokyo, no. 25, repr. (color).

SELECTED REFERENCES: Waldemar George, "Cinquante ans de peinture française," *L'Amour de l'Art*, 7 July 1925, repr. p. 275; Lemoisne [1946–49], III, no. 1234 (as 1899); Minervino 1974, no. 1029; Boggs 1985, p. 35, fig. 25; Lipton 1986, p. 215 n. 32.

342.

After the Bath

c. 1896
Oil on canvas
35 × 45¾ in. (89 × 116 cm)
Vente stamp lower right
Philadelphia Museum of Art. Purchased: The Trustees of the Estate of George D. Widener (1980-6-1)

Lemoisne 1231

The third in Degas's series of related nudes of about 1896,[1] this work is so thinly painted that bare canvas can be seen in areas of the towel over the chaise. It is so limited in color that it could be considered a monochromatic study in red; indeed, analysis of it by the Conservation Laboratory at the Philadelphia Museum of Art proves it to have been painted with only four hues: charcoal black, zinc-oxide white, red ochre, and burnt sienna.[2] Such a degree of simplification has led many commentators to believe it to be unfinished, intended as an underpainting for thickly encrusted oils like the other two versions of the subject. They suggest that this is substantiated by Degas's having used a color that was a favorite for the under-

342

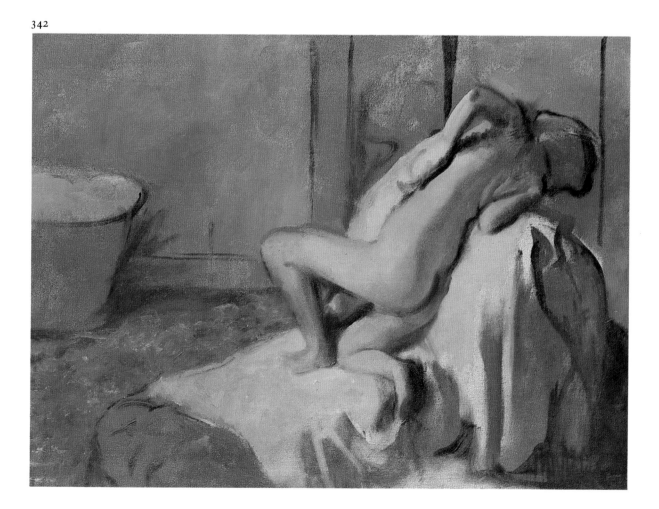

painting of Venetian artists such as Titian.[3] These commentators also suggest that the painting was an experiment and therefore the first in the series.

However, there are arguments in favor of Degas's not having carried the painting further because he felt it to be resolved. The evidence lies in his increasing defense in his late years of his work in terms of abstraction. For example, he told Georges Jeanniot that a picture was "an original combination of lines and tones which make themselves felt."[4] This canvas is also a highly consistent painting. The figure of the nude is smaller in relation to the space than are the figures in the other two versions; she seems smothered by the red of the room and the smoky floor, and her vulnerability is enhanced by the pink and white of the towel and increased by the black gash on the wall above her wrist. On one level, the work seems an exercise in abstraction, to which Degas would not have been averse. On another, it is simply a very poignant painting.

1. See "After the Bath," p. 548.
2. Boggs 1985, p. 32.
3. Rouart 1945, pp. 50–54; Reff 1976, p. 296.
4. Jeanniot 1933, p. 158.

PROVENANCE: Atelier Degas (Vente II, 1918, no. 17); bought by Dr. Georges Viau, Paris, for Fr 23,000 (first Viau sale, Drouot, Paris, 11 December 1942, no. 94, pl. XXXI, for Fr 500,000); H. Lutjens, Zurich; with Feilchenfeldt, Zurich; bought from Mrs. Feilchenfeldt by the museum 1980.

EXHIBITIONS: 1936 Philadelphia, no. 54, repr. p. 106; 1964, Lausanne, Palais de Beaulieu, *Chefs-d'oeuvre de collections suisses de Manet à Picasso*, no. 11, repr.; 1976, New York, The Museum of Modern Art, 17 December 1976–1 March 1977, *European Master Paintings from Swiss Collections: Post-Impressionism to World War II* (text by John Elderfield), repr. (color) p. 25; 1983, Philadelphia Museum of Art, 7 May–3 July, "100 Years of Acquisitions" (no catalogue); 1985 Philadelphia.

SELECTED REFERENCES: Jamot 1924, pl. 72b (as c. 1890–95); Rouart 1945, pp. 50–54, repr. p. 51; Lemoisne [1946–49], III, no. 1231, repr. (as 1896); Jean Grenier, "La révolution de la couleur," *XXe Siècle*, XXII:15, 1950, repr. p. 14; Reff 1976, p. 296, fig. 213 (detail); Jean Sutherland Boggs, "New Acquisition: Museum Acquires Late Degas Painting," *Freelance Monitor*, 1, October–November 1980, pp. 28–33, repr. (color) pp. 28–29; Boggs 1985, pp. 32–35, no. 15 p. 47, repr. (color) p. 33.

343.

The Masseuse

c. 1895
Bronze
Height: 17 in. (43.2 cm)
Original: brown plasteline.[1] National Gallery of Art, Washington, D.C. Collection of Mr. and Mrs. Paul Mellon

Rewald LXXIII

Although this rather large group is normally dated in the twentieth century, an earlier date is proposed here because of the work's almost anecdotal quality—its closeness to genre, unlike the more generalized, universal nature of Degas's later work. The maidservant massages the outstretched leg of a bather who is lying on a chaise longue. The body of the bather is forcefully twisted across the chaise, with the diagonally pulled sheets uniting the work and adding to its spatial interest. With her puffed sleeves and tidy hair, the small masseuse is gently concentrated on her task. From behind, her body and dress make a dignified simple form, which is still too human to be monu-

343

mental. Charles Millard has written that this work is the "most sculpturally satisfying of the series" of seated bathers, among them *Woman Seated in an Armchair, Drying under Her Left Arm* (cat. no. 318) and *Seated Bather Drying Her Left Hip* (cat. no. 381).[2]

1. See Millard 1976, p. 37 n. 55.
2. Ibid., p. 109.

SELECTED REFERENCES: 1921 Paris, no. 68; Rewald 1944, no. LXXIII (as 1896–1911), p. 143, Metropolitan 55A; 1955 New York, no. 69; Rewald 1956, no. LXXIII, Metropolitan 55A, pl. 89; Tucker 1974, p. 158, fig. 154 p. 157; 1976 London, no. 68; Millard 1976, pp. 37 n. 55, 109, 110, fig. 139; 1986 Florence, no. 55 p. 202, pl. 55 p. 152.

A. *Orsay Set P, no. 55*
Musée d'Orsay, Paris (RF2132)

Exhibited in Paris

PROVENANCE: Acquired thanks to the generosity of the heirs of the artist and of the Hébrard family 1930.

EXHIBITIONS: 1931 Paris, Orangerie, no. 68 of sculptures; 1969 Paris, no. 295; 1984–85 Paris, no. 82 p. 207, fig. 207 p. 203.

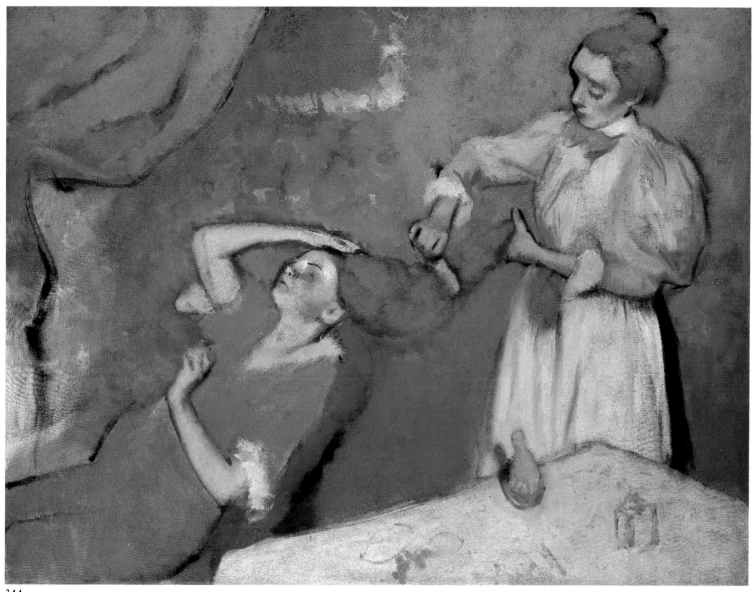

344

B. *Metropolitan Set A, no. 55*
The Metropolitan Museum of Art, New York.
 Bequest of Mrs. H. O. Havemeyer, 1929.
 H. O. Havemeyer Collection (29.100.371)

Exhibited in Ottawa and New York

PROVENANCE: Bought from A.-A. Hébrard by Mrs.
H. O. Havemeyer 1921; her bequest to the museum
1929.

EXHIBITIONS: 1922 New York, no. 68; 1930 New
York, under Collection of Bronzes, nos. 390–458;
1971, Louisville, Speed Art Museum, 1 November–
5 December, *French Sculpture*, no. 61; 1974 Dallas, no
number; 1975 New Orleans; 1977 New York, no. 68
of sculptures (dated by Millard as 1900–1912).

344.

The Coiffure

c. 1896
Oil on canvas
48⅞ × 59 in. (124 × 150 cm)
Vente stamp on verso
The Trustees of the National Gallery, London
 (4865)

Lemoisne 1128

Some fifteen years before Degas painted
The Coiffure, the mother of his friend Mary
Cassatt wrote to her son Alexander about
an observation of Degas's: "He says it is one
of those works which are sold after a man's
death, and artists buy them not caring
whether they are finished or not."[1] This
daring work, which is usually described as
unfinished, has qualities that have attracted
painters since the death of Degas; Henri

Matisse was for some years the owner of it.

The position of the pregnant woman[2] hav-
ing her hair combed is awkward, even pain-
ful. Degas made several preparatory drawings
of the figure, including one pastel that re-
mained in the family of the painter's brother
René until 1976 (L1130). In that drawing,
the woman's right hand grasps her forehead
as if she were suffering from migraine; the
anguish is physical. In the painting, arrived
at through a sequence of such drawings, the
physical accent is less strong, though the
body is frail, the pregnant stomach distended,
the face reduced to the features of a delicate
clown, the mouth a small slit, and the eye
disturbingly contracted into a black hole in
the middle of a purplish shadow. While not
reducing the pathos but making it less obvi-
ously physical, Degas in various drawings
developed the movement through the arms
of the seated woman, the right slightly lifted

and the left raised protectively. With black contours he strengthened this movement, which continues through the magnificently heavy orange hair and terminates in the figure of the attentive standing maidservant. The servant's massive body in some of the preparatory drawings suggests that Degas's maid, Zoé Closier, could have posed originally,[3] and that she was replaced later by a more conventional model who stands with great serenity and stability in marked contrast to her mistress.

In this painting, Degas restrained his color, allowing an orange red to dominate.[4] Although he did not restrict his palette as in the Philadelphia *After the Bath* (cat. no. 342), it is clear that in both he enjoyed working within a limited range. The result is, of course, an elegant performance in which we can indulge our love of color in the pink of the maidservant's shirtwaist against the orange wall or the red in the heavy folds of the curtain. We can admire the confidence with which Degas draws his black contours, suggests the lightest of white material around the left arm of the seated figure, or provides a break in the monochromatic orange reds and pinks with the amber color of the comb and brush. At the same time the work is expansive, almost the antithesis of *Young Girl Braiding Her Hair* (cat. no. 319). Even the strains we feel in the seated woman seem resolved in the figure of the maidservant.

1. Quoted in Mathews 1984, pp. 154–55, letter of 10 December [1880].
2. To my knowledge, first observed by Richard Kendall; see Kendall 1985, p. 26.
3. In particular, IV:168.
4. A particularly sensitive analysis of the color is found in Kendall 1985, pp. 26–27.

PROVENANCE: Atelier Degas (Vente I, 1918, no. 44); bought by Trotti Gallery, Paris, for Fr 19,100; Winkel and Magnussen 1920; with Galerie Barbazanges; Henri Matisse, Paris, who sold it about 1936 to his son, Pierre Matisse; bought from the Pierre Matisse Gallery by the museum 1937.

EXHIBITIONS: 1920, Stockholm, Svensk-Franska Konstgalleriet, *Degas*, no. 15; 1936 Philadelphia, no. 52, pl. 52; 1952 Edinburgh, no. 32.

SELECTED REFERENCES: Hoppe 1922, p. 66, repr.; Lemoisne [1946–49], III, no. 1128 (as c. 1892–95); Martin Davies, *National Gallery Catalogues: French School*, London, 1957, pp. 74–75; Minervino 1974, no. 1172; Sigurd Willoch, "Edgar Degas: Nasjonalgalleriet," *Kunst Kultur*, Oslo, 1980, pp. 22–24, repr. p. 25; Kendall 1985, p. 27; Sutton 1986, p. 250, pl. 248 (color) p. 252.

345.

The Coiffure

after 1896
Oil on canvas
32¼ × 34¼ in. (82 × 87 cm)
Vente stamp lower right
Nasjonalgalleriet, Oslo (NG1292)

Lemoisne 1127

One of the most tender paintings Degas ever made of two women at a toilette is this one in Oslo. Like the London painting (cat. no. 344), this work could be described, with even more reason, as unfinished; Degas did not hesitate to leave parts of the canvas uncovered, while other parts provide, as Sigurd Willoch, former director of the Nasjonalgalleriet in Oslo, described it, a "lightly smudged, broken-up surface."[1] Instead of reducing the painting chromatically as much as in the London work, Degas played here with a glowing range from a penetrating greenish yellow to a watermelon pink, against which he used whites for the chemises and the sheets, executed in very rough, highly scumbled paint; the whites seem ashen. The seated figure is a mere girl, small, slight, even an invalid, wearily lifting her heavy mass of henna-colored hair. The standing figure is also frail, her shoulders bent, her own dark tresses falling over her face like the wing of a bird as she tends the other's hair. Both convey an aching sense of apathy and futility.

The two women might suggest figures on a Greek mourning stela or lecythus, except that, significantly, there is no difference in scale to indicate difference in status. The painting nevertheless gives an equivalent sense of human loss.

1. Sigurd Willoch, "Edgar Degas: Nasjonalgalleriet," *Kunst Kultur*, Oslo, 1980, p. 24.

PROVENANCE: Atelier Degas (Vente I, 1918, no. 99); bought at that sale by Jos Hessel, Paris, for Fr 19,000; with Ambroise Vollard, Paris; gift of Nasjonalgalleriets Venner, Oslo, 1919.

SELECTED REFERENCES: Hoppe 1922, p. 67; Lemoisne [1946–49], III, no. 1127 (as 1892–95); Minervino 1974, no. 1173, pl. LVIII (color); Sigurd Willoch, "Edgar Degas: Nasjonalgalleriet," *Kunst Kultur*, Oslo, 1980, pp. 22–24, repr. p. 24.

Bathers in a Landscape

cat. nos. 346–350

An undated group of pastels by Degas seem dedicated to the enjoyment of nudity out of doors. Against landscapes of meadows with long grass, trees with trunks as fluid as Art Nouveau glass, and shallow pools of water, bathers indulge in the movement of their bodies in sun and air—figures thrust diagonally into the enveloping space. The sheer animality of their pleasure seems underlined by the ghostly presence of a faint red cow in one large pastel (cat. no. 346) and the introduction of a cocky black dog into another (L1075). The nudes themselves, sometimes almost androgynous, range from tenderly adolescent figures to those that are heftier and more mature. These compositions represent a departure from most of Degas's nudes since the 1860s in the variety of the actions of the bathers within a single pastel and in the contrasts of their often awkward positions.

On the other hand, there are elements of nudes of the eighties in these figures, though their very awkwardness gives them a greater muscular reality. They have connections with the single pastel of a nude against a landscape, *Nude Woman Pulling On Her Chemise* (fig. 186), in the National Gallery of Art in Washington, which, dated 1885, is certain to have been in the last Impressionist exhibition in 1886. The landscapes and the bathers' flesh in these works are, however, less luminous. The figures also evoke images of Degas's nudes of thirty years earlier for *Scene of War in the Middle Ages* (cat. nos. 46–57), but without any of the same tragic intensity. It is as if he were using memories of an old vocabulary to convey a very different, hedonistic meaning.

It is tempting to seek an external stimulus for these compositions, and we seem to find it in the nineties. It is not probable that it could have been the work of Gauguin, much as Degas was moved by the exhibitions of that artist's works, both when they were put up for sale before Gauguin went to Tahiti in 1891 and after his return in 1893. Perhaps it was a response to the nudes of Courbet, whose *L'atelier* he was to hope to buy in 1897.[1] The earthy relish of the nudity of Degas's bathers is not so far removed from that of Courbet's. It is easy to believe that Degas would have been provoked by the glimpses of bathers by Cézanne in Vollard's gallery from 1895. Indeed, Richard Brettell has suggested that his purchase of two bathers by Cézanne may have provided the stimulus for these works and consequently is inclined to date them after 1895.[2] One pastel of this group, which is in the Barnes Collection

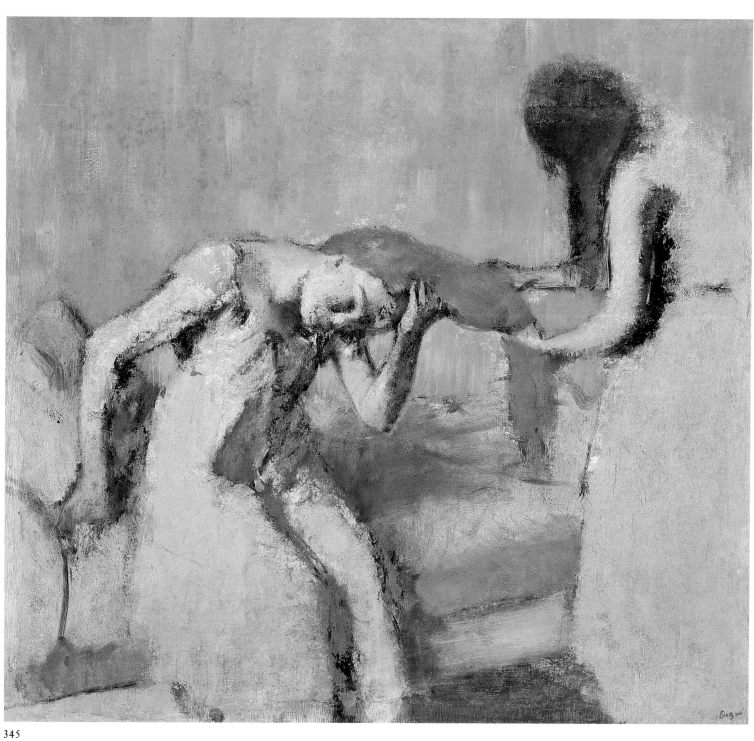

345

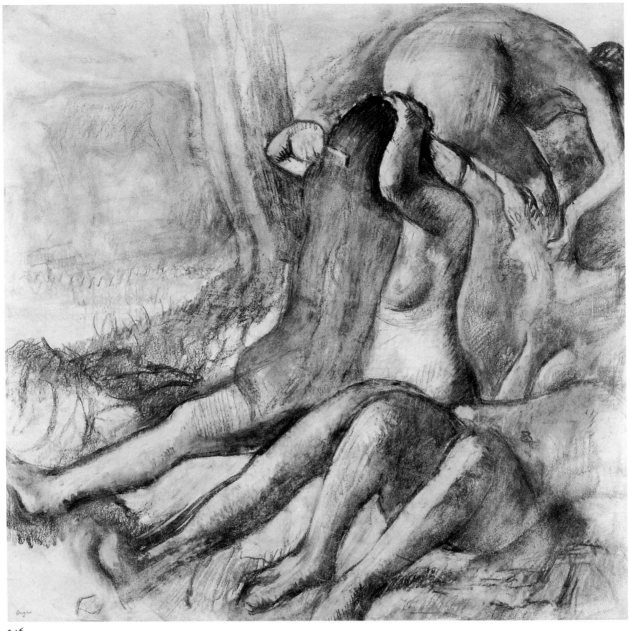

346

(L1087), almost has Cézanne's daring.

In studying the drawing *Bather* (cat. no. 348), lent by Princeton to this exhibition, it was discovered that it was related to another large composition of bathers that Degas had laid out in a charcoal drawing (fig. 314) now in the Musée des Arts Décoratifs in Paris.[3] This drawing has such explicit allegorical allusions (see the catalogue commentary for the *Bather*) that it seems possible Degas thought of all his bathers in a landscape as related to the allegorical tradition in Renaissance painting.

One problem in dating these works is provided by a related pastel (L1075) of two bathers wading with a black poodle. It is tempting to identify this pastel with the work described by Félix Fénéon in his review of the 1886 Impressionist exhibition as three bathers with a dog,[4] or perhaps with another pastel that George Moore in 1890 wrote about seeing in the painter's studio, depicting "three large peasant women plunging into a river, not to bathe, but to wash or cool themselves (one drags a dog in after her)."[5] Aside from the fact that the pastel has two bathers instead of three, there are stylistic reasons—which, admittedly, reworking might explain—that make it unlikely this group of bathers could be from the eighties.

A letter has recently come to light that might help date the bathers. It is from Degas to the painter Louis Braquaval, whom Degas may have met for the first time in 1896.[6] In any case, Degas refers to his brother René, with whom it is unlikely he was reconciled until after the death of their

Fig. 312. *Bathers* (L1079), c. 1896. Pastel, 41⅛ × 42⅝ in. (104.6 × 108.3 cm). The Art Institute of Chicago

brother Achille in 1893. Degas wrote: "I have begun a large painting in oil, three women bathing in a stream edged with birches. My brother, who knows the countryside like a poacher, always knows right away where to find the birches that I need. I will send you a preliminary outline for this idea, and if you find some trees that will suit my purposes, I would be very pleased if you would make me a sketch or a small study in pastel."[7]

Although nothing has survived of a painting in oil of bathers against a landscape, the letter does seem to substantiate the proposal that Degas must have made these pastels of bathers about 1896.

1. Rouart 1937, p. 13.
2. 1984 Chicago, p. 189.
3. The discovery was made by Gary Tinterow and Anne M. P. Norton of the Metropolitan Museum, who prepared the commentary for cat. no. 348.
4. Thomson 1986, p. 189.
5. Moore 1890, p. 425.
6. See "Late Landscapes at Saint-Valéry-sur-Somme," p. 566.
7. Unpublished letter, private collection, Paris.

346.

Bathers

c. 1896
Pastel and charcoal on tracing paper
42⅞ × 43¾ in. (108.9 × 111.1 cm)
Vente stamp lower left
Dallas Museum of Art. The Wendy and Emery Reves Collection (1985.R.24)

Exhibited in New York

Lemoisne 1071

It is clear that Degas worked through several studies for this large composition in charcoal and pastel, presumably unfinished, that is now in the Dallas Museum of Art. Since it is the same size as *Bathers* (fig. 312) in the Art Institute of Chicago, another unfinished work which Degas enlarged to this size, it has been suggested by Richard Brettell that the two were conceived as a pair.[1] In any case, both belong to a long tradition of pastoral nudity in painting.

The Dallas pastel is full of contrasts between the figures and their poses. For example, Degas teasingly placed the head and left arm of the young girl combing her hair against the rump of the nude leaning over to dry her leg. In another highly developed pastel of these two figures alone (L1072), he made the contrast so much more physically distasteful that sometime before 1970, the crouching figure was removed by a restorer to make a more neutral background for the seated figure.[2]

1. 1984 Chicago, pp. 189–91. Because Brettell believes the Chicago work was influenced by Degas's purchases of Gauguin's *The Day of the God* (fig. 275) and Cézanne's *Bather beside the River* in 1895, he dates the two large pastels of bathers 1895–1905.
2. Brame and Reff 1984, no. 135.

PROVENANCE: Atelier Degas (Vente I, 1918, no. 212); bought at that sale by Ambroise Vollard, Paris, for Fr 7,900; Emery Reves; acquired by the museum 1985.

EXHIBITIONS: 1936, Paris, Galerie Vollard, *Degas*.

SELECTED REFERENCES: Lemoisne [1946–49], III, no. 1071 (as c. 1890–95); Minervino 1974, no. 1006.

Fig. 313. *Nude Woman Leaning Forward*, study for *Scene of War in the Middle Ages*, c. 1863–65. Pencil, 14 × 9 in. (35.6 × 22.9 cm). Musée d'Orsay, Paris (RF15514)

347

347.

Bather Seated on the Ground, Combing Her Hair

c. 1896
Pastel and charcoal on three pieces of pale buff laid paper
21¾ × 26⅜ in. (55 × 67 cm)
Signed in red chalk lower right: Degas
Musée d'Orsay, Paris (RF31840)

Exhibited in Paris

Lemoisne 1073

In this drawing for the large pastel composition in Dallas (cat. no. 346), the appealingly adolescent body with outstretched toes is dominated by a magnificently fluid head of hair that completely screens the girl's face as she combs her golden tresses. Degas had often drawn and painted superbly long and lustrous heads of hair, but the precedent for this drawing seems to be the pained, crouching figure of a girl (fig. 313) in *Scene of War in the Middle Ages* (cat. no. 45), painted thirty years before. Remembering that work makes us realize how free of pain and tension this drawing is.

PROVENANCE: With Ambroise Vollard, Paris; Albert S. Henraux; acquired in 1967 for the Louvre from Mme Henraux, who retained life interest.

EXHIBITIONS: 1924 Paris, no. 180; 1937 Paris, Orangerie, no. 168; 1939 Paris, no. 33.

SELECTED REFERENCES: Vollard 1914, pl. LXX; Lemoisne [1946–49], III, no. 1073 (as 1890–95); Paris, Louvre and Orsay, Pastels, 1985, no. 84, pp. 86–87, repr. p. 86.

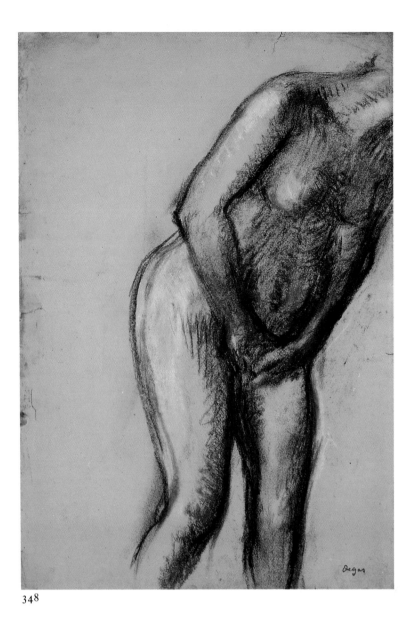

348

ing work in a group of pastels of bathers wading in a pond or resting in a grassy field.[1] It would have differed from the others in the group because of the inclusion of a specific narrative detail: the large dog (or small bear) at the left that has frightened the bathers at the right.

The pose in this drawing is a traditional one used by artists since Masaccio for Eve's expulsion from the garden of Eden (fig. 315); occasionally it was adopted for one of the attendant nymphs of the goddess Diana during her encounter with Acteon. It is possible that Degas meant in his large unfinished pastel (fig. 314) to refer to the scene in which Diana, bathing, changes one of her nymphs, Callisto, into a bear. With her slumping shoulders and awkward gait, the figure—even without a head—powerfully conveys fright and shame. After the completely un-selfconscious nudes of the 1870s and 1880s, the modesty of this figure seems poignantly retrogressive; it conjures memories not only of nudes by Masaccio, Titian, and Rembrandt but also of the chaste nudes of Degas's own youth. There is a commonality of feeling that joins the figure in this work with the figures of wounded women at the left in *Scene of War in the Middle Ages* (cat. no. 45) and with the figure in the wash drawing (L351, Kunstmuseum Basel) for the disgraced woman of Degas's genre picture *Interior* (cat. no. 84).

Degas made a counterproof of this drawing, presumably to study the figure in reverse (L1020 bis), though he never used the leftward-turning figure in a subsequent

348.

Bather

c. 1896
Charcoal and pastel on robin's-egg blue wove
 paper
18½ × 12⅝ in. (47 × 32 cm)
Vente stamp lower right
The Art Museum, Princeton University. Gift of
 Frank Jewett Mather, Jr. (43-136)

Vente III:337.1

Degas made this figure drawing, one of the most expressive of the bather studies, in preparation for an enormous pastel of women bathing out of doors. Only the underdrawing of that pastel was completed (fig. 314), but had he finished it, it would have ranked as one of the largest of his pictures, larger than the pastel of four bathers in Chicago (fig. 312) and nearly the same size as the Basel *Fallen Jockey* (cat. no. 351). The composition was apparently destined to be the culminat-

Fig. 314. *Bathers* (IV:254), c. 1896. Charcoal and pastel, 63¾ × 76 in. (162 × 193 cm). Musée des Arts Décoratifs, Paris

Fig. 315. Masaccio, *The Expulsion of Adam and Eve*, c. 1425. Fresco, 81⅞ × 34⅝ in. (208 × 88 cm). Brancacci Chapel, Santa Maria del Carmine, Florence

composition. The counterproof is on tracing paper, and while it is possible that he placed the tracing paper on top of this drawing, traced an outline, reversed the sheet, and filled in the contours, more probably he made a simple sandwich of this drawing and the tracing paper and ran it through a press. This process would have created a faint impression on the tracing paper, which he then would have heightened. It is clear that he made the present drawing first, for the robin's-egg blue paper is too opaque to have been used for tracing; the use of pink chalk to erase some of the charcoal lines on the neck, breast, and hip is evidence of the care he gave this work. The subtle modeling of the torso in reddish brown chalk is especially fine.

In all, there are thirteen drawings of this figure: five pairs, each with an original drawing and a counterproof, and three related but slightly different drawings.[2] Just as Degas perfected the movement of Rose Caron's arm by repeating the pose on successive sheets of transparent paper in one of his notebooks,[3] so he created the figure of this nude, who began in one of his first studies (III:340.2) as a slight young woman with long hair and an expression of curiosity, and ended, through repetition, as a heavier and no doubt older woman, almost crouching in fear (III:345.1). Degas modeled a sculpture of a figure in this pose, *Woman Taken Unawares* (cat. no. 349), and the large number of associated drawings may relate to his work on the wax model.

GT

1. L1070, L1071, and the studies L1072–L1074; L1075–L1082. See cat. nos. 346, 347, 350.
2. III:346.2 and its counterproof III:340.2; II:156 (L1020) and its counterproof IV:369; III:337.1 and its counterproof IV:326 (L1020 bis); III:345.2 and its counterproof IV:336 (L1020 ter); IV:371 and its counterproof III:337.2; as well as three drawings without known counterproofs, III:191, III:340.1, and III:345.1.
3. Reff 1985, Notebook 36 (Metropolitan Museum, 1973.9, pp. 17, 21–26, 29).

PROVENANCE: Atelier Degas (Vente III, 1919, no. 337.1); bought at that sale by Bernheim-Jeune, Paris, for Fr 900. With Weyhe Gallery, New York; Frank Jewett Mather, Jr.; his gift to the museum 1943.

EXHIBITIONS: 1981 San Jose, no. 58.

SELECTED REFERENCES: Bazin 1931, p. 300, fig. 93; Boggs 1985, p. 29, fig. 21, compared with bronze cast (see cat. no. 349).

349.

Woman Taken Unawares

c. 1896
Bronze
Height: 16 in. (40.6 cm)
Original: Yellow-brown wax. National Gallery of Art, Washington, D.C. Collection of Mr. and Mrs. Paul Mellon

Rewald LIV

In an article of 1931, ten years after Degas's sculptures were first exhibited in Paris, Germain Bazin related this sculpture to drawings such as *Bather* (cat. no. 348) and grouped the works under the suggestive title "La femme blessée" (The Wounded Woman).[1]

He saw them as descendants of the battered women in *Scene of War in the Middle Ages* (cat. no. 45), though in fact they relate more directly to Degas's project of the mid-1890s for a large pastel of women bathing out of doors (fig. 314). While this bather's pose clearly indicates that she has been startled and modestly wishes to cover herself, there is nothing to suggest that she has been hurt or is in mortal danger.

The sculpture differs from the drawings in a significant way. While in the drawings Degas was able to convey only a suggestion of sculptural relief, here he was able to claim all three dimensions for his figurine. With her head sharply turned, her shoulders twisted, her back inclined, and her legs caught in mid-movement, the action of the

349

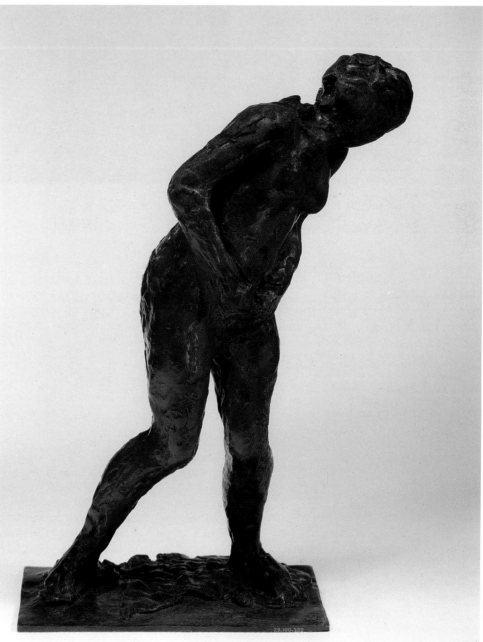

sculptured figure is much more dynamic than that in the drawings. The sculpture presents an interesting view from every direction—even from the back, which is how it is often exhibited and photographed. Comparing Degas to Renoir, Bazin identified as characteristic of Degas's talent his ability to work in three dimensions and to actively engage the surrounding space. "For Renoir, sculpture is the conquest over mass. For Degas, it is the definitive conquest over space. . . . Renoir's statue is a monument, it forms an isolated block, shut off from space. Degas's statuette cuts into space, tears at it in every direction."[2]

The modeling of the surface falls midway between the extremes of finish that Degas allowed himself. It is lively and varied, but it has neither the smooth polished skin of an early bather such as *Woman Washing Her Left Leg* (RLXVIII) nor the rough unfinished texture of *Dancer Putting on Her Stockings* (RLVII). A serious break at the back of the neck of the wax model was left unrepaired by the foundry in casting.

GT

1. Bazin 1931, p. 300.
2. Ibid., p. 301.

SELECTED REFERENCES: Lemoisne 1919, repr. p. 114, wax; 1921 Paris, no. 61; Bazin 1931, p. 293, figs. 90–92 p. 300; Havemeyer 1931, p. 223, Metropolitan 42A; Paris, Louvre, Sculptures, 1933, p. 71, no. 1778, Orsay 42P; Rewald 1944, no. LIV (as 1896–1911), Metropolitan 42A; Borel 1949, p. 10, n.p. repr.; Rewald 1956, no. LIV, Metropolitan 42A; Beaulieu 1969, p. 380 (as 1890), fig. 21 p. 379, Orsay 42P; Minervino 1974, no. S64; 1976 London, no. 61; Boggs 1985, pp. 28–29, no. 15 (as c. 1892); 1986 Florence, pp. 193–94, no. 42, pl. 42 p. 139.

A. *Orsay Set P, no. 42*
Musée d'Orsay, Paris (RF2125)

Exhibited in Paris

PROVENANCE: Acquired by the Louvre thanks to the generosity of the heirs of the artist and of the Hébrard family 1930.

EXHIBITIONS: 1931 Paris, Orangerie, no. 61; 1937 Paris, Orangerie, no. 235; 1969 Paris, no. 292; 1984–85 Paris, no. 38 p. 190, fig. 163 p. 185.

B. *Metropolitan Set A, no. 42*
The Metropolitan Museum of Art, New York. Bequest of Mrs. H. O. Havemeyer, 1929. H. O. Havemeyer Collection (29.100.389)

Exhibited in Ottawa and New York

PROVENANCE: Bought from A.-A. Hébrard by Mrs. H. O. Havemeyer late August 1921; Mrs. H. O. Havemeyer Collection, New York, 1921–29; her bequest to the museum 1929.

EXHIBITIONS: 1922 New York, no. 3; 1930 New York, under Collection of Bronzes, nos. 390–458; 1974 Dallas, no number; 1977 New York, no. 46 of sculptures.

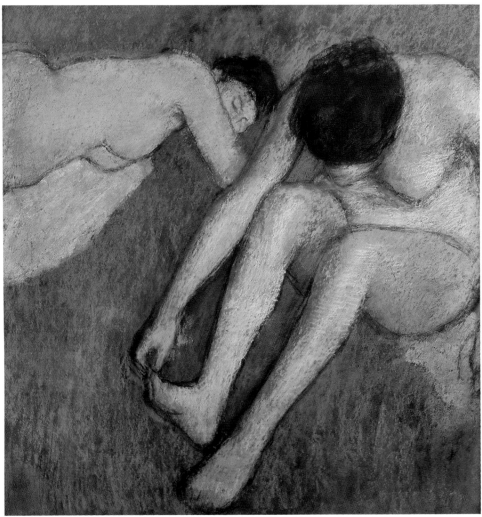

350

350.

Two Bathers in the Grass

c. 1896
Pastel on heavy wove paper
27½ × 27½ in. (70 × 70 cm)
Vente stamp lower left
Musée d'Orsay, Paris (RF29950)

Exhibited in Paris

Lemoisne 1081

The almost palpable energy of the indolent figures in *Two Bathers in the Grass*, the intensity of color and handling of the yellow-green pastel of the grass on which they recline, even the size of the work are characteristic of nine of the late compositions of bathers.[1] The pastel is rich and sumptuous. The bodies are simplified, particularly in this picture, to the point where they seem to anticipate the work of Matisse.

1. L1072; L1075; L1076; L1077; L1078, Antwerp; L1080; L1082, The Barnes Foundation, Merion Station, Pa.; L1083.

PROVENANCE: Atelier Degas (Vente I, 1918, no. 308); bought at that sale by Ambroise Vollard, Paris, for Fr 6,000; acquired by the Louvre 1953.

EXHIBITIONS: 1936, Paris, Galerie Vollard, *Degas*; 1969 Paris, no. 220.

SELECTED REFERENCES: Lemoisne [1946–49], III, no. 1081 (as 1890–95); Paris, Louvre, Impressionnistes, 1958, no. 100; Monnier 1969, p. 368; Minervino 1974, no. 1001; 1984 Chicago, no. 91; Paris, Louvre and Orsay, Pastels, 1985, no. 72, repr. p. 79.

The Late Horses and Riders

cat. nos. 351–353

The pastels Degas made of horses and riders after 1895 are far removed from the racecourse itself. They have moved into abstractions of color, line, and texture. In some ways, they are comparable to tapestries, which the very interweaving of the strokes of pastel are apt to suggest.

One phenomenon in the late nineties is a new version of *The Steeplechase*,[1] which Degas had exhibited, without arousing any attention, in the Salon of 1866. We know that he had this work on his mind in 1897, since he spoke of it when he ran into the journalist François Thiébault-Sisson in Clermont-Ferrand that year. Thiébault-Sisson recorded their conversations there and at neighboring Mont-Dore. Degas had remarked, "You are probably unaware that, about 1866 I perpetrated a *Scène de steeplechase*, the first, and for long after the only one of my pictures inspired by the racecourse."[2] Sometime about 1897, he took a canvas the same size he had used for *The Steeplechase* thirty years before and reduced the composition to one horse, the jockey, and a barren landscape. The sky is stormy, and the black-bearded jockey, wearing gold and luminous white, is obviously dead as he lies with his arms spread out like a puppet's on the green grass. Over him is the leaping dark brown horse, casting a shadow and ostensibly the symbol of death.

1. See the commentary by Gary Tinterow, cat. no. 351, and fig. 316.
2. Thiébault-Sisson 1921, p. 3.

351.

Fallen Jockey

c. 1896–98
Oil on canvas
70¾ × 59½ in. (181 × 151 cm)
Vente stamp lower right
Oeffentliche Kunstsammlung, Kunstmuseum
 Basel (G1963.29)

Lemoisne 141

Fallen Jockey was probably painted during a single campaign in the 1890s, but it is closely allied to *The Steeplechase* (fig. 316), painted in 1866 and reworked in 1880–81. It seems likely that his lingering dissatisfaction with the reworked *Steeplechase* finally led Degas to paint *Fallen Jockey*, which became a restatement and synthesis of the earlier picture in his late expressive style.

Degas exhibited *The Steeplechase* only once during his lifetime—at the Salon of 1866. It was a large painting for the thirty-four-year-old artist, even by the standards of history painting to which he aspired in the 1860s. As John Rewald has suggested, Degas probably followed the same rules as those expressed by Frédéric Bazille: "In order to be noticed at the exhibition, one has to paint rather large pictures that demand

very conscientious preparatory studies and thus occasion a good deal of expense; otherwise, one has to spend ten years until people notice you, which is rather discouraging."[1] Yet despite the size of the canvas, and the dozen or so preparatory drawings that preceded its execution, *The Steeplechase* went quite unnoticed at the Salon. Critical attention was focused on the notoriety of Courbet's *Woman with a Parrot* (The Metropolitan Museum of Art, New York). Zola was preoccupied with the Refusés.[2]

Had Zola not been distracted, he might have observed that Degas's painting was based on Manet's entry to the Salon of two years earlier, *Incident in the Bullring* (fragments of which are now in the Frick Collection, New York, and the National Gallery of Art, Washington, D.C.).[3] Degas adopted not only the subject (an athlete killed in competition) and to some extent the composition (a sharply foreshortened recumbent figure in the foreground with additional figures and animals above), but most important the ambition: to take a scene from contemporary life and enlarge it to heroic proportions.

The genesis of Degas's *Steeplechase* remains unclear. A logical ordering for the preparatory drawings has been proposed,[4] but this sequence does not explain the curious appearance in the painting of two riderless horses, with only one dismounted jockey; nor has the existence of drawings of the leaping horse in the foremost plane, seen in reverse (as in fig. 318), been noted. Furthermore, no one has yet put forward a plausible explanation for the small picture Degas painted, perhaps in the 1870s, that shows *The Steeplechase* hanging in his studio with *one* riderless horse (fig. 317). Until now, all the related works have been dated to the 1860s.

In all probability, when *The Steeplechase* was shown at the Salon of 1866, it had only one runaway horse in the foreground and looked much as it does in the little painted copy later, fig. 317. It may have included as well the fallen horse visible at the far right of fig. 317. Degas presumably decided about 1881 to add to the painting the second riderless horse, found in a drawing from the 1860s in his studio (IV:235.b), and traced it in reverse on a sheet of tracing paper (fig. 318) and traced it again, in reverse, for inclusion in a compositional study (IV:227.b). Seeing the second (foremost) riderless horse as an afterthought would explain its awkward placement immediately over the body of the jockey, and justify the large number of pentimenti in its execution. It seems Degas was not satisfied with the pose: he probably changed the position of the horse behind it in accommodation, and may have regretted the inclusion after all.

His dissatisfaction with the painting is documented in letters from the Cassatt family. Mary Cassatt attempted in 1880 to secure *The Steeplechase* for her brother Alexander. Cassatt's mother wrote to Alexander about the picture on 10 December 1880: "I don't know whether Mary has written to you or not on the subject of pictures. I didn't encourage her much as to buying the large one being afraid that it would be too big for anything but a gallery or a room with a great many pictures in it—but as it is unfinished or rather as a part of it has been washed out and Degas imagines he cannot retouch it without painting the whole over again and can't make up his mind to do that, I doubt if he ever sells it."[5]

It must have been at this point, the winter of 1880–81, that Degas planned his changes, most notably in the addition of the second leaping horse. In a remarkable letter written thirty-seven years later, when *The Steeplechase* was finally sold at the Degas atelier sales (fulfilling the artist's prediction), Mary Cassatt recalled Degas's campaign of revision: "Joseph [Durand-Ruel] bought for Fr 9,000 the splendid picture of the steeple chase. Degas you know wanted to retouch it and drew black lines over the horses [sic] head and wanted to change the movement. I thought these could be effaced but it was not possible. Well now Joseph has had the lines filled in no doubt he will sell it for $40,000 or more. I wanted the picture for my brother Aleck and Degas declared it was my fault that he spoiled it! I begged him so to give it as it was, it was very finished, but he was determined to change it."[6] Evidently, it was not only Degas who reworked *The Steeplechase*, but a restorer employed by Durand-Ruel as well, and it is to this last revision that one can attribute the lack of congruence between Degas's "black lines" and the modeling of the forwardmost horse.

Having "spoiled" *The Steeplechase* about 1881, Degas later made *Fallen Jockey*. The appearance of its painted surface is inconceivable before the 1890s.[7] On a canvas identical in size to that of *The Steeplechase*, Degas impatiently scumbled the most abbreviated of landscapes, articulated only by the sharply rising hill at the right and the hint of a plain at the left. The sky, though bright and blue, is agitated and far more forbidding than the calm pink-and-yellow haze of the earlier picture. Bursting through the horizon, the runaway horse, frightened and frenzied, turns his head to the viewer before starting toward his right. The jockey, larger, full-bearded, and thus seemingly older than the jockey in the earlier painting, has fallen flat on his back; and though his pose is less crumpled than that of the figure in *The Steeplechase*, the image Degas con-

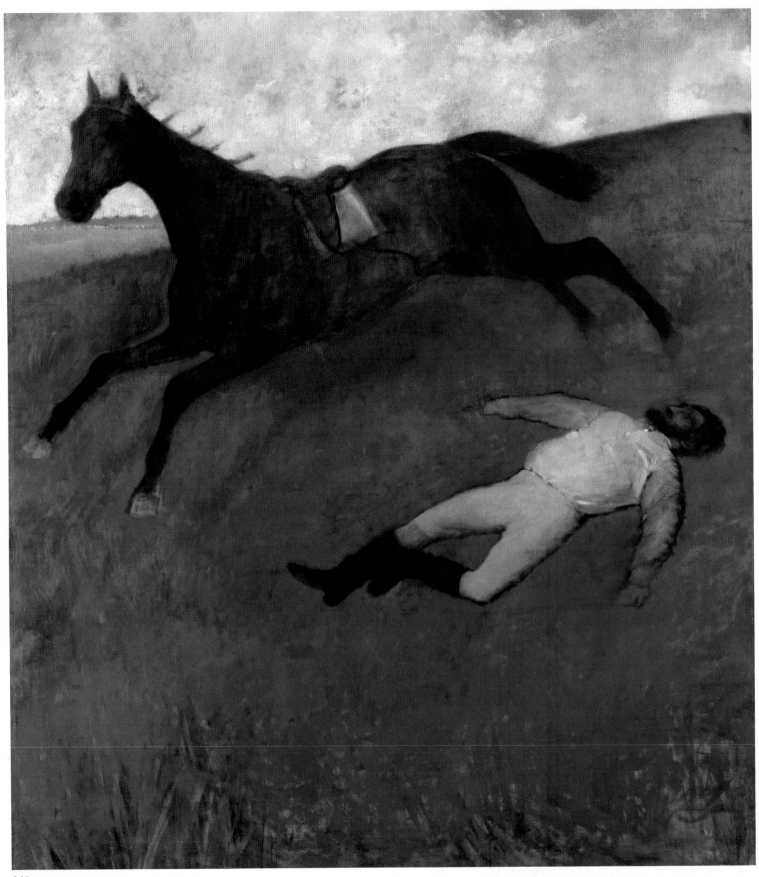

351

Fig. 316. *The Steeplechase* (L140), 1866, re-worked 1880–81. Oil on canvas, 70⅞ × 59⅞ in. (180 × 152 cm). Collection of Mr. and Mrs. Paul Mellon, Upperville, Va.

Fig. 317. *Studio Interior with "The Steeplechase"* (L142), 1870s. Oil on canvas, 10½ × 16⅜ in. (26.5 × 41.5 cm). Private collection

Fig. 318. *Runaway Horse* (IV:234.c). Pencil, 7¼ × 11 in. (18.5 × 28 cm). Location unknown

jures is one of finality, whereas in the earlier painting one suspects that the jockey might possibly be revived.

The runaway horse in *Fallen Jockey* is loosely based on the riderless horse in *The Steeplechase* as it would have appeared before Degas changed its "movement" and added the second horse in the foreground. Both derive from the elaborately worked drawing in the Clark Art Institute (cat. no. 67) that dates from the mid-1860s, and it in turn seems to derive as much from English sporting prints as it does from the study of na-

ture. Degas of course knew prints by Herring and others—he made notes from them at Haras du Pin in 1861, and he copied one for inclusion in *Sulking* (cat. no. 85). Both the Clark drawing and *The Steeplechase* were executed before Eadweard Muybridge's photographic studies of the movement of horses (see "Degas and Muybridge," p. 459). And although Degas painted *Fallen Jockey* long after he had studied Muybridge's photographs, he retained for this picture the antiquated (and incorrect) position of the legs.

Degas did not bother to paint the jump over which the horse in *Fallen Jockey* has presumably just leaped, yet the event is no less clearly understood. Much of the persuasive power of the image seems to reside in Degas's spare, epigrammatic treatment of the figures and the space, and the result is a picture compelling in its pathos.

GT

1. Letter from Bazille to his parents, 4 May 1866, in Rewald 1973, p. 140.
2. Rewald noted the absence of reviews of Degas's painting and listed works exhibited in the same Salon by Bazille, Fantin-Latour, and Monet, among others (Rewald 1973, p. 193 n. 2). Only two mentions of this painting, as exhibited in 1866, are now known: see cat. no. 67.
3. For reviews, see George Heard Hamilton, *Manet and His Critics*, New Haven: Yale University Press, 1954, pp. 81–87. The obvious relationship between Manet's painting and Degas's has been ignored in both the Manet and the Degas literature. Charles F. Stuckey seems to have been the first to note it (1984–85 Paris, p. 21).
4. Paul-Henry Boerlin, "Zum Thema des gestürzten Reiters bei Edgar Degas," *Jahresbericht des Oeffentlichen Kunstsammlung Basel*, Basel, 1963, pp. 45–54.
5. Quoted in Mathews 1984, pp. 154–55.
6. Unpublished letter to Louisine Havemeyer, 22 September [1918], on deposit at the Metropolitan Museum. (The date 1918 seems accurate in relationship to the atelier sales discussed, and is substantiated by the fact that Mrs. Havemeyer clipped the letter to two additional letters dating from the summer of 1918.)
7. It must be acknowledged that there is a possibility, albeit unlikely, that *Fallen Jockey* was begun at the same time as *The Steeplechase*, about 1866, or in the early 1880s, when Degas reworked *The Steeplechase*. Infrared reflectographs of *Fallen Jockey* show a number of pentimenti under the painting of the horse. Regardless, however, of the beginnings of *Fallen Jockey*, the surface now visible was almost certainly applied in the late 1890s.

PROVENANCE: Deposited by the artist with Durand-Ruel, Paris, 22 February 1913 (as "Cheval emporté," 70⅞ × 59½ in., 180 × 151 cm, stock no. 10251). Atelier Degas (Vente I, 1918, no. 56); bought at that sale by Jos Hessel, for Fr 16,000 (sale, Drouot, Paris, Tableaux Modernes, 9 June 1928, no. 36, repr.); bought at that sale by Georges Bernheim, for Fr 20,000.[1] Benatov collection, Paris, by 1955, until 1957; E. and A. Silberman Galleries, New York, by 1959; bought by the museum 21 March 1963.

1. "Chronique des ventes," *Gazette de l'Hôtel Drouot*, 37:68, 12 June 1928, p. 1: "A large painting by Degas, 'Le cheval emporté,' which sold for Fr 16,000 at the Degas atelier sale in 1918, went for Fr 20,000 to M. Bernheim."

EXHIBITIONS: 1955 Paris, GBA, no. 29 (label on reverse identifies M. Benatov as lender); 1957 Paris, no. 87 (as "Le jockey blessé," 58¼ × 58¼ in., 148 × 148 cm); 1959, New York, E. and A. Silberman Galleries, 3–21 November, *Exhibition 1959: Paintings from the Galleries' Collection*, no. 1, repr. frontispiece.

SELECTED REFERENCES: Lemoisne [1946–49], II, no. 141 (as c. 1866); Guy Dumur, "Consultons le dictionnaire," *L'Oeil*, 33, September 1957, repr. p. 36 (as Benatov collection, Paris); Paul-Henry Boerlin, "Zum Thema des gestürzten Reiters bei Edgar Degas," *Jahresbericht der Oeffentlichen Kunstsammlung Basel*, Basel, 1963, pp. 45–54, figs. 6 (color), 11 (detail); Minervino 1974, no. 169; Weitzenhoffer 1986, pp. 26–27.

352.

Three Jockeys

c. 1900
Pastel on tracing paper mounted on board
19¼ × 24½ in. (49 × 62 cm)
Vente stamp lower left
Private collection, New York

Exhibited in Ottawa and New York

Lemoisne 763

This pastel is the last in a group of three works, spread over about twelve years, in which the same principal figures recur. The earliest (L762) is identical in size and was made about 1888; the second, in a long horizontal format (L761), seems to date to the early 1890s. In the foreground of all three is a mounted horse with its neck extended, possibly about to bite off a clump of grass (which racehorses are trained not to do) or buck the rider. So exceptional, and comical, is the horse's action that the other jockeys have turned to watch. This horse first appeared—reversed—in a panel executed in 1882 (cat. no. 236), and was used again in later variants.

Degas constructed the pastels with the same methodical approach as for the oil paintings on panel. He drew each figure a number of times in order to refine precisely the action he wanted, and then transferred his figures—often by squaring—onto the support for the pastel. Several of the drawings for this work are squared, as is the pastel itself at the far right.[1] After the pastel was largely completed, Degas through squaring transferred the jockey and the turning horse onto the preexisting design, in the process obscuring a fourth horse and rider just visible between the jockey in blue and the jockey at the far right. Although the artist had executed a similar figure many times in the past, he nevertheless continued to adjust and refine this one, leaving a trail of revisions and corrections. One of the

drawings for the jockey at the left (IV:391) bears the artist's note to himself "faire sentir l'omoplate" (bring out the shoulder blade), which he followed by heightening the back of the figure with a bright white highlight across the shoulders. Another drawing (fig. 319) is notable for what looks to be the sun placed in the upper right corner[2]—hence the brilliant yellow in the pastel's remarkably changeable sky, which runs the gamut from raindrops and clouds at the left to bright sun at the right.

Lemoisne dates this work 1883–90, a wide latitude that signals some of the difficulties of accurately assigning a date. While the composition of this work descends directly from the 1882 panel paintings, the intensity of the color and the handling of the pastel point to a date about 1900. Certainly not before 1890 does one find Degas applying his pastel as he does here, in deliberate,

independent strokes that make no concession to the contours of the forms they describe. And not until the period around 1898–1900 does he apply pastel so heavily or work it so extensively. Much of the surface has been burnished through rubbing and then further worked with a kind of scrawled sgraffito (either with the butt of a brush or a small stick) that is prevalent only in the late pastels, such as the series of Russian dancers.[3] It is curious that Degas did not correct the movement of the horses' legs, as one might have expected him to do in a work made after his examination of Muybridge's publications of 1887. This may be because he relied on earlier studies of horses in wax, such as *Rearing Horse* (cat. no. 281) and RXII, though it is more likely the result of his change in emphasis from an accurate description of movement to a synthesis of motion and the evocative effects of rich, tapestry-like texture.

GT

1. There are two drawings for the jockey and the turning horse, IV:245.b and III:114.2, and another which conforms exactly to the artist's squaring still visible to the right in the pastel IV:237.c. See also cat. no. 96.
2. As seen in the reproduction of the drawing in the catalogue of Vente III, 1919. The right margin was obscured in the reproduction in the catalogue of the René de Gas estate sale (Paris, Drouot, 10 November 1927, no. 22 upper); it was evidently trimmed from the original sheet at an unknown date, for it is no longer part of the drawing. However, it is possible that the sun appearing in this illustration is only an optical effect produced by a round label on the verso of the drawing which could have formed creases on the surface.

3. See "The Russian Dancers," p. 581, and cat. nos. 367–370.

PROVENANCE: Atelier Degas (Vente I, 1918, no. 136); bought at that sale by Jacques Seligmann, Paris, for Fr 11,000 (Seligmann sale, American Art Association, New York, 27 January 1921, no. 27); bought at that sale by Durand-Ruel, New York, for $1,850;[1] deposited with Galeries Durand-Ruel, Paris (stock no. 12547), 4 July 1921; acquired by G. and J. Durand-Ruel, New York, 10 September 1924 (stock no. 4675); bought by Hugo Perls, 20 May 1927, for Fr 13,600 (stock no. 12593); Esther Slater Kerrigan collection, New York (Kerrigan collection sale, Parke-Bernet Galleries, New York, 8–10 January 1942, no. 47); bought at that sale by Lee A. Ault, New York, for $3,600 (sale, Parke-Bernet Galleries, New York, 24 October 1951, no. 93, consigned by V. Dudensing); bought at that sale by French and Co., New York, for $6,000 (Bryon Foy collection sale, Parke-Bernet Galleries, New York, 26 October 1960, no. 75); bought at that sale by present owner, for $65,000.

1. According to the Durand-Ruel archives and labels on verso. In the American Art Association archives, however, Ambroise Vollard is listed as purchaser, acting in association with Durand-Ruel and Seligmann.

EXHIBITIONS: 1926, Maison-Laffitte, Château de Maison-Laffitte, 20 June–25 July, *Les courses en France*, no. 88, p. 23, repr. facing p. 33 (as "Trois jockeys," lent by MM. Durand-Ruel); 1968 New York, no. 12, repr., lent anonymously; 1978 New York, no. 29, repr. (color).

SELECTED REFERENCES: James N. Rosenberg, "Degas—pur sang," *International Studio*, LXXIII, March 1921, repr. p. 21; Henri Hertz, "Degas, coloriste," *L'Amour de l'Art*, V, March 1924, repr. p. 67; Lemoisne [1946–49], III, no. 763 (as c. 1883–90); Minervino 1974, no. 713; 1983 London, no. 25 (as 1882–85); 1987 Manchester, p. 101, fig. 129 p. 100 (as c. 1900).

Fig. 319. *Jockey* (III:354.1), c. 1900. Charcoal, 5⅞ × 7⅞ in. (15 × 20 cm). The Burrell Collection, Glasgow

352

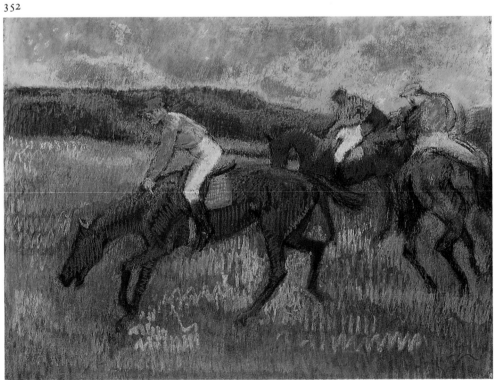

353.

Racehorses

1895–1900
Pastel on tracing paper, with strip added at
 bottom
21¼ × 24¾ in. (54 × 63 cm)
Signed in red lower right: Degas
National Gallery of Canada, Ottawa (5771)

Lemoisne 756

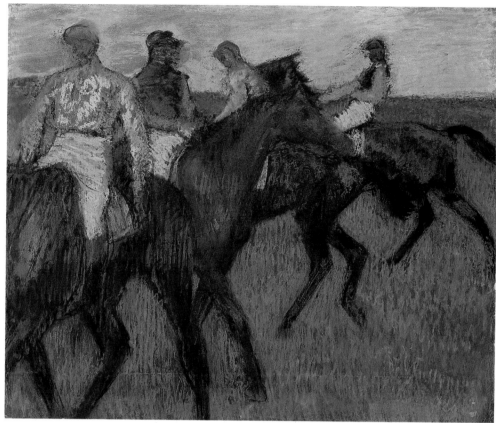

353

Unlike the Thyssen-Bornemisza pastel (cat. no. 306) of 1894, this scene subordinates the landscape to the horses and riders. Although both the jockeys and the animals are larger, they are no more individualized than in the Thyssen pastel. Degas has deliberately smudged or scraped the faces of the riders into apparitions. The horses are even less articulated. The coats of the horses and the jackets of the riders are less silken and more insistently the texture of pastel. Degas has entered a level of abstraction here in which the riders seem symbols of a directionless energy.

There are precedents in the eighties for this composition, as for the Thyssen work. One is a very animated, articulated, and sunny pastel, *Before the Race*, in the Cleveland Museum of Art (fig. 320). In a charcoal-and-pastel drawing in the Museum of Art of the Rhode Island School of Design in Providence (L757), this composition is reversed, its landscape reduced to a field and sky, and its handling made more rudimentary. It may have been this drawing that was used for the beautiful color lithograph made by George William Thornley and published by Boussod et Valadon in 1889.

With tracing paper, Degas worked during the next decade toward the pastel now in Ottawa. All that seems to have survived of what must have been a series of drawings on tracing paper is one in charcoal (fig. 321). At this stage, he had decided to remove the horse and rider on the left of the Cleveland pastel and to move in closer. However, in making another drawing on tracing paper as the basis for the Ottawa work, he restored the horse and jockey on the left. For the pastel, he made other changes, all at the cost of the articulation in the drawing. He also added an extra piece of paper at the bottom.

Degas's tracing in charcoal on the paper used for the Ottawa work was so heavily fixed that it looks like graphite. It was professionally mounted before he began to work with the pastel. Degas drew boldly and assertively, using the brush, particularly in the sky. At some intermediate point, he applied a fixative that gives the pastel a certain gloss. But he seems to have drawn with dark blue pastel over the surface to unite

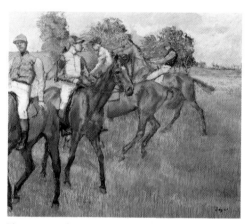

Fig. 320. *Before the Race* (L755), c. 1884. Pastel, 22⅝ × 25¾ in. (54 × 62 cm). The Cleveland Museum of Art

Fig. 321. *Three Jockeys* (II:270), c. 1895–1900. Charcoal, 18⅞ × 19⅝ in. (48 × 50 cm). Location unknown

and strengthen the drawing.[1] What emerges is a work of great daring and artfulness. Ronald Pickvance was the first to reject Lemoisne's dating of 1883–85 and to propose that this was probably the last of Degas's racetrack scenes, emerging in the late nineties.[2] It may evoke the works Degas had done in the eighties, but it carries them to a new intensity as they are remembered through his vivid, abstracting imagination.

1. The observations on technique were influenced by the examination report made by Anne Maheux and Peter Zegers, Pastel Project, National Gallery of Canada.
2. 1968 New York, no. 17, and last page of introduction, n.p.

PROVENANCE: With Ambroise Vollard, Paris; bought from the Vollard estate by the museum 1950.

EXHIBITIONS: (?) 1939 Paris, no. 40; 1950, Ottawa, National Gallery of Canada, November, *Vollard Collection*, no. 10, repr.; 1958 Los Angeles, no. 44, repr. p. 50; 1968 New York, no. 17, repr. (as late 1890s).

SELECTED REFERENCES: Vollard 1914, pl. VIII; Lemoisne [1946–49], III, no. 756 (as c. 1883–85); Minervino 1974, no. 704.

Late Landscapes at Saint-Valéry-sur-Somme

cat. nos. 354–356

Although Degas was entering a period when his intransigent stand on the Dreyfus Affair meant the end of old friendships, in particular with the Halévys, whom he did not see after 1897 except under the most unusual circumstances, he did form some new friendships with artists and their families. One was with Georges Jeanniot, who was to describe Degas making a landscape monotype.[1] Another was with Louis Braquaval.

Braquaval was, like Jeanniot, a man of independent means, and also like Jeanniot had a house in the country as well as in Paris. This country house was at Saint-Valéry-sur-Somme, where Degas seems to have vacationed forty years before.[2] It must have been in 1896 that Degas saw Braquaval painting at Saint-Valéry and went up to him and said: "I am impressed, my friend, with your energy, and the steady pace at which you work. But that isn't what painting is: let me give you a little of my poison."[3]

Although it is usually assumed that they met in 1898,[4] Degas had addressed a familiar New Year's letter to Braquaval on 1 January 1897 in which he wrote: "You love that rocky headland, the solitude of the seashore."[5]

They became friends, and Degas continued to give him advice. It was a friendship that was to embrace the whole family, including the Braquavals' daughter Loulou.[6] Degas seems to have gone often to Saint-Valéry-sur-Somme, apparently with his brother René.

Jeanne Raunay has described Saint-Valéry-sur-Somme and its importance for Degas:

Degas, with his brother and his nieces, frequented a seaside resort where the Channel merges into the North Sea and where, as a result, the light shifts constantly, as do the colors and the moods of the water—from brown to gold, from animation to reflection, from turbulence to calm. In these regions of transition, nature seems to become truly personified, with all the attendant floods of temperament, whimsy, and tenderness.

Degas enjoyed coming back to this little village where his parents had brought him from childhood. There he found everything that he loved: the sea with its surprises, the streets lined with old houses, the ruined castle walls, the monumental arched gate under which Joan of Arc had passed. But more than that, he found in these surroundings the first memories of his childhood and could recall in them all those whom he had loved.[7]

At Saint-Valéry-sur-Somme, Degas became a landscape painter again, somewhat more rooted to the source of his inspiration than he had been when he was making the landscape monotypes at the beginning of the nineties. He also seems to have taken photographs, which he had enlarged, of trees and the seashore at Saint-Valéry.[8] He wrote in September 1898 to Alexis Rouart, "Were it not for landscapes that I am determined to try, I should have left. My brother had to go back to his newspaper [*Le Petit Parisien*] on the 1st, and the landscapes(!) kept me here a few days longer." He added, with his usual awareness that his landscapes would always surprise his friends and critics, "Your brother [Henri Rouart], will he believe this?"[9]

Most of these Saint-Valéry landscapes were in Degas's studio at the time of his death. His niece Jeanne Fevre owned two, but perhaps this was because she had received

354

them during the division of some of his works before the sales. Degas's new friend Braquaval not unexpectedly owned two others. But the pictures were not generally known in Degas's lifetime.

1. See "Landscape Monotypes," p. 502.
2. Reff 1985, Notebook 14A (BN, Carnet 29, pp. 40–41); Notebook 18 (BN, Carnet 1, p. 161). Both notebooks are dated by Reff to about 1859–60.
3. *Oeuvres de Braquaval (1854–1919)* (exhibition catalogue, introduction by Albert Besnard), Paris: Galeries Simonson, 1922, p. 7.
4. Ibid.
5. Unpublished letter, 1 January 1897, private collection, Paris.
6. See "The Braquavals," in Ambroise Vollard, *Degas: An Intimate Portrait*, New York: Dover, 1986, pp. 50–54.
7. Jeanne Raunay, "Degas: souvenirs anecdotiques," *La Revue de France*, 11th year, II, 15 March 1931, p. 274.
8. Fogg Art Museum, Cambridge, Mass. See Terrasse 1983, nos. 60, 61.
9. Lettres Degas 1945, CCXX, p. 225; Degas Letters 1947, no. 218, pp. 210–11.

355

354.

View of Saint-Valéry-sur-Somme

1896–98
Oil on canvas
20⅛ × 24 in. (51 × 61 cm)
The Metropolitan Museum of Art, New York.
 Robert Lehman Collection, 1975 (1975.1.167)

Brame and Reff 150

In painting the small town of Saint-Valéry-sur-Somme, Degas was apparently attracted to the way nature intruded on the town. He seems to have painted the scenes, some thirteen of them identified (L1212–L1219; BR150–BR154), in a warm but hazy autumnal light.

This view is, of all of them, the most distant and panoramic. It also reduces the foliage to a minimum so that the picture, as Denys Sutton has pointed out, seems almost an anticipation of Cubism in its illusive architectural forms.[1] However that may be, Degas, with his photographer's eye, also gives an unerring sense of the atmosphere of this seaside town on an early autumn day.

Julie Manet, the daughter of Berthe Morisot, wrote in her journal on 16 October 1897: "Suddenly, autumn arrived, with its golden foliage; how beautiful it was at sunset after the rain. It was exactly like the landscapes of D. [sic] Degas, with their

sweeping lines of hills, their colors, the harmony of green meadows and yellow trees."[2]

This account is significant not only for its revelation of Julie Manet's sensitivity to seasonal landscapes and Degas's paintings of them but also for its indication, from the date of the entry, that some of the landscapes may have been produced before September 1898, perhaps as early as 1896.

1. Sutton 1986, p. 301.
2. Manet 1979, p. 136.

PROVENANCE: Jeanne Fevre, Nice (sale, Galerie Charpentier, Paris, 11 June 1934, no. 135). Robert Lehman, New York; his gift to the museum 1975.

EXHIBITIONS: 1957, Paris, Orangerie des Tuileries, May–June, *Exposition de la collection Lehman de New York*, no. 65; 1960 New York, no. 67, repr.; 1977 New York, no. 19 of the paintings; 1978 New York, no. 53, repr. (color); 1983, Oklahoma City, Oklahoma Museum of Art, 23 April–18 July, *Impressionism and Post-Impressionism: XIX and XX Century Paintings from the Robert Lehman Collection*, pp. 32–33, repr. (color).

SELECTED REFERENCES: George Szabó, *The Robert Lehman Collection*, New York: The Metropolitan Museum of Art, 1975, p. 100, pl. 100; Brame and Reff 1984, no. 150, repr.; Sutton 1986, p. 301, pl. 286 p. 302.

355.

At Saint-Valéry-sur-Somme

1896–98
Oil on canvas
26⅝ × 31⅞ in. (67.5 × 81 cm)
Vente stamp lower right
Ny Carlsberg Glyptotek, Copenhagen (883c)

Lemoisne 1215

In this painting, decorative trees are played against the faceless buildings of a typical French town. The scene is somewhat damp and mournful; neither the long walls nor the road present an inviting prospect. On the other hand, it is beautiful in its colors, with pink and lavender, sometimes intermingled with green. In the very freedom with which Degas did not cover the canvas—if not in the reticence of the color—he anticipated some Fauve painting in the next decade.

PROVENANCE: Atelier Degas (Vente II, 1918, no. 44); bought at that sale by Clausen, Paris, for Fr 4,100; Carl J. Becker; his bequest to the Statens Museum for Kunst, Copenhagen, December 1941; transferred from Statens Museum for Kunst 1945.

EXHIBITIONS: 1948 Copenhagen, no. 127.

SELECTED REFERENCES: Meier-Graefe 1920, p. 29; Lemoisne [1946–49], III, no. 1215; Minervino 1974, no. 1180.

356.

The Return of the Herd

c. 1898
Oil on canvas
28 × 36¼ in, (71 × 92 cm)
Vente stamp bottom left
Leicestershire Museums and Art Galleries,
 Leicester (11A1969)

Lemoisne 1213

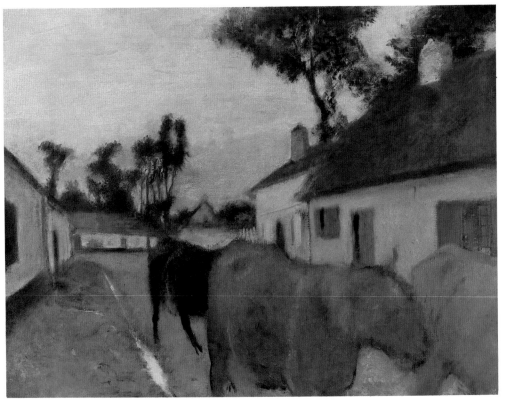

356

In painting his townscapes and landscapes at Saint-Valéry-sur-Somme about 1898, Degas must often have thought of the work of Gauguin, whose paintings he so much admired. Only three years before, at the Gauguin sale (18 February 1895) where he himself bought eight works, he had persuaded the twenty-three-year-old Daniel Halévy to buy one of Gauguin's Tahitian landscapes, *Te Fare* or *La maison*, for Fr 180.[1] Halévy used to relate that, as Degas grew older and his eyesight was failing, whenever he visited Halévy he would get very close to the painting and say, "Ah, even Delacroix never painted quite like that."[2]

It is in the muted harmony of color that *The Return of the Herd* suggests Gauguin. That harmony evokes the climate of the seaside village—moody and wet. Whether it is the quiet before or after a storm or whether it is dawn or dusk is uncertain, but the painting possesses a trancelike calm. Degas provides surprises in color with a subjectivity and imagination like Gauguin's own. There is the remarkable sulphur yellow, mixed with rose in the sky and more intense in the building in the right foreground. Behind the dark green trees are halos of color, orange at the left, green behind those in the center, and a bluer green behind those at the right. Degas has painted lavender over the house at the left, used pink over turquoise blue for a door, and scrubbed on an orange-yellow paint roughly, thickly, and vigorously on the chimney at the right. As with Gauguin, that essential daring with color (without the use of primaries) is subordinated in these landscapes to the harmony of the whole.

On the other hand, the Norman village of Saint-Valéry-sur-Somme was obviously far removed from Tahiti. In the paintings of Degas, it retains the hermetic secretiveness of French towns. Nevertheless, Degas did try at two points here to suggest, tantalizingly, that it might open up. A gutter of water in the street leads our eyes back—almost, but not quite—to the wine-red door of the low building in the distance. Through an open window at the right, he even suggests the interior of a room. But basically, we are strangers in the street.

The cows add to the sense of alienation. They are painted in such a summary fashion that they seem out of focus. We are beside them but look beyond.

1. Wildenstein 1964, no. 474, p. 191.
2. As told to the author by Daniel Halévy.

PROVENANCE: Atelier Degas (Vente III, 1919, no. 38); bought at that sale by Avorsen, Oslo, for Fr 3,100 (sale, Sotheby's, London, 23 June 1965, no. 78); Peter Koppel 1969; bought by the museum.

SELECTED REFERENCES: Hoppe 1922, pp. 58, 59, repr. p. 59; Lemoisne [1946–49], III, no. 1213.

The Dancer in the Amateur Photographer's Studio

cat. nos. 357–366

In 1978, *Image*, the journal of the George Eastman House in Rochester, New York, published an article by Janet E. Buerger on three glass collodion plates, assumed to be by Degas, in the Bibliothèque Nationale. Buerger followed up the first article with another one in the same journal in 1980 after she had seen the plates in Paris.[1] The attribution of the photography and developing to Degas must be regarded as hypothetical.

Although Buerger does not state how the Bibliothèque Nationale acquired the three plates, one must assume that they were with archival material, including Degas's notebooks and other photographic plates, that came into the library's possession as a gift of the artist's brother René in 1920. The plates were made by the collodion process, with which it is clear Degas was familiar from a letter he wrote to Pissarro about 1880.[2] Collodion-based negatives were becoming obsolete by 1873 and were almost unknown after 1881; this would seem to date the photographs before 1881 if we think of Degas as a technical innovator. If, however, like Eugenia Parry Janis, we see him as ingenious technically but often prepared to use archaic means, the 1881 date does not provide a terminus ante quem.[3]

There seem to have been certain problems with the plates. The emulsion coated them unevenly, and crazed. In addition, they are not, as one would have expected, negatives but rather positives from which only negatives can be printed. Apparently this reversal, or solarization as it is called, can result from extreme overexposure in the camera, exposure to light in the darkroom, or the use of certain developing agents, whether intentional or accidental. Another aspect of the solarization phenomenon found in these plates is the presence of so-called Sabatier lines which give a halolike luminosity to the contours. Finally, whereas a conventional collodion negative plate is pale green and transparent—the pale green producing the lights, the transparent areas the darks—these plates are dark green and red orange, the latter printing dark.

It should be pointed out that these photographs, if indeed they are by Degas, are his only known photographs of dancers. The same dancer clearly posed for all three (cat. no. 357; figs. 322, 323). In one, she holds her right hand to her throat and lifts her left hand to grasp the top of the screen, giving the arm a strong diagonal movement. In another, her left elbow is raised as her hand meets the other to adjust her right shoulder strap. In the third, we see her from behind with her elbows out, each hand grasping, in a gesture seemingly cultivated by dancers, the nearer shoulder strap. She is dressed in a rather short, meager tutu, beginning below the waist. The bodice is like a corselet, decorated at the skirt with something corresponding to the more generous frill around the neckline. The model is placed against flimsy, temporary screens covered with sheets—surely amateurish and more temporary than a professional photographer would have provided in his studio. Although her features are often lost in the photography or in the developing process, the dancer seems, in the second view (adjusting her shoulder strap), to be conventionally pretty—perhaps even beautiful.

Janet Buerger indicates the pleasure Degas must have taken in the red-orange-and-green glass plates. Since they were positives, he would receive from the recto an impression of what he or another photographer would have seen when the model posed. If he looked at the back of the plate, he would find the composition reversed, a mirror image, with which he had often experimented, particularly in making counterproofs from his drawings.[4] As Buerger points out, collodion plates "generally exhibit a marked tendency to reverse tonal values (light vs. dark) when held in the hands and tipped in different directions."[5] Degas, who was clearly fascinated by such

transformations of images throughout his life, must have enjoyed examining these effects with the plates in his hands and could have been inspired by them. Nevertheless, by the late nineties when, as Buerger indicates, these photographs provided source material for some one hundred paintings, pastels, and drawings, he was sufficiently troubled by his failing eyesight to have found it difficult to work with such small objects. Thus, he must have had prints made—if only the negative reversals—and presumably enlarged by his friend Tasset, who had enlarged other photographs for him.[6]

One question—perhaps never to be resolved, since so few vintage prints of photographs associated with Degas are believed to have survived—is whether in a spirit of experimentation, not unknown to him, he would have had as many variations of prints made as did the Bibliothèque Nationale in 1976. The Bibliothèque made six different prints of each plate—two negative prints, one a combination of positive and negative as a result of solarization, and the mirror image of all three.

A second question is whether the photographs themselves—undoubtedly used by Degas in the late nineties—could have been made earlier, even as early as the seventies, which Buerger suggests as a probability. In their smallness, the images have a delicacy of contour and of light and shadow that is apt to suggest, as it does to Buerger, Degas's works in the seventies, when the technique of collodion photography was common. However, the fact that Degas sometimes

chose to use archaic techniques in his work makes it possible that he could have used collodion in the nineties, counting on his ingenious friend Tasset to help him develop and possibly enlarge the prints. In addition, the contrived poses suggest that Degas directed the model as he had also directed the poses of the Halévys and their friends for more conventional photographs. Even the strange lighting effects, reminiscent of his earlier monotypes and of the light of the theater, would have enchanted him. Whether or not the date can be determined,[7] and whether or not these three are the only surviving photographs of many more he made of dancers in the late nineties, it is clear that they were the inspiration for many of his late paintings and pastels of dancers.

1. Buerger 1978, pp. 17–23; Buerger 1980, p. 6.
2. Lettres Degas 1945, XXV, p. 53; Degas Letters 1947, no. 34, p. 57.
3. 1984–85 Paris, pp. 468–69.
4. Although he did make counterproofs and occasionally drawings from these, a substantial majority of any motif were nevertheless facing in the same direction.
5. Buerger 1980, p. 6.
6. On Degas's relationship with Tasset, see Newhall 1956, pp. 124–26.
7. Terrasse, in Terrasse 1983, nos. 26–34, pp. 46–47, dates the photographs from about 1896. Shackelford, in 1984–85 Washington, D.C., figs. 5.2, 5.3, 5.4, pp. 112–14, questions Degas's authorship and proposes a date of c. 1895. Janis, in 1984–85 Paris, figs. 330–33 pp. 476–77, suggests a date of c. 1896; Thomson, in 1987 Manchester, no. 104 p. 142, fig. 160-2 p. 120, dates the photographs c. 1895 or earlier.

Fig. 322. *Dancer from the Corps de Ballet* (T28), c. 1896. Photograph printed from a glass negative in the Bibliothèque Nationale, Paris

Fig. 323. *Dancer from the Corps de Ballet* (T34), c. 1896. Photograph printed from a glass negative in the Bibliothèque Nationale, Paris

357

357.

Dancer from the Corps de Ballet

c. 1896
Glass collodion plate
7 × 5⅛ in. (18 × 13 cm)
Bibliothèque Nationale, Paris

Exhibited in Paris

Terrasse 27

PROVENANCE: Atelier Degas; (?) René de Gas, Paris; his gift to the Bibliothèque Nationale, Paris, (?) 1920.

SELECTED REFERENCES: Buerger 1978, repr. p. 17; Crimp 1978, repr. pp. 96, 97; Buerger 1980; Terrasse 1983, figs. 26, 27, 30; 1984–85 Paris, p. 477, figs. 332, 333; 1984–85 Washington, D.C., p. 114, fig. 5.2; 1987 Manchester, p. 120, fig. 160–2 left.

358.

Dancers in Blue

c. 1893
Oil on canvas
33⁷⁄₁₆ × 29¾ in. (85 × 75.5 cm)
Vente stamp lower left
Musée d'Orsay, Paris (RF1951.10)

Exhibited in Paris

Lemoisne 1014

Although this painting does not use the poses of the photographs[1] and is clearly based on the composition of the Metropolitan's *Dancers, Pink and Green* (cat. no. 293), in the intensity of the pervasive blue and the rhythmic play with the dancers' arms it suggests Moscow's *Behind the Scenes* (fig. 325), the work most dependent on the photographs. Indeed, it could almost be a larger version in oil of that pastel.

For the Orsay *Dancers in Blue*, Degas simplified considerably the composition of *Dancers, Pink and Green*. He reduced the number of principal figures from five to four, and eliminated the suggestion of a male onlooker. In effect, the emphasis has now shifted entirely away from narrative and toward the more abstract concerns of picture making: color, form, surface, and scale. Although Degas made the dancers in the background more legible than in *Dancers, Pink and Green*, the focus is concentrated more specifically on the dancers in the foreground; the simplified scenery provides little distraction from the rhythmic interweaving of the four dancers turning in on themselves, their arms akimbo reflecting the shape of their tutus. We do not know if Degas referred to models while making this picture, but if he did, he may have used one model for all four figures. Viewing the painting, one can imagine that the artist actually revolved around the model to examine her from all directions, and then compressed into a single block of figures the kinds of observations depicted laterally in Cleveland's *Frieze of Dancers* (L1144).

In comparison with *Dancers, Pink and Green*, this picture is painted more broadly (with a concomitant reduction of detail) and in colors of greater intensity and uniformity. These factors suggest a date later than that of the New York painting, perhaps as late as 1893 if the earlier painting dates from about 1890. GT

1. See "The Dancer in the Amateur Photographer's Studio," p. 568.

PROVENANCE: Atelier Degas (Vente I, 1918, no. 72); sold at that sale for Fr 80,000; Danthon collection, Paris; Dr. and Mme Albert Charpentier collection, Paris, by 1937; their gift to the Louvre 1951.

EXHIBITIONS: 1934, Paris, Galeries Durand-Ruel, 11 May–16 June, *Quelques oeuvres importantes de Corot à Van Gogh*, no. 11; 1936, Paris, Bernheim-Jeune for the Société des Amis du Louvre, 25 May–13 July, *Cent ans de théâtre, music-hall et cirque*, no. 36; 1936, Paris, Galeries Durand-Ruel, March–April, *Peintures du XXe siècle*, no. 17, repr., no lender listed; 1937 Paris, Orangerie, no. 45, lent by Dr. Albert Charpentier; 1937 Paris, Palais National, no. 311, lent by Dr. Albert Charpentier; 1938, Amsterdam, Stedelijk Museum, 2 July–25 September, *Honderd Jaar fransche Kunst*, no. 110 (private collection); 1951–52 Bern, no. 47, repr.; 1952 Amsterdam, no. 42, repr.; 1952 Edinburgh, no. 28; 1955, Brives/La Rochelle/Rennes/Angoulême (traveling exhibition), *Impressionnistes et précurseurs*, no. 17, repr.; 1956, Warsaw, Muzeum Narodowe, 15 June–31 July, *French Painting from David to Cézanne*, no. 36, pl. 87; 1956, Moscow, Pushkin Fine Art Museum/Leningrad, Hermitage Museum, *Peinture française du XIXe siècle*, no. 36, pl. 37; 1957, Besançon, Musée des Beaux-Arts, 6 September–15 October, *Concerts et musiciens*, no. 62; 1967–68, Paris, Orangerie des Tuileries, 16 December 1967–March 1968, *Vingt ans d'acquisitions au Musée du Louvre 1947–1967*, no. 408; 1969 Paris, no. 33; 1971 Madrid, no. 35; 1985–86, Antibes, 15 June–9 September/Toulouse, 19 September–11 November/Lyons, 21 November 1985–15 January 1986, *Orsay avant Orsay*, no. 12.

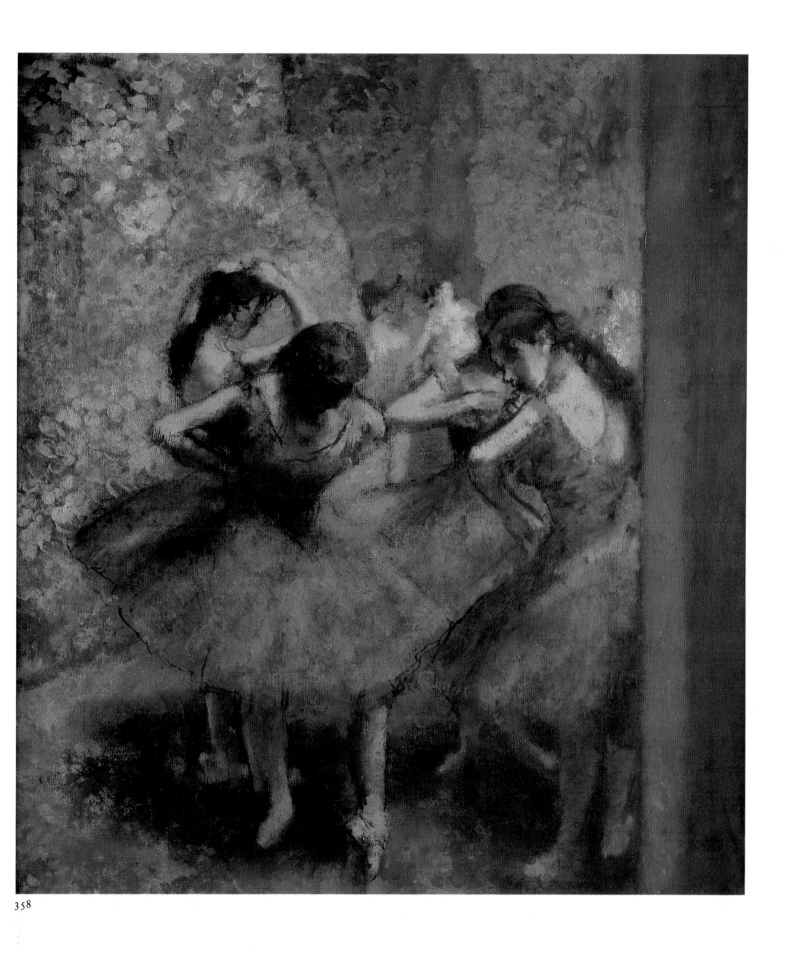

358

SELECTED REFERENCES: Lemoisne 1937, repr. p. B; Lemoisne [1946–49], III, no. 1014 (as 1890); Paris, Louvre, Impressionnistes, 1958, p. 52, no. 99; Minervino 1974, no. 856; Keyser 1981, p. 66; 1984–85 Paris, fig. 150 (color) p. 175; Paris, Louvre and Orsay, Peintures, 1986, III, p. 197.

359.

Dancers

c. 1899
Pastel on tracing paper mounted on wove paper
23⅛ × 18¼ in. (58.5 × 46.3 cm)
Vente stamp lower left
The Art Museum, Princeton University. Bequest
of Henry K. Dick (54-13)

Exhibited in New York

Lemoisne 1312

This pastel, from Princeton, was not based on any of the known collodion photographic plates,[1] but the dancer in the photographs could have posed for these figures, though their hair is worn loose and hers is not. The poses have the same exaggeration, and the contours of neckline and arms the same linear interest. The pattern of lights and darks, which could be explained by solarization in the photographs, suggests theatrical lighting here. And the Sabatier-effect aura finds an equivalent in the vibrant strokes of the pastel.

Degas characteristically made several studies in pastel and in charcoal of a group of three dancers waiting in the wings, with the principal dancer dramatically holding her left hand to her head and more prosaically scratching her back through the bodice with her right.[2] The movement in this figure is as strong as anything in the three photographs, the contours strengthened by continuous heavy lines of black and relieved by the curls of her hair. While the dancer adjusting her strap remains constant, the figure at the right, facing us, definitely does not. In this, the smallest and the richest pastel of the group, Degas gives that dancer a haunting, tragic face and lifts her left arm in a gesture of despair. In another version, in the Detroit Institute of Arts (fig. 324), she is almost a classical statue in her impassivity. Degas's interest in landscape is revealed in the variation of the stage flats in each version and in the harmony he establishes, almost as inevitable as the seasons, between the dancers and the background.

With a rather loose use of pastel, Degas created a tapestry of hills and sky for the flat. The hills are shot through with squiggles of blue, green, and pink, and dabs of orange. The dancer in front wears a rose tutu which Degas enlivened by some strokes of orange and pink, a foil for the wonderful surface of red orange he gives her hair, applied over a darker ground. The skin is vibrant with hatching that breaks through what might have been the monotonously continuous contours and is pink and green as well as flesh-colored. Hauntingly beautiful in its color, the Princeton *Dancers* also moves us through the inexplicably tragic figure of the dancer behind.

1. See "The Dancer in the Amateur Photographer's Studio," p. 568.
2. L1313, L1314, II:295, II:298.

PROVENANCE: Atelier Degas (Vente I, 1918, no. 275); bought at that sale by Gustave Pellet, Paris, for Fr 9,000; Maurice Exsteens, Paris; Henry K. Dick; his bequest to the museum 1954.

EXHIBITIONS: 1949 New York, no. 90, lent by Henry K. Dick; 1972, Princeton, The Art Museum, 4 March–9 April, *19th and 20th Century French Drawings from the Art Museum, Princeton University*, pp. 62–

359

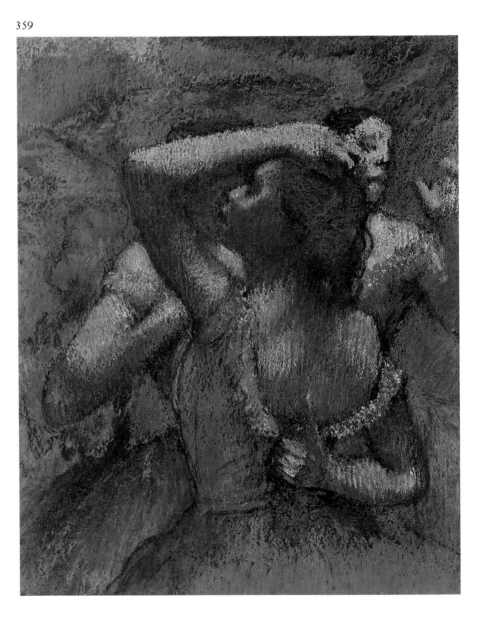

Fig. 324. *Dancers* (L1311), c. 1899. Pastel, 25¾ × 20 in. (65.4 × 50.8 cm). The Detroit Institute of Arts

63, no. 33, repr.; 1979 Northampton, no. 20, repr. p. 35; 1984–85 Washington, D.C., no. 52, repr. (color) p. 117.

SELECTED REFERENCES: Lemoisne [1946–49], III, no. 1312 (as c. 1898).

360.

Dancers

1899
Pastel on tracing paper, laid down
23⅝ × 24¾ in. (60 × 63 cm)
Signed in pencil lower right: Degas
Private collection, France

Exhibited in Paris

Lemoisne 1352

In 1898 and 1899, Degas made three approximately square and very rich pastels of groups of three or four dancers waiting to go on stage. Of these, *Dancers*, which was acquired from the artist by Durand-Ruel, may be the last. The first to be bought by Durand-Ruel, on 12 November 1898, was *Behind the Scenes* (fig. 325), now in Moscow, in which the poses of three of the figures are clearly derived from the Bibliothèque Nationale photographs, while little is seen of the bending fourth figure in the foreground.[1] The second *Dancers* (fig. 326), in Toledo, was bought on 7 July 1899; Degas had modified the poses, varied the color, and eliminated the fourth dancer. The third, this pastel, which was sold to Durand-Ruel on 9 August 1899, reintroduced a fourth figure and placed that dancer in the foreground; Degas also changed the position of the left arm of the dancer on the left. The Moscow pastel, which is closest to the photographs, though not monochromatic is predominantly and intensely blue. In the two pastels Degas sold in 1899, he plays with a much greater variety of color.

All three pastels, in addition to providing evidence of their common use of the three small photographs, bear a clear relationship to the very large oil painting *Four Dancers* (fig. 271), now in the Chester Dale Collection at the National Gallery of Art in Washington. In this work, which is almost six feet (180 centimeters) wide, four dancers share approximately half the canvas against a background of painted shrubbery. The rest is given over to a view of fields with rounded trees and a rose-colored sky that is clearly neither landscape nor stage scenery; the dancers' freely painted tutus seem to reflect that background. The problem is whether this work, in which green and orange predominate, perhaps in response to the even

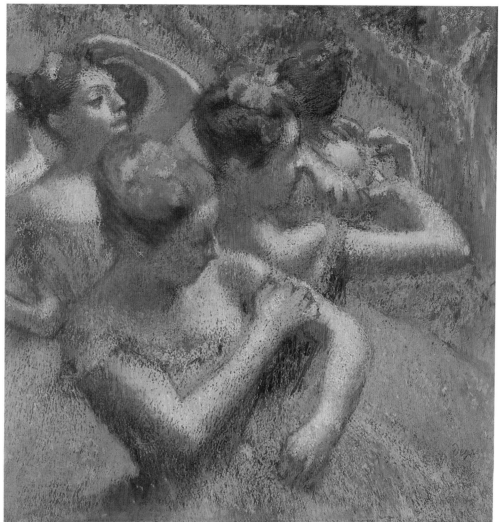

360

more intense color of the three collodion plates, was the result of the studies of the other works or whether, instead, it spawned the three pastels. No external evidence has been found to date the large painting, which was not exhibited in Degas's lifetime and was in his studio at the time of his death. The scale of *Four Dancers* indicates Degas's ambitions for it as a masterpiece to be treasured in his studio rather than as an "article"

Fig. 325. *Behind the Scenes* (L1274), c. 1898. Pastel, 26 × 26⅜ in. (66 × 67 cm). Pushkin Fine Art Museum, Moscow

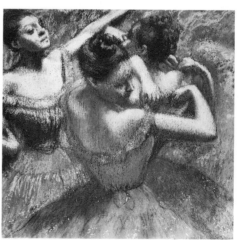

Fig. 326. *The Dancers* (L1344), c. 1899. Pastel, 24½ × 25½ in. (62.2 × 64.8 cm). The Toledo Museum of Art

573

for sale. It seems probable that it was painted first, and that from the drawings he made for it, tracing, making counterproofs, changing the poses somewhat, he found the poses to be used in the pastels.[2]

In the final work, exhibited here—as in the pastels in Moscow and Toledo—we come physically very close to the half-length dancers, looking down at them in a spatially improbable way. More than in the other two, Degas creates in this composition a gracefully unified movement through the limbs of the dancers. Whereas in the Moscow pastel he limited himself largely to an intense blue, and whereas he seems to have based Toledo's on the brilliant contrasts of the three complementary colors with the violet dress of the dancer on the left, here he worked primarily with red (which becomes pink) and green. There is an almost acid contrast between the intense yellow green of some of the costumes against the phosphorescent pinks. The red hair is like burning coals. And the dancers harmonize with the landscape, in which the bare tree trunk in the green grass has the pinks and reds of some of the tutus and the hair.

In each of these pastels and in the painting in Washington, the dancer on the left, based always in some way on the photograph of the dancer with the upstretched arm, stands somewhat in isolation. Like the haunted figure at the right in the Princeton pastel (cat. no. 359), she appears oracular, as a reminder that this is illusion. In the Washington painting, she is gaunt, shorn of most of her hair by the frame. In the Moscow pastel—the closest to the photograph—she turns away from the other dancers. In the Toledo pastel, she is aloof but benevolent. In this work, she seems only for a moment preoccupied, as she puts her hand on her head. Always she reminds us that a spell has been cast.

1. See "The Dancer in the Amateur Photographer's Studio," p. 568. Janet Buerger (Buerger 1978, p. 20) refers to the suggestion based on a statement by Jean Cocteau in *Secret professionnel* (Paris: Librairie Stock, 1924, p. 18) in an article by Luce Hoctin ("Degas photographe," *L'Oeil*, no. 65, May 1960, pp. 38–40) that Degas may have worked directly on enlargements of photographs. Hoctin incorrectly suggests that this might have been done with *Dancer Posing for a Photograph* (cat. no. 139) in Moscow. Buerger more reasonably proposes that this could have been done with Moscow's *Behind the Scenes* (fig. 325). Nevertheless, an enlargement even to its modest size of 26 × 26⅜ in. (66 × 67 cm) would have been an ambitious undertaking. And a photograph would surely not provide a practical surface on which to work with pastel.
2. L1268, L1269, L1272, L1273, L1359, L1361, L1362, BR147, III:392, III:185, IV:349 (counterproof), IV:368 (counterproof).

PROVENANCE: Bought from the artist by Durand-Ruel, 9 August 1899 (stock no. 5424, "Danseuses avec fleurs dans les cheveux"); private collection.

EXHIBITIONS: 1905 London, no. 64; 1916, New York, Durand-Ruel, 5–29 April, *Exhibition of Paintings and Pastels by Édouard Manet and Edgar Degas*, no. 20 (as 1898); 1918, New York, Durand-Ruel, 9–26 January, *Exhibition: Paintings and Pastels by Degas*, no. 14; 1937 Paris, Orangerie, no. 11; 1960 Paris, no. 60; 1970, Hamburg, Kunstverein, 28 November 1970–24 January 1971, *Französische Impressionisten: Hommage à Durand-Ruel*, no. 14; 1974, Paris, Durand-Ruel, 15 January–15 March, *Cent ans d'impressionnisme, 1874–1974*, no. 18; 1984–85 Washington, D.C., no. 51, repr. (color) p. 108.

SELECTED REFERENCES: Coquiot 1924, pp. 176–77; Lemoisne [1946–49], III, no. 1352 (as 1899); Browse [1949], p. 412, pl. 240; Minervino 1974, no. 1133.

361.

The Rehearsal Room

c. 1898
Oil on canvas
16⅜ × 36¼ in. (41.5 × 92 cm)
Vente stamp lower right
E. G. Bührle Foundation Collection, Zurich

Exhibited in Paris

Lemoisne 996

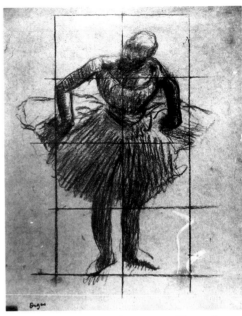

Fig. 327. *Dancer* (III:267), c. 1898. Charcoal, 18⅞ × 14⅛ in. (48 × 36 cm). Location unknown

In *The Rehearsal Room*, adult and even huskily broad-shouldered dancers are captured in a moment of relaxation. One bends to adjust her shoe, another pulls at both straps of her bodice, the third flounces her tutu. Behind them are other dancers, but they are indistinct. A door opens provocatively, creating a passage of light on the floor at the left. George Shackelford has found an engraving, after an earlier composition of this kind by Degas, that shows a spiral staircase, presumably leading to the theater beyond the open door.[1]

That the forms and coarse black contours are not the result of overpainting is clear from the many drawings made in preparation for this work—from the total composition to individual figures. Degas executed squared drawings for each of the principal dancers (fig. 327, for example), a process that made them, in the final work, more frontal and more monumental. Shadows are indicated by brusque, continuous zigzag hatching. Such drawings underline the painting and have created these robotlike figures that have grown to gigantic proportions within the low frame of the picture. The dancer fluffing out her tutu must bow her head a little to avoid the top of the canvas.

In the presence of this work, we are captivated by the color and accept the gigantic dancers as the vehicles for it. Their tutus of blue green are so luminous they are almost phosphorescent. There is a marvelous orange glow to the wall and to the door. Degas took his brush of black paint and at places gave the dancers the severest of contours so that we would not succumb to the seduction of color.

He added to the sense of mystery in the work by the orange through the open door and by the inexplicable splash of red on the wall at the left.

Degas applied his paint with the kind of freedom that makes us feel any instrument, including his fingers, could have been used. The painting is often described as unfinished. And certainly it lacks finish. But as Paul Valéry explained "finish" in writing about Degas, "nothing could be remoter from the taste or, if you will, the whims of Degas."[2] He had argued earlier that "to *complete* a work consists of getting rid of everything that reveals or hints at how it was made. . . . It has come to seem as if finish were not only useless and troublesome but even a hindrance to *truth, sensibility,* and the revelation of *genius.*"[3] Degas would have been embarrassed by the assumption of genius, but he would have agreed with the fascination in the process of creating a work of art, as he had chosen, after innumerable careful studies, to expose it here.

1. Shackelford argues that under the Bührle canvas is the original from which the lithograph was made (1984–85 Washington, D.C., p. 98, fig. 4.6). This seems unlikely.
2. Valéry 1965, p. 45; Valéry 1960, p. 21.
3. Valéry 1965, p. 44; Valéry 1960, pp. 20–21.

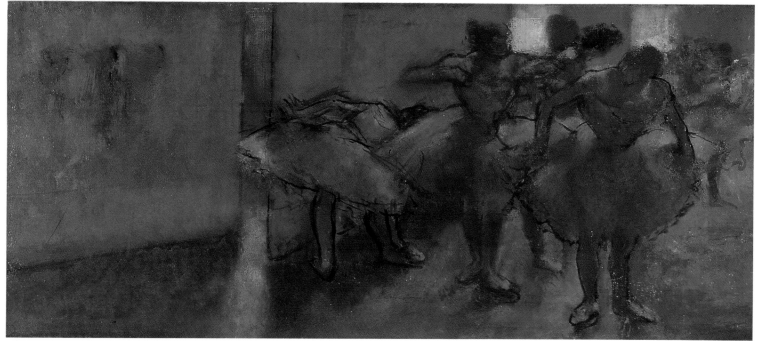

361

362.

Group of Dancers

c. 1898
Oil on canvas
18⅛ × 24 in. (46 × 61 cm)
Vente stamp lower left
National Gallery of Scotland, Edinburgh.
 Maitland Gift, 1960

Exhibited in Ottawa and New York

Lemoisne 770

PROVENANCE: Atelier Degas (Vente II, 1918, no. 11); bought at that sale by Durand-Ruel, New York, for Fr 11,200 (stock no. 11398); with Durand-Ruel, Paris; private collection, Paris; acquired by Emil G. Bührle, Zurich, 1951.

EXHIBITIONS: 1951–52 Bern, no. 46; 1952 Amsterdam, no. 41; 1958, Kunsthaus Zürich, 7 June–September, *Sammlung Emil G. Bührle*, no. 162 p. 106, fig. 46 p. 213; 1984–85 Washington, D.C., no. 41, repr. p. 98, repr. (color) p. 140.

SELECTED REFERENCES: Lemoisne [1946–49], III, no. 996 (as c. 1899); Minervino 1974, no. 852.

Even in the 1870s, Degas had been interested in the professional world of the dancer at the periphery of the stage, waiting for a performance or a rehearsal to begin. At its wittiest and bawdiest, it was seen through the eyes of Ludovic Halévy and his fictional characters, the Cardinals.[1] In the eighties the theme continued, though very much subdued and without the wit of the previous decade. In one pastel, *Dancers in the Studio* (fig. 328),[2] dated 1884 by Lemoisne, Degas had used the horizontal frieze format to show a group of four dancers to the right of the composition, with the back of one reflected in a large wall mirror. Somewhat later, presumably in the early nineties rather than in 1884 as Lemoisne dates it, Degas made another, squarer version, in oil, *Four Dancers in the Studio* (fig. 329). Not only had the dancers aged and lost their wistful charm, but Degas had inserted another, highly muscular figure

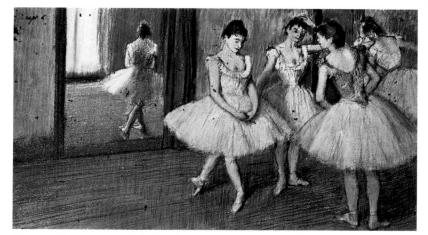

Fig. 328. *Dancers in the Studio* (L768), c. 1884. Pastel, 15 × 28⅜ in. (38 × 72 cm). Location unknown

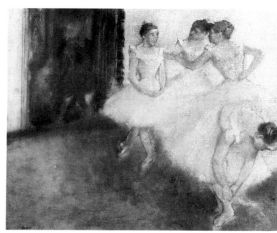

Fig. 329. *Four Dancers in the Studio* (L769), c. 1892. Oil on canvas, 21¼ × 25⅝ in. (54 × 65 cm). Location unknown

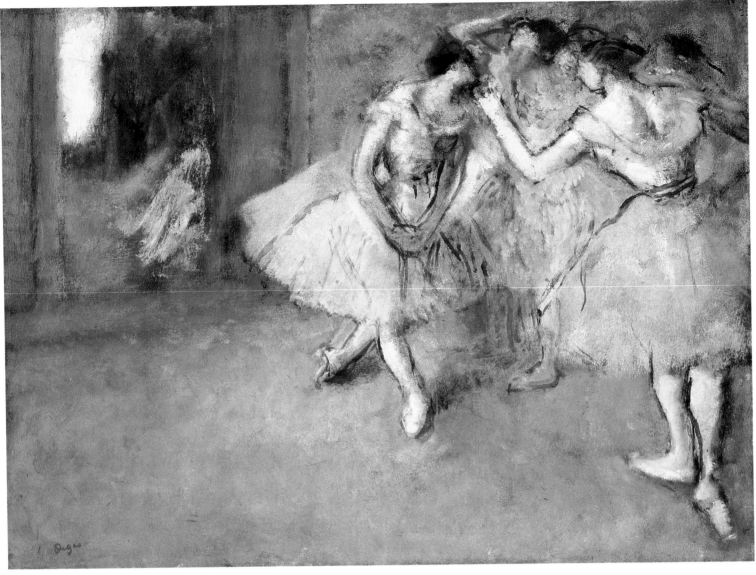

362

in the foreground bending over to tie her
shoe. It was even later in the nineties that he
produced another version, *Group of Dancers*,
now in the National Gallery of Scotland in
Edinburgh.[3]

In the Edinburgh painting, the emphasis
is placed on the two dancers found in each
of the earlier versions and drawings[4]—the
one reflected in the mirror and the one with
her back to us who raises her left arm. The
dancer on the right has been enlarged and
strengthened so that the bending dancer can
be eliminated. The dancer on the left, though
(like all the figures) more spectral than in
the earlier versions, turns more gracefully to
her companions; consequently, less is re-
flected in the mirror. The other dancers are
reduced to smudges of paint.

Group of Dancers is freely painted and the
contours applied with a particular daring.[5]
Its emerald greens, orange, and luminous
whites, much more decorative than the acid
yellows, oranges, and greens of the earlier

Four Dancers in the Studio, are reminiscent of
the Bührle Foundation's *The Rehearsal Room*
(cat. no. 361), or the *Four Dancers* in Wash-
ington (fig. 271). There are obviously draw-
ings in preparation for this painting, as there
are for the earlier *Dancers in the Studio* and
Four Dancers in the Studio (see note 4). But
like Washington's *Four Dancers*, this strong
painting could also have spawned some
drawings (including cat. nos. 363, 364) and
one major pastel (fig. 330).

1. See "Degas, Halévy, and the Cardinals," p. 280.
2. This cannot be the work put on sale at Sotheby
 Parke Bernet, New York, 14 May 1980, no. 214;
 see Brame and Reff 1984, no. 92.
3. Although Lemoisne (Lemoisne [1946–49], III,
 pp. 438, 830) assigned the date of 1884 to both
 fig. 329 and cat. no. 362, he pointed out their rela-
 tionships to L1459 (fig. 330), L1460–L1462, which
 he dated c. 1906–08.
4. A drawing for *Dancers in the Studio* is fig. 328, and
 for *Four Dancers in the Studio*, fig. 329.
5. See Kendall 1985, p. 27, for a brilliant analysis of
 the color.

PROVENANCE: Atelier Degas (Vente I, 1918, no. 51);
bought at that sale by Jos Hessel, Paris, for Fr 14,000;
S. Sevadjian (sale, Drouot, Paris, 22 March 1920,
no. 6, repr.); Jules Strauss, Paris. With Arthur Tooth
and Sons, Ltd., London; bought by Mr. and Mrs.
Alexander Maitland 1953; their gift to the museum
1960.

EXHIBITIONS: 1979 Edinburgh, no. 119.

SELECTED REFERENCES: Lemoisne [1946–49], III, no. 770
(as 1884); Kendall 1985, p. 27.

363.

Dancers on the Stage

c. 1898
Charcoal and pastel on tracing paper
22⅜ × 23¾ in. (56.8 × 60.3 cm)
Vente stamp lower left
Private collection, New York

Lemoisne 1461

It is tempting to think of this drawing, in which the dancers are executed so lightly that they might be apparitions, as coming toward the end of Degas's career. Nevertheless, it was probably drawn somewhat earlier than that.[1] What we seem to have here is a development beyond the Edinburgh painting (cat. no. 362) of an emphasis on a group of three dancers talking—with some suggestion of two others behind. Degas was exploring; the bodies under the tutus are revealed, for example. As he changed his mind, he smudged the charcoal, particularly in the arms and legs. What is extraordinary is the confidence with which he varied the weight and width of his line, from the light strokes to suggest the two dancers in the background, almost like a late drawing by Daumier, to the velvety but harsh lines that define the legs nearest to us. It is a drawing that suggests the positions of the figures confidently. Degas used the vibrant strokes of pastel (the tracing paper must have been placed on a rough surface) to indicate the color of the tutus, to emphasize economically the central group by drawing a shadow above them rather like a halo, and to enliven the floor which he had drawn with waving, coarse black lines. The focus narrows finally to the foreground group—particularly the part enclosed by the dancers' arms. Degas comes close to indicating intimacy between two human beings as the two front dancers, whose hair he has masterfully drawn, talk to each other. Everything in the end is so essentially intangible and elusive that it suggests a longing for a world that to the artist had proved ephemeral.

1. I now believe it is earlier than the c. 1905 I suggested in 1967 Saint Louis, no. 156, p. 228.

PROVENANCE: Atelier Degas (Vente III, 1919, no. 60); bought at that sale by Durand-Ruel, Paris, for Fr 1,010 (stock no. 11444); with Knoedler, Paris; Mrs. John H. Winterbotham, New York; Theodora W. Brown and Rue W. Shaw, Chicago; with E. V. Thaw, New York; Jaime Constantine, Mexico City (sale, Christie's, London, 1 July 1980, no. 118); with E. V. Thaw, New York; present owner.

EXHIBITIONS: 1967 Saint Louis, no. 156 (as 1905), lent by Theodora W. Brown and Rue W. Shaw, Chicago; 1974 Boston, no. 90, lent by E. V. Thaw and Co. Inc.; 1981 San Jose, no. 62, repr.; 1983, Maastricht, 23 April–28 May/London, 14 June–29 July, *Impressionists*, organized as exhibition-sale by Noortman and Brod, no. 5; 1984 Tübingen, no. 226, repr. (color) (as 1906–08), lent by E. V. Thaw.

SELECTED REFERENCES: Lemoisne [1946–49], III, no. 1461 (as 1906–08); Browse [1949], no. 255 (as 1905–12).

363

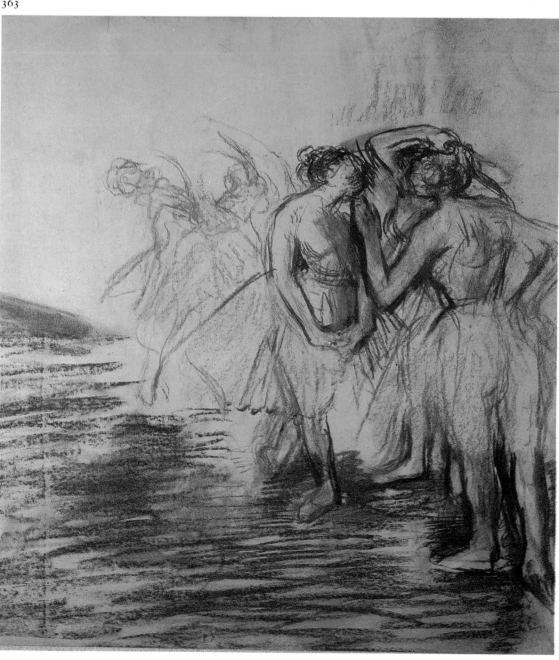

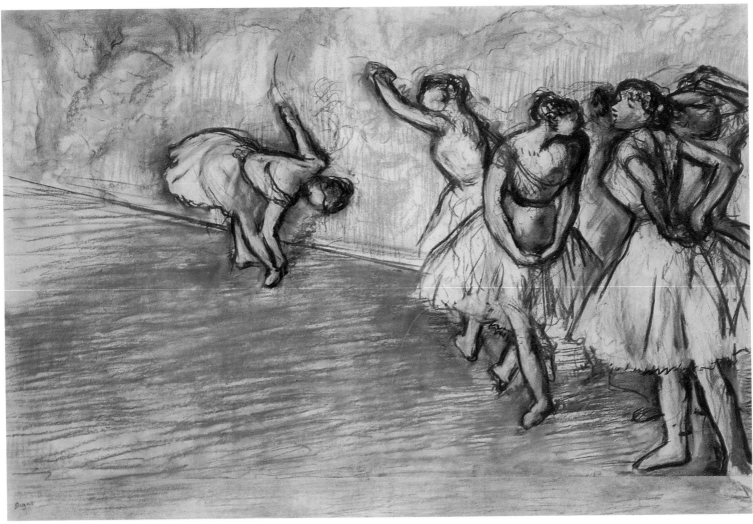

364

364.

Dancers on the Stage

c. 1898
Pastel on tracing paper, with strip added
 at bottom
29 × 41½ in. (73.7 × 105.4 cm)
Vente stamp lower left
The Carnegie Museum of Art, Pittsburgh.
 Acquired through the generosity of the Sarah
 Mellon Scaife family, 1966 (66.24.1)

Withdrawn from exhibition

Lemoisne 1460

This large drawing in pastel on tracing pa-
per, from the Carnegie Museum of Art in
Pittsburgh, is one of several studies Degas
made between the painting in the National
Gallery of Scotland (cat. no. 362) and a fin-
ished pastel in the Chester Dale Collection of
the National Gallery of Art in Washington
(fig. 330).[1] Several things have happened.
Degas obviously decided on a horizontal
format and a formal composition of a cer-

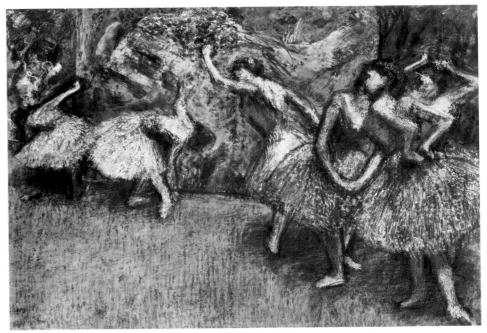

Fig. 330. *Ballet Scene* (L1459), c. 1898. Pastel, 30¼ × 43¾ in. (76.8 × 111.2 cm).
Chester Dale Collection, National Gallery of Art, Washington, D.C.

tain size, because this drawing is the same size as the finished pastel. He also changed the position of the arms of the figure nearest the front, which does not provide the same link with the other figure as in the smaller composition but gives the arms a greater suggestion of energy and reveals the dancer's breast.[2] The intimate link between the three figures is gone. Each now seems estranged from the other. The dancers, vague in the Edinburgh painting, have now assumed a decisive character—one, with her arm raised, acknowledges another dancer to the left, who makes a deep bow to her. Behind the figures in the Pittsburgh work is a continuous curtain with exuberantly drawn shrubbery in red pastel, breaking into an intense blue sky in the upper left corner.

Degas did two unexpected things. He contrasted the new alienation of the members of the group in the foreground—psychologically in the wings—with the dramatic dialogue between two performers on the stage. He also broke down the physical separation of wings and stage. Perhaps this was because he was representing a rehearsal rather than a performance. Whatever his intentions, the muted blue floor and the painted curtain continue, and there is no other barrier between those dancing and those waiting to perform. Such ambiguities add to the mystery of this great drawing, which is so fresh in its color and so forceful in its execution.

A postscript should be added about the pastel in Washington, which is the culmination of this series. It is brilliant, complex, rich, and luminous; its colors are seductive, with predominant blues, greens, and oranges over pinks. Particularly astonishing is the stage curtain, which is even more fantastic in form and color than in the Pittsburgh drawing, in fact so full of bravura, so essentially abstract, that it could be an Abstract Expressionist painting. It seems to reinforce the movement of the dancers, though above the bowing dancer at the left the curtain breaks into a form like that of the dancing Loïe Fuller, whose performances in the nineties must have been the antithesis of their own.

. In particular, L1462 (Von der Heydt-Museum, Wuppertal), executed between L1461 (cat. no. 363) and L1460 (cat. no. 364); and BR162, executed between L1460 (cat. no. 364) and L1459.
. This figure is a reversal of the principal figure in cat. no. 308.

ROVENANCE: Atelier Degas (Vente I, 1918, no. 209); ought at that sale by Durand-Ruel (stock no. D12731) nd Ambroise Vollard (1CS23), Paris, for Fr 8,100; Max Pelletier, Paris; with Sam Salz, Inc., New York; ought by the museum 1966.

XHIBITIONS: 1932, Paris, Galerie Paul Rosenberg, 23 November–23 December, *Pastels et dessins de Degas*, o. 16; 1936, Paris, Galerie Vollard, *Degas*.

SELECTED REFERENCES: Étienne Charles, "Les mots de Degas," *La Renaissance de l'Art Français et des Industries de Luxe*, April 1918, p. 7; Lemoisne [1946–49], I, repr. (detail) p. 199, III, no. 1460 (as 1906–08); Browse [1949], no. 233, repr. (as 1905–12); F. A. Myers, "Two Post-Impressionist Masterworks," *Carnegie Magazine*, XLI:3, March 1967, pp. 81, 84–86, repr. p. 85; *Catalogue of Painting Collection, Museum of Art*, III, Pittsburgh: Museum of Art, Carnegie Institute, 1973, p. 51.

365.

Three Nude Dancers

c. 1895–1900
Charcoal on tracing paper
35 × 34⅝ in. (89 × 88 cm)
Signed lower right in black pastel: Degas
Cabinet des Dessins, Musée du Louvre (Orsay), Paris (RF29941)

Exhibited in Paris

This strong drawing makes no concession to grace or finish as it concentrates on the energy of the figures. Degas's handling of the charcoal is bold and at moments unexpectedly decisive in the exaggeration of certain contours. He does not hesitate to leave what could have been first thoughts or even mistakes, as around the upper left arm, but somehow he exploits these strokes to increase the suggestion of action. He achieves the same effect in the raised hand of the central figure, which gains in expressiveness by its very openness. No painting or pastel seems to have survived for which this powerful drawing, with its diagonal thrust back into space, could have been a study, though there is a related drawing (II:285), somewhat fussier and more explicit about the setting, with something resembling a statue visible at the left.

PROVENANCE: Henri Rivière; his bequest to the Louvre 1952.

EXHIBITIONS: 1955–56 Chicago, no. 154; 1959–60 Rome, no. 184; 1962, Warsaw, 20 March–20 April, *Francuskie Rysunki XVII–XXw. I Tkaniny*, no. 12; 1963, Aarau, Argauer Kunsthaus, 11 April–12 May, *Handzeichnungen und Aquarelle aus den Museen Frankreichs*, no. 97; 1964 Paris, no. 72; 1969 Paris, no. 224.

365

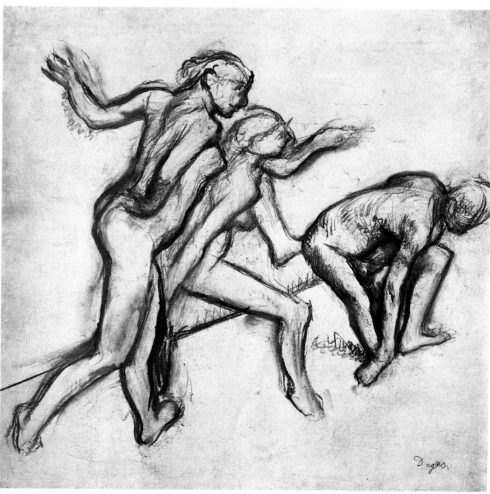

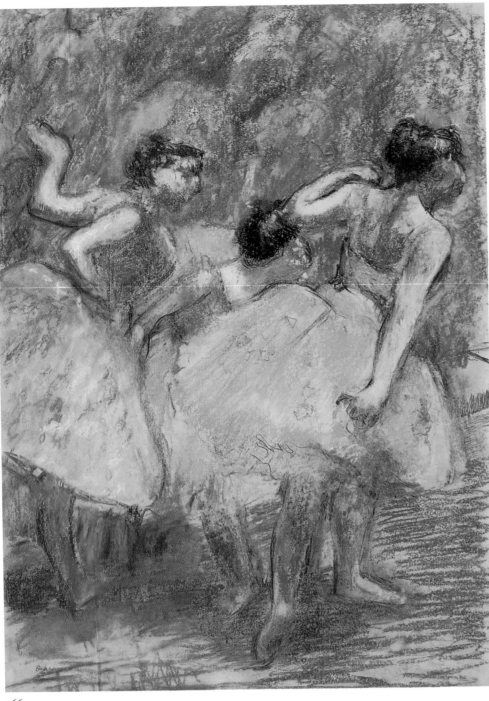

366

366.

Dancers

c. 1895–1900

Pastel and charcoal on two pieces of tracing paper, mounted on wove paper, mounted on board

37 5/8 × 26 3/4 in. (95.4 × 67.8 cm)

Vente stamp lower left

Memorial Art Gallery of the University of Rochester. Gift of Mrs. Charles H. Babcock (31.21)

Exhibited in Ottawa

Lemoisne 1430

This pastel of dancers shows the same direction of diagonal movement onto the stage and beside the flats as *Dancers, Pink and Green* (cat. no. 307). But there is not the same physical clarity in the movement, the same definition of muscles and sinews in the bodies, or the same glimpse of individual personalities. Some of the dancers' legs are indiscernible. And the figures themselves are not as clearly distinguished from the flats in the background, which are also less precisely rendered; the jade-green bushes in these flats are like luminous toadstools. But

the dancers seem to have a fierce energy, emphasized by the charcoal contours underneath and over the pastel that draw the figures together. They are not graceful in themselves, and their features are somewhat demoniac. They may not be the exotic medusas evoked by Paul Valéry in considering Degas and the dance, but they are, in spite of their bodies, "incomparably translucent," their tutus "domes of floating silk" with pinks worked into the blue tutu and orange into the yellow.[1] The work indeed has the translucency, range, and fragility of a rainbow, this beauty a seeming contradiction of the harshness of the figures.

Apparently, Degas began the work as a charcoal drawing on two attached pieces of tracing paper, working on a smooth surface. When he decided to add pastel, he moved the tracing paper to a rough surface, which gives the pastel a nubby texture. He smudged on or stumped the colors, not actually covering all the paper, which probably contributes to the translucent effect of the pastel. After the tracing paper was mounted on a smooth support, he defined the image further with charcoal on the hair and contours.[2]

About this pastel, Linda Muehlig has written recently: "The brilliant, jewel-like creatures that wait and watch in the Rochester pastel are dancers certainly, though not individualized: they exist as semaphore rather than statement. Like all Degas's dancers, but especially those at the close of his career, they are the work of an informed imagination, an artifice enacted upon the essential artifice of the dance."[3]

1. Valéry 1965, p. 27; Valéry 1960, p. 17.
2. Based on a special report by Anne Maheux of the National Gallery of Canada Degas Pastel Project.
3. Linda Muehlig, "The Rochester *Dancers*: A Late Masterpiece," *Porticus*, IX, 1986, p. 8.

PROVENANCE: Atelier Degas (Vente I, 1918, no. 296); bought at that sale by Durand-Ruel, New York, for Fr 16,100 (stock no. N.Y. 4352); transferred to Durand-Ruel, Paris, 23 January 1920; bought by the museum 2 May 1921, for $4,000 (stock no. N.Y. 4658).

EXHIBITIONS: 1947 Cleveland, no. 52, pl. XLIV.

SELECTED REFERENCES: Lemoisne [1946–49], III, no. 1430 (as c. 1903); Minervino 1974, no. 1151; Buerger 1978, p. 22, repr. p. 23; Linda Muehlig, "The Rochester *Dancers*: A Late Masterpiece," *Porticus* The Journal of the Memorial Art Gallery of the University of Rochester, IX, 1986, pp. 2–9, repr. (color cover.

The Russian Dancers

cat. nos. 367–371

Until the publication of Julie Manet's journal in 1979, there had been a great deal of uncertainty about the dating of a group of pastels of Russian dancers that Degas made toward the end of his working life. Speculation ranged from his having seen a troupe of such dancers at the Folies-Bergère in 1895 (Lemoisne) to his having been inspired by the first appearance of Diaghilev's ballet company in Paris in 1909 (Lillian Browse).[1] Julie Manet, however, wrote enthusiastically of Degas's showing her these pastels when she visited his studio on 1 July 1899:[2]

M. Degas was as solicitous as a lover. He talked about painting, then suddenly said to us: "I am going to show you the orgy of color I am making at the moment," and then he took us up to his studio. We were very moved, because he never shows work in progress. He pulled out three pastels of women in Russian costumes with flowers in their hair, pearl necklaces, white blouses, skirts in lively hues, and red boots, dancing in an imaginary landscape, which is most real. The movements are astonishingly drawn, and the costumes are of very beautiful colors. In one the figures are illuminated by a pink sun, in another the dresses are shown more crudely, and in the third, the sky is clear, the sun has just disappeared behind the hill, and the dancers stand out in a kind of half-light. The quality of the whites against the sky is marvelous, the effect so true. This last picture is perhaps the most beautiful of the three, the most engaging, completely overwhelming.[3]

Lemoisne reproduces fourteen pastels and colored drawings of these dancers, and there are additional drawings as well, including *Three Russian Dancers* (cat. no. 371). The style of some of them has an abandon that suggests they might have been drawn later than the three pastels Degas showed Julie Manet; *Three Russian Dancers* is probably related to these later works. In the National-museum in Stockholm, there is a rather thinly covered pastel (L1181) of the same composition as the three he showed that one might think was one of the three. However, judging from the attractive rounded features of the dancer on the right, the decided prettiness of the salmon-colored skirts against the red shoes and white blouses, and the thinness of the pastel, it is probable that this was an "article" intended for the market. In fact, it was sold on 9 November 1906 to Durand-Ruel, probably not long after Degas made . The three pictures Julie Manet saw are most likely the versions in the Lehman Collection in the Metropolitan Museum in New York (cat. no. 367), the Museum of Fine Arts in Houston (cat. no. 368), and the collection of Mr. and Mrs. Alexander Lewyt of New York (cat. no. 370).

1. Lemoisne [1946–49], III, no. 1181; Browse [1949], pp. 63–64.
2. Also noted in Sutton 1986, pp. 179–82.
3. Manet 1979, 1 July 1899, p. 238.

367.

Russian Dancers

1899
Pastel on tracing paper
24¾ × 25½ in. (62.9 × 64.7 cm)
Vente stamp lower left
The Metropolitan Museum of Art, New York. Robert Lehman Collection, 1975 (1975.1.166)

Exhibited in New York

Lemoisne 1182

The salmon sky in this pastel gives the impression of being lit by a red sun which, against the muted lavender and green of the grass and hill, brings out the wonderful richness of the dancers' garments and what Degas described as his "orgy of color."[1] The white blouses are somewhat blued by the coming shadows. The flowers in the dancers' hair are a soft peach, exploding like sparklers with touches of white pastel. And the colors of the skirts above the red boots move from a violet and rose through a blue with green to the yellow of the dancer in the foreground. The figures are united through color as well as through the vigorously drawn movement that had so thrilled Julie Manet. There are many layers of pastel covering a support of mounted tracing paper. A sharp instrument has been used to burnish the surface.

1. Manet 1979, p. 238; see also "The Russian Dancers," above.

PROVENANCE: Atelier Degas (Vente I, 1918, no. 266); bought at that sale by Danthon, for Fr 10,000; M. and Mme Riché, Paris; M. E.R. (sale, Drouot, Paris, 16 May 1934, no. 3, repr.); M. R. (sale, Drouot, Paris, 17 March 1938, no. 120, repr.); Mr. Van Houten (sale, Drouot, Paris, 12 June 1953, no. 8, repr.); anon. (sale, Charpentier, Paris, 15 June 1954, no. 80, repr. [color]). Robert Lehman, New York; his bequest to the museum 1975.

EXHIBITIONS: 1932, Paris, Galerie Paul Rosenberg, 23 November–23 December, *Pastels et dessins de Degas*, no. 10; 1937, London, Adams Gallery, exhibition closed 4 December, *Degas 1834–1917*, no. 10; 1959, Cincinnati Art Museum, 8 May–5 July, *The Lehman Collection*, no. 146; 1977 New York, no. 51 of works on paper.

SELECTED REFERENCES: Lemoisne [1946–49], III, no. 1182 (as 1895); Minervino 1974, no. 1074.

368.

Russian Dancers

1899
Pastel on tracing paper mounted on cardboard
24½ × 24¾ in. (62.2 × 62.9 cm)
Signed lower left: Degas
The Museum of Fine Arts, Houston. The John A. and Audrey Jones Beck Collection. On extended loan to the museum (TR 186-73)

Exhibited in Ottawa and New York

Lemoisne 1183

Houston's *Russian Dancers* is less harmonious in its colors than the Lehman pastel (cat. no. 367). The brash separation of color in the skirts of the dancers, which Julie Manet had described, gives the work great vigor.[1] The flowers around the hair and necks of the dancers are an orange red and seem more abundant than in the Lehman pastel. They match the young women's magnificent boots and the pattern over gold on their sashes. The skirt at the left is a vibrant emerald green, the skirt in the middle an intense blue threaded with red, and the last a more muted violet. As in the Lehman work, these figures are placed against a landscape with tough grass and a low hill, an unexpected setting for the Dionysian intensity of their dance but a very sympathetic one.

1. Manet 1979, p. 238. Michael Shapiro (Shapiro 1982, p. 12), without knowing of the reference in Julie Manet's journal, wrote: "The hue of each color is slightly harsh."

PROVENANCE: With Ambroise Vollard, Paris; Mary S. Higgins, Worcester, Mass. (sale, Sotheby Parke Bernet, New York, 10 March 1971, no. 15, repr. [color]); Mr. and Mrs. John A. Beck, Houston; their gift to the museum 1973.

EXHIBITIONS: 1937 Paris, Orangerie, no. 181; 1946, Worcester, Mass., Worcester Art Museum, 9–14 October, *Modern French Paintings and Drawings from the Collection of Mr. and Mrs. Aldus C. Higgins*, no number; 1974, Houston, The Museum of Fine Arts, *The Collection of John A. and Audrey Jones Beck* (catalogue by Thomas P. Lee), p. 34, repr. (color) p. 35.

SELECTED REFERENCES: Vollard 1914, pl. V; Lemoisne [1946–49], III, no. 1183 (as 1895); Minervino 1974, no. 1075; Shapiro 1982, pp. 9–22, fig. 1; *The Collection of John A. and Audrey Jones Beck* (compiled by Audrey Jones Beck), Houston: The Museum of Fine Arts, 1986, p. 38, repr. (color) p. 39.

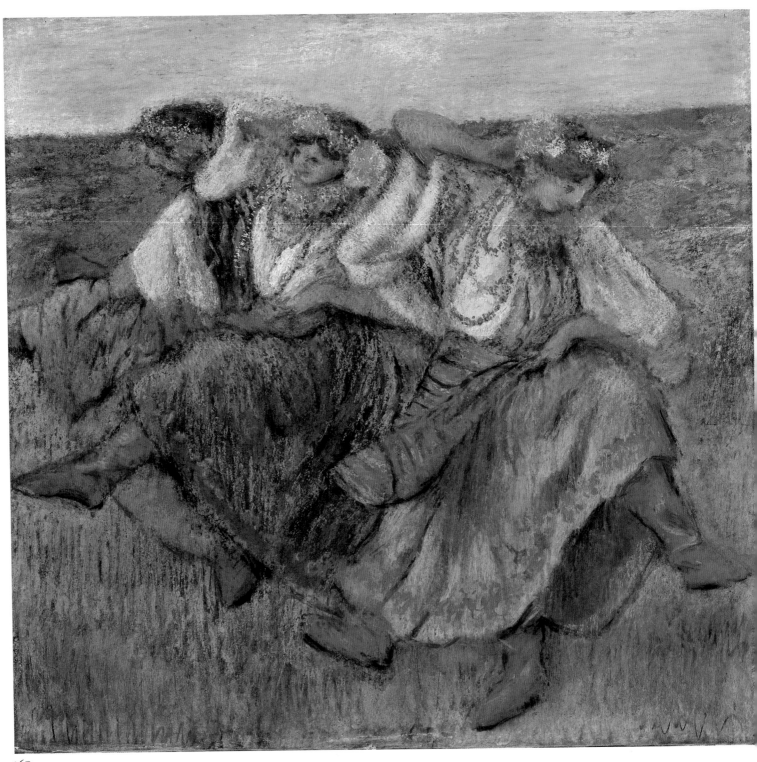

367

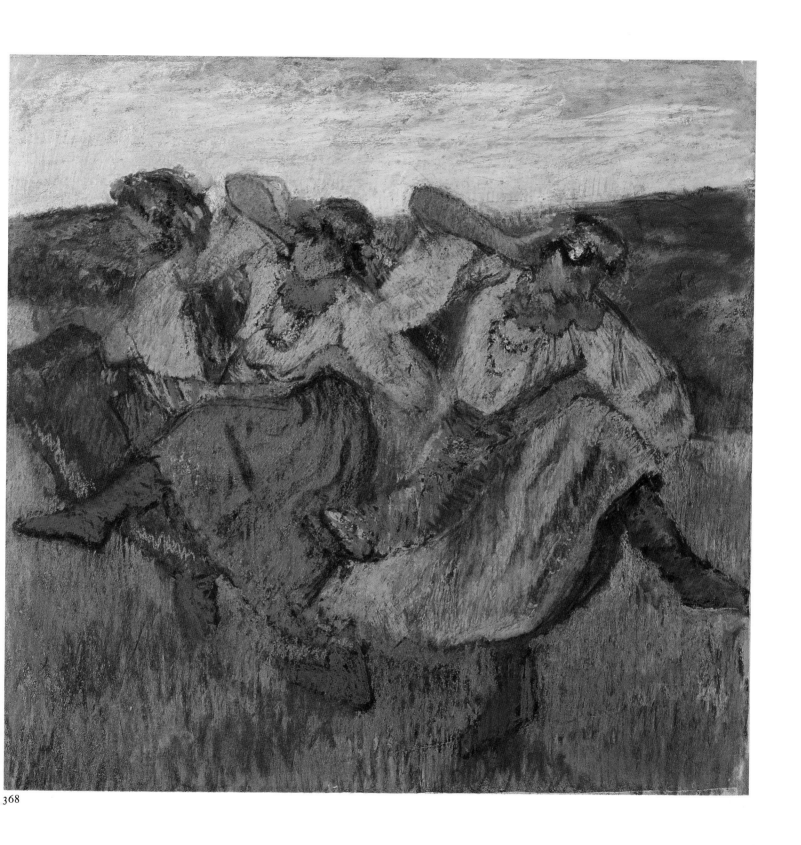

368

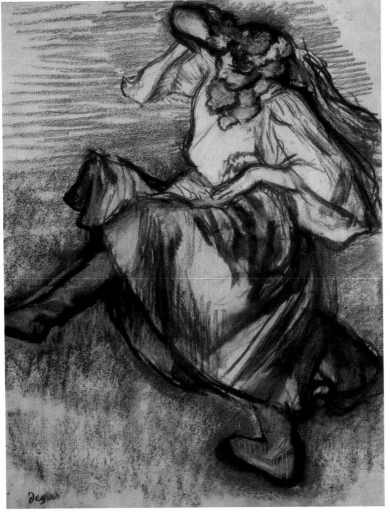

369

the white blouse with dolman sleeves that floats above it. The accessories are right, too—the magnificent reddish boots, the peach, lavender, and pale blue flowers at the neck and hair, and the mass of deep blue ribbons that flow from the dancer's head-dress down her back. The variations within the broad movements come from the falling of the garments against the moving body.

Forceful as she is, the dancer still bows her head. Energetic as she is, the movement seems to be motivated by convention rather than by a radiant joy. This figure was used in the third composition, apparently to shove the former front dancer into second place and to take over the leading role herself.

1. Manet 1979, p. 238.

PROVENANCE: With Ambroise Vollard, Paris; Mrs. H. O. Havemeyer, New York; her bequest to the museum 1929.

EXHIBITIONS: 1922 New York, (?) no. 82 (as "Danseuse espagnole [sic] en jupe rose"); 1930 New York, no. 154; 1977 New York, no. 50 of works on paper.

SELECTED REFERENCES: Vollard 1914, pl. LXXXVII; Havemeyer 1931, pp. 185–86, repr.; Lemoisne [1946–49], III, no. 1184 (as 1895); Browse [1949], no. 242; Minervino 1974, no. 1079; Shapiro 1982, pp. 10–11, fig. 2; 1984 Tübingen, p. 395.

369.

Russian Dancer

1899
Pastel and charcoal on tracing paper
24⅜ × 18 in. (62 × 45.7 cm)
Signed lower left in black charcoal: Degas
The Metropolitan Museum of Art, New York.
 Bequest of Mrs. H. O. Havemeyer, 1929.
 H. O. Havemeyer Collection (29.100.556)

Exhibited in New York

Lemoisne 1184

This is a drawing for the figure in the left foreground of what was probably the third pastel Julie Manet saw in Degas's studio (cat. no. 370).¹ It is not surprising to see Degas at this time suggesting the texture of sky and grass so cursorily but effectively with pastel. The energy of the figure is also not unexpected. But these colorful garments make us realize the restrictions of the classical ballet tutu. Degas, who always had a feeling for dress—male or female—reveals it here in the bulky, glowing peach skirt and

370

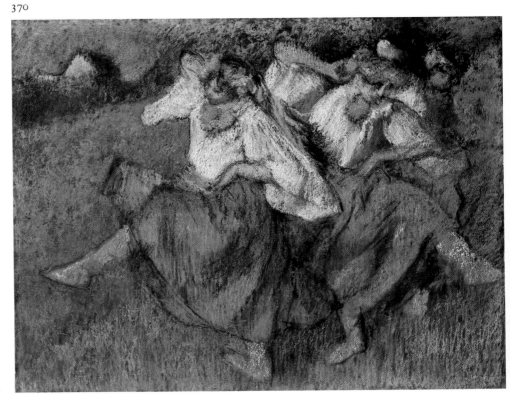

370.

Russian Dancers

1899
Pastel and brush on tracing paper
23 × 30 in. (58.4 × 76.2 cm)
Vente stamp lower left
Collection of Mrs. Alexander Lewyt

Lemoisne 1187

For the third of the pastels of dancers in
Russian peasant dress, Degas used a wider
paper and broadened the composition, giving
the former primary dancer a secondary role,
and introducing the figure for which the
drawing in the Metropolitan Museum (cat.
no. 369) is a preparatory study. He was able
to add more landscape—trees and a house
peering above the edge—and he had more
space to give greater emphasis to the out-
stretched leg of the dancer at the left. With
its strong unity of burnt orange reds for
boots, skirts, and ornament, against a land-
scape bathed by the fading sun, it is indeed
as Julie Manet described it: "This last pic-
ture is perhaps the most beautiful of the
three, the most engaging. It is extraordi-
nary, completely overwhelming."[1]

1. Manet 1979, p. 238.

PROVENANCE: Atelier Degas (Vente I, 1918, no. 270);
bought at that sale by René de Gas, the artist's
brother, for Fr 26,500 (sale, Drouot, Paris, 10 Novem-
ber 1927, no. 38); Diéterle, Paris; Albert S. Henraux,
Paris.

EXHIBITIONS: 1960 New York, no. 64, repr., lent by Mr.
and Mrs. Alex M. Lewyt; 1967 Saint Louis, no. 155,
repr. (color) frontispiece; 1978 New York, no. 50,
repr. (color).

SELECTED REFERENCES: Lemoisne [1946–49], III,
no. 1187 (as 1895); Minervino 1974, no. 1076.

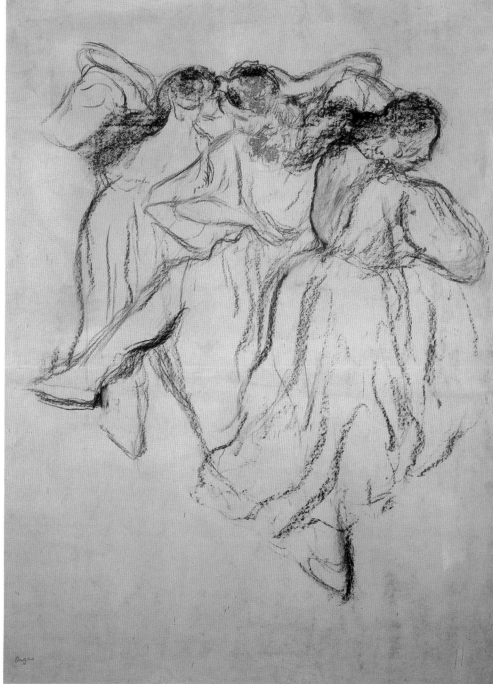

371

371.

Three Russian Dancers

1900–1905
Charcoal and pastel on tracing paper
39 × 29½ in. (99 × 75 cm)
Vente stamp lower left
Collection of Mrs. Alexander Lewyt

Vente III:286

Although there is no clear evidence, it
seems that this drawing belongs to a later
group of Russian dancers by Degas,[1] clearly
based, however, on the pastels of 1899. The
earlier dancers are united in the fanlike com-
position formed by their bodies and costumes
and do not possess any marked individual-
ity, but, at least in the Lehman and Houston
pastels (cat. nos. 367, 368), they can be dis-
tinguished by color.[2] Here, however, the
figures flow into each other, in a way that
makes them appear inseparable, in fact one
organic being. Degas drew on the tracing
paper with great fluidity consistent with the
organic conception of the group of dancers.
He must have worked over a rough surface,
which explains the seemingly granulated
strokes of charcoal at certain points. He varied
the weight and width of his lines to add to the
sense of rhythmic unity. Finally, he touched
up the drawing, adding pastel to the flowers
in the hair of the central dancer.

1. In particular, L1188, L1189, and L1190.
2. Shapiro 1982, p. 12.

PROVENANCE: Atelier Degas (Vente III, 1919, no. 286);
bought at that sale by Ambroise Vollard, Paris, for
Fr 1,350; Christian de Galea, Paris.

EXHIBITIONS: 1967 Saint Louis, no. 154; 1979 North-
ampton, no. 18, repr. p. 32; 1984 Tübingen, no. 223.

SELECTED REFERENCES: Browse [1949], p. 413, under
no. 243; Eugenia Parry Janis, "Degas Drawings,"
Burlington Magazine, CIX:772, July 1967, p. 414.

First Arabesque Penchée, erroneously called Grande Arabesque, Third Time (First Study)

Of the seventy-four works of sculpture by Degas cast in bronze, seven were of dancers executing a variety of arabesques—RXXXVI–RXXXIX and RXL–RXLII. They range from the beginning of his career as a sculptor (RXXXVII, a child tentatively executing a fourth arabesque, which almost certainly predates *The Little Fourteen-Year-Old Dancer* [cat. no. 227] and is thus one of the earliest sculptures of a dancer to have survived), to the period in the mid-1880s when his sculpture reached a kind of classical zenith (RXXXVI, a lithe young woman in a first arabesque penchée), to the period in the 1890s when the present work was made. As Degas became older and heavier, so too did his sculpted dancers. If his dogged determination to continue working during his seventh decade was in part an act of defiance, so too can this unlikely dancer be seen as defiant in her attempt to perform gracefully despite a sagging stomach and stocky legs. The very improbability of such a woman holding such a pose is evidence of the shift in Degas's sensibility away from naturalism toward an expressive symbolism.

In Paris, visitors to this exhibition (or at other times to the Musée d'Orsay) have been able to compare the original wax by Degas with the bronze that was cast after his death. In one of the few instances of such a reversal, the bronze cast indicates something no longer visible in the original wax: the large and dangerous crack in the left leg just above the knee. A.-A. Hébrard, in consultation with Degas's friend the sculptor Albert Bartholomé, made the decision to replicate, as far as possible, all the imperfections of the original waxes in order to obtain "truthful" casts. At a later date, however, the crack in the wax was repaired.

Degas included dancers in arabesques in a number of paintings and pastels from the 1870s through the 1890s,[1] but in no other instance did he describe an arabesque penchée as here.　　　　　　　　　　　　GT

1. For example, L445, L493, L591, L601, L653, L654, L735, L736, L1131, L1131 bis, BR124.

SELECTED REFERENCES: 1921 Paris, no. 7; Havemeyer 1931, p. 223, Metropolitan 60A; Paris, Louvre, Sculptures, 1933, p. 66, no. 1724, Orsay 60P; Rewald 1944, no. XXXIX (as 1882–95), Metropolitan 60A; Rewald 1956, no. XXXIX, Metropolitan 60A; Paris, Louvre, Impressionnistes, 1958, p. 220, no. 439, wax; Pierre Pradel, "Nouvelles acquisitions: quatre cires originales de Degas," *La Revue des Arts,* 7th year, January–February 1957, pp. 30–31, fig. 3 p. 31, wax (erroneously as "Danseuse: grande arabesque: deuxième temps"); Beaulieu 1969, p. 374 n. 39; 1976 London, no. 7; Millard 1976, p. 35 (as after 1890); 1986 Florence, p. 204, no. 60, pl. 60 p. 157.

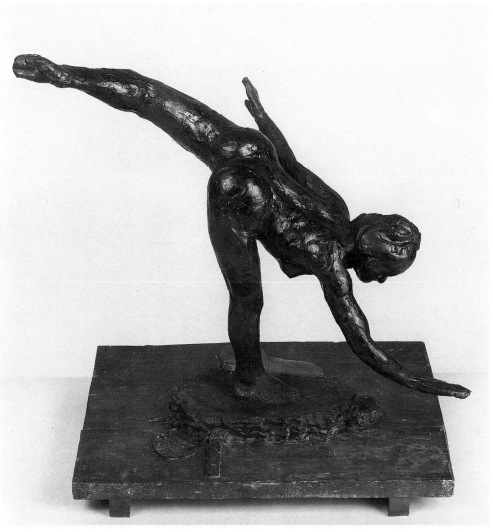

372

372.

First Arabesque Penchée, erroneously called Grande Arabesque, Third Time (First Study)

c. 1892–96
Brown wax, with pieces of wood and cork in the base
Height: 17¼ in. (43.8 cm)
Musée d'Orsay, Paris (RF2769)

Exhibited in Paris

Rewald XXXIX

PROVENANCE: Atelier Degas; his heirs to A.-A. Hébrard, Paris, 1919, until c. 1955; consigned by Hébrard to M. Knoedler and Co., New York; acquired by Paul Mellon from M. Knoedler and Co. 1956; his gift to the Louvre 1956.

EXHIBITIONS: 1955 New York, no. 38; 1967–68, Paris, Orangerie des Tuileries, 16 December 1967–March 1968, *Vingt ans d'acquisitions au Musée du Louvre 1947–1967,* no. 326 (as executed between 1882 and 1895; erroneously as Rewald XL); 1969 Paris, no. 249, pl. 14 (as 1877–83); 1986 Paris, no. 61, p. 138, repr. p. 137 (as c. 1885–90).

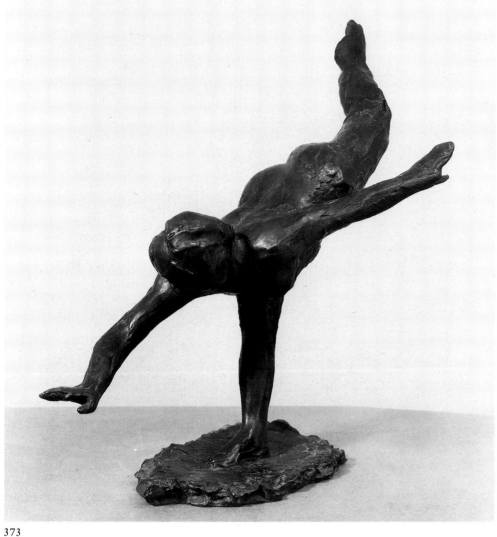

373

Dancers at the Barre

c. 1900
Pastel and charcoal on tracing paper
49¼ × 42⅛ in. (125 × 107 cm)
Vente stamp lower left
National Gallery of Canada, Ottawa (1826)

Lemoisne 808

Degas made many drawings of these two dancers at the exercise barre, both nude and dressed, separately and together. This study with pastel was probably his last before attempting the oil painting (cat. no. 375) now in the Phillips Collection in Washington. The charcoal drawing in this pastel, with its heavy, repeated contours, is not unlike that in the Louvre's *Three Nude Dancers* (cat. no. 365), though it goes further in rendering the fierceness and angularity of the bodies. It is also similar to the Rochester *Dancers* (cat. no. 366) in that the diaphanous blue tutus distract us with their prettiness from the harshness of the drawing. Confronted with the boniness, the inertia, and the apathy of the dancer at the right, and the lack of a sense of governing intelligence, we are not allowed the escape that the Rochester pastel provides. Comparison with the much earlier *Dancers at the Barre* in the British Museum (cat. no. 164) emphasizes the sense of futility in both figures in the later composition.

There are problems in dating this work, but it can be safely placed close to 1900.[1]

1. Boggs 1964, pp. 1–9.

PROVENANCE: Atelier Degas (Vente I, 1918, no. 118); bought at that sale by Ambroise Vollard, Paris, for Fr 15,200; Jacques Seligmann (sale, American Art Association, New York, 27 January 1921, no. 62); with Scott & Fowles, New York; bought by the museum 1921.

EXHIBITIONS: 1934, Ottawa, National Gallery of Canada, January/The Art Gallery of Toronto, February/ The Art Association of Montreal, March, *French Painting*, no. 41; 1949, The Art Association of Montreal, 7–30 October, "Masterpieces from the National Gallery" (no catalogue).

SELECTED REFERENCES: Lemoisne [1946–49], III, no. 808 (as c. 1884–88); Browse [1949], no. 321 (as 1900–1905); R. H. Hubbard, *The National Gallery of Canada Catalogue of Paintings and Sculpture, II: Modern European Schools*, Ottawa: National Gallery of Canada, 1959, p. 20, repr.; Boggs 1964, pp. 1, 2, 5, fig. 9 (color); Minervino 1974, no. 833.

373.

First Arabesque Penchée, erroneously called *Grande Arabesque, Third Time (First Study)*

c. 1892–96
Bronze
Height: 17¼ in. (43.8 cm)
Original: brown wax, Musée d'Orsay, Paris (RF2769)

Rewald XXXIX

A. *Orsay Set P, no. 60*
Musée d'Orsay, Paris (RF2073)

Exhibited in Paris

PROVENANCE: Acquired thanks to the generosity of the heirs of the artist and of the Hébrard family 1930.

EXHIBITIONS: 1931 Paris, Orangerie, no. 8; 1937 Paris, Orangerie, no. 224; 1971 Madrid, no. 104, repr. p. 155; 1984–85 Paris, no. 57 p. 196, fig. 182 p. 193.

B. *Metropolitan Set A, no. 60*
The Metropolitan Museum of Art, New York.
 Bequest of Mrs. H. O. Havemeyer, 1929.
 H. O. Havemeyer Collection (29.100.390)

Exhibited in Ottawa and New York

PROVENANCE: Bought from A.-A. Hébrard by Mrs. H. O. Havemeyer late August 1921; her bequest to the museum 1929.

EXHIBITIONS: Probably 1921 Paris (no catalogue); 1922 New York, no. 55 (as second state); (?) 1923–25 New York; 1930 New York, under Collection of Bronzes, nos. 390–458; 1947 Cleveland, no. 79, pl. LIX; 1974 Dallas, no number; 1977 New York, no. 39 of sculptures.

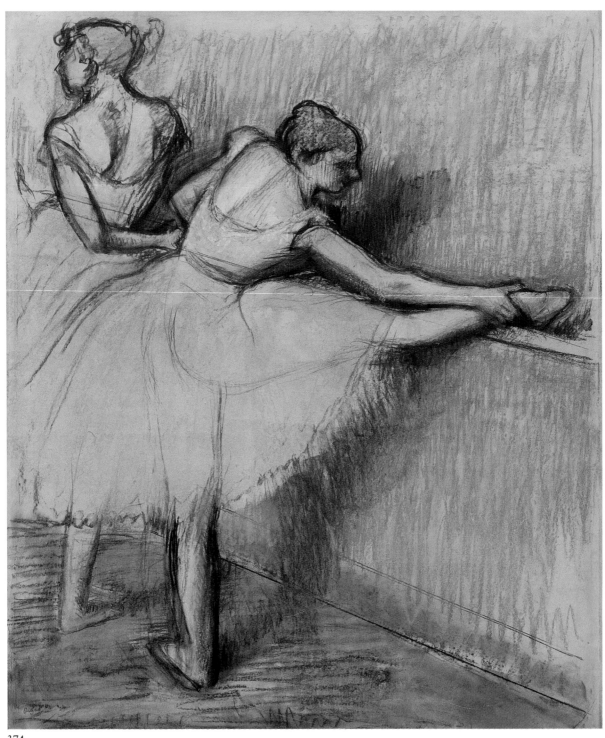

374

375.

Dancers at the Barre

c. 1900
Oil on canvas
51 × 38 in. (130 × 96.5 cm)
Vente stamp lower right
The Phillips Collection, Washington, D.C.

Lemoisne 807

The Ottawa pastel *Dancers at the Barre* (cat. no. 374) was transformed into this oil paint-ing, now in the Phillips Collection in Wash-ington. The painting is almost the same width as the pastel, but it is slightly higher to allow a greater area of wall and floor. The raised foot of the dancer on the right has been cut by the frame, but now Degas shows the uncomfortable position of the outstretched leg of the dancer at the left. In some ways, these works can be seen as interesting exer-cises in the exploration of differences in me-dium. Degas worked lightly, palely, and openly with pastel, hatching in parallel strokes that are often linked to each other. In the oil, he turned the red and brown strokes of pastel on the wall into smudges of a glow-ing orange paint. Similarly, the blue of the tutus becomes more solid. The strokes of the floor in the painting run vertically, com-pared with those of the pastel, contradicting the floor's architectural character. The orange on the dancers' stockings is particularly ar-resting. *Dancers at the Barre* is a strong, mad painting in which the dancers, in Mallarmé's terms, are not women and do not dance.[1] The figures seem to express even more viv-idly than those in the Ottawa pastel a sense

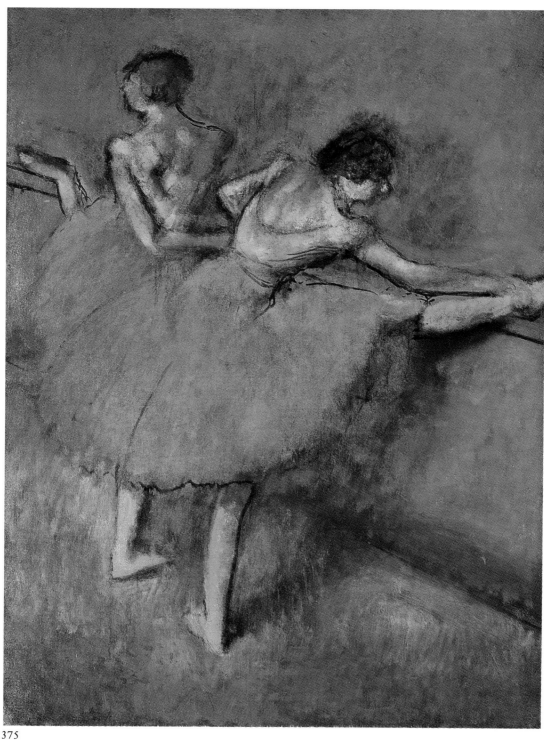

375

of futility in the very expenditure of energy that cannot be rationally explained.

1. Stéphane Mallarmé, *Oeuvres complètes*, Paris; Gallimard, 1945, p. 304. Mallarmé observes that a "danseuse" is not a woman dancing. She is not a woman but a metaphor, summing up all the fundamental elements of our being. And she is not dancing; she is the personification of a work of art—a poem, independent of the writer's craft.

PROVENANCE: Atelier Degas (Vente I, 1918, no. 93, for Fr 15,200); with Ambroise Vollard, Paris; with Jacques Seligmann, Paris and New York (sale, American Art Association, New York, 27 January 1921, no. 65); with Scott and Fowles, New York (sale, American Art Association, New York, 17 January 1922, no. 22). Mrs. W. A. Harriman, New York; Valentine Gallery, New York; bought by the museum 1944.

EXHIBITIONS: 1950, New York, Paul Rosenberg, 7 March–1 April, *The 19th Century Heritage*, no. 6; 1950, New Haven, Yale University Art Gallery, 17 April–21 May, *French Paintings of the Latter Half of the 19th Century from the Collections of Alumni and Friends of Yale*, no. 5, repr.; 1955, The Art Institute of Chicago, 20 January–20 February, *Great French Paintings: An Exhibition in Memory of Chauncey McCormick*, no. 12, repr.; 1978 New York, no. 32, repr. (color); 1979 Northampton, no. 5, repr. p. 22; 1981, San Francisco Fine Arts Museum, 4 July–1 November/Dallas Museum of Fine Arts, 22 November 1981–16 February 1982/Minneapolis Institute of Fine Arts, 14 March–30 May/Atlanta, High Museum of Art, 24 June–16 September, *Master Paintings from the Phillips Collection*, p. 54, repr. p. 55.

SELECTED REFERENCES: Lemoisne [1946–49], III, no. 807 (as c. 1884–88); Browse [1949], no. 220 (as 1900–1905); *The Phillips Collection*, Washington, D.C.: Phillips Collection, 1952, p. 27, pl. 59 (color); Boggs 1964, pp. 1, 2, 5, fig. 8; Minervino 1974, no. 832.

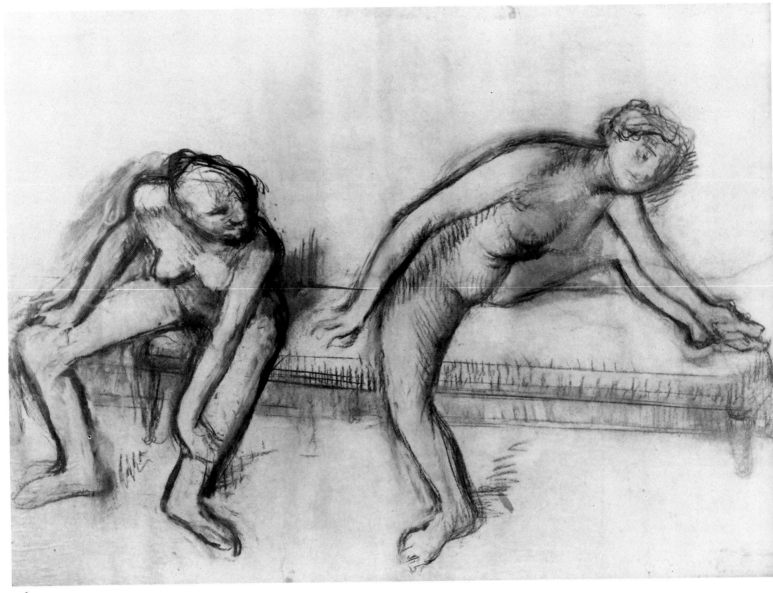

376

376.

Two Nude Dancers on a Bench

c. 1900
Charcoal on tracing paper
31½ × 42⅛ in. (80 × 107 cm)
Private collection

In many ways, *Two Nude Dancers on a Bench* is stylistically close to the Louvre's *Three Nude Dancers* (cat. no. 365), but the differences are perhaps even more significant. This drawing is almost twice the size of the other, neither the composition nor the figures are as active, and the dancers are more exposed— their breasts, their pelvic regions, and even their faces. They succumb wearily, and without defense, to inertia.

In spite of this weariness that overcomes action and certain decencies, *Two Nude Dancers on a Bench* is by no means a prudish or inept work. One reason is that, as in the Louvre's drawing, Degas has used his charcoal as if it were a chisel or an ax, an unyielding weapon he forced again and again to form the outlines of the bodies or describe their three-dimensional reality. It is not surprising that a great modern sculptor—Henry Moore—should have owned the drawing. It has a monumentality and sculptural presence made all the more forceful by its scale and by the breadth of the contours and the economy with which they bind the two figures so inevitably together.

Such a drawing was undoubtedly used for the pastel of the same size, *Two Dancers on a Bench* (cat. no. 377), where the figures are more frail and the position of the dancer on the left is one of greater lassitude, though in fact the drawing is closer to another pastel, *Two Dancers Resting* (L1258, Paris art market, 1987). The charcoal drawing is charged with a certain drama because, though the figures do not face each other, there is in the dancer at the left a brutal and almost masculine force that at least challenges the passivity of the other dancer. In the expression of the latter's rudimentarily rendered face, there is a shade of wistfulness.

PROVENANCE: Durand-Ruel, Paris; Browse and Delbanco, London; Henry Moore; by descent to present owner.

EXHIBITIONS: 1976–77 Tokyo, no. 77; 1984 Tübingen, no. 196.

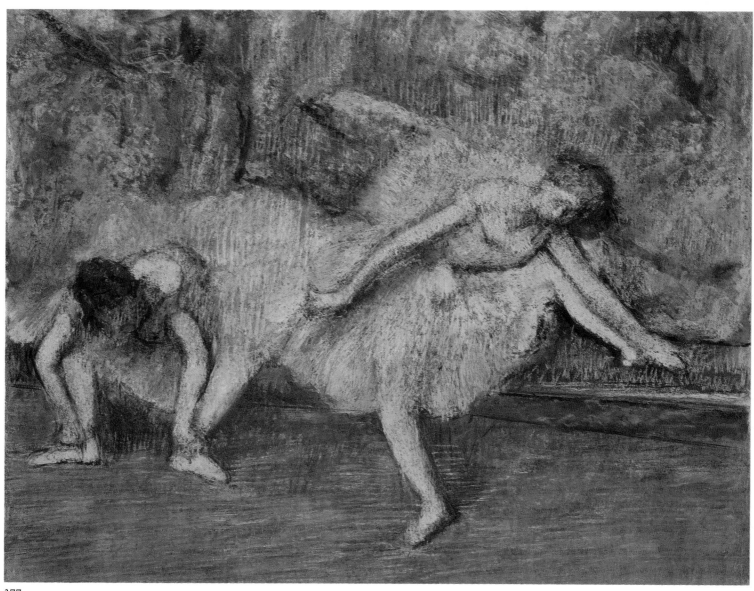

377

377.

Two Dancers on a Bench

c. 1900
Pastel on tracing paper, laid down on cardboard
32⅝ × 42⅛ in. (83 × 107 cm)
Private collection

Lemoisne 1256

In his catalogue raisonné, Lemoisne reproduces seven pastels of two dancers on a bench (L1254–L1259 bis), all about the same size, which he dates c. 1896. *Two Dancers on a Bench* is one of a group in which the dancers are shown at their weariest and most frail. The figure on the left appears to support herself by grasping her ankles and is scarcely able to raise her head. The arms of

the dancer on the right are poignantly thin and her position on the bench hardly stable, though she clearly has a place on the bench and the other dancer may not. Even her head seems small, particularly when set off against the spot of purple in the curtain behind. Through these fragile figures, Degas mourns the expectations, the vitality, and the courage of his dancers of the past. But the pathos he arouses is not in criticism of the dancers, but of a world that no longer permits them to determine their destiny. These figures have been drained of will. The atmosphere of dispiritedness is in striking contrast to the wonderful richness of the colors of the dancers' costumes—a lavender pink over the orange of the tutus and an orange that is more solid in the bodices and in the hair of the dancer

at the right. In addition, there is the magnificent purple in the shadow as the dancer on the left bows her head. Degas has squiggled strokes of pastel freely across contours and forms, producing his equivalent of shimmering artificial light.

The greatest shock is in the stage curtain, which at first seems like the one in the Washington *Ballet Scene* (fig. 330). The curtain appears here to be a magnificently liberated abstract painting, not quite as full of movement as that in the *Ballet Scene*, but dazzling nevertheless. It is only as we look at it longer that the heavy tree trunk at the left asserts itself and an impression of other foliage emerges. Degas increased the sense of abstraction by roughly hatching orange strokes of pastel over the landscape and onto

the unstable bench. The abstractions of color and texture and the illusion of theatrical lighting are stirring for us but oppressive for the two dancers, whose weariness has been depicted so movingly with the charcoal lines that emerge from under the pastel.

PROVENANCE: Atelier Degas (Vente I, 1918, no. 144); bought at that sale by Jacques Seligmann, for Fr 9,500; with Ambroise Vollard, Paris. Mr. and Mrs. Edward G. Robinson, Los Angeles; sold through Knoedler 1957; Stavros Niarchos by 1958; with Tarica, Paris; bought by present owner 1986.

EXHIBITIONS: 1957, New York, Knoedler Gallery, 3 December 1957–18 January 1958/Ottawa, National Gallery of Canada, 5 February–2 March/Boston, Museum of Fine Arts, 15 March–20 April, *The Niarchos Collection of Paintings*, p. 28, no. 12, repr. p. 29; 1958, London, The Arts Council of Great Britain, 23 May–29 June, *The Niarchos Collection*, no. 13, pl. 31; 1976–77 Tokyo, no. 53, repr. (color); 1984 Tübingen, no. 197, repr. (color).

SELECTED REFERENCES: Vollard 1914, pl. LXXX; Lemoisne [1946–49], III, no. 1256 (as 1896).

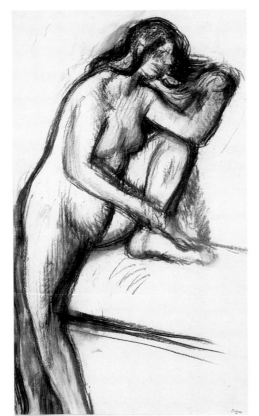

378

378.

Seated Nude Dancer

1905–10
Charcoal and pastel on tracing paper, laid down
28⅞ × 17 in. (73.3 × 43.2 cm)
Vente stamp lower right
Private collection

Lemoisne 1409

This drawing of a nude dancer sitting in an athletic pose on a bench is particularly disturbing because the body is handled in such a perfunctory way; there are almost no concessions to its articulation and none to its beauty. Even the luxuriant long hair, in which Degas used to love to indulge himself, seems more like the hair of a figure by Edvard Munch than by Edgar Degas. The contours are unusually heavy and persistent, particularly in creating something like a mourning border for the total figure. In fact, the hair could be a mourning veil as well. Degas used very little pastel, a touch of blue on the skin, of red in the hair, to relieve this terrible vision he had of the future of humanity. *Seated Nude Dancer* is a study for the pastel *Two Dancers with Yellow Bodices* (fig. 331).

PROVENANCE: Atelier Degas (Vente II, 1918, no. 207); bought at that sale by Ambroise Vollard, Paris, for Fr 800; Marlborough Fine Art Ltd., London.

SELECTED REFERENCES: Lemoisne [1946–49], III, no. 1409 (as c. 1902).

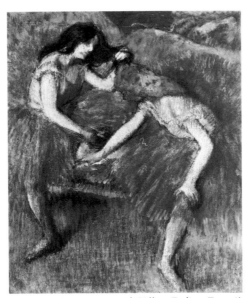

Fig. 331. *Two Dancers with Yellow Bodices* (L1408), c. 1905–10. Pastel, 32¾ × 27½ in. (81 × 68 cm). London art market

379.

Two Dancers Resting

c. 1910
Pastel and charcoal on light buff wove paper
30¾ × 38⅝ in. (78 × 98 cm)
Vente stamp lower left
Musée d'Orsay, Paris (RF38372)

Exhibited in Paris

Lemoisne 1465

It seems inevitable that, at the end of his career, when his poor eyesight made it almost impossible for him to work and he was succumbing to depression, Degas should have chosen to continue to show his dancers resting or idling on a bench rather than preparing to dance. But in earlier works, such as *In a Rehearsal Room* (cat. no. 305), even the dancers on the bench show a certain vitality, and in *Two Dancers on a Bench* (cat. no. 377), though the figures appear weary and frail, the work itself has great energy. In this heavily worked pastel, the weariness of the dancers and the artist seem one. The indifference of the dancer on the right seems to have infected the artist.

Nevertheless, the pastel is as strange and mesmerizing as a Byzantine mosaic. Although the strokes of gold on the background have none of the refined discipline of tesserae and the hue is a little raw, the free calligraphic strokes of orange yellow remove us as much from reality as do Byzantine backgrounds of gold. The intense blue swag at the left is as difficult to determine as are such forms on the walls of *The Rehearsal Room* (cat. no. 361) and preparatory studies for it.[1] The dancers and their tutus at first seem ashen (like many formal Byzantine figures), but that ash is animated with strokes of pink and yellow that give it at least a half-hearted supernatural glow. In this strange environment, the two dancers seem less than human. In fact, the dancer nearer to us appears to be wearing a mask that from one direction can be read as a grinning satyr and from another as the profile of a beaked bird. Degas had reached a time when retirement was the only escape from his vivid imagination, his cynical intelligence, and even his relentlessly expressive hand.

1. L997, Toledo Museum of Art; L998, Wallraf-Richartz Museum, Cologne.

PROVENANCE: Atelier Degas (Vente II, 1918, no. 137, for Fr 7,600); with Nunès et Fiquet, Paris; Elisabeth and Adolphe Friedmann, Paris; gift in lieu of succession duties 1979.

EXHIBITIONS: 1955 Paris, GBA, no. 164; 1980, Paris, Grand Palais, 15 October 1980–2 March 1981, *Cinq années d'enrichissement du patrimoine national*, no. 207, repr. (color).

SELECTED REFERENCES: Lemoisne [1946–49], III, no. 1465 (as c. 1906–08); Minervino 1974, no. 1154; "Les récentes acquisitions des musées nationaux," *La Revue du Louvre et des Musées de France*, 4, 1980, p. 263; Paris, Louvre and Orsay, Pastels, 1985, no. 87, repr. p. 90.

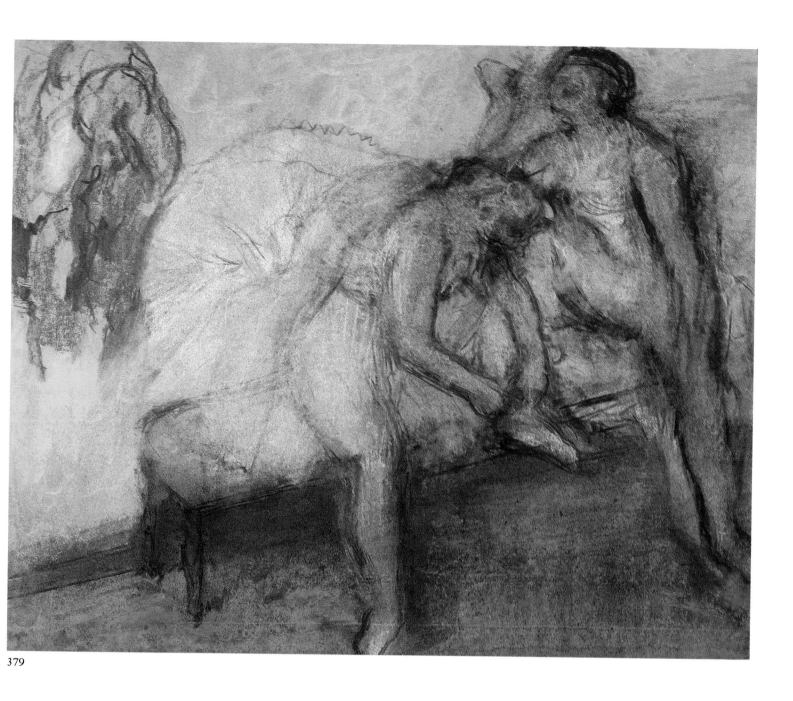

379

The Last Nudes

cat. nos. 380–386

In the years after 1900 when visitors found Degas working in his studio, he was usually drawing on tracing paper or modeling in wax and plasteline, and the subject was almost invariably a nude. He would become obsessed with a motif and pursue it relentlessly—tracing and retracing, as he himself said.

Jules Chialiva, the son of Luigi Chialiva, the artist who is supposed to have given Degas his recipe for his fixative for pastel, claims that he—the son—may have been indirectly responsible for Degas's having used tracing paper. When Jules was at the École des Beaux-Arts and his father wanted to touch up one of his son's drawings to show him how it might be improved, Jules asked him to make the changes on tracing paper rather than on the original, as it was done at the school. As the son recalled it: "My father was immediately struck by the advantages of this means of making comparisons, the time saved, and the avoidance of risk in making a drawing (or certain lines of a drawing) too heavy or of losing a sketch which, at that moment, might be just right. The very next morning, as soon as he arrived at his studio, he first posed the model nude, then asked her to change her poses slightly and made corrections through a series of tracings. Finally, he asked the model to dress and altered his drawings accordingly, always by superimposing tracing paper."[1]

One evening, Degas visited Chialiva's studio and saw ten or twelve of these drawings that had just been fixed. "From that day," Jules wrote, "Degas enthusiastically adopted the technique of drawing and redrawing on superimposed tracing paper, and never again drew in any other way."[2]

Degas had used tracing paper as early as 1860.[3] In addition, in a notebook now in the Metropolitan Museum, we see that about 1882–85 he had played with the transparency of a thin paper—not tracing paper—to superimpose one image on another.[4] Whether or not it was Chialiva's drawings that in-

spired him to go further, Degas did use tracing paper and would write, for example, to his painter friend Louis Braquaval in 1902, "I trace and I retrace."[5]

At the same time that Degas was using tracing paper, which he seems always to have had mounted professionally before he finished a drawing or pastel, making it less ephemeral than it would otherwise have been, he was also refusing to consider having his works of sculpture in wax or plasteline cast into bronze. To Ambroise Vollard, who was disappointed to see a "little dancing girl" reduced to "the original lump of wax from which it had sprung," Degas answered, "I wouldn't take a bucket of gold for the pleasure I had in destroying it and beginning over again."[6] He enjoyed the processes of drawing and modeling in themselves; beginning again was one of the pleasures in his life as he grew old.

In Degas's last works, since his eyesight was an increasing problem, we cannot presume an ideal sequence for these studies, moving from the tentative to the fully realized, from hesitation to assurance, from the specific to the general. Undoubtedly, factors beyond the artist's control, including accident, determined the character of these very late bathers.

1. Jules Chialiva, "Comment Degas a changé sa technique de dessin," *Bulletin de la Société de l'Histoire de l'Art Français*, 1932, p. 45.
2. Ibid.
3. Reff 1985, Notebook 18 (BN, Carnet 1, pp. 96, 100, 106).
4. Reff 1985, Notebook 36 (Metropolitan Museum, 1973.9).
5. Unpublished letter, 29 September 1902, private collection, Paris.
6. Ambroise Vollard, *Degas: An Intimate Portrait*, New York: Dover, 1986, p. 89.

380.

After the Bath

1896–1907
Charcoal and traces of pastel on tracing paper
22 × 20⅞ in. (56 × 53 cm)
Signed in red upper left: Degas
Musée des Arts Décoratifs, Paris (25.452)

When Paul-André Lemoisne published his small but pioneering book on Degas in 1912, he ended with this drawing, which was then in the collection of Lucien Henraux. He wrote that "the artist was able to sum up, in a few extraordinary, precise lines, this image of a woman leaving her bath." And he noted further "the heavy strokes of crayon [sic] and the bold black hatching. Yet

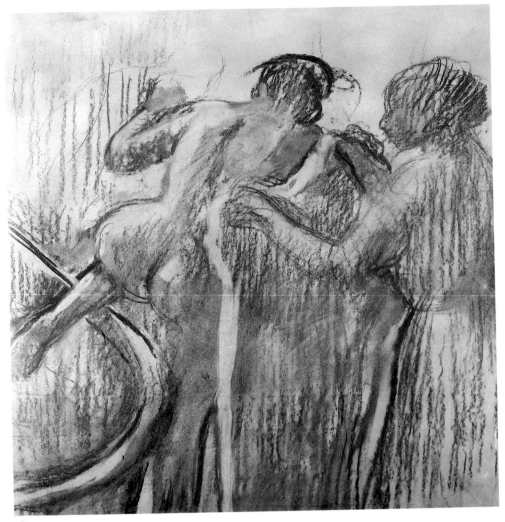

380

what powerful realism, what character there is in this little scene; we could not provide a better example of the artist's last style."[1]

When the collector and author Étienne Moreau-Nélaton went to Degas's studio at the end of 1907, he described a pastel with which he said Degas "had been fencing all day." He went on: "Nearby was the pastel, pinned to cardboard; it had been done on tracing paper. It represented a young woman leaving her bath, with a servant in the background. In the foreground was the pink stuff that was not to be disturbed. The execution was a bit summary, as was everything done during this period by this man whose sight was weakening day by day. But what vigorous, magnificent drawing!"[2]

Although *After the Bath* is a charcoal drawing with only the slightest smudge of color and the servant here is in the foreground, it does seem the kind of work Moreau-Nélaton could have seen on his 1907 visit. The execution could be described as summary—harsh hatching that seems to vibrate because the artist must have worked over a coarse paper or card under the tracing paper. At the same time, it is a magnificent, vigorous

Fig. 332. *After the Bath* (L1204), c. 1895–1900. Pastel, 30 × 32⅝ in. (76.2 × 82.8 cm). The Phillips Collection, Washington, D.C.

drawing in which the maidservant in profile, who holds out a great towel, is a figure of stability to balance the diagonal thrust of the bather's body. The bather is crowned by heavy arcs across her hair that seem symbols for the energy she has revealed.

This drawing is related to one of the finest of Degas's pastels, *After the Bath* (fig. 332), in the Phillips Collection in Washington, which is even closer to Moreau-Nélaton's description of the 1907 pastel but because of the sensuousness of its drawing and color must be of an earlier date.

1. Lemoisne 1912, pp. 111–12.
2. Moreau-Nélaton 1931, p. 267.

PROVENANCE: Lucien Henraux, Paris; his bequest to the museum 1925.

SELECTED REFERENCES: Lemoisne 1912, pp. 111–12, pl. XLVIII; Rivière 1922–23, pl. 100; Lemoisne [1946–49], I, p. 195, repr.; 1986 Florence, p. 209, fig. 71B.

381.

Seated Bather Drying Her Left Hip

c. 1900
Bronze
Height: 14¼ in. (36.2 cm)
Original: red wax, cork and wood visible at back. National Gallery of Art, Washington, D.C. Collection of Mr. and Mrs. Paul Mellon

Rewald LXIX

381, METROPOLITAN

In this statue of a bather, which seems to have a great inner centrifugal force, Degas placed the figure out of doors. She is propped on the edge of the stump of a tree, her knees touching but her enormous feet spread apart and firmly attached to the earth. Both tree and ground are richly textured. By contrast, the back of the bather (which in photographs seems almost as smooth as a bronze by Maillol) is in fact, like her head and her breasts, modeled more harshly, almost as if it were cut with a knife. In his effort to avoid any sense of individual personality, Degas broke the head into illusive planes, somewhat suggestive of what the Cubists were, or would be, doing.[1] The bather sits back on her tree trunk but projects forward daringly into space with very little evident support—a courageous performance for the sculptor.

In the wax original, color seems used for emphasis or clarification. The tree trunk is redder than the earth. Red is used with telling emphasis on the body—for example, along the spine, in the buttocks, on the right shoulder blade, and along the right arm.

1. He had also done this in the pastel *Three Dancers* (L1446).

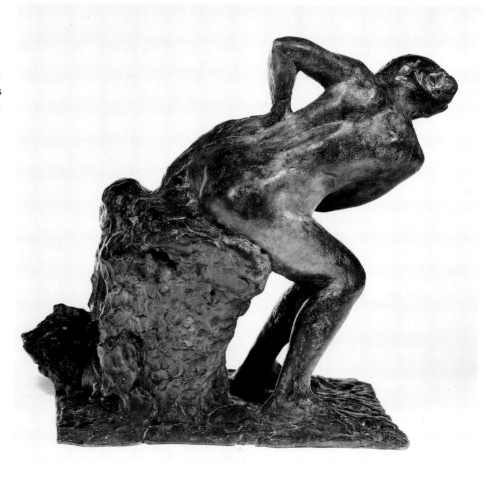

SELECTED REFERENCES: 1921 Paris, no. 59; Rewald 1944, no. LXIX (as 1896–1911), p. 135, Metropolitan 46A; 1955 New York, no. 65; Rewald 1956, no. LXIX, Metropolitan 46A; Minervino 1974, no. S59; 1976 London, no. 67; Millard 1976, pp. 109–10, fig. 133; 1986 Florence, no. 54 p. 202, pl. 54 p. 151.

A. *Orsay Set P, no. 46*
Musée d'Orsay, Paris (RF2123)

Exhibited in Paris

PROVENANCE: Acquired thanks to the generosity of the heirs of the artist and of the Hébrard family 1930.

EXHIBITIONS: 1931 Paris, Orangerie, no. 59 of sculptures; 1969 Paris, no. 287 (dated c. 1884); 1984–85 Paris, no. 79 p. 207, fig. 204 p. 202.

B. *Metropolitan Set A, no. 42*
The Metropolitan Museum of Art, New York.
 Bequest of Mrs. H. O. Havemeyer, 1929.
 H. O. Havemeyer Collection (29.100.389)

Exhibited in Ottawa and New York

PROVENANCE: Bought from A.-A. Hébrard by Mrs. H. O. Havemeyer 1921; her bequest to the museum 1929.

EXHIBITIONS: 1922 New York, no. 31; 1930 New York, under Collection of Bronzes, nos. 390–458; 1974 Boston, no. 49; 1974 Dallas, no number; 1975 New Orleans; 1977 New York, no. 58 of sculptures (dated by Millard as after 1895).

382.

Nude Woman Drying Herself

c. 1900
Charcoal and pastel on tracing paper
31 × 32 in. (78.7 × 83.8 cm)
Vente stamp lower left
The Museum of Fine Arts, Houston. The Robert Lee Blaffer Memorial Collection, Gift of Sarah Campbell Blaffer (56.21)

Lemoisne 1423 bis

One motif to which Degas devoted himself in his late years was a standing nude, seen from behind, whose body arches as she bends to dry her neck vigorously with her right hand while holding out her generous head of hair with her left. (She undoubtedly derives from the nudes in the lithographs of the 1890s, cat. nos. 294–296.) The motif must have appealed to Degas because, though the gesture itself is routine, it involves a representation of classical nudity and provides an opportunity to draw masses of red hair.

The variations he worked on the motif were undoubtedly partly intentional and partly accidental. Sometimes the nude was depicted indoors (cat. no. 383), sometimes in a wood with some shallow water (L1423). Sometimes, as in this drawing, the bather

handles her hair so easily that it falls in generous waves. At other times (L1423), she pulls at it as if intent on wrenching it out by the roots. Sometimes, the pressure on the neck is so great it threatens to sever the head from the body (L1427). Although always somewhat heavily proportioned, the body can be reasonably well articulated, like the present nude, or it can be so perfunctorily and strangely drawn that the bather seems to be another form of life (L1464). The originals of the known works in this series still usually possess dazzling color.

Nude Woman Drying Herself is probably an early stage of the motif, when Degas, in drawing the contours of the figure with charcoal and accenting it, was still concerned with what could be seen. Although there is some modeling of the contours in the Houston work, the effect is not so much sculptural as it is suggestive of the softness of flesh. Inevitably, the body's rhythms set up a foil for the wonderful fluidity of the red hair. Behind the head, a hanging towel stabilizes the composition and further emphasizes the hair. Although this is a rational work, it hovers on the edge of the strangely irrational.

382

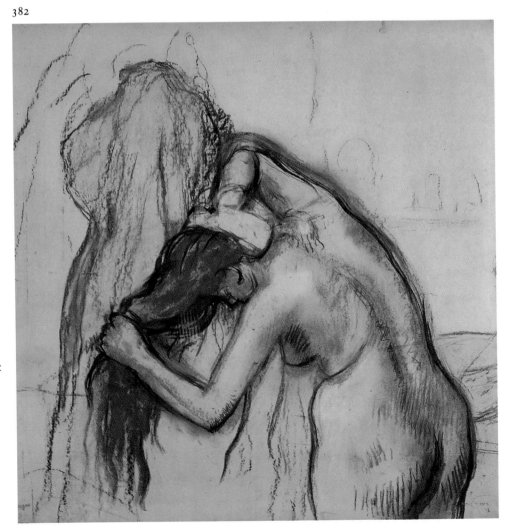

PROVENANCE: Atelier Degas (Vente II, 1918, no. 70); bought at that sale by Nunès et Fiquet, Paris, for Fr 4,950; Mrs. Robert Lee Blaffer, Houston; her gift to the museum 1956.

SELECTED REFERENCES: Lemoisne [1946–49], III, no. 1423 bis (as c. 1903); Shapiro 1982, pp. 12–16, fig. 4; 1984 Chicago, p. 185.

383.

After the Bath, Woman Drying Her Hair

c. 1905
Pastel on three pieces of tracing paper, mounted
33¾ × 29⅛ in. (85.8 × 73.9 cm)
Vente stamp lower left
Private collection

Lemoisne 1424

The most famous of the studies Degas made in the twentieth century of the back of a bather is undoubtedly *Woman at Her Toilette* (fig. 333), a pastel at the Art Institute of Chicago. In that composition, a yellow-orange curtain is pulled down and across the

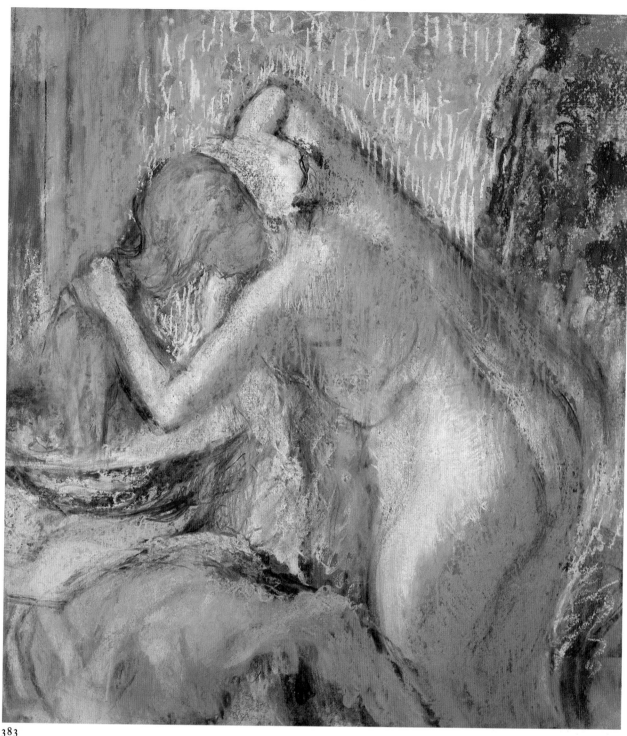

383

woman's hip to conceal the lower part of her body and her gloriously auburn hair is reinforced by some red-orange fabric hanging on the wall behind her.[1] *After the Bath* may be a study on the way to that richly finished and heavily fixed pastel, or it may be another and even later version.

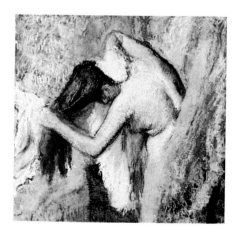

Fig. 333. *Woman at Her Toilette* (L1426), c. 1905. Pastel, 29⅜ × 28⅛ in. (74.6 × 71.3 cm). The Art Institute of Chicago

As Anne Maheux of the National Gallery of Canada's Pastel Project has pointed out, Degas made this version probably without using fixatives; instead, he burnished and rubbed the pastel to make it stable. He began with a strong charcoal drawing on tracing paper which seems, however, less crisp than the drawing in the Houston *Nude Woman Drying Herself* (cat. no. 382). Sometime in the process, while already working with pastel, he added a strip of paper for compositional reasons at the bottom. He seems to have been uncertain about the position of the figure and left his first attempts clearly visible

behind the bather's back and rump and more difficult to detect through her stomach.

Although the charcoal drawing may have some vagaries, the application of pastel is decisive and full of resonant color. The blue of the basin, over which the woman holds her lustrous yellow-brown hair, recalls blue basins in Degas's work back into the eighties. With his fingertips, he smudged more blue into the curtain at the right. He used an orange red to bind the composition together, applying it in broad swirls on the background and in decisive hatching over the bather's body, radiating beyond its contours. He applied roughly parallel vertical strokes of yellow pastel like golden rain in the background. The ponderous weight of the body is transformed by this pyrotechnic performance, uniting dazzling color and the calligraphic strokes of pastel.

1. On the Chicago work, see Richard R. Brettell in 1984 Chicago, no. 89, pp. 184–85; Shapiro 1982, pp. 15, 16, fig. 10.

PROVENANCE: Atelier Degas (Vente I, 1918, no. 282); bought at that sale by Vollard and Durand-Ruel, Paris, for Fr 14,000; transferred from Durand-Ruel, Paris (stock no. 11300), to Durand-Ruel, New York (stock no. N.Y. 4501), November–December 1920; bought by Sam Salz, New York, 9 November 1943,

for $6,000. Sale, Sotheby Parke Bernet, New York, 17–18 January 1945, no. 165, for $4,250. Present owner.

SELECTED REFERENCES: Lemoisne [1946–49], III, no. 1424 (as c. 1903).

384.

Woman Arranging Her Hair

1900–1910
Bronze
Height: 18¼ in. (46.4 cm)
Original: yellow wax. Collection of Mr. and Mrs. Paul Mellon, Upperville, Virginia

Rewald L

In addition to making pastels and drawings on the theme of a bather drying her neck, Degas pursued the subject in a piece of sculpture he modeled from yellow wax. Charles W. Millard points out that this work is one of "the two most canonically classical figures among all the Degas sculpture" and that it inevitably suggests a classical Aphrodite.[1] From the nicely modeled back, it could be inferred that, as in the pas-

tels and drawings, this was the point of view Degas preferred; in some ways, it seems an equivalent in sculpture to the Houston drawing (cat. no. 382). From the front, the handling of the woman's body is rougher and we discover that her feet seem to grow out of the soil, as if rooted there. Although it contains elements of classicism, *Woman Arranging Her Hair* anticipates the forceful Expressionism of the developing twentieth century.

1. Millard 1976, pp. 69–70.

SELECTED REFERENCES: 1921 Paris, no. 62; Paris, Louvre, Sculptures, 1933, no. 1779; Rewald 1944, no. L (as 1896–1911); 1955 New York, no. 48; Rewald 1956, no. L, pl. 75; Beaulieu 1969, p. 380 (as 1903); Minervino 1974, no. S62; 1976 London, no. 62; Millard 1976, pp. 69–70, fig. 107; 1986 Florence, no. 64 p. 206, pl. 64 p. 161.

A. *Orsay Set P, no. 50*
Musée d'Orsay, Paris (RF2126)

Exhibited in Paris

PROVENANCE: Acquired thanks to the generosity of the heirs of the artist and of the Hébrard family 1930.

EXHIBITIONS: 1931 Paris, Orangerie, no. 62 of sculptures; 1969 Paris, no. 293 (as c. 1903); 1984–85 Paris, no. 73 p. 196, fig. 198 p. 201.

384, METROPOLITAN

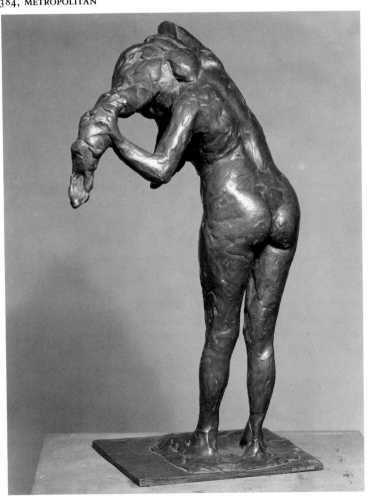

384, ORSAY

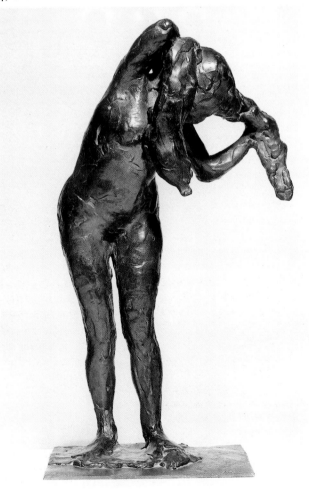

B. *Metropolitan Set A, no. 50*
The Metropolitan Museum of Art, New York.
 Bequest of Mrs. H. O. Havemeyer, 1929.
 H. O. Havemeyer Collection (29.100.438)

Exhibited in Ottawa and New York

PROVENANCE: Bought from A.-A. Hébrard by Mrs.
H. O. Havemeyer 1921; her bequest to the museum
1929.

EXHIBITIONS: 1922 New York, no. 9; 1923–25 New
York; 1930 New York, under Collection of Bronzes,
nos. 390–458; 1974 Dallas, no number; 1977 New
York, no. 42 of sculptures (dated by Millard as after
1890).

385.

Bather Drying Her Legs

c. 1900
Charcoal and pastel on three pieces of tracing paper
26¾ × 14⅛ in. (68 × 36 cm)
Vente stamp lower left
Collection of Barbara and Peter Nathan, Zurich

Lemoisne 1383

One activity of his bathers that obsessed
Degas in the opening years of the twentieth
century was their sitting on the edge of a
tub while leaning over to dry their shins or
ankles. Among the earlier of these works is
the present drawing, executed with charcoal
and pastel on tracing paper.

Bather Drying Her Legs is reminiscent of a
pastel now in the Dayton Art Institute (fig.
334) that Degas had made of a bather in a
similar pose about 1886, the time of the last
Impressionist exhibition. Although he
greatly reduced and simplified the setting
for the later pastel, Degas retained the tub
in the same position, gave some semblance
of a patterned rug to the olive-colored floor,
placed a red slipper in a position similar to
that of the pink one in the earlier work, and
introduced a rose-colored fabric (now only a
patch of color) on the wall behind the bather
in the same position as the fuller curtain in
the Dayton pastel. These similarities, how-
ever, are hardly identifiable in the austerity
and compression with which he worked out
his new composition, fitting the bather into
a vertical format and increasing the effect by
adding paper to the bottom, on which he
drew, and to the top, which he left un-
touched.

Degas must have worked from a model
for this work, because it evokes a strong
sense of the bather's substantial body and
the energy she is exerting in drying her
legs. She bends down farther than her Day-
ton predecessor, her hair flowing down and
her features hidden. The body is drawn

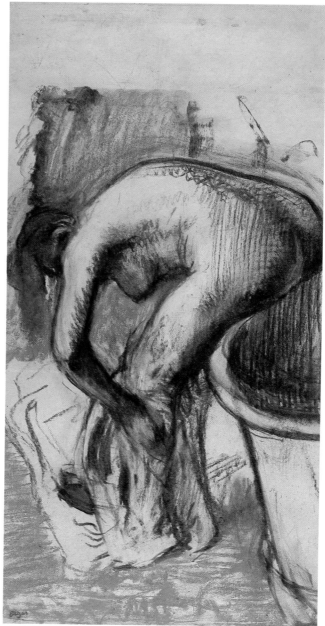

385

with assurance. The hatching sometimes, as
on the arm, follows the form of the body,
but more often, as on the haunches, works
quite independently of it. Sometimes the
strokes, like the squiggle on the spine, be-
come ornamental. The great force in the
figure is in the area above the left arm. Be-
low it, the towel, used to dry the legs, be-
comes limp—not threatening the bather's
stability, however, because the tub seems to
insure her equilibrium. The drawing con-
veys a wonderful sense of contained energy.

PROVENANCE: Atelier Degas (Vente II, 1918, no. 53);
bought at that sale by Ambroise Vollard, Paris, for
Fr 2,450. Present owners.

EXHIBITIONS: 1953, Paris, Galerie Charpentier, *Figures
nues d'école française*, no. 48 or 49; 1984 Tübingen,
no. 214, repr. (color).

SELECTED REFERENCES: Lemoisne [1946–49], III,
no. 1383 (as c. 1900); 1969 Nottingham, under no. 27.

Fig. 334. *Bather Drying Herself* (L917), c. 1886.
Pastel, 18 × 23¼ in. (48 × 62 cm). The Dayton
Art Institute

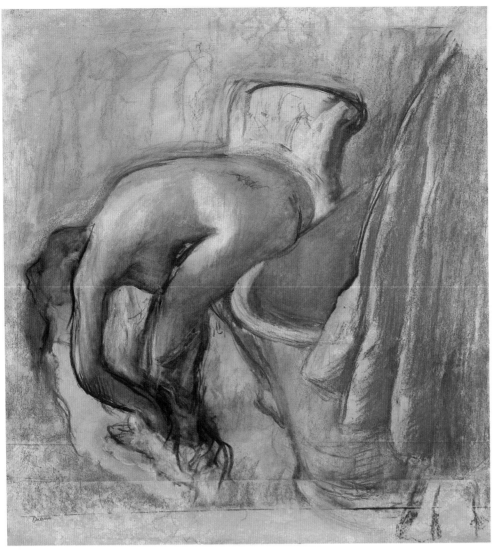

386

PROVENANCE: Atelier Degas (Vente I, 1918, no. 243); bought at that sale by Jos Hessel, for Fr 12,100; Thorsten Laurin, Stockholm. Sale, Christie's, London, 1 December 1980, no. 25, repr. (color); bought by present owner.

EXHIBITIONS: 1920, Stockholm, Svensk-Franska Konstgalleriet, *Degas*, no. 37; 1926, Stockholm, Liljevalchs Konsthall, no. 151; 1954, Stockholm, Liljevalchs Konsthall, *Från Cézanne till Picasso*.

SELECTED REFERENCES: Otto von Benesch, "Die Sammlung Thorsten Laurin in Stockholm," *Die bildenden Künste, Wiener Monatshefte*, 3rd year, 1920, p. 170, repr. p. 169; Hoppe 1922, repr. p. 68; Ragnar Hoppe, *Catalogue de la collection Thorsten Laurin*, Stockholm, 1936, no. 420, repr.; Lemoisne [1946–49], III, no. 1380 (as c. 1900).

The São Paulo Bather

cat. nos. 387, 388

In the Museu de Arte in São Paulo, there is a charcoal-and-pastel drawing, *Woman at Her Toilette* (fig. 335), in which a bather dries her legs. Unusual for Degas, this drawing is dated. In the upper right corner, he wrote "Degas 1903." This makes it a particularly valuable document, the only work the artist inscribed with a date in the twentieth century.

The São Paulo drawing is closer in composition to *After the Bath, Woman Drying Herself* (cat. no. 386) than to the Nathan pastel, *Bather Drying Her Legs* (cat. no. 385). The furnishings and the room are much

386.

After the Bath, Woman Drying Herself

c. 1900–1902
Pastel and charcoal with white wash on
 tracing paper
31½ × 28¼ in. (80 × 72 cm)
Vente stamp lower left
Private collection

Lemoisne 1380

Because this pastel and the drawing of the bather in the Nathan collection (cat. no. 385) were both executed on tracing paper, with the image of the bather approximately the same size, either one could have been traced from the drawing of the other, as was Degas's custom at this time. It does seem, however, that the Nathan drawing is closer to the model and that this pastel is more stylized, as though it came later. The stylization is increased by the use of an almost completely monochromatic orange red which, with the

charcoal and white, gives the work a surprising chromatic unity.

It is interesting to see what has happened to the conception of the earlier Dayton pastel (fig. 334). Obviously, the penetrating but cozy hues of the Dayton work have gone. Although Degas used some of the same elements—a rug, an upholstered chair, and a curtain—he moved the chair to provide a sympathetic termination to the actions of the figure and brought the curtain into the foreground at the right, partly concealing the tub, to give the composition a stability that is neither oppressive nor rigid.

This drawing is grander and more integrated in conception than the Dayton pastel. As the bather moves farther forward and down, the contours of her body become wonderfully unified rhythmically, and the interior contours, including that of one breast, are heavily and protectively reinforced by deep shadow.

Although less concentrated and austere than the Nathan drawing, this is nevertheless a rich and powerful work.

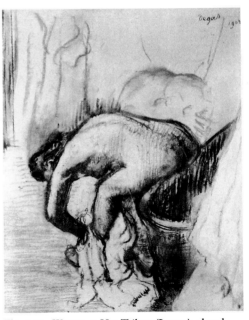

Fig. 335. *Woman at Her Toilette* (L1421), dated 1903. Charcoal and pastel, 22⅞ × 21¼ in. (58 × 54 cm). Museu de Arte, São Paulo

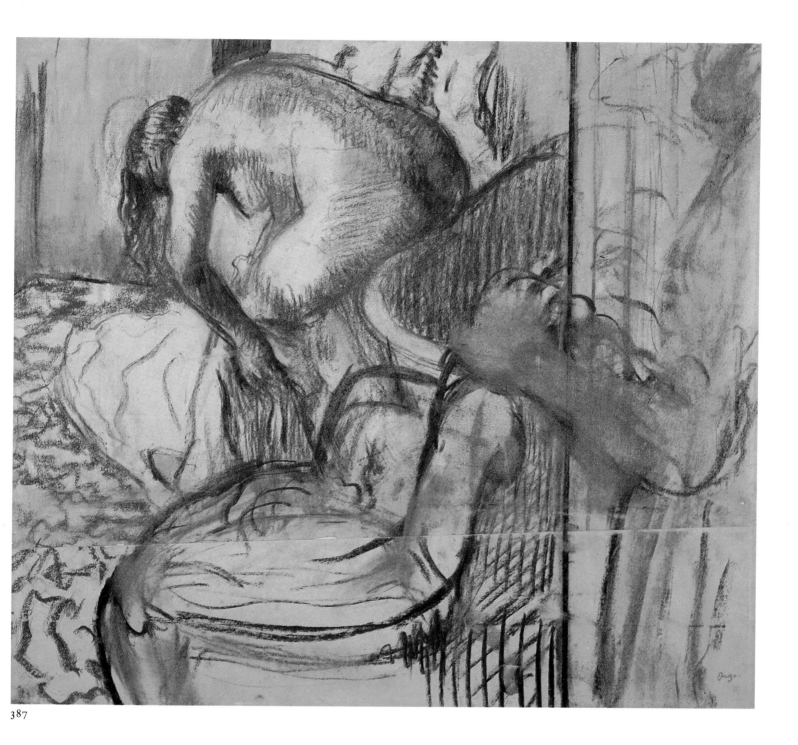

387

more loosely executed, though a slightly open door—mysterious as always—has been introduced at the upper left. However, it is in the figure in particular that we feel the difference between this bather and the other two. Using a linear vocabulary closer to that of the Nathan pastel, Degas drew with even greater force and violence. The contours are very heavy, the hatching seemingly gouged out of the paper with charcoal, the shadows a magnificent black. Most surprising are the strokes of heavy black irregular hatching outside the bather's body but along her back, creating an impression of the frenetic nature of her actions. In contrast to this excessively active figure, the

softness and limpness of the towel are suggested by a few mimetic lines of charcoal.

This then is a dated work—somewhat later than either *Bather Drying Her Legs* or *After the Bath, Woman Drying Herself*—against which later works must be measured. Degas was perhaps persuaded to date the drawing by the dealer Ambroise Vollard, who was its first owner and who would have been conscious, through the example of the younger artists in his stable—including Picasso—of the significance of dating works to give a sense of an artist's development. It is also a work whose abstract force Vollard would very much have admired.

387.

After the Bath

c. 1905
Charcoal and pastel on two pieces of tracing paper
23½ × 21⅛ in. (59.7 × 53.6 cm)
Vente stamp lower right
The Art Gallery of Ontario, Toronto. Ayala and Sam Zacks Collection. Permanent loan to the Israel Museum, Jerusalem

Lemoisne 1382

In all these drawings of bathers drying their legs (cat. nos. 385, 386, and fig. 335), there is a suggestion of the energy that is needed to overcome inertia—and energy has been

triumphant. But as Degas continued to work after 1903, inertia spread insidiously. This is true of the handsome drawing in the Zacks collection in which the nude is much heavier, her shoulders rounded, her movements more difficult, and even her hanging hair somewhat limp. There is no longer the sense of a centrifugal force radiating from her body.

This is another work that Degas clearly left unfinished—a work in process for other artists to appreciate and enjoy. The maid-servant beside the door or partition at the right is barely blocked in, her form smudged like a shadow. The chair is as cursorily and boldly drawn as if it were a Matisse, five years into the future. There are wonderful decorative touches—the dark red used for the pattern of the rug and the lighter red for the wall. As in the São Paulo drawing (fig. 335), the wall has a slightly open door. The yellow slipper is a surprise. Degas added a large piece of paper to the bottom of the original sheet to put the bather even farther back in space. As a result, we are not too overcome by the physical, psychological, and spiritual inertia the figure represents, and delight instead in the ornamental character of the drawing.

PROVENANCE: Atelier Degas (Vente II, 1918, no. 67); bought at that sale by Pellé (Gustave Pellet?), Paris, for Fr 3,600; Gaïdé, Paris; Dr. Roblyn, Brussels; Sam and Ayala Zacks, Toronto (acquired in Basel 1959); their gift to the museum 1970.

EXHIBITIONS: 1960, Montreal Museum of Fine Arts, 19 January–21 February, *Canada Collects: European Paintings*, no. 192; 1967 Saint Louis, no. 141; 1971, Toronto, The Art Gallery of Ontario, 21 May–27 June/Ottawa, National Gallery of Canada, 2–31 August, *A Tribute to Samuel J. Zacks: From the Sam and Ayala Zacks Collection*, no. 103, repr.

SELECTED REFERENCES: Lemoisne [1946–49], III, no. 1382 (as c. 1900).

388.

After the Bath, Woman Drying Her Feet

c. 1905
Pastel, charcoal with stump, black wash, and
 touches of red and blue chalk on buff wove
 tracing paper, pieced, laid down on sulphite
 board
22⅜ × 16 in. (56.7 × 40.8 cm) (maximum)
Vente stamp lower left
The Art Institute of Chicago. Gift of Mrs. Potter
 Palmer II (1945.34)

Exhibited in Ottawa and New York

Vente II:307

The Art Institute of Chicago has one of the last, most beautiful, and most disturbing of the drawings of a bather drying her legs or feet. The pose of the figure is the simplest of the group, more nearly a profile seen directly rather than from above. The woman's left arm is straight, forming with her leg and torso a rough triangle that encircles some rather evocative imagery. At the same time, in spite of this greater simplicity, she seems perilously placed on the tub and even endangered by the black shadow beneath her leg. The poignancy of this situation is increased by the touches of red and blue chalk Degas used with the charcoal on the skin and the hair. Symbolized perhaps by her hair, which loses itself beautifully as it falls into shadow, the bather's energy appears to drain actively from her, a seemingly inevitable descendant of the bather in the lithograph of about 1891, *Nude Woman Standing Drying Herself* (cat. no. 294). She is tragically without expectations or hope.

PROVENANCE: Atelier Degas (Vente II, 1918, no. 307, for Fr 1,350); with Jacques Seligmann and Co., New York; bought by the museum 1945.

EXHIBITIONS: 1946, The Art Institute of Chicago, 16 February–summer, *Drawings Old and New* (catalogue by Carl O. Schniewind), no. 11, repr.; 1947 Washington, D.C., no. 1; 1963, New York, Wildenstein, 17 October–30 November, *Master Drawings from the Art Institute of Chicago* (catalogue by Harold Joachim and John Maxon), no. 105; 1976, Paris, Musée du Louvre, 15 October 1976–17 January 1977, *Dessins français de l'Art Institute de Chicago: de Watteau à Picasso*, no. 59, repr.; 1977, Frankfurt, Städtische Galerie, 10 February–10 April, *Französische Zeichnungen aus dem Art Institute of Chicago* (catalogue by Margaret Stuffman), no. 60 (as c. 1900); 1984 Chicago, no. 90.

SELECTED REFERENCES: Agnes Mongan, *French Drawings*, vol. 3 of *Great Drawings of All Times* (edited by Ira Moskowitz), New York: Sherwood Publishers, 1962, no. 791.

388

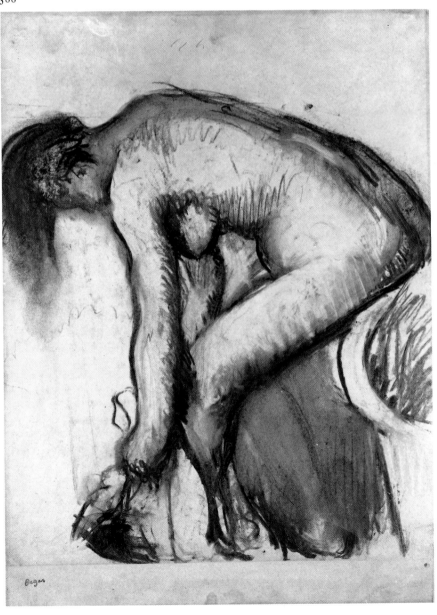

The Last Portraits and Genre

cat. nos. 389–392

In the last works Degas devoted to portraiture and genre, we must expect neither optimism nor much sense of the individual. Although his portraits in pastel of the Rouarts of about 1904–05 have a certain originality in conception, in this genre he was content to rework earlier themes. The emphasis in most of these works is on individual will— harsh, unyielding, demanding— which is normally expressed through the diagonal thrusts of the bodies in the compositions. Lillian Browse observes a relationship between Degas's "innate sense of, and emphasis upon, rhythm through posture" in the Lausanne *Washerwomen and Horses* (cat. no. 389) and in the photograph *Paul Poujaud, Mme Arthur Fontaine, and Degas* (cat. no. 334).[1] However, the poses in the photograph are conceived as if for the stage, whereas the diagonal thrusts in *Washerwomen and Horses*, the portraits of the Rouarts (cat. nos. 390, 391), and the Orsay *At the Milliner's* (cat. no. 392) have the harsh reality of the human spirit exposed.

1. Browse [1949], no. 235a, p. 411.

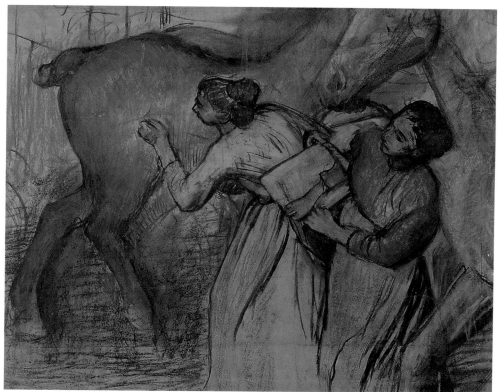

389

389.

Washerwomen and Horses

c. 1904
Charcoal and pastel on tracing paper with strip
 added at bottom
33⅛ × 42⅛ in. (84 × 107 cm)
Vente stamp lower left
Musée Cantonal des Beaux-Arts, Lausanne (333)

Lemoisne 1418

Almost thirty years after having painted *Laundresses Carrying Linen in Town* (fig. 336), which he had exhibited at the Impressionist exhibition of 1879, Degas drew another in pastel, almost four times as large, in which the laundresses are not "in town" but in a stable yard with gigantic horses. Since the horses are in all probability Percherons, which were bred in Normandy not too far from Ménil-Hubert, Paul Valpinçon's chateau in Orne, a visit to the Valpinçons in 1904 may have inspired the work.[1] It is quite clear that, though he was now drawing in pastel on tracing paper, Degas had not forgotten the earlier painting. Even though the laundress at the left stretches out her left arm, and the position of the woman at the right is reversed and her body laps over the other, reminders of the earlier

Fig. 336. *Laundresses Carrying Linen in Town* (L410), c. 1876–78. Oil on canvas, 18⅛ × 24 in. (46 × 61 cm). London art market

painting survive. Admittedly, the laundresses have grown taller, leaner, and older, and they are more harshly drawn. Between the painting of the seventies and the pastel, Degas made drawings of the laundress on the left (L960, L961)—perhaps, as Lemoisne suggests, about 1888–92—which give a sense of physical charm that is absent in either the early painting or this vigorous late pastel.

The relationship of the two women to the horses in this work is curious. In one way, they are threatened by them. In another, they seem to be characters in an operatic situation that does not have much sense of reality. Richard Thomson sees it differently: "The horses help set the figures in an enclosed, yet still relief-like, metropolitan space, and act as a metaphor for the laboring laundresses."[2]

1. See Degas Letters 1947, no. 256, p. 220, to Hortense Valpinçon, 3 August 1904. On the other hand, if the pastel was the *Laundresses* shown in Manchester in 1907–08, it may be dated, as the catalogue indicated, 1902.
2. 1987 Manchester, pp. 103–05.

PROVENANCE: Atelier Degas (Vente I, 1918, no. 182, for Fr 5,000); with Paul Rosenberg, Paris; M. Snayers, Brussels (sale, 4 May 1925, no. 45, repr.); Dr. A. Widmer, Valmont-Territet; his bequest to the museum.

EXHIBITIONS: (?)1907–08 Manchester, no. 173 (as 1902); 1951–52 Bern, no. 69; 1952 Amsterdam, no. 56; 1967, Geneva, Musée de l'Athénée, *De Cézanne à Picasso*; 1984 Tübingen, no. 218, repr. (color) p. 97; 1984–85 Paris, no. 16 p. 126, fig. 100 (color) p. 119; 1987 Manchester, pp. 103, 105, fig. 135 p. 104.

SELECTED REFERENCES: Lemoisne [1946–49], III, no. 1418 (as c. 1902); Browse [1949], no. 235a, p. 411; Cooper 1952, pp. 14, 26, no. 31, repr. (color); Janis 1967, pt. I, p. 22 n. 14; René Berger, *Promenade au Musée Cantonal des Beaux-Arts, Lausanne*, Lausanne: Crédit Suisse et René Berger, 1970, p. 40, repr. p. 41; *Catalogue du Musée des Beaux-Arts*, Lausanne: Musée Cantonal des Beaux-Arts, 1971; Minervino 1974, no. 1192; Sutton 1986, pl. 287 (color) p. 303.

390.

Mme Alexis Rouart

c. 1905
Charcoal and pastel on cream-colored grained
 paper
23½ × 18 in. (59.7 × 45.7 cm)
Vente stamp lower left
The Saint Louis Art Museum

Exhibited in Ottawa and New York

Vente III:303

Paul-André Lemoisne observed that the last
portraits Degas drew or painted were of Mme
Alexis Rouart and her children about 1904
or 1905. He also reported that his sitters had
sensed the artist's increasing disabilities and
frustrations.[1] Certainly Degas's irritation
comes out in this drawing of Mme Alexis
Rouart alone. She was the daughter-in-law
of his great friend Henri and the wife of
Alexis, whom he had painted about ten
years earlier with his father (cat. no. 336).
An undated letter to Alexis Rouart shows
his affection for the younger man.[2] Earlier,
he had written of Alexis's wife with a sug-

gestion of affectionate camaraderie.[3] The ir-
ritation revealed in the drawing was certain-
ly directed more at himself than at Mme
Rouart. And the reduction of her eyes to
slits was clearly more autobiographical than
descriptive.

In spite of certain shortcomings, this draw-
ing is exceedingly expressive. Mme Rouart's
impatience is indicated by the energetic thrusts
and counterthrusts of her angular body in
the relentlessly curving chair. With a little
pastel in the hair, Degas ornamented the
drawing and reduced its violence.

1. Lemoisne [1946–49], I, p. 163.
2. Lettres Degas 1945, CCXX, pp. 225–26; Degas
 Letters 1947, no. 239 p. 211.
3. See letter in Chronology IV, 1 December 1897.

PROVENANCE: Atelier Degas (Vente III, 1919, no. 303);
bought at that sale by Durand-Ruel, Paris, for Fr 360
(stock no. 11496); with Nierendorf Galleries, New
York; Col. Samuel A. Berger, New York (sale, Sothe-
by Parke Bernet, New York, 27 April 1972, no. 55);
Greenberg Gallery of Contemporary Art, Saint Louis;
bought by the museum 1979.

EXHIBITIONS: 1967 Saint Louis, no. 144, repr. p. 216.

SELECTED REFERENCES: Boggs 1962, pl. 145.

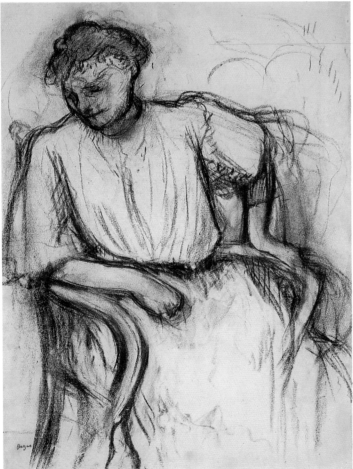

390

391.

Mme Alexis Rouart and Her Children

c. 1905
Charcoal and pastel on tracing paper
63 × 55½ in. (160 × 141 cm)
Vente stamp lower left; atelier stamp on verso
Musée du Petit Palais, Paris (PPD3021)

Exhibited in Paris

Lemoisne 1450

In describing the circumstances surrounding
the portraits Degas made of Mme Alexis
Rouart and her children, Lemoisne admitted
that, in spite of the strangeness of the draw-
ing, Degas was still a consummate colorist.[1]
And indeed, this very large pastel is enchant-
ing in color, its harmonious pinks, yellows,
violets, and greens a happy contradiction of
the emotions revealed in the drawing.

The features and hair of Mme Rouart are
more conventional and more serene than in
the Saint Louis drawing of her alone (cat.
no. 390), but the thrust of her body conveys
a suggestion of impatience. She leans toward
her small son, who seems to be seeking
comfort from her. In contrast, her daughter,
with shapeless clothes, long, untamed hair,
and an eldritch face, twists on her chair so
that she turns her back on her mother. Mme
Rouart's desperation may be suggested by
her straw hat lying on the grass.

To understand Degas's own feelings
about Mme Rouart and her children, we are
dependent on one undated letter to Alexis
Rouart. Degas obviously enjoyed Madeline,
the daughter, about whom he wrote: "That
Madeline, I could spend whole days talking
to her; what an individual she is."[2] Indeed,
Lemoisne published a photograph of Degas
and the Rouart children at their country
house at La Queue-en-Brie with one of them,
presumably Madeline, at its axis, propped
beside the painter.[3] That Degas was not un-
aware of a strain between mother and daugh-
ter may be revealed in his final sentence in
the letter to Alexis: "Regards to the poor little
woman, mother of Madeline, and also to
Madeline's father." Although he had often
found tensions in his portraits of the Rouarts,
of whom he had once written to the elder
Alexis Rouart (Henri's brother), "You are
my family,"[4] in earlier times he might not
have expressed them as openly.

Charles W. Millard sees a relationship
between this work and Degas's relief The
Apple Pickers (cat. no. 231).[5] There are cer-
tain similarities, but the drawings, at least
for the relief, suggest the possibility of unin-
hibited happiness, which his earlier work
could exhibit but his later work did not admit.[6]

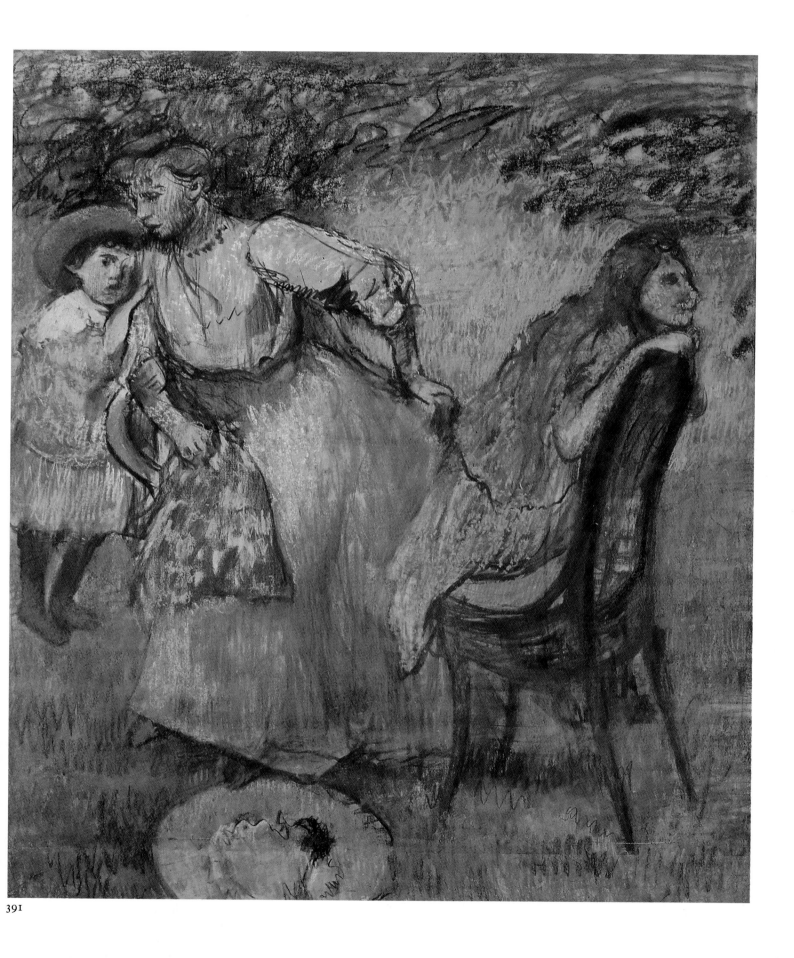

391

1. Lemoisne [1946–49], I, p. 163.
2. Lettres Degas 1945, CCXX, pp. 225–26; Degas Letters 1947, no. 239, p. 211 (translation revised).
3. Lemoisne [1946–49], I, before p. 223.
4. Lettres Degas 1945, CCXXXVII, p. 238; Degas Letters 1947, no. 262, p. 223, 27 December 1904 (translation revised).
5. Millard 1976, p. 16 n. 57, fig. 45.
6. Reff 1976, figs. 164–69, pp. 251–53.

PROVENANCE: Atelier Degas (Vente I, 1918, no. 159); bought at that sale by Ambroise Vollard, Paris, for Fr 10,000; gift of M. Galea for the heirs of Ambroise Vollard 1950.

SELECTED REFERENCES: Lemoisne [1946–49], III, no. 1450 (as c. 1905); Boggs 1962, pp. 77–78, 125, pl. 144; Minervino 1974, no. 1197; Millard 1976, p. 16 n. 57, fig. 45; *Catalogue sommaire illustré des pastels* (by M.-C. Boucher, with Daniel Imbert), Paris: Musée du Petit Palais, 1983, no. 34, repr. (color).

392.

At the Milliner's

c. 1905–10
Pastel on three joined sheets of tracing paper
35¾ × 29½ in. (91 × 75 cm)
Vente stamp lower left
Musée d'Orsay, Paris (RF37073)

Exhibited in Paris

Lemoisne 1318

At the Milliner's in the Musée d'Orsay was not the only scene of milliners that Degas made late in his life. There is a painting in the Émile Roche collection of two milliners with a feather and a hat between them (L1315), as well as a pastel (L1316) and at least three drawings (L1317, L1319, and III:85.3).[1] In none is there a customer, and the two milliners in aprons are either featureless or seemingly caricatured, though there is a graceful rhythm binding the figures together.

This pastel seems to have the same characters, though a distinction is made between the milliner who works on the hat and the standing figure in the apron. The milliner is more intent here than in the other works, and the standing figure seems to play a more subordinate role, like the maidservants in many of Degas's scenes of bathers. Another difference is that the two figures are seen across a table with a hatstand and certain ornaments. In some respects, the verticality of the composition (achieved in the pastel by additional pieces of paper) and the discovery of the milliner behind the hats remind us of another pastel, *At the Milliner's* (fig. 179), which Degas dated 1882 and which was in the collection of Mme Mellet-Lanvin. However, the later work is more raw in color, more two-dimensional, and without the same coquetry.

The Orsay pastel has been so flattened into decorative areas of color—such as the orange ornament in the foreground, the intense blue feathers on the hat, and the red waist on the figure at the right—that it suggests an Art Nouveau poster, like the famous one Pierre Bonnard made for *La Revue Blanche* in 1894. It is almost as if Degas had crushed his pastels into the paper to achieve both the flatness and the intensity of color.

The vibrancy of the blue against the softer oranges and yellows jars enough that we are not lulled into thinking of this as a decorative pastel. For those who are sociologically inclined, it could represent at least two levels of servitude—the maid to the milliner and the milliner to her customers, represented by the hats—and even by implication a third, the adornment of women to serve men or society. And yet if this is what Degas intended, it could have been part of a social chain of being, a natural law from which he saw no escape. But the elements of revolution are here.

The ingredients of this pastel are not rendered with the clarity, distinctness, and charm of an earlier pastel that he had dated 1882, *The Little Milliners* (fig. 207), now in the Nelson-Atkins Museum of Art in Kansas City. Looking at the hands of the milliner in the later work, we could not imagine Degas telling Mme Straus—the great Paris beauty, famous for her salons—that he liked to go with her when she went to her tailor's for fittings because of "the red hands of the little girl who holds the pins."[2]

The milliner's hands in the Orsay pastel are not articulated in the same loving way as were the young women's hands in the Kansas City work. Indeed, all the forms are somewhat indistinct and seem about to transform themselves into other shapes, though the metamorphosis is never fully realized. The milliner may suggest a crow—but she is much more a woman. Although she is a woman, and even a woman with a suggestion of turn-of-the century elegance with her silhouette of leg-of-mutton sleeves, she is quite without the affectations of the two milliners from the eighties. Her body has been reduced to an image of thrusts of desperate energy, her gentle profile is mocked by the flamboyant hat, and the blue feather held out by the maidservant seems a challenge she consciously ignores. With determination she concentrates on the hat—an illustration of individual will which Degas had always admired, and admired even here where it appears taunted and suppressed.

It has often been considered—quite unreasonably, and inaccurately—that Degas was a misogynist, even though he did, for example, encourage the talents of women artists, including Mary Cassatt, Berthe Morisot, and Suzanne Valadon.[3] Even Mary Cassatt, in 1914, commented ironically on Louisine Havemeyer's idea of having an exhibition of the work of Degas "in favor of the suffrage. It is 'piquant' considering Degas's opinions."[4] In his later years, Degas was frequently closer to contemporary issues than was generally supposed. And in his stand on the Dreyfus Affair, that black mark in his personal life, he at least never pretended it was not an issue in France. Here, in *At the Milliner's*, he produced an image—probably unconsciously—that could have been used as a poster for Cassatt's and Mrs. Havemeyer's political cause. Although the woman in black could represent oppressed but productive energy, the maidservant on the right offers her the blue feather, provoking her to thought or action while at the same time providing, in the tradition of her predecessors in the poignant London and Oslo paintings (cat. nos. 344, 345), a strong sense of stable, sisterly support.

1. Apparently based on L1110, which has the appearance of being an earlier work.
2. Lettres Degas 1945, CXVII n. 1, p. 147; Degas Letters 1947, "Annotations," no. 129, p. 267.
3. Broude 1977.
4. Unpublished letter to Mrs. H. O. Havemeyer, 15 February 1914, Archives, The Metropolitan Museum of Art, New York, C96.

PROVENANCE: Atelier Degas (Vente I, 1918, no. 153, for Fr 13,000); Comte de Beaumont, Paris; thence by descent (sale, Christie's, London, 6 December 1977, no. 18, repr. [color]); bought by the museum from Comtesse Eliane de Beaumont 1979.

SELECTED REFERENCES: Lemoisne [1946–49], III, no. 1318; Minervino 1974, no. 1187 (as c. 1898); "Les récentes acquisitions des musées nationaux," *La Revue du Louvre et des Musées de France*, XXIX:4, 1979, p. 315, fig. 9; Paris, Louvre and Orsay, Pastels, 1985, no. 86, pp. 88, 90, repr. p. 89.

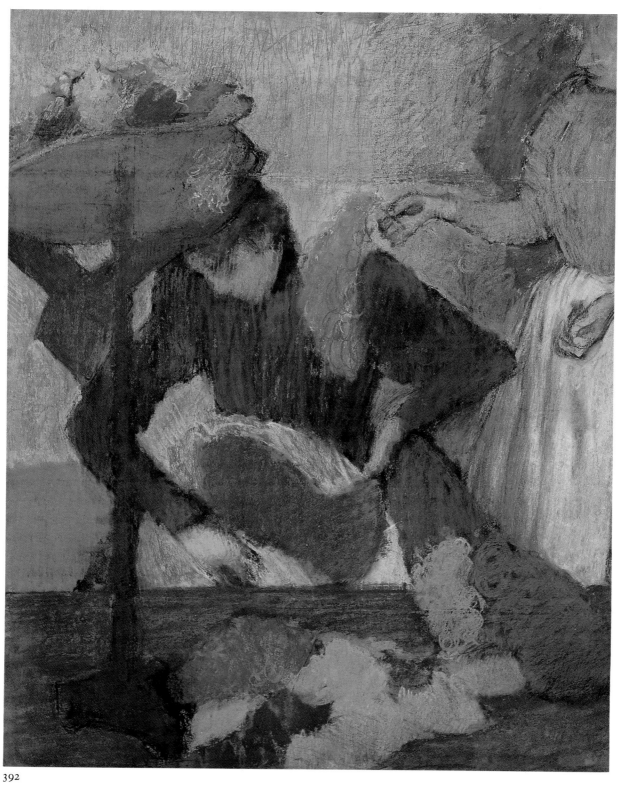

392

A Note on Degas's Bronzes

GARY TINTEROW

The bronzes included in this exhibition, like those widely distributed throughout the world, are posthumous, second-generation casts of the original wax sculptures by Degas. In a letter of 7 June 1919 to Royal Cortissoz, the art critic of the *New York Tribune*, Joseph Durand-Ruel stated that when he made the inventory of the contents of Degas's studio, he found "about one hundred fifty pieces [of sculpture] scattered over his three floors. . . . Most of them were in pieces, some reduced to dust. We put apart those that we thought might be seen, which was about one hundred, and we made an inventory of them. Out of these, thirty are about valueless; thirty badly broken up and very sketchy; the remaining thirty quite fine. . . . They have all been entrusted to the care of the sculptor, Bartholomé, who was an intimate friend of Degas, and in the near future, work will be started by the founder, Hébrard, who will reproduce them in *cire perdue.*"[1]

According to John Rewald, work had begun at Hébrard's by the end of 1919.[2] In all, seventy-two sculptures were cast in bronze in time for an exhibition at Hébrard's gallery in 1921. *The Little Fourteen-Year-Old Dancer* (cat. no. 227), Degas's largest surviving sculpture, seems to have been cast in an unnumbered edition of at least twenty-five examples in the 1920s—that is, after the smaller sculptures; *The Schoolgirl*, the seventy-fourth, was not cast until the 1950s. After considerable repair to the surviving statuettes, molds were made from these original sculptures—fragile plasteline, wax, and cork amalgams supported by amateurish armatures—and from these molds, a set of "master bronzes" or *modèles* was fabricated through the lost-wax process. Afterward, editions of at least twenty-two bronze casts were made of each statuette from molds taken from the *modèles*. Those intended for sale were marked with a letter from A through T; examples reserved for the artist's family were marked HERD, and examples reserved for the foundry were marked either HER or HERD. Outside of the group marked A through T, only two additional casts of each statuette were to be made.

By means of the two-step system involving the creation of intermediary bronze *modèles*, the original waxes were preserved. (These were sold by Hébrard in 1955, having been out of view since 1921, and acquired by Paul Mellon, who gave several to the Musée du Louvre [cat. nos. 80, 290, 322, 372]. The bronze *modèles* were sold by Hébrard in 1976 and acquired by Norton Simon. From time to time, other *modèles*, marked FR MODÈLE, have appeared.)[3] But the virtue of saving the original sculptures exacted a cost in the manufacture of the final edition of bronzes, because with each of the two generations after the original model there was inevitably a significant loss of precision. Incidental details, such as fingerprints, threads, and wires of the ad-hoc armatures—reproduced with surprising fidelity in the *modèles*—appear indistinct or blurred in the final edition of the bronzes. Even the *modèles* lack much of the liveliness still evident today in the original waxes, and the original waxes now differ in some respects from photographs taken of them between 1917 and 1919.[4]

Despite the difficulties attending the casting of such fragile originals, Hébrard's work was widely acclaimed when the pieces were first exhibited in Paris in 1921. This was largely due to the skill of the caster, Albino Palazzolo, and to the supervision of Degas's friend Albert Bartholomé. So remarkable was the result that Palazzolo, who had known Degas and had given him advice on his armatures, was awarded the Legion of Honor.[5] Degas would no doubt have scoffed at the medal, for he detested such worldly honors.[6] He would also have deplored the casting of his sculptures. He toyed with the idea of having them cast more than once in the late 1880s and the 1890s, and could have arranged to do so at any time; in one letter, he referred to Bartholomé as his possible *fondeur* (caster).[7] Of all his sculptures, he exhibited only one, after hesitating for a year: *The*

1. Published by Royal Cortissoz in "Degas as He Was Seen by His Model," *New York Herald*, 19 October 1919, section IV, p. 9.
2. Rewald 1986, pp. 150–51.
3. See John Rewald's account of the appearance of the *modèles* in Rewald 1986, pp. 152–56, an article originally written for the catalogue of the first exhibition of the *modèles* at the Lefevre Gallery, London, in 1976.
4. Paul Gsell first published some of these photographs, now in the Durand-Ruel archives, in 1918. He reproduced seven original waxes and two plaster casts (Paul Gsell, "Edgar Degas, Statuaire," *La Renaissance de l'Art Français et des Industries de Luxe*, December 1918, pp. 373–78). Patricia Failing has recently published two of these documentary photographs in "Cast in Bronze: The Degas Dilemma," *Art News*, January 1988, pp. 136–41.
5. See Jean Adhémar's interview with Palazzolo, "Before the Degas Bronzes" (translation by Margaret Scolari), *Art News*, 54, no. 7, November 1955, pp. 34–35, 70. See also Charles Millard's analysis of the history of the manufacture of the bronzes, "Exhibition, Casting and Technique," in Millard 1976, pp. 27–39.
6. There are many accounts of Degas's railing against the conferring of medals on artists or friends. One of the most amusing is recounted by the model Pauline, in Michel 1919, p. 624.
7. Lettres Degas 1945, CI, p. 127; Degas Letters 1947, no. 112, p. 125.

Little Fourteen-Year-Old Dancer, which he showed at the 1881 Impressionist exhibition. In the end, he had allowed only three works to be cast—in plaster—sometime around 1900: *Dancer Looking at the Sole of Her Right Foot* (RXLV), *Spanish Dance* (RXLVII), and *Woman Rubbing Her Back with a Sponge, Torso* (RLI).[8] Sensitive and intelligent observers, such as Mary Cassatt, were opposed to the posthumous casting. In an unpublished letter to Louisine Havemeyer, Cassatt wrote that she had received a letter "from Mlle Fevre, Degas's niece, with the account of how their [the family's] hands were forced by the press [to have them cast], under the instigation of a sculptor friend of Degas [Bartholomé] who needs to wrap himself in Degas's genius, not having any of his own."[9]

What Degas seems to have valued most in his waxes was their mutability. Many visitors to his studio, models, and friends describe him constantly at work on them in his late years.[10] And it was probably because of his reluctance to finish the sculptures—in tandem with the lack of motive to exhibit them—that he continually refused to commit them to bronze. Vollard recounted that Degas once threatened to finish a statuette of a dancer that was in its twentieth transformation: "'This time I have it. One or two more sittings and Hébrard [his founder] can come.' The next day I [Vollard] found the dancer once again returned to the state of a ball of wax. Faced with my astonishment [Degas said]: 'You think above all of what it was worth, Vollard, but if you had given me a hatful of diamonds my happiness would not have equalled that which I derived from demolishing [the figure] for the pleasure of starting over.'"[11]

8. Millard 1976, p. 30.
9. Letter of 9 May 1918, on deposit in the archives of The Metropolitan Museum of Art, New York.
10. See Thiébault-Sisson 1921; reprinted in English as "Degas on Sculpture" in 1984–85 Paris, pp. 177–82.
11. Vollard 1924, pp. 112–13; translation by Charles Millard (Millard 1976, p. 36).

Key to Abbreviations

Exhibitions

1874 Paris
35 boulevard des Capucines, Société Anonyme des Artistes Peintres, Sculpteurs, Graveurs, etc., 15 April–15 May, *Première exposition.*

1876 London
Deschamps Gallery, 168 New Bond Street, Spring, *Twelfth Exhibition of Pictures by Modern French Artists.*

1876 Paris
11 rue Le Peletier, Société Anonyme des Artistes Peintres, Sculpteurs, Graveurs, etc., April, *2e exposition de peinture.*

1877 Paris
6 rue Le Peletier, April, *3e exposition de peinture.*

1879 Paris
28 avenue de l'Opéra, 10 April–11 May, *4me exposition de peinture.*

1880 Paris
10 rue des Pyramides, 1–30 April, *5me exposition de peinture.*

1881 Paris
35 boulevard des Capucines, 2 April–1 May, *6me exposition de peinture.*

1886 New York
American Art Association, 10–28 April, and National Academy of Design, 25 May–, *Special Exhibition: Works in Oil and Pastel by the Impressionists of Paris.*

1886 Paris
1 rue Laffitte, 15 May–15 June, *8me exposition de peinture.*

1898 London
Prince's Skating Ring, The International Society of Sculptors, Painters and Gravers, 26 April–22 September, *Exhibition of International Art.*

1905 London
Grafton Galleries, January–February, *Pictures by Boudin, Cézanne, Degas, Manet, Monet, Morisot, Pissarro, Renoir, Sisley* (exhibition organized by Durand-Ruel, Paris).

1907–08 Manchester
Manchester City Art Gallery, Winter, *Modern French Paintings.*

1911 Cambridge, Mass.
Fogg Art Museum, 5–14 April, *A Loan Exhibition of Paintings and Pastels by H. G. E. Degas.*

1915 New York
M. Knoedler and Co., 6–24 April, *Loan Exhibition of Masterpieces by Old and Modern Painters.*

1918 Paris
Petit Palais, 1 May–30 June, *Expositions exceptionnelles: hommage de la "Nationale" à quatre de ses présidents décédés.*

1921 Paris
Galerie A.-A. Hébrard, May–June, *Exposition des sculptures de Degas.*

1922 New York
The Grolier Club, 26 January–28 February, *Prints, Drawings, and Bronzes: by Degas.*

1923–25 New York
The Metropolitan Museum of Art, February 1923–January 1925, *Sculptures by Degas,* 12 works (no catalogue).

1924 Paris
Galeries Georges Petit, 12 April–2 May, *Exposition Degas* (introduction by Daniel Halévy).

1925–27 New York
The Metropolitan Museum of Art, January 1925–December 1927, *Degas Bronzes* (no catalogue).

1929 Cambridge, Mass.
Fogg Art Museum, 6 March–6 April, *Exhibition of French Paintings of the Nineteenth and Twentieth Centuries.*

1930 New York
The Metropolitan Museum of Art, 10 March–2 November, *The H. O. Havemeyer Collection.*

1931 Cambridge, Mass.
Fogg Art Museum, 9–30 May, *Degas.*

1931 Paris, Orangerie
Musée de l'Orangerie, 19 July–1 October, *Degas: portraitiste, sculpteur* (preface by Paul Jamot).

1931 Paris, Rosenberg
Galerie Paul Rosenberg, 18 May–27 June, *Grands maîtres du XIXe siècle.*

1932 London
Royal Academy of Arts, 4 January–5 March, *Exhibition of French Art, 1200–1900* (commemorative catalogue, Oxford: Oxford University Press/London: Humphrey Milford, 1933).

1933 Chicago
The Art Institute of Chicago, 1 June–1 November, *A Century of Progress: Exhibition of Paintings and Sculpture.*

1933 Northampton
Smith College Museum of Art, 28 November–18 December, *Edgar Degas: Paintings, Drawings, Pastels, Sculpture.*

1933 Paris
Musée des Arts Décoratifs, April–July, *Le décor de la vie sous la IIIe République.*

1933 Paris, Orangerie
Musée de l'Orangerie, *Les achats du Musée du Louvre et les dons de la Société des Amis du Louvre 1922–1932.*

1934 New York
Marie Harriman Gallery, 5 November–1 December, *Degas.*

1935 Boston
Museum of Fine Arts, 15 March–28 April, *Independent Painters of Nineteenth-Century Paris.*

1936 Philadelphia
The Pennsylvania Museum of Art [now Philadelphia Museum of Art], 7 November–7 December, *Degas: 1834–1917* (organized by Henry McIlhenny; prefatory note by Paul J. Sachs; introduction by Agnes Mongan).

1936 Venice
Padiglione della Francia, XXa Esposizione Biennale Internazionale d'Arte, 1 June–3 September, *Mostra retrospettiva di Edgar Degas (1834–1917).*

1937 New York
Durand-Ruel Galleries, 22 March–10 April, *Exhibition of Masterpieces by Degas.*

1937 Paris, Orangerie
Musée de l'Orangerie, 1 March–20 May, *Degas* (catalogue by Jacqueline Bouchot-Saupique and Marie Delaroche-Vernet; preface by Paul Jamot).

1937 Paris, Palais National
Palais National des Arts, Summer and Fall, *Chefs-d'oeuvre de l'art français.*

1938 New York
Wildenstein & Co., Inc., 1–29 March, *Great Portraits from Impressionism to Modernism.*

1939–40 Buenos Aires
Museo Nacional de Bellas Artes, July–August 1939/Montevideo, Salon Nacional de Bellas Artes, April 1940, *La pintura francesa, de David a nuestros dias,* 2 vols.

1939 Paris
Galerie André Weil, 9–30 June, *Degas: peintre du mouvement* (preface by Claude Roger-Marx).

1940–41 San Francisco M. H. de Young Memorial Museum, December 1940–January 1941, *The Painting of France: Since the French Revolution*.

1941 New York The Metropolitan Museum of Art, 6 February–26 March, *French Painting from David to Toulouse-Lautrec* (preface by Harry B. Wehle).

1947 Cleveland Cleveland Museum of Art, 5 February–9 March, *Works by Edgar Degas* (introduction by Henry Sayles Francis).

1947 Washington, D.C. Phillips Memorial Gallery, 30 March–30 April, *Loan Exhibition of Drawings and Pastels by Edgar Degas, 1834–1917*.

1948 Copenhagen Ny Carlsberg Glyptotek, 4–26 September/Stockholm, Galerie Blanche, 9 October–7 November, *Edgar Degas 1834–1917* (by Haavard Rostrup).

1948 Minneapolis The Minneapolis Institute of Arts, 6–28 March, *Degas's Portraits of His Family and Friends* (unnumbered checklist).

1949 New York Wildenstein & Co., Inc., 7 April–14 May, *A Loan Exhibition of Degas for the Benefit of the New York Infirmary* (text by Daniel Wildenstein).

1949 Paris Musée de l'Orangerie, May–June, *Pastels français des collections nationales et du Musée La Tour de Saint-Quentin*.

1950–51 Philadelphia Philadelphia Museum of Art, 4 November 1950–11 February 1951, *Diamond Jubilee Exhibition: Masterpieces of Painting*.

1951–52 Bern Kunstmuseum Bern, 25 November 1951–13 January 1952, *Degas* (catalogue by Fritz Schmalenbach).

1952 Amsterdam Stedelijk Museum, 8 February–24 March, *Edgar Degas*.

1952 Edinburgh Edinburgh Festival Society and Royal Scottish Academy, 17 August–6 September/London, Tate Gallery, 20 September–19 October, *Degas* (introduction and notes by Derek Hill).

1952–53 Washington, D.C. National Gallery of Art/The Cleveland Museum of Art, 9 December 1952–11 January 1953/Saint Louis, City Art Museum/Cambridge, Mass., Fogg Art Museum, 23 February–8 March/New York, The Metropolitan Museum of Art, 20 March–19 April, *French Drawings: Masterpieces from Five Centuries*.

1953–54 New Orleans Isaac Delgado Museum of Art, 17 October 1953–10 January 1954, *Masterpieces of French Painting through Five Centuries 1400–1900*.

1954 Detroit The Detroit Institute of Arts, 24 September–6 November, *The Two Sides of the Medal: French Painting from Gérôme to Gauguin* (by Paul Grigaut).

1955 New York M. Knoedler & Company, Inc., 9 November–3 December, *Edgar Degas: Original Wax Sculptures* (foreword by John Rewald).

1955 Paris, GBA Gazette des Beaux-Arts, opened 8 June, *Degas: dans les collections françaises* (catalogue by Daniel Wildenstein).

1955 Paris, Orangerie Musée de l'Orangerie, 20 April–3 July, *De David à Toulouse-Lautrec: chefs-d'oeuvres des collections américaines*.

1955 San Antonio Marion Koogler McNay Art Institute, 16 October–13 November, *Paintings, Drawings, Prints and Sculpture by Edgar Degas*.

1955–56 Chicago The Art Institute of Chicago, 13 October–27 November 1955/The Minneapolis Institute of Arts/The Detroit Institute of Arts, 11 January–11 February 1956/San Francisco, California Palace of the Legion of Honor, 7 March–10 April, *French Drawings: Masterpieces from Seven Centuries*.

1956 Paris Cabinet des Dessins, Musée du Louvre, 11 July–3 October, *Pastels du XIXe siècle* (no catalogue).

1957 Paris Musée Jacquemart-André, May–June, *Le second empire de Winterhalter à Renoir*.

1958 London The Lefevre Gallery, April–May, *Degas Monotypes, Drawings, Pastels, Bronzes* (foreword by Douglas Cooper).

1958 Los Angeles Los Angeles County Museum of Art, March, *Edgar Hilaire Germain Degas* (by Jean Sutherland Boggs).

1958–59 Rotterdam Boymans Museum, 31 July–28 September 1958/Paris, Musée de l'Orangerie, 1958–59/New York, The Metropolitan Museum of Art, 3 February–15 March, *French Drawings from American Collections: Clouet to Matisse* (published in Rotterdam as *Van Clouet tot Matisse, tentoonstelling van Franse tekeningen uit Amerikaanse collecties*, and in Paris as *De Clouet à Matisse: dessins français des collections américaines*).

1959 Williamstown Sterling and Francine Clark Art Institute, opened 3 October 1959, *Degas*.

1959–60 Rome Palazzo di Venezia, 18 December 1959–14 February 1960/Milan, Palazzo Reale, March–April, *Il disegno francese da Fouquet a Toulouse-Lautrec* (edited by Jacqueline Bouchot-Saupique; catalogue by Ilaria Toesca).

1960 New York Wildenstein & Co., Inc., 7 April–7 May, *Degas* (foreword by Kermit Lansner; introduction by Daniel Wildenstein).

1960 Paris Galerie Durand-Ruel, 9 June–1 October, *Edgar Degas 1834–1917* (introduction by Agathe Rouart-Valéry).

1962 Baltimore The Baltimore Museum of Art, 18 April–3 June, *Paintings, Drawings, and Graphic Works by Manet, Degas, Berthe Morisot and Mary Cassatt* (catalogue by Lincoln Johnson).

1964 Paris Cabinet des Dessins, Musée du Louvre, *Dessins de sculpteurs de Pajou à Rodin* (entries on drawings by Lise Duclaux, entries on sculptures by Michèle Beaulieu and Françoise Baron).

1964–65 Munich Haus der Kunst, 7 October 1964–6 January 1965, *Französische Malerei des 19. Jahrhunderts von David bis Cézanne* (preface by Germain Bazin).

1965 New Orleans Isaac Delgado Museum, 2 May–16 June, *Edgar Degas: His Family and Friends in New Orleans* (articles by John Rewald, James B. Byrnes, and Jean Sutherland Boggs).

1965–67 Cambridge, Mass. Fogg Art Museum, 15 November 1965–15 January 1966/New York, The Museum of Modern Art, 19 December 1966–26 February 1967, *Memorial Exhibition: Works of Art from the Collection of Paul J. Sachs* (catalogue by Agnes Mongan).

1967 Saint Louis City Art Museum of Saint Louis, 20 January–26 February/Philadelphia Museum of Art, 10 March–30 April/The Minneapolis Society of Fine Arts, 18 May–25 June, *Drawings by Degas* (by Jean Sutherland Boggs).

1967–68 Paris Musée de l'Orangerie, 16 December 1967–March 1968, *Vingt ans d'acquisitions au Musée du Louvre 1947–1967*.

1967–68 Paris, Jeu de Paume Musée du Jeu de Paume, Spring, *Autour de trois tableaux majeurs par Degas* (no catalogue).

1968 Cambridge, Mass. Fogg Art Museum, 25 April–14 June, *Degas Monotypes* (by Eugenia Parry Janis). Cited as 1968 Cambridge, Mass. for works in the exhibition. Cited as Janis 1968 for the checklist; see under Selected References.

1968 New York Wildenstein & Co., Inc., 21 March–27 April, *Degas' Racing World* (by Ronald Pickvance).

1968 Richmond Virginia Museum of Fine Arts, 23 May–9 July, *Degas.*

1969 Nottingham Nottingham University Art Gallery, 15 January–15 February, *Degas: Pastels and Drawings* (by Ronald Pickvance).

1969 Paris Musée de l'Orangerie, 27 June–15 September, *Degas: oeuvres du Musée du Louvre* (preface by Hélène Adhémar).

1970 Williamstown Sterling and Francine Clark Art Institute, 8 January–22 February, *Edgar Degas* (introduction by William Ittmann, Jr.).

1970–71 Leningrad The Hermitage Museum, 1 December 1970–10 January 1971/Moscow, Pushkin Fine Art Museum, 25 January–1 March, *Les impressionnistes français.*

1971 Madrid Museo Español de Arte Contemporaneo, April, *Los impresionistas franceses.*

1973–74 Paris Cabinet des Dessins, Musée du Louvre, 25 October 1973–7 January 1974, *Dessins français du Metropolitan Museum of Art, New York, de David à Picasso.*

1974 Boston Museum of Fine Arts, 20 June–1 September, *Edgar Degas: The Reluctant Impressionist* (by Barbara S. Shapiro).

1974 Dallas Dallas Museum of Fine Arts, 6 February–24 March, *The Degas Bronzes* (text by Charles Millard).

1974 Paris Bibliothèque Nationale, October 1974–January 1975, *L'estampe impressionniste* (catalogue by Michel Melot).

1974–75 Paris Grand Palais, 21 September–24 November, *Centenaire de l'impressionnisme*/New York, The Metropolitan Museum of Art, 12 December 1974–10 February 1975, *Impressionism: A Centenary Exhibition* (preface by Jean Chatelain and Thomas Hoving; foreword by Hélène Adhémar and Anthony M. Clark; introduction by René Huyghe; catalogue by Anne Dayez, Michel Hoog, and Charles S. Moffett).

1975 New Orleans New Orleans Museum of Art, 12 June–15 July, *Sculpture by Edgar Degas* (no catalogue).

1975 Paris Cabinet des Dessins, Musée du Louvre, June–September, *Pastels du XIXe siècle* (no catalogue).

1976 London The Lefevre Gallery, 18 November–21 December, *The Complete Sculptures of Degas* (introduction by John Rewald).

1976–77 Tokyo Seibu Museum of Art, 23 September–3 November/Kyoto City Art Museum, 7 November–10 December/Fukuoka Art Museum, 18 December 1976–16 January 1977, *Degas* (introduction and catalogue by François Daulte; articles by Denys Sutton, Antoine Terrasse, Pierre Cabanne, and Shuji Takashina).

1977 New York The Metropolitan Museum of Art, 26 February–4 September, *Degas in the Metropolitan* (checklist by Charles S. Moffett).

1978 New York Acquavella Galleries, Inc., 1 November–3 December, *Edgar Degas* (introduction by Theodore Reff).

1978 Paris Musée du Louvre, *Donation Picasso* (entries on Degas by Geneviève Monnier, Arlette Sérullaz, and Maurice Sérullaz).

1978 Richmond Virginia Museum of Fine Arts, 23 May–9 July, *Degas.*

1979 Bayonne Musée Bonnat, October–December, *Dessins français du Musée du Louvre d'Ingres à Vuillard.*

1979 Edinburgh National Gallery of Scotland for the Edinburgh International Festival, 13 August–30 September, *Degas 1879* (catalogue by Ronald Pickvance).

1979 Northampton Smith College Museum of Art, 5 April–27 May, *Degas and the Dance* (by Linda D. Muehlig).

1979–80 Ottawa National Gallery of Canada, 6 July–2 September/St. Catharines, Ont., Rodman Hall Art Centre, 1–30 November/Surrey, B.C., Surrey Art Gallery, 15 December 1979–15 January 1980/Regina, Sask., Mackenzie Art Gallery, 1–28 February/Charlottetown, P.E.I., Confederation Centre Art Gallery, *Prints of the Impressionists* (no catalogue; organized by Brian B. Stewart).

1980 Paris Musée Marmottan, 6 February–20 April [extended to 28 April], *Degas: la famille Bellelli* (introduction by Yves Brayer).

1980–81 New York The Metropolitan Museum of Art, 16 October–7 December 1980/Boston, Museum of Fine Arts, 24 January/22 March 1981, *The Painterly Print: Monotypes from the Seventeenth to the Twentieth Century* (essays by Eugenia Parry Janis, Barbara Stern Shapiro, Colta Ives, and Michael Mazur; catalogue by Barbara Stern Shapiro).

1981 San Jose San Jose Museum of Art, 15 October–15 December, *Mary Cassatt and Edgar Degas* (essay by Nancy Mowll Mathews).

1983 London Artemis Group (David Carritt Limited), 2 November–9 December, *Edgar Degas: 1834–1917* (introduction by Ronald Pickvance).

1983 Ordrupgaard Ordrupgaardsamlingen, Copenhagen, 11 May–24 July, *Degas et la famille Bellelli* (catalogue by Hanne Finson; introduction by Jean Sutherland Boggs).

1984 Chicago The Art Institute of Chicago, 19 July–23 September, *Degas in the Art Institute of Chicago* (introductions and catalogue by Richard R. Brettell and Suzanne Folds McCullagh).

1984 Tübingen Kunsthalle Tübingen, 14 January–25 March/Berlin, Nationalgalerie, 5 April–20 May, *Edgar Degas: Pastelle, Ölskizzen, Zeichnungen* (by Götz Adriani). English edition, *Degas: Pastels, Oil Sketches, Drawings*, New York: Abbeville Press, 1985.

1984–85 Boston Museum of Fine Arts, 14 November 1984–13 January 1985/Philadelphia Museum of Art, 17 February–14 April/London, Arts Council of Great Britain, Hayward Gallery, 15 May–7 July, *Edgar Degas: The Painter as Printmaker* (selection and catalogue by Sue Welsh Reed and Barbara Stern Shapiro; contributions by Clifford S. Ackley and Roy L. Parkinson; essay by Douglas Druick and Peter Zegers). Also cited as Reed and Shapiro 1984–85; see under Selected References.

1984–85 Paris Centre Culturel du Marais, 14 October 1984–27 January 1985, *Degas: Form and Space* (essays by Maurice Guillaud, Charles F. Stuckey, Thiébault-Sisson, Theodore Reff, Eugenia Parry Janis, David Chandler, and Shelley Fletcher). French edition, *Degas: le modelé et l'espace*, same publisher.

1984–85 Rome Villa Medici, 1 December 1984–10 February 1985, *Degas e l'Italia* (preface by Jean Leymarie; selection and catalogue by Henri Loyrette).

1984–85 Washington, D.C. National Gallery of Art, 22 November 1984–10 March 1985, *Degas: The Dancers* (by George T. M. Shackelford).

1985 London Arts Council of Great Britain, Hayward Gallery, 15 May–7 July, *Degas Monotypes* (organized by Lynne Green; foreword by R. B. Kitaj; catalogue by Anthony Griffiths).

1985 Paris Cabinet des Dessins, Musée du Louvre (Orsay), *Pastels du XIXe siècle* (catalogue by Geneviève Monnier). Also cited as Paris, Louvre and Orsay, Pastels, 1985; see under Selected References.

| 1985 Philadelphia | Philadelphia Museum of Art, 17 February–14 April, *Degas in Philadelphia Collections* (no catalogue). |

1985 Philadelphia Philadelphia Museum of Art, 17 February–14 April, *Degas in Philadelphia Collections* (no catalogue).

1986 Florence Palazzo Strozzi, 16 April–15 June/Verona, Palazzo di Verona, 27 June–7 September, *Degas scultore* (essays by Ettore Camesasca, Giorgio Cortenova, Thérèse Burollet, Lois Relin, Lamberto Vitali, Giovanni Piazza, and Luigi Rossi).

1986 Paris Grand Palais, 10 April–28 July, *La sculpture française au XIXe siècle* (edited by Anne Pingeot; entries on waxes by France Drilhon and Sylvie Colinart).

1986 Washington, D.C. National Gallery of Art, 17 January–6 April/The Fine Arts Museums of San Francisco, 19 April–6 July, *The New Painting: Impressionism 1874–1886* (by Charles S. Moffett, with essays by Stephen F. Eisenman, Richard Shiff, Paul Tucker, Hollis Clayson, Richard R. Brettell, Ronald Pickvance, Charles S. Moffett, Fronia E. Wissman, Joel Isaacson, and Martha Ward).

1987 Manchester Whitworth Art Gallery, 20 January–28 February/Cambridge, Mass., Fitzwilliam Museum, 17 March–3 May, *The Private Degas* (by Richard Thomson).

1987–88 New York The Jewish Museum, 13 September 1987–15 January 1988, *The Dreyfus Affair: Art, Truth, and Justice*.

Selected References

Adam 1886 Paul Adam, "Peintres impressionnistes," *La Revue Contemporaine Littéraire, Politique et Philosophique*, 4 April 1886, pp. 541–51.

Adhémar 1958 Cited as Paris, Louvre, Impressionnistes, 1958.

Adhémar 1974 Jean Adhémar and Françoise Cachin, *Degas: The Complete Etchings, Lithographs and Monotypes* (translated by Jane Brenton, foreword by John Rewald), New York: Viking Press, 1974. French edition, *Edgar Degas: gravures et monotypes*, Paris: Arts et Métiers Graphiques, 1973.

Adriani 1984 Cited as 1984 Tübingen; see under Exhibitions.

Ajalbert 1886 Jean Ajalbert, "Le Salon des impressionnistes," *La Revue Moderne*, Marseilles, 20 June 1886, pp. 385–93.

Alexandre 1908 Arsène Alexandre, "Collection de M. le Comte Isaac de Camondo," *Les Arts*, 83, November 1908, pp. 22–26, 29, 32.

Alexandre 1912 Arsène Alexandre, "La collection Henri Rouart," *Les Arts*, 132, December 1912, pp. 2–32.

Alexandre 1918 Arsène Alexandre, "Degas: graveur et lithographe," *Les Arts*, XV:171, 1918, pp. 11–19.

Alexandre 1929 Arsène Alexandre, "La collection Havemeyer: Edgar Degas," *La Renaissance de l'Art Français et des Industries de Luxe*, XX:10, October 1929, pp. 479–86.

Alexandre 1935 Arsène Alexandre, "Degas: nouveaux aperçus," *L'Art et les Artistes*, XXIX:154, February 1935, pp. 145–73.

Barazzetti 1936 S. Barazzetti, "Degas et ses amis Valpinçon," *Beaux-Arts*, 190, 21 August 1936, pp. 1, 3; 191, 28 August, pp. 1, 4; 192, 4 September, pp. 1–2.

Bazin 1931 Germain Bazin, "Degas: sculpteur," *L'Amour de l'Art*, 12th year, VII, July 1931, pp. 292–301.

Bazin 1958 Germain Bazin, *Trésors de l'impressionnisme au Louvre*, Paris: Éditions Aimery Somogy, 1958.

Beaulieu 1969 Michèle Beaulieu, "Les sculptures de Degas: essai de chronologie," *La Revue du Louvre et des Musées de France*, 19th year, 6, 1969, pp. 369–80.

Bénédite 1894 Léonce Bénédite, "La collection Caillebotte et l'école impressionniste," *L'Artiste*, VIII, August 1894, pp. 131–32.

Beraldi 1886 Henri Beraldi, *Les graveurs du XIXe siècle*, Paris: Librairie L. Conquet, V, 1886, p. 153.

Blanche 1919, 1927 Jacques-Émile Blanche, *Propos de peintre*, I, *De David à Degas*, Paris: Émile Paul Frères, 1st edition, 1919. 9th edition, 1927.

Boggs 1955 Jean Sutherland Boggs, "Edgar Degas and the Bellellis," *Art Bulletin*, XXXVII:2, June 1955, pp. 127–36, figs. 1–17.

Boggs 1958 Jean Sutherland Boggs, "Degas Notebooks at the Bibliothèque Nationale, I, Group A, 1853–1858," *Burlington Magazine*, C:662, May 1958, pp. 163–71; "II, Group B, 1858–1861," C:663, June 1958, pp. 196–205; "III, Group C, 1863–1886," C:664, July 1958, pp. 240–46.

Boggs 1962 Jean Sutherland Boggs, *Portraits by Degas*, Berkeley: University of California Press, 1962.

Boggs 1963 Jean Sutherland Boggs, "Edgar Degas and Naples," *Burlington Magazine*, CV:723, June 1963, pp. 273–76, figs. 30–37.

Boggs 1964 Jean Sutherland Boggs, "*Danseuses à la barre* by Degas," *The National Gallery of Canada Bulletin*, II:1, 1964, pp. 1–9.

Boggs 1967 Cited as 1967 Saint Louis; see under Exhibitions.

Boggs 1985 Jean Sutherland Boggs, "Degas at the Museum: Works in the Philadelphia Museum of Art and John G. Johnson Collection," *Philadelphia Museum of Art Bulletin*, LXXXI:346, 1985.

Bouchot-Saupique 1930 Cited as Paris, Louvre, Pastels, 1930.

Bouret 1965 Jean Bouret, *Degas*, Paris: Éditions Aimery Somogy, 1965. English edition (translated by Daphne Woodward), London: Thames and Hudson, 1965.

Brame and Reff 1984 Philippe Brame and Theodore Reff, *Degas et son oeuvre: A Supplement*, New York: Garland Press, 1984.

Brettell and McCullagh 1984 Cited as 1984 Chicago; see under Exhibitions.

Brière 1924 Cited as Paris, Louvre, Peintures, 1924.

Broude 1977 Norma Broude, "Degas's Misogyny," *Art Bulletin*, LIX:1, March 1977, pp. 95–107.

Browse [1949] Lillian Browse, *Degas Dancers*, London: Faber and Faber, [1949].

Browse 1967 Lillian Browse, "Degas's Grand Passion," *Apollo*, LXXXV:60, February 1967, pp. 104–14.

Buerger 1978 Janet F. Buerger, "Degas' Solarized and Negative Photographs: A Look at Unorthodox Classicism," *Image*, XXI:2, June 1978, pp. 17–23.

Buerger 1980 Janet F. Buerger, "Another Note on Degas," *Image*, XXIII:1, June 1980, p. 6.

Burroughs 1919 Bryson Burroughs, "Drawings by Degas," *The Metropolitan Museum of Art Bulletin*, XIV:5, May 1919, pp. 115–17.

Burroughs 1932 Louise Burroughs, "Degas in the Havemeyer Collection," *The Metropolitan Museum of Art Bulletin*, XXVII:5, May 1932, pp. 141–46.

Burroughs 1963 Louise Burroughs, "Degas Paints a Portrait," *The Metropolitan Museum of Art Bulletin*, XXI:5, January 1963, pp. 169–72.

Cabanne 1957 Pierre Cabanne, *Edgar Degas*, Paris: Pierre Tisné, 1957.

Cabanne 1973 Pierre Cabanne, "Degas chez Picasso," *Connaissance des Arts*, 262, December 1973, pp. 146–51.

Cachin 1974 Jean Adhémar and Françoise Cachin, *Degas: The Complete Etchings, Lithographs and Monotypes* (translated by Jane Brenton, foreword by John Rewald), New York: Viking Press, 1974. French edition, *Edgar Degas: gravures et monotypes*, Paris: Arts et Métiers Graphiques, 1973.

Callen 1971 Anthea Callen, "Jean-Baptiste Faure, 1830–1914: A Study of a Patron and Collector of the Impressionists and Their Contemporaries," unpublished M.A. thesis, University of Leicester, 1971.

Cambridge, Fogg, 1940 Cambridge, Mass., Fogg Art Museum, *Drawings in the Fogg Museum of Art* (by Agnes Mongan and Paul J. Sachs), 3 vols., Cambridge: Harvard University Press, 1940.

Chevalier 1877 Frédéric Chevalier, "Les impressionnistes," *L'Artiste*, 1 May 1877.

Claretie 1877 Jules Claretie, "Le mouvement parisien: l'exposition des impressionnistes," *L'Indépendance Belge*, 15 April 1877.

Claretie 1881 Jules Claretie, *La vie à Paris: 1881*, Paris: Victor Havard, 1881.

Cooper 1952 Douglas Cooper, *Pastels by Edgar Degas*, Basel: Holbein, 1952/New York: British Book Center, 1953.

Cooper 1954 Douglas Cooper, *The Courtauld Collection*, London: University of London, Athlone Press, 1954.

Coquiot 1924 Gustave Coquiot, *Degas*, Paris: Ollendorff, 1924.

Crimp 1978 Douglas Crimp, "Positive/Negative: A Note on Degas's Photographs," *October*, 5, Summer 1978, pp. 89–100.

Crouzet 1964 Marcel Crouzet, *Un méconnu du réalisme: Duranty (1833–1880), l'homme, le critique, le romancier*, Paris: Librairie Nizet, 1964.

Degas Letters 1947 *Degas Letters* (edited by Marcel Guérin, translated by Marguerite Kay), Oxford: Cassirer, 1947. French edition cited as Lettres Degas 1945.

Degas Sonnets 1946 *Huit Sonnets d'Edgar Degas* (preface by Jean Nepveu-Degas), Paris: La Jeune Parque, 1946.

Dell 1913 R.E.D. [Robert E. Dell], "Art in France," *Burlington Magazine*, XXII:119, February 1913, pp. 295–98.

Delteil 1919 Loys Delteil, *Edgar Degas*, Le peintre-graveur illustré, IX, Paris: privately printed, 1919.

Dunlop 1979 Ian Dunlop, *Degas*, New York: Harper, 1979.

F. F. 1921 'F. F., "Des peintres et leur modèle," *Le Bulletin de la Vie Artistique*, 2nd year, 9, 1 May 1921.

Fénéon 1886 Félix Fénéon, "Les impressionnistes en 1886 (VIIIe exposition impressionniste)," *La Vogue*, 13–20 June 1886, pp. 261–75 (reprinted in *Au-delà de l'impressionnisme* [edited by Françoise Cachin], Paris: Hermann, [1966], pp. 64–67).

Fénéon 1970 Félix Fénéon, *Oeuvres plus que complètes* (edited by Joan U. Halperin), 2 vols., Geneva: Librairie Droz, 1970.

Fevre 1949 Jeanne Fevre, *Mon oncle Degas* (edited by Pierre Borel), Geneva: Pierre Cailler, 1949.

Flint 1984 *Impressionists in England: The Critical Reception* (edited by Kate Flint), London: Routledge and Kegan Paul, 1984.

Fosca 1921 François Fosca [Georges de Traz], *Degas*, Paris: Messein, 1921.

Fosca 1930 François Fosca [Georges de Traz], *Les albums d'art Druet*, VI, Paris: Librairie de France, 1930.

Fosca 1954 François Fosca, *Degas: étude biographique et critique*, Le goût de notre temps, Geneva: Skira, 1954.

Frantz 1913 Henry Frantz, "The Rouart Collection," *Studio International*, L:199, September 1913, pp. 184–93.

Geffroy 1886 Gustave Geffroy, "Salon de 1886," *La Justice*, 26 May 1886, n.p.

Geffroy 1908 Gustave Geffroy, "Degas," *L'Art et les Artistes*, IV:37, April 1908, pp. 15–23.

Gerstein 1982 Marc Gerstein, "Degas's Fans," *Art Bulletin*, LXIV:1, March 1982, pp. 105–18.

Giese 1978 Lucretia H. Giese, "A Visit to the Museum," *Boston Museum of Fine Arts Bulletin*, LXXVI, 1978, pp. 43–53.

Goetschy 1880 Gustave Goetschy, "Indépendants et impressionistes [sic]," *Le Voltaire*, 6 April 1880.

Goncourt Journal 1956 Cited as Journal Goncourt 1956.

Grappe 1908, 1911, 1913 Georges Grappe, *Edgar Degas*, L'art et le beau, 3rd year, I, Paris: Librairie Artistique et Littéraire, 1908. Reprint editions, 1911, 1913.

Grappe 1936 Georges Grappe, *Edgar Degas*, Éditions d'histoire et d'art, Paris: Librairie Plon, 1936.

Gruetzner 1985 Anna Gruetzner, "Degas and George Moore: Some Observations about the Last Impressionist Exhibition," in *Degas 1834–1984* (edited by Richard Kendall), Manchester: Department of History of Art and Design, Manchester Polytechnic, 1985, pp. 32–39.

Guérin 1924 Marcel Guérin, "Notes sur les monotypes de Degas," *L'Amour de l'Art*, 5th year, March 1924, pp. 77–80.

Guérin 1931 Marcel Guérin, *Dix-neuf portraits de Degas par lui-même*, Paris: privately printed, 1931.

Guérin 1932 Marcel Guérin, "Trois portraits de Degas offerts par la Société des Amis du Louvre," *Bulletin des Musées de France*, 7, July 1932, pp. 106–07.

Guérin 1945 Cited as Lettres Degas 1945.

Guérin 1947 Cited as Degas Letters 1947.

Guest 1984 Ivor Guest, *Jules Perrot: Master of the Romantic Ballet*, London: Dance Books, 1984.

Halévy 1960 Daniel Halévy, *Degas parle . . .*, Paris: La Palatine, 1960.

Halévy 1964 Daniel Halévy, *My Friend Degas* (translated and edited by Mina Curtiss), Middletown: Wesleyan University Press, 1964. French edition cited as Halévy 1960.

Havemeyer 1931 *H. O. Havemeyer Collection: Catalogue of Paintings, Prints, Sculptures and Objects of Art*, New York: privately printed, 1931.

Havemeyer 1961 Louisine W. Havemeyer, *Sixteen to Sixty: Memoirs of a Collector*, New York: privately printed, 1961.

Haverkamp-Begemann 1964 Cited as Williamstown, Clark, 1964.

Hermel 1886 Maurice Hermel, "L'exposition de peinture de la rue Laffitte," *La France Libre*, 27 May 1886.

Hertz 1920 Henri Hertz, *Degas*, Paris: Librairie Félix Alcan, 1920.

Hoetink 1968 Cited as Rotterdam, Boymans, 1968.

Holst 1982 Cited as Stuttgart, Staatsgalerie, 1982.

Hoppe 1922 Ragnar Hoppe, *Degas och hans arbeten: Nordisk ägo*, Stockholm: P. A. Norstedt & Söner, 1922.

Hourticq 1912 Louis Hourticq, "E. Degas," *Art et Décoration*, suppl., XXXII, October 1912, pp. 97–113.

Huth 1946 Hans Huth, "Impressionism Comes to America," *Gazette des Beaux-Arts*, XXIX, April 1946, pp. 225–52.

Huyghe 1931 René Huyghe, "Degas ou la fiction réaliste," *L'Amour de l'Art*, 12th year, July 1931, pp. 271–82.

Huyghe 1974 René Huyghe, *La relève du réel: impressionnisme, symbolisme*, Paris: Flammarion, 1974.

Huysmans 1883 Joris-Karl Huysmans, *L'art moderne*, Paris: G. Charpentier, 1883.

Huysmans 1889 Joris-Karl Huysmans, *Certains: G. Moreau, Degas, Chéret, Whistler, Rops, Le Monstre, Le Fer, etc.*, Paris: Tresse et Stock, 1889.

Jacques 1877 Jacques [pseud.], "Menu propos: exposition impressionniste," *L'Homme Libre*, 12 April 1877.

Jamot 1914 Paul Jamot, "La collection Camondo au Musée du Louvre: les peintures et les dessins," pt. 2, *Gazette des Beaux-Arts*, 684, June 1914, pp. 441–60.

Jamot 1918 Paul Jamot, "Degas," *Gazette des Beaux-Arts*, XIV, April–June 1918, pp. 123–66.

Jamot 1924 Paul Jamot, *Degas*, Paris: Éditions de la Gazette des Beaux-Arts, 1924.

Janis 1967 Eugenia Parry Janis, "The Role of the Monotype in the Working Method of Degas," *Burlington Magazine*, CIX:766, January 1967, pp. 20–27; CIX:767, February 1967, pp. 71–81.

Janis 1968 Eugenia Parry Janis, *Degas Monotypes*, Cambridge, Mass.: Fogg Art Museum, 1968. Cited as Janis 1968 for works in the checklist; cited as 1968 Cambridge, Mass., for works in the exhibition; see under Exhibitions.

Janis 1972 Eugenia Parry Janis, "Degas and the 'Master of Chiaroscuro,'" *Museum Studies, The Art Institute of Chicago*, VII, 1972, pp. 52–71.

Janneau 1921 Guillaume Janneau, "Les sculptures de Degas," *La Renaissance de l'Art Français*, IV:7, July 1921, pp. 352–53.

Jeanniot 1933 Georges Jeanniot, "Souvenirs sur Degas," *La Revue Universelle*, LV, 15 October 1933, pp. 152–74; 1 November 1933, pp. 280–304.

Journal Goncourt 1956 Edmond and Jules de Goncourt, *Journal: mémoires de la vie littéraire* (edited by Robert Ricatte), 4 vols., Paris: Fasquelle, Flammarion, 1956.

Keller 1962 Harald Keller, *Edgar Degas: Die Familie Bellelli*, Stuttgart: Recham, 1962.

Kendall 1985 Richard Kendall, "Degas's Colour," in *Degas 1834–1984* (edited by Richard Kendall), Manchester: Department of History of Art and Design, Manchester Polytechnic, 1985, pp. 19–31.

Keyser 1981 Eugénie de Keyser, *Degas: réalité et métaphore*, Louvain-la-Neuve: Institut Supérieur d'Archéologie et d'Histoire de l'Art, Collège Erasme, 1981.

Koshkin-Youritzin 1976 Victor Koshkin-Youritzin, "The Irony of Degas," *Gazette des Beaux-Arts*, LXXXVII, January 1976, pp. 33–40.

Lafond 1918–19 Paul Lafond, *Degas*, 2 vols., Paris: H. Floury, 1918–19.

Lassaigne 1945 Jacques Lassaigne, *Edgar Degas*, Paris: Éditions Hypérion, 1945.

Lemoisne 1912 Paul-André Lemoisne, *Degas*, L'art de notre temps, Paris: Librairie Centrale des Beaux-Arts, 1912.

Lemoisne 1919 Paul-André Lemoisne, "Les statuettes de Degas," *Art et Décoration*, XXXVI, September–October 1919, pp. 109–17.

Lemoisne 1921 Paul-André Lemoisne, "Les carnets de Degas au Cabinet des Estampes," *Gazette des Beaux-Arts*, LXIII, April 1921, pp. 219–31.

Lemoisne 1924 Paul-André Lemoisne, "Artistes contemporains: Edgar Degas à propos d'une exposition récente," *Revue de l'Art Ancien et Moderne*, XLVI, June 1924, pp. 17–28; July 1924, pp. 95–108.

Lemoisne 1931 Paul-André Lemoisne, "À propos de la collection inédite de M. Marcel Guérin," *L'Amour de l'Art*, 12th year, July 1931, pp. 284–91.

Lemoisne 1937 Paul-André Lemoisne, "Degas," *Beaux-Arts*, 75th year, new series, 219, 12 March 1937, pp. A–B.

Lemoisne [1946–49] Paul-André Lemoisne, *Degas et son oeuvre*, 4 vols., Paris: Paul Brame and C. M. de Hauke, Arts et Métiers Graphiques, [1946–49]. Reprint edition, New York/London: Garland Publishing, 1984.

Leprieur and Demonts 1914 Cited as Paris, Louvre, Camondo, 1914, 1922.

Lettres Degas 1945 *Lettres de Degas* (edited by Marcel Guérin), Paris: Grasset, 1931. New edition with additional letters, 1945. English edition cited as Degas Letters 1947.

Lettres Gauguin 1984 *Correspondance de Paul Gauguin* (edited by Victor Merlhès), I, Paris: Fondation Singer-Polignac, 1984.

Lettres Pissarro 1950 *Camille Pissarro: lettres à son fils Lucien* (edited with the assistance of Lucien Pissarro by John Rewald), Paris: Éditions Albin Michel, 1950.

Lettres Pissarro 1980 *Correspondance de Camille Pissarro*, I: *1865–1885* (edited by Janine Bailly-Herzberg; preface by Bernard Dorival), Paris: Presses Universitaires de France, 1980.

Leymarie 1947 Jean Leymarie, *Les Degas au Louvre*, Paris: Librairie des Arts Décoratifs, 1947.

Lipton 1986 Eunice Lipton, *Looking into Degas: Uneasy Images of Women and Modern Life*, Berkeley/Los Angeles: University of California Press, 1986.

Loyrette 1984–85 Cited as 1984–85 Rome; see under Exhibitions.

Manet 1979 Julie Manet, *Journal (1893–1899)*, Paris: Librairie C. Klincksieck, 1979. English edition, *Growing up with the Impressionists: The Diary of Julie Manet* (translated, edited, and with an introduction by Rosalind de Boland Roberts and Jane Roberts), London: Sotheby's Publications, 1987.

Manson 1927 J. B. Manson, *The Life and Work of Edgar Degas*, London: Studio, 1927.

Mantz 1877 Paul Mantz, "L'exposition des peintres impressionnistes," *Le Temps*, 22 April 1877.

Mantz 1881 Paul Mantz, "Exposition des oeuvres des artistes indépendants," *Le Temps*, 23 April 1881.

Marx 1897 Roger Marx, "Cartons d'artistes: Degas," *L'Image*, 11, October 1897, pp. 321–25.

Masson 1927 Cited as Paris, Luxembourg, 1927.

Mathews 1984 *Cassatt and Her Circle: Selected Letters* (edited by Nancy Mowll Mathews), New York: Abbeville Press, 1984.

Mathieu 1974 Pierre-Louis Mathieu, "Gustave Moreau en Italie (1857–1859) d'après sa correspondance inédite," *Bulletin de la Société de l'Histoire de l'Art Français*, 1974, pp. 173–91.

Mathieu 1976 Pierre-Louis Mathieu, *Gustave Moreau*, Boston: New York Graphic Society, 1976.

Mauclair 1903 Camille Mauclair, "Artistes contemporains: Edgar Degas," *Revue de l'Art Ancien et Moderne*, XIV:80, November 1903, pp. 381–98.

Maupassant 1934 Guy de Maupassant, *La Maison Tellier*, Paris: Vollard, 1934.

Mayne 1966 Jonathan Mayne, "Degas's Ballet Scene from Robert le Diable," *Victoria and Albert Museum Bulletin*, II:4, October 1966, pp. 148–56.

McMullen 1984 Roy McMullen, *Degas: His Life, Times and Work*, Boston: Houghton Mifflin Company, 1984/London: Secker and Warburg, 1985.

Meier-Graefe 1920, 1924 Julius Meier-Graefe, *Degas*, Munich: R. Piper, 1920. Reprint edition, 1924.

Meier-Graefe 1923 Julius Meier-Graefe, *Degas* (translated by J. Holroyd-Reece), London: Ernest Benn, 1923. German edition cited as Meier-Graefe 1920, 1924.

Michel 1919 Alice Michel, "Degas et son modèle," *Mercure de France*, 16 February 1919, pp. 457–78, 623–39.

Migeon 1922 Cited as Paris, Louvre, Camondo, 1922.

Millard 1976 Charles W. Millard, *The Sculpture of Edgar Degas*, Princeton: Princeton University Press, 1976.

Minervino 1974 Fiorella Minervino, *Tout l'oeuvre peint de Degas* (introduction by Jacques Lassaigne), Paris: Flammarion, 1974. Original Italian edition, Milan: Rizzoli, 1970.

Mirbeau 1886 Octave Mirbeau, "Exposition de peinture," *La France*, Paris, 21 May 1886, pp. 1–2.

Moffett 1979 Charles S. Moffett, *Degas: Paintings in the Metropolitan Museum of Art*, New York: The Metropolitan Museum of Art, 1979.

Moffett 1985 Charles S. Moffett, *Impressionist and Post-Impressionist Paintings in the Metropolitan Museum of Art*, New York: The Metropolitan Museum of Art, Abrams, 1985.

Moffett 1986 Cited as 1986 Washington, D.C.; see under Exhibitions.

Mongan 1932 Agnes Mongan, "Portrait Studies by Degas in American Collections," *Bulletin of the Fogg Art Museum*, I:4, May 1932, pp. 61–68.

Mongan 1938 Agnes Mongan, "Degas as Seen in American Collections," *Burlington Magazine*, LXXII:423, June 1938, pp. 290–302.

Mongan and Sachs 1940 Cited as Cambridge, Fogg, 1940.

Monnier 1969 Geneviève Monnier, "Les dessins de Degas du Musée du Louvre: historique de la collection," *La Revue du Louvre et des Musées de France*, 19th year, 6, 1969, pp. 359–68.

Monnier 1978 Geneviève Monnier, "La genèse d'une oeuvre de Degas: 'Sémiramis construisant une ville,'" *La Revue du Louvre et des Musées de France*, 28th year, 5–6, 1978, pp. 407–26.

Moore 1890 George Moore, "Degas: The Painter of Modern Life," *Magazine of Art*, XIII, 1890, pp. 416–25.

Moore 1891 George Moore, *Impressions and Opinions*, New York: Scribner's, 1891.

Moore 1892 George Moore, "Degas in Bond Street," *The Speaker*, London, 2 January 1892, pp. 19–20.

Moore 1907–08 George Moore, "Degas," *Kunst und Künstler*, III, 6th year, 1907–08, pp. 98–108, 138–51.

Moore 1918 George Moore, "Memories of Degas," *Burlington Magazine*, XXXII:178, January 1918, pp. 22–29; XXXII:179, February 1918, pp. 63–65.

Moreau-Nélaton 1926 Étienne Moreau-Nélaton, *Manet raconté par lui-même*, 2 vols., Paris: H. Laurens, 1926.

Moreau-Nélaton 1931 Étienne Moreau-Nélaton, "Deux heures avec Degas," *L'Amour de l'Art*, 12th year, July 1931, pp. 267–70.

Morisot 1950 *Correspondance de Berthe Morisot*, Paris: Quatre Chemins-Éditart, 1950.

Morisot 1957 *The Correspondence of Berthe Morisot* (edited by Denis Rouart, translated by Betty W. Hubbard), London: Lund Humphries, 1957. French edition cited as Morisot 1950.

Newhall 1956 Beaumont Newhall, "Degas: Amateur Photographer, Eight Unpublished Letters by the Famous Painter Written on a Photographic Vacation," *Image*, V:6, June 1956, pp. 124–26. French translation, "Degas, photographe amateur," *Gazette des Beaux-Arts*, LXI, January 1963, pp. 61–64.

New York, Metropolitan, 1931 Cited as Havemeyer 1931.

New York, Metropolitan, 1943 New York, The Metropolitan Museum of Art, *European Drawings from the Collections of the Metropolitan Museum of Art, II: Flemish, Dutch, German, Spanish, French, and British Drawings*, New York, 1943.

New York, Metropolitan, 1967 New York, The Metropolitan Museum of Art, *French Paintings: A Catalogue of the Collection of the Metropolitan Museum of Art, III: XIX–XX Centuries* (by Charles Sterling and Margaretta M. Salinger), Greenwich: New York Graphic Society, 1967.

Nora 1973 Françoise Nora, "Degas et les maisons closes," *L'Oeil*, 219, October 1973, pp. 26–31.

Paris, Louvre, Camondo, 1914, 1922 Paris, Musée National du Louvre, *Catalogue de la collection Isaac de Camondo* (by P. Leprieur and L. Demonts), 1st edition, 1914. Second edition, 1922.

Paris, Louvre, Impressionnistes, 1947 Paris, Musée National du Louvre, *Catalogue des peintures et sculptures exposées au Musée de l'Impressionnisme, Jeu de Paume des Tuileries: les impressionnistes, leurs précurseurs et leurs contemporains* (entries on paintings by Hélène Adhémar, assisted by Mlles Berhaut, Bouthet, and Dureteste; entries on sculptures by Michèle Beaulieu), Paris: Musées Nationaux, 1947.

Paris, Louvre, Impressionnistes, 1958 — Paris, Musée National du Louvre, *Catalogue des peintures, pastels, sculptures impressionnistes exposés au Musée de l'Impressionnisme, Jeu de Paume des Tuileries* (entries on paintings by Hélène Adhémar, assisted by Madeleine Dreyfus-Bruhl; entries on pastels by Maurice Sérullaz; entries on sculptures by Michèle Beaulieu; preface by Germain Bazin), Paris: Musées Nationaux, 1958.

Paris, Louvre, Impressionnistes, 1973 — Paris, Musée du Louvre, *Musée du Jeu de Paume* (edited by Hélène Adhémar and Anne Dayez), Paris: Éditions des Musées Nationaux, 1973.

Paris, Louvre, Impressionnistes, 1979 — Paris, Musée du Louvre, *Musée du Jeu de Paume* (edited by Hélène Adhémar and Anne Dayez-Distel), Paris: Éditions de la Réunion des Musées Nationaux, 4th edition, revised, 1979.

Paris, Louvre, Pastels, 1930 — Paris, Musée National du Louvre, *Catalogue des pastels* (by Jacqueline Bouchot-Saupique), 1930.

Paris, Louvre, Peintures, 1924 — Paris, Musée National du Louvre: *Catalogue des peintures exposées dans les galeries*, I: *École française* (edited by Gaston Brière), Paris: Éditions des Musées Nationaux, 1924.

Paris, Louvre, Peintures, 1959 — Paris, Musée National du Louvre, *Peintures*, II: *École française: XIXe siècle* (by Charles Sterling and Hélène Adhémar), Paris: Éditions des Musées Nationaux, 1959.

Paris, Louvre, Peintures, 1972 — Paris, Musée National du Louvre, *Catalogue des peintures*, I: *École française*, Paris: Éditions des Musées Nationaux, 1972.

Paris, Louvre, Sculptures, 1933 — Paris, Musée National du Louvre, *Catalogue des sculptures du Moyen Age, de la Renaissance et des temps modernes*, suppl. (preface by Paul Vitry), Paris: Musées Nationaux, 1933.

Paris, Luxembourg, 1894 — Paris, Musée National du Luxembourg, *Catalogue sommaire des peintures, sculptures, dessins, gravures en médailles et sur pierres fines et objets d'art divers de l'école contemporaine exposés dans les galeries du Musée National du Luxembourg*, Paris, 1894.

Paris, Luxembourg, 1927 — Paris, Musée National du Luxembourg, *Catalogue des peintures, sculptures et miniatures*, Paris: Musées Nationaux, 1927.

Paris, Louvre and Orsay, Pastels, 1985 — Paris, Musée du Louvre, Cabinet des Dessins, Musée d'Orsay, *Pastels du XIXe siècle* (by Geneviève Monnier), Paris: Éditions de la Réunion des Musées Nationaux, 1985. Also cited as 1985 Paris for works in the exhibition; see under Exhibitions.

Paris, Louvre and Orsay, Peintures, 1986 — Paris, Musées du Louvre et d'Orsay, *Catalogue sommaire illustré des peintures du musée du Louvre et du musée d'Orsay: école française* (by I. Compin and Anne Roquebert), 3 vols., Paris: Éditions de la Réunion des Musées Nationaux, 1986.

Paris, Orsay, Sculptures, 1986 — Paris, Musée d'Orsay, *Catalogue sommaire illustré des sculpteurs* (by Anne Pingeot, Antoinette Le Normand-Romain and Laure de Margerie), Paris: Éditions de la Réunion des Musées Nationaux, 1986.

Passeron 1974 — Robert Passeron, *Impressionist Prints*, New York: Dutton, 1974.

Pica 1907 — Vittorio Pica, "Artisti contemporanei: Edgar Degas," *Emporium*, XXVI:156, December 1907, pp. 405–18.

Pickvance 1962 — Ronald Pickvance, "Henry Hill: An Untypical Victorian Collector," *Apollo*, LXXVI:10, December 1962, pp. 789–91.

Pickvance 1963 — Ronald Pickvance, "Degas's Dancers: 1872–1876," *Burlington Magazine*, CV:723, June 1963, pp. 256–66.

Pickvance 1966 — Ronald Pickvance, "Some Aspects of Degas's Nudes," *Apollo*, LXXXIII:47, January 1966, pp. 17–23.

Pickvance 1968 — Cited as 1968 New York; see under Exhibitions.

Pickvance 1979 — Cited as 1979 Edinburgh; see under Exhibitions.

Pissarro Letters 1980 — *Camille Pissarro: Letters to His Son Lucien* (edited with the assistance of Lucien Pissarro by John Rewald, translated by Lionel Abel), London: Routledge and Kegan Paul, 4th edition, 1980. French edition cited as Lettres Pissarro 1950.

Pittaluga and Piceni 1963 — M. Pittaluga and E. Piceni, *De Nittis*, Milan: Bramante, 1963.

Pothey 1877 — A. P. [Alexandre Pothey], "Beaux-Arts," *Le Petit Parisien*, 7 April 1877.

Raimondi 1958 — Riccardo Raimondi, *Degas e la sua famiglia in Napoli: 1793–1917*, Naples: SAV, 1958.

Reed and Shapiro 1984–85 — Sue Welsh Reed and Barbara Stern Shapiro, *Edgar Degas: The Painter as Printmaker* (with contributions by Clifford S. Ackley and Roy L. Parkinson; essay by Douglas W. Druick and Peter Zegers), Boston: Museum of Fine Arts, 1984. Cited as 1984–85 Boston for works in the exhibition; see under Exhibitions.

Reff 1963 — Theodore Reff, "Degas's Copies of Older Art," *Burlington Magazine*, CV:723, June 1963, pp. 241–51.

Reff 1964 — Theodore Reff, "New Light on Degas's Copies," *Burlington Magazine*, CVI:735, June 1964, pp. 250–59.

Reff 1965 — Theodore Reff, "The Chronology of Degas's Notebooks," *Burlington Magazine*, CVII:753, December 1965, pp. 606–16.

Reff 1968 — Theodore Reff, "Some Unpublished Letters of Degas," *Art Bulletin*, L:1, March 1968, pp. 87–93.

Reff 1969 — Theodore Reff, "More Unpublished Letters of Degas," *Art Bulletin*, LI:3, September 1969, pp. 281–89.

Reff 1971 — Theodore Reff, "Further Thoughts on Degas's Copies," *Burlington Magazine*, CXIII:82, September 1971, pp. 534–43.

Reff 1976 — Theodore Reff, *Degas: The Artist's Mind*, New York: The Metropolitan Museum of Art, Harper and Row, 1976.

Reff 1977 — Theodore Reff, "Degas: A Master among Masters," *The Metropolitan Museum of Art Bulletin*, XXXIV:4, Spring 1977, n.p.

Reff 1985 — Theodore Reff, *The Notebooks of Edgar Degas*, 2 vols., New York: Hacker Art Books, 2nd revised edition, 1985. First edition, London: Clarendon Press, 1976.

Rewald 1944 — John Rewald, *Degas, Works in Sculpture: A Complete Catalogue*, New York: Pantheon Books/London: Kegan Paul, Trench, Trubner and Co., 1944.

Rewald 1946, 1961, 1973 — John Rewald, *The History of Impressionism*, New York: Museum of Modern Art, 1st edition, 1946. Third revised edition, 1961. Fourth revised edition, 1973.

Rewald 1946 GBA — John Rewald, "Degas and His Family in New Orleans," *Gazette des Beaux-Arts*, XXX, August 1946, pp. 105–26. Reprinted in 1965 New Orleans; see under Exhibitions.

Rewald 1956 — John Rewald, *Degas: Sculpture*, New York: Abrams, 1956.

Rewald 1973 GBA — John Rewald, "Theo van Gogh, Goupil and the Impressionists," *Gazette des Beaux-Arts*, LXXXI, January 1973, pp. 1–64; February 1973, pp. 65–108.

Rewald 1986 John Rewald, *Studies in Post-Impressionism* (edited by Irene Gordon and Frances Weitzenhoffer), New York: Abrams, 1986.

Rich 1951 Daniel Catton Rich, *Degas*, New York: Abrams, 1951.

Rivière 1877 Georges Rivière, "L'exposition des impressionnistes," *L'Impressionniste*, 6 April 1877.

Rivière 1935 Georges Rivière, *Mr. Degas, bourgeois de Paris*, Paris: Floury, 1935.

Rivière 1922–23 Henri Rivière, *Les dessins de Degas*, Paris: Éditions Demotte, I, 1922; II, 1923. Reprint edition, 1973.

Roberts 1976 Keith Roberts, *Degas* (with notes by Helen Langdon), Oxford: Phaidon/New York: Dutton, 1976.

Rosenberg 1959 Jakob Rosenberg, *Great Draughtsmen from Pisanello to Picasso*, Cambridge, Mass.: Harvard University Press, 1959. Revised edition, 1974.

Roskill 1970 Mark Roskill, *Van Gogh, Gauguin and the Impressionist Circle*, Greenwich: New York Graphic Society, 1970.

Rotterdam, Boymans, 1968 Rotterdam, Museum Boymans-van Beuningen, *Catalogus van de Verzameling* (by H. R. Hoetink), 1968.

Rouart 1937 Ernest Rouart, "Degas," *Le Point*, 1 February 1937, pp. 5–36.

Rouart 1945 Denis Rouart, *Degas à la recherche de sa technique*, Paris: Floury, 1945.

Rouart 1948 Denis Rouart, *Degas monotypes*, Paris: Quatre Chemins-Éditart, 1948.

Scharf 1968 Aaron Scharf, *Art and Photography*, London: Allen Lane, 1968/Baltimore: Penguin, 1972.

Sérullaz 1979 Maurice Sérullaz, *L'univers de Degas*, Paris: Henri Scrépel, 1979.

Shackelford 1984–85 Cited as 1984–85 Washington, D.C.; see under Exhibitions.

Shapiro 1980 Michael Shapiro, "Degas and the Siamese Twins of the Café-concert: The Ambassadeurs and the Alcazar-d'Été," *Gazette des Beaux-Arts*, XCV:1335, April 1980, pp. 153–64.

Shapiro 1982 Michael Edward Shapiro, "Three Late Works by Edgar Degas," *The Bulletin, Museum of Fine Arts, Houston*, Spring 1982, pp. 9–22.

Sickert 1917 Walter Sickert, "Degas," *Burlington Magazine*, XXXI:176, November 1917, pp. 183–92.

Silvestre 1879 Armand Silvestre, "Le monde des arts," *La Vie Moderne*, 1 May 1879, pp. 52–53.

Sterling and Adhémar 1959 Cited as Paris, Louvre, Peintures, 1959.

Sterling and Salinger 1967 Cited as New York, Metropolitan, 1967.

Stuttgart, Staatsgalerie, 1982 Stuttgart, Staatsgalerie, *Malerei und Plastik des 19. Jahrhunderts* (edited by Christian von Holst), Stuttgart: Staatsgalerie, 1982.

Sutton 1986 Denys Sutton, *Edgar Degas: Life and Work*, New York: Rizzoli, 1986. French translation, *Degas: vie et oeuvre*, Fribourg: L'Office du Livre, 1986.

Sutton and Adhémar 1987 Denys Sutton and Jean Adhémar, "Lettres inédites de Degas à Paul Lafond et autres documents," *Gazette des Beaux-Arts*, CIX:1419, April 1987, pp. 159–80.

Terrasse 1974 Antoine Terrasse, *Edgar Degas*, Milan: Fratelli Fabbri, 1971, 1972/Garden City: Doubleday, 1974

Terrasse 1981 Antoine Terrasse, *Edgar Degas*, Frankfurt, Berlin, and Vienna: Ullstein Bücher, 1981.

Terrasse 1983 Antoine Terrasse, *Degas et la photographie*, Paris: Denoël, 1983.

Thiébault-Sisson 1921 François Thiébault-Sisson, "Degas sculpteur par lui-même," *Le Temps*, 23 May 1921, p. 3. Reprinted in 1984–85 Paris, pp. 177–82; see under Exhibitions.

Thomson 1979 Richard Thomson, "Degas in Edinburgh," *Burlington Magazine*, CXXI:919, October 1979, pp. 674–77.

Thomson 1985 Richard Thomson, "Notes on Degas's Sense of Humour," in *Degas 1834–1984* (edited by Richard Kendall), Manchester: Department of History of Art and Design, Manchester Polytechnic, 1985, pp. 9–19.

Thomson 1986 Richard Thomson, "Degas's Nudes at the 1886 Impressionist Exhibition," *Gazette des Beaux-Arts*, CVIII, November 1986, pp. 187–90.

Thomson 1987 Cited as 1987 Manchester; see under Exhibitions.

Thornley 1889 George William Thornley, *Quinze lithographies d'après Degas*, Paris: Boussod et Valadon, 1889.

Tietze-Conrat 1944 Erika Tietze-Conrat, "What Degas Learned from Mantegna," *Gazette des Beaux-Arts*, XXVI, December 1944, pp. 413–20.

Tucker 1974 William Tucker, *Early Modern Sculpture: Rodin, Degas, Matisse, Brancusi, Picasso, Gonzalez*, New York: Oxford University Press, 1974.

Valéry 1934, 1936, 1938, 1946, 1965 Paul Valéry, *Degas danse dessin*, Paris: Vollard, 1934, 1936/Gallimard, 1938, 1946, 1965.

Valéry 1960 Paul Valéry, *Degas Manet Morisot* (translated by David Paul), New York: Pantheon Books, 1960.

Vente I, 1918 *Catalogue des tableaux, pastels et dessins par Edgar Degas et provenant de son atelier . . .* , Paris: Galeries Georges Petit, 6–8 May 1918.

Vente II, 1918 *Catalogue des tableaux, pastels et dessins par Edgar Degas et provenant de son atelier . . .* , Paris: Galeries Georges Petit, 11–13 December 1918.

Vente III, 1919 *Catalogue des tableaux, pastels et dessins par Edgar Degas et provenant de son atelier . . .* , Paris: Galeries Georges Petit, 7–9 April 1919.

Vente IV, 1919 *Catalogue des tableaux, pastels et dessins par Edgar Degas et provenant de son atelier . . .* , Paris: Galeries Georges Petit, 2–4 July 1919.

Vente Collection I, 1918 *Catalogue des tableaux modernes et anciens: aquarelles, pastels, dessins . . . composant la collection Edgar Degas . . .* , Paris: Galeries Georges Petit, 26–27 March 1918.

Vente Collection II, 1918 *Catalogue des tableaux modernes: pastels, aquarelles, dessins, anciens et modernes . . . faisant partie de la collection Edgar Degas . . .* , Paris: Hôtel Drouot, 15–16 November 1918.

Vente Collection Estampes, 1918 *Catalogue des estampes anciennes et modernes . . . composant la collection Edgar Degas . . .* , Paris: Hôtel Drouot, 6–7 November 1918.

Vente Estampes, 1918 *Catalogue des eaux-fortes, vernis-mous, aqua-tintes, lithographies et monotypes par Edgar Degas et provenant de son atelier . . .* , Paris: Galerie Manzi-Joyant, 22–23 November 1918.

Venturi 1939 Lionello Venturi, *Les archives de l'impressionnisme*, 2 vols., Paris/New York: Durand-Ruel, 1939.

Villard 1881 Nina de Villars [sic], "Variétés: exposition des artistes indépendants," *Le Courrier du Soir*, 23 April 1881.

Vingt dessins [1897] *Degas: vingt dessins, 1861–1896*, Paris: Goupil et Cie, Boussod, Manzi, Joyant et Cie, [1896–98].

Vollard 1914 Ambroise Vollard, *Degas: quatre-vingt-dix-huit reproductions signées par Degas*, Paris: Vollard, 1914.

Vollard 1924 Ambroise Vollard, *Degas*, Paris: G. Crès et Cie, 1924.

Vollard 1936 Ambroise Vollard, *Recollections of a Picture Dealer* (translated by Violet M. Macdonald), London: Constable, 1936. French edition, *Souvenirs d'un marchand de tableaux*, Paris: Albin Michel, 1937. Revised and enlarged edition, 1959.

Vollard 1938 Ambroise Vollard, *En écoutant Cézanne, Degas, Renoir*, Paris: Grasset, 1938.

Walker 1933 John Walker, "Degas et les maîtres anciens," *Gazette des Beaux-Arts*, X, September 1933, pp. 173–85.

Wehle 1930 H. B. Wehle, "The Exhibition of the H. O. Havemeyer Collection," *The Metropolitan Museum of Art Bulletin*, XXV, March 1930, pp. 54–76.

Weitzenhoffer 1986 Frances Weitzenhoffer, *The Havemeyers: Impressionism Comes to America*, New York: Abrams, 1986.

Wick 1959 Peter A. Wick, "Degas' Violinist," *Boston Museum of Fine Arts Bulletin*, LVII:309, 1959, pp. 87–101.

Wildenstein 1964 Georges Wildenstein, *Gauguin*, Paris: Les Beaux Arts, 1964.

Williamstown, Clark, 1964 Williamstown, Sterling and Francine Clark Art Institute, *Drawings from the Clark Art Institute* (by Egbert Haverkamp-Begemann, Standish D. Lawder, and Charles W. Talbot, Jr.), 2 vols., New Haven/London: Yale University Press, 1964.

Williamstown, Clark, 1987 Williamstown, Sterling and Francine Clark Art Institute, *Degas in the Clark Collection* (by Rafael Fernandez and Alexandra R. Murphy), Williamstown: Sterling and Francine Clark Art Institute, 1987.

Index of Former Owners

General Index

Page numbers are in roman type and refer to material in the footnotes as well as to the texts. Catalogue numbers and figures are so designated. The index does not include references to contemporary authors, critics, exhibitions, or museums. The lists of exhibitions and selected references have not been indexed. For the provenances, see the Index of Former Owners, pages 621–22. (General Index compiled by Susan Bradford.)

Photograph Credits

Except for the following, photographs have been supplied by the owners or custodians of the works reproduced; the courtesy of all is gratefully acknowledged.

WORKS IN THE CATALOGUE

Allschwil-Basel, Hans Hinz 351
Amsterdam, Rijksmuseum 127
Boston, Geoffrey Stein Studio 294
Boston, Museum of Fine Arts 152, 194
Cambridge, Mass., Harvard University Art Museums (Fogg Art Museum) 378
Cleveland, The Cleveland Museum of Art 8
Cologne, DuMont Buchverlag 19
Copenhagen, Ole Woldbye 111
Dallas, Dallas Museum of Art 259
Leipzig-Mölkau, Gerhard Reinhold 154
Leningrad, Aurora Publishing 139
London, James Kirkman Ltd. 149
Montreal, Canadian Centre for Architecture 301
Narberth, Pa., Eric Mitchell 258
Nashville, Lyzon 260
New York, Giraudon/Art Resource 27
New York, Malcolm Varon for The Metropolitan Museum of Art 114, 143, 317
New York, The Metropolitan Museum of Art 71, 94, 112, 161, 175, 177, 202, 206, 215, 221, 228, 253, 270, 277, 307, 308, 332, 336, 339, 352, 356, 370, 386
New York, Pollitzer, Strong & Meyer 237
New York, Wildenstein and Co., Inc. 319

Paris, Bulloz 391
Paris, Réunion des Musées Nationaux 24, 43, 146, 214, 341
Paris, Studio Lourmel, Photo Routhier 230, 313, 360
Pau, Marie-Louise Pérony 115
Planegg, Blauel-Artothek 98
Toronto, The Art Gallery of Ontario 383
Zurich, Foto-Studio H. Humm 28, 86, 158, 205, 278, 385
Zurich, Walter Dräyer 361

COMPARATIVE FIGURES

Berlin, Walter Steinkopf Photographisches Atelier 112
Boston, Geoffrey Stein Studio 37
Cambridge, Mass., Harvard University Art Museums (Fogg Art Museum) 395
Chicago, The Art Institute of Chicago 100, 101, 103, 104
Chicago, John Crerar Library, University of Chicago 102
Chicago, The Newberry Library 99
Florence, Alinari 14, 15
Hamburg, Ralph Kleinhempel 248
London, Browse & Darby Ltd. 166
London, Christie's Colour Library 49
London, The Lefevre Gallery 245, 331
London, Tate Gallery 336
Merion Station, Pa., photograph © 1988 by the Barnes Foundation 176

New York, Acquavella Galleries, Inc. 230, 268, 291
New York, Art Resource 34, 38, 315
New York, Barbara Mathes Gallery Inc. 223
New York, The Metropolitan Museum of Art 75, 189, 196, 272
New York, Robert G. Osborne 228
New York, Sotheby's 33, 204
New York, Wildenstein and Co., Inc. 11, 234, 304
Ottawa, Karsh 9, 169, 270, 285
Ottawa, National Gallery of Canada 12, 66, 95, 96, 97, 106, 108, 135, 141, 203
Ottawa, National Library of Canada 298
Paris, Durand-Ruel archives 86, 92, 117, 123, 133, 138, 151, 156, 159, 160, 167, 175, 211, 215, 220, 231, 232, 236, 244, 246, 247, 257, 263, 267, 290, 292, 294, 308, 318, 319, 321, 328, 329
Paris, Bulloz 143, 205
Paris, Caisse Nationale des Monuments Historiques et des Sites, © Archives Photographiques, Paris/S.P.A.D.E.M. 27, 53, 185, 296, 306
Paris, Giraudon 305
Paris, Robert Schmit 239
Saint Louis, Mo., Michael Shapiro 140, 142, 240
Washington, D.C., National Gallery of Art 122
Zurich, Foto-Studio H. Humm 149
Lois Dinnerstein 182
Provided by the authors 23, 24, 35, 39, 44, 47, 57, 60, 71, 72, 73, 78, 81, 90, 124, 147, 150, 161, 163, 178, 179, 184, 188, 193, 195, 197, 199, 212, 214, 224, 225, 229, 235, 238, 252, 253, 254, 256, 258, 259, 284, 299, 317, 327